American Decorative Arts and Paintings in the Bayou Bend Collection

David B. Warren, Michael K. Brown,
Elizabeth Ann Coleman, and Emily Ballew Neff

THE MUSEUM OF FINE ARTS, HOUSTON
in association with
PRINCETON UNIVERSITY PRESS

American Decorative Arts and Paintings in the Bayou Bend Collection is made possible by the support of the Henry R. Luce Foundation and the National Endowment for the Arts.

Library of Congress Cataloging-in-Publication Data

American decorative arts and paintings in the Bayou Bend Collection / by David B. Warren, Michael K. Brown, Elizabeth Ann Coleman, and Emily Ballew Neff.

 p. cm.

 "The Museum of Fine Arts, Houston, in association with Princeton University Press."

 Includes bibliographical references and index.

 ISBN 0-691-05962-4 (cloth)—ISBN 0-89090-085-x (paperback)

 1. Bayou Bend Collection—Catalogs. 2. Art, American—Catalogs. 3. Decorative arts—United States—Catalogs. 4. Hogg, Ima—Art collections—Catalogs. 5. Art—Texas—Houston—Catalogs. 6. Decorative arts—Texas—Houston—Catalogs. I. Warren, David B., 1937– . II. Museum of Fine Arts, Houston.

NK805.A675 1998

709′.73′0747641411—dc21 98-17179

 CIP

FRONT COVER: High Chest of Drawers, Philadelphia (detail), 1760–1800 [cat. no. F133]

BACK COVER: Charles Willson Peale, *Self-Portrait with Angelica and Portrait of Rachel*, ca. 1782–85 [cat. no. P27]

MAIN FRONTISPIECE: John Singleton Copley, *Portrait of a Boy*, ca. 1758–60 [cat. no. P15]

FOREWORD FRONTISPIECE (p. VI): Bayou Bend, north facade

ACKNOWLEDGMENTS FRONTISPIECE (p. VIII): Queen Anne Sitting Room

INTRODUCTION FRONTISPIECE (p. XII): Drawing Room

Page 1: Detail of cat. no. F33

Page 163: Detail of cat. no. P29

Page 219: Detail of cat. no. W6

Page 245: Detail of cat. no. T23

Page 267: Detail of cat. no. M20

Page 369: Detail of cat. no. C96

Page 403: Detail of cat. no. G93

Photograph Credits

Front cover, back cover, and main frontispiece by Thomas R. DuBrock, department of photographic services, the Museum of Fine Arts, Houston.

Foreword, acknowledgments, and introduction frontispieces by Rick Gardner; Hogg family photograph (p. XIII), Prints and Photographs Collection, CN 00347a, the Center for American History, the University of Texas at Austin; all other photographs (pp. XIV–XX), archives of the Museum of Fine Arts, Houston.

Catalogue photographs by Thomas R. DuBrock, with Edward Bourdon, Lynn Diane De Marco, Rick Gardner, Hickey and Robertson, and Allen Mewbourn, for the Museum of Fine Arts, Houston.

Published by the Museum of Fine Arts, Houston, in association with Princeton University Press

In the United Kingdom: Princeton University Press, Chichester, West Sussex

10 9 8 7 6 5 4 3 2 1

Contents

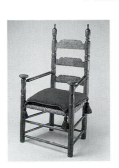

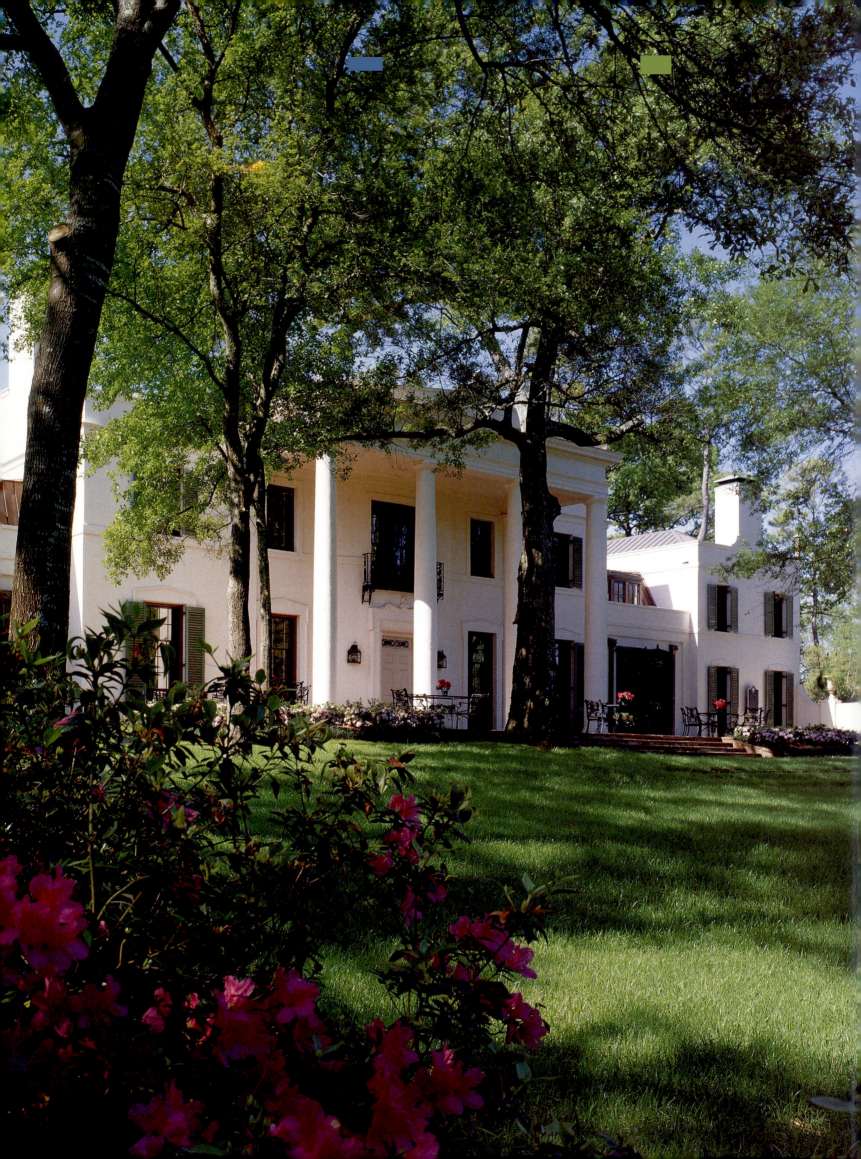

Foreword

Not long after Miss Ima Hogg (1882–1975), a native Texan, purchased her first piece of colonial American furniture in 1920, she conceived the idea of forming a collection for a museum in Texas. On the face of it, that idea may not seem particularly remarkable today. However, Miss Hogg's desire to establish such a collection should be viewed in its proper context. The Museum of Fine Arts, Houston—the first art museum in Texas—did not open to the public until 1924. That same year, The Metropolitan Museum of Art in New York opened its American Wing, the first permanent museum display of American furniture.

It was Miss Hogg's dream to assemble an outstanding collection of Americana in Houston so that the people of Texas would benefit from firsthand exposure to their colonial heritage. Over a period of more than fifty years, Miss Hogg relentlessly pursued the very finest American art and antiques. Although she intended initially to collect only furniture, she later broadened her scope and acquired paintings, textiles, sculpture, works on paper, metalwork, ceramics, and glass, all of which date from 1620 through 1870.

Throughout her career as a collector, Miss Hogg often worried about living so far away from the major centers of supply found along the Atlantic seaboard. Yet, as this book attests, being based in Texas in no way impeded her search to acquire the very best for her collection. As Miss Hogg continued to augment her holdings of American fine and decorative arts, she realized that a special building would be needed to house her vast collection. Thus she decided to leave her cherished works *in situ* at her beautiful residence, Bayou Bend, and Miss Hogg generously donated Bayou Bend to the Museum of Fine Arts, Houston, in 1957. Bayou Bend now serves as the American decorative arts wing of the museum.

After Bayou Bend formally opened to the public in 1966, the Museum of Fine Arts, Houston, sought to publish the collection, thereby enabling readers across the nation to learn about its impressive holdings. The first collection catalogue, published in 1975, documented only furniture, silver, and painting. During the past twenty years, the collection has grown in all areas.

Realizing the importance of updating information and publishing the entire collection, the Museum of Fine Arts, Houston, applied for and received a generous grant from the Henry R. Luce Foundation to support the cataloguing of the Bayou Bend Collection. A grant from the National Endowment for the Arts funded the research for a new, comprehensive catalogue.

A conservation survey of the collection, supported by a grant from the Getty Grant Program of the J. Paul Getty Trust, the Institute of Museum Services, the National Endowment for the Arts, the Cultural Arts Council of Houston, and the Texas State Historical Commission, revealed a wealth of new information and led to the establishment of a full-time conservation department for Bayou Bend. A team of curators and conservators began to research the collection. This book is the result of that productive collaboration.

I wish to give special thanks to and to salute the authors of *American Decorative Arts and Paintings in the Bayou Bend Collection:* David B. Warren, director of Bayou Bend, who served as project director of the publication; Michael K. Brown, curator of Bayou Bend; Elizabeth Ann Coleman, formerly curator of textiles and costume at the Museum of Fine Arts, Houston, and current David and Roberta Logie Curator of Textiles and Costume at the Museum of Fine Arts, Boston; and Emily Ballew Neff, curator of American painting and sculpture at the Museum of Fine Arts, Houston. Their contributions were invaluable, and I greatly appreciate the support that each author received from the formidable team of curatorial assistants and the panel of advisory consultants.

In closing, Miss Hogg once conveyed her wish that Bayou Bend would serve as a bridge between Texas and the rest of the nation and, in her own words, would "bring us closer to the heart of an American heritage which unites us." *American Decorative Arts and Paintings in the Bayou Bend Collection* signifies an important step toward fulfilling Miss Hogg's inspiring vision. I am extremely proud that this publication fully chronicles the Bayou Bend Collection, one of the greatest treasures of the Museum of Fine Arts, Houston.

Peter C. Marzio, *Director*
The Museum of Fine Arts, Houston

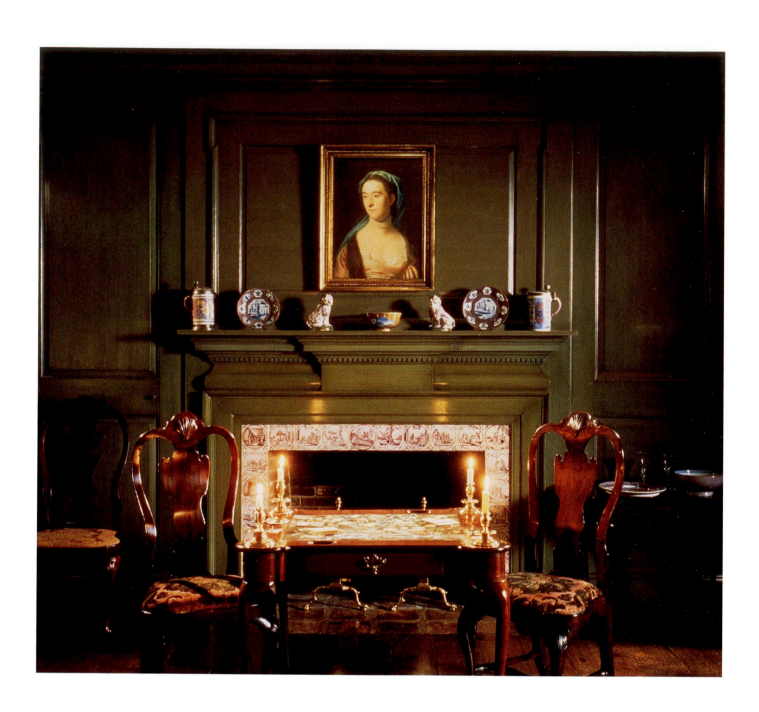

Acknowledgments

This catalogue would not have been possible without the considerable contributions and gracious assistance of many institutions and individuals. First, the authors would like to thank the generous funders who enabled the Museum of Fine Arts, Houston, to make this catalogue a reality. The Henry R. Luce Foundation provided an enormously generous grant under its program to support cataloguing American art collections. Without this grant, the project would very likely never have begun. A grant from the National Endowment for the Arts for the research phase of the project was also crucial. A conservation survey, funded by the Getty Grant Program of the J. Paul Getty Trust, the Institute of Museum Services, the National Endowment for the Arts, the Cultural Arts Council of Houston, and the Texas State Historical Commission, benefited the preparation of the catalogue. The Louise du Pont Crowninshield Fellowship awarded by the Henry Francis du Pont Winterthur Museum to Michael Brown allowed him invaluable access to the Winterthur collection and libraries.

We are most grateful to the Trustees of the Museum of Fine Arts, Houston, and the members of the Bayou Bend Board of Trustees for their ongoing support of our efforts. At the museum there are many staff members who deserve recognition. First and foremost, we thank Peter C. Marzio, director, who was an enthusiastic proponent of the project from the outset. Christine Waller Manca, editor in charge of the project, deserves special thanks. We also extend sincere thanks to Gwendolyn H. Goffe, associate director, finance and administration; Margaret C. Skidmore, associate director, development; Lorraine A. Stuart, archivist; O. B. Dyer, Tanzee Nicholls, Kathleen B. O'Connor, Nichole Pruitt, Lisa M. Roth, and Anne Schell at Bayou Bend; Barbara de la Torre, Andrea di Bagno, Wynne Phelan, Steven Pine, and Christopher Shelton in the conservation department; Britt Chemla, G. Clifford Edwards, Tina Llorente, Katherine S. Howe, and Cindi Strauss in the curatorial department; Barbara Michels, deputy development director; Beth Schneider, education director; Jacqui Allen, Jeannette Dixon, Jon Evans, Margaret Ford and Lea Whittington in the museum's Hirsch Library; Marty Stein, image librarian; Thomas R. DuBrock, photographer; David Aylsworth, Deborah Breckeen, Kathleen Crain, Richard Hinson, Eric Jones, Kelley Loftus, Ken Mazzu, and David Miller in the preparations department; Diane P. Lovejoy, publications director; Eula Mae Moore, publications secretary; Frances Carter Stephens, public relations director; Charles J. Carroll, Phyllis A. Hastings, and George Zombakis in the registrar's office; and Misty Moye and Alice Ross in the office of rights and reproductions. We thank Dorwayne Clements, Lois Corcoran, Marilyn O. Allen, Suzanne Decker, Karyn Galetka, Heidi Gerstacker, Shannon Halwes, Honey Harrison, Alice R. M. Hyland, Nancy Packer, Lisa Speich, and William R. Thompson, former staff members; and Catherine I. Farish, Laura K. Griffis, Eleanor Hero, and Karen Skaer, former interns. Frank Futral, former curatorial assistant, co-authored two entries in the paintings section (indicated by the initials FF). Photography by Thomas R. DuBrock was supplemented by the work of the late Edward Bourdon, Lynn Diane De Marco, Rick Gardner, Hickey and Robertson, and Allen Mewbourn.

We owe a deep debt of gratitude to the Bayou Bend docents, whose research papers executed during their provisional years have been an invaluable resource. We would particularly like to recognize those docents whose research has made significant contributions to this book: Janet Anderson, Betty Baird, Sarah Bartow, Margaret Baze, Marilyn Biehl, Fredricka Brecht, Leslie Bucher, Nancy Burns, Carol Butler, Florine F. Carr, Jean Cathriner, Elinor M. Christian, Lisa Davis, Elise Derrick, Maxine Dobrin, Marilyn Elliott, Mary Louise Emrich, Betty Frankhouser, Rocky Franzen, Carol Graham, Virginia Hamilton, Mary Lou Herbert, Cyril Hosley, Elwyn Hutchinson, Rebecca Jenkins, Carol O'Kelly Kayem, Terry Kelsey, Carol K. Kors, Susan Lawhon, Joan McClure, Jan McCracken, Linda Mims, Sallie Morian, Claudia R. Moursund, Phoebe Muzzy, Ann S. Noel, Mary Love Olsen, Donna Olney Passmore, Betty Lou Pecora, Sheila Perryman, Jane Rainey, Gayle Randol, Anne Ribble, Cecilia Mazzola Rockwell, Sara Rogers, Sarah Rommel, Christine Scheupbach, Cynthia Shealor, Cynthia Snell, Carolyn Vail, Joan Vaseliades, Toni Wallingford, and Lynda Walsh.

We thank the panel of advisory consultants who brought their expertise to the project during its early phases: Linda Baumgarten, textiles; Donald Fennimore,

metals; Morrison H. Heckscher, furniture; Jules D. Prown, paintings; and Arlene Palmer Schwind, ceramics and glass. Thanks also go to those who participated in the conservation survey: Mark Anderson, Greg Landry, and Michael Podmaniczky, furniture; Mary Ballard, textiles; Joseph Fronek, paintings; Andrew Lins, objects; and Wynne Phelan, works on paper. Gerald W. R. Ward served as scholarly reader and offered many insightful suggestions for improving the manuscript. Ellen G. Miles, curator of painting and sculpture, National Portrait Gallery, Smithsonian Institution, Washington, D.C., gave thoughtful advice for the paintings and drawings. The late Lillian B. Miller, historian of American culture and editor, the Peale Family Papers, National Portrait Gallery, graciously reviewed the catalogue entries involving Peale family members. R. Bruce Hoadley carried out the invaluable microscopic analysis of woods for the furniture entries.

In preparing this catalogue, we have benefited from the gracious cooperation and assistance of innumerable colleagues. We would like to thank the following professionals and academics and their respective institutions: Albany Institute of History and Art, Tammis K. Groft; American Antiquarian Society, Georgia Barnhill and Kathleen A. Major; American Numismatic Society, John M. Kleeburg; Art Institute of Chicago, Judith Barter and Kimberly Rhodes; Boston University, John T. Kirk; the Brooklyn Museum, Teresa A. Carbone and Kevin Stayton; Brown University, Robert P. Emlen; Center for Wood Anatomy Research, Regis Miller; Chester County Historical Society, Margaret Bleeker Blades; Chipstone Foundation, Luke Beckerdite; City of Mobile, Museum Department, Roy V. Tallon; City University of New York (The Graduate School and University Center), William H. Gerdts; Cleveland Museum of Art, Henry Hawley; Colonial Williamsburg, Wallace B. Gusler, Graham Hood, Ronald Hurst, Ivor Noël Hume, and Carolyn J. Weekley; Cooper-Hewitt Museum, David McFadden and Gail S. Davidson; Courtauld Institute of Art, Aileen Ribeiro; Dallas Museum of Art, Charles L. Venable; Daughters of the American Revolution Museum, Anne Ruta; Dubuque County Historical Society, Jerome A. Enzler; Fine Art Museums of San Francisco, Janice R. Hellman and Paula B. Freedman; Fine Arts Museum of the South at Mobile, Nan Yurcisin; Frick Art Reference Library, Patricia Barnett and Helen Sanger; Gibbes Museum of Art, Marianne Clare; Gibbs Memorial Library, the late Ruth Clark; Gold Leaf Studio, William Adair; Harvard University (Baker Library), Brent Sverdloff; Henry Ford Museum and Greenfield Village, the late Katherine B. Hagler;

High Museum of Art, Donald Peirce; Historic Deerfield, Peter Spang and Philip Zea; Historic Mobile Preservation Society, Sidney A. Smith; Historical Society of Pennsylvania, Jeanne Roberts; Honolulu Academy of Arts, James Jensen; Horticultural Society of New York, Charles B. Webster; Independence National Historic Park, Charles G. Dorman, Doris D. Fanelli, and Robert L. Giannini, III; Los Angeles County Museum of Art, Leslie Greene Bowman; Louisiana State University Museum of Art, H. Parrott Bacot; Lyman Allyn Museum, Edgar DeN. Mayhew; Marblehead Historical Society and Jeremiah Lee Mansion, Judy Anderson, Michele B. Cutting, and Karen MacInnis; Mariner's Museum, Richard C. Malley; Maryland Historical Society, Jennifer F. Goldsborough and Gregory R. Weidman; Massachusetts Historical Society, Peter Drummey, Marjorie Gutheim, Edward W. Hanson and Lynn Tucker; Metropolitan Museum of Art, Rudolph W. Colban, Alice Cooney Frelinghuysen, Morrison H. Heckscher, Peter Kenny, Carrie Rebora, Ellin Rosenzweig, Frances G. Safford, and Marjorie Shelley; Minneapolis Institute of Arts, Christopher Monkhouse; Monticello, Susan R. Stein; Mount Vernon Ladies Association, Christine Meadows; Museum of Art, Rhode Island School of Design, Elizabeth C. Leuthner and Thomas Michie; Museum of Early Southern Decorative Arts, Rosemary N. Estes, Frank Horton, and Bradford L. Rauschenberg; Museum of Fine Arts, Boston, the late Kathryn C. Buhler, Jonathan Fairbanks, Jeannine Falino, Erica E. Hirshler, Rhona Macbeth, and James M. Wright; Museum of the City of New York, the late Margaret Sterns and Deborah D. Waters; National Gallery of Art, Deborah Chotner; National Maritime Museum, Iain MacKenzie, Lindsey Macfarlane, D. J. Lyon, Mrs. P. M. Plackett-Barber, and Roger Quarm; National Portrait Gallery, London, Kai-Kin Yung; National Trust for Historic Preservation, the late Michael W. Berry and Elizabeth M. Laurent; National Trust, London, the late Gervase Jackson-Stops; Nelson-Atkins Museum of Art, George L. McKenna; New England Historic Genealogical Society, Gary B. Roberts; New Orleans Museum of Art, John Keefe; New York State Historical Association, Amy Barnum and Gilbert T. Vincent; New York State Office of Parks, Recreation and Historic Preservation, David Bayne and Susan May Haswell; Newark Museum, Ulysses G. Dietz; Old Dartmouth Historical Society, Richard C. Kugler; Parish of Trinity Church, New York, John Panter; Peabody Essex Museum, Prudence K. Backman, Daniel Finamore, Paul F. Johnston, Dean Lahikainen, Mary Silver Smith, and Robert K. Weis; Pennsylvania

Academy of Fine Arts, Susan Danly; Philadelphia Contributionship, Carol Wojtowicz; Philadelphia Museum of Art, Beatrice B. Garvan, Jack Lindsey, and Darrel L. Sewell; Phillips Trust House, Arthur Emery; Pierpont Morgan Library, Ruth Kraemer; Redwood Library and Atheneum, Richard L. Champlin; Rice University, Ira Gruber; Salem Maritime National Historic Site, John Frayler; Shelburne Museum, Lauren B. Hewes; *Silver* magazine, the late Diana Cramer; Smithsonian Institution, Kathleen Robinson; Society for the Preservation of New England Antiquities, Jane and Richard Nylander; South Carolina Historical Society, Elfrida M. Raley; Tate Gallery, Andrew Wilton; Temple Newsam House, Christopher Gilbert; *The Magazine Antiques,* Eleanor H. Gustafson and Allison E. Ledes; Tryon Palace Historic Sites and Gardens, Nancy Richards; University of Pennsylvania, Robert B. St. George; Wadsworth Atheneum, William N. Hosley, Jr.; Walters Art Gallery, William R. Johnston; Washington County Museum of Fine Arts, Jean Woods; Henry Francis du Pont Winterthur Museum, Janice H. Carlson, Wendy Cooper, Bert Denker, Deborah Duerbeck, the late Benno M. Forman, E. McSherry Fowble, Charles Hummel, Brock Jobe, E. Richard McKinstry, and Neville Thompson; Witte Museum, Cecilia Steinfeldt; Woodstock Historical Society, Inc., James W. Stockwell; Worcester Art Museum, Virginia Harding; Worcester Historical Museum, Richard V. Riccio; and Yale University, Millicent D. Abell, David Barquist, Edward S. Cooke, Jr., Helen A. Cooper, Patricia Kane, and Susan Prendergast Schoelwer. Thanks are also due to the following institutions and their staffs: Archives of American Art, Smithsonian Institution; Brown Fine Arts Library and Fondren Library, Rice University; Catalogue of American Portraits at the National Portrait Gallery, Smithsonian Institution; Houston Public Library, Clayton Library Center for Genealogical Research; New-York Historical Society; and New York Public Library.

The following dealers and auctioneers have been of great assistance: Ruth E. Bacon, Chris Bailey, Ronald Bourgeault, G.K.S. Bush, F. J. Carey, III, Janis Conner and Joel Rosenkranz; William Core Duffy, Stuart P. Feld, Edwin Firestone, J. Michael Flanigan, H. Grossman, Peter Hill, D. Roger Howlett, Leigh Keno, Joseph Kindig, III, Constantine Kollitus, Edward F. LaFond, Jr., Deanne Levison, Bernard Levy, S. Dean Levy, Frank Levy, Joseph C. Lionetti, Robert Lionetti, Israel E. Liverant, James Maroney, Albert Sack, Harold Sack, Robert Sack, Herbert Schiffer, Eric Shrubsole, Charlotte and Edgar Sittig, David Stockwell, Gary and Diana Stradling, Dave Thomas, Robert Trent, Phyllis Tucker, the late John S. Walton, Michael J. Weller, Rudolph G. Wunderlich; at Christie's, Jay Cantor, Ralph Carpenter, Dean F. Failey, John Hayes, and Jeanne Sloane; and at Sotheby's, Christine Ciampa, Wendell D. Garrett, Leslie Keno, Katherine Ross, and William Stahl.

We are grateful to the many collectors, conservators, independent scholars, and other individuals who have helped us: Mrs. Malcolm H. Barto, Henry L. P. Beckwith, John Bivins, the late Mary C. Black, Bache Bleecker, Lois Brazda, Kate P. Carey, Charles H. Carpenter, Dorothy S. Coleman, Francis Lowell Coolidge, Barry Dressel, Nancy Goyne Evans, Martha Gandy Fales, Alice Ford, Kathleen A. Foster, Madeleine Ginsburg, Thomas A. Gray, Jas A. Gundry, Joseph W. Hammond, Jonathan Harding, Benjamin Hewitt, Samuel J. Hough, Wilber H. Hunter, Phillip M. Johnston, Neil Kamil, Myrna Kaye, John T. Kirk, John Kollocik, Glee Krueger, Alice and Thomas Kugelman, Natasha Loeblich, Sharon Macpherson, the late Jack R. Maguire, Eleanor Price Mather, Kristan H. McKinsey, Jerry D. Meyer, Alan Miller, Robert Mussey, Milo M. Naeve, Bettina A. Norton, Thomas W. Parker, Mrs. Henry Carter Patterson, Mrs. Joshua Winslow Peirce, Ralph Pokluda, William K. du Pont, Stephen D. Pratt, Ian M. G. Quimby, Deborah McCraken Rebuck, Edward M. Riley, Betty Ring, Marguerite Riordan, Beatrix Rumford, Stanley Sax, Kenneth Scott, D. Albert Soeffing, Barbara A. Soltis, Harold Spencer, Mrs. Joseph T. Sullivan, II, Susan Swan, Kevin Sweeney, Page Talbott, David Tatham, Dorothy M. Vaughan, Keith Vincent, Barbara McLean Ward, Ralph Gibbs Whedon, Jr., John S. Whitehead, Mrs. Frederic Winthrop, Robert Winthrop, and Catherine Zusy.

It has been a pleasure to publish this catalogue in partnership with Princeton University Press. We are most grateful to Patricia Fidler, art editor, for her careful editing and her steadfast attention to every aspect of the volume. We also thank June Cuffner, proofreader; Lory Frankel, copy editor; Kathleen Friello, indexer; and Mary Kate Maco, publicity director. Deep appreciation goes to Bruce Campbell for the book's elegant design.

David B. Warren, Michael K. Brown,
Elizabeth Ann Coleman, and Emily Ballew Neff

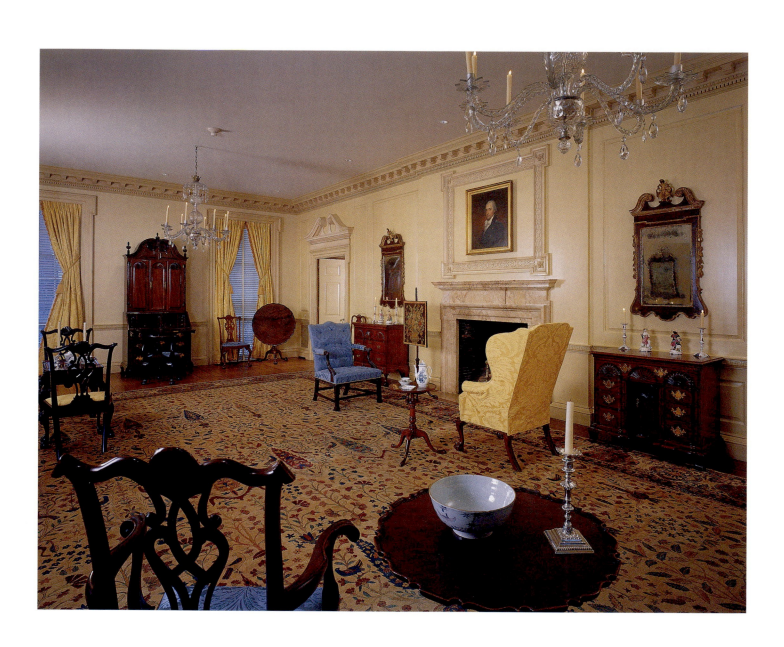

Introduction

Bayou Bend, the Collector, and the Collection

In 1920, Miss Ima Hogg (1882–1975) was sitting for a portrait in the New York studio of Wayman Adams. Not content simply to pose, she looked around the room, noting its contents. Her eyes fell upon a maple armchair, and she asked Adams about it. She was astonished to learn that it had been made in New England before the American Revolution. Miss Hogg was familiar with the nineteenth-century antebellum furniture in her grandparents' home and at the Governor's Mansion in Austin, where, as the daughter of Texas's first native-born governor, she had lived as a child. However, she was not aware, until that moment, of the existence of colonial American antiques.[1] It was this revelation that led to the inception of the Bayou Bend Collection.

Shortly after the illuminating discovery in Adams's studio, Miss Hogg purchased a similar "country Queen Anne armchair" from Manhattan dealers Collings and Collings (cat. no. F50). Although Miss Hogg had been collecting antiques, primarily English, before this time, acquiring this chair served as the catalyst for her focus on American antiques. Soon after, the concept of collecting early American furniture for a museum in Texas began to evolve. Miss Hogg wanted to provide the citizens of her beloved state the opportunity to become acquainted with this important facet of their American heritage.

Ima Hogg, born in the little East Texas town of Mineola, was the second child and only daughter of James Stephen and Sarah Stinson Hogg.[2] Their three sons were named William Clifford, Michael, and Thomas Elisha. Although the Hoggs were descended on both sides from genteel southern plantation stock, they found themselves living in relatively modest circumstances during the post-Civil War era. James, a newspaper owner and lawyer, became active in Texas politics and was successively elected attorney general (1886–90) and governor (1891–95). During his tenure as governor the family lived in the 1857 Greek Revival-style Governor's Mansion in Austin. In later years, Miss Hogg recalled the thrill of sleeping in the huge four-poster bed that had be-

longed to Sam Houston. This was certainly one of her early introductions to American antique furniture, and the experience of living in the mansion whetted her interest in history. Her father's position also brought her to new places. She first visited New York City and Providence, Rhode Island, in 1894, accompanying Governor Hogg on a political trip. Her mother died of tuberculosis the following year. In 1898 Ima traveled with her father to the kingdom of Hawaii when he was part of the American delegation that officiated over Hawaii's annexation to the United States. Seventy years later she reminisced at Bayou Bend with a visitor from Hawaii, noting, "I met your queen when I was a girl." An avid student of the piano from an early age, Ima moved to New York in 1901 to study at the National Conservatory of Music for five years. In 1907 she went to Berlin for three years of study before returning to Houston.

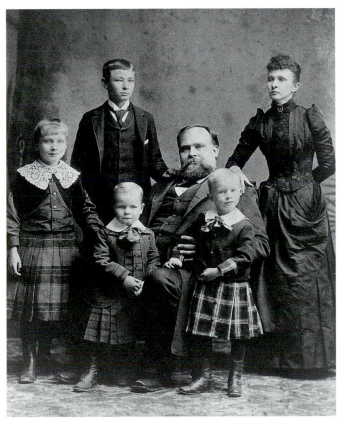

The Hogg family, ca. 1890. Left to right: Ima, William C., Thomas E., Governor James S., Michael, and Sarah Stinson Hogg.

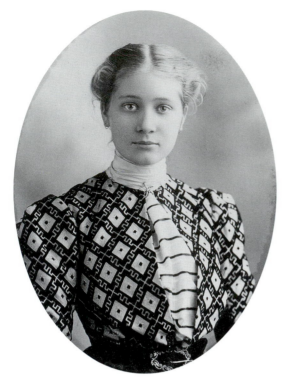

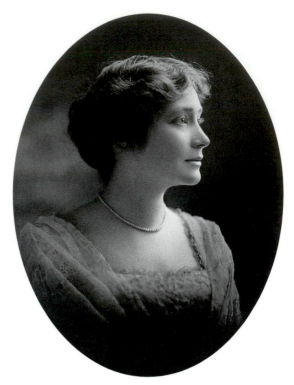

Ima Hogg, ca. 1894.

Ima Hogg, ca. 1913.

After James Hogg left the Governor's Mansion in 1895, he set up a law office, first in Austin and later in Houston. He also became involved in the nascent oil and gas business in Texas. He participated in a minor way at Spindletop in 1901 with the Hogg Swayne Syndicate and was a founder of the Texas Oil Company, which in 1906 became Texaco.[3] Hogg's 1901 purchase of Varner Plantation, an antebellum Greek Revival-style house and sugar plantation near West Columbia, forty miles south of Houston, was intended to provide a family home for him and his children. He was confident that there was oil on the property and, prior to his death in 1906, asked his children not to sell the property for at least twenty years. Indeed, oil was discovered there in January 1918, establishing the basis for the family fortune. That fortune led to a family real estate company that established River Oaks, the planned garden suburb in Houston, and the adjacent Homewoods where Bayou Bend would be built. William Hogg went on to become a civic leader and a founder of the Museum of Fine Arts, Houston, which opened to the public in 1924. Miss Ima Hogg, who was a founder of the Houston Symphony (1913), became interested in mental health, founding both the Houston Child Guidance Clinic (1927) and the Hogg Foundation for Mental Health (1938). Miss Hogg also became a zealous and renowned gardener and in later years pursued her interests in both collecting and historic preservation.[4]

Miss Hogg once noted that she had heard that collecting was a disease and that she thought she must have had it from childhood. Indeed, she was an inveterate collector, not only of Americana but also in other areas of art.[5] Evidence indicates that not long after her initial 1920 purchase, Miss Hogg's collecting of American antiques went into high gear. A revealing letter of January 1921 from Miss Hogg to her brother William (Will) is indicative of the course she would follow: "I want to make you a proposal. As I have my own ideas about antiques and furniture, and am fond of collecting them, let me do this. I missed a wonderful opportunity in the fall. You'd be amazed at the scarcity of American things."[6] Throughout her collecting career Miss Hogg never ceased to worry about the scarcity of fine American antiques. She also felt far removed from the center of the antiques trade when she was in Houston rather than in New York at the family's apartment at 290 Park Avenue purchased by Will Hogg in 1920. In the early 1920s she kept abreast of the field by subscribing to magazines, including *The Antiquarian; Arts and Decoration; International Studio;* and *The Magazine Antiques,* which, from 1922 through the early 1930s, came to both the New York apartment and the Houston residence. She also became friends with Charles O. Cornelius, curator of the American Wing at The Metropolitan Museum of Art, New York, with whom she enjoyed discussing Americana. In later years, she

noted that in the early 1920s there were no books available on American furniture and glass. However, in the late 1920s and early 1930s, as new publications began to be issued, she immediately enriched her library with these books, each carefully inscribed with her name and the date, usually the year of publication.

Despite her concerns about scarcity and isolation, the 1920s were marked by a steady stream of purchases, primarily of furniture. Purchases ranged from the Mannerist style of the seventeenth century (cat. no. F32) to the Neoclassical style of the late eighteenth century (cat. no. F175). The sources were prominent New York dealers—Collings and Collings (cat. no. F178), Israel Sack (cat. nos. F81, F99), and Ginsburg and Levy (cat. no. F79), among others—and auctions at the American Art Association, Anderson Galleries, of pioneer Americana, notably the sales of Louis G. Myers in 1921 and Jacob Paxson Temple in 1922 and 1923. Additionally, a number of pieces of glass (e.g., cat. no. G109) were acquired at these sales, as well as examples of Tucker porcelain (e.g., cat. no. C96). In the late 1920s, Miss Hogg also purchased glass from the glass scholar and

dealer George McKearin. A 1923 auction house receipt for a dozen or so lots of glass is made out in the name of Wayman Adams, suggesting that, in this instance, he was acting as an agent for Miss Hogg.[7] Will Hogg was also making purchases, and the majority of the Windsor furniture at Bayou Bend was bought by him at the Myers sale. Although the Hoggs' taste in paintings tended more toward the work of George Inness for Miss Hogg and of Frederic Remington for Will, an Edward Hicks painting of Penn's Treaty was also acquired in the Temple sale (cat. no. P42). Miss Hogg extended her search for paintings and folk art into New England, where she loved to make motoring trips in search of antiques. One find was a trade figure acquired in Boston in 1927 (cat. no. P61). A notation written on the bill in Miss Hogg's hand relates that it was to be held by the dealer, perhaps for a year, until the Hoggs were ready to receive it in Houston.[8] The antiques purchased by Miss Hogg and her brother furnished not only the Hogg residence in Houston but also the Hogg Brothers office, Varner Plantation, and the Park Avenue apartment.

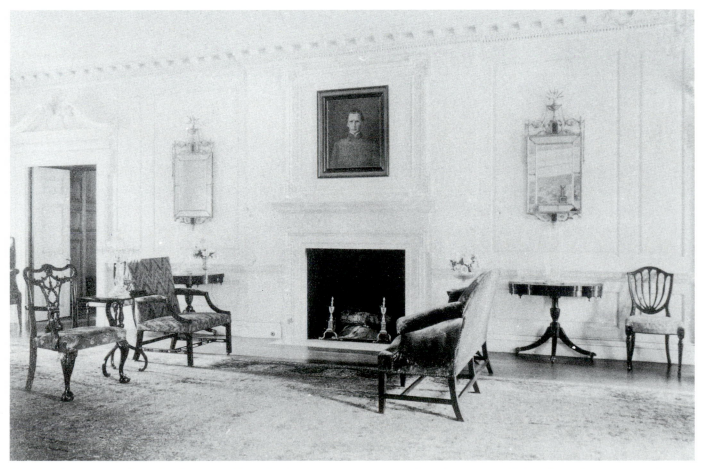

The Drawing Room at Bayou Bend, ca. 1930. Above the fireplace hangs a portrait of Ima Hogg's grandfather, General Joseph Lewis Hogg. The sofa (see cat. no. F161) has remained in the room continuously from 1928 to the present. Also visible are a pair of pier glasses (see cat. no. F185) and a pair of card tables (see cat. no. F207).

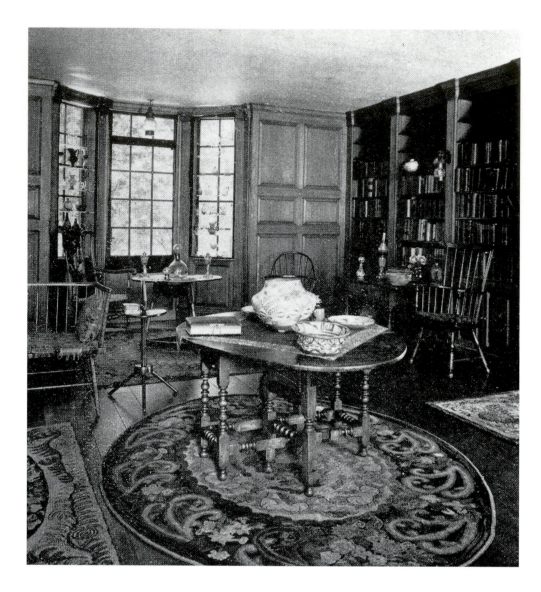

The Library (now known as the Pine Room) as it was illustrated in *House and Garden* magazine in March 1931. The armchair that was Ima Hogg's first acquisition of early American furniture (see cat. no. F50) is to the left of the window. A Windsor settee (see cat. no. F265) is at left, a Windsor armchair (see cat. no. F244) at right.

In 1926, Miss Hogg and her two bachelor brothers, Will and Michael (Mike), commissioned two Houston architects, Birdsall Briscoe and John F. Staub, to design a new residence for them. The house was to be located on a fourteen-acre site in Homewoods, an area of Houston being developed by the Hogg real estate interests, adjacent to their planned garden community of River Oaks, then also under development. Although Staub has historically been credited as the sole architect of Bayou Bend, the working drawings list Staub and Briscoe as associate architects.[9] Miss Hogg later recalled that she had considerable input on the final design. While she desired a gracious five-part neo-Palladian plan, she felt a brick Georgian elevation was not appropriate to the semitropical climate of the Gulf Coast. The resultant pink stucco exterior with ornamental cast-iron details, dubbed by Staub "Latin Colonial," was loosely based on Regency and Greek Revival architecture of antebellum Charleston and New Or-

leans. On the interior, Staub combined a variety of eighteenth- and early nineteenth-century styles to create harmonious settings for the growing Hogg collection. A year later, the house was completed, and the family was in residence in their new home in late November 1928. The design of the house excited critical interest and was published twice nationally in 1931.[10]

Although Miss Hogg by this time had explicitly referred to her plan to make the collection part of a museum eventually, the house was never intended as anything other than a residence. Early photographs of the interior show a delightful colonial revival mix, arranged for comfort and use. A name for the house provoked considerable deliberation in the family. As early as 1925, in a letter to her close friend Julia Ideson, Ima Hogg discussed naming the house. She related that she wanted a name that would suggest "quiet, contentment, country" and mentioned Bayou Banks as a possibility.[11] Indeed, the bill for the trade figure refers to

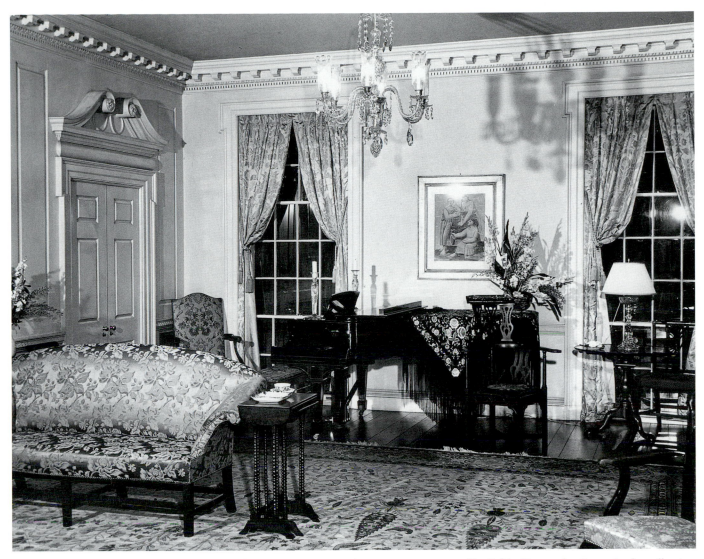

The Drawing Room, ca. 1947. Above the piano hangs *Three Women at the Fountain,* a 1921 pastel by Pablo Picasso that is now in the collection of the Museum of Fine Arts, Houston. A roundabout chair (see cat. no. F94) stands before the piano.

Bayou Banks, and the first guest book for the new house bears that name. The final name, Bayou Bend, firmly in place by 1929, reflects the topography; the Buffalo Bayou curves around three sides of the rolling wooded site.

In 1930, not long after the Hoggs had settled into Bayou Bend, Will died. Perhaps in reaction to the death of her fellow collector and mentor, the collection of Americana virtually ceased. In 1931, the prominent glass dealer George McKearin, apparently frustrated by the lack of response to his offerings, wrote, "I dislike to seem persistent, but really you are missing a wonderful opportunity to add some very rare pieces to your collection of early American glass."[12] Rather than following her penchant for Americana, Miss Hogg turned instead to contemporary European art and Southwestern Native American pottery, which she avidly collected. It was also during the 1930s that she extensively developed the gardens at Bayou Bend.

A few purchases of furniture were made in the early 1940s, including the rather daring acquisition of a set of Belter furniture (cat. no. F232), but it was not until after World War II that Miss Hogg resumed in earnest her pursuit of Americana. In 1946, Miss Hogg wrote to Joseph Downs, curator of the American Wing at The Metropolitan Museum of Art, to ask for his help and guidance. Having not collected for years, she explained, she felt "a little rusty and out of touch."[13] Interestingly, while Miss Hogg had worked with the most outstanding dealers in the 1920s, she did not then become acquainted with the other prominent collectors of the time, such as Francis P. Garvan or Henry Francis du Pont. She later came to know Mr. du Pont through her friendship with his sister, Louise du Pont Crowninshield, with whom she worked as an officer of the Garden Club of America in the early 1940s. In August 1947, she visited Mr. du Pont's collection at Winterthur for the first time. Two years later, through the newly

Fellow collector Katharine Prentis Murphy (left) joined Ima Hogg at the dedication of the Murphy Room at Bayou Bend, 1959.

established Antiques Forum at Colonial Williamsburg, she met the circle of collectors who would become her close friends: Katharine Prentis Murphy, Maxim Karolik, Electra Havemeyer Webb, Helen and Henry Flynt, and Ralph and Cynthia Carpenter. In a letter to Miss Hogg, Karolik called the group the "Antiquees" and commented that they were kindred souls.[14] Perhaps the closest of these friends was Katharine Murphy, for whom the Murphy Room at Bayou Bend is named. In later years Miss Hogg and Mrs. Murphy spoke by telephone every Sunday. The interaction with other collectors proved an important stimulus to Miss Hogg, helping her focus the goals for her own collection. In March 1956 many of these collector friends, including Katharine Murphy, Electra Webb, Henry and Helen Flynt, and Ruth and Henry du Pont, traveled to Houston for a house party given by Miss Hogg. There they discussed the collection at Bayou Bend and its future. While

there had been some thought of placing it in a museum context, Mr. du Pont, for example, encouraged her to leave the collection at Bayou Bend and create a house museum, which is eventually what happened.[15]

The acquisitions during the 1950s were remarkable for both their quality and their diversity. Such rare pieces of furniture as the Massachusetts japanned high chest (cat. no. F77), the Massachusetts easy chair with original Irish stitch show cover (cat. no. F97), the Newport block-and-shell desk and bookcase (cat. no. F123), and the Wharton family high chest (cat. no. F133) entered the collection. The concept of a house museum with room settings meant that the collection needed to be expanded beyond a nucleus group of furniture to be displayed in conventional museum galleries. Entire new areas of collecting began to be explored. In 1954, the first early American paintings were acquired—two John Singleton Copley oils (cat. nos. P15, P18), two Copley

pastels (cat. nos. P16, P17), five Copley drawings (cat. nos. P19–23), and a *Peaceable Kingdom* by Edward Hicks (cat. no. P41). Miss Hogg also began to collect metals, particularly silver and later pewter. She had always been fond of ceramics, and during this period she began to acquire an outstanding assemblage of eighteenth-century English earthenwares: Delft, Whielden, and salt glaze.

There is written evidence from as early as 1929 that the collection was destined for a museum. Over the years the Hogg family had formed close ties with the Museum of Fine Arts, Houston; in fact, Will Hogg was one of the museum's founders, and by 1945 three Hogg family collections had already been donated to the museum.[16] It was natural then that Miss Hogg should select the Museum of Fine Arts, Houston, to be the recipient of not only her collection of Americana, but also of the house and property that was Bayou Bend. A series of lengthy negotiations ensued after her initial proposal. Finally, in 1957, Bayou Bend was deeded to the Museum of Fine Arts, Houston, with the understanding that a house museum be created. Miss Hogg retained the right to reside at Bayou Bend for the remainder of her life, eventually transferring the collection to the museum in a series of gifts made over nearly two decades.

Shortly after the gift of the property, preparations began to transform what had been a comfortable home into a museum with a comprehensive program of historic room settings. In some cases, furniture of a specific geographic origin and style, formerly scattered in various locations, was gathered together for interpretation in one room, such as William and Mary furniture in the former library, renamed the Pine Room, or Chippendale examples in the Blue Room, which became the Massachusetts Room. In other cases, the existing interiors were reworked into entirely new rooms to provide settings for the collection. The first of these was the Murphy Room, created in honor of Katharine Murphy and intended to provide a setting for the earliest furniture in the collection. Miss Hogg based the interior on a room given by Mrs. Murphy to the New Hampshire Historical Society. Other rooms include the Newport Room and the Federal Parlor (which was originally intended to showcase southern furniture, but not enough examples were available). In each of the rooms, Miss Hogg attempted to create a correct architectural setting. In a salute to her beloved native state, she created a Texas Room, reproducing woodwork from an East Texas house where Sam Houston was thought to have lived. There she installed a collection of glass flasks depicting Mexican war heroes that had been at Bayou Bend since the late 1920s, prints of the Mexican War, and a collection of Texian Campaigne china. While most interiors at Bayou Bend parallel those in other collections, the Texas Room is unique.

By 1965, the conversion was virtually complete. A curator, David B. Warren, was hired, and Miss Hogg

Ima Hogg, photographed for the January 1953 issue of *Vogue* magazine.

Ima Hogg at age 91, 1973.

moved from the house to a high-rise apartment. In March 1966, Bayou Bend was formally opened to the public as a decorative arts branch of the Museum of Fine Arts, Houston. Miss Hogg's interest in Bayou Bend and the collection did not cease, however. She began collecting an entirely new period of furniture, acquiring superb early nineteenth-century Empire-style examples for the future Chillman Rooms, which opened in 1969. It had long been Miss Hogg's intention to have a "Belter Parlor," highlighting the innovative furniture of John Henry Belter, as well. That goal was achieved in 1971. While collecting for that room she

was offered a suite of furniture by Belter with its original 1855 bill. As she had already purchased a parlor set for Bayou Bend (cat. no. F235), she bought the documented Belter set for use at the Governor's Mansion in Austin. In the early 1980s the Belter set reverted to Bayou Bend (cat. no. F232). Superb individual pieces also acquired in the late 1960s and early 1970s include a portrait of Anne McCall by Robert Feke (cat. no. P7) and a tankard by John Coney (cat. no. M20). At the time of her death in 1975, Miss Hogg was negotiating the purchase of Ralph Earl's portrait of Mason Fitch Cogswell (cat. no. P33).

Miss Hogg always hoped that the Bayou Bend Collection would continue to grow. During the two decades since her death, following "wish lists" that she created, significant acquisitions have been made. A dressing table made in North Carolina is the sort of southern example she eagerly sought (cat. no. F127). A still life by James Peale added a new genre of painting to the collection (cat. no. P29). Two cut-glass tumblers from the Bakewell factory expanded the scope of the glass collection (cat. nos. G93, G94). A rare example of porcelain by Bonnin and Morris complemented the extensive Tucker porcelain holdings (cat. no. C94). The Decatur tureen represented an important genre of presentation silver given to heroes of the War of 1812 (cat. no. M86). Most recently, acquisition of a court cupboard (cat. no. F33), a wainscot chair (cat. no. F1), and a silver dram cup by John Hull and Robert Sanderson, Sr. (cat. no. M15), fulfilled three of Miss Hogg's long-standing, high-priority desires for the Bayou Bend Collection.

1. It is interesting to note in retrospect that Miss Hogg had traveled in New England, where she was obviously exposed to colonial furniture, but it apparently did not register at the time. In 1894, she and her father visited the home of Governor Brown of Rhode Island, where she would have seen his family's Townsend-Goddard furniture.

2. The unusual name Ima, came from an epic Civil War poem, *The Fate of Marvin,* written by James Hogg's uncle Thomas Elisha Hogg and published in Houston in 1873. The heroine's name was Ima. Popular stories of a twin sister named Ura are purely fictional.

3. Spindletop, the location of a large salt dome outside Beaumont, was the site of the first major oil discovery in Texas in 1901. In the ensuing development boom, the surrounding land was divided into sectors and sold to investors, both large and small, including the Hogg Swayne Syndicate.

4. She was recognized by the Garden Club of America with the Amy Angell Collier Montague Award in 1959 and received the National Trust for Historic Preservation Louise du Pont Crowninshield Award in 1969.

5. Miss Hogg's other collecting activities have been well documented elsewhere; see Warren 1982.

6. Ima Hogg to Will Hogg, January 27, 1921, Will Hogg papers, Eugene B. Barker Texas History Center, University of Texas, Austin.

7. Jacob Paxson Temple Sale, 1923. Bayou Bend Archives.

8. Bayou Bend object files.

9. Undated, Bayou Bend Archives. The bills indicate that each was paid an equal fee.

10. "'Bayou Bend'— A Georgian Residence in Texas," *House and Garden,* March 1931, 63–65; *Southern Architecture Illustrated* (Atlanta: Harman Publishing Company, 1931) 34–38.

11. Ima Hogg to Julia Ideson, September 1925, Ima Hogg papers, Eugene B. Barker Texas History Center, Austin.

12. Bayou Bend Archives.

13. Bayou Bend Archives.

14. Maxim Karolik to Ima Hogg, July 11, 1957, Bayou Bend Archives.

15. Letter from H. F. du Pont to the author, February 11, 1966, Winterthur Archives.

16. Will Hogg's collection of paintings by Frederick Remington (1943), Ima Hogg's collection of twentieth-century European modernist paintings, drawings, and prints (1939), and Ima Hogg's collection of Southwestern Native American pottery and kachina dolls (1944).

Notes to the Reader

Selection of objects: The catalogue documents objects in the Bayou Bend Collection, primarily of American origin. It also includes some objects of English or Continental origin that have strong historical or iconographic associations with America.

Authors of catalogue entries: Catalogue entries for each chapter are written by the following authors. Exceptions are designated by an author's initials at the end of the entry.

Furniture
Mannerist and Early Baroque	David B. Warren
Late Baroque	Michael K. Brown
Rococo	Michael K. Brown
Neoclassical	Michael K. Brown
Grecian	David B. Warren
Rococo Revival	David B. Warren
Windsor	David B. Warren
Paintings, Drawings, and Sculpture	Emily Ballew Neff
Prints and Other Works on Paper	David B. Warren
Textiles	Elizabeth Ann Coleman
Metals	Michael K. Brown
Ceramics	David B. Warren
Glass	David B. Warren

Catalogue numbers: Catalogue numbers include letter prefixes indicating the respective chapters.

Furniture	F
Paintings, Drawings, and Sculpture	P
Prints and Other Works on Paper	W
Textiles	T
Metals	M
Ceramics	C
Glass	G

Woods: All woods used in furniture construction have been identified through microscopic analysis by Dr. R. Bruce Hoadley, unless otherwise noted. In the main object headings, primary woods are given, followed by the phrase "and secondary woods" when appropriate; in technical notes, primary woods are cited first, secondary woods are cited following a semicolon, and wood locations are given in parentheses.

Dimensions: All measurements were made from the outermost extents of each object (for example, in teapots and coffeepots, from edge of spout to handle). Unless otherwise specified, dimensions are given as height by width by depth by diameter (as noted) in inches, with conversion to centimeters in parentheses.

Donor credit: All objects are the gift of Miss Ima Hogg, unless otherwise noted.

Accession numbers: The first element of the accession number, "B," identifies the object as part of the Bayou Bend Collection within the Museum of Fine Arts, Houston. The number after the first decimal point generally indicates the year the object was acquired by Bayou Bend. However, in 1969, the museum embarked on a program to assign formal accession numbers to objects in the collection; hence many objects bear an accession number beginning "B.69." During the decades of amassing her collection, Miss Hogg used various methods of recording acquisitions, and when possible, the accession number reflects the year Miss Hogg acquired the piece. After the second decimal point is a number that begins with the first acquisition of the calendar year and runs consecutively within that year. The number or letter after the third decimal point designates a specific object within a set.

Exhibitions: Exhibition histories are provided for paintings, drawings, and sculptures only. Bayou Bend's paintings, either individually or in groups, were often exhibited at the Museum of Fine Arts, Houston, but reference to these exhibitions are omitted from the exhibition histories. Exhibition histories for other objects are available in the Bayou Bend object files.

References: References in the catalogue entries indicate published citations or illustrations of the object catalogued, or, in the case of prints, other examples of the same edition.

Furniture: All designations of left and right for furniture imply proper left and proper right.

Silver and gold objects: Weights are not given when other materials are incorporated in the object.

Silver and pewter flatware: Unless otherwise noted, marks appear on the back of the handle and engraving on the front of the handle.

Upholstery: All upholstery is modern, unless otherwise noted.

Bibliography: Author-date citations in the catalogue refer to the Bibliography, where full citations are given.

Illustrations: Objects not illustrated are indicated by a star after the catalogue number.

Abbreviations:

Chipstone	*Chipstone Foundation, Milwaukee, Wisconsin*
DAPC	*Decorative Arts Photographic Collection, the Henry Francis du Pont Winterthur Museum, Winterthur, Delaware*
Historic Deerfield	*Historic Deerfield Inc., Deerfield, Massachusetts*
MESDA	*Museum of Early Southern Decorative Arts, Winston-Salem, North Carolina*
MFA, Boston	*The Museum of Fine Arts, Boston*
MFA, Houston	*The Museum of Fine Arts, Houston*
MMA	*The Metropolitan Museum of Art, New York*
NGA	*National Gallery of Art, Washington, D.C.*
PMA	*Philadelphia Museum of Art, Pennsylvania*
RISD	*Museum of Art, Rhode Island School of Design, Providence*
SPNEA	*Society for the Preservation of New England Antiquities, Boston and Waltham, Massachusetts*
Strawbery Banke	*Strawbery Banke, Inc., Portsmouth, New Hampshire*
Toledo	*Toledo Museum of Art, Ohio*
Wadsworth	*Wadsworth Atheneum, Hartford, Connecticut*
Williamsburg	*Colonial Williamsburg Foundation, Williamsburg, Virginia*
Winterthur	*The Henry Francis du Pont Winterthur Museum, Winterthur, Delaware*
Yale	*The Yale University Art Gallery, New Haven, Connecticut*

New York refers to New York City.

FURNITURE

F1

Great Chair

1640–85
Essex County, Massachusetts
*White oak; 37⅝ x 23½ x 20¾″ (95.6 x 59.7 x
52.7 cm)*
Gift of Miss Ima Hogg by exchange, B.94.11

A high-style representative of joined seating furniture made with mortise-and-tenon construction, the great chair conveyed its owner's elevated social status in seventeenth-century America. Contemporaneous with turned spindle-back and slat-back great chairs (see cat. nos. F2, F4), the joined examples are considerably rarer today. The Bayou Bend chair is one of six closely related examples, several of which

have strong Essex County histories, and it is likely they were made there. All feature front legs and arm supports resembling rudimentary Tuscan columns, square in section, that have been worked with a saw, drawknife, and plane rather than being turned, as well as a flat crest rail that projects over the stiles. While each crest has arcadelike carved ornament, the number of semicircular arches in the arcade ranges from four on one example to eight on two other chairs; two more have five, and the Bayou Bend chair has seven. The carved, scrolled ornament on the upper stiles varies in design, placement, and size. Similarly, the carved decoration of the inset back panel presents four distinct variations. These factors indicate that rather than being the product of one shop, these joined great chairs were made by several individual Essex County joiner-carvers who looked to a common model. That East Anglia, England, may be the source is suggested by the shallow,

Mannerist-style strapwork, semicircular arches, and abstract leaf carving, which relate to the vocabulary of carved ornament found on East Anglian examples. The scrolls that appear on the stiles of all six are also seen in East Anglian work.

PROVENANCE: [James L. Moulton, Lynn, Massachusetts]; purchased by James Lovell Little, Brookline, Massachusetts, August 21, 1875; to his daughter, Laura Little, Brookline; purchased by Bertram K. and Nina Fletcher Little, Brookline, May 1944; purchased by Bayou Bend at Sotheby's, New York, sale 6612, October 22, 1994, part II, lot 661.

RELATED EXAMPLES: MMA, with five arches and arc-and-leaf carved panel, arc-and-leaf carving on frame below (Keyes 1938, p. 297, fig. 4), is most similar to the Bayou Bend chair; MFA, Boston, with eight arches on crest rail and guilloche carved panel, uncarved frame below (Randall 1965, no. 120); Pilgrim Hall Museum, Plymouth, Massachusetts, with eight arches and strapwork carved panel, interlaced arc-and-leaf carving on frame below; Winterthur, with five arches and strapwork

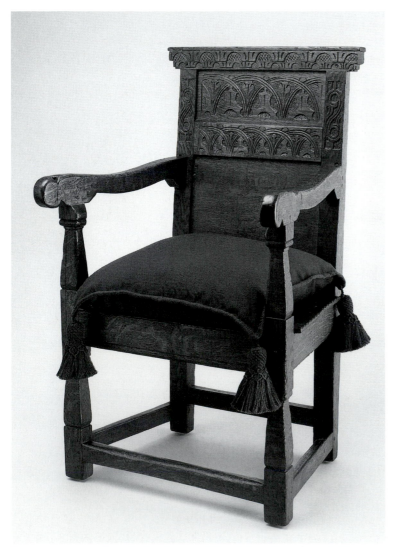

F1

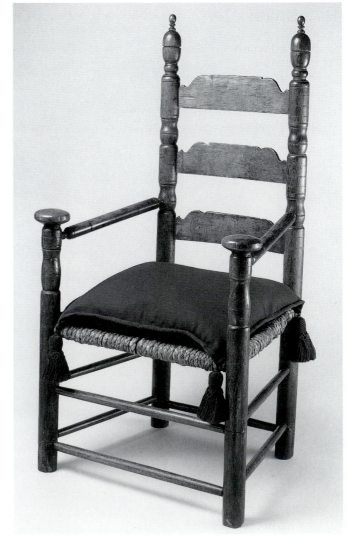

F2

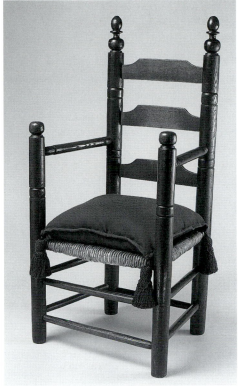

F3

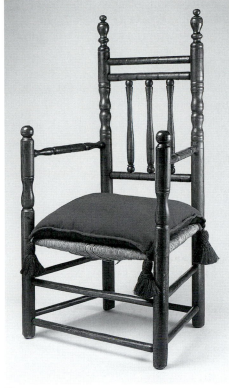

F4

carved panel (similar but not identical to the Pilgrim Hall chair), arc-and-leaf carving on frame below (Forman 1988, 148, no. 18); Danvers Historical Society, Massachusetts, with four arches and interlaced semicircular and leaf carved panel, geometric fret carving on frame below, arc-and-leaf carving on front seat rail (Lockwood 1957, 300, fig. LXXVII).

REFERENCES: Fales 1965, no. 71; Garrett 1981, p. 678, pl. V; Carved and Painted 1984; Little 1984, no. 90; Burton 1997, p. 224f.

F2

Great Chair

1670–1700
Connecticut, probably Norwich area
Soft maple and white oak; 49 x 27 ⅜ x 20 ⅝"
(124.5 x 69.5 x 52.4 cm)
B.60.32

This turned chair with slat back is one of a group that relates closely in terms of design and ornament. Variations, particularly as to size and details of the turnings, suggest that the group is not the product of one shop but represents the style of a regional group of turners. The outsize

mushroom-shaped terminals of the front posts, clearly a turner's conceit, add a distinctive note. Other identifying details are the tall, ovoid stile terminals capped with contrastingly small finials, as well as the ogee profile at the upper ends of each slat. Vase turnings in the posts and stiles recall those of cat. no. F4, made in coastal Connecticut. However, this group probably originated from the inland area of Norwich. While it has been suggested that the arms of the chair in the Bayou Bend Collection, which are not set with the sharp, upward rake seen in most of the related examples, have been altered, there is no evidence that this is so. At some time in the chair's history its back and seat appear to have been covered with upholstery.

PROVENANCE: Purchased by Miss Hogg from Israel Sack, New York, 1960.

TECHNICAL NOTES: Soft maple (arms, slats, right rear post, right front leg), white oak (right seat rail, lower front stretcher). Old restoration on front and rear feet.

RELATED EXAMPLES: Two are at Winterthur. One (acc. no. 58.691) is larger overall and has shallow turnings resembling multiple lines in the cylindrical sections of the rear stiles. The other (acc. no. 74.40) is smaller than the Bayou Bend example. Both have a distinctive

cant to the back not present here (Forman 1988, pp. 124–28). Other examples are in Williamsburg (Greenlaw 1974, no. 33); Art Institute of Chicago (acc. no. 1985.240); Lyon 1925, fig. 58; Nutting 1962, no. 1887; Chipstone (Rodriguez Roque 1984, no. 74); Leffingwell Inn, Norwich, Connecticut (Johnson 1961, p. 568; Ross 1997, p. 158).

REFERENCES: Sack 1969–92, vol. 1, p. 17, no. 57; Warren 1975, p. 6, no. 1; Agee et al. 1981, pp. 62–63 (with incorrect accession number).

F3

Great Chair

1660–1700
Probably Salem, Massachusetts
Ash; 44½ x 22⅛ x 18" (113 x 56.2 x 45.7 cm)
B.69.520

The slat-back example represents a variant contemporaneous with the spindle-back great chair. The straight slats with concave upper corners and crisply turned urn-and-flame finials relate the chair at Bayou Bend to a group associated with the North Shore of Massachusetts, thought most likely to originate in Salem. While the other examples feature flat blade arms that echo the design of the slats, the turned arms here are apparently original.

PROVENANCE: Purchased by Miss Hogg from Ginsburg and Levy, New York, 1963.

RELATED EXAMPLES: A very similar example at the Milwaukee Art Museum (Jobe et al. 1991, p. 29, no. 1); Baltimore Museum of Art (Elder and Stokes 1987, no. 1); Essex Institute, Salem, Massachusetts (Clunie, Farnham, and Trent 1980, no. 3); Fales 1976, p. 20, no. 11.

REFERENCES: Warren 1975, p. 6, no. 2.

F4

Great Chair

1660–1700
East Haven–Branford, Connecticut area
Ash; 49 x 26 x 20" (124.5 x 66 x 50.8 cm)
B.69.354

The relatively large size of this great chair underscores its importance as an object of status in the seventeenth-century house-

hold. While basically a simple turned and joined form, the great chair derived its ornament and distinctive differences from the variety of turnings chosen by the craftsman as he worked the members on his lathe. He often emphasized the termination of the stiles with tall finials. Repetition of long ogee shapes, as seen here on the stiles and front posts, has been identified with chairs produced in the New Haven Colony. A Mannerist attenuation distinguishes the three vase-shaped spindles of the back.

PROVENANCE: By tradition owned by the Palmer and Harrison families, Branford, Connecticut; purchased by Miss Hogg from John Kenneth Byard, Norwalk, Connecticut, 1953.

RELATED EXAMPLES: Kane 1973, p. 71, illustrates a chair probably made by the same craftsman, along with other examples, pp. 75–77; Kirk 1967, no. 202; MMA (acc. no. 10.125.208).

REFERENCES: Kane 1973, p. 73; Warren 1975, p. 7, no. 5.

F5

Great Chair

1675–90
Shop of Ephraim Tinkham II (1649–1713)
Plymouth County, Massachusetts
Ash, white oak, and soft maple; 43½ x 23⅛ x 15¾" (110.5 x 58.7 x 40 cm)
B.56.4

It is rare that the work of an individual seventeenth-century chairmaking shop can be identified. In general, the turned members, triple spindles of the back, finials, and front post terminals of this small example conform to the norm of turned great chairs produced in Massachusetts in the late seventeenth century and known today by the generic term Carver after a similar one traditionally owned by Governor John Carver (1575–1621) of the Plymouth Colony. However, the distinctive turnings of this example, in particular, the double flattened ball of the front post terminals, have been identified as hallmarks of one of a related group of Plymouth County craftsmen whose style is thought to have evolved in the shop of Ephraim Tinkham II.[1]

PROVENANCE: By tradition owned by the Ellis family of Carver, Plymouth County, Massachusetts; purchased by Miss Hogg from John S. Walton, New York, 1956.

TECHNICAL NOTES: Ash (posts, stretchers), white oak (rear seat rail), soft maple (middle vertical spindle); rush (replaced).

RELATED EXAMPLES: St. George 1979, figs. 46, 47, 49; Sotheby's, New York, sale 5599, June 26, 1987, lot 200, a similar example but with turnings under the seat in the so-called Brewster style.

REFERENCES: Advertisement of P. W. Hathaway, *Antiques* 58 (July 1950), p. 15; Warren 1975, p. 7, no. 6; St. George 1979, p. 50, fig. 48; Warren 1988, p. 15.

1. This group, which includes Tinkham's father-in-law and brother-in-law (both carpenters named John Thompson), has been identified and discussed in detail in St. George 1979, pp. 27, 50, 100.

F6

Great Chair

1680–1710
Probably Massachusetts
Soft maple and secondary wood; 46 x 24½ x 20" (116.8 x 62.2 x 50.8 cm)
B.69.350

The turned design of the spindles on the back of this great chair, with their arrowhead-shaped terminals, points to a Massachusetts provenance. Idiosyncrasies of the overall turnings, such as the upper rail, which in design does not match the other two horizontal rails, and variations in the turnings of the spindles have been thought to indicate replacement elements. However, consistency of wear, color, and finish history indicate that these elements are original. The inconsistencies of turning would then suggest that this chair is the product of either a rural craftsman or an urban maker of moderate skill.

PROVENANCE: By tradition owned by Solomon Levy, Boston; purchased by Miss Hogg from John Kenneth Byard, Norwalk, Connecticut, 1953.

TECHNICAL NOTES: Soft maple (right rear post, left middle spindle); ash (right seat rail), rush (replaced).

REFERENCES: Warren 1975, p. 8, no. 7.

F7

Side Chair

1670–1700
New York State or possibly northern New Jersey
Cherry and secondary woods; 35⅞ x 18⅜ x 15" (91.1 x 46.7 x 38.1 cm)
Museum purchase with funds provided by the Houston Junior Woman's Club, B.97.6

This low spindle-back chair represents the turner's alternative to the more expensive upholstered, so-called Cromwellian, chair introduced to the Continent and England in the early seventeenth century.[1] It is part of a group of American chairs that differs considerably from the spindle-back chairs of New England, reflecting a type common in the Netherlands and northwestern Germany.[2] Salient features include the low back, urn-shaped finials, and long, ovoid, sausagelike turnings seen on the stretchers and back spindles. These distinctive sausage turnings do not appear on contemporaneous New England furniture but are seen on a group of chairs thought to be from New York.[3] A table also at Bayou Bend, possibly from New York or New Jersey, displays similar sausage turnings (cat. no. F22). The urn finials appear on later slat-back chairs associated with New Jersey.[4] Finally, the style of the conjoined initials HH branded on the chair, like those of a closely related pair, resembles that seen on furniture with histories of New York Dutch ownership.[5] All these factors point to the area of Dutch settlement as the origin for this group of chairs.

PROVENANCE: With its mate, Jess Pavey, Birmingham, Michigan; Mr. and Mrs. James O. Keene, Detroit; purchased by Bayou Bend at Sotheby's, New York, sale 6954, January 16, 1997, lot 33.

TECHNICAL NOTES: Cherry; unidentified secondary woods. Conjoined double H is branded on right rear stile, a portion of the left front foot is missing, finish and rushing are very old but not original.

RELATED EXAMPLES: MMA[6]; other examples differ in some details, particularly the number

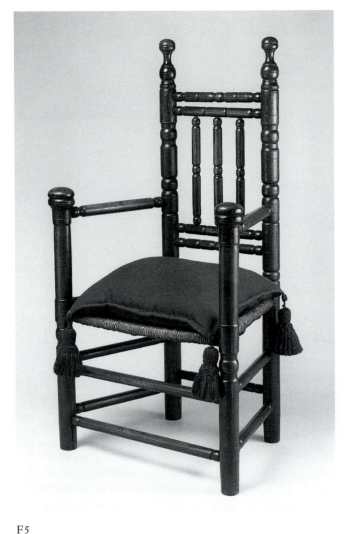

F5

F7

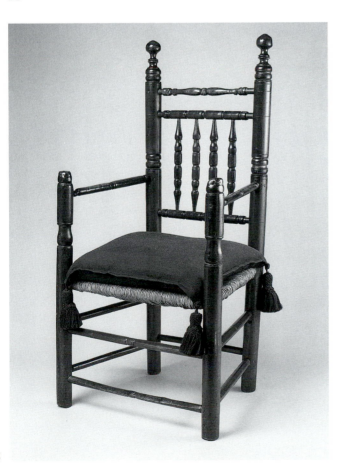

F6

of back spindles: a pair at Sleepy Hollow Restorations, Tarrytown, New York, with five spindles and branded with conjoined Hs on the right rear stile may be from the same set (Butler 1983, p. 52, no. 35); a pair at New Jersey State Museum, Trenton, with five spindles and branded HG on the right rear stile (Lenape 1971, p. 44, no. 106); one in a private collection, Milwaukee, with a taller back and five spindles; American Art Association, Anderson Galleries, New York, Garvan Collection sale, January 8–10, 1931, lot 107, with five spindles; Sotheby's, New York, sale 6589, June 23, 1994, lot 432, with five spindles; private collection, Vermont, with a taller back and five spindles; Winterthur (Forman 1988, nos. 11, 12), two with four spindles; Nutting 1962, no. 2085, with four spindles; American Museum in Britain, Bath (Huitson 1993, p. 411), with four spindles; Yale (Kane 1976, no. 5), with three spindles. The only related armchair has ovoid bobbin turnings, its back with two vertically stacked rows of six spindles (Blackburn et al. 1988, p. 175, fig. 189); a child's side chair, DAPC (acc. no. 82.159).

1. The mate to this chair, part of lot 33 at Sotheby's (see Provenance), was sold by Bayou Bend to MMA, February 1997.

2. Forman 1988, fig. 51; for examples in the Rijksmuseum, Amsterdam, see Kirk 1965, p. 798, figs. 19, 20.

3. Butler 1983, p. 52, fig. 34. Similar sausage turnings are also seen on a New York high chair branded RS for Robert Sanders (Blackburn et al. 1988, p. 191, fig. 226) and occasionally appear on later eighteenth-century turned chairs made in Connecticut (Kirk 1967, figs. 194, 195, 211, 214).

4. Forman 1988, p. 117, fig 53.

5. This pair, at the New Jersey State Museum, Trenton, is branded HG. Although at one time this pair was ascribed to Henryk Glaever of Crosswicks, New Jersey, that attribution has been now dismissed (Forman 1988, p. 114). For a discussion of the custom of branding furniture among New York families of Dutch descent, see Blackburn 1976, p. 112; the pair sold at Sotheby's in June 1994 have a DePeyster and Bancker family history.

6. See n. 1 above.

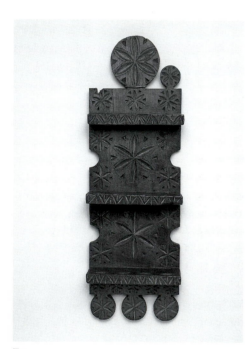

F8

Spoon Rack

1700–1800
Bergen County, New Jersey, or Hudson Valley, New York
Yellow-poplar with traces of pigment; 26 x 8½ x 2¾" (66 x 21.6 x 7 cm)
B.64.49

The Dutch custom of storing spoons in carved wall racks placed in the kitchen was apparently transmitted to the New

Netherlands, and approximately sixty American examples survive today. Traditionally, a bride received the spoon rack from her new husband, and it remained her personal possession. While the extant American examples vary in individual ornament, they all share the basic vertical format and have three shelves fitted with slots for spoons. Commonly made of poplar and decorated with shallow, typically northern European chip carving, the racks were usually painted; this example shows traces of a dark orange-red pigment.

PROVENANCE: Purchased by Miss Hogg from Carl and Celia Jacobs, Deep River, Connecticut, 1964.

TECHNICAL NOTES: A small ornamental disk at the top right is missing. Traces of red paint in the recesses of the chip carving appear to be original and seem consistent with what has been found on related objects of the period; the red is an iron oxide, unevenly ground (indicating hand grinding of the pigments), in an oil and resin binder.

RELATED EXAMPLES: Chipstone (Rodriguez Roque 1984, no. 187); Milwaukee Art Museum (Jobe et al. 1991, p. 89, no. 32); Bergen County Historical Society, River Edge, New Jersey (Blackburn et al. 1988, pp. 159–61), and New Jersey 1958, no. 54.

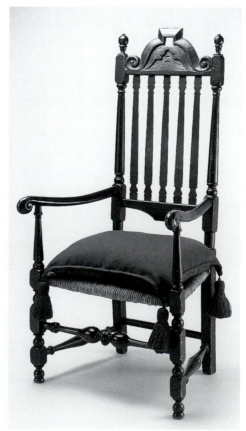

F9

F9–10

Armchair and Side Chair

1700–1725
New England, probably Boston area
Various woods (see Technical notes);
B.69.54: 47⅝ x 23⅞ x 22½" (121 x 60.6 x 57.2 cm);
B.69.55: 45¾ x 17½ x 16¾" (116.2 x 44.5 x 42.5 cm)
B.69.54–.55

Painted banister-back chairs offered an inexpensive alternative to the leather-upholstered chairs made in Boston. The application of a black painted finish made it possible to combine four inexpensive woods. This armchair and accompanying side chair represent survivals of a larger group and are indicative of the large sets of matching seating furniture that became common in the Early Baroque period. Less common is the design of the crest, which is more solid than the norm. The Baroque arched and scrolled elements echo the design of contemporary gravestones, while the central vertical detail relates to the cresting of a small group of early upholstered easy chairs. Double-ball feet, like those on the armchair, occur occasionally in eastern Massachusetts.[1] The simple columnar design

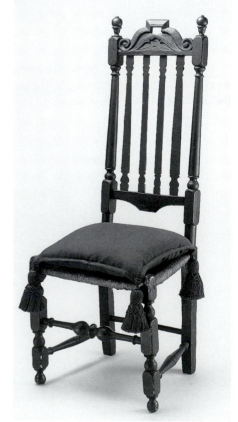

F10

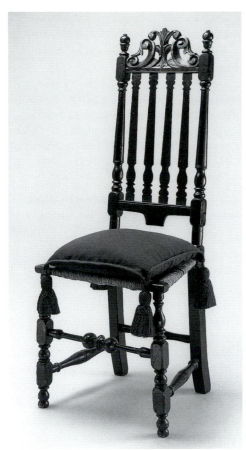

F11

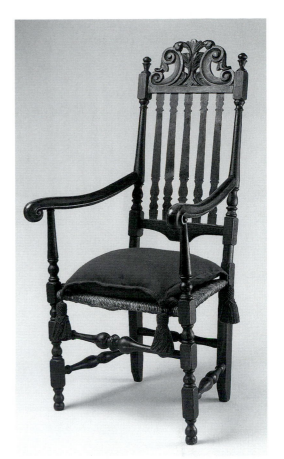

F13

RELATED EXAMPLES: A third chair of the set that descended in the Williams family, private collection, Portland, Oregon; Historic Deerfield (Fales 1976, p. 29, no. 35); private collection, Mendenhall, Pennsylvania; PMA (acc. no. 73–259–3).

REFERENCES: Warren 1975, p. 8, no. 8.

1. Fales 1976, p. 29; Forman 1988, no. 67.

F11–12

Two Side Chairs

1720–50
New England, possibly Boston
Various woods (see Technical notes);
B.69.46: 47¾ x 19 x 18⅜" (121.3 x 48.3 x 46.7 cm);
B.69.47: 47½ x 19 x 17¾" (120.7 x 48.3 x 45.1 cm)
B.69.46–.47

This type of chair, with turned banisters for back slats, represented an easily produced, less expensive variant on leather and cane-backed chairs. Often made in sets, these chairs were widely produced over a long period of time throughout New England.

PROVENANCE: Purchased by Miss Hogg from Israel Sack, New York, 1954.

TECHNICAL NOTES: B.69.46, painted poplar (legs), soft maple (crest rail), black ash (front stretcher, left seat rail, banisters, stay rail), elm (left stretcher), white oak (front seat rail); B.69.47, various woods, materials not analyzed microscopically.

RELATED EXAMPLES: MMA (acc. nos. 10.125.218; 52.195.8,9); Concord Museum, Massachusetts (Wood 1996, p. 63, no. 26); Jobe et al. 1991, pp. 70, 72, fig. 21.

REFERENCES: Warren 1975, p. 9, no. 11.

F13

Armchair

1700–1730
New England, probably Boston
Soft maple, ash, and poplar; 48 x 24½ x 24½"
(121.9 x 62.2 x 62.2 cm)
B.58.106

used for the turned arm supports, stiles, and banisters and a history of ownership on the frontier west of Boston suggest the possibility of rural rather than urban manufacture.

PROVENANCE: By tradition owned by John Bigelow (1674–1769) and his wife, Jerusha Garfield Bigelow (1677–1758), who were married in 1696 in Waterfield, Massachusetts, and later settled in Marlborough, Massachusetts; to their son Gershom Bigelow (d. 1812); to his son Timothy Bigelow (d. 1817); to his son Ephraim Bigelow (d. 1843); to his sister Lovinia Bigelow; to her daughter; to her son William Williams by 1883; to his granddaughter Mildred E. McCurdy by 1940; purchased by Miss Hogg from Lillian Blankley Cogan, Farmington, Connecticut, 1954.

TECHNICAL NOTES: B.69.54, soft maple (crest rail, left front leg, arms, stretchers, right seat rail), ash (front seat rail, right banister), poplar (left rear post), hickory (rear stretcher); B.69.55, poplar (crest rail, left rear post), ash (left stretcher, left banister), soft maple (front and rear stretcher, front seat rail); center two split banisters and left seat rail are replacements; both stiles are broken above urn on block.

The design of this banister-back armchair presents contradictions. While it displays a foliate scrolled crest and scrolled arm terminals somewhat bolder than the norm, as well as turned stiles and banisters crisp in profile, the juncture of the upwardly raked arms with the turned section of the stiles is awkward, and the turnings of the lower section are more schematic.

PROVENANCE: Purchased by Miss Hogg from Israel Sack, New York, 1958.

TECHNICAL NOTES: Soft maple (crest rail, right arm), ash (front seat rail, center banister, front stretcher), poplar (right rear post). There are four compass circles containing six-point arcs on the skirt of one long side, one truncated by the joint with the leg.

RELATED EXAMPLES: Cat. no. F9 has similar double-ball feet and tapering columnar arm supports, as opposed to vase turnings, as does an example at MFA, Boston (Randall 1965, no. 125).

REFERENCES: Warren 1975, p. 9, no. 12 (with incorrect accession number); Sack 1993, p. 23.

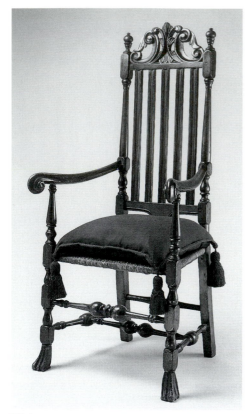

F14

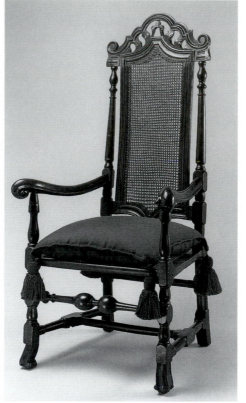

F15

at the base of the rear legs and a high placement of the rear stretcher very similar to sophisticated caned chairs of Boston origin.

PROVENANCE: Judge Jonathan Remington (1677–1745), Boston; Judge Edmund Trowbridge (1700–1793); Judge Francis Dana (1743–1814); Richard Henry Dana (1787–1870)[1]; further descent in the Dana family; purchased by Miss Hogg from Ginsburg and Levy, New York, 1958.

TECHNICAL NOTES: Caning not original.

RELATED EXAMPLES: Yale (Forman 1988, p. 254); Concord Museum, Massachusetts (Wood 1996, p. 59, no. 24).

REFERENCES: Warren 1975, p. 10, no. 14.

1. This information is provided on an engraved brass plaque affixed to the back of the chair.

F16

Armchair

1720–30
Boston
Soft maple and birch; 46⅜ x 24½ x 22"
(117.8 x 62.2 x 55.9 cm)
B.61.40

In response to competition from imported London-made caned seating furniture, Boston chairmakers and turners began producing their own cane products at the beginning of the eighteenth century. This armchair, with its molded stiles, represents a late type; indeed, the yoke design of the crest anticipates the later Baroque treatment. The turned rear legs, centrally placed medial stretcher, and high front and rear stretchers, all features that derive from English caned chair design, differentiate this type of chair from the treatment seen on the banister-back chair (see cat. no. F13). The Bayou Bend armchair bears a punched capital I with a central cross serif on the back seat rail. No fewer than twenty-six other Boston caned chairs bearing the same device are now known.[1]

PROVENANCE: Purchased by Miss Hogg from Ginsburg and Levy, New York, 1961.

TECHNICAL NOTES: Soft maple, birch (rear seat rail). All four feet have new pieces, which

F14

Armchair

1710–35
New England, probably Boston
Various woods (see Technical notes); 50⅜ x
24½ x 22½" (128 x 62.2 x 57.2 cm)
B.69.521

Although at first glance this chair appears to be simply a variant on the ubiquitous banister-back armchair, several elements of its design set it apart and suggest that its maker was looking at English caned-back models. Most distinctive is the arrangement of the stretchers, which employs an extra turned medial stretcher to connect the side stretchers. The juncture of the arms with the stiles, an unturned area above a turned vase-shaped form, is also uncommon. These features appear on a caned-back English example at Bayou Bend (cat. no. F15), which has a long history of Boston ownership. The reeded banisters echo the framing elements used to support the caned back of more expensive chairs. The scrolled design of the front feet, commonly called Spanish, seen in Boston caned chairs of the early eighteenth century, was borrowed from Continental furniture.

PROVENANCE: Purchased by Miss Hogg from John Kenneth Byard, Norwalk, Connecticut, 1953.

TECHNICAL NOTES: Soft maple (crest rail), birch (forward portion of front seat rail), ash (left stretcher, inner strip of left seat rail), poplar (right arm, right center banister), basswood (outer strip of left seat rail), beech (right seat rail), rush (replaced).

RELATED EXAMPLES: SPNEA (Jobe and Kaye 1984, p. 326, no. 85).

REFERENCES: Advertisement of John Kenneth Byard, Antiques 64 (July 1953), p. 7; Warren 1975, p. 10, no. 13 (with incorrect accession number); Sack 1969–92, vol. 1, p. 17, no. 58; Jobe and Kaye 1984, p. 327, no. 85b.

F15

Armchair

1685–1700
London
Beech; 48¾ x 26 x 24¼" (123.8 x 66 x 61.6 cm)
B.58.142

Boston chairmakers of the early eighteenth century had to compete with the very chairs that served as models. This chair with a caned back and seat, imported from London, displays turnings

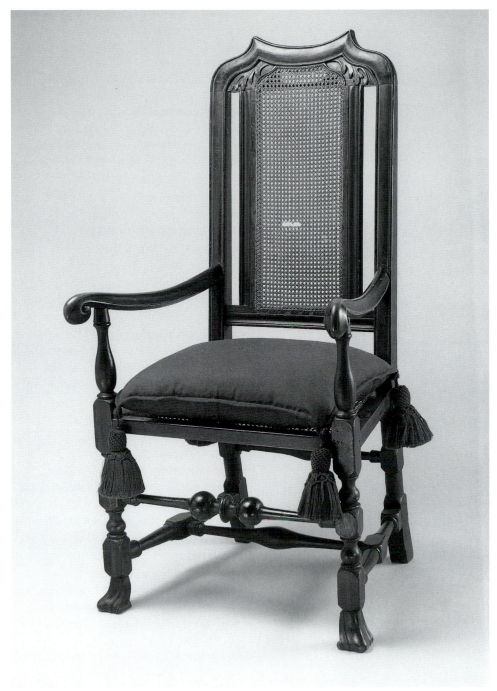

F16

Easy Chair

1715–35
Boston
Soft maple, eastern white pine, hard maple,
and birch; 48 x 32⅞ x 31½″ (121.9 x 83.5 x 80 cm)
B.58.104

In the first decade of the eighteenth century, a new luxurious upholstered form, the easy chair, was introduced in America.[1] Large wings that attach to the back and afford the sitter, usually someone old or ill, protection from cold and drafts characterize the type. Padding on the interior of the wings and deep, down-filled cushions provided added comfort. Intended as a piece of bedroom furniture, the easy chair was also occasionally fitted out as a commode or pot chair. The double-scroll arms with C-shaped panels are common to models produced before the late 1730s. The Bayou Bend chair is unusual in several features. It combines the bold Baroque scalloped skirt and block-and-vase turned front legs, elements of the early type of easy chair, with a tripartite ball-and-ring medial stretcher, which replaced the earlier multiple vase-and-ring turned stretchers. Unlike the earlier type, the ball-and-ring stretcher was located not centrally but closer to the front legs and attached to blocks on long, vase-shaped side stretchers. While typically those later chairs with the ball-and-ring stretcher have nascent cabriole legs, or crookt feet (see cat. no. F55), this example uses the earlier turned format.

PROVENANCE: Theophilus Parsons (1750–1813), Ipswich, Massachusetts[2]; by descent to J. Lewis Stackpole, Boston (d. 1953); [John Kenneth Byard, Silvermine, Connecticut, probably by 1949]; purchased by Miss Hogg from Israel Sack, New York, 1958.

TECHNICAL NOTES: Soft maple (front, rear, and right seat rail, stay rail, right S wing, front and right stretcher, right stile, right arm support, filler block in front of right arm support), eastern white pine (left front corner block, right top corner block, interior right arm), hard maple (right front leg), birch (exterior right arm). At some point during the eighteenth century, as witnessed by the use of wrought nails, the chair's upper frame was modified: the upper horizontal members of the wings and the crest rail were replaced and

replaced losses when the chair was converted into a rocker. At one time the chair was upholstered over the back and seat, as evidenced by nail holes. The caning is not original, nor is the reddish grained paint. A paint sample shows that this black-and-red graining overlies a brown ground layer (applied rapidly, judging from the large number and size of air holes), which covered the wood and the remnants of an earlier brown paint film.

RELATED EXAMPLES: The closest is a side chair with identical crest in the collection of the Pilgrim Hall Museum, Plymouth, Massachusetts. A chair almost identical was adver-

tised by Ginsburg and Levy (*Antiques* 126 [October 1984], p. 656). A single chair was exhibited at the Bernard and S. Dean Levy Gallery, New York, in 1988 (Levy Gallery 1988b, p. 9); another was advertised by Peter H. Eaton Antiques, Newton Junction, New Hampshire (*Antiques* 123 [March 1983], p. 530).

REFERENCES: Advertisement of Ginsburg and Levy, *Antiques* 80 (November 1961), p. 401; Warren 1975, p. 10, no. 15.

1. See Forman 1988, pp. 260–61, for a table and discussion of the group and the theory that the mark represents that of a caner.

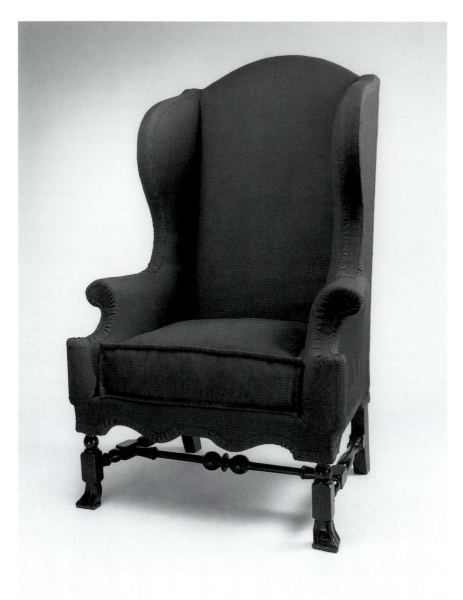

F17

Couch

1720–40
Boston
Soft maple; 37½ x 21½ x 65⅛" (95.3 x 54.6 x 165.4 cm)
Museum purchase with funds provided by the Agnes Cullen Arnold Endowment Fund, B.90.5

The couch, whose name comes from the French verb *coucher,* to lie down, is essentially a chair with an extended seat. Derived from the French form known as the *lit de repos,* the couch was introduced from the Continent to England in the mid-seventeenth century. Caned examples of the couch form, along with caned chairs, were being exported from London to America by the late seventeenth century. To compete with these imports, local Boston chairmakers produced large numbers of leather-covered, turned chairs with arched, molded backs, which came to be called Boston chairs. A small group of Boston-made couches, of which this is one, relates in design to those Boston chairs, and was undoubtedly produced by the same craftsmen. Typically made of maple, finished with a dark stain, these couches feature arched and molded back frames that could be raised or lowered by means of adjustable chains to the desired angle. The turned vase finials, legs, and bulb-and-ring stretcher echo those elements of the Boston chair.

PROVENANCE: [John S. Walton, Jewett City, Connecticut]; Mr. and Mrs. Hubert Harrison, Austin, Texas; purchased by Bayou Bend from Mr. and Mrs. Harrison, 1990.

TECHNICAL NOTES: The upholstery arrangement of boxed mattress, cushion, and two pillows of graduated sizes is based on two early eighteenth-century English couches with surviving show covers (Macquoid 1987, vol. 1, fig. 197; and vol. 2, fig. 69 and p. 75, stating that the tradition of graduated-size pillows dates from the sixteenth century).

RELATED EXAMPLES: Two are at Winterthur (Forman 1988, p. 355, no. 83, and p. 356, no. 84); Milwaukee Art Museum (Jobe et al. 1991, p. 75, no. 24); Yale (Kane 1976, p. 235, no. 221); RISD (Monkhouse and Michie 1986, no. 94); MMA (Nutting 1962, no. 1591); private collection (Read 1938); Old Manse, Concord, Massachusetts; Sotheby's, New York, sale 6954, January 16, 1997, lot 37; American Art Association,

the fronts of the wings had pieces added just above the arm to make them deeper and more vertical. These alterations may have been an attempt to update the chair by creating a simple arched crest and deeper, forward sloping wings. The Spanish feet are original and made of several pieces glued together; the rear stretcher lacks the central ball-and-ring turning and simply swells at the center. The rear legs have lost about two inches in height. The shape of the upholstery and loss of back legs was corrected by conservation in 1996.

RELATED EXAMPLES: An easy chair at MMA, with similar front legs and small Spanish feet but with an early multiple-vase turned stretcher, demonstrates what the Bayou Bend example may have looked like before the alteration of its wings and crest (Davidson and Stillinger 1985, p. 109, fig. 142); Winterthur, two early types with similar scalloped skirt (Forman 1988, nos. 87, 88) and three later types with ball-and-ring stretcher and cabriole legs (Forman 1988, nos. 90–92); MFA, Boston,

an early scalloped-skirt type (Fairbanks et al. 1981, p. 595, pl. VII); Williamsburg, formerly in the Blagojevich Collection, an early example (Winchester 1963, p. 134); Sotheby Parke Bernet, New York, sale 4116, April 27–29, 1978, lot 920, a turned-leg, Spanish-foot example with ball-and-ring stretcher.

REFERENCES: Advertisement of John Kenneth Byard, *Antiques* 57 (June 1950), p. 401; Sack 1950, p. 64; advertisement of Israel Sack, Inc., *Antiques* 73 (June 1958), inside front cover; Comstock 1962, no. 44; Warren 1966, p. 808; Warren 1971a, p. 41, fig. 7; Bishop 1973, p. 31; Warren 1975, p. 11, no. 17; Naeve 1981, p. 18, no. 19.

1. Forman 1988, p. 358.
2. This information is given in a statement, dated April 29, 1949, written by J. Lewis Stackpole (now located in Museum's object files). However, Parsons would have been born too late to be the chair's original owner.

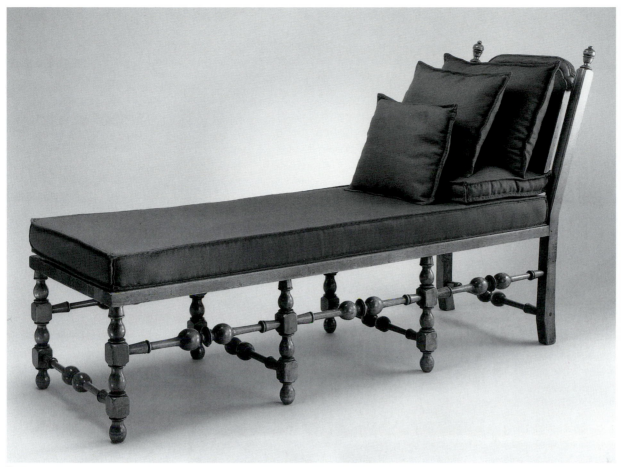

F18

Anderson Galleries, New York, Garvan Collection sale, January 8–10, 1931, lot 282.

F19

Stool

1710–30
New England
Soft maple; 21½ x 13½ x 21⅜" (54.6 x 34.3 x 54.3 cm)
B.58.105

While small joined stools were a common form of seating furniture in the seventeenth and early eighteenth centuries, few survive today. This example is made with relatively light turned legs ornamented with paired vases in the manner of gateleg tables of the Early Baroque style. That feature and the use of maple suggest a late date for this stool. Although the turnings are somewhat simple, the maker has shown some interest in detail with the double rings at the center of the

paired vases and the thumbnail molding of the top, skirt, and stretchers.

PROVENANCE: Purchased by Miss Hogg from Israel Sack, New York, 1958.

RELATED EXAMPLES: Nutting 1962, nos. 2725, 2731; Pendleton Collection, RISD (Monkhouse and Michie 1986, no. 82).

REFERENCES: Warren 1975, p. 11, no. 18.

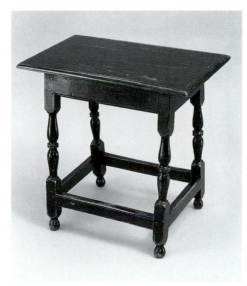

F19

F20

Table with Drawer

1710–40
New England, possibly Massachusetts or Rhode Island
Maple and secondary woods; 26¼ x 26⅞ x 17¾"
(66.7 x 68.3 x 45.1 cm)
B.69.14

This small, utilitarian table with a drawer evolved from the earlier so-called joint stool, which undoubtedly served as both table and stool. The flattened ball-and-ring motif at either end of the paired vases of the crisply turned legs is an unusual and distinctive detail that recalls the stretcher treatment of a Boston armchair (cat. no. F14) and the leg turning seen on Newport low-back Windsors.[1]

PROVENANCE: Purchased by Miss Hogg from Ginsburg and Levy, New York, 1964.

TECHNICAL NOTES: Materials (maple, eastern white pine, southern yellow pine) not analyzed microscopically. The drawer sides are dovetailed to the front and back boards. The top edges of the drawer sides are beaded. The bot-

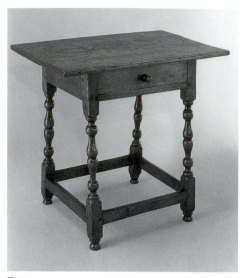

F20

tom board is nailed all around, with grain running side to side. The front and sides of the bottom are beveled. The front edge of the bottom is fit into a rabbet in the front board. Drawer glides are nailed over the drawer bottom at the sides with what appear to be wrought nails. The drawer face is angled to match the canted angle of the apron. Knob is original.

REFERENCES: Warren 1975, p. 12, no. 19.

1. Evans 1996, p. 239, fig. 6–2.

F21

Table with Drawer

1715–30
New England
Eastern white pine and soft maple; 29¼ x 43¼ x 27⅜" (74.3 x 109.9 x 69.5 cm)
B.58.145

This medium-size table with single drawer represents the sort of utilitarian form that could be placed against a wall or pulled out into a room as usage required. The design, with the single lower stretcher and high front and back stretchers, appears in the seventeenth century. However, the use of maple rather than oak and the crisp vase and paired-vase turnings, which relate to the stretcher design of early easy chairs of about 1715–30, indicate a later origin.[1]

PROVENANCE: Purchased by Miss Hogg from Ginsburg and Levy, New York, 1958.

TECHNICAL NOTES: Eastern white pine (top, right drawer runner), soft maple (left front leg). The drawer construction is dovetailed, the flat bottom let into the sides and back.

RELATED EXAMPLES: Sack 1950, p. 236; Nutting 1962, no. 854.

REFERENCES: Warren 1975, p. 12, no. 21.

1. Forman 1988, no. 89.

F22

Table with Drawer

1695–1725
New York or New Jersey
White oak, soft maple, and secondary woods; 27½ x 46⅝ x 27" (69.9 x 118.4 x 68.6 cm)
B.22.18

Although previously published as a New England example, this table has several features that suggest another origin. The unusual H-shaped stretcher arrangement echoes that seen in Continental tables and perhaps reflects a Dutch or Huguenot influence.[1] The sausage turnings of the medial stretcher, distinctly different from the more common bobbin-shape turnings of the chairs and tables of the turn of the eighteenth century, also appear on the stretchers and back spindles of a group of small turned side chairs (cat. no. F7) that have Continental antecedents and seem to have been made in New York or northern New Jersey, an area of Dutch settlement. The thin neck and rings of the feet also recall the treatment on some of these chairs.

PROVENANCE: Purchased by Miss Hogg from Collings and Collings, New York, 1922.

TECHNICAL NOTES: White oak (top, skirt, drawer front), soft maple (legs, stretchers); southern yellow pine (drawer bottom, right drawer guide, lower drawer guides), white oak (drawer rear and sides, upper drawer guides). The thick drawer sides, dovetailed to the front, hang on side runners, a feature seen on an Early Baroque walnut-veneered New York chest-on-frame at Winterthur (acc. no. 58.559). The drawer construction is dovetailed, the bottom board nailed, with grain running side to side.

RELATED EXAMPLES: Wadsworth (Nutting 1962, no. 886), thought also to be of mid-Atlantic origin; Nutting 1962, no. 852; Lockwood 1957, no. 697; New York State Museum, Albany (Scherer 1984, no. 2); Bybee Collection, Dallas Museum of Art, a Delaware Valley table with related but somewhat more truncated vase turnings and a drawer also hung on side runners (Venable 1989, p. 4, no. 2).

REFERENCES: Warren 1975, p. 13, no. 22.

1. Puig 1989, p. 158; Bird 1994, p. 166.

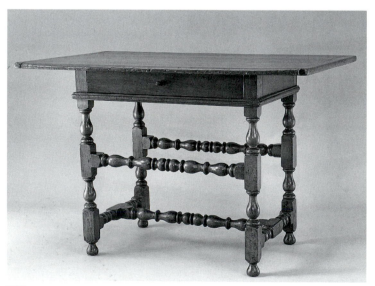

F21

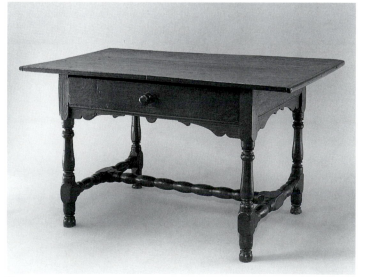

F22

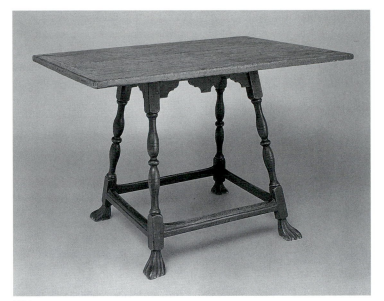

F23

F23

Table

1740–70
Portsmouth, New Hampshire, or southern
Maine
Soft maple, eastern white pine, and secondary
wood; 25½ x 36⅝ x 26½" (64.8 x 93 x 67.3 cm)
B.69.351

This small table is part of a group that
has been identified as the product of one
craftsman working in the Piscataqua
River area.[1] All have distinctively raked
legs with slender paired vase turnings and
vigorously carved Spanish feet. The feet
are made of one piece of wood, like
those of chairs produced in the Ports-
mouth area. Also distinctive is the double
ogival arch design of the skirt, which re-
calls the skirt treatment on high and low
chests. Although in earlier literature they
have been romantically described as tav-
ern tables, it is more likely that they were
intended for serving tea in the parlor.
This example, like the others, bears traces
of a reddish brown stain intended to
make the maple surfaces resemble more
expensive walnut.

PROVENANCE: By tradition owned by James
and Keturah Jenkins Webber (married in Kit-
tery, Maine, on February 13, 1729). Purchased
by Miss Hogg from Israel Sack, Boston, 1926.

TECHNICAL NOTES: Soft maple (legs, stretch-
ers, apron), eastern white pine (top); white
oak (cleat underneath top). The rectangular
top is old but not original. Undoubtedly the

original top was oval, like other examples, and
was secured by a cleat to prevent warping.

RELATED EXAMPLES: MMA (Davidson and
Stillinger 1985, p. 108, fig. 141; Jobe et al. 1993,
no. 46); SPNEA (Jobe et al. 1993, no. 46b); His-
toric Deerfield (Fales 1976, p. 142); Wadsworth
(Nutting 1962, no. 1225); Prentis Collection,
New Hampshire Historical Society, Concord
(Guyol 1958, fig. 8); Old Gaol Museum, York,
Maine (Randall 1964a, no. 2); a private collec-
tion (advertisement for the Cobbs Antiques in
Antiques 132 [September 1987], p. 483).

REFERENCES: Comstock 1962, no. 132;
Warren 1975, p. 13, no. 23.

1. See Jobe et al. 1993, pp. 218–20.

F24

Table

1700–1730
Boston
Black walnut and secondary woods; open:
27⅝ x 56½ x 48½" (70.2 x 143.5 x 123.2 cm);
closed: 27⅝ x 17 x 48½" (70.2 x 43.2 x 123.2 cm)
B.59.71

The Early Baroque period saw the advent
of folding oval dining tables. This is an
unusual example made of walnut, rather
than the more common maple. At vari-
ous times this table has been ascribed to
Rhode Island, on the basis of the chestnut
used as a secondary wood, and to Ports-
mouth, New Hampshire, on the basis of
the boldly carved paintbrush feet. How-
ever, it seems appropriate to assign this
example to Boston, where chestnut was
also employed in furniture. No docu-
mented Rhode Island tables with paint-
brush feet have been identified, and
Portsmouth feet were made with solid
construction rather than pieced, the
Boston norm, as in this table.

PROVENANCE: Purchased by Miss Hogg from
John S. Walton, New York, 1959.

TECHNICAL NOTES: Black walnut (drop leaf,
drawer front, lower stretcher); soft maple
(gateleg rail, rail between gatelegs), chestnut
(drawer bottom), and eastern white pine (cen-
ter rail underneath drawer). The drawer con-

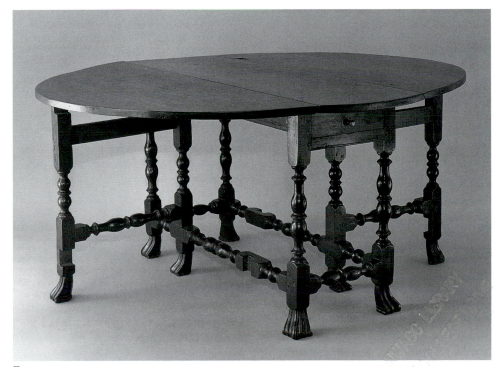

F24

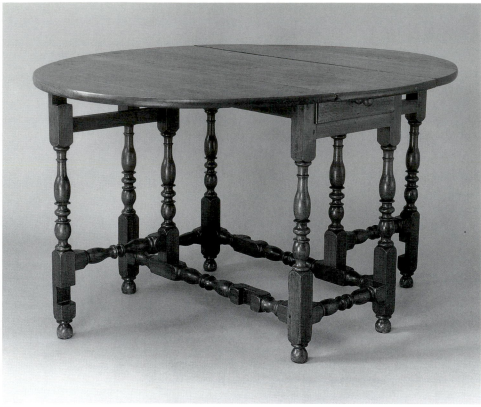

F25

struction is dovetailed, the bottom board nailed. Hinges and drawer knob are replacements. Top of leg posts have been beveled.

RELATED EXAMPLES: Art Institute of Chicago (Naeve 1981, p.18); Williamsburg (Greenlaw 1974, p. 156, no. 135); Historic Deerfield (Fales 1976, p. 117, no. 239); Winterthur (Comstock 1957c, p. 59); Wadsworth (Nutting 1962, no. 963); W. K. duPont Collection (Kennedy and Sack 1977, no. 27); Christie's, New York, sale 7924, June 22, 1994, lot 209. All these examples, save the one at Winterthur, have pieced feet.

REFERENCES: Warren 1966, p. 806; Warren 1975, p. 13, no. 24.

F25
Table

1720–30
Pennsylvania, Maryland, or Virginia
Black walnut and secondary wood; open:
29¼ x 51¾ x 42¼" (74.3 x 131.4 x 107.3 cm);
closed: 29¼ x 17½ x 42¼" (74.3 x 44.5 x 108 cm)
B.71.8

This table, somewhat smaller than cat. no. F24, is also made of walnut. The paired vase leg turnings seen on the Boston table are here supplanted with crisply turned small vases surmounted by

tall ring-necked vase forms. That same motif is repeated in the gates. This use of tall vase shapes is seen in examples made in Pennsylvania, as well as adjacent Maryland and nearby Virginia.

PROVENANCE: Purchased by Miss Hogg from James Craig Antiques, Raleigh, North Carolina, 1965.

TECHNICAL NOTES: Black walnut; southern yellow pine (medial brace, drawer sides, bottom, and back). The drawer construction is dovetailed, the deeply beveled bottom let into the sides, back, and front.

RELATED EXAMPLES: Baltimore Museum of Art (Elder and Stokes 1987, no. 91); Schiffer 1978, no. 120; Barquist, Garrett, and Ward 1992, p. 122, no. 43.

REFERENCES: Advertisement of James Craig Antiques, *Antiques* 88 (October 1965), p. 406; Warren 1975, p. 14, no. 25.

F26
Table

1710–50
Connecticut
Cherry; open: 27⅝ x 41⅛ x 34" (70.2 x 104.5 x 86.4 cm); closed: 27⅝ x 17½ x 34" (70.2 x 44.5 x 86.4 cm)
B.69.51

This small, multipurpose oval table with drop leaves reflects the eighteenth-century interest in conserving space when furniture was not in use. The use of shaped brackets, which support the open leaves, seems to have been particularly popular in Connecticut. That feature caused the form to be called butterfly in the twentieth century.

PROVENANCE: Purchased by Miss Hogg from Israel Sack, New York, 1954.

RELATED EXAMPLES: Yale (Barquist, Garrett, and Ward 1992, nos. 46, 47); Wadsworth (Kirk 1967, nos. 142, 144); MMA (acc. nos. 52.77.54, 10.125.124).

REFERENCES: Warren 1975, p. 14, no. 26.

F27
Chamber Table

1690–1710
Boston
Various woods (see Technical notes); 31⅞ x 27½ x 18¾" (81 x 69.9 x 47.6 cm)
Museum purchase with funds provided by the Houston Chapter, Kappa Alpha Theta, B.70.24

This chamber table is raised on turned legs and features a paneled storage section, accessed by a lift top, above one drawer.[1] Originally intended for use in the bedroom as a toilet or dressing table, it is part of a group decorated with painted highlights, often red and black. In some cases, as here, traces of a leafy tree

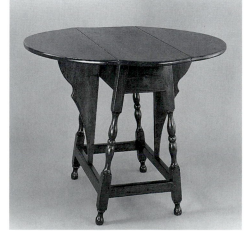

F26

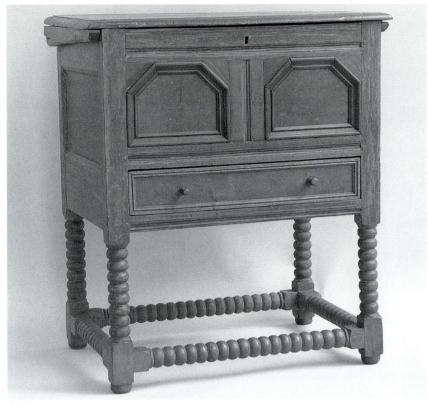

F27

no. 236). This latter example, however, is made of maple. Others with vase-and-ring turnings: Brooklyn Museum (Comstock 1962, no. 58); Shelburne Museum, Shelburne, Vermont (Winchester 1957b, p. 442); Winterthur (Forman 1970, fig. 7); New-York Historical Society; Nutting 1962, nos. 214–16; advertisement of Israel Sack, *Antiques* 4 (July 1923), p. C-2; Sanford 1947, p.184; Landman 1975, p. 930; Sack 1969–92, vol. 3, p. 602, no. 1370; Levy Gallery 1992, p. 6, no. 1. The painted ornament of these toilet tables relates to a group of one-drawer chests in Comstock 1962, no. 66; Nutting 1962, no. 53.

REFERENCES: Warren 1971a, p. 38, no. 5; Warren 1975, p.14, no. 27; Greenlaw 1979, p. 549, pl. III; Agee et al. 1981, p. 3, no. 113.

1. Forman 1987.

F28

Dressing or Toilet Table

1700–1720
Boston
Black walnut, aspen, soft maple, and secondary wood; 28¼ x 38 x 21¾" (71.8 x 96.5 x 55.2 cm)
B.69.52

The seeming simplicity of this dressing or toilet table, with single drawer and plain walnut, rather then veneered, surfaces, belies the sophistication evidenced by the turned elements and saltire-shaped stretcher. The design of the turned legs, with high, rounded cup and little rebate below, echoes that on both other high-style case pieces of Boston origin and on a rare and sophisticated Boston-made slate-top table. The stretcher is molded rather than following the more common flat design; the angled terminals at the turned legs add a distinctive detail.

PROVENANCE: Purchased by Miss Hogg from Ginsburg and Levy, New York, 1951.

TECHNICAL NOTES: Black walnut (top, sides, drawer front, front skirt, cross stretchers and finial, five block caps), aspen (feet, center drop), soft maple (legs); eastern white pine (backboard, corner case posts, drawer runners, center block). Brasses are not original. The drawer construction is dovetailed, the bottom board nailed, with grain running side to side.

RELATED EXAMPLES: Connecticut Historical Society, Hartford (Forman 1987, p. 161, no. 12);

ornament remain within the panels. While the majority of examples of this genre have the conventional vase-and-ring turnings on the legs, this table and two others were made with bobbin turnings.

PROVENANCE: Purchased by Bayou Bend from Israel Sack, New York, 1970.

TECHNICAL NOTES: Red oak (right rear post, right lower case rail), eastern white pine (drawer front, case backboard), soft maple (knobs), hemlock (drawer stop). The drawer is side-hung. The drawer construction is dovetailed; the bottom is a single slab of wood let into the front and nailed to the sides and back. Drawer sides are half lapped at back. The drawer knobs, end cleats, front panel moldings, and drawer moldings are not original.

RELATED EXAMPLES: Two with bobbin turnings: Nutting 1962, no. 213; Henry Ford Museum, Dearborn, Michigan (Lockwood 1957,

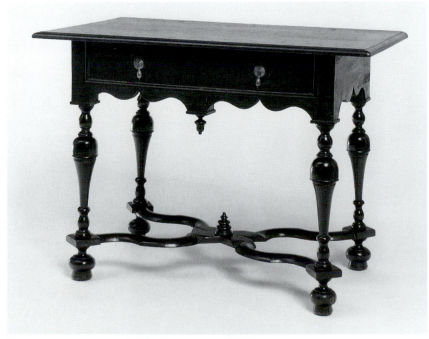

F28

similar leg design: Nutting 1962, nos. 388, 1092, a dressing table and high chest; Randall 1965, no. 55, a slate-top table.

REFERENCES: Warren 1975, p. 15, no. 28.

F29

Dressing or Toilet Table

1700–1725
Boston
Black walnut and walnut veneer, aspen, and secondary wood; 30¼ x 33⅝ x 21¾″ (76.8 x 85.4 x 55.2 cm)
B.69.45

The dressing table was often produced en suite with the high chest and was also used in the bedroom. As with the finest examples of the period, this dressing table is veneered with richly figured walnut. Four flitches, fitted together on the top to create a bold pattern, are surrounded by inlaid herringbone and cross-banded borders, and that motif is repeated on the three drawer fronts. The profile of the turned legs relates closely to the style of turning associated with Boston.

PROVENANCE: By tradition owned by Parson Thomas Smith, Newport, Rhode Island, and later Falmouth (now Portland), Maine, late eighteenth century; purchased by Miss Hogg from Ginsburg and Levy, New York, 1956.

TECHNICAL NOTES: Black walnut and walnut veneer, aspen (legs, feet); eastern white pine (top, back and front interior framing, drawer components, backboard). Brasses are replaced. The drawer construction is dovetailed, the bottom board nailed to the sides.

RELATED EXAMPLES: Levy Gallery 1992, p. 10, no. 5; Yale (Ward 1988, p. 197, no. 93); Comstock 1966, p. 261; advertisement of R. W. Worth Antiques, *Maine Antique Digest,* August 1996, p. 39-E. The turnings match those on a Boston high chest at Winterthur (Forman 1970, p. 21).

REFERENCES: Warren 1975, p. 15, no. 29.

F30

Miniature Chest with Drawer

1725–35
Attributed to Robert Crossman (1707–1799), Taunton, Massachusetts
Painted eastern white pine and secondary wood; 20½ x 22⅝ x 13″ (52.1 x 57.5 x 33 cm)
B.57.92

This chest, made with the simplest plank construction, is attributed to Robert Crossman, a Taunton drum maker who is also thought to have produced and decorated a distinctive body of furniture. The group ranges from miniature one-drawer chests, as represented by the Bayou Bend

example, to full-size chests of drawers. They are all ornamented with variations on the tree of life, probably inspired by printed or embroidered textiles. This chest displays decoration typical of Crossman's earlier works, which is segmented and confined to the drawer front and chest panel. His later pieces have decoration that covers the overall facade.

PROVENANCE: Purchased by Miss Hogg from John S. Walton, New York, 1957.

TECHNICAL NOTES: Painted eastern white pine; chestnut (drawer bottom). Pull is replaced. The drawer construction is dovetailed, the bottom board nailed to back and let into the sides and front. Backboards of chest are nailed.

RELATED EXAMPLES: Williamsburg (Greenlaw 1974, no. 72) and Lockwood 1957, fig. 39, have miniature one-drawer chests similarly

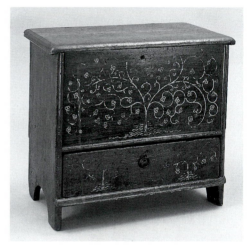

F30

decorated with trees on the drawer; Art Institute of Chicago (Comstock 1962, no. 180) and Fraser 1933, fig. 3, have miniature one-drawer chests; Winterthur has a miniature two-drawer chest in the late style, dated 1742 (Fales 1972, fig. 46); Sack 1969–92, vol. 10, p. 2659, no. P6358, a three-drawer chest dated 1732 on the front; Yale (Fraser 1933, fig. 4) and MMA (acc. no. 45.78.5) each has a three-drawer chest.

REFERENCES: Warren 1975, p. 15, no. 30.

F31

Chest with Drawers

1670–1710
Massachusetts, Hatfield area
White oak and secondary woods; 38¾ x 48⅛ x 17¾″ (98.4 x 122.2 x 45.1 cm)
B.69.356

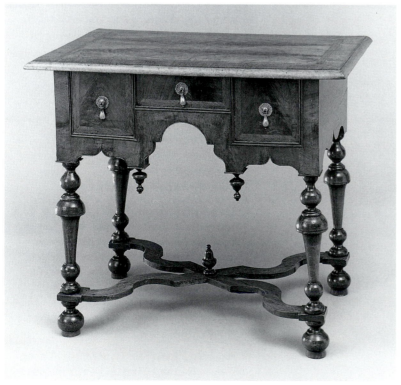

F29

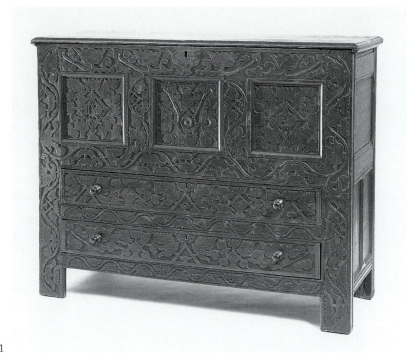

F31

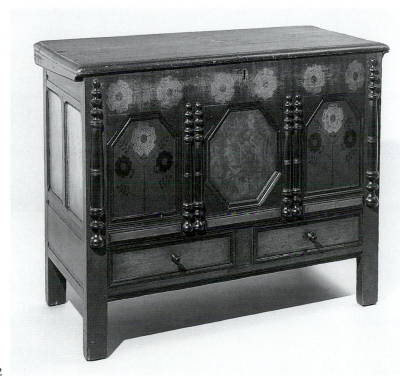

F32

PROVENANCE: Purchased by Miss Hogg from Ginsburg and Levy, New York, 1954.

TECHNICAL NOTES: White oak (right front leg, right bottom rail); southern yellow pine (lift top, bottom, backboard of bottom drawer), red oak (right side of upper drawer). Lift top and pulls are replaced. Backboard is a beveled panel let into the frame of the chest section; a different board with chamfered edges is nailed to the back of the drawer section. The drawer is side-hung. The beveled drawer bottom is let into the front and nailed to the sides and back, with grain running side to side. The drawer sides are half-lapped front and back. There is an inscription: Mary Allyns Chistt Cutte and joyned by Nich: Disbrowe [now considered spurious; see Hoopes 1933, p. 171].

RELATED EXAMPLES: Kane 1975, pp. 110–11, discusses eleven closely related examples.

REFERENCES: *Antiques* 4 (September 1923), p. 115; Lockwood 1957, pp. 335–37; Sack 1950, p. 108; *Connoisseur* 134 (September 1954), p. 60; Ormsbee 1957, pl. V, pp. 31–32; Comstock 1962, no. 55; Kane 1975, p. 80; Warren 1975, p. 16, no. 31; Agee et al. 1981, p. 63, no. 112; *Antiques* 128 (August 1985), p. 204.

F32

Chest with Drawer

1690–1710
Boston area
Painted oak and secondary wood; open: 27⅝ x 41⅛ x 34" (70.2 x 104.5 x 86.4 cm); closed: 27⅝ x 17½ x 34" (70.2 x 44.5 x 86.4 cm)
B.69.48

This chest is part of a group of relatively late Mannerist examples that feature double-paneled ends and cleated hinged tops. The applied moldings on the front panels define a variety of angular geometric shapes—octagons, squares, and cruciforms. Elongated spindles with multiple ringed turnings in the upper section also are typical.

PROVENANCE: Purchased by Miss Hogg from Miss Katrina Kipper, Queen Anne Cottage, Accord, Massachusetts, 1926.

TECHNICAL NOTES: Materials of oak and pine (secondary wood) not analyzed microscopically. The side-hung drawer is made with two dovetails, and the grain of the drawer bottom is parallel to the front. The bottom is nailed all around. The drawer sides are half-lapped to the backboard and nailed. The back-

This chest with upper storage area, accessed via a lift top, and two lower drawers represents a relatively common form of case furniture in late-seventeenth-century New England. These chests, produced by joiners using mortise-and-tenon construction, reflect the traditional techniques of joinery of Elizabethan and Jacobean England transferred to the New World. Typically, the drawers are suspended on side runners, as seen in the present example. The carved ornament of the facade makes this chest, and the group to which it belongs, distinctive. The vine, tulip, and leaf motif appears with variations on a relatively large number of surviving chests produced in the Connecticut River valley around Hatfield and Hadley, Massachusetts, and possibly as far south as Hartford, Connecticut. Features of the Bayou Bend chest that point to its origins in the Hatfield area are the undulating vines on the stiles and the lozenges with initials, rosettes, and tulips on the panels.

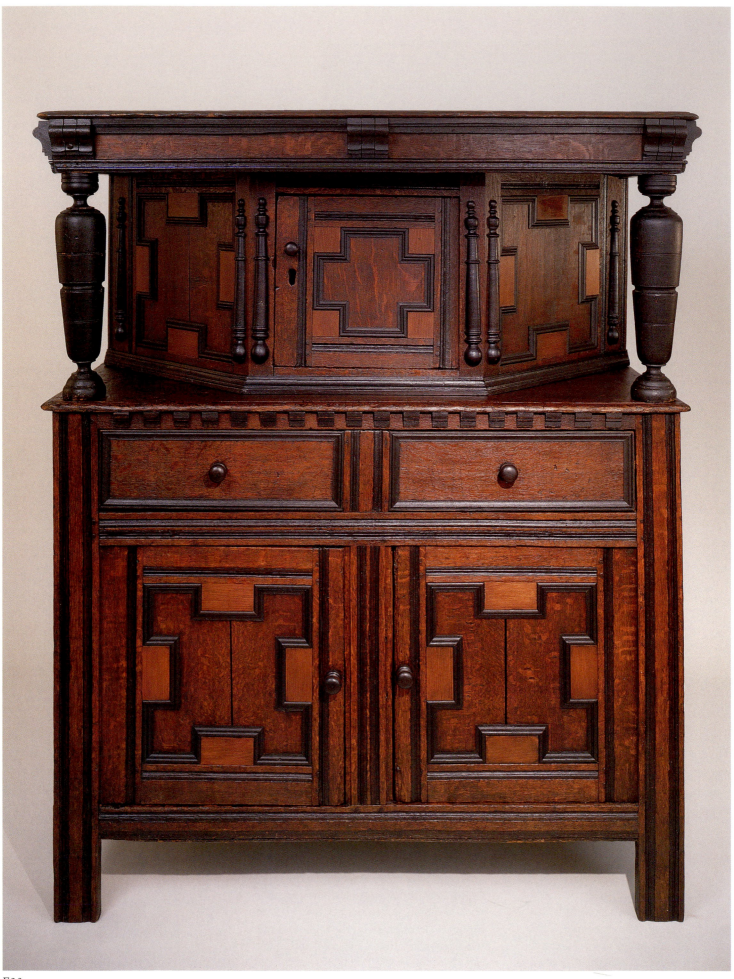

F33

board is a beveled panel above the drawer. The stylized Tudor roses of the rail and the two flanking front panels have been laid out with a compass. The roses and wavy grain-painted ornament on the stiles and rails appear to be contemporaneous with the chest. The grain-painted ornament on the sides and the central panel of the front are nineteenth-century embellishments.

RELATED EXAMPLES: MFA, Boston (Randall 1965, no. 12); Wadsworth (Nutting 1962, no. 45); Forman 1970, fig. 6, is an earlier example. The six-sided panels here relate to the design seen on a group of North Shore toilet tables (see cat. no. F27).

REFERENCES: Advertisement for Miss Kipper's Queen Anne Cottage, *Antiques* 2 (August 1922), p. 94; Nutting 1962, no. 33; Comstock 1962, no. 65; Warren 1975, p. 18, no. 34.

F33

Cupboard

1670–1700
Boston area
Red oak, red maple, and secondary woods;
60 x 49¾ x 23¼" (152.4 x 126.4 x 59.1 cm)
Museum purchase with funds provided by the
Theta Charity Antiques Show, B.93.11

The joined cupboard was among the most expensive furniture forms found in the seventeenth-century colonial American house, exceeded only by joined presses, elaborate chests of drawers, and uphol-stered pieces. These cupboards appear to have been placed in a room used for din-ing that also usually served as the parlor. While most seventeenth-century case furniture was rather utilitarian, this par-ticular form, with its partially open upper section, provided the opportunity to show off expensive silver, glass, or ceramics, and its possession clearly indicated that the owner was both affluent and an im-portant member of the community.

The upper section of this cupboard is architectonic, as is typical of the form. The frieze, which features a dentil course and moldings, is supported by vase forms that evoke the reverse tapering shape of columns in Mannerist architecture. Simi-larly, the applied spindles of the upper case take the form of Tuscan columns, which, in the unsettling anticlassic mode

of Mannerism, have no architectural sup-port. The three corbels of the frieze are repeated in dentil form along the top frame of the lower case.

Although this cupboard has previously been associated with the Harvard College joiner tradition of Middlesex County, differences of construction technique and ornament suggest that it is more closely related to the Boston school.[1] The dis-tinctive decorative motifs of this cup-board—bold corbels and dentils in the upper frieze and mitered cruciform panels on the doors—represent elements origi-nating in England in the mid-seventeenth century. Scholars believe that London-trained craftsmen in the Mason-Messinger shops introduced these innovations to Boston.[2] Incorporation of these decora-tive motifs on the Bayou Bend cupboard suggest that its maker was emulating their new and fashionable designs.[3] Yet not totally at home with them, he has used the turned vase-shaped columns and recessed upper cupboard arrangement that represents an earlier, more conserva-tive taste. The turning of the vase-shaped pillars and applied spindles, which also re-late to the Boston style, further strength-ens a Boston or Boston-area attribution.

PROVENANCE: Louise Crowninshield Bacon; Mrs. Francis B. Lathrop; purchased by Bayou Bend at Christie's, New York, sale 7710, June 23, 1993, lot 140.

TECHNICAL NOTES: Red oak, red maple (right column); white pine (drawer bottom), western redcedar (replacement moldings). Three cor-bels replicate originals over turned balusters; applied mitered moldings on the panels and dentils at the top of the lower section were re-stored following the ghost images left by the originals. The loss of about three inches at the bottom of the legs was also restored. Knobs, although old, are not original. The drawer is side-hung. The drawer construction is dove-tailed, the bottom board let into the sides and front, with grain running side to side. The drawer back is butt-jointed to the sides.

RELATED EXAMPLES: Winterthur (Trent 1975, fig. 4), a cupboard with open lower section and an Essex County cupboard with drawers that incorporate similar corbels and serrated toothlike dentils (Nutting 1965, no. 199); Art Institute of Chicago, a one-drawer chest that incorporates similar construction techniques of double inset end panels and has one section of mitered molding (Trent 1975, fig. 5). For an English example with a similar combination of new and old ideas, see Kirk 1982, p. 201, no. 587.

EXHIBITED: National Historic Site, Saugus, Massachusetts, 1951–93.

1. Trent 1975. Trent cites chamfered slablike boards nailed to the back of the case as a telltale technique of the school, but the back panel here incorporates framed inset panels of a type associated with Boston and Essex County. The double end panels and drawer construction are also at variance with the Cambridge model.
2. See Fairbanks and Trent 1982, vol. 3, p. 522, no. 481.
3. Examples ascribed to the Mason-Messinger shops that featured corbeled cornice and mitered panels are at MFA, Boston (Fair-banks and Trent 1982, vol. 3, no. 493), and Yale (Ward 1988, no. 51).

F34

High Chest

1700–1725
Boston
Various woods (see Technical notes); 68¼ x
40¼ x 22¼" (173.4 x 102.2 x 56.5 cm)
B.69.43

The Early Baroque high chest, a form of furniture introduced in that period, was intended for use in the bedroom. Pro-duced by sophisticated craftsmen known as cabinetmakers, the form represented the acme of case furniture, both in terms of expense and complexity of manufac-ture. The design is architectural and re-lates to room interior details of the period. The case and drawers were put together with dovetails and the surface was usually veneered with a figured wood.

The Bayou Bend example has several distinctive features. The composition is crowned with a bold molded cornice and a pulvinated frieze, an architectural detail associated with the Ionic order. The sur-face is richly veneered with burled wal-nut, not only on the facade but also on the sides, and in an unusual detail the drawer divides and surrounds are also ve-neered, all features that point to an item of unusual luxury.

PROVENANCE: Purchased by Miss Hogg from John S. Walton, New York, 1953.

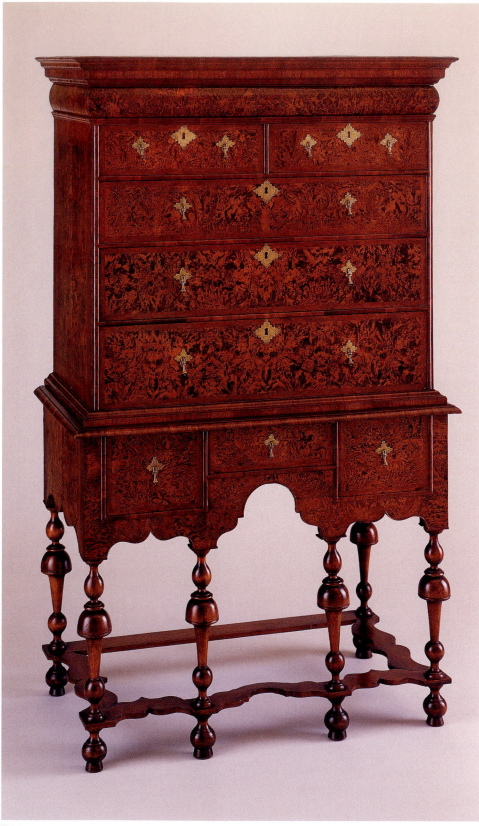

F34

bottom board let into the front and nailed to the sides.

RELATED EXAMPLES: Winterthur (acc. no. 66.1306) is very similar but differs in detail, such as in the design of the turned legs. That example is inscribed "JM 1720," which was thought by Benno Forman to be either James Maverick or John Mattocks, both Boston cabinetmakers.[1] MMA (Yarmon 1952, p. 40) also varies in the turned elements; MFA, Boston (Randall 1965, no. 51); Yale (Ward 1988, p. 237, no. 122) has a similar pulvinated frieze but may be from New York; Historic Deerfield, a japanned example (Fales 1976, p. 204, no. 420); Mr. and Mrs. R. M. Hansen, Grosse Pointe, Michigan (Hansen 1948).

REFERENCES: Warren 1975, p. 16, no. 33; Greenlaw 1979, p. 548, pl. I; Agee et al. 1981, p. 64, no. 114; Warren 1988, p. 17; Marzio et al. 1989, pp. 226–27.

1. Letter in object files dated March 2, 1976.

F35

Desk

1700–1730
New York
Various woods (see Technical notes); open: 41¼ x 36¼ x 33⅜" (104.8 x 92.1 x 84.8 cm); closed: 41¼ x 36¼ x 19⅝" (104.8 x 92.1 x 49.8 cm)
B.69.42

The slant-front writing desk was a new form of case furniture in the Early Baroque period. The earliest examples typically gave access to a storage space under the writing surface through an opening covered by a panel that slides under the pigeonhole area. As with the most sophisticated and expensive case furniture of the period, the exterior is ornamented with figured veneers on the slant top and drawer fronts. Unlike the single broad panel of Boston veneered facades, the burled surface of the Bayou Bend desk has been compartmented across the drawer fronts by vertical strips of darker veneer, visually resembling two smaller drawers rather than one large, horizontal drawer. The outside of the slant top repeats this treatment. While the Bayou Bend example had long been thought to be from Boston, the appearance of this motif on a documented western Long

TECHNICAL NOTES: Black walnut and burled walnut veneer (right front leg, moldings and caps at top of legs), soft maple (stretchers), aspen (remaining legs, feet), eastern white pine (interior framing, drawer components), hemlock (horizontal brace across back on interior upper case, an addition), birch (back of left front stretcher, probably a replacement).

The upper section of the case shows evidence that it was enlarged vertically with a dovetailed extension, apparently concurrent with the date of the rest of the piece, suggesting that the pulvinated frieze, which conceals a drawer, may be a detail added to the original design. Brasses are replaced. The drawer construction is dovetailed, the

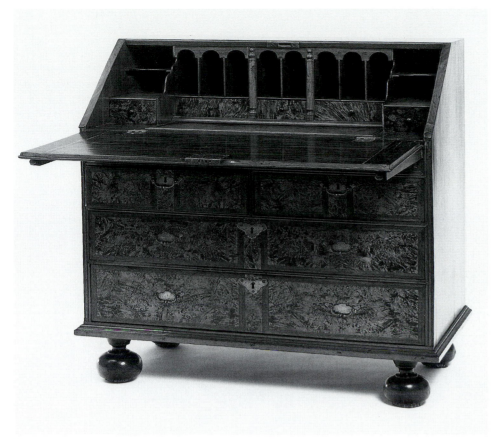

F35

Island high chest suggests a New York provenance for this desk.[1] Close analogies between the Bayou Bend desk and one with a history of ownership in the Livingston family add credence to a New York provenance. The use of yellow-poplar and black walnut also suggest an origin other than Boston. The joining of the backboard to the side with dovetails, an unusual technique, has been observed on other case pieces from New York, including the Livingston family desk.[2]

PROVENANCE: Purchased by Miss Hogg from Collings and Collings, New York, 1927.

TECHNICAL NOTES: Black walnut, undetermined burl veneer, eastern white pine (writing surface); eastern white pine (fronts and bottoms of writing section drawers, below center section of interior compartment, horizontal veneered board above lower drawers, drawer dividers, fronts of lower drawers, bottom board, horizontal strips that feet are attached through), black walnut (below outer writing section drawers, molding that frames sliding panel in writing section, slides to support lid, end cleats on lid), yellow-poplar (backboard, sides and backs of writing section drawers, components of lower drawers, center divider between and horizontal brace behind the two side-by-side lower drawers, large board below writing surface), cherry (right drawer runner

of center lower drawer), Cuban oyster wood (*Gymnanthes lucida;* knobs of writing section drawers). The turned chestnut feet are replacements. The hinges on the writing surface are replaced. There is evidence of a covering, possibly leather or baize, previously nailed to the writing surface.

RELATED EXAMPLES: Winterthur (acc. no. 58.1799), with the unusual detail that the writing surface carries veneer that repeats the pattern on the lid, ascribed to Rhode Island; Sleepy Hollow Restorations, Tarrytown, New York (Butler 1983, no. 84), which has a closely related interior with well and a similar arrangement of veneers on the exterior; Art Institute of Chicago (acc. no. E9719); a private collection with history of ownership in the Livingston family; Levy Gallery 1988b, p. 16; advertisement of David Stockwell (*Antiques* 98 [September 1970], p. 289). MMA (acc. no. 50.228.2), a high chest that has similar burled veneer on drawer fronts.

REFERENCES: Warren 1975, p. 18, no. 35.

1. Winterthur, acc. no. 57.512, inscribed by the maker Samuel Clement of Flushing and dated 1726. For another New York high chest with similar patterns of burl veneer with compartmentalized design, see Miller 1956, p. 21, no. 20.
2. Winterthur, acc. no. 58.559, a chest-on-frame with spiral-turned legs.

LATE BAROQUE

F36

Side Chair

1730–75
Boston
Mahogany and secondary wood; 44 x 20½ x 21½" (111.8 x 52.1 x 54.6 cm)
B.57.75

The Late Baroque, more popularly known as the Queen Anne style, was integrated into the vocabulary of Boston furniture makers by 1729.[1] The bold, curvilinear contours that had characterized the Early Baroque continued to define the style; however, while previously the emphasis had been placed on detail, the later style placed it on the overall form. The vertical orientation of this handsome side chair suggests a persistence of the Early Baroque, yet its pad feet, cabriole legs, vase-shaped banister, and crest rail embody a sinuous Late Baroque Boston version.[2] Native walnut was the preferred primary wood; the choice of imported mahogany is uncommon, although references to its use occur in Boston as early as the 1730s.[3]

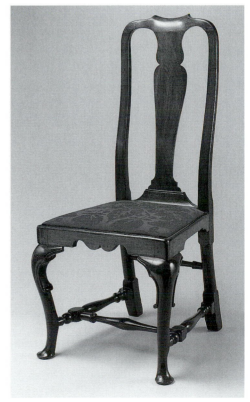

F36

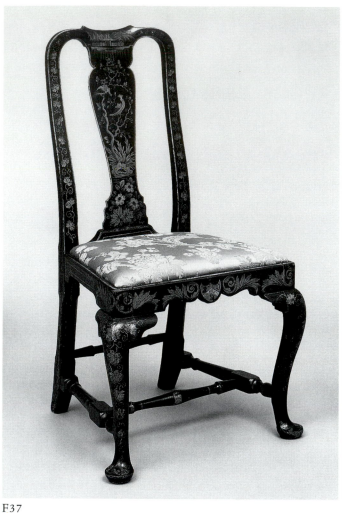

F37

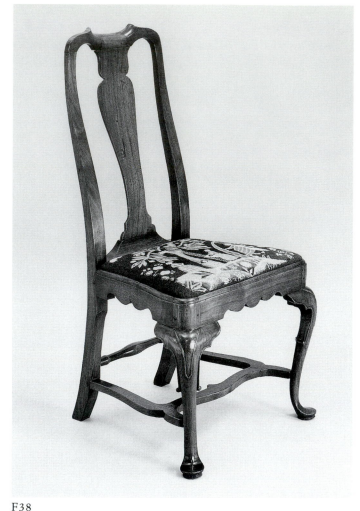

F38

PROVENANCE: Purchased by Miss Hogg from Teina Baumstone, New York, 1957.

TECHNICAL NOTES: Mahogany; beech (slip seat). The construction is typical of New England chairs from this period. The stretchers were retained, the front legs extended to form the seat frame corners. The thinly cut seat rails correspond to the seat frame's shape. The seat rail is incised X, the slip seat, III.

RELATED EXAMPLES: Kirk 1972b, p. 129, no. 161; Ott 1975, p. 949; Fairbanks et al. 1981, p. 598; SPNEA, interior file no. 57. John Smibert's 1732 portrait of Mrs. Andrew Oliver and son depicts a similar chair (Saunders 1995, pp. 95, 176).

REFERENCES: Jobe 1974, pp. 42, 44; Warren 1975, p. 23, no. 37.

1. For documentation of the style's date span, see Jobe 1974, p. 42. John Singleton Copley's 1768 portrait of John Amory suggests that the Late Baroque was still considered fashionable (Hipkiss 1941, pp. 8–9).
2. Scholars have long debated the regional origin of this type of chair, attributing it to Boston or Newport (Ott 1965, pp. 4–5, no. 3; Jobe 1974, pp. 42, 44; Trent and Nelson 1985, pp. 102–3). Examples with Boston histories

support that regional attribution (see Related examples).
3. Lyon 1925, p. 169; Dow 1967, p. 110.

F37

Pair of Side Chairs

1730–1800, decoration added ca. 1800–1843
Eastern Massachusetts
Black walnut and secondary woods; B.69.247.1:
39⅞ x 22 x 20½" (101.3 x 55.9 x 52.1 cm);
B.69.247.2: 39¾ x 21¾ x 20½" (101 x 55.2 x
52.1 cm)
B.69.247.1–.2

These chairs, with block-and-spindle stretchers, vase-shaped splat, straight stiles, and yokelike crest, are classic examples of Late Baroque New England chair making. Fashioned of walnut, their exotic chinoiserie decoration, added in the early nineteenth century, represents a revival of japanning (see cat. no. F77).[1] In America, unlike in England, the surfaces of furni-

ture to be japanned were not gessoed. Instead, a pigmented varnish was applied directly to the wood, followed by a combination of brush and stencil work. Gold powders were then added to complete the decoration. Typically, this ornamental work was executed by an artist who undertook a range of projects, including the decoration of window shades, floor cloths, trade signs, and even carriages, sleighs, and other vehicles.[2]

PROVENANCE: Two distinct numbering systems found in the nine known chairs indicates that at least two sets were combined, presumably for Samuel Pickering Gardner (1767–1843). It is published that the chairs descended to Gardner's grandniece Eliza Blanchard, but the provenance of two of them suggests a direct line of descent through Gardner's descendants.[3] The Bayou Bend chairs' history, subsequent to Gardner's ownership, is not known. Purchased by Miss Hogg from John S. Walton, New York, 1953.

TECHNICAL NOTES: Black walnut; soft maple (slip seat), eastern white pine (corner blocks). The construction is typical of New England

chairs from this period (see cat. no. F36). Some of the original large triangular corner blocks remain. The back is devoid of decoration. Analysis of the decoration does not suggest a conclusive date. The seat rail of B.69.247.1 is incised with one triangular notch, its slip seat with four notches. The seat rail of B.69.247.2 has three notches, its slip seat, five.

RELATED EXAMPLES: Nine side chairs and a related armchair are known, eight of which are published: Fales 1976, pp. 42–43, nos. 71–72; Fairbanks et al. 1981, p. 599; Sack 1969–92, vol. 7, pp. 1794–95, no. P4991; Sotheby's, New York, sale 5810, January 26–28, 1989, lot 1503. The ninth side chair and the armchair remain with Gardner descendants. Other publications including these chairs are Deerfield 1956, p. 234; Fales 1972, p. 67; Fairbanks and Bates 1981, p. 137; Bishop and Coblentz 1982, pp. 72–73.

REFERENCES: Comstock 1962, no. 174; Davidson 1967, pp. 150–51; Bishop 1972, pp. 70–73; Fales 1972, pp. 66–67; Fales 1974a, pp. 62, 65, 68; Warren 1975, p. 23, no. 36.

1. George Hepplewhite commented on this vogue in England in his influential volume *The Cabinet-Maker and Upholsterer's Guide:* "For chairs, a new and very elegant fashion has arisen within these few years, of finishing them with painted or japanned work. . . ." (Hepplewhite 1969, p. 2). See also *Antiques* 121 (April 1982), p. 878.
2. Cooney 1978.
3. The Blanchard association is first recorded in Fales 1972, p. 67. The chair Sotheby's auctioned in 1989 descended from Gardner's daughter Mary (Mrs. Francis Cabot Lowell, 1802–1854); to her daughter Mary (Mrs. Algernon Coolidge, 1833–1915); to her daughter Mary (Mrs. Frederick Otis Barton, 1868–1957); to the consignor. A second chair, owned by Gardner's son George (1809–1884), descended to his daughter Elizabeth (Mrs. Charles W. Amory, b. 1843); to her daughter Clara (Mrs. T. Jefferson Coolidge, b. 1872); to her son.

F38

Pair of Side Chairs

1730–75
Boston
Black walnut and soft maple; B.60.31.1: 41¾ x 22 x 21⅛" (106 x 55.9 x 53.7 cm); B.60.31.2: 41¾ x 21⅞ x 21¼" (106 x 55.6 x 54 cm)
B.60.31.1–.2

These superb chairs are among the most accomplished expressions of Late Baroque New England seating furniture. Their

overall form is akin to the standard pattern (see cat. no. F37); however, a series of refinements sets them apart. These details include the flat, curvilinear stretchers, molded C-scrolls and lambrequins on the knees, and scalloped seat rails on the front and sides. Previously, they were attributed to Newport, but recent scholarship and visual evidence, such as John Singleton Copley's portrait of the Boston merchant John Barrett delineating similar ornament on his chair, support a Boston attribution.[1]

PROVENANCE: Herbert Lawton, Boston; auctioned in 1937; purchased by Miss Hogg from Israel Sack, New York, 1960.

TECHNICAL NOTES: Black walnut, soft maple (rear seat rail, stretcher); soft maple (slip seat). The construction is typical of New England chairs from this period (see cat. no. F36). Period English needlework was adapted for the seats. The front seat rail of B.60.31.1 is incised V, its slip seat, III, while the corresponding elements on B.60.31.2 are marked IIII.

RELATED EXAMPLES: The closest published examples are Downs 1952, no. 110; Sack 1969–92, vol. 3, p. 607, no. 1381; Randall 1965, pp. 170–71, no. 133.

REFERENCES: American Art Association, Anderson Galleries, New York, sale 4314, April 2–3, 1937, lot 392; *Antiques* 31 (March 1937), p. 142; Keyes 1937, p. 310; Sack 1969–92, vol. 1, p. 40, no. 123; Warren 1975, p. 23, no. 38.

1. Keno, Freund, and Miller 1996; Taggart 1982, p. 1027.

F39

Side Chair

1730–75
Boston
Black walnut and secondary wood; 40 x 21¾ x 21" (101.6 x 55.2 x 53.3 cm)
B.60.51

Flat, curvilinear stretchers such as these have long been associated with Newport furniture. More distinctive and unusual is the hooped shoulder joining the stiles and crest rail, a detail patterned after English chairs. On the basis of these elements, along with the publication of a set purportedly made by Job Townsend for the Eddy family, chairs of this type were routinely assigned to Newport, many of

them attributed to Townsend.[1] The documentation for these chairs has never been substantiated, and recent scholarship has established a Boston origin.[2]

PROVENANCE: Purchased by Miss Hogg from Israel Sack, New York, 1960.

TECHNICAL NOTES: Black walnut; soft maple (slip seat). The construction is typical of New England chairs from this period (see cat. no. F36). The crest rail is joined to the stiles at the top of the ear rather than near the shoulder. The front seat rail and slip seat are incised IIII.

RELATED EXAMPLES: Chairs with shaped front seat rails include Greenlaw 1974, pp. 60–61, no. 52; Sack 1969–92, vol. 2, p. 363, no. 914; vol. 4, p. 1015, no. P3838; vol. 6, p. 1650, no. P4768; *Antiques* 147 (May 1995), p. 642. Unpublished examples belong to the Art Institute of Chicago (acc. no. 1970-102); and The Denver Art Museum (acc. no. 1979.62). Similar chairs with plain seat rails are American Art Association, Anderson Galleries, New York, sale 3804, January 2–4, 1930, lot 492; Carpenter 1954, p. 39, no. 13; Ott 1965, pp. 4–5, no. 4; Hummel 1970–71, pt. 2, pp. 902–4; Sack 1969–92, vol. 8, p. 2354, no. P5887; *Antiques* 131 (January 1987), p. 45; an unpublished example belongs to the Newport Historical Society.

REFERENCES: Warren 1975, p. 24, no. 39; Moses 1984, pp. 14, 58.

1. American Art Association, Anderson Galleries, New York, sale 3804, January 2–4, 1930, lot 492.
2. Keno, Freund, and Miller 1996, p. 278.

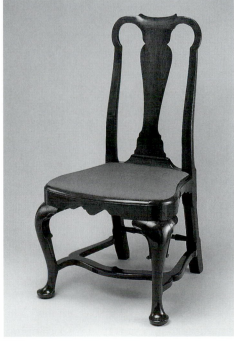

F39

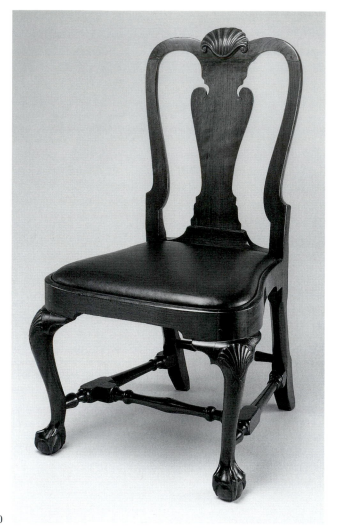

F40

F40

Pair of Side Chairs

1735–95
Boston
Black walnut; B.58.141.1: 38½ x 21¾ x 21⅝″
(97.8 x 55.2 x 54.9 cm); B.58.141.2: 38¼ x 21⅞ x
21⅞″ (97.2 x 55.6 x 55.6 cm)
B.58.141.1–.2

Another type of chair traditionally as-
cribed to Newport incorporates S-curved
stiles with carved scallop shells on the
knees and crest rail. Surprisingly, this
attribution is based largely on the shells'
similarities with those that ornament
Newport's distinctive case furniture.
While more than fifty chairs matching
this general description are recorded,
there is only one documented set, be-
lieved to have been supplied to Providence
merchant Moses Brown by the Newport
cabinetmaker John Goddard.[1] Besides the
Goddard-Brown chairs, no examples of
the so-called Newport type with a Rhode
Island provenance are known. However,

several chairs with histories in Massachu-
setts, New Hampshire, and Maine, sup-
port an attribution to the Boston area.[2]

PROVENANCE: Guy Warren Walker, Jr., Bev-
erly, Massachusetts; purchased by Miss Hogg
from Israel Sack, New York, 1958.

TECHNICAL NOTES: No original secondary
woods remain. The construction is typical of
New England chairs from this period (see cat.
no. F36). The stiles' exterior curve is attached
to the corresponding interior segment. The
interior seat rail of B.58.141.1 is incised I, and
of B.58.141.2, V.

RELATED EXAMPLES: Sack 1950, p. 23; Jobe
and Kaye 1984, pp. 358–60, no. 99; Rodriguez
Roque 1984, pp. 116–17, no. 49; Heckscher 1985,
pp. 42–43, no. 7.

REFERENCES: Carpenter 1954, p. 31, no. 5;
Sack 1969–92, vol. 1, p. 61, no. 193; Warren
1975, p. 24, no. 40; Moses 1984, p. 220.

1. Carpenter 1954, p. 37, no. 11.
2. Jobe and Kaye 1984, p. 359. Additional chairs
 with a provenance include Fales 1976, p. 46,
 no. 79; and Sotheby's, New York, sale 5755,

October 22, 1988, lot 389. A pair appears in
an 1890s photograph of Dr. Summer's par-
lor in Shrewsbury, Massachusetts (SPNEA,
interior file, no. 161).

F41

Pair of Side Chairs

1735–95
Boston
Black walnut and secondary wood; B.69.90.1:
39½ x 22 x 21½″ (100.3 x 55.9 x 54.6 cm);
B.69.90.2: 39½ x 22 x 20⅝″ (100.3 x 55.9 x
52.4 cm)
B.69.90.1–.2

PROVENANCE: See cat. no. F29.[1] Purchased
by Miss Hogg from Ginsburg and Levy, New
York, 1953.

TECHNICAL NOTES: Black walnut; soft maple
(slip seat). The construction is typical of New
England chairs from this period (see cat. no.
F36). The seat rails are numbered 25.664.
B.69.90.1: The front rail and seat are incised X.
B.69.90.2: The front rail is incised VIII; the
front of the slip seat bears the mark III.

RELATED EXAMPLES: See cat. no. F40.

1. Another set of chairs with this provenance
 is recorded in *Antiques* 55 (June 1949), p. 417;
 Ott 1965, pp. 8–9, no. 8; Keno, Freund, and
 Miller 1996, pp. 295–96. Whether this is the
 same individual who purportedly owned
 the Bayou Bend chairs has not been deter-
 mined. Coincidentally, both sets of chairs
 came through the same dealer.

F42

Side Chair

1735–1800
Norwich or Hartford, Connecticut, area
Cherry, birch, and secondary wood; 40⅝ x
21½ x 20¼″ (103.2 x 54.6 x 51.4 cm)
B.69.218

The striking individuality evident in Con-
necticut's eighteenth-century furniture
affirms that it was a crossroads of design,
its craftsmen's work influenced by their
Boston, Newport, New York, and
Philadelphia counterparts. Some artisans
trained outside Connecticut, and on their
return they introduced the regional de-
signs and construction techniques learned
during their apprenticeships. The Bayou
Bend side chair, while derived from the
classic New England pattern, substitutes a

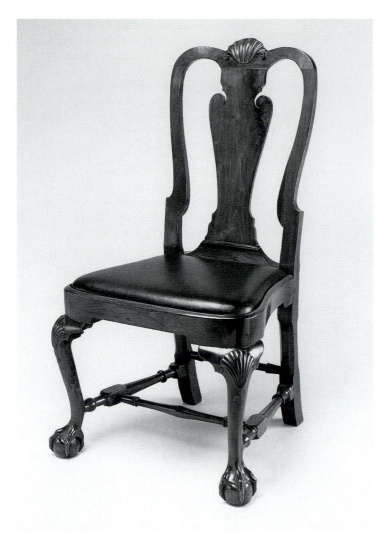

F41

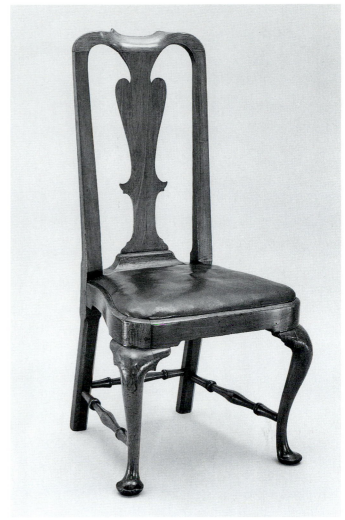

F42

more complex banister, one also present in Philadelphia chairs (see cat. nos. F47, F48), and a singular stretcher arrangement, presumably patterned after an English model.[1]

PROVENANCE: Purchased by Miss Hogg from Israel Sack, New York, 1948.

TECHNICAL NOTES: Cherry, birch (side seat rails); soft maple (slip seat). The construction is typical of New England chairs from this period (see cat. no. F36). The chair retains its original upholstery foundation. The front seat rail and slip seat are incised X.

RELATED EXAMPLES: Best known within this group are chairs purportedly made for Connecticut Governors Gurdon Saltonstall (1666–1724) of Branford and Norwich and William Pitkin (1694–1769) of East Hartford, although the former's date of death predates the style's introduction (Trent and Nelson 1985, pp. 68–69, 72–73, nos. 12, 14). Another example is inscribed "Cheney," which has been interpreted as either the mark of East Hartford joiner Benjamin Cheney (ca. 1698–1760) or as referring to an early owner (Ward and Hosley 1985, p. 236, no. 118; Trent and Nelson

1985, p. 76–77, no. 16). For other examples, see *Antiques* 125 (January 1984), p. 253; Trent and Nelson 1985, pp. 67–75, nos. 12, 14–15. Similar chairs exhibiting a range of banister patterns are recorded in Ward and Hosley 1985, p. 236, no. 118.

REFERENCES: Warren 1975, p. 24, no. 41.

1. Kirk 1982, p. 243, no. 801.

F43

Side Chair

1750–75
New York
Mahogany, beech, and secondary woods; 41½ x 22½ x 21½" (105.4 x 57.2 x 54.6 cm)
B.69.33

Reverse ciphers introduced a novel device for ornamenting and personalizing silver during the Late Baroque period in England and America (see cat. no. M50). Ironically, by the early 1750s, as their application on silver began to diminish, ciphers

were becoming fashionable on furniture.[1] The Bayou Bend chairs represent the singular instance of an American craftsman embracing this vogue. A specific precedent for its carefully delineated cipher is not known in furniture, silver, or among published designs. In other respects, this side chair embodies the New York interpretation of the Late Baroque. Its generous proportions disclose a closer affinity with English design than with its New England or Philadelphia counterparts.

PROVENANCE: By family tradition the cipher is for Robert Livingston (1718–1775) and Margaret Beekman Livingston (1724–1800), married 1742[2]; to their daughter Catherine (Mrs. Freeborn Garretson, 1752–1849) or son Robert R. Livingston (1746–1813); to his daughter Margaret Maria (Mrs. Robert L. Livingston, 1783–1818); to her daughter Maria (Mrs. John C. Tillotson, 1800–1830); to her daughter Cornelia Ridgely (Mrs. William Pratt Wainwright, b. 1830); to her son John Tillotson Wainwright, I (1864–1900); to his son John Tillotson Wainwright, II (1898–1930); to his wife Alice Cutts Wainwright, who sold five

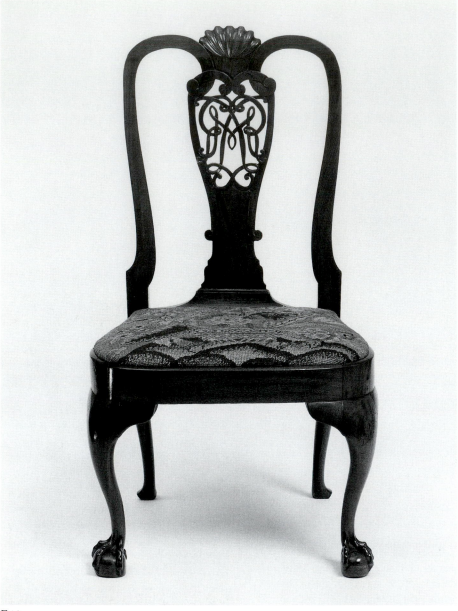

F43

F43 (detail)

1976, pp. 81–82, no. 61; Naeve 1978, p. 9, no. 10; Hawley 1989, pp. 326–31. Other publications citing these chairs are: Downs 1951, p. 47; Hanks 1972; *Art News* 51 (November 1952), p. 10; *Antiques* 64 (August 1953), p. 78; *Antiques* 99 (January 1971), p. 4; *Antiques* 101 (February 1972), p. 314; Kirk 1972a, pp. 423–24; Kirk 1972b, p. 112; Kane 1980, p. 1316; *Colonial Homes* 10 (May–June 1984), p. 123.

REFERENCES: Comstock 1962, no. 171; Bishop 1972, pp. 142–43; Warren 1975, p. 25, no. 42; Fairbanks and Bates 1981, p. 94; Agee et al. 1981, p. 73, no. 128; *American Heritage* 1992, p. 1482; Beckerdite 1996, pp. 260–62.

1. For English cipher-back chairs, see Hawley 1989, p. 326; White 1990, p. 124; and Hayward and Kirkham 1980, pp. 24, 78, 101.
2. While it is plausible that the chairs were owned by his parents, Robert (1688–1775) and Margaret Howarden Livingston (d. 1748), married 1717, or his son and daughter-in-law Robert R. (1746–1813) and Mary Stevens Livingston (1752–1814), married 1770, the monogram of Catherine Livingston Garretson (1752–1849) on a seat cover implies the suite descended from her parents, Robert and Margaret Beekman Livingston (Clarkson 1869; Piwonka 1986).

F44

Side Chair

1730–75
Philadelphia
Black walnut and secondary woods; 40½ x 19⅞ x 19¾" (102.9 x 50.5 x 50.2 cm)
B.69.69

It is generally believed that the Late Baroque style, introduced in Philadelphia about 1730, was largely disseminated through quantities of imported Boston-made chairs. Although the impact of the Boston model is most readily apparent on simple, inexpensive chairs (see cat. no. F55), it also influenced this more costly walnut version, with its related yoke-shaped crest rail. The chair's design is further enhanced by the graceful, inward curving rear legs, complementing its cabriole front legs, a refinement more common in English furniture. The intagalio carving on the chair's knees also appears on some of William Savery's documented furniture; however, that detail by itself is hardly sufficient to support an attribution to Savery.[1]

chairs to [Roger Bacon, Exeter, New Hampshire]; [John Kenneth Byard, Norwalk, Connecticut]; purchased by Miss Hogg from John S. Walton, New York, 1952.

TECHNICAL NOTES: Mahogany, beech (rear seat rail); cherry (slip seat), eastern white pine (front and rear corner blocks, diagonal brace), yellow-poplar (left front corner block). The seat is constructed with corner cross braces, a technique more prevalent in English furniture. The front corner blocks are a combination of polygonal shapes lapping triangular blocks. The rear seat rail brackets and the stiles' lower interior curves are applied, the latter derived from the exteriors in a manner consistent with New York craftsmanship. Labeled: on the seat frame, "Jack Wainwright"; on the slip seat, IIII.

RELATED EXAMPLES: Originally a set of eight; four others are in public collections: Hummel 1970–71, pt. 2, pp. 904, 906; Kane

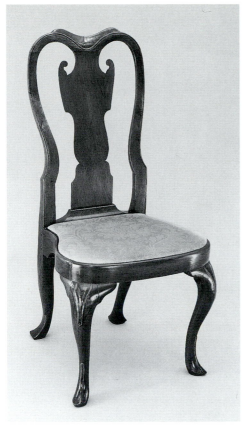

F44

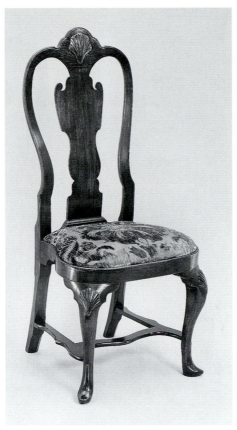

F45

TECHNICAL NOTES: Black walnut; black walnut (slip seat front and sides), southern yellow pine (slip seat back). The construction is typical of Philadelphia chairs from this period (see cat. no. F44). B.69.407.1: The seat frame is incised I, its slip seat, VI. B.69.407.2: The front seat rail is marked VII (probably the earlier mark) and II. The seat is stamped I. The rear seat rails are branded GE. Loan numbers and a fragmentary PMA label identify Mr. Wurts as a previous owner of the chairs.

RELATED EXAMPLES: Miller 1937a, vol. 1, pp. 131, 134, nos. 62–63; Downs 1952, no. 112; *Antiques* 101 (March 1972), p. 411; Hornor 1977, p. 194, pl. 315; Lloyd 1983, p. 279; Christie's, New York, sale 5890, May 23, 1985, lot 192; Elder and Stokes 1987, pp. 21–22, no. 7.

REFERENCES: *Antiques* 47 (May 1945), p. 262; Warren 1975, p. 25, no. 44.

1. For Germanic influences on early-eighteenth-century Philadelphia chair-making, see Forman 1983, pp. 166–70, and Caldwell 1985, pp. 29–34, 70–72.

F46

Side Chair

1735–95
Philadelphia
Black walnut and secondary woods; 42⅜ x 20¾ x 19¾" (107.6 x 52.7 x 50.2 cm)
B.69.246

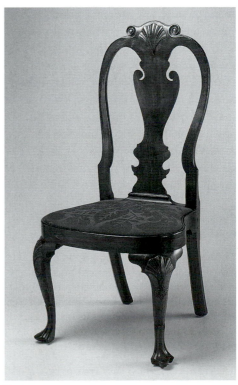

F46

PROVENANCE: Purchased by Miss Hogg from David Stockwell, Philadelphia, 1953, who noted its descent from Lieutenant Governor James Hamilton (ca. 1710–1783) to the Cox family.

TECHNICAL NOTES: Black walnut; black walnut (slip seat front and sides), southern yellow pine (slip seat back). The construction is typical of Philadelphia chairs from this period. The front legs are round-tenoned through the seat rail, and its applied lip secures the seat. The side seat rails are tenoned completely through the stiles. The cutouts from the front and side seat rails form the corresponding elements in the detachable seat. The front and side seat rails are incised III. The slip seat is marked with two chiseled gouges resembling a ratchet.

RELATED EXAMPLES: *Antiques* 65 (March 1954), p. 197; *Antiques* 89 (February 1966), p. 165; *Antiques* 129 (May 1986), p. 908; Parke-Bernet, New York, sale 599, November 8–11, 1944, lot 410; Downs 1952, no. 111; PMA 1976, pp. 34–35, no. 27; Heckscher 1985, pp. 79–81, no. 36; Fairbanks and Bates 1981, pp. 91, 104; Sotheby's, New York, sale 6731, June 22, 1995, lot 219; Zimmerman 1996, pp. 739–40.

REFERENCES: Warren 1975, p. 25, no. 43.

1. Woodhouse 1925; Comstock 1962, no. 176.

F45

Pair of Side Chairs

1730–75
Philadelphia
Black walnut and secondary woods; B.69.407.1: 42½ x 20 x 19⅛" (108 x 50.8 x 48.6 cm); B.69.407.2: 42¾ x 19¾ x 19¼" (108.6 x 50.2 x 48.9 cm)
B.69.407.1–.2

Pointed slipper feet, flat, curvilinear stretchers, elongated banisters, and carved shells framed within the crest rail are common characteristics of a group of Late Baroque Philadelphia chairs. In addition to their regional configuration, these chairs exhibit construction techniques attributable to immigrant German craftsmen, including the concealment of the front legs' round tenons behind the front seat rail and the tenoning of the side seat rails through the stiles, which in time became standard in the Philadelphia area.[1]

PROVENANCE: Charles R. K. Wurts, Philadelphia; purchased by Miss Hogg from David Stockwell, Philadelphia, 1948, who noted the chairs' descent from George Emlen (1695–1754) or his son and namesake (1741/42–1812). See Technical notes.

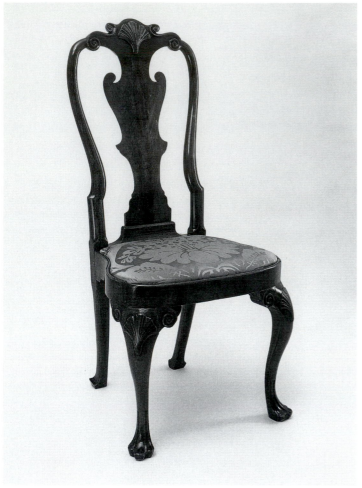

F47

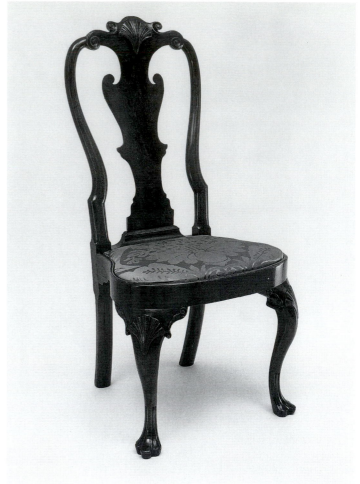

F48

Stylistic differences between this chair and the preceding example (cat. no. F45) represent the two predominant interpretations in Late Baroque Philadelphia chair making. The present example is characteristic of the more complex type, with its three-part, or trifid, foot and vase-shaped banister advancing a dramatic, three-dimensional contour, which, in concert with the scrolled volutes, evokes a sense of movement not realized in the previous chairs. The combination of these elements, depending on the client's taste and pocketbook, resulted in either a simple or complex expression.

PROVENANCE: Purchased by Miss Hogg from Israel Sack, New York, 1949.

TECHNICAL NOTES: Black walnut; black walnut (slip seat front and sides), southern yellow pine (slip seat back). The construction is typical of Philadelphia chairs from this period (see cat. no. F44). The seat retains its original upholstery foundation. The seat frame and slip seats are incised I and IIII, respectively.

RELATED EXAMPLES: Sack 1950, p. 25; *Antiques* 81 (March 1962), p. 237; Comstock

1962, no. 167; Heckscher 1985, p. 85, no. 40; Sotheby's, New York, sale 5500, October 24–25, 1986, lot 242; Sack 1993, p. 32.

REFERENCES: Warren 1975, p. 26, no. 45.

F47

Side Chair

1735–95
Philadelphia
Black walnut and secondary woods; 42¼ x 19¾ x 20½" (107.3 x 50.2 x 52.1 cm)
B.69.66

William Hogarth's *Analysis of Beauty* pronounces the S curve the "line of beauty," its undulating line conveying pleasure to the eye: "How inelegant would the shapes of all our moveables be without it?"[1] This superb side chair, along with the following example (cat. no. F48), elegantly illustrates Hogarth's observation and concurrently manifests the fully developed

interpretation of the Late Baroque in Philadelphia seating furniture. Here, in this rhythmic flow of curves, the craftsman has further accentuated the chair's contours by fully rounding its stiles and integrating them into the crest rail. The pair of scrolled volutes that frame the crest's scalloped shell repeats the graceful S shape and crowns the overall effect.

PROVENANCE: Purchased by Miss Hogg from David Stockwell, Philadelphia, 1953.

TECHNICAL NOTES: Black walnut; black walnut (slip seat front and sides), southern yellow pine (slip seat back). The rear leg terminals are unconventional for Philadelphia seat furniture. The seat rim is cut directly from the rails rather than applied. The upper portion of the shoe is replaced. The rear seat rail is incised I.

RELATED EXAMPLES: *Antiques* 79 (March 1961), p. 229; Kindig 1978, no. 24; Monkhouse and Michie 1986, p. 165, no. 106. See also cat. no. F48.

REFERENCES: *Antiques* 60 (October 1951), p. 279.

1. Hogarth 1908, p. 93.

F48

Side Chair

1745–95
Philadelphia
Black walnut and secondary wood; 41⅞ x
19¾ x 19¼" (106.4 x 50.2 x 48.9 cm)
B.69.65

The most discernible of the subtle differences between this side chair and the previous example (cat. no. F47) is the handling of the knee brackets, here terminating in a simple ruffle, a presage of the Rococo.

PROVENANCE: Purchased by Miss Hogg from David Stockwell, Philadelphia, 1953. See Technical notes.

TECHNICAL NOTES: Black walnut; southern yellow pine (slip seat). For the most part this chair was assembled using the standard Philadelphia formula (see cat. no. F44). The seat rails and rim are constructed of solid walnut and the rear seat brackets are applied rather than cut out of the solid. The seat framing is not square, as the sides flare outward. The inside front and rear seat rails, as well as the slip seat, are incised IV. A label attached to the seat reads: "This chair belonged to 'Aunt Shoemaker,' a great Aunt of Grand Mother H. Williams. It is probably 150 years old April 8, 1892."[1]

RELATED EXAMPLES: Heckscher 1985, pp. 86–87, no. 42, records another chair from this set. A similar example is in Rodriguez Roque 1984, pp. 114–15, no. 48.

REFERENCES: Warren 1975, p. 26, no. 46.

1. A Late Baroque Boston tea table (Sack 1969–92, vol. 8, p. 2263, no. P5701) bears a similarly worded label: "This table belonged to Susanna Shoemaker (a Great Aunt to Grand Mother Hannah Williams) she died early in the century—it is probably 150 years old (H. W. Roberts 1892). There are two high backed walnut chairs with loose hair seats to go with it. I prize this set very much." The tea table also bears a chalk inscription, "S. Williams Parti[illegible]." Sack publishes the provenance: Susanna Shoemaker to Margaret Shoemaker Williams (1792–1873); to Jesse Williams I (1780–1814); to Jesse Williams II (1814–1874); to Edward B. Williams (1856–1930); to Edward S. Williams (b. 1907).

F49

Armchair

1750–90
Philadelphia
Black walnut and secondary wood; 43½ x
32¾ x 23" (110.5 x 83.2 x 58.4 cm)
B.69.249

Armchairs were not produced in significant numbers during the colonial period, being decidedly more expensive than side chairs.[1] Save for the occasional pair, they were made singly or en suite with side chairs. Indicative of their cost, they were intended for the parlor or the principal bedchamber. This example is a dramatically conceived, proportioned, and executed Late Baroque design, its banister's cutouts probably patterned after English chairs and perhaps a presage of complex Rococo piercings.[2]

PROVENANCE: By family tradition owned by Thomas Chandler (1709–1785), Westminster, Vermont; to his son John Chandler (1736–1821); to his son Dr. Chauncy Cheney Chandler (1773–1833); to his son Lucius Henry Chandler (1812–1871)[3]; to his daughters Sarah Farley Chandler (b. 1837) and Susan Robbins Chandler (b. 1844); to their niece Emma Chandler (Mrs. James Wilburn Goldthwaite, 1870–ca. 1952); to her son and daughter-in-law, Scott and Mildred Goldthwaite; purchased by Miss Hogg from Israel Sack, New York, 1952.

TECHNICAL NOTES: Black walnut; southern yellow pine (slip seat). The front rim is integral with the seat rail, while applied on the side rails. The rear seat rail, with its contoured brackets, is fashioned from a single board. The inside front and rear seat rails as well as the slip seat's front are incised II.

RELATED EXAMPLES: Winchester et al. 1959, p. 74; Kindig 1978, no. 23; Sack 1969–92, vol. 8, p. 2079, no. P5551; Christie's, New York, sale 7980, October 21, 1994, lot 176.

REFERENCES: Warren 1975, p. 27, no. 48.

1. Weil 1979, p. 182; Fitzgerald 1982, p. 290.
2. Heckscher 1989, pp. 102–3, nos. 31, 32.
3. Chandler 1883.

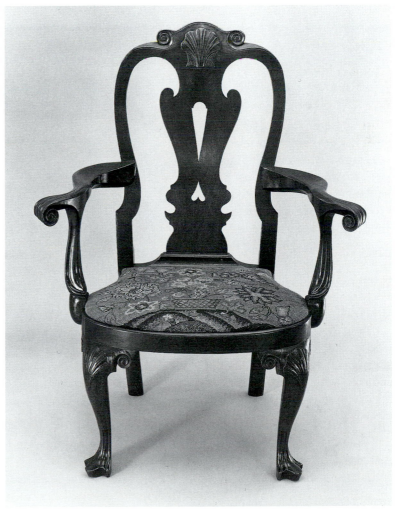

F49

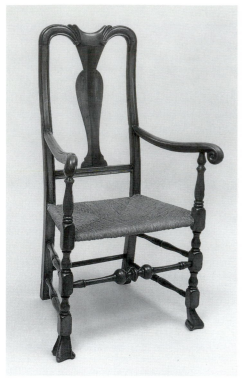

F50

F50

Armchair

1735–90
New England, probably Connecticut
Soft maple and ash; 45¼ x 25¼ x 21¾″ (114.9 x 64.1 x 55.2 cm)
B.20.1

This banister-back armchair represents a type that was produced throughout New England (see cat. no. F51) over a long period. Combining elements of both the Early and Late Baroque styles, with its earlier turned legs and stretchers and later yoke crest and vase-shaped banister, this type of chair is ultimately derived from the leather-bottomed and caned chairs produced in Boston in the 1730s (see cat. no. F16). When a less expensive bottom was desired, or in rural areas that had no upholsterers, the rush bottom was substituted. The extremely slender banister or splat signals a chair of Connecticut origin. The double vase-turned side stretchers are unusual. DBW

PROVENANCE: Purchased by Miss Hogg from Collings and Collings, New York, 1920.

TECHNICAL NOTES: Soft maple, ash (stretchers); rush (replaced). The front feet are replacements.

RELATED EXAMPLES: A set of one armchair and four side chairs at MMA (Davidson and Stillinger 1985, p. 111); advertisement of Mr. and Mrs. Jerome Blum (*Antiques* 107 [June 1975], p. 1026); Mabel Brady Garvan Collection (Kane 1976, pp. 93–96); Concord Museum, Massachusetts (Wood 1996, p. 73, no. 31). A more sophisticated slip-seated, cabriole-leg example is at Chipstone (Rodriguez Roque 1984, no. 76). A set of seven side chairs and one armchair was advertised by John S. Walton (*Antiques* 125 [May 1984], p. 926).

REFERENCES: Warren 1971a, p. 36, fig. 1; Warren 1975, p. 117, no. 214; Warren 1982, p. 229; Warren 1988, p. 6.

F51

Armchair

1735–90
New England
Soft maple, birch, and secondary wood; 45½ x 24 x 23½″ (115.6 x 61 x 59.7 cm)
B.68.3

Although similar to cat. no. F50, this chair is much simpler in its overall details. However, the columnar turning of the arm supports is distinctive. The single spindle-shaped side stretchers of this

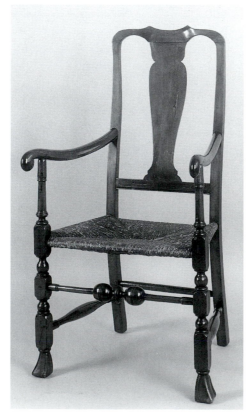

F51

example place it closer to the Boston caned and leather-bottomed chairs, which were its prototype. DBW

PROVENANCE: Wayman Adams, before 1920[1]; to Adams's son, Austin, Texas; purchased by Miss Hogg from the son's estate, 1968.

TECHNICAL NOTES: Soft maple (front legs, stretchers), birch (rear legs, front seat rail); ash (side and rear seat rails).

RELATED EXAMPLES: Sack 1969–92, vol. 10, p. 2590, no. P-6185.

REFERENCES: Warren 1971a, p. 36, fig. 2; Warren 1975, p. 117, no. 215; Warren 1988, p. 6.

1. Miss Hogg saw this chair in Adams's New York studio in 1920. She later wrote that seeing this piece inspired her to begin collecting Americana (see cat. no. F50).

F52

Two Side Chairs

1760–1815
New York State
Various woods (see Technical notes); B.69.510.1: 40⅞ x 20¾ x 16⅝″ (103.8 x 52.7 x 42.2 cm); B.69.510.2: 40½ x 21¾ x 16½″ (102.9 x 55.2 x 41.9 cm)
B.69.510.1–.2

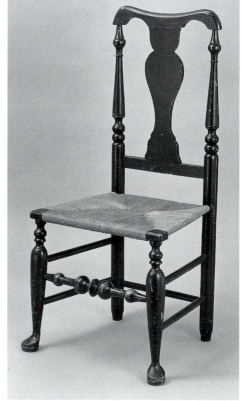

F52

This type of rush-bottom chair with vase-shaped splat, yoke crest, and tubular front legs with pad feet was produced in great numbers in New York as well as adjacent New Jersey and Connecticut. The tubular leg and foot motif may be derived from chairs produced in northern England. Although the ball-and-ring stretcher, vase splat, and pad feet are all elements seen in the early Baroque period, these chairs continued to be made in the late eighteenth and early nineteenth centuries.

PROVENANCE: Unknown (at Bayou Bend prior to 1965).

TECHNICAL NOTES: **B.69.510.1**, soft maple (legs, front seat rail), hickory (stretchers, side and rear seat rails), yellow-poplar (splat), sweetgum (crest rail, stay rail), rush (replaced); **B.69.510.2**, soft maple (legs, front stretcher), hickory (remaining stretchers, rear and side seat rails), yellow-poplar (crest rail, splat), eastern white pine (stay rail, exposed corners of front seat rail), cherry (front seat rail), rush (replaced); WS branded on back (probably the mark of an owner).

RELATED EXAMPLES: A pair at MMA bears the stamp of Michael Smith (Heckscher 1985, p. 61, no. 20); Mabel Brady Garvan Collection (Kane 1976, pp. 103–4, no. 88).

REFERENCES: Warren 1975, p. 117, no. 216.

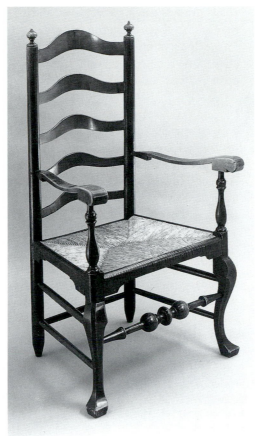

F53

F54

F53

Armchair

1735–50
Attributed to the shop of Soloman Fussell (1704?–1762?), Philadelphia
Soft maple and secondary woods; 45⅝ x 25¾ x 21⅜" (115.9 x 65.4 x 54.3 cm)
B.66.24

Slat-back armchairs and side chairs (see cat. no. F54) constituted the staple seating furniture in Philadelphia and environs during much of the eighteenth century. The genre has been commonly identified as Delaware Valley, and scholarship has revealed Soloman Fussell as one of its major producers.[1] These distinctive chairs combine elements of both New England and Germanic design. The flat, undercut arms are Germanic in origin, while the

ball-and-ring stretcher reflects the influence of imported Boston chairs. The most noteworthy detail of this example is the faceted cabriole leg, commonly called a "crookt" foot in the period. This feature added both style and cost, as did the multiple slats. The turnings of the baluster-form arm support, made separately and joined to the top of the cabriole leg, have been identified as hallmarks of Fussell's production.[2] A frame of figured maple finishes off the seat. As was the practice in the period, the maple surfaces are colored with a dark stain. D B W

PROVENANCE: Purchased by Miss Hogg from David Stockwell, Wilmington, Delaware, 1966.

TECHNICAL NOTES: Soft maple; hard maple (right interior seat rail), soft maple (remaining seat rails).

RELATED EXAMPLES: Winterthur (Forman 1980, p. 47, fig. 2); MMA (acc. no. 10.125.235); private collection (Forman 1980, p. 56, fig. 12); Christie's, New York, sale 7710, June 23, 1993, lot 131.

REFERENCES: Warren 1975, p. 116, no. 211.

1. Forman 1980.
2. Forman 1980, p. 50.

F54

Pair of Side Chairs

1735–50
Attributed to the shop of Soloman Fussell (1704?–1762?), Philadelphia
Soft maple; B.58.148.1: 45½ x 19⅝ x 15½" (115.6 x 49.8 x 39.4 cm); B.58.148.2: 45⅝ x 19¾ x 15½" (115.9 x 50.2 x 39.4 cm)
B.58.148.1–.2

Incorporating turned front legs and five arched slats, these side chairs represent another variant of the Delaware Valley type (see cat. no. F53). Although such Delaware Valley chairs continued to be produced into the nineteenth century, particularly in the New Jersey shop of the Ware family, these chairs are early examples of the genre. Details such as the scalloped skirt and the rectangular section top of the front legs are not seen in later examples made by the Wares. The distinctive turning of the front stretcher and the finials link these chairs to the Fussell shop. D B W

PROVENANCE: Purchased by Miss Hogg from Harry Arons, Ansonia, Connecticut, 1958.

TECHNICAL NOTES: Soft maple; rush (replaced).

RELATED EXAMPLES: Forman 1980, p. 56, fig. 12, an armchair with five very similar arched slats and the same stretcher and finial turnings.

REFERENCES: Warren 1975, p. 116, no. 212.

F55

Armchair

1740–60
Philadelphia
Soft maple and secondary woods; 41½ x 25¼ x 23½" (105.4 x 64.1 x 59.7 cm)
B.69.223

This armchair with arched crest and vase-shaped splat, referred to as banister-back in the period, represents the most stylish variant of the Philadelphia crookt-foot chairs (see cat. no. F53). These banister-back armchairs bear certain analogies to maple rush-bottom, banister-back arm-chairs produced in New England, and it may be that they reflect the presence in Philadelphia of imported Boston-made chairs. The molded, vertically curved arms and ball-and-ring stretcher certainly reflect New England design (see cat. nos. F50 and F51).[1] Related Philadelphia chairs with characteristic flat arms bear the label of William Savery (1721/22–1787), who early in his career worked with Soloman Fussell.[2] However, this example differs from the Savery chairs in several important details beyond the New England–style arm and front stretcher features. It has turned single side stretchers that swell gently at the center and have cone-shaped terminals, unlike the Savery arrangement of double unornamented stretchers, and the vase-shaped turnings of the arm supports are shorter than those found on Savery's armchairs. DBW

PROVENANCE: Purchased by Miss Hogg from David Stockwell, Philadelphia, 1953.

TECHNICAL NOTES: Soft maple; red oak (rear interior seat rail), soft maple (front and left interior seat rails), rush (replaced).

RELATED EXAMPLES: Winterthur (Forman 1980, p. 62); Wright's Ferry Mansion, Columbia, Pennsylvania (Zimmerman 1996, p. 736, pls. I, Ia).

REFERENCES: Warren 1975, p. 116, no. 213.

1. A New England example with a similar crookt foot is at Chipstone (Rodriguez Roque 1984, no. 76).
2. Forman 1980, p. 46.

F56

Roundabout Chair

1730–90
New England, possibly Rhode Island
Black walnut and secondary wood; 31⅝ x 32¾ x 30¼" (80.3 x 83.2 x 76.8 cm)
B.69.250

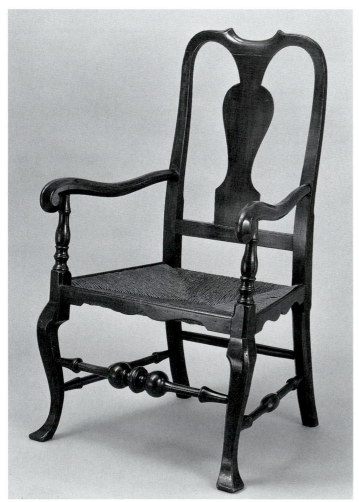

F55

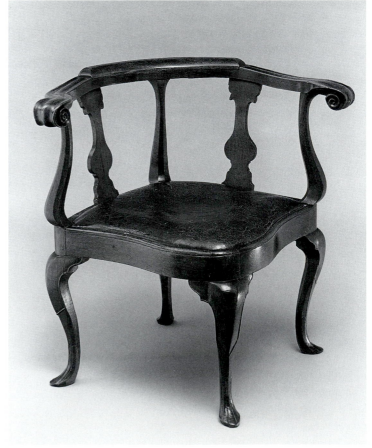

F56

The term *roundabout* is the most descriptive and frequent period designation for these chairs, although contemporary sources also refer to them as corner half-moon, corner elbow, smoking, barber's, writing, and desk chairs.[1] Today it is generally recognized that they were intended for use at a desk, their configuration suggesting a forerunner to the swivel chair. The reversed orientation of the unusually shaped banisters makes this a singular example. A New England origin seems probable in light of its design, secondary wood, construction, and exhibition history.[2]

PROVENANCE: Purchased by Miss Hogg from Ginsburg and Levy, New York, 1952, who noted its descent in the Bowler family of Portsmouth, Rhode Island, and the Duncan family of Philadelphia.

TECHNICAL NOTES: Black walnut; soft maple (slip seat). The legs show evidence of cross stretchers. The front leg is mortised and tenoned into the seat rails.[3] The seat frame lip is integral with the rail. The inside seat rail repeats the contour of its curvilinear exterior. The banisters are inverted into the rear seat rails. The arms are carved and molded, stopping short of the crest and central support. They are joined and capped by the T-shaped crest. The slip seat retains its original foundation and leather cover. The rear seat rail bears the label: "Mrs. E. A. Duncan."

RELATED EXAMPLES: This chair is most like one advertised in *Antiques* 94 (November 1968), p. 698, and reminiscent of a group of tea tables (Sack 1969–92, vol. 7, pp. 1838, 1924, nos. P5109, 5201).

REFERENCES: *Antiquarian* 7 (January 1927), p. 40; *Antiques* 62 (August 1952), p. 91; Comstock 1962, no. 153; Warren 1975, p. 27, no. 50.

1. Sack and Levison 1991, p. 935.
2. See Technical notes. In 1927 the chair was lent to the Rhode Island School of Design (*Antiquarian* 7 [January 1927], p. 40).
3. Sack and Levison 1991, pp. 938–40.

F57

Easy Chair

1730–75
Boston
Black walnut, soft maple, and secondary woods;
48 x 33⅜ x 30½" (121.9 x 84.8 x 77.5 cm)
B.69.252

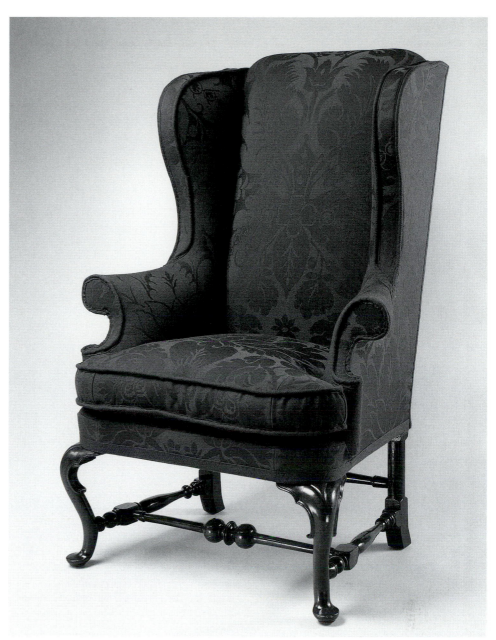

F57

This easy chair should be recognized as among the earliest and most accomplished Late Baroque interpretations. It discreetly varies from earlier examples (see cat. no. F17), retaining the tripartite medial stretcher and C-scrolled arms while updating the brush feet, turned legs, and shaped skirt with pad feet, cabriole legs, and a rounded front seat rail. Traditionally, this chair has been assigned to Newport, an attribution largely based on the presence of the lambrequins and beading that outline the contour of the legs; however, this treatment is more closely identified with Boston furniture.[1]

PROVENANCE: Purchased by Miss Hogg from Ginsburg and Levy, New York, 1952.

TECHNICAL NOTES: Black walnut (front legs, front stretcher), soft maple (rear legs, rear stretcher); soft maple (front and side seat rails, wing crests), hard maple (rear seat rail), beech (crest rail), sylvestris pine (rail's arm support). The easy chair's construction follows the standard eighteenth-century New England practice. The medial and rear stretchers are mortised and tenoned. The front legs are dovetailed into the seat rail. The rear legs and stiles are integral. An unusual aspect of this chair's construction is that the arms are constructed with a split-yoke design. The pad feet are restored. The frame retains fragments of its original green worsted cover.

RELATED EXAMPLES: Sack 1969–92, vol. 3, p. 618, no. 1401; *Antiques* 117 (June 1980), p. 1151; *Antiques* 145 (May 1994), p. 653.

REFERENCES: Warren 1975, p. 28, no. 53; Warren 1993, pp. 332, 336.

1. See cat. nos. F36, F38.

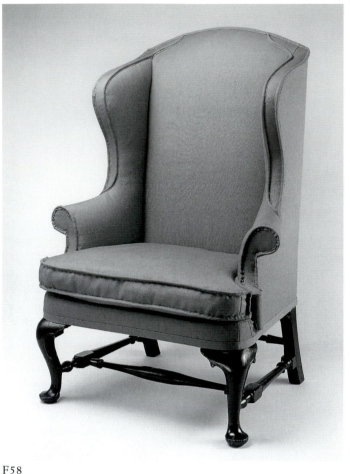

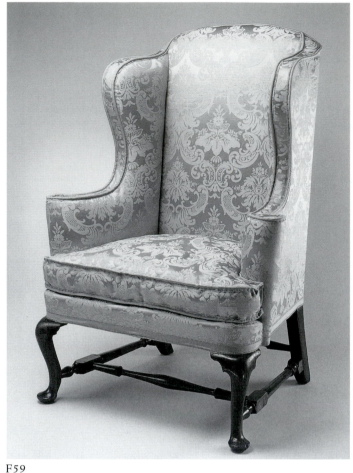

F58

F59

F58

Easy Chair

1730–75
Eastern Massachusetts or possibly Rhode Island
Soft maple and secondary woods; 48¼ x 33¾ x
26¼″ (123.2 x 85.7 x 66.7 cm)
B.60.90

Compared with the previous example (cat. no. F57), this easy chair's precise origin is more open to debate, as it exhibits characteristics of both Boston and Newport furniture.[1] During the eighteenth century (and still true today), the principal expense in producing an easy chair was the upholsterer's materials and labor rather than the bare frame. While charges varied, depending on the frame's complexity and the materials selected, it is estimated that the labor on a typical easy chair was 20 percent of its total expense, the wooden frame 25 percent, and its webbing, stuffing, and cover 55 percent.[2]

PROVENANCE: Purchased by Miss Hogg from John S. Walton, New York, 1960.

TECHNICAL NOTES: Soft maple; soft maple (seat rails, arm supports), eastern white pine (arm scrolls), elm (arm stiles). The easy chair's construction follows the standard eighteenth-century New England practice (see cat. no. F57), except that the front legs are secured with a square tenon rather than being dovetailed in. The legs are covered with an intractable overpaint. In 1992 a spurious pencil inscription, "Gostelowe, Jonathan March 10, 1750," was uncovered on an interior vertical support.[3]

RELATED EXAMPLES: Forman 1988, p. 366.

1. See cat. nos. F36, F38; Forman 1988, p. 366.
2. Jobe et al. 1991, p. 120.
3. Presumably referring to the Philadelphia cabinetmaker Jonathan Gostelowe (1744–1795), who was six years old in 1750 and would not have produced a New England–style chair.

F59

Easy Chair

1730–1800
Eastern Massachusetts or Rhode Island
Black walnut, soft maple, and secondary wood;
47¾ x 34¼ x 27½″ (121.3 x 87 x 69.9 cm)
B.59.95

In this easy chair, a classic Late Baroque New England example, the C-scrolled arm supports seen on earlier chairs have been replaced by tapering conical shapes, which in New England remained popular throughout the Late Baroque and Rococo periods. By the mid-eighteenth century this design had become so standardized that regional characteristics are difficult to discern.

PROVENANCE: Purchased by Miss Hogg from David Stockwell, Wilmington, Delaware, 1959.

TECHNICAL NOTES: Black walnut, soft maple (rear legs); soft maple. The top of the wings and crest rail retain their original upholstery materials and were not sampled. The easy chair's construction follows the standard eighteenth-century New England practice (see cat. no. F57). The back retains its original webbing, grass stuffing, and linen cover.

RELATED EXAMPLES: Downs 1952, no. 74; Kane 1976, pp. 227–29, no. 212; Jobe and Kaye 1984, pp. 362–64, no. 101; Heckscher 1985, pp. 121–22, nos. 70, 71; Jobe et al. 1991, pp. 120–22, no. 44; Wood 1996, pp. 68–69, no. 29.

REFERENCES: Warren 1975, p. 28, no. 52.

F60

Easy Chair

1730–1800
Eastern Massachusetts or Rhode Island
Soft maple and secondary woods; 48½ x 36 x
27¼" (123.2 x 91.4 x 69.2 cm)
B.66.1

In 1757 George Washington received a shipment of English furniture that included "A Mahagoney easy Chair—on Casters coverd with ditto [yellow silk and worsted damask] and a Check Case. . . ."[1] In addition to a fine upholstery fabric, easy chairs typically had a durable slipcover that could be easily removed and cleaned. The Bayou Bend example's loose-fitting reproduction cover suggests this practice.[2] This fine easy chair is also distinguished by its shell carved knees.

PROVENANCE: Purchased by Miss Hogg from Ginsburg and Levy, New York, 1966, who noted the chair was from the Winsor family of Providence.

TECHNICAL NOTES: Soft maple; birch (top of the wings), soft maple. The construction follows the standard eighteenth-century New England practice (see cat. no. F57).

RELATED EXAMPLES: Downs 1952, no. 80. The Bayou Bend chair's carved knees bear comparison with the carving on a high chest attributed to the cabinetmaker Grindal Rawson (1719–1803) of Providence (Monahon 1980, p. 134).

REFERENCES: *Antiques* 84 (December 1963), p. 643; Warren 1975, p. 29, no. 54.

1. Fede 1966, pp. 14–15.
2. A period description of this practice appears in the correspondence of the Gillows, an English cabinetmaking firm: "We presume [the chair] will require some sort of *washing* cover which requires a good deal of nicety to make them fit well to such sort of chairs" (Montgomery 1970, p. 79). An easy chair at Chipstone that retains its original upholstery foundation lacks evidence of ever having been fitted with a tacked cover (Baumgarten 1993, pp. 5–6).

F61

Easy Chair

1740–95
Philadelphia or New York
Black walnut and secondary woods; 45½ x
33¾ x 28½" (115.6 x 85.7 x 72.4 cm)
B.69.251

The provenance of this graceful easy chair suggests a Philadelphia origin; however, its configuration and the presence of sweetgum and cherry as secondary woods introduce the alternative attribution to New York. In place of the characteristic slipper, trifid, or ball-and-claw feet, a pad foot was substituted, and the conventional stump rear legs were replaced by cabriole supports, conveying a more balanced and stationary appearance. The arm terminating in a cone shape replaces the earlier C-scroll, producing a version that corresponds to the prevailing London fashion.

F60

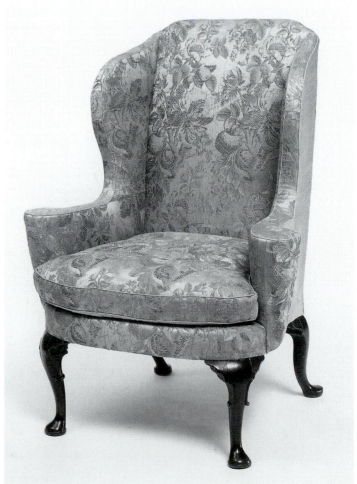

F61

PROVENANCE: Purchased by Miss Hogg from John S. Walton, New York, 1953, who noted that it was made for William Cooper of Philadelphia and descended to Mrs. Reeves.

TECHNICAL NOTES: Black walnut; black walnut (seat rails, stiles), sweetgum (arm support), cherry (arms), soft maple (top of wings, crest rail). The antique cover is not original; it prevented examination of the frame.

RELATED EXAMPLES: Miller 1937a, vol. 1, pp. 239–40, no. 392; Downs 1952, nos. 77, 78; Sotheby Parke Bernet, New York, sale 3947, January 26–29, 1977, lot 1161; Cooper 1980, pp. 66, 74–75; Bishop 1972, p. 126, no. 140; Rodriguez Roque 1984, pp. 198–99, no. 91; Christie's, New York, sale 8208, June 21, 1995, lot 217. Vertically rolled arms are unusual on a Philadelphia easy chair; a published example is Winchester 1963, p. 172.

REFERENCES: Antiques 62 (September 1952), p. 166; Warren 1975, p. 29, no. 55.

F62

Easy Chair

1740–95
Philadelphia
Black walnut and secondary woods; 46½ x 37½ x 34⅜" (118.1 x 95.3 x 87.3 cm)
B.69.31

F62

The contours of the Philadelphia easy chair changed little between the Late Baroque and Rococo periods, the only discernible difference being the execution of the knee ornament. The Bayou Bend example is a classic expression, with ball-and-claw feet, carved shells on the knees, and stump rear legs. In Philadelphia the earlier C-scrolled arms were retained, whereas in New England and New York craftsmen followed the English practice of substituting inverted cones. Both the 1772 and 1786 Philadelphia cabinetmakers' price lists record the form, offering the option of "plain feet and knees" or "Claw feet and Leaves on the Knees," the former implying the Late Baroque's persistence.[1]

PROVENANCE: Purchased by Miss Hogg from John S. Walton, New York, 1954.

TECHNICAL NOTES: Black walnut; white oak (front seat rail, arm supports), soft maple (side and rear seat rails), white oak (arm supports' rear component), ash (rear posts), yellow-poplar (arm supports' middle section, wings, stiles, crest). The front legs' dovetailed extensions fit into the seat rail. The front rail is lapped over and pegged to the side rails. The rear stiles are supported by the triangular ends of the rear legs and are slotted into the side seat rails. The inner armrest is dovetailed to the cone support.

RELATED EXAMPLES: Downs 1952, no. 85; Antiques 63 (January 1953), p. 5; Sack 1969–92, vol. 1, p. 63, no. 200; Cooper 1973a, pp. 329, 332; Montgomery and Kane 1976, pp. 145–46, no. 91; Antiques 114 (November 1978), p. 848; Heckscher 1987a, pp. 105–6.

REFERENCES: Warren 1975, p. 52, no. 93.

1. Weil 1979, p. 183.

F63

Tea Table

1735–82
Hartford–Wethersfield, Connecticut, area
Cherry; 26 x 29 x 20¾" (66 x 73.7 x 52.7 cm)
B.69.349

Tea drinking gained widespread social acceptance late in the seventeenth century, corresponding with the proliferation of an assortment of vessels deemed appropriate and necessary for the occasion.[1] The tea table's origins, like the beverage itself, go back to China, a precedent for the form being the Oriental wine table with its raised rim.[2] As early as 1708 a "Tee table" is recorded in Boston, and a few Early Baroque examples, primarily from New York, are known.[3] By the Late Baroque period the form became requisite, and in Wethersfield references to it date from the 1730s.[4] The pleasing simplicity of this example, with its undulating skirt and ogival arch, is indebted to a Salem, Massachusetts, design.[5]

PROVENANCE: By tradition owned by Dr. Ezekiel Porter (1705–1775), Wethersfield, Connecticut, though more recent scholarship suggests it originally belonged to his son-in-law and daughter, Colonel Thomas Belden (1732–1782) and Abigail Belden; to their daughter Mary (Mrs. Frederick Butler, 1771–1811); to her daughter Abigail (Mrs. James Bidwell, 1798–1832); to her daughter Esther E. Bidwell (1826–1910); to Mary Belden (Mrs. John Parsons, d. 1910), Wethersfield; to her husband, Doctor John Parsons; purchased by Miss Hogg from Ginsburg and Levy, New York, 1928, along with a high chest of drawers (cat. no. F79).[6]

TECHNICAL NOTES: The rails are shaped on all four sides. The top is pinned to the sides and the molded rim is separate. The table retains much of its finish history.

RELATED EXAMPLES: Kirk 1967, p. 91, no. 158; Antiques 56 (September 1949), p. 147; Antiques 101 (March 1972), p. 416; Antiques 128 (August

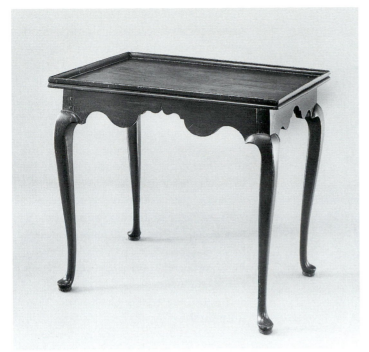

F63

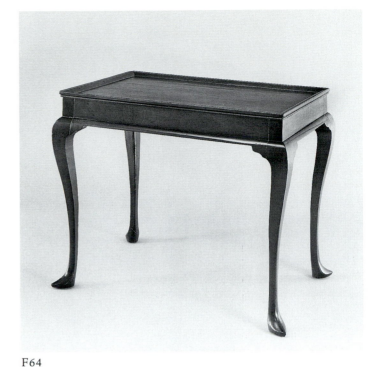

F64

1985), p. 177; *Antiques* 130 (July 1986), p. 111; *Antiques* 132 (July 1987), p. 96; *Antiques and The Arts Weekly*, November 11, 1988, p. 20-I; *Antiques and The Arts Weekly*, July 28, 1995, p. S-3. The table's contours relate it to a group of Hartford–Wethersfield area dressing tables and high chests: Kirk 1967, pp. 48, 102, nos. 81, 179; Sack 1969–92, vol. 8, p. 2288, no. P5705; *Antiques* 136 (December 1989), p. 1204; Jobe et al. 1991, pp. 130–32, no. 47.

REFERENCES: Lockwood 1913, vol. 2, p. 206; Warren 1975, p. 30, no. 59; Sweeney 1984b, p. 1159; Levy Gallery 1988a, p. 31, no. 21.

1. Roth 1988.
2. Shixiang 1986, p. 26.
3. Lyon 1925, p. 232. An Early Baroque Massachusetts example is illustrated in Sack 1969–92, vol. 1, p. 242, no. 601; those attributed to New York are recorded in Blackburn et al. 1988, pp. 86–87, no. 45; *Antiques* 132 (October 1987), p. 848; and Christie's, New York, sale 8208, June 21, 1995, lot 208; and a Virginia table is given in Hurst and Prown 1997, pp. 293–96.
4. Sweeney 1988, p. 274.
5. Elder and Stokes 1987, pp. 87–88, no. 60; Jobe et al. 1991, pp. 130–32, no. 47. Among the earliest furniture craftsmen working in the Connecticut River valley was William Manley (ca. 1703–1787) of Charlestown, Massachusetts. Through him or his apprentice Return Belden (1721–1764), coastal Massachusetts details were integrated into the local vocabulary (Sweeney 1984b, p. 1156).
6. For further information on the Porter-Belden house and its furniture, see Randall 1965, pp. 173–75, no. 136; Kirk 1967, pp. 48,

102, nos. 81, 179; Kane 1976, pp. 78–80, no. 58; Sweeney 1984b, p. 1162; Heckscher 1985, pp. 150–51, no. 90; Sweeney 1988, p. 281; Benes 1982, pp. 36–37, no. 68; Peirce and Alswang 1983, pp. 13–21.

F64

Tea Table

1740–90
Rhode Island
Mahogany; 25½ x 20¾ x 31¼" (64.8 x 52.7 x 79.4 cm)
B.57.94

At the same time that Chinese tea was introduced to the West, quantities of Oriental furniture were also imported. During one four-year period at the end of the seventeenth century, more than 6,500 wine tables were shipped to London.[1] While it is not known when Chinese furniture first made its way to America, the purity of line distinguishing this tea table is consistent with an Oriental aesthetic. A related table descended in John Townsend's family and similar furniture are documented to Job and Christopher Townsend's shops in Newport during the 1740s; however, the Bayou Bend table and related examples are characterized by a simple design and generic construction that preclude any credible attributions.[2] Traditionally, they

were assigned to Newport, but it is entirely plausible that this design was also produced by Providence's well-organized cabinet trade, or elsewhere in Rhode Island.[3]

PROVENANCE: Purchased by Miss Hogg from Ginsburg and Levy, New York, 1957, who noted it came through the Barats family of New London, Connecticut.

TECHNICAL NOTES: No original secondary wood remains. The top is composed of two boards, the subtop diagonally cut at each corner to accommodate the stiles and blocks. The quarter-round convex rim, which shares the same profile as the applied skirt molding, is accented by a molded bead. It retains remnants of an old surface treatment.

RELATED EXAMPLES: Benes 1982, p. 58, no. 109; Sack 1969–92, vol. 7, p. 1959, no. P5234; Moses 1984, p. 73; Heckscher 1985, pp. 185–86, no. 115; *Antiques* 132 (December 1987), p. 1164; *Antiques* 137 (January 1990), p. 141; *Antiques* 142 (October 1992), p. 418; *Antiques* 145 (June 1994), p. 785; Wood 1996, pp. 46–48, no. 18.

REFERENCES: Warren 1975, p. 32, no. 60; Moses 1984, pp. 12, 45; Sotheby's, New York, sale 6801, January 20, 1996, lot 115.

1. Edwards and Macquoid 1986, vol. 3, p. 206.
2. Moses 1984, pp. 40, 73; Rodriguez Roque 1984, pp. 38–39, no. 17.
3. The 1757 Providence joiners' price list includes a "Common tea table," possibly referring to this type (Lyon 1925, p. 265). A related table has a Providence provenance (Heckscher 1985, pp. 185–86, no. 115).

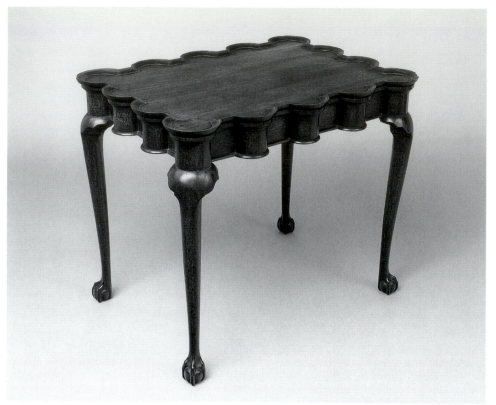

F65

F65

Tea Table

1735–90
Boston
Mahogany; 27¾ x 32⅛ x 23⅝″ (70.5 x 81.6 x 60 cm)
B.69.362

The distinctive "turret" top and boldly contoured skirt rails combine to make this tea table one of the Boston cabinet-maker's most dynamic Late Baroque creations. With its shaped rim, the top secured the tea service, while its semi-circular scalloping framed the vessels. When compared with related tables, differences in their design, carving, and even the rim confirm that they represent the work of more than one shop. A documented source for this design has not been identified; however, locally made card tables (see cat. nos. F67, F68), contemporary English card, tea, and supper tables, or even a silver salver could have supplied the prototype.[1]

PROVENANCE: Frederick Beck (1818–ca. 1906), Brookline, Massachusetts; purchased by Miss Hogg from the Louis E. Brooks Collection, Marshall, Michigan, through Israel Sack, New York, 1951.

TECHNICAL NOTES: No original secondary wood survives. All four sides are finished. A coved base molding mirrors the top molding. The rim is integral with the top and except for this component the table retains an old finish.

RELATED EXAMPLES: Hipkiss 1941, pp. 112–13, no. 60; Downs 1952, no. 370; Comstock 1957a, p. 258; Randall 1965, pp. 112, 115, 117, no. 81, now identified as having belonged to Ebenezer (b. 1748) and Mary Jones Hall, Medford, Massachusetts; Fales 1976, p. 150, no. 315; Sotheby's, New York, sale 6051, June 27–28, 1990, lot 549.

REFERENCES: Conover 1907, p. 85; Comstock 1962, no. 393; Randall 1965, p. 112; Warren 1975, p. 32, no. 61.

1. Christie's, London, sale 2631, June 6–9, 1983, vol. 1, lot 133. A kettle stand with a trefoil-shaped top is illustrated in Fales 1976, p. 160, no. 342. Related is John Burt's unique hexafoil salver (Buhler 1965, pp. 41–43).

F66

Tea Table

1735–80
Philadelphia
Mahogany and secondary woods; top up: 44″; top down: 28½″; diam.: 30⅛″ (111.8 x 71.4 x 76.5 cm)
B.54.10

In Philadelphia the rectangular tea table was never produced in the same numbers as its tripod-based counterpart. One explanation for its scarcity can be inferred from the 1772 cabinetmakers' price list, which reveals that a "Squair Tea Table" was more expensive than the tripod form.[1] The latter's popularity is also explained by its convenience, the revolving top offering greater versatility. When the table was not in use the top could be turned upright and placed against the wall—a desirable feature for a multi-functional room. This example's inverted baluster support, reminiscent of Early Baroque turnings on tea tables, dressing tables, and high chests, corresponds to an English precedent but is atypical in America.[2]

PROVENANCE: Purchased by Miss Hogg from Joe Kindig, Jr., York, Pennsylvania, 1954.

TECHNICAL NOTES: Mahogany; mahogany (cleats), cherry (small brackets extending from the cleats). The legs are secured by an iron bracket. The cleats have an unusual layout, forming a large rectangular frame, its width corresponding with the box's dimensions, with perpendicular arms positioned at their ends. The latch is original. Luke Beckerdite ascribes the carving on the legs to Samuel Harding's Philadelphia shop.[3]

RELATED EXAMPLES: Hart 1925, p. 14; Sack 1950, p. 262; Sotheby's, New York, sale 5500, October 24–25, 1986, lot 223A; Conger 1991, pp. 80–81, no. 2. The carving relates to that displayed by a group of tea and dressing tables: Hornor 1977, pl. 73; Mooney 1978, pp. 1036, 1039, 1041; *Antiques,* 130 (November 1986), p. 804; Ward 1988, pp. 220–22, no. 112.

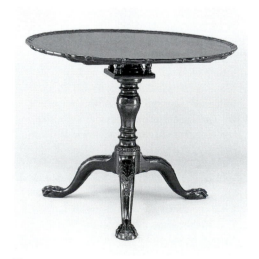

F66

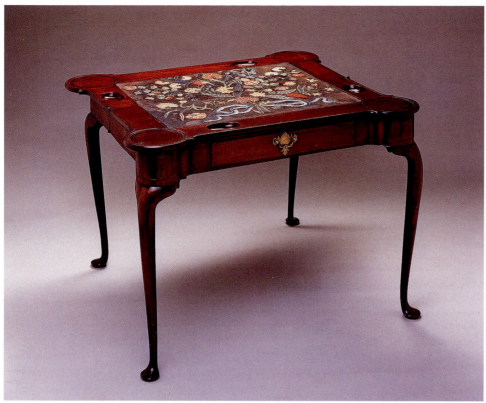

F67

REFERENCES: Comstock 1962, no. 233; Warren 1975, p. 32, no. 62.

1. Weil 1979, pp. 187–88.
2. An English kettle stand with a similar support descended in Philip Livingston's (1717–1778) family (Blackburn 1976, p. 80, no. 58).
3. Beckerdite 1994, pp. 260–74.

F67

Card Table

1730–60
Boston
Mahogany, inlay, and secondary woods; open: 26¾ x 37 x 32⅛" (67.9 x 94 x 81.6 cm); closed: 27¼ x 36¼ x 18" (69.2 x 92.1 x 48.3 cm)
B.69.406

In spite of efforts to legislate card playing in colonial Boston, the existence of several sophisticated Late Baroque game tables corroborates that by the second quarter of the eighteenth century playing cards was an accepted social activity.[1] This table and its privately owned mate are the earliest pair of American game tables. The Bayou Bend table, with its needlework playing surface and concertina action support, is particularly noteworthy. Bands of checkered inlay accentuate the table's graceful Late Baroque contour.

The inspiration for all these features can be found in English furniture dating from the 1720s, suggesting that the table's design and construction was derived from an imported example or perhaps represents the work of a craftsman recently migrated. The top's prominent candle recesses correspond to what the 1772 and 1786 Philadelphia price lists describe as a card table "With Round Corners."[2]

The playing surface provided the colonial woman with an opportunity to display her needlework skills. Here, a bountiful bouquet is carefully worked in a tambour stitch. This still life may be after a hand-drawn design or, more likely, one available through a published pattern book.[3] The cover represents a second generation, as the tambour stitch was not used in America until the 1770s, and its beautifully worked bowknot expresses a Neoclassical aesthetic.

PROVENANCE: By family tradition owned by Peter Faneuil (1700–1743). However, his estate inventory does not refer to these tables. On the other hand, there is no question of their descent in the family of his sister, Mary Anne (Mrs. John Jones, 1715–1790), and it is plausible that they were made for her, and perhaps she stitched the covers; to her son Edward Jones (1757–1835); to Peter Faneuil Jones; eventually, to the Peter Faneuil Roberts family; purchased by Miss Hogg from Ginsburg and Levy, New York, 1951.[4]

TECHNICAL NOTES: Mahogany; unidentified inlay; mahogany (drawer), cherry (drawer rails), eastern white pine (corner blocks), spruce (blocks, probably replacements). The card table is constructed with a concertina action. The side rails are hinged so that they can be folded in. The vertical concave transitions between the sides and turrets are separate elements. The drawer is constructed of thin mahogany components, reminiscent of English workmanship. Two-part triangular interior corner blocks join the turret and the sides. Each of the sides, the drawer, the needlework panel, the candle recesses, and the top edge are outlined with an inlay of alternating light and dark horizontal rectangles bordered by a light line inlay. Remnants of an earlier surface treatment survive. The playing surface is covered with a wool tabby-weave cloth embroidered in tambour, a chain stitch, and French knots. A label attached to the drawer reads: ". . . property of Peter Faneuil Jones. and his two daughters."

RELATED EXAMPLES: Card tables with needlework tops include Randall 1965, pp. 111–14, nos. 79, 80; Fairbanks et al. 1975, pp. 82–83, no. 95; *Antiques* 126 (July 1984), p. 81; Rodriguez Roque 1984, pp. 320–21, no. 150. A small number of Boston card tables with concertina actions are recorded: Winchester 1957a, p. 154; Randall 1965, pp. 111–13, no. 79; *Antiques* 97 (April 1970), pp. 448–49; Sotheby's, New York, sale 5429, January 30–February 1, 1986, lot 617; Levy Gallery 1988b, pp. 32–33; Christie's, New York, sale 8494, October 18, 1996, lot 119; and in at least one instance by a New York cabinetmaker: Heckscher 1985, pp. 174–75, no. 105.

REFERENCES: *Antiques* 60 (August 1951), p. 89; Comstock 1962, no. 215; Randall 1965, pp. 111, 145, nos. 79, 111; Wright et al. 1966, pp. 286–87; Warren 1975, pp. 30–31, no. 57; Clabburn 1976, p. 51; Agee et al. 1981, p. 70, no. 123; Sotheby Parke Bernet, New York, sale 5056, June 30–July 1, 1983, lot 358; Jobe and Kaye 1984, pp. 25, 27; Levy Gallery 1988b, p. 32; Marzio et al. 1989, pp. 232–33; Christie's, New York, sale 7820, January 21–22, 1994, lot 279.

1. Jobe et al. 1993, pp. 252–53.
2. Weil 1979, p. 186.
3. Deutsch 1991.
4. It is entirely plausible that the card tables were made for John and Mary Anne Faneuil Jones. Undoubtedly they are the pair of card tables with "work(d) tops" recorded in the inventory of their son Edward (Suffolk County Probate Records, Boston, no. 30952). When the second card table was auctioned by Sotheby's the sale also included a bureau table and a silver coffeepot,

consigned by the same individual. The latter, bearing John Blowers's stamp, is engraved with the Jones's arms, suggesting that at least this object, and perhaps both pieces of furniture, belonged to the Joneses. Another candidate for the needlework is Peter Faneuil's niece, Mary Faneuil Bethune (Randall 1965, pp. 145, 147, no. 111).

F68

Card Table

1735–95
Boston
Mahogany and secondary woods; open: 26½ x 36¼ x 35″ (67.3 x 92.1 x 88.9 cm); closed: 27¼ x 36¼ x 18″ (69.2 x 92.1 x 48.3 cm)
B.69.132

The principal difference between this card table and the previous example (cat. no. F67) is the preference for ball-and-claw feet over the more conventional pad. It is believed this motif is derived from the Chinese dragon's claw grasping a pearl. In England it was adopted by the late seventeenth century, becoming integral to Late Baroque design. Paradoxically, in America the ball-and-claw foot has long been associated with the subsequent style, the Rococo, thereby implying a later date for

this table. In Boston, however, this motif is documented as early as 1733.[1]

PROVENANCE: Mrs. K. Sanders, Birchbrow, Haverhill, Massachusetts, from Henry V. Weil; Mrs. J. Amory Haskell, Red Bank, New Jersey, and New York; auctioned by Parke-Bernet, New York, 1944; purchased by Miss Hogg from Ginsburg and Levy, New York, 1947.

TECHNICAL NOTES: Mahogany; mahogany (turrets, rear corner blocks), black walnut (front corner blocks), soft maple (fly leg hinged rail, pin), eastern white pine (fixed back rail, top glue blocks, drawer runners, sides, back), basswood (drawer bottom). The fly leg is attached by a five-part hinge. The top is recessed for a cover as well as for counters and candlesticks. The drawer runners are dovetailed into the front rail and tenoned into the backboard. The shell pendant does not appear in the 1944 auction catalogue illustration. On the drawer bottom is a pencil inscription, largely worn off; its last segment appears to be "[—]Chest St."

RELATED EXAMPLES: Examples with ball-and-claw feet are pictured in *Antiques* 96 (July 1969), p. 1; Sotheby Parke Bernet, New York, sale 5001, January 27–29, 1983, lot 415; Sack 1969–92, vol. 8, pp. 2260–61, no. P5773.

REFERENCES: Parke-Bernet, New York, sale 613, part V, December 6–9, 1944, lot 839; Comstock 1962, no. 216; Warren 1975, p. 30, no. 58; Greenlaw 1978b, p. 15.

1. Jobe et al. 1991, p. 119.

F69

Drop-Leaf Table

1730–1800
New England
Soft maple, birch, and secondary woods; open: 25 x 28⅝ x 30⅛″ (63.5 x 72.7 x 76.5 cm); closed: 25 x 10¼ x 30⅛″ (63.5 x 26 x 76.5 cm)
B.69.220

During the Late Baroque period the drop-leaf table underwent a series of adjustments. Its turned legs were replaced by cabriole supports, and the top's sharp edge was now molded. These changes had as much to do with comfort as they did with style since the stretchers were no longer in the way of those sitting at the table. The form managed without the pivot posts and stretchers. In addition, during this period and the subsequent Rococo, the drop-leaf table rarely incorporated a drawer, sacrificing limited storage to ensure a stronger joint between the two stationary legs. The form retained its flexibility, both in terms of augmenting or reducing the top's surface, and when not in use the leaves dropped down and the table was placed against the wall. This diminutive example, too small to sit at for dining, probably functioned for tea drinking, gaming, and reading.

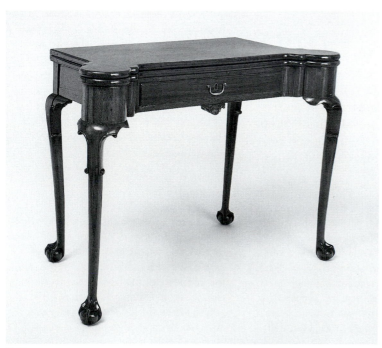

F68

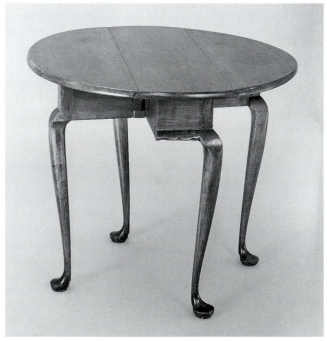

F69

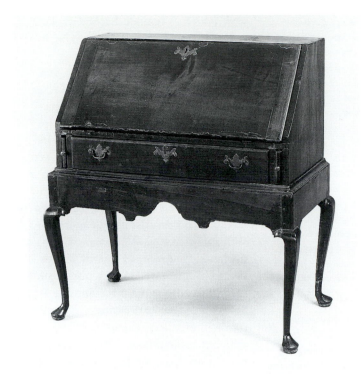

F70

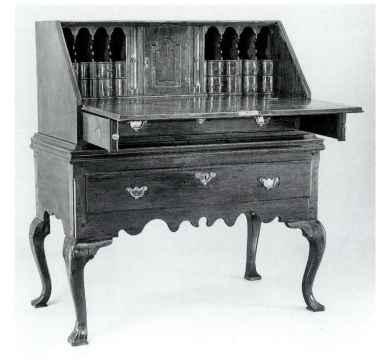

F71

PROVENANCE: Purchased by Miss Hogg from Ginsburg and Levy, New York, 1956, who noted it had been owned by Isaac Smith (1719–1787) and Elizabeth Storer Smith (1726–1786), Boston.

TECHNICAL NOTES: Soft maple (legs, end rails), birch (top); eastern white pine (fixed rails, medial brace), birch (hinge pins). The construction follows the standard eighteenth-century New England practice, with dovetailed ends and scalloped molding. The top is pinned at each end. A medial brace stabilizes the frame with vertical corner glue blocks. It retains remnants of an old finish and the number 27184.

RELATED EXAMPLES: Most similar is Downs 1952, no. 304. The only examples attributed to a specific craftsman are assigned to Samuel Sewall (1724–1814) of York, Maine (Kaye 1985, pp. 279–84); others with a provenance or markings include Sotheby's, New York, sale 5376, October 26, 1985, lot 38; Levy Gallery 1988a, p. 12, no. 6; and *Antiques* 134 (October 1988), p. 644.

REFERENCES: Warren 1975, p. 29, no. 56.

F70
Desk-on-Frame

1730–1800
New England
Soft maple and secondary wood; closed:
40⅝ x 37½ x 20½" (103.2 x 95.3 x 52.1 cm)
B.71.10

The desk, or escritoire, evolved from the simple writing box. The earliest American examples date from the second quarter of the eighteenth century. During this period it was fabricated as a single unit or, as in this instance, with the cabinet resting on a stand, in much the same way the upper case of a high chest of drawers is secured. The arched cutout reminiscent of Early Baroque dressing tables and high chests is another similarity between these forms observable on the Bayou Bend example.

PROVENANCE: Purchased by Miss Hogg from Collings and Collings, New York, 1922.

TECHNICAL NOTES: Soft maple; eastern white pine. The legs are integral with the corners of the frame. The bottom of the writing case is dovetailed to the sides, its top nailed on. The large drawer is joined by a single large dovetail and a half dovetail. The interior is composed of two large drawers with dividers channeled in above, resulting in seven small openings with seven larger compartments over them.

RELATED EXAMPLES: Sack 1969–92, vol. 8, p. 2237, no. P5764. A high chest with a similar contoured skirt was advertised in Blackwood March's auction brochure, June 29, 1995.

REFERENCES: Warren 1975, p. 36, no. 70.

F71
Desk-on-Frame

1730–1800
Philadelphia
Black walnut and secondary woods; closed:
42½ x 38½ x 21" (108 x 97.8 x 53.3 cm)
B.61.82

This desk-on-frame, the visual successor to the previous example (cat. no. F70), exhibits the subsequent stage in the form's development. Here, the writing box is supported by a table with a drawer that introduces additional storage. The form relates to the dressing table, and, indeed, one group of Philadelphia desks is characterized by a deeply arched skirt and a series of small drawers reminiscent of Early Baroque dressing tables.[1] Bayou Bend's desk presents the alternative format, consisting of one deep drawer and a scalloped skirt. A striking contrast with its relatively plain exterior is a lively interior composed of double tiers of serpentine drawer fronts flanking an arched, field-paneled prospect door.

PROVENANCE: Purchased by Miss Hogg from David Stockwell, Wilmington, Delaware, 1961, who noted its descent in the Hamilton family of Philadelphia, and that it may have belonged to the attorney Andrew Hamilton (d. 1741).

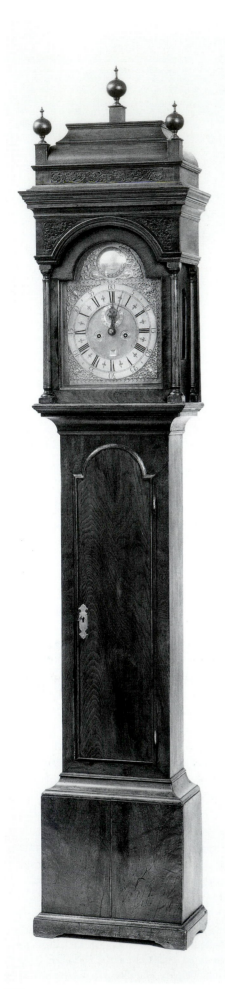

TECHNICAL NOTES: Black walnut; yellow-poplar (backs and sides of two principal drawers, drawer guides in upper case, bottom board of upper case), red oak (sides and backs of interior serpentine drawers), Atlantic white cedar (serpentine drawers' bottoms), chestnut (sides and backs of prospect drawers), eastern white pine (lower case drawer runners, glue blocks), black walnut (upper case drawer guide). The stiles have chamfered corners and are secured with unusually large pins. The dividers are dovetailed in. The sides are dovetailed to the top. The interior serpentine drawers have their bottoms let in and rest on the sides. When opened, the prospect door reveals two stacked drawers and a pigeonhole. The hardware, while of the period, is not original. Inscribed on the prospect door: "George D. Mason."

RELATED EXAMPLES: Holloway 1928, pl. 13; Sack 1969–92, vol. 1, p. 40, no. 124; Mooney 1978, p. 1036; Christie's, New York, sale 5594, June 16, 1984, lot 331. Sotheby's, New York, sale 6051, June 27–28, 1990, lot 386. Related interiors are pictured in Downs 1952, no. 220; *Antiques* 130 (September 1986), p. 544.

REFERENCES: *Antiques* 75 (January 1959), p. 72; Warren 1975, p. 37, no. 71.

1. Downs 1952, no. 220; Biddle 1963, p. 34, no. 61.

F72

Tall Clock

1725–46
Movement by Peter Stretch (1670–1746),
Philadelphia[1]
Case: Philadelphia
Black walnut and secondary woods; 103 x
20⅜ x 10⅝" (261.6 x 51.8 x 27 cm)
Museum purchase with funds provided by the
Theta Charity Antiques Show in memory of
Betty Black Hatchett, B.86.4

The clock was a rarity in the colonial home; if a timepiece was included it was invariably a tall clock. The form developed during the 1660s in order to accommodate a longer, more accurate pendulum; the earliest clocks had only an hour hand, and it was not until the century's close before second and minute hands

were added. A bonnet that slid in place enclosed the movement, protecting it from dust.

Peter Stretch, a native of Leek, Staffordshire, was apprenticed to his uncle Samuel Stretch. A Quaker, in 1702 he immigrated to Philadelphia, where he became the second documented clockmaker, following Abel Cottey (1655–1711), to ply his craft there. Within six years of his arrival Stretch became a member of the city's Common Council, a position he held until his death. He trained his sons William (d. 1748) and Thomas (d. 1765), the latter the maker of the celebrated Pennsylvania State House clock. Distinct variations among the cases housing Peter Stretch's movements confirm that their production reflects the work of more than one cabinet shop. This stately clock, with its arched door, fretwork carving, and sarcophagus top, is completely in the Late Baroque idiom, representing the most fully developed Philadelphia interpretation of the form.

PROVENANCE: Marshall P. Sullivan (1878–1953), Elkins Park, Pennsylvania; to his son Joseph T. Sullivan II (1908–1985), Huntingdon Valley, Pennsylvania; auctioned by Christie's, New York, January 25, 1986; purchased by Bayou Bend through Philip H. Bradley Co., Downingtown, Pennsylvania.

TECHNICAL NOTES: Black walnut; southern yellow pine (case backboard, bottom board front strip, shelf), eastern white pine (bottom board rear strip), Atlantic white cedar. The backboard extends from the foot upward to form the supports for the movement's shelf. Inside the door are cutouts for the brass hinges. The glass, which appears to be early, may be original. The lock, hinges, escutcheon, spandrel fretwork, central plinth, and finials are restorations. The movement is an eight-day rack and snail striking clock with anchor-recoil escapement. Chalk figures are recorded inside the case.

RELATED EXAMPLES: A number of Stretch clocks are known. Those closely related to the Bayou Bend example include *American Collector* 10 (August 1941), p. 1; *Antiques* 65 (June 1954), p. 440; Hornor 1977, p. 56, pl. 34; *Antiques* 114 (November 1978), p. 841; *Antiques* 132 (October 1987), p. 652.

REFERENCES: Christie's, New York, sale 6074, January 25, 1986, lot 342; *Antiques* 132 (September 1987), p. 474; Marzio et al. 1989, pp. 230–31.

1. Stretch 1932, pp. 225–35; PMA 1976, pp. 15–16; Hornor 1977, p. 56; Gibbs 1984, pp. 69–73.

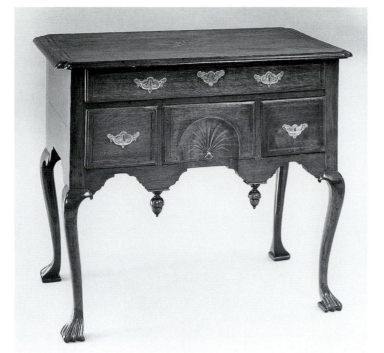

F73

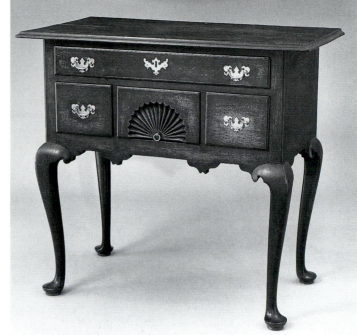

F74

F73

Dressing Table

1730–75
Boston
Black walnut, inlay, and secondary wood;
29⅝ x 33½ x 20½" (75.2 x 85.1 x 52.1 cm)
B.69.134

This sophisticated dressing table master-fully integrates both Early and Late Baroque styles. Cabriole legs have super-seded turned ones, yet instead of the cor-responding pad feet, the earlier brush feet, still regarded sufficiently fashionable, were retained. The turned pendants are also vestiges of the previous style, their placement suggestive of the central front legs on an Early Baroque high chest. The subtle line inlay that defines the table's surface frames both its shell drawer and its top with its compass-inspired detail.[1]

PROVENANCE: Purchased by Miss Hogg from Ginsburg and Levy, New York, 1952, who noted its descent in the Delano family of Duxbury and Plymouth, Massachusetts.

TECHNICAL NOTES: Black walnut, uniden-tified inlay; eastern white pine. The brush feet are carved from a single piece of wood. The construction is more characteristic of Early Baroque case pieces, the drawer parti-tions tapering upward toward the back. The

top drawer rests on side runners, the lower drawers on medial supports. The drawer bottoms are nailed to the sides. The top is molded on all four sides. Inlay composed of a dark line flanked by light-colored lines de-fines the drawer fronts and top.

RELATED EXAMPLES: *Antiques and The Arts Weekly*, December 22, 1989, p. 115; and a high chest in *Antiques* 131 (May 1987), p. 957.

REFERENCES: Warren 1975, p. 33, no. 63.

1. Two case pieces with similar inlays are doc-umented to 1739 (*Antiques* 107 [May 1975], pp. 952–53; Randall 1965, pp. 68, 70–71). The *Boston Gazette* advertised in 1757 "A beautiful Mahogany Case of Draws, with a Compass Top" (Dow 1967, p. 116).

F74

Dressing Table

1740–1800
Hartford, Wethersfield, or Glastonbury,
Connecticut
Cherry and secondary wood; 33½ x 36 x 19¾"
(85.1 x 91.4 x 50.2 cm)
B.59.70

Well-to-do families aspired to create inte-riors that were unified in their appear-ance. This concept included coordinating textiles and furnishings, which led to the production of suites of matching furni-

ture. The Bayou Bend dressing table and a similar high chest of drawers (see cat. no. F79) are evocative of this vogue. They were made by a Connecticut cabinet-maker, their configuration revealing a transfer of design from a principal urban style center, in this instance Boston-Salem, to a less populous one.

PROVENANCE: Purchased by Miss Hogg from Israel Sack, New York, 1959.

TECHNICAL NOTES: Cherry; eastern white pine. The drawers' partitions and dividers are dovetailed in. The indigenous cherry was stained to resemble imported mahogany. The dressing table has an aged finish.

RELATED EXAMPLES: *American Collector* 10, no. 7 (August 1941), p. 1; *Antiques* 60 (October 1951), p. 255; Jobe and Kaye 1984, pp. 193–94, no. 34; *Antiques* 137 (April 1990), p. 833; Nadeau's Auction Gallery, Colchester, Con-necticut, March 31, 1990.

REFERENCES: Sack 1969–92, vol. 1, p. 38, no. 116; Warren 1975, p. 33, no. 65.

F75

Dressing Table

1730–1800
Delaware Valley, possibly Philadelphia
Soft maple and secondary woods; 29⅛ x 31¾ x
20⅜" (74 x 80.6 x 51.8 cm)
B.69.238

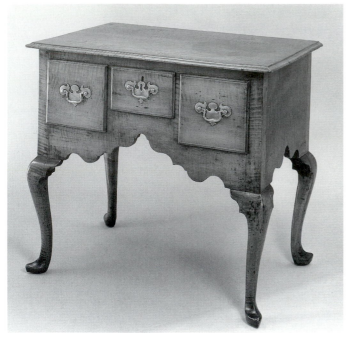

F75

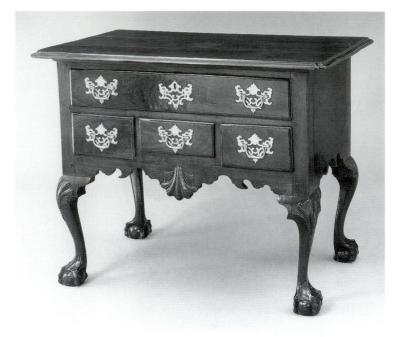

F76

From New England to Pennsylvania, indigenous maple with curled grain, although difficult to work, was highly prized for its figured pattern, which, as here, was customarily stained to imitate the appearance of imported mahogany. The prominent profile of the arched skirt relates this dressing table to others with Delaware Valley origins. Perhaps this feature is a continuation from the Early Baroque, or conversely, the copy of an English Late Baroque example.[1]

PROVENANCE: Purchased by Miss Hogg from Ginsburg and Levy, New York, date unknown.

TECHNICAL NOTES: Soft maple; southern yellow pine (upper drawer divider's rails, drawer sides, backs, and case back), Atlantic white cedar (framing strips, runners, drawer bottoms). The drawer partitions abut the divider and skirt. The drawer supports are mortised into the back. Just above the upper drawer opening are braces running front to back and free of the top.

RELATED EXAMPLES: Dressing tables with similar skirt profiles include Downs 1952, no. 322; Sack 1966–92, vol. 4, p. 904, no. P3603.

REFERENCES: Warren 1975, p. 34, no. 66.

1. Kirk 1982, p. 368, no. 1475.

F76
Dressing Table

1740–1800
Delaware Valley, possibly Philadelphia
Black walnut and secondary woods; 29¼ x 36 x 22" (74.3 x 91.4 x 55.9 cm)
B.66.15

The facade of this dressing table recalls Early Baroque examples in which the central drawer also appears shallower than those flanking it. In a new stylistic development, the void below is filled with an inverted carved shell. The dressing table's overall configuration changed little between the Late Baroque and Rococo periods, the principal difference being that the central drawer assumed a greater prominence.

PROVENANCE: Purchased by Miss Hogg from Israel Sack, New York, 1946, who wrote that the table was obtained from Mrs. Charles Pendleton, Bradford, Pennsylvania.

TECHNICAL NOTES: Black walnut; southern yellow pine (drawer runners), Atlantic white cedar (drawer bottoms, glue blocks below side drawer rails), yellow-poplar (drawer sides and backs), spruce (backboard). Located beneath the carved shells on the knees is an ornament composed of two beads that terminate in an arrowlike shape. The rear legs and feet are fully carved.

RELATED EXAMPLES: A dressing table with similarly ornamented knees is published in Ward 1988, pp. 223–24, no. 114.

REFERENCES: Sack 1950, p. 199; Warren 1975, p. 60, no. 116.

F77
High Chest of Drawers

1730–60
Boston
Soft maple, eastern white pine, and secondary wood; 87 x 41½ x 23" (221 x 105.4 x 58.4 cm)
B.69.348

Japanning is a Western imitation of Oriental lacquer work. In 1688 John Stalker and George Parker issued in London the earliest manual describing its production; subsequent publications appeared through the 1750s.[1] In America japanned furniture survives from Boston and New York, while contemporary sources record its ownership in Philadelphia and Charleston.[2]

Americans did not adhere to the prescribed English formula and designs. Unlike their London counterparts, who worked with porous oak, Bostonians used maple or pine for their base, finding it unnecessary to build up a layer of gesso.

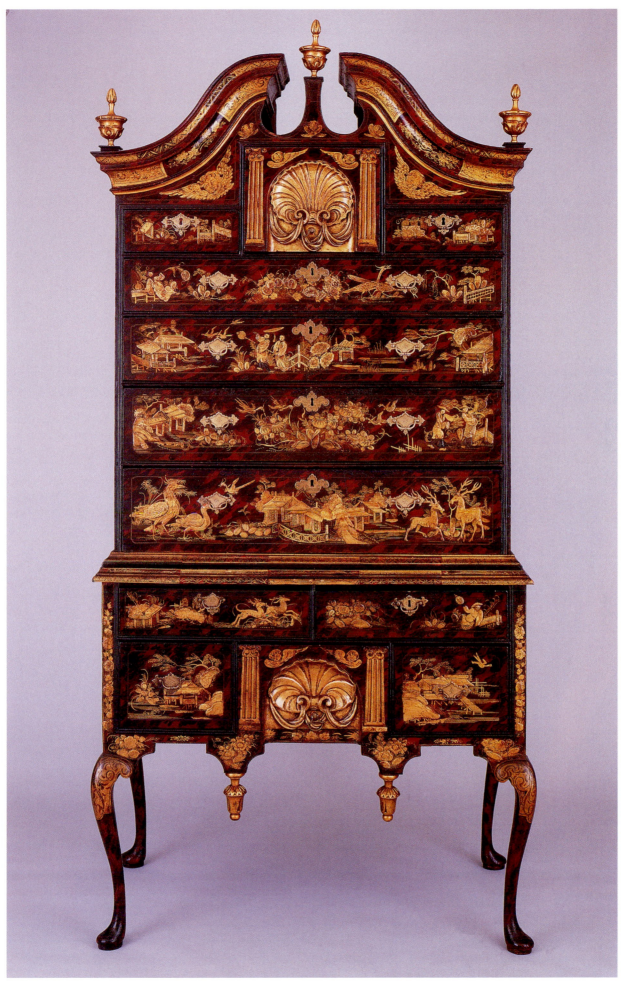

F77

Instead, they applied the background color directly onto the wood surface. The earliest survivals, on Early Baroque high chests and a dressing table, have a solid black background and large-scale ornamentation. A 1733 bill from the Boston japanner William Randle for "Japanning a Piddement (pedimented) Chest & Table Tortoiseshell & Gold" records both the reconfiguration of earlier forms and their decoration.[3]

During the Late Baroque period japanning was applied to an even greater range of forms, including tall clock cases, looking glasses, and bureau tables. At the same time, the decoration underwent a refinement, such as the combination of vermilion and black paints to simulate tortoiseshell. This process was followed by the application of a clear resin, more paint, and resin-based toners. The raised figures were cast in place, using a gesso putty or gypsum, and then decorated with metallic powders, paints, and leafs.[4] The finished high chest represents the master craftsman's orchestration of skilled specialists, including cabinetmakers, carvers, gilders, turners, and japanners.

PROVENANCE: By tradition Miss Mary Anne Wales, Stoughton, Massachusetts; to her sister Elizabeth (Mrs. Nathaniel Henry Emmons, 1809–1890); to her daughter Anne Wales (Mrs. Benjamin Brewster, 1829–1911), the mother of Frank Brewster.[5] Frank Brewster (1857–1935); to his daughter Marie (Mrs. Laurence Johnson, Jr.); [Louis Joseph, Boston, 1954]; purchased by Miss Hogg from John S. Walton, New York, 1955.

TECHNICAL NOTES: Soft maple (legs, drawer fronts), eastern white pine; eastern white pine. The drawer surrounds are double-beaded. The base is capped by a two-part molding, the upper case bottom framed by a molding in a manner typical of Early Baroque case furniture. The lower case sides are relieved by broad, flat arches. The cornice's circular openings have an applied bead. The back of the lower case is relieved by an inverted, flat arch. A full dustboard separates the three small top drawers from those of the full-length drawer. The finials are copied from those of the related high chest and the pendants from those on a walnut dressing table (Fales 1976, p. 209, no. 428). The japanning survives in a remarkable state. Its decoration incorporates silver leaf and powder, an unusual if not unique instance, its layered structure most closely relating to that shown in Downs 1952, no. 187.[6] A drawer back is inscribed: "This cabinet repaired and

redecorated Jan. 1900, Joseph Norton, decorative artist, with J.H. Boody, Brookline." (Joseph Norton and James H. Boody [b. 1847] appear in the 1900 Brookline directory as painters.) The extent of Norton and Boody's restoration has not been determined; however, losses have been filled and painted over on the facade and its sides overlaid with exotic motifs, presumably to disguise losses.

RELATED EXAMPLES: The Bayou Bend high chest's cabinet work and carving is clearly from the same shop as Heckscher 1985, pp. 240–42, no. 155; however, the japanning is completely different in concept. Other japanned, pedimented high chests include Downs 1952, no. 188; Greenlaw 1974, pp. 90–92, no. 80; Rhoades and Jobe 1974, pp. 1084–85, 1087–88; Jobe and Kaye 1984, pp. 197–201, no. 36; William Doyle Galleries, New York, April 16, 1986, lot 510; and another at MFA, Boston (acc. no. 1976.653). A walnut-veneered high chest with painted shell drawers is similar in proportion and appearance (Sack 1969–92, vol. 7, pp. 1718–19, no. P4848).

REFERENCES: Downs 1937, pp. 63, 65; *Antiques* 67 (February 1955), p. 104; Randall 1965, p. 67, no. 52; Warren 1971a, p. 42, no. 9; Fales 1974a, pp. 54, 58, no. 39; Warren 1975, pp. 34–35, no. 68; Heckscher 1985, p. 240; Heckscher, Safford, and Fodera 1986, pp. 1053–54; Marzio et al. 1989, pp. 234–35; *Antiques* 140 (September 1991), p. 286; Linley 1996, pp. 54–55.

1. Stalker and Parker 1960; Edwards and Darly 1754.
2. Boston: Lyon 1925, p. 79. Dow 1967, p. 267; Hitchings 1974; Kaye 1974, pp. 276–77, 281, 284–85, 288, 291, 293–94, 300–302. New York: Fales 1972, pp. 64–65, nos. 90, 92. Philadelphia: Hornor 1977, pp. 48–50; Charleston: Prime 1969, vol. 1, pp. 260, 300.
3. Heckscher, Safford, and Fodera 1986, pp. 1054–55, 1058–61. Jobe and Kaye 1984, p. 197.
4. Fales 1974a, pp. 49–50; Hill 1976.
5. Jones 1908, vol. 2, pp. 746–47; Emmons 1905, pp. 70, 120–21, 170.
6. Based on the research of Johanna Bernstein.

F78

High Chest of Drawers

1730–75
Eastern Massachusetts
Soft maple, black walnut, inlay, and secondary wood; 66¾ x 37⅜ x 21¼" (169.5 x 94.9 x 54 cm)
B.69.221

This diminutive high chest, while fully in the Late Baroque mode, evinces subtle changes from its Early Baroque predecessors. The facade is still covered with a figured veneer, but checkered banding now accentuates the drawer fronts. However, the principal stylistic development is discernible in the lower case; in place of the six turned legs are four cabriole supports, the turned pendants suggesting the center legs. The great central arch and undulating stretchers have also been eliminated, and the skirt rail is divided into three segments. The focus has shifted to the central drawer, with its inlaid, stylized Late Baroque shell.

PROVENANCE: Purchased by Miss Hogg from Ginsburg and Levy, New York, 1953.

TECHNICAL NOTES: Soft maple, black walnut (bottom central drawer, veneer on remaining drawers with unidentified contrasting checkered inlay); eastern white pine. The sides terminate with large dovetails extending beyond the drawer backs. Dividers separate the full-length drawers except for the top two, which are separated by a full dustboard. Two vertical braces are set in between the top drawers and the case top. The top is dovetailed to the sides. A fragmentary label from an unidentified Boston company is attached. Two drawers are inscribed "Martha" and "E C Crow."

RELATED EXAMPLES: Nutting 1962, no. 400; *Antiques* 64 (September 1953), p. 149; *Antiques* 134 (September 1988), p. 379. Pedimented high chests with similar inlaid shell drawers are published in Downs 1952, no. 190; *Antiques* 70 (July 1956), p. 4; *Antiques* 125 (April 1984), p. 700.

REFERENCES: Warren 1975, p. 34, no. 67; Warren 1988, pp. 20–21.

F79

High Chest of Drawers

1750–82
Hartford, Wethersfield, or Glastonbury, Connecticut
Cherry and secondary woods; 83½ x 39⅞ x 20" (212.1 x 101.3 x 50.8 cm)
B.28.1

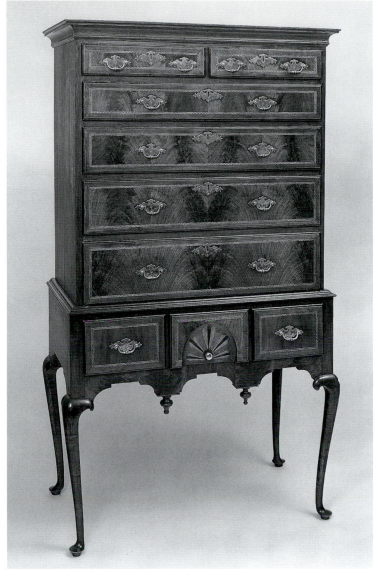

F78

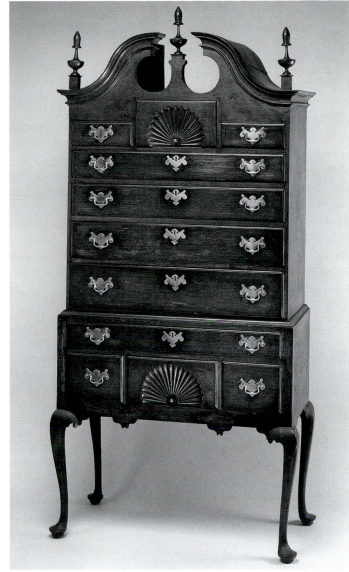

F79

Period sources document a remarkably brisk transfer of design between urban and rural America. By the 1730s, within a decade of the Late Baroque's earliest appearance in Boston, household inventories in Wethersfield list furniture forms revealing the style's introduction there.[1] The design of both the Bayou Bend high chest and a related tea table in the collection (see cat. no. F63) were clearly inspired by the Boston-Salem aesthetic.[2] By the 1750s, when Wethersfield cabinetmakers began producing high chests with "crown tops," the enclosed bonnet that is uniquely American, the style's integration was complete.[3]

PROVENANCE: See cat. no. F63. The high chest cannot be identified in either Doctor Ezekiel Porter's inventory or that of his son-in-law, Colonel Thomas Belden, and may have entered into the family through another member.

TECHNICAL NOTES: Cherry; eastern white pine (some drawer bottoms, moldings, bonnet, backboards), southern yellow pine (some drawer bottoms). The high chest is constructed in a conventional manner. Below the top sequence of drawers is a full dustboard; the remainder of the drawers are separated by dividers.

RELATED EXAMPLES: *Antiques* 71 (May 1957), p. 410; Kirk 1970, p. 27, no. 14; *Antiques and The*

Arts Weekly, May 29, 1987, p. 42; Ward 1988, pp. 275–76, no. 144.

REFERENCES: Belden 1898, facing page 218; Lockwood 1913, vol. 1, pp. 95–96; Warren 1975, p. 36, no. 69; Warren 1982, pp. 229–30.

1. Sweeney 1988.
2. Related furniture with Boston–Salem area provenances include Sack 1969–92, vol. 6, p. 1504, no. P4583; Christie's, New York, sale 8082, January 27–28, 1995, lot 1064; and Sweeney 1995, pp. 154–55.
3. Sweeney 1988, p. 278.

ROCOCO

F80

Pair of Side Chairs

1750–1805
Attributed to the shop of George Bright
(1727–1805), Boston[1]
Mahogany, black cherry, and secondary wood;
B69.138.1: 37½ x 20⅛ x 19½" (94.6 x 51.1 x
49.5 cm); B.69.138.2: 37¼ x 20¼ x 19¼"
(94.6 x 51.4 x 48.9 cm)
B.69.138.1–.2

The Rococo style was introduced in
Boston by 1744, its inspiration emanating
from French designs that combined natu-
ralistic elements in asymmetrical fan-
tasies. During the nineteenth century this
furniture was first referred to as Chippen-
dale, in honor of the London cabinet-
maker's 1754 volume, *The Gentleman and
Cabinet-Maker's Director,* the most com-
plete and widely distributed furniture
design book up to that time. While the
pattern of this side chair is reminiscent of
one of Chippendale's plates, the direct
source was in all likelihood an imported
chair.[2] By this date in England, the Late
Baroque ball-and-claw foot was passing
from fashion, as evidenced by Chippen-
dale's predilection for scrolled and Marl-

borough legs. The latter, referring to a
straight, square leg, was commented on
in Boston as early as 1746.[3]

PROVENANCE: Purchased by Miss Hogg from
John Kenneth Byard, Norwalk, Connecticut,
1953, who noted their descent from Christo-
pher Leffingwell (1734–1810), Norwich, Con-
necticut, to family members in New Haven.[4]

TECHNICAL NOTES: Mahogany, black cherry
(rear seat rail); soft maple (slip seat). Both
stretchers and seat rails are molded on top. The
banister is set into the shoe. A strip attached
inside the rear seat rail provides additional
support for the slip seat. The seats retain their
original foundation and crewelwork covers.
The front seat rail of B.69.138.1 is stamped III
and is notched eight times on its slip seat. The
seat rail of B.69.138.2 is stamped IIII and bears
the ink initials MML on its slip seat.

RELATED EXAMPLES: The attribution of the
Bayou Bend chairs is based on a documented
pair (Jobe and Kaye 1984, pp. 411–12, no. 123).
Variants include Biddle 1963, p. 8, no. 14; Sack
1969–92, vol. 3, p. 611, no. 1391; Bishop 1972, p.
150, no. 183; Sack 1969–92, vol. 4, pp. 1080–81,
no. P4000; Sack 1969–92, vol. 5, pp. 1260–61,
no. P4259; Kane 1976, pp. 113–14, no. 95.

REFERENCES: Warren 1975, p. 46, no. 76; Jobe
and Kaye 1984, p. 412.

1. Randall 1964b; Jobe and Kaye 1984, pp.
 142–46, 278–79.
2. Heckscher 1994, pp. 185–89. The chair back
 relates to pl. XVI in the 1762 edition. John

Singleton Copley frequently used this chair
in his compositions (Prown 1966, vol. 1, pls.
217, 218, 277, 318, 319, 331). One of them (pl.
331) depicts Pennsylvania Governor Thomas
Mifflin and his wife, and since this pattern
is not known in Philadelphia furniture it
seems plausible to assume that it was an
artist's prop.
3. Jobe and Kaye 1984, pp. 11, 391.
4. According to Byard, the needlework seat
 covers were stitched and initialed MML
 by Leffingwell's wife, whose name Byard
 gave as Margaret. However, these initials
 do not correspond with any of Leffingwell's
 three wives, Elisabeth (m. 1760, d. 1762),
 Elizabeth (m. 1764, d. 1796), and Ruth
 (m. 1799). It has been suggested that they
 may refer to his daughter-in-law Margaret
 Chestney Leffingwell (1787–1864). In spite
 of the uncertainty regarding their author-
 ship, the designs can be attributed to the
 Norwich area.

F81

Set of Eight Side Chairs

1750–1800
Eastern Massachusetts, probably Boston area
Mahogany and secondary wood; B.69.361.2:
38½ x 23⅝ x 22¼" (97.2 x 60 x 56.5 cm);
B.69.361.3: 38¼ x 23⅜ x 22" (97.2 x 59.4 x
55.9 cm); B.69.361.4 and B.69.361.5: 38 x 23½ x
22" (96.5 x 59.7 x 55.9 cm); B.69.361.6: 38⅛ x
23⅛ x 21¾" (96.8 x 58.7 x 55.2 cm); B.69.361.7:
38⅛ x 23⅝ x 22" (96.8 x 60 x 55.9 cm); B.69.361.8:
38 x 23¼ x 22¼" (96.5 x 59.1 x 56.5 cm);
B.69.361.9: 38¼ x 23½ x 22½" (97.2 x 59.7 x
57.2 cm)
B.69.361.2–.9

The English designer Robert Manwaring
was one of Thomas Chippendale's most
prominent contemporaries. Manwaring's
pattern books had a far greater impact on
the cabinet trade in New England than
did Chippendale's or any other publica-
tion.[1] The Bayou Bend side chair, reminis-
cent of Manwaring's designs, relates even
more closely to English examples.[2] Re-
markably, this chair, its seven mates, and
the related settee (see cat. no. F99) have
remained intact, illustrative of the eigh-
teenth-century fashion to furnish a room
en suite and symmetrically.

PROVENANCE: By family tradition owned
by Elizabeth Cheney (Mrs. Aaron White,
1747/48–1827), Roxbury, Massachusetts; to her
son and daughter-in-law William White

F80

F81

F82

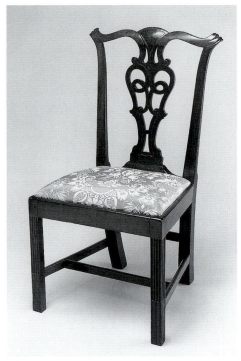

F83

(b. 1779) and Nancy Avery White (1785–ca. 1864); purchased by Reverend William Howe Sanford (1800–1879); to his son Charles Ethan Sanford (1840–1896); to his son George Ruggles Sanford, who sold the suite[3]; purchased by Miss Hogg from Collings and Collings, New York, 1927.

TECHNICAL NOTES: Mahogany; birch (slip seats). The construction follows the standard New England practice of the period (see cat. no. F36). The front seat rails are all stamped, B.69.361.2, VIII; B.69.361.3, IIII; B.69.361.4, III; B.69.361.5, I; B.69.361.6, II; B.69.361.7, IV; B.69.361.8, V; B.69.361.9, VII.

RELATED EXAMPLES: Keyes 1925; Downs 1952, no. 152; Randall 1965, pp. 180, 182, no. 143; Sack 1969–92, vol. 1, p. 243, no. 605; Greenlaw 1974, pp. 62–63, no. 54; Fales 1976, pp. 53–55, nos. 92–96; Kane 1976, pp. 146–50, nos. 124–28; Fairbanks et al. 1981, p. 602; Weidman 1984, pp. 51–52, no. 7; Jobe and Kaye 1984, pp. 381–89, nos. 109–12; another belongs to the Bostonian Society (acc. no. 1898.22).

REFERENCES: Comstock 1962, no. 258; Warren 1975, p. 45, no. 74; Jobe and Kaye 1984, p. 385; Sack and Wilk 1986, p. 177.

1. Heckscher 1994, pp. 193–95.
2. Jobe and Kaye 1984, p. 383, no. 109a.
3. This information came from a letter Miss Hogg received in 1955 from Emma Corbet Sanford, sister of George Ruggles Sanford, in whose family this furniture descended. Holmes 1893, p. 62; Estes 1894, pp. 216–21; Pope 1897, p. 62; Sanford 1911, vol. 1, part 2, pp. 499–500, vol. 2, part 1, p. 885.

F82

Set of Four Side Chairs

1750–1800
Eastern Massachusetts, probably Boston area
Mahogany, birch, and secondary wood;
B.69.135.1: 37¼ x 23¾ x 21¼" (94.6 x 60.3 x 54 cm); B.69.135.2: 37⅛ x 23¼ x 21¼" (94.3 x 59.1 x 54 cm); B.69.135.3: 37¼ x 23¼ x 21¼" (94.6 x 59.1 x 54 cm); B.69.135.4: 37¼ x 24 x 21¼" (94.6 x 61 x 54 cm)
B.69.135.1–.4

This strapwork pattern was the most popular Rococo chair design in Massachusetts. In addition to its identifiable outline, other regional attributes include shallow carving, retracted side claws, persistence of stretchers, thin interior seat rails, and blunt, molded ears. This set of chairs, together with the previous example (cat. no. F81), suggests the range of options available, such as the amount of carving, type of foot, and manner of upholstery. Despite the pattern's prevalence, the only documented examples are those for which George Bright billed Jonathan Bowman in 1770.[1]

PROVENANCE: Unknown. See Technical notes.

TECHNICAL NOTES: Mahogany, birch (rear seat rails); birch. The construction is similar to

that of cat. no. F36. The seat rails are secured by large, triangular corner blocks. Attached to each chair is a typed label that reads: "Formerly the property of Lieut. Governor Hutchinson. Saved from his house in Garden Court Street, Boston, when it was sacked by the Sons of Liberty, August 26th, 1765." The origin of this account is unknown. Thomas Hutchinson lived from 1711 to 1780.

RELATED EXAMPLES: See cat. no. F81.

REFERENCES: Warren 1975, p. 45, no. 73; Jobe and Kaye 1984, p. 385; Heckscher 1985, p. 56.

1. Jobe and Kaye 1984, pp. 389–91, no. 113.

F83

Side Chair

1770–1810
Rhode Island
Mahogany and secondary wood; 38⅛ x 21⅛ x 19" (96.8 x 53.7 x 48.3 cm)
B.57.71

Rhode Island cabinetworkers and their clientele never embraced the Rococo style with the same degree of exuberance that their Massachusetts, New York, Philadelphia, and Charleston counterparts displayed. This side chair's design may have been adapted from a plate in Robert Manwaring's design book, but it more likely is patterned after an English example.[1] The combination of stop-fluted Marlborough legs and distinctive banister identifies this chair as among the most fully developed Rococo interpretations in Rhode Island furniture. Although it is traditionally ascribed to Newport, no documented example is recorded, and a reference to similar chairs with Providence histories raises the possibility that the type was fashioned in more than one place.[2]

PROVENANCE: Purchased by Miss Hogg from Maxim Karolik (1893–1963), Newport, 1957.

TECHNICAL NOTES: Mahogany; soft maple (slip seat). The banister is set into the shoe. The seat retains its original webbing and stuffing. The front seat rail is impressed twice with II, the seat, V.

RELATED EXAMPLES: Chairs in museum collections include Bishop 1972, pp. 160–61, no. 202; Jobe and Kaye 1984, pp. 409–10, no. 122.

REFERENCES: Warren 1975, p. 45, no. 75; Jobe and Kaye 1984, p. 410.

1. White 1990, p. 75, pl. 9; Kirk 1982, p. 267, no. 940.
2. Ott 1965, pp. 12–13, no. 12.

F84
Pair of Side Chairs

1750–1800
New York area
Mahogany, red gum, and secondary woods;
B.69.23.1: 39¼ x 23¼ x 22¾" (99.7 x 59.1 x
57.8 cm); B.69.23.2: 39¼ x 23¼ x 20¾" (99.7 x
59.1 x 52.7 cm)
B.69.23.1–.2

Elements associated with New York Rococo furniture include prominent square ball-and-claw feet, scrolled banister incorporating a diamond-shaped device, deeper carving than is typically found on New England chairs, and the addition of heels on the rear legs. The latter, a practical consideration, protected walls from being damaged by the crest rail, a convention more typical of English furniture.[1] Also of English derivation is the decorative ruffle extending above the leg to the seat rail. The presence of these motifs demonstrates a more pervasive impact from imported cabinetwork than is evident in Boston, Newport, or Philadelphia.

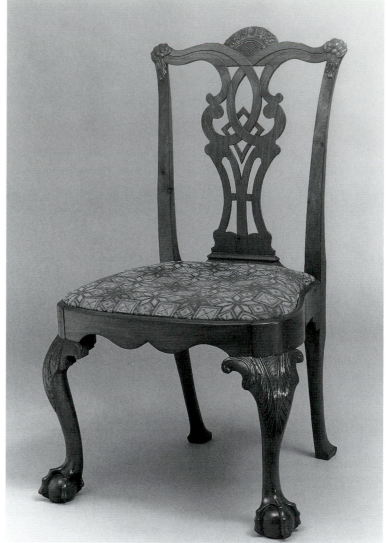

F85

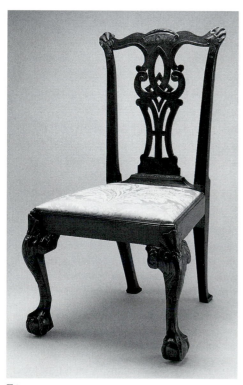

F84

PROVENANCE: Purchased by Miss Hogg from Ginsburg and Levy, New York, 1943, who noted they came from the Pendleton and Rogers families of Hyde Park, New York.

TECHNICAL NOTES: Mahogany, red gum (rear seat rail); black cherry (slip seat), eastern white pine (corner blocks), Atlantic white cedar (shims behind rear corner blocks). The vertical corner blocks are quarter round. The rear seat rail is not as deep as the shoe, and shims are fitted between the corner blocks and rail. The slip seats are cut out in the back to accommodate the placement of the corner blocks. The seat rails are tenoned through the stiles, a practice more common in Philadelphia than New York. The seat rail of B.69.23.1 is stamped VII, the rear rail penciled 2. The seat rail of B.69.23.2 is impressed VI, the rear rail penciled 1.

RELATED EXAMPLES: Kirk 1972b, p. 120, no. 144. These chairs relate to a small group with histories from Albany to New Brunswick, New Jersey (Blackburn 1976, p. 94, no. 88; Fairbanks and Bates 1981, p. 150).

REFERENCES: *Antiques* 29 (March 1936), p. 117; *Antiques* 29 (May 1936), p. 216; Ginsburg and Levy 1942, no. 13; Comstock 1962, no. 260; Mourot 1975; Warren 1975, p. 47, no. 79.

1. "One of the most useful directions (to a new servant) is that of putting away chairs, tables, and anything that goes next to the wall, with the hand behind it. For want of this trifling attention, great pieces are frequently knocked out of the stucco and [furnishings] leave a mark on the wall" (Whatman 1987, p. 39).

F85
Side Chair

1750–95
New York
Mahogany and secondary woods; 39⅜ x 23¼ x 22½" (100 x 59.1 x 57.2 cm)
B.69.34

This side chair possesses many of the same features as cat. no. F84; however, its well-articulated carving and scalloped front seat rail elevate it as a consummate New York expression of the Rococo. A nineteenth-century account purports that it belonged to Sir William Johnson, Britain's superintendent of Indian affairs, who used it in his Mohawk Valley home. Despite Johnson's close proximity to Albany, his papers reveal that for fine furniture he had to look to New York City. Responding to Johnson's 1770 inquiry for chairs, Thomas Shipboy of Albany replied, "as for good Chairs there is none Ready made in this pleace, but there is a man in town that make midling good ones."[1]

PROVENANCE: Purchased by Miss Hogg from John S. Walton, New York, 1952. A provenance can be reconstructed from an 1892 sketch of Peter H. Mabee[2]: Sir William Johnson (1715–1774); purchased by Abraham Gerretson; to his daughter Maria (Mrs. Abraham Newkirk, 1769–1835); to her daughter Maria (Mrs. Harmanus Mabee, 1801–1880); to her son Peter Mabee (1838–1905).

TECHNICAL NOTES: Mahogany; yellow-poplar (glue blocks), red oak (slip seat). The seat retains its original stuffing and fragments of a red moreen that is probably the original cover. The crest rail is a replacement. The banister is set into the shoe. The front corner blocks are quarter round and the back ones L-shaped. The seat rail is incised V, the slip seat, VII.

RELATED EXAMPLES: Others from the set include Downs 1952, no. 149; Kane 1976, pp. 121–23, no. 102; Rodriguez Roque 1984, pp. 128–29, no. 55; the Minneapolis Institute of the Arts (acc. no. 31.15.12); and two that are privately owned. These chairs are also recorded in Frothingham 1892, p. 240; American Art Association, Anderson Galleries, New York, sale 3804, January 2–4, 1930, lot 447, and sale 3940, January 9, 1932, lot 68; Keyes 1932, pp. 122–23; Susswein 1934, pp. 6–7; Samuel T. Freeman, *Collection of the Late Charles M. Davenport,* November 23, 1943, lot 248; Parke-Bernet, sale 529, February 11–12, 1944, lot 373; *Antiques* 45 (June 1944), p. 277; Sack 1950, p. 43; Winchester 1956, p. 439; Wright et al. 1966, pp. 308–9; Kirk 1972b, p. 120, no. 143; Butler 1973, pp. 67–69; Hummel 1976, p. 20; Cooper 1980, pp. 185, 188–89, no. 205; Blackburn 1983, pp. 430–31; *Antiques* 141 (June 1992), p. 898; Sack 1993, p. 50; Petraglia 1995, p. 82; *Maine Antique Digest,* February 1996, p. 11-D.

REFERENCES: *Antiques* 62 (November 1952), p. 359; Warren 1975, p. 46, no. 77.

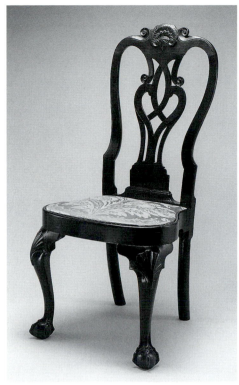

F86

1. Flick 1930, p. 337.
2. Frothingham 1892, p. 240: "Mr. Mabee has in his possession many interesting relics of the early days in the valley, among them having five parlor chairs, which were the property of William Johnson, which were a portion of his effects confiscated and sold. They were purchased by Mr. Mabee's great-grandfather Garrison, and have since been handed down from one generation to another in the family."

F86

Pair of Side Chairs

1750–80
Philadelphia
Mahogany and secondary woods; B.69.76.1: 42½ x 20½ x 21¼" (108 x 52.1 x 54 cm); B.69.76.2: 42½ x 20½ x 19½" (108 x 52.1 x 49.5 cm)
B.69.76.1–.2

These unusual side chairs are essentially Late Baroque in contour; however, the conventional solid banister has been replaced by a Rococo strapwork one. The juxtaposition of these diverse elements, in all likelihood, reflects a client's preference. Chairs incorporating elements of two, and sometimes even three styles are considered a composite rather than tran-

sitional—although in this instance both may be accurate estimations.[1]

PROVENANCE: Robert R. Logan; [Joe Kindig, Jr., York, Pennsylvania, by 1940]; Henry Francis du Pont, Winterthur, Delaware; purchased by Miss Hogg from John S. Walton, New York, 1953. The probable descent is "from the Logans of Stenton, or the master of 'Norris's Great house'" through Doctor George Logan (1753–1821) and Deborah Norris Logan (1761–1839); to their son Albanus (1783–1853); to his son Gustavus George Logan, father of Robert R. Logan.[2]

TECHNICAL NOTES: Mahogany; mahogany (slip seat front and outer, rounded sides—the frame cutouts), southern yellow pine (slip seat interior sides and back). The seat rails are tenoned through the stiles. The rear brackets are attached to the seat rails. The banister is set into the shoe, which is deeper than the rear seat rail. The inside rear seat rail of B.69.76.1 is incised VII, its slip seat, VII. The inside seat rail of B.69.76.2 is incised I, its slip seat, VIII.

RELATED EXAMPLES: Other chairs from this set are published in *Antiques* 37 (January 1940), inside front cover; Downs 1952, no. 117; Hornor 1977, p. 204, pl. 81; Zimmerman 1981, pp. 305–6. Similar chairs include Hornor 1977, pl. 72; Sack 1969–92, vol. 6, p. 1545, no. P4480; Heckscher 1985, pp. 89–90, 92, nos. 44, 46.

REFERENCES: *Antiques* 64 (September 1953), p. 150; Warren 1975, p. 26, no. 47.

1. Zimmerman 1981, pp. 305–7.
2. Hornor 1977, p. 204.

F87

Pair of Side Chairs

1760–1800
Philadelphia
Mahogany and secondary woods; B.58.146.1: 40⅝ x 23⅜ x 21½" (103.2 x 60 x 54.6 cm); B.58.146.2: 40¾ x 23⅝ x 21½" (103.5 x 60 x 54.6 cm)
B.58.146.1–.2

The contrast of a solid banister on what is otherwise a Rococo side chair offers an alternative to the previous example in its juxtaposition of Late Baroque and Rococo elements (see cat. no. F86). This particular configuration is reminiscent of a working drawing, inscribed "Plain Chair," attributed to the Philadelphia craftsman Samuel Mickle (b. 1746).[1] The persistence

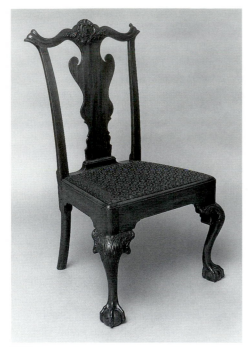

F87

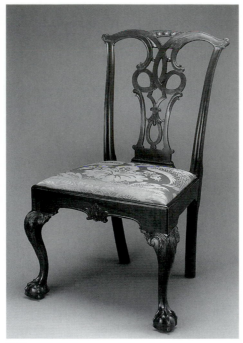

F88

of earlier motifs can be inferred from the 1786 Philadelphia cabinetmakers' price list, which records "Chairs With Crooked Legs," "plain feet & bannester," the term plain presumably referring to a slipper or trifid foot with solid banister. A year later, cabinetmaker Charles Ford advertised "Plain, claw-feet and ornamented chairs of the newest taste," implying the continuing preference for Late Baroque and Rococo elements into the Neoclassical period.[2] The crest rail's beautifully articulated cartouche and naturalistic flowering branches sharply contrast with Mickle's terse title.

PROVENANCE: Purchased by Miss Hogg from Ginsburg and Levy, New York, 1958, who noted they came from Robert W. Chambers, Broadalbin, New York.

TECHNICAL NOTES: Mahogany; Atlantic white cedar (corner blocks). B.58.146.1: eastern white pine (slip seat sides), spruce (slip seat front and back); B.58.146.2: yellow-poplar (slip seat). The seat rails are tenoned through the stiles. The front corner blocks are two-part quarter round, the rear composed of a single quarter round. Shims were added behind the latter to fill the void, since the shoe is deeper than the rear seat rail. The front seat rail of B.58.146.1 is stamped II and I. The front seat rail of B.58.146.2 is impressed IIII, and 21418 is recorded on the seat. A chalk inscription on the front seat rail of B.58.146.1, possibly "Chambers," may refer to a previous owner.

RELATED EXAMPLES: Another chair from this set is recorded in Levy Gallery 1984, p. 42. The

carving's articulation is reminiscent of that on another chair and a high chest illustrated in *Antiques* 31 (April 1937), p. 189 and PMA 1976, pp. 132–35, no. 104a. Luke Beckerdite assigns the carving to Nicholas Bernard and Martin Jugiez (d. 1815).[3]

REFERENCES: Probably the chairs auctioned at Parke-Bernet, New York, sale 564, May 6, 1944, lot 87; *Connoisseur* 143 (May 1959), p. LXXII; Hinckley 1960, p. 132, no. 133; Warren 1975, p. 47, no. 80.

1. PMA 1976, p. 87; Bishop 1972, p. 139, no. 164.
2. Fitzgerald 1982, p. 290; Prime 1969, vol. 2, p. 177.
3. Beckerdite 1985.

F88
Side Chair

1755–1800
Philadelphia
Mahogany and secondary woods; 38¾ x 23½ x 22" (98.4 x 59.7 x 55.9 cm)
B.69.80

Although an exact prototype for this chair has not been identified, certain motifs are related to designs by both Thomas Chippendale and Robert Manwaring.[1] The asymmetrical ruffle of the seat rail bears comparison with labeled chairs by James Gillingham (1736–1781), Thomas Tufft (d. 1788), and Benjamin Randolph (1721–1791).[2] Attempts to link the Bayou Bend

chair to a documented example underscore a natural propensity to ascribe objects to a craftsman, while challenging the logic of basing an attribution on a singular motif.

PROVENANCE: [Ginsburg and Levy, New York]; purchased by Miss Hogg from David Stockwell, Philadelphia, 1953.

TECHNICAL NOTES: Mahogany; southern yellow pine (slip seat, interior rear seat rail), Atlantic white cedar (front corner blocks), yellow-poplar (rear corner blocks). The seat rails are tenoned through the stiles. The front corner blocks are two-part quarter round, while the rear blocks are single quarter round. The frame retains its eighteenth-century webbing and stuffing. The front seat rail bears the stamped letters CC, the slip seat, C.

RELATED EXAMPLES: *Antiques* 15 (June 1929), p. 468; *Antiques* 32 (August 1937), p. 51; Comstock 1953, p. 474; *Antiques* 83 (March 1963), p. 259; *Antiques* 93 (June 1968), p. 685; Davis 1972, p. 197, no. 8; *Antiques* 106 (December 1974), p. 905; *Antiques* 110 (November 1976), p. 837; Sotheby's, New York, sale 5682, January 30, 1988, lot 1775.

REFERENCES: *Antiques* 51 (February 1947), p. 91; Warren 1975, p. 48, no. 82.

1. Chippendale 1966, pl. XI; Manwaring 1970, pl. 4.
2. Conger 1979, p. 116; Downs 1952, no. 134; Woodhouse 1930, pp. 21, 23. The fact that journeymen carvers were employed by more than one shop, and worked independently as well, further complicates making an attribution.

F89
Pair of Side Chairs

1755–1800
Philadelphia
Mahogany and secondary woods; each 39¾ x 23¼ x 22¼" (101 x 59.1 x 56.5 cm)
B.69.77.1–.2

Philadelphia's population at the threshold of revolution is estimated at 28,000, making it colonial America's principal urban center. Characteristics of Philadelphia Rococo seat furniture are integrated into these pleasing chairs. The articulated claw feet, mirror-image shells on the front seat rail and undulating crest rail, stumplike rear legs, and seat frame are all executed in the manner identified with that city.

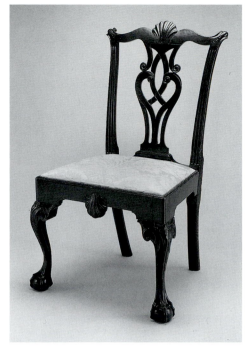

F89

PROVENANCE: Purchased by Miss Hogg from David Stockwell, Philadelphia, 1948, who noted they were owned by Miss Ella Parsons.

TECHNICAL NOTES: Mahogany; yellow-poplar (corner blocks, seat frame), southern yellow pine (slip seat frame), Atlantic white cedar (shims behind rear corner blocks). The carved shell is integral with the front seat rail. The front blocks are two-part quarter round, the rear triangular with a shim beneath the shoe. The slip seats retain their original foundations. The front seat rail of B.69.77.1 is stamped VI, its slip seat VII. The front seat rail of B.69.77.2 is stamped I, its slip seat II.

RELATED EXAMPLES: Similar chairs, possibly from the same set, include *Antiques* 37 (March 1940), p. 114; *Antiques* 37 (May 1940), p. 224; *Antiques* 46 (October 1944), p. 185; Kirk 1972b, p. 80, no. 69; Kane 1976, pp. 133–34, no. 112; Christie's, New York, sale 5047, April 11, 1981, no. 477; Kirk 1982, p. 257, no. 878. A similar example bears William Savery's label (Sack 1969–92, vol. 9, p. 2468, no. P6134).

REFERENCES: Warren 1975, p. 47, no. 81.

F90

Armchair

1750–80
Philadelphia
Mahogany and secondary wood; 42¾ x 30½ x 23¼" (108.6 x 77.5 x 59.1 cm)
B.69.2

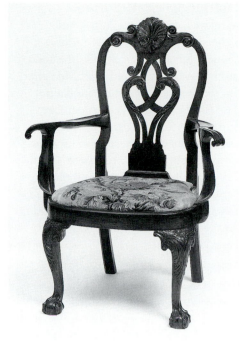

F90

This masterful armchair reflects the maturity of the Late Baroque yet, with its carved acanthus knees, foliate, strapwork banister, and naturalistic shell topping the crest rail, it is fully conversant with Rococo taste. This unusual configuration may represent the brief period of transition between the Late Baroque and Rococo, or perhaps it is a design that never realized widespread popularity.[1]

PROVENANCE: Purchased by Miss Hogg from Ginsburg and Levy, New York, 1954.

TECHNICAL NOTES: Mahogany; eastern white pine (slip seat). The interior front seat rail is bowed and its lip is applied. The seat rails are tenoned through the stiles. The rear seat rail is not nearly as deep as the shoe. The inside of the front and rear seat rails is carved I. An illegible inscription is on the slip seat frame. Luke Beckerdite comments that the carving imitates the body of the work he has assigned to the same hand that carved the great Philadelphia high chest in the Garvan Collection at Yale (Ward 1988, pp. 280–83, no. 147), referring to the unknown craftsman as the "Garvan carver."

RELATED EXAMPLES: Most closely related is Heckscher 1985, pp. 90–92, no. 45. A side chair with related carving is in Downs 1952, no. 115. Wallace Nutting offered a reproduction of this armchair in *Antiques* 36 (November 1939), p. 214.

REFERENCES: *Antiques* 41 (April 1942), p. 234; Ginsburg and Levy 1942, no. 7; *Connoisseur* 133 (May 1954), p. 195; *Antiques* 66 (August 1954), p. 87; Ramsey 1954, vol. 1, pl. 39B; Comstock 1962, no. 149; Warren 1966, p. 805; Warren

1971a, p. 42, no. 10; Warren 1975, p. 27, no. 49; Warren 1988, pp. 26–27; Marzio et al. 1989, pp. 236–37.

1. Zimmerman 1981, pp. 305–7.

F91

Armchair

1750–1800
Boston-Salem, Massachusetts area, or possibly Portsmouth, New Hampshire
Mahogany and secondary woods; 36½ x 29½ x 22¾" (92.7 x 74.9 x 57.8 cm)
B.57.95

Colonial armchairs, considerably more expensive than side chairs, were never produced in quantity. The Bayou Bend armchair is comparable to English examples; its banister, similar to a Robert Manwaring design, is probably modeled after an import. Furthermore, the lack of stretchers, unusual for New England furniture of this date, is typical of English examples.[1] This armchair's regional origin is problematic; its pattern is found on chairs with histories in Boston, Portsmouth, and Virginia.[2]

PROVENANCE: Purchased by Miss Hogg from Ginsburg and Levy, New York, 1957, who noted its descent in the Weston family of Williamstown, Massachusetts.

TECHNICAL NOTES: Mahogany; soft maple (front and side seat rails), birch (rear seat rail,

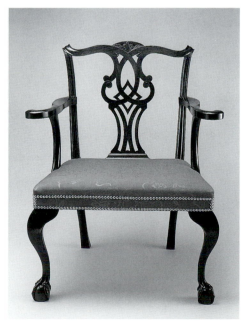

F91

corner blocks). The seat rails are secured by large, triangular corner blocks. The banister is a replacement.

RELATED EXAMPLES: Armchairs include *Antiques* 42 (September 1942), p. 109; Jobe and Kaye 1984, pp. 396–97, no. 116. Side chairs include Sack 1969–92, vol. 8, p. 2167, no. P5632; Randall 1965, pp. 191–93, nos. 151, 152; Sotheby's, New York, sale 6132, January 30–February 2, 1991, lot 1478; Sack 1969–92, vol. 10, p. 2674, no. P6377.

REFERENCES: Warren 1975, p. 48, no. 83; Jobe and Kaye 1984, pp. 396–97, no. 116.

1. Kirk 1982, pp. 256–57, nos. 870–72, 874–77.
2. Jobe et al. 1993, pp. 330–31.

F92

Roundabout Chair

1750–1800
New York
Mahogany and secondary woods; 31½ x 30½ x 26½" (80 x 77.5 x 67.3 cm)
B.58.107

The American roundabout chair was produced exclusively during the Early and Late Baroque and Rococo periods. As with so many Late Baroque forms and motifs, a plausible precedent may be found in Chinese furniture, specifically, the continuous horseshoe or round chair.[1] In America, the first references to roundabouts date from the 1730s.[2] A considerable number of New England and New York examples survive, attesting to its widespread popularity in those areas. Essentially Late Baroque in contour, the Bayou Bend chair is distinguished by the fluid passage of Rococo carving ornamenting the crest rail.[3]

PROVENANCE: Matthias Burnet (1749–1806), Jamaica, New York, and later Norwalk, Connecticut[4]; purchased by Dr. Jonathan Knight (ca. 1758–1829); purchased by Hezekiah Betts (1760–1837); to his daughter Juliette Betts (1805–1896)[5]; Malcolm Rutherford Thorpe (ca. 1891–1958); purchased by Miss Hogg from Israel Sack, New York, 1958.

TECHNICAL NOTES: Mahogany; sweetgum (corner blocks), eastern white pine (seat rail strips), red oak (slip seat). The front leg is tenoned inside the seat rail. The banister is set into the shoe. The curved arms overlap one another where they join. The crest rail is secured on top of the arms. Attached to the rear rails are horizontal strips supporting the slip seat. The knee brackets are replacements. An early ink inscription on the slip seat may refer to the chair's fabrication, possibly instructions for the upholsterer: "Please Let the Nails Come [—] he [—] otherwise the Seat will go in too hard." A penciled note attached to the slip seat reads: "This chair was the property of Rev. Matthias Burnet Pastor of the First Congregational Society Norwalk 21 years.—died 1806 Jonathan Knight M.D.—(Our Family Physician) Bought it. He died about 1831. Father (Hezekiah Betts) bought it at Auction. It has been in our family ever since Juliette Betts Norwalk Feb. 20th 1894."

RELATED EXAMPLES: Downs 1952, no. 66; Campbell 1975, p. 24; *Antiques* 112 (October 1977), p. 629.

REFERENCES: *Antiques* 74 (November 1958), inside front cover; Comstock 1962, no. 257; Warren 1975, p. 49, no. 86; Sack and Wilk 1986, pp. 145–50; Sack and Levison 1991, pp. 943, 946–47; Sack 1969–92, vol. 10, pp. 85, 88–89.

1. Ellsworth 1970, pp. 86–89, 122–30, nos. 14–21; Shixiang 1986, pp. 24, 308.
2. Lyon 1925, p. 168.
3. Perhaps English roundabout chairs supplied the inspiration for the crest rail's ornament. One other American example is discussed in Hummel 1970/71, p. 901.
4. In 1775 Burnet became pastor of the Presbyterian Church in Jamaica, New York. A loyalist sympathizer, Burnet eventually was

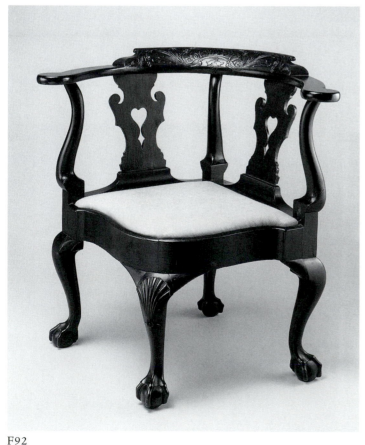

F92

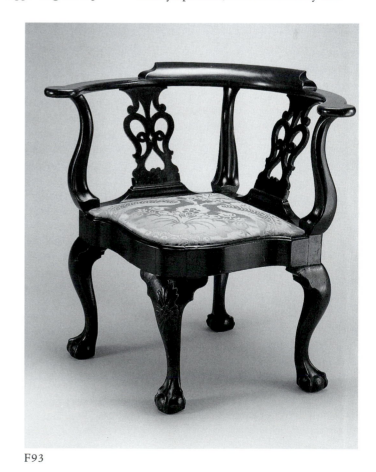

F93

forced to resign his pulpit. He later became pastor of the First Congregational Church in Norwalk, Connecticut.

5. Betts and Betts 1888, pp. 85–86; Golding 1936, pp. 35–36.

F93

Roundabout Chair

1750–1800
New York
Mahogany and secondary wood; 32 x 32¼ x 25¼″ (81.3 x 81.9 x 64.1 cm)
B.69.401

This chair back, adapted from a design by Robert Manwaring, was espoused in Newport (cat. no. F83), Philadelphia, and New York, each varying it slightly.[1] Roundabouts were fashioned with either turned columnar or cabriole arm supports, mirroring the legs' contour. The unusual foliate carved knee ornament on this example, and a related easy chair, suggests they may have been produced en suite with a set of side chairs for General Philip Schuyler.[2]

PROVENANCE: Purchased by Miss Hogg from Israel Sack, New York, 1950. Possibly once belonged to Philip Schuyler (1733–1804), Albany.

TECHNICAL NOTES: Mahogany; mahogany (corner blocks), yellow pine (slip seat). The side and rear corner blocks are quarter round, with additional support below from protruding knee brackets. The arms abut over the central cabriole support and are capped by the crest rail.

RELATED EXAMPLES: Other furniture with related carving include Rice 1962, p. 43; Sack 1969–72, vol. 5, p. 1148, no. P4039; Scherer 1984, p. 12, no. 9.

REFERENCES: Warren 1975, p. 49, no. 87; Heckscher 1985, pp. 67, 127.

1. Manwaring 1970, pl. 9. A Philadelphia armchair is published in Downs 1952, no. 40.
2. The chairs were possibly made en suite. Schuyler's accounts (New York Public Library) do not mention specifically a roundabout chair, but they do record the purchase of "1 cheare" and "8 mahogney chears" from Henry Wendell. Schuyler's Albany mansion is maintained as a museum.

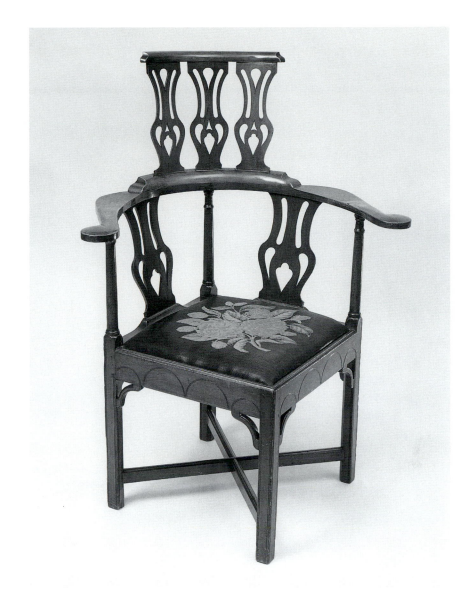

F94

F94

Roundabout Chair

1750–1810
New England
Black cherry and secondary wood; 44⅝ x 32 x 30½″ (113.3 x 81.3 x 77.5 cm)
B.69.143

This extraordinary roundabout is a spirited maverick exuding the individuality and vitality that distinguishes the very best rural cabinetry. It delights the eye with such idiosyncrasies as the undulating knee brackets, the graduated series of incised arcs on the seat rail, and the diminutive banister supports on the headrest. Contrasting with this imaginative design is the attachment of the battens to the inner seat frame to secure a commode, a common function of roundabout chairs.[1]

PROVENANCE: Purchased by Miss Hogg from Israel Sack, New York, 1946, who noted it came from the Reed family of Woodstock, Vermont.

TECHNICAL NOTES: Black cherry; black cherry (slip seat), eastern white pine (corner blocks). The legs are channeled from the bottom, the overlapping stretchers slid in, and the exposed channel plugged. The rear seat rails are incised in the same manner as the front rails. The shoes are integral with the rear seat rails. The seat rails are secured with triangular corner blocks. Framing strips are attached at the bottom of the seat rails and along the corner blocks. The two arms abut in the center. The seat retains its original upholstery foundation and a nineteenth-century horsehair and Berlinwork cover.

RELATED EXAMPLES: The roundabout appears to be unique; its closest affinity is with a group of Essex County, Massachusetts, chairs illustrated in Jobe and Kaye 1984, pp. 414–16, no. 125.

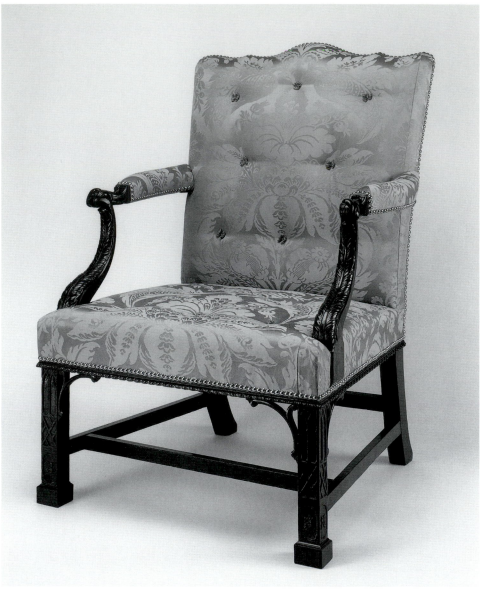

F95

suite with the great Chew family sofa at Cliveden.[4] John Penn's superb seat furniture, like its English counterparts, was conceived as forming an impressive row lining the walls of one of his principal rooms, conveying his position to all who entered.

PROVENANCE: Matthew Brooke III, Birdsboro, Pennsylvania; to Mr. and Mrs. Robert E. Brooke; purchased by Arthur Sussel, Philadelphia; purchased by Miss Hogg at Parke-Bernet, New York, 1959 through John S. Walton, New York. The Bayou Bend armchair is believed to have been part of the John Penn suite. The earliest documentation for these chairs appears in the donations list for Friends Hospital of Philadelphia acknowledging Samuel W. Fisher's 1817 gift of "2 Large Armchairs formerly ownd by Governor Penn."[5]

TECHNICAL NOTES: Mahogany; white oak. The armchair is constructed with corner braces in both its seat and back. The bases, brackets, and crest rail peaks are restorations. Another chair from the set retains evidence of its original red silk upholstery and gilt tacks.[6] Luke Beckerdite has attributed the chair's carving to Bernard and Jugiez.

RELATED EXAMPLES: Nine other armchairs are recorded: Milley 1980, pp. 117, 119, 195; PMA 1976, pp. 100–101, no. 79; Hummel 1976, p. 54; Conger 1991, pp. 138–39, no. 55; Heckscher and Bowman 1992, pp. 212–13, no. 151; and one in a private collection. What appears to be another chair from this set is pictured in *Antiques* 84 (September 1963), p. 308. These chairs are also published in Kimball 1931a, p. 375; *Antiques* 27 (May 1935), p. 192; Carson 1947, pp. 10–11, 13; *Antiques* (November 1951), p. 354; LACMA 1955, pp. 40, 44; Carson 1968, p. 188; Hummel 1970–71, part 2, pp. 907–9; Hornor 1977, pl. 117; Fitzgerald 1982, p. 66; Sack 1987, p. 170; Federhen 1994, pp. 300–303.

REFERENCES: *Antiques* 60 (November 1951), p. 360; Parke-Bernet, New York, sale 1872, January 22–24, 1959, lot 710; Warren 1972a, p. 9; Warren 1975, p. 50, no. 89; Hornor 1977, p. 137, pl. 285.

1. Heckscher 1994, pp. 185–89.
2. Hornor 1977, pp. 74–77.
3. Chippendale 1966, pp. 3–4, pl. XIX.
4. Penn sold his Philadelphia townhouse for an exorbitant sum to Benjamin Chew in 1771, fueling speculation that the sale included the furniture (Shepherd 1976, pp. 5–6; Heckscher and Bowman 1992, p. 211, no. 150). Cliveden is a property of the National Trust for Historic Preservation.
5. Kimball 1931a; Kimball 1931b; Heckscher and Bowman 1992, p. 213.
6. Conger 1991, pp. 138–39, no. 55.

1. Both 1772 and 1786 Philadelphia price lists include "Corner Chair for Close Stool," the most expensive version costing more than an easy chair frame (Weil 1979, p. 183; Fitzgerald 1982, p. 290).

F95

Armchair

1763–71
Philadelphia
Mahogany and secondary wood; 40¾ x 28⅜ x 28½″ (103.5 x 72.1 x 72.4 cm)
B.60.30

Thomas Chippendale's *The Gentleman and Cabinet-Maker's Director* was the most popular eighteenth-century furniture design book, and in colonial America the most influential of a plethora of publications.

Its greatest impact was in Philadelphia, where the cabinetmakers Thomas Affleck and Benjamin Randolph, as well as the Library Company, owned copies.[1] In 1775, Philadelphia cabinetmaker John Folwell proposed publishing an American edition.[2]

This magnificent armchair, commissioned by Lieutenant Governor John Penn of Pennsylvania (1729–1795), masterfully integrates Chinese and Gothic fretwork and richly carved, French asymmetrical scrolls, the trio of inspirational sources that Chippendale advanced. The chair's lines, proportions, and ornament are highly unusual in American furniture. Their design, more closely related to English examples, recall a series of plates for "French Chairs" published in the *Director*.[3]

Nine chairs from this set are known, and it is believed that they were made en

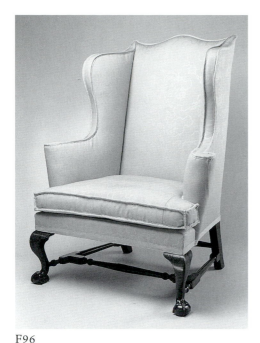

F96

F96

Easy Chair

1750–1800
Eastern Massachusetts
Mahogany, soft maple, birch, and secondary woods; 47¼ x 37 x 32¼" (120 x 94 x 81.9 cm)
B.57.76

With the Rococo's assimilation, the contours of the easy chair evolved in response to the new fashion. The Late Baroque's curvilinear seat frames became straight, tapering backward, while the rounded crest rail took on a serpentine shape. New England chairs retained their stretchers, while their New York and Philadelphia counterparts incorporated more substantial framing so that these unharmonious structural components were no longer deemed necessary.

PROVENANCE: Purchased by Miss Hogg from Ginsburg and Levy, New York, 1957.

TECHNICAL NOTES: Mahogany (front legs), soft maple (rear legs), birch (rear stretcher); soft maple (side seat rails), birch (front and rear seat rails). Since the frame retains its original webbing and sacking on the back and wings, it was not possible to sample the interior framework.

RELATED EXAMPLES: Campbell 1975, p. 43; Heckscher 1985, p. 125, no. 73; Heckscher 1987a, pp. 97–98, fig. 83; Baumgarten 1993, pp. 5–6.

F97

Easy Chair

1750–1800
Eastern Massachusetts
Mahogany and secondary woods; 45½ x 32¾ x 31¾" (115.6 x 83.2 x 80.6 cm)
B.60.89

This colorful easy chair, complete with its vivid Irish stitch cover, is among the most highly prized survivals of eighteenth-century American upholstered furniture. It represents the contributions of several individuals: the needlewoman, who in all probability was not a professional but an upper-class lady whose husband had commissioned the frame; the chairmaker; and the upholsterer who constructed the foundation, attached the needlework, and made up the cushion.

The relatively undisturbed frame of this chair presents an extraordinary document of the outline and contours characteristic of colonial upholstery. The interior is fully stuffed to ensure its occupant the utmost comfort; by contrast, the exterior is thinly padded, resulting in a taut appearance. The back is upholstered with an English stamped harrateen of watered patterning with meandering band, butterflies, and flowers. Originally, the seams were concealed by welt and tape.

Upholstery work was the principal, and most logical, of all the decorative arts-related trades for a woman to pursue. In Philadelphia Ann King advertised the establishment of her own shop after having "the care of the Women's work, in the Upholstery business, at Mr. John Webster's, for near seven years." There she made up mattresses, cord, and fringes, claiming distinction as "the first American tossel (tassel) maker that ever brought that branch of business to any degree of perfection in this part of the world. . . ."[1] In many respects the eighteenth-century upholsterer was the forerunner of the nineteenth- and twentieth-century inte-

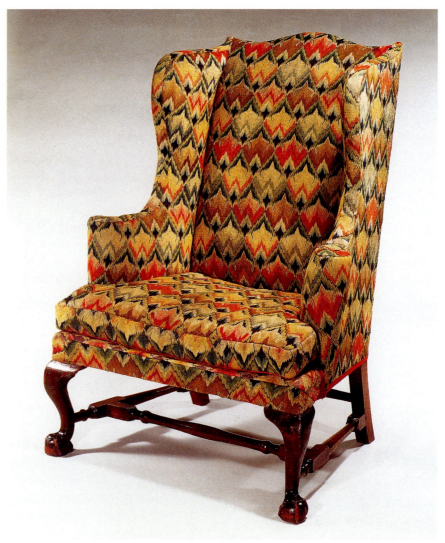

F97

rior designer. For Webster, King, and others in the upholstery trade, it offered the potential for a livelihood second only to that realized by the silversmith.

PROVENANCE: Purchased by Miss Hogg from John S. Walton, New York, 1960, who noted it came from the Gillette estate, Oyster Bay, Long Island.

TECHNICAL NOTES: Mahogany; white pine (corner blocks), maple (seat rails). The upholstered frame could not be sampled. At the time of the chair's purchase, Miss Hogg consulted Charles F. Montgomery regarding the upholstery's conservation. It was agreed that Ernest LoNano would make minor repairs and clean the material.[2] Miss Hogg wrote to John Walton requesting that LoNano complete the treatment without disturbing the upholstery. Surprisingly, she approved making up a new cushion using the needlework from the original so it would "fit the chair properly." A radiograph indicates that LoNano removed the needlework from the frame, presumably to facilitate in the cleaning of the textile, but left the foundation largely undisturbed.

RELATED EXAMPLES: American easy chairs with their original needlework upholstery intact are all of New England origin: Downs 1952, no. 74; Heckscher 1985, pp. 122–24, no. 72. Another chair retains its original worsted cover: Heckscher 1987a, pp. 98–103. Easy chairs with some of their original show cover in place include *Antiques* 54 (July 1948), p. 3; Passeri and Trent 1983, pp. 26A–28A; Cooke 1987, now at the MFA, Boston (acc. no. 1994.267); Forman 1988, p. 366; Wood 1996, pp. 68–69, no. 29A. A Marlborough-legged Massachusetts easy chair is pictured in *Antiques* 90 (August 1966), inside cover.

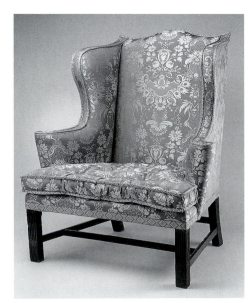

F98

REFERENCES: *Antiques* 78 (July 1960), p. 4; Jobe 1974, pp. 36, 39; Warren 1975, pp. 50–51, no. 90; Agee et al. 1981, p. 76, no. 133; Fairbanks and Bates 1981, p. 161; Heckscher 1985, p. 122; Heckscher 1987a, p. 103; Anderson 1990, p. 14.

1. Prime 1969, vol. 1, pp. 205–6.
2. For an illustration showing the chair before this treatment, see *Antiques* 78 (July 1960), p. 4.

F98

Easy Chair

1770–1810
Rhode Island
Mahogany and secondary woods; 47⅞ x 35¾ x 28¾" (121.6 x 90.8 x 73 cm)
B.60.84

The stop-fluted Marlborough leg is a regional preference that is unique in America to Rhode Island furniture. It appears on a range of forms, including side chairs (cat. no. F83), sofas, a variety of table types (cat. no. F172), and beds. The Bayou Bend easy chair, with its stop-fluted legs, requisite stretchers, and tapered conical arms, is a classic interpretation of the form. Like New England cabriole-legged examples, these chairs were produced with rounded or occasionally serpentine crest rails, the latter more in keeping with this type of leg. The chair's tufted cushion reproduces a period example.[1]

PROVENANCE: Purchased by Miss Hogg from David Stockwell, Wilmington, Delaware, 1960.

TECHNICAL NOTES: Mahogany; soft maple (rear upholstery rail, arm supports), birch (wing stile). The stretchers are blind-tenoned. There is no evidence that the frame was finished with decorative tacking. Penciled on a wing is the notation: "UPHOLSTERED JULY 30, 1914 AT 347 MOODY ST"; the city has not been identified.

RELATED EXAMPLES: Greenlaw 1974, pp. 78–79, no. 69; Stillinger 1990, pp. 52–53, 152.

REFERENCES: *Antiques* 78 (September 1960), p. 177; *Antiques* 78 (October 1960), p. 279; Warren 1975, p. 52, no. 92.

1. The present upholstery is based on a similar chair with its original underupholstery (Sack 1969–92, vol. 5, p. 1274, no. P4254).

F99

Settee

1750–1800
Eastern Massachusetts, probably Boston
Mahogany, birch, and secondary wood; 40½ x 76 x 26¾" (102.9 x 193 x 67.9 cm)
B.69.361.1

The chair-back settee was unknown in America prior to the mid-eighteenth century. Examples survive from all the principal urban centers; however, their relative rarity suggests that they were never produced in significant numbers. The majority have a Massachusetts origin, most probably Boston, where English-made examples were owned by the Hancock and Quincy families. Entirely different in appearance, these English settees may have supplied inspiration but had little, if any, influence on Boston's craftsmen and their clientele.[1] The seven examples assigned to Massachusetts incorporate one of just two banister designs, Bayou Bend's representing the more prevalent. This settee is notable for its impressive, albeit awkward, breadth as well as for surviving en suite with eight matching side chairs (cat. no. F81).

PROVENANCE: See cat. no. F81.

TECHNICAL NOTES: Mahogany, birch (rear seat rail); southern yellow pine. The slip seat has a scooped medial brace. The crest rail is pinned through all four stiles; the central stiles completely through the rear seat rail.

RELATED EXAMPLES: Cooper 1977, pp. 41–42, 44.

REFERENCES: Comstock 1962, no. 350; Bishop 1972, p. 154, no. 187; Warren 1975, p. 53, no. 94; Cooper 1977, pp. 41, 44; Sack and Wilk 1986, p. 177.

1. Cooper 1977; Jobe and Kaye 1984, pp. 377–79, no. 107.

F100

Sofa

1750–1800
Eastern Massachusetts
Mahogany and secondary woods; 34⅝ x 54⅛ x 26½" (87.9 x 137.5 x 67.3 cm)
B.69.142

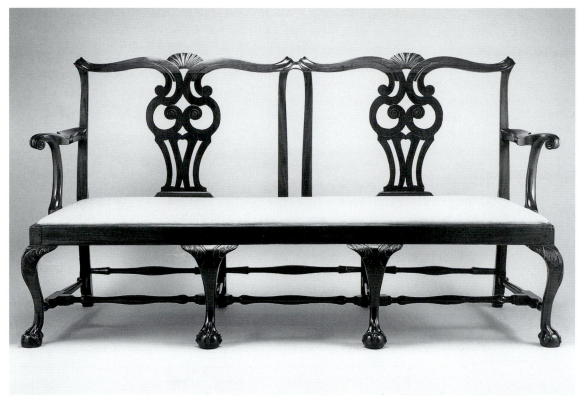

F99

The term *sofa,* as well as the form itself, is of Arabic origin, introduced to England and America early in the eighteenth century. One contemporary source described it as "A sort of Alcove much used in Asia, it is An apartment of State, raised about two Foot higher than the Floor, and furnished with rich Carpets and Cushions, where honorable Personages are entertained."[1] The Bayou Bend sofa is a diminutive version of the standard serpentine-back form. Its seat and arms are unusually high and the curve to the back less pronounced than seen in most fully developed examples. The shaped terminals on its rear legs, a feature common in English furniture, is often associated with New York seating furniture; however, the raked back claws and secondary woods proffer a Massachusetts origin.

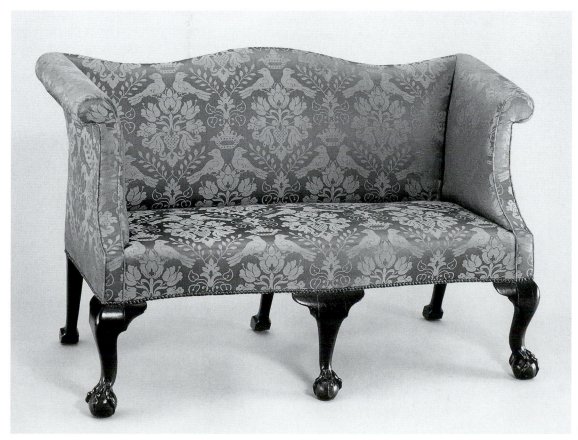

F100

PROVENANCE: Mrs. John H. Harwood, Brookline, Massachusetts, by 1945; purchased by Miss Hogg from Israel Sack, New York, 1950.

TECHNICAL NOTES: Mahogany; mahogany (corner braces), white oak (front seat rail), red oak (side and rear seat rails), spruce (left side back rail, medial back brace, and crest rail). The center rear leg is a replacement.

RELATED EXAMPLES: *Antiques* 74 (July 1958), p. 4.

REFERENCES: *Antiques* 48 (November 1945), p. 273; Warren 1975, p. 53, no. 95; Sack 1993, p. 248.

1. Bailey 1736. Fully upholstered American sofas are first known in the Late Baroque (Downs 1952, no. 269; Hummel 1970–71, part 2, pp. 905, 908; Heckscher 1985, pp. 136–37, no. 80). The term *couch* in this period refers to the form that in the twentieth century is usually called a day bed (see cat. no. F18).

F101

Sofa

1750–1801
Philadelphia
Mahogany and secondary woods; 39 x 89¼ x 37¼" (99.1 x 226.7 x 94.6 cm)
B.59.73

This graceful sofa, with its classic lines, corresponds with the heading "Soffas Marlborough Feet" in the 1772 and 1786

Philadelphia price lists.[1] The Bayou Bend example exhibits the added refinements of "bases" terminating the feet and a serpentine front seat rail mirroring the contour of the back.[2] The price lists specify other options such as brackets, carved fretwork, and moldings, although only one known example corresponds to this description.[3] In addition, they record "Soffas with crooked Legs" and "Settees," the former uncommon, the latter exceedingly rare in Philadelphia. An explanation for its paucity may be inferred from these lists, as the settee is the more costly form.[4]

PROVENANCE: Purchased by Miss Hogg from David Stockwell, Wilmington, Delaware, 1959, who noted it was from the Harrison Wood family.

TECHNICAL NOTES: Mahogany; red oak (seat rails), yellow-poplar (seat braces), southern yellow pine (arm supports), white oak (tacking bar), eastern white pine (medial back stile, crest rail). The central leg is not continuous and is tenoned to the seat rail. The back frame is upholstered as a separate unit, leaving visible the top extensions of the rear legs. The present upholstery corresponds to Thomas Chippendale's recommendation: "When made large, they have a Bolster and Pillow at each End, and Cushions at the Back, which may be laid down occasionally, and form a Mattrass."[5] The original tacking pattern is reproduced. Inscribed on the crest rail, possibly contemporary with the sofa's manufacture: "1st 1 month 1801."

RELATED EXAMPLES: Institutional examples include Downs 1952, no. 274; Campbell 1975, p. 14; PMA 1976, pp. 109–10, no. 88; Heckscher 1985, pp. 142–43, no. 84; and another notable for its original moreen back panel, in Conger 1991, pp. 154–55, no. 69.

REFERENCES: Warren 1975, p. 53, no. 96.

1. Weil 1979, p. 184; Fitzgerald 1982, p. 291.
2. Neither the 1772 nor 1786 price list mentions the serpentine seat rail; however, it appears in Thomas Affleck's 1770 bill in the Cadwalader accounts, "Mahogany Commode Sophias for the Recesses. . . ." (Wainwright 1964, p. 44).
3. Heckscher and Bowman 1992, p. 211, no. 150.
4. Weil 1979, pp. 184–85.
5. Chippendale 1966, p. 4.

F102

Fire Screen

1750–1800
Philadelphia
Mahogany and black walnut; 59½ x 22⅛ x 19½"
(151.1 x 56.2 x 49.5 cm)
B.56.5

The fire screen was introduced during the Rococo period. The London cabinet-maker Thomas Sheraton explained its use as "to shelter the face or legs from the fire," to retain heat and block drafts.[1] His contemporary George Hepplewhite recommended that "screens may be ornamented variously, with maps, Chinese figures, needle-work, etc.," the latter providing a highly visible display for the lady of the household's stitchery.[2] The Philadelphia cabinetmaker's price lists specify a fire screen similar to this example, with claw feet, "Leaves on the knees," and "fluting the Pillars" for exactly the same charge as a folding stand with carved feet, leaves, and a plain top.[3]

PROVENANCE: Purchased by Miss Hogg from Ginsburg and Levy, New York, 1956.

TECHNICAL NOTES: Mahogany (base), walnut (pole). The legs are dovetailed into the column and secured with a Y-shaped iron. The pole and frame are replacements. The needle-work probably dates from the late nineteenth or early twentieth century.

RELATED EXAMPLES: *Antiques* 83 (February 1963), inside front cover.

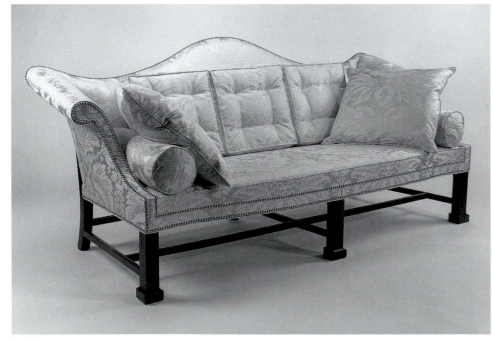

F101

REFERENCES: Warren 1975, p. 55, no. 102; Clabburn 1976, p. 208.

1. Sheraton 1970b, vol. 2, p. 302.
2. Hepplewhite 1969, p. 17.
3. Weil 1979, p. 190.

F103

Stand

1750–1800
Connecticut, New York State, or Pennsylvania
Black cherry; top up: 37¼"; top down: 26½";
diam.: 20¼" (94.6 x 67.3 x 51.4 cm)
B.58.144

Tripod tables with turned supports were fashioned with tops in a variety of diameters for various purposes. Even the smallest examples could function as a side table, a candlestand, a game table, a writing table, a tea table, or even, for intimate collations, dining table. Its top was either fixed or hinged. If the latter, when not in

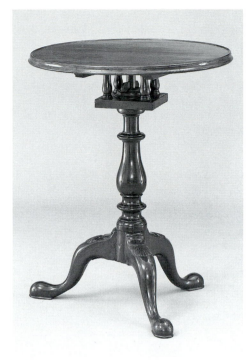

F103

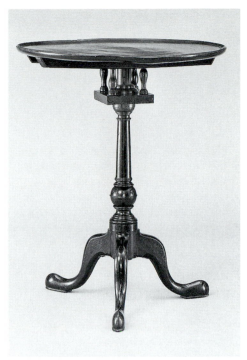

F104

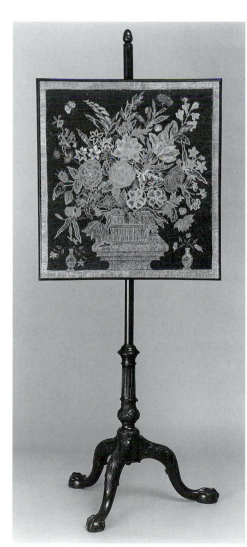

F102

use it could be turned upright, removed from the center of the room, and stored against the wall. For an additional charge a new device that permitted the top to rotate, called a box (now known as a birdcage), was added. The baluster-shaped pedestal and presence of cherry suggest a regional origin for this stand.

PROVENANCE: Purchased by Miss Hogg from Ginsburg and Levy, New York, 1958.

TECHNICAL NOTES: The legs are dovetailed into the column and secured with a Y-shaped iron. The cleats have a shaped contour and the ends are cut at an angle. The top is hinged to the box; its integral rim is unusual. The period hardware was retained.

RELATED EXAMPLES: *Antiques* 33 (May 1938), p. 238; Kirk 1967, p. 97, no. 168; Sack 1969–92, vol. 7, p. 2035, no. P5379; Hagler 1976, p. 47; Ward and Hosley 1985, pp. 224–26, no. 105; Barquist, Garrett, and Ward 1992, pp. 233–35, no. 123; *Antiques* 152 (November 1997), p. 582.

REFERENCES: Warren 1975, p. 54, no. 99.

F104

Stand

1740–1800
Philadelphia
Mahogany; top up: 38⅝"; top down: 27⅛";
diam.: 21⅝"(98.1 x 68.9 x 54.9 cm)
B.69.63

The Philadelphia price lists describe tables with tops twenty-two inches in diameter as "folding Stands." Typically they incorporated a box, plain feet, and top, as exemplified by the Bayou Bend stand. The cabinetmakers price lists register a number of options for a relatively simple object: a choice of mahogany or black walnut, with a folding or fixed top, plain or claw feet, the consummate example complete with carved knees and a fluted pillar.[1] The form's versatility accounts for its widespread popularity and may have prompted the mass production of standardized components.[2]

PROVENANCE: Purchased by Miss Hogg from Ginsburg and Levy, New York, 1954.

TECHNICAL NOTES: The legs are dovetailed into the column and secured with a Y-shaped iron. Two of the box's four balusters are inverted and may have been installed that way since they show no signs of having been disassembled. The top is scored with a center point lining up with the box. The hardware is original. The iron bracket is marked in chalk 27179.

RELATED EXAMPLES: Garrett 1976, p. 755; Bishop and Coblentz 1982, p. 78; Heckscher 1985, pp. 191–92, no. 120; Monkhouse and Michie 1986, p. 135, no. 73; Venable 1989, p. 47, no. 21; Barquist, Garrett, and Ward 1992, pp. 242–47, nos. 129–32.

1. Weil 1979, p. 187.
2. This concept is advanced in Heckscher 1985,

p. 192. When Philadelphia cabinet and chairmaker William Robinson disbanded his business he advertised, "The shop is well assorted for a beginner, consisting of mahogany and walnut plank, inch and Half-inch ditto, banisters and back-feet, rule-joint stuff, half inch poplar, with sundry other sorts of wood suitable to the business" (Prime 1969, vol. 1, p. 180). Another advertisement placed by the joiner Samuel Williams offers "mahogany and walnut tea table columns" (Prime 1969, vol. 1, pp. 185–86). This arrangement ensured quality and an efficient, cost-effective production.

F105

Stand

1750–1810
Chester County, Pennsylvania
Black walnut; top up: 33⅜"; top down: 23⅞";
diam.: 16¾" (84.8 x 60.6 x 42.5 cm)
B.61.79

Chester County's close proximity to Philadelphia is manifested in its decorative arts, in this instance the flattened ball and columnar-shaped turnings. This stand exemplifies a distinct regional character, most notably in the configuration of the box, or birdcage, as the Chester County craftsman developed a circular device that is more cohesive to the overall design than the square Philadelphia box.

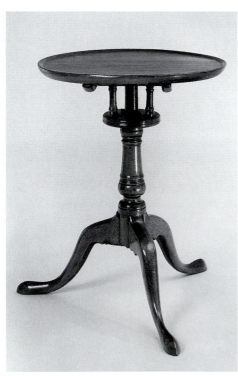

F105

PROVENANCE: Purchased by Miss Hogg from David Stockwell, Wilmington, Delaware, 1962, who noted its descent in the Price family of Chester County, Pennsylvania.

TECHNICAL NOTES: The legs are dovetailed into the column and secured with a Y-shaped iron. The box never incorporated a collar and is secured with a wooden pin; its columns are concave. Beneath the top is branded M.B., perhaps for Moses Brown, a turner (Schiffer 1978, p. 41). No other furniture with this brand has yet been recorded.

RELATED EXAMPLES: Fales 1976, p. 156, no. 327; *Antiques* 144 (September 1993), p. 270; unpublished examples are in the collections of the Chester County Historical Society, West Chester, Pennsylvania, and Winterthur (acc. no. 58.66).

REFERENCES: Warren 1975, p. 55, no. 101.

F106

Tea Table

1750–1800
Philadelphia
Mahogany; top up: 41⅛6"; top down: 28⅞";
diam.: 23⅝" (105.3 x 73.3 x 60 cm)
B.69.360

This table varies discreetly from the previous examples, with claw feet substituted for the plain ones and its top slightly greater in diameter. According to the Philadelphia price lists these additions increased the cost of the simpler table by approximately 21 percent. While the lists do not specify the tea table top's dimensions, they define that a folding stand's diameter was no more than twenty-two inches, implying that anything larger was a tea table.

PROVENANCE: Purchased by Miss Hogg from John S. Walton, New York, 1954.

TECHNICAL NOTES: The legs are dovetailed into the column and secured with a Y-shaped iron.

RELATED EXAMPLES: Downs 1952, no. 280; Comstock 1962, no. 234; Elder and Stokes 1987, pp. 167–68, no. 127; Venable 1989, p. 48, no. 22; Conger 1991, p. 107, no. 27; and a labeled tea table by Philadelphia cabinetmaker Edward James (Sack 1969–92, vol. 1, p. 200, no. 507).

REFERENCES: Warren 1975, p. 55, no. 100.

F107

Tea Table

1750–1800
Philadelphia
Mahogany; top up: 48¾"; top down: 29";
diam.: 34½" (123.8 x 73.7 x 87.6 cm)
B.69.35

Tea and dining tables are the largest of all tripod-based forms. In Philadelphia two types of supports evolved: a leaf-carved urn shape (see cat. no. F102) and the compressed ball, both surmounted by columnar shafts. The price lists record a medley of options, this table representing the most fully developed version, with claw feet and carved knees. Its top, almost three feet in diameter, is fashioned from a single board of dramatically figured crotch mahogany and framed by a rim composed of twelve segments rather than the usual eight.

PROVENANCE: Probably purchased by Miss Hogg from Collings and Collings, New York.

TECHNICAL NOTES: The legs are dovetailed into the column and secured with a Y-shaped iron.

RELATED EXAMPLES: Tables with tops composed of twelve segments are in *Antiques* 17 (January 1930), p. 65; *Antiques* 27 (March 1935), p. 81. Institutional examples include Hipkiss 1941, pp. 104–7, nos. 56, 57; Downs 1952, nos. 376–81; PMA 1976, pp. 75–76, no. 57; Heckscher 1985, pp. 193–96, nos. 123, 124; Monkhouse and Michie 1986, pp. 136–37, nos. 74, 75; Conger 1991, pp. 152–53, 171, nos. 68, 84; Barquist, Garrett, and Ward 1992, pp. 235–37, no. 124.

REFERENCES: Warren 1975, p. 56, no. 103.

F108

Tea Table

1750–1800
Charleston
Mahogany; top up: 43⅛6"; top down: 27¾";
diam.: 28" (109.4 x 70.5 x 71.1 cm)
B.61.96

Charleston was the principal southern urban center in the eighteenth century. As its culture and economy were closely tied to Britain through trade and immigration, vast quantities of English-made

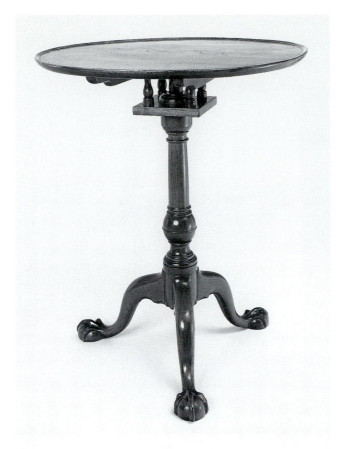

F106

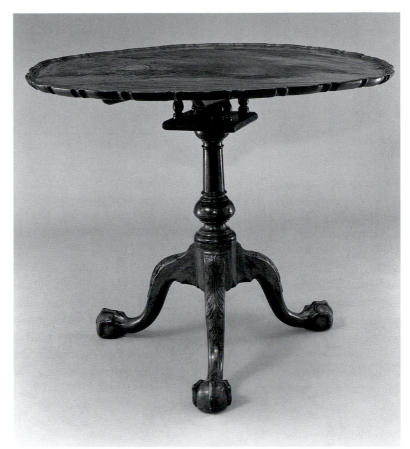

F107

furniture were imported into the city. Concurrently, Charlestonians sustained a sizable cabinet trade comprised of journeymen, apprentices, and slave labor. The Bayou Bend tea table exemplifies the quality of craftsmanship available, and the pervasive English influence in its undercut scrolls.

PROVENANCE: Purchased by Miss Hogg from Ginsburg and Levy, New York, 1961.

TECHNICAL NOTES: The legs are dovetailed into the column and secured with a Y-shaped iron. The scalloped rim is applied rather than carved from the solid top; it was probably altered. The cleats appear reduced. The legs are dovetailed into the column but not secured with a bracket.

RELATED EXAMPLES: Most closely related is another Charleston table (*Rhode Island History* 31, nos. 2–3 [May–August 1972], inside front cover). A table with a similar baluster support is illustrated in Burton 1955, fig. 130.

REFERENCES: *Antiques* 91 (January 1967), p. 107; Warren 1975, p. 56, no. 104.

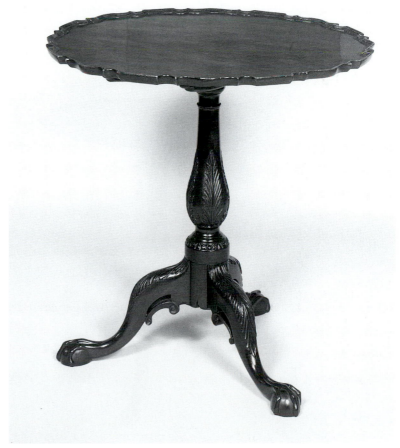

F108

F109

Tea Table

1750–1800
Eastern Massachusetts
Mahogany and secondary wood; 27 x 23½"
(diam.) (68.6 x 59.7 cm)
B.59.33

The Massachusetts tea table was available
with a choice of round, square, serpen-
tine, or scalloped tops. Of these the latter
was the most costly, as well as unusual.
The Bayou Bend table is clearly influenced
by English examples; in fact, were it not
for its stationary top and block made
from native maple, it could be mistaken
for an English table. American tripod ta-
bles with spiral carved urns were produced
in both Newport and eastern Massachu-
setts. The sinuous carved feet on this ex-
ample suggests an attribution to the latter.

PROVENANCE: Purchased by Miss Hogg from
Teina Baumstone, New York, 1959.

TECHNICAL NOTES: Mahogany; hard maple
(block above the pillar). The legs are dove-
tailed into the column and secured with a Y-
shaped iron. The hinged top is attached to a
solid block.

RELATED EXAMPLES: Nutting 1962, no. 1121;
others include Comstock 1954, p. 57; Sack
1969–92, vol. 5, p. 1317, no. P4352; *Antiques* 123

(February 1983), p. 272; Sack 1969–92, vol. 8,
p. 2159, no. P2274.

REFERENCES: *Antiques* 75 (January 1959),
p. 49; Warren 1975, p. 54, no. 97.

F110

Stand

1785–1810
Eastern Massachusetts
Mahogany and secondary wood; 28¼ x 17½ x
17⅝" (71.8 x 44.5 x 44.8 cm)
B.69.214

This diminutive stand with its claw feet,
urn-shaped support, and serpentine
molded top well represents this classic
Massachusetts form. In the period it was
used for a multiplicity of purposes, in-
cluding writing, tea and dining, or as a
candlestand.

PROVENANCE: Purchased by Miss Hogg from
Teina Baumstone, New York, 1954.

TECHNICAL NOTES: Mahogany; soft maple
(top support). The construction follows that
for cat. no. F106. The top is stationary.

RELATED EXAMPLES: Similar stands with pad
feet and tilt tops include Randall 1965, pp.
141–43, no. 106; Jobe and Kaye 1984, pp. 304–5,
no. 76; Elder and Stokes 1987, p. 167, no. 126;
Sack 1969–92, vol. 2, p. 491, no. 1193. Stands

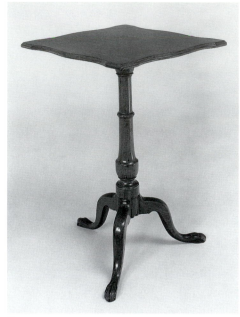

F110

with fixed tops are published in Greenlaw
1974, pp. 34–35, no. 23; *Antiques* 117 (January
1980), p. 4; Rodriguez Roque 1984, pp. 354–55,
368–69, nos. 167, 174.

F111

Tea Table

1750–1800
Rhode Island
Mahogany and secondary wood; 26⅛ x 33⅜ x
20¼" (66.4 x 84.8 x 51.4 cm)
B.58.108

In contrast to Philadelphia, Rhode Island
square tea tables continued to be produced
concurrently with Rococo style round
ones. The Bayou Bend tea table, with
its severe lines and minimal ornament,
is emblematic of the Rhode Island aes-
thetic. Its undercut talons, inspired by
English work, represent a finesse of carv-
ing that in America is virtually unique to
Newport.[1]

PROVENANCE: Lucy A. Weeden (1848–1937)
and Elizabeth C. Weeden Barber (1852–1936);
to May B. Henne; [Nathan Liverant, Colches-
ter, Connecticut]; purchased by Miss Hogg
from Israel Sack, New York, 1958. Possibly
made for Daniel Weeden, Jamestown, Rhode
Island; to his son John; to his son William Au-
gustus Weeden (1793–1864); to his son George W.
Weeden (1822–1893); to his daughters Lucy
and Elizabeth.

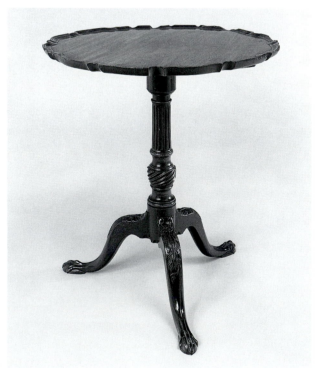

F109

TECHNICAL NOTES: Mahogany; chestnut (brace beneath the top). A medial brace spans the width of the top. The knee brackets are replacements. Underneath the top is a paper label that reads: "To May B Henne From Lucy A. Weeden and Elizabeth C Barber."

RELATED EXAMPLES: Most closely related is Monkhouse and Michie 1986, pp. 133–34, no. 71. Similar are a slab table in Ott 1965, pp. 32–33, no. 30 and a tea table in *Antiques* 136 (October 1989), p. 674.

REFERENCES: Comstock 1962, no. 392; Warren 1975, p. 56, no. 105; Moses and Moses 1982, pp. 1139–41; *Bulletin of Rhode Island School of Design* 69, no. 2 (October 1982), p. 13; Moses 1984, p. 154.

1. The exceptions being Salem, Massachusetts, furniture (*Antiques* 61 [May 1952], p. 379; Sotheby's, New York, sale 5376, October 26, 1985, lot 92).

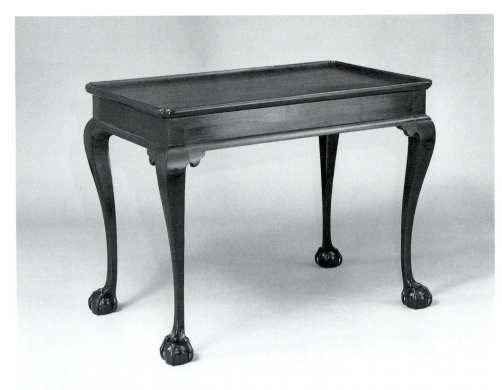

F111

F112

Tea Table

1755–90
Newport
Mahogany; 26⅞ x 33¾ x 20½" (68.3 x 85.7 x 52.1 cm)
B.57.1

The subtle undulating movement that animates the lines of this splendid tea table fully embraces a Late Baroque aesthetic. This contour and the distinctive block-and-shell facade comprise two of the outstanding achievements of eighteenth-century American design. The Bayou Bend table also exemplifies many of the characteristics that distinguish Newport's furniture from that of other colonial centers, including carefully delineated ball-and-claw feet, angular cabriole legs, and stylized carving. The cyma-sculpted sides, their shape echoed in the molded tops, constitute the most memorable feature of the finest tea tables.[1]

A related tea table by John Goddard (1723/24–1785), documented in 1763, together with a card table signed by John Townsend (1732/33–1809) a year earlier, suggests a time frame for related furniture but does not accurately reflect the period when this furniture was

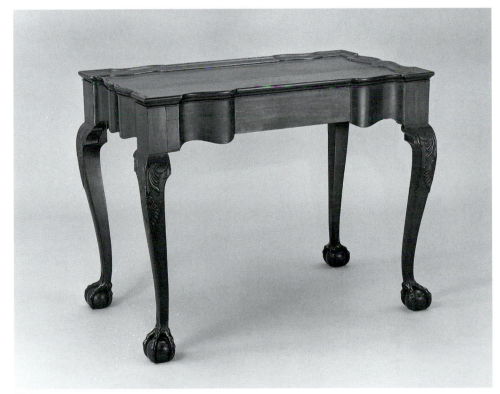

F112

produced.[2] It is tempting to ascribe the Bayou Bend table to Goddard's shop, but differences in construction—along with the fact that similar carving on a high chest signed by Newport cabinetmaker Benjamin Baker (d. 1822)—brings into question the validity of such an attribution.[3]

PROVENANCE: Purchased by Miss Hogg from Elizabeth Hope (Mrs. Alexander Winsor), Weston, Massachusetts, 1957, through Charles L. Bybee. The Winsors proposed that the table was made for Captain Benjamin Ives (d. 1763) and Elizabeth Hale Ives (1725–1767) and descended to their son Robert Hale Ives (1744–1773). This history is debatable since the Ives resided in Massachusetts and probably

would not have ordered furniture from Rhode Island. Perhaps it came into the family through Robert's son Thomas Poynton Ives (1769–1835), a successful Providence merchant, to his sister Elizabeth Ives (Mrs. Thomas Bancroft, 1767–1801). Another possibility is through Elizabeth's orphaned son, Thomas Poynton Bancroft (1799–1852), who was raised by his uncle Thomas in Providence. From Thomas Poynton Bancroft to his son Robert Hale Bancroft (1843–1918), Mrs. Winsor's father.[4]

TECHNICAL NOTES: No secondary woods remain. Some knee brackets are replacements. A discrete bead is channeled into the sides just below the top. The molded rim is integral with the top, which is screwed to the sides. Labels are numbered 37.1932, and F132.

RELATED EXAMPLES: Downs 1952, nos. 372, 373; Carpenter 1954, p. 105, no. 77; Levy Gallery 1988a, p. 24, no. 16. The last, which is most like the Bayou Bend example, has legs that form the skirt corners rather than being concealed. Another example is attributed to John Townsend (Flanigan 1986, pp. 40–41, no. 12).

REFERENCES: Comstock 1962, no. 394; Warren 1975, p. 57, no. 106; Warren 1982, pp. 233, 236; Moses and Moses 1982, pp. 1139; Moses 1984, p. 223.

1. This same undulating contour appears on the three drawer fronts within the bookcase of Bayou Bend's Newport desk (cat. no. F123).
2. Cooper 1980, p. 27, no. 24; Moses 1984, pp. 196–97, p. 204.
3. Moses 1984, p. 194.
4. Cooke 1889, pp. 93, 339–52.

F113

Card Table

1755–90
Newport
Mahogany and secondary woods; open: 27⅝ x 34¼ x 34" (70.2 x 87 x 86.4 cm); closed: 28⅜ x 34¼ x 18⅛" (72.1 x 87 x 46 cm)
B.69.88

Newport card tables exhibit a variety of contoured fronts and tops, including half-round shape ends, rounded ends, cyma-curved with blocked ends, blocked centers, and ends with blocked corners and a straight front.[1] The Bayou Bend table, representing the latter configuration, in all probability was modeled after tables produced in Boston or New York, where this shape was more prevalent. The juxta-

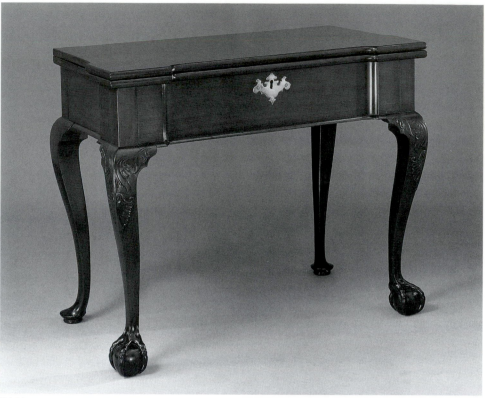

F113

position of claw and pad feet is characteristic of Newport, as well as New York and England, and presumably indicates a conscious choice to control costs.

PROVENANCE: Purchased by Miss Hogg from Ginsburg and Levy, New York, 1953.

TECHNICAL NOTES: Mahogany; soft maple (rails); eastern white pine (bottom); redcedar (interior dividers). The talons are undercut. Typical for Newport card tables, both rear legs pivot outward to support the hinged top. The fly legs are not the full height of the skirt and are fitted around outer rear rails. The two hinges are composed of five segments. Once opened the top reveals a plain playing surface. Both leaves of the lower tops are hinged, concealing a well with two partitions. Inside the well is the chalk number 25689.

RELATED EXAMPLES: Carpenter 1954, p. 93, no. 65; Nutting 1962, nos. 792–96; *Antiques* 102 (August 1972), p. 188; *Antiques* 121 (May 1982), p. 1226; Moses 1984, p. 120; Sotheby's, New York, sale 6763, October 22, 1995, lot 270; Sotheby's, New York, sale 6899, October 19, 1996, lot 242.

REFERENCES: *Antiques* 64 (July 1953), p. 11; Carpenter 1954, p. 91, no. 63; Comstock 1962, no. 365; Warren 1975, p. 57, no. 107; Moses and Moses 1982, p. 1138; Moses 1984, p. 231.

1. Examples are pictured in Moses 1984, pp. 45, 78, 109, 151–53, 228, 230, 245.

F114

Card Table

1763–75
Attributed to the shop of Marinus Willett (1740–1830) and Jonathan Pearsee (act. ca. 1763–75), New York[1]
Mahogany and secondary woods; open: 26¾ x 34¾ x 33¾" (67.9 x 88.3 x 85.7 cm); closed: 27⅝ x 34¾ x 17½" (70.2 x 88.3 x 44.5 cm)
B.69.24

Serpentine-front card tables are the most original and dynamic Rococo furniture forms produced in New York. The design, which appears to have originated there, is characterized by its serpentine facade and the addition of a fifth leg that pivots outward to support the opened top.[2] The knees are ornamented with either a carved leaf or C-scroll design, and the front rail with gadrooning or foliate carving. Typically, the top is cut out for a baize liner, coins and counters, and to accommodate a candlestick at each corner.[3] More than seventy-five examples are recorded, representing several distinct shop traditions; the only one identified is that of Marinus Willett and Jonathan Pearsee, to which the Bayou Bend table is attributed.[4]

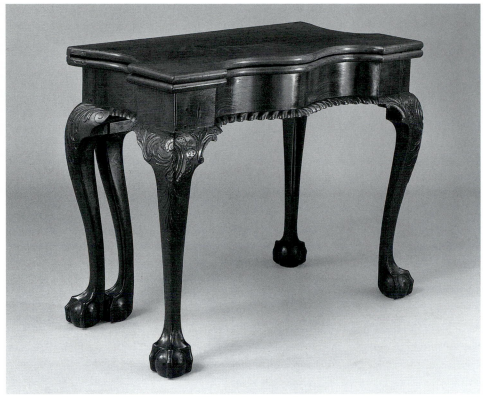

F114

PROVENANCE: Louis Guerineau Myers (1874–1932), New York; auctioned by the American Art Association, 1921; purchased by Miss Hogg from Joe Kindig, Jr., York, Pennsylvania, 1949.

TECHNICAL NOTES: Mahogany; eastern white pine (drawer runners), red gum (fixed rail), white oak (hinged rail). The pin is metal.

The fly leaf is attached with a five-part hinge. The interior rail is cut out to accommodate a drawer, now missing. The top is secured with screws. Its inset hinges are stamped "H:TIBATS," probably for Hugh Tibbats, a Wolverhampton, England, hinge maker.[5] Stamped beneath the gadrooning appears to be "[—]4405." The cover is reproduction baize.

RELATED EXAMPLES: Morrison Heckscher's initial study (Heckscher 1973) classifies the Bayou Bend table as Type I, the Van Rensselaer, Group B. Nine other tables are recorded: Monkhouse and Michie 1986, p. 139, no. 77; Barquist, Garrett, and Ward 1992, pp. 46, 167–69, no. 74; Levy 1993, pp. 760–61; one belonging to the Nelson-Atkins Museum of Art, Kansas City, Missouri (acc. no. 44–12); the remainder in private collections, one with the chalk signature "Willet."[6]

REFERENCES: The American Art Association, New York, February 24–26, 1921, lot 672; Heckscher 1973, p. 983; Warren 1975, p. 58, no. 109; Greenlaw 1978b, p. 15; Barquist, Garrett, and Ward 1992, p. 169; Levy 1993, pp. 756, 758, 761.

1. A portrait of Willett in his Revolutionary War uniform was painted by Ralph Earl (Kornhauser 1991, pp. 176–77, no. 39).
2. Previously it was thought that the New York card table was based on an English example; however, those cited are now regarded as nineteenth-century (Gilbert 1978, vol. 2, pp. 316–17, no. 391; Christie's East, New York, sale 6885, October 10, 1989, lot 296).
3. Included among William Hamilton's possessions to be auctioned were "Three pair of plated tea or card table candlesticks" (Prime 1969, vol. 1, p. 193).
4. Levy 1993.
5. Ibid, p. 761.
6. Ibid, p. 756.

F115

Card Table

1760–1800
Philadelphia
Mahogany and secondary woods; open: 29¼ x 36¾ x 36" (74.3 x 93.3 x 91.4 cm); closed: 30⅛ x 36¾ x 18¾" (76.5 x 93.3 x 47.6 cm)
B.69.19

This superb table exemplifies a type introduced during the Late Baroque period that persisted into the Rococo. Both the 1772 and 1786 Philadelphia price lists record "Card tables With Round Corners" as one of three models available. The simplest rendition, with "Claw feet & plain knees," was £5, as compared to tables with Marlborough feet or crooked legs listed at £3 and £3.10.0, respectively. "Leaves on knees & carved molding" increased the price another three pounds, while the addition of "Carved Rales" raised it two more, for a total of £10,

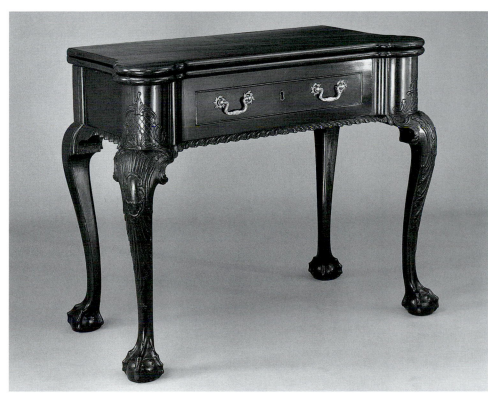

F115

making it the most expensive table one could order.[1]

PROVENANCE: By tradition George Ross (1730–1779), Philadelphia; to his son George (1752–1832); to his daughter Eliza (Mrs. Abraham Carpenter, 1797–1871); to her daughter Caroline (Mrs. David G. Eshleman, 1828–1906); to her grandson, John H. MacMurdy; [Albert Duveen, New York, 1943]; purchased by Miss Hogg from Ginsburg and Levy, New York, 1952.

TECHNICAL NOTES: Mahogany; hickory (hinge pin), Atlantic white cedar. The fly leg is attached to a five-part hinge. The round corners are screwed to the sides. The top's method of attachment is not visible. Opened, it is relieved for candlesticks and a liner. The hardware appears to be second-generation. The inside rail is inscribed "D. G. Eshelman" (see Provenance). The table is branded HK, possibly for Henry Kepple.[2] An intriguing document in the Lancaster, Pennsylvania, land records cites a 1774 deed between Kepple and George Ross, Jr.[3]

RELATED EXAMPLES: Downs 1952, no. 343; *Antiques* 94 (September 1968), p. 302; Hummel 1976, pp. 108, 113–14; Cooper 1980, p. 192; Burke 1981, pp. 114–15; Flanigan 1986, pp. 44–45; Conger 1991, p. 166–67, no. 80; Sotheby's, New York, sale 6132, January 30–February 2, 1991, lot 1459, now at Chipstone, and one at the PMA (acc. no. 67-69-1). The Bayou Bend table's carving relates to that on a slab table illustrated in Downs 1952, no. 359.

REFERENCES: *Antiques* 60 (November 1951), p. 361; Comstock 1962, no. 369; Warren 1966, p. 797; Warren 1975, p. 58, no. 110; Greenlaw 1978b, p. 15; Freund 1993, p. 35.

1. The 1786 price list indicates only these card tables, tea kettle stands, commode dressing tables, china tables, dumbwaiters, and bedsteads as available in mahogany (Fitzgerald 1982, pp. 292–95).
2. A Philadelphia side chair is also recorded with this brand (*Antiques* 103 [January 1973], p. 17).
3. Fulton and Mylin 1973.

F116

Card Table

1755–1800
Philadelphia
Mahogany and secondary woods; open: 27⅜ x 35¼ x 34½" (69.5 x 89.5 x 87.6 cm); closed: 28¼ x 35¼ x 17¼" (71.8 x 89.5 x 43.8 cm)
B.70.23

The name "Marlborough" as a furniture term is unique to eighteenth-century America, although its exact relationship to this type of leg is not clear.[1] According to the Philadelphia price lists, card tables with Marlborough supports were the least expensive of the three models available. They could be either plain, molded, or, like the present example, ornamented with fretwork carving. The most expensive, incorporating bases, brackets, carved moldings, and a drawer, was priced at four pounds, or 80 percent of what the basic card table with round corners cost (see cat. no. F115).[2] The Bayou Bend table is among the most fully developed examples of this type, incorporating both Chinese and Gothic designs into its fretwork.

PROVENANCE: Professor Samuel Claggett Chew (1888–1960); purchased by Miss Hogg from Ginsburg and Levy, New York, 1970. A purely conjectural history begins with Samuel Lloyd Chew (1737–1790); to his son John Hamilton Chew (1771–1830); to his son Dr. Samuel Chew (1806–1863); to his son Dr. Samuel Claggett Chew (d. 1915); to his son, Professor Samuel Claggett Chew.[3]

TECHNICAL NOTES: Mahogany; yellow-poplar (fixed rail, vertical drawer guides, medial brace over the drawer, left rear corner block), southern yellow pine (front and right rear corner blocks, bottom supports for the drawer), white oak (hinged rail), hickory (pin). The fly leg and interior rail show the opening for a drawer. A medial brace spans the depth. The vertical, triangular corner blocks are two-part in the front and single in the rear. The top is screwed to the sides and when open reveals a plain playing surface.

RELATED EXAMPLES: Marlborough-legged card tables with fretwork carving include Comstock 1957a, p. 256, no. 9. Similar fretwork appears on Philadelphia cabinetmaker John Folwell's speaker's chair (Hornor 1977, pl. 97). Related chairs are published in Hornor 1977, pl. 260; Monkhouse and Michie 1986, pp. 167–68, no. 109. The Gothic skirt and the gadrooning as well are virtually identical to those defining the seat rail of the great Chew sofa.[4]

REFERENCES: *Antiques* 78 (September 1960), p. 186; *Antiques* 81 (June 1962), p. 575; Aronson 1965, pp. 133, 434, nos. 413, 1269; Warren 1970c; Warren 1975, p. 58, no. 111; Federhen 1994, pp. 300, 304.

1. The term may refer to George Spencer, fourth duke of Marlborough, to whom Ince and Mayhew dedicated their *The Universal System of Household Furniture*.
2. Weil 1979, p. 186; Fitzgerald 1982, pp. 291–92.
3. Jordan 1911, pp. 509–12.
4. Heckscher and Bowman 1992, p. 211, no. 150.

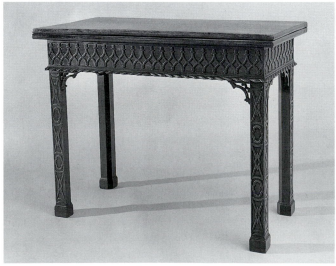

F116

F117

F117

Dining Table

1750–1800
Eastern Massachusetts
*Mahogany and secondary woods; open: 28⅜ x
48 x 47" (72.1 x 121.9 x 119.4 cm); closed: 28⅜ x
48 x 16⅞" (72.1 x 121.9 x 42.9 cm)*
Gift of the estate of Miss Ima Hogg, B.76.163

The dining table continued to undergo
stylistic and functional adaptations during
the Rococo period. The presence of ball-
and-claw feet on this example suggests a
stylistic evolution, yet concurrently these
tables were available with pad feet. The
substitution of a square top with flat
edges for an oval one with rounded edges
introduced greater flexibility. Further-
more, now tables could be ordered in
pairs and placed side by side, doubling the
expanse of surface space.[1] Cabinetmakers
supplied dining tables in different sizes,
according to their customer's require-
ments. The 1772 and 1786 Philadelphia
price lists record the form beginning at
"3 feet in the bed," referring to the width
of the rails, and increasing by six-inch in-
crements. They recommended that tables
five feet in width have six legs; for those
whose width exceeded five feet six inches,
eight were recommended.[2]

PROVENANCE: Unknown.

TECHNICAL NOTES: Mahogany; eastern
white pine (fixed rail); birch (hinged rail),
southern yellow pine (corner blocks), hickory
(hinge pin, visual identification).

RELATED EXAMPLES: Fales 1976, p. 122, no.
252; Jobe and Kaye 1984, pp. 280–81, no. 64;
Heckscher 1985, pp. 179–80, no. 109.

1. Jobe and Kaye 1984, pp. 278–79, no. 63.
2. Weil 1979, p. 185; Fitzgerald 1982, p. 291.

F118

Slab Table

1750–1800
Philadelphia
*Mahogany, secondary woods, and marble;
33 x 49¾ x 26¾" (83.8 x 126.4 x 68.6 cm)*
B.69.67

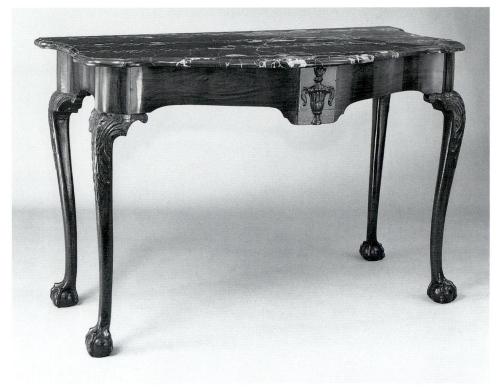

F118

Massachusetts Governor John Endicott's
1665 inventory included "A marble table,
In the Hall," one of the first references to
the slab table. Endicott's table was un-
usual in either England or America at this
time.[1] A group of Massachusetts Early
Baroque slate-topped tables comprise the
earliest surviving examples that relate to
this form.[2] A stone top, or slab, was ide-
ally suited for dining and entertaining,
being less vulnerable to heat or liquid
than wood. The slab table was produced
in Philadelphia by the Late Baroque pe-
riod, but it was not prevalent until the
Rococo.[3] The carved urn ornamenting
the Bayou Bend table's skirt has been in-
terpreted as a Neoclassical prelude, but
more likely it was inspired by a Palladian
element.

PROVENANCE: By tradition Samuel Rowland
Fisher (1745–1834), Philadelphia; to his daugh-
ter Deborah (Mrs. William Wharton,
1795–1888); to her granddaughter Deborah
Wharton Barker (Mrs. Edward Mellor,
1854–1943)[4]; purchased by Miss Hogg from
Ginsburg and Levy, New York, 1951.

TECHNICAL NOTES: Mahogany; southern
yellow pine (medial brace), eastern white pine
(larger corner block component), yellow-
poplar (smaller section of the same block).
The front rails consist of two cyma sections
with a central three-part block composed of
the principal element, an extension, and, over-
laying both, the applied urn. The rounded

corners have transitional elements set in-
between them and the rails. Each corner is
secured with a two-part block. A medial brace
is dovetailed into the principal central block
and rear rail. The top is a replacement. Luke
Beckerdite has assigned the carving to the part-
nership of Bernard and Jugiez.

RELATED EXAMPLES: A privately owned side
chair, said to have descended in the Fisher
family, has an urn carved on its crest rail remi-
niscent of the one on the table's skirt.

REFERENCES: *Antiques* 58 (October 1950),
p. 241; Comstock 1962, no. 390; Warren 1975,
p. 59, no. 113; Hornor 1977, p. 137, pl. 205.

1. Lyon 1925, p. 206.
2. Swan 1953, p. 40.
3. Hornor 1977, p. 19. Early Philadelphia tables
 include Swan 1953, p. 41; and Christie's, New
 York, sale 7526, October 24, 1992, no. 138.
4. Smith 1896, pp. 46–48, 66–68, 106, 155;
 Carpenter and Carpenter 1912, pp. 222, 234.

F119

Slab Table

1760–1800
Philadelphia
*Mahogany, secondary woods, and marble;
29½ x 49⅞ x 22½" (74.9 x 126.7 x 57.2 cm)*
B.59.82

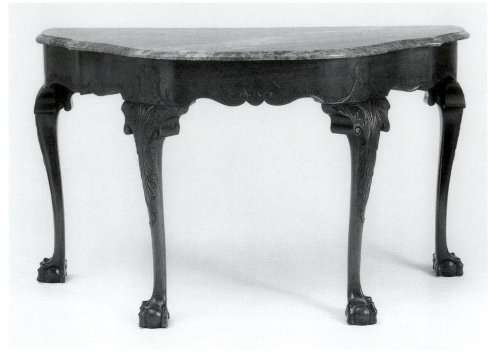

F119

The 1772 Philadelphia cabinetmakers' price book lists "frame for Marble Slab," specifying that the basic model was four feet in length, to which could be added a range of options, primarily for the table supports. One could select Marlborough or cabriole legs, the latter, with "Claw feet," "Leaves on the kness," and "Carved Moldings," a description reminiscent of the Bayou Bend table, being the most costly. While the price book records the basic form in either mahogany or walnut, all of the available options are specified only in mahogany, further asserting the slab table's prominence as well as expense.[1]

The marble tops for many of these tables were quarried outside Philadelphia at King of Prussia. In 1748 Peter Kalm visited the site and commented that it "is very good for working, though it is not one of the finest kinds of marble. People make tombstones and tables, enchase (encase) chimneys and doors and lay floors and flags in front of fireplaces, of this kind of marble. A quantity of this commodity is shipped to different parts of America."[2] An approximate value for the marble can be inferred from John Cadwalader's accounts when he was remodeling his Philadelphia residence. David and William Chambers, marble masons, billed him twelve shillings per foot of new marble.[3] Applying that formula, a top corresponding to the dimensions of the Bayou Bend table would cost approximately five

pounds, exactly the same amount as the finest mahogany frame specified on the price list.

This extraordinary table, together with its mate in the Pendleton Collection, Rhode Island School of Design, Providence, must have made an impressive ensemble in eighteenth-century Philadelphia. They were probably commissioned for a principal parlor, or perhaps adjoining rooms, where their placement produced a mirrored symmetry. Although neither provenance is known prior to the twentieth century, there is no doubt they were conceived as a pair. This is confirmed by the subtle yet complementary variations observed on the two pieces: for example, on the Bayou Bend frame the carved leaves trailing down the legs curl outward, while on the Pendleton table they turn inward. The central ruffles carved on the skirts, while identical in execution, also display a paired orientation, maintaining an asymmetry consistent with Rococo dictates.

PROVENANCE: Hiram Rickert, Yardley, Pennsylvania; purchased by Miss Hogg from Israel Sack, New York, 1959.

TECHNICAL NOTES: Mahogany; southern yellow pine (front skirt), white oak (backboard), yellow-poplar (cross braces). There is an extension where the legs and rails join, but it is significantly smaller than the legs' width. The rails are composed of a two-part vertical lamination. Four large, stabilizing braces are

dovetailed into the front and rear rails (Sack 1969–92, vol. 1, p. 83, no. 257).

RELATED EXAMPLES: Monkhouse and Michie 1986, p. 110, no. 48.

REFERENCES: *Antiques* 60 (November 1951), p. 354; *Antiques* 76 (July 1959), inside front cover; Sack 1969–92, vol. 1, p. 83, no. 257; Comstock 1962, no. 388; Warren 1966, p. 799; Warren 1975, p. 59, no. 114; Agee et al. 1981, p. 77, no. 136; Fairbanks and Bates 1981, p. 166; Heckscher 1985, p. 160; Monkhouse and Michie 1986, p. 110; Sack and Wilk 1986, pp. 178–81; Warren 1988, p. 23.

1. Weil 1979, p. 189.
2. Kalm 1966, vol. 1, p. 46. See also *Antiques* 98 (July 1970), p. 56.
3. Wainwright 1964, p. 27.

F120

Spice Box

1740–1800
Delaware Valley, probably Chester County, Pennsylvania
Black walnut and secondary woods; 28½ x 16¼ x 10¼" (72.4 x 41.3 x 26 cm)
B.65.8

The Pennsylvania spice box, like the Rococo high chest, represents the persistence of one form after it had gone out of fashion elsewhere. Spice boxes are known in England and America as early as the seventeenth century and remained popular through the first quarter of the eighteenth century. In the Delaware Valley,

F120

specifically Philadelphia and Chester County, they continued to be made throughout the 1700s.[1] The Bayou Bend example is compelling for its juxtaposition of Early and Late Baroque as well as Rococo elements.

PROVENANCE: Purchased by Miss Hogg from David Stockwell, Philadelphia, 1948. An accompanying tag states the box was acquired from Ira S. Reed, who obtained it from the Caldwell family of Philadelphia and Gap.

TECHNICAL NOTES: Black walnut; black walnut (drawer sides and backs), chestnut (drawer bottoms), yellow-poplar (bottom, back, hood).

REFERENCES: Warren 1975, p. 37, no. 72.

1. Griffith 1986a, b.

F121

Desk and Bookcase

1745–80
Boston
Mahogany and secondary woods; 98 x 44½ x 22⅞" (248.9 x 113 x 58.1 cm)
B.69.363

Bombé furniture was produced on the European continent as well as in England, with historical precedents for it dating back to ancient Rome. In colonial America

F121 (*detail*)

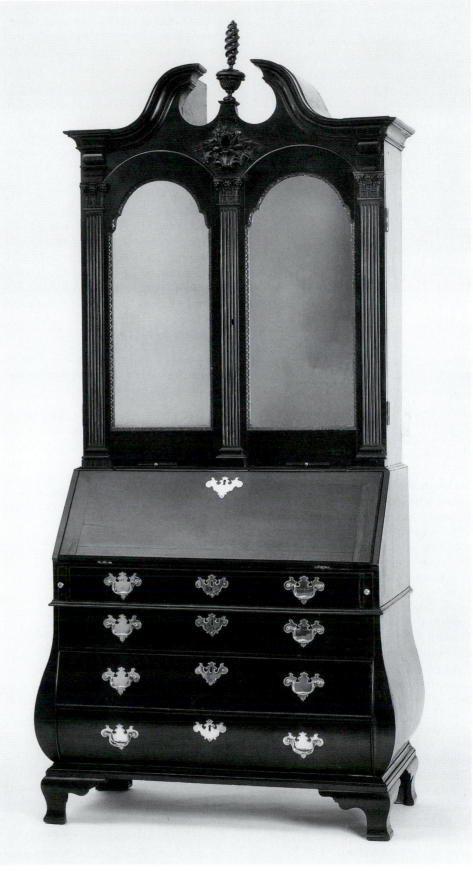

F121

its inspiration was derived from imported English furniture and design books, its production limited to the Boston area and neighboring Essex County.[1] The earliest documented example is not a piece of domestic furniture but the majestic pulpit created in 1749 by Abraham Knowlton (d. ca. 1749) for the First Church of Ipswich.[2] Four years later the Charlestown, Massachusetts, cabinet-

maker Benjamin Frothingham (1734–1809) signed a monumental desk and bookcase, now recognized as the earliest documented piece of bombé furniture.[3] The Bayou Bend desk is closely related in appearance, manifesting the earliest phase of the bombé in America.

PROVENANCE: Purchased by Frederick Beck, Sandwich, at auction, Massachusetts, 1818; purchased by Miss Hogg from Joe Kindig, Jr., York, Pennsylvania, 1948. According to the drawer's inscription the desk was owned by Cornelius Waldo (1684–1753) or James Ivers (1727–1815); to Benjamin Austin, Sr. (1716–1806), or Benjamin Austin, Jr. (1752–?).[4]

TECHNICAL NOTES: Mahogany; mahogany (candle slides, lopers), eastern white pine (foot blocks, bottom board, dustboards, backboards for both sections, board underneath the writing section's compartments and drawers, drawer compartments in both the bookcase and writing sections, pigeonholes' interior framing, top board above the highest row of pigeonholes), yellow-poplar (horizontal glue blocks above the feet, large drawers' side runners, large drawers' bottoms and backs, board laminated to the second drawer, glue blocks beneath the writing surface, and the horizontal brace running across the back of the bookcase's bottom shelf, all probably modern replacements), black cherry (large drawers' replaced sides). Glue blocks that correspond with the base molding extend through cutouts in the rear feet. In the desk section the large drawers are straight-sided, reflecting the earliest phase of construction (Vincent 1974, pp. 169–73, figs. 119, 120). The interiors of the curved sides are roughly hewn. The large drawers' sides, backs, and bottoms are rebuilt. There are full dustboards. The fall board is repaired. The writing interior consists of valance drawers, flanking the portable prospect cabinet composed of an arched door with adjacent pilasters. Inside is a bottom drawer. When the cabinet is removed it reveals three secret drawers, which can be accessed only from the back. The bookcase consists of four drawers across the bottom with five stacked pigeonholes on either side and eleven spanning the top. The center is notched and supports two shelves. The arches are richly carved with shells, leaves, and scrolls. The bonnet is fully enclosed. The finial is a restoration, the collaboration of Miss Hogg and Joe Kindig, Jr. The hardware is appropriate for the period but may not be original. Inscribed on a writing section interior drawer: "this desk was in the possession of [—] Father to the wife of Benjamin Austin Esq. for 30 years and then in the possession of said Austin for a number of years; then bought at Auction April 23. 1818 by Frederick Beck for his school

room, cost twenty-two dollars being then rather ancient and out of fashion." Another interior drawer is signed "Charlotte C." and what appears to be "York." Chalked initials may be BON.

RELATED EXAMPLES: The Bayou Bend desk and bookcase is the only example with bombé construction among a sophisticated group of case pieces attributed to an unidentified Boston cabinet shop, the carving on some attributed to John Welch (1711–1789): Jobe 1991; Miller 1993. Most closely related is the Quincy block-front desk (Miller 1993, pp. 172–74). The Bayou Bend desk and bookcase is also reminiscent of two other desk and bookcases (Morse 1924, pp. 134–36) and to the well-known example by Benjamin Frothingham (Conger 1991, pp. 93–94, no. 13). The discovery of a block-front desk inscribed Boston cabinet-maker by Richard Walker (d. 1777) has associated his name with this body of furniture (Zimmerman and Levy 1995).

REFERENCES: Warren 1975, p. 68, no. 133; Jobe 1991, pp. 415–16; Jobe et al. 1991, pp. 125–26; Miller 1993, pp. 190–91, 193.

1. For bombé furniture's antecedents and American manifestations, see Vincent 1974b.
2. Benes and Zimmerman 1979, pp. 40, 42–44.
3. Conger 1991, pp. 93–94, no. 13.
4. If Cornelius Waldo, it may be the "1 Book Case £40," the second most valuable piece of furniture listed in his inventory (Suffolk County Probate Records, no. 10482).

F122

Desk and Bookcase

1780–1800
Boston
Mahogany and secondary wood; 94⅝ x 40 x 21⅜" (240.3 x 101.6 x 54.3 cm)
B.69.139

Few pieces of American furniture possess the sculptural qualities of this diminutive desk and bookcase. Notable for its bombé sides, the case exhibits an even greater complexity and movement with its serpentine front. This sense of motion is further accentuated by the scalloped mirrors framed within the bookcase doors. Although the desk's scale and construction suggest it was produced toward the end of the century, as the popularity of the Rococo was beginning to diminish, it fully embraces the Late Baroque aesthetic.

It is provocative to think that the desk's original owner, Thomas Dawes, assumed a central role in its design and attentively oversaw its construction. Initially trained as a mason, he eventually became a recognized architect. Dawes was clearly versed with the bombé form, having designed a pulpit in this contour patterned after plate 112 in Batty Langley's *The City and Country Builder's and Workman's Treasury of Designs* for Boston's Brattle Street Church in 1772.[1] His library included other important architectural volumes by James Gibbs, Wiliam Salmon, William Pain, and Colen Campbell, and books of furniture designs by Robert Manwaring. Perhaps these were a source of inspiration for the desk's design, particularly its bombé shape, writing interior, and architectonic bookcase.[2]

PROVENANCE: Thomas Dawes (1731–1809), Boston; to his son Judge Thomas Dawes (1757–1825); to his son Thomas Dawes (b. 1783); to his daughter Sarah Ann (Mrs. Chauncey Parkman Judd, 1827–1919); to her daughter Edith (Mrs. Edward Hall Nichols, 1863–1950); to her son Hall Nichols; [Harry Arons, Ansonia, Connecticut, 1954]; purchased by Miss Hogg from David Stockwell, Philadelphia, 1954.

TECHNICAL NOTES: Mahogany; eastern white pine. The full-length drawers conform to the sides, the typical construction method (Vincent 1974b, pp. 172–73). The backs of the rear feet remain uncarved. On the front and sides braces frame the bottom, extending through the rear legs. The dividers and sides are beaded. The writing interior consists of a central prospect door with a carved shell tablet, flanked by document drawers with columnar fronts. On either side are small serpentine drawers. Inside the prospect door is a small drawer, a large recess, and a suspended drawer with a cyma-shaped cutout. An old photograph confirms that the mirrors, their back panels, the finial, and the hardware are replacements, the latter for Neoclassical oval brasses. The desk section has the chalk notation "T.Dawes" and an illegible date. The surname is also written on the section's backboard. Inscribed in pencil in the bottom drawer is "Oliver No. [—] 178 [—]."

RELATED EXAMPLES: Other bombé desk and bookcases with serpentine fronts include Podmaniczky and Zimmerman 1994; Monkhouse and Michie 1986, pp. 100–101, no. 41. Two desks are recorded in Mussey and Haley 1994, pp. 81–83, 86–87. Five bombé desk and bookcases with pitched pediments are recorded:

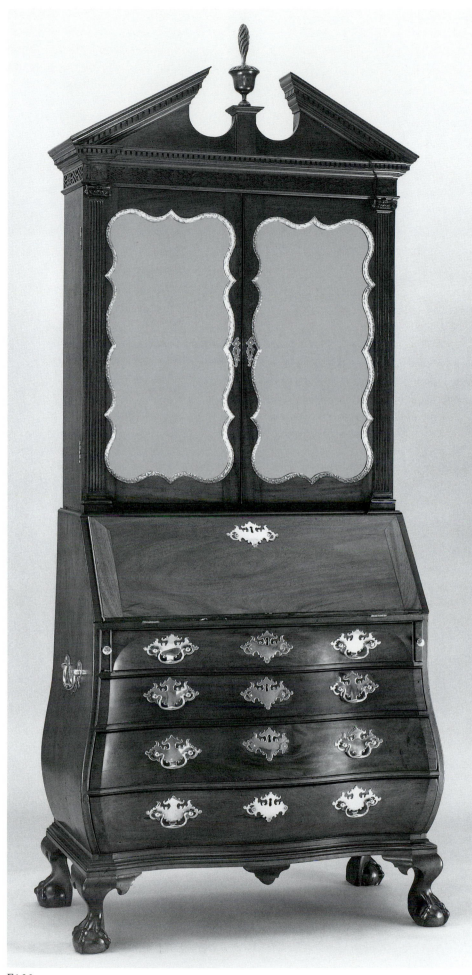

F122

Monkhouse and Michie 1986, pp. 100–101, no. 41; Vincent 1974b, pp. 186, 188–89; Fales 1976, pp. 236–37; one offered by Bernard and S. Dean Levy, New York. The fifth was restored with a pitched pediment, although evidence is inconclusive that this reproduces the original configuration. Its prospect door, pilastered document drawers, and ornamental fretwork on the bookcase are related to the Bayou Bend desk and bookcase (Conger 1991, pp. 168–69, no. 82). A group of serpentine-front bombé case pieces is attributed to John Cogswell's (1738–1819) Boston shop in Mussey and Haley 1994. The authors do not include the Bayou Bend desk and bookcase in this group. Coincidentally, in 1773 Cogswell's younger brother William married Thomas Dawes's sister.[3]

REFERENCES: *Antiques* 66 (October 1954), p. 237; Comstock 1962, no. 329; Warren 1966, p. 800; Warren 1971a, p. 44, no. 13; Warren 1975, p. 68, no. 134; Detwiller 1977, pp. 6–7; Weidman 1984, p. 62, no. 24; Heckscher 1985, p. 267, no. 174; Sack 1989, p. 1183; Mussey and Haley 1994, pp. 73, 101.

1. Benes and Zimmerman 1979, pp. 44–45; Mussey and Haley 1994, pp. 74–77, Park 1973, pp. 5, 33, 38, 51, 54, 55, 58, 61, 67–73; Detwiller 1977, p. 2; Heckscher 1994, pp. 181, 183, 194.
2. The fretwork design appears to be adapted from John Crunden's 1765 *The Joyner and Cabinet-Maker's Darling*, pl. 9 (White 1990, p. 417, pl. 8).
3. Mussey and Haley 1994, p. 101.

F123

Desk and Bookcase

1755–1800
Newport
Mahogany and secondary woods; 99¾ x 44¼ x 26¼" (253.4 x 112.4 x 66.7 cm)
B.69.22

The monumental block-front desk and bookcase is one of Newport's acknowledged masterpieces. Commissioned by entrepreneurial merchants and accomplished attorneys, these impressive objects proclaim their owner's professional achievements and testify to their position within society.

None of the desk and bookcases is dated or identified by its maker; however, two possess tangential associations with the Newport cabinetmaker John Goddard (1723/24–1785).[1] That this group of furniture was produced in more than one shop

is perceptible by comparing its writing interiors' minor variations, such as the presence or lack of rosettes, or an open or closed pediment. The Bayou Bend writing section's distinctive shell-carved drawers, rather than the typical scalloped pattern, are set within relieving arches, while the bookcase harbors a tier of three drawers with cyma-sculptured fronts reminiscent of the great tea and card tables.[2]

PROVENANCE: Purchased in London by Charles F. Montgomery for the Winterthur Museum; [John S. Walton and Israel Sack]; purchased by Miss Hogg from John S. Walton, New York, 1952. Reportedly owned by the London dealer Frank Partridge in the 1930s.

TECHNICAL NOTES: Mahogany; eastern white pine (vertical foot blocks, large drawers' bottoms, top drawer runners, bonnet), soft maple (bottom board), chestnut (front frame of the desk base), redcedar (bookcase drawers' sides and backs, interior writing section), poplar—aspen or cottonwood (drawer sides and backs, board underneath the desk's interior compartments), white oak (middle drawer runners), Spanish cedar or cedrela (three bookcase drawers' bottoms). The writing section incorporates a well to provide direct access to the top drawer. When the desk was purchased for Winterthur the base moldings were carved, molding strips attached to the sides of the writing section, and each of the pediment panels comprised a pair of up-ended shells, their bases abutted. Prior to its being offered for sale, these elements, deemed at the time to be later additions, were altered. A photograph showing the desk before these alterations were made is on file. The hardware is not original.

RELATED EXAMPLES: Bayou Bend's Newport desk and bookcase is one of eleven known examples, including three made for the brothers Nicholas (1729–1791), John (1736–1803), and Joseph (1737–1785) Brown of Providence (Christie's, New York, sale 6844, June 3, 1989, lot 100; Ward 1988, pp. 45, 339–44, no. 177; Ott 1965, pp. 106–7, no. 67). Seemingly related to the Browns' desks is one published in Hipkiss 1941, pp. 30–32, no. 19. The remaining six desk and bookcases, including Bayou Bend's, form a second group: Downs 1952, no. 232; Randall 1965, pp. 84–86, no. 62; Heckscher 1985, pp. 282–84, no. 184; Monkhouse and Michie 1986, pp. 96–99, nos. 39, 40. A privately owned example is referenced in Jobe and Kaye 1984, p. 46. Other Rhode Island desk and bookcases are known with a pair of shells carved on the bookcase doors (Moses 1984, pp. 342–43). Another desk and bookcase, with three shells on the lid, is said to be by Grindal Rawson (1719–1803) of Providence (Ott 1965, pp. 104–5,

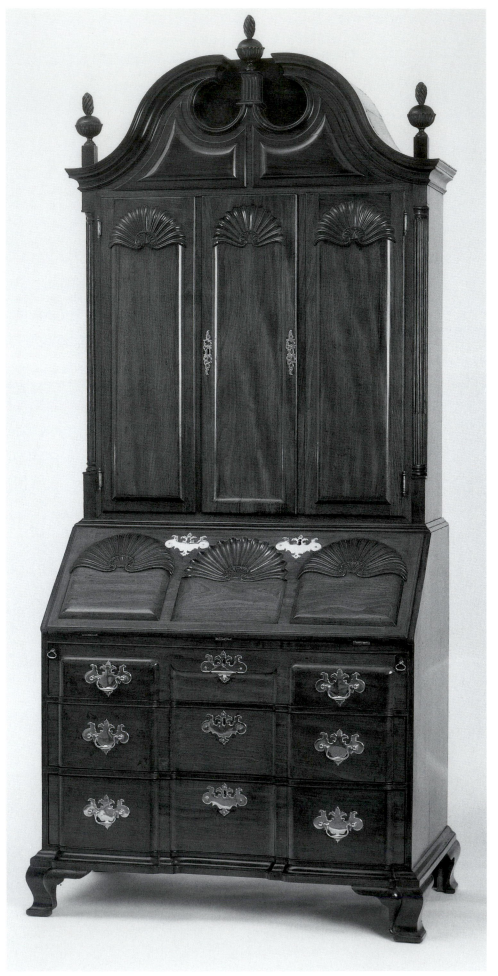

F123

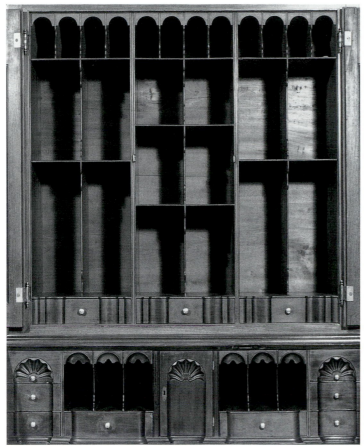

F123 (*detail*)

no. 66) and related to one with three shells on the fall board and two on the bookcase doors (Christie's, New York, sale 8578, January 18, 1997, lot 278).

REFERENCES: Comstock 1962, no. 330; Randall 1965, p. 84, no. 62; Warren 1975, p. 69, no. 135; Moses 1984, pp. 302, 320–21; Heckscher 1985, p. 284; Linley 1996, pp. 64–65.

1. One of the desk and bookcases is inscribed: "Made by John Goddard 1761 and repaired by Thomas Goddard his son 1813." As the inscription suggests, it was probably added in 1813, and scholars have long debated its meaning (Monkhouse and Michie 1986, pp. 96–97). A letter written by John Goddard to Nicholas Brown in 1766 may refer to his desk and bookcase (Cooper 1973a, p. 334). More recently it has been suggested that Newport block-front furniture corresponds to German and other Continental baroque designs (Kirk 1982, pp. 4–6, 125–28).

2. Desks labeled by Job Townsend, Sr. (1699/1700–1765), and John Goddard exhibit this drawer configuration (Moses 1984, pp. 195–96, 201; Monkhouse and Michie 1986, pp. 94–96, no. 38; Jobe et al. 1991, pp. 126–30, no. 46).

F124

Tall Clock

ca. 1753–85
Movement by Edward Spaulding (1732–1785),
Providence[1]
Case: Providence or Newport
Mahogany and secondary woods; 100⅜ x
21½ x 12" (255 x 54.6 x 30.5 cm)
B.59.83

Edward Spaulding is one of a group of clockmakers, including Lambert Lescoit (act. 1769–70), Payton Dana (act. ca. 1800), Seril Dodge (d. 1802), and Caleb Wheaton (1757–1827), working in Providence during the second half of the eighteenth century. It is not known with whom Spaulding trained, but his earliest clock is inscribed "Providence" and dated 1753, presumably the same year he completed his apprenticeship. Invariably his movements have arched tops and are ornamented with cast spandrels or engraved ornament. In the Bayou Bend clock, a rocking ship is

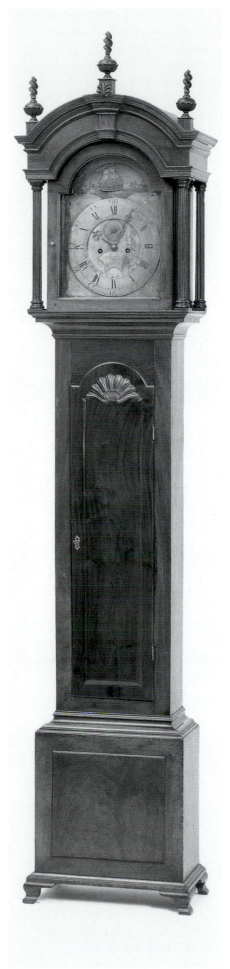

F124

incorporated into the lunette along with an enigmatic inscription. The block-front case, unusual with its applied shell, is traditionally assigned to Newport, yet might well have been constructed in Providence.

PROVENANCE: Dr. John T. Germon, Evanston, Illinois; purchased by Miss Hogg from Israel Sack, New York, 1959, who noted its descent in the Calder family of Providence.

TECHNICAL NOTES: Mahogany; chestnut (backboards), white oak (platform supporting movement), black cherry (bonnet's interior base strips), eastern white pine (bonnet cover, inner face frame, top and sides); southern yellow pine (bottom member of inner face frame). There is no bottom board. The base facade has mitered corners with a raised panel over the opening. The backboard is the same width as the midsection and extends the case's entire height. The shaft front boards lap over the sides. Blocks are added inside to accommodate the door hinges. The hood's pilasters are tenoned in with four separate elements for the columnar feet, bases, capitals, and caps. The carved shell is applied. The dial is engraved "Spaulding/Providence"; on the arch is painted: "The Man Is Yet Unborn That Duly Weighs An Hour." On the inside backboard are indecipherable chalk figures. The strike train of the eight day movement employs a rack hook locking mechanism.

RELATED EXAMPLES: *Antiques* 63 (April 1953), p. 304; 79 (March 1961) p. 215; 85 (January 1964), p. 50; 128 (July 1985), p. 47; 131 (May 1987), p. 897; 132 (November 1987), p. 934; 139 (February 1991), inside cover; 143 (May 1993), p. 699. Also Chase 1940, p. 118; Sack 1969–92, vol. 7, p. 1702, no. P4857; Battison and Kane 1973, pp. 154–56, no. 34.

REFERENCES: Sack 1969–92, vol. 1, p. 7, no. 21; Warren 1975, p. 69, no. 136.

1. Act. ca. 1753–85. Chase 1940.

F125

Tall Clock

1762–84
Movement by the shop of Nathan Howell
(1740/41–1784), New Haven[1]
Case: New Haven area
*Black cherry and secondary woods; 91½ x
20 x 11¼″ (232.4 x 50.8 x 28.6 cm)*
B.60.48

Nathan Howell is typical of most American clockmakers who, once they had completed a movement, left the matter of

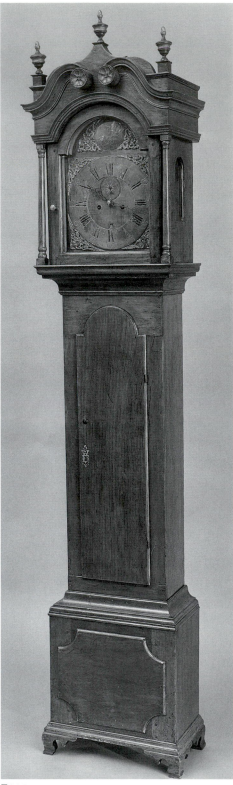

F125

its housing to their client. Today five of Howell's clocks are recorded and, not surprisingly, they are installed in a variety of cases. That of the Bayou Bend example has a distinctive boxed and scrolled pediment, probably patterned after an imported English model.

PROVENANCE: Purchased by Miss Hogg from Ginsburg and Levy, New York, 1960.

TECHNICAL NOTES: Black cherry; eastern white pine (case bottom, backboard's side strip, the movement's shelf, bonnet roof), yellow-poplar (backboard). The waist's sides extend from the base to the hood and have braces that the door is hinged to. The top is flat. The thick front boards lap over the side ones. The movement has a recoil escapement and strike locking between the plates.

RELATED EXAMPLES: Two unpublished clocks belong to the New Haven Colony Historical Society, one housed in a case that is clearly by the same cabinet shop that made the Bayou Bend case. Other examples include *Antiques* 93 (June 1968), p. 696; *Maine Antique Digest,* September 1986, p. 22-c. The maker of the Bayou Bend case also constructed one for an Isaac Doolittle, Sr., movement now in a private collection.

REFERENCES: *Antiques* 69 (April 1956), p. 286; Warren 1975, p. 69, no. 137; Distin and Bishop 1976, p. 44, no. 73.

1. Act. ca. 1762–84 (Hoopes 1930, pp. 91–92).

F126

Dressing Table

1750–1800
Rhode Island, probably Newport
*Mahogany and secondary woods; 31¼ x 35½ x
22⅛″ (79.4 x 90.2 x 56.2 cm)*
B.59.96

Rhode Island dressing tables are not known in the comparable numbers of their companion form, the high chest of drawers. By contrast the bureau table, which functioned in a similar manner, was more prevalent, as evidenced by the existence of perhaps three times the number of examples. The Bayou Bend table, with its unadorned surfaces, recessed shell, and undercut claws, is characteristic of Rhode Island design and craftmanship. The legs are separate components, perhaps for flexibility in packing and shipping, a construction seemingly carried over from the Early Baroque period. The drawer arrangement is reminiscent of that on Early Baroque dressing tables and the lower case of Rhode Island high chests. An added refinement is the use of claw rather than pad feet for the rear legs and the molded top's notched corners.

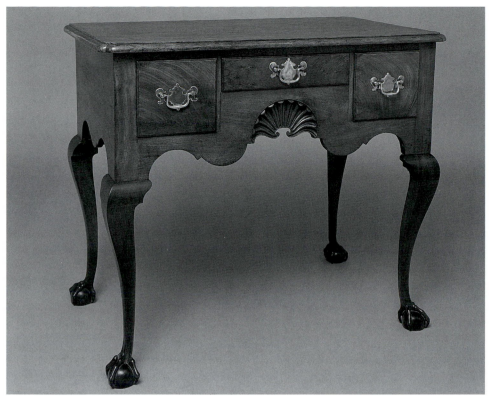

F126

PROVENANCE: Purchased by Miss Hogg from David Stockwell, Wilmington, Delaware, 1959, who noted it was from Mrs. Chase of the Portland, Maine, vicinity by descent in her family, which lived in Providence.

TECHNICAL NOTES: Mahogany; yellow-poplar (drawer sides and bottoms, rails flanking the central drawer, central and left runners, blocks, backboard), eastern white pine (drawer backs, top interior rails, corner

blocks), chestnut (right drawer runner). The legs are separate, secured in place by blocks, with facing strips covering the front stiles. The drawers rest on medial braces dovetailed in front and tenoned to the back. The case front, sides and back are dovetailed. The hardware is replaced. Inscribed in chalk on the back: "Charlotte Foster to whom her Sister left her Mother's Furniture."

RELATED EXAMPLES: *Antiques* 55 (February 1949), pp. 88–89; *Antiques* 89 (January 1966), p. 56; Carpenter 1972, p. 286; Sotheby's, New York, sale 4785Y, January 27–30, 1982, lot 1055; *Antiques* 125 (March 1984), p. 544.

REFERENCES: *Antiques* 77 (January 1960), p. 1; Comstock 1961, p. 572; Comstock 1962, no. 221; Warren 1966, p. 803; Warren 1975, p. 60, no. 115; Moses 1984, p. 187.

F127

Dressing Table

1756–76
Attributed to the shop of Thomas White (1730–1791), Perquimans County, near Hertford, North Carolina[1]
Mahogany and secondary woods; 28¼ x 32½ x 21¾" (71.8 x 82.6 x 55.2 cm)
Museum purchase with funds provided by the Theta Charity Antiques Show and Miss Ima Hogg, by exchange, B.87.12

Born in Isle of Wight, Virginia, to a Quaker family, Thomas White is believed to have apprenticed in Newport, Rhode Island, where a substantial Quaker community existed, and his idiosyncratic furniture suggests his training there. Aspects of Newport design and construction are clearly identifiable in the furniture attributed to his shop, most notably seen on the Bayou Bend dressing table with the carved shell within an incised arc. The trifid foot, obviously derived from Philadelphia cabinetry, is unique in White's ascribed work.[2]

PROVENANCE: George H. and George Burford Lorimer, Philadelphia; purchased by Bayou Bend from Bernard and S. Dean Levy, New York, 1987.

TECHNICAL NOTES: Mahogany; southern yellow pine (left center drawer runner), Atlantic white cedar. Thin knee brackets are attached to the sides. The drawer partitions are dovetailed into the dividers. Below the front skirt rail is an inset component corresponding

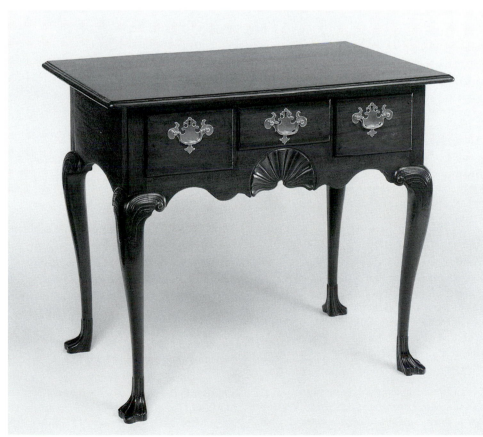

F127

to the flanking drawers' additional depth. The skirt rails are finished with an incised line repeating their contour. A two-inch replacement board has been set into the top. There are two battens above the partitions that lap over the top divider. Within the central drawer is a till with a sliding lid. The brasses are cobbled together with old parts.

RELATED EXAMPLES: Bivins 1988, pp. 192–94. A desk attributed to White has the suggestion of a trifidlike foot (Bivins 1988, p. 187).

REFERENCES: Levy Gallery 1988b, pp. 78–79, Bivins 1988, pp. 192, 194; *Antiques* 133 (May 1988), pp. 1082, 1086; *Luminary* 9, no. 2 (Summer 1988), p. 1.

1. Act. 1756–76. Bivins 1988, pp. 185–201.
2. It has been suggested that White visited Philadelphia, where he observed this motif; however, it seems more likely that he first became aware of it through imported furniture. Philadelphia furniture with North Carolina histories include Sack 1969–92, vol. 1, p. 219, no. 553; Christie's, New York, sale 7526, October 24, 1992, lot 138.

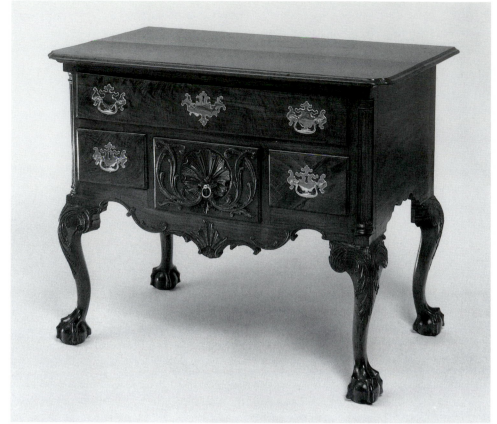

F128

F128

Dressing Table

1760–1800
Philadelphia
Black walnut and secondary woods; 29⅝ x 36 x 20½" (75.2 x 91.4 x 52.1 cm)
B.69.78

The 1772 and 1786 Philadelphia price lists specify, for the majority of forms recorded, two price scales depending on whether the object was fashioned of imported mahogany or indigenous black walnut, the difference being 25 to 40 percent greater for the former.[1] Not only was mahogany the more stylish, it was also preferred, being easier to work, worm-resistant, and less likely to warp or crack. On occasion black walnut was substituted, presumably for reasons of economy. The Bayou Bend dressing table, with its well-executed ornament and figured facade, belongs to a small group of richly carved Philadelphia furniture crafted of native wood.[2]

PROVENANCE: Purchased by Miss Hogg from David Stockwell, Philadelphia, 1948, who acquired it through William MacPherson

Hornor, advertising its descent in Philadelphia's Percival, Zantzinger, and Helmuth families.

TECHNICAL NOTES: Black walnut; black walnut (top drawer's runners and side braces), yellow-poplar (case bottom, drawer bottoms, sides, and backs), Atlantic white cedar (drawer glides, central drawer partitions, backboard, lowest side braces). The partitions are butted and tenoned through the drawer dividers, with the interior partition extending to, and channeled in, the backboard. The molding beneath the top is replaced. Alterations suggest that none of the hardware is original. The right drawer's bottom was repeatedly branded "I. MAYBERRY," presumably denoting an early owner. This is the only recorded use of this brand, possibly for John Mayberry, a Philadelphia carpenter listed in the directories between 1799 and 1805.

RELATED EXAMPLES: The dressing table's carving relates it to a group of furniture re-corded in Conger 1991, p. 140, no. 57. A dressing table similar in concept and of black walnut is recorded in Monkhouse and Michie 1986, pp. 80–81, no. 26. Luke Beckerdite has attributed the Bayou Bend dressing table's ornament to an unidentified carver known as "Spike."

REFERENCES: *Antiques* 52 (September 1947), p. 168; *Antiques* 54 (October 1948), p. 220; Warren 1975, p. 61, no. 118; Monkhouse and Michie 1986, pp. 80–81, no. 26; Sack and Wilk 1986, p. 178.

1. Weil 1979; Fitzgerald 1982.
2. Other richly carved black walnut furniture includes Downs 1952, no. 197; Ward 1988, pp. 226–27, 280–83, nos. 116, 147; and Conger 1991, pp. 98–100, no. 17.

F129

Dressing Table

1760–1800
Philadelphia
Mahogany and secondary woods; 30½ x 34½ x 20" (77.5 x 87.6 x 50.8 cm)
B.58.147

The Philadelphia Rococo dressing table is among the most successful adaptations and design achievements of the colonial period. In England the form was no longer current, yet in America it persisted and in Philadelphia was masterfully integrated into the Late Baroque and Rococo idioms.

PROVENANCE: Perhaps first owned by Joseph Longstreth (1744–1803), Southampton Township, Bucks County, Pennsylvania; to his son Joshua (1775–1869), who married Sarah Williams (1781–1848) in 1800; to their daughter

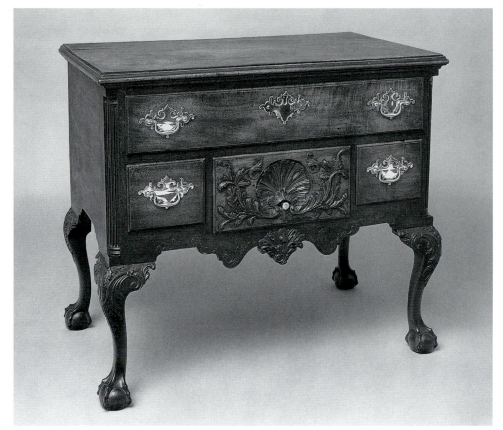

F129

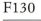

F130

Dressing Table

1760–1800
Maryland or Philadelphia
Black walnut and secondary woods; 28⅜ x
34¾ x 19¾" (72.1 x 88.3 x 50.2 cm)
B.69.527

Defining the characteristics of Maryland furniture presents a scholarly challenge because of the difficulty in distinguishing it from Philadelphia work. While in Annapolis English-born craftsmen and imports dominated, in Baltimore the influence of Philadelphians is more readily discernible. Two of Baltimore's principal cabinetmakers, Robert Moore (1723–1787) and Gerrard Hopkins (1742–1800), had previously worked in Philadelphia.[1] The Bayou Bend dressing table is reminiscent of Philadelphia examples, yet its pendant shell suspended from an inverted bell-flower is similar to one on a high chest assigned to Maryland.[2]

Lydia (Mrs. Richard Price, 1801–1843); or her daughter, Rebecca (Mrs. William Hunt, b. 1834); to her son George W. Hunt (1860–1907); or his son, George W. Hunt, Jr.[1]; purchased by Miss Hogg from Ginsburg and Levy, New York, 1958.

TECHNICAL NOTES: Mahogany; southern yellow pine (backboard, all the drawer runners except those flanking the central drawer), yellow-poplar (central drawer runners, drawer sides and backs, vertical partitions, glue blocks), Atlantic white cedar (drawer bottoms and blocks). The top exhibits an uncommon method of construction, being inset and framed by moldings. Neither the central drawer's applied grasses nor the skirt rail's intaglio carving is original. The partitions are tenoned through the drawer dividers and attached to a secondary partition channeled into the back. The brasses appear to be original. Labels attached to the backboard recount the table's history: "George W. Hunt: this bureau belonged to my great grandfather, Joshua Longstreth, Barclay Hall," and "George W. Hunt, Jr.: this bureau belonged to his great-great grandmother Sarah Williams Longstreth, born 1781, died at Barclay Hall, third month 16th 1848. Sixth month, 29, 1917."

RELATED EXAMPLES: Stillinger 1990, pp. 46–47, 151.

REFERENCES: *Connoisseur* 142 (January 1959), p. LXIX; Comstock 1962, no. 375; Warren 1975, p. 61, no. 119; Warren 1988, p. 23.

1. Taylor 1909, vol. 1, pp. 63–65, 89–91, 170–71; vol. 2, pp. 368–69, 629.

PROVENANCE: George H. Lorimer, Philadelphia; purchased by Miss Hogg from Ginsburg and Levy, New York, 1969.

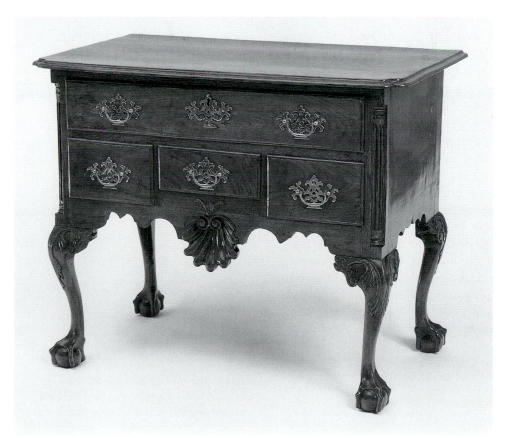

F130

TECHNICAL NOTES: Black walnut; red gum (backboard), Atlantic white cedar (drawer bottoms), yellow-poplar (drawer sides and backs), southern yellow pine (smaller, outside drawers' runners), eastern white pine (center drawer runners). The skirt rail has an additional component beneath the center drawer corresponding with the difference in depth of the flanking drawers. The front side knee brackets are replacements. The hardware is replaced. "L50.13.30" is painted on and a label is numbered 23.69.

RELATED EXAMPLES: This dressing table is closely related to a high chest in Elder and Stokes 1987, pp. 74–76, no. 50. Another high chest possesses the same configuration of elements, appearing to be virtually identical, and perhaps was made en suite with the dressing table (Parke-Bernet, sale 2510, January 28, 1967, lot 101).

REFERENCES: Warren 1970b; Warren 1975, p. 61, no. 120; Conger 1991, p. 92.

1. Weidman 1984, pp. 44–47, 66–67, no. 29.
2. Elder and Stokes 1987, pp. 74–76.

F131

High Chest of Drawers

1750–1800
Rhode Island
Mahogany and secondary woods; 87 x 41 x 22⅝"
(221 x 104.1 x 57.5 cm)
B.69.89

Rhode Island's predilection for bold outlines and minimal surface treatment is epitomized by this high chest of drawers. The earliest examples were fashioned with slipper or pad feet and flat tops, while later ones introduce options such as pad or ball-and-claw feet, carving on the legs, quarter columns on the pedimented upper case, and a formulaic drawer arrangement. In many respects these chests are most closely related to Early Baroque examples, their legs being separate components, the case dovetailed together, the midmolding attached to the upper case, the drawer configuration, and the retention of medial braces.

PROVENANCE: Purchased by Miss Hogg from David Stockwell, Philadelphia, 1953, who noted it came from the Bartol family of Boston.

TECHNICAL NOTES: Mahogany; eastern white pine (drawers, some interior dividers),

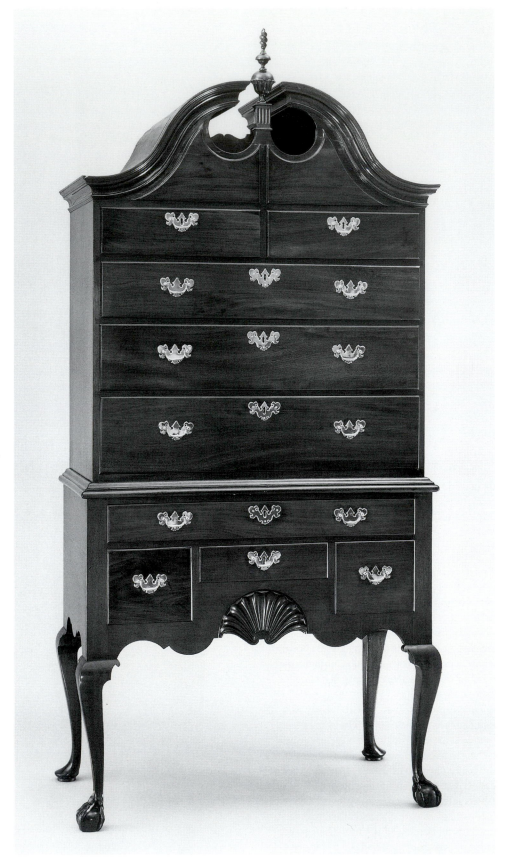

F131

yellow-poplar (remaining dividers), southern yellow pine (divider between the bank of drawers in the lower case), chestnut (backboards, some glue blocks). The claw feet are undercut. The detachable legs are secured by glue blocks. The lower case is dovetailed together with facing strips over the front stiles. The three small drawers in the lower case are supported by medial runners. The two smaller top drawers have additional supports attached to the backboard. Except for the bottom divider in the upper case all the others

are dovetailed into the sides. The bonnet interior is secured by a contoured, center bracket on the interior. The side and pediment molding extends into the pediment, running its entire depth. The plinth is fluted on the front and both sides. The finial is fully carved in the round, the corkscrew appears to be added. The hardware appears to be original.

RELATED EXAMPLES: Signed high chests include one by John Townsend (Ward 1988, pp. 265–68, no. 140) and another by Benjamin Baker (d. 1822) (Moses 1984, p. 194). Examples in public collections include Hipkiss 1941, pp. 56–57, no. 32; Downs 1952, no. 191; Rodriguez Roque 1984, pp. 26–28, no. 12; Moses 1984, pp. 180–81, 184; Heckscher 1985, pp. 247–48, no. 161; *Antiques* 131 (May 1987), p. 980; Ward 1988, pp. 268–72, nos. 141, 142; Conger 1991, pp. 106–7, no. 25.

REFERENCES: *Antiques* 63 (April 1953), p. 331; Comstock 1962, no. 315; Warren 1975, p. 64, no. 124; Moses 1984, pp. 9, 39.

F132

High Chest of Drawers

1750–80
Philadelphia or Maryland
Black-mangrove and secondary woods; 96¾ x 44 x 23¾" (245.7 x 111.8 x 60.3 cm)
B.69.64

Philadelphia's familial and commercial relationship with Annapolis and Baltimore has long complicated the identification of Maryland's Rococo furniture. Elements previously thought to indicate a Maryland origin include the carved shell pendant, fluted, chamfered corners terminating in a lamb's-tongue carving, and the vertically oriented pediment, although all of these can also be perceived in early Philadelphia Rococo furniture.[1] By contrast, the earliest drawer arrangement of Philadelphia high chests was probably patterned after their New England counterparts (see cat. no. F77).

PROVENANCE: George S. Palmer, Esq. (1855–1934), New London, Connecticut; purchased by Miss Hogg at American Art Association, Anderson Galleries, New York, through Mrs. Wayman Adams, 1927.

TECHNICAL NOTES: Black-mangrove[2]; black cherry (interior drawer partitions), Atlantic white cedar (drawer bottoms, upper case top), yellow-poplar (drawer sides and backs, back-

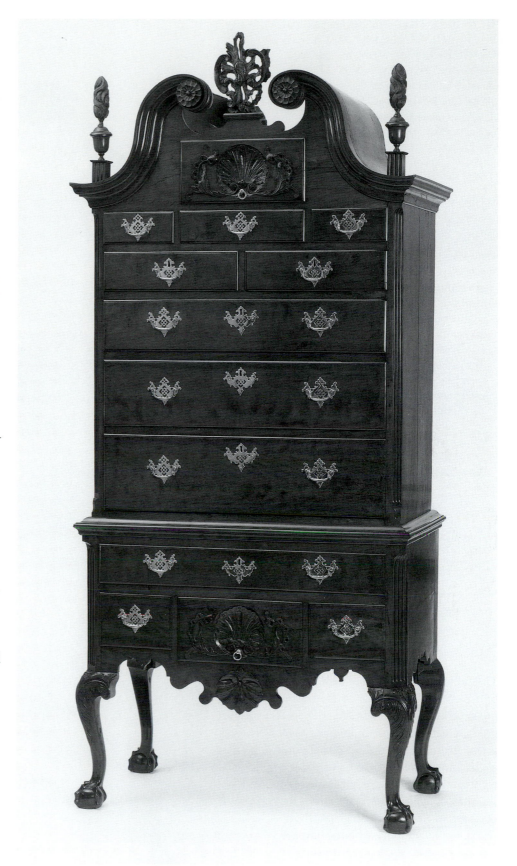

F132

boards), black walnut (interior corner glue blocks), eastern white pine (pediment blocks). The chest is constructed with full dust boards and partitions. The bottom and bonnet are fully enclosed. The rest of the assembly is handled in the typical manner. The drawers are numbered in pencil. The lower case top extends to the back of the chest. The brasses appear to be original.

RELATED EXAMPLES: A high chest signed and dated by the Philadelphia cabinetmaker Henry Clifton in 1753 exhibits a number of similarities with the Bayou Bend high chest

(Heckscher and Bowman 1992, pp. 182, 199). A dressing table matching the Clifton high chest was sold at Christie's, New York, sale 7710, June 23, 1993, lot 218. Other high chests are recorded in Moore 1903, p. 140; Moon 1908, pp. 178–79; Eberlein and McClure 1914, pl. xviii, fig. 6; American Art Association, Anderson Galleries, New York, sale 3878, January 8–10, 1931, lot 396; *Antiques* 89 (June 1966), p. 774; Naeve 1978, p. 14; Monkhouse and Michie 1986, p. 82, no. 28.

REFERENCES: American Art Association, Anderson Galleries, New York, sale 2192, part 2, November 11–12, 1927, lot 282.

1. See Elder 1968, pp. 72–73, 80–83; Weidman 1984, pp. 66–67, no. 29. The complexities of separating Philadelphia and Maryland furniture are discussed in Hummel 1976, p. 117; Conger 1991, pp. 90–92, no. 10; Beckerdite 1994.
2. In an instance apparently unique to early American furniture, the primary wood has been identified as black-mangrove. It propagates in swamp lands ranging from southern Florida to northern South America and is not considered a cabinet wood. This identification was made by Dr. Regis Miller, Center for Wood Anatomy Research, U.S. Forest Products Laboratory, Madison, Wisconsin.

F133

High Chest of Drawers

1760–1800
Philadelphia
Mahogany and secondary woods; 94⅜ x 46½ x 30⅝" (239.7 x 118.1 x 77.8 cm)
B.69.75

The fully mature Philadelphia high chest of drawers has long been coveted as one of the American cabinetmakers' most brilliant achievements. In England the form never realized widespread popularity, passing from fashion by the mid-eighteenth century to be succeeded by the chest-on-chest and clothespress. By contrast, in America the high chest persisted, in Philadelphia evolving into a refined, unique Rococo expression.

In his preface to *The Gentleman and Cabinet-Maker's Director,* Thomas Chippendale wrote, "Of all the Arts which are either improved or ornamented by Architecture, that of CABINET-MAKING is not only the most useful and ornamental, but capable of receiving as great Assistance from it as any whatever. . . ."[1] The

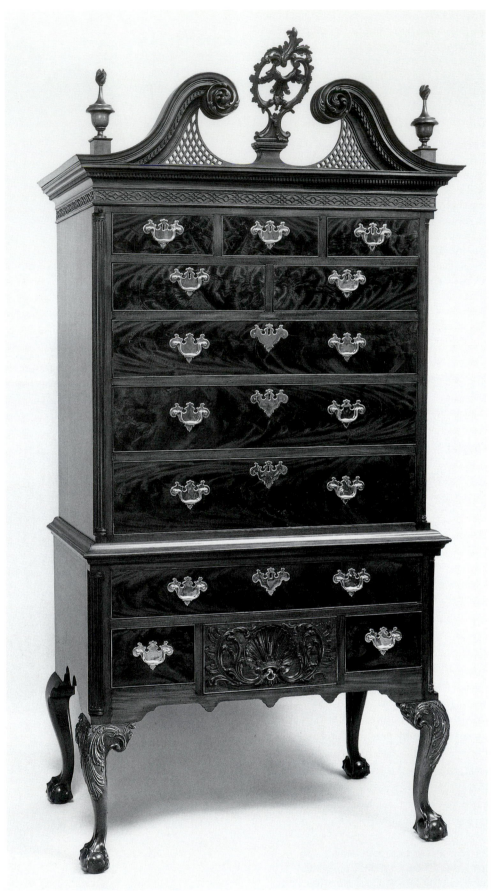

F133

Director's stance is ably translated in the Bayou Bend high chest, with its quarter columns, cornice, dentils, and scrolled pediment, elements corresponding to an eighteenth-century door frame. Giving contrast to its classical verticality, the series of stacked drawers accentuating the midmolding, the fretwork, cornice, and

Late Baroque skirt rail convey a sense of horizontality. The pediment drawer favored earlier has been eliminated and replaced by an intricately pierced tympanum. The 1772 and 1786 Philadelphia price lists reveal that a fully developed high chest of drawers with "claw feet," "leaves on the knees," "shell drawers," "quarter columns," "carved work," "dentl fret," "scroll pedimt. head" and "shield" (cartouche) or a comparable chest-on-chest comprised the most expensive furniture forms.[2]

PROVENANCE: By tradition made for Joseph Wharton (1707–1776); to his son Charles (1743–1836); to his daughter Hannah (Mrs. Thomas G. Hollingsworth, 1794–1854); to her daughter Elizabeth (Mrs. Charles A. Lyman, 1823–1881); to her daughter Fanny (Mrs. Robert Patton Lisle, b. 1855); to her son Robert Clifton Patton Lisle[3]; purchased by Miss Hogg from Robert Clifton Patton Lisle through Charles L. Bybee, 1952.

TECHNICAL NOTES: Mahogany; mahogany (drawers), Atlantic white cedar (drawer bottoms, upper case drawer partitions, upper case backboard, pediment's cover boards), cedar (blocks securing the pediment), southern yellow pine (lower case's drawer runners, dividers, backboard), yellow-poplar (drawer sides and back, lower case's medial brace, drawer side runners, dustboards, pediment backboard). The high chest is composed of three sections. The quarter columns are made up of five elements. The drawer partitions are tenoned through the dividers. The drawer fronts, with the exception of the carved drawer, are veneered and beaded. The carved drawer is solid mahogany. Throughout the high chest are full dustboards. The divider between the two top tiers of drawers extends the full depth. The crown is roofed over. The plinths and finials are added. The hardware appears to be original. One of the drawers is inscribed "BLOCK." Luke Beckerdite suggests the carving represents a late collaboration of Bernard and Jugiez.

RELATED EXAMPLES: The Bayou Bend high chest is believed to have been made en suite with a desk and bookcase (Comstock 1962, no. 337). The carved frieze and scrolled pediment relate to that on a desk and bookcase and two chest-on-chests in Sotheby's, New York, sale 5295, February 2, 1985, lot 1144; Hornor 1977, pl. 171; and Christie's, New York, sale 7012, January 19–20, 1990, lot 497. A high chest labeled by Thomas Tufft (d. 1788) shares the same frieze pattern (Christie's, New York, sale 7294, June 25, 1991, lot 276). Joseph Wharton, who is believed to have originally owned the Bayou Bend high chest, is also thought to have owned the high chest labeled by William

Savery (PMA 1976, pp. 94–95, no. 75).

REFERENCES: Butler 1973, p. 51; Comstock 1962, no. 311; Connoisseur 167 (April 1968), p. 271; Warren 1971a, p. 44, no. 12; Warren 1975, p. 64, no. 125; Hornor 1977, p. 103, pl. 174; Warren 1982, pp. 233–34, 236; Heckscher 1985, p. 226; Warren 1985; Sack 1988, p. 1126; Marzio et al. 1989, pp. 238–39.

1. Chippendale 1966, preface.
2. Weil 1979, p. 181; Fitzgerald 1982, p. 289.
3. Carpenter and Carpenter 1912, pp. 212–13, 215, 218, 225, 238.

F134

Chest of Drawers

1745–1800
Eastern Massachusetts
Mahogany and secondary wood; 29¾ x 35¼ x 21⅞" (75.6 x 89.5 x 55.6 cm)
B.69.39

The American block-front chest was probably inspired by English dressing glasses and desk interiors. Produced from New Hampshire to Virginia, it is most closely identified with Boston and Newport.[1] A desk and bookcase signed and dated by the Boston cabinetmakers Job Coit, Sr. (1692–1742), and Jr. (1717–1745), in 1738 implies both its geographic and

chronological origins.[2] Blocked facades were also employed on dressing glasses, bureau tables, dressing tables, chests-on-chests, and high chests. In Boston, two distinct contours developed. Flat-blocking, the more common, occurs on a complete range of forms (see cat. nos. F141, F142). More unusual and aesthetically satisfying is the bowed contour on the Bayou Bend chest, evidently reserved for smaller case furniture. In addition to the undulating movement of its facade, this example is distinguished by its baluster-shaped feet and deep, overhanging top.

PROVENANCE: Purchased by Miss Hogg from Rudolph P. Pauly, Boston, 1927, who noted it came from the estate of Mary Eliot and had belonged to her maternal grandmother, Mrs. Bassett, a descendant of Elizabeth Foster Vergoose and Thomas Fleet.[3]

TECHNICAL NOTES: Mahogany; eastern white pine. The brackets extend through cutouts in the rear feet. The drawer surrounds are beaded. Typical of Massachusetts construction are the vertical strips attached to the front sides and the dividers extending through the sides below the two top drawers. The top of the drawers' sides and back are beaded. A large, rectangular-shaped dovetail secures the base molding to the secondary board behind it. The chest appears to retain its original brasses. Chalk letters, apparently A and M, are inscribed in a number of places.

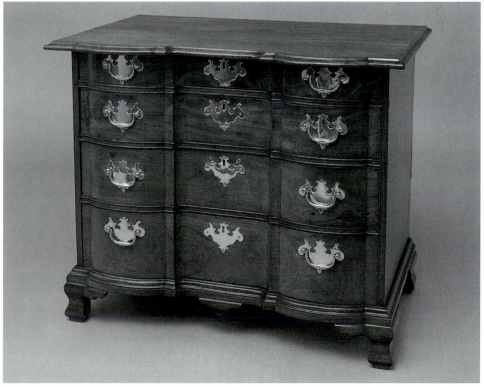

F134

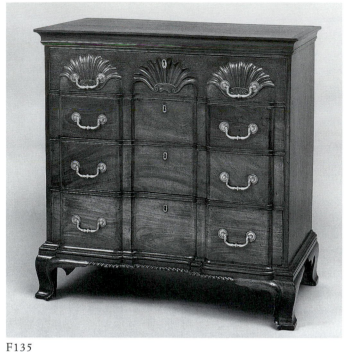

F135

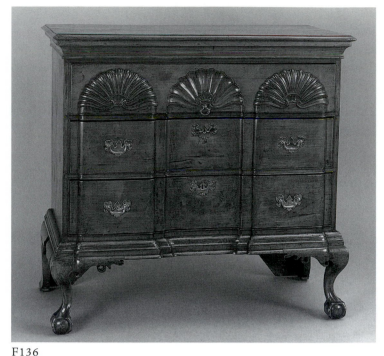

F136

RELATED EXAMPLES: A block-front bureau table illustrated in *Antiques* 101 (May 1972), p. 744, shares the same bombé feet as the museum's chest, as does a chest-on-chest in *Antiques* 139 (January 1991), p. 20. Perhaps all three were made en suite for a single patron. See also Downs 1952, no. 169; Whitehill, Jobe, and Fairbanks 1974, p. ix; Jobe and Kaye 1984, pp. 138–46, nos. 14, 15; Heckscher 1985, pp. 215–16, no. 138; Monkhouse and Michie 1986, pp. 62–63, nos. 9, 10; Ward 1988, pp. 141–42, no. 62; Venable 1989, pp. 56–57, no. 27; Baron 1995, p. 171; Wood 1996, pp. 13–16, no. 7A.

REFERENCES: Warren 1975, p. 65, no. 126.

1. Lovell 1974.
2. Evans 1974.
3. Pauley's history corresponds with that of a teapot Miss Eliot bequeathed to the Museum of Fine Arts, Boston (Buhler 1972, vol. 1, pp. 233–34, no. 194).

F135

Chest of Drawers

1760–1800
Probably Rhode Island or possibly eastern Massachusetts
Mahogany and secondary woods; 38¼ x 37½ x 20" (97.2 x 95.3 x 50.8 cm)
B.69.32

This chest of drawers belongs to a group of mahogany and black cherry examples previously assigned to Middletown and

Norwich, Connecticut, although the contour of its bracket feet, articulated gadrooning, and shell carving—all features of Newport design—are unknown in that locale, and the use of mahogany is atypical. The application of vertical drawer strips on either side of the facade is a technique associated with Massachusetts furniture. As the chest is based on a Newport formula and is not related to neighboring New London County furniture, a revised attribution seems credible.

PROVENANCE: Purchased by Miss Hogg from Israel Sack, New York, 1948, who noted it came from the Kilroe Collection, Winter Park, Florida.

TECHNICAL NOTES: Mahogany; eastern white pine (foot blocks, bottom, backboard, drawer bottoms, sides, and backs). Drawer runners and stops are replacements. The drawers are cut out of the solid with the exception of the top drawer where the shells are applied. The drawer surrounds are beaded. Facing strips, typical of Massachusetts case furniture, cover the front sides. There is a subtop and attached to it is a thin mahogany panel set in-between the front and side cornice. In all likelihood, originally there was a molded top.

RELATED EXAMPLES: *Antiquarian* 15 (October 1930), p. 3; *Antiques* 47 (June 1945), p. 305; Downs 1952, no. 170; Ginsburg 1974, p. 1107; Sack 1969–92, vol. 4, p. 977, P3753.

REFERENCES: Comstock 1962, no. 299; Warren 1975, p. 66, no. 129.

F136

Chest of Drawers

1787–1800
Attributed to the shop of James Higgins (1766–1827), Chatham Township, Middlesex County, Connecticut[1]
Black cherry and secondary wood; 38½ x 37⅜ x 19" (97.8 x 94.9 x 48.3 cm)
B.69.26

Few objects in the Bayou Bend Collection present a clearer perspective on the transmission of design and construction from one regional center to the next than does this block-front chest. It belongs to a group of case pieces identified from Middlesex County, Connecticut. The design of this chest of drawers is clearly influenced by Newport furniture yet, with its juxtaposition of ball-and-claw feet and bracket feet, distinctive carved shells, and use of native black cherry, it exudes its own individuality.[2]

PROVENANCE: The Post family, Haddam, Connecticut; to Mr. and Mrs. Frank Wade, Westfield, Massachusetts; Malcolm A. Norton; Herbert Lawton, Boston; [Ginsburg and Levy, New York, 1937]; purchased by Richard Loeb; [Charlotte and Edgar Sittig, Shawnee on Delaware, Pennsylvania]; purchased by Miss Hogg from Joe Kindig, Jr., York, Pennsylvania, 1947.

TECHNICAL NOTES: Black cherry; eastern white pine. The rear feet are dovetailed. The

convex shells are applied. Braces running front to back are attached to the sides above the top drawer. The top rests on the molding. The hardware appears to be original. Inside the top drawer is penciled: "This three shell block-front bureau belonged to the old Post family of Haddam Conn and was inherited by Mr. Frank Wade of #17 Hancock St., Westfield, Mass. who is a member of the Post Family of Haddam. I purchased it from Mrs. Wade in June 1919. Malcolm A. Norton."

RELATED EXAMPLES: Chests from this group include Downs 1952, no. 172; Kirk 1967, p. 38, no. 63; Myers and Mayhew 1974, p. 37; and possibly Comstock 1962, no. 300.

REFERENCES: Norton 1923, pp. 63–64; American Art Association, Anderson Galleries, New York, sale 4314, April 2–3, 1937, pp. 156–57, lot 385; *Antiques* 32 (July 1937), p. 4; Hinckley 1953, p. 340, no. 1069; Nutting 1962, no. 270; Warren 1975, p. 65, no. 128; Trent 1989, pp. 125–26, no. 47.

1. Evans 1997, p. 369.
2. Distinct groups of furniture are assigned to Benjamin Burnham (ca. 1730–ca. 1773) of Colchester and Samuel Loomis (1748–1814), who may have apprenticed to Burnham and worked in Colchester, Saybrook, and Essex. The only documented example from Burnham's shop is the well-known desk signed and dated 1769 (Heckscher 1985, pp. 270–72, no. 178). At least three other groups, designated X, Y, and Z, are classified. Bayou Bend's chest is assigned to the first, and now identified as James Higgins's shop (Myers and Mayhew 1974, pp. 5–7, 32–37; Evans 1997, p. 369). Thomas P. Kugelman has studied the Bayou Bend chest and confirmed the attribution to the Higgins shop.

F137
Chest of Drawers

1760–1800
Attributed to the shop of Nathaniel Gould (1734–1782) or Henry Rust (1737–1812), Salem, Massachusetts
Mahogany and secondary wood; 36⅝ x 37 x 21"
(93 x 94 x 53.3 cm)
B.69.136

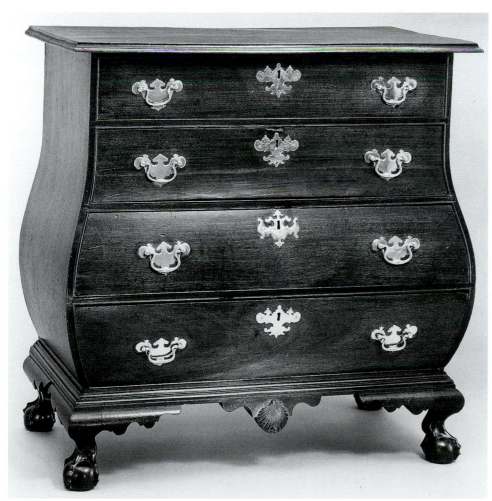

F137

The bombé contour was never as prevalent as the block-front or serpentine because it was more complex and costly to manufacture. Nonetheless, it was translated into a variety of forms besides the chest of drawers—from diminutive dressing glasses to commanding case pieces. While bombé furniture is most closely identified with the Boston area, a small number of examples, including the Bayou Bend chest, are ascribed to Salem and Essex County.[1] Its design, proportions, ornament, and construction relate to three case pieces signed by Salem cabinetmaker Henry Rust.[2] In addition, an inscription on a desk and bookcase, possibly in Rust's handwriting, implies a familiarity with Nathaniel Gould, the most successful of all eighteenth-century Salem cabinetmakers.[3] The Gould and Rust shops may have employed similar designs and construction techniques, complicating a more specific attribution.

PROVENANCE: Purchased by Miss Hogg from Joe Kindig, Jr., York, Pennsylvania, 1946.

TECHNICAL NOTES: Mahogany; eastern white pine. The rear feet are fully carved. The case sides, vertical at the base molding, conclude in a dovetail for the sliding top. The drawer sides conform to the shape of the case. The drawer dividers are dovetailed into the sides and have characteristic beading. The brasses are replacements.

RELATED EXAMPLES: Downs 1952, no. 166; Aronson 1965, p. 117, no. 365; Chamberlain 1977, p. 1170. Also related are a bombé chest-on-chest at the Nelson-Atkins Museum of Art, Kansas City, Missouri (acc. no. 34–123) and two desks illustrated in *Antiques* 46 (November 1944), p. 255, and Sack 1989, p. 1183.

REFERENCES: Comstock 1962, no. 296; Vincent 1974b, pp. 193, 195, no. 137; Warren 1975, p. 65, no. 127; Ketchum 1982, no. 208; Sack 1989, pp. 1182, 1185.

1. It seems plausible that the bombé was introduced to Salem by way of Boston. Boston bombé furniture with Salem provenances include Fairbanks et al. 1991, p. 36; Mussey and Haley 1994, pp. 96–97, fig. 40.
2. Venable 1989, pp. 58–63, no. 28; Sack 1969–92, vol. 4, pp. 898–99, no. P3657; Lovell 1974, p. 122.
3. Heckscher 1985, pp. 276–79, 366, no. 181.

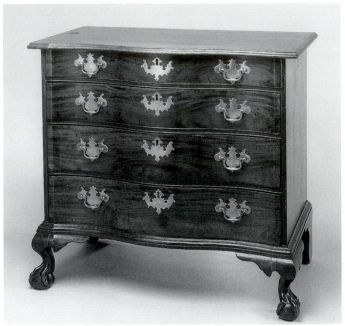

F138

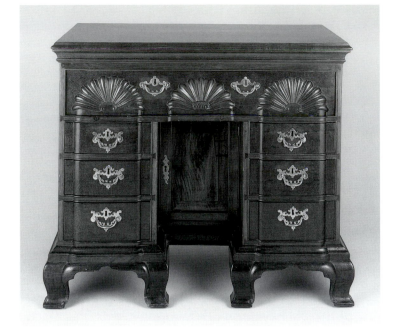

F139

F138

Chest of Drawers

1760–1800
Eastern Massachusetts
Mahogany and secondary wood; 32¼ x 35⅜ x
20″ (81.9 x 89.9 x 50.8 cm)
Gift of the estate of Miss Ima Hogg, B.76.161

The graceful serpentine facade was taken directly from English furniture and may have evolved from the block-front. The facade on this diminutive chest of drawers probably represents its earliest incarnation, as it is flush with the chest's sides and the serpentine is slightly indented— a configuration that also occurs on block-front and serpentine-bombé cases. The pleasing undulating contour persisted into the Neoclassical period, when price books reveal its expense as 50 percent greater than a bowed-front chest and double that of a straight-fronted one.[1] An unusual feature on this example is the juxtaposition of bracket and ball-and-claw feet.

PROVENANCE: Purchased by Miss Hogg from Israel Sack, Boston, 1925.

TECHNICAL NOTES: Mahogany; eastern white pine. The bottom is flush with the base molding. The top is secured by sliding dovetails. The hardware appears to be original. The drawers and base, exterior backboard, and the base are inscribed A. The base is also marked "x" and "Botom."

RELATED EXAMPLES: Similar chests, but with ball-and-claw feet, are pictured in Sack 1950, p. 100; *Antiques* 143 (March 1993), p. 375; *Antiques* 152 (November 1997), p. 574; a bracket-footed example is illustrated in Randall 1965, pp. 36– 37, no. 29. The juxtaposition of claw and bracket feet appears on a block-front desk and bookcase (Sack 1969–92, vol. 1, p. 85, no. 261) and two serpentine-front chests (Wood 1996, pp. 30–32, no. 12A), one labeled by Hartford cabinetmakers Samuel Kneeland (1755–1828) and Lemuel Adams (d. 1821) and dated 1793 (Ward and Hosley 1985, pp. 256–57). Another example, attributed to Samuel Sewall (1724– 1814), York, Maine, is inspired by the Boston model and suggests the regional range (Kaye 1985, p. 276).

1. Montgomery 1966b, p. 182.

F139

Bureau Table

1760–1800
Newport or possibly Providence
Mahogany and secondary woods; 31½ x 36¾ x
20¾″ (80 x 93.3 x 52.7 cm)
Gift of Mr. and Mrs. James L. Britton, Jr., B.92.6

The bureau table was intended for the bedchamber, which in the eighteenth century functioned as both a public and private space. An eighteenth-century English architect commented on this duality: "A dressing-room in the house of a person of fashion is a room of consequence, not only for its natural use in being the place of dressing, but for the several persons who are seen there. The morning is a time many choose for dispatching business; and as persons of this rank are not to be supposed to wait for people of that kind, they naturally give themselves orders to come about a certain hour, and admit them while they are dressing."[1]

Bureau tables functioned in a variety of ways. Some had a hinged top drawer that dropped down to reveal a desk interior.[2] Such tables likely had a dressing glass set on top. Others, like the Bayou Bend table, were intended for personal grooming, with an adjustable mirror and fitted compartments for cosmetics, combs, brushes, scissors, razors, and other personal accoutrements.

In Rhode Island the bureau table was a popular form, as attested by the survival of more than fifty examples. The typical case is blocked, culminating in a series of convex and concave shells, the overall effect reminiscent of an architectural arcade. Traditionally these tables are assigned to Newport; however, it is plausible that Providence craftsmen also supplied their prominent locals.[3]

PROVENANCE: By tradition John Brown (1736–1803), Providence; to his daughter Abigail (Mrs. John Francis, b. 1766); to her son John Brown Francis (1791–1864); to his daughter Ann (Mrs. Marshall Woods, 1828–1896);

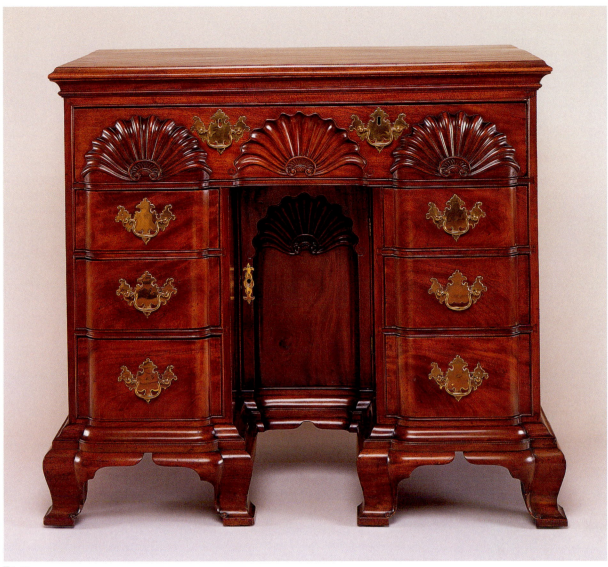

F140

to her daughter Abby (Mrs. Samuel Abbot, 1849–1895); to her daughter Madeleine (Mrs. John O. Ames, b. 1876); to her sister Anne (Mrs. Charles A. Kilvert, Sr., b. 1879); to her son Charles A. Kilvert, Jr; purchased by Mr. and Mrs. James L. Britton, Jr., Houston, at Christie's, New York, 1982.

TECHNICAL NOTES: Mahogany; mahogany (interior sliding panel, secret drawer front), eastern white pine (foot blocks, drawer runners), chestnut (drawer sides and bottoms), soft maple (prospect cabinet partitions, panel beneath top drawer, rear rail support for the top drawer), yellow-poplar (writing board), cedrela (writing board frame). The foot blocks are triangular. A filler was let in between the side bracket feet. The bottom is recessed and runners were introduced for the two bottom drawers. The drawer bottoms are chamfered and slid into a rabbet but not nailed. The prospect door is framed with a thin, beaded strip. Inside, it reveals two shelves. The top drawer when closed rests on a bracket attached to the back. The top drawer retains its original fittings, but the hinged writing board

seems to be an addition. The brasses are probably original. Inside the back of the large drawer is what appears to be the letter A. The bank of small drawers are numbered for orientation. The bottom drawer is inscribed: "A.W. MENDE 1943."

RELATED EXAMPLES: This is the only Rhode Island bureau table outfitted as a dressing table. Its configuration, most notably the prospect door with its rectangular panel, relates most closely to Moses 1984, pp. 34, 332.

REFERENCES: Cooper 1973a, pp. 334–35; *Antiques* 121 (June 1982), p. 1233; Christie's, New York, sale 5153, June 12, 1982, lot 198; Monkhouse and Michie 1986, p. 84, no. 30; Warren 1993, p. 336.

1. Harrison 1971, p. 98; see also Goyne 1967.
2. Moses 1984, pp. 32, 268–69, 287; Monkhouse and Michie 1986, pp. 84–85, no. 30.
3. By the 1750s Providence had a well-organized and sizable cabinet industry, as evidenced by the "Rule and Price of Joyners Work" drawn up in 1756 and 1757 to regulate prices

(Ott 1965, pp. 104–5, no. 66, 174–75; see also Ott 1982; Flanigan 1986, p. 76).

F140

Bureau Table

1785–1800
Attributed to the shop of John Townsend (1732/33–1809), Newport[1]
Mahogany and secondary woods; 34½ x 39¼ x 22" (87.6 x 99.7 x 55.9 cm)
B.69.91

This splendid bureau table is one of the most brilliant renditions of the Newport block-front—an acknowledged masterpiece of American design. The form, representing the marriage of the dressing table and chest of drawers, was variously interpreted in Rhode Island. A handful are known with plain facades, and within the block-front group a series of options

F141

were available, primarily in the execution of the prospect door and the outfitting of the top drawer.

The Bayou Bend bureau table belongs to a group confidently attributed to John Townsend. The son of Christopher Townsend, presumably he apprenticed with his father. During the course of his long career he signed or labeled more than thirty pieces of furniture, a number far greater than any other eighteenth-century American cabinetmaker (see cat. no. F149). This unparalleled body of documented work, identifiable motifs, and construction techniques make it possible to identify Townsend's cabinetry with a high degree of certainty. His earliest block-front case piece is dated 1765, and for more than three decades he continued to work in this idiom. John Townsend's furniture offers a unique survey of one cabinet shop's production and chronicles the maker's rise to become one of America's master craftsmen.[2]

PROVENANCE: Probably made for Samuel Vernon (1711–1792), Newport; to his daughter Elizabeth (Mrs. Valentine Wightman, 1738–1812); probably to her daughter Mary Wightman (1773–1840); to her cousin, William Vernon (1788–1867); to his daughter Ann (Mrs. Robert M. Oliphant, b. 1832); to her daughter Grace

(Mrs. George Casper Kellogg, d. 1950); purchased by Miss Hogg from the estate of Grace Kellogg through Israel Sack, New York, 1950.[3]

TECHNICAL NOTES: Mahogany; chestnut (interior framing, backboard, bottom), yellow-poplar (drawer, sides, back, and bottoms, drawer runners). The foot blocks' contour corresponds to the bracket feet. Between the side brackets a molding has been set in. The dividers are dovetailed in and a bead surrounds each opening. There is a single shelf in the cabinet. A full dustboard separates the top drawer and the first tier of flanking drawers. Braces are attached to the sides just above the top drawer with a second set above running side to side. At the top of the backboard is the key device associated with Townsend's shop. The brasses appear to be original. A drawer is inscribed: "Eliza Wightman" (see Provenance).

RELATED EXAMPLES: Downs 1952, no. 175; Heckscher 1982, pp. 1150–51; Moses 1984, pp. 100, 134; Heckscher 1985, pp. 211–12, no. 135; Ward 1988, pp. 40, 216–17, no. 109.

REFERENCES: Warren 1971a, p. 43, no. 11: Warren 1975, pp. 62–63, no. 123; Cooper 1980, pp. 177, 200; Agee et al. 1981, p. 79, no. 140; Warren 1982, pp. 233, 235; Heckscher 1982, p. 1151; Moses 1984, pp. 143, 159, 161, 163; Ward 1988, p. 217; Marzio et al. 1989, pp. 246–47.

1. Act. ca. 1754–1809 (Cornelius 1928; Carpenter 1954, pp. 16–18; Moses 1984, pp. 65–170).
2. Heckscher 1982.

3. In 1946 Miss Hogg first learned of this table from Israel Sack, whom she entrusted to acquire it. He responded, "You have my assurance that I will do my very best to have you get the desk if it is at all possible. I have learned from experience with all these very superior pieces of furniture that a lot of patience is required under such circumstances. All the fine old furniture that was made in this country from 1600–1800 or any other country for that matter was built with great patience, and it requires patience to acquire the fine things." Patience was indeed required; Sack's offer was refused. In 1950, Miss Hogg was traveling abroad when Sack cabled that Mrs. Kellogg had died and inquired if she was still interested in the bureau table. She responded immediately and this time Sack succeeded (letter from Sack in object files).

F141

Bureau Table

1750–1800
Essex County, Massachusetts, or possibly the Boston area
Mahogany and secondary wood; 29¾ x 36 x 20⅝" (75.6 x 91.4 x 52.4 cm)
B.69.358

In Rhode Island and Massachusetts, the bureau table was often produced with a blocked front; however, each region's interpretation was entirely different. Massachusetts craftsmen adeptly integrated into the facade either a rounded or flattened contour, fitting it with a tablet-shaped prospect door or, on rare occasions, one with carving. The Bayou Bend table, with its carved and gilded shell, represents the fully developed form. This bureau table and a matching chest-on-chest (cat. no. F142) are the only extant American examples remaining en suite.[1]

PROVENANCE: Alice and Luke Vincent Lockwood (1872–1951), Greenwich, Connecticut; purchased by Miss Hogg at Parke-Bernet, New York, May 15, 1954, through John S. Walton, New York.

TECHNICAL NOTES: Mahogany; eastern white pine. The foot blocks are quarter round. The side braces pass through the rear feet. The bottom drawers rest on the case bottom. Inside the prospect door is a shelf with a cyma-shaped scalloped front repeating the base profile of the drawer immediately above

it. The tops of the drawer sides are double-beaded. Below the top drawer are full dust-boards. The hardware appears to be original. The drawers and dividers are consecutively numbered.

RELATED EXAMPLES: Most closely related is a bureau table in the collection of the Honolulu Academy of Arts, which retains a fragment of what may be a cabinetmaker's label (Sotheby's, New York, sale 4268, June 20–23, 1979, lot 1249A). Similar tables include *Antiques* 99 (January 1971), p. 7; Sotheby Parke Bernet, New York, sale 3923, November 18–20, 1976, lot 1008. Bureau tables with carved prospect doors include *Antiques* 75 (May 1959), inside front cover; *Antiques* 101 (May 1972), p. 744; Christie's, New York, sale 7526, October 24, 1992, lot 205.

REFERENCES: Lockwood 1957, vol. 1, pp. 359, 363; Sack 1950, p. 151; Parke-Bernet, New York, sale 1521, May 13–15, 1954, pp. 178–79, lot 520; *Connoisseur* 134 (November 1954), p. 120; Comstock 1962, no. 380; Warren 1975, p. 62, no. 121; Warren 1988, pp. 28–29.

1. Just as dressing tables were made to match high chests of drawers, chests-on-chests were produced en suite with tables (Weil 1979, p. 181; Fitzgerald 1982, p. 289). A chest-on-chest and related chest of drawers are published in Jobe and Kaye 1984, pp. 154–56, 176–78, nos. 19, 27.

F142

Chest-on-Chest

1750–1800
Essex County, Massachusetts, or possibly the Boston area
Mahogany and secondary wood; 91¾ x 44 x 24¾″ (233 x 111.8 x 62.9 cm)
B.69.357

The chest-on-chest was introduced during the Late Baroque years. Usually identified with that style and the Rococo, in Massachusetts it persisted into the Neoclassical period. This imposing example is notable for the unconventional configuration of its lower case. The drawer arrangement replaces the standard format of graduated full-length drawers. The end result, while sacrificing storage space, better complements the chest's companion bureau table (cat. no. F141). Another unusual aspect is the application of gilding to the shells, pilasters, pediment moldings, and finials. Gilt highlights became stylish in

F142

England by the second quarter of the eighteenth century. Contemporary publications promoted its fashionability, yet little American furniture survives with this fragile decoration intact.[1]

PROVENANCE: See cat. no. F141.

TECHNICAL NOTES: Mahogany; eastern white pine. See cat no. F141. The cabinet has two cyma-shaped scalloped shelves. The upper tier of drawers in both sections has full dust boards below. The partitions flanking the top central drawer are dovetailed in, the rest tenoned. The top tier of drawers opens up to

the bonnet roof. The hardware appears to be original.

RELATED EXAMPLES: Six chests-on-chests exhibiting this unusual drawer configuration are published: Nutting 1962, nos. 313, 314; *Apollo* 38 (October 1943), p. XII; Parke-Bernet, New York, sale 706, November 16–17, 1945, lot 349; *Antiques* 100 (July 1971), p. 13; *Antiques* 101 (February 1972), p. 268; *Antiques* 109 (March 1976), p. 541. A number of other chests-on-chests, while lacking the unusual drawer recess, are similar with arched side drawers. This design seems to be indicative of case furniture produced largely in Essex County, although some may originate from the Boston area. These include Swan 1945, p. 224; *Antiques* 52 (October 1947), p. 223; *Antiques* 68 (July 1955), inside front cover; Randall 1960, pp. 152–55; Randall 1965, pp. 52–53, no. 41; Lovell 1974, pp. 109–11; Sack 1969–92, vol. 4, p. 980, no. P48; Whitehill, Jobe, and Fairbanks 1974, p. vi; *Antiques* 112 (August 1977), p. 166; Sack 1969–92, vol. 8, p. 2353, no. P5823; Ward 1988, pp. 167–68, no. 79; Christie's, New York, sale 7146, October 19, 1990, lot 284.

REFERENCES: Lockwood 1957, vol. I, pp. 359, 362; Sack 1950, p. 116; Parke-Bernet, New York, sale 1521, May 13–15, 1954, lot 519; *Connoisseur* 134 (December 1954), pp. 206–7; Warren 1975, p. 66, no. 130; Warren 1982, pp. 233–34; Warren 1988, pp. 28–29.

1. Cross sections of the gilding determined that the chest-on-chest has undergone three distinct surface treatments. The mahogany was first finished with a natural resin-oil mixture. Next, the finished wood was gessoed, oil-gilded, and recoated with natural resin. The third layer consists of a third coat of resin and metallic paint for touching up the gilding. At this time there is no means available to determine whether or not the oil-gilding was part of the original concept.

F143

Chest-on-Chest

1760–1800
Philadelphia
Mahogany and secondary woods; 92½ x 47⅛ x 23¾" (235 x 119.7 x 60.3 cm)
B.69.74

The chest-on-chest was produced throughout eighteenth-century America. In some places, such as New York and Charleston, where the high chest of drawers was no longer fashionable, the chest-on-chest or clothespress became the requisite bedroom form. In Philadelphia

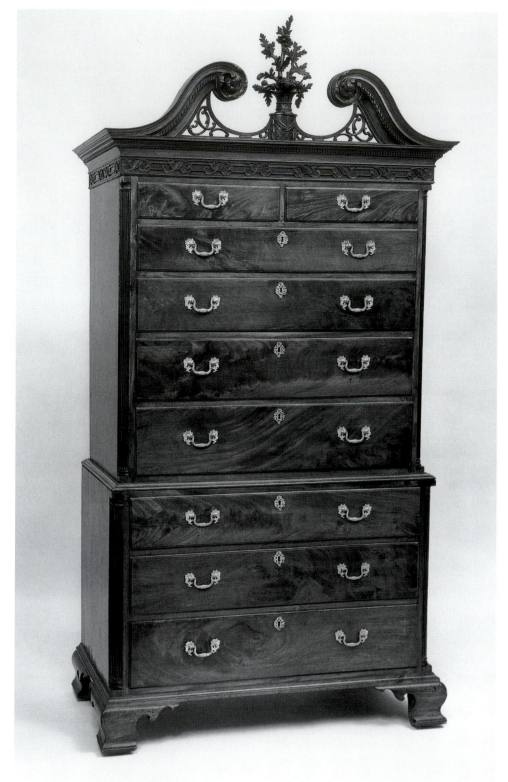

F143

the price lists specify that the chest-on-chest cost exactly the same amount as a high chest, the two being the most expensive forms recorded.[1]

The scale of the Bayou Bend chest-on-chest is less overpowering than most, producing a piece of furniture on a more human scale. Like the Philadelphia high chest, it asserts an architectural presence. Its drawer configuration is unusual: the

three small horizontal drawers traditionally across the top tier have been omitted, allowing for an additional full-length drawer below, resulting in more usable storage and a successful, linear arrangement of the hardware. The asymmetrical drawer pulls challenge the horizontality of the stacked drawers and divert attention toward the cornice, scrolled pediment, and central ornament.

PROVENANCE: Mary Reakirt (Mrs. Robert H. Large), Philadelphia; to Howard Reifsnyder, Philadelphia, by 1924; purchased by Thomas Curran at American Art Association, New York, 1929, on behalf of Mrs. Frederick Fish, South Bend, Indiana; purchased by Mrs. Thompson (?); purchased by Miss Hogg from Ginsburg and Levy, New York, 1951, who noted that it was originally owned by Governor Thomas Mifflin of Pennsylvania (1744–1800). If correct, its descent through the Mifflin family was circuitous, since there were no direct heirs. His nephew, Thomas, married Ebenezer Large's daughter Sarah (1777–1856). A plausible alternative is from William Large (1722–1764) to his son Ebenezer (1750–1810); to his son John Baldwin (1780–1866); to his son Robert Hartshorne (1809–1868); to his son John Baldwin (1846–1892); to his son and daughter-in-law, Robert H. (1875–1917) and Mary Reakirt Large.

TECHNICAL NOTES: Mahogany; mahogany (cornice's interior front and sides, side brace of lower case's center drawer), Atlantic white cedar (dustboards, horizontal divider between the two upper drawers, corner glue blocks, backboards, upper chest top, cornice glue blocks), yellow-poplar (foot blocks, board behind middle drawer in upper case), white oak (carved basket's pin), southern yellow pine (the remaining secondary woods). The foot blocks are quarter round. The bottom drawer is flush with the case bottom. Braces aligned with the top of each drawer are attached to the side with vertical glue blocks in each front corner. The drawers are separated by full dustboards. A guide separates the two uppermost drawers. The third component is the removable cornice and pediment. Charleston cabinetmaker Richard McGrath's 1772 advertisement implies its flexibility as a separate unit: "Double chests of Drawers, with neat and light Pediment Heads, which take off and put on occasionally. . . ."[2] The top of the upper case is dovetailed to the sides, with beveled corners and an interior frame secured by blocks. The chest retains its original hardware, which, with the addition of tinted shellac, produces the appearance of gilding. A number of illegible chalk inscriptions may be contemporary with the chest's manufacture.

RELATED EXAMPLES: A similar pediment appears on a desk and bookcase illustrated in Hummel 1976, p. 94.

REFERENCES: Wister and Jayne 1924, pp. 157, 160; Holloway 1927, p. 99; Holloway 1928, p. 92, pl. 39; American Art Association, New York, *Colonial Furniture: The Superb Collection of the Late Howard Reifsnyder,* April 24–27, 1929, lot 704; *Antiquarian* 12 (June 1929), p. 31; *Antiques* 21 (January 1932), p. 29; *Antiques* 53 (April 1948), pp. 246–47; Warren 1966, p. 799;

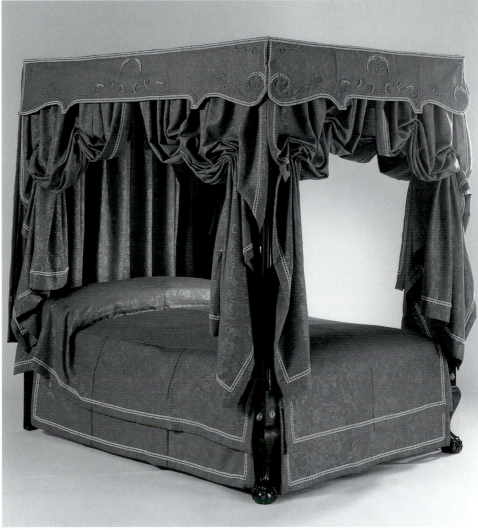

F144

Warren 1975, p. 67, no. 131; Kirk 1982, pp. 150–51, no. 388; Warren 1982, pp. 231, 233.

1. Weil 1979, p. 181; Fitzgerald 1982, p. 289.
2. Prime 1969, vol. 1, p. 176.

F144

Bedstead

1750–1800
Eastern Massachusetts
Mahogany; 85⅝ x 59 x 81" (217.5 x 149.9 x 205.7 cm)
B.69.137

A fully dressed bed was the costliest and most labor-intensive piece of upholstered furniture. It required the skills of a chairmaker to construct it, a turner to produce the posts, a carver to ornament them, and an upholsterer to construct the canvas support, mattress, bolster, and pillows. The hangings, consisting of a top, a back panel, curtains, and valances, incurred the principal expenditure and were supplied by the upholsterer or a seamstress, who often provided coordinated window treatments. This bedstead, extravagantly fashioned entirely of mahogany, may well have sported an elaborate set of hangings.

PROVENANCE: Purchased by Miss Hogg from Collings and Collings, New York, 1928.

TECHNICAL NOTES: The head posts are square and taper upward. The rails show evidence of a tacked and laced canvas support, undoubtedly similar to that surviving on cat. no. F191. Both side rails were lengthened approximately four inches. The top three and one-half inches of all four posts are restored.

RELATED EXAMPLES: Greenlaw 1974, pp. 18–19, no. 7.

REFERENCES: Warren 1975, p. 70, no. 138; Schwartz 1982, no. 228.

F145

Pair of Side Chairs

1785–1820
Boston area
Mahogany, inlay, and secondary wood;
B.69.378.1: 38½ x 21⅜ x 21" (97.8 x 54.3 x
53.3 cm); B.69.378.2: 38¾ x 21⅜ x 21¼"
(98.4 x 54.3 x 54 cm)
B.69.378.1–.2

Following the war for independence, Americans experienced a revolution of design, as the Rococo taste was supplanted by Neoclassicism. The vigorous motifs that characterized the Rococo idiom were replaced by elements derived from Classical antiquity, such as swags and urns. Marquetry and line inlays were reintroduced for the first time since the Late Baroque period, employed on this example to form oval patera and lunette.[1] Appropriately, these elements are framed within a shield, described in the period as a "vase back." Carving similar to that on the shield is found on both Boston and Salem furniture, complicating efforts to distinguish between the work of their respective craftsmen. In this instance an attribution to the former is based on the provenance of these chairs and related examples.

PROVENANCE: Purchased by Miss Hogg from John S. Walton, New York, 1954, who noted the chairs were first owned by Major Thomas Melville (1751–1832) and Priscilla Melville of Boston.[2]

TECHNICAL NOTES: Mahogany, unidentified inlay; birch (seat rails, corner blocks). The medial stretchers are dovetailed in. On B.69.378.1 the side stretchers and rear seat rail are pinned to the stiles. The back consists of a crest rail, three vertical splats, and the two-part stay rail. The upholstery reproduces the original tacking pattern.

RELATED EXAMPLES: Hipkiss 1941, pp. 156–57, no. 93; Montgomery 1966b, pp. 88–89, no. 33. Chairs with slight variations are *Antiques* 88 (July 1965), p. 17; *Connoisseur* 161, no. 650 (April 1966), p. LXIX; Fales 1976, pp. 72–73, no. 132; Garrett 1977, p. 1001. These chairs relate to another group with virtually identical crest rails, typified by Montgomery 1966b, pp. 89–90, no. 35, whose seat rail is stamped I*C. Related chairs are stamped SF and WF, possibly for the Boston area cabinetmakers Samuel Fiske (d. 1797) and his son William (1770–1844).

REFERENCES: Warren 1975, p. 77, no. 140.

1. Charleston cabinetmaker Martin Pfeninger provided a pre-Revolutionary reference to inlays in his 1773 advertisement offering "Inlaid Work in any Taste. . . ." (Prime 1969, vol. 1, p. 179).
2. A pastel of Thomas Melville and a painting of his Green Street residence are recorded in Cabot 1979, pp. 20, 66–67.

F146

Set of Four Side Chairs

1800–1820
Boston area
Mahogany, inlay, and secondary woods;
B.77.24.1: 35½ x 20¼ x 22" (90.2 x 51.4 x 55.9 cm);
B.77.24.2: 35½ x 20¼ x 21¼" (90.2 x 51.4 x 54 cm); B.77.24.3: 35⅝ x 20¼ x 21½" (90.5 x 51.4 x 54.6 cm); B.77.24.4: 35¾ x 20⅜ x 20½" (90.8 x 51.8 x 52.1 cm)
Gift of John F. Staub, B.77.24.1–.4

In contrast with the "vase-back" chair and its profusion of ornament (cat. no. F145), these side chairs present a more restrained interpretation. *The London Chair-Makers' and Carvers' Book of Prices for Workmanship* for 1802 describes chairs such as these as a "Square back with elliptic cornered top containing a tablet." The design is purely linear, the only hint of classicism found in the columnarlike reeding that relieves the front legs, stiles, and diagonal slats. The execution of the latter, most typical of New York chairmaking, is otherwise unknown in New England. However, the secondary woods and related examples with a provenance recommend Boston or one of its outlying communities, Charlestown, Dorchester Lower Mills, or Roxbury, as their place of origin.

PROVENANCE: Caroline Rogers Louder, Bangor, Maine; through her family to her granddaughter, Kate Hill (Mrs. Charles W. Turner); to her daughter, Helen H. Turner; purchased by John F. Staub (1892–1981), Bayou Bend's architect, in 1945, who donated them to Bayou Bend in 1977.

TECHNICAL NOTES: Mahogany, unidentified inlay; soft maple (seat rails), yellow-poplar (corner blocks). The crest rail tablet and the back's corner joints are further accentuated by a dark line inlay. Each vertical splat is fashioned out of a single piece of wood. The corner blocks are triangular. The decorative tacking reproduces the original pattern. On the seat rails of several chairs is written: "H. R. Hill."

RELATED EXAMPLES: Hipkiss 1941, pp. 176–77, no. 114; Randall 1965, pp. 214–15, no. 174; Sack 1969–92, vol. 2, p. 421, no. 1061. Variations

F145

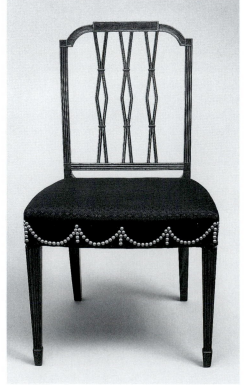

F146

include Montgomery 1966b, pp. 84–85, no. 26; Sack 1969–92, vol. 8, p. 2215, no. P5609.

F147

Pair of Side Chairs

ca. 1785–1820
Salem, Massachusetts, or possibly the
Boston area
Mahogany and secondary woods; B.69.376.1:
37 x 20⅞ x 20¼" (94 x 53 x 51.4 cm); B.69.376.2:
37 x 21 x 20¼" (94 x 53.3 x 51.4 cm)
B.69.376.1–.2

In spite of diverging political ideologies between England and the newly independent United States, American furniture continued to be largely influenced by English design. London furniture designer George Hepplewhite was among the first to popularize Neoclassicism, with his book *The Cabinet-Maker and Upholsterer's Guide* (1788), which includes the Gothic-inspired design for these side chairs.[1] The preference for carving over inlay seems characteristic of Salem, and traditionally, much of this carved furniture was attributed to Samuel McIntire (1757–1811), the celebrated wood carver and housewright. However, other locals, such as his son Samuel Field McIntire (1780–1819), Daniel Clarke (1768–1830),

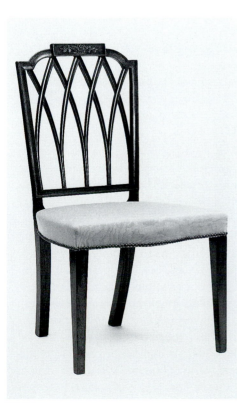

F147

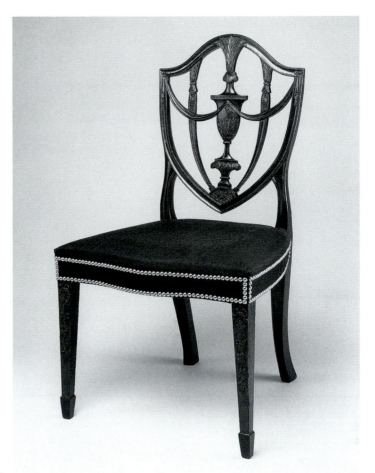

F148

and Joseph True (1785–1858), must have supplied similar work, and some of this furniture may have been produced in the Boston area as well.[2]

PROVENANCE: Purchased by Miss Hogg from Ginsburg and Levy, New York, 1953.

TECHNICAL NOTES: Mahogany; eastern white pine (corner blocks), ash (front seat rail), beech (rear seat rail), birch (side seat rails on B.69.376.1), and hard maple (side seat rails on B.69.376.2). The Gothic tracery is composed of eight interlocking components. The corner blocks are triangular.

RELATED EXAMPLES: Most closely related is Kane 1976, pp. 172–73, no. 153. This tablet was produced with carved eagles, swags, or baskets of fruit ornamenting the crest rail. Examples of the latter include Randall 1965, pp. 210–11, no. 170; Sack 1969–92, vol. 3, no. 1405; Sotheby Parke Bernet, New York, sale 4116, April 27–29, 1978, lot 1057; Clunie, Farnam, and Trent 1980, p. 32; Sack 1969–92, vol. 9, p. 2520, no. P6135; Christie's, New York, sale 6742, January 20–21, 1989, lot 700.

REFERENCES: *Antiques* 52 (August 1947), p. 85; *Antiques* 64 (October 1953), p. 296.

1. This design appears in the subsequent 1789 and 1794 editions (White 1990, p. 91). Salem

cabinetmaker Jacob Sanderson (1757–1810) owned no fewer than four copies of Hepplewhite's Guide (Swan 1934b, p. 38; Heckscher 1994, p. 198).

2. McIntire's career and the validity of the attributions are debated in Kimball 1930–31; Swan 1931a, 1931b, Swan 1932; Kimball 1932; Swan 1934a, 1934b, Swan 1957. True's position within Salem's cabinet trade is analyzed in Clunie 1977. In addition to carving, McIntire was fully cognizant of the less expensive alternative provided by composition. His estate appraisers assign a value of thirty-five dollars on "Composition Ornaments & Draws," compared with a valuation of thirty dollars assigned to "300 Chisels & Gouges" (Kimball 1957, pp. 30–31).

F148

Pair of Side Chairs

1785–99
Boston area or Salem, Massachusetts
Mahogany, ebony, and secondary woods;
B.61.92.1: 38 x 21¾ x 20⅝" (96.5 x 55.2 x 52.4 cm);
B.61.92.2: 37⅞ x 21¾ x 20½" (96.2 x 55.2 x 52.1 cm)
B.61.92.1–.2

Always an active port, by the Revolutionary period Salem enjoyed an unprecedented prosperity as a result of privateering and the blockade of Boston harbor. These factors contributed to the town's ranking in the 1790 census as the young nation's sixth in terms of population; it also boasted the highest per capita income. One of its merchants, Elias Hasket Derby, inaugurated New England's extensive and lucrative trade with China, as well as trading with Siam, Mauritius, Arabia, Madeira, and parts of Europe. No one benefited more from these mercantile successes than this savvy entrepreneur, who became America's first millionaire. The ultimate conspicuous consumer, Derby remodeled or built no less than four residences, culminating in the ambitious mansion begun in 1795 from Charles Bulfinch's designs and completed four years later under Samuel McIntire's direction.[1] The magnificent furniture commissioned for these houses represents a wealth of the most sumptuous expressions of American Neoclassicism.[2]

The design of these chairs is literally translated from George Hepplewhite's *The Cabinet-Maker and Upholsterer's Guide.*[3] The finished chair surpasses the published plate, incorporating carved grape clusters into the splat, lunette, and suspended from the bowknots at the top of each leg, trailing downward to terminate in ebony spade feet. Traditionally, this carving has been ascribed to Samuel McIntire; however, in the absence of any documented furniture carving this association is suspect if based solely on the stylistic similarity between the motifs on Salem-owned furniture and the architectural detail of McIntire's houses.[4]

Between 1784 and 1798, Samuel McIntire billed Elias Hasket Derby for a range of activities, everything from "mending garden fence" to carving furniture. This collaboration between craftsman and client has long formed the basis for ascribing these chairs and much of the Derby's furniture to McIntire's hand; however, an attribution to other craftsmen, specifically those working in the Boston area, merits serious investigation. The Derby accounts and documented furniture hint at this possibility, specifying that many of Elias Hasket Derby's important commissions were carried out by Boston craftsmen, such as the cabinetmakers John Cogswell

(1738–1818) and Stephen Badlam (1751–1815) and the carvers John (1746–1800) and Simeon Skillin, Jr. (1757–1806), as well as their apprentice John Richardson.[5]

PROVENANCE: Purchased by Miss Hogg from Ginsburg and Levy, New York, 1961, who noted that the chairs were acquired from Richardson Morris, although how they came into his possession has not been established.

TECHNICAL NOTES: Mahogany, ebony (feet); eastern white pine (corner blocks), ash (front and side seat rails), soft maple (rear seat rail). The chair backs are composed of twelve elements: the crest rail, the three vertical splats, the four separate segments of the swags between the splats, the stiles, and the two-part stay rail. The corners have large, triangular blocks. The nonintrusive upholstery reproduces the original tacking scheme.

RELATED EXAMPLES: Originally a set of eight chairs, the Bayou Bend pair descended with one recorded in Davidson and Stillinger 1985, p. 139. The others are Hipkiss 1941, pp. 154–55, no. 91; Randall 1965, pp. 203, 205, 207, no. 165; Montgomery 1966b, pp. 75–77, no. 14; Flanigan 1986, pp. 106–7, no. 34; Sack 1993, p. 58. In addition, these chairs, excluding the Bayou Bend examples, have been published in Kimball 1930–31, part 3, p. 30; Karolik 1947, pp. 47–49, nos. VI, VII; Sack 1950, p. 53; Comstock 1962, no. 426; Tracy et al. 1976, no. 35; Kirk 1982, p. 287, no. 1060; Heckscher 1994, p. 198. Later generations of the Derby family commissioned copies, some by the twentieth-century Boston cabinetmaker Isidor Braverman (Parke-Bernet, New York, sale 1181, October 7, 1950, lot 132; Ward 1977, p. 76, no. 98). Two other groups of chairs based on this design are Hipkiss 1941, pp. 154–55, no. 90; Randall 1965, pp. 203–4, no. 164; Bishop 1972, p. 242, no. 357; Naeve 1978, pp. 20–21, no. 24; and Fales 1965, no. 61; Levy Gallery 1988b, p. 160; Northeast Auctions, November 5, 1995, lot 425.

REFERENCES: Warren 1966, p. 813; Warren 1971a, p. 46, no. 15; Warren 1975, p. 77, no. 139; Agee et al. 1981, p. 89, no. 155; Marzio et al. 1989, pp. 248–49.

1. Thomas and Ward 1989.
2. Swan 1931b; Hipkiss 1941, pp. 74–75, 120–21, 134–35, 154–57, 168–69, 182–83, 204, nos. 41, 64, 74, 75, 90–92, 106, 120, 136; Montgomery 1966b, pp. 75–79, nos. 14–18; Davidson and Stillinger 1985, p. 63.
3. This design appears in all three editions of Hepplewhite (White 1990, p. 86, pl. 2).
4. See cat. no. F147, n. 2.
5. Fairbanks et al. 1991, p. 36, no. 9; Ward 1988, pp. 171–77, no. 82.

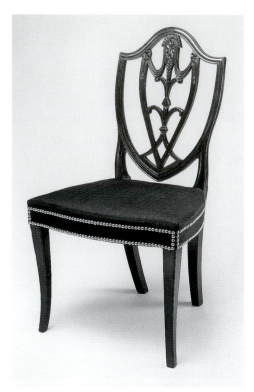

F149

(detail of label)

F149

Pair of Side Chairs

1800
Shop of John Townsend (1732/33–1809),
Newport[1]
Mahogany and secondary woods; B.66.11.1:
38½ x 21⅜ x 21" (97.8 x 54.3 x 53.3 cm); B.66.11.2:
38⅜ x 21⅜ x 20½" (97.5 x 54.3 x 52.1 cm)
B.66.11.1–.2

During the 1790s, Newport cabinetmaker John Townsend began to espouse the Neoclassical idiom while continuing to fashion block-front and Marlborough-legged furniture. His labeled work in this style evinces a direct influence from New York cabinetwork. The pattern of these chairs, for example, which does not appear in any published source, seems to come from England, undoubtedly derived from an import, but probably by way of New York. In addition to the design, the seat construction, with its medial braces, imitates New York examples. These side chairs, the latest documented work by

John Townsend, present a notable conclusion to his remarkable career.

PROVENANCE: Admiral Stephen B. Luce (1827–1917), Newport; [H. Grossman, Boston]; purchased by Miss Hogg from John S. Walton, New York, 1966.

TECHNICAL NOTES: Mahogany; birch (seat rails), soft maple (medial braces), eastern white pine, poplar (corner blocks). There are quarter-round blocks between the medial braces, with no evidence of others. The back comprises a stay rail, integral banister, two stiles, and serpentine crest rail. Fragments of original horsehair upholstery support George Hepplewhite's contention, "Mahogany chairs should have seats of horse hair, plain, striped, checquered, &c. at pleasure. . . ."[2] The decorative tacking scheme has been reproduced. A brace is penciled 20. The rear seat rails are labeled: "Made by John Townsend/Newport 1800."

RELATED EXAMPLES: Originally a group of four. No other chairs of this design are attributed to Townsend's shop. Similar examples include *Antiques* 59 (March 1951), p. 165; Rice 1962, p. 50; Montgomery 1966b, pp. 107–8, no. 53; Monkhouse and Michie 1986, pp. 178–79, no. 121; Scherer 1988, p. 13. This pattern appears on New York cabinetmaker Elbert Anderson's label (Sotheby's, New York, sale 5357, June 27–28, 1985, lot 429).

REFERENCES: Ott 1968; Bishop 1972, p. 262, no. 398; Warren 1975, p. 77, no. 141; Ott 1975, p. 941; Cooper 1980, pp. 22, 28; Moses 1984, pp. 13–14, 56, 69, 99–100; Monkhouse and Michie 1986, pp. 178–79, no. 121.

1. Act. ca. 1754–ca. 1809. See cat. no. F140.
2. Hepplewhite 1969, p. 2

F150

Pair of Armchairs

1785–1820
New York
Mahogany and secondary wood; each 39¼ x 24¼ x 19½" (99.7 x 61.6 x 49.5 cm)
B.69.375.1–.2

Thomas Sheraton authored one of the Neoclassical period's major design sources, *The Cabinet-Maker and Upholsterer's Drawing-Book* (issued in four parts between 1791 and 1794). This chair back, a composite of two designs published by Sheraton, was favored in Rhode Island and New York.[1] It represents another element in the com-

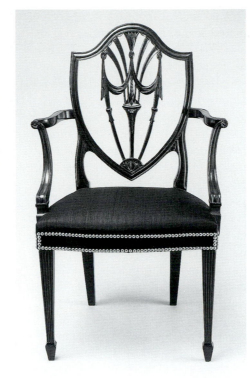

F150

plex interchange between these two geographic centers, perceptible in the design and construction of the furniture produced in both areas (see cat. F149). By this period regional preferences are increasingly difficult to discern. This homogeneity is explained by the availability of printed sources, a growing migration of artisans, and a burgeoning coastal trade. The use of ash in these armchairs is consistent with a New York origin.

PROVENANCE: Purchased by Miss Hogg from John S. Walton, New York, 1955.

TECHNICAL NOTES: Mahogany; black ash. The top of each arm is ornamented with a carved leaf. The chair backs consist of a stay rail, an integral splat, two stiles, and a crest rail. The seats were never outfitted with medial braces. The present tacking replicates the original arrangement.

RELATED EXAMPLES: Hipkiss 1941, pp. 158–59, nos. 94, 95; *Antiques* 52 (July 1947) inside front cover; Ott 1965, pp. 18–19, no. 17; *Antiques* 101 (February 1972), p. 334; Fales 1976, p. 76, no. 140; Sack 1969–92, vol. 7, pp. 2060–61, no. P5443; Monkhouse and Michie 1986, pp. 180–81, no. 123.

REFERENCES: Warren 1975, p. 79, no. 145.

1. Sheraton 1970a, appendix, pl. XXVIII.

F151

Armchair

1785–1820
New York
Mahogany and secondary woods; 39⅛ x 22½ x 19½" (99.4 x 57.2 x 49.5 cm)
B.69.384

The earliest known depiction of an American Neoclassical-style chair appears in George Shipley's 1790 advertisement for his New York shop.[1] The Bayou Bend armchair is one of a group that relates to this illustration, its popularity substantiated by the expansive range of its production, from the Boston area down to Charleston. In the south its prevalence is attributable to New York's substantial trade routes, which also extended to the West Indies, South America, and beyond. Neoclassical-style chairs enjoyed a lengthy chronological tenure as evidenced by the 1815 edition of the New York book of prices.[2]

PROVENANCE: Louis Guerineau Myers (1874–1932), New York; purchased by Miss Hogg at American Art Association, New York, 1921.

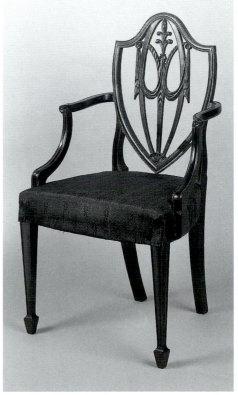

F151

TECHNICAL NOTES: Mahogany; ash (seat rails), eastern white pine (corner blocks), sweetgum (medial braces). The banister is a single element. The seat frame is constructed with two medial braces and angular rear corner blocks.

RELATED EXAMPLES: New York chairs include Hipkiss 1941, pp. 160–61, nos. 96, 97; Miller 1956, pp. 52, 54, no. 77; Gaines 1961, p. 465; Randall 1965, pp. 198, 199, 201, no. 159; Montgomery 1966b, pp. 81–82, 106, nos. 22, 50; White House 1975, p. 84; *Antiques* 114 (October 1978), p. 666; Lyle and Zimmerman 1980, p. 200; Jobe et al. 1991, pp. 215–16, no. 82; Fales 1976, p. 76, no. 139. Norfolk and Charleston examples are recorded in Kane 1976, pp. 162–63, no. 140; Hind 1979, p. 11; Hurst and Prown 1997, pp. 132–34.

REFERENCES: American Art Association, New York, February 24–26, 1921, lot 583.

1. Montgomery 1966b, pp. 101–2.
2. New York Prices 1815, pp. 77–78.

F152
Set of Four Side Chairs

1785–1820
New York
Mahogany and secondary woods: B.64.9.1, B.64.9.2: 36 x 21¼ x 19¾" (91.4 x 54 x 50.2 cm); B.64.9.3: 36 x 21½ x 21" (91.4 x 54.6 x 53.3 cm); B.64.9.4: 36 x 21½ x 20½" (91.4 x 54.6 x 52.1 cm) B.64.9.1–.4

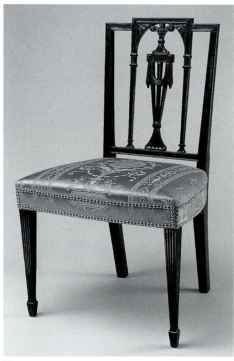

F152

One reliable form of identifying regional preferences during the Neoclassical period is through chair backs. This particular pattern, derived from Thomas Sheraton's *Drawing-Book,* must have been among the most popular in New York, judging by the number of known examples.[1] Within nine years of Sheraton's publication, the design appeared in the 1802 price book as "A Square Back Chair, No. IV." It defines the basic model, such as Bayou Bend's, as composed of "A drapery bannister, with a feather top; a splatt on each side, to form an arch with the top rail; bannister and splatts pierc'd; sweep stay and top rail, with a break in ditto; sweep seat rails, for stuffing over ditto; plain taper'd legs."[2]

PROVENANCE: Purchased by Miss Hogg from Israel Sack, New York, 1964, who noted that the chairs were from the Meyers-Peters family, Montclair, New Jersey.

TECHNICAL NOTES: Mahogany; ash (seat rails), eastern white pine (corner blocks), black cherry (medial braces). The back is composed of a crest rail, a stay rail, and three vertical splats. The seat frame is assembled with two medial braces and rounded corner blocks. Slight variations between the chairs may reflect the work of several craftsmen within the same shop, or from more than one establishment, or that the group is assembled of chairs from more than one set.

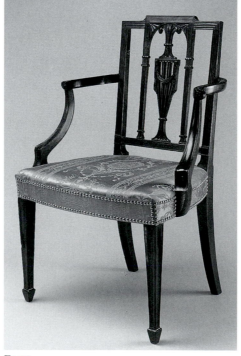

F153

RELATED EXAMPLES: New York chairs include Hipkiss 1941, pp. 170–71, no. 107; Miller 1956, pp. 57–58, no. 87, Rice 1962, p. 46; Randall 1965, pp. 214–16, no. 175; Montgomery 1966b, pp. 110–12, nos. 58, 60; White House 1975, pp. 122, 125, 146–47; Bishop 1972, p. 228, no. 327; Fales 1976, p. 77, no. 141; Kane 1976, pp. 167–68, no. 146; Butler 1983, p. 59, no. 51. Chairs documented to the shop of Norfolk, Virginia, cabinetmaker James Woodward (d. 1839) incorporate the same pattern and suggest the range of its popularity (Venable 1989, pp. 74–77, no. 35) and to the Troy partnership of Graff and Hayden at the PMA (acc. no. 1995.80.1).

REFERENCES: Warren 1975, p. 78, no. 143

1. This pattern appears in all three editions (White 1990, p. 94, pl. XXXVI).
2. Montgomery 1966b, p. 103.

F153
Pair of Armchairs and Six Side Chairs

1785–1820
New York
Mahogany and secondary woods; B.60.37.1: 37½ x 25 x 21" (95.3 x 63.5 x 53.3 cm); B.60.37.2: 37½ x 21½ x 20" (95.3 x 54.6 x 50.8 cm); B.60.37.3: 37½ x 21¾ x 20¼" (95.3 x 55.2 x 51.4 cm); B.60.37.4: 37½ x 21¾ x 19¾" (95.3 x 55.2 x 50.2 cm); B.60.37.5: 37½ x 24¾ x 20" (95.3 x 62.9 x 50.8 cm); B.60.37.6: 37½ x 21¾ x 19½" (95.3 x 55.2 x 49.5 cm); B.60.37.7: 37½ x 21½ x 19¾" (95.3 x 54.6 x 50.2 cm); B.60.37.8: 37½ x 21¾ x 19½" (95.3 x 55.2 x 49.5 cm) B.60.37.1–.8

Although derived from the same Sheraton design as the previous example (cat. no. F152), these chairs exhibit a number of subtle differences. When commissioning a piece of furniture, a client could request certain options, such as hollowed rather than reeded legs, which would affect the final price, as well as ornamental variations to suit individual taste. On the present examples, carved leaves were substituted for the plumes topping the urn. The most prominent variation is the banister's incorporation of a fourth vertical member, a more literal translation of the published design.

PROVENANCE: Purchased by Miss Hogg from Ginsburg and Levy, New York, 1960, who noted they were owned by Emily Phyfe Dunham, a great-niece of the New York cabinetmaker Duncan Phyfe, and by descent in the

Scott family. However, their style indicates that Dunham, a minimum of two generations younger than Phyfe, could not have been their original owner, which brings into question the attribution.

TECHNICAL NOTES: Mahogany; eastern white pine (corner blocks), ash (front and side seat rails, side chairs' rear seat rails), red oak (armchairs' rear seat rails), sweetgum (armchairs' medial braces), black cherry (side chairs' medial braces). Each chair has two medial braces, with construction following that of cat. no. F152. The blocks are quarter round, two part in the front and a single block in the back.

RELATED EXAMPLES: Another example in an institutional collection is Scherer 1988, p. 16.

REFERENCES: Warren 1975, p. 78, no. 144.

F154

Pair of Side Chairs

1785–1820
New York
Mahogany, holly, and secondary wood; B.92.11.1: 36 x 21⅛ x 20½″ (91.4 x 53.7 x 52.1 cm); B.92.11.2: 36 x 21¼ x 20¾″ (91.4 x 54 x 52.7 cm)
Museum purchase with funds provided by the Theta Charity Antiques Show, B.92.11.1–.2

These side chairs introduce another variation on the New York square-back design. In this instance the pattern has been skillfully interpreted by a craftsman such as Benjamin Atkinson, an "inlayer and cabinet-maker,"[1] or else it represents a collaboration between a chairmaker and inlayer. The inlays, accentuated by darkened incising, produce an arresting effect, presenting greater contrast and definition than is readily apparent in the carved version. Interpretations of the same design by a carver and by an inlayer are highly unusual and indicative of the profound contributions made by specialist craftsmen.

PROVENANCE: Purchased by Bayou Bend from F. J. Carey, III, Penllyn, Pennsylvania, 1992.

TECHNICAL NOTES: Mahogany, holly (inlays); ash (seat rails). The construction follows that of cat. no. F152. The medial braces have been removed. Only the rear, rounded, two-part corner blocks remain.

RELATED EXAMPLES: *Antiques* 28 (October 1935), p. 164; Hipkiss 1941, pp. 170–71, no. 108;

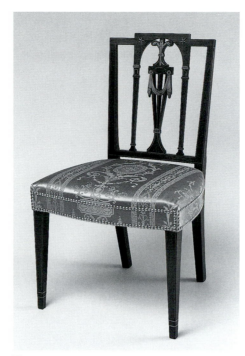

F154

Garrett 1977, p. 996. Variations in the crest rail are recorded, some plain, others suggesting an archway: Montgomery 1966b, p. 111, no. 59; Flanigan 1986, pp. 122–23, no. 42; Monkhouse and Michie 1986, pp. 179–80, no. 122; Zimmerman 1997, pp. 721, 723. In addition to being fashioned with carving or inlays, this pattern was also articulated with ornamental painting: Elder and Stokes 1987, pp. 43–45.

1. Duncan 1794, p. 8.

F155

Pair of Armchairs

1785–1820
Philadelphia
Painted yellow-poplar, mahogany, and secondary wood; B.61.43.1: 37½ x 24 x 22½″ (95.3 x 61 x 57.2 cm); B.61.43.2: 37⅞ x 24⅛ x 22½″ (96.2 x 61.3 x 57.2 cm)
B.61.43.1–.2

The Neoclassical period witnessed the reintroduction of painted furniture into formal interiors. This decoration, like inlay, was fashionable during the Late Baroque period but during the Rococo was superseded in favor of figured mahogany and rich carvings. These armchairs are unusual in Philadelphia, where the vogue for ornamental painting seems to have been restrained. In addition to their polychrome surfaces, the chairs exhibit a series of unusual elements, including the beading reminiscent of pearlwork borders on silver and the practical substitution of mahogany arms in place of painted ones.

PROVENANCE: Probably Benjamin Chew (1722–1810); possibly to his great-grandson Richard Albert Tilghman; to his wife's cousin Colonel Owen Jones (1819–1878); to the Reverend George W. McLaughlin; to his daughters Annie L. McLaughlin and Carrie V. Emery; purchased by Howard Reifsnyder; auctioned by American Art Association, New York, 1929; purchased by Miss Hogg from David Stockwell, Wilmington, Delaware, 1961.

TECHNICAL NOTES: Yellow-poplar, mahogany (arms); yellow-poplar. Microscopic examination of the chairs' surface indicates that the present paint scheme is of a later date and that much of the original decoration has been abraded.

RELATED EXAMPLES: Two examples remain at Cliveden, Germantown, Pennsylvania. See Konkle 1932, facing p. 267; Winchester 1959, p. 535; Shepherd 1976, p. 8; Hornor 1977, p. 266, pl. 430; Hendrickson 1983, p. 262. Reminiscent is a side chair illustrated in *Antiques* 103 (January 1973), p. 175.

REFERENCES: Holloway 1928, p. 111, pl. 51B; *Good Furniture Magazine* 30 (February 1928), pp. 87–88; American Art Association, Anderson Galleries, *Colonial Furniture: The Superb Collection of the Late Howard Reifsnyder,* New York, April 24–27, 1929, lot 693; *Antiques* 80 (July 1961), p. 1; Fales 1972, pp. 108–9; Warren 1975, p. 79, no. 146.

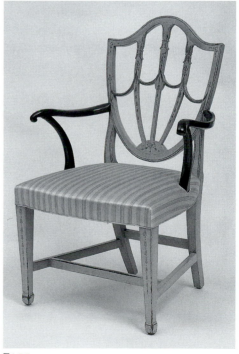

F155

Armchair

1785–1815
Philadelphia
Painted and gilded ash; 36½ x 20¾ x 20⅞"
(92.7 x 52.7 x 53 cm)
Museum purchase with funds provided by the
Theta Charity Antiques Show, B.91.51

With extensive commercial activity and its position as the young nation's capital, Philadelphia was eighteenth-century America's largest, most cosmopolitan center. English and Continental models set the fashion, as evidenced by this lavish armchair, representing one of the most ambitious collaborations by American craftsmen emulating European Neoclassicism.[1]

George Hepplewhite succinctly defined the form: *"Chairs with stuffed backs are called cabriole chairs,"*[2] while Thomas Sheraton illustrated a similar example described as "Drawing Room Chairs" with double-scooped arms and supports integral with the front legs. Sheraton explains, "These chairs are finished in white and gold or the ornaments may be japanned; but the French finish them in mahogany with gilt mouldings."[3] In spite of the obvious foreign influences, this armchair is more accurately an expression of American design and craftsmanship.

The brilliant contrast of painted and gilded decoration was introduced during the Rococo period, although in Pennsylvania this taste seems to have been confined to church furniture and looking glasses.[4] In fact, the armchair's painted, gilt, and composition decoration has some features in common with looking glasses.[5] The substitution of cast composition ornaments for carving, ubiquitous in the English cabinet trade, is highly unusual in America. Robert Adam was the first to patent composition, an amalgam of chalk, rosin, glue, and drying oil. Almost immediately it was employed by architects and housewrights for interior woodwork and, on occasion, by cabinetmakers as well. Matthew Armour, "Carpenter and Builder from London," related its advantages to Philadelphians in his 1785 advertisement: "Full enriched composition chimney pieces may be had at . . . 50 per cent cheaper than wood carving." By 1794 a local concern, Annsley & Com-

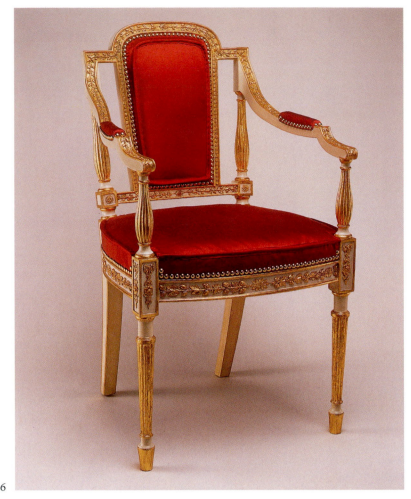

F156

pany, established the first manufactory of composition ornaments there.[6] While the source of this armchair's composition has not been identified, its exquisite ornament, with contrasting gilded and painted surfaces, must have made a lasting impression on Philadelphia's tastemakers.

PROVENANCE: Snyder family, Milford, Delaware; purchased by Bayou Bend at Christie's, New York, sale 7368, October 19, 1991, through Leigh Keno, New York. The Snyder family recounts an unsubstantiated history that the chair was part of a set made for Thomas Jefferson. Another tradition states the set belonged to Robert Morris (1734–1806).

TECHNICAL NOTES: Ash with composition applications. The arm supports are integral with the front legs. The moldings flanking the seat rail composition panels are applied. The original upholstery foundations for the seat, back, and arms remain intact. The upholstered back is framed from the rear. The tacking sequence follows the original.

RELATED EXAMPLES: Originally this armchair was one of at least eight, purportedly with a matching settee. Others from this set are published in Montgomery 1966a, p. 328; Montgomery 1966b, pp. 142–43, 145, no. 92; Davidson 1968, pp. 22–23, no. 12; Bishop 1972,

p. 215, no. 297; Fales 1972, p. 109; Butler 1973, pp. 90–91; Cooper 1980, pp. 130, 136; Sotheby's, New York, sale 4529Y, January 31, 1981, lot 1514; Passeri and Trent 1983b, pp. 1C–3C; Flanigan 1986, pp. 130–31, no. 46; *Antiques* 140 (October 1991), p. 487; *Antiques and the Arts Weekly*, November 1, 1991, p. 63; Christie's, New York, sale 7368, October 19, 1991, lots 210, 212, 213. Sands 1993; Fennimore et al. 1994, p. 69; Christie's, New York, sale 8494, October 18, 1996, lot 156. Their distinctive arms appear on only two other sets of Philadelphia furniture (Montgomery 1966b, pp. 144–45, no. 93; Fairbanks and Bates 1981, p. 241).

REFERENCES: Christie's, New York, sale 7368, October 19, 1991, lot 211, pp. 132–33; Brown and Shelton 1994.

1. The elevated status of European design and craftsmanship by comparison to America's is woefully apparent in Isaac John's advertisement: " . . . he cannot boast of an European Education, in the above business" (Prime 1969, vol. 2, p. 185).
2. Hepplewhite 1969, p. 2.
3. Sheraton 1970a, p. 387, pl. XXXII; appendix, pp. 11–12, pl. VI; "An Accompaniment," pp. 21–22, pl. X.
4. Wainwright 1964, pp. 124–25; Snyder 1975a; Heckscher and Bowman 1992, pp. 187–89.
5. Evidence of the workings between the

looking glass trade and carving and gilding is implied in the Philadelphia directories, which list James Reynolds and Charles Harford as a "carver, gilder & looking glass manufacturer" in the 1794 and 1797 editions.

6. Philadelphia newspapers and directories identify early composition retailers beginning with Matthew Armour, John Dorsey, W. Y. Birch, William Zane, and George R. Chapman (Prime 1969, vol. 1, pp. 289–90; vol. 2, pp. 316, 318–19). Besides Annsley & Co., other Philadelphia manufacturers included Freeman & Co. and William Poyntell and Co. (Prime 1969, vol. 2, pp. 316–18). The 1799 directory records John Hopkins, "celebrated razor strap and composition manufactore," and the 1801 edition first records Robert Wellford as an "ornamental composition manufacturer."

F157

Pair of Side Chairs

1805–20
Boston
Mahogany, birch, inlay, and secondary woods;
B.57.70.1: 34¼ x 19½ x 20½" (87 x 49.5 x 52.1 cm);
B.57.70.2: 34⅜ x 20 x 20⅝" (87.3 x 50.8 x 52.4 cm)
B.57.70.1–.2

These graceful side chairs, among the most refined expressions of American Neoclassicism, are also precursors of the Grecian style. Their design is modeled after one described in the 1802 *London Chair-Makers' and Carvers' Book of Prices for Workmanship,* which specifies a charge for veneering "tablets in tops" and, more importantly, records the earliest mention of scrolled backs and sprung legs, elements that clearly define the more historically correct taste.[1] The harmonious lines are accentuated by discreet inlays, passages of carving, contrasting veneers, and an interplay between positive and negative spaces.

PROVENANCE: Purchased by Miss Hogg from Maxim Karolik (1893–1963), Newport, 1957.

TECHNICAL NOTES: Mahogany, birch (veneer), unidentified inlay; birch (seat rails), soft maple (corner blocks). The rear seat rail is faced with mahogany. The back is composed of three separate horizontal rails. Four brackets compose the lower tracery, while a single piece is employed above.

RELATED EXAMPLES: *Antiques* 50 (November 1946), inside front cover; Bishop 1972, p. 250, no. 380; Kane 1976, pp. 174–75, no. 154. A number of variations exist: Hipkiss 1941,

pp. 178–79, no. 116; Montgomery 1966b, pp. 91–92, no. 38; Tracy et al. 1970, n.p., no. 14; Flanigan 1986, pp. 132–35, nos. 47–48. This pattern was also adapted for settees: Montgomery 1966b, pp. 90–93, nos. 37, 39.

REFERENCES: Warren 1975, p. 78, no. 142.

1. London 1802, p. 39. Similar elements appear in Sheraton 1970b, vol. 1, pl. 3.

F158

Lolling Chair

1785–1825
New England
Mahogany, black cherry, and secondary woods;
45⅜ x 26 x 28¾" (115.3 x 66 x 73 cm)
B.69.369

The Neoclassical lolling chair is a singular form of American seating furniture produced only in New England. It evolved from Late Baroque and Rococo examples, often retaining the serpentine crest rail and set-back arm supports, but its overall proportions lack the breadth of its predecessors. The form was updated simply by the substitution of tapered or turned legs,

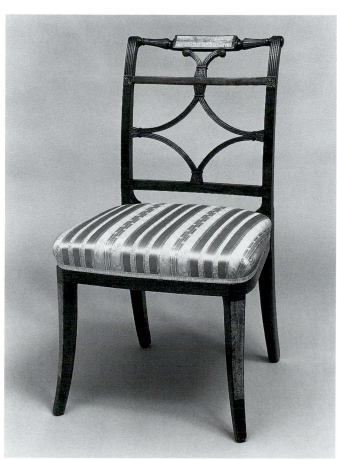

F157

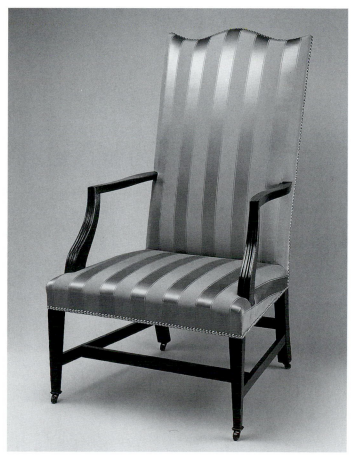

F158

arm supports extending to meet the front legs, and unupholstered wooden armrests. Here the unusual coupling of mahogany arms with mahoganized black cherry legs and stretchers prompts a rural attribution.

PROVENANCE: See cat. no. F151.

TECHNICAL NOTES: Mahogany (medial stretcher, arms), black cherry (legs, side and back stretchers, originally stained to resemble mahogany); soft maple (right seat rail), ash (remaining seat rails). The back frame was not sampled. The original tacking pattern is reproduced.

RELATED EXAMPLES: The arm supports are reminiscent of those for a chair in Montgomery 1966b, p. 158, no. 107.

REFERENCES: American Art Association, New York, February 24–26, 1921, lot 627; Warren 1975, p. 79, no. 147.

F159

Lolling Chair

1810–25
Portsmouth, New Hampshire
Mahogany, birch, and secondary woods;
44½ x 25¾ x 29″ (113 x 65.4 x 73.7 cm)
B.69.128

The term "lolling chair" suggests an informal piece of seating furniture for repose. This impression, however, is belied by its domestic placement and implied expense; contemporary inventories typically record them as pairs and confirm their use in both parlors and bedchambers. This superb chair, with its contrasting birch veneers, sinuous arms, and delicately turned legs and arm supports, the latter essentially a mirror image, belongs to a distinguished group assigned to Portsmouth.

PROVENANCE: Herbert Lawton, Boston; [Israel Sack, New York]; [Ginsburg and Levy, New York, 1945]; purchased by Ellerton Jette; purchased by Miss Hogg from John S. Walton, New York, 1954.

TECHNICAL NOTES: Mahogany, birch (veneers); birch (seat rails), eastern white pine (corner blocks). Rear legs spliced to stiles. Triangular corner blocks. The present upholstery reproduces the original tacking.

RELATED EXAMPLES: Montgomery and Kane 1976, pp. 178, 298–99, no. 132; Flanigan 1986, pp. 142–43, no. 52; Jobe et al. 1991, pp. 219–20, no. 84; Jobe et al. 1993, pp. 367–72, nos. 102, 102A, 103, 103A, 103B. Related also are a group of sofas: Montgomery 1966b, pp. 303–4, 306–7, nos. 268, 271, 272; Garvin, Garvin, and Page 1979, pp. 40–41, no. 10; Jobe et al. 1993, pp. 378–81, nos. 105, 106, 106B.

REFERENCES: *Antiques* 47 (April 1945), p. 199; Stoneman 1959, p. 321, no. 218; Warren 1975, p. 80, no. 148.

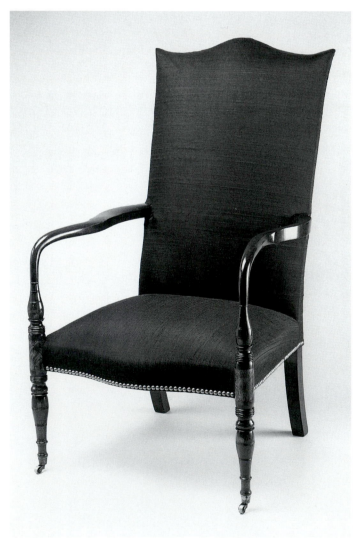

F159

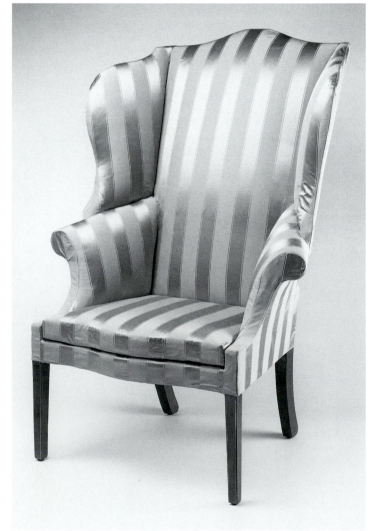

F160

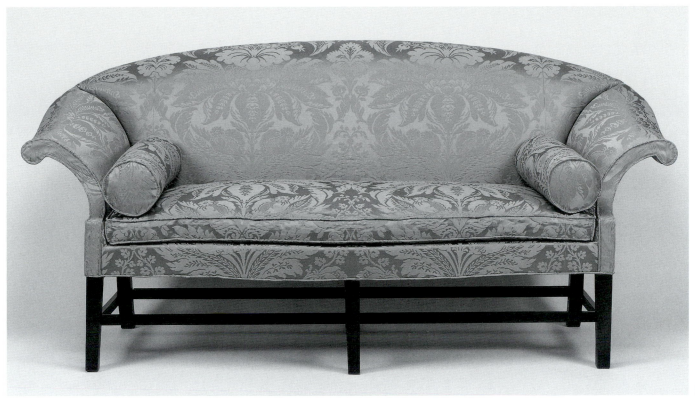

F160

Easy Chair

1785–1820
Baltimore or possibly Philadelphia
Mahogany, inlay, and secondary woods;
50⅛ x 34¾ x 30½" (127.3 x 88.3 x 77.5 cm)
B.60.93

The Neoclassical easy chair was fashioned with either a "square" back, such as this example, or else in a brand new form appropriately described as "circular," its back assuming a cylindrical contour. In another evolutionary change, the wings were fabricated and upholstered as separate units, resting on the horizontally rolled arms. In Maryland the arms were oriented downward, like a Rococo-style sofa, thereby providing a more natural support. By the post-Revolutionary period the practice of outfitting an easy chair with a closestool, or chamber pot, became more prevalent. Perhaps this change can be explained by the declining fashion of the roundabout chair, the form previously used in this capacity.

PROVENANCE: Purchased by Miss Hogg from David Stockwell, Wilmington, Delaware, 1961.

TECHNICAL NOTES: Mahogany, unidentified inlay; ash (seat rails), eastern white pine (lower back rail, top strip of inside rail),

yellow-poplar (middle and lower strips of inside rail, element behind cove), red oak (arm supports). Battens remain for the chamber pot deck. Some original upholstery foundation survives. The tacking evidence indicates that the chair was intended to be slipcovered, corresponding to George Hepplewhite's recommendation that an easy chair be upholstered in "leather, horse-hair; or have a linen case to fit over the canvas stuffing as is most usual and convenient" (Hepplewhite 1969, p. 3).

RELATED EXAMPLES: Elder 1992, p. 835.

REFERENCES: Warren 1975, p. 80, no. 149.

F161

Sofa

1785–1820
New York area
Mahogany and secondary woods; 38½ x
79⅞ x 29" (97.8 x 202.9 x 73.7 cm)
B.69.37

Throughout the colonial period the sofa was a costly and rare domestic form. Although craftsmen began to produce it more often during the late eighteenth century, it remained an uncommon type of seating furniture. Regarding a sofa's dimensions, George Hepplewhite advised, "[they] vary according to the size of the room and pleasure of the purchaser. The following is the proportion in general use:

length between 6 and 7 feet, depth about 30 inches, height of the seat frame 14 inches: total height in back 3 feet 1 inch."[1] During the Neoclassical period, the sofa frame's contours dramatically evolved. Some, like this example, display subtle changes from their predecessors, and others introduce a variety of new shapes. The Bayou Bend sofa belongs to a small group identified with the New York area. While it retains Rococo elements, the overall shape is reminiscent of a Hepplewhite design that successfully integrates Neoclassical motifs, notably, the combination of its Rococo-derived flared arms and the classically inspired arched back and tapered legs.[2] These features realize a design that is both cohesive and unique.

PROVENANCE: See cat. no. F151.

TECHNICAL NOTES: Mahogany; birch (seat rails), eastern white pine (back medial stile, crest rail). The back retains its original sacking.

RELATED EXAMPLES: The sofa is constructed in the same manner as the one illustrated in Levy Gallery 1986, p. 72. Another example is Blackburn 1976, p. 70, no. 40.

REFERENCES: American Art Association, New York, February 24–26, 1921, lot 691.

1. Hepplewhite 1969, pp. 4–5.
2. Hepplewhite 1969, pl. 22, and in both earlier editions.

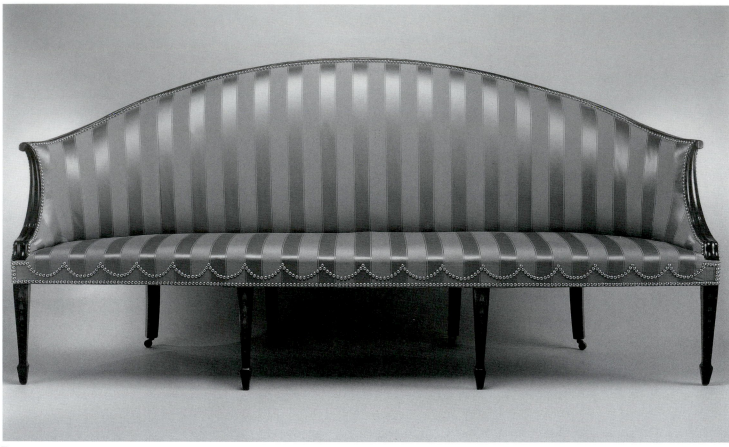

F162

F162

Cabriole Sofa

1785–1820
New York
Mahogany, inlay, and secondary woods;
38⅝ x 83⅜ x 26" (98.1 x 212.4 x 66 cm)
B.61.13

The cabriole sofa, with its arms and back merged into an elegant, sweeping contour, fully embodies the harmonious aesthetics of Neoclassicism. Its descriptive name, *cabriole,* referring to its curvilinear contour, is found in pattern and price books. In America this form is uncommon, undoubtedly due to its vulnerable structure and the high cost of fabricating such a complex shape. In New York the cabriole sofa is first recorded in the 1796 price book and then in subsequent editions through 1815. The New York sofas are distinctive for their graceful lines and outward flaring arms.

PROVENANCE: Purchased by Miss Hogg from Ginsburg and Levy, New York, 1961.

TECHNICAL NOTES: Mahogany, unidentified inlay; hard maple (cross brace), ash (seat rails,

seat rail braces). The molded arm supports are integral with the legs. The crest rail is supported by two banisters, and two large medial braces are dovetailed into the rails. Fragments of original horsehair upholstery survive, and the tacking sequence is reproduced.

RELATED EXAMPLES: Singleton 1901, vol. 2, facing p. 466; *Antiques* 10 (November 1926), p. 391; *Antiques* 54 (September 1948), p. 129; *Antiques* 72 (October 1957), p. 284; Winchester 1957a, p. 153; Montgomery 1966b, pp. 300–301, no. 265; White House 1975, p. 83; Bishop 1972, p. 271, no. 419; *Antiques* 111 (February 1977), p. 225; *Antiques* 135 (March 1989), p. 557.

REFERENCES: Warren 1975, p. 80, no. 150.

F163

Square Sofa

1790–1820
Salem, Massachusetts, or possibly the Boston area
Mahogany and secondary woods; 34⅜ x 76⅜ x 31¼" (87.3 x 194 x 79.4 cm)
B.56.172

Cabriole and square are the two principal sofa variations introduced during the Neoclassical era. In all likelihood Thomas Sheraton's closely related design incorporating a new element, the freestanding arm support, provided the model for this version.[1] One of the most literal American translations of Sheraton's design, this sofa is traditionally assigned to Salem. Its distinctive carved rails, composed of swags and vines setting off a bountiful fruit basket, relate to other profusely carved furniture habitually attributed to Samuel McIntire (1757–1811). In 1802 and 1803 McIntire billed Jacob Sanderson for "Carving Sofa & working top rail"; however, neither the carving on the Bayou Bend sofa—or any other—can be documented, and a comparison of similar examples indicates the hand of more than one carver.[2]

PROVENANCE: Possibly Guy Warren Walker, Beverly, Massachusetts; purchased by Miss Hogg from Israel Sack, New York, 1956.

TECHNICAL NOTES: Mahogany; eastern white pine (seat blocks), spruce (upholstery rails), birch (seat rails, back seat frame and rails). Front and rear legs are not aligned.

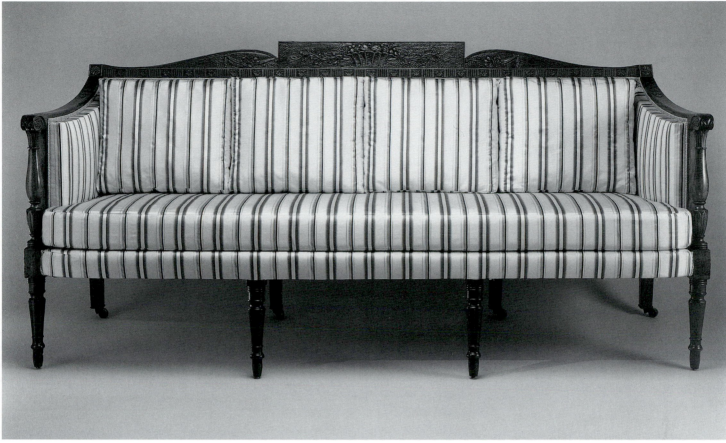

F163

RELATED EXAMPLES: The only documented sofa of this type is from Nehemiah Adams's (1769–1840) Salem shop (Clunie 1977, p. 1013). Similar examples have a crest rail worked with arrows, corresponding to Sheraton's design (Hipkiss 1941, pp. 186–87, no. 122), an eagle (examples include the documented Adams-Foster sofa cited above; Montgomery 1966b, p. 305, no. 270; Davidson and Stillinger 1985, pp. 138–39; *Antiques* 151 [January 1997], p. 151) or a basket of fruit (the most prevalent; the principal subgroup can be seen in Hipkiss 1941, pp. 184–85, no. 121; Montgomery 1966b, pp. 304–5, no. 269; *Antiques* 95 [January 1969], p. 12; Kane 1976, pp. 242–44, no. 227; Sack 1969–92, vol. 8, pp. 2264–65, no. P5729; *Antiques* 146 [November 1994]; Warren 1996, p. 730). A sofa catalogued in Kane 1976, pp. 240–42, no. 226, has similar carving but is oriented differently. The Bayou Bend sofa's rail is distinct from those cited, the composition being more centered so that the fruit does not appear compressed.

REFERENCES: Sack 1950, p. 231; *Antiques* 57 (April 1950), p. 235; Comstock 1962, no. 528; Garrett et al. 1969, p. 291; Bishop 1972, p. 246, no. 369; Butler 1973, p. 101, Warren 1975, p. 81, no. 151; Warren 1993, p. 333, 336.

1. Sheraton 1970a, p. 388, pl. 35. He recommends, "These are done in white and gold, or japanned. The loose cushions at the back

are generally made to fill the whole length, which would have taken four; but I could not make the design so striking with four, because they would not have been distinguished from the back of the sofa by a common observer. These cushions serve at times for bolsters, being placed against the arms to loll against. The seat is stuffed up in front about three inches high above the rail, denoted by the figure of the sprig running longways; all above that is a squab, which may be taken off occasionally. If the top rail be thought to have too much work, it can be finished in a straight rail, as the design shews."

2. Swan 1957, p. 93. See also cat. nos. F147, F148.

F164

Bellows

1785–1815
New York
Mahogany, inlay, and secondary wood; closed:
20⅝ x 9 x 1½″ (52.4 x 22.9 x 3.8 cm)
Museum purchase with funds provided by the Gulf Coast Chapter of the American Society of Interior Designers, B.83.1

Newspapers confirm the use of bellows by smiths and other artisans as well as domestically. In New York as early as 1726 William Fletcher, a brush maker, advertised making and mending bellows.[1] Eventually specialists, such as John Covil, and small manufactories came to domi-

F164

nate the craft.[2] These bellows are noteworthy for their complex inlays, patterns believed to have been fabricated by specialists in America, or possibly in England for export.[3]

PROVENANCE: Purchased by Bayou Bend from Israel Sack, New York, 1983.

TECHNICAL NOTES: Mahogany, unidentified inlay; white oak (clappers).

RELATED EXAMPLES: Carved bellows are catalogued in Montgomery 1966b, pp. 428–29, nos. 429, 430. No other inlaid bellows attributable to America are published. Similar marquetry inlays, perhaps representing the passionflower, appear on a number of Neoclassical looking glasses of a type unique to New York: *Antiques* 102 (November 1972), p. 727; Fales 1976, p. 278; Sack 1969–92, vol. 6, p. 1507, no. P4584; *Antiques* 143 (May 1993), p. 637; Christie's, New York, sale 8082, January 27–28, 1995, lot 1160.

REFERENCES: Bellows 1983, p. 78, no. 3.

1. Gottesman 1938, p. 334.
2. Longworth 1798, n.p.; Gottesman 1965, p. 386; *Antiques* 115 (February 1979), p. 370.
3. English pictoral inlays were advertised by Robert Courtney and Richard Wevill (Prime 1969, vol. 2, pp. 209, 230), and C. Brenneysen (Gottesman 1954, p. 136).

F165

Fire Screen

1785–1820
Boston area or Essex County, Massachusetts
Mahogany and inlay; 57½ x 19¼ x 16⅝″
(146.1 x 48.9 x 42.2 cm)
B.61.77

The Bayou Bend fire screen is doubly atypical, first, in having wooden rather than framed textile or paper panels, and second, for an accompanying folding shelf, an addition that corresponds to the "fire Screen with a leaf to sett candlestick on," charged by Salem cabinetmaker Jacob Sanderson in 1802.[1] Its pictorial marquetry inlay of shells appears on a variety of furniture forms, largely of eastern Massachusetts origin.[2] The presence of similar inlays on New York and Baltimore card tables raises the possibility of a common English origin.[3]

PROVENANCE: Purchased by Miss Hogg from John S. Walton, New York, 1961.

TECHNICAL NOTES: Mahogany, unidentified inlay. The legs are secured with an iron brace; the T-shaped bracket is held in place by an attached support. The screen appears to retain its original hardware.

RELATED EXAMPLES: Comstock 1965, no. 545, purportedly made by Thomas Hodgkins; *Antiques* 63 (March 1953), p. 171; Montgomery 1966b, pp. 246–47, no. 203; Sack 1969–92, vol. 4, p. 1017, no. P3820; *Antiques* 117 (March 1980), p. 458. Candlestands with comparable turnings include Swan 1945, pp. 223–24; Sack 1969–92, vol. 2, p. 305, no. 744.

REFERENCES: Warren 1975, p. 83, no. 158.

1. Swan 1934b, p. 20.
2. The shelf's inlay may represent a *Tibia insulaechorab,* identified by Johann Heinrich Röding in 1798, and the screen's possibly a *Harpa ventricosa.* Sandon 1992, may be relevant to the production of shell inlay.
3. Furniture exhibiting these inlays include Stoneman 1959, p. 209, no. 124; Montgomery 1966b, pp. 262–64, no. 215; Fairbanks

F165

and Bates 1981, p. 230; Hewitt, Kane, and Ward 1982, pp. 79, 126–27, no. 10; Hewitt 1982, pp. 1168, 1171; *Antiques* 136 (September 1989), p. 604. Hewitt also records unpublished Boston card tables at MFA, Boston (acc. no. 1971.423), and the Museum of the City of New York (acc. no. 60.103.19).

F166

Stand

1785–1850
Connecticut River Valley
Black cherry, inlay, and secondary wood;
27⅞ x 16½ x 19⅜″ (70.8 x 41.9 x 49.2 cm)
B.69.373

An urn-shaped columnar support and stringing divulges this stand's classical inspiration, while the drawer, spanning the width of the top and opening front and back, bespeaks its Connecticut Valley origin. The addition of an attached rim is a practical feature that corresponds to earlier tea tables.[1]

PROVENANCE: Noah Callender; purchased by Miss Hogg from Teina Baumstone, New York, 1954.

TECHNICAL NOTES: Black cherry, unidentified inlay; eastern white pine (drawer bottom and sides), cherry. The D-shaped bracket supporting the top is beautifully finished with chamfered ends. The drawer evinces the same workmanship, its bottom flush with the sides.

F166

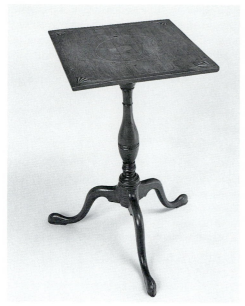

F167

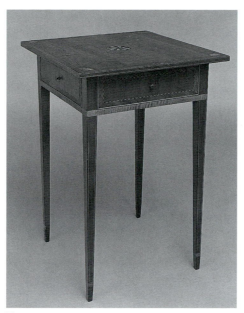

F168

real and three sham drawers, combine to make this object whimsical as well as functional.

PROVENANCE: Unknown.

TECHNICAL NOTES: Black cherry, unidentified inlay; eastern white pine. The top is secured by screws and blocks. All four cast brass pulls are original.

RELATED EXAMPLES: Similar in concept is Montgomery 1966b, pp. 402–3, no. 398. The Bayou Bend table's inlaid top is reminiscent of a card table labeled by John Dunlap II (Barquist, Garrett, and Ward 1992, pp. 176–78, no. 80), as well as of cat no. F167.

REFERENCES: Warren 1975, p. 84, no. 160.

Penciled on the underside of the top is: "Noah Callender's Stand."

RELATED EXAMPLES: Sack 1969–92, vol. 4, p. 884, no. P3561; Sack 1969–92, vol. 7, p. 1846, P5130; Ward and Hosley 1985, p. 258, no. 146.

REFERENCES: Warren 1975, p. 83, no. 159.

1. Sweeney 1988, pp. 277–78.

F167

Stand

1785–1850
New England or New York State
Black cherry and inlay; 26⅞ x 16½ x 20″
(68.3 x 41.9 x 50.8 cm)
B.69.368

The design and material of this stand suggest that it is the product of a rural cabinet shop. Black cherry was often stained to approximate the appearance of mahogany, a wood not readily available to the rural craftsman. In this instance an earlier shape was updated with the introduction of inlay. Its cabriole supports, terminating in a so-called snake foot, are elements usually associated with eighteenth-century furniture; however, their enduring fashionability is confirmed by the 1834 New York book of prices.[1]

PROVENANCE: Unknown.

TECHNICAL NOTES: Black cherry, unidentified inlay. Iron strips secure the legs to the

column. The two-board top is screwed to the columnar bracket.

RELATED EXAMPLES: *Antiques* 82 (November 1962), p. 486; Ginsburg 1974, p. 1109; Sack 1969–92, vol. 4, p. 1045, no. P3817; Sack 1969–92, vol. 7, p. 1846, no. P5130, vol. 6, p. 2282, no. P5744; Barquist, Garrett, and Ward 1992, pp. 74–76, no. 6; Christie's, New York, sale 7710, June 23, 1993, lot 155. The stand's inlaid top is reminiscent of a card table labeled by John Dunlap II (1784–1869) of Antrim, New Hampshire (Barquist, Garrett, and Ward 1992, pp. 176–78, no. 80). See also cat. no. F168.

1. New York Prices 1834, pl. 2, no. 4.

F168

Work Table

1785–1830
Massachusetts or New Hampshire
Black cherry, inlay, and secondary wood;
25⅜ x 17⅝ x 17¼″ (64.5 x 44.8 x 43.8 cm)
B.69.127

Diminutive four-legged tables, a more costly variation on the earlier tripod stands, were introduced during the Neoclassical period. They were used for drawing, writing, gaming, or as a candlestand. A ubiquitous form, the legs of the Bayou Bend table terminate in a pointed double taper, a motif specific to its regional origin. Abundant inlays and the illusory treatment of the sides, composed of one

F169

Work Table

1800–1820
Boston or Salem, Massachusetts, areas
Mahogany and secondary woods; 28⅛ x
22¼ x 19″ (71.4 x 56.5 x 48.3 cm)
B.69.383

In the Neoclassical period women played an increasingly prominent role in society. One means in which this change can be perceived is through the introduction of furniture forms.[1] Of these the most novel

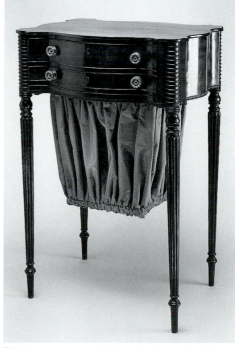

F169

is the work table, often configured with a suspended fabric-covered bag. Thomas Sheraton, referring to it as a "pouch table," explained its use "by the ladies to work at, in which bag they deposit their fancy needle work."[2] In the United States its earliest recorded appearance is in the 1795 and 1796 Philadelphia and New York price books. Contrary to their delicate stance, these tables were often put into service for games, reading, drawing, and writing. The Bayou Bend table originally incorporated a writing board with adjacent compartments for an inkwell and writing accoutrements. Work tables were fashioned in a variety of shapes; this example, with its bold serpentine sides, possesses a vigor matched by few others.

PROVENANCE: Purchased by Miss Hogg from Teina Baumstone, New York, 1954.

TECHNICAL NOTES: Mahogany, mahogany veneer; eastern white pine, mahogany (interior compartment dividers), hard maple (workbag bottom). The sides and backs are completely enclosed. The front legs are screwed to the table's sides. The top drawer retains evidence of a hinged writing board, supports, and compartments. In the back is a cover lapped over the sides and nailed. The front portion of the lower drawer consists of one rectangular compartment flanked by two square ones, presumably for writing accoutrements, as evidenced by the ink stains. Battens attached to the skirt support the workbag. The hardware is original, and the workbag's bottom may be as well.

RELATED EXAMPLES: Most closely related is Sack 1969–92, vol. 4, p. 963, no. P3709. Tables with similar turned legs include Hipkiss 1941, pp. 128–29, no. 69; Sack 1969–92, vol. 1, p. 182, no. 475; Sack 1969–92, vol. 2, p. 321, no. 801; Sack 1969–92, vol. 8, p. 2247, no. P5795; *Antiques* 135 (March 1989), p. 580. Two others are labeled by Charlestown, Massachusetts, cabinetmaker Jacob Forster (1764–1838): *Antiques* 76 (September 1959), p. 183; Sack 1969–92, vol. 2, p. 498, no. 1207.

REFERENCES: *Antiques* 65 (May 1954), p. 353; Warren 1975, p. 84, no. 161.

1. The 1654 inventory of Major-General Edward Gibbons of Boston specifies "In the Study, 1 Greene desk for a woman, 6s.," implying that on occasion, before the post-Revolutionary period, specific forms were created for women (Lyon 1925, p. 110).
2. Sheraton 1970b, vol. 2, p. 292.

F170

Work Table

1800–1830
Salem, Massachusetts
Mahogany and secondary woods; 28⅛ x 22¼ x 19¼" (71.4 x 56.5 x 48.9 cm)
B.61.97

In 1807 Samuel McIntire billed the Salem cabinetmaker Jacob Sanderson for "Reeding & Carving 4 legs for worktable."[1] Although the Bayou Bend table cannot be documented to a specific carver or cabinetmaker, it, too, provides insight into the pivotal role of specialists in the furniture trade. The benefits of this arrangement ensured efficient, high-quality workmanship and, equally important, a more cost-effective production. While the carving on this table cannot be assigned to a specific hand, the articulation of the leaves corresponds to two pieces of documented Salem furniture. While the ornament on all three is similar, their turnings vary, suggesting the participation of as many as three different turners.[2]

PROVENANCE: Purchased by Miss Hogg from Ginsburg and Levy, New York, 1961, who noted it came from the Phippen family in Salem, Massachusetts.

TECHNICAL NOTES: Mahogany; mahogany (drawer divider), northern white cedar (drawer sides), eastern white pine. The in-

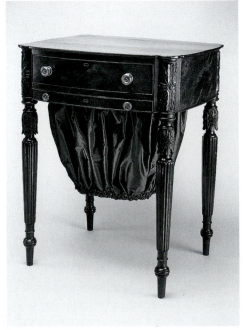

F170

terior sides are fully enclosed. The top is secured with glue blocks. The bag frame is constructed with corner brackets secured by glue blocks. The stamped brass knobs are original.

RELATED EXAMPLES: Most closely related is Sotheby's Arcade Auctions, New York, sale 1242, June 21, 1988, lot 220. Tables with related turnings include Sack 1969–92, vol. 4, p. 963, no. P3707; Sack 1969–92, vol. 8, p. 2247, no. P5795; Conger 1991, pp. 244–45, no. 154.

REFERENCES: Warren 1975, p. 84, no. 162.

1. Swan 1957, p. 94.
2. Christie's, New York, sale 5264, January 22, 1983, lot 488; Bivins 1989, p. 69, no. 37.

F171

Gaming Table

1800–1820
Salem, Massachusetts
Mahogany, inlay, and secondary wood; 30¼ x 28¼ x 19" (76.8 x 71.8 x 48.3 cm)
B.69.377

This unusual little table undoubtedly derives its inspiration from English and Continental versions.[1] It is designed so that it could be employed for a variety of purposes. The top is inlaid with a game board for checkers or chess, which can be easily removed to disclose a painted backgammon board within the interior. When no longer required for gaming, its top could be reversed, revealing an unadorned mahogany board, suitable for card games such as whist, loo, quadrille, and faro. The overall dimensions and shape also suggest that it could function as a work, side, or breakfast table.

PROVENANCE: Purchased by Miss Hogg from Ginsburg and Levy, New York, 1954.

TECHNICAL NOTES: Mahogany, unidentified inlay; eastern white pine. All four sides are finished, indicating that the table was meant to be seen in the round. The reversible top is secured by a leaf-edge tenon. Once removed it reveals a recessed area painted for backgammon with a low central divider; two more substantial dividers are at either end of the playing board. The drawer pulls appear to be ivory.

RELATED EXAMPLES: A small number of American tables with integral checker and

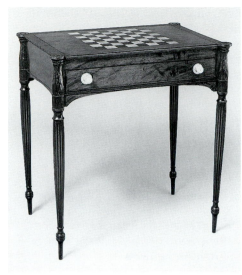

F171

backgammon boards are known: McClelland 1939, p. 190; Sack 1969–92, vol. 2, p. 316, no. 784; Sack 1969–92, vol. 5, p. 1247, no. P4100; Flanigan 1986, pp. 196–97, no. 79; Elder and Stokes 1987, pp. 128–29, no. 93. Tables with closely related components are illustrated in American Art Association, New York, February 24–26, 1921, lot 578; *Antiques* 47 (March 1945), p. 131; Montgomery 1966b, p. 363, no. 343; Sack 1969–92, vol. 1, p. 257, no. 639; *Antiques* 128 (December 1985), p. 1068; Sack 1969–92, vol. 10, p. 2695, no. P3459.

REFERENCES: Davidson 1953, p. 296; Warren 1975, pp. 82–83, no. 156; Agee et al. 1981, p. 90, no. 157.

1. Sheraton 1970b, vol. 2, pl. 59; Smith 1970a, pl. 78.

F172

Card Table

1785–1815
Rhode Island
Mahogany, inlay, and secondary woods; open: 29 x 33 x 34" (73.7 x 83.8 x 86.4 cm); closed: 29⅞ x 33 x 17" (75.9 x 83.8 x 43.2 cm)
B.57.61

Throughout the second half of the eighteenth century Rhode Island cabinetmakers and their clientele chose to retain many of the forms and motifs popular during the Late Baroque period, rarely embracing the Rococo style. An exception is the stop-fluted Marlborough leg. Even so, this Rococo element was not recorded in Newport until the mid-1780s, forty years after the Marlborough leg made its appearance in Boston.[1] Here the addition of inlay underscores the protraction of this element. By this date Providence was beginning to surpass Newport, and in all likelihood its craftsmen were making similar tables, which complicates identifying a more precise origin.[2]

PROVENANCE: Purchased by Miss Hogg from Ginsburg and Levy, New York, 1957, who noted that formerly it has been in the Nowark Collection.

TECHNICAL NOTES: Mahogany, unidentified inlay; mahogany (side rails), eastern white pine (front rail blocks, fixed back rail), birch

(hinge rail, pin). The hinge consists of five parts. There are two rear rails with spacers in-between. Large blocks back the concave sections of the front skirt. The lower half of the top has a discrete line inlay around the edge. The playing surface is completely plain. The frame carries a label with the number 15519/v-x.

RELATED EXAMPLES: Tables in museum collections include Greenlaw 1974, pp. 162–63, no. 140; Jobe and Kaye 1984, pp. 291–94, no. 70; Jobe et al. 1991, pp. 182–85, no. 68.

REFERENCES: *Antiques* 32 (December 1937), p. 284; *Antiques* 46 (August 1944), p. 61; *Antiques* 60 (November 1951), p. 361; Comstock 1962, no. 366; Warren 1975, p. 57, no. 108.

1. Heckscher 1985, pp. 167–68, no. 100.
2. Sack 1969–92, vol. 6, p. 1456, no. P4415.

F173

Card Table

1800–1820
Essex County, Massachusetts, or southern New Hampshire
Mahogany, inlay, and secondary woods; open: 29¼ x 36 x 34½" (74.3 x 91.4 x 87.6 cm); closed: 30 x 36 x 17⅜" (76.2 x 91.4 x 44.1 cm)
B.65.9

In his preface to *The Cabinet-Maker and Upholsterer's Guide*, George Hepplewhite comments that his audience included the

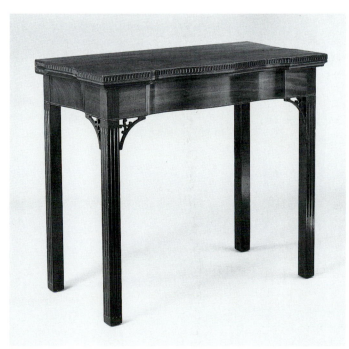

F172

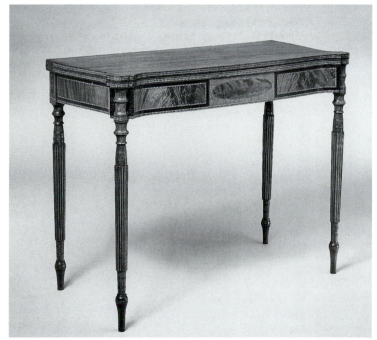

F173

"Countrymen and Artizans whose distance from the metropolis makes even an imperfect knowledge of its improvements acquired with much trouble and expence."[1] The sort of craftsman to whom Hepplewhite directed his introduction was responsible for this unconventional card table. Its pretensions to urban style are readily apparent, yet upon closer inspection, it lacks cohesiveness, its inlays are idiosyncratic, and the legs' reeding is incomplete, falling short of the ornamental turnings. In spite of these visual shortcomings, the table's sweeping serpentine facade, profuse inlays, and contrasting veneers combine to make it an ambitious piece of cabinetwork.

PROVENANCE: Purchased by "Hogg Bros" from Collings and Collings, New York, January 24, 1920. This card table is the earliest recorded acquisition for what would become the Bayou Bend Collection.

TECHNICAL NOTES: Mahogany, unidentified inlay; hard maple (hinged rail), hickory (hinge pin), eastern white pine. The rear rail consists of three adjacent components. The fly leg is attached to the back with a five-part hinge. On the back rail is inscribed: "Joel Foster's" and what appears to be "Linnell."

RELATED EXAMPLES: Stoneman 1959, pp. 218–29, nos. 132, 133; Antiques 57 (March 1965), p. 296; Sotheby's, New York, sale 4785Y, January 27–30, 1982, lot 1083; Hewitt, Kane, and Ward 1982, pp. 128–29, no. 13; Antiques 134 (September 1988), p. 385; Barquist, Garrett, and Ward 1992, pp. 184–86, no. 87; Christie's, New York, sale 7294, June 25, 1991, lot 157.

Closely related are work tables in Morse 1924, p. 151; Otto 1965, p. 43, no. 96. While visually unrelated, a card table signed in 1827 by John Dunlap II (1784–1869) of Antrim, New Hampshire, shares with them turnings similar in concept (Garvin, Garvin, and Page 1979, pp. 112–13, no. 46).

REFERENCES: Warren 1975, p. 82, no. 155.

1. Hepplewhite, 1969, n.p.

F174
Card Table

1800–1820
Philadelphia
Mahogany, inlay, and secondary woods; open: 28⅝ x 36 x 34½" (72.7 x 91.4 x 87.6 cm); closed: 29¼ x 36 x 17¼" (74.3 x 91.4 x 43.8 cm)
B.69.408

Card tables became increasingly prevalent during the post-Revolutionary years. Examples in a variety of shapes and exhibiting a range of regional idiosyncrasies exist in even greater numbers in the United States than were available in England at the time.[1] The contour of this table is unique to the Philadelphia-Baltimore region, its overall design and inlay being specific to Philadelphia. Its shape is described in the 1811 Philadelphia price book as "kidney end . . . with serpentine middle."[2]

PROVENANCE: Unknown.

TECHNICAL NOTES: Mahogany, unidentified inlay; black cherry (hinge rail), eastern white pine (lamination of front and fixed rail). The hinged rail is flush with the stationary rear rail. The table is constructed with the knuckle hinges associated with the New Jersey-Pennsylvania-Maryland region.

RELATED EXAMPLES: Nutting 1962, no. 1035; Garrett et al. 1985, p. 118, no. 118; Barquist, Garrett, and Ward 1992, pp. 213–15, nos. 109, 110.

REFERENCES: Warren 1975, p. 81, no. 153.

1. Hewitt, Kane, and Ward 1982, p. 47.
2. Pennsylvania 1811, p. 36; Hewitt, Kane, and Ward 1982, pp. 67–68.

F175
Card Table

1785–1820
Baltimore
Mahogany, satinwood, inlay, and secondary woods; open: 28⅝ x 37⅛ x 36½" (72.7 x 94.3 x 92.7 cm); closed: 29½ x 37⅛ x 18¼" (74.9 x 94.3 x 46.4 cm)
B.69.129

Card tables were intended as multifunctional domestic furniture. When the table was not used for gaming its top was folded over, in this instance revealing a pictorial inlay, so that it could function as a side or pier table. The Bayou Bend table's playing surface is fabric-covered; however, by this date most tables' interi-

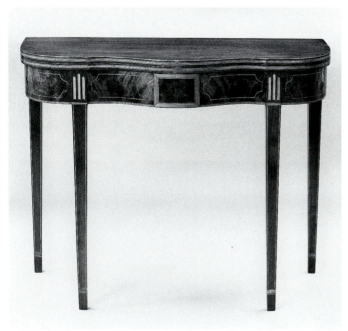

F174

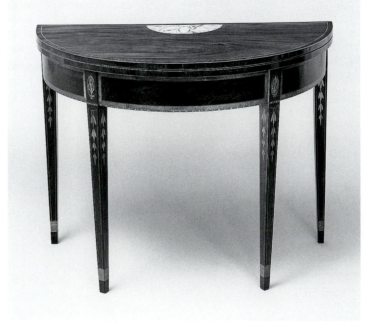

F175

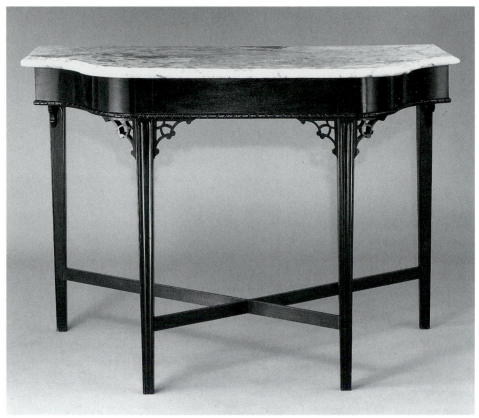

F176

ors were finished simply, the counter and candle recesses of the earlier periods no longer deemed a necessity. In contrast with Maryland furniture of the Rococo period, Maryland's Neoclassical furniture is more readily identifiable; in the Bayou Bend table, the use of veneered panels framed by contrasting bands and floral inlays, combined with regional construction practices, indicates Baltimore cabinetry.

PROVENANCE: See cat. no. F151.

TECHNICAL NOTES: Mahogany, satinwood, unidentified inlay; yellow-poplar (front rail's middle lamination), white oak (hinged back rail), hickory (hinge pin), southern yellow pine (fixed back rail, glue blocks). The cuffs are veneered on all four sides and the front and sides of each leg stile are inlaid. Typical of Baltimore, both rear legs pivot outward on five-part hinges. The skirt rails consist of four horizontal laminations, the bottom two being comparable in height to each of the others. The lower of the two larger laminants is composed of two segments. The interior back is flush with the fly legs. The hinged outer rail is screwed to the interior one. A single, leaf-edge helps secure the opened top. The playing surface corresponds to George Hepplewhite's recommendation that it be "lined with green cloth. . . ." (Hepplewhite 1969, p. 12). Under-

neath is a typed label: "641-From Auction of L.G. Myers Collection of Early American Furniture at American Art Association Rooms, February 26th, 1921. . . . This is the finest American-made table of the type that has come down to the writer's knowledge. It was found in Maryland, but is doubtless of Philadelphia origin. . . ."

RELATED EXAMPLES: Baltimore 1947, pp. 24–25, no. 1; Montgomery 1966b, pp. 325–26, no. 291; *Antiques* 91 (January 1967), p. 113.

REFERENCES: American Art Association, New York, February 24–26, 1921, lot 641; Warren 1975, p. 82, no. 154; Greenlaw 1978b, p. 16, fig. 4.

F176

Pier Table

1785–1820
Rhode Island, possibly Providence
Mahogany, hard maple, and secondary woods;
32⅜ x 45¼ x 22½" (82.2 x 114.9 x 57.2 cm)
B.69.200

In the late eighteenth century the term "pier table" came into general use, referring to the pier wall, the expanse between

two windows or doors, where these tables were positioned. Thomas Sheraton observed, "As pier tables are merely for ornament under a glass, they are generally made very light, and the style of finishing them is rich and elegant. Sometimes the tops are of solid marble. . . ."[1] Marble-topped, or slab, tables had long been popular in Rhode Island, and in this singular instance the form was reconfigured into a bold new contour, one equally suitable for the sideboard. The Bayou Bend table, with its molded legs and brackets, is a composite of the Rococo and Neoclassical styles. The complexity of establishing a precise date is underscored by a documented Marlborough-legged sofa by Adam Coe of Newport dated 1812, confirming the continued popularity of the earlier style well into the nineteenth century.[2]

PROVENANCE: Purchased by Miss Hogg from Harry Arons, Ansonia, Connecticut, 1955, who noted its descent in the Bowen family of Providence to William M. P. Bowen. Possibly made for Nathan Bowen (1729–1814) or his son Nathan II (d. 1848); to his son William Bradford Bowen (b. 1808); to his son Amos Miller Bowen (1838–1907); to his son William Manuel Perez Bowen (b. 1864).[3]

TECHNICAL NOTES: Mahogany, hard maple (stretchers); birch (back rail), eastern white pine (corner blocks). The triangular blocks in the front have fills set in-between the block and front rail; the rear blocks are replaced. The lapped cross stretchers may be replacements or perhaps a later addition to strengthen the frame. Beneath the marble top is painted "IP." over "16." Attempts to identify the initials have proved inconclusive.[4]

RELATED EXAMPLES: This is the only example of this form published; however, there is a group of related sideboards: Montgomery 1966b, pp. 372–73, no. 359; *Antiques* 90 (December 1966), p. 732; *Antiques* 118 (September 1980), p. 418.

REFERENCES: Comstock 1962, no. 386; Warren 1975, p. 59, no. 112.

1. Sheraton 1970a, appendix, p. 8.
2. Downs 1952, nos. 276, 398.
3. Rhode Island 1908, vol. 1, pp. 470–72.
4. Joseph Proud (d. ca. 1769) has been suggested, yet he is known only as a chairmaker. Providence cabinetmaker John Power was probably no longer active by this date. Another candidate is James Pittman (act. 1782).

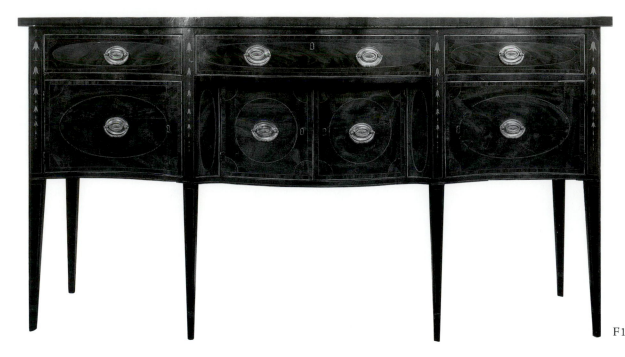

F177

F177

Sideboard

1785–1815
New York
Mahogany, inlay, and secondary woods;
40¼ x 74 x 28¼" (102.2 x 188 x 71.8 cm)
B.69.199

The sideboard was introduced during the Neoclassical period. George Hepplewhite remarked, "The great utility of this piece of furniture has procured it a very general reception; and the conveniences it affords render a dining-room incomplete without a sideboard."[1] Indeed, the sideboard proved invaluable, being used to store silver flatware, napkins, tablecloths, and spirits.

PROVENANCE: Purchased by Miss Hogg from Israel Sack, New York, 1951.

TECHNICAL NOTES: Mahogany, unidentified inlay; eastern white pine (framing boards on the underside of the top, sides, partitions, back, back section of the bottom, the left and right drawer fronts, bottoms, and blocks, the upper and lower laminations of the central drawer, drawer runners), yellow-poplar (framing on the underside of the top, drawer sides and backs, central drawer bottom, middle lamination of the drawer front), black cherry (drawer dividers, doors, bottom below the doors, and leg posts). The hardware is original.

REFERENCES: Warren 1975, p. 85, no. 164.

1. Hepplewhite 1969, p. 6.

F178

Tambour Desk

1794–1810
Attributed to the shop of John (ca. 1738–1818)
and Thomas (1771–1848) Seymour or Thomas
Seymour's Boston Furniture Warehouse,
Boston[1]
Mahogany, inlay, and secondary woods;
41⅜ x 37½ x 19½" (105.1 x 95.3 x 49.5 cm)
B.65.12

In 1797 young Harriet Clark waxed enthusiastic over a tambour desk she had seen: "Dr. Prince has a new kind of desk and I wish Papa would permit me to have one like it—the lower desk that is a parcel of drawers hid with doors made in reeds to slip back and in the middle a plain door, 'tis the handsomest thing in the kind I ever saw."[2] This new furniture form, along with the work table, attests to the increasing prominence women were assuming in American society.

The Bayou Bend desk is reminiscent of Thomas Sheraton's design for "A Lady's Cabinet and Writing Table"; however, substituted for the doors is a pair of tambour shutters that more closely correspond to the diminutive French writing table called the *bonheur du jour*.[3] Prior to the American Revolution French furniture was occasionally recorded in colonial households. Subsequently it found its way in increasing quantities through Americans returning from abroad or by emigrés fleeing the turbulence of Revolution. For

example, George Washington purchased a *bonheur du jour* from the marquise de Brehan, who accompanied the comte de Moustier to New York when he served as ambassador to the young nation.[4]

American versions of the European form were produced by cabinetmakers in New England and as far away as North Carolina, Kentucky, and Ohio. The Bayou Bend desk is similar to one labeled by the Boston cabinetmakers John and Thomas Seymour. An attribution to their shop is given further credence by the discovery of the script initials TS or JS on the lower case. Although these relationships support an attribution, they are hardly sufficient to identify a specific craftsman, considering the collaborative system then in effect. Seymour's own advertisements imply as much: ". . .Useful, and Ornamental Cabinet Furniture all made by or under the direction of Thomas Seymour."[5]

PROVENANCE: [Israel Sack, New York, 1928]; purchased by Miss Hogg from Collings and Collings, New York, 1928.

TECHNICAL NOTES: Mahogany, unidentified inlay; eastern white pine (interior framing, large drawers and bottoms of the smaller interior drawers), red oak (small interior drawers' sides and backs). The cabinet sits within a molding attached to the lower case, framed in front by the writing flap. When the flap is opened it reveals an ivory escutcheon for the cabinet. The desk retains its original enameled drawer pulls, loper pulls, and most of its interior pulls. The pigeonholes are painted blue.

On the writing section board covered by the cabinet are the boldly inscribed initials TS or JS (Brown 1997, p. 203, pl. I).

RELATED EXAMPLES: Most closely related is Warren 1996, pp. 731, 735. Similar examples include Stoneman 1959 (pp. 60–61, no. 14; Montgomery 1966b, pp. 228–29, no. 184; *Antiques* 133 (May 1988), p. 1086. The legs of the Bayou Bend desk terminate in a molded spade foot, not unlike that on a labeled Seymour card table (Flanigan 1986, pp. 178–79, no. 70).

REFERENCES: Nutting 1962, no. 655; Comstock 1962, no. 490; Warren 1966, p. 812; Davidson 1968, p. 55, no. 63; Garrett et al. 1969, pp. 289–90; Warren 1971a, p. 46, no. 16; Butler 1973, pp. 89–90, Warren 1975, p. 87, no. 168; Agee et al. 1981, pp. 89–90, no. 156; Warren 1982, p. 229; Warren 1988, pp. 42–43; Marzio et al. 1989, pp. 250–51; Brown 1997.

1. Swan 1937; Hastings 1941; Randall 1959; Randall 1962; Stoneman 1959; Stoneman 1965; Sprague 1987.
2. *Antiques* 100 (July 1971), p. 58.
3. Sheraton 1970a, pl. 50. Thomas Seymour owned a copy of the *Drawing-Book*

(Heckscher 1994, pp. 199–200). Tambour is thought to have originated in mid-eighteenth-century France. In England it was first illustrated in 1788 in Thomas Shearer's *The Cabinet-Maker's London Book of Prices*, pl. 13, fig. 2. Sheraton explains, "Tambour tables, amongst cabinet-makers, are of two sorts, one for a gentleman or lady to write at; and another for the latter to execute needlework by." He further comments, "The writing tambour tables are almost out of use at present, being both insecure, and very liable to injury. They are called tambour from the cylindrical form of their tops, which are glued up in narrow slips of mahogany, and laid upon canvas, which binds them together, and suffers them, at the same time, to yield to the motion their ends make in the curved groove in which they run, so that the top may be brought round to the front, and pushed at pleasure to the back again, when it is required to be open" (Sheraton 1970b, vol. 2, p. 316; Otto 1960).

4. Fede 1966, pp. 2, 34–37.
5. Swan 1937, p. 179.

F179

Gentleman's Secretary

1790–1820
Salem, Massachusetts
Mahogany, eastern white pine, soft maple, inlay, and secondary woods; 96⅜ x 72⅛ x 20¼"
(244.8 x 183.2 x 51.4 cm)
B.61.94

The gentleman's secretary, more commodious than the earlier desk and bookcase, also differs by having its writing desk discreetly concealed behind a fall-front sliding drawer. Thomas Sheraton published a related design and alluded to its diverse functions: "[It] is intended for standing to write at, and therefore the height is adjusted for this purpose. . . . The door on the right incloses a cupboard for a pot and slippers, and the left side contains a place for day book, ledger, and journal, for a gentlemen's own accounts."[1]

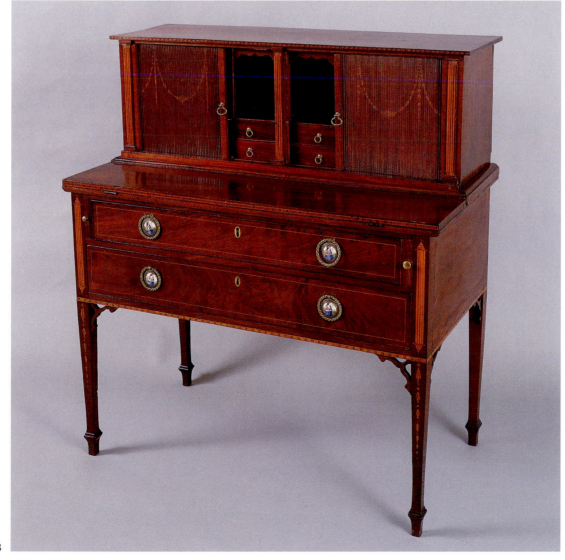

F178

An imposing and costly form, these secretaries are closely identified with Salem, where examples were locally owned as well as manufactured for export.[2]

PROVENANCE: Purchased by Miss Hogg from Ginsburg and Levy, New York, 1961, who noted that the desk came from descendants of John Peirce (1746–1814), Portsmouth, New Hampshire.[3]

TECHNICAL NOTES: Mahogany, eastern white pine (eagle), soft maple (finials), unidentified inlay; birch (finial dowels, bottom framing members), yellow-poplar (cabinet doors' core), eastern white pine (shelves, drawers, backboards, top). The bottoms of the side cabinets are framed, recessed, and secured with glue blocks. The doors have an applied backing. The cabinets' interiors have nailed horizontal supports for the shelves, two in the right and a single in the left cabinet. The top central drawer is outfitted as a desk, the front hinged to drop down and function as a writing surface. It comprises a central bank with three stacked drawers. On either side are three pigeonholes with a single, rectangular drawer above. Within the bookcase side panels create notched openings for the sliding shelves. The interior is stained red, undoubtedly to resemble mahogany. The glazing bars' pattern was derived from *The Cabinet-Maker's London Book of Prices* (1793) and is ascribed to "W. Casement," presumably a pseudonym for the designer.[4] There is no indication of hardware for the bookcase doors' curtains. The cornice is a facade backed with partitions. Two finials are replacements. The brasses appear to be original. Behind the bottom drawer is "EH Tucker 1896" and the initials HMT inscribed in pencil. The interior stacked and side drawers are numbered consecutively.

RELATED EXAMPLES: Lockwood 1913, vol. 1, pp. 201, 203; Hinckley 1953, p. 350, no. 1092; Montgomery 1966b, pp. 224–26, no. 181; Fede 1966, pp. 68, 70, no. 56; *Antiques* 119 (March 1981), p. 643; Christie's, New York, sale 6320, January 24, 1987, lot 292; Theta 1988, p. 75; Sotheby's, New York, sale 6350, October 25, 1992, lot 277; Christie's, New York, sale 8238, October 21, 1995, lot 217.

REFERENCES: Elwell 1896, pl. XXV; Warren 1975, p. 86, no. 167; Jobe et al. 1993, pp. 63–64.

1. Sheraton 1970a, pl. LII; 1970b, vol. 2, p. 303.
2. Several of these secretaries have histories to

F179

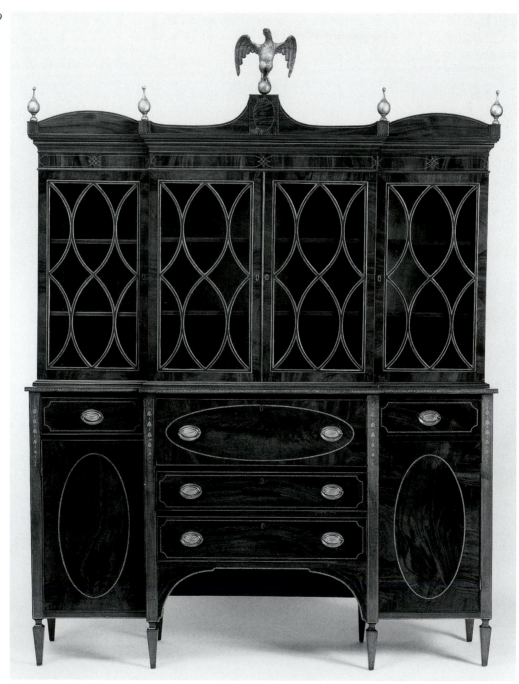

F180

F181

support their being produced for export: Kimball 1933a, pp. 162, 169, frontispiece; Montgomery 1966b, pp. 224–26, no. 181; Christie's, New York, sale 6320, January 24, 1987, lot 292.

3. In 1896 this secretary was pictured in Elwell 1896, pl. LII. An adjacent illustration is identified as Portsmouth's John Peirce house, and it has been inferred that the museum's secretary was photographed there and originally belonged to Peirce. His estate inventory does not yield a listing that can be identified as this piece (John Peirce inventory, Rockingham County probate records, old series 8909). Furthermore, Mrs. Joshua Winslow Peirce, who resided there for more than half a century after her marriage in 1911, possessed no recollection of it.

4. This pattern also appears in the 1803 edition (White 1990, p. 248, pl. 27, no. 3). It persisted and appears as late as the 1834 New York price book (New York Prices 1834, pl. VI, no. 21).

F180

Wall Cupboard

1800–1820
Virginia, possibly Shenandoah Valley
Walnut and pine; 95½ x 49¼ x 20½" (242.6 x 125.1 x 52.1 cm)
Gift of Miss Ima Hogg, B.61.117

The unusually tall proportions of this cupboard relate to those found in a group of late Rococo and Neoclassical walnut desks and bookcases made in Norfolk, Virginia. However, the exuberant and somewhat naive Neoclassical frieze ornament overlaid on what is basically a conservative eighteenth-century form suggests a rural origin. Similar inset paneled doors and frieze ornament have been found in pieces made in Rockingham County in the Shenandoah Valley. An

unusual feature of the piece is that it does not separate at midsection but, rather, is constructed entirely in one piece.

DBW

PROVENANCE: Purchased by Miss Hogg from the Charles A. MacLellan Estate, Wilmington, Delaware, 1961.

REFERENCES: Warren 1975, p. 121, no. 227.

F181

Cupboard

1800–1830
Berks County, Pennsylvania
Painted yellow-poplar; 83½ x 63 x 17⅞" (212.1 x 160.0 x 45.4 cm)
Museum purchase with funds provided by the Theta Charity Antiques Show and the Friends of Bayou Bend, B.79.287

Large cupboards or dressers, designed for the storage and display of dishes and glasswares, constituted an important standard feature of the Pennsylvania German kitchen furnishing plan. Typically, the form has closed cupboards in the lower section. While in the earlier examples the upper shelves were left open, at the end of the eighteenth century they began to be closed with glazed doors. The tripartite arrangement of the Bayou Bend piece is unusual. The basically English form, with ogee bracket feet, fielded panels, and architectural cornice, has been given both a personal touch and a Germanic flavor through the application of fanciful multicolor painted and grained decoration.

DBW

PROVENANCE: William Greenberg, Allentown, Pennsylvania; [Charlotte and Edgar Sittig, Shawnee on Delaware, Pennsylvania]; to Mitchell Taradash, Tarrytown, New York, by the late 1940s; [Israel Sack, New York]; purchased by Bayou Bend from Israel Sack, New York, 1979.

TECHNICAL NOTES: The ogee bracket feet have been cut down; the hardware is replaced.

RELATED EXAMPLES: An example from nearby Schuykill County inscribed with the date 1830 has a similar double door and central section of fixed glass (Garvan 1982, p. 31, no. 16).

REFERENCES: Sack 1969–92, vol. 6, p. 1628, no. P4727.

F182

F182

Barometer

1801–4
Probably England, possibly made or assembled in New York
Corti, Vecchio & Co. (1801–4), New York, retailers and possibly makers[1]
Mahogany, inlay, and secondary woods;
38¼ x 10 x 2¼" (97.2 x 25.4 x 5.7 cm)
B.74.10

The wheel barometer, a mid-seventeenth-century innovation, was not widely produced until the late eighteenth century, coinciding with the introduction of the banjo shape case. In America the earliest record of barometer production credits James Winthrop in about 1786.[2] Corti, Vecchio & Co. advertised that its firm made and repaired barometers, in addition to retailing looking glasses, art supplies, prints, and paintings. While it is debatable whether the company actually produced barometers, this example's similarity to English ones suggests that Corti, Vecchio & Co. imported English components and simply assembled them.

PROVENANCE: Unknown.

TECHNICAL NOTES: Mahogany veneer, unidentified inlay; spruce (frame and rear door), dogwood, probably European, possibly North American (behind the upper dial). Originally the window was fitted with a convex glass. A turned brass finial was probably intended for the pediment.

RELATED EXAMPLES: This is the only known barometer marked by Corti, Vecchio & Co. English examples are recorded in Goodison 1968, pp. 204–5; Christie's, New York, sale 6842, June 3, 1989, lot 23.

REFERENCES: Van Cott 1989, p. 228, fig. 1.

1. Paschal Corti, probably Joseph del Vecchio (d. 1815), and John Paul del Vecchio (ca. 1778–1815). Ormsbee 1944; Gottesman 1965, pp. 37–39, 56, 59, 162–65; Ring 1981, p. 1182; Van Cott 1989. The English barometer trade was dominated by a number of makers with the surnames Corti and del Vecchio. Any relationship between these individuals

and members of Corti, Vecchio & Co. has yet to be established (Goodison 1968; Banfield 1991).
2. Middleton 1968, pp. 338–53. Joseph Donegany and Joseph Gatty advertised as thermometer and barometer makers in post-Revolutionary New York (Gottesman 1954, pp. 303, 311–12).

F183

Wall Clock

1802–30
Shop of Aaron Willard, Sr. (1757–1844) or Aaron Willard, Jr. (1783–1864), Boston[1]
Gilded eastern white pine, basswood, mahogany, black cherry; 40 x 10¼ x 3⅞"
(101.6 x 26 x 9.8 cm)
Gift of Alice C. Simkins, B.79.290

America's earliest significant horological contribution is credited to Simon Willard (1753–1848), who, attempting to produce a substitute for the eight-day tall-case clock, developed a new movement and corresponding case. In 1802 he registered his "patent timepiece," popularly known today as a banjo clock. The Bayou Bend example is considered to be a presentation model. The bottom glass is painted appropriately with a representation of Aurora, the goddess of morning, being spirited away as the sun rises from behind.

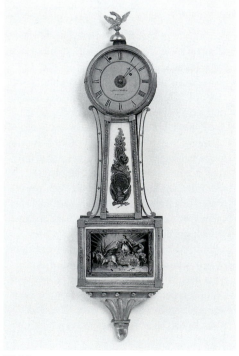

F183

PROVENANCE: Mr. and Mrs. Mike Hogg, the latter later Mrs. Harry Hanszen, Houston; to her niece, Alice C. Simkins.

TECHNICAL NOTES: Gilded eastern white pine (acorn pendant, concave support for lower case), basswood (horizontal spacer), mahogany (sides of lower case), cherry. Filister head screws hold the back plate of the recoil escapement movement to the case's backboard. The inside cut of the head is elliptical. This clock was originally outfitted with an alarm, which has since been removed. On the dial is painted: "Aaron Willard/Boston."

RELATED EXAMPLES: Sack 1969–92, vol. 1, p. 285, no. 704; Sack 1969–92, vol. 2, p. 453, no. 1127; Sack 1969–92, vol. 3, p. 770, no. P3323; Greenlaw 1974, pp. 99–100, no. 85; Sack 1969–92, vol. 7, pp. 1930–31, no. P5276; Levy Gallery 1988b, p. 204.

1. Willard 1968; Husher and Welch 1980.

F184

Pier Glass

1785–1820
England and/or the United States
Gilded spruce, eastern white pine, and
secondary materials; 61¼ x 26¾ x 8⅛″
(155.6 x 67.9 x 20.6 cm)
B.21.2

Looking glasses of this type are inspired by the elegant examples first produced in England during the 1760s. In the United States looking glasses were not fabricated in any quantity prior to the nineteenth century. Craftsmen were certainly available to take up the task, but glass manufacturers lacked the means to produce clear, smooth, silvered plates. The Bayou Bend pier glass belongs to a small group that may represent the collaboration of English and American craftsmen. Spruce and sylvestris pine, which was used as a secondary wood, are more consistent with English work; however, the presence of eastern white pine may attest to an American contribution. The pier glass may have been made in England from imported wood, or from trees that had been transplanted there. Alternatively, the glass and rectangular frame might have been made in England and, for the convenience of shipping and to avoid the possibility of damage, the ornaments were introduced in America.[1]

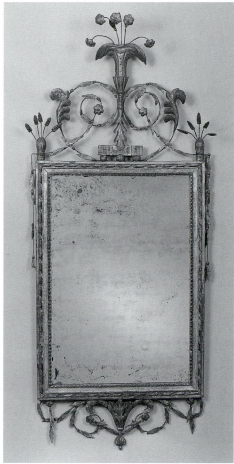

F184

PROVENANCE: Unknown.

TECHNICAL NOTES: Spruce; eastern white pine (drop stem, base scrolls, upright post, cross bar), sylvestris pine (backboards). The flowers and leaves are composition.

RELATED EXAMPLES: Only a small number of looking glasses have been microscopically analyzed. Those with a similar makeup are catalogued in Montgomery 1966b, pp. 269–71, 273–74, nos. 226, 227, 231; Rodriguez Roque 1984, pp. 260–61, no. 121; Barquist, Garrett, and Ward 1992, pp. 51, 318–19, no. 178.

1. The difficulties of establishing the origins of looking glasses are detailed in Barquist, Garrett, and Ward 1992, pp. 295–96. Thomas Sheraton, discussing the merits of eastern white pine, forewarns that by 1803 its presence can no longer be undisputed evidence of an American origin: "Within fifty years past, they have been planted in Great Britain in considerable plenty" (Sheraton 1970b, vol. 2, pp. 286–87). An overmantle looking glass at Bayou Bend (acc. no. B.69.180) that incorporates eastern white pine components is labeled by Thomas Fentham (1774–1825), a London carver, gilder, glass grinder, and picture frame maker (Beard and Gilbert 1986, p. 296).

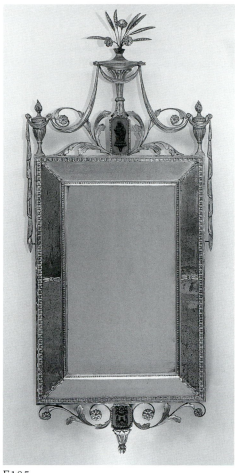

F185

F185

Pair of Pier Glasses

1785–1820
England and/or the United States
Gilded eastern white pine; B.69.386.1: 56⅛ x
23½ x 4⅛″ (142.6 x 59.7 x 10.5 cm); B.69.386.2:
55⅝ x 23½ x 4⅝″ (141.3 x 59.7 x 11.7 cm)
B.69.386.1–.2

One of the earliest published references to looking glasses in America dates to 1729, when James Foddy, recently arrived in New York, advertised "Looking Glass-Maker, late from London Hath brought a Parcel of very fine Pier Glasses. . . ."[1] The designs employed by Americans were, predictably, derived from published sources and imported glasses. The form is arguably the least understood and studied in American decorative arts. Research has not sufficiently advanced to determine regional preferences, complicating a more precise identification.[2] These superb glasses, fashioned entirely of eastern white pine, are inconclusively attributed to America or England.[3]

PROVENANCE: Purchased by Miss Hogg from Charles Woolsey Lyon, New York, 1922.

TECHNICAL NOTES: Gilded eastern white pine; composition (figures).

RELATED EXAMPLES: See cat. no. F184.

1. Gottesman 1938, p. 130.
2. Barquist, Garrett, and Ward 1992, pp. 27–36, 294–98.
3. Barquist, Garrett, and Ward 1992, p. 310.

F186

Pier Glass

1785–1820
England and / or the United States
Gilded sylvestris pine and eastern white pine;
54½ x 21¼ x 2½" (138.4 x 54 x 6.4 cm)
B.69.381

The European looking glass trade was highly organized, confronting the American craftsmen with overwhelming competition. The preponderance of these imported glasses is evidenced in the Philadelphia carver and gilder James Reynolds's advertisements: ". . . a full

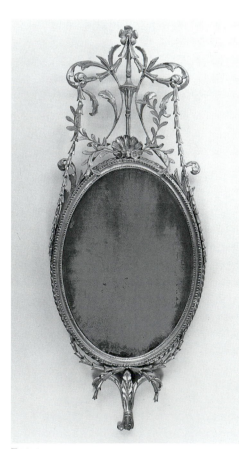

F186

assortment of Looking Glasses Imported from France, England and Germany, a great variety of sizes, in carved and gold, mahogany and gold, white or plain mahogany frames. . . . He has for sale, and makes to order, every kind of Looking Glass, acknowledged superior to any imported work. Together with picture framed House Work, and every other branch of the Carving, Gilding and Looking Glass Business, at the very lowest rates."[1]

PROVENANCE: Purchased by Miss Hogg from Charles Woolsey Lyon, New York, 1922, who noted that the looking glass was acquired from Mrs. Oddie of Massapequa, New York, and that it had descended to her late husband from William Floyd (1734–1821).

TECHNICAL NOTES: Gilded sylvestris pine (frame and backboard), eastern white pine (shell and cartouche support). The ornaments are made of composition.

RELATED EXAMPLES: See cat. no. F184.

1. Prime 1969, vol. 2, pp. 233–34.

F187

Basin Stand

1785–1820
Essex County, Massachusetts, or Portsmouth, New Hampshire
Mahogany, birch, inlay, and secondary wood;
39⅞ x 26 x 15½" (101.3 x 66 x 39.4 cm)
Museum purchase with funds provided by Mr. and Mrs. Richard J. Price, B.82.9

The basin stand was first produced in England during the 1750s and shortly thereafter in America.[1] By the 1780s the form evolved into a number of shapes, including this configuration, which George Hepplewhite deemed "a very useful shape, as it stands in a corner out of the way."[2] Both Thomas Shearer and Thomas Sheraton improved on the design by adding a higher splashboard and splayed front legs; the latter "spring forward, to keep them from tumbling over."[3] Their published plates relate to the Bayou Bend stand, one of the most pleasing American interpretations of the form.

PROVENANCE: Purchased by Bayou Bend from Israel Sack, New York, 1982.

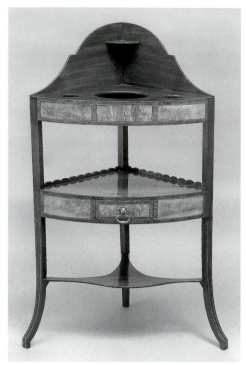

F187

TECHNICAL NOTES: Mahogany, birch (veneer; visual analysis); eastern white pine. The T-shaped shelf is constructed of two perpendicular boards joined by a concealed, lapped dovetail. The splashboard sits on the top and is dovetailed at the corner. The cast brass pull appears to be original.

RELATED EXAMPLES: Sack 1969–92, vol. 8, p. 2210, no. P5674.

REFERENCES: Sack 1969–92, vol. 7, p. 2045, no. P5338; Brown 1985, pp. 522, 524.

1. Askew 1969, pp. 258–63.
2. Hepplewhite 1969, p. 15.
3. Sheraton 1970b, p. 36. This design appeared in Hepplewhite and the 1788 edition of the London book of prices, pl. 12, fig. 1, credited to Shearer (White 1990, p. 257).

F188

Bureau

1805–20
Portsmouth, New Hampshire
Mahogany, birch, and secondary wood;
37 x 40⅛ x 21¼" (94 x 101.9 x 54 cm)
B.69.379

Thomas Sheraton describes a bureau as "in French, a small chest of drawers," a term that Americans embraced rather than the English expression "dressing

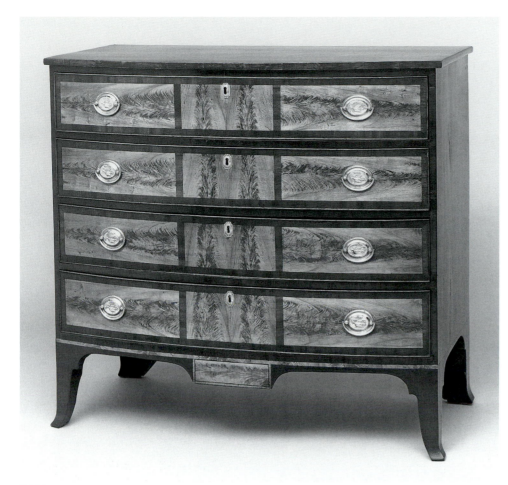

F188

the top has almost a full dust board with only a spacer near the front. The escutcheons are original, the pulls replacements.

RELATED EXAMPLES: Similar chests in museum collections include Sprague 1987, pp. 185–86, no. 98; Jobe et al. 1993, pp. 114–15, no. 11.

REFERENCES: Warren 1975, p. 85, no. 165; Jobe et al. 1993, p. 115.

1. Sheraton 1970b, vol. 1, p. 111.
2. Jobe et al. 1993, p. 122, no. 14.

F189

Commode

1800–1825
New York
Mahogany and secondary woods; 44⅜ x 48⅝ x 23⅞″ (112.7 x 123.5 x 60.6 cm)
B.69.83

This French-derived form was introduced to America during the Rococo period and, while infrequent, continued to be produced throughout the Neoclassical era.[1] The New York price books first record it in 1810 and continue to list it as

chest."[1] The bureau was produced with a variety of shaped fronts as recorded in the cabinetmakers' price books, including straight, serpentine, and, as seen here, round. The craftsmen working in New Hampshire and Maine's Piscataqua region masterfully juxtaposed mahogany and contrasting birch veneers to create one of the most visually arresting facades in American Neoclassical furniture. An added regional refinement is the characteristic drop-panel pendant.

PROVENANCE: Purchased by Miss Hogg from Israel Sack, New York, 1948.

TECHNICAL NOTES: Mahogany (veneer on feet and drawers), birch (top and sides stained to resemble mahogany, drawer fronts), birch (veneer); eastern white pine. The combination mahogany and birch as primary woods appears to be typical, as evidenced by the Portsmouth cabinetmaker Ebenezer Lord's 1827 advertisement that he makes "Mahogany Bureaus—birch ends and tops with mahogany fronts."[2] The foot blocks conform to the leg profile. The lowest drawer is flush with the bottom. The third drawer down and the top drawer receive additional support by braces attached to the back. The second drawer from

F189

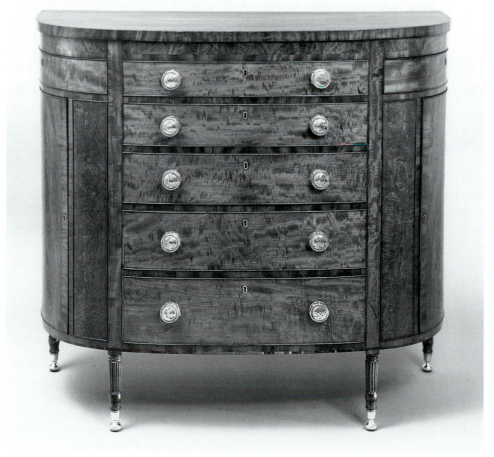

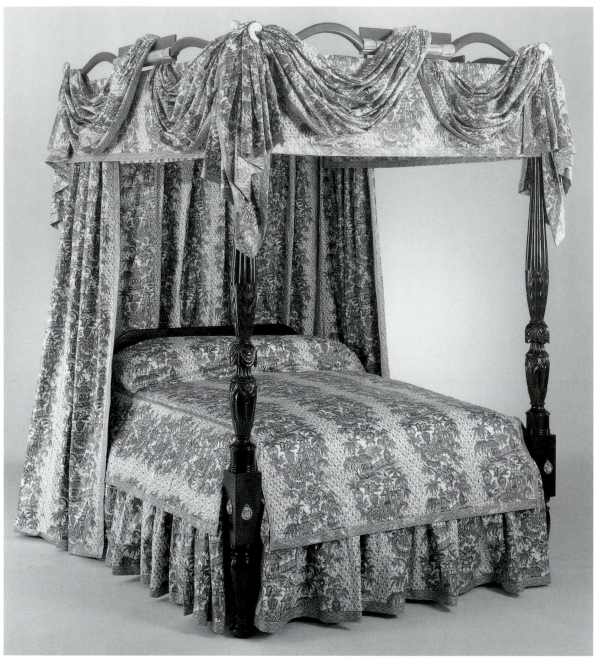

F190

late as 1834, its description "with Eliptic Ends, and Straight Middle," corresponding to the Bayou Bend example. Thomas Sheraton comments that the commode could be used in a variety of settings for distinct purposes. Some were "chiefly for ornament, to stand under a glass in a drawing room," while others were "used by ladies to dress at, in which there is a drawer fitted up with suitable conveniences for the purpose."[2] The Bayou Bend example was intended for the latter, as its top drawer is arranged for an adjustable looking glass, jewelry, powder, pomade, scent bottles, and other grooming accessories.

PROVENANCE: Purchased by Miss Hogg from Charles Woolsey Lyon, New York, 1947, who noted that it was previously owned by Eric Bayer, Poughkeepsie, New York.

TECHNICAL NOTES: Mahogany; mahogany (top drawer rachet), cedrela (drawer sides, bottoms, bottom drawer blocks, backs, drawer stops), eastern white pine (drawer dividers, side cupboards' shelves, vertical interior sides, interior top framing), yellow-poplar (dustboards). All four legs are fully reeded. The side doors and drawers are hinged at the back. The top central drawer is lined with a vertical partition corresponding to its interior compartments. The latter consists of a rectangular center flanked on either side by four identical cubicles. The presence of diminutive corner posts implies that originally

they were outfitted with covers. The center retains its ratchet support, presumably for a looking glass. The hardware is replaced.

RELATED EXAMPLES: *Antiques* 27 (April 1935), p. 128; *Antiques* 65 (March 1954), p. 179; Comstock 1962, no. 491; *Antiques* 102 (December 1972), p. 941, the latter outfitted with a looking glass in the top drawer while the drawer below functions as a writing desk.

REFERENCES: *Antiques* 44 (October 1943), p. 145; Warren 1975, p. 86, no. 166; Warren 1988, pp. 36–37.

1. Fairbanks and Bates 1981, p. 177; Heckscher 1985, pp. 218–19, no. 140.
2. Sheraton 1970b, vol. 1, p. 172.

F190

Bedstead

1800–1820
Boston, Salem, Massachusetts, or Providence
Mahogany, birch, basswood, eastern white pine,
and secondary wood; 95 x 62 x 77⅜" (241.3 x
157.5 x 196.5 cm)
B.69.393

This handsome bedstead is related to
similarly carved examples representing a
range of shops and, possibly, urban cen-
ters. Traditionally, they are associated
with the Boston-Salem area; however, the
presence of ivory attachments on one
example, combined with a local prove-
nance, has prompted a possible attribu-
tion to Providence. The distinctive
painted and gilded cornice, comprising
bows and quivers of arrows, has been
interpreted as referring to love and even
more explicitly to conjugal relations.

PROVENANCE: Purchased by Miss Hogg from
Joe Kindig, Jr., York, Pennsylvania, 1946.

TECHNICAL NOTES: Mahogany (headboard,
foot posts), birch (head posts, rails), basswood
(quivers), eastern white pine (remainder of
cornice); soft maple (lacing knobs). The cor-
nice's original green and gilt decoration
survives; however, it is covered with an intrac-
table overpaint, which has been repainted
with a reversible paint duplicating the original
tint. A fragment of the original yellow wool
hangings was discovered on the tester frame.

RELATED EXAMPLES: Most closely related is
Monkhouse and Michie 1986, pp. 221–22, no.
163. Others include Nutting 1962, nos. 1513–15;
American Art Association, New York, sale
4394, May 5–6, 1938, lot 304; Sack 1950, p. 95;
Antiques 62 (July 1952), p. 13; *Antiques* 89 (Feb-
ruary 1966), p. 175; catalogue of *The Delaware
Antiques Show*, 1968, p. 6; Sack 1969–92, vol. 5,
p. 1182, no. P4085; Davidson and Stillinger
1985, p. 63; Monkhouse and Michie 1986,
pp. 218–22, no. 162; Sack 1969–92, vol. 5,
p. 1355, no. P4400; Roy 1992, p. 110. Those
with painted cornices are in Randall 1965,
pp. 258–59, no. 214; Montgomery 1966b,
pp. 60–61, no. 1; unpublished examples belong
to SPNEA, the White House, and the Pea-
body Essex Museum, Salem, Massachusetts.
On file at RISD is a photograph of one in the
Arnold Green homestead, Providence.

REFERENCES: Warren 1975, p. 88, no. 171.

F191

Camp or Field Bed

ca. 1800–1815
New England, probably Massachusetts
Birch, soft maple, eastern white pine, canvas,
and leather; 62½ x 56¾ x 75½" (158.7 x 144.1 x
91.7 cm); height with canopy 79" (200.6 cm)
Gift of Miss Ima Hogg by exchange, B.93.3

This example, with its tentlike top, repre-
sents a new type of bed introduced at the
end of the eighteenth century. Thomas
Sheraton explains that the camp or field
bed is derived from the sort of bed used
on the camp field and is suited for low
rooms used for either servants or chil-
dren.[1] The Bayou Bend bed, with vase-
shaped, reeded foot posts and tapering,
spade-footed legs, is distinctive because it
retains the original thin red stained sur-
face as well as the original canvas sacking.

DBW

PROVENANCE: Purchased by Bayou Bend
from Nathan Liverant and Son Antiques,
Colchester, Connecticut, 1993.

TECHNICAL NOTES: Original canvas sacking
attached to head rail with leather strip and
rose-headed nails; narrow canvas panels at-
tached to side and foot rails in the same man-
ner; both sacking and panels fitted with hand
sewn eyelets through which rope could be
threaded to attach sacking to the panels. Thin
stain of iron oxide pigment loosely bound in
oil on all surfaces; thin glaze of clear varnish
over the stain on the posts.

RELATED EXAMPLES: Winterthur (Mont-
gomery 1966b, no. 9); two other examples
with original sacking are found in MMA
(Heckscher 1985, p. 151, no. 91) and in the
SPNEA collection (Jobe et al. 1993, p. 392).

REFERENCES: Warren 1993, p. 336.

1. Sheraton 1970b, p. 123, illustrated pl. 15. The
treatment of the bed hangings, which are
held open by loops and buttons, is based on
Sheraton's illustration.

F191

GRECIAN

F192

Two Side Chairs

1810–20
New York
Mahogany and secondary woods; B.68.14.1:
32⅜ x 19¼ x 22" (82.2 x 48.9 x 55.9 cm); B.68.14.2:
32½ x 18⅝ x 21½" (82.6 x 47.3 x 54.6 cm)
B.68.14.1–.2

During the early-nineteenth-century Grecian phase of revived classical taste, an attempt was made to create furniture design that was archaeologically correct. However, classical details were often used in ways that had no antique precedent. Thus, New York City craftsmen adapted the lyre, a musical instrument associated with Classical Greece, to the stay rail design of Grecian-style chairs, and the motif was sufficiently popular to be listed as a standard option in the 1810 price book.[1]

PROVENANCE: Purchased by Miss Hogg from Israel Sack, New York, 1943.

TECHNICAL NOTES: Mahogany, mahogany veneer; ash (front and rear seat rails), cherry (slip seat). While the two Bayou Bend chairs share basically the same design, minor differences of detail, particularly in the lyre, suggest they were originally in different sets.

RELATED EXAMPLES: Winterthur (Montgomery 1966b, no. 73); MMA (Davidson and Stillinger 1985, pp. 146–47, fig. 228; Tracy et al. 1970, no. 27); Sack 1950, p. 61; Milwaukee Art Museum, without the leaf carving on the leg fronts (Jobe et al. 1991, no. 86). A sketch attributed to Duncan Phyfe, now at Winterthur, illustrates a similar chair (Montgomery 1966b, no. 72a).

REFERENCES: Warren 1975, p. 93, no. 173 (with incorrect accession number).

1. New York Prices 1810.

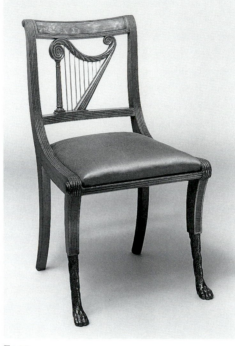

F193

F192

F193

Side Chair

1810–20
New York
Mahogany and secondary woods; 32¾ x 18¼ x 22¼" (83.2 x 46.4 x 56.5 cm)
B.72.114

While the scroll-back Grecian chair with paw feet was relatively common in New York, the most popular form features the lyre or spread-wing eagle as stays or banisters. This example, with its harp and column stay, one of only seven or eight known today, would seem a rare form. Yet the 1817 New York price book includes the harp banister with column as an expensive alternative to the lyre. Another costly detail is the cross-banded veneer on the leading surface of the front legs between the seat rail and paw feet.

PROVENANCE: Purchased by Miss Hogg from S. Dean Levy, New York, 1972.

TECHNICAL NOTES: Mahogany, mahogany veneer; ash (front and rear seat rails), cherry (slip seat), brass.

RELATED EXAMPLES: A pair at Winterthur (acc. nos. 57.717.1, .2, see Montgomery 1966b, no. 74); MMA (acc. no. 1972.136); Kaufman Collection, Norfolk, Virginia (Cooper 1993, fig. 70); Stone Collection, Washington, D.C. (Sack 1993, p. 63). At one point a pair was in the collection of Walter Jeffords, New York ("Girl Scout Loan Exhibit," New York, 1929), and the same pair or another was in the collection of Mitchel Taradash (Winchester 1941, p. 90). The Taradash chairs are presumably the ones now in the Kaufman and Stone collections. A single chair was offered by Christie's (sale 7822, January 22, 1994, lot 388). The Christie's example is marked V (of a set). The Bayou Bend, Winterthur, and Kaufman chairs are not marked.

REFERENCES: Warren 1975, p. 93, no. 174.

F194

Pair of Side Chairs

1810–20
New York
Mahogany and secondary wood; each 33⅝ x 18¼ x 20¼" (85.4 x 46.4 x 51.4 cm)
B.69.87.1–.2

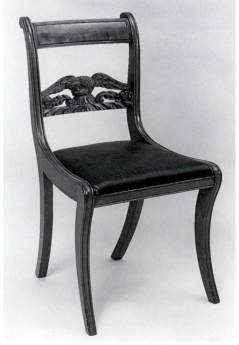

F194

Adaptation of the flowing lines of the Grecian prototype klismos chair was most successful in this New York scroll-back model, which first appeared in the second decade of the nineteenth century. In a departure from antique models, the spread-wing eagle, ubiquitous symbol of the American nation, has been introduced as the stay rail. The bold, stylized carving of the eagle and leafage is typical of New York design of the 1810s and early 1820s. While a number of variations on the eagle-stay rail theme exist, there is no known design source for this type of chair, nor any mention of it in the price books.

PROVENANCE: Purchased by Miss Hogg from Ginsburg and Levy, New York, 1943.

TECHNICAL NOTES: Mahogany; ash (front and rear seat rails). Both chairs have repaired breaks at the crest and stay rail joints, and B.69.87.2 has had its right front and rear legs repaired.

RELATED EXAMPLES: Five virtually identical examples are at Winterthur (Montgomery 1966b, no. 76); one that is very similar but different in the carved details is at Yale (Kane 1976, no. 155). Related chairs: Los Angeles County Museum of Art (acc. no. M.82.125); Indianapolis Museum of Art (acc. no. 78.158); advertisement of Israel Sack, *Antiques* 136 (July 1989), p. 49; Gordon-Banks House, Milledgeville, Georgia (Farnham 1972, p. 441).

REFERENCES: Advertisement of Ginsburg and Levy, *Antiques* 40 (July 1941), p. 11; Warren 1975, p. 93, no. 172 (with incorrect accession number).

F195

Side Chair

1810–25
Boston
Mahogany and secondary woods; 33¼ x 19½ x 21¾" (84.5 x 49.5 x 55.2 cm)
Museum purchase with funds provided by the Houston Junior Woman's Club, B.88.2

This chair represents a distinct Boston interpretation of the classically inspired klismos chair. The bold reeding of the legs, stiles, and front seat rail is seen on a number of different Boston models. Seemingly unique to Boston design are the rectangular tablets of the crest and upper stay rails, here ornamented with

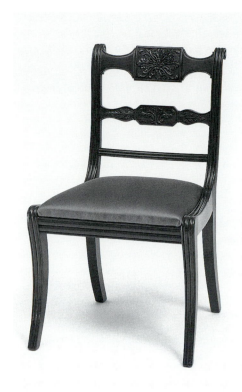

F195

crisply carved acanthus leaf and scroll decoration.

PROVENANCE: Purchased by Bayou Bend from Israel Sack, New York, 1988.

TECHNICAL NOTES: Mahogany; ash (slip seat), soft maple (front and rear seat rails), mahogany (left seat rail), white oak (left rear corner block).

RELATED EXAMPLES: Very similar chairs were purchased by Nathan Appleton for his Boston house in 1819 (Talbott 1975, pp. 885, 887, fig. 12); the Annual Summer New Hampshire Auction, Manchester, August 5–6, 1995, lots 610, 633. A related pair is at MMA (acc. nos. 1971.180.29–.30). The Bayou Bend chair was one of three purchased by the Sack firm (Talbott 1991, p. 965; Sack 1969–92, vol. 10, p. 2679, no. P6033). For a variant with paw feet, see Tracy et al. 1970, no. 30.

F196

Set of Four Side Chairs

1815–25
New York
Soft maple and painted soft maple; B.67.27.1, B.67.27.3: 32¼ x 18½ x 20¼" (81.9 x 47 x 51.4 cm); B.67.27.2: 32¼ x 18⅜ x 20⅛" (81.9 x 46.7 x 51.1 cm); B.67.27.4: 32¼ x 18½ x 21¼" (81.9 x 47 x 54 cm) B.67.27.1–.4

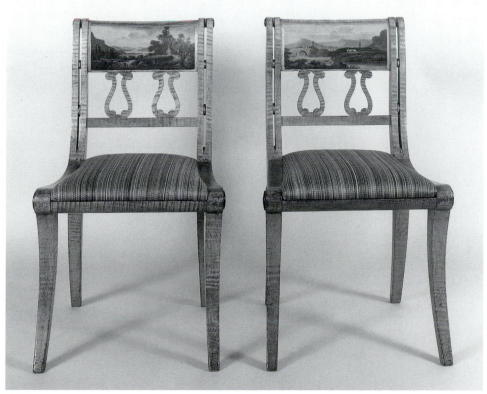

F196

These sophisticated chairs illustrate two distinct facets of Grecian furniture produced in New York—a small body of refined seating furniture made of maple and a larger body of furniture ornamented with landscape scenes. The Bayou Bend examples include several particular details that vary from the norm of New York Grecian chairs. The tablets, contained between the rails, are wider to accommodate the landscapes, and the usual single lyre has been replaced with a pair of smaller lyres. While front legs and stiles, as a rule, are molded or reeded, here the surface is left plain and the stiles are pierced to add visual lightness. Also unusual are the two small disks that are inserted in the pierced area of each stile. The artist who created the landscapes, each of which is different and includes romantic ruins, is unknown but was possibly the product of one of the painting academies in New York. The work parallels, although is not directly related to, the easel paintings produced by the contemporaneous Hudson River School.

PROVENANCE: Purchased by Miss Hogg from Israel Sack, New York, 1967.

TECHNICAL NOTES: Marks appear as follows (inscribed in pen): B.**67.27.1**: on the seat frame,

4, on the seat rail, 4H; B.**67.27.2**: on the seat frame, N1, on the seat rail, N1; B.**67.27.3**: on the seat frame, 9, on the seat rail, 9; B.**67.27.4**: on the seat frame, 3, on the seat rail, 3.

RELATED EXAMPLES: Two identical chairs, formerly in a private Massachusetts collection and then with Israel Sack in 1996, have a history of ownership in the Caswell family of New York. Related examples are at Winterthur (Montgomery 1966b, no. 469); Sleepy Hollow Restorations, Tarrytown, New York, with a painted scene virtually identical to that of B.67.27.2, indicating a common source, either a painting or a print (Garrett et al. 1969, p. 302). A New York maple caned-back Grecian sofa, with a history of belonging to John Jay, now at Bayou Bend (see cat. no. F205), is related in concept; a mahogany pair has similar open stiles with disks (Christie's, New York, sale 8208, June 21, 1995, lot 288).

REFERENCES: Bishop 1972, p. 295, no. 473; Warren 1970d, p. 124; Warren 1975, p. 94, no. 176.

F197

Pair of Side Chairs

1815–20
New York
Mahogany and secondary woods; each 32⅛ x 18⅛ x 19½" (81.6 x 46 x 49.5 cm)
B.63.22.1–.2

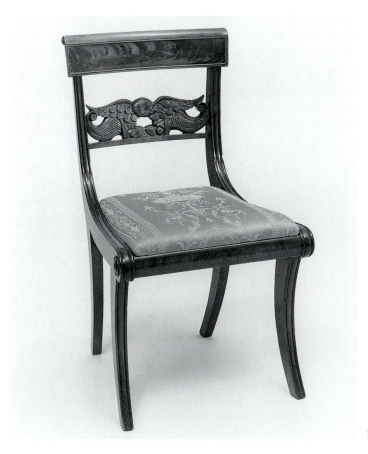

F197

With the wide tablet that extends over the stiles, this model follows more closely ancient prototypes than the more common model of New York chairs with spreadwing eagle stays (see cat. no. F194). The placement of the legs, set back from the front seat rail, is an unusual feature, as is the combination of spread-wing eagle and cornucopia on the stay rail.

PROVENANCE: Purchased by Miss Hogg from Carl and Celia Jacobs, Southwick, Massachusetts, 1963.

TECHNICAL NOTES: Mahogany, mahogany veneer; ash (front and rear seat rails, slip seat side rails), white oak (slip seat front and rear rails).

RELATED EXAMPLES: Tracy and Gerdts 1963, no. 40, has a similar scrolled tablet top. Others have eagles and cornucopia: Anderson Galleries, New York, Lawton sale 2214, January 6–7, 1928, lot 42; Sack 1969–92, vol. 7, p. 1974, no. P5231, vol. 2, p. 444, no. 1108 (similar setback to legs).

REFERENCES: Warren 1970d, p. 125; Warren 1975, p. 94, no. 175 (with incorrect accession number).

F198

Pair of Side Chairs

ca. 1808
Designed by Benjamin H. Latrobe (1764–1820)
Possibly made by Thomas Wetherill (d. 1824)
Painted decoration attributed to George Bridport (b. England before 1794–d. 1819)
Philadelphia or possibly Baltimore
Various painted and gilded woods (see Technical notes); each 34½ x 20 x 20½" (87.6 x 50.8 x 52.1 cm)
Museum purchase with funds provided by the Agnes Cullen Arnold Endowment Fund, B.90.9.1–.2

This pair of chairs is part of an extensive suite of furniture made for Philadelphian William Waln to furnish a new house that Benjamin Henry Latrobe designed for him between 1805 and 1808.[1] Latrobe's relatively archaeologically correct interpretation of the Greek klismos form draws on the designs of Thomas Hope published shortly before and represents perhaps the earliest documented example of the style in America.[2] The overall form, with severe rectangular lines and wide tablet, is a distinctive Philadelphia

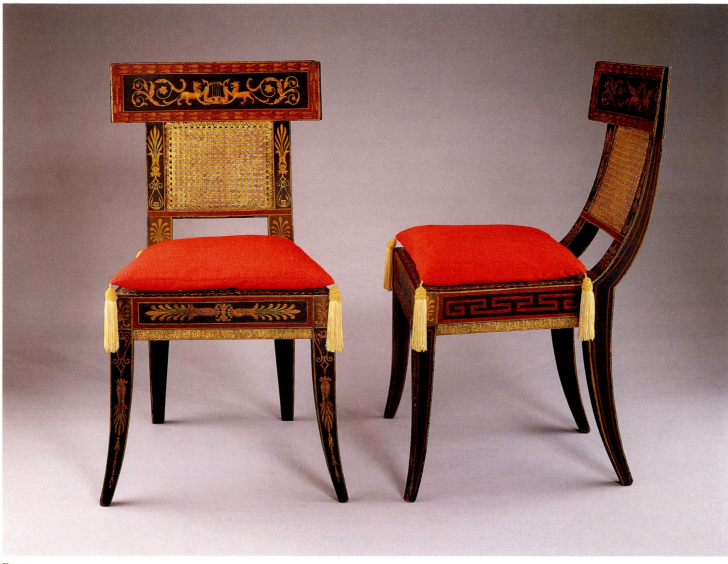

F198

type (see cat. no. F199). However, the painted decoration seems to have no parallel in other Philadelphia furniture, although very closely related painted decoration is documented to Baltimore. Likewise, the design of the en suite card table and pier table does not resemble that of other Philadelphia examples but relates to pieces made in Baltimore. By 1809 Latrobe was designing similar furniture for the White House, which, although possibly made in Philadelphia, was decorated in Baltimore. What remains unclear, then, is whether these chairs were made and painted in Philadelphia, made in Philadelphia and decorated in Baltimore, or made completely in Baltimore.

PROVENANCE: Purchased by Bayou Bend from Israel Sack, New York, 1990.

TECHNICAL NOTES: Painted and gilded yellow-poplar, oak, maple, and eastern

white pine (not analyzed microscopically). The chairs survive with original gilded caning in their backs. Removal of the composition molding screwed to the seat rails revealed consistent tacking patterns, tack holes, and tack heads, as well as silk fiber remnants, indicating some sort of upholstery detail, perhaps tassels suspended by cords. The same tacking patterns are seen on the PMA chairs (see Related examples). Similar composition molding appears on the skirts of the en suite card and pier tables, sofa, and window seats.

RELATED EXAMPLES: To date fifteen chairs have come to light. They are in MMA; PMA; Saint Louis Art Museum; High Museum, Atlanta; Kaufman Collection, Norfolk, Virginia; and a private collection. The decoration on the backs of each is unique. For full illustrations, see Lindsey 1991. Latrobe's drawing for the White House chair is also illustrated in that article. For Baltimore examples that relate to the card and pier table, see Elder 1972, nos. 46, 53.

REFERENCES: Lindsey 1991, pp. 217–18, pls. L, M; Sack 1969–92, vol. 10, p. 2603, no. P6311.

1. For extensive consideration of the Waln furniture, see Garvan 1987, pp. 90–93, which cites Bridport as having made, for Latrobe, the painted decoration for the interiors of the Waln house; however, it does not necessarily follow that he also painted the furniture. The pier table bears the name Thomas Wetherill, a Philadelphia carpenter. The single-piece construction of the chairs' back legs and stiles has been cited as a Philadelphia technique, whereas in documented Baltimore examples a two-piece construction is used (see Lindsey 1991, p. 213). Yet, that this suite of furniture seems unique in the context of Philadelphia work while many related Baltimore examples are known makes a solid Philadelphia attribution difficult.

2. Hope 1971, pls. 24, 25.

F199

F199

Pair of Side Chairs

1810–25
Philadelphia
Mahogany, ebony, rosewood, and secondary
materials; B.69.72.1: 31¾ x 19 x 22¼" (80.6 x
48.3 x 56.5 cm); B.69.72.2: 31¾ x 18⅜ x 22¼"
(80.6 x 46.7 x 56.5 cm)
B.69.72.1–.2

These chairs, with wide tablets and rigorous classical lines, represent a Philadelphia type of Grecian chair. While the design source ultimately derives from Thomas Hope (1769–1831) and his archaeologically correct furniture, the designs of Benjamin Latrobe and the furniture he made for William Waln in 1808 may represent a more immediate inspiration (see cat. no. F198). The overall character of the chairs suggests English influences. The severe surfaces are ornamented with both lavish brass inlay and exotic woods—ebony and rosewood—in accordance with the suggestions of both Thomas Hope and George Smith (act. 1804–28).[1] The inlaid brass decoration, imported from English sources, appears in related combinations on other forms of Philadelphia-made furniture. This brass is let into the wood in the English manner rather than applied, as was the French custom. While the form is not listed in the 1828 Philadelphia price book, that source shows that brass stringing was two and one-half times the cost of wood, indicating that these were expensive chairs.

PROVENANCE: By tradition owned by Thomas Powel Hare, who changed his name to Thomas Hare Powel and built a Grecian-style house, Powelton, in 1826; to Miss Esther Binney Hare, until 1968; purchased by Miss Hogg from R. T. Trump and Company, Philadelphia, 1969.

TECHNICAL NOTES: Mahogany, ebony rosewood (tablet); ash (seat frame), eastern white pine (slip seat), brass (inlay). One seat is numbered III, and the other is numbered V. The seat frames were built up in 1993 to conform to the design found on the Winterthur set, which retains its original upholstery foundations.

RELATED EXAMPLES: These chairs were originally part of a set of twelve. Two others are at PMA (PMA 1976, pp. 266–67); two in the Kaufman Collection, Norfolk, Virginia. (Flanigan 1986, p. 138, no. 50); and six others are in a private Texas collection. Another identical set of nine are at Winterthur (Fennimore et al. 1994, p. 70). A single example with ebony Greek key inlay rather than brass and a similar Powel family history is now at MMA (acc. no. 1986–449, see PMA 1976, pp. 266–67; Biddle 1963, p. 17, no. 34); six others identical in form but with carved rosettes on the seat rail and tablet are in the collection of the Governor's Mansion, Austin; a pier table at Winterthur is ornamented with the same combination of ostrich feather and star brass inlay (Montgomery 1966b, p. 366, no. 348).

REFERENCES: Advertisement of R. T. Trump & Co., *Antiques* 95 (January 1969), p. 57; Warren 1970d, p. 126; Warren 1971a, p. 48, no. 18; Warren 1975, p. 94, no. 177.

1. For a description of Philadelphia chairs, see Smith 1970a, p. 9, pls. 39–40 and Hope 1971, no. 3, pl. 24.

F200

Pair of Side Chairs

1820–35
Pennsylvania or Maryland
Various painted woods (see Technical notes);
B.67.30.5: 32¾ x 18 x 20" (83.2 x 45.7 x 50.8 cm);
B.67.30.6: 33 x 17½ x 20" (83.8 x 44.5 x 50.8 cm)
B.67.30.5–.6[1]

F200

Inexpensive, highly decorative painted seating furniture found great favor in the early nineteenth century. Interchangeable factory-produced parts, such as front legs, back stays, and crest rails, provided potential for a wide variety of models. In the Bayou Bend chairs, the round front legs with ring turnings at the top relate to those seen on a genre of Baltimore painted chairs, while the bobbinlike ornament of the seat rail appears on a group of Philadelphia Empire-style furniture.[2] That chairs of this sort had geographically wide-ranging ownership may simply be a reflection of broad patterns of trade.

PROVENANCE: Purchased by Miss Hogg from Margo Authentic Antiques, St. Louis, Missouri, 1967.

TECHNICAL NOTES: Maple (rear legs, rear stretcher), hickory (side stretchers), yellow-poplar (front and right seat rails), soft maple (front stretcher, front legs), hard maple (stay rail, front corner seat block). The painted decoration is original. The cream-colored base is now yellowed and darkened by the varnish that covers it. The composition is well developed and the decoration applied with speed and confidence. The front stretcher is partially turned up at a slight angle in order to present the faux turned decoration to the eye of the viewer. The rush seat is also original. The nails in the side panels that cover the seat show no indications of nail removal and resultant loss of paint decoration (examined in UV light).

RELATED EXAMPLES: For Baltimore leg design, see Elder 1972, nos. 37, 40; for a Philadelphia seat rail, see Garvan 1987, p. 71; a rosewood-grained pair at Winterthur attributed to Baltimore have identical painted anthemion stay rails but a tablet crest rail (Montgomery 1966b, no. 466; Evans 1996, p. 169, figs. 4–18); a rosewood-grained example at the Henry Ford Museum, Dearborn, Michigan, is identical in form except for the stay rail (Fales 1972, fig. 309); a third variant painted yellow ocher has different stay and crest rails (Fales 1972, fig. 308).

REFERENCES: Warren 1975, p. 95, no. 178.

1. This was originally a set of six chairs. Two (B.67.30.1 and .3) were deaccessioned by Bayou Bend (Hart Galleries, Houston, April 11–12, 1992, lot 515), and two (B.67.30.2 and .4) are now in Bayou Bend's teaching collection.
2. The printed bill head of Abraham McDonough, a Philadelphia chair manufacturer, dated 1833, shows a chair with similar "Baltimore-style" legs (Evans 1996, p. 146, fig. 3–142).

F201

F201

Set of Six Side Chairs

1830–50
Probably New York
Mahogany and secondary woods; B.64.39.1: 33¼ x 18⅜ x 20⅝" (84.5 x 46.7 x 52.4 cm); B.64.39.2: 33⅛ x 18½ x 21½" (84.1 x 47 x 54.6 cm); B.64.39.3: 33 x 18½ x 21½" (83.8 x 47 x 54.6 cm); B.64.39.4: 33⅛ x 18¼ x 21" (84.1 x 46.4 x 53.3 cm); B.64.39.5: 33¼ x 18⅜ x 20¾" (84.5 x 46.7 x 52.7 cm); B.64.39.6: 33⅛ x 18⅜ x 21½" (84.1 x 46.7 x 54.6 cm)
B.64.39.1–.6

In the late 1820s, the Grecian klismos-form chair began to be supplanted by a model derived from Roman sources and characterized by a semicircular seat, rounded tublike back, and wide vase-shaped splat. This type of chair appears as number 11 of the famous 1833 Joseph Meeks and Son New York broadside.[1] The new Roman form, which was produced with minor variations in ornament at the tablet top of the back, found wide acceptance. On the Bayou Bend examples the scrolls at the outer edge of the tablet are distinctive.

PROVENANCE: Purchased by Miss Hogg from Mrs. Kirtley Lynch, Opelousas, Louisiana, 1964.

TECHNICAL NOTES: Mahogany, mahogany veneer; ash (glue blocks), cherry (rear rail, one side of slip seat), black walnut (other three sides of slip seat, glue blocks). Incised marks appear as follows: B.64.39.1: on the seat rail, II, on the slip-seat frame, VI; B.64.39.2: on the seat rail, V, on the slip-seat frame, VII; B.64.39.3: on the seat rail, IIII, on the slip-seat frame, VIIII; B.64.39.4: on the seat rail, XI, on the slip-seat frame, XI; B.64.39.5: on the seat rail, VI, on the slip-seat frame, III(?); B.64.39.6: on the seat rail, VIIII, on the slip-seat frame, XII.

RELATED EXAMPLES: Henry Ford Museum, Dearborn, Michigan (Otto 1965, fig. 214); Varner-Hogg State Park, West Columbia, Texas (Otto 1965, fig. 213); Bybee Collection, Dallas Museum of Art (Venable 1989, p. 68); New York State Museum, Albany (Scherer 1984, no. 76).

REFERENCES: Warren 1975, p. 95, no. 180 (with incorrect accession number); Naeve 1981, no. 47.

1. Davidson and Stillinger 1985, p. 164.

F202

Side Chair

1810–20
Baltimore
Mahogany, ash, and maple; 32⅝ x 18⅛ x 20¾" (82.9 x 46 x 52.7 cm)
Museum purchase with funds provided by the Wunsch Foundation, B.75.1

F202

This chair, with its square back, reeded stiles, and balloon seat, relates in concept to balloon-seated, scroll-back chairs produced in New York. However, the bold reeding of the legs, open at the top, is a feature that appears on a group of Baltimore sofas and tables, and this chair represents a very popular Baltimore design. On the Bayou Bend chair, the reeding of the legs takes on an appearance that is less classical and more like cluster columns in the Gothic taste. It thus relates to the architectural design of the Gothic colonnade of the back, where what might appear to be reeding is actually intended to evoke Gothic ribbing. The Gothic style was introduced into Baltimore at a relatively early date, first by Benjamin Latrobe's unrealized 1804 design for the new Roman Catholic cathedral, and in 1806 by Maximilian Godefoy's chapel built for Saint Mary's Seminary.

PROVENANCE: Purchased by Bayou Bend from Bernard and S. Dean Levy, New York, 1975.

TECHNICAL NOTES: Mahogany, ash, and maple (not analyzed microscopically).

RELATED EXAMPLES: Twelve chairs made for Governor Charles C. Ridgely of Hampton display the same basic form, embellished with leaf carving on the crest (Hampton National Historic Site, Baltimore); six in a private Baltimore collection are identical to the Bayou Bend example (Weidman et al. 1993, fig. 151); Maryland Historical Society (Weidman 1984, no. 63); Christie's, New York, sale 6742, January 20–21, 1989, lot 546.

F203

Side Chair

1815–30
Piedmont region, Georgia, possibly Augusta
Mahogany, birch, and secondary wood;
32¾ x 19½ x 20" (83.2 x 49.5 x 50.8 cm)
Museum purchase with funds provided by Mr. and Mrs. Robin Elverson, B.85.18

With its reeded stiles and boxy seat, this side chair reflects both New York and Philadelphia design, while the large inlaid oval of light-colored wood on the tablet relates more to slightly earlier furniture made in the Boston-Salem area of Massachusetts. The stay rail of interlaced ovals and the break of the front legs below the seat rail are unusual details; the overall result is something difficult to place. However, the use of birch as a secondary wood as well as the inlay is seen in Piedmont, Georgia, furniture of this period, and the overscale bold oval recalls the ornament of a Georgia sideboard, suggesting a Georgia provenance for this example.

PROVENANCE: Purchased by Bayou Bend from Robert M. Hicklin, Jr., Spartanburg, South Carolina, 1985.

TECHNICAL NOTES: Mahogany, birch (inlaid oval panel); birch (right and rear seat rails, right front corner block).

RELATED EXAMPLES: A ca. 1810 sideboard in the collection of MESDA is made of birch and ornamented with overscale, slightly naive oval inlays, dark as opposed to light, which relate in concept to the oval on the tablet of this chair (Hind 1979, p. 72). A chest of drawers thought to be from the Augusta area features birch drawers framed in dark cherry (Green 1976a, no. 122). For other examples made of birch, see Green 1976a, nos. 4, 105, 111–13, 138, 144. The Bayou Bend chair was documented in the early 1980s in MESDA's survey of southern decorative arts (ID no. S-11671). A pair of southern side tables at Winterthur (57.582.1–.2) have similar large pale ovals inlaid

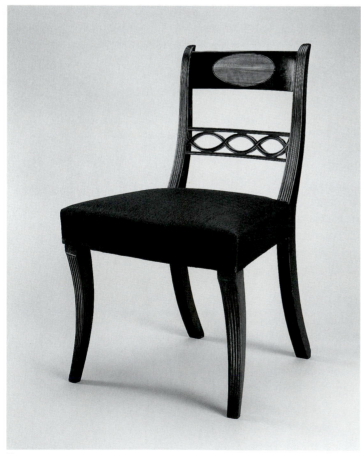

F203

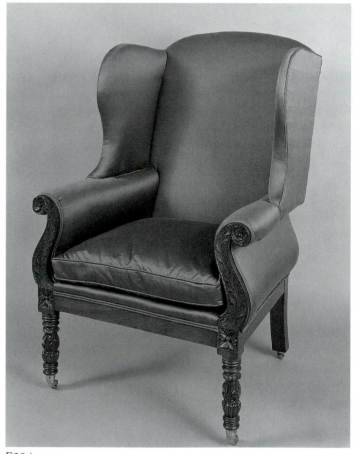

F204

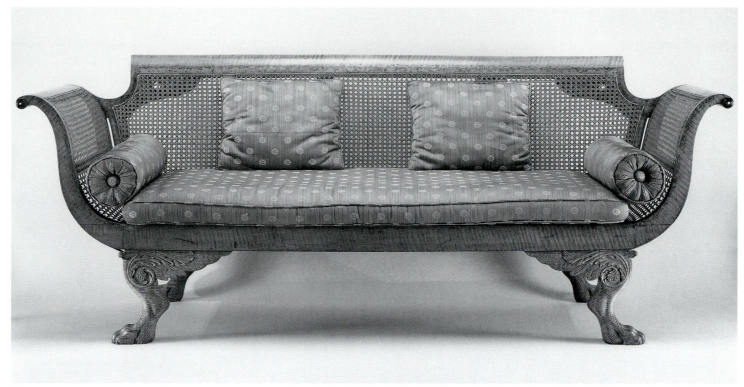

F205

in mahogany (Montgomery 1966b, pp. 370–71, no. 356).

REFERENCES: Smith et al. 1985, p. 147, no. 84.

F204

Easy Chair

1820–30
Philadelphia
Mahogany and secondary woods; 48 x 31¼ x 32¾" (121.9 x 79.4 x 83.2)
Gift of Mrs. Fred T. Couper, Jr., B.79.295

Turned and carved front legs and acanthus-carved Grecian scrolled arm fronts provide a stylistic update and an interesting adaptation of the basic easy chair form introduced more than a century earlier. Traditionally a bedchamber form made for use by the elderly, many easy chairs were originally fitted out under the seat with a removable board with circular hole to receive a chamber pot (see cat. no. F160). Surviving moldings under the seat indicate such was the case for the Bayou Bend example.

PROVENANCE: Purchased by Mrs. Fred T. Couper, Jr., from Kenneth Hammitt, Woodbury, Connecticut, 1979.

TECHNICAL NOTES: Mahogany (legs); ash (seat rails), yellow-poplar (narrow strip inside right seat rail).

RELATED EXAMPLES: A very similar example without the leaf carving in the arm fronts, also fitted out as a commode chair, is at Winterthur (acc. no. 88.14); an example thought to be from New York or New England is in a private collection in Natchez, Mississippi (Cooper 1993, p. 216, fig. 173).

REFERENCES: Advertisement of Kenneth Hammitt, *Antiques* 115 (June 1979), p. 1161.

F205

Sofa

1810–20
New York
Maple, cane, and ivory; 32½ x 85 x 26" (82.6 x 215.9 x 66 cm)
Gift of Mr. and Mrs. James L. Britton, Jr., B.92.5

This scroll-back Grecian sofa represents two bodies of furniture produced in New York City in the early nineteenth century. One is a group of expensive caned sofas; the other is a group of high-style seating furniture made of figured maple. References to both caned and Grecian sofas appear in the June 1810 New York price

book, indicating that the form was an established entity by that date.[1] The price book also reveals that these caned maple sofas were approximately five times the cost of a base upholstered mahogany model. The later July 1815 price book describes a Grecian sofa with "the foot to form a lion's paw," that cost £5.3.6 and indicates that preparing the form for caning was an additional two pounds.[2]

PROVENANCE: By tradition owned by John Jay (1745–1829); purchased by James L. Britton, Jr., in the early 1960s.

TECHNICAL NOTES: Materials were not analyzed microscopically. When the sofa was purchased by Mr. Britton, it was entirely covered in upholstery; only the paw feet were exposed. The maple and extant caning were discovered by Mr. Britton's upholsterer. The feet may originally have been a dark color.

RELATED EXAMPLES: A recamier-style version in a private collection is very similar, except for the eagle heads of the feet, which turn inward (Farnham 1972, p. 444, pl. VII); a mahogany version is in McClelland 1939, pl. 288; Art Institute of Chicago (Naeve 1981, p. 26, no. 41); a set of maple side chairs (see cat. no. F196).

REFERENCES: Hatfield 1975, p. 530, pl. IV.

1. New York Prices 1810, p. 57.
2. New York Prices 1815, p. 5.

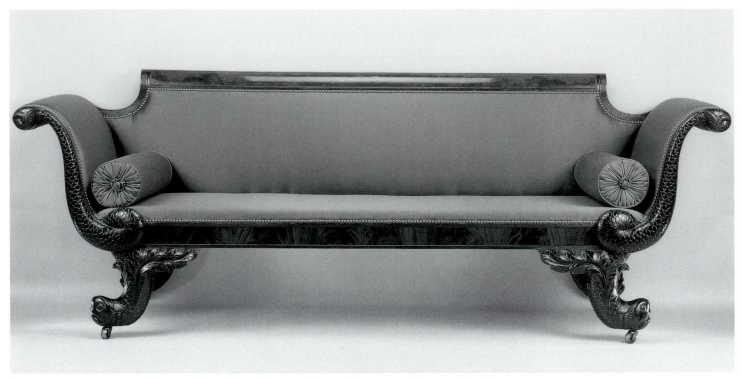

F206

F206

Sofa

1810–30
New York
Mahogany and secondary woods; 34¾ x 94¼ x 27" (88.3 x 239.4 x 68.6 cm)
Museum purchase with funds provided by the Theta Charity Antiques Show, B.78.79

The second phase of revived classical taste reached America during the first decade of the nineteenth century. In seating furniture design the later forms more nearly approached antique prototypes seen on vase paintings, wall frescoes, and grave stelae than did those of the first phase. The most salient feature was the incorporation of the scrolled line of Grecian chairs and Roman couches into the backs and arms of chairs and sofas, and indeed, "Grecian Sofa" was the contemporary term for an example such as this one. The scrolled back rail here, with reeding and inset panel, conforms to the norm for New York chairs and sofas made by the shop of Duncan Phyfe and others in the late 1810s.

The dolphin motif, also drawn from antiquity, was popular in England following the maritime victories of the Napoleonic wars. In America, while dolphin supports were more common to card table design, the motif was also used on sofas. In the particular New York group to which this example belongs, a single twisting dolphin is adroitly adapted to form the leg and scrolled arm. Also characteristic of the group is the dolphin's tapering blunt nose. Often, as on the Bayou Bend example, an organic seaweedlike branch forms the leg bracket. While it is clear that these New York sofas, which differ from each other in minor details, are the product of the finest craftsmen, it has not been possible to ascribe any to a specific maker or shop.

PROVENANCE: Cassandra and Edward Stone; [Peter Hill, East Lempster, New Hampshire]; purchased by Bayou Bend from Peter Hill, 1978.

TECHNICAL NOTES: Mahogany; mahogany (blocks above left rear leg), ash (rear seat rail), cherry (cross brace), eastern white pine (left front leg block). Gold leaf applied over finished mahogany surfaces on the dolphin heads and tails was removed in 1996.

RELATED EXAMPLES: MMA (Davidson and Stillinger 1985, p. 158); the White House, Washington, D.C. (White House 1975, pp. 52, 57); Naval Memorial Museum, Washington, D.C. (Fitzgerald 1982, p. 118); Chrysler Museum, Norfolk, Virginia; Fort Hill, Clemson University, Clemson, South Carolina (Aronson 1965, p. 402). Related but with the addition of eagles on the back in a private collection (Cooper 1980, pl. 49); Annual Summer New Hampshire Auction, Manchester, August 5–6, 1995, lot 714; Richard Jenrette collection, Tarrytown, New York; Hirschl and Adler Galleries, New York; Minneapolis Institute of Arts has an example of related design, but the dolphins are different (Gustafson 1984b, p. 784). A card table with virtually identical dolphins is in the Los Angeles County Museum of Art (acc. no. M.82.102).

REFERENCES: Advertisement of Peter Hill, *Antiques* 114 (October 1978), p. 755; Agee et al. 1981, no. 162; Marzio et al. 1989, p. 252; Gustafson 1984b, p. 784; Warren 1988, p. 45.

F207

Pair of Card Tables

1805–10
New York
Mahogany and secondary wood; B.69.385.1: open: 28¾ x 36 x 36" (73 x 91.4 x 91.4 cm); closed: 29⅝ x 36 x 18" (75.2 x 91.4 x 45.7 cm); B.69.385.2: open: 28⅝ x 36¼ x 36" (72.7 x 92.1 x 91.4 cm); closed: 29½ x 36¼ x 18" (74.9 x 92.1 x 45.7 cm) B.69.385.1–.2

These pedestal card tables, with three saber legs, display a type produced in New York City in the first decade of the nineteenth century and described in the

1810 price book as "eliptic pillar and claw foot." Often made in pairs, these tables carry an unusual leg arrangement, which facilitated the placement of the piece against the wall when not in use; when the table is opened, the rear legs swing backward 45 degrees to provide stability. The finest examples are richly ornamented with highly figured mahogany veneers and typically carved with water leaves on the legs and vase. The cross-banded tablet at the center of the skirt of these tables is unusual.

PROVENANCE: Purchased by Miss Hogg from Collings and Collings, New York, 1928.

TECHNICAL NOTES: Mahogany, mahogany veneer; eastern white pine (laminated front apron), brass (casters). The brass casters are original.

RELATED EXAMPLES: While traditionally assigned to the shop of Duncan Phyfe, such an attribution is unwarranted given that the type appears in the 1810 price book and a similar example at the Henry Ford Museum, Dearborn, Michigan, bears the stamp of Michael Allison (Comstock 1962, no. 559). Other examples are at Winterthur (Montgomery 1966b, no. 314); a pair, ex coll. Ronald Kane (Christie's, New York, sale 7822, January 22, 1994, lot 431); Kaufman Collection, Norfolk, Virginia (Flanigan 1986, p. 186, no. 74); a satinwood pair, MFA, Boston (Comstock 1962, no. 558); Sack 1969–92, vol. 10, p. 2713, no. P5752.

REFERENCES: Warren 1975, p. 96, no. 182; Greenlaw 1978a; Greenlaw 1978b, p. 16.

F208
Card Table

1820–30
New York
Grained, painted, and gilded mahogany, birch, and secondary woods; open: 30⅛ x 36¾ x 36¾"
(76.5 x 93.3 x 93.3 cm); closed: 30⅞ x 36¾ x 18⅜"
(78.4 x 93.3 x 46.7 cm)
B.68.31

In the Grecian period, the card table continued to be an important form of parlor furniture, often made in pairs and positioned as small pier tables when not in use. The Bayou Bend example manifests the eclectic combination of references to the antique that characterize the style: paw feet in the Roman taste, lotus-shaped capitals of vaguely Egyptian taste, and Grecian anthemia on the central bronze mount. The use of painted surfaces to suggest more expensive or exotic woods returned to favor; the mahogany surfaces of this table have been grained to resemble rosewood and the paw feet painted black to look like ebony.

PROVENANCE: Purchased by Miss Hogg from Peter Hill, Washington, D.C., 1966.

TECHNICAL NOTES: Grained, painted, and gilded mahogany, birch (turned columns); mahogany veneer on eastern white pine with black walnut banding (top), ash (center section of left front foot), eastern white pine

(outer section of right front foot, bottom of upper section, carved eagle bracket), cherry (braces for top). The casters are original.

RELATED EXAMPLES: A virtually identical table, save for the central mount of the skirt, was in the collection of the Chrysler Museum, Norfolk, Virginia, then sold at Christie's, New York, June 2, 1990, sale 8006, lot 173, present location unknown. It had been suggested that the Bayou Bend table was part of a set of furniture that included a music stand inscribed "Miss M.A. Babcock/April 1824" (Tracy and Gerdts 1963, no. 47). However, there does not seem to be any concrete evidence to support this.

REFERENCES: Warren 1970d, p. 123; Warren 1975, p. 97, no. 184.

F209
Card Table

1820–25
New York
Mahogany, rosewood, ebony, and secondary woods; open: 28¾ x 36 x 36" (73 x 91.4 x 91.4 cm); closed: 29⅝ x 36 x 18" (75.2 x 91.4 x 45.7 cm)
B.68.32

While the vigorously carved winged paw feet with acanthus leaf of this example conform to many New York-made card tables of the Grecian period, the combination of the swan-necked griffin-head terminals of the lyre and the concave lobate shell at the lyre's base is unusual.

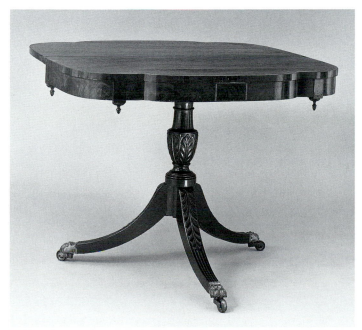

F207

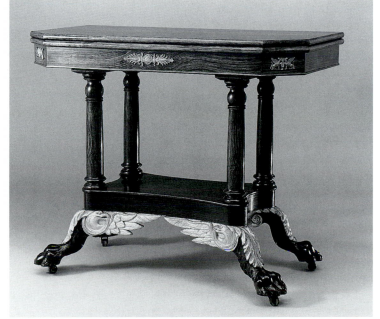

F208

The hexagonal stretcher joining the two lyre elements is distinctive. Subtle details such as the brass stringing on the edge of the top, the brass and ebony crossbar at the top of the lyre, the ebony banding at the base of the skirt, and the cross-banding on the top surface all indicate that this was an expensive piece of furniture.

PROVENANCE: Purchased by Miss Hogg from John S. Walton, New York, probably in the late 1950s.[1]

TECHNICAL NOTES: Mahogany, mahogany veneer, rosewood (banding), ebony (crossbar); yellow-poplar (bottom board), cherry (cross braces), eastern white pine (front apron framing), brass.

RELATED EXAMPLES: A sewing table, labeled "Michael Allison 1823," has a very similar griffin-headed lyre (McClelland 1939, p. 195, pl. 179); Davidson and Stillinger 1985, p. 149, fig. 232.

REFERENCES: Warren 1975, p. 97, no. 185.

1. Classical furniture was being bought in the 1950s for the restoration of Varner Plantation, the Hogg family home in West Columbia, Texas. The exact purchase date of this table is not known. However, the table was at Bayou Bend prior to 1965.

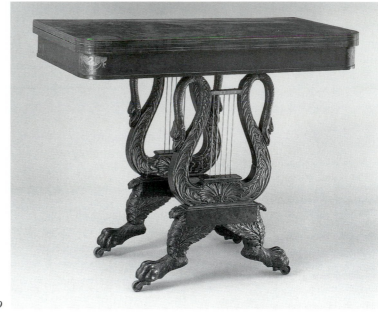

F209

PROVENANCE: Purchased by Bayou Bend from Israel Sack, New York, 1970.

TECHNICAL NOTES: Mahogany, mahogany veneer; yellow-poplar (base), brass.

RELATED EXAMPLES: A very similar example, which the owner thinks might have been made in Albany, is in a private New York City collection; also, Sotheby Parke-Bernet, New York, sale 3981, April 27–30, 1977, lot 931.

REFERENCES: Warren 1971a, p. 48, fig. 19; Warren 1975, p. 98, no. 187; Sack 1969–92, vol. 3, p. 661, no. 1473.

F210

Stand

1815–25
New York State, probably New York City
Mahogany and secondary wood; 27½ x 22¾ x 18½" (69.9 x 57.8 x 47 cm)
Museum purchase with funds provided by the Friends of Bayou Bend, B.70.27

This sophisticated little table represents a rare continuum of the tradition of the tilt-top stand that was introduced in the middle of the eighteenth century. A dual function as table and candlestand is suggested by the fact that the tilting surface is veneered and cross-banded on both sides. Derived from the card table, the form of the Bayou Bend stand is ingenious in the introduction of a three-part lyre that conforms to the tripod lower section. Brass stringing along the base and brass rods in the lyre complete the composition.

F211

Work Table

1810–20
New York
Mahogany and secondary woods; 30⅛ x 23 x 15⅛" (76.5 x 58.4 x 38.4 cm)
B.69.391

The early nineteenth century witnessed the introduction of many specialized forms of furniture, some intended for use

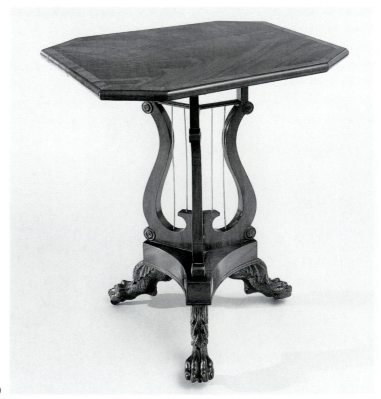

F210

by ladies (see cat. no. F178). This small lady's work table, an example of that genre, represents the New York school at its most sophisticated and most expensive, with its attention to detail, such as the canted corners with recessed panels and the reeded edge to the lift top. Unusual is the fact that the urn is uncarved and that there is no reeding below the leaf carving of the legs. The inside upper compartment is fitted out with an adjustable writing surface and storage areas for writing materials. Behind the tambour door are two sliding shelves with mahogany veneered fronts.

PROVENANCE: Purchased by Miss Hogg from Collings and Collings, New York, 1928.

TECHNICAL NOTES: Mahogany, mahogany veneer; yellow-poplar (interior top and sides, drawer components, drawer runners), eastern white pine (interior base), cherry (cross support over pedestal), brass. The casters are original.

RELATED EXAMPLES: A very similar table at Winterthur varies in small details (Montgomery 1966b, no. 408); another is illustrated in the *Antiquarian* 16 (February 1931), p. 14; a related example, but with a four-column and platform lower section, as opposed to the central vase and four saber legs of the Bayou Bend table, was auctioned at Christie's, New York, sale 8006, June 2, 1990, lot 204. For a similar satinwood example, see Cooper 1980, p. 263, no. 303.

REFERENCES: Nutting 1962, no. 1183; Warren 1975, p. 98, no. 188.

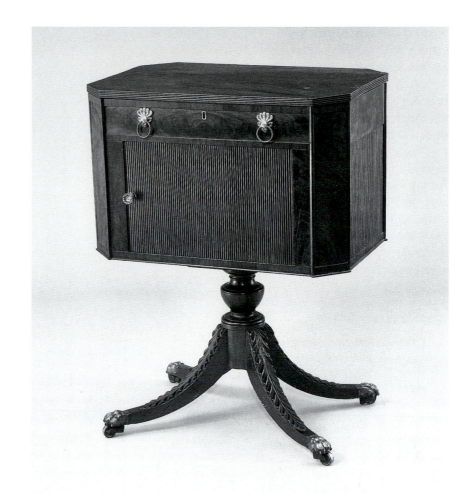

F211

F212

Pier Table

1815–25
New York
Mahogany, secondary woods, and marble;
37¼ x 42 x 18¾" (94.6 x 106.7 x 47.6 cm)
B.67.29

While the marble-topped pier table had been known in America since the mid-eighteenth century, the form assumed new importance as a key piece of Grecian parlor furniture in the early nineteenth century. Often made in pairs and intended to be placed between windows, these tables incorporated classical elements, including columns and pilasters, and often mirror glass completed the back of the

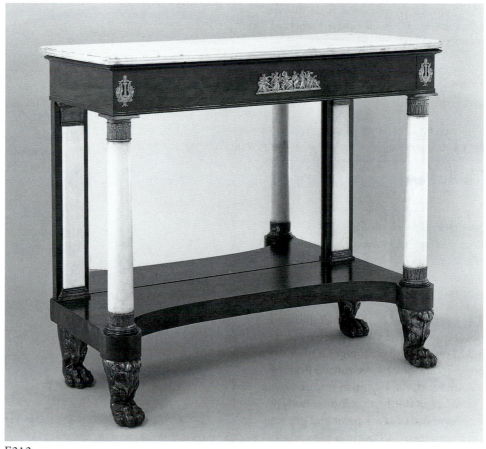

F212

lower section. This type of pier table, with marble elements, does not appear in the New York price book of 1815, suggesting it was either a specialty item or a form not prevalent enough to be included.[1] However, the 1833 Meeks broadside illustrates several versions, the basic form described as "mahogany pier table with white marble top and columns," and indicates that the same table with black and gold "egyptian marble" cost one-third more.[2] Even so, with the marble elements, looking glass, and gilt bronze mounts, this piece represented an expensive and stylish piece of parlor furniture.

PROVENANCE: Purchased by Miss Hogg from Ginsburg and Levy, New York, 1967.

TECHNICAL NOTES: Mahogany, mahogany veneer; eastern white pine (table base, apron), mahogany (vertical side framing), yellow-poplar (carved feet), marble, mirror glass, brass, gilt.

RELATED EXAMPLES: Two in the Empire Parlor at Winterthur are, like this example, relatively restrained in design (Sweeney 1963, p. 128); a slightly later pair has stenciled rather than ormolu decoration (Sack 1969–92, vol. 7, p. 1757, no. P4899); Anglo-American Art Museum, Louisiana State University, Baton Rouge (*Antiques* 105 [March 1974], p. 470).

REFERENCES: Warren 1970d, p. 126; Warren 1975, p. 98, no. 189 (with incorrect accession number).

1. New York Prices 1815.
2. MMA (acc. no. 43.15.8). See Davidson and Stillinger 1985, p. 164.

F213
Table

1825–35
New York
Rosewood, secondary woods, and marble;
28⅝ x 29¾" (diam.) (72.7 x 75.6 cm)
B.67.40

The overall form of this small, multipurpose, tripod stand with a marble top is based on antique prototypes. Other references to antiquity—the turned Roman-inspired feet, the Egyptian-inspired lotus-shaped capitals of the columns, and the extensive use of black paint and gilt stenciled ornament, all features associated with the later phases of the Grecian

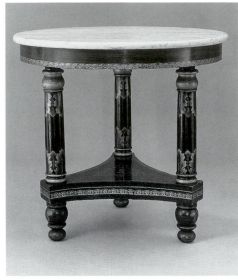

F213

style—are found in examples made in New York City.

PROVENANCE: Purchased by Miss Hogg from Peter Hill, Washington, D.C., 1967.

TECHNICAL NOTES: Rosewood veneer; eastern white pine (inner apron rim, T-support, base), soft maple (columns, feet), marble, paint, gilt.

RELATED EXAMPLES: Levy Gallery 1975, p. 48.

REFERENCES: Warren 1975, p. 99, no. 190.

F214
Center Table

1825–35
Possibly by the shop of Brazilia Deming (1781–1854) and Erastus Bulkley (1792–1854), New York
Mahogany and secondary woods; 27½ x 36" (diam.) (69.9 x 91.4 cm)
B.69.526

By about 1820, the placement of a round table in the center of the room became standard for the furnishing plan of the fashionable American parlor. Thomas Webster in his Encyclopaedia of Domestic Economy describes the form and relates that such tables "are made with the pillar extremely strong."[1] This example, with its plain, uncarved, tapering circular pillar and simple cone-shaped feet, is in the late classical taste of the Restoration style. The top is painted with an idyllic lakeside scene in the Romantic taste, and paint is skillfully used to emulate rosewood and brass ornament on the pillar and platform base. The landscape, which is surrounded by a border of gilt cornucopia and scrolls, relates to landscapes on a group of New York chairs (see cat. no.

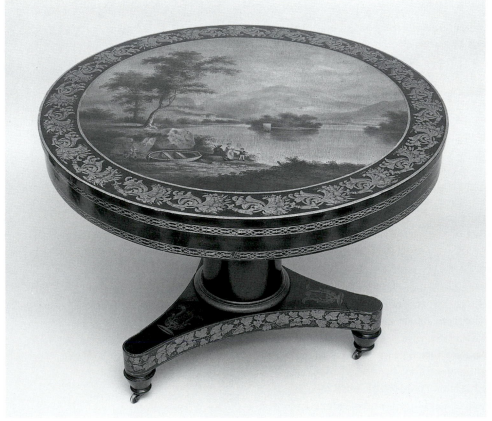

F214

F196) and also to a small body of center tables that feature painted scenes on their tops. The gilt freehand grapevine decoration around the base recalls the ornament on a group of furniture made in New York by the partnership of Brazilia Deming and Erastus Bulkley and retailed in Charleston, South Carolina.[2]

PROVENANCE: Purchased by Miss Hogg from Ginsburg and Levy, New York, 1969.

TECHNICAL NOTES: Mahogany (top, feet); eastern white pine (rim, top two braces under top, base, board underneath column), cherry (lowest brace under top), paint, gilt.

RELATED EXAMPLES: This table, with its wood top, seems to be a less expensive version of center tables with slate tops painted with enamels, often referred to as Italian tops, and ornamented with Romantic scenes; two Baltimore examples with borders of oak leaves are shown in Elder 1972, no. 29 with a similar water scene, and no. 30 with a classical ruin scene. Elder suggests, p. 52, that these scenes may be derived from the work of either Claude Vernet or Carle Vernet, French landscape painters. A New York example with a naval engagement is at Winterthur (Sweeney 1963, p. 128).

REFERENCES: Advertisement of Ginsburg and Levy, *Antiques* 97 (January 1970), p. 9; Fales 1972, pp. 160–61, nos. 259, 259a; Warren 1975, p. 99, no. 191.

1. Webster 1845, p. 259.
2. Deming and Bulkley advertised in 1820 a suite of rosewood furniture ornamented with "a border in imitation of a grape vine," as cited in McInnis and Leath 1996, p.152, which shows examples at figs. 20, 32.

F215

Center, or Loo, Table

1825–35
Philadelphia
Painted and gilded mahogany and secondary woods; 29¼ x 48" (diam.) (74.3 x 121.9 cm)
Museum purchase with funds provided by Mrs. Harry C. Hanszen, B.67.7

The *Philadelphia Cabinet and Chair Maker's Union Book of Prices* for 1828 very nearly describes this example in listing "loo table with solid top three feet eight inches in diameter," noting that the top can be turned up "with clamps and catch."[1] While inclusion of this type of tilt-top

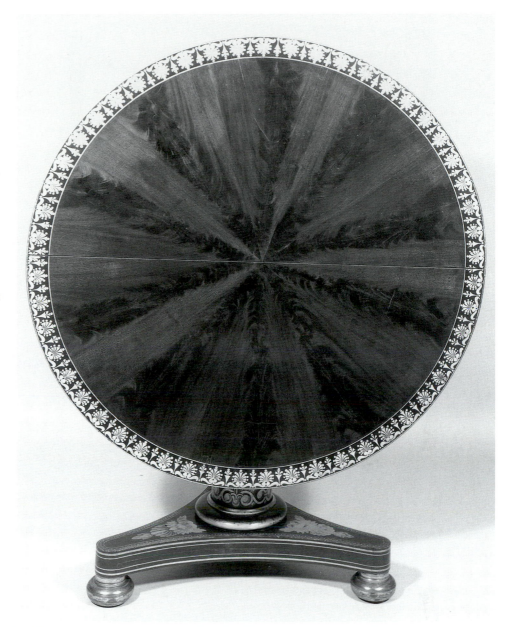

F215

table in the Philadelphia price book would suggest that it was common there, no other examples have been discovered. However, highly figured wedge-shaped rays of mahogany veneer also appear on the top of a group of extremely sophisticated Philadelphia center and card tables, which tends to confirm Philadelphia as this piece's place of origin. This ray ornament is not found on English tables of this type, although it is seen in German and Austrian tables, suggesting a possible Germanic influence at work in Philadelphia. However, the painted black and gold band around the outer edge of the top echoes the use of inlaid brass on English Regency library center tables. Contrasting with the mahogany top, the skirt, pedestal, and base are ebonized with skillfully stenciled gilt ornament. The design

source for this table may be plate 69 of George Smith's 1808 *Designs*, where figure 2 illustrates a closely related example with molded skirt and acanthus leaf ornament at the base of the pillar. Smith describes how the top turns up as usual and how the molded frame or skirt conceals the block and pin mechanism, all features found in this example.[2] The compressed ball-shaped brass feet, which closely resemble those in the Smith illustration, bear the mark of Yates and Hamper, a leading brass manufacturer in Birmingham, England. While the Bayou Bend table represents the acme of Philadelphia Grecian taste, it is not possible to assign it to a specific maker.

PROVENANCE: Purchased by Bayou Bend from Peter Hill, Washington, D.C., 1967.

F216

TECHNICAL NOTES: Mahogany, mahogany veneer; eastern white pine (fixed rails), black cherry (hinge rails), brass.

RELATED EXAMPLES: Burroughs 1967, p. 60, pl. VII; Sotheby's Parke-Bernet, New York, sale 4048, November 17–19, 1977, lot 717.

REFERENCES: Warren 1975, p. 100, no. 193.

F217

Patent Model for an Extension Dining Table

ca. 1851
Lewis Thorn (act. 1844–52), Philadelphia
Walnut and secondary woods; open: 11 x 30¾ x 12¼" (27.9 x 78.1 x 31.1 cm); closed: 11 x 13⅞ x 12¼" (27.9 x 35.2 x 31.1 cm)
Museum purchase with funds provided by the William Hill Land and Cattle Company in honor of Jeanie Kilroy, B.93.10

In 1790 Congress established the United States Patent Office, where records of inventions could be registered with the government and their inventors' rights given protection. Those making an application were required to submit working drawings and, when pertinent, a working model. As the nineteenth century progressed, many craftsmen explored new and innovative methods of furniture manufacture (see cat. no F232). One form that received considerable attention was a dining table that could be expanded easily. In 1851 Lewis Thorn was awarded patent no. 7997 for an "improved" extension dining table based on this working model. Thorn's solution is cleverly conceived so that when the table is opened to its full expanse, the center boards receive addi-

TECHNICAL NOTES: Painted and gilded mahogany, mahogany veneer (table top and block); yellow-poplar (pedestal, table top rim), eastern white pine (base). Stamped on bottom of brass feet, below a crown-shaped symbol: "PATENT / YATES & HAMPER."

RELATED EXAMPLES: Examples ascribed to Philadelphian Anthony Quervelle (1789–1856) often utilized the motif of wedge-shaped veneers, both on the tops of center tables and on the bases of pier tables (see Smith 1973, p. 90). Two Philadelphia tables at Winterthur also have this ornament (Montgomery 1966b, nos. 316, 349). A table bearing the stamp of Quervelle in the Baltimore Museum of Art has feet marked Yates and Hamper (Cooper 1993, p. 60, no. 36), as does an identical table in a private New York collection; a sofa table bearing the stamp of Quervelle has similar brass feet (PMA 1976, p. 277). For an English example with inlaid brass, see Christie's, London, sale 5404, June 8, 1995, Fine English Furniture, lot 231; for a Baltimore example, see Weidman et al. 1993, p. 128, fig. 155.

REFERENCES: Warren 1970d, p. 123, fig. 2; Fales 1972, p. 165; Warren 1975, p. 99, no. 192.

1. Loo was a popular card game in the late eighteenth and early nineteenth centuries.
2. Smith 1970a, pp. 12–13.

The multiple-use, three-part dining table was a new furniture form introduced at the end of the eighteenth century as American households began to reserve rooms specifically for dining. Typically, the central section is fitted with swing legs and drop leaves; the end sections (in the case of the Bayou Bend table, D-shaped) attach to the drop leaves or, when removed, can be placed against the wall like pier tables. The otherwise severe design of this table is relieved by complicated twist-turned legs derived from the late designs of Thomas Sheraton, which, with their ropelike appearance, ultimately make reference to England's maritime victories of the Napoleonic era. While this table has a southern history and has been published as possibly of Charleston origin, the secondary woods are of such ubiquitous types that pinpointing the city of origin is not possible.

PROVENANCE: Joseph Jones, Liberty County, Georgia; to his son John Carolynn Jones; to his granddaughter Frances Jones Bidwell, New York; purchased by Miss Hogg from Frances Bidwell, 1963.

F216

Dining Table

1810–30
Eastern United States
Mahogany and secondary woods; overall: 28⅞ x 53⅞ x 115⅜" (73.3 x 136.8 x 293.1 cm); end sections, each: 28⅞ x 53⅞ x 23⅛" (73.3 x 136.8 x 58.7 cm); center section, open: 28⅞ x 53⅞ x 69⅛" (73.3 x 136.8 x 175.6 cm)
B.63.76

F217

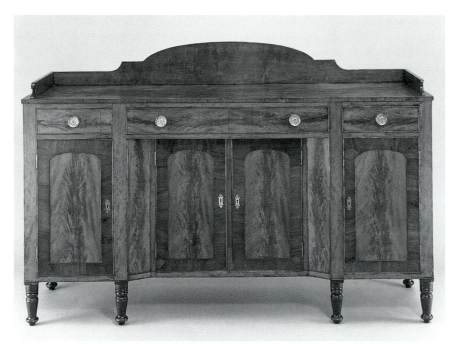

F218

legs, is typical of the later examples produced in the south.

PROVENANCE: Purchased by Miss Hogg from Mrs. Albert Guinn Hope, Knoxville, Tennessee, through John F. Staub, architect of Bayou Bend, and Mrs. Hope's nephew, 1961.

TECHNICAL NOTES: Black cherry, mahogany veneer (arch surrounds of cupboard doors), undetermined crotch-grain veneer (panels of cupboard doors), black cherry (feet, drawer fronts, framing posts); yellow-poplar (drawer components, interior framing). The brasses replace original glass pulls, removed in 1961.

REFERENCES: Warren 1975, p. 100, no. 195.

F219

Sideboard

1825–35
Attributed to the shop of Joseph Meeks and Son (act. 1797–1868), New York
Gilded mahogany and secondary woods; 60¼ x 68½ x 28" (153 x 174 x 71.1 cm)
Museum purchase with funds provided by Mrs. Harry C. Hanszen, B.67.6

tional support from the turned legs that, when the table is closed, are concealed in the central columnar support. Despite Thorn's successful patent, his cabinet business apparently did not prosper, for by 1853 the Philadelphia city directory lists him as a confectioner.

PROVENANCE: U.S. Patent Office; purchased by Bayou Bend from Joan Bogart, Roslyn, New York, 1993.

TECHNICAL NOTES: Walnut (top, outside rail of center sliding mechanism); eastern white pine (end apron), yellow-poplar (side apron), cucumber tree (nonveneered inside portion of center column), white oak (middle rail of center sliding mechanism). The model bears a paper tag that reads: "No. 7997 / L. Thorn. / Extension Table / Patented Mar. 25. 1851." The top is removable, but the model does not seem to have come with the other half of the top.

RELATED EXAMPLES: A similar full-size table is at Varner-Hogg State Park, West Columbia, Texas (Otto 1965, fig. 213).

By the second quarter of the nineteenth century, the sideboard had become a common form in upper-middle-class American households. This example, with splashboard above and, in the lower section, tall cupboards above short, turned

F218

Sideboard

1815–30
Probably eastern Tennessee
Black cherry, mahogany, and secondary woods; 48⅜ x 72⅛ x 20¼" (122.9 x 183.2 x 51.4 cm)
Gift of Miss Ima Hogg, B.61.28

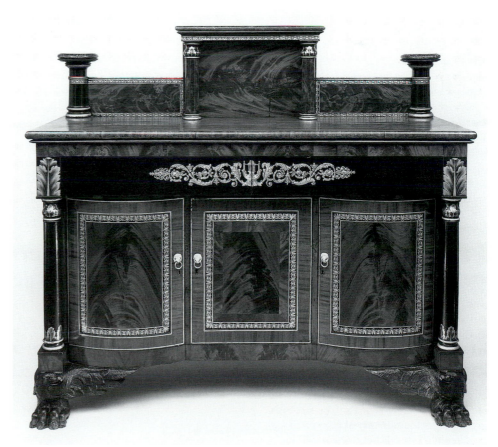

F219

By the 1820s New York City had become the major center for the manufacture of furniture by large firms such as the shops of Duncan Phyfe or Joseph Meeks. The furniture line of the Meeks firm is well documented by its 1833 broadside.[1] Indeed, in its general scheme, this sideboard closely resembles one illustrated there as number 33, differing primarily in its central raised platform on the splashboard and in its massive eagle brackets and paw feet. By this period such details could be added to or deleted from the basic model, so the possibility exists that the Bayou Bend example might well be the product of the Meeks factory. The magnificent figured mahogany veneers, ebonizing, and gilded decoration represent the acme of New York taste in the late classical style and indicate that originally this was a very expensive piece of furniture.

PROVENANCE: By tradition owned by Robert Gilbert Livingston, friend of John Wilkinson; to John's son Robert Wilkinson; to his son William Wilkinson; to his son Robert Frederick Wilkinson; to his daughter Edith Wilkinson; purchased by her niece, Mrs. Robert Wilkinson, Jr., through Edith Wilkinson's estate[2]; purchased by Bayou Bend from Peter Hill, Washington, D.C., 1967.

TECHNICAL NOTES: Mahogany (small columns on top; side slides), mahogany veneer; mahogany (feet, pedestals on top, drawer sides), white oak (vertical strips on either side of center door), soft maple (large columns on sides), ash (case corner blocks by drawer sides), eastern white pine (horizontal support underneath drawers, inner framing and back of drawers, upper backboards), yellow-poplar (horizontal board above drawers, six-inch front base rail veneered with mahogany, drawer backs and bottoms), brass casters and pull (slide on left side). Ash divider in right drawer is a later addition. The lion's-head pulls on the lower section are an early replacement. In 1966, Peter Hill restored the stenciled leaves to the tops of the two columns flanking the portico and restored the painted border around the pedestals at the ends of the back rail. The gilded decoration across the front of the two drawers has been modified. The perimeter of the black background on the drawer front has been strengthened by the addition of an unsympathetic muddy black. The cross sections indicate more than one layer of gold. Based on three samples taken, there appears to be a correlation between the earlier gold placement and the later. It is possible but unclear that the current decoration matches the original.

RELATED EXAMPLES: Advertisement of Aileen Minor American Antiques (*Antiques* 42 [October 1992], p. 472) illustrates a very similar example. Similar in concept, although not in execution, is an example at Montgomery Place, Tarrytown, New York (Butler 1988, p. 297).

REFERENCES: Fales 1972, p. 165; Warren 1975, p. 101, no. 196; Warren 1982, p. 239.

1. Davidson and Stillinger 1985, p. 164.
2. According to Peter Hill, this piece has a Livingston family history, but this cannot be substantiated.

F220

Cellarette

1815–25
New York
Gilded and painted mahogany, yellow-poplar, and secondary woods; 24¾ x 22¾ x 22¾" *(62.9 x 57.8 x 57.8 cm)*
B.67.31

Furnishings for the dining room became increasingly elaborate during the Grecian period of the early nineteenth century. One of the specialized new forms was the cellarette, which was made en suite with the pedestal sideboard and was intended for the storage of bottled wine or spirits. In keeping with the references to antiquity, the form here is based on the classical sarcophagus. Casters, concealed in the *vert antique* paw feet, facilitate moving the piece from its usual location near the sideboard to a spot adjacent to the dining table. Superbly figured mahogany veneers,

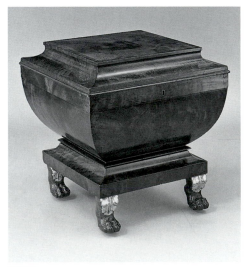

F220

skillfully applied to the curved surfaces, lend a note of richness to this otherwise severe form.

PROVENANCE: Purchased by Miss Hogg from Peter Hill, Washington, D.C., 1967.

TECHNICAL NOTES: Mahogany, mahogany veneer, yellow-poplar (feet); eastern white pine (lower left front glue block, bottom board, lower framing), mahogany (interior bottom), paint, gilt.

RELATED EXAMPLES: McClelland 1939, pl. 107, illustrates a similar cellarette placed in the central open section of its en suite sideboard. A similar one was sold at the Doyle Galleries, New York, December 4, 1985, lot 662. Other examples: an advertisement of Doyle Galleries, *Maine Antique Digest,* May 1997, p. 23-H; Yale (Ward 1988, no. 229). For an extensive consideration of the form, see Solny 1996 and Solny 1997.

REFERENCES: Warren 1970d, p. 125, fig. 8; Warren 1975, p. 102, no. 197; Solny 1996, example 2; Solny 1997, example 2.

F221

Writing Table and Bookcase

1825–35
New York
Gilded mahogany and secondary woods and materials; 77¾ x 47¾ x 21¼" (197.5 x 121.3 x 55.2 cm)
Museum purchase with funds provided by Mrs. Fred T. Couper, Jr., in loving memory of her mother, Mrs. William Victor Bowles, B.82.4

The writing table and bookcase, a relatively rare form today, appears in the 1810 New York price book.[1] The design, as the name suggests, places a bookcase on top of a pier table. Often the drawer is fitted out with an adjustable writing surface and areas for pens, as seen here. The upper section usually features mullioned glass doors. The Bayou Bend example, with its severe plain surfaces veneered with richly figured mahogany, exemplifies the French-inspired Restoration style at its most sophisticated. Gilt-bronze mounts and gilding on the typically ovoid fluted feet provide bright accents that relieve the severity and unite the overall composition.

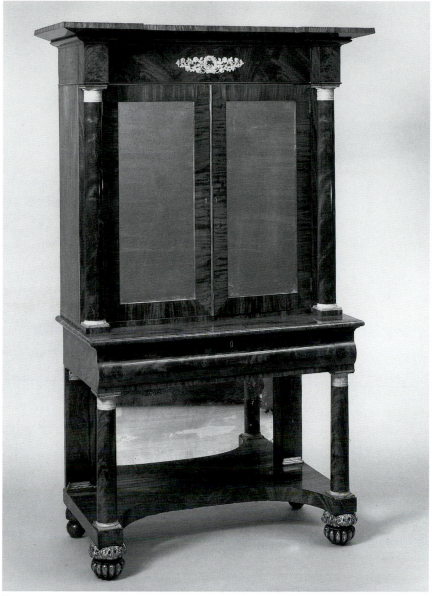

F221

a Philadelphia example (Flanigan 1986, p. 220, no. 90); a Baltimore example (Weidman et al. 1993, p. 136). A group of New York square sofas exhibit similar veneered columns and fluted carved feet (Tracy and Gerdts 1963, no. 57).

1. New York Prices 1810, p. 32.

F222

Desk

1840–70
Probably Zoar, Ohio
Various woods (see Technical notes); 52¾ x 45½ x 26⅜" (134 x 115.6 x 67 cm)
Gift of Mr. and Mrs. Richard N. Gould, B.84.8

The Restoration style, characterized by the use of large scrolled ornament, had become ubiquitous throughout the United States by the middle of the nineteenth century, as attested by this desk, which has an Ohio provenance. It is thought to have been made in the community of Zoar, founded by a group of German pietists in 1817. Case pieces produced in nonurban areas were often made of figured maple rather than the more expensive mahogany.

PROVENANCE: Purchased by Mr. and Mrs. Richard N. Gould in Ohio, 1983.

PROVENANCE: Purchased by Bayou Bend from F. J. Carey, Pennlyn, Pennsylvania, 1982.

TECHNICAL NOTES: Mahogany, mahogany veneer; eastern white pine (drawer front, cornice, lower mirror frame, drawer runners, front feet, front section of corner blocks on either side of drawer, all interior drawer framing except front horizontal drawer support and rear section of corner blocks on either side of drawer, bookshelves, framing members in back of upper case), yellow-poplar (back of lower mirror, rear section of corner blocks on either side of drawer, front horizontal drawer support, drawer bottom, shelf steps, two framed backboard panels in upper case), gilding, glass, gilt-bronze mounts. The lock on the upper case is stamped "TURNER."

RELATED EXAMPLES: A stenciled New York example at MMA (Tracy et al. 1970, no. 70); one from Albany, New York, at Baltimore Museum of Art (Cooper 1993, p. 212, no. 169);

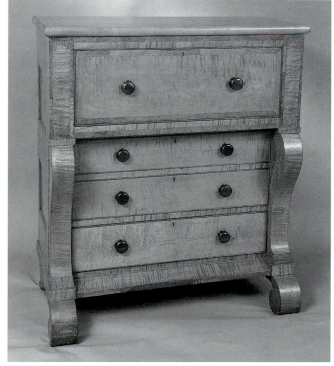

F222

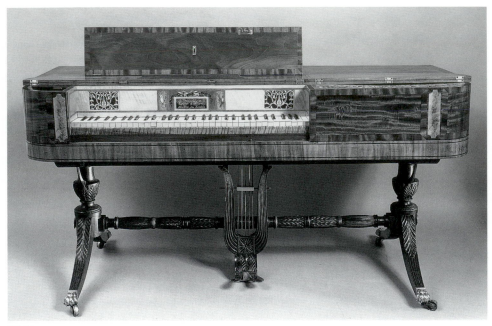

F223

TECHNICAL NOTES: Hard maple (writing surface, large bottom drawer front, front veneer, face veneer inside right front foot), eastern white pine (right base rail, rear base rail, right side rail), mahogany (knob of large bottom drawer), cherry (banding along lower edge of large bottom drawer), red oak (right rear foot); hard maple (knob of small bottom drawer behind prospect door), eastern white pine (right side back panel, center stile of back frame, right guide for large bottom drawer, drawer components of small bottom drawer behind prospect door), yellow-poplar (right rear frame post).

RELATED EXAMPLES: Ohio Historical Center, Columbus (Adamson and Muller 1984, p. 16); Zoar 1984, p. 87.

REFERENCES: Gustafson 1986, p. 966.

F223

Square Piano

1810–15
Case and works: shop of Thomas Gibson and Morgan Davis (act. ca. 1801–22), New York
Base: unidentified New York shop
Painted and gilded mahogany and secondary woods; 37¼ x 71⅝ x 32" (94.6 x 181.9 x 81.3 cm)
B.57.4

About 1700, the pianoforte, a new musical instrument operated with hammers sounding the strings, evolved in Florence, Italy. In the mid-eighteenth century the English adapted the Italian invention to the clavichord case, creating the square

piano. By 1800 that form was being produced by American craftsmen, including the immigrant British piano makers Gibson and Davis, who founded their New York partnership in 1801. Their pride in English training is conveyed by the inscription on the painted name board, where they also indicate that this model is a horizontal grand. The trestle or cheval bases, produced for the piano makers by cabinetmaking shops, derive from the sofa table form, for which the 1810 New York price book describes "two turned . . . pillars straight stretcher and four claws."[1]

PROVENANCE: Mrs. J. Insley Blair; purchased by Miss Hogg from Ginsburg and Levy, New York, 1957.

TECHNICAL NOTES: Mahogany, mahogany veneer, satinwood (inlaid panels with cut corners), soft maple (strip below keyboard), holly (name board and sides, open fretwork, veneer at end of keys); yellow-poplar (black piano keys, D-shaped ends for hammers' support, core of music rack base, panels behind fretwork, board on which hammers rest), holly (veneer layer below string board, interior fretwork on right side of case, veneer on interior sides of case, tuning pin board, string pin board, interior lining board left of keyboard), beech (tuning string supports), basswood (key bars), cherry (rocker pin board for supporting key bars), soft maple (molding surrounding horizontal triangular fretwork in right side of case), eastern white pine (soundboard in right side of case, name board on which holly is veneered, bottom board of piano case, painted cover board), hemlock (cleat under painted board), mahogany (hammer shafts, hammer

mechanism parts, hammer board to which they are hinged, trim around the soundboard, music rack, lid support, interior carved fretwork to right of keyboard), ash (support frame for piano case). This piano appears to have had the earlier simple wire pedals and later, perhaps in the 1820s or 1830s, was adapted with the current lyre pedal arrangement. Name board is inscribed: "Gibson & Davis/ New York from London" and "Patent Grand."

RELATED EXAMPLES: Henry Ford Museum, Dearborn, Michigan (Otto 1965, no. 44); a virtually identical example, but without the lyre pedal, at MMA (Libin 1985, pp. 168–69); advertisement of Carl and Celia Jacobs, *Antiques* 90 (October 1966), p. 446; advertisement of Ginsburg and Levy, *Antiques* 107 (March 1975), p. 381; advertisement of Israel Sack, *Antiques* 138 (September 1990), p. C-2; Sack 1969–92, vol. 10, p. 2620, no. P6228.

REFERENCES: Comstock 1962, no. 509; Warren 1975, p. 103, no. 199.

1. New York Prices 1810, p. 24.

F224

Looking Glass

1830–37
Shop of Charles del Vecchio (1786–1854), New York
Mahogany, cherry, and secondary woods and materials; 32¼ x 18¼ x 3¼" (81.9 x 46.4 x 8.3 cm)
Museum purchase with funds provided by the Alice Sneed West Foundation in memory of Natalie Gallagher, B.90.16

Charles del Vecchio was a member of a large and prolific family of craftsmen working in the New York City cabinet trade in the early nineteenth century.[1] This little, late pillar frame looking glass is typical of New York City's large output. Del Vecchio's label (see Technical notes) is indicative of the geographic spread of the market, although whether this mirror was intended for export to the West Indies or South America is not clear.

PROVENANCE: Purchased by Bayou Bend from Bernard and S. Dean Levy, New York, 1990.

TECHNICAL NOTES: Mahogany (sight edge, frieze, moldings across frieze, right side of top molding), cherry (bottom rail, right stile); eastern white pine (backboard, top cross rail on back behind top molding), soft maple

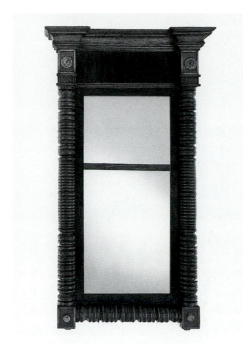

F224

(raised edge of right corner block), brass, mirror glass. The lower left corner block is replaced. Label on backboard: "C. DEL VECCHIO, / Fabricante De Espejos Y Marcos / TODA CLASE DE PINTURAS / En Su Fabrica No. 44 Calle De Chatham / NUEVA YORK. / Donde tiene constantemente entre manos un suendo j[]neral de Espejos, inclusos los de Sala, / de sobre mesa como de colgar y tambien de / cuerpo-entero para adonarse, fabricados con / forme los recientes modelas de mas moda. / Marcos para Retraios, y de todas descrip- / ciones, los hace a la orden. / Azoga nueva- mente las Lunas de los Espejos / viejos, y redora los marcos. Todo empaquetado / en el mejor orden para las navagaciones y los / viajes a precios equitativas. / C. DEL VECCHIO habla las lenguas Espanola, Francesa, Inglesa, [] Italiana." [C. DEL VECCHIO, manufac- turer of looking glasses and frames. Every kind of paintings in his factory No. 44 Chatham Street, New York, where he con- stantly possesses a wide variety of looking glasses, including those for drawing rooms, for tabletops, and also for hanging, as well as full length for dressing, all made according to the latest fashion. Frames for portraits, of every description, can be made to order. Re- plate old looking glasses and refurbish gold leaf on frames. Everything packed for over- seas travel at competitive prices. C. DEL VECCHIO speaks the Spanish, French, English, and Ital- ian languages.]

RELATED EXAMPLES: Van Cott 1989, pp. 221–34.

1. For information on the New York del Vecchios, see Van Cott 1989 and Ring 1981, p. 1182. For information on the Dublin del Vecchios, see Fitz-gerald 1981.

F225

Looking Glass

ca. 1835
Shop of Thomas Natt (act. 1809–41),
Philadelphia
Eastern white pine and secondary materials;
53½ x 33½ x 2⅜" (135.9 x 85.1 x 6 cm)
B.68.26

Thomas Natt was an importer and maker of a wide variety of frames (see also cat. no. F226). A number of his labeled dressing glasses or shaving stands survives. This large gilt looking glass, with its lotus- ornamented baluster frame and corner rosettes, is made in such a way that it could have been used either horizontally over a mantel or vertically between win- dows as a pier glass.[1]

PROVENANCE: Purchased by Miss Hogg from Peter Hill, Washington, D.C., 1968.

TECHNICAL NOTES: Eastern white pine; gesso, gold leaf, mirror glass. Label on backboard: "THOMAS NATT, / CARVER, GILDER, / AND IMPORTER OF / British and French Loooking [sic] Glasses, / ENGRAVINGS & c. / No. 192, / Chestnut Street Near Eighth St. / PHILADELPHIA. / AN ELEGANT ASSORTMENT OF / GILT FRAMED MANTEL AND PIER GLASSES. / MAHOGANY Do. Do. [MANTEL AND PIER GLASSES] / TOILETTE AND SWING GLASSES. / PICTURE and PORTRAIT FRAMES made to any pattern, at the shortest notice. / YOUNG, PRINTER."

REFERENCES: Warren 1970d, p. 126; Warren 1975, p. 92.

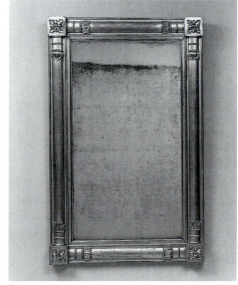

F225

1. While the Philadelphia directories do not place Natt at 192 Chestnut until 1837, two bill heads dated by hand in 1835 provide the address at 192. These are in the DAPC; one, dated August 29, 1835, is made out to the College of New Jersey, the other, dated December 7, 1835 to Mr. Latimer.

F226

F226

Dressing Box

1825–35
Shop of Thomas Natt (act. 1809–41),
Philadelphia
Mahogany and secondary materials; 24 x 23½ x
8" (61 x 59.7 x 20.3 cm)
Gift of Donnie Duplissey, B.94.8

Philadelphia city directories list Thomas Natt at 134 High Street from 1825 to 1837, although it is known that he had left that address by 1835 (see cat. no. F225). While the label on this box reads Market Street, High is another name used for that street in the nineteenth century. This form must have been a very popular Philadelphia product, as a number of examples labeled by Natt and many other Philadelphia- made dressing boxes survive. However, in a later label (see cat. no. F225), Natt omit- ted mention of dressing boxes and added mantel, pier, and toilette glasses.

PROVENANCE: Purchased by Donnie Duplis- sey from J. and L. West Antiques, Fairville, Pennsylvania, 1994.

TECHNICAL NOTES: Mahogany; eastern white pine (backboard of base case, mirror backboard), holly (stringing around front drawers), yellow-poplar (bracket behind front left foot, possibly a replacement), brass, mir- ror glass. Label on backboard: [THO]MAS

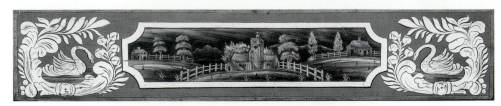

F227

NATT, / AT HIS / [WHOL]ESALE AN[D RET]AIL / [LOOKING G]LASS MA[NUF]ACTORY, / [NO. 134, M]ARKET STREET SOUTH SIDE, / [THREE D]OORS ABOVE FOURTH STREET, / [K]eeps constantly on hand / [A LARGE] AND GENERAL ASSORTMENT OF / GIL[T, MAHOGAN]Y, AND FANCY FRAMED LOOKING-GLASSES, / [DRESSIN]G-BOXES, SWINGS, SCONCES, &c. &c. / S[ou]thern, Western, and other Merch[a]nts, suppli[ed] on the low / est terms, for Cash or Acceptances. / N. B. Importer of P[la]te Glass, and Looking-glass P[la]tes of all dimensions.

RELATED EXAMPLES: Winterthur, Historic Houses of Odessa, Delaware, David Wilson House (DAPC); PMA; two advertised by Elizabeth R. Daniel, *Antiques* 125 (April 1984), p. 726; and *Antiques* 180 (July 1986), p. 34.

F227
Set of Six Valances

1820–40
Probably New York State
Yellow-poplar, paint, and gold leaf; each 8⅝ x 44¼ x ⅜" (21.9 x 112.4 x 1 cm)
B.68.4.1–.6

While originally thought to be window cornices, these are more likely valances for venetian blinds, judging from related extant examples that remain with their blind sets. The naive, fanciful landscapes of the central panels depict a stone windmill, a Gothic church, a Gothic bridge, an octagonal garden folly, and houses on two, suggesting that the painter's inspiration came from prints.

PROVENANCE: Purchased by Miss Hogg from Peter Hill, Washington, D.C., 1968.[1]

RELATED EXAMPLES: A virtually identical example is in the Bybee Collection, Dallas Museum of Art. Similar valance boards, painted cream rather than green, were found in the attic of the Pettus Home in Woodville, Mississippi, and were installed at Rosemont Plantation, Woodville. Another set in Murfeesboro, Tennessee, has been documented in MESDA's survey of southern decorative arts (letters in object files, Bayou Bend). Other examples are illustrated in Waring 1968, fig. 153; Christie's, New York, June 4, 1988, sale 6622, lot 111; Sotheby's, New York, October 26, 1991, sale 6627, lot 111; Northeast Auctions, Manchester, New Hampshire, May 23–24, 1992, lots 400, 401; and *Antiques and The Arts Weekly*, October 6, 1995, p. 134E.

REFERENCES: Warren 1975, p. 91.

1. According to Hill they were found in upstate New York.

F228
Table

1850–80
Brenham area, Washington County, Texas
Eastern redcedar, ash, and secondary woods; 29⅞ x 26 x 23¾" (75.9 x 66 x 60.3 cm)
B.62.50

This simple table reflects the late classical taste of the immigrant German population in Texas (see also cat. no. F230). Particularly distinctive are the tapering legs, which flare outward at the bottom and conform to Germanic prototypes. A semicircular notch on the drawer bottom provides access without disturbing the clean lines so favored by the German classical style.

PROVENANCE: H. F. Hohlt family, Brenham; Mrs. E. Finney Clay; purchased by Miss Hogg from John Boeker, Brenham, 1962.

TECHNICAL NOTES: Eastern redcedar (top, apron, drawer front), ash (legs); southern yellow pine (drawer sides and back, upper drawer guides), eastern redcedar (drawer bottom, drawer runners). Typically, the drawer bottom is a beveled panel, which is let into the sides of the dovetailed drawer. A later addition of a drawer knob has been removed.

RELATED EXAMPLES: Steinfeldt and Stover 1973, nos. 79, 83.

REFERENCES: Taylor and Warren 1975, p. 189, no. 6.7; Warren 1975, p. 120, no. 223.

F229
Draw Table

1860–80
Fayette or Washington County, Texas
Eastern redcedar and ash; open: 29½ x 35⅞ x 71¾" (74.9 x 91.1 x 182.2 cm); closed: 29½ x 35⅞ x 39" (74.9 x 91.1 x 99.1 cm)
B.69.444

F228

F229

The draw table was among the forms brought to nineteenth-century Texas by immigrant German settlers. A space-saving form originating in the seventeenth century, this type of table, which continued to be made in Germany, featured extensions that were either stored under the central surface or drawn out at either end for increased length.

PROVENANCE: Purchased by Miss Hogg from Mrs. Esther Lawrence, 1970.

TECHNICAL NOTES: Eastern redcedar (top, side rails, drawer runners), ash (legs, leaf support).

RELATED EXAMPLES: Steinfeldt and Stover 1973, pp. 76–77, no. 92.

REFERENCES: Warren 1975, p. 120, no. 224.

F230

Desk on Chest

1860–90
Washington County, Texas
Black walnut, basswood, and secondary wood; open: 50 x 41⅝ x 41¾" (127 x 105.7 x 106 cm); closed: 50 x 41⅝ x 23⅜" (127 x 105.7 x 59.4 cm)
B.62.48

Mid-nineteenth-century German settlers brought with them to Texas the late classical Biedermeier style, Germanic forms of furniture, and traditional methods of construction. The block feet, plinths, flanking columns, and broad, flat arch of the chest section reflect that late classical style. The desk section simply rests on the chest rather than being attached, a typical

Germanic feature. The wide, open central section of the desk interior is also commonly seen in German desks of the period.

PROVENANCE: Carl Linstaeder (1834–1919), Washington County, Texas; purchased by Miss Hogg from Mrs. Thelma Horne, Cobweb Corners, Houston, 1962.[1]

TECHNICAL NOTES: Black walnut, basswood (drawer inlay), black walnut (drawer inlay); southern yellow pine (lower case backboard, top right small drawer bottom). A later addition of latticework railing on the top has been

removed. Mortise-and-tenon construction with inset beveled panels is used throughout.

RELATED EXAMPLES: Steinfeldt and Stover 1973, pp. 32–33, no. 46.

REFERENCES: Taylor and Warren 1975, p. 234, no. 7.12; Warren 1975, p. 121, no. 226; Warren 1982, p. 238; Venable 1985, p. 1166; Warren 1988, p. 61.

1. By tradition the desk was made in Brenham, Texas.

F231*

Box

1840–70
Northeastern United States
Painted and gilded pine; 7½ x 14⅞ x 10⅝" (19.1 x 37.8 x 27 cm)
Gift of Jas A. Gundry, B.96.15

PROVENANCE: Purchased by Jas A. Gundry from Nancy S. Boyd Antiques, New York, 1996.

TECHNICAL NOTES: Pine; paint, gilding (not analyzed microscopically). Surface is crackled all over with numerous deep scratches. Corners and edges are worn. Black paint splatters on interior. Lock plate and hinges, both possibly replacements, are loose.

F230

F232

Parlor Set

1855
Shop of John Henry Belter (1804–1865),
New York
Rosewood and secondary woods; B.81.9.1, Sofa:
47 x 77⅛ x 35⅝" (119.4 x 195.9 x 90.5 cm);
B.81.9.2, Sofa: 45¾ x 71¼ x 32⅛" (116.2 x 181 x
81.6 cm); B.81.9.3, Armchair: 42⅝ x 24½ x
30½" (108.3 x 62.2 x 77.5 cm); B.81.9.4, Armchair:
43½ x 24 x 31" (110.5 x 61 x 78.7 cm); B.81.9.5,
Side chair: 37⅞ x 18¼ x 25" (96.2 x 46.4 x 63.5 cm);
B.81.9.6, Side chair: 38 x 18½ x 25" (96.5 x
47 x 63.5 cm); B.81.9.7, Side chair: 38⅞ x 18¼ x
25" (98.7 x 46.4 x 63.5 cm); B.81.9.8, Side chair:
38 x 18¼ x 25" (96.5 x 46.4 x 63.5 cm); B.81.9.9,
Center table: 28¼ x 41 x 31½" (71.8 x 104.1 x 80 cm);
B.81.9.10, Étagère: 100¼ x 65½ x 16⅝" (254.6 x
166.4 x 42.2 cm)
Gift of the estate of Miss Ima Hogg, B.81.9.1–.10

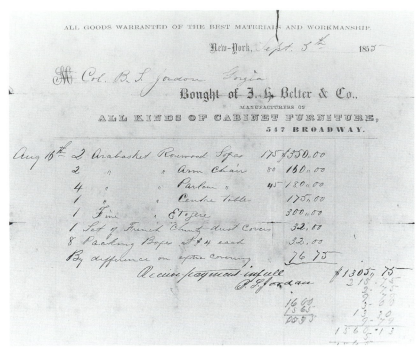

F232 (*bill of sale*)

F232

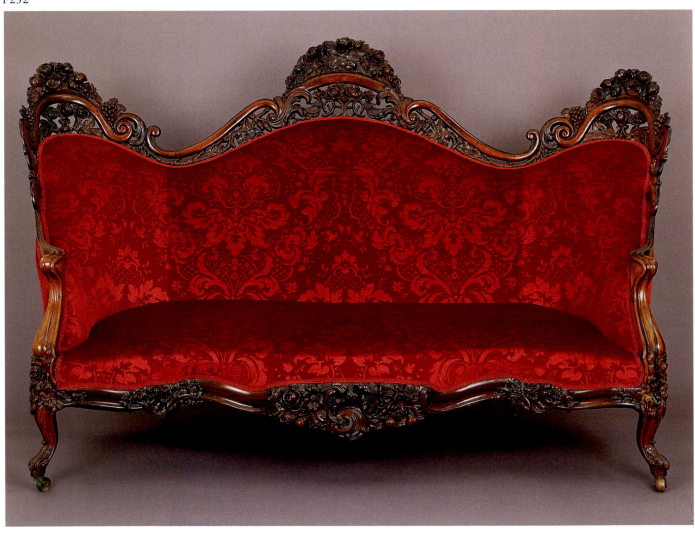

By the middle of the nineteenth century, the fashionable American parlor was furnished en suite with a large parlor set, such as this example. The furniture arrangement was anchored by a center table placed in the middle of the room. The étagère, a new furniture form, provided a means to exhibit precious items that revealed the family's taste and interests. What today is called the Rococo Revival, often referred to as the French taste, was considered the appropriate style for the parlor. Cabriole legs and floral and scrolled ornament of the eighteenth-

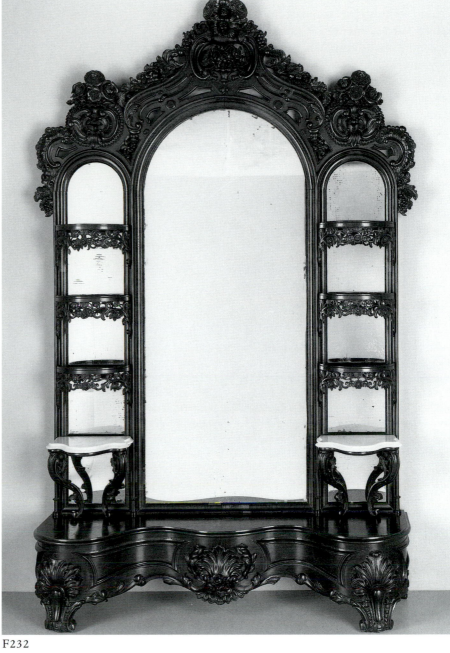

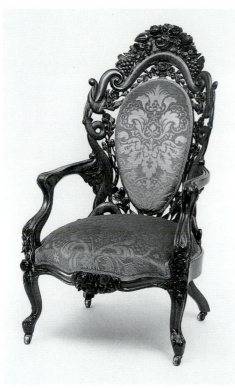

F232

F232

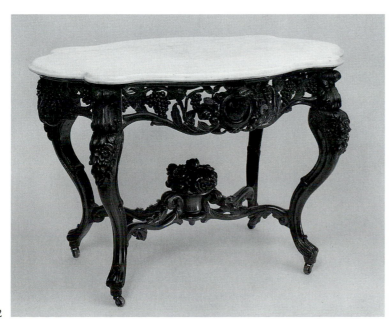

F232

century Rococo were adopted and reinterpreted in the new style.

The furniture of John Henry Belter is interesting in the history and development of furniture making in that it combines both the handwork traditions of the past and the use of lamination and steam pressure that look to the future. Belter, one of the hundreds of immigrant Germans working in the New York furniture trade at the mid-nineteenth century, attained fame in his time as the inventor of a patented process by which laminated layers of wood, under steam pressure, could be shaped in molds to provide strong, curving backs for his intricately carved and pierced Rococo Revival-style furniture. Indeed, the name Belter

became synonymous with this style of mid-nineteenth-century parlor and bedroom furniture. While a number of individual documented pieces from Belter's prolific factory survive, this set is unique in that it is still together with its original bill of sale.

The set is one of two purchased by Benjamin Smith Jordan—one for himself, the other for his brother Green Hill Jordan.[1] The Jordan brothers lived on nearby plantations, Westover and Jackson Hill, outside Milledgeville, Georgia. Their wives were sisters. According to family tradition, the Jordan houses were furnished virtually identically. The two parlor sets were originally upholstered in brocade—blue-green for the Green Jordan set, and pink-red for the Benjamin Jordan set.[2]

PROVENANCE: Purchased from Belter by Benjamin S. Jordan acting as agent for Green H. Jordan; estate of Green H. Jordan (1789–1855) to his wife, Elizabeth Taylor Sanford Jordan (1796–1858); to her daughter Martha Goodwin Sanford Jordan Gardner; to her daughter Martha Jordan Gardner Denny (1867–1904); to her daughter Martha Goodwin Denny Galphin (1901–1963); to her daughter Martha Goodwin Galphin; purchased by Miss Hogg in 1973 from Martha Goodwin Galphin; given to the Governor's Mansion in Austin in 1974; reverted to Bayou Bend in 1981.

TECHNICAL NOTES: B.81.9.9: Rosewood, rosewood veneer; ash (corner block), black walnut (rail under corner top); B.81.9.10: Rosewood, rosewood veneer; black walnut (right panel of mirror back), mahogany (horizontal board of bottom shelf), eastern white pine (base backboard), yellow-poplar (panel over left back side), and an undetermined exotic wood, possibly eucalyptus (inner stile of right back panel frame, rear horizontal rail at bottom of upper assembly).

RELATED EXAMPLES: Belter called this furniture "Arabasket." Whether that term refers solely to this pattern or, as has been suggested, was used to describe all pierced, carved furniture is not entirely clear (see Tracy et al. 1970, no. 126). Other examples in this pattern are in Schwartz, Stanek, and True 1981: an armchair, p. 47, no. 12; a sofa, p. 63, no. 37; and a parlor set with busts on the crest rail, relating in concept to the busts on the skirt of the center table, p. 49.

REFERENCES: Gustafson 1983, p. 954; Brown 1985, p. 517; Douglas 1990, pp. 12–14.

1. Although the September 5, 1855, bill is made out to Benjamin Jordan, the receipt

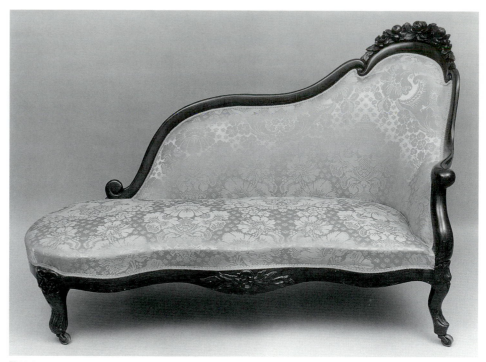

F233

notation on the back indicates he paid the bill on behalf of his recently widowed sister-in-law, Mrs. Green H. Jordan. What remains of the Benjamin S. Jordan set is now in the possession of the University of Georgia at Athens.
2. Family letters and reminiscences in object files at Bayou Bend.

F233

Meridienne or Couch

1850–60
Attributed to the shop of John Henry Belter (1804–1865), New York
Rosewood and secondary wood; 38⅜ x 58½ x 29½" (97.5 x 148.6 x 74.9 cm)
B.71.57

The meridienne was an alternative to the small sofa in the Rococo Revival parlor set. The form derives ultimately from French Neoclassical sources, featuring one high and one open end. The Bayou Bend example is made with laminated rosewood, but the absence of the elaborate openwork carving that characterizes other production of John Henry Belter (see cat. no. F232) indicates it was a less ambitious and thus less expensive piece.

PROVENANCE: By tradition owned by the Rev. George H. Houghton, New York; purchased by Miss Hogg from Carll S. Chace, New York, 1944.[1]

TECHNICAL NOTES: Rosewood, rosewood veneer; ash.

REFERENCES: Warren 1975, p. 108, no. 207.

1. This piece was part of a nine-piece parlor set. The other pieces of the set were given by bequest of Miss Hogg to the Governor's Mansion in Austin, Texas, where they remain today.

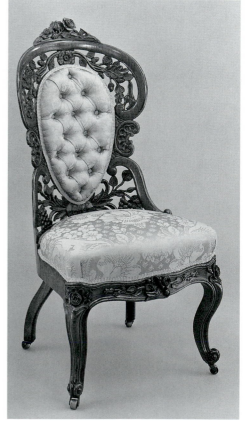

F234

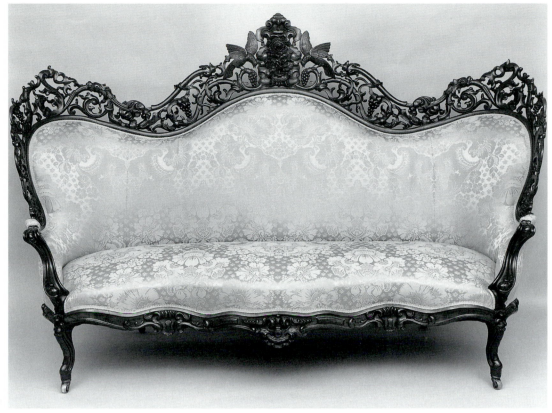

F235

F234

Pair of Side Chairs

1850–60
New York
Rosewood and secondary woods; B.57.6.1: 39
x 19 x 23½" (99.1 x 48.3 x 59.7 cm); B.57.6.2: 38⅝
x 19⅛ x 23¾" (98.1 x 48.6 x 60.3 cm)
B.57.6.1–.2

While these chairs relate in overall design to the documented work of John Henry Belter, they differ in detail. The carving is somewhat flatter, the seat rail less sinuous, and the front legs terminate in scrolls rather than a leaf-carved tubular terminus, as seen on cat. no. F232. The rose carving of the floral crest is skillfully executed, however, and in this detail the maker has given the pair of chairs mirror asymmetry.

PROVENANCE: Purchased by Miss Hogg in 1957 from Dickson's Antique Mansion, New Orleans.

TECHNICAL NOTES: Rosewood, rosewood veneer; eastern white pine (corner blocks), hard maple (front seat rail), ash (side and rear seat rails).

RELATED EXAMPLES: There are several similar chairs, incorrectly ascribed to Belter: one with very similar seat and legs but with different back design at the Museum of the City of New York (Miller 1956, p. 82, no. 143); another

side chair and an armchair in the Manney Collection at Winterthur (Schwartz, Stanek, and True 1981, p. 55, no. 24; p. 43, no. 9).

F235

Partial Parlor Set

1850–60
New York
Rosewood and secondary woods; B.71.34,
Sofa: 54¼ x 81 x 31" (137.8 x 205.7 x 78.7 cm);
B.71.35.1, Armchair: 49 x 25½ x 29½" (124.5 x
64.8 x 74.9 cm); B.71.35.2, Armchair: 50⅜ x
26⅛ x 29¾" (128 x 66.4 x 75.6 cm); B.71.36.1, Side
chair: 43 x 18¾ x 24¾" (109.2 x 47.6 x 62.9 cm);
B.71.36.2, Side chair: 43½ x 19 x 23½" (110.5 x
48.3 x 59.7 cm)
B.71.34; B.71.35.1–.2; B.71.36.1–.2

Originally part of a larger set with an additional small sofa and two more side chairs, these laminated and carved pieces represent the production of a fine New York workshop, one other than that of John Henry Belter. While the design of meandering, leafy vine and grapes is not unlike that seen in the work of Belter, the overall lightness gives it a very different feeling from the Germanic quality of Belter's work, suggesting that what we see here is perhaps French-inspired. The

round seat of the armchairs and side chairs also distinguish these examples from documented work of Belter. Distinctive features of the Bayou Bend set include the bird's nest with flanking birds

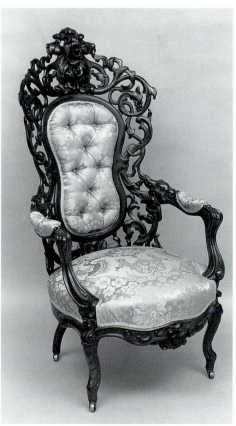

F235

carved on the crest of the sofa and the scalelike ornament on the front legs of all the pieces.

PROVENANCE: Charles Brackett, Providence; George Corliss House, Providence, Brown University; purchased by Miss Hogg from Brown University through Nino Scotti, Providence, 1971.[1]

TECHNICAL NOTES: Rosewood, rosewood veneer; ash, mahogany (right front corner block of armchair B.71.35.1).

RELATED EXAMPLES: An identical sofa and side chair are in the Smithsonian Institution, Washington, D.C. (acc. no. 47–864); a small sofa is in the collection of the Saint Louis Art Museum (Springer 1980, p. 35; Springer 1982, p. 1193); another parlor set is in a private Tennessee collection.

REFERENCES: Warren 1971a, p. 50, figs. 21, 22; Warren 1975, pp. 106–8.

1. The set was part of the furnishings of the George Corliss House in Providence, which had been left to Brown University. The set was owned by Charles Brackett and was apparently placed in the Corliss House when Brackett redecorated it in the Rococo Revival style in the 1920s.

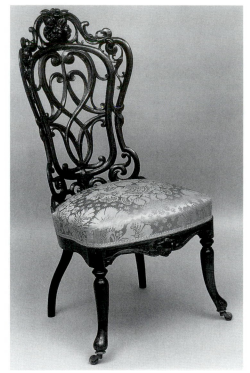

F236

1985, p. 172, view 196); a piano stool in the Manney Collection on loan to MMA (acc. no. L.1983.109.5); a child's chair at MMA (acc. no. 69.46). The fact that others periodically show up at auction (for example, Neal Alford Company, New Orleans, May 2, 1987, lot 571) suggests that the form was relatively common.

REFERENCES: Warren 1975, p. 107, no. 203.

F236

Side Chair

1850–60
New York
Rosewood and secondary woods; 39½ x 19¾ x 23½" (100.3 x 50.2 x 59.7 cm)
B.71.37

This little side chair with its light, lyrical back design of interlaced scrolls defines a high peak of openwork design made possible by the use of lamination. The tubular, outward-flaring front legs add an unusual note.

PROVENANCE: See cat. no. F235.

TECHNICAL NOTES: Rosewood, rosewood veneer; ash. The oak and pine glue blocks are replacements.

RELATED EXAMPLES: Cooper-Hewitt Museum, New York (Comstock 1962, no. 648); Daughters of the American Revolution Museum, Washington, D.C. (Garrett et al.

F237

Partial Parlor Set

1850–60
Probably New York
Rosewood and secondary wood; B.82.5.1, Armchair: 42¼ x 24½ x 31¾" (107.3 x 62.2 x 80.6 cm); B.82.5.2, Armchair: 42½ x 25 x 31¾" (108 x 63.5 x 80.6 cm); B.82.5.3, Side chair: 36⅛ x 18 x 25½" (91.8 x 45.7 x 64.8 cm); B.82.5.4, Side chair: 36½ x 18 x 25½" (92.7 x 45.7 x 64.8 cm); B.82.5.5, Ottoman: 14¾ x 35½ x 22⅛" (37.5 x 90.2 x 56.2 cm)
Gift of Mr. and Mrs. Robert F. Strange, B.82.5.1–.5

These fine Rococo Revival pieces of seating furniture, in contrast with the work of John Henry Belter, offer both a more subdued and more archaeologically correct interpretation of the eighteenth-century Rococo. As such, they are probably more typical of the better Rococo Revival parlor furniture produced in the innumer-

able manufactories that had sprung up in New York by the mid-nineteenth century. Many of these shops were staffed with talented European craftsmen. Indeed, this furniture has an oral tradition of being purchased from a French maker in New York City. As these pieces were used along with the pair of card tables (cat. no. F238) that can be clearly attributed to the shop of Charles Baudouine, it is tempting to leap to the assumption that these pieces were also made there. However, buyers did not always limit themselves to a single

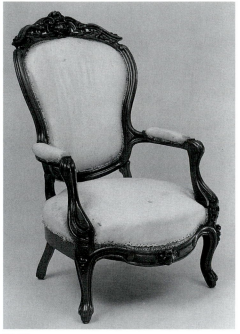

F237

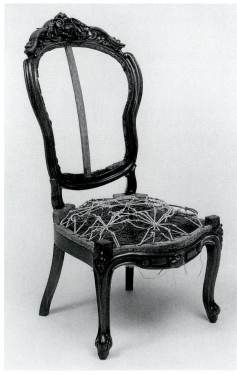

F237

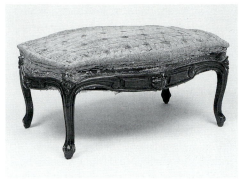

F237

source, and as the Bayou Bend pieces display no strong stylistic tie to documented Baudouine pieces, there does not seem to be a reasonable basis for such an attribution.[1]

PROVENANCE: Frederick W. Heitmann (1828–1889), Houston; to his son, Frederick August Heitmann (1859–1955); to his daughter, Mrs. Robert F. Strange (Blanche Heitmann). This partial parlor set and a pair of card tables (cat. no. F238) furnished Frederick W. Heitmann's home and, according to family tradition, were purchased in New York from a French cabinetmaker.

TECHNICAL NOTES: B.82.5.2: Rosewood, rosewood veneer; ash (center brace in seat back, seat rails). Chair backs and pierced crests are carved out of the solid rather than laminated. The original upholstery foundation remains on both armchairs and ottoman; two fragments of an 1850s cotton and silk lampas with a pink ground, woven with a bright green repeat motif, found under original nails indicate the original show cover.

1. The best-documented Baudouine client was James Watkins Williams, who purchased from him both the labeled card tables that match the Bayou Bend pair and a parlor set, which, in its details, such as the shape of the backs and the juncture of the arms and seat, differs from the Bayou Bend set. Williams also patronized other New York vendors (see Franco 1973).

F238

Pair of Card Tables

1853–55
Shop of Charles Baudouine (act. 1829–55), New York
Mahogany and secondary woods; open: 28½ x 45¼ x 30½" (72.4 x 114.9 x 77.5 cm); closed: 29½ x 45¼ x 15¼" (74.9 x 114.9 x 38.7 cm)
Gift of Mr. and Mrs. Robert F. Strange, B.74.4.1–.2

By the 1850s the furniture forms found in the Rococo Revival parlor were virtually standardized—one or more sofas, armchairs and side chairs, étagère, and center table. The meridienne, or couch, added another form of seating furniture. However, the full-blown Rococo-style card table with folding top, such as this pair, seems to be a relatively rare form; in fact, it can be traced to one shop only, that of Charles Baudouine. Documentation is found in an 1852 bill of sale, where an identical pair is described as multiform. Indeed, these two tables, when not used for cards or placed against the wall as small pier tables, can be placed back to back and secured with knobbed screws to form a center table.

PROVENANCE: See cat. no. F237.

TECHNICAL NOTES: Mahogany (top board, front rail, drawer front); yellow-poplar (drawer bottom base), black walnut (support panel underneath drawer pocket, side of drawer pocket), ash (top rail of swing leg), primavera (right side of drawer, drawer bottom veneer, drawer back).

RELATED EXAMPLES: An identical pair was purchased by James Watson Williams for his Utica, New York, house, Fountain Elms, and is documented by a bill from Baudouine dated May 26, 1852. The tables (Comstock 1962, no. 650) remain at Fountain Elms, but the bill is now in the collection of the Brooklyn Museum (for information on Fountain Elms, see Franco 1973). It is interesting to note that the Heitmanns were married just a year later, suggesting this sort of table was a model available from Baudouine in the early 1850s. Other examples: a pair in the collection of Stuart P. Feld; one in a private collection on loan to the Los Angeles County Museum of Art; MFA, Boston (acc. no. 1981.299).

REFERENCES: Vincent 1974a, pp. 228–31; Greenlaw 1978b, p. 16.

F239

Center Table

1850–60
New York
Rosewood, secondary wood, and marble; 30¼ x 36¾" (diam., including legs) (76.8 x 93.3 cm)
B.70.42

The center table was an important piece in the furnishing scheme of the Rococo Revival parlor. Often made en suite with

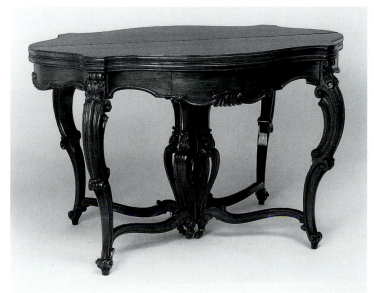

F238

F239

large parlor sets (see cat. no. F232), the form is characterized by bold cabriole legs and crossed stretchers, often ornamented with a central finial or carved basket of flowers, as here. That this table is round rather than oval and the top inset places it outside the norm.

PROVENANCE: Purchased by Miss Hogg from M. S. Rau, New Orleans, 1970.

TECHNICAL NOTES: Rosewood, rosewood veneer; ash, marble.

RELATED EXAMPLES: Otto 1965, no. 348 and plate II; *Maine Antique Digest,* April 1989, p. 27-C.

REFERENCES: Warren 1975, p. 108, no. 208.

F240

Dressing Table with Looking Glass

1850–60
Probably New York
Mahogany, secondary woods, and marble; 67⅞ x 45 x 24⅝" (172.4 x 114.3 x 62.5 cm)
B.57.5

In addition to its use in the parlor, the Rococo Revival was also deemed a proper style for the bedroom. In response, large, luxurious sets of matching bedroom furniture, often including dressing tables, were produced. These found particular favor in the antebellum south, yet, while this example has a southern history, it was likely imported from the northeast.

PROVENANCE: Purchased by Miss Hogg from Kane's Antiques, New Orleans, 1957.

TECHNICAL NOTES: Mahogany, mahogany veneer; eastern white pine (dustboard underneath drawer, drawer front layer between veneers), eastern redcedar (right side and bottom of drawer), cherry (left drawer runner), marble.

RELATED EXAMPLES: Otto 1965, nos. 288, 291.

REFERENCES: Warren 1975, p. 109, no. 209; Howe 1979, p. 560.

F241

Étagère

1850–60
Attributed to the shop of John Henry Belter (1804–1865), New York
Rosewood, secondary wood, marble, and mirror glass; 96½ x 54¼ x 16¾" (245.1 x 137.8 x 42.5 cm)
B.71.41

In the middle of the nineteenth century, a new form of parlor furniture, called the étagère by the French and the whatnot by the English, was introduced into fashionable American households. Characteristically, the form includes many small shelves, often backed with mirror glass, designed for the display of "articles of virtu—bouquets of flowers, scientific curiosities, or whatever,"[1] or, in other words, the eclectic array of knickknacks, intended to reflect the character and taste of the owner, that so typify Victorian interiors. The Bayou Bend example combines the concept of a parlor cabinet below with the étagère shelves above. The small, semicircular shelves above are supported by laminated floral scrolls that relate to documented work by Belter's shop, as does the floral and fruit carving of the arched crest.

PROVENANCE: Purchased by Miss Hogg from M. S. Rau, New Orleans, 1971.

TECHNICAL NOTES: Rosewood, rosewood veneer; marble, mirror glass, ash.

RELATED EXAMPLES: An identical example was sold at auction in New Orleans (*Antiques*

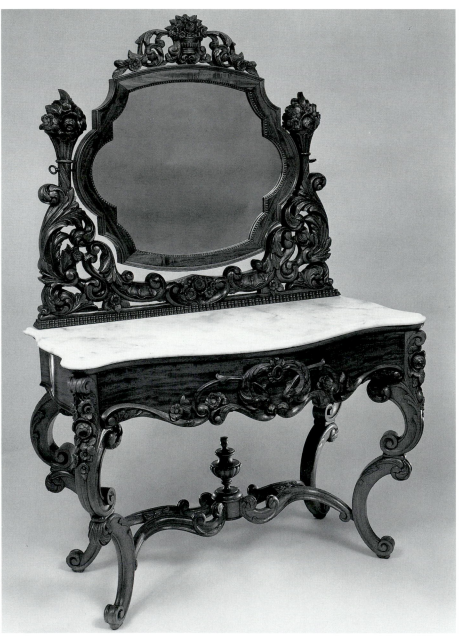

F240

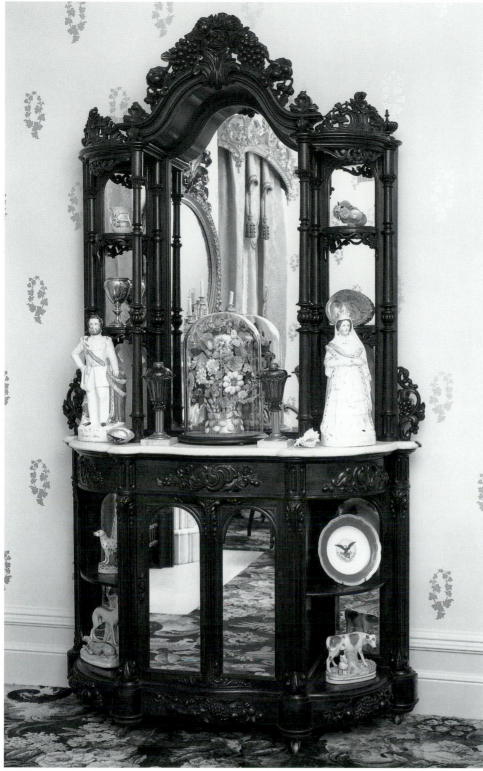

F241

By the middle of the nineteenth century, the French taste, a revival of the Rococo variously called Louis XIV, French Modern, or French Antique, predominated in the fashionable American parlor. An important element of the style was the use of two types of large, gilt framed mirrors that were elaborately carved with leafage and scrolled ornament. A. J. Downing documented their role and placement: "Nothing so much adds to the splendor and gayety of an apartment as mirrors. . . . we think one or two large ones are indispensible in the drawing-room of a first-rate villa. The two most effective positions for mirrors are as chimney mantel-glasses and pier-glasses."[1] A Galveston, Texas, newspaper advertisement of 1855 describes "Fashionable Parlor Furniture" and lists rich sets of seating furniture as well as "Large gilt Pier and Mantle Mirrors, Rich gilt curtain cornices. . . ."[2] The advertisement suggests the widespread acceptance of the style, particularly in prosperous areas of the pre–Civil War south. There are indications that these mirrors (called at the time mantel mirrors, rather than the incorrect term "over-mantel mirror" in use today) were produced by shops that made them a specialty, and undoubtedly the influx, after 1848, of talented carvers from Germany and France provided the craftsmen. The plate glass, however, may have been imported.[3]

The Bayou Bend mirror exhibits an unusual horizontal oval glass element, rather than the more common arched form. The scrolled elements at the outer bottom relate to the treatment often used at the juncture of the upper and lower sections of the contemporary étagère. Stylistically, this example, with its symmetrical leaf or feather crest and symmet-

and *The Arts Weekly,* December 19, 1980, p. 85); another that is identical except for the crest, which is carved with a bust, sold at auction in New Jersey (*Antiques and The Arts Weekly,* June 8, 1990, p. 29).

REFERENCES: Warren 1975, p. 109, no. 210.

1. Downing 1969, p. 456.

F242

Mantel Mirror

1855–65
Frame: eastern United States
Glass: possibly Europe
Eastern white pine, gold leaf, and secondary materials; 57¼ x 69⅝ x 7½" (145.4 x 176.8 x 19.1 cm)
B.71.38

F242

rical scrolled ornament, together with the bosses on the oval frame, displays more in common with Renaissance Revival than Rococo Revival features. Given the quantity of high-quality, elaborately carved Rococo Revival furniture from New York and the paucity of such furniture from other centers, it is tempting to assign this mirror to New York City. However, evidence of equally high-quality mirrors from Philadelphia and Albany precludes such an attribution.[4]

PROVENANCE: See cat. no. F235.

TECHNICAL NOTES: Eastern white pine, gesso, gold leaf, bronze paint, glass. The mirror is made with both carved and applied ornament. The gilding, both water- and oil-based, is applied directly over the gesso and is burnished in some areas. A thin bronze paint wash on the background adds a further contrast of colors.

RELATED EXAMPLES: An identical example is at MMA (Davidson and Stillinger 1985, p. 83); one with round, beveled glass is at Winterthur (Fennimore et al. 1994, p. 75); another at the Brooklyn Museum, supplied in 1856 by James Barton of Albany to Robert Milligan, has a much more elaborate and intricately carved upper section (Otto 1965, p. 123). A similar Renaissance-style boss ornament appears on an 1859 New York silver presentation pitcher (Warren, Howe, and Brown 1987, p. 126) and on a New York étagère made by Jules Dessoir between 1855 and 1860 (Tracy et al. 1970, no. 148), suggesting a date of manufacture close to 1860.

REFERENCES: Warren 1975, p. 104; Warren 1982, p. 240; Warren 1988, p. 48.

1. Downing 1969, p. 435.
2. Advertisement of the House Furniture Ware House, *Galveston Tri-Weekly News,* December 29, 1855.
3. For a discussion of immigrant craftsmen, see Voorsanger 1994, pp. 56–77. The use of imported plate glass is documented with what is called a mantle mirror exhibited at the New York Crystal Palace Exhibition of 1853, and described as being made by "The eminent manufacturers of mirror frames, Messrs E. Newland & Co. of Philadelphia. . . . The mirror plate . . . is one of the finest glass manufactured at St. Gobain. . . ." See Silliman and Goodrich 1854, p. 204; an 1856 bill head of Albany manufacturer and dealer in looking glasses, James Barton & Co., lists "French and German Looking Glass Plates." The bill is to Robert Milligan for a "large gilt mirror" for his house in Saratoga Springs, New York. Both mirror

F243

and bill are in the collection of the Brooklyn Museum. The term "mantel mirror" also appears in the 1855 Galveston advertisement cited in n. 2 above.
4. See n. 3 above for Philadelphia and Albany citations.

F243

Set of Three Window Cornices

1850–60
Eastern United States
Eastern white pine, gesso, gilt; 27½ x 71¾ x 13"
(69.9 x 182.2 x 33 cm)
B.71.76.1–.3

As the nineteenth century progressed, window treatment became more and more elaborate, utilizing yards and yards of fabric in multiple layers. By midcentury, the voluminous drapes were "finished by heavy cornices and the richest corresponding decorations."[1] Such cornices were closely related to the pier and mantle mirrors that were essential to fashionable parlor decor, in either the Rococo Revival style, as in the Bayou Bend example, or the Renaissance Revival style. These cornices employ the same vocabu-

lary of ornament—central leaf-and-scroll cartouche, flanking scrolls, and corner scroll-bordered reserves—and techniques of manufacture as did contemporaneous mirror and picture frames. It is likely they were made in a shop that specialized in those wares.

PROVENANCE: See cat. no. F235.

RELATED EXAMPLES: Very similar deep cornices are part of the 1853 furnishings of the parlor at Lansdowne in Natchez, Mississippi. In a departure, while the furniture of this room is in the Rococo taste, the pier and mantle mirrors are in the Renaissance taste (Miller and Miller 1986, p. 60). Other examples: a deep triple example in the bay window of the parlor at Stanton Hall, Natchez, built 1850–58 (Garrett 1993, p. 95); an illustration in *Godey's Lady's Book,* February 1854 (Grier 1988, p. 33, fig. 8).

REFERENCES: Warren 1975, p. 104; Warren 1982, p. 240; Warren 1988, p. 48.

1. *Godey's Lady's Book,* February 1854 (Grier 1988, p. 32); for an 1855 newspaper advertisement for gilt window cornices, see cat. no. F242.

WINDSOR

F244

Armchair

1765–70
Philadelphia
Various woods (see Technical notes); 45¼ x 27¼ x 23⅜" (114.9 x 69.2 x 59.4 cm)
B.69.413

Windsor, the generic name given to utilitarian turned, stick, and bentwood seating furniture that had originated in England in the 1720s, first appeared in America in Philadelphia about a decade later. Production of high-back Windsors, the earliest form, began in the mid-1740s. While Philadelphia remained an impor-

tant center, by the end of the century Windsor chairs were being produced all along the Atlantic seaboard. Definite regional traits evolved, occasionally in form, but more commonly in the design of the turned members. This example typifies the early Philadelphia high-back design, with its scrolled ears on the crest rail, elongate vase-turned arm supports, and distinctive combination of cylindrical and blunt arrow turnings in the lower section of the legs. The gently swelling medial stretcher design, which lacks the ball-and-ring turnings of the earliest examples, indicates that this example is slightly later.

PROVENANCE: Purchased by William C. Hogg at the American Art Association Rooms, New York, Louis Guerineau Myers sale, February 25, 1921, lot 493; W. C. Hogg bequest to Ima Hogg, 1930 (Hogg inv. no. 331).

TECHNICAL NOTES: Soft maple (crest rail, turned arm supports, legs, and stretchers), yellow-poplar (seat), ash (arms), hickory (interior spindle).

RELATED EXAMPLES: Evans 1996, p. 86, fig. 3–13; Santore 1981, p. 63, no. 29; RISD, an example of the related earlier type (Monkhouse and Michie 1986, p. 204, no. 145).

REFERENCES: Warren 1975, no. 217; Warren 1988, p. 57.

F245

F245

Armchair

1765–75
Philadelphia
Various woods (see Technical notes); 44⅝ x 30 x 24" (113.3 x 76.2 x 61 cm)
B.69.424

While similar in design to cat. no. F244, this large high-back Windsor features the slightly later short baluster and long, tapering leg turnings. The outboard back spindles flare as they rise to the crest.

PROVENANCE: Purchased by William C. Hogg at the American Art Association Rooms, New York, Louis Guerineau Myers sale, February 25, 1921, lot 489; W. C. Hogg bequest to Ima Hogg, 1930 (Hogg inv. no. 247).

TECHNICAL NOTES: Soft maple (legs, stretchers), white oak (crest and arm rails), hickory

F244

(spindles), yellow-poplar (seat). The spindles and the lower part of the legs, just below the urn turning, are restorations.

RELATED EXAMPLES: Evans 1996, p. 91, fig. 3-24, which features the later scrolled-knuckle arm terminal.

F246

Armchair

1760–70
Attributed to Francis Trumble (ca. 1716–1798),
Philadelphia
Various woods (see Technical notes); 28⅜ x 27 x 21¾" (72.1 x 68.6 x 55.2 cm)
B.64.31

The low-back Windsor armchair, an English form derived from the corner chair, first appeared in Philadelphia around the mid-eighteenth century, and that city produced the majority of low-back Windsors as well. These chairs, which relate to the high-backs in overall design, are made with a back rail that overlaps the ends of the arms, adding strength. This crisply turned example has the typical early Philadelphia form of leg and its ball-shaped foot, but the gently swelling stretcher is indicative of a slightly later design.[1] The thick arms with rounded upper edges, an unusual feature, are also seen on a sophisticated cabriole-legged high-back example.[2]

PROVENANCE: Purchased by Miss Hogg from Ginsburg and Levy, New York, 1964.

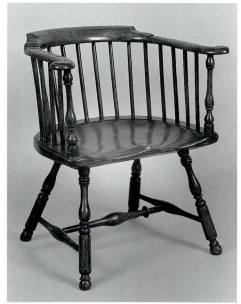

F246

TECHNICAL NOTES: Yellow-poplar (seat), ash (legs, arm supports, spindles), white oak (arm crest), soft maple (stretchers, spindles), hickory (spindles). The right stretcher is a replacement made of beech.

RELATED EXAMPLES: Evans 1996, p. 87, fig. 3-14; Santore 1981, p. 79, no. 61.

1. The turning design of the front legs, with its distinctive flattened ball and ring in the upper section, is identical to that on a high-back armchair attributed to Trumble (Evans 1996, p. 83, fig. 3-6).
2. Evans 1996, p. 84, fig. 3-9.

F247

Armchair

1770–85
Philadelphia
Various woods (see Technical notes); 29 x 27¾ x 19½" (73.7 x 70.5 x 49.5 cm)
B.79.204

This low-back Windsor represents the later Philadelphia style, featuring a general softness of turnings and a tapering design of the lower leg section.

PROVENANCE: Purchased by William C. Hogg at the American Art Association Rooms, New York, Louis Guerineau Myers sale, February 25, 1921, lot 499; W. C. Hogg bequest to Ima Hogg, 1930.

TECHNICAL NOTES: Yellow-poplar (seat, center section of crest rail), soft maple (legs, stretchers, and arm supports), red oak (arms), hickory (spindles). Both handholds are replacements made of ash.

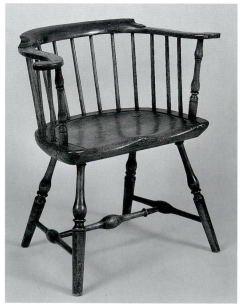

F247

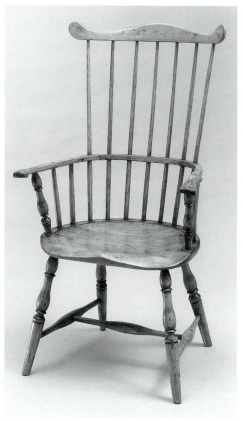

F248

F248

Armchair

1790–1800
Probably Connecticut
Yellow-poplar, soft maple, and hickory; 44⅞ x 24½ x 21½" (114 x 62.2 x 54.6 cm)
B.69.434

Upward-turned ears and chamfered round seat are features found on the New England version of the high-back chair; the exaggeration of the upturned ears signals a Connecticut example.

PROVENANCE: Purchased by William C. Hogg at the American Art Association Rooms, New York, Louis Guerineau Myers sale, February 25, 1921, lot 495; W. C. Hogg bequest to Ima Hogg, 1930 (Hogg inv. no. 48).

TECHNICAL NOTES: Yellow-poplar (seat), soft maple (legs, stretchers, arm supports, arm spindles), hickory (back spindles). A non-period stencil, "Made in 1776," is on the underside of the seat.

RELATED EXAMPLES: Evans 1996, p. 329, fig. 6-169.

F249

High Chair

1780–1800
New England, probably Rhode Island or
Connecticut
Various woods (see Technical notes); 36½ x
16 x 19¼" (92.7 x 40.6 x 48.9 cm)
B.61.83

The high-back type of Windsor first ap-
peared in armchairs, and by about 1770
sets of side chairs began to be made. In
this example, the high-back armchair
form has, in the upper section, been re-
duced in scale to suit the intended func-
tion as a chair for use by a child at table.
The added height is achieved by elongat-
ing the design of the legs' vase turnings
and tapering feet. The relative robustness
at the base of the vase turnings allows for
the application of a footrest. Except for
cradles, specificity of form for use by a
child is relatively rare in eighteenth-
century furniture.

PROVENANCE: Purchased by Miss Hogg from
John S. Walton, New York, 1961.

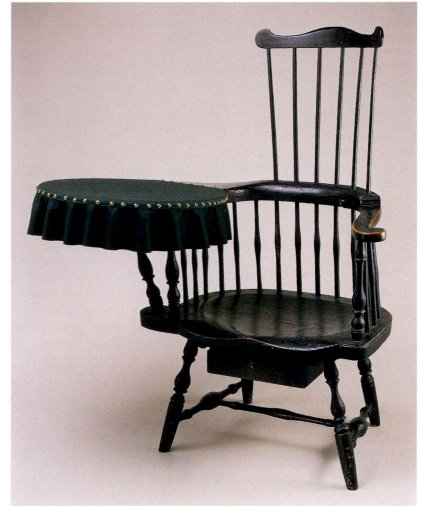

F250

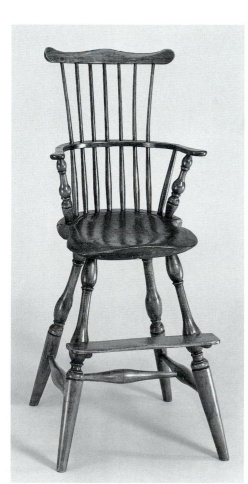

F249

TECHNICAL NOTES: Soft maple (left front
leg), hickory (center spindle), birch (right
front leg, medial stretcher), basswood (seat),
beech (right lower stretcher), white oak (crest
rail, arms).

RELATED EXAMPLES: For other examples of
high chairs, see Santore 1987, pp. 209–12, figs.
225–30, For related Connecticut comb-back
armchairs, see Santore 1987, pp. 56, 57, figs.
23–25. Evans 1996 illustrates a Rhode Island
bow-back armchair with similarly turned arm
supports (p. 283, fig. 6-91).

F250

Writing-arm Chair

1770–1803
Ebenezer Tracy (1744–1803), Lisbon, Connecticut
Various painted woods (see Technical notes);
46¾ x 37 x 30" (118.7 x 94 x 76.2 cm)
B.69.409

This example, adapted from the high-
back armchair type produced in Philadel-
phia in the 1760s, is designed to function

like a small office, with writing arm sur-
face with drawer below and a drawer un-
derneath the seat. The application of a
green wool covering to the writing arm
reflects a common eighteenth-century
usage for writing surfaces. Very often
Windsor chairmakers branded their name
to their product; this example bears the
brand of Ebenezer Tracy, a prolific maker
working in Lisbon, Connecticut.

PROVENANCE: Purchased by William C.
Hogg for the Hogg Brothers from Israel Sack,
Boston, 1922; W.C. Hogg bequest to Ima
Hogg, 1930 (Hogg inv. no. 77).

TECHNICAL NOTES: Eastern white pine (lock-
ing board, writing arm, writing arm drawer
bottom, seat drawer bottom, seat drawer stop),
yellow-poplar (writing arm drawer sides,
seat drawer sides, seat drawer front and back),
soft maple (left arm, locking slide runners,
writing arm drawer runners, legs, turned
arm supports, crest rail, seat drawer runners),
white oak (supporting arm, horizontal back
member, stretchers, spindles), chestnut (seat),
butternut (writing arm drawer stop). Branded
EB:TRACY at the bottom of the seat behind

the drawer. The modern baize cover on the writing surface is based on evidence of green wool threads found under original tacks and also on Ralph Earl's *Portrait of Dr. Mason Fitch Cogswell*, 1791 (cat. no. P33), in which the subject is seated in a low-back Windsor writing-arm chair.

RELATED EXAMPLES: A low-back chair, formerly at Williamsburg (Greenlaw 1974, no. 159), transferred in 1993 to Historic Deerfield; a related example with Tracy's name, Norwich, Connecticut, and the date 1797 branded beneath the seat (Anderson Galleries, New York, Maynard sale, 1926, lot 144); Connecticut Historical Society, Hartford (*Antiques and The Arts Weekly*, October 1, 1988); Yale (Kane 1976, no. 173); Kirk 1967, no. 249; Historic Deerfield (Fales 1976, p. 85, no. 161); four in DAPC; Sack 1969–92, vol. 1, p. 3, no. 5, Sack 1969–92, vol. 1, p. 39, no. 121, and Sack 1969–92, vol. 8, p. 2238, no. 2758. According to Nancy Goyne Evans, 160 branded examples of Tracy's work have been identified (Evans 1982). An unidentified chair at MMA is surely the work of Tracy (Davidson and Stillinger 1985, p. 154).

REFERENCES: Warren 1993, p. 332.

F251

Armchair

1790–1800
New England, probably Massachusetts
Various woods (see Technical notes); 41 x 24⅝ x 24⅜" (104.1 x 62.5 x 61.9 cm)
Gift of the estate of Miss Ima Hogg, B.76.209

The fan-back Windsor represents a variant on the high-back form, differing in the armchair version by the absence of the back rail connecting the arms. Characteristically, the spindles flare or fan outward. The form seems to be common in New England, particularly in Massachusetts, and the cylindrical section of stiles at the arm juncture seen in the Bayou Bend chair is similar to the medial and side stretcher juncture of Massachusetts Windsors.

PROVENANCE: Purchased by William C. Hogg at the American Art Association Rooms, New York, Louis Guerineau Myers sale, February 25, 1921, lot 503; W. C. Hogg bequest to Ima Hogg, 1930.

TECHNICAL NOTES: Eastern white pine (seat), birch (right arm, left rear arm spindle), soft maple (legs, medial and left stretcher), white oak (crest rail), ash (left rear arm support), elm (right stretcher, replacement). The rear legs had been broken above the top ring and repaired with spoke-shaved replacements.

RELATED EXAMPLES: Santore 1987, p. 84, no. 64; for stretcher examples, see Santore 1987, nos. 143, 157, 159.

F252

Side Chair

1780–1800
Pennsylvania
Yellow-poplar, soft maple, and hickory; 36½ x 23⅜ x 19⅜" (92.7 x 59.4 x 49.2 cm)
B.69.405

This type of fan-back side chair was produced primarily in Pennsylvania and New England. The horizontality of the scrolled-ear crest rail conforms with the norm of Pennsylvania design.

PROVENANCE: Unknown (at Bayou Bend prior to 1965).

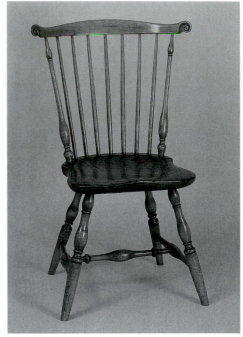

F252

TECHNICAL NOTES: Yellow-poplar (seat), soft maple (legs, stretchers), hickory (crest rail, spindles).

F253

Armchair

1775–85
Pennsylvania, possibly Lancaster County
Yellow-poplar, soft maple, and hickory; 36⅛ x 27 x 23½" (91.8 x 68.6 x 59.7 cm)
B.72.26

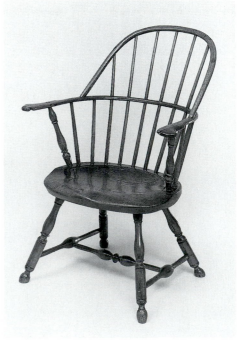

F253

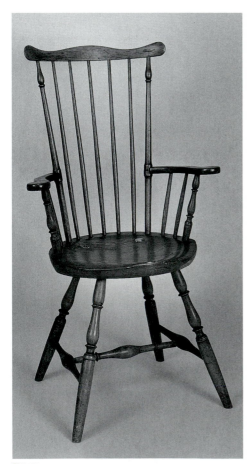

F251

The sack-back Windsor armchair, characterized by a bent, bow-shaped crest, was introduced in Philadelphia in the early 1760s, where it was produced in great numbers. This example has the early features of tubular leg turnings and blunt arrow feet as well as a ball-and-ring stretcher. However, the turnings of the arm supports are less vigorous than those produced in Philadelphia, suggesting an origin outside that city.

PROVENANCE: Unknown (at Bayou Bend by 1943).

TECHNICAL NOTES: Yellow-poplar (seat), soft maple (legs, stretchers, arm supports, external portion of right handhold), hickory (back-spindles, crest and arm rails).

RELATED EXAMPLES: Evans 1996, p. 95, fig. 3-35, p. 110, fig. 3-61; Santore 1981, no. 103, p. 101.

F254
Armchair

1790–1805
Lancaster County, Pennsylvania
Yellow-poplar, soft maple, and hickory; 42½ x 25¼ x 26″ (108 x 64.1 x 66 cm)
B.69.435

This tall sack-back Windsor armchair represents a distinct Lancaster County type. Typical features include the high back

with squarish corners, the nipped waist above the arms, and the combination of blunt arrow front legs and tapering rear legs. The scrolled arm terminals add a note of refinement.

PROVENANCE: Purchased by William C. Hogg at the American Art Association Rooms, New York, Louis Guerineau Myers sale, February 25, 1921 lot 473; W. C. Hogg bequest to Ima Hogg, 1930.

TECHNICAL NOTES: Yellow-poplar (seat, external portion of right handhold), soft maple (legs, stretchers, arm supports), hickory (spindles, crest and arm rails).

RELATED EXAMPLES: Evans 1996, p. 113, fig. 3-65; Santore 1981, p. 102, no. 105; Santore 1987, p. 99, no. 84.

F255
Armchair

1795–1815
Pennsylvania, possibly Lancaster County
Various woods (see Technical notes); 38½ x 25¼ x 20¾″ (97.8 x 64.1 x 52.7 cm)
B.79.205

The use of turned wood to imitate bamboo came from England to Philadelphia in the 1780s and soon was incorporated into Windsor chair design. This sack-back armchair with its soft-contour bamboo turnings combines the new motif with

the scrolled-knuckle arm terminals of earlier design.[1] The flared front feet occur on Lancaster examples.

PROVENANCE: Purchased by William C. Hogg at the American Art Association Rooms, New York, Louis Guerineau Myers sale, February 25, 1921, lot 481; W. C. Hogg bequest to Ima Hogg, 1930.

TECHNICAL NOTES: Soft maple (right arm support, medial stretcher, right rear leg), oak (wedges in tenons), hickory (crest rail, long back spindle, second from right), yellow-poplar (seat, external portion of right handhold).

RELATED EXAMPLES: Santore 1987, p. 115; Evans 1996, p. 124, fig. 3-94, with similar flared feet.

1. Evans 1996, pp. 102–3.

F256
Armchair

1785–1800
New England, probably Rhode Island
Various woods (see Technical notes); 37¾ x 22½ x 22¼″ (95.9 x 57.2 x 56.5 cm)
B.69.423

The balloon-shape contour of the bent back is an unusual feature in sack-back armchairs. A similar design is used on a group of Rhode Island bow-back side chairs, and the lower leg turnings with

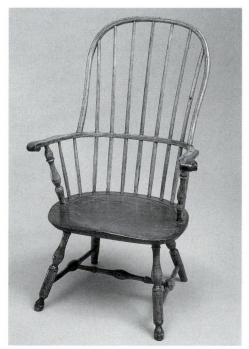

F254

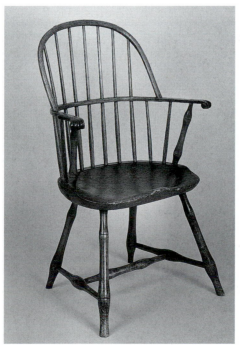

F255

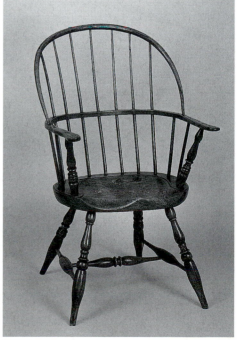

F256

inward curve also conform to Rhode Island design.

PROVENANCE: Purchased by William C. Hogg at the American Art Association Rooms, New York, Louis Guerineau Myers sale, February 25, 1921, lot 469; W. C. Hogg bequest to Ima Hogg, 1930.

TECHNICAL NOTES: Soft maple (seat), white oak (arm and crest rails), ash (legs, stretchers, spindles), hickory (right-hand rest, replaced).

RELATED EXAMPLES: For related bow-back side chairs, see Evans 1996, p. 277, fig. 6-75; Santore 1987, p. 136, no. 140.

F257

Armchair

1780–90
New England, probably Rhode Island
Various woods (see Technical notes); 37 x 25¾ x 23½" (94 x 65.4 x 59.7 cm)
B.69.414

The relatively narrow, oval, sharply saddled seat of this sack-back chair is often

seen in New England, and the inward taper of the lower legs is typical of Rhode Island.

PROVENANCE: Purchased by William C. Hogg at the American Art Association Rooms, New York, Louis Guerineau Myers sale, February 25, 1921, lot 475; W. C. Hogg bequest to Ima Hogg, 1930.

TECHNICAL NOTES: Southern yellow pine (seat), white oak (crest and arm rails), ash (legs, stretchers, spindles, right arm support), birch (left arm support).

RELATED EXAMPLES: Evans 1996, p. 255, fig. 6-26.

F258

Armchair

1785–1800
Eastern Connecticut or Rhode Island
Various woods (see Technical notes); 38¼ x 23½ x 20¼" (97.2 x 59.7 x 51.4 cm)
B.69.402

While this late sack-back armchair has rather bland turnings, the knuckled, scrolled arm terminals offer an attractive feature.

PROVENANCE: Unknown (at Bayou Bend by 1943).

TECHNICAL NOTES: Eastern white pine (seat), soft maple (legs, stretchers, arm supports), ash (spindles), red oak (crest rail), white oak (arm rail). The chair is stamped "D W Call" seven times on the underside of the seat, probably the name of an early owner.

RELATED EXAMPLES: Evans 1996, p. 310, fig. 6-131.

REFERENCES: Evans 1996, p. 687.

F259

Armchair

1785–95
New York
Various woods (see Technical notes); 37⅜ x 20⅜ x 22½" (94.9 x 51.8 x 57.2 cm)
B.69.410

The continuous-bow Windsor armchair, with the arm and back made of one sinuous piece of bent wood, apparently originated in New York City after the Revolution and then spread north to

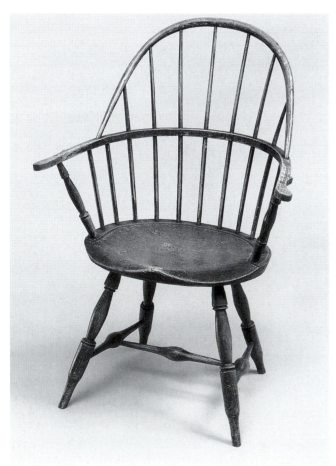

F257

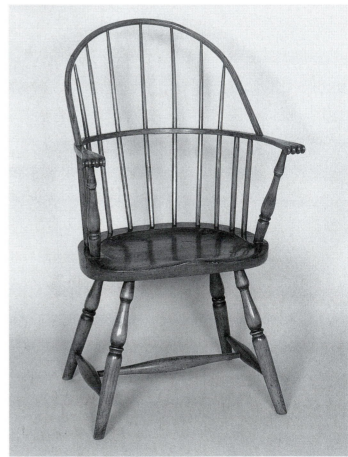

F258

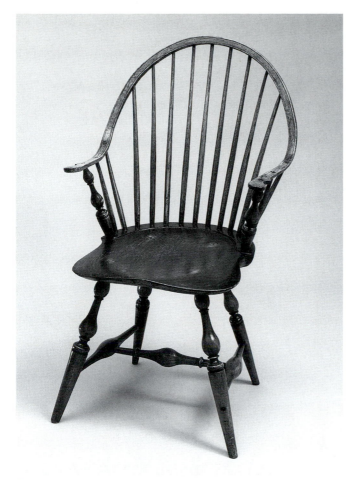

F259

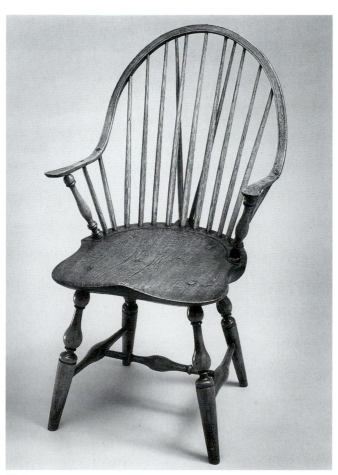

F260

Rhode Island (see cat. no. F260), Connecticut (see cat. no. F261), and Massachusetts. The form's design, which seems to have no English prototype, makes a strong visual impression. The concept of arm flowing into back and crest parallels that seen in the cabriole sofa introduced at the same period (see cat. no. F162), but that may be only coincidental. The vigorously turned raked legs and canted arm supports are typical of this type of Windsor.

PROVENANCE: Purchased by William C. Hogg at the American Art Association Rooms, Louis Guerineau Myers sale, New York, February 25, 1921, lot 485; W. C. Hogg bequest to Ima Hogg, 1930.

TECHNICAL NOTES: Yellow-poplar (seat), soft maple (legs, stretchers, left arm support), oak (spindle fifth from left), ash (all remaining spindles).

RELATED EXAMPLES: Evans 1996, p. 203, fig. 5-19; Santore 1987, p. 147, no. 149, p. 148, no. 150.

F260

Armchair

1790–1810
Rhode Island
Yellow-poplar, soft maple, and hickory; 37½ x 21½ x 23½" (95.3 x 54.6 x 59.7 cm)
B.69.415

The addition of diagonally splayed braces attached to the crest rail and a tail piece at the center rear of the seat, a form known as the brace-back, is almost entirely limited to Windsor furniture made in New York and New England. The turnings of the legs and arm supports of this example are less vigorous than those of cat. no. F259, suggesting a slightly later date, and the arm supports lack the tapering arrow shape in the lower section just above the seat.

PROVENANCE: Possibly purchased by William C. Hogg at the American Art Association Rooms, New York, Louis Guerineau Myers sale, February 25, 1921; W. C. Hogg bequest to Ima Hogg, 1930 (Hogg inv. no. 60).

TECHNICAL NOTES: Yellow-poplar (seat), soft maple (legs, stretchers, arm supports), hickory (crest rail, spindles).

RELATED EXAMPLES: Evans 1996, p. 278, fig. 6-77.

F261

Armchair

1790–1810
New England, possibly Connecticut
Various woods (see Technical notes); 37½ x
22½ x 22¼" (95.3 x 57.2 x 56.5 cm)
B.69.422

This continuous-bow Windsor is made in the New York tradition but has less bulbous and bold turnings. The vertical void between the back arm spindle and outboard back spindle is more vertical and less harp-shaped than that of New York chairs of this type.

PROVENANCE: Unknown (at Bayou Bend by 1943).

TECHNICAL NOTES: Yellow-poplar (seat), soft maple (right rear leg, left stretcher), elm (crest rail), ash (spindle fourth from left), birch (left arm support), beech (right arm support).

F262

Armchair

1790–1800
Rhode Island
Various painted woods (see Technical notes);
38¼ x 23 x 19½" (97.2 x 58.4 x 49.5 cm)
B.69.411

This chair represents a distinctive Rhode Island variant on the bow-back Windsor that originated in Philadelphia. The notable Rhode Island features are the mahogany arms, which lend a quality of elegance, and the inward taper at the bottom of the legs. While mahogany arms appear also in Philadelphia examples, they tend to be ovoid in cross section, as opposed to the rectangular design here. The vase-turned lower section of the back spindles echoes the back spindle design found in an equally distinctive group of Rhode Island low-back Windsor armchairs with cross stretchers.[1] The crisp turnings, raked arm supports, and curved, scrolled design of the arms make this chair a particularly fine example.

PROVENANCE: Purchased by Miss Hogg from Ross H. Maynard, Springfield, Massachusetts, 1925, who noted a long history of ownership in the Poughkeepsie, New York, area.

TECHNICAL NOTES: Eastern white pine (seat), mahogany (arms), soft maple (legs, stretchers, arm supports), white oak (crest rail, spindles), ash (spindles). Old but not original green paint.

RELATED EXAMPLES: Williamsburg (Greenlaw 1974, nos. 150, 152); MFA, Boston; advertisement of Tillou Gallery, *Antiques* 96 (October 1969), p. 453; RISD (Michie and Monkhouse 1986, no. 150); Santore 1987, no. 137, p. 134; Chipstone (Rodriguez Roque 1984, no. 107); Evans 1996, p. 275, fig. 6-71.

REFERENCES: Warren 1988, p. 57.

1. See Evans 1996, p. 241, fig. 6-6.

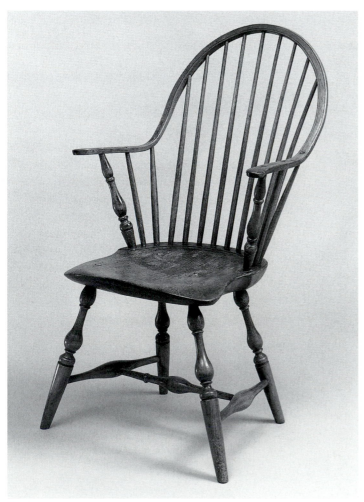

F261

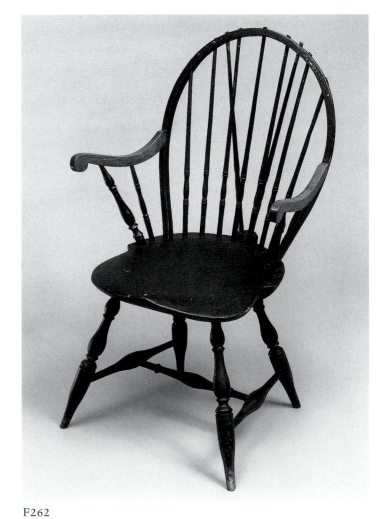

F262

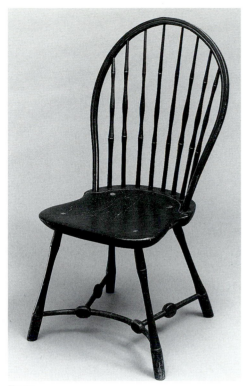

F263

F263

Side Chair

1800–1805
Possibly William Seaver and James Frost
(act. 1800–1803), Boston
Various painted woods (see Technical notes);
36⅜ x 16⅛ x 21" (92.4 x 41 x 53.3 cm)
B.69.427

While the bow-back Windsor is a relatively common form, this example, with its yoke-shaped front stretcher, represents a design that seems to be peculiar to side chairs thought to have been produced by the Boston shop of Seaver and Frost.[1] The undulating bamboo-turned spindles are also typical of the Boston area.

PROVENANCE: Purchased by Miss Hogg from Rudolph P. Pauly, Boston, 1927.

TECHNICAL NOTES: Eastern white pine (seat), birch (right rear leg), ash (crest rail, front curved stretcher, spindle third from left, wedges in legs), soft maple (left side stretcher, wedges in legs). Old but not original dark green paint.

RELATED EXAMPLES: Santore 1987, p. 137, no. 142; a related though not identical example, branded Seaver and Frost (letter from Nancy Goyne Evans, July 24, 1975, in object files); a third with partial brand at Chipstone (Rodriguez Roque 1984, no. 104); Evans 1996, p. 358, figs. 6-207, 6-208.

1. For further discussion, see Evans 1996, p. 358.

F264

Settee

1780–1800
Pennsylvania, possibly Lancaster County
Yellow-poplar, soft maple, and hickory; 30¾ x
87¼ x 22½" (78.1 x 221.6 x 57.2 cm)
B.69.421

As with most types of Windsor furniture in America, the settee was first made in Pennsylvania. The form, which appeared in the 1760s, relates in both design and construction to the contemporaneous low-back armchair (see cat. nos. F246, F247). Typically, the molded crest is lapped over the extension of the arms where they meet in the back. The knuckled arm terminals and arrow turnings at the ends of the stretchers here are early features, superseded by the later style of bamboo-turned spindles and legs. An unusually large number of spindles—sixty-three—distinguishes this settee. The outward flare at the base of the legs is a feature associated with Lancaster County.

PROVENANCE: Purchased by Miss Hogg at the Anderson Galleries, New York, Jacob Paxson Temple sale, January 16, 1922, lot 1520, through Wayman Adams; used in the Hogg Brothers Company office and later at Varner Plantation and Winedale; transferred to Bayou Bend in 1967.

TECHNICAL NOTES: Yellow-poplar (seat, crest rail), soft maple (middle right rear leg, left medial stretcher, spindles), hickory (spindles).

RELATED EXAMPLES: Santore 1987, p. 192, no. 205, has a similar outward flare at the base of the front legs.

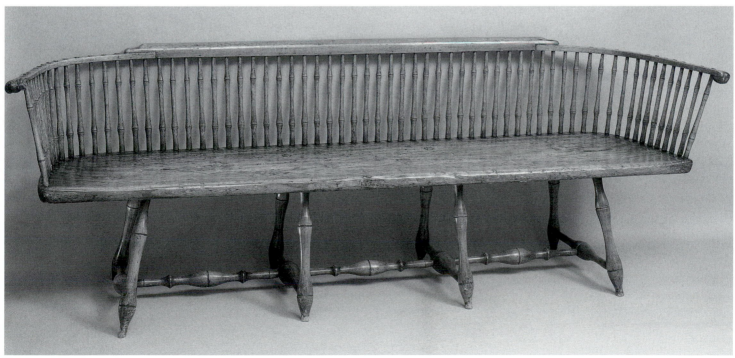

F264

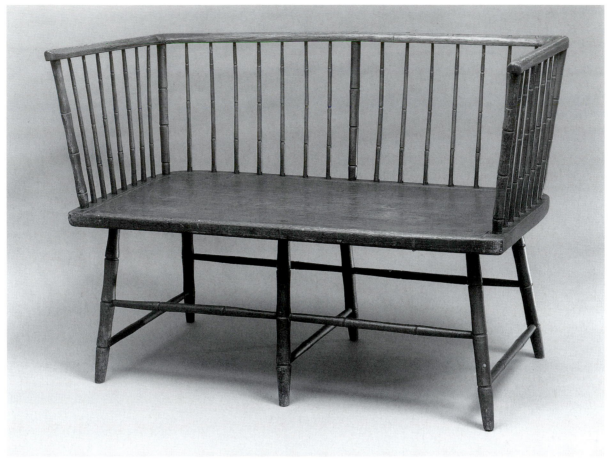

F265

F265

Settee

1800–1820
Probably Pennsylvania
Various painted woods (see Technical notes);
32½ x 45 x 21½″ (82.6 x 114.3 x 54.6 cm)
B.69.426

This unusual settee, with its bentwood crest rail, relates in design and construction to cradles or cribs. The overall concept echoes as well the design of rod-back chairs and settees of the early nineteenth century, especially those made in Pennsylvania.

PROVENANCE: Purchased by Miss Ima Hogg at the Anderson Galleries, New York, Jacob Paxson Temple sale, January 16, 1922, lot 1192, through Wayman Adams.

TECHNICAL NOTES: Soft maple (main corner posts, legs), red oak (crest rail), white oak (stretchers), hickory (spindles). Old but not original green paint.

RELATED EXAMPLES: Earlier versions: MMA (acc. no. 34.100.26); Santore 1981, nos. 185, 186.

F266

Set of Six Side Chairs

1840–60
Pennsylvania
Various painted woods (see Technical notes);
B.71.130.1: 33½ x 18½ x 21″ (85.1 x 47 x 53.3 cm);
B.71.130.2: 33⅜ x 18⅜ x 21″ (84.8 x 46.7 x 53.3 cm); B.71.130.3: 33⅛ x 18⅜ x 21¼″ (84.1 x 46.7 x 54 cm); B.71.130.4: 33½ x 18⅜ x 20½″ (85.1 x 46.7 x 52.1 cm); B.71.130.5: 33 x 18⅜ x 21″ (83.8 x 46.7 x 53.3 cm); B.71.130.6: 33¼ x 18⅜ x 21¾ (84.5 x 46.7 x 55.2 cm)
B.71.130.1–.6

These plank-seated balloon-back chairs with their vase-shaped splats and hoop backs are a rural adaptation of the high-style *chaise gondole* (see cat. no. F201). Typically, they are ornamented with painted decoration, here apple green with a stenciled fruit and flower design.

PROVENANCE: Purchased by Miss Hogg from an unknown source (at Bayou Bend prior to 1965).

TECHNICAL NOTES: Cherry, beech, yellow-poplar, soft maple, paint.

RELATED EXAMPLES: PMA (Garvan 1982, p. 41, nos. 22, 23); Winterthur (Evans 1996, p. 150, fig. 3–149); Sotheby Parke-Bernet, New York, sale 4048, November 17–19, 1977, lot 802.

REFERENCES: Warren 1975, p. 119, no. 220; Evans 1993, pp. 110–11, fig. 33.

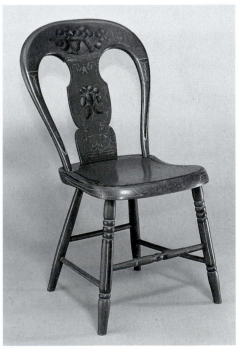

F266

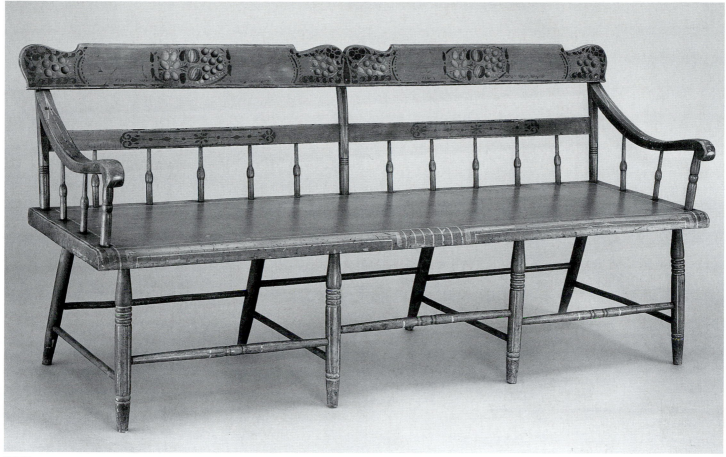

F267

F267

Bench

1840–60
Pennsylvania
Painted pine; 33½ x 71⅛ x 23″ (85.1 x 180.7 x 58.4 cm)
B.71.131

This type of late bench derived ultimately from the Windsor settee. Typical of Pennsylvania design are the wide tablet with ogee corners, stay rail, and short spindles. This example is ornamented with green paint, yellow stripes, and stenciled fruit and flowers.

PROVENANCE: Purchased by Miss Hogg from an unknown source (at Bayou bend prior to 1965).

TECHNICAL NOTES: Pine, paint (not analyzed microscopically).

RELATED EXAMPLES: Lea 1960, pp. 148–50; Sotheby's York Avenue Galleries, June 30 and July 1, 1982, sale 4905Y, lots 373 and 413; MMA (Fales 1972, p. 262); Evans 1996, p. 147, fig. 3-145.

REFERENCES: Warren 1975, p. 119, no. 221.

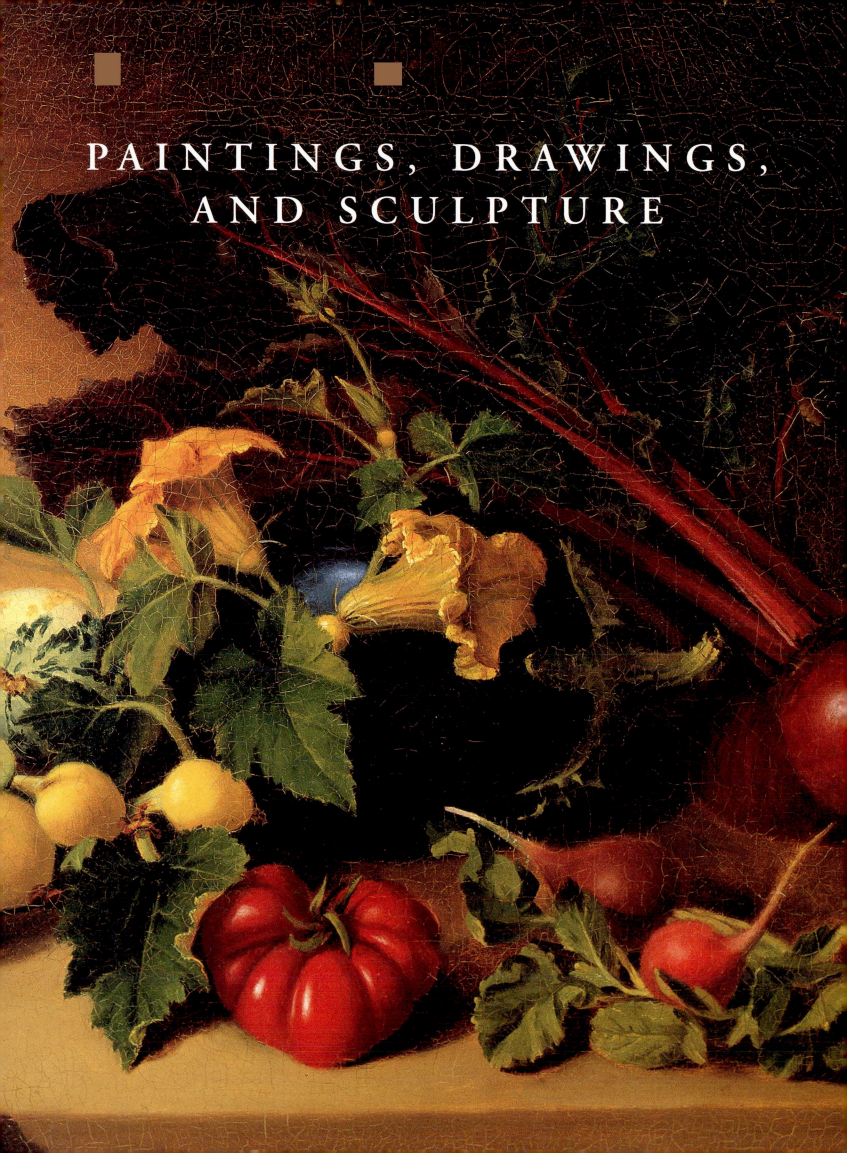

PAINTINGS, DRAWINGS, AND SCULPTURE

P1

Portrait of a Boy

ca. 1711–16
ATTRIBUTED TO THE PIERPONT LIMNER
(act. 1711–16), New England or possibly
New York
Oil on canvas; 30⅛ x 24⅜" (76.5 x 61.9 cm)
B.62.39

The history of art produced in England's North American colonies before the 1729 arrival of John Smibert (1688–1751; cat. nos. P3–P4) largely concerns itinerant and anonymous portrait painters, called limners to distinguish them from house-painters and painters of coaches and signs. Artists are often given a name associated with specific portraits in which the sitter has been identified, and paintings that share stylistic and technical similarities are ascribed to this artist. Thus, the artist of *Portrait of a Boy* has been attributed to the Pierpont Limner, identified by portraits of the Reverend James Pierpont and his wife Mrs. James Pierpont (1711, Yale University Art Gallery, New Haven).[1]

According to Pierpont family tradition, the Pierpont Limner was "an English painter of repute, temporarily sojourning" in Boston.[2] Clearly this artist was well trained and accomplished, for he exhibits a level of sophistication not seen in works by such contemporaries as the Pollard Limner (working in the Boston area). The 30-by-25-inch format, consisting of a partial profile set within a painted oval, was popularized in England by Sir Godfrey Kneller (1648–1723), a German-born and Dutch- and Italian-trained artist who worked in the studio of Rembrandt, from whom he absorbed a sensitivity to depicting forms within diffused light.[3] These are the very effects that characterize this portrait, as well as other portraits attributed to the Pierpont Limner, and it may be that this artist trained in or was somehow associated with Kneller's studio.

Although much of the canvas has been restored, technical evidence—a reddish ground and a combination of thick, opaque and thin, translucent pigments—links this portrait to the work of the Pierpont Limner.[4] The composition, in which the sitter is placed in profile before a partially illuminated monochromatic background and within an oval, is characteristic of the work of this artist.[5] The portrait reveals an especially sensitive effect of light on form, throwing into prominence the closely observed face and strong draftsmanship.

The facial characteristics of this sitter are similar to those of Edward Collins, the son of John and Margarita Schuyler Collins of Albany, in a portrait attributed to the Pierpont Limner (see Related examples). It has been suggested that Edward Collins may have had his likeness painted in Boston while visiting Ver Plank cousins.[6] Because the Pierpont Limner likely painted Caleb Heathcote, a dignitary of the New York area, a portrait of Edward Collins may have been painted near Albany, which would indicate the Pierpont Limner's itinerancy beyond New England to include the New York area.[7] It has also been proposed that this portrait may represent a brother or other relative of Edward.[8]

PROVENANCE: Purchased by Miss Hogg from Vose Galleries, Boston, 1962.

RELATED EXAMPLES: *Edward Collins,* inscribed at a later date under portrait: "Edward Collins, born in Albany anno 1704 D-ft, 1753," ca. 1716, Albany Institute of History and Art; *Elisha Lord,* the Connecticut Historical Society, Hartford; and *Richard Lord,* Deerfield Academy, Deerfield, Massachusetts.

REFERENCES: House and Garden 1973, p. 93; Warren 1975, p. 124, no. 234; McGarry 1993, p. 91.

1. Early scholars of American art, such as Alan Burroughs, discuss the limner tradition, but James Thomas Flexner appears to be the first to propose the title of the Pierpont Limner. See Burroughs 1936 and Flexner 1947, pp. 40–42.
2. See Warren 1958, specifically p. 113.
3. For information on Sir Godfrey Kneller and his training, see Stewart 1983, pp. 1–12.
4. Warren 1958, p. 98; conservation notes of Joseph Fronek in object files, 1989.
5. See Warren 1958 for a pictorial survey of works related to the Pierpont Limner.
6. See object files, copy of letter from James M. Babcock, chief, Burton Historical Collection, Detroit Public Library, September 15, 1958; and Warren 1958, p. 102.
7. See Craven 1986, pp. 122–23, 128–31; and New-York Historical Society 1974, vol. 1, pp. 344–45, no. 898 (Caleb Heathcote).
8. Suggested in Warren 1975, p. 124, no. 234. Edward, however, had no brothers. Edward did have a cousin, John Collins (age unknown), who was living in London in 1714 (see n. 6 above). Biographical details regarding John Collins are unknown, but if the Bayou Bend portrait represents him, it would have to have been painted before John moved to London by 1714. Conversely, John could not have had his portrait painted by the Pierpont Limner sometime after 1714 unless the sitter had moved from London to the colonies. A relationship between Edward Collins and the Bayou Bend sitter may exist, but identifying a sitter only on the basis of likeness is problematic and speculative.

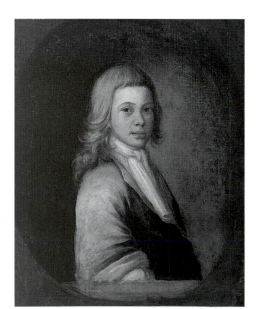

P1

P2

Portrait of Ebenezer Coffin

ca. 1714–30
ATTRIBUTED TO NEHEMIAH PARTRIDGE
(1683–before 1737), Massachusetts, probably Boston
Oil on canvas; 44 x 34½" (111.8 x 87 cm)
B.63.75

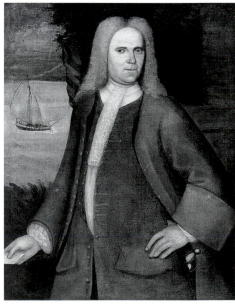

P2

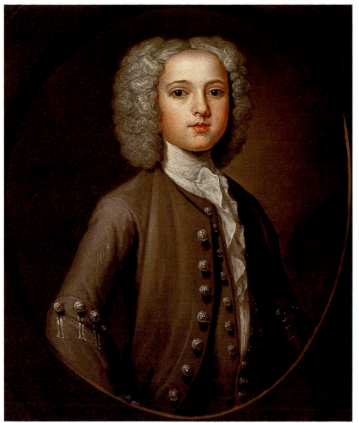

P3

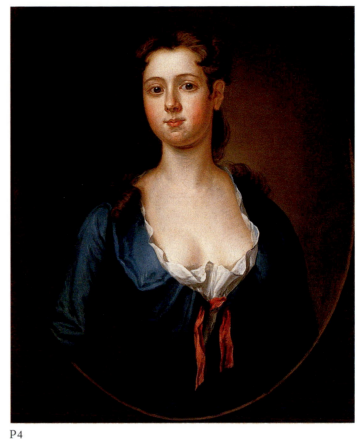

P4

According to Vose Galleries, this portrait descended in the Coffin family of Nantucket, one of the original founding families of this Massachusetts shipping island. Identified as Ebenezer Coffin (1678–1730),[1] the bewigged sitter assumes the posture of an English gentleman, with his left hand positioned on his hip near his sword and his right hand clutching a letter that may refer to his shipping business, which is likewise alluded to by the sloop in the background. Coffin is recorded in 1714 building the sloop *Nonsuch,* named after Elizabeth I's favorite country palace. His 1730 will indicates his considerable estate of two thousand pounds, including properties in Nantucket, Tuckernut, and Boston.[2]

Despite the poor condition of the painting, the scholar Mary Black has attributed the painting to Nehemiah Partridge.[3] Nehemiah was the son of William Partridge (ca. 1652–1728) and Mary Brown Partridge. He is recorded in Boston in 1712–14, where he worked as a japanner and painter of ships and portraits; in New York City and in Albany from 1715–21; possibly in Newport and Tidewater, Virginia, in 1722–23; and in the upper Hudson River Valley in 1724–25.[4] Nehemiah Partridge may have painted

Coffin in Boston around 1714 to mark the commissioning of his ship *Nonsuch.*

PROVENANCE: Descendants of the Coffin family; to Mrs. Charlotte Dillingham (née Coffin), Hyannisport, Massachusetts; [Robert E. Eldred, East Dennis, Massachusetts]; purchased by Miss Hogg from Vose Galleries, Boston, 1963.

EXHIBITED: "The Voyage of Life," Bayou Bend Museum of Americana at Tenneco, Houston, September 22, 1991–February 26, 1993.

RELATED EXAMPLES: Identical portrait of sitter, which may be a study by Partridge for the Bayou Bend painting, oil on panel, 10⅜ x 13¼", spurious inscription by a later hand: "R. Feake / AD-1728"; Department of Collections, Williamsburg; attributed to Nehemiah Partridge (?), *Captain Samuel Doty,* ca. 1730, Shelburne Museum, Shelburne, Vermont; attributed to Nehemiah Partridge, *Captain Benjamin Ellery, Sr.,* ca. 1717, Newport Historical Society.

REFERENCES: *Antiques* 84 (July 1963), p. 33; House and Garden 1973, p. 93; Warren 1975, p. 124, no. 235.

1. Ebenezer Coffin was the seventh of twelve surviving children of James Coffin and Mary Severance Coffin and the grandson of Tristram Coffin, whose family left revolutionary England during the reign of Charles I. He married Eleanor Barnard (1679–1769) in 1700 and had six surviving children.

2. Letter in object files from Edouard Stackpole, director, the Peter Foulger Museum, Nantucket, June 2, 1980.

3. Letter in object files from Mary Black, February 5, 1986. Nehemiah Partridge was formerly known as the Aetatis Suae painter. Nehemiah Partridge's maternal grandmother was Elizabeth Greenleaf, whose sister Judith married Ebenezer Coffin's grandfather Tristram Coffin. The artist and sitter, then, were related.

4. See Black 1980 and Saunders and Miles 1987, p. 92, no. 11.

P3

Portrait of Samuel Pemberton

1734
JOHN SMIBERT (1688–1751), Boston
Oil on canvas; 30⅛ x 25½" (76.5 x 64.8 cm)
B.72.7

P4

Portrait of Mary Pemberton

1734
JOHN SMIBERT (1688–1751), Boston
Oil on canvas; 30⅛ x 25⅛" (76.5 x 63.8 cm)
B.72.8

In her will, the mother of the subjects of these portraits named these likenesses of Samuel and Mary Pemberton by John Smibert as personal bequests, in addition to those of jewelry and silver.[1] Considering the vast estate of the wealthy Pembertons to be disposed, the specific mention of these portraits testifies to the esteem in which the family held them, as specimens of the work of a celebrated artist and as tokens of affection for family members. According to contemporary beliefs about the function of portraiture, portraits helped to nurture and sustain a set of hierarchical family relations, a point these portraits illustrate.[2]

As the heir to family fortune, the son held a privileged place within the eighteenth-century family. In the case of the Pembertons, Bostonians whose wealth derived from merchant trade and real estate, Samuel (1723–1779) was the first child to be painted by Smibert. Several months later, Smibert painted portraits of Samuel's elder sisters, Hannah, aged nineteen (1734, MMA), and Mary (1717–1763). The elder Pemberton son, however, was not Samuel but James (1713–1756), who was painted by Smibert three years later, in 1737. It is likely that when James's siblings were painted, he, at age twenty-one, was no longer part of the household.[3] It is not certain that Smibert initially received the commission to paint all three children; the parents, evidently pleased with the portrait of Samuel, may have asked Smibert to paint the two daughters several months later. The three portraits likely hung together, with Samuel at center, flanked by his sisters on either side: Mary at right, wearing a blue dress ornamented by a pink ribbon, and Hannah at left, wearing red.[4]

Smibert portrays young Samuel as a bewigged gentleman in a soft gray suit, proudly erect, with an alert expression, his large eyes enhanced by exquisitely rendered eyelashes.[5] A great deal of attention and care has been lavished on painting the graceful swirls of his wig, the braid and buttons of his coat and waistcoat, and the ruffle of his stock. Despite the formulaic composition, Smibert's portrait of Samuel has considerable charm and verve, whereas the portrait of his sister Mary is slightly less appealing. She wears a dress Smibert painted ad infinitum, a type likely borrowed from

mezzotints after Sir Godfrey Kneller.[6]

John Smibert arrived in the colonies from London in 1729, whereupon he quickly became a celebrated, successful Boston artist. Born in Edinburgh, Smibert moved to London to work as a coach painter and picture dealer copyist. In 1719, he left London to take the Grand Tour so that he could study the great masterpieces of Europe, particularly of Italy. After three years, he returned to London, where he began his portrait business. Part of a society that believed in the westward expansion of culture and the progress of civilization, Smibert received and accepted the call to travel to the colonies to found a university in Bermuda with the renowned philosopher Dean George Berkeley. Once arrived in the colonies, Smibert found himself at loose ends when the project stalled, and in the interim, he traveled to Boston to paint portraits. He became an overnight sensation, for he was the best-trained artist the New England colonies had ever seen. Furthermore, he did much to foster the arts in the colonies, for his studio and color shop in Boston, even long after he died, served as a gathering place for aspiring artists eager to learn a profession that had, as yet, no academy in the colonies.

PROVENANCE: Both portraits belonged to the sitters' parents, James and Hannah Penhallow Pemberton, until 1757, at which point each sitter was bequeathed his or her portrait. At Mary's death in 1763, her portrait passed to her brother Samuel. Samuel owned both his and his sister's portrait until 1779, and thereafter the two portraits descended together, to their niece Mrs. Ephraim Ward (Mary Colman), until 1809; to her son Benjamin Colman Ward; to his unmarried daughters, Ellen Maria Ward and Julia Elizabeth Ward, until ca. 1900[7]; to their cousin George H. Davenport, Boston, until 1932; to his daughter Mrs. William Truman Aldrich, until 1949; to George Aldrich; purchased by Miss Hogg from Vose Galleries, Boston, 1972.

FRAME NOTES: Both portraits retain their original Baroque frames, constructed of eastern white pine, carved and regilded, and include in their design a flat-sanded frieze, strapwork, flower and leafage ornament, and leaf carving at the inner edge.

EXHIBITED: B.72.7, MFA, Boston, 1878[8]; "One Hundred Colonial Portraits," MFA, Boston, June 19–September 21, 1930, p. 68; "The Smibert Tradition," Yale University Art Gallery,

New Haven, October 8–November 20, 1949, no. 23; probably exhibited at Somerset Club, Boston, 1954[9]; "The Masterpieces of Bayou Bend, 1620–1870," Bayou Bend Museum of Americana at Tenneco, Houston, September 22, 1991–February 26, 1993; B.72.8, MFA, Boston, 1878; "One Hundred Colonial Portraits," MFA, Boston, June 19–September 21, 1930, p. 67; MFA, Boston, 1944[10]; "The Smibert Tradition," Yale University Art Gallery, New Haven, October 8–November 20, 1949, no. 22; probably exhibited at Somerset Club, Boston, 1954; "The Masterpieces of Bayou Bend, 1620–1870," Bayou Bend Museum of Americana at Tenneco, Houston, September 22, 1991–February 26, 1993.

RELATED EXAMPLES: *Hannah Pemberton*, 1734, MMA. Smibert often repeated the pose, oval format, and dress of the sitter in related portraits. Interesting examples of portraits conceived as pendants are Smibert's portrait of Lydia Henchman (1730, Colby College Museum of Art, Waterville, Maine) and that depicting her fiancé, Thomas Hancock (1730, MFA, Boston).

REFERENCES: B.72.7, Bayley 1929, p. 413; Foote 1950, pp. 178–79; Smibert 1969, 1734 entry, p. 92, no. 94 ("94. Mr. J. Pembertons yr. son H.P. 3/4 25-0-0"); Warren 1975, p. 125, no. 236; Saunders 1979, vol. 1, p. 179, vol. 2, pl. 131; Caldwell and Rodriguez Roque 1994, p. 19; Saunders 1995, p. 184, no. 96; B.72.8, Bayley 1929, p. 411; Foote 1950, pp. 75 (Foote describes the portrait of Mary as a "delightful little idyl"), 178; Smibert 1969, 1734 entry, p. 92, no. 99 ("99. Mrs. [*sic*, sitter was unmarried] Marey Pemberton H.P. 3/4 25-0-0"); Warren 1975, p. 125, no. 237; McGarry 1993, p. 93; Caldwell and Rodriguez Roque 1994, p. 19; Saunders 1995, p. 187, no. 101.

1. Will of Hannah Penhallow Pemberton, December 1757, Suffolk County Probate Court, Boston, no. 11723.
2. See, for example, Richardson 1971, pp. 13–14.
3. James Pemberton graduated from Harvard in 1732, and in 1734, the year his siblings were painted, he purchased the estate from which Pemberton Square in Boston takes its name. His portrait is unlocated; see Saunders 1995, pp. 233–34, no. 397.
4. First suggested in Warren 1975, p. 125.
5. Samuel graduated from Harvard in 1745 and tried his hand at the ministry before taking over his father's business in 1752. He entered public life in 1764 as a justice of the peace and became a prominent and active Son of Liberty. Accounts describe him as quiet and intellectual; indeed, the first paragraphs of his will do not dispose of his considerable wealth but grant free-

dom to his slave and distribute his collection of treasured books.

6. For example, see Sir Godfrey Kneller's portrait of the *Countess of Ranelagh*, 1699, mezzotint by John Smith in Sellers 1957, p. 438.

7. Mary, who predeceased Hannah and Samuel, bequeathed the majority of her estate and remainders to Samuel (Will, April 1764, Suffolk County Courthouse, Boston, no. 13433). Samuel left his estate to Hannah's children (Will, July 1779, Suffolk County Courthouse, no. 17048). See Shipton 1960, pp. 161–62. The three Smibert portraits were then divided among Mary Colman Ward's children. For the provenance of Hannah Pemberton's portrait, see Caldwell and Rodriguez Roque 1994, p. 19; the three portraits were united with Ellen Maria Ward, who appears to have owned them in the last quarter of the nineteenth century before they were dispersed again among cousins.

8. According to the paper label on back of the frames of both portraits, they were exhibited at the MFA, Boston, in June 1878, and, at that time, belonged to Ellen M. and Julia E. Ward, Boston.

9. A label on the back side of both frames indicates the paintings were on loan at the Somerset Club in Boston. Anonymous handwritten notes added to a copy of Foote 1950 indicate that both portraits were on loan at the Somerset Club, Boston, in 1954.

10. According to a label attached to the stretcher, the portrait of Mary was loaned to the MFA, Boston, March 9, 1944, and, at the time, belonged to Mrs. William T. Aldrich.

P5

Portrait of John Gerry

1745
Joseph Badger *(1708–1765), Boston*
Oil on canvas; 50⅛ x 36⁵⁄₁₆″ (127.3 x 92.2 cm)
B.53.13

Miss Hogg began acquiring colonial American paintings more than thirty years after she started her collection of decorative arts. *Portrait of John Gerry* by Joseph Badger is her first acquisition in this area. Little is known of this elusive painter. Badger, like many early colonial American artists, aspired to be a portraitist but, to make a living, also painted houses, coaches, and signs. The son of a tailor living in Charlestown, Massachusetts, young Badger moved to Boston in

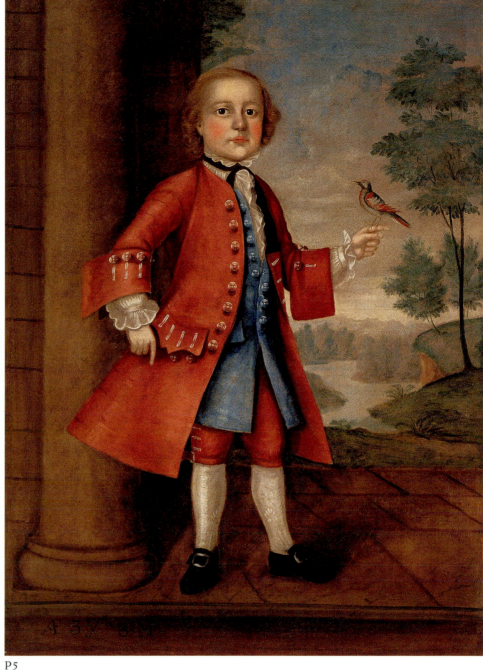

P5

the 1730s. No information on his early training exists, none of his letters or diaries survives, and none of the paintings attributed to him is signed. Although he was insolvent at the time of his death in 1765, Badger enjoyed a relatively modest twenty-year career as a portraitist in Boston.[1] After John Smibert (see cat. nos. P3, P4) began failing in his abilities in the early 1740s, and before Joseph Blackburn's arrival in Boston in 1755 and John Singleton Copley's artistic success by the late 1750s (see cat. nos. P15–P23), Badger was one of the few competent portraitists in a thriving city of roughly 16,000 people.

The commission to paint John Gerry (1741–1786), son of Thomas and Elizabeth Greenleaf Gerry, came early in Badger's career. The date of the portrait derives from the inscription giving Gerry's age and from his birthdate of October 8, 1741. The Gerrys were a prominent family living in a grand three-story house in Marblehead, Massachusetts. John's father was a sea captain and merchant and commander of Fort Sewall. The Gerry brothers John, Samuel, and Elbridge continued the merchant trade they inherited from their father.[2] John served as naval officer of the port of Marblehead during the War of

Independence. He married Sarah Quincy Wendell of Boston in 1763 and had one daughter, Sarah (Sally), in whose family this portrait descended, along with the coat worn by the sitter in his portrait (cat. no. P6).

Badger appears to have painted only one Gerry child, John, the fifth child born in a family of sixteen, few of whom survived childhood. While the circumstances surrounding the commission do not survive, it may be that the Gerrys wanted a portrait of John because he was their eldest surviving child; the four preceding him had died as infants. As the Gerry's eldest child and heir, John Gerry appears suitably grand in this portrait. He stands in a fictitious classical architectural setting with a luminous landscape behind him. The bird that he holds and his gesture of pointing to the ground below are stock conventions in Baroque painting, which Badger could have borrowed from mezzotint engravings after English aristocratic portraits.[3] Although the sitter is only three years and eight months old, as the inscription testifies, he wears the costume of a gentleman, in keeping with portrait customs of the time.

Badger never attained the brilliance of Robert Feke (see cat. no. P7) or Copley. Badger's sitters often appear stilted, rigid, and unconvincing. Some scholars, however, have recognized the "quaintness and . . . naive and piquant charm" or "wraithlike" qualities of Badger's appealing portraits of children, for which he is best known and of which *John Gerry* stands as an excellent and early example.[4]

INSCRIBED (LOWER LEFT): AE 3Ys 8 M.

PROVENANCE: The sitter's father, Thomas Gerry, until 1774; to the sitter, until 1786; to his daughter Sarah Gerry Orne, until 1846; to her daughter Sarah Wendell Orne Austin (1793–1846); to her son Loring H. Austin; to his daughter Lillian Ivers Austin de Silva; to her son Mark T. de Silva, until 1952; purchased by Miss Hogg from Hirschl and Adler Galleries, New York, 1953.

FRAME NOTES: The painting probably retains its original frame, constructed of eastern white pine, carved and gilded, and includes in its design pierced, serpentine C-scrolls at the four corners, a flat-sanded frieze, strapwork and leafage ornament with punched surface, and leaf carving at the inner and outer edges.

EXHIBITED: On long-term loan to the MFA, Boston, sometime before acquisition; "Colonial Portraits from the Collection of Miss Ima Hogg," Music Hall, Houston, February 26–March 4, 1957; "The Voyage of Life," Bayou Bend Museum of Americana at Tenneco, Houston, September 22, 1991–February 26, 1993.

RELATED EXAMPLES: Only about ten of the approximately thirty paintings that Badger painted of children are full-length portraits, five of which are boys in a landscape with props: *James Badger,* 1760, MMA (with bird); *Thomas Dawes,* ca. 1764, MFA, Boston (with orange); *John Joy, Jr.,* 1758, Massachusetts Historical Society, Boston (with dog); *Jeremiah Belknap,* ca. 1758, Cleveland Museum of Art (with dog); *Thomas Mason,* ca. 1758, private collection, Massachusetts (with squirrel).

REFERENCES: *Antiques* 62 (October 1952), p. 274 (on view at Vose Galleries, Boston); *Antiques* 64 (November 1953), p. 340 (on view at Hirschl and Adler Galleries, New York); Warren 1966, p. 805; Nylander 1972, p. 55; House and Garden 1973, p. 92; Warren 1975, p. 128, no. 240; Warren 1982, p. 231; *Antiques* 135 (February 1989), p. 361; Caldwell and Rodriguez Roque 1994, p. 38.

1. In 1757, Badger received six pounds sterling for portraits measuring about 50 by 40 inches (Park 1917, p. 160). John Singleton Copley, twelve years later and at the height of his colonial career, was charging almost twenty pounds sterling. Badger died intestate.
2. The younger brother Elbridge also entered politics, signing the Declaration of Independence and serving as the fifth vice president of the United States and governor of Massachusetts.
3. The blue, white, and red plumage of the finchlike bird echoes the colors of the boy's costume. Badger includes birds as props in a number of children's portraits, such as in *Rebecca Barrett* (ca. 1765, Daughters of the American Revolution Museum, Washington, D.C.). Birds, dogs, and squirrels were typical props in children's portraiture of the time. See Fleischer 1988, pp. 3–35.
4. Park 1917, p. 161; and Richardson 1956, p. 43.

P6

Boy's Body Coat

ca. 1745
Probably Massachusetts
Wool and secondary materials (see Technical notes); 22½ x 23" (57 x 58.5 cm)
B.69.245

In Joseph Badger's portrait of John Gerry (cat. no. P5), the young boy has been "breeched"[1] and is attired as an adult: body coat, waistcoat, breeches, shirt, and so forth. A small boy's coat survives that has traditionally been associated with the portrait; it carries the note: "Coat of / John Gerry / Born 1740 / See / Picture / of / Little Grandpa."[2] This coat of bright rose worsted bears considerable physical evidence of being the coat in the portrait: the collarless neckline, the eight-button front closure, the flare of the skirt, the bracket-shaped pocket flaps, the deep sleeve cuffs. Although the trim on the cuffs and pocket flaps is now missing, there is stitching evidence of its previous existence.

EAC

PROVENANCE: See cat. no. P5.

TECHNICAL NOTES: Tabby-weave wool (exterior cloth); silk taffeta (body lining), linen (sleeve lining). Linen has also been used in the inner lining and facings and interfacings. Buckram stiffens the coattails. Wrapped silver thread worked in a star motif covers the buttons, and cream silk thread couches silver thread to outline the button holes.

1. Breeching—taking a young boy out of a long gown and putting him into a pair of breeches—could occur anywhere between the ages of two and six.
2. This note was probably written by Gerry's granddaughter Sarah Wendell Orne (1793–1846). According to published genealogies, John Gerry was born October 8, 1741.

P6

Portrait of Mrs. Samuel McCall, Sr.

1746
ROBERT FEKE *(ca. 1707–1751), Philadelphia*
Oil on canvas; 49⅞ x 39⅞" (126.7 x 101.3 cm)
B.71.81

Robert Feke was the first major native-born artist of the American colonies. Born in Oyster Bay, Long Island, Feke lived and worked in Newport, Philadelphia, Boston, perhaps Virginia, and Barbados, where he died in 1751. Borrowing from the tradition of Baroque aristocratic portraiture, Feke included swags of brightly colored drapery, columns, elegant dresses, and props in his relatively large, imposing canvases. His grand portraits of colonial sitters dressed and posed in the guise of English nobility evoke dignity, grace, and a spare elegance.

An excellent example of Feke's combination of grandeur and simplicity, the Bayou Bend portrait features a young woman standing erect in front of an Ionic column and beside a swath of crimson drapery and a Rococo marble-topped table on which she rests her hand. The sitter is dressed in a crystal-buttoned, radiant blue silk dress, accentuated at its narrow waist by a tassel belt, and a salmon pink underskirt. She gracefully holds a peony in her left hand, displaying her long, tapering fingers.

This portrait descended in the Willing family of Philadelphia, along with another portrait of a woman, both identified previously as Margaret and Mary Willing.[1] Henry Wilder Foote first suggested that these portraits represented the McCall sisters, one of whom married into the Willing family.[2] In 1968, R. Peter Mooz identified the Bayou Bend portrait as Mrs. Samuel McCall, Sr. (Anne McCall, 1720–1785), one of three portraits Feke painted during his 1746 trip to Philadelphia.[3] According to Mooz, this portrait of twenty-six-year-old Anne, along with portraits of her twenty-one-year-old sister Mary (1725–1799) and their mother, Mrs. George McCall (Anne Yeates, 1697–1745/46; see Related examples), formed a trio of paintings. Each is depicted in a similar style dress and holds a peony. X-rays reveal that the Bayou Bend sitter originally

P7

wore a white lace cap similar to that worn by Mary McCall in her portrait.[4]

At the time Feke painted Anne, she had been married for nine years to her cousin Samuel McCall, Sr. (so designated to distinguish him from Anne's brother Samuel, ten years his junior, who became head of the family at their father's death in 1740). Maintaining a three-story house on Water Street, Philadelphia, she delivered six children, only two or three of whom had survived by the time Feke painted her in 1746.[5] Her father and husband were prominent merchants in Philadelphia, and her family was a member of the elite Philadelphia Dancing Assembly, to which a number of Feke's patrons also belonged.

PROVENANCE: The painting probably remained with the subject's brother Samuel McCall, until 1762; to the sitter's niece and namesake, Mrs. Thomas Willing (Anne McCall); to her grandson Dr. Charles Willing; to Mrs. Charles Willing, until 1887; to her relative Esther Binney Hare; to J. Innes Clark Hare, until 1905; to T. Truxton Hare, Jr.; purchased by Miss Hogg from Vose Galleries, Boston, 1971.

EXHIBITED: "Loan Exhibition of Historical Portraits," Pennsylvania Academy of the Fine Arts, Philadelphia, December 1887–January 1888, no. 472; long-term loan, PMA, 1967–71; "Philadelphia Painting and Printing to 1776," Pennsylvania Academy of the Fine Arts, 1971, no. 9; "The Masterpieces of Bayou Bend, 1620–1870," Bayou Bend Museum of Americana at Tenneco, Houston, September 22, 1991–February 26, 1993.

RELATED EXAMPLES: The pose and composition are related to the mezzotint of Queen Caroline by John Faber (1684–1756) after Joseph Highmore (1692–1780); see Mooz 1971a,

p. 152. Feke portraits of other McCall family members include *Mary McCall*, 1746, Pennsylvania Academy of the Fine Arts, Philadelphia; *Margaret McCall*, the sitter's sister (1731–1804), 1749, the Dietrich American Foundation, Philadelphia; *Anne Yeates McCall*, 1746, destroyed by fire (ex coll. Mrs. John M. Keating, Wawa, Pennsylvania).[6]

REFERENCES: Foote 1930, pp. 205–8; Mooz 1968, pp. 702–7; Mooz 1971a, pp. 151–54; *Antiques* 103 (June 1973), p. 1070; Warren 1975, pp. 126–28, no. 239; Agee et al. 1981, p. 74, no. 130.

1. Margaret Willing was previously identified as the subject of the Bayou Bend portrait. The other portrait, previously associated with Mary Willing, is now thought to represent Margaret McCall (1731–1804), whom Feke painted three years later. See Related examples.
2. See Foote 1930, pp. 205–8.
3. See Mooz 1968; Philadelphia Painting and Printing 1971, no. 9; and Mooz 1971a. According to Mooz, Samuel, Jr.'s account book includes an entry of payment to Feke for the portrait of Margaret McCall in 1749. Because the portraits of Anne and Margaret descended with Samuel, Jr., Mooz speculates that the portrait of Ann, along with the portraits of two other McCalls, were commissioned by him in 1746.
4. See Mooz 1971a, p. 154.
5. See Keen 1881, p. 341.
6. Because death dates for Anne Yeates McCall are given variously as 1745 and 1746, it is possible that the mother had died when Feke came to paint in Philadelphia. This portrait may instead depict either the eldest McCall daughter, Catherine, or the youngest McCall daughter, Eleanor.

P8

Portrait of Mrs. John Greenleaf

ca. 1748
JOHN GREENWOOD (1727–1792), Boston
Oil on canvas; 34⅛ x 28⅛" (86.7 x 71.4 cm)
B.59.98

Boston-born John Greenwood served as an apprentice to the sign painter, japanner, and engraver Thomas Johnston (1708–1767) from 1742 until about 1745, whereupon he became a successful portrait painter until his departure in 1752 for Surinam, a Dutch colony in South America. After painting in Surinam, then studying mezzotint engraving in Amsterdam,

P8

Greenwood moved in 1762 to London, where he became a successful art dealer, auctioneer, and a founder of the Society of Artists.

This portrait descended in the family of Judge Robert Brown (1682–1775) of Plymouth, Massachusetts, and when originally acquired was thought to be a portrait of the judge's wife, Priscilla Johnson Brown. However, Robert Brown's wife died in 1744, when Greenwood was still serving as an apprentice.[1] Critical to the identification of the sitter is the fact that this portrait descended with the Brown family of Plymouth.

Recent research suggests that this portrait represents one of Robert Brown's daughters, Priscilla (b. 1725), who married Dr. John Greenleaf of Boston in 1743 and gave birth to three children: Priscilla (b. 1746), Elizabeth (b. 1748), and John (b. 1750; see Related examples).[2] The Greenleaf children predeceased their parents, thus explaining why the portrait of their mother would have descended with the Brown rather than the Greenleaf family. It is possible that Judge Brown commissioned this portrait of his daughter, Priscilla, after she married John Greenleaf in 1743 and moved to Boston. An example of Greenwood's interest in genteel poses, clarity of modeling, and sharp color contrasts, this portrait hung in the Brown family home in Plymouth until 1936.

PROVENANCE: Judge Robert Brown, Plymouth (1682–1775); to his son Robert Brown (1739–1810); to his son William Brown

(1784–1845); to his son Johnston Brown; to his daughter Mrs. Joseph L. Buckingham (Mary S. Brown); to their son Frank L. Buckingham, until 1936; [C. W. Lyon, agent]; purchased by Miss Hogg from Vose Galleries, Boston, 1959.

EXHIBITED: "The Voyage of Life," Bayou Bend Museum of Americana at Tenneco, Houston, September 22, 1991–February 26, 1993.

RELATED EXAMPLES: Joseph Blackburn, *Priscilla Brown* (private collection). From 1756 to 1758, John Singleton Copley painted the children of Dr. John and Priscilla Brown Greenleaf several years after their nurse apparently poisoned them with laudanum: Priscilla (private collection); Elizabeth and John (ex coll. Mr. and Mrs. Howard Joynt, Alexandria, Virginia). Copley's portraits were based on earlier (ca. 1752) works painted by Joseph Badger of the two daughters or some other lost images. The Bayou Bend portrait is similar in format and style to many other Greenwood portraits, such as *Mrs. Benjamin Austin*, 1747–52, Winterthur, and it appears to be a variant of the mezzotint prototype by John Smith of the *Portrait of Princess Anne* after Sir Godfrey Kneller, 1692; see Sellers 1957, p. 430.

REFERENCES: Warren 1975, pp. 128–29, no. 241.

1. See Burroughs 1943, pp. 14, 17, 65.
2. See Cooper 1980, pp. 80–81.

P9

Overmantel Painting

ca. 1750–75
Unknown artist, Marblehead, Massachusetts
Oil on two planks; 23½ x 53⅜" (59.7 x 135.6 cm)
Museum purchase with funds provided by the Friends of Bayou Bend, B.77.21

In the eighteenth century, itinerant artists traveled through New England painting "landskips" for overmantels, doors, and walls.[1] These pictures, often derived from prints after landscapes by English and French artists or even wallpaper designs, were often embellished with local references to buildings or landscapes.

The Bayou Bend example was once part of the woodwork of a second-story bedroom in the Hawkes house on Washington Street in Marblehead. It features a variety of structures, specifically, two three-story homes, both with columned porticoes, as well as a rolling topography

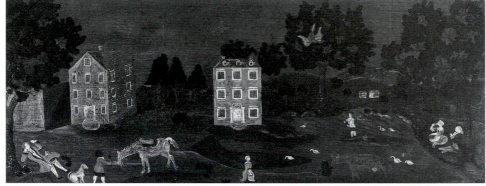

P9

dotted with trees, ducks, cows, birds, and various human figures. These—a reclining male, a young male with a dog and horse, a strolling woman, another young male, and a seated couple, one of whom drinks from some sort of stemware—are delightfully out of scale and proportion to one another. A prototype print, if the artist worked from prints, and the identification of the buildings or estates are not known.

PROVENANCE: Removed from its original setting at the Hawkes house on Washington Street in Marblehead, Massachusetts; purchased by Bayou Bend from Childs Gallery, Boston, 1977.

RELATED EXAMPLES: Perhaps the same hand produced the overmantel for the Jeremiah Lee Mansion in Marblehead, Massachusetts (Marblehead Historical Society).

REFERENCES: Bishop 1979, pl. 3.

1. See Little 1972b, pp. 25–52.

P10

Portrait of a Naval Officer, Known as Augustus Keppel

ca. 1749
JOHN WOLLASTON *(act. 1742–75)*
Oil on canvas; 49⅞ x 40" (126.7 x 101.6 cm)
Gift of Mr. and Mrs. Harris Masterson in memory of Libbie Johnston Masterson, B.69.343

Of all the paintings in Bayou Bend's collection, this fine portrait by John Wollaston has proved the most elusive in terms of the identity of the sitter and the date and location of its execution. The attribu-

tion to Wollaston, the midcentury English artist who first introduced Rococo style—the latest in English portrait fashion—to the colonies, has never been at issue. Wollaston was a successful and celebrated colonial artist, painting as many

as two hundred portraits in his sporadic career. The son of John Wollaston, an early eighteenth-century portrait artist, Wollaston received his artistic training in London with a drapery painter, probably Joseph van Aken.[1] The finesse with which he painted silks, satins, braids, and lace attests to his specialized training. Such peculiar mannerisms in his portraits as lips with upturned corners and almond-shaped eyes are consistent with the English portrait traditions established by artists like Thomas Hudson and Allan Ramsay, which were transferred to the colonies through Wollaston and Joseph Blackburn (act. 1752–ca. 1778).

Wollaston migrated to the American colonies in 1749, where he became, over the next decade, a prolific and prominent portraitist in both the middle and southern colonies. From 1749 to 1752, Wollaston

P10

painted the New York gentry (see cat. no. P11). From 1752 to 1757, he painted in Philadelphia, Annapolis, and in Virginia, before returning to Philadelphia in 1758–59. Wollaston left the colonies for the British West Indies around 1759, returning in 1765, this time traveling south to Charleston, South Carolina, where he painted the local gentry until 1767 (see cat. no. P12). He returned to London in 1767, and little documentation of his later whereabouts survives.[2]

This three-quarter portrait presents a confident young man surrounded by props that identify his profession. Set against a brilliant seascape background featuring a double-decker ship with an ensign and red mast pennant, the sitter clutches a telescope and rests his hand on a cannon, features common in portraits of British naval officers.[3] The sitter wears a sword and a navy jacket with silver trim; its blue lapels, white cuffs, and braid identify his rank as captain. His waistcoat is of shimmering white satin, providing textural contrast to his starched cuffs and stock.

When acquired by Bayou Bend in 1969, the portrait was identified as a "naval Captain, probably Admiral Keppel when a young man."[4] Keppel (1725–1786) was a popular British hero of the American Revolution; he became the subject of numerous portraits, prints, and commemorative ceramics. Research on the sitter's uniform in 1988 revealed a problem in the portrait's dating; the sitter's blue lapels and white cuffs indicate the uniform of a captain of under three years seniority. In 1755, Keppel had been a captain of over three years seniority for over five years.[5] There is no reason why Keppel would have been portrayed in a uniform of inferior rank, especially since portraits of military officers were usually commissioned to mark a promotion in rank. The portrait was then redated to Wollaston's English period.[6] At the same time, the ship in the background, if it represented a specific ship at all, was identified as either the *Anson,* a sixty-gun double-decker that Keppel commanded in 1747, or the *Centurion,* which he commanded in 1749.

It is difficult to date the painting on style alone, as Wollaston's late English and early colonial paintings are quite similar.[7] Recent research conducted on other elements of the picture—namely, the uni-

form and flags—has provided new information but does not resolve the dating issue. For example, the silver, rather than the usual gold, braid on the uniform suggests that the uniform was created either before uniform standards were established in 1748 or sometime around 1748.[8] A more interesting discovery, however, is that all the other known Wollaston portraits of naval officers that relate to the Bayou Bend portrait (see Related examples) also feature red mast pennants, which identify the ships within the red squadron.[9] All of these sitters, then, may have served under higher officers of the red squadron, which may eventually help to identify a sitter.

PROVENANCE: Purchased by Mr. and Mrs. Harris Masterson, Houston, from Sabin Galleries, London, 1968–69.

RELATED EXAMPLES: Several by Wollaston include *Portrait of a Naval Officer, probably Samuel, Viscount Hood,* ca. 1746, National Maritime Museum, Greenwich, England; *Portrait of a Naval Officer,* ca. 1749, Art Institute of Chicago; *Portrait of an Officer (Sir Charles Hardy?),* ca. 1755(?), the Brooklyn Museum, Brooklyn, New York; *Unidentified British Navy Officer,* ca. 1745, NGA; and *Captain Thomas Noel,* undated, Christie's, London, Important English Pictures, sale 3257, November 22, 1985, lot 108. Also English school, possibly by Wollaston, *Portrait of a Captain,* ca. 1750, National Maritime Museum, Greenwich.

REFERENCES: Warren 1975, p. 130, no. 244; Weekley 1976, pp. 117–18, fig. 25; Miles 1995, p. 354.

1. The slim bibliography on Wollaston includes Bolton and Binsse 1931, pp. 30–33, 50, 52; Groce 1952; Weekley 1976; Craven 1975; and Saunders and Miles 1987, pp. 176–82.
2. In 1767, the *South Carolina Gazette* announced that Wollaston, a "celebrated limner," had left Charleston for London aboard the *Snow Portland,* and in 1775, in London, Wollaston apparently met an acquaintance from the Leeward Islands, the last known mention of the artist during his lifetime (see Saunders and Miles 1987, p. 182).
3. See, for example, works by such artists as Sir Anthony Van Dyck (*Algernon Percy, 10th Earl of Northumberland,* ca. 1636, Alnwick Castle) and Michael Dahl (two portraits of Sir Cloudisley Shovell, ca. 1702, National Maritime Museum, Greenwich, England).
4. Sabin Galleries, London, had no record of the painting's history or any proof of the attribution to Keppel. Nonetheless, the portrait was identified as Keppel and was dated

1755, the only date in which Wollaston could have painted Keppel in the colonies, since that was the date of the latter's visit to Williamsburg. Keppel sailed the HMS *Centurion,* accompanied by the *Norwich* and the *Syren,* for America late in December 1754 and reached Virginia on February 20, 1755, by which time Wollaston had arrived in Virginia. Keppel visited Alexandria in March 1755, went back to Williamsburg in April, and returned to England in August 1755; official correspondence of Commodore Keppel to the secretary to the admiralty from December 1754 to September 1755 at Colonial Williamsburg (British Public Record Office, Admiralty 1480, ff. 481–614).
5. Furthermore, Keppel had already sat to Sir Joshua Reynolds in 1749 wearing the uniform of a captain of over three years seniority that featured white lapels and white cuffs.
6. Keppel was promoted to captain in December 1744, before uniform standards were enacted in 1748. Involved in passing the order, Keppel may have worn a prototype uniform before the official change (see object files, letter from D. J. Lyon, National Maritime Museum, Greenwich, March 9, 1988). Keppel was promoted to lieutenant during George Anson's voyage around the world, became a second lieutenant in 1744, and was promoted to captain on December 11, 1744.
7. In 1976, Wollaston scholar Carolyn Weekley stated that she did not believe that the Bayou Bend portrait compared with Wollaston portraits executed prior to 1749 (Weekly 1976, p. 118). However, at the time of her research, few English Wollastons, other than the somewhat crude *George Whitefield Preaching* (1742, the National Portrait Gallery, London), were well known or published. *Unidentified British Navy Officer* (ca. 1745, NGA), the portrait of *Viscount Hood* (ca. 1746, the National Maritime Museum) and *Sir Thomas Hales* (1744) and *Thomas Appleford* (1746, both at the New-York Historical Society) demonstrate the speed in which Wollaston matured in just a few years.
8. It took considerable time for officers to have uniforms made to specifications, especially if an officer was at sea. Mrs. P. M. Plackett-Barber, formerly curator of uniforms, medals and weapons, and Roger Quarm, curator of pictures, at the National Maritime Museum, over the years have provided helpful information regarding the sitter's uniform. Even after consulting other experts as well, they simply cannot account for the uniform, other than to speculate that it could possibly date to 1748.
9. The ensign of the red squadron features a union flag floating on a red field and erected over the poop; see Falconer 1789.

Portrait of Mrs. Richard Nicholls

1749
JOHN WOLLASTON *(act. 1742–75), New York*
Oil on canvas; 30 x 25″ (76.2 x 63.5 cm)
Gift of Mr. and Mrs. Harris Masterson in
memory of Libbie Johnston Masterson, B.69.344

P11

Like John Smibert (see cat. nos. P3, P4), English artist John Wollaston became an immediate success in colonial America and was celebrated in the local press—a sign of the rising status of the artist in colonial culture.[1] During his career in New York, Wollaston painted approximately seventy-five portraits, only three of which are signed and dated.[2] This portrait, although not signed by the artist, bears an inscription on the reverse identifying the sitter as Mrs. Margaret Nicholls, her age as fifty, and the date of execution as 1749. Since 1749 was the first year in which Wollaston traveled to the colonies and began painting the New York gentry, Mrs. Nicholls (Margaret Tudor, 1699–1772) would have been among Wollaston's earliest colonial sitters.

The first published notice of the sitter is of her death. Her obituary reads: "Last Saturday Night departed this Life, greatly lamented, Mrs. Margaret Nichols, the amiable Consort of Richard Nichols, Esq; of this City, in the 73d Year of her Age. Her Remains were last Monday Evening decently interred in the Family Vault, in Trinity Church Yard."[3] Margaret was married in 1720 to Richard Nicholls (d. 1775), a prominent New York attorney, coroner, postmaster, and vestryman of Trinity Church from 1732 to 1766.[4] They had at least five children: Mary (d. 1797; first married Thomas Tucker, then the Reverend Samuel Auchmuty, who also sat to Wollaston); Elizabeth (1725–1774; married Alexander Colden, whose family also sat to Wollaston); William Robert (d. before 1775); Jane (married George Harrison); and Susannah (first married John Burgess).[5]

This painting is among the most appealing and brilliantly painted of the artist's New York smaller-format portraits. He repeated this compositional format in many of his portraits of women: the sitter, her face partially cast in shadow, is set within a painted oval. A frilly lace cap surrounds her face, a lace fichu covers her chest, and the silky, buff-colored satins of her dress shimmer against the dark background. Wollaston's signature oval, half-lidded eyes, and delicate, upturned mouth are present here, as is his attention to detail in picking out with tiny brushstrokes the patterns of crisp lace in cap and fichu and broadly painting the dramatic highlights of the sitter's dress. This portrait format was evidently successful, for wealthy and fashionable New Yorkers thronged to Wollaston's studio to have their likenesses painted.

INSCRIBED (ON VERSO): AEt. 50 / 1749; Mrs. Margt. Nicholls of New York, N. America / Grandmother to Mrs. Frances Montresor (below in another hand).[6]

PROVENANCE: Purchased by Mr. and Mrs. Harris Masterson from Sabin Galleries, London, 1968–69.

FRAME NOTES: The portrait probably retains its original Dutch-style frame with gilded and carved inner edge.

EXHIBITED: "The Voyage of Life," Bayou Bend Museum of Americana at Tenneco, Houston, September 22, 1991–February 26, 1993.

RELATED EXAMPLES: Wollaston followed a similar format for most of his New York portraits. Notable related examples include *Susannah Marshall*, ca. 1749, Vose Galleries, as of 1975; *Mrs. Joseph Reade*, ca. 1749–52, MMA; *Mrs. Cadwallader Colden*, ca. 1749–52, MMA; and *Mrs. Ebenezer Pemberton*, ca. 1749–51, RISD.[7] For an example of an English precedent, see Allan Ramsay's portrait of his first wife, Anne Bayne, ca. 1739–40, Scottish National Portrait Gallery, Edinburgh.

REFERENCES: Warren 1975, p. 129, no. 242; Saunders and Miles 1987, p. 178, n. 6.

1. For example, see the poem to Smibert by the minister Mather Byles, "To Mr. Smibert on the Sight of His Pictures," *Daily Courant*

(London), April 14, 1730 (quoted in Foote 1950, pp. 54–55). By 1753, just a few years after Wollaston's arrival in the colonies, a poem celebrating his abilities appeared in the March 15 edition of Annapolis's *Maryland Gazette*. Five years later, Francis Hopkinson published a poem in the *American Magazine and Monthly Chronicle for the British Colonies,* in which he encouraged the young artist Benjamin West (see cat. nos. P24, P25) to " . . . tread/ The pleasing paths thy Wollaston has lead./ Let his just precepts all your works refine,/ Copy each grace, and learn like him to shine" (quoted in Groce 1952, p. 142).

2. Saunders and Miles 1987, pp. 177–78.

3. From the *New York Journal;* or, the *General Advertiser,* Thursday, July 23, 1772 (quoted in New-York Historical Society 1870, p. 225). Margaret Tudor was the daughter of Captain John Tudor, an attorney and a lieutenant of His Majesty's Independent Company of Fusiliers ("Papers Relating to Settlement of the Estate of Richard Nicholls," in "Papers of Richard Harrison," box 2, New-York Historical Society).

4. Richard Nicholls was possibly the grandson of Captain Mathias Nicolls of Northamptonshire, England, who may have been related to the first English governor of New York, also named Richard Nicholls (Townsend 1932, p. 73). The family name is spelled variously Nichols, Nicholls, or Nicolls. Richard Nicholls is undoubtedly the Nicholls referred to in 1752 notes of the vestry board of Trinity Church, in which he joined others in proposing to commission Wollaston to paint a copy of a portrait of the "Reverend Commissary Vesey" (Bolton and Binsse 1931, p. 30).

5. *Abstract of Wills,* Liber 29, in New-York Historical Society 1899, pp. 295–96.

6. The Frances Montresor mentioned in the inscription refers to Frances Tucker Montresor (1744–1826), the daughter of Mary Nicholls and Thomas Tucker (d. 1745), and the stepdaughter of Rev. Auchmuty, Mary's second husband. According to Nicholls's will, Mary Auchmuty and his granddaughter Frances Montresor received one-quarter of his estate. Because the Bayou Bend portrait inscription refers to Frances Montresor, it may be that this portrait descended through Mary Auchmuty to her daughter, Frances. The Montresors were patrons of John Singleton Copley (see cat. nos. P15–23). When he traveled to New York in 1771, Copley painted Frances Tucker Montresor and her husband, the engineer of the British Army, John Montresor (1736–1788). Copley painted Frances again in England (the Montresors were Loyalist exiles), and it is possible, even likely, that the Bayou Bend portrait descended in England with the three Copley

P12

Montresor portraits. See Prown 1966, vol. 1, p. 223, no. 295, and vol. 2, p. 427, no. 426. See also Rebora and Staiti 1995, pp. 300–303, on the Copley Montresor portraits, including an illustration of Copley's earlier portrait of Frances Montresor.

7. The inventory description of Bayou Bend's portrait from Sabin Galleries, London, mentions that Margaret Nicholls's sister was painted by Wollaston, and the portrait was "understood to be in the Museum at Providence, Rhode Island." The only Wollaston portrait in a Providence institution is of Mrs. Ebenezer Pemberton, who was not Margaret's sibling. It should be noted that the codicil of Margaret's husband's will provided funds to her sisters, if in need, which indicates that Margaret had more than one sister. Any Wollaston portrait of a sister of Margaret's has not been identified.

P12

Portrait of William Holmes

ca. 1765–67
JOHN WOLLASTON *(act. 1742–75), Charleston*
Oil on canvas; 30⅛ x 25⅛" (76.5 x 63.8 cm)
B.54.20

After mysteriously disappearing from the North American colonies for six years, probably working in the West Indies, Wollaston resurfaced in Charleston, where he worked from 1765 to 1767.[1] Wollaston's Charleston portraits reveal a complexity not seen in his earlier work, as well as a stronger sense of confidence. They are also characterized by greater detail in costume, a Rococo palette, softer edges, and halo effects around the sitters' heads, features apparent in this charming portrait of a young boy dressed in a pink silk waistcoat and buff-colored jacket, standing before a rosy sky and caressing his adoring pet.[2]

Jeremiah Theus (see cat. no. P13), Charleston's portraitist of record, was still active in the late 1760s, and while the relationship between these two artists is unknown, Wollaston certainly received commissions from families whose members had also been painted by Theus.[3] One such family was the Holmeses. In fact, the Holmeses were unique in the patterns of commissions of Charleston families in that three artists—Theus, Wollaston, *and* the Boston painter John Singleton Copley

(see cat. nos. P15–23)—painted immediate family members. William's father, Isaac Holmes, moved from Boston to Charleston sometime before 1759, when he married Rebecca Bee (ca. 1741–1821), a member of a prominent Charleston family. Isaac and Rebecca had two sons, John Bee Holmes (1760–1827) and William (1762–ca. 1818/20).[4] The father died in 1763, and two years later John was painted by Copley in Boston (see Related examples).[5] When Wollaston came to Charleston, Mrs. Holmes turned to him, not Theus, to have portraits painted of her and her second son.

William's portrait has long been considered a pendant to Copley's earlier portrait of his brother.[6] Both are the same size and both show boys with pets associated with childhood—a chained squirrel for John and a dog for William. The young John looks toward his left while William turns his head toward his right, subtle compositional devices common to pendant portraiture. However, other alternatives are possible. The portrait of the sitters' mother, Rebecca Bee Holmes, also a work by Wollaston from his Charleston period, together with the portraits of the sons may have functioned as a triptych, with the mother at center, or as the pendant to the Wollaston portrait of William, in which the mother inclines her head toward her younger son.[7]

PROVENANCE: Dwight W. Prouty, Boston, ca. 1915[8]; to Brooks Reed, New York; [Frank W. Bayley]; purchased by Miss Hogg from Hirschl and Adler Galleries, New York, 1954.

EXHIBITED: "Two Hundred Years of American Art," Hirschl and Adler Galleries, New York, January 13–February 20, 1954, no. 19.

RELATED EXAMPLES: Wollaston, *Rebecca Bee Holmes*, ca. 1765–67, Mead Art Museum, Amherst College, Amherst, Massachusetts; Copley, *John Bee Holmes* (1765, the Dietrich American Foundation, Philadelphia, on loan to PMA); and Theus, *Portrait of a Man, Thought to Be Isaac Holmes*, Worcester Art Museum, Worcester, Massachusetts. Stylistically similar to Wollaston's Holmeses portraits are Wollaston's portraits of Ann Gibbes, 1767, Worcester Art Museum, and Judith Smith, 1767, Gibbes Museum of Art, Charleston.

REFERENCES: Perkins 1873, p. 73 (attributed to Copley); Bayley 1915, p. 145 (attributed to Copley); Parker and Wheeler 1938, p. 253 (questions attribution to Copley and suggests

Henry Benbridge); Middleton 1953, p. 138 (attributed to Jeremiah Theus); Hirschl and Adler 1954, p. 19 (attributed to Wollaston); Warren 1975, p. 130, no. 245; Warren 1982, p. 231.

1. Weekley 1976, p. 17.
2. Ibid., p. 20; see object files, letter from Carolyn Weekley, September 1971.
3. Weekley 1976, p. 21.
4. John and William married women who were sisters. John married Elizabeth Edwards, and William married Elizabeth's younger sister, Margaret Edwards, in 1791; she died at age forty-two in 1806. They had five children: John Bee (b. 1794); Mary Fisher (b. 1796); William Henry (b. 1797); James Fisher (b. 1798); and Elizabeth Harriet (b. 1799).
5. It is likely that John had his portrait painted by Copley when he visited his father's relatives in Boston, many of whom had already sat to Copley, such as the Amorys, Coffins, and Langdons.
6. Warren 1975, pp. 130–31, no. 245.
7. Taken as a series of three, the portraits suggest the cultural sophistication of the Holmeses. Both children play with pets. Importantly, the child is shown to have trained the pet, indicated by the chain circling the squirrel's neck and the outstretched paw of the dog shaking Williams's hand. In eighteenth-century child-rearing practices, the training of pets was encouraged, for as children worked to improve the behavior of a pet, it was believed that they promoted their own moral development; for example,

see Locke 1913; Jean-Jacques Rousseau, *Emile, or On Education,* trans. Allan Bloom (New York: Basic Books, 1979); and Shawe-Taylor 1990, pp. 188–201. The mother's sophistication is indicated by not only her elegant dress, but also her thoughtful pose, in which her head rests on her finger, and by the book displayed on her table, volume seven of Joseph Addison's *The Spectator,* an enormously popular series of essays on the taste and social customs of polite Londoners.
8. The portrait of Rebecca Bee Holmes in the Mead Art Museum descended in the Holmes family to Mr. Charles Rutledge Holmes, who sold the painting in 1904 to the New York art dealer William MacBeth, who sold it to Herbert L. Pratt in 1913, about the same time that the Bayou Bend portrait is listed as having changed hands to Dwight W. Prouty, Boston. The Bayou Bend Wollaston, however, does not appear in MacBeth's records.

P13

Portrait of Mrs. John Champneys

possibly 1763
JEREMIAH THEUS *(ca. 1719–1774), Charleston*
Oil on canvas; 30⅛ x 25³⁄₁₆″ (76.5 x 64 cm)
B.60.50

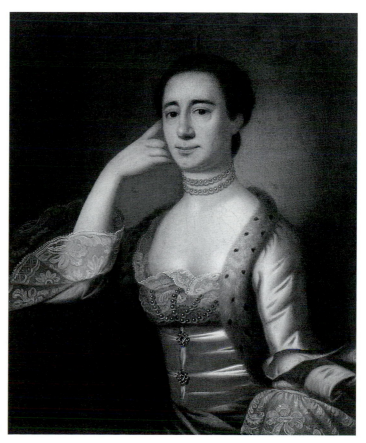

P13

With virtually no competition from other colonial painters until Wollaston's arrival in 1765 (see cat. no. P12), Jeremiah Theus dominated the eighteenth-century art scene of Charleston, South Carolina, and its environs for about three decades.[1] Charleston was the fifth-largest colonial town when Theus emigrated from Chur, a small town in easternmost Switzerland, around 1735. Charleston, or "Charles Town," as it was known in the eighteenth century, was described by one contemporary observer as "a polite agreeable place, the people live very Gentile and very much in the English taste."[2] Theus's portraits must have suited the Anglophile taste of his southern colonial sitters, for he produced numerous portraits of them patterned after the costumes and poses of seventeenth- and eighteenth-century mezzotints of English aristocratic portraits (see Related examples).

Theus's portrait of Anne Livingston Champneys demonstrates Theus's modest skill in rendering the shimmering quality of the sitter's silk dress, its bejeweled bodice, the decorative patterns of lace that line the sleeves, the fur of the ermine trim, and the reflective surface of the pearls, all details that derive from mezzotint sources.[3] The rather plain sitter shares facial mannerisms with other Theus sitters: an unusually large, pronounced nose, dimpled chin, and curvilinear, V-shaped lips. Theus typically used monochromatic, dark backgrounds against which the sitter was dramatically lit. In this portrait in particular, the strong chiaroscuro amplifies the silvery folds of the subject's dress.

The circumstances surrounding the commission of the portrait are unknown. Anne Livingston Champneys (b. 1746– d. after 1776)[4] probably had her portrait painted in Charleston in the early 1760s, possibly in 1763, the year of her marriage to John Champneys, a Charleston merchant and Loyalist. The only reference to her was published in her marriage notice in the November 5, 1763, issue of the *South-Carolina Gazette,* in which she is described as "an amiable young lady."[5] No known portraits of Anne's siblings or her husband exist. The portrait descended in the family of the Champneys's only surviving child, Sarah Champneys Tunno.

PROVENANCE: To the sitter's daughter, Sarah Champneys Tunno (b. 1775); to her descendants; [Rebecca Bryan, Charleston]; Mrs. L. F. Harza, Highland Park, Illinois, ca. 1940–41; purchased by Miss Hogg from Miss Eunice Chambers, Hartsville, South Carolina, agent, 1960.

RELATED EXAMPLES: The sitter's costume relates to those in other portraits by Theus, including *Mrs. James Skirving,* Gibbes Museum of Art, Charleston; *Mrs. John Dart,* MMA; and *Mrs. Samuel Prioleau III,* United Missouri Bancshares. A source for these portraits was probably James Watson's mezzotint engraving of *Lady Ann Fortescue* after Francis Cotes and James McArdell's 1757 mezzotint after Sir Joshua Reynolds's portrait of the same sitter. The gesture of her head resting on her fingers is not usual in Theus's oeuvre; its mezzotint source may have been John Simon's engraving of *Sarah, Duchess of Marlborough,* after Sir Godfrey Kneller, ca. 1706; see Sellers 1957, p. 449.

REFERENCES: Middleton 1953, p. 123; Warren 1975, p. 131, no. 247.

1. Nothing is known of Theus's early training. Like many colonial artists, Theus practiced many trades related to painting early in his career before firmly establishing himself as a limner. The fact that he died a rich man attests to his success in satisfying the cultural needs of his clientele. His obituary described him as an "ingenious and honest man . . . who had followed the Business of a Portrait Painter here upwards of 30 Years" (*South-Carolina Gazette,* May 23, 1774, quoted in Middleton 1953, p. 48).
2. Harriott Horry Ravenel's *Eliza Pinckney* (1896), as quoted in Severens 1985, p. 56.
3. See Severens 1985.
4. Anne's parents, George Livingston, a merchant, and Eleanor, widow of John Beamor, lived in Port Royal Island, South Carolina, a town on the Broad River, where Anne was born in 1746, one of five children. Her father moved from Port Royal to Charleston by at least 1765 (*Journal of the Court of Ordinary, 1764–1771, Probate Records of South Carolina,* vol. 3, p. 9, dated March 15, 1765). At the age of seventeen, she became the second wife of the merchant John Champneys (1743–1820). Anne gave birth to her only surviving child in 1775. The following year she gave birth to a son who died in infancy. Since John Champneys's third wife, Mary Champneys, died in 1800, Anne died sometime after 1776 and before 1800. She probably died during Loyalist exile, as no record of her death appears in state archives.
5. Middleton 1953, p. 123.

P14

Portrait of the Reverend James Diman

1760s
ATTRIBUTED TO BENJAMIN BLYTH
(1746–1795), Salem, Massachusetts
Pastel on paper; cut oval: 13¾ x 12" (34.9 x 30.5 cm)
B.61.106.1

The sitter of this portrait was once identified as the Reverend Dinham of Newburyport, Massachusetts, but no such person is recorded in Newburyport and Essex County records. Between 1737 and 1785, the Reverend James Diman (1707–1788) served as pastor in the Second (or East) Church of Salem, and he is now thought to be the subject of this pastel.[1]

The pastel portrait displays the sitter in an elegant powdered wig, dressed in his black robe with brilliant white stock, and set against a blue background. The portrait is stylistically consistent with the works of the Salem pastellist Benjamin Blyth, by whom about thirty works survive.[2]

This pastel was acquired with another, thought to represent the reverend's wife (B.61.106.2). Her portrait, however, is by a different hand and is probably English.

PROVENANCE: Purchased by Miss Hogg from Israel Sack, New York, 1961.

RELATED EXAMPLES: Blyth, *Portrait of John Adams,* 1763, Massachusetts Historical Society,

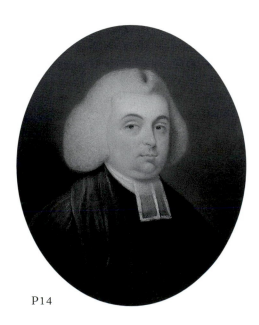

P14

Boston; Blyth also painted Eunice Diman, James Diman's daughter, ca. 1774, Massachusetts Historical Society.

1. A Harvard graduate and married to Mary Orne (daughter of Timothy and Lois Pickering Orne) in 1743, Diman served successfully in the Second Church of Salem until parish discord erupted over the minister's "despotic rule" about 1770, at which point his career steadily declined (Shipton 1951, p. 698). By 1785, Diman was forced to resign, and his colleague the Reverend William Bentley noted in his diary: "Thus ended a most perplexing dispute carried on with a want of total candor by the Parish Minister and great violence by the People" (Bentley 1962, p. 24).
2. See Foote 1957; Little 1972a; Norton 1994.

P15

Portrait of a Boy

ca. 1758–60
JOHN SINGLETON COPLEY *(1738–1815)*,
Boston
Oil on canvas; 48⅝ x 36¼" (123.5 x 92.1 cm)
B.54.31

For almost twenty-five years, the unrivaled portraitist of the American colonies was John Singleton Copley, a Boston painter whose artistic vision, technical mastery, and high ambition set a standard for the encouragement and development of the arts of North America. Of humble origins, the son of Irish immigrants and tobacco shopkeepers, Copley rose to fame and fortune, providing spectacular portraits of Boston's largely mercantile and upwardly mobile elite, clergymen, military leaders, Whigs, Tories, and such political figures as Samuel Adams, Paul Revere, and John Hancock. Trained by his stepfather Peter Pelham (see cat. no. W61), a mezzotint engraver from London, and further educated by the theoretical and anatomical treatises he eagerly read, Copley aspired to be a history painter, by tradition the highest genre of painting an artist could practice. History painting held little interest for the pre-Revolutionary colonies, however, so Copley focused his talent on painting "likenesses," producing over three hundred portraits before leaving the colonies on the eve of the Revolutionary War in 1774.

Bold color, dramatic chiaroscuro, and a

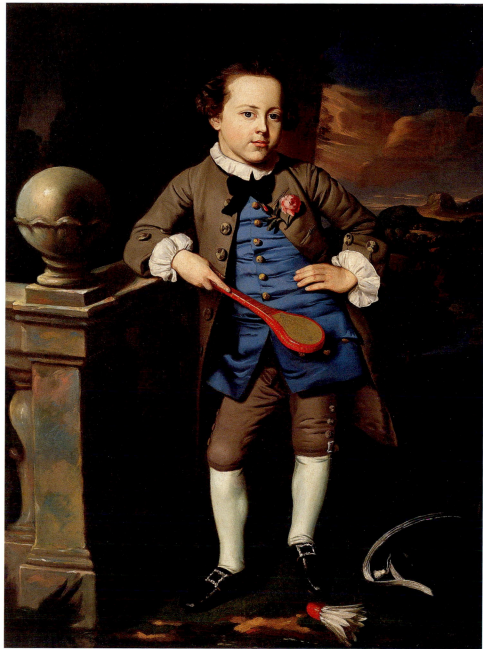

P15

legendary facility for painting forms convincingly—faces as well as finery—are the characteristic features of Copley's portraits throughout his colonial career. Earlier works, such as the *Portrait of a Boy*, demonstrate his knowledge and use of the props, costumes, and settings of eighteenth-century English mezzotints. In later works, as in the *Portrait of Mrs. Paul Richard* (see cat. no. P18), Copley relinquishes the exuberance of his earlier works, preferring to portray sitters emerging from dark, monochromatic backgrounds with greater value contrasts and more somber tones, which tends to heighten the psychological presentation of the sitter. At the time Copley painted

this portrait, he had absorbed the Rococo ebullience of Joseph Blackburn (act. 1752–ca. 1778) and had mastered a variety of compositional elements from his predecessors Robert Feke (see cat. no. P7) and Joseph Badger (see cat. no. P5). Rich color, dramatic chiaroscuro, and a playful and generous use of props characterize many works of this period, in which the artist was quickly establishing himself as the most astonishing and skillful artist the colonies had ever seen.

The identity of the boy holding a battledore continues to elude scholars. On the basis of its status as a large, full-length portrait, one can speculate that the boy was probably the firstborn son and heir

of a wealthy and socially ambitious family. Its profusion of props—a shuttlecock to accompany the battledore, a braid-trimmed tricorn hat tossed to the ground, a marble or stone architectural element borrowed from a Continental or English portrait mezzotint—and complex landscape details, including a stream in the immediate foreground dotted with plants and a hilly landscape and vivid sunset in the background, point to the artist's considerable effort to impress his patrons with his knowledge of Continental and English prototypes, as well as to flatter the sitter and his family by loading his image with objects associated with aristocratic portraits. Furthermore, the sitter's posture, derived ultimately from antique sculpture and popularized in the mid-eighteenth century in portraits by Thomas Hudson and Allan Ramsay, suggests nonchalance and easy confidence, esteemed characteristics of behavior endorsed by etiquette books of the period.[1] His jaunty pose is reinforced by the dapper rose pinned to his jacket, a prop that is unique in Copley's oeuvre. Pentimenti reveal that Copley initially portrayed the sitter holding a book, but changed the prop to a battledore and shuttlecock, an attribute with more youthful associations, and one that connects Copley's portrait with the English artist Francis Cotes's portraits of aristocratic children with kites or cricket bats.

The first written record of the portrait appeared in 1884 at the Francis Alexander sale at Leonard and Co., Auctioneers, Boston.[2] The catalogue stated that the portrait depicted the son of John Hancock by Copley (this mistaken identity persisted until 1938), and that it once belonged to Moses Kimball, who bought the portrait at the sale of the Portsmouth Museum, along with portraits of John and Dorothy Quincy Hancock. Nothing of this catalogue description can be substantiated.[3]

Recent research plausibly suggests that the sitter is a member of the Bourne, Gorham, or, most likely, Swett families. Francis Alexander, an American artist living in Florence, probably did not purchase the painting from Moses Kimball or anyone else at all, particularly since he was a collector of Italian Old Masters, not eighteenth-century American portraitists. Rather, the portrait was likely an ancestral painting belonging to Alexander's

wife, Lucia Gray Swett Alexander (1814–1916), who had inherited about 1866 another Copley portrait, of Mrs. Sylvanus Bourne (ca. 1766, MMA), which, like the Bayou Bend portrait, descended to her daughter before both portraits were distributed among cousins.[4] Lucia likely inherited both portraits from her father, Colonel Samuel Swett (1782–1866), of Boston. Samuel Swett probably inherited them from his parents, John Barnard Swett and Charlotte Bourne Swett (b. 1760), of Newburyport. Inasmuch as Charlotte Bourne Swett inherited the portrait of her grandmother, Mrs. Sylvanus Bourne, it is possible that either she inherited the Bayou Bend portrait at the same time (and the sitter represents a member of the Gorham or Bourne families), or, more likely, the portrait belonged to her husband John Barnard Swett and represents a member of the Swett family.[5]

PROVENANCE: The sitter, probably a member of the Swett, Bourne, or Gorham families; probably to Colonel Samuel Swett (1782–1866), Boston; probably to his daughter Mrs. Francis Alexander (Lucia Gray Swett, 1814–1916), Florence, Italy; [Leonard and Co., Boston, as of 1884, not sold]; to her daughter Esther Frances ("Francesca") Alexander (1837–1917), Florence, Italy; to her cousin Charlotte Bartlett Williamina Gray Hallowell, West Medford, Massachusetts; purchased by the Honorable Alvan Tufts Fuller (1878–1958), Boston; purchased by Miss Hogg from Vose Galleries, Boston, 1954.

FRAME NOTES: The painting retains its original Baroque frame, constructed of eastern white pine, carved and gilded, and includes in its design a flat-sanded frieze, strapwork and leafage ornament with punched surface, egg-and-dart-patterned outer edge, and leaf carving at the inner edge.

EXHIBITED: "The Summer Exhibition of Colonial Portraits," Vose Galleries, Boston, 1926; "Colonial Portraits from the Collection of Miss Ima Hogg," Music Hall, Houston, February 26–March 4, 1957; "The Masterpieces of Bayou Bend, 1620–1870," Bayou Bend Museum of Americana at Tenneco, September 22, 1991–February 26, 1993; "John Singleton Copley in America," MFA, Boston, June 7–August 27, 1995; MMA, September 26–January 7, 1996; MFA, Houston, February 4–April 28, 1996, unlisted (exhibited at Houston only); Milwaukee Art Museum, May 22–August 25, 1996 (Rebora and Staiti 1996).

RELATED EXAMPLES: In terms of technique, this portrait relates to Copley, *Mary and Eliza-*

beth Royall, ca. 1758, MFA, Boston. Bayou Bend's portrait also relates to Copley's portraits of children: *Thomas Aston Coffin,* ca. 1757–59, Munson-Williams-Proctor Institute, Utica, New York; *Young Lady with a Bird and Dog,* 1767, Toledo; *Mary Elizabeth Martin,* 1771, Addison Gallery of American Art, Andover, Massachusetts; and *Daniel Crommelin Verplanck,* 1771, MMA. Bayou Bend's portrait is the last in which the artist used the prop of the battledore and shuttlecock, having used it previously in his portrait of *Thomas Aston Coffin.* The prop was not uncommon in English portraiture. Copley may have been the first colonial portraitist to introduce this prop, followed by such artists as William Williams, in his portrait of *Stephen Crossfield,* ca. 1775, MMA, and John Green, in his portrait of *Clayton Trott,* ca. 1780, Hereward Trott Watlington collection. The jaunty pose of the sitter, in which he leans against a marble element with his other arm resting on an out-thrust hip, also appears in Copley's *George Scott,* 1755–57, the Brook, New York; *Moses Gill,* 1764, RISD; *Thaddeus Burr,* ca. 1758–60, Saint Louis Art Museum; *Epes Sargent,* ca. 1760, NGA; among other portraits of the 1760s.

REFERENCES: Leonard and Co., Auctioneers, Boston, *A Large Portion of the Private Collection of Paintings of the Late Francis Alexander,* April 24–25, 1884, lot 91 (as "Portrait of Son of John Hancock"); *Antiquarian* 4 (April 1925), frontis., the photograph designated "Courtesy Mrs. Ehrich," which refers to the Ehrich Gallery, New York, from whom the painting was consigned to Vose Galleries from January 3 to 10, 1925 (Vose Invoice Book, no. 6843); Bolton and Binsse 1930, p. 116 (as "Hancock, Master. Full length 1759 [?] Alvan T. Fuller"); before 1954, untitled, undated pamphlet of the collection of the Honorable Alvan T. Fuller in the archives of the MFA, Boston (as "John Singleton Copley, The Hancock Boy, Portrait of the son of Governor John Hancock")[6]; Parker and Wheeler 1938, p. 191, pl. 104 (as an unknown sitter, "Boy Called Master Hancock"); Prown 1966, vol. 1, p. 231, no. 88; Warren 1975, p. 132, no. 248; Vose 1981, p. 19 (mistakenly cited as the first colonial painting acquired by Miss Hogg); Warren 1982, p. 231; Fleischer 1988, p. 18 n. 30; Miles 1995, p. 25; *Antiques* 149 (April 1996), p. 495.

1. See "The State and Estate of Nature" in Bermingham 1986, specifically pp. 20–28; and Carol Troyen's catalogue entry on Copley's portrait of Moses Gill, in Rebora and Staiti 1995, pp. 200–203, no. 18.
2. The painting was offered for sale but was either withdrawn or went unsold.
3. *A Large Portion of the Private Collection of Paintings of the Late Francis Alexander (1800–1881).* Copley could not have painted John George Hancock; he was born four

years after Copley left the colonies for England. The Portsmouth Museum closed in 1800, seven years before Kimball's birth, making it impossible for him to make the purported acquisition for his "Old Boston Museum" (Boston Museum and Gallery of Fine Arts, founded 1841). Copley's portraits of the Hancocks (Edward Savage's portraits of them as well) did not descend with Moses Kimball, and none of the portraits has any association with the Portsmouth Museum. The Portsmouth Museum, owned and operated by Nicholas Rousselet, consisted of engravings and curiosities (see Brewster 1972, pp. 215–16). The contents of Rousselet's will and inventory, and that of his heir, do not include any reference to this portrait. Also, the Portsmouth Museum could not have been confused with the Portsmouth Athenaeum, founded in 1817; it was never a selling institution. The Portsmouth Athenaeum, further, has no record that this portrait or the portrait of Dorothy Quincy Hancock ever entered its premises. The cataloguer of the Alexander sale may have confused the Portsmouth Museum with the New England Museum and Gallery of Fine Arts, from which Moses Kimball acquired a number of works in 1839, putting them on view in his Boston Museum in 1841. Because the portrait does not appear in any of Kimball's Boston Museum catalogues and does not appear in Kimball family papers, including wills and inventories, it is unlikely that this portrait was ever associated with the Kimball family.

4. See Caldwell and Rodriguez Roque 1994, pp. 88–90. According to the signed affidavit of Frank Bayley, the director of the Copley Gallery in Boston and an early historian of Copley portraits, this painting belonged to Francis Alexander, "who went to live in Florence, Italy in 1875 taking this portrait together with another portrait by Copley. . . ." (records of Vose Galleries, Boston). The other Copley was, presumably, the MMA's portrait of Mrs. Sylvanus Bourne. Further, he states that the paintings passed to Francis Alexander's wife, then his daughter, Francesca, and, at her death, were returned to Boston to be sold in settlement of her estate. However, they were not sold but, rather, passed to Francesca's beneficiaries. The will of Francesca Alexander (written June 18, 1891, proved January 1917, Suffolk County Courthouse, Boston, no. 176380) bequeathed all of her properties to her mother, and if her mother predeceased her, to the children of her mother's three brothers: William G. Swett, Dr. S. B. Swett, and John Barnard Swett. While not named specifically, the Bayou Bend portrait descended to the daughter of William G. Swett, Charlotte Hallowell, West Medford,

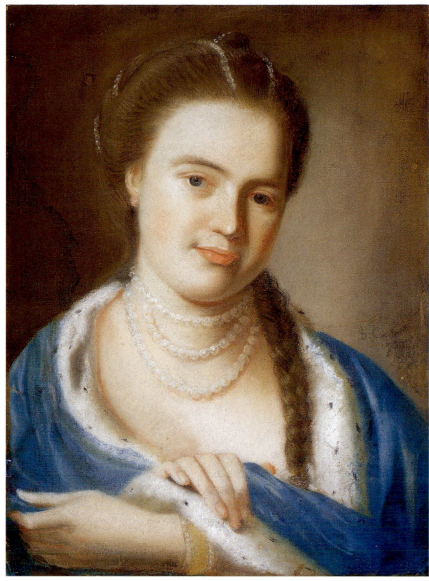

P16

Massachusetts, from whom Alvan Tufts Fuller acquired the picture, and the MMA's portrait of Mrs. Sylvanus Bourne went to the daughter of John B. Swett, Mrs. J. Barnard French (Elisabeth), Bristol, Rhode Island, who probably predeceased her husband; county records list Francesca's beneficiary as J. Barnard French, from whom the MMA purchased its portrait.

5. It is possible that this sitter is Lucia Gray Swett Alexander's grandfather, John Barnard Swett (1752–1796), the firstborn son of Captain Samuel and Anna Woodbury Swett, eight years old at the time of the sitting if the portrait represents him. Anna Woodbury Swett was the adopted daughter of the Reverend John Barnard, who also adopted as his grandson John Barnard Swett, later a prominent doctor of Newburyport. It is possible, of course, that the sitter is some other relative of the Swett, Woodbury, or Barnard families. Regarding the Bourne/Gorham side of the family, the first record of those families

commissioning the services of Copley date to 1766. Mercy Gorham Bourne's mother, however, was an Otis, and several Otises patronized Copley in the late 1750s, leaving open the slim possibility that the sitter represents a member of the Otis family. If this portrait depicts a member of the Swett family, it would represent among the first Marblehead commissions for Copley.

6. I thank Carol Troyen, associate curator at the MFA, Boston, for finding and sharing this catalogue.

P16

Portrait of Mrs. Gawen Brown

1763
JOHN SINGLETON COPLEY (1738–1815), *Boston*
Pastel on laid paper, mounted on bleached plain-weave linen; 17½ x 14½" (44.5 x 36.8 cm)
B.54.21

Continental late Baroque and Rococo fashion in the early 1700s included the production of pastel portraits, a trend that such artists as Henrietta Johnston (d. 1729) and Benjamin Blyth (see cat. no. P14) followed in the American colonies. Copley, too, experimented with pastels, beginning in 1758, surpassing his precursors and colleagues.[1] Despite his facility for working in pastel, he used the medium for only about fourteen years. As early as 1766, Benjamin West (1738–1820), Copley's mentor abroad, discouraged him from continuing to practice in this medium, claiming it to be inferior to the oil medium used by the more serious history and Grand Manner portrait painters, whose ranks Copley aspired to join.[2]

Portrait of Mrs. Gawen Brown (Elizabeth Byles, 1737–1763) is one of approximately fifty-five surviving pastel portraits by Copley. The portrait dates to 1763, one year after Copley expressed his ambition to succeed in this medium in a letter to the eminent Swiss pastellist Jean-Étienne Liotard (1702–1789).[3] As he did for his oils, Copley borrowed props and poses from Continental and English portrait mezzotints, in this case, the portrait of Maria, Countess of Coventry, by Thomas Frye (1710–1762). Copley modified the prototype by reducing the elaborate headdress to single strands of pearls woven through the sitter's hair, which ends in a long braid; simplifying the necklace to three simple strands of pearls; and eliminating the dangle earrings altogether (the bracelet and luxurious ermine-trimmed robe remain). The artist also turned the head of the sitter so that she gently gazes toward the viewer. The feathery quality of the pastel medium endows the work with a soft, ethereal glow.

Although Copley portrayed Elizabeth Byles Brown as a modified version of an elegant countess, she was, in fact, the daughter of the minister Mather Byles (see cat. no. W61) and Anna Noyes and the wife of Gawen Brown (1719–1801), an esteemed Boston clockmaker. Something of a poet, she penned the following lines "on her Infant Son," Mather Brown (1761–1831), who eventually would become a portraitist:[4] "When with a Parents partial Eye / My Babe within my Arms I spy, / I form a thousand airy Schemes / And paint his future Life in Dreams. / But ah! how different may it be / From what

a mother hopes to see / The lovely Infant ne'er may know / A joyous Moment here below: / Yet oh that Heaven would hear my Prayer, / And pour its Blessings on my Heir. / Grant him those Graces from above, / Of Faith, Humility and Love / Let him thy Loving Favor find, / As years increase enlarge his Mind. . . ."[5] The sitter, however, did not live long after voicing her dreams, wishes, and prayers for her son; she died the same year Copley produced this portrait.

INSCRIBED (CENTER RIGHT): ISC [monogram] del.1763.

PROVENANCE: The sitter's niece Mrs. William Almon (Rebecca Byles), Halifax, Nova Scotia; to her daughter Mrs. George W. Hill (Emma Almon), Halifax, Nova Scotia; to her daughter Sophie A. Hill, Tunbridge Wells, Kent; to Charles Henry Hart (1847–1918), New York; [Vose Galleries, Boston]; purchased by Thomas B. Clarke (1848–1931), New York, until 1919; auctioned by Plaza Hotel, New York, *Thomas B. Clarke Collection Sale,* January 7, 1919; purchased by Luke Vincent Lockwood, New York, until 1954; purchased by Miss Hogg at Parke-Bernet, New York, Lockwood sale, May 13–15, 1954, lot 452.

EXHIBITED: "Early American Portraits Collected by Mr. Thomas B. Clarke," American Art Association, New York, January 7, 1919, no. 34; "Girl Scout Loan Exhibition," American Art Galleries, New York, September 25–October 9, 1929, no. 828; "An Exhibition of Paintings by John Singleton Copley," MMA, December 22, 1936–February 14, 1937, no. 7; "John Singleton Copley, 1738–1815," MFA, Boston, February 1–March 15, 1938, no. 14; "John Singleton Copley in America," MFA, Boston, June 7–August 27, 1995; MMA, September 26–January 7, 1996; MFA, Houston, February 4–April 28, 1996 (exhibited at Houston only); Milwaukee Art Museum, May 22–August 25, 1996, no. 13 (Rebora and Staiti 1995).

RELATED EXAMPLES: Copley painted the sitter again in oils in the same year, possibly after the pastel: *Mrs. Gawen Brown,* ca. 1763, private collection.[6]

REFERENCES: Perkins 1873, supplement, p. 17; Plaza Hotel, New York, *Thomas B. Clarke Collection Sale,* January 7, 1919; Bolton 1923, no. 8; Bayley 1929, pp. 179, 181; Parker and Wheeler 1938, p. 218, pl. 126; *Art Digest* 25 (February 15, 1951), p. 10; Parke-Bernet, New York, *Seventeenth-Eighteenth Century American Furniture and Paintings: The Celebrated Collection Formed by the Late Mr. and Mrs. Luke Vincent Lockwood,* May 13–15, 1954, lot 452; Prown 1966, vol. 1,

p. 210, no. 110; Warren 1975, p. 134, no. 250; Fairbrother, 1981, p. 129; Warren 1982, pp. 231, 233; Fales 1995, pp. 10, 12, colorpl. 1 and pl. 1.

1. Marjorie Shelley, "Painting in Crayon: The Pastels of John Singleton Copley," in Rebora and Staiti 1995, pp. 127–41. See also Thomas A. Gray, "American Pastel Portraits by John Singleton Copley, 1756–1772," paper, Winterthur Program, University of Delaware, 1973.
2. See Benjamin West to Copley, August 4, 1766, London, in Copley-Pelham Letters 1972, pp. 43–45.
3. Copley requested "one sett of Crayons of the very best kind such as You can recommend [for] liveliness of colour and Justness of tints" (Copley to Jean-Étienne Liotard, September 30, 1762, Boston, in Copley-Pelham Letters 1972, p. 26).
4. The Copleys, Browns, and Byles were apparently close friends; Copley helped Mather Brown with introductions in London (see Shipton 1945, p. 487).
5. "By Mrs. Elizabeth Brown on her Infant Son," Byles Papers (P114), Massachusetts Historical Society, Boston. The poem contains lines added by Mather Byles.
6. See Prown 1966, vol. 1, p. 56, pls. 199, 200.

P17

Portrait of Mrs. Joseph Henshaw

ca. 1770
JOHN SINGLETON COPLEY (*1738–1815*), *Boston*
Pastel on paper, mounted on linen; 24 x 17¾"
(61 x 45.1 cm)
B.54.25

Over the years, Copley's technique in pastel became more sophisticated. The greater availability of ready-made pastel sticks in a vast array of tones allowed the artist to apply and blend strokes of individual shades so that the general effect was one of subtle modulation rather than sharp contrasts between light and dark, as seen in such earlier pastels as *Portrait of Mrs. Gawen Brown* (cat. no. P16).[1] This more refined technique, which heightened the plasticity and realism of the sitter's form and props, is demonstrated in the portrait of Mrs. Henshaw, among the last pastels Copley produced. The uncorseted salmon-colored gown trimmed with brilliant white lace and bordered by

brown fur, the velvet texture of the pearl-trimmed headdress, and the silvery luster of the necklace appear especially vivid, setting off the creamy quality of the sitter's skin.

Copley may have borrowed the pose for this portrait from a ca. 1770 allegorical print, *Catherine McCaulay, in the Character of a Roman Matron Lamenting the Lost Liberties of Rome*, circulating in the *London Magazine* of July 1770.[2] The pose and headdress are, indeed, similar, although in the engraving the sitter holds a scroll. The specific gesture of clasping a mantle or garment, which Copley used five years earlier, perhaps derived from mezzotints of portraits by Sir Anthony Van Dyck or Sir Peter Lely, where it is used, for both male and female sitters, to suggest elegance and grace.

Sarah Henshaw (1736–1822) married her cousin Joseph Henshaw in 1758. From a wealthy mercantile family in Boston, Joseph graduated from Harvard before entering the shipping business himself. His first frigate was named for his fiancée.[3] After they married, they lived first in Boston, then in Leicester, by 1773, and, following the Revolutionary War, in Shrewsbury. Sarah, who bore no children, was a brilliant needleworker, leaving behind an elegant family coat of arms (private collection) as well as an elaborate history piece, *The Death of Absalom* (MFA, Boston).[4]

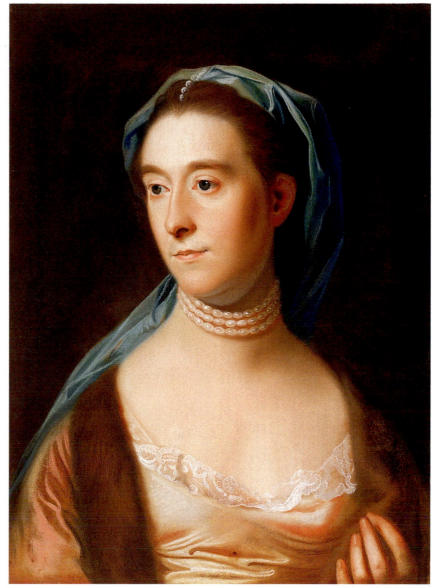

P17

PROVENANCE: Descended from the sitter to a great-grandnephew, Dr. J. McLean Hayward; to Sidney W. Hayward, Wayland, Massachusetts, until about 1936; purchased by Herbert Lawton, until 1937; auctioned by American Art Association, Anderson Galleries, New York, *The American Collection of Herbert Lawton,* April 2–3, 1937, no. 345; purchased by Mr. and Mrs. Luke Vincent Lockwood, New York, until 1954; purchased by Miss Hogg at Parke-Bernet, Lockwood sale, May 13–15, 1954, lot 453.

EXHIBITED: MFA, Boston, 1919, on loan from Sidney W. Hayward; "John Singleton Copley, 1738–1815," MFA, Boston, February 1–March 15, 1938, no. 43; "John Singleton Copley in America," MFA, Boston, June 7–August 27, 1995; MMA, September 26–January 7, 1996; MFA, Houston, February 4–April 28, 1996 (exhibited at Houston only); Milwaukee Art Museum, May 22–August 25, 1996, no. 57 (Rebora and Staiti 1995).

RELATED EXAMPLES: Copley painted several members of the Henshaw family: Sarah's fa-

ther, Joshua Henshaw, ca. 1770, Fine Arts Museums of San Francisco; her brother Joshua Henshaw, Jr., and his wife, Mrs. Joshua Henshaw, Jr., ca. 1770–74, private collection, unsold at Christie's, New York, sale 5108, December 11, 1981; and Sarah's husband, her cousin Joseph Henshaw, 1727–1794, private collection. Her hand gesture, in which her fingers delicately clasp her fur tippet, is also seen in Copley's pastel portraits of Jonathan Jackson, ca. 1767–69, MFA, Boston; Joseph Barrell, ca. 1767–69, Worcester Art Museum, Worcester, Massachusetts; Mrs. Elijah Vose, ca. 1770–72, Hirschl and Adler Galleries, New York; and Mrs. Henry Hill, ca. 1770, Art Institute of Chicago; and is similar to the oil portraits of Mrs. Joseph Scott, ca. 1765, Newark Museum, Newark, New Jersey; and Mrs. Henderson Inches, ca. 1765, The Huntington Library, Art Collections and Botanical Gardens, San Marino, California.

REFERENCES: Perkins 1873, p. 71; Bayley 1915, p. 142; Bolton 1923, no. 28; Parker and

Wheeler 1938, p. 225, pl. 126; Winchester 1961a, pp. 22–23; Winchester 1961b, p. 237; Prown 1966, vol. 1, p. 67, no. 238; Warren 1966, p. 804; Warren 1971a, p. 41; House and Garden 1973, p. 92; Warren 1975, p. 134, no. 251; Cooper 1980, p. 190; Warren 1982, pp. 231, 233; Ring 1993, vol. 1, p. 56.

1. Marjorie Shelley, "Painting in Crayon: The Pastels of John Singleton Copley," in Rebora and Staiti 1995, pp. 127–41. She notes, for example, that Sarah Henshaw's lips alone include as many as seven individual tones of red and brown.
2. See Warren 1975, p. 135, no. 251, n. 48, in which he cites Fox 1968, p. 133.
3. Henshaw was a Son of Liberty and a member of the revolutionary inner circle, including James Otis and Samuel Adams (see Shipton 1962, pp. 268–71).
4. Ring 1993, vol. 1, pp. 56, 68.

Portrait of Mrs. Paul Richard

1771
JOHN SINGLETON COPLEY *(1738–1815),*
New York
Oil on canvas; 50 x 39½″ (127 x 100.3 cm)
B.54.18

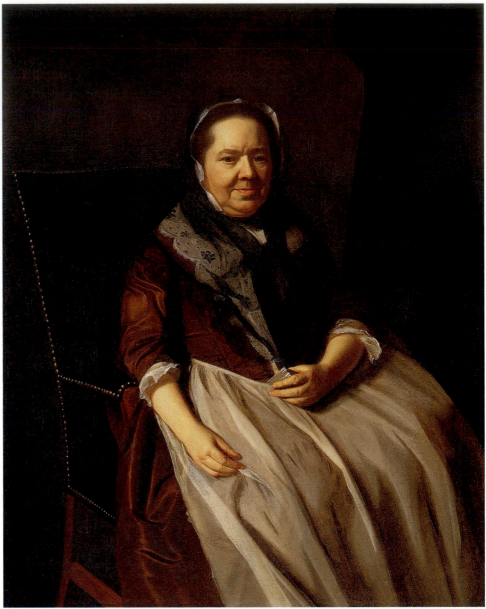

P18

Copley portraits dating from his 1771 trip to New York City are extremely rare.[1] While the name of Mrs. Paul Richard (Elizabeth Garland, 1700–1774) does not appear on Copley's subscription list for his New York sojourn, the name of Miles Sherbrook does.[2] Mrs. Richard's niece Elizabeth Van Taerling married Sherbrook, and Mrs. Richard perhaps met Copley through her nephew by marriage. Of the New York portraits that survive, *Mrs. Paul Richard* depicts the only dowager.

In his portraits, Copley often posed older women seated in damask-upholstered armchairs, wearing satins usually in a warm brown, with a mob-cap and transparent black mantle. Mrs. Richard, here seventy-one years old and a widow of fifteen years, wears a plain apron, a prop that appears in another Copley portrait.[3] She holds an unidentifiable object in her left hand, perhaps a small book, a box, or, more likely, playing cards.[4] Elizabeth Richard's slightly puffy hands, with their pronounced knuckles, and shadowed, good-humored face, worn with deep crevices, knotted brow, protruding lower lip, and piercing eyes, are closely observed, lifelike details for which Copley portraits were so justly famous.

As the wife of Paul Richard (1697–1756), a wealthy importer and mayor of New York from 1735 to 1739,[5] Elizabeth was a prominent woman. The "only daughter and heiress of Thomas Garland, Gentleman," and Rachel Garland, she was born in London, May 7, 1700, and moved to the colonies sometime before her marriage to Paul Richard around 1722.[6] Paul Richard makes three references to his wife in his correspondence in the spring of 1746, each time lamenting her poor health.[7] Despite her ill health, Elizabeth lived to be seventy-four, outliving Paul by ten years. Mrs. Richard never remarried and died childless. The Bayou Bend portrait descended to the executor of her will, her nephew Theophylact Bache, who, according to family history, immigrated to the colonies in 1751 at the age of seventeen to help with the Richard merchant business.[8] By a quirk of fate, this portrait was joined with a New York period Copley portrait of Daniel Crommelin Verplanck (1771, MMA) when descendants of the two sitters intermarried in the twentieth century.

PROVENANCE: From the sitter to her nephew Theophylact Bache (1734–1807), New York; to his grandson Theophylact Bache Bleecker; to his son Theophylact Bache Bleecker, Jr.; to his son Charles M. Bleecker, Cold Spring Harbor, New York; purchased by Miss Hogg from M. Knoedler and Co., New York, 1954.

EXHIBITED: "John Singleton Copley, 1738–1815," MFA, Boston, February 1–March 15, 1938, no. 65; "Master Painters," Des Moines Art Center, September 11–October 7, 1951, no. 12; "Colonial Portraits from the Collection of Miss Ima Hogg," Music Hall, Houston, February 26–March 4, 1957; "Collecting: A Texas Phenomenon," Marion Koogler McNay Art Museum, San Antonio, November 21–December 24, 1986, p. 7; "The Masterpieces of Bayou Bend, 1620–1870," Bayou Bend Museum of Americana at Tenneco, Houston, September 22, 1991–February 26, 1993; "John Singleton Copley in America," MFA, Boston, June 7–August 27, 1995; MMA, September 26–January 7, 1996; MFA, Houston, February 4–April 28, 1996; Milwaukee Art Museum, May 22–August 25, 1996, no. 73 (Rebora and Staiti 1995).

RELATED EXAMPLES: Similar portraits by Copley include *Mrs. Thomas Boylston,* 1766, MFA, Boston; *Mrs. Sylvanus Bourne,* ca. 1766, MMA; *Mrs. Nathaniel Ellery,* ca. 1766, MFA, Boston; *Mrs. James Russell,* ca. 1770, North Carolina Museum of Art, Raleigh; *Mrs. Michael*

Gill (?), ca. 1770–71, Tate Gallery, London. Similar portraits by British artists include Allan Ramsay, *Mary Adam,* 1754, Yale Center for British Art, New Haven; and Joseph Wright of Derby, *Mrs. John Ashton,* ca. 1769, Fitzwilliam Museum, Cambridge, England.

REFERENCES: Parker and Wheeler 1938, p. 162, pl. 110; Flexner 1948, p. 47, pl. 15; Winchester 1961a, p. 28; Prown 1966, vol. 1, p. 81, no. 287; Warren 1966, p. 801; Warren 1971a, p. 51; Warren 1975, p. 132, no. 249; Agee et al. 1981, p. 80, no. 142; Warren 1982, p. 231; Marzio 1989, p. 260; Goodfriend 1992, pp. 183–84; Kamensky 1995, p. 65.

1. Perhaps only half of the portraits of various sizes and media survive from this seven-month period, and these represent only a small fraction of his colonial production overall (estimates provided by Prown 1986, pp. 31–39, at p. 31).
2. The portrait of Sherbrook is now in the Chrysler Museum, Norfolk, Virginia. The subscription list, assembled by Captain Stephen Kemble, the brother of Mrs. Thomas Gage (Margaret Kemble), appears in Copley-Pelham Letters 1972, pp. 113–14.
3. *Portrait of Mrs. Nathaniel Appleton,* 1763, Fogg Art Museum, Harvard University, Cambridge, Massachusetts. Embroidered or decorated aprons appear in *Portrait of Dorothy Quincy* (later Mrs. John Hancock), ca. 1772, MFA, Boston; and *Mr. and Mrs. Thomas Mifflin,* 1773, Historical Society of Pennsylvania, Philadelphia.
4. In Rebora and Staiti 1995, p. 307, Rebora suggests the object represents a box. Either a box or cards would be unprecedented in Copley's work.
5. In addition to the merchant business he and his brothers formed, growing to include branches in New Haven, Norfolk, Bermuda, and Belfast, Richard was a charter member of King's College (now Columbia University) and a long-time member of the General Assembly.
6. Goodfriend 1992, p. 183. In family genealogies, the name Garland also appears as Garlin, Gorling, and Gorland. See also Totten 1935, pp. 138–39, 246.
7. In April 1746, Richard wrote to his agent Colonel Jacob Wendell, "but as Mrs. Richard Enjoyes so Little health do not share [?] any Imploy that should call me from home. . . ." (Paul Richard to Jacob Wendell, April 21, 1746, New-York Historical Society). In May 1746, he wrote again to Wendell, "You say you are sorry I refused being a Commissioner, I had severall Good reasons but this Only I shall Give you and I hope itt will be Satisfactory, Mrs Richard is in a Badd state of health. . . ." (Richard to Wendell, May 12, 1746, *New England Historical and Genealogical Register,* 1878, pp. 59–60).

In an eloquent profession of his love for her, he continued, "as You Know how I am Sircomstanced, haveing no Issue She is my all and Second Selfe. . . ." Later the same year in June, he wrote Wendell that "I goe out of Towne every Saturday to Se Mrs. Richard who is at Elizabeth Towne with her Physician verry unwell, Tho' hope the Country Air and Exercise will be of Considerable Service to her" (Richard to Wendell, June 19, 1746, New-York Historical Society).
8. Will of Elizabeth Richard, *Abstract of Wills on File in the Surrogates Office, City of New York,* vol. 8, Liber 29, pp. 201–2. A pertinent item not mentioned in the will that descended in the Richard family is an apron with tags identifying it as the apron worn by Elizabeth Richard for her portrait by Copley. The tagged apron is embroidered. If this is, indeed, the apron Mrs. Richard wore, Copley eliminated the swirling patterns of embroidery from his version of the garment.

P19

Study for William Murray, First Earl of Mansfield

1782–83
JOHN SINGLETON COPLEY (1738–1815), London
Graphite and black and white chalk on blue-gray paper; 12¼ x 19½" (31.1 x 49.5 cm)
B.54.26

In contrast with Copley's colonial period, numerous studies for portraits and history paintings survive from the artist's career in London, which dates from 1775 until 1815. This study relates to a commission to create a full-length portrait of William Murray (1705–1793) from the

artist's widely acclaimed contemporary epic history painting *The Death of the Earl of Chatham* (Tate Gallery, London, on loan to the National Portrait Gallery, London).[1] In this monumental composition, a scene of the House of Lords on the fateful day when William Pitt, the earl of Chatham, fought for continuing the war effort in the American colonies, Lord Mansfield appears seated at a table at far left.

This study and the finished oil indicate Copley's efforts to win portrait commissions from the sitters who appeared in his contemporary history paintings. Copley generated from *Chatham,* in fact, four portraits of various sitters.[2] The artist exhibited the full-length portrait of Mansfield at the Royal Academy of Arts exhibition of 1783, perhaps in an effort to advertise such commissions while reminding his audience of the larger history painting, which had no buyer at that time.

PROVENANCE: The artist, until 1815; to his son, John Singleton Copley, Jr., Lord Lyndhurst (1772–1863), London, until 1864; auctioned at Christie's, London, the Lyndhurst Library sale, February 26–27, 1864, lot 670; purchased by Edward Basil Jupp, London; to the Amory family, Boston (descendants of the artist); to Edward Linzee Amory (1844–1911), Boston, the artist's great-grandson, until 1911; to his servant; purchased by Miss Hogg from Childs Gallery, Boston, 1954.

RELATED EXAMPLES: The Bayou Bend drawing is one of six known studies for Copley's full-length oil portrait of *William Murray, First Earl of Mansfield* (1782–83, National Portrait Gallery, London). The other studies for the portrait belong to the Yale University Art Gallery, New Haven; the Mead Art Museum, Amherst College, Amherst, Massachusetts; the Cleveland Museum of Art; the British

P19

Museum, London; and a private collector.[3]

REFERENCES: Prown 1966, vol. 2, p. 426, no.
431; Warren 1975, p. 136, no. 256; Warren 1982,
p. 231.

1. See William Pressly, "The Challenge of
 New Horizons," in Neff 1995, pp. 50–52.
 See also Prown 1966, vol. 2, pp. 275–91.
2. See Neff 1995, pp. 70, 164, no. 37.
3. Prown 1966, vol. 2, nos. 430, 432, 434, 435,
 433. A life study of the sitter for the large
 history painting belongs to the Boston
 Athenaeum (Prown 1966, vol. 2, no. 406).

P20

Study for "The Siege of Gibraltar" (Study of Lieutenant Colonel Lindsay and Figures Pulling on a Rope)

ca. 1786–87
JOHN SINGLETON COPLEY (1738–1815),
London
Graphite and black and white chalk on gray-blue paper; 14¼ x 22½" (36.2 x 57.2 cm)
B.54.27

With the loss of the American colonies looming, the successful British defense of Gibraltar in 1782, besieged for three years by Spain and its French allies, was a much needed morale booster to British military affairs. After a continuous barrage of fire, the British troops defeated the Spanish floating batteries, a turning point in the siege, which ended one month later when Admiral Howe broke the last vestiges of the blockade. To commemorate the victory at Gibraltar, the city of London awarded Copley the most important commission of his career: a large painting for the Court of Common Council Room at Guildhall, a project that would take eight arduous years to complete.[1]

Contemporary history painting, as defined by Benjamin West and Copley, required the artist to be a diligent researcher by gathering firsthand accounts of the event, making life studies of the officers present at the battle, documenting uniforms, and arranging fortress and ship models in the studio to re-create the correct positions of the battlements and vessels. Copley made over eighty preparatory studies on paper for The Siege of Gibraltar (1791, Guildhall Art Gallery,

P20

P21

P22

London).[2] The majority of the artist's drawings concentrate on the depiction of struggling survivors at left rather than the commemorative officer group at right. This drawing, however, contains figures from both sides of the final painting.

PROVENANCE: See cat. no. P19 (lot 661 in Lyndhurst Library sale, 1864).

RELATED EXAMPLES: This sketch is one of two of the Honorable Lieutenant Colonel Lindsay, the Highland officer at the far right of the painting; the other sketch of Lindsay belongs to the Victoria and Albert Museum, London. The rope pullers are part of the rescue team at left in the final version of the painting. They are related to similarly oriented figures appearing in two other sketches: another Bayou Bend drawing (see cat. no. P21) and one in a private collection in New York (1966).[3] Sketches of a rope puller in the bow of the gunboat belong to the British Museum, London; Munson-Williams-Proctor Institute, Utica, New York; and the Mead Art Museum, Amherst College, Amherst, Massachusetts.[4]

REFERENCES: Prown 1966, vol. 2, p. 453, no. 553; Warren 1975, p. 136, no. 255; Warren 1982, p. 231.

1. See Prown 1966, vol. 2, pp. 322–36; and Howgego 1958, pp. 34–43.
2. Prown 1966, vol. 2, nos. 500–583.
3. Ibid., no. 506.
4. Ibid., nos. 578–81.

P21

Study for "The Siege of Gibraltar" (Study of Figures Pulling on a Rope)

1785–86
JOHN SINGLETON COPLEY (1738–1815), London
Black and white chalk on gray-blue paper;
14 x 22½" (35.6 x 57.2 cm)
B.54.29

This drawing is a study for the rope pullers at the left side of The Siege of Gibraltar (1791, Guildhall Art Gallery, London). Reminiscent of a violent scene from the Last Judgment, this portion of the canvas stood in stark contrast to the commemorative officer group at right, dominated by the commanding figure of General George Augustus Eliott (later Lord Heathfield).

PROVENANCE: See cat. no. P19 (lot 661 in Lyndhurst Library sale, 1864).

RELATED EXAMPLES: See cat. no. P20.

EXHIBITED: Harry Shaw Newman Gallery, New York, May 1947.

REFERENCES: Comstock 1947, p. 104; Prown 1966, vol. 2, p. 448, no. 505; Warren 1975, p. 135, no. 252; Warren 1982, p. 231.

P22

Study for "The Siege of Gibraltar" (Study of Rescued Figure and Two Figures Pulling on an Oar)

1785–86
JOHN SINGLETON COPLEY (1738–1815), London
Black and white chalk on gray-green paper;
14¼ x 23" (36.2 x 58.4 cm)
B.54.28

Reminiscent of Benjamin West's history painting of the seventeenth-century Battle of La Hogue (ca. 1775–80, NGA) and Copley's own Watson and the Shark (1778, NGA), this study reveals the continued development of the artistic theme of rescued figures pulled from turbulent waters. Shown with two studies—two figures pulling on an oar and a rough sketch of a leaning figure with head upturned—the outstretched nude is the most finished drawing of the group and is squared for transfer to canvas. These figures relate to the rescue groups on the left side of Copley's final canvas.

The pose of the nude, gripped at the wrist by a rescuer, echoes that of Brook Watson in Copley's Watson and the Shark, which, in turn, recalls ancient and Old Master prototypes such as the Borghese Gladiator, the first-century A.D. sculpture of The Laocoön, and the deranged child in Raphael's The Transfiguration.[1] History painters borrowed poses from admired ancient sculptures as well as Old Master paintings to emulate the grandeur and nobility associated with biblical and mythological figures.

PROVENANCE: See cat. no. P19 (lot 661 in Lyndhurst Library sale, 1864).

RELATED EXAMPLES: The rescued nude relates to about fourteen other studies, includ-

ing works in the Victoria and Albert Museum, London; MMA; and the British Museum, London.

REFERENCES: Prown 1966, vol. 2, p. 451, no. 532; Warren 1975, pp. 135–36, no. 254; Warren 1982, p. 231.

1. For discussions of prototypes of Copley's Watson and the Shark, see Prown 1966, vol. 2, pp. 271–73; Stein 1976, pp. 85–130, specifically pp. 97–103; for a comprehensive assessment of sources, see Miles 1995, pp. 54–71.

P23

Study for "The Siege of Gibraltar" (Study for a Figure on a Cannon in the Longboat)

1785–86
JOHN SINGLETON COPLEY (1738–1815), London
Black and white chalk on gray-blue paper;
23⅛ x 14½" (58.7 x 36.8 cm)
B.54.30

This drawing, which relates to the cascade of figures that make up the dramatic rescue tableau on the left side of Copley's finished canvas, reveals Copley's varied techniques in making preparatory sketches. The artist has combined both broadly handled, loose suggestions of movement and form and crisply delin-

P23

eated figures on one sheet. He also includes indications of light and shade through firm hatching.

PROVENANCE: See cat. no. P19 (lot 661 in Lyndhurst Library sale, 1864).

EXHIBITED: Harry Shaw Newman Gallery, New York, May 1947.

REFERENCES: Comstock 1947, p. 107 (as a study for *The Death of Major Peirson*); Prown 1966, vol. 2, p. 449, no. 512; Warren 1975, p. 135, no. 253; Warren 1982, p. 231.

P24

P24

Conversion of Onesimus

ca. 1780
BENJAMIN WEST (*1738–1820*), *London*
Pen, ink, and sepia wash on paper; 5 x 7½"
(12.7 x 19.1 cm)
B.67.26

This is one of only two works by Benjamin West in the Bayou Bend Collection. West, the Pennsylvania artist who became history painter to King George III and was a founder of the Royal Academy of Arts, London, ranks among the most important painters of the eighteenth century.

West scholars have confirmed the attribution of this drawing to West, although they disagree on the subject of the work.[1] The subject of this drawing most likely derives from the biblical story related in Acts, chapters 15–18, in which Paul blesses the converted Onesimus (shown with his arms crossed as if receiving a blessing), a runaway slave and fellow prisoner with his master Epaphras (who draws back in astonishment at the event). As the converted Onesimus was thought to be the later bishop of Ephesus, who gathered together the epistles of Saint Paul, this story was considered significant and formed a part of the fourth dispensation, the last epoch of Christian salvation.

This may be a preparatory study for the mural commission on the subject of revealed religion that West received in 1780 from King George III for a new royal chapel at Windsor. The painting for this subject may never have been realized. Only twenty-eight of the thirty-five intended works were finished before the king canceled the project. An alternative is that this sketch is a study for an altar window based on the Conversion of Saint Paul in Birmingham, another commission that West received from the king.[2]

PROVENANCE: Paul Magriel, New York; W. M. Ittmann, Jr., Williamstown, Massachusetts; purchased by Miss Hogg from Kennedy Galleries, New York, 1967.

REFERENCES: Warren 1975, p. 137, no. 258.

1. Ruth Kraemer and Helmut von Erffa affirm the attribution to West. The title of the work at the time of purchase was *Study for Saint Paul in Prison*, which David Warren refined to its present title (Warren 1975). Helmut von Erffa has speculated that the subject might instead be Joseph telling about the dreams of two prisoners (object files, letter from Helmut von Erffa, November 30, 1972).

2. Jerry Meyer doubts that the drawing relates to any of West's three religious projects, the royal chapel at Windsor, the Greenwich Chapel at the Royal Naval Hospital, or the Pauline Windows for the church of St. Paul, Birmingham (object files, letter from Jerry D. Meyer, March 12, 1975).

P25

Noah Sacrificing

probably 1797–1801
BENJAMIN WEST (*1738–1820*), *London*
Pen, ink, and sepia wash on paper; 4¼ x 8½"
(10.9 x 21.6 cm)
B.67.25

This gestural sketch is thought to be a study for *Noah Sacrificing* (ca. 1801, San Antonio Museum of Art), a scene

P25

included in West's mural commission for the unrealized royal chapel at Windsor on the subject of revealed religion.[1] Noah, standing before an altar with upraised hands, is surrounded by loosely drawn people and animals.

INSCRIBED: Ben^n: West Esq^r: / N^o: 14 Newman S^t (on verso, in ink); Noah's Sacrifice: a sketch by B. West. P.R.A. (on recto, below image, in pencil).

PROVENANCE: Mr. and Mrs. Lawrence A. Fleischman, Detroit; purchased by Miss Hogg from Kennedy Galleries, New York, 1967.

EXHIBITED: "American Drawings, Pastels and Watercolors, Part One: Works of the Eighteenth and Early Nineteenth Centuries," Kennedy Galleries, New York, March 14–April 28, 1967, no. 4.

RELATED EXAMPLES: Two drawings by West on the subject of Noah Sacrificing, one in black chalk, one in pen and ink, date to the 1790s, the Pierpont Morgan Library New York.

REFERENCES: Warren 1975, pp. 136–37, no. 257; Kraemer 1975, pp. 31–32, nos. 48, 49 (mistakenly listed as on the New York market); von Erffa and Staley 1986, p. 287.

1. The subject derives from Genesis 8:20: "And Noah built an altar unto the Lord; and took of every clean beast and of every clean fowl, and offered burnt offerings on the altar." For more information about the chapel, see Meyer 1975, pp. 247–65.

P26

P26

Boy with Toy Horse

1768
CHARLES WILLSON PEALE (1741–1827), London
Oil on canvas; 36³/₁₆ x 28″ (28 x 71.1 cm)
B.55.15

In 1769, a Maryland student living in London referred in a letter to a "Mr Peal a Man formed by nature for whatsoever Business he undertakes In London he has been exceedingly caressed by all our great Painters as a promising Genius."[1] The student was referring to Charles Willson Peale, a saddler from Annapolis, Maryland, turned aspiring artist, who would go on to become one of the most prominent artists of his day. He was also celebrated as an inventor, scientist, founder of a public museum, and head of a distinguished family of artists, including his younger brother James Peale (see cat. nos. P28, P29), and his children, among them Rembrandt Peale (see cat. no. P30).

This portrait of a child is one of the few paintings Peale completed during his two-year stint in London studying with Benjamin West (see cat. nos. P24, P25), and it represents among the most ambitious paintings of his sojourn. A young child dressed in pink, turned slightly to engage the viewer, stands in an interior setting that includes a patterned carpet, a Chippendale side chair, a fireplace with glowing embers, a tea table, and two portraits hanging on the wall. An oval portrait representing an older gentleman hangs slightly above the sitter's head, and the other, seen over the fireplace, duplicates the painting itself. The child clutches a toy horse with one hand and clasps the string that leads from it with his left hand. The string, caught on the skirt, pulls at the pink overgown, a detail that lends an air of informality and spontaneity to the scene.

Since this portrait was acquired, the gender and identity of the child have been questioned. In 1954, Peale scholar Charles Coleman Sellers suggested that the Bayou Bend portrait was exhibited publicly as *A Portrait of a Girl* with the Society of Artists in 1768.[2] No other known Peale painting comes as close as the Bayou Bend picture to the description of the exhibited work. Sellers further speculated

that the painting presented a challenge to John Singleton Copley (see cat. nos. P15–P23), his closest rival in the colonies. The year before, Copley had exhibited *Young Lady with a Bird and Dog* (1767, Toledo), which had been severely criticized. Peale, the younger, aspiring artist, could have been offering a corrective to Copley's painting of a similar subject: a young child at play in an interior setting with patterned carpet.[3] This identity of the sitter as a girl and the identification of this painting with the picture exhibited in 1768 have, for the most part, been supported by Peale scholars.[4]

The costume and toy prop, however, challenge the sitter's identity as a girl. Costume experts have shown that dresses were worn by boys until they were breeched, and that the color of dress was not gender specific in the eighteenth century. Girls usually wore a cap or headdress with the front-fastened gown, and toy horses were generally pictured with male subjects only.[5] Since 1987, the sitter has been identified as male. It is conceivable that the painting was incorrectly identified in the Society of Artists exhibition catalogue. The sitter may represent one of West's children or, simply, someone who has not yet been identified.

INSCRIBED (LOWER LEFT, ON CHAIR RAIL): C. Peale Pinx Londini, 1768.

PROVENANCE: Purchased by Hirschl and Adler, New York, in London, 1954; purchased by Miss Hogg from Hirschl and Adler, 1955.

EXHIBITED: Society of Artists Exhibition (?), London, catalogue dated September 30, 1768, in honor of King Christian VIII of Denmark ("no. 84, 'A Portrait of a Girl'"); "Colonial Portraits from the Collection of Miss Ima Hogg," Music Hall, Houston, February 26–March 4, 1957 (identified as a female subject); "Benjamin West and His American Students," National Portrait Gallery, Washington, D.C., October 16, 1980–January 4, 1981; Pennsylvania Academy of the Fine Arts, Philadelphia, January 30–April 19, 1981 (identified as a female subject); "The Voyage of Life," Bayou Bend Museum of Americana at Tenneco, Houston, September 22, 1991–February 26, 1993.

RELATED EXAMPLES: Similar paintings of a "picture within a picture" or a child playing with a toy horse can be seen in the conversation pieces of Johann Zoffany, specifically *John, 14th Lord Willoughby de Broke and His Family*, 1766, J. Paul Getty Museum, Los Angeles.

REFERENCES: Sellers 1952, no. 1037 (painting described as unlocated); Sellers 1969a, pp. 71–73; Sellers 1969b, pp. 83–84, 113, no. 150; Sellers 1974, p. 11; Warren 1975, p. 137, no. 259; Peale Papers 1983–96, vol. 1, pp. 73–74 n; Miller and Ward 1991, pp. 37, 41, 45, 84, 86, fig. 20; Steinberg 1993, pp. 28–29.

1. Benjamin Galloway to John Galloway, March 8, 1769, in Peale Papers 1983–96, vol. 1, p. 78.
2. Sellers first makes this suggestion in a letter to Norman Hirschl, Hirschl and Adler Galleries, New York (object files, Charles Coleman Sellers to Hirschl, October 9, 1954).
3. Ibid. Sellers suggests the relationship between Copley's *Young Lady with a Bird and Dog* and the Bayou Bend painting. See also Sellers 1969a, pp. 71–72; and Sellers 1969b, p. 84. Sellers's interpretation of the painting as a challenge to Copley is persuasive. Peale had met with Copley in Boston in 1765, and by 1768, he had studied with Benjamin West for a year and would have seen Copley's *Young Lady with a Bird and Dog* at the Society of Artists exhibition, a painting that Benjamin West specifically criticized (Benjamin West to Copley, London, June 20, 1767, in Copley-Pelham Letters 1972, pp. 56–58). Peale was poised to show up his rival, one who, at that point in his career, had not yet benefited from study abroad, as Peale had. The problems identified with Copley's submission could not be extended to Peale's.
4. Jules David Prown, "Charles Willson Peale in London," in Miller and Ward 1991, pp. 38, 41–43; Steinberg 1993, pp. 28–29; Lillian Miller questioned whether the portrait represented a boy (object files, letter from Miller, April 1, 1992).
5. Madeleine Ginsburg, assistant keeper of textile furnishings and dress, Victoria and Albert Museum, London (object files, letter to Gervase Jackson-Stops, the National Trust, June 22, 1987); Aileen Ribeiro, History of Dress Department, University of London, Courtauld Institute of Art (object files, letter from Ribeiro, June 18, 1987).

P27

Self-Portrait with Angelica and Portrait of Rachel

ca. 1782–85
CHARLES WILLSON PEALE (1741–1827), *Philadelphia*
Oil on canvas; 36⅛ x 27⅛" (91.8 x 68.9 cm)
B.60.49

Charles Willson Peale painted a number of self-portraits throughout his career, but the Bayou Bend portrait is one of his most complex and revealing statements about his art and its close relationship to domesticity, family enterprise, and the educational role of art. Seated in a Windsor armchair while painting a portrait, the artist turns slightly and directs his gaze toward the viewer. Without actually gripping the brush, his daughter Angelica Kauffmann Peale (1775–1853) at right playfully appears to guide it with one hand, as her other hand points toward heaven, assuming the role of the allegorical muse of painting.[1] To the left, Rachel Brewer Peale (1744–1790), the artist's wife, peers out of the painted canvas toward the viewer with an expression as lifelike as those of the artist and daughter. Peale, then, challenges the viewer to consider issues of illusion and reality and the artist's magical ability to transform pigment (as suggested by the blobs of paint revealed to the viewer on the palette, carefully juxtaposed with the painted canvas) into life (as revealed by the vibrantly alive portrait of his wife on the easel). Such investigations into the art of portraiture as more than a mimetic enterprise are characteristic of the artist's most sophisticated works (see also the conceit of a painting within a painting in cat. no. P26).

The painting has been variously dated. Charles Coleman Sellers first proposed ca. 1782–85, which is supported by other Peale scholars.[2] The date of 1790 was also proposed (and later rescinded) by Sellers; Rachel Brewer Peale died in 1790, which would make the portrait one of remembrance. Warren, however, argues for a date of ca. 1788 based on the relative ages of the sitters and their appearance in the painting. Stylistically, the portrait compares most closely with Peale's works of the earlier 1780s.

PROVENANCE: By tradition in the Peale Museum, Philadelphia, until 1854[3]; to George Rowan Robinson, grandson of Angelica Kauffmann Peale Robinson (b. 1826), St. Louis[4]; Mrs. Richard P. Esty, by 1952; purchased by Miss Hogg from Kennedy Galleries, New York, 1960.

EXHIBITED: Peale's portrait gallery (?), Independence Hall, Philadelphia, ca. 1782, then the Peale Museum, Philadelphia, from ca. 1786–

P27

1854; "The Fabulous Peale Family," Kennedy Galleries, New York, June 13–July 8, 1960; "The Voyage of Life," Bayou Bend Museum of Americana at Tenneco, Houston, September 22, 1991–February 26, 1993.

RELATED EXAMPLES: Possible sources and prototypes cited by David Steinberg in Miller and Ward 1991 include Edward Fisher after Jean-Baptiste Van Loo, *Colley Cibber and His Daughter,* 1758, The Huntington Library, Art Collections and Botanical Gardens, San Marino, California; and Dirck Jacobsz, *Jakob Cornelisz van Oostsanen Painting a Portrait of His Wife,* ca. 1550, Toledo; another interesting comparison is Gerrit van Honthorst, *Pictura Is Painting a Likeness of the Artist* or *The Love of the Painter Is Returned by His Muse,* 1648, Galerie Neuse, Bremen.

REFERENCES: *Art in America* 2, no. 6 (1914), p. 424; Sellers 1952, p. 159, no. 626 (dates the painting to ca. 1782–85, and painting is described as unlocated); *Kennedy Quarterly* 1, no. 3 (June 1960), p. 68, no. 69; *Antiques* 77 (June 1960), p. 524; Warren 1966, p. 798; Sellers 1969a, pl. 6 (dates the painting to ca. 1790); Sellers 1969b, pp. 75, 122, no. 107; Warren 1971a, p. 39; Warren 1975, pp. 138–39, no. 260; Miller 1981, pp. 47–68, especially pp. 67–68; Agee et al. 1981, p. 87, no. 152; Richardson, Hindle, and Miller 1982, pp. 202, 208, 260; Peale Papers 1983–96, vol. 1, pl. 6; Marzio 1989, pp. 262–63; David Steinberg, "Charles Willson Peale: The Portraitist as Divine," in Miller and Ward 1991, pp. 131–43; Brigham 1995, pp. 42–43; Wilson 1996, p. 83.

1. See David Steinberg in Miller and Ward 1991, pp. 131–41, for the most stimulating discussion of the Bayou Bend portrait to date.
2. Specifically David Steinberg, who argues that Peale would have wanted this complex portrait to have appeared in his newly expanded gallery of "worthy Personages" at Independence Hall by 1782 (ibid., pp. 131, 140 n).

P28

3. Family tradition asserts that the portrait was acquired from the 1854 museum sale, but Charles Coleman Sellers notes that the portrait does not appear in the sale catalogue. It may be that the painting was acquired by a descendant before the sale.
4. At this time, it was said to have been cleaned by Rembrandt Peale, who identified it as a work by his father.

P28

Pleasure Party by a Mill

late 1780s
JAMES PEALE *(1749–1831), Bloomsbury, New Jersey*
Oil on canvas; 26¼ x 40⅛" (66.7 x 101.9 cm)
B.62.16

The younger brother of Charles Willson Peale (see cat. nos. P26, P27), James Peale assisted his brother until he became an independent artist in the mid-1780s, painting miniatures and still lifes (cat. no. P29).

As evidenced by the artist's only extant sketchbook, the younger Peale was drawing landscapes possibly as early as 1786. The studies for the Bayou Bend landscape, including drawings of the various buildings, bridges, and botanical life of the site, identified as the Musconetcong Creek ironworks and gristmill at Bloomsbury, New Jersey, are contained in this sketchbook.

The Bayou Bend picture, among the earliest and most significant of James Peale's landscape paintings, merges various landscape traditions with the growing interest in the American landscape (this interest would culminate in the so-called Hudson River school). This landscape is essentially topographical, inasmuch as it documents a specific site and offers a vivid account of the botanical life of the area. The landscape is also a part of the British picturesque tradition, with its preference for scenic imagery.[1] With the exception of the lone figure at far left, who appears to be the only one joined to the landscape by work, these charming

figures at their leisure may represent the fashionable clientele who summered at nearby Schooley's Mountain Hotel.[2] The figures mark the burgeoning tourism of American picturesque sites and the eager market for images of them.

PROVENANCE: Possibly raffled in 1788 in Annapolis, to James Carroll, Charles Wallace, or James Latimer, and thence to Percival Christie (?)[3]; Lawrence Fleischman, Detroit; purchased by Miss Hogg from Kennedy Galleries, New York, 1962 (as a work by Charles Willson Peale).

EXHIBITED: "Painting in America," the Detroit Institute of Arts, 1957, p. 10, no. 41 (as a work by Charles Willson Peale); "Nine Generations of American Painting," United States Information Agency (USIA) Tour of Scandinavia, 1958, no. 4; USIA Tour of Greece, 1958, no. 4; USIA Tour of Iceland, 1959, p. 7 (as a work by Charles Willson Peale); "American Painting, 1760–1960," the Milwaukee Art Museum, March 3–April 4, 1960, pp. 21, 24 (as a work by Charles Willson Peale); "Views and Visions: American Landscapes before 1830," Wadsworth, September 21–November 30, 1986; Fine Arts Museums of San Francisco,

December 19, 1986–March 29, 1987; the Corcoran Gallery of Art, Washington, D.C., April 25–June 21, 1987, pl. 81 (Nygren et al. 1986); "The Masterpieces of Bayou Bend, 1620–1870," Bayou Bend Museum of Americana at Tenneco, Houston, September 22, 1991–February 26, 1993; "The Peale Family: Creation of a Legacy," PMA, October 26, 1996–January 5, 1997; Fine Arts Museums of San Francisco, January 25–April 6, 1997; the Corcoran Gallery of Art, Washington, D.C., April 25–July 6, 1997, no. 105 (Miller 1996).

RELATED EXAMPLES: The James Peale Sketchbook (American Philosophical Society, Philadelphia), includes six studies for the Bayou Bend landscape. The earliest dated work in the sketchbook is 1786 and the latest is 1801; James Peale, *The Ramsay-Polk Family at Carpenter's Point* (ca. 1793, Copeland Collection, Delaware); and *View on the Wissahickon* (1830, PMA).

REFERENCES: Warren 1966, p. 813; Warren 1975, pp. 139–40, no. 261; Agee et al. 1981, pp. 87–88, no. 153.

1. See Miller 1996, pp. 76–78 and Linda Crocker Simmons in Miller 1996, pp. 207–9.
2. James Ogelsby Peale, a descendant of the artist, speculated that the Peale family vacationed at the fashionable Schooley's Mountain Hotel near the site pictured here

(object files, letter from Peale, November 14, 1972).
3. In 1969, Jeffrey Brown, University of Maryland, College Park, first suggested that six landscapes by James Peale were raffled off in Annapolis on June 19, 1788. He says Percival Christie was the owner of the Bayou Bend picture, and the ancestors from whom he possibly inherited the picture may have been the recipients of the raffle: James Carroll, James Latimer, and Charles Wallace (object files, letter from Brown, March 1, 1969). This painting may, indeed, have been one of the works raffled off, but there is no evidence that it once belonged to Percival Christie. See Peale Papers 1983–96, vol. 1, pp. 502, 504, 562.

P29

Still Life with Vegetables

1826
JAMES PEALE (1749–1831), Philadelphia
Oil on canvas; 20 x 26½" (50.8 x 67.3 cm)
Museum purchase with funds provided by the Theta Charity Antiques Show in honor of Mrs. Fred T. Couper, Jr., B.85.2

James Peale painted portraits, both miniatures and larger works in oils, the mainstay of his profession, until about 1818, when his eyesight began to fail. He then painted still lifes, quickly becoming one of America's foremost still-life painters, along with his nephew Raphaelle Peale (1774–1825).[1] The crisp and solemn tone of his still lifes have been associated with those by seventeenth-century Spanish artists, specifically the work of Juan Sánchez Cótan, whose paintings were shown at the Pennsylvania Academy of the Fine Arts in 1818.[2] The perishable foodstuffs alluded to the transience of life, a theme that may have served as a personal rumination on aging for this artist late in his career. This still life was painted for Peale's daughter Anna Claypoole Peale Staughton (1791–1878) and may, in fact, be among three vegetable still lifes the artist exhibited in 1827 at the Pennsylvania Academy of the Fine Arts.[3]

INSCRIBED (ON VERSO): Property of A. C. Staughton / Painted by James Peale / Philad 1826 Aged 76.

P29

PROVENANCE: Auctioned at Sotheby Parke Bernet, New York, *American 18th, 19th and 20th Century Paintings, Drawings and Sculpture and Decorative Prints*, January 26–27, 1984, lot 358; purchased by Bayou Bend from Bernard and S. Dean Levy, New York, 1985.

EXHIBITED: "The Masterpieces of Bayou Bend, 1620–1870," Bayou Bend Museum of Americana at Tenneco, Houston, September 22, 1991–February 26, 1993.

RELATED EXAMPLES: Copy by the artist, *Still Life with Vegetables*, 1828, Winterthur.

REFERENCES: Brown 1985, p. 518; *Antiques* 27 (January 1985), p. 9; Marzio 1989, pp. 266–67; Fennimore et al. 1994, p. 122.

1. For a brief assessment of James Peale and still-life painting, see Linda Crocker Simmons in Miller 1996, pp. 217–19.
2. Gerdts and Burke 1971, pp. 31–36.
3. Gerdts and Burke (1971, p. 36) suggest that one of the three vegetable still lifes exhibited in 1827 is now in the collection of the MMA: *Still Life—Cabbage, Balsam Apple &c.* The Bayou Bend picture may be the one listed in the exhibition catalogue as "191. *Still Life—Squashes and other Vegetables.*" See Rutledge 1988–89, vol. 1, p. 164.

P30

P30

Portrait of Henry Robinson

ca. 1816–20
REMBRANDT PEALE (1778–1860),
Philadelphia or Baltimore
Oil on paper, mounted on canvas; 21⅝ x 17¼"
(54.1 x 43.8 cm)
Museum purchase with funds provided by the Theta Charity Antiques Show, B.77.17

Rembrandt Peale was one of Charles Willson Peale's most enterprising and ambitious children. Trained by his father, by 1795 he was making copies of portraits of Revolutionary heroes in his father's gallery in order to open a second (and ultimately unsuccessful) Peale museum in Baltimore. A trip to London to display the mastodon skeleton he and his father had excavated and assembled and to study with Benjamin West (see cat. nos. P24, P25) soon followed. The wartime climate of Europe forced the young artist home to Philadelphia, where he became a founding member of the Pennsylvania Academy of the Fine Arts in 1805. After a successful journey to Paris in 1808–9 and again in 1810 to paint French luminaries

and to study Old Masters in the Louvre, Rembrandt returned home. In 1814, with Henry Robinson (1775 or 1784–1848) as a backer, Rembrandt opened the first building specifically designed to be a museum, the Baltimore Museum and Gallery of Paintings on Holliday Street; in 1822, he sold the museum to his brother Rubens Peale and moved to New York, where he eventually became president of the American Academy of Fine Arts.

Family tradition suggests that this portrait of Robinson was painted for his family as a token of gratitude for looking after Rembrandt Peale's daughter Rosalba Carriera Peale (1799–1874) during his trips abroad.[1] More likely Peale painted the portrait for Robinson in thanks for his support of the Peale Museum and for gas illumination for the museum and for the city of Baltimore, which led to their partnership to form the Baltimore Gas Company. The painting appears to be related to a gesture of partnership and friendship, not unlike the gift of portraits to Robinson that Thomas Sully (see cat. no. P44)

made in 1821 in exchange for Robinson's hospitality.[2]

The Bayou Bend portrait probably dates to ca. 1816–20, as this encompasses the period during which Robinson supported Rembrandt Peale's endeavor, both the museum itself and the Baltimore Gas Company. In addition, the sitter wears garments of the teens and 1820s, although dating a portrait by costume cannot be definitive.[3] The Bayou Bend painting is one of three portraits of Robinson by Peale. The picture's freshness and intensity suggest that it was completed first, followed by the portrait of Robinson in the Washington County Museum of Fine Arts, Hagerstown, Maryland, and a posthumous portrait signed and dated 1849 in a private collection (see Related examples).[4]

PROVENANCE: The sitter, until 1848; to his friend Garret P. Demarest (1799–1869); to his son-in-law Frank Robinson Garrett (d. 1872); to his daughter by Valeria Demarest Garrett, Lillie May Garrett (d. 1973); to George M.

Stites, New Jersey, in 1972; purchased by Bayou Bend from George Stites, 1977.

EXHIBITED: "Artists Fund Society Exhibition"(?), Pennsylvania Academy of the Fine Arts, 1844[5]; Panama-Pacific International Exposition (?), San Francisco, 1915, no. 2789 (owner not given); on long-term loan to the Peale Museum, Baltimore, January 1973–June 1976; Theta Charity Antiques Show, Houston, October 6–10, 1982.

RELATED EXAMPLES: Attributed to Rembrandt Peale, *Portrait of Henry Robinson*, 1816(?), Washington County Museum of Fine Arts, Hagerstown, Maryland[6]; Rembrandt Peale, *Portrait of Henry Robinson* (1849, private collection, New Jersey). In medium and format, this portrait is similar to Rembrandt Peale's portrait of Richardson Stuart, who also backed Peale's museum (ca. 1815, NGA).[7] Thomas Sully also painted Henry Robinson (1846, location unknown) and his wife, Rosa Maxwell Robinson (1849, Indianapolis Museum of Art).

REFERENCES: *Antiques* 116 (September 1979), p. 496; Caldwell and Rodriguez Roque 1994, p. 343 (dated 1846 and mistaken for Thomas Sully's 1846 portrait of Robinson).

1. Object files, letter from former owner George Stites, May 17, 1977.
2. See Caldwell and Rodriguez Roque 1994, pp. 341–45. By 1827, Robinson lived in Boston, where he became founder and president of the Boston Gas Company.
3. I thank Elizabeth Ann Coleman for sharing her expertise on costume.
4. I am indebted to the late Lillian B. Miller, editor of the Peale Family Papers, National Portrait Gallery, Smithsonian Institution, Washington, D.C., for establishing the chronology of the Robinson portraits. See object files, letter from Lillian Miller, November 12, 1997.
5. "No. 74 'Portrait of Henry Robinson, founder of the Boston Gas Works'" (does not mention owner); Rutledge 1988–89, vol. 1, p. 167.
6. According to object files, this portrait was purchased from Kennedy Galleries, New York, in 1964. Ehrich Gallery, New York, previously owned the painting. The Hagerstown portrait was authenticated by Charles Coleman Sellers on the basis of a photograph and without the knowledge that there were several other versions (object files, Sellers to Rudolph G. Wunderlich, Kennedy Galleries, May 15, 1963).
7. I thank Ellen G. Miles, curator of painting and sculpture at the National Portrait Gallery, Smithsonian Institution, Washington, D.C., for bringing this portrait to my attention.

P31

Portrait of Robert Livingston

ca. 1789
GILBERT STUART *(1755–1828), Dublin, Ireland*
Oil on canvas; oval: 30 x 25" (76.2 x 63.5 cm)
Gift of Mr. and Mrs. Harris Masterson, B.72.117

Rhode Island-born Gilbert Stuart rose to great prominence as a portraitist of post-Revolutionary America and image maker of its first president, George Washington. As a youth, Stuart learned the principles of painting from the Scottish artist Cosmo Alexander (1724–1772) and followed him to Edinburgh in 1771 to work in his studio. After Alexander died a year later, Stuart returned home briefly before embarking on a twelve-year sojourn in London, studying with Benjamin West (see cat. nos. P24, P25) for many years before setting up his own studio in 1781. He quickly became one of the premier portraitists of London. At the height of his power and fame in London, Stuart found his personal finances in disarray and traveled to Dublin both to avoid London creditors and to respond to his Irish patron, Charles Manners, duke of Rutland.[1] In 1787, a notice appeared in the London newspapers: "Mr. Stewart [*sic*] the portrait-painter, is not gone to France, but to Ireland; when it is probable that he will embark for America:—where it is hoped his merit will find an asylum, preferable to what he experienced in England."[2] In Dublin, Stuart began painting prominent political figures, Irish personalities, and the gentry. The portrait of Robert Livingston (b. 1733),[3] one of the many Irish sitters Stuart painted in his five-year stay in Dublin, is typical of the artist's style: the sitter's intense, engaging expression, loose, fluid brushwork, rich color, and bravura handling of the whites of the sitter's costume, here displayed in the starched ruffles of his shirt.

PROVENANCE: Purchased by Mr. and Mrs. Harris Masterson from Sabin Galleries, London, 1970.

FRAME NOTES: The painting retains its original gilded frame from Jackson of Essex Bridge, Dublin, confirmed by a label on the reverse. In addition to the frame label, a handwritten paper label glued to the stretcher reads: "Robertus Livingstone / Anno et. 56 / 1789."

EXHIBITED: "Irish Portraits 1660–1860," National Gallery of Ireland, Dublin, August 14–October 14, 1969; National Portrait Gallery, London, October 30, 1969–January 4, 1970;

P31

Ulster Museum, Belfast, January 28–March 9, 1970, no. 89.

RELATED EXAMPLES: Similar Dublin portraits by Stuart in the oval format include *Luke White,* ca. 1787, NGA; *John Richardson,* ca. 1788, in Park 1926, pp. 645–46, no. 707; and *Reverend William Preston,* ca. 1788, in Park 1926, p. 624, no. 679.

REFERENCES: Warren 1975, p. 141, no. 263.

1. For a recent account of Stuart's Dublin sojourn, see Crean 1990.
2. V&A Press Cuttings, vol. 2, p. 321.
3. Little is known of this sitter, except that he was Port Reeve, or chief officer, in County Amagh in 1810 or 1813.

P32

Portrait of John Vaughan

ca. 1795
GILBERT STUART *(1755–1828), Philadelphia*
Oil on canvas; 30⅛ x 25¼" (76.5 x 64.1 cm)
B.61.55

Gilbert Stuart returned permanently to the United States in 1793, first settling briefly in New York. In 1794 he moved to Philadelphia, where John Vaughan (1756–1842) was among his early patrons and supporters.[1] His name appears among Stuart's list of thirty-two subscribers for a portrait of George Washington, which he sent to his father Samuel, living in London (*George Washington [Vaughan Portrait],* 1795, NGA).[2] At the time Stuart painted the Washington portrait for John's father, he probably painted John. This dashing portrait features the young Vaughan with powdered hair tied back in a bow, its dust falling on the back of his blue coat with brown velvet collar and brass buttons. Stuart provides the illusion of an oval placed in front of the sitter, who stands before a lushly painted reddish-black background, the darker areas surrounding the sitter's head. The unmodulated reds of the background border the sitter's brilliant white stock, testimony to Stuart's keen use of dramatic color and light. As in all great Stuart portraits, the swift and short brushstrokes lend a note of dash and spontaneity, and the warm, carefully modulated flesh tones suggest an astonishing lifelikeness.

P32

Vaughan's long life and career epitomize the Enlightenment ideals in federal America of human progress and development. He avidly supported the arts and sciences, largely through his association with the American Philosophical Society, for which he served as treasurer and librarian, in the latter capacity for over forty years. He was a successful merchant, specializing in importing French wine, a prominent Unitarian, and an advocate of good citizenry in Philadelphia. Harvard President Sparks described him as a "cicerone and friend to all the strangers who visit the city, occasional preacher in the Unitarian Church and parish minister to all the poor of that Society . . . recommender general of all schoolmasters, inventors, young men just entering their professions, and every sort of personage, whose characters are good, and who can be benefited by his aid."[3]

PROVENANCE: The sitter; to his nephew John A. Vaughan (1795–1865); to his nephew Dr. Charles Everett Vaughan (1835–1894), Boston; to his son John F. Vaughan (1872–1953), Boston; purchased by Miss Hogg from Childs Gallery, Boston, 1961.

EXHIBITED: MFA, Boston, 1880[4]; "The Masterpieces of Bayou Bend, 1620–1870," Bayou Bend Museum of Americana at Tenneco, Houston, September 22, 1991–February 26, 1993.

RELATED EXAMPLES: Two portraits of John Vaughan painted by Thomas Sully, one signed and dated 1823, American Philosophical Society; another version of 1823, Bowdoin College Museum of Art, Brunswick, Maine.

REFERENCES: Park 1926, vol. 2, p. 778, no. 869; Mount 1946, pp. 207 (compared with portrait of Alexander James Dallas and William Kerin Constable), 209–10, 264, 298 (compared with unfinished portrait of Joseph Priestly); Warren 1975, pp. 142–43, no. 265; Warren 1971a, p. 51; Agee et al. 1981, p. 88, no. 154; Marzio 1989, p. 264.

1. Vaughan was born in Jamaica, the fourth son of Samuel and Sarah Hallowell Vaughan. In 1782, he moved to Philadelphia, where Benjamin Franklin's daughter and son-in-law, Sarah and Richard Bache, helped him settle. Richard Bache was Mrs. Paul Richard's nephew (see cat. no. P18).

2. This portrait, since the 1840s, has been thought to represent the life portrait of Washington that Stuart took in 1795 (see Miles 1995, pp. 201–6). Stuart's list indicated that Vaughan paid two hundred dollars for two portraits (Miles 1995, p. 201). It is not known for whom young Vaughan intended the second portrait of Washington, unless the payment refers to the portrait of Vaughan himself.

3. Quoted in APS 1961, p. 95.

4. According to Park 1926, vol. 2, p. 778.

P33

Portrait of Dr. Mason Fitch Cogswell

1791
RALPH EARL *(1751–1801), Hartford*
Oil on canvas; 37¼ x 32″ (94.6 x 81.3 cm)
Museum purchase with funds provided in memory of Miss Ima Hogg by her friends, B.76.184

Massachusetts-born Ralph Earl began his artistic career in New Haven, Connecticut, as a history painter and portraitist. The Revolution impelled this ardent Loyalist to flee to London in 1778, leaving his wife and family behind. Like other American artists visiting London, he studied in the studio of Benjamin West (see cat. nos. P24, P25) and began exhibiting his graceful and fashionable portraits at the prestigious Royal Academy of Arts. He returned to the United States in 1785 and set up a portrait studio in New York, which proved successful until hard drinking and mounting debts led to his imprisonment in 1786. After his release in 1788, he became an itinerant painter in the Connecticut River valley and Long Island, dying of alcoholism in 1801. A bigamist, debtor, and alcoholic, Earl was among the most ambitious painters working in the United States after the departure of John Singleton Copley (see cat. nos. P15–P23) for London. Earl tailored his style to his local market; his New York portraits, for example, have a fashionable English panache,

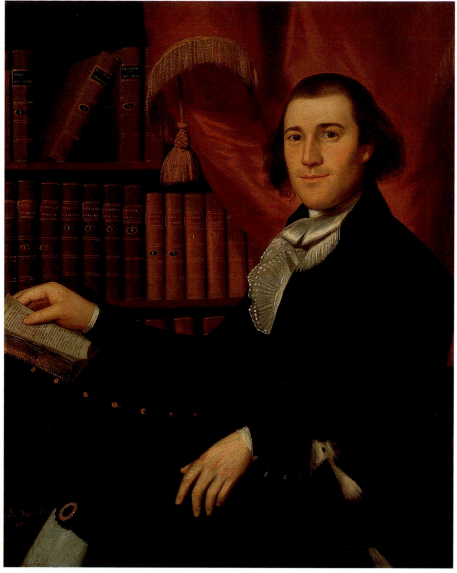

P33

while his Connecticut River valley portraits, of which the Bayou Bend painting is one, suggest a modified style that accommodated his pious and republican patrons.[1]

Mason Fitch Cogswell (1761–1830), a Yale graduate and doctor, was practicing in New York when Earl was in debtor's prison.[2] The doctor arranged for the artist's release in 1788 and, through his family connections in Connecticut, provided the artist with numerous new patrons. Earl painted Cogswell in Hartford in 1791 in exchange for medical attention.[3] Among the artist's most endearing and animated paintings, this portrait shows the fashionably dressed doctor seated in a Windsor chair with a green fabric-covered writing arm, gazing at the viewer with an engaging smile, his hand turning the page of his book, as if temporarily interrupted in his study.[4] His attentive spaniel, look-

ing for affection, lifts his head at the doctor's side. He is posed before a crimson drapery with tassel and fringe and, as an indication of his profession, an array of shelved medical books.[5]

INSCRIBED (LOWER LEFT): R. Earl Pinx[t] 1791.

PROVENANCE: The sitter; to his son Mason Fitch Cogswell (1807–1865); to his son Ledyard Cogswell (b. 1852); to his son Ledyard Cogswell, Jr. (1878–1954); to his wife, Mrs. Ledyard Cogswell (Dorothy Treat Arnold), Loudonville, New York; to Arnold Cogswell; purchased by Bayou Bend from Vose Galleries, Boston, 1976.[6]

EXHIBITED: "Connecticut Portraits by Ralph Earl, 1751–1801," Yale University Art Gallery, New Haven, August 1–October 15, 1935, no. 12; "Ralph Earl, 1751–1801," Whitney Museum of American Art, New York, October 16–November 21, 1945; Worcester Art Museum, Worcester, Massachusetts, December 13, 1945–January 13, 1946, no. 26; "American Art in Alumni

Collections," Yale University Art Gallery, 1968, no. 19; "The Great River: Art and Society of the Connecticut Valley," Wadsworth, September 22, 1985–January 12, 1986, no. 44 (Ward and Hosley 1985); "Ralph Earl: The Face of the Young Republic," NGA, November 1, 1991– January 1, 1992; Wadsworth, February 2– April 5, 1992; Amon Carter Museum, Fort Worth, Texas, May 16–July 12, 1992, no. 40 (Kornhauser 1991).

RELATED EXAMPLES: Ralph Earl, *Portrait of an Unidentified Doctor of Divinity*, 1784, location unknown, in which the sitter is posed before a library, a device that Earl used in the Bayou Bend painting and repeated again in portraits of Connecticut's learned men, for example: *Reverend Judah Champion*, 1789, the Litchfield Historical Society, Litchfield, Connecticut; and *Reverend Nehemiah Strong*, 1790, Yale University Art Gallery, New Haven.

REFERENCES: Sherman 1939, p. 177; Gaines 1959, p. 432; Brown 1985, pp. 514–25, pl. 1; Warren 1982, pp. 231–32; Kornhauser 1988, specifically chapter 3; Evans 1996, p. 45.

1. See Kornhauser 1991, pp. 41–42.
2. Born in Saybrook, Connecticut, Cogswell was the son of the Reverend James Cogswell and Alice Fitch. He played a significant role in Connecticut's medical community as a doctor and surgeon and helped to found the Society of the Relief of Distressed Debtors, the Connecticut Medical Society, and the Connecticut Asylum for the Education of Deaf and Dumb Persons (now the American School for the Deaf).
3. According to the doctor's ledger, Cogswell treated Earl for "sundries" in the amount of "5s.6d." on July 29, 1791, and April 29, 1792, and was paid "By painting in full," a reference to the Bayou Bend portrait (Ward and Hosley 1985, p. 152).
4. Kornhauser 1991, p. 178, asserts that the Windsor chair with writing arm represents one made for Cogswell by the Hartford cabinetmaker Stacey Stackhouse in exchange for medical attention.
5. These books are identified as William Cullen's *First Lives of the Practice of Physics*, Benjamin Fell's *System of Surgery*, Andrew Fyfe's *System of Anatomy*, and *Malaria Medica*.
6. Miss Hogg was considering the purchase of this painting when she died in 1975; the painting was bought in her memory by her friends.

P34

Portrait of John Adams

ca. 1800–1832
Member of the James Sharples family,
United States or England
Pastel on gray paper, 9 x 7″ (22.9 x 17.8 cm)
B.57.62

P35

Portrait of Thomas Jefferson

ca. 1800–1832
Member of the James Sharples family,
United States or England
Pastel on gray paper; 9 x 7″ (22.9 x 17.8 cm)
B.57.63

James Sharples, an English artist who specialized in making small, cabinet-size pastel portraits, came to the United States with his family in 1793. He and his family worked both in America and England subsequently. Typically, his works are three-quarter or profile view on standard 9-by-7-inch gray paper. Sharples's wife, Ellen, made many copies of her husband's work, as did his children, Felix, James, Jr., and Rolinda. The entire family purposely worked in the same style and none signed his or her work, making it difficult to sort out the individual hands.

DBW

PROVENANCE: Private collection, England; purchased by Miss Hogg from Ginsburg and Levy, New York, 1957.

INSCRIBED (B.57.63, ON BACKBOARD, IN PENCIL): John Adams & Thos Jefferson died on 4th July 1826, the former aged 92 the latter aged 84,

P34

P35

being the 50th Anniversary of the Declaration of Independence. The only person whose name appears as a signer of that important document now surviving is Charles Carroll of Carrollton (?) Charleston.

RELATED EXAMPLES: Portraits of Adams and Jefferson at Independence Hall, Philadelphia (Milley 1975) and at City Art Gallery, Bristol, England (Knox 1972, pp. 99–100).

REFERENCES: B.57.63, Bush 1962, pp. 38–39 (attributes it to another hand than Philadelphia version, perhaps that of Ellen Sharples); B.57.62, advertisement of Ginsburg and Levy, *Antiques* 91 (April 1967), p. 408.

P36

Portrait of a Man

ca. 1804
CHARLES BALTHAZAR-JULIEN FÉVRET DE SAINT-MÉMIN *(1770–1852)*
Black chalk heightened with white on pink paper; 21½ x 15½" (54.6 x 39.4 cm)
B.59.52

The fashion for profile portraits flourished from the 1790s until the early decades of the nineteenth century. Among its best-known practitioners was Saint-Mémin, who immigrated to the United States in 1793 from his native Dijon in the wake of the French Revolution (see also cat. nos. W62, W63).[1] Saint-Mémin set up a profile portrait practice in New York in 1796 with his partner Thomas Blugeut de Valdenuit, another French émigré. There, Saint-Mémin and Valdenuit popularized the profile portrait made with a physiognotrace, an instrument for taking an accurate likeness of a sitter. Valdenuit returned to France in 1797, and Saint-Mémin's family moved to Burlington, New Jersey, in 1798. He assumed the life of an itinerant artist, traveling to Philadelphia, Baltimore, Washington, D.C., Richmond, and Charleston. As he visited these cities, Saint-Mémin was both creating and satisfying the demand for profile portraits, which were relatively inexpensive, accurate, and recalled the classical images of profile portraits in ancient Greco-Roman medals and vase painting.[2] Before permanently settling in his native Dijon in 1814,

P36

Saint-Mémin had created nearly one thousand portraits, of which more than 800 he also engraved.

The identification of the sitter of this portrait is unknown. When John Hill Morgan acquired the portrait in 1917, its sitter was identified as Vice President Richard Mentor Johnson who had served in Martin Van Buren's administration.[3] Morgan then noted the sitter's resemblance to Alexander Smith in a Saint-Mémin portrait engraving (see Related examples), which included Saint-Mémin's inscription naming the sitter and giving the date of 1804; Morgan believed Smith was from Baltimore.[4] In 1975, however, it was discovered that Alexander Smith

could not be found in city directories for Baltimore during the years in which Saint-Mémin might have worked there.[5] Based on the sitter's resemblance to another possible Saint-Mémin subject from Baltimore, David Conyngham Stewart (1775–ca. 1820; see Related examples), a member of the Philpot family of Maryland County, Stewart was offered as an alternative identification to Smith.[6]

PROVENANCE: By tradition belonged to descendants of Vice President Richard Mentor Johnson; auctioned by Stan V. Henkels, Philadelphia, May 28–29, 1917, lot 23; [MacBeth Gallery, New York]; John Hill Morgan; purchased by Miss Hogg from The Old Print Shop, New York, 1959.

1. Miles 1994, pp. xiii–xv.
2. Ibid., pp. 27–35.
3. Object files, letter from Stan B. Henkels,
 Auction Commission Merchant, June 16,
 1917.
4. Object files, letter from John Hill Morgan,
 June 6, 1917. The engraving of Smith ap-
 pears in Dexter 1862, p. 54, no. 390.
5. Warren 1975, pp. 142, 144, no. 266; Saint-
 Mémin worked in Washington, D.C., in
 1804, and so it is possible that Smith was a
 Washington, not Baltimore, sitter (object
 files, letter from Ellen G. Miles, National
 Portrait Gallery, Smithsonian Institution,
 Washington, D.C., September 21, 1976).
6. Object files, letter from Eugenia Calvert
 Holland, Maryland Historical Society, Sep-
 tember 20, 1976. The Stewart portrait is
 published in Pleasants 1947, p. 60.

P37

Portrait of Standish Barry

ca. 1808–11
JACOB EICHHOLTZ (1776–1842), *Philadelphia*
Oil on panel; 6½ x 5" *(16.5 x 12.7 cm)*
Gift of Tiffany and Co., B.67.42

Jacob Eichholtz exemplifies the itinerant,
essentially self-taught artist who practiced
a craftsman's trade until he established
himself as a successful portraitist. Of
German heritage and trained as a copper-
and tinsmith, Eichholtz lived and worked
in Philadelphia and Lancaster, Pennsylva-
nia, and traveled to other cities such as
Baltimore and Pittsburgh to paint. He
contributed to the Neoclassical fashion of
painting profile portraits already popular-

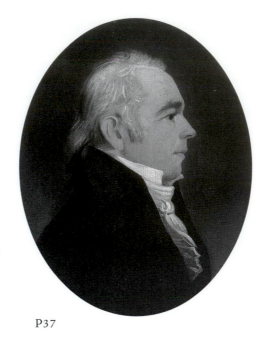

P37

ized by Charles Balthazar-Julien Févret de
Saint-Mémin (see cat. nos. P36, W62, W63)
and the Sharples family (see cat. nos. P34,
P35) during the 1790s and the early 1800s.

The Bayou Bend portrait is one of
Eichholtz's early works, although its so-
phisticated handling suggests it was com-
pleted sometime after 1808. The portrait
depicts the silversmith Standish Barry
(1763–1844), with whom Eichholtz was
close friends.[1] In 1810, Barry changed ca-
reers, leaving silversmithing for the mer-
chant trade, and later becoming a grocer
and sugar refiner. His exact profession
at the time of his portrait sitting is un-
known, but he wears the black waist-
coat and white stock of a fashionable
gentleman.

portraits of the Boston engraver Nathanial
Hurd, ca. 1765, Cleveland Museum of Art, and
the silversmith Paul Revere, ca. 1768, MFA,
Boston; Charles Willson Peale's portrait of the
Philadelphia clockmaker David Rittenhouse,
1772, American Philosophical Society, Philadel-
phia; James Sharples's portrait of the New
York silversmith William Gilbert, private col-
lection; and Charles Balthazar-Julien Févret de
Saint-Mémin's *Portrait of Paul Revere* (cat. no.
W62).

REFERENCES: Antiques 69 (June 1956), p. 480;
Comstock 1959, p. 322.

1. For a biographical sketch of Barry, see
 Pleasants and Sill 1930, pp. 94–98; and
 Goldsborough 1975, pp. 49–50. A tea service
 by Barry (cat. no. M58) is in Bayou Bend's
 collection.
2. See Beale 1969, pp. 10, 319, cat. no. 30.

P38

Portrait of Mrs. John Earnest Poyas

1818–19
SAMUEL FINLEY BREESE MORSE
(1791–1872), *Charleston*
Oil on canvas; 30 x 23⁹⁄₁₆" *(76.2 x 59.8 cm)*
B.67.32

A native of Charlestown, Massachusetts,
Samuel Morse was perhaps the most pop-
ular portraitist working in Charleston,
South Carolina, since Jeremiah Theus (see
cat. no. P13) and John Wollaston (see cat.
no. P12) several generations earlier. A stu-
dent of Washington Allston in London,
Morse produced portraits that evoked the
aristocratic elegance of Gilbert Stuart
(see cat. nos. P31, P32) and his contempo-
rary Thomas Sully (see cat. no. P44). A
founder of the short-lived South Carolina
Academy of Fine Arts, a founding mem-
ber of the National Academy of Design,
New York, and its president from 1827 to
1845 and 1860 to 1862, Morse abruptly
ended his painting career in 1837 to pur-
sue his scientific interests, including the
telegraph, which he invented and
patented the following year.

After failing dismally to break Stuart's
monopoly on the portrait trade in
Boston, Morse traveled to Charleston.
There, he quickly established his reputa-
tion, relinquishing the somber style of
Allston and adopting the elegant virtuos-
ity of Stuart's manner, which had proved

so enduring in Boston: flickering highlights, saturated colors, and fluid brushwork.[1] In his first winter in Charleston in 1818–19, Morse painted Catherine Smith Poyas (1769–1836) and her husband, Dr. John Poyas (1759–1824).[2] A prominent Charlestonian, the wife of a city doctor and owner of a vast slave-holding plantation, Catherine peers out of a brilliantly painted white ruffled cap and ruche that completely frame her head and face, providing stark contrast with her black silk dress and the tiny black tendrils of hair visible underneath her cap. The effect is echoed by the dramatic sky that forms the background. Morse's virtuoso skill in rendering crisp whites and luxurious blacks set off with accents of red in the upholstered armchair and patterned paisley shawl lends a note of aristocratic ease to this rather homely but intelligent-looking sitter, whose aging hand the artist sensitively portrays.

PROVENANCE: The sitter; to her descendants[3]; [purchased by Eunice Chambers, Hartsville, South Carolina from Poyas descendants]; purchased by Miss Hogg from Eunice Chambers, 1967.

FRAME NOTES: The painting probably retains its original Federal-style frame, regilded.

RELATED EXAMPLES: Morse, *Dr. John Earnest Poyas,* 1818, ex coll. Thomas J. Watson (Sotheby's, New York, sale 1517, September 28, 1995, lot 50). Jeremiah Theus presumably painted Catherine Smith as a child, but that portrait is unlocated.[4] This portrait is similar in costume, composition, and background to other Morse portraits of Charleston women, for example, *Mrs. James Ladson,* 1818, the Gibbes Museum of Art, Charleston; and *Martha Pawley LaBruce,* ca. 1819, private collection.

REFERENCES: Warren 1970d, p. 126; Warren 1975, p. 147, no. 272; Staiti 1989, pp. 49, 51.

1. Staiti 1981, pp. 269–73.
2. Catherine was the eldest daughter of Henry and Elizabeth Ball Smith, wealthy and prominent plantation owners. In four months, Morse started fifty-three portraits of prominent Charleston sitters before returning to Charlestown, Massachusetts, to marry Lucretia Pickering (Kloss 1988, p. 50). He completed his portrait of John Poyas in Charleston, but carried his unfinished portrait of Catherine north. Presumably, Morse brought the picture with him when he returned to Charleston that winter (Staiti 1989, p. 51).

3. The Poyases had six surviving children, in whose hands the portrait descended.
4. See Middleton 1953, p. 166.

P39

Portrait of a Woman

ca. 1820
SAMUEL LOVETT WALDO (1783–1861), New York
Oil on scored panel[1]; 35¾ x 27⅝" (90.8 x 70.2 cm)
B.67.37

Connecticut-born Samuel Waldo received artistic training from the painter Joseph Steward in Hartford before beginning his career as a portrait painter. After brief stints painting portraits in Hartford and Litchfield, Connecticut, and Charleston, South Carolina, Waldo traveled to London to study with Benjamin West (see cat. nos. P24, P25) and at the Royal Academy, where he absorbed the painterly qualities of the British portraitist Thomas Lawrence (1769–1830). Waldo returned in 1809 to New York, where he became a respected portraitist. William Jewett (1792–1874), by training a coach painter, became Waldo's apprentice in 1812 and his partner in 1817. Together, Waldo and Jewett formed one of the most artistically and commercially successful portrait studios in nineteenth-century New York. Between 1817 and 1854, Waldo and Jewett painted prominent New York families, celebrities, and dignitaries, and both became associate members of the National Academy of Design, New York. Waldo, the superior artist, usually painted the sitter and Jewett the props, costumes, and background.[2]

This portrait, when acquired, was attributed to Samuel Waldo alone. In 1975, the painting was assigned to both artists on the basis that they were in partnership by the time this portrait was painted. Throughout his career, Waldo painted portraits independently of his partner, and Marcia Goldberg has suggested that this portrait may be by Waldo alone, based on its similarity to other portraits of young women of this same period; further, she argues for a date of about 1820 because of the sitter's costume.[3]

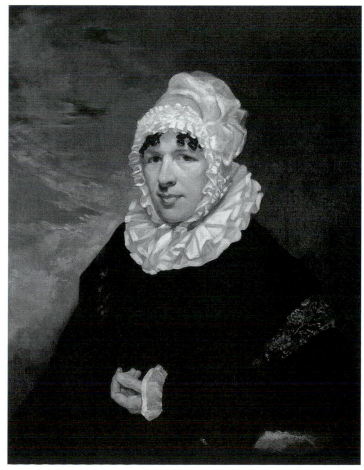

P38

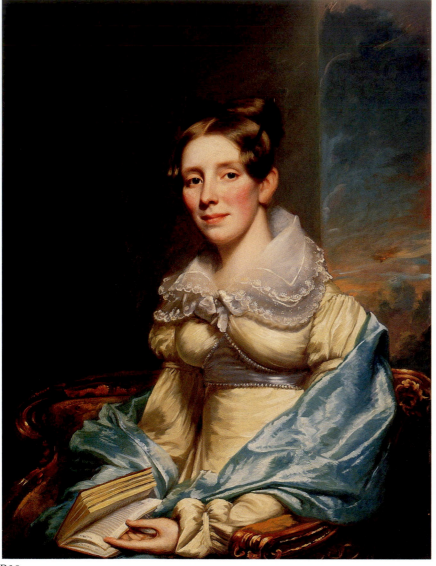

P39

Although the identity of this sitter has eluded scholars, she is depicted as a fashionable, cultivated, and wealthy woman, posed against a dramatic background sky and seated on a bergère. She looks up from her reading to meet the viewer's gaze, her long, graceful fingers marking her place in her book. Her elegant yellow dress suggests the taste for Empire-style dress made fashionable by Empress Josephine during Napoleon's reign. With a sure hand and painterly brio, the artist has suggested the rich qualities of the various fabrics and textures—the light silks and transparent lace double collar, the sheen of her upswept hair, and her delicate skin. The bravura handling of this painting characterizes Waldo's strongest work.

PROVENANCE: [Victor D. Spark, New York, ca. 1964][4]; Mrs. A. G. Smith[5]; purchased by Miss Hogg from James Graham and Sons, New York, 1967.

EXHIBITED: "The American Scene, 1800–1900," the Fine Arts Museums of San Francisco, July 4–August 16, 1964 (as a work by Waldo); "The Masterpieces of Bayou Bend, 1620–1870," Bayou Bend Museum of Americana at Tenneco, Houston, September 22, 1991–February 26, 1993.

RELATED EXAMPLES: Those by Waldo include *Mrs. John Gamble,* ca. 1816, Munson-Williams-Proctor Institute, Utica, New York; and *Hester Hanford,* early 1820s, Albany Institute of History and Art.[6]

REFERENCES: Warren 1970d, p. 126 (as a work by Waldo); Warren 1975, p. 146, no. 270 (as a work by Waldo and Jewett).

1. Some artists, notably Gilbert Stuart, used the practice of texturing the surface or ground of panel paintings in the first decades of the nineteenth century. Both Waldo and Jewett often prepared their surfaces in this way. This portrait has been diagonally scored, either in the ground or in

the panel, probably for its textured effects (see Goldberg 1993, pp. 33–42; and Currie 1995, pp. 69–75).

2. See Sherman 1932, pp. 17–18, for a discussion on the difficulty in distinguishing the artists' hands.

3. Object files, letter from Marcia Goldberg, affiliate scholar, Oberlin College, Oberlin, Ohio, August 5, 1994. Elizabeth Ann Coleman provided detailed information about the Empire-style dress that the sitter wears in this portrait.

4. According to a 1964 loan agreement to the exhibition "The American Scene, 1800–1900" (object files, letter from Janice R. Hellman, archives assistant, the Fine Arts Museums of San Francisco, March 23, 1983).

5. According to a pencil inscription on the back of the panel.

6. I thank Marcia Goldberg for providing information regarding related portraits.

P40

Portrait of Mrs. John Trumbull

1820–23

JOHN TRUMBULL *(1756–1843), New York*
Oil on panel; 24⅛ x 19¾" (61.3 x 50.2 cm)
Museum purchase with funds provided by the Theta Charity Antiques Show, B.91.25

Among the most important artists and cultural figures in American history, John Trumbull sprang from aristocratic roots in Lebanon, Connecticut, graduated from Harvard College, rose to the rank of colonel in the Revolutionary War, and moved to Boston during the war to embark on a painting career. Trumbull took several trips to England, visiting Benjamin West (see cat. nos. P24, P25) and John Singleton Copley (see cat. nos. P15–P23), both of whom advised this young, ambitious, and well-educated artist. After vigorous efforts in England and the United States to paint the most significant events of the Revolutionary War, Trumbull engaged in a brief career in diplomacy beginning in 1794 before returning to his brush in 1800, the same year he married Sarah Hope Harvey Trumbull (1774–1824), the subject of this portrait. The couple moved to New York, where they lived from 1804–8, and again from 1815 until his death in 1843. In 1817, he received the commission to paint four of the eight paintings in the Capitol Rotunda that commemorate the

Revolutionary War. Trumbull served on the board of the American Academy of Fine Arts, New York, and was its president for nineteen years. His increasingly dogmatic prescriptions for the advancement of the arts alienated younger generations, and toward the end of his life, his professional disappointments and bleak financial situation prompted him to enter into an unusual but significant agreement: to donate all of his works and papers to Yale College in exchange for a lifetime annuity. The Trumbull Gallery, originally built in 1832 and now part of the Yale University Art Gallery, was the first college art museum built in this country.

Trumbull painted his wife, about whom little is known, at least thirteen times.[1] Scholars have suggested that she was previously married to someone with the surname Harvey and that Trumbull may have found himself in a situation in which he was obliged to marry her.[2] Evidently anxious about the reception his wife would receive at home among his aristocratic friends and family, he sent home as a kind of introduction a portrait of his bride dressed elegantly in white, clutching a cross at her breast (*Sarah Trumbull in a White Dress,* ca. 1800, Mrs. Charles Higgins), followed by an apologetic letter to his brother Jonathan in which he provided some scant biographical information about her.[3] He described her as "beautiful beyond the usual beauty of women!" and seems to have remained devoted to her despite her bouts of emotional instability and alcoholism.[4]

Sarah Trumbull was almost fifty when her husband painted her here, dressed in black with a brilliant white stand-falling ruff, or layered collar, its vivid whites are echoed in her lace-edged cuffs and cap. Her narrow face, the down-turned ends of her eyes, the thin, angular nose, and pronounced curves of her lips are familiar features in the many portraits of her Trumbull painted. The portrait perhaps suggests the artist's ideal image of his wife as a feminized, demure beauty and, in this regard, makes an interesting comparison with George Romney's serial paintings of Emma, Lady Hamilton, which Trumbull would have known from his journey to London in the 1780s.

PROVENANCE: The artist's brother David Trumbull (1751/52–1822), Lebanon, Connecticut[5];

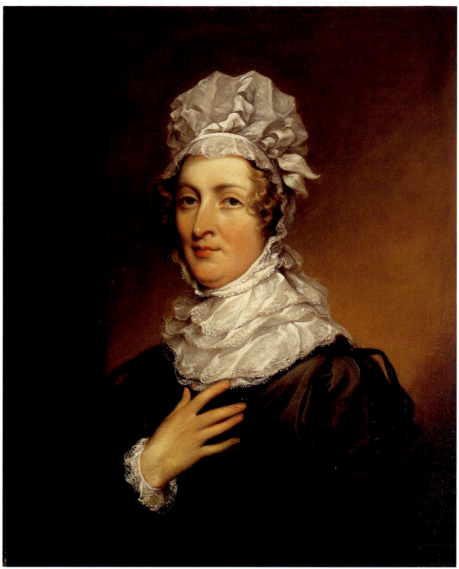

P40

to his daughter Mrs. Peter Lanman (Abigail Trumbull, 1781–1861), Lebanon, Connecticut[6]; to her daughter Mrs. Frederic Bull, Connecticut; to her son William Lanman Bull, New York; to Frederic Bull, New Canaan, Connecticut; to Mrs. Helen Bull Richardson, New York; auctioned at Sotheby Parke Bernet, New York, sale 4038, October 27, 1977, lot 1; purchased by Mr. and Mrs. George Arden; to Mrs. George Arden, until 1983; purchased by Bayou Bend at Christie's, New York, sale 7304, May 22, 1991, lot 1.

EXHIBITED: "The Masterpieces of Bayou Bend, 1620–1870," Bayou Bend Museum of Americana at Tenneco, Houston, September 22, 1991–February 26, 1993.

RELATED EXAMPLES: The most closely related of Trumbull's thirteen other portraits of his wife are *Mrs. John Trumbull as "Innocence,"* 1816–24, Yale University Art Gallery, New Haven; *Miniature of Mrs. Trumbull,* private collection[7]; and *Mrs. John Trumbull in a Lace Cap,* Lt. Col. Trumbull Warren, Corwhin Acres, Puslinch, Ontario.[8] Also, a pencil sketch of

Sarah as "Innocence," ca. 1816, is included in "Trumbull's Autobiography interleaved with extra original drawings" (Sterling Memorial Library, Yale University, New Haven).

REFERENCES: Sizer 1950, p. 56; Sizer 1967, p. 73; Jaffe 1975, p. 313.

1. Sizer 1967, pp. 73–74; Cooper 1982, pp. 156, 159, 163, 168–69, cat. nos. 112, 115, 118, 122.
2. Jaffe 1975, pp. 194–95.
3. Trumbull wrote that Sarah had lost her parents at a young age, that she was passed to several households, where she learned reading, writing, and the fundamentals of "housewifery." "You will not," he wrote, "therefore expect to see a modern fine Lady" (ibid., p. 191).
4. Quoted in ibid., pp. 191, 195–97.
5. For genealogical information about the Trumbull family, see Cutter 1911, vol. 1, pp. 404, 463.
6. Mrs. Lanman also owned *Mrs. John Trumbull in a White Dress* (Mrs. Charles Higgins, New York). See Jaffe 1975, p. 312.

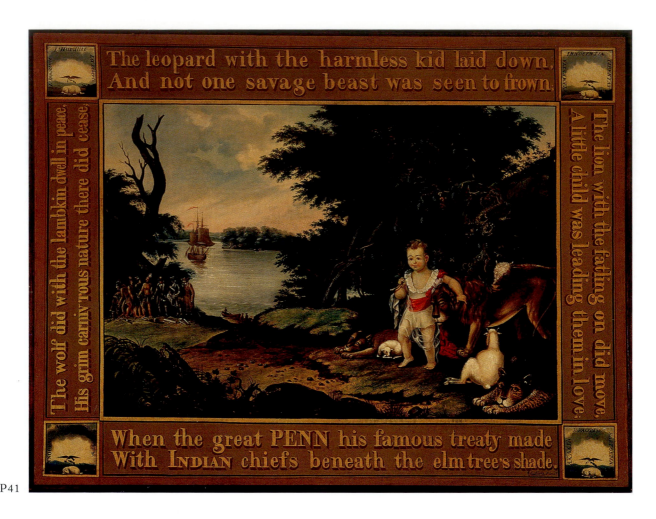

The leopard with the harmless kid laid down,
And not one savage beast was seen to frown.

The wolf did with the lambkin dwell in peace.
His grim carnivrous nature there did cease.

The lion with the fatling on did move,
A little child was leading them in love;

When the great PENN his famous treaty made
With INDIAN chiefs beneath the elm tree's shade.

P41

7. According to Sizer, this miniature is identical to the Bayou Bend portrait (Sizer 1967, p. 73; and Jaffe 1975, p. 313).

8. This version of the portrait of Sarah is probably the one once belonging to Benjamin Silliman, Trumbull's nephew-in-law, who was instrumental in Yale's acquisition of the Trumbull Gallery in 1832 (see Jaffe 1975, p. 313; and Cooper 1982, pp. 17–18).

P41

Peaceable Kingdom

ca. 1826–28
EDWARD HICKS *(1780–1849), Bucks County, Pennsylvania*
Oil on canvas; 32⅜ x 42⅜" (82.2 x 107.6 cm)
B.54.1

An appreciation for American folk art, a problematic term that refers to art made by untrained, so-called naive artists, burgeoned in the 1920s and 1930s as artists and scholars identified this kind of art as an ancestor of modernist American styles of the period. Foremost among these artists was Edward Hicks, the nineteenth-century Quaker preacher and coach and sign painter, whose fascination with the religious theme of the peaceable kingdom from 1826 to 1849 constitutes one of the most popular and complex stories in American art.

Given his strong sense of duty to his religion, which considered painting suspect, Hicks concentrated on painting subjects of direct relevance to his religion and politics, specifically, the theme of the peaceable kingdom. The concept of a peaceable kingdom derives from the prophecy of Isaiah (Is. 11:6–8), who foretold a time in which peace, wisdom, and understanding between peoples would reign supreme.[1] Hicks's versions of the theme include a child, a wolf and lamb, a leopard and kid, a calf (or oxen) and lion, as well as, as in the Bayou Bend version, an image of the Delaware Water Gap with a sailing vessel in the distance and the Quaker William Penn signing a treaty with the Indians. Hicks saw this historical "event" as the partial fulfillment of Isaiah's prophecy in which Quakers established a peaceable kingdom on earth.

The earliest date for a firmly documented version of a *Peaceable Kingdom* is 1826 (PMA). The various *Peaceable Kingdoms,* numbering over sixty, have been classified according to four types.[2] The earliest group is composed of the *Peaceable Kingdoms* "of the branch" (ca. 1825/26–30), showing a child with a grapevine, a reference to wine and, by extension, the blood of Christ as a symbol of atonement. Hicks borrowed this figure from the popular illustrated version of the Bible, available in Philadelphia after 1815, by British artist and Royal Academy member Richard Westall (1765–1836). By appropriating Westall's image, Hicks invested high art with local meaning.

The Bayou Bend painting is of the second type (see Related examples), executed between 1826 and 1830, which included rhymed borders combining the events of Isaiah with those of Penn's treaty.[3] The third group includes Quakers bearing banners (ca. 1827–35), followed by *Peaceable Kingdoms* in which the centrality of the child is replaced by the animals mentioned in Isaiah, specifically the ox and the lion.

The second type is especially provocative. As Hicks scholar David Tatham points out, the rhyming couplets that

appear on the second type are "a product of partisan calculation rather than naivete" because they do not treat the Scriptures as Holy Writ, as Orthodox Quakers upheld.[4] In fact, Hicks's treatment of the peaceable kingdom theme during these years suggests his support of the Hicksite cause over that of Orthodox Quakers.[5] The *Peaceable Kingdoms* that include the couplets, then, should be seen as an expression of strong political and religious beliefs and, in the context of the period, a form of Hicksite propaganda.

INSCRIBED: The leopard with the harmless kid laid down, / And not one savage beast was seen to frown; // The wolf did with the lambkin dwell in peace, / His grim carniv'rous nature there did cease; // The lion with the fatling on did move, / A little child was leading them in love; // When the great PENN his famous treaty made / With INDIAN chiefs beneath the elm tree's shade (on painted frame); illustrations of a dove and a lamb, and the words, Meekness, Innocence, and Liberty, written in English, French, Latin, and Greek (on corner blocks); Edw Hicks Pinxt (lower right).

PROVENANCE: A friend of the artist, Amos Campbell, Newtown, Bucks County, Pennsylvania; to his great-granddaughter Mrs. Henrietta C. Collins, Haddonfield, New Jersey; [possibly to Robert Carlen, Philadelphia][6];

purchased by Miss Hogg from Hirschl and Adler Galleries, New York, 1954.

EXHIBITED: "Two Hundred Years of American Art," Hirschl and Adler Galleries, New York, January 13–February 20, 1954, no. 11; "In Quest of Excellence," Center for the Fine Arts, Miami, January 12–April 22, 1984.

RELATED EXAMPLES: There are six other known versions of this theme with rhymed borders: Friends Historical Library of Swarthmore College, Swarthmore, Pennsylvania; PMA; Abby Aldrich Rockefeller Folk Art Center, Williamsburg, Virginia; New York State Historical Association, Cooperstown, New York; and two in private collections.

REFERENCES: House and Garden 1973, p. 92; Warren 1975, p. 145, no. 268; Warren 1982, p. 231; Mather and Miller 1983, p. 103, no. 10; Ford 1985, p. 73.

1. The passage in Isaiah reads: "The wolf will live with the lamb, / the leopard will lie down with the goat, / the calf and the lion and the yearling together, / and a little child will lead them. / The cow will feed with the bear; / their young will lie down together; / and the lion will eat straw like the ox. / The infant will play near the hole of the cobra, / and the young child put his hand into the viper's den."
2. Mather and Miller 1983. For a discussion of Hicks's theology, see Mather 1973, pp. 84–99.
3. Here, Hicks was clearly inspired by Ben-

jamin West's celebrated painting of the same theme (1771, Pennsylvania Academy of the Fine Arts, Philadelphia), which was engraved by John Ball for the London print publisher John Boydell. See cat. no. P42.
4. Tatham 1981, pp. 44–45.
5. Elias Hicks, the artist's cousin and charismatic Quaker preacher, withdrew from the Quaker Orthodoxy following accusations of heresy; he believed that the Bible and its stories were a form of allegory and that the source of salvation was the "inner light," not the literal act of Christ dying on the cross. Thus, two of Edward Hicks's paintings show Quakers with banners that read, "Mind the light within" (ex coll. Dorothy C. Miller, now private collection) and "Mind the light" (Winterthur).
6. According to Mather and Miller 1983, p. 103.

P42

Penn's Treaty with the Indians

ca. 1830–40
EDWARD HICKS *(1780–1849), Bucks County, Pennsylvania*
Oil on canvas; 17⅝ x 23⅝" (44.8 x 60 cm)
Gift of Alice C. Simkins in memory of Alice Nicholson Hanszen, B.77.46

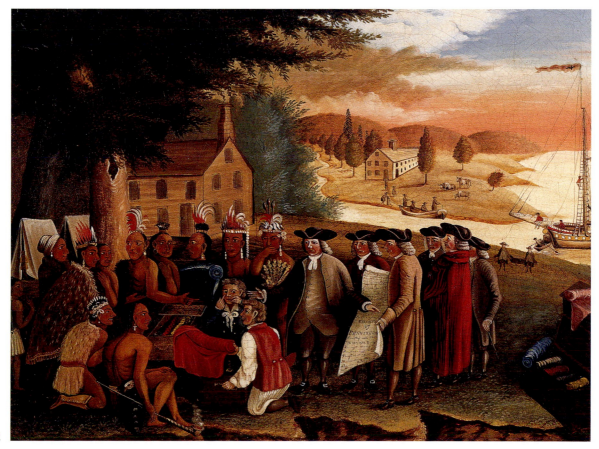

P42

Besides his *Peaceable Kingdoms,* Edward Hicks painted signal events in American history, including *Washington Crossing the Delaware,* the *Declaration of Independence,* and, most famously, *Penn's Treaty with the Indians.* This latter theme provided Hicks with a political and historical "event" that he could cite as an example of the partial fulfillment of biblical prophecy of a peaceable kingdom on earth. After about 1830, Hicks began to paint the scene individually for his Quaker friends.

The event portrayed refers to the disembarkation of the Quaker William Penn in 1682 and his meeting with Native Americans in Delaware at Shackamaxon to exchange gifts for land. Quakers viewed this meeting as a model of mutual consent, which they believed should rule future negotiations with the indigenous civilizations. In fact, Penn did meet with the Lenape Indians, but no documentation of a treaty exists. The story is now thought to be apocryphal, and Benjamin West's version of the event an eighteenth-century idealization of colonial relations.

In the painting, the portly Penn stands at center, pointing to the charter, surrounded by his Quaker colleagues, who include Penn's secretary James Logan (holding the scroll), the Quaker minister Thomas Story (behind Penn), and the deputy governor Thomas Lloyd (cloaked).[1] At left, the Lenapes survey the presents assembled, including bolts of cloth and a tray filled with Jew's harps, their function demonstrated by one of Penn's company. The use of Jew's harps is unusual in Hicks's works; it probably came from a biography of William Penn by Mason L. Weems ("Parson Weems"), who asserts that one hundred of these instruments helped to pay for Pennsylvania land. Penn's landing on Dock Street is featured in the background and derives from another print source included in John F. Watson's *Annals of Philadelphia and Pennsylvania* (1830).[2]

INSCRIBED (ON SCROLL): CHARTER OF PENNSYLVANIA Treaty with the INDIANS [followed by indecipherable writing].

PROVENANCE: Jacob Paxson Temple, Tanguy, Chester County, Pennsylvania; [Anderson Galleries, New York]; auctioned at Anderson Galleries, New York, *The Jacob Paxson Temple Collection of Early American Furniture and Objects of Art,* January 23–28, 1922, lot 1319; purchased by

Will C. Hogg (1875–1930), 1922; to his brother, Mike Hogg (1885–1940); to his wife, Alice Nicholson Hogg, later Mrs. Harry Hanszen (1900–1977), Houston; to her niece Alice C. Simkins, San Antonio.

EXHIBITED: "New World, New Visions," Santa Barbara Museum of Art, Santa Barbara, California, June 6–August 11, 1991.

RELATED EXAMPLES: Abby Aldrich Rockefeller Folk Art Center, Williamsburg, Virginia; Thomas Gilcrease Institute of American History, Tulsa, Oklahoma; Mercer Museum of the Bucks County Historical Society, Doylestown, Pennsylvania; Delaware County Historical Society, Chester, Pennsylvania; Shelburne Museum, Shelburne, Vermont; NGA; Meyer P. Potamkin, Philadelphia; private collection, New York (ex coll. The Dietrich American Foundation, Philadelphia). Four others are owned anonymously.[3]

REFERENCES: *Antiques* 113 (June 1978), p. 1257; Agee et al. 1981, p. 95, no. 166; Warren 1982, p. 229; Mather and Miller 1983, pp. 50, 176, cat. no. 87; Brown 1985, pp. 514–15; Ford 1985, p. 121; American Folk Paintings 1988, p. 271; Marzio 1989, pp. 268–69; Chotner 1992, p. 191.

1. Chotner 1992, pp. 189–91.
2. Object files, letter from Eleanor Price Mather, December 27, 1977. The print is in vol. 1, facing p. 127.
3. Chotner 1992, p. 191.

P43

P43

Portrait of Andrew Jackson

ca. 1835
RALPH E. W. EARL *(ca. 1785–1838),*
Washington, D.C.
Oil on canvas; 28⅜ x 22⁵⁄₁₆" (72.1 x 56.7 cm)
Gift of Miss Ima Hogg in memory of Margaret Trousdale Caldwell, B.68.22

For eight years, Ralph Eleaser Whiteside Earl, son of Ralph Earl (see cat. no. P33), lived in the White House, where he satisfied the enormous demand for portraits of the seventh president of the United States, Andrew Jackson (1767–1845).[1] This portrait relates to four others of the same sitter (see Related examples). Here, in contrast to earlier versions, Earl reduced the props and background detail considerably. Like most, if not all, of Earl's portraits of Jackson, this portrait likely belonged to Andrew Jackson Donelson, a member of the president's staff, and the nephew of the president's wife, Rachel Donelson Jackson.

PROVENANCE: Probably Andrew Jackson Donelson (Andrew Jackson's secretary and Rachel Jackson's nephew); to his son William Alexander Donelson; to his widow, Bettie M.

Donelson; purchased by Rogers Clark Caldwell, 1940[2]; purchased by Miss Hogg from Caldwell's estate, 1968.

RELATED EXAMPLES: Earl painted four other portraits of Jackson that relate stylistically to Bayou Bend's: the Hermitage, Hermitage, Tennessee[3]; Pennsylvania Academy of the Fine Arts, John Frederick Lewis Memorial Collection, Philadelphia; Friends of Linden Place, Bristol, Rhode Island; and a private collection.

REFERENCES: Warren 1970d, p. 126; Warren 1975, p. 147, no. 271; Barber 1991, pp. 25, 231, fig. 203.

1. See MacBeth 1971 and Bumgardner 1986.
2. Object files, letter from Sharon Macpherson, curator of research, the Hermitage, Hermitage, Tennessee, August 17, 1988.
3. Caldwell apparently owned three portraits of Andrew Jackson. One is by George Catlin (private collection) and two are by Earl (Bayou Bend and the Hermitage, Tennessee). The two Earl portraits were sold in 1968 or 1969 as part of Caldwell's estate. The Hermitage portrait is illustrated in Barber 1991, p. 232, fig. 206.

P44

Portrait of James Cornell Biddle

1841
THOMAS SULLY *(1783–1872), Philadelphia*
Oil on canvas; 36¼ x 28⅛" (92.1 x 71.4 cm)
Museum purchase with funds provided by Miss Ima Hogg and Hirschl and Adler Galleries by exchange and the Friends of Bayou Bend, B.81.11

The son of English actors who immigrated to Virginia, Thomas Sully received training from a miniaturist before traveling to New York to paint portraits and venturing to Boston to receive advice from the eminent Gilbert Stuart (see cat. nos. P31, P32). Travel abroad to study with Benjamin West (see cat. nos. P24, P25) in London soon followed. After meeting the British portraitist Thomas Lawrence (1769–1830), whose elegant and romantic sense of swagger he soon emulated, Sully returned to Philadelphia in 1810 and became its leading artist for more than thirty years.

Over the course of his long career, Sully painted nearly sixty portraits for the extended family of the prominent Biddles of Philadelphia. James Cornell Biddle (1795–1838), the eleventh of twelve children born to Clement and Rebekah Cornell Biddle, was among the last ten Sully painted of the Biddle family.[1] James had died three years before, and so, according to Sully's register of portraits (in the Historical Society of Pennsylvania, Philadelphia), the artist used an existing portrait of the sitter by Henry Inman as his guide (see Related examples).[2] The portrait was likely commissioned by a member of the Biddle family to commemorate their recently deceased relation.

Sully's portrait of Biddle is an excellent example of the artist's ability to flatter his sitters with a sense of relaxed elegance, a quality recognized by the early American art critic Henry Tuckerman, who wrote, "All of his [Sully's] men, and especially his women, have an air of breeding, of high tone, and a genteel carriage. . . . One always feels at least in good society among his portraits."[3] Averting his head from the viewer, exposing his Byron-like windswept hair and long sideburns, Biddle cuts an elegant figure, dressed in a black, double-breasted coat and white stock, sitting in a red-figured upholstered chair, and set against the standard props of portraiture: a swag of drapery, a plain column, a brilliant sky, and, in his lap, a book, in which the sitter marks his place as he pauses from reading. Dramatic lighting from above sweeps across the

P44

sitter's face and animates the brilliant white stock at his neck. The bravura quality of the painting is exceptional for Sully's late works.

The Inman prototype is lost, but a study for the painting exists, which is virtually identical to the Houston portrait in costume, props, and composition, suggesting Sully possibly copied the Inman portrait.

PROVENANCE: The Biddle family[4]; to Catherine Meredith C. and Sarah Biddle, Philadelphia, by 1921; Biddle family descendants, until 1976; purchased by Bayou Bend from Hirschl and Adler Galleries, New York, 1981.

EXHIBITED: "Recent Acquisitions of American Art: 1769–1938," Hirschl and Adler Galleries, New York, March 3–31, 1979, no. 10; "The Masterpieces of Bayou Bend, 1620–1870," Bayou Bend Museum of Americana at Tenneco, Houston, September 22, 1991–February 26, 1993.

RELATED EXAMPLES: Henry Inman (1801–1846), *Portrait of James Cornell Biddle,* ca. 1831–34, location unknown[5]; Thomas Sully, *Study for James Cornell Biddle,* 1841, Cooper-Hewitt Museum, New York.

REFERENCES: Hart 1909, p. 128, no. 126; Biddle and Fielding 1969, p. 98, no. 130 (mentions that the portrait was owned by the Misses Catherine Meredith C. and Sarah Biddle); *Antiques* 125 (June 1984), p. 1294; Brown 1985, pp. 514–25, pl. 3.

1. Biddle and Fielding 1969, pp. 98–101, passim. James Cornell Biddle was a prominent Philadelphia attorney. The Biddle family also patronized the portraitist Jacob Eichholtz (see cat. no. P37).
2. The entry reads: July 8 / Kit Kat / Jas. C. Biddle, deceased, from Inman / 300 / July 16. According to his register, Sully worked on the portrait from July 8 to 16, 1841, and received three hundred dollars.
3. Tuckerman, 1867, p. 159.
4. The great-great-grandson of William and Sarah Kempe Biddle, Quaker immigrants to the Pennsylvania colonies, James Cornell Biddle married Sarah Caldwell Keppele in 1825, uniting two prominent Philadelphia families. If this portrait was commissioned from an immediate family member, it may have descended in the family of one of their six children.
5. The Frick Art Reference Library lists Elizabeth C. Biddle (d. 1947) as the owner of the Inman portrait in 1927. Efforts to locate the portrait through Inman scholar William Gerdts and through Biddle family members have proved unfruitful. Gerdts suggests that the Inman portrait may bear a date earlier

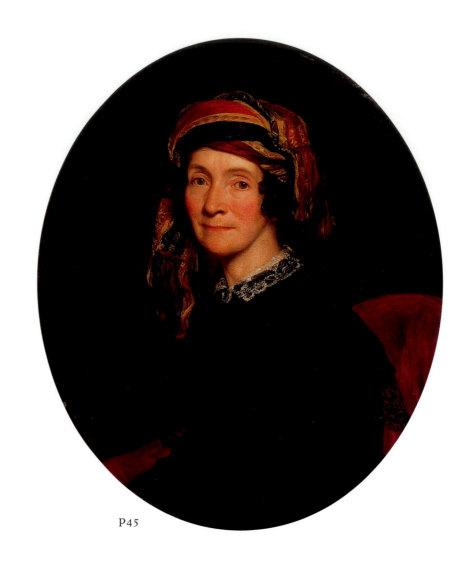

P45

than 1831–34, inasmuch as Inman painted Philadelphia sitters before he worked there between 1831 and 1834 and because the costume suggests a slightly earlier date (object files, letter from William Gerdts, March 8, 1990).

P45

Portrait of Mrs. Jonathan Russell

ca. 1845
GEORGE PETER ALEXANDER HEALY
(1813–1894), Boston
Oil on canvas; oval: 30 x 25" (76.2 x 63.5 cm)
B.71.39

Son of an Irish immigrant sea captain in Boston, George P. A. Healy taught himself the rudiments of painting and established a portrait trade in Boston, where he came to the attention of Thomas Sully (see cat. no. P44), who encouraged him to study abroad.[1] After studying in the atelier of Antoine-Jean Gros in Paris and tak-

ing the Grand Tour of Europe, Healy began his long and prolific career as a fashionable and celebrated international portraitist, known for his virtuoso talent, speed of execution, and charming demeanor.[2] In 1842, Healy began a series of trans-Atlantic crossings to Washington, D.C., and Boston to paint American presidents and dignitaries for King Louis-Phillipe of France's Versailles Gallery. On one of these Boston sojurns, he painted the widow Lydia Smith Russell, the subject of Bayou Bend's portrait.

Lydia Smith Russell (1786–1859) was a worldly, cultured, well-educated artist. The daughter of Barney Smith and Ann Otis, Lydia lived in France and England as a child and studied with Gilbert Stuart (see cat. nos. P31, P32).[3] According to family tradition, she also studied with Benjamin West (see cat. nos. P24, P25). While in France, Lydia studied at the rigorous school of Madame Campan, whose philosophy for raising young women was, in her own words, to "not give way to a belief of the impossibility of uniting, in a

girl perfectly educated, accomplishments and duties, which general opinion falsely deems incompatible. . . ."[4] In 1817, Lydia became the second wife of Jonathan Russell (1771–1832) of Providence, Rhode Island, who earlier had served as chargé d'affaires in Paris (1810) and London (1811) and as commissioner to negotiate peace with Great Britain to end the War of 1812.[5]

Lydia had been a widow for at least ten years when Healy painted her. She is seated in a crimson-colored upholstered armchair, dressed in an elegant black dress trimmed with black lace off the shoulders and white lace at the neck. Shot through with red, green, and gold, a fanciful turban knotted around her head, its tassels dangling at the sides to frame her face, adds an exotic touch to a rather dignified and restrained portrait, in which Lydia turns toward the viewer with alert yet mournful eyes and just the hint of a smile.

This fanciful headgear is related to the eighteenth-century fashion for dressing "à la turque," a vaguely Turkish style popular at London masquerade parties and later revived following Napoleon's return from Egypt.[6] Of course, turbans worn by American women sitters had a long history before Healy, including Thomas Sully's bravura portrait of his Baltimore patron Mrs. Robert Gilmor (1823, Gibbes Museum of Art, Charleston) and Charles Bird King's *Portrait of Mrs. Samuel Harrison Smith* (1829, Redwood Library, Newport). The Healy portrait is perhaps most similar to Sarah Miriam Peale's portrait *Mrs. Richard Cooke Tilghman* (ca. 1830–33, Baltimore Museum of Art), in which the Baltimore sitter is portrayed within an oval format wearing a plain black dress, a white scarf at the neck, and a fanciful turban.[7] Given Lydia's artistic accomplishments, it is tempting to associate her wearing a turban with the paintings of turban-clad "Turkish bathers" by Jean-Auguste-Dominique Ingres (1780–1867), the dominant artist of France during her own artistic coming-of-age.

PROVENANCE: The sitter; to her daughter Rosalie Genevieve Russell (1822–1897), Milton, Massachusetts; to the niece of her sister Mrs. George Rivers (Geraldine Russell), Mary Rivers, Milton, Massachusetts, until 1917; to her nephew Robert Wheaton Rivers, Santa Barbara, California; purchased by Miss Hogg from Kennedy Galleries, New York, 1971.

FRAME NOTES: The painting retains its original oval, gilded frame, constructed of eastern white pine, and includes in its design tooled composition ornament with a repeated anthemion and flower pattern.

EXHIBITED: "The Voyage of Life," Bayou Bend Museum of Americana at Tenneco, Houston, September 22, 1991–February 26, 1993.

RELATED EXAMPLES: George P. A. Healy, *Mrs. Andrew Stevenson*, ca. 1839, Virginia Historical Society, Richmond[8]; Gilbert Stuart, *Lydia Smith*, ca. 1807, private collection.

REFERENCES: *Kennedy Quarterly* 9, no. 4 (May 1970), p. 263, no. 265; Warren 1971b, pp. 30, 36; Warren 1975, p. 148, no. 274.

1. The literature on this artist is slim; standard references include Healy 1894; and his granddaughter's account of his life and art in De Mare 1954.
2. Healy's distinguished sitters included King Louis-Philippe of France, Otto von Bismarck of Germany, and Pope Pius IX of Rome.
3. Stuart had painted and would soon paint other members of her family over the course of his career. Stuart painted young Lydia about the time he painted the aunt for whom she was named, Lydia Otis Smith.
4. Quoted in Deutsch 1989, p. 742. In 1806, Lydia received a medal for drawing from Napoleon.
5. It is possible that the Smith family, as Americans abroad, knew Russell in these early years of his career. From 1814 to 1818, Russell served as the United States minister to Norway, until the couple returned to the United States permanently, and Russell served briefly as a United States Congressman before political intrigue ended his career (*Dictionary of American Biography*, vol. 8, part 2, s. v. "Jonathan Russell," p. 245).
6. See Ribeiro 1984, pp. 174–78; also, Pointon 1993, pp. 141–57. The turban, which revived in popularity around 1800, following Napoleon's return from Egypt, was often referred to as a "mameluke," named after the warriors who dominated Egypt (see le Bourhis 1989, pp. 222, 226). Judging by American portraiture and fashion magazines, the turban or mameluke, with its exotic and romantic associations with distant cultures and romantic poets, remained popular well into the 1840s. It appears to have been worn in the evening by married or older women, as is the case with Bayou Bend's sitter (see Byrde 1992, pp. 37, 45).
7. This composition is similar to the format and dress of an unlocated and undated portrait by James Wood of President James Madison's fashionable wife, Dolley Payne Madison (known through a contemporaneous print by James Herring), which suggests the role the First Lady had in establishing high fashion during her tenure in the White House.
8. In a letter to her sisters, Mrs. Andrew Stevenson (Sarah Coles) mentioned that Healy portrayed her in "a gold turban very like the one I sent you & c. & c.," which confirms the continuing fashion for the turban, and that it was the sort of garment worn and owned by Healy's sitters (see Hall 1981, p. 232).

P46

Portrait of Zachary Taylor

ca. 1850
UNKNOWN ARTIST
Reverse oil painting on convex glass; oval: 2⅛ x 1⅝" (5.4 x 4.1 cm)
B.69.202

This portrait of Zachary Taylor is an example of reverse painting on glass in the format of a portrait miniature—a very rare combination. Portrait miniatures were immensely popular in America from the mid-eighteenth to the mid-nineteenth century. Following the invention of the daguerreotype in 1839, the fascination with photographic images began to eclipse the popularity of portrait miniatures, most of which were painted in watercolor on ivory. During this time, many miniature painters redirected their skills to coloring photographs; some even

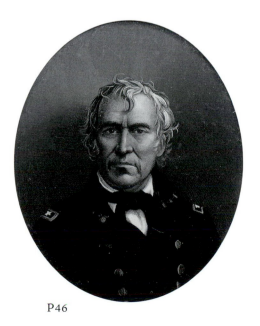

P46

became photographers themselves. This image of Zachary Taylor may be the work of such an artist. Referring to an engraving after a daguerreotype portrait from the 1840s, the artist first copied the engraved lines onto the glass and then applied paint—highlights and details first and background last. A similar effect could be achieved by a process known as print transfer, a technique that involved transferring a wet print onto a glass surface, removing the paper, and painting over the lines that remained. This work, however, was not produced as a print transfer and is not the work of an amateur. The artist possessed the technical skill found in the best examples of reverse paintings on glass, traditional portraiture, and portrait miniatures.

Nicknamed "Old Rough and Ready," Zachary Taylor (1784–1850) was a hero of the Mexican War following the annexation of Texas by the United States in 1845. Taylor became the nation's twelfth president in 1849, serving only sixteen months before he died in 1850.

<div style="text-align:right">FF/EBN</div>

1. The only earlier known history is that Mr. Kuntz purchased the miniature about 1950–52 from a dealer in Stroudsburg, Pennsylvania.
2. According to William F. Stapp, curator of photographs at the National Portrait Gallery, Washington, D.C. (object files, letter from Stapp, November 29, 1985). A reproduction of the engraving can be found in Cirker and Cirker 1967, p. 612.
3. According to Richard K. Doud, keeper, Catalog of American Portraits, National Portrait Gallery, Washington, D.C. (object files, letter from Doud, December 2, 1985).

P47

Portrait of the Jones Children of Galveston

ca. 1853
THOMAS FLINTOFF *(ca. 1809–1892),*
Galveston, Texas
Oil on canvas; 56¾ x 42⁷⁄₁₆" (144.1 x 107.8 cm)
B.59.132

English-trained artist Thomas Flintoff immigrated to Texas in the 1850s, where he worked for a decade, painting portraits of a number of prominent Texans and carrying out important commissions from the state. *The Jones Children of Galveston,* his only known portrait of children, offers one of the artist's largest and most ambitious works.[1]

The children portrayed are, from top to bottom, Llewellyn Memucan "Curley" Jones (1850–1930), Warwick Jones (1844–1861), Walter Charles Jones (1848–1906), holding a peach, and Ella Burdette Jones (1847–1933), hugging a pet fawn said to belong to a neighbor. In the tradition of western art, fruit appears frequently in portraits of children, and it is often invested with symbolic meaning, although those meanings may be lost to contemporary audiences. The peach held by Walter might be a family reference to Virginia Point, a two-thousand-acre family estate near Columbus, Texas, where the Jones children were born and where their father raised cattle, cotton, and peaches. Among

PROVENANCE: Felix H. Kuntz, New Orleans[1]; purchased by Miss Hogg from Kuntz, 1962.

FRAME NOTES: The casework for the miniature, probably original, is black lacquered composition surmounted by gilded brass swags of drapery, an eagle, and ornamental piping around the three remaining sides. On the reverse of the frame, a printed paper label on the back reads: "Major General / Zachary Taylor / Born 1784 / Elected President / of the United States / 7ᵗʰ November 18[] / Palo Alto / Resaca De La Palma / Monterey / Buena-Vista" (the place names refer to Taylor's battle victories of the Mexican War). The paper label, surrounded by morocco, covers the place where the glass is inserted into a metal bezel. A piece of oval-cut pulp board placed behind the glass reveals part of a printed advertisement: "[]MBUTEAU / Nᵒ 31 / [] de Montures pour Broderies. / []UBIRAN, / [] Velours, Maroquin / []AINIERS, ECRANS, ÉTUIS 8 / []ARIS"

RELATED EXAMPLES: This miniature was probably copied from an 1848 engraving by Alexander Hay Ritchie (1822–1895) after a daguerreotype from the Mexican War period (original now lost).[2] No other miniature portraits are known, although there are at least three canvases of Zachary Taylor based on the same engraving. Each of the canvas portraits was painted by a different hand.[3]

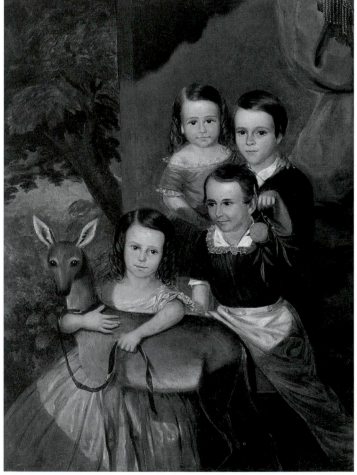

P47

other meanings, the peach symbolizes immortality and longevity, and it is tempting to speculate that the peach held these meanings for the Joneses, who had just relocated to Galveston after a yellow fever epidemic had taken the lives of three of their seven children.[2] Of course, a narrative possibility exists as well, as Walter, whose attention is directed toward the fawn, holds the peach as if attempting to feed the animal.

The children's father, William Jefferson Jones (1810–1897), following his successful quelling of a Cherokee Nation uprising near Austin in 1839, was selected to serve as associate judge for the Supreme Court of the Republic of Texas.[3] He married Elizabeth Gibberson (1818–1903), whom he had met in Matagorda County, in 1841. Of their children, Warwick joined Terry's Regiment of the Texas Rangers in 1861 and died a year later of tuberculosis; Walter Jones served in the Confederate Navy, inherited his father's real estate interests at Virginia Point, and served as mayor of Galveston from 1899 to 1901; Curly owned a general store in Vox Populi; and Ella married a Confederate veteran and settled in Galveston.

FF/EBN

INSCRIBED (LOWER RIGHT): [T] Flintoff.

PROVENANCE: William Jefferson Jones (1810–1897), Galveston; to his wife, Elizabeth Gibberson Jones (1818–1903), Galveston; to her daughter, a sitter in the portrait, Ella Burdette (Jones) Thompson (1847–1933), Galveston; to her daughter Lucy Fenton Thompson (after 1870–1955), Galveston; purchased by Miss Hogg from Reveille Antiques, Houston, 1959.

EXHIBITED: "Classical Taste in America, 1800–1840," the Baltimore Museum of Art, June 27–September 26, 1993; Mint Museum of Art, Charlotte, North Carolina, November 20, 1993–March 13, 1994; MFA, Houston, May 1–July 24, 1994 (exhibited at Houston only).

RELATED EXAMPLES: Other works by Flintoff from his period in Texas are located at the San Jacinto Museum, San Jacinto, Texas; the Barker Library, the University of Texas at Austin; and Austin College, Sherman, Texas.

REFERENCES: Pinckney 1967, pp. 57, 65, 68; House and Garden 1973, p. 92; Warren 1975, p. 115.

1. For an account of Flintoff's career, see Pinckney 1967, pp. 57–68.

2. See, for example, Olderr 1986, p. 100.
3. For a biographical sketch of Judge Jones, see Texas 1895, pp. 722–28.

P48

Portrait Plaques of George Washington and Daniel Webster

1856
CARL L. H. MÜLLER *(1820–1887), New York[1]*
Zinc; B.94.4.1: 12³⁄₁₆ x 9½ x 2⅛″ (31 x 24.1 x 5.4 cm);
B.94.4.2: 12⅛ x 9⅝ x 1¾″ (30.8 x 24.4 x 4.4 cm)
Museum purchase with funds provided by Michael W. Dale in honor of Linda and Ken Lay, B.94.4.1–.2

Carl Müller, a German immigrant, became one of nineteenth-century America's most renowned porcelain designers. As a young man he studied at the Royal Academy in Paris and, following his immigration, resumed his training at the National Academy of Design in New York. Müller exhibited at New York City's 1853 Crystal Palace Exhibition, and replicas of his work were issued through the flourishing art unions. His portrait plaques of Washington and Webster date from this period. In 1874 he was hired by the Union Porcelain Works and assigned the responsibility of preparing the factory's display for the upcoming Philadelphia Centennial Exposition. His best-known work is the pair of "Century Vases," created specifically for the exposition, that chronicle America's achievements over her first century.[2]

MKB

P48

P48

MARKS: B.94.4.1, WASHINGTON (below shoulder); B.94.4.2, WEBSTER. Each is inscribed (lower right): C.MULLER. / 1856, along with a stamp resembling a cherub with a water pipe. At the base of B.94.4.2, in raised letters, is the notation: FROM COS ART ASSOCIATION.

PROVENANCE: Purchased by Bayou Bend from the Stradlings, New York, 1994.

RELATED EXAMPLES: According to the *Cosmopolitan Art Journal* Müller produced companion portraits of Benjamin Franklin, Henry Clay, and John C. Calhoun (see References). Twenty copies of each would be distributed

among the Cosmopolitan Art Association's membership. A similar Washington profile by Henry Kirke Brown (1814–1886) is recorded in Sack 1969–92, vol. 6, p. 1611, no. P4667.

REFERENCES: *Cosmopolitan Art Journal*, vol. 1 (November 1856), p. 9, and vol. 2 (March 1857), pp. 84–85; Yarnall and Gerdts 1986, vol. 4, pp. 2519–20; Frelinghuysen 1989, p. 177.

1. Frelinghuysen 1989, pp. 33–34, 156–58, 174–81. Contemporary documents spell his first name Carl, although it is also found as Karl (as in Frelinghuysen 1989).

2. Frelinghuysen 1989, pp. 174–79; Peirce 1997.

P49

a window, the woman at midground tugging on the man's jacket as if anxious for news indicate the artist's skill in storytelling, an aspect of Bellows's art that surely contributed to his popularity as a genre painter.

INSCRIBED (LOWER LEFT): A.F. Bellows 1857.

PROVENANCE: Purchased by Miss Hogg from Kennedy Galleries, New York, 1969.

EXHIBITED: Washington, D.C., Art Association, 1859.

REFERENCES: Tuckerman 1867, p. 486; Warren 1975, pp. 149–50, no. 276.

1. See, for example, "Full of Home Love and Simplicity," in Johns 1991, pp. 137–73; and Edwards 1986.

P49

The Lost Child Returned

1857
ALBERT FITCH BELLOWS *(1829–1883),*
Belgium
Oil on canvas; 33⅜ x 48⅛" (84.8 x 122.2 cm)
B.71.80

Genre painting was popular in the United States from about 1830 until the outbreak of the Civil War. Among its well-known practitioners is Albert Fitch Bellows. A painter born in Milford, Massachusetts, Bellows apprenticed at an early age with a lithographer in Boston and later with the architectural firms of Ammi Burnham Young and J. B. Toule, before becoming headmaster of the New England School of Design in Boston. In 1857–58, he studied art in Antwerp and Paris, and he was elected an honorary member of the Royal Society of Painters of Belgium. He returned to the United States in 1858 and settled in New York City, where he eventually was elected to the National Academy of Design. He traveled to Europe again in 1867, returning to Boston, then, following a disastrous fire that destroyed his studio, resettled in New York. He was also represented in the Centennial Exposition in Philadelphia and the Paris Exposition of 1878. A specialist in moral and sentimental tales of childhood and rural

village scenes depicting humble and simple pleasures, Bellows also painted lush landscapes in watercolor and, later, made etchings.

The Lost Child Returned is the only genre painting in Bayou Bend's collection. It takes as its themes two popular views in Victorian America: the restoration of domestic harmony and the vision of country life as unaffected and simple.[1] The picture was painted during Bellows's year of study in Belgium. The village architecture and the sign outside the building at left that reads "KANTES" (Dutch for lace, which is echoed visually by the bit of lace fluttering in the wind beside the gable) identify it as a Belgian setting, specifically one that included the lace making for which Belgium was internationally famous. Bellows built the scene in a pyramid: its center, composed of the village processional—the father and daughter, other interested parties hearing the news of her return; its left, a village shopkeeper (identified by his apron) and a shopper (identified by her basket of vegetables and wrapped bundle); and its right, the joyful family group under a spreading tree, which envelops the scene—the mother, children, perhaps a friend or relative, and, presumably, the grandmother at the doorway holding a cane. Delightful details such as the dog carrying the child's shoe in his mouth, the curious neighbor poking her head out of

P50

Infant Flora

1861
ERASTUS DOW PALMER *(1817–1904),*
New York
Marble; 16⅝ x 11⅝ x 7" (42.2 x 29.5 x 17.8 cm)
Gift of William James Hill in honor of Carroll and Harris Masterson, III, B.94.18

Erastus Dow Palmer was among the few early American sculptors who did not study in Italy, the site of fine academies, exquisite marble, and plentiful skilled workmen, and a strong lure for any aspiring American sculptor. The sculpture bust of *Infant Flora* is one of four known extant versions, carved after a clay study Palmer included in an exhibition of his work at the Church of the Divine Unity in New York City in 1856. This small exhibition of twelve sculptures placed Palmer at the forefront of sculptors working in the United States. The ideal type presented in *Infant Flora* was immediately popular, praised for its naturalism, absence of sentimentality, and skillful, delicate handling. According to Palmer's 1856 catalogue, the sitter was the four-year-old sister of the model for his first famous bust, *The Infant Ceres* (1851).[1]

INSCRIBED (ON BACK): E.D. PALMER SC. 1861.

PROVENANCE: Possibly L. C. Hopkins, Cincinnati[2]; William Becker, Royal Oak, Michigan; [Conner/Rosenkranz, New York];

purchased by William James Hill, Houston, until 1994.

RELATED EXAMPLES: Other versions of the *Infant Flora* are found in the Walters Art Gallery, Baltimore (1857); the Albany Institute of History and Art (1857); and a private collection, Washington, D.C., as of 1983 (without the floral rope).

REFERENCES: R. S. Chilton, "To Palmer's *Infant Flora*," poem published in the *New York Post*, April 26, 1859, in which the poet writes of the sculpture: ". . . thou marble bud / Of the sweet Goddess whom men worshipped / For sowing earth with flowers. . . ."; Taft 1930, p. 135; Craven 1968, p. 159, fig 5.6; Whitney 1976, no. 187, fig. 64; Webster 1983, p. 153, pl. 58.

1. Webster 1983, p. 153.
2. L. C. Hopkins of Cincinnati appears in Palmer's account book as owing six hundred dollars for "bust of 'Infant Flora' (marble)" under March 7, 1863, for which payment was entered the following day (Webster 1983, p. 153).

P51

P50

P51

Hill Country Landscape

1862
HERMANN LUNGKWITZ (1813–1891), Fredericksburg, Texas
Oil on canvas; 18⅜ x 23¹³⁄₁₆″ (46.7 x 60.5 cm)
B.67.39

The landscape was the most esteemed genre of nineteenth-century American painting when European-trained Hermann Lungkwitz immigrated to New York in 1850 in the wake of revolution in Germany. By 1851 he left New York, home to America's most admired Hudson River school painters, and settled permanently in the Hill Country of Texas, becoming one of the first artists in Texas to make a contribution to this genre. A photographer, impresario of magic lantern shows, and, later, a draftsman and photographer for the General Land Office in Austin as well as a painter, Lungkwitz applied the Romantic tradition of landscape to the dramatic Hill Country, a new, developing region of Texas. Like other American landscape painters, Lungkwitz worked in his studio from a variety of sketches made on site, incorporating the unusual geological features and scenic wilderness of the Pedernales and Guadalupe Rivers near Fredericksburg into highly Romantic landscapes.

INSCRIBED (LOWER RIGHT): H. Lungkwitz /
1862.

PROVENANCE: Purchased by Miss Hogg from
James Graham and Sons, New York, 1967.

EXHIBITED: "Hermann Lungkwitz, Romantic
Landscapist on the Texas Frontier," the Uni-
versity of Texas Institute of Texan Cultures at
San Antonio, November 25, 1983–January 8,
1984; Sarah Campbell Blaffer Gallery, Univer-
sity of Houston, January 14–February 26, 1984;
Texas Memorial Museum, the University of
Texas at Austin, May 6–June 10, 1984.

RELATED EXAMPLES: A drawing by Lungk-
witz, *Sisterdale*, private collection.[1]

REFERENCES: Warren 1975, p. 149, no. 275;
McGuire 1983, pp. 74, 185, cat. no. 235; Goetz-
mann and Goetzmann 1986, p. 89.

1. This image of a cypress tree on the banks
 of the Guadalupe is repeated in several
 paintings later composed by the artist, in-
 cluding the Bayou Bend landscape. He first
 sketched the tree in 1853 in Sisterdale. The
 drawing is reproduced in McGuire 1983,
 p. 109. For more information on Lungkwitz,
 see Steinfeldt 1993, pp. 154–65.

P52

P52

On the Big Canadian River

1869
VINCENT COLYER *(1825–1888), Texas*
Watercolor on paper; 8⁹⁄₁₆ x 13³⁄₈" (21.7 x 34 cm)
Museum purchase with funds provided by the
Finger family in honor of Nanette Finger at
"One Great Night in November, 1996," B.96.17

INSCRIBED: On the Big Canadian river /
Northern Texas May 1869 (lower right); No 8
(on verso mount).

P53

P53

Two Hundred Miles East of Bascom

1869
VINCENT COLYER *(1825–1888), Texas*
Watercolor on paper; 3⁵⁄₁₆ x 5" (8.4 x 12.7 cm)
Museum purchase with funds provided by the
Finger family in honor of Nanette Finger at
"One Great Night in November, 1996," B.96.18

INSCRIBED: 200 miles East of Bascom May
1/69 (lower right); On Big Canadian river [?]
Texas (on lower center mount); North Side of
the Big Canadian river [?] / 200 miles east of

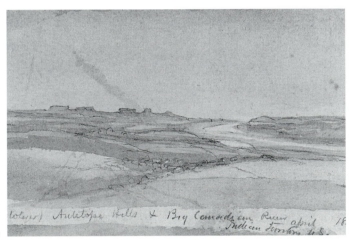

P54

P55

Fort Bascom / 1869 (on lower right mount); 125 (on verso mount, lower right); No 5 (on verso mount, upper center).

P54

Antelope Hills and Big Canadian River

1869
VINCENT COLYER *(1825–1888), Texas*
Watercolor on paper; 2⅜ x 3¹¹⁄₁₆″ (6 x 9.4 cm)
Museum purchase with funds provided by the Finger family in honor of Nanette Finger at "One Great Night in November, 1996," B.96.19

INSCRIBED (BOTTOM OF IMAGE): V. Colyer Antelope Hills & Big Canadian River / Indian Territory U.S. / April 186[].

P55

Scene on the Canadian River

1869
VINCENT COLYER *(1825–1888), Texas*
Watercolor on paper; 5¹⁵⁄₁₆ x 10″ (15.1 x 25.4 cm)
Museum purchase with funds provided by the Finger family in honor of Nanette Finger at "One Great Night in November, 1996," B.96.20

INSCRIBED: White sand bank (across image, left edge); reddish yellow ochre (lower left); yellow ochre (lower center); [illegible] reflecting [illegible]; Reddish yellow sand (lower right); A13780 (on verso mount).

P56

Wild Gili Flower of the Prairie

1869
VINCENT COLYER *(1825–1888), Texas*
Watercolor on paper; 13⅜ x 8″ (34 x 20.3 cm)
Museum purchase with funds provided by the Finger family in honor of Nanette Finger at "One Great Night in November, 1996," B.96.21

INSCRIBED: Length of Flower / full bloom flower / 5 full layers & 15 buds in 6 layers on / on this [?] stories [?] / Wild Gili flower of the Prairie / On the banks of the Canadian River / Indian Territory / V. Colyer. April 29 1869 (lower left); 32121 (on mount, lower right); Penstemen (on mount, lower left).

These five unpublished drawings document areas on the Canadian River of north Texas following the Civil War.

P56

A landscape artist, portraitist, and lithographer, Vincent Colyer was elected in 1849 to the National Academy of Design, New York. He exhibited his work in New York and at the Boston Athenaeum, the Pennsylvania Academy of the Fine Arts, Philadelphia, and the Maryland Historical Society, Baltimore. Following the Civil War, during which time he painted portraits and attended the sick and wounded, Colyer settled in Connecticut in 1866. In 1869, he served as an Indian commissioner, hired by the United States government to travel to the various Native American agencies of north Texas, Kansas, New Mexico, Colorado, Alaska, and what is now Oklahoma. It was at this time that Colyer documented the terrain and flora of north Texas.

Colyer's topographical renderings of this area may have assisted the U.S. Army's operations on the Southern Plains during the Indian Wars. His artistic activities in Texas also coincide with the government's effort to investigate western lands in a series of surveys from 1867 to 1879 in order to encourage settlement, promote tourism, and assess natural resources. His work, then, relates to that of such other artist-explorers as Albert Bierstadt (1830–1902), who made his first government expedition west in 1859, and Thomas Moran (1837–1926), who headed west two years after Colyer.

PROVENANCE: **P52–P56**, Edward Eberstadt & Sons, New York, ca. 1958; purchased by Bayou Bend from Kennedy Galleries, New York, 1996.

P57

Horse Weathervane

1850–75
Rochester Iron Works, Rochester, New Hampshire
Iron; without base: 20 x 26½ x 6½″ (50.8 x 67.3 x 16.5 cm)
B.55.9

P57

In the early nineteenth century, American farmers and breeders became increasingly interested in raising purebred stock to be exhibited at Agricultural Society fairs. Fine bloodstock became the model for the farm weathervane, in this case, an elegant horse with luxuriant silky tail. Although this cast-iron horse weathervane is a multiple, the image is virtually an icon of American folk art, versions of it having been in the pioneer collection of Edith Halpert and exhib-ited at the Newark Museum in 1931 and the Museum of Modern Art, New York, in 1932.

D B W

P58

PROVENANCE: By tradition found in Connecticut, 1953; Edith Gregor Halpert, New York; purchased by Miss Hogg from the American Folk Art Gallery, New York, 1955.

EXHIBITED: Downtown Gallery, New York, May 1954.

TECHNICAL NOTES: Cast iron (body), sheet iron (tail). The paint over the tail and the rest of the body appears to be old and is consistent overall.

RELATED EXAMPLES: The Shelburne Museum, Shelburne, Vermont; MMA; and MFA, Boston. For others, see MOMA 1932, no. 149; Lipman 1948, fig. 41; Bishop and Coblentz 1981, p. 72, fig. 118; Miller 1984, p. 27; Sotheby's, New York, Feldman sale, June 23, 1988, lot 50.

REFERENCES: Warren 1988, p. 54.

P58

Rooster Weathervane

ca. 1872–1900
Attributed to L. W. Cushing and Sons,
Waltham, Massachusetts
Iron; without base: 29¾ x 34 x 3⅞" (75.6 x 86.4 x 9.8 cm)
B.55.10

The rooster was one of the most popular of the barnyard animals chosen for the ubiquitous nineteenth-century weathervane. This cast example with sheet-iron tail is attributed to the Cushing factory on the basis of surviving molds.[1] While it is commonly assumed that these weathervanes were used in farm situations, at least one other example of this multiple has a solid history of usage in the city of Newport.

D B W

PROVENANCE: History of usage in Taunton, Massachusetts; Edith Gregor Halpert, New

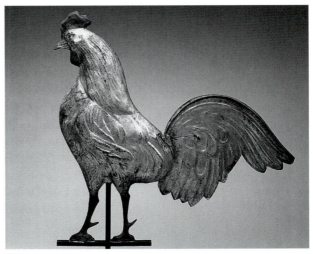

P59

York; purchased by Miss Hogg from the American Folk Art Gallery, New York, 1955.

TECHNICAL NOTES: Hollow cast-iron (body), sheet-iron (tail).

RELATED EXAMPLES: One with a history of usage on the carriage house at Chateau-Sur-Mer in Newport is illustrated in Bishop 1974, p. 65, fig. 92. Others include Lipman 1948, fig. 36; Abby Aldrich Rockefeller Folk Center, Williamsburg, Virginia (acc. no. 31.800.8); MFA, Boston (acc. no. 1968.294); Ross 1997, p. 159.

REFERENCES: MOMA 1932, no. 153; Warren 1971a, p. 54, fig. 30; Warren 1975, p. 122, no. 229.

1. The molds were acquired by Edith Halpert in 1953 and are now in the collection of the Smithsonian Institution, Washington, D.C.

(object files, Abby Aldrich Rockefeller Folk Art Center, Williamsburg, Virginia).

P59

Gamecock Weathervane

1875–1900
United States
Sheet iron, gilded and painted copper;
23¾ x 23¼ x 4" (60.3 x 59.1 x 10.2 cm)
B.71.129

This example is typical of the hollow copper weathervanes produced in great numbers by such factories as A. R. & W. T. Westervelt in New York.

D B W

PROVENANCE: Unknown (at Bayou Bend prior to 1965).

RELATED EXAMPLES: A very similar weather-vane, differing only in the design of the tail, is illustrated in Westervelt 1982, p. 31, no. 162.

P60

Statue of Liberty Weathervane

ca. 1886–1900
E. G. Washburne and Company, New York
Hammered copper; 38¾ x 13¾ x 4" (98.4 x 34.9 x 10.2 cm)
Museum purchase with funds provided by the Theta Charity Antiques Show, B.74.7

The theme of Frédéric-Auguste Bartholdi's figure of Liberty holding her torch high to enlighten the world was adapted to the weathervane after the statue's installation on Bedloe's Island in 1886. This example, stamped "Washburne & Co." on the book underneath the figure's left arm, was produced by the firm founded in 1853 and still in business in Danvers, Massachusetts.

DBW

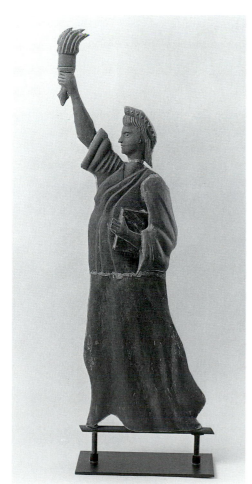

P60

PROVENANCE: Purchased by Miss Hogg from Kennedy Galleries, New York, 1974.

RELATED EXAMPLES: Advertisement of Steve Miller American Folk Art, *Antiques* 133 (March 1988), p. 546.

P61

Shop Figure

1860–90
Probably an eastern seaport of the United States
Painted eastern white pine; 72 x 24 x 21⅜" (182.9 x 61 x 54.3 cm)
B.68.17

Although freestanding wooden shop figures made for tobacconists appeared in the United States as early as the eighteenth century, they did not reach their peak of popularity until after 1850. In seaport cities, as the demand for ship figure-heads waned, carvers began to produce figures that combined the size of the figurehead with the full length of the smaller shop figure, thus creating a new tradition of life-size, full-length shop figures.[1] The technique involved inserting an iron bar for support in either end of the raw log, allowing the log to hang free as the carver worked it. A plug in the head of this figure confirms that its maker was working in that tradition. Native Americans were the most popular representation, but Turks, Scotsmen, Jack Tars, and ladies and gentlemen of fashion were also prevalent.

Paint analysis of this figure reveals that she was originally a red-haired Caucasian wearing a gold-fringed, white tunic and bright green tights. While her headpiece relates to the crowns seen on Goddess of Liberty figures and her facial features have strong Neoclassical overtones, the identity of her original character is not clear. However, the costume suggests she was intended to portray some sort of performer or acrobat and thus was likely a type of "theatrical" figure that was displayed outside theaters.[2] Over the years, the figure received many layers of new paint, something not unexpected for a wooden figure exposed to the elements. In her last incarnation, she was converted into an Indian princess, her skin darkened and her garments painted in dark green with yellow fringe, a scheme that appears

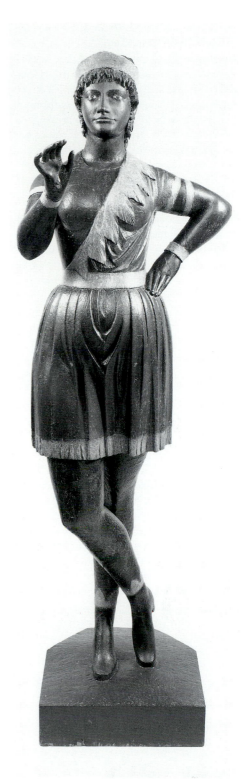

P61

on figures of Indians that date from the last decade of the nineteenth century.[3]

DBW

PROVENANCE: Purchased by Miss Hogg from T. V. Carey Antiques and Decorations, Boston, 1927.

TECHNICAL NOTES: Eastern white pine; redwood (replacement base). The figure is sculpted from a single log except for the addition of arms, earrings, and base. There have

been significant restorations over several campaigns of repair. Round plugs in the hips and fills in splits along the vertical axis are not in plane. The right elbow has a large metal spike and several smaller wire nails joining it to the upper arm. The right hand is poorly restored and crudely defined. A history of breakage at the narrow ankles indicates that the mass of the figure is prone to short grain breakage. The material forward of the arches on both feet is inconsistent with the mass of the legs and may be replaced.

RELATED EXAMPLES: The figure's pose with crossed legs is relatively rare. Two examples are shown in Hornung 1972, vol. 1, nos. 116, 139; one in a similar yellow-fringed, dark green garment and crossed legs, by New York carver S. A. Robb, in Sessions 1997, pl. XII; another with a yellow-fringed, green tunic at Maryland Historical Society, Baltimore (acc. no. 1969.127.1); a lady of fashion with a similar classic visage at New York State Historical Association, Cooperstown, New York (Sessions 1997, pl. IV).

REFERENCES: Warren 1971a, p. 55, fig. 31; Bishop 1974, no. 489; Warren 1975, p. 123, no. 233; Warren 1988, p. 55.

1. For discussion of the production of shop figures by figurehead carvers, see Sessions 1997.
2. Object files, letter from Ralph Sessions, October 15, 1997, in which he describes theatricals and relates they were noted for their "alarmingly short skirts."
3. Two late-nineteenth-century figures by S. A. Robb, one with its original paint surface, feature the same yellow-fringed dark green color scheme (Sessions 1997, pls. XI, XII).

P62

Eagle

1850–1900
Probably New England
Unidentified wood, paint; 33 x 60 x 34"
(83.8 x 152.4 x 86.4 cm)
B.55.6

This ferocious-looking eagle typifies the nineteenth-century interpretation of the United States of America's national symbol. The uncarved upper surfaces of the wings indicate that this example was intended to be viewed from below. While its original usage is not clear, two related examples have maritime associations or are described as pilothouse eagles, sug-

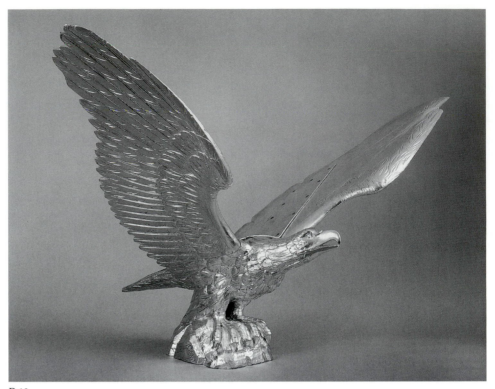

P62

gesting that this eagle may also have ornamented a boat.

DBW

PROVENANCE: History of ownership in Connecticut; Edith Gregor Halpert, New York; purchased by Miss Hogg from the American Folk Art Gallery, New York, 1955.

TECHNICAL NOTES: Wood at the beak was restored to complete the structural detail of the form. Examination revealed early gilding underneath multiple layers of paint. These layers of paint were removed. Traditional gesso, tinted orange shellac, and 24-karat gold leaf were reapplied overall in 1991. The wings are braced with an iron strip.

RELATED EXAMPLES: A smaller example at the Smithsonian Institution, Washington, D.C., had been used on a Hudson River towboat (Welsh 1965, fig. 11); another, attributed to Charles Brown, has a history of usage on an oyster boat named *The City of Bridgeport*, advertisement of Greenleaf Antiques, *Antiques* 121 (April 1982), p. 896; one attributed to William Rush, advertisement of Nathan Liverant and Son, *Antiques* 124 (October 1983), p. 652. For other related examples classified as pilothouse eagles in the Index of American Design, see Hornung 1972, vol. 1, pp. 42–45, nos. 82, 90, 92, 93. No. 93 has a similar wide wingspan, which, like the Bayou Bend example, is reinforced with metal strips applied to the upper side.

REFERENCES: Warren 1975, p. 123, no. 231.

P63

Sheep

1850–1900
Probably New England
Painted eastern white pine; 32¼ x 38⅜ x 14"
(81.9 x 97.5 x 35.6 cm)
B.71.88

In the second half of the nineteenth century, carved wooden figures of various sorts were produced by anonymous self-taught artisans as well as trained wood-

P63

carvers, many of them European immigrants. This naturalistic sheep was carved by someone with a sure and accomplished hand. Despite an oral tradition of being the sign for a woolen mill, the original purpose is unknown, although there is evidence that it stood outside for many years.

D B W

PROVENANCE: Purchased by Miss Hogg from Henry Cogar, 1971.

RELATED EXAMPLES: A slightly smaller version of this sheep was exhibited at the Newark Museum, Newark, New Jersey, in 1931 (American Folk Sculpture 1931, p. 63, no. 74B) and was later in the Abby Aldrich Rockefeller Folk Art Collection. Deaccessioned in 1981, it was exhibited at the Hirschl and Adler Folk Art Gallery, New York, in 1987. Found in Marblehead, Massachusetts, it, too, showed evidence of having been outside. That there is more than one would strengthen the assumption that the maker was a professional carver.

REFERENCES: Bishop 1974, p. 34, no. 41; Warren 1975, p. 122, no. 230.

P64

P64

Eagle

1875–90
Wilhelm Schimmel (1817–1890),
Cumberland County, Pennsylvania
Willow and eastern white pine; 12 x 17 x 9"
(30.5 x 43.2 x 22.9 cm)
B.57.69

This spread-wing eagle, with its crosshatched and faceted feather patterns, is a visual throwback to the fierce heraldic eagles of late medieval and Renaissance Germany. It was made by Wilhelm Schimmel, an itinerant wood-carver

active in Cumberland County in the late nineteenth century. His eagles, among his most distinctive products, came in a variety of sizes.

D B W

PROVENANCE: Purchased by Miss Hogg from the American Folk Art Gallery, New York, 1957.

EXHIBITED: "Looking at Sculpture," MFA, Houston, September 15–December 29, 1991.

TECHNICAL NOTES: Willow (body), eastern white pine (wings). Examination in 1957 revealed that a coat of gilt and later green paint had been applied over the body, which the artist had left unpainted.

RELATED EXAMPLES: Lipman 1948, fig. 141; Smithsonian Institution, Washington, D.C.; Shelburne Museum, Shelburne, Vermont (American Sampler 1987, p. 72, no. 16); a large collection at Winterthur; other examples at MMA and MFA, Boston. Schimmel's work has been thoroughly discussed by Milton E. Flower (Flower 1943; Flower 1960; Flower 1965, p. 7, no. 3).

REFERENCES: Warren 1975, p. 123, no. 232.

P65

Toy Horse

1850–1900
United States
Spruce and flax; with base: 13½ x 13½ x 4" (34.3 x 34.3 x 10.2 cm); without base: 12 x 12¾ x 3⅛" (30.5 x 32.4 x 7.9 cm)
B.55.7

This carved wooden toy is rendered with the simplification of form, almost to the point of abstraction, that made folk art so appealing in the 1920s and 1930s to contemporary artists and collectors. Indeed, this horse could almost be taken for a work by Elie Nadelman, who was himself a collector of folk art. Lugs carved under the hooves suggest that it was mounted on a base, presumably with wheels, so that it could be towed.

D B W

PROVENANCE: Found in New Jersey in the 1920s; Edith Gregor Halpert, New York; purchased by Miss Hogg from the American Folk Art Gallery, New York, 1955.

EXHIBITED: The Museum of the City of New York, March 1936; "Children in American Art,"

the Downtown Gallery, April 1937; Phillips Memorial Gallery, Washington, D.C., February 1938; New Jersey State Museum, Trenton, New Jersey, December 1945; "Up Close and Personal: Daily Life in America," MFA, Houston, February–June 1997.

TECHNICAL NOTES: Replaced ears (woven flax) and tail (spun flax). Based on the early photograph sent from the Index of American Design at the NGA, it is apparent that the ears and tail have been changed. In the photograph the ears extend forward (with the fabric cupped in imitation of actual ears). The current ears hang down from the mounting holes on either side of the head. The left ear, considerably older than the right ear, is made of a plain-weave linen rolled at the end and inserted into the mounting hole. There is a dark stain near the head and an overall soiling and stiffness to the ear. The right ear is glued to the side of the head, not into the mounting hole. The bobbed tail in the Index of American Design photograph may be the remnants of the original tail. Ocher-colored flax is glued into the mounting hole for the tail. The current tail is also flax, which is gathered at the top and pinned to the mounting hole. The replacement base has remnants of two identical stickers on the bottom that identify the American Folk Art Gallery.

RELATED EXAMPLES: A larger one from the Dorothy C. Miller (Mrs. Holger Cahill) Collection was exhibited in the "American Folk Sculpture" show, Newark Museum, Newark, New Jersey, 1931–32 (Jeffers 1995, p. 333, pl. XIII).

REFERENCES: Reproduced in the Index of American Design, NGA, no. 1943.8.15590 (NYC-mscl-toy-76).

P65

PRINTS AND OTHER
WORKS ON PAPER

W 1

W 1

The Bloody Massacre

1770
Paul Revere, Jr. (1734–1818), Boston
Hand-colored line engraving and etching on laid
paper; image: 7⅞ x 8⅝" (20 x 21.9 cm); sheet:
10⅜ x 9¼" (26.4 x 23.5 cm); plate: 10⅜ x 8⅞"
(26.4 x 22.5 cm)
Museum purchase with funds provided by the
Sarah Campbell Blaffer Foundation, B.84.9

By the late 1760s, England had incurred large debts from the French and Indian War (1756–63) and the subsequent need to station and maintain troops in the expanded Empire. One of Parliament's solutions to this fiscal problem was the adoption in 1767 of the Townshend Acts, which levied taxes on exported glass, painter's colors, lead, paper, and tea. In the American colonies these new taxes were extremely unpopular, and in 1768 the Massachusetts House of Representatives sent a circular letter of protest to the other colonies. When the House did not respond to Parliament's demand to rescind the letter, British troops were sent to occupy Boston. The presence of these troops was bitterly resented by Bostonians, and on March 5, 1770, a mob provoked one of the soldiers. A skirmish ensued, and five citizens were killed by British fire. Just twenty-three days later Paul Revere produced this propagandistic and historically inaccurate print, which became an instant symbol of British tyranny. Revere plagiarized the composition from a print by Henry Pelham, a young Boston engraver, who had shown his work to Revere. There are two states of the print. Although the incident occurred after ten o'clock, Revere's first version shows the hands of the Old State House clock at 8:10. The mistake was corrected in the second state to show the hands at 10:20, as can be seen in the present example.

INSCRIBED: See *Antiques* 11 (March 1927), p. 214.

PROVENANCE: Private collection, Lowell, Massachusetts; estate of Hyman Weiner, Boston; purchased by Bayou Bend from Ronald Bourgeault, Hampton, New Hampshire, 1984.

RELATED EXAMPLES: While there is only one known example of the first state (Middendorf 1967, p. 88, no. 60a), there are a number of surviving impressions of the second state. Three are at the MFA, Boston, one of which is signed by the colorist Christian Remick (Fairbanks et al. 1975, p. 113, no. 165); another is in the collection of Mr. and Mrs. Stanley Stone (Kennedy and Sack 1977, no. 90). The Bayou Bend example is unsigned, but its coloring compares very closely with the signed Boston version. For other examples, see Shadwell 1969, p. 28.

REFERENCES: Brown 1985, p. 521.

W2★

Congress Voting Independence

1795
Edward Savage (1761–1817), Philadelphia, after Robert Edge Pine (ca. 1730–1788) and Edward Savage, Philadelphia
Stipple engraving on laid paper; image: 18⅞ x 25⁷⁄₁₆" (47.9 x 64.6 cm); sheet: 20¹⁄₁₆ x 27⅛" (51 x 68.9 cm)
Museum purchase with funds provided by Robert H. Allen in honor of Robert L. Gerry, III, at "One Great Night in November, 1991," B.91.45

PROVENANCE: Purchased by Bayou Bend from The Philadelphia Print Shop, Philadelphia, 1991.

REFERENCES: Shadwell 1969, p. 37, no. 618; *The Philadelphia Print Shop Catalogue 1–91, no. 47.*

W3★

Union

1852
Henry S. Sadd (act. ca. 1832–ca. 1852), New York, after Tompkins H. Matteson (1813–1884), Sherburne, New York
Engraving on wove paper, first state; image: 19⅝ x 26½" (49.8 x 67.3 cm); sheet: 23¾ x 30" (60.3 x 76.2 cm)
Museum purchase with funds provided by Phyllis and Charles Tucker, B.90.2

INSCRIBED (BELOW IMAGE): PAINTED BY T. H. MATTESON (left); ENGRAVED BY H. S. SADD. 1852. / PRINTED BY W. PATE (right); UNION. / Entered according to the act of Congress, in the year 1852 by Augustus W. Seaton in the Clerks Office of the U. S. District Court, for the Southern District of New York (center).

PROVENANCE: Purchased by Bayou Bend from The Philadelphia Print Shop, Philadelphia, 1990.

REFERENCES: Reilly 1991, p. 350, no. 1852-7.

W4

Union

ca. 1861
Henry S. Sadd (act. ca. 1832–ca. 1852), New York, after Tompkins H. Matteson (1813–1884), Sherburne, New York
Engraving on wove paper, second state; image: 19½ x 26½" (49.5 x 67.3 cm); sheet: 24 x 30⅛" (61 x 76.5 cm)
Museum purchase with funds provided in honor of Mr. and Mrs. Fred T. Couper, Jr., by their friends, B.91.22

This print represents an interesting reworking of the 1852 engraving (see cat. no. W3). Made to capitalize on the swell of support for the Union after the fall of Fort Sumpter in 1861, this second state of the print shows the likeness of Calhoun has been replaced by that of Lincoln.

INSCRIBED (BELOW IMAGE): PAINTED BY T. H. MATTESON (left); ENGRAVED BY H. S. SADD. / PRINTED BY W. PATE (right); UNION. / Published by William Pate. 16 Burling Sli[p?]. N. Y. / Entered according to act of Congress, in the year 1852 by Augustus W. Seaton, in the Clerks Office of the U. S. District Court for the Southern District of New York (center).

PROVENANCE: Purchased by Bayou Bend from The Philadelphia Print Shop, Philadelphia, 1991.

REFERENCES: Holzer, Boritt, and Neely 1984, p. 69.

W5★

The Burning of the American Fregate [sic] the Philadelphia in the Harbour of Tripoli

1805
John B. Guerazzi (act. ca. 1800–ca. 1810), Livorno, Italy
Hand-colored line engraving on laid paper;

image: 11³⁄₁₆ x 15⁷⁄₁₆" (28.4 x 39.2 cm); sheet: 12³⁄₁₆ x 16¾" (31 x 42.5 cm)
Museum purchase with funds provided by Robert H. Allen, Jack S. Blanton, Jr., Jack S. Blanton, Sr., Roy H. Cullen, Mark Elias, Ike Massey, Dee S. Reasoner, Blake Tartt, and Blake Tartt, III, at "One Great Night in November, 1992," B.92.16

INSCRIBED: See Mugridge and Conover 1972, p. 74.

PROVENANCE: Purchased by Bayou Bend from Mongerson Wunderlich Gallery, Chicago, 1992.

REFERENCES: Smith 1974, p. 64, no. 40; Mugridge and Conover 1972, pl. 33.

W6

A View of the Bombardment of Fort McHenry

ca. 1815
John Bower (act. 1809–19), Philadelphia
Hand-colored aquatint on wove paper; image: 10¾ x 17" (27.3 x 43.2 cm); sheet: 12⅝ x 17⅝" (32.1 x 44.8 cm)
Museum purchase with funds provided by "One Great Night in November, 1988," B.90.14

W4

W6

The successful defense of Fort McHenry, located in the Baltimore harbor, and the repulse of the British naval forces, was a turning point in the War of 1812 and an event that became an almost instant legend. For two nights, September 12 and 13, the British forces pounded the American fort unmercifully, throwing some 1,500 shells at the defenders. The valiant defense was immortalized by Francis Scott Key, who observed the battle as prisoner on a ship in the harbor and wrote the poem that would become the words to our national anthem. The information engraved on this print suggests that John Bower was also an eyewitness, taking his sketch on the second morning of the engagement. Fort McHenry—with the American flag flying bravely—stands in the center of the middle ground. In the distance, the British fleet lobs cannonballs, which are shown arcing toward the tiny fort and bursting in mid-air, just as Francis Scott Key wrote.

INSCRIBED (BELOW IMAGE): Copy Right, Secured. J. Bower, sc. Phil.ª / A VIEW of the

BOMBARDMENT of Fort McHenry, near Baltimore, by the British fleet, taken from the / Observatory, under the Command of Admirals Cochrane, & Cockburn, on the morning of the 13th of Septr 1814. which lasted 24 hours, & / thrown from 1500, to 1800 shells. in the Night attempted to land by forcing a passage up the ferry branch but were repulsed with great loss, (center); References. / A, Fort McHenry._ / B, Lazaretto. / C, Salauave House_ / ɣ. Admiral Ship. ɣ ɣ. North Point. / E, Ferry and Fort. (right).

PROVENANCE: Purchased by Bayou Bend from Hirschl and Adler Galleries, New York, 1990.

RELATED EXAMPLES: Other impressions: Peale Museum, Baltimore (two); Chicago Historical Society (two); Maryland Historical Society, Baltimore; New York Historical Society; Robert Merrick, Baltimore. The print was probably the source for a depiction of the bombardment engraved on a silver punch bowl presented by the citizens of Baltimore to the battle's hero Lt. Col. George Armistead (Warren, Howe, and Brown 1987, p. 110, no. 132).

REFERENCES: Biddle 1963, no. 230; Middendorf 1967, p. 110, no. 75; Shadwell 1969, p. 51, no. 101.

W7

A Correct View of the Battle Near the City of New Orleans

1815–16
Francisco Scacki (act. ca. 1800–25), Philadelphia
Engraving on wove paper; image: 16 x 23¾"
(40.6 x 60.3 cm); sheet: 19⅜ x 25½" (49.2 x 64.8 cm)
Museum purchase with funds provided by Richard B. Finger and Jonathan S. Finger in honor of Jerry Elliot Finger at "One Great Night in November, 1991," B.91.46

The Battle of New Orleans on January 8, 1815, was a popular American victory in the War of 1812 and was commemorated by a number of prints. Most, as here, were not historically accurate but were designed to please the purchasing public. This unusual sheet bears both Scacki's first state (recto) and second state (verso), where wounded soldiers were added at lower left.

INSCRIBED: A CORRECT VIEW OF THE BATTLE Near the city of NEW ORLEANS, on the / Eighth

of January 1815, Under the Command of Gen! And! Jackson, Over 10,000 British Troups, in / which 3 of their most distinguished Generals were killed, & several wounded. and upwards of 3,000 of their choisest / Soldiers were killed, wounded, and made Prisoners, & c. (on recto and verso, below image); THE·BRAVE·GEN!·ANDREW·JACKSON (on recto and verso, around oval portrait below image); Copy Right (on recto, lower right); Francisco Scacki Copy Right Secured (on verso, below image); A Camp Jackson . . . American Officers. / George J. Ross. Col. 44th Reg! / W!!! M! Rea. Lieut. Col. Artillery / H. D. Peire Major 44th Regiment. / A. Lacarriere, Late 1st Engineer 7th M.D. / J.B. Panche. Major. Humber. Brig Genl (on verso, lower left, first column); S. Geme. Captain Major. / P. Lacaste. Major. / Louis Daquin. Do. / Ed Livingston. A. Davesae Castera. / A. L. Duncan. Aids, to Gen! Jackson (on verso, lower left, second column); B. Gen! Packenham killed. C.C. Right and Left British Columns. / D. General Gibb Mortally Wounded / E. General Keene. F. British Staff Officers / G. The British Artillery and Mortars (on verso, lower right).

PROVENANCE: Edmund Edward Hurja, Washington, D.C.; purchased by Bayou Bend from The Philadelphia Print Shop, Philadelphia, 1991.

TECHNICAL NOTES: WB watermark. The double-sided treatment of this print is unusual and may have been part of the proofing process.

REFERENCES: Drepperd 1928, p. 129, fig. 1; Tyler 1983, p. 5, fig. 2.

W8★

Battle of New Orleans and Death of Major General Packenham

1815–16
Joseph Yeager (ca. 1792–1859), Philadelphia, after William Edward West (1788–1857), Philadelphia
Hand-colored engraving on wove paper, first state; image: 13 x 19" (33 x 48.3 cm); sheet: 18 x 22½" (45.7 x 57.2 cm); plate: 15⅞ x 20¾" (40.3 x 52.7 cm)
Museum purchase with funds provided by C. Pharr Duson, Joe H. Foy, Irvin L. Levy, and Sidney V. Smith in honor of Isaac Arnold, Jr., at "One Great Night in November, 1991," B.91.47

INSCRIBED: West. Del. J. Yaeger fc. / BATTLE OF NEW ORLEANS/AND DEATH OF MAJOR PACKENHAM / On the 8th of January 1815. / Copy Right Secure'd Accordg to Law Published and Sold by J. Yaeger No 103 Race S! Philad! (on recto, below image); Portrait of Mi[—]ell Jackson vignette / ? catalogue - 1st state very rare Philadelphia (on recto, lower right, in pencil); ⑤, 14382 (on verso, in pencil).

PROVENANCE: Purchased by Bayou Bend from The Philadelphia Print Shop, Philadelphia, 1991.

REFERENCES: Stauffer 1907, no. 3433; Mugridge and Conover 1972, pl. 48; Smith 1974, p. 186, no. 161; Tyler 1983, p. 5, no. 3; Deák 1988, no. 293; Drepperd 1928, p. 130, illustrates the second state of this print.

W9★

Naval Scene with the Dido, New Orleans and the Constitution

1836
Unknown engraver and printer
Hand-colored lithograph on wove paper; image: 11⅞ x 16¾" (30.2 x 42.5 cm); sheet: 17¾ x 20¼" (45.1 x 51.4 cm)
Gift of the estate of Miss Ima Hogg, B.79.286

INSCRIBED: See Reilly 1991, p. 76. Byron's complete text is inscribed as follows: Can freedom find no champion and no child / Such as Columbia saw arise when she / Sprung forth a Pallas, arm'd and undefiled? / Or must such minds be nourished in the wild, / Deep in the unpruned forest, 'midst the roar / Of caturacts, where nursing nature smiled / On infant Washington? Has earth no more / Such seeds within her breast, or Europe no such shore? / Byron. Ch. Har. Pilg. XCVI.

PROVENANCE: Miss Ima Hogg.

REFERENCES: Reilly 1991, p. 76, no. 1836–2; *The Philadelphia Print Shop Catalogue* I–91, no. 62.

W10★

The Battle of Palo Alto

1846
Sarony and Major (act. 1846–57), New York[1]
Hand-colored lithograph on wove paper; image: 7⅞ x 12⅜" (20 x 31.4 cm); sheet: 10 x 14⅛" (25.4 x 35.9 cm)
B.69.266

W7 (*recto*)

W7 (*verso*)

INSCRIBED (BELOW IMAGE): THE BATTLE OF PALO ALTO. / Which was fought by the American & Mexican armies, on the 8.th May. The Americans proving victorious. Loss of the enemy 300 killed; / number of wounded not known. Loss of the Americans; 43 killed, 103 wounded. Duration of engagement, 5 hours.

PROVENANCE: Purchased by Miss Hogg from Kennedy Galleries, New York, 1958.

1. Napoleon Sarony (1821–1896); Henry B. Major (act. 1844–54).

W11*

Major Ringgold, Mortally Wounded

1846
James Baillie (act. 1843–49), New York
Hand-colored lithograph on wove paper; image:
8¼ x 12⅝" (21 x 32.1 cm); sheet: 9⅞ x 13⅞"
(25.1 x 35.2 cm)
B.69.262

INSCRIBED: MAJOR RINGGOLD, MORTALLY WOUNDED / At the BATTLE of PALO ALTO, May 8th 1846 When the gallant Major fell, Captain Duncan offered to take charge of him. "No" replied he "you [have?] more important duties to attend to, / I shall be taken care of." (below image); EWC (lower left of image).

PROVENANCE: Unknown (at Bayou Bend prior to 1965).

W12*

Death of Major Ringgold

1846
Nathaniel Currier (1813–1888), New York
Hand-colored lithograph on wove paper; image:
8⅜ x 12½" (21.3 x 31.8 cm); sheet: 10⅛ x 14⅛"
(25.7 x 35.9 cm)
B.69.261

INSCRIBED: See Gale 1984, no. 1624.

PROVENANCE: Purchased by Miss Hogg from The Old Print Shop, New York, 1961.

REFERENCES: Gale 1984, no. 1624.

W13*

Genl. Taylor at the Battle of Palo Alto

1846
Nathaniel Currier (1813–1888), New York
Hand-colored lithograph on wove paper; image:
8⅛ x 12¼" (20.6 x 31.1 cm); sheet: 10 x 13⅞"
(25.4 x 35.2 cm)
B.69.273

INSCRIBED: See Gale 1984, no. 2517.

PROVENANCE: See cat. no. W10.

REFERENCES: Gale 1984, no. 2517.

W14*

Battle of Resaca de la Palma May 9th 1846

1846
Nathaniel Currier (1813–1888), New York
Hand-colored lithograph on wove paper; image:
7⅞ x 12⅝" (20 x 32.1 cm); sheet: 10 x 13¹/₁₆"
(25.4 x 33.2 cm)
B.69.267

INSCRIBED: See Gale 1984, no. 0477.

PROVENANCE: Purchased by Miss Hogg from The Old Print Shop, New York, 1959.

REFERENCES: Gale 1984, no. 0477.

W15*

The Brilliant Charge of Capt. May

1846
Nathaniel Currier (1813–1888), New York
Hand-colored lithograph on wove paper; image:
8⅜ x 12½" (21.3 x 31.8 cm); sheet: 10 x 14"
(25.4 x 35.6 cm)
B.69.265

INSCRIBED: See Gale 1984, no. 0772.

PROVENANCE: Purchased by Miss Hogg from Florence Peto, Tenafly, New Jersey, 1954.

REFERENCES: Gale 1984, no. 0772.

W16*

Battle of Monterey

1846–47
Nathaniel Currier (1813–1888), New York, after John Cameron (b. ca. 1828), New York
Hand-colored lithograph on wove paper; image:
8¼ x 12¾" (21 x 32.4 cm); sheet: 10 x 14⅛"
(25.4 x 35.9 cm)
B.69.270

INSCRIBED: See Gale 1984, no. 0463; J. Cameron 1847 (lower right of image).

PROVENANCE: See cat. no. W10.

REFERENCES: Gale 1984, no. 0463, which does not carry Cameron's signature.

W17*

Storming of Independence Hill at the Battle of Monterey

1847
Kelloggs and Thayer (act. 1846–47), New York; E. B. and E. C. Kellogg (act. 1843–52), Hartford; D. Needham (act. 1846–47, 1849–52), Buffalo[1]
Hand-colored lithograph on wove paper; image:
8 x 12¼" (20.3 x 31.1 cm); sheet: 10 x 14" (25.4 x 35.6 cm)
B.69.269

INSCRIBED (BELOW IMAGE): STORMING OF INDEPENDENCE HILL AT THE BATTLE OF MONTEREY. / 276.

PROVENANCE: Purchased by Miss Hogg from The Old Print Shop, New York, 1951.

1. The Kelloggs had multiple offices: in New York as Kelloggs and Thayer (Edmund Burke Kellogg [b. 1809], Elijah Chapman Kellogg [1811–1881], and Horace Thayer [b. 1811]); and in Hartford as E. B. and E. C. Kellogg. D. Needham was a partner and distributor of the Kelloggs working in Buffalo.

W18*

Storming at Monterey.—Attack On the Bishop's Palace

1847
Kelloggs and Thayer (act. 1846–47), New York; E. B. and E. C. Kellogg (act. 1843–52), Hartford; D. Needham (act. 1846–47, 1849–52), Buffalo

Hand-colored lithograph on wove paper; image: 8 x 12½" (20.3 x 31.8 cm); sheet: 10 x 13¾" (25.4 x 34.9 cm)
B.69.268

INSCRIBED (BELOW IMAGE): STORMING OF MONTEREY.—ATTACK ON THE BISHOP'S PALACE. / 283.

PROVENANCE: See cat. no. W10.

W19*

Capitulation of Monterey

1848
Sarony and Major (act. 1846–57), New York
Hand-colored lithograph on wove paper; image: 8¼ x 13" (21 x 33 cm); sheet: 9¾ x 14" (24.8 x 35.6 cm)
B.69.271

INSCRIBED (BELOW IMAGE): Gen! Ampudia treating for the CAPITULATION OF MONTEREY, with Gen! Taylor, 24ᵗʰ Sept: 1846. / Art. IV. That the citadel of Montery be evacuated by the Mexican, and occupied by the American forces, to-morrow morning / at 10 O'Clock.

PROVENANCE: See cat. no. W10.

W20*

General Taylor Never Surrenders

1847
Nathaniel Currier (1813–1888), New York
Hand-colored lithograph on wove paper; image: 8¼ x 12⅝" (21 x 32.1 cm); sheet: 10⅛ x 14" (25.7 x 35.6 cm)
B.69.272

INSCRIBED (BELOW IMAGE): SANTA ANNA'S MESSENGERS REQUESTING GENᴸ· TAYLOR TO SURRENDER HIS FORCES AT DISCRETION, PREVIOUS TO THE BATTLE OF BUENA VISTA. / "GENERAL TAYLOR NEVER SURRENDERS" / Sir: in reply to your note of this date, summoning me to surrender my forces at discretion, I beg leave to say that I decline acceding to your request. _ With high respect, I am, sir, your obedient serv't, z. TAYLOR. / 453.

PROVENANCE: See cat. no. W10.

REFERENCES: Gale 1984, no. 2461 (but uses "according" instead of "acceeding" in inscription); Warren 1988, p. 53.

W21*

Battle of Buena Vista

1847
Henry R. Robinson (act. 1843–48), New York
Chromolithograph on wove paper; image: 18⅝ x 28¾" (47.3 x 73 cm); sheet: 22⅛ x 30½" (56.2 x 77.5 cm)
B.69.278

INSCRIBED (BELOW IMAGE): FROM A SKETCH TAKEN ON THE SPOT BY MAJOR EATON, AID DE CAMP TO GENᴸ· TAYLOR. LITH. PUB. & PRINTED IN COLORS BY H. R. ROBINSON, 142 NASSAU Sᵀ N. YORK./BATTLE OF BUENA VISTA./VIEW OF THE BATTLE-GROUND AND BATTLE OF "THE ANGOSTURA" FOUGHT NEAR BUENA VISTA, MEXICO FEBRUARY 23ᴿᴰ· 1847. (LOOKING S. WEST.).

PROVENANCE: See cat. no. W10.

W22*

The Gallant Charge of the Kentucky Cavalry Under Col. Marshall

1847
Nathaniel Currier (1813–1888), New York
Hand-colored lithograph on wove paper; image: 8⅛ x 12¾" (20.6 x 32.4 cm); sheet: 10³⁄₁₆ x 14" (25.9 x 35.6 cm)
B.69.274

INSCRIBED: See Gale 1984, no. 2396.

PROVENANCE: See cat. no. W10.

REFERENCES: Gale 1984, no. 2396.

W23*

Flight of the Mexican Army

1847
Nathaniel Currier (1813–1888), New York
Hand-colored lithograph on wove paper; image: 8¼ x 12⅜" (21 x 31.4 cm); sheet: 10 x 13⅞" (25.4 x 35.2 cm)
B.69.275

INSCRIBED: See Gale 1984, no. 2181.

PROVENANCE: See cat. no. W10.

REFERENCES: Gale 1984, no. 2181.

W24*

Battle of Buena Vista

1847–48
Nathaniel Currier (1813–1888), New York, after John Cameron (b. ca. 1828), New York
Hand-colored lithograph on wove paper; image: 8 x 12⅝" (20.3 x 32.1 cm); sheet: 10 x 13⅞" (25.4 x 35.2 cm)
B.69.276

INSCRIBED: See Gale 1984, no. 0432.

PROVENANCE: Unknown (at Bayou Bend prior to 1965).

REFERENCES: Gale 1984, no. 0432.

W25*

Battle of Buena Vista

1851
Adolphe-Jean Baptiste Bayot (b. 1810), Paris, after Carl Nebel (1805–1855), Paris
Hand-colored lithograph on wove paper; image: 10⅞ x 16⅞" (27.6 x 42.9 cm); sheet: 13⅝ x 18½" (34.6 x 47 cm)
B.71.46

INSCRIBED: See Sandweiss, Stewart, and Huseman 1989, no. 38.[1]

PROVENANCE: See cat. no. W12.

REFERENCES: Sandweiss, Stewart, and Huseman 1989, no. 38.

1. This print was originally published in *The War Between the United States and Mexico Illustrated by Carl Nebel and by Geo. Wilkins Kendall* (Philadelphia: George S. Appleton, 1851).

W26*

Sheet Music, *Buena Vista March*

1846
Julius Manouvrier and P. Snell (act. ca. 1846–52), New Orleans, lithographers
William T. Mayo, New Orleans, publisher
Lithograph on wove paper; sheet: 9¾ x 13³⁄₁₆" (24.8 x 33.5 cm)
Gift of the estate of Miss Ima Hogg, B.79.192

INSCRIBED: Buena Vista March / Most respectfully dedicated / to / Genl. Taylor / By a disapointed [sic] Volunteer, who hoped to have / marched under his command to the city of Mexico (below image); Lucy Stone (on verso, in pencil).

PROVENANCE: Unknown (at Bayou Bend prior to 1965).

W27*

Seige [sic] of Vera Cruz March 1847

1847
Nathaniel Currier (1813–1888), New York, after John Cameron (b. ca. 1828), New York
Hand-colored lithograph on wove paper; image: 8⅛ x 12⅞" (20.6 x 32.7 cm); sheet: 10 x 14⅛" (25.4 x 35.9 cm)
B.69.283

INSCRIBED: See Gale 1984, no. 5858.

PROVENANCE: See cat. no. W10.

REFERENCES: Gale 1984, no. 5858.

W28*

Capitulation of Vera Cruz

1847
Nathaniel Currier (1813–1888), New York
Hand-colored lithograph on wove paper; image: 7⅝ x 12½" (19.4 x 31.8 cm); sheet: 10 x 13¾" (25.4 x 34.9 cm)
B.69.282

INSCRIBED: See Gale 1984, no. 0889.

PROVENANCE: See cat. no. W10.

REFERENCES: Gale 1984, no. 0889.

W29*

Landing of the American Forces Under Genl. Scott

1847
Nathaniel Currier (1813–1888), New York
Hand-colored lithograph on wove paper; image: 8⅛ x 12⅞" (20.6 x 32.7 cm); sheet: 10 x 14" (25.4 x 35.6 cm)
B.69.281

INSCRIBED: See Gale 1984, no. 3701.

PROVENANCE: See cat. no. W10.

REFERENCES: Gale 1984, no. 3701.

W30*

Attack of the Gun Boats upon the City, & Castle of San Juan de Ulloa

1847
Nathaniel Currier (1813–1888), New York, after James M. Ladd (d. 1847), Mexico[1]
Hand-colored lithograph on wove paper; image: 7⅞ x 12⅞" (20 x 32.7 cm); sheet: 10 x 14⅛" (25.4 x 35.9 cm)
B.69.280

INSCRIBED: See Sandweiss, Stewart, and Huseman 1989, no. 113.

PROVENANCE: See cat. no. W10.

REFERENCES: Mugridge and Conover 1972, pl. 63; Gale 1984, no. 0321; Sandweiss, Stewart, and Huseman 1989, no. 113.

1. James M. Ladd was a midshipman in the U.S. Navy during the Mexican War, at which time he made many sketches. For more information on Ladd, see Sandweiss, Stewart, and Huseman 1989, p. 264, n. 2.

W31*

Naval Bombardment of Vera Cruz

1847
Nathaniel Currier (1813–1888), New York
Hand-colored lithograph on wove paper; image: 8 x 12¹³⁄₁₆" (20.3 x 32.5 cm); sheet: 10 x 14¹⁄₁₆" (25.4 x 35.7 cm)
B.69.279

INSCRIBED: See Gale 1984, no. 4775.

PROVENANCE: See cat. no. W10.

REFERENCES: Gale 1984, no. 4775.

W32*

Victorious Bombardment of Vera Cruz

1847
Sarony and Major (act. 1846–57), New York
Hand-colored lithograph on wove paper; image: 8¼ x 12½" (21 x 31.8 cm); sheet: 10⅛ x 14" (25.7 x 35.6 cm)
B.69.347

INSCRIBED (BELOW IMAGE): VICTORIOUS BOM-BARDMENT OF VERA CRUZ. / by the united forces of the Army and Navy of the U. S. March 24th. and 25th. 1847.

PROVENANCE: Purchased by Miss Hogg from The Old Print Shop, New York, date unknown.

W33*

Bombardment of Vera Cruz

1851
Adophe-Jean Baptiste Bayot (b. 1810), Paris, after Carl Nebel (1805–1855), Paris
Hand-colored lithograph on wove paper; image: 10¾ x 16¾" (27.3 x 42.5 cm); sheet: 13½ x 18¼" (34.3 x 46.4 cm)
B.71.43

INSCRIBED: See Sandweiss, Stewart, and Huseman 1989, no. 115.[1]

PROVENANCE: See cat. no. W12.

REFERENCES: Sandweiss, Stewart, and Huseman 1989, no. 115.

1. See cat. no. W25, n. 1.

W34*

Storming of the Heights of Cerro Gordo

1847
Nathaniel Currier (1813–1888), New York, after John Cameron (b. ca. 1828), New York
Hand-colored lithograph on wove paper; image: 8 x 12⅜" (20.3 x 31.4 cm); sheet: 10 x 14" (25.4 x 35.6 cm)
B.69.285

INSCRIBED: See Gale 1984, no. 6279; Cameron 1847 (foreground of image).

PROVENANCE: See cat. no. W10.

REFERENCES: Gale 1984, no. 6279, which does not carry Cameron's signature.

W35★

Battle of Cerro Gordo

1847
Nathaniel Currier (1813–1888), New York
Hand-colored lithograph on wove paper; image:
8 x 12½″ (20.3 x 31.8 cm); sheet: 10⅛ x 14⅛″
(25.7 x 35.9 cm)
B.69.286

INSCRIBED: See Gale 1984, no. 0436; 466 (stock number).

PROVENANCE: See cat. no. W10.

REFERENCES: Gale 1984, no. 0436, which carries a different stock number.

W36★

Battle of Sierra Gordo . . .

ca. 1847
James Baillie (act. 1843–49), New York
Hand-colored lithograph on wove paper; image:
7⅝ x 11⅞″ (19.4 x 30.2 cm); sheet: 9¾ x 14″
(24.8 x 35.6 cm)
B.69.288

INSCRIBED (BELOW IMAGE): BATTLE OF SIERRA GORDO, APRIL 17th & 18th 1847, BETWEEN GENL. SCOTT AND SANTA ANNA. / Capture of Santa Anna's Carriage, Cash, Papers, Dinner, & Wooden leg. (center); American Force 8,000; / killed & wounded 500 men (left); Mexican Force 15,000 / Prisoners, killed, wounded & / run away 15,000 (right); Agents: J. Bardsley, Cor. of Arch & 2d St. Phila Joseph Ward, 52 Cornhill, Boston Mass. G. J. Loomis, No. 9 Washington St Albany, N. Y. (bottom).

PROVENANCE: Unknown (at Bayou Bend prior to 1965).

W37★

Battle of Molino del Rey . . .

1848
James Baillie (act. 1843–49), New York, after
John L. Magee (act. 1844–ca. 1860), New York
and Philadelphia
Hand-colored lithograph on wove paper; image:
8 x 12″ (20.3 x 30.5 cm); sheet: 10⅛ x 14″ (25.7 x
35.6 cm)
B.69.291

INSCRIBED: BATTLE OF MOLINO DEL REY, FOUGHT SEPT 8TH 1847. / Blowing up the Foundry by the Victorious American Army under Genl. Worth~Published by James Baillie, 87th St near 3rd Avenue N. Y. (below image); Magee (lower right of image).

PROVENANCE: See cat. no. W10.

W38★

Molino del Rey—Attack upon the Cas [sic] Mata

1851
Adolphe-Jean Baptiste Bayot (b. 1810), Paris,
after Carl Nebel (1805–1855), Paris
Hand-colored toned lithograph on wove paper
with gelatin highlights; image: 10¾ x 16¾″
(27.3 x 42.5 cm); sheet: 13½ x 18⅜″ (34.3 x 46.7 cm)
B.71.45

INSCRIBED: See Sandweiss, Stewart, and Huseman 1989, no. 141.[1]

PROVENANCE: See cat. no. W12.

1. See cat. no. W25, n. 1.

W39★

Molino del Rey—Attack upon the Molino

1851
Adolphe-Jean Baptiste Bayot (b. 1810), Paris,
after Carl Nebel (1805–1855), Paris
Hand-colored toned lithograph on wove paper
with gelatin highlights; image: 10¾ x 17″
(27.3 x 43.2 cm); sheet: 13½ x 18½″ (34.3 x 47 cm)
B.71.44

INSCRIBED: See Sandweiss, Stewart, and Huseman 1989, no. 140.[1]

PROVENANCE: See cat. no. W12.

1. See cat. W25, n. 1.

W40

The Storming of Chapultepec Sept. 13th 1847

1848
Sarony and Major (act. 1846–57), New York,
after James B. Walker (1818–1889), New York
Chromolithograph on wove paper; image:
23⅝ x 36″ (60 x 91.4 cm); sheet: 26⅞ x 38″
(68.3 x 96.5 cm)
B.71.49

The successful storming of Chapultepec Palace, located in a commanding position on a hill outside Mexico City, led to the fall of the Mexican capitol and the end of

W40

the war between the United States and Mexico. James Walker, a naturalized American of English origins, had gone to Mexico in the late 1830s and was residing in Mexico City at the time of the 1847 American invasion. Walker made his way to the American forces and volunteered as an interpreter. He thus was present at the battles of Contreras, Churubusco, and Chapultepec where he made sketches of the battle scenes. At the conclusion of the war, Walker returned to New York where he produced paintings based on his sketches. It is likely that he also supervised the production of this unusually large chromolithograph as it is virtually identical to the original painting. Captain Benjamin Stone Roberts, who is cited as the painting's owner, is credited with raising the American flag over the fallen Chapultepec Palace.[1]

INSCRIBED: See Sandweiss, Stewart, and Huseman 1989, p. 329.

PROVENANCE: Purchased by Miss Hogg from The Green Bottle, Houston, Texas, 1962.

REFERENCES: Mugridge and Conover 1972, pl. 67; Marzio 1979, p. 49, pl. 43, where the artist is incorrectly cited as Henry Walke; Sandweiss, Stewart, and Huseman 1989, p. 329, no. 148 and pl. 22 (nos. 149 and 150 are versions of the same print with descriptions in Spanish of the battle).

1. For information on Roberts and Walker, see Sandweiss, Stewart, and Huseman 1989, pp. 329–35.

W41*

The Repulsion of the Mexicans, and Bombardment of Metamoras [sic]

1848
Sarony and Major (act. 1846–57), New York
Hand-colored lithograph on paper; image:
8⅛ x 12¾" (20.6 x 32.4 cm); sheet: 10³⁄₁₆ x 14"
(25.9 x 35.6 cm)
B.69.289

INSCRIBED (BELOW IMAGE): THE REPULSION OF THE MEXICANS, AND BOMBARDMENT OF META-MORAS [sic]; / by the U. S. Troops, under Major Brown; at 5 A. M. of the 3rd May. / 700 Mexicans killed; 1 American.

PROVENANCE: See cat. no. W10.

W42*

Major General Winfield Scott

1846
Nathaniel Currier (1813–1888), New York
Hand-colored lithograph on wove paper; image:
12¼ x 8½" (31.1 x 21.6 cm); sheet: 14 x 10" (35.6 x 25.4 cm)
B.69.284

INSCRIBED: See Gale 1984, no. 4241.

PROVENANCE: Purchased by Miss Hogg from The Old Print Shop, New York, 1952.

REFERENCES: Gale 1984, no. 4241.

W43*

Brigadier General Z. Taylor

1846
James Baillie (act. 1843–49), New York
Hand-colored lithograph on wove paper; sheet:
14 x 10⅛" (35.6 x 25.7 cm)
B.69.277

INSCRIBED (BELOW IMAGE): BRIGADIER GENERAL Z. TAYLOR. / COMMANDER OF THE U. S. FORCES ON THE RIO GRANDE. / (From a portrait in possession of Major Clarke.).

PROVENANCE: See cat. no. W10.

W44*

Gen. Zachary Taylor

1846–47
Illman and Sons (act. 1845–47), Philadelphia
Engraving on wove paper; sheet: 19⅜ x 15¼"
(49.2 x 38.7 cm)
B.59.59

INSCRIBED (BELOW IMAGE): engraved by ILLMAN AND SONS FROM AN ORIGINAL PICTURE / GEN. ZACHARY TAYLOR. / Z. Taylor.

PROVENANCE: See cat. no. W14.

W45*

Old Rough and Ready

1846
Sarony and Major (act. 1846–57), New York
Hand-colored lithograph on wove paper; image:
8 x 12" (20.3 x 30.5 cm); sheet: 10 x 14" (25.4 x 35.6 cm)
B.69.263

INSCRIBED (BELOW IMAGE): OLD ROUGH AND READY.

PROVENANCE: See cat. no. W10.

W46*

Genl. Zachary Taylor

1848
James Baillie (act. 1843–49), New York, after Henry Buoholzer (b. ca. 1815), New York
Hand-colored lithograph on wove paper; image:
11⅜ x 8¼" (28.9 x 21 cm); sheet: 14 x 10" (35.6 x 25.4 cm)
B.69.287

INSCRIBED: GENL. ZACHARY TAYLOR. / THE HERO OF BUENA VISTA (below image): H. Buoholzer (lower right of image).

PROVENANCE: See cat. no. W10.

W47*

Major-General Zachary Taylor

1849–52
Sartain & Sloanaker (act. 1849–52), Philadelphia[1]
Mezzotint on wove paper; image: 20⅞ x 15¾"
(53 x 40 cm); sheet: 31¾ x 24" (80.6 x 61 cm)
Museum purchase with funds provided by Joseph D. McCord in honor of Harry H. Cullen at "One Great Night in November, 1992," B.92.19

INSCRIBED (BELOW IMAGE): FROM AN ORIGINAL DAGUERREOTYPE ENGRAVED BY JOHN SARTAIN / MAJOR-GENERAL ZACHARY TAYLOR. / PRESIDENT OF THE UNITED STATES.

PROVENANCE: Purchased by Bayou Bend from The Philadelphia Print Shop, Philadelphia, 1992.

1. John Sartain (1808–1897) and William Sloanaker (act. ca. 1847–53).

W48

Mexican News

ca. 1851
Alfred Jones (1819–1900), New York, after Richard Caton Woodville (1825–1855), Düsseldorf, London, and Paris
J. Dalton (n.d.), printer
Hand-colored engraving on wove paper; image:
20⅝ x 18⅜" (52.4 x 46.7 cm); sheet: 25¾ x 22¹⁵⁄₁₆"
(65.4 x 58.3 cm) [bottom edge has been trimmed]

W48

Museum purchase with funds provided by Louis K. Adler in honor of Meredith J. Long, in celebration of the North American Free Trade Agreement, at "One Great Night in November, 1993," B.93.26

While the output of Richard Caton Woodville was not large, his paintings are well known through prints such as the present example, commissioned by the American Art Union, which was founded in 1839 to promote the growth of fine art through the annual distribution of prints. The Mexican War, which resulted from the United States annexing Texas, was an extremely popular cause with Americans. Woodville has captured the excitment of the war news in his painting.[1] The war's popularity made a natural market for the Art Union's distribution of its print after Woodville's painting.

INSCRIBED: PAINTED BY R. C. WOODVILLE (below image, left); ENGRAVED BY ALFRED JONES. / PRINTED BY J. DALTON (below image, right); MEXICAN NEWS. / Engraved from the Original Picture / American Art-Union 1851 (below image, center); R. C. W. 1848 (lower left of image).

PROVENANCE: Purchased by Bayou Bend from Mongerson Wunderlich Gallery, Chicago, 1993.

RELATED EXAMPLES: Maryland Historical Society, Baltimore; Amon Carter Museum, Fort Worth; Varner Hogg State Park, West Columbia, Texas.

REFERENCES: Tyler 1987, p. 186, no. 123; Roylance 1990, p. 141.

1. Now at the National Academy of Design, New York (Stebbins et al. 1983, p. 259, no. 53).

W49*

U. S. Dragoons

1846
Nathaniel Currier (1813–1888), New York
Hand-colored lithograph on wove paper; image: 8½ x 12¾" (21.6 x 32.4 cm); sheet: 10⅛ x 14" (25.7 x 35.6 cm)
B.69.513

INSCRIBED: See Gale 1984, no. 6815.

PROVENANCE: See cat. no. W10.

REFERENCES: Gale 1984, no. 6815.

W50*

Pursuit of the Mexicans by the U. S. Dragoons

1847
Nathaniel Currier (1813–1888), New York
Hand-colored lithograph on wove paper; image: 8¼ x 12⅜" (21 x 31.4 cm); sheet: 10⅛ x 14" (25.7 x 35.6 cm)
B.69.290

INSCRIBED: See Gale 1984, no. 5398.

PROVENANCE: See cat. no. W10.

REFERENCES: Gale 1984, no. 5398.

W51

Am I Not a Man and a Brother?

ca. 1837
Unknown engraver and printer, New York
Wood engraving on wove paper; sheet: 19⅞ x 11¾" (50.5 x 29.8 cm)
Museum purchase with funds provided by various donors, B.95.4

This broadside was published in response to a February 1837 resolution in the U.S. House of Representatives that slaves do not possess the right of petition secured to the people by the Constitution. The vivid image of the supplicant slave in chains in combination with John Greeleaf Whittier's (1807–1892) moving poem

"Our Countrymen in Chains!" provide a powerful statement for the abolitionist cause.

INSCRIBED: AM I NOT A MAN AND A BROTHER? (on banner, below image); Sold at the American Anti-Slavery Office, 143 Nassau Street, New-York (below text of poem).

PROVENANCE: Purchased by Bayou Bend from Kennedy Galleries, New York, 1995.

W52*

The Confederates Evacuating Brownsville, Texas

ca. 1864
Unknown lithographer, possibly New York, after unknown English artist
Hand-colored lithograph on wove wood pulp paper; image: 6 x 9¼" (15.2 x 23.5 cm); sheet: 7⅜ x 11⅜" (18.7 x 28.9 cm)
B.59.58

INSCRIBED (BELOW IMAGE): THE CONFEDERATES EVACUATING BROWNSVILLE, TEXAS. [Sketched by an English Artist.].

PROVENANCE: See cat. no. W14.

REFERENCES: Harper's Weekly, February 13, 1864, p. 100.

W51

W 53

W 54

W53

Martial Law

1872
John Sartain (1808–1897), Philadelphia, after
George Caleb Bingham (1811–1879), Kansas City
and Columbia, Missouri
George C. Bingham & Co., Kansas City
and Columbia, Missouri, publisher
Hand-colored mezzotint and line engraving
on wove paper; image: 21⅝ x 30⅞" (54.9 x
78.4 cm); sheet: 25¾ x 35¾" (65.4 x 90.8 cm)
Museum purchase with funds provided by
"One Great Night in November, 1988," B.88.28

Bingham's painting, upon which this print
is based, was a vehicle for the artist to
express his outrage at the inhumane treat-
ment of his fellow Missourians in this un-
happy Civil War evacuation.[1] The widely
circulated Sartain print aroused such
strong public response that Bingham was
obliged to write a pamphlet defending his
depiction of the events.

INSCRIBED (BELOW IMAGE): MARTIAL LAW. / as
exemplified in the desolation of border coun-
ties of Missouri during the enforcement of
Military Orders, / issued by Brigadier General
Ewing of the Federal Army, from his Head
Quarters, Kansas City, August. 25th, 1863. /
Dedicated to the Friends of Civil Liberty, by
the Publishers (center); GENERAL ORDERS N.º II.
HEAD-QUARTERS DISTRICT OF THE BORDER, /
KANSAS CITY, MO. AUGUST 25th 1863. . . . H. HAN-
NAHS, Adjutant (left and right).

PROVENANCE: Purchased by Bayou Bend
from Mongerson Wunderlich Gallery,
Chicago, 1988.

REFERENCES: Reilly 1991, p. 603, no. 1872-13.

1. Bloch 1986, nos. 343, 352.

W54

The National Lancers . . .

1837
Fitz Hugh Lane (1804–1865), Boston, after
Charles Hubbard (1801–1876), Boston
Lithograph on laid paper; image: 14¾ x 20¼"
(37.5 x 51.4 cm); sheet: 20 x 23¾" (50.8 x 60.3 cm)
Museum purchase with funds provided by "One
Great Night in November, 1988," B.88.27

While Lane is best known as a painter of
the Luminist landscape, the first years
of his career were devoted primarily to
printmaking. In this early work he depicts
the brigades annual review held in May
on the Boston Common.

INSCRIBED (BELOW IMAGE): C. Hubbard del.
On Stone by F. H. Lane Moore's Lithography,
Boston. / THE NATIONAL LANCERS WITH THE RE-
VIEWING OFFICERS ON BOSTON COMMON. / Taken
from the Original Painting (as designed and
executed by C. Hubbard) on the Standard,
which was presented to the Company of His
Excellency the Governor of Massachusetts, on
the 30th of August 1837. / This print published
by request is respectfully dedicated to the
Corps. Boston, Sept 1837.

PROVENANCE: Purchased by Bayou Bend
from Susan Sheehan, Inc., New York, 1988.

REFERENCES: Susan Sheehan, Inc., New
York, *American Historical Prints,* April–May
1987, no. 30; Pierce and Slautterback 1991,
p. 49, no. 39.

W55*

The Court of Death

1859
Sarony, Major, and Knapp (act. 1857–67), New
York, after Rembrandt Peale (1778–1860),
Philadelphia
Chromolithograph on wove paper; image:
15¼ x 26⅝" (38.7 x 67.6 cm); sheet: 18⅞ x 28"
(47.9 x 71.1 cm)
Museum purchase with funds provided by Fred
M. Nevill, B.90.1

INSCRIBED (BELOW IMAGE): THE COURT OF
DEATH. / FROM THE ORIGINAL PAINTING, BY REM-
BRANDT PEALE (with an additional 40 lines of
text explicating the inspiration and iconogra-
phy of the image).

PROVENANCE: Purchased by Bayou Bend
from The Philadelphia Print Shop, Philadel-
phia, 1990.

REFERENCES: Marzio 1979, pp. 51 and 216, pl. 47.

W56

The Washington Family

1800
Edward Bell (act. 1794–1819), London, after
Jeremiah Paul (d. 1820), Philadelphia
Hand-colored mezzotint on wove paper; image:
18 x 23⅞" (45.7 x 60.6 cm); sheet: 19½ x 24⅝"
(49.5 x 62.5 cm)
B.65.5

Edward Bell was a member of a London
family of engravers working in the late

W56

W57

eighteenth and early nineteenth centuries. Jeremiah Paul was a painter active in Philadelphia, where he was a member of Charles Willson Peale's academic organization Columbianum.[1] At times it was difficult for artists to make a living solely from painting. Prints after their paintings, particularly of famous subjects, often became an important source of supplementary income. In this case, Paul may have taken his cue from fellow Philadelphia artist Edward Savage who had two years earlier published a successful print after his painting of the same subject. Although the image is rare today, the Paul print had a wide circulation in the nineteenth century, and it served as the prototype for schoolgirl embroideries.

INSCRIBED (BELOW IMAGE): Printed by J. Paul Junr Philadelphia Published December 1st 1800 by Atkins & Nightingale No. 143. Leadenhall Street, London & No. 35 North Front Street Philadelphia. Engraved by E. Bell, London / The Washington Family.

PROVENANCE: Purchased by Miss Hogg from The Old Print Shop, New York, 1965.

RELATED EXAMPLES: New York Public Library, McAlpin Collection (Guadagni 1967, p. 527, fig. 2, where the recently rediscovered original painting is illustrated as fig. 1); Parke-Bernet Galleries, sale 147, November 30, 1939, lot 148; Kennedy Galleries (Kennedy and Sack 1977, no. 104, with reference to Hart no. 765, which is catalogue of Charles H. Hart [Hart 1904]).

REFERENCES: Ring 1993, p. 87, where it is illustrated with a Boston needlework picture based on the print.

1. For information on Bell, see Smith 1883, p. 95; for more information on Paul, see Dickson 1947, p. 392.

W57

Pater Patriae

1803–10
Enoch G. Gridley (act. 1803–18), New York and Philadelphia, after John Coles, Jr. (b. 1776 or 1780, d. 1854), Boston
Stipple and line engraving with etching on wove paper; image: 13 1/16 x 8 13/16" (33.2 x 22.5 cm); sheet: 13 15/16 x 9 3/4" (35.4 x 24.8 cm) [irregular sheet]
Museum purchase with funds provided by the family and friends of Dr. Robert A. McClure, B.96.5

Americans marked the death of George Washington with a variety of mourning imagery, including prints and schoolgirl embroideries based on print prototypes (see cat. no. T41). This rare engraving, based on a lost painting by John Coles, Jr., incorporates iconography appropriate to the new nation: a liberty cap, a mourning Columbia, and a banner citing Washington's military victories. The oval image of Washington is based on Edward Savage's life portrait of 1792.

INSCRIBED: See Fowble 1987, p. 461, no. 325.

PROVENANCE: Purchased by Bayou Bend from The Old Print Gallery, Washington, D.C., 1996.

RELATED EXAMPLES: Brown University, Providence; Historic Deerfield; MFA, Boston; MMA; Winterthur (Fowble 1987, p. 461, no. 325). Another is illustrated in Deutsch 1977, p. 325.

REFERENCES: The Old Print Gallery Showcase 23, no. 1 (March 1996), p. 1.

W58

Benjamin Franklin

1793
Edward Savage (1761–1817), London, after David Martin (1737–1798), London
Mezzotint on wove paper; image: 17 3/4 x 13 7/8" (45.1 x 35.2 cm); sheet: 20 7/8 x 16" (53 x 40.6 cm) B.63.160

In 1793 Edward Savage published a print of George Washington and several months later issued this print of Franklin. As the two sitters are arranged to face each other, it is thought that the prints were conceived as a pair.

INSCRIBED (BELOW IMAGE): D. Martin pinx.t (left); E. Savage sculp.t (right); Benjamin Franklin L.L.D.—F.R.S. / London published Sept.r 17. 1793, by E. Savage, No. 50, Hatton Garden (center).

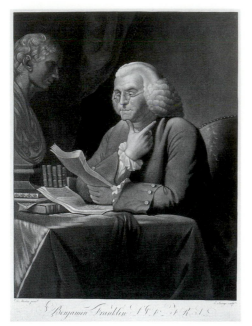

W58

PROVENANCE: Purchased by Miss Hogg from Kennedy Galleries, New York, 1963.

RELATED EXAMPLES: Shadwell 1969, p. 45, no. 83; the Martin portrait painting is at the White House (White House 1975, pp. 54–55); Washington print at Winterthur (Fowble 1987, no. 201).

W59*

Portrait of Sam Houston with a City View (two engravings)

ca. 1855–60
Steel-faced engraving on wove paper; image:
4¼ x 2¾" (10.8 x 7 cm); sheet: 5⅝ x 4¼" (14.3 x
10.8 cm), each
Gift of the estate of Miss Ima Hogg, B.77.33.1–.2

INSCRIBED (BELOW CITY VIEW): Sam Houston.

PROVENANCE: Purchased by Miss Hogg from Mr. Herbert Fletcher, Salado, Texas, 1962.[1]

1. Mr. Fletcher conveyed that this portrait was selected by Houston's son, Colonel Andrew Jackson Houston, as the best likeness of his father. It was used as a frontispiece for the deluxe edition of Houston's book, *Texas Independence.*

W60*

Mrs. Sam Houston

1860
Daguerreotype; image: 3⅝ x 2⅝" (9.2 x 6.7 cm);
case: ¾ x 4¾ x 3¾" (1.9 x 12.1 x 9.5 cm)
Gift of the estate of Miss Ima Hogg, B.89.19

PROVENANCE: Presented by Mrs. Ben Calhoun to Miss Hogg before 1968.

REFERENCES: Seale 1970, following p. 12.

W61*

Mather Byles

1732–39
Peter Pelham (ca. 1697–1751), Boston
Mezzotint on laid paper; sheet: 7⅛ x 5" (18.1 x
12.7 cm); plate: 6³⁄₁₆ x 4½" (15.7 x 11.4 cm)
B.61.69

INSCRIBED: See Fowble 1987, p. 286, no. 184.

PROVENANCE: Purchased by Miss Hogg from The Old Print Shop, New York, 1962.

REFERENCES: Fowble 1987, p. 286, no. 184.

W62*

Portrait of Paul Revere

1800
Charles Balthazar-Julien Févret de Saint-Mémin
(1770–1852), Philadelphia
Mezzotint on laid paper; image 2³⁄₁₆" (diam.)
(5.6 cm); sheet: 3⅜ x 3" (8.6 x 7.6 cm)
Museum purchase with funds provided by Alice
C. Simkins, B.84.1

INSCRIBED (BELOW IMAGE): Drawn & engr[d] by S[t] Memin Philad[a].

PROVENANCE: Paul Revere to his son, Paul Revere, Boston; to George Revere; to George Brigham Revere; to George Otis Revere; to Herbert Revere; to Paul Revere; [Bland Gallery, New York, 1951]; purchased by Bayou Bend at Christie's, New York, sale 5484, January 21, 1984, lot 84.

REFERENCES: Miles 1994, p. 378, no. 690.

W63*

Portrait of James Ashton Bayard

1800
Charles Balthazar-Julien Févret de Saint-Mémin
(1770–1852), Philadelphia
Mezzotint on laid paper; image: 2³⁄₁₆" (diam.)
(5.6 cm); sheet: 4½ x 4½" (11.4 x 11.4 cm)
Gift of Mrs. David Bland in memory of Frankie
Maud Murphy Aves, B.77.20

INSCRIBED (BELOW IMAGE): Drawn & engrav[d] by S[t] Memin Philadel[a].

PROVENANCE: Mrs. David Bland, Houston.

REFERENCES: Miles 1994, p. 245, no. 46, p. 378, no. 690.

W64*

Hollow-cut Silhouette of a Man

ca. 1800–05
Wove paper with black ink; image: 2½ x 1⅜"
(6.4 x 3.5 cm); sheet: 5 x 3⅞" (12.7 x 9.8 cm)
B.74.18

PROVENANCE: Unknown (at Bayou Bend prior to 1965).

TECHNICAL NOTES: The profile is cut out of the middle of the wove paper and is placed on top of another sheet of wove paper, which has been colored black from applied ink. Details of the hair and the ruffled shirt have been drawn with black ink on top layer.

W65*

Silhouette of a Lady

ca. 1800–50
United States
Black paper with gilt highlights; image: 3¾ x
1½" (9.5 x 3.8 cm); sheet: 4¼ x 3⅛" (10.8 x 7.9 cm)
B.74.14

PROVENANCE: Unknown (at Bayou Bend prior to 1965).

W66*

Silhouette of a Man

ca. 1800–50
United States
Black paper with gilt highlights; image: 2¾ x
1½" (7 x 3.8 cm); sheet: 5 x 4¼" (12.7 x 10.8 cm)
B.74.15

PROVENANCE: Purchased by Miss Hogg from Village Green Antiques, Richland, Michigan, 1969.

W67*

Revealed Silhouette of a Young Woman

1813–20
Moses Williams (ca. 1802–20), Philadelphia
Wove paper with black ink; image: 2⅞ x 1½"
(7.3 x 3.8 cm); sheet: 4¼ x 3⅛" (10.8 x 7.9 cm)
B.74.17

Revealed silhouettes were made as souvenirs for visitors to the Peale Museum in Philadelphia. Moses Williams, an African American who worked at the museum, used a physiognatrace to make the image.

EMBOSSED (AT THE BASE OF REVEAL): MUSEUM.

PROVENANCE: Unknown (at Bayou Bend prior to 1965).

TECHNICAL NOTES: The profile is cut out of the middle of the wove paper and is placed on top of another sheet of wove paper, which has been colored black with applied ink. Reframed in the mid-nineteenth century.

W68*

Silhouette of a Man

1820s
United States
Black paper, graphite, and gilt highlights;
image: 10 x 2¾" (25.4 x 7 cm); sheet: 12½ x 10½"
(31.8 x 26.7 cm)
B.74.16

PROVENANCE: Unknown (at Bayou Bend prior to 1965).

W69*

Silhouette Drawing of a Lady

1830–40
United States
Black ink with brown and white chalk
delineation on wove paper; image: 3 x 1½"
(7.6 x 3.8 cm); sheet: 4¼ x 3" (10.8 x 7.6 cm)
B.69.239

PROVENANCE: Purchased by W. C. Hogg at Anderson Galleries, New York, *The Jacob Paxson Temple Collection*, January 23, 1922, lot 88; estate of W. C. Hogg to Ima Hogg, 1930.

W70*

Revealed Silhouettes of a Man

1839
Wilmington, Delaware
Wove paper with black ink; images (each): 2¾ x
1⅜" (7 x 3.5 cm); sheet: 4⁷⁄₁₆ x 6¹¹⁄₁₆" (11.3 x 17 cm)
Gift of the estate of Miss Ima Hogg, B.79.172

INSCRIBED (BELOW RIGHT IMAGE): Elhana W. Gilbert / Wilmington Del, / copied 1839.[1]

PROVENANCE: Unknown (at Bayou Bend prior to 1965).

TECHNICAL NOTES: Two mirror images are cut out of the same sheet of wove paper and are placed on top of another sheet of paper, which has been colored black with applied ink.

1. Elhana W. Gilbert was listed as a reverend in the 1830 and 1840 census for Wilmington, Delaware. These works appear to be copies of silhouettes done at Peale's Museum in Philadelphia between 1803 and the late 1820s (object files, letter from Anne Verplanck, Maryland Historical Society, July 23, 1997).

W71

Silhouette Drawing of a Young Woman

ca. 1840s
Probably Philadelphia
Black ink with chalk delineation on wove wood
pulp paper; image: 3 x 1⅜" (7.6 x 3.5 cm); sheet:
4⅜ x 3¼" (11.1 x 8.3 cm)
Gift of Mrs. David Bland in memory of Frankie
Maud Murphy Aves, B.77.19

W71

This silhouette drawing is unusual in that the subject is an African American. A fragment from a Philadelphia newspaper within the frame suggests that the work was produced there. The Spanish-style comb in her hair and large sleeves of her dress lend a note of fashionable elegance.

PROVENANCE: Mrs. David Bland.

W72*

Wild Turkey

ca. 1827–32
William H. Lizars (1788–1859), Edinburgh, after
John James Audubon (1785–1851), United States
Hand-colored aquatint on wove paper; sheet:
25½ x 38¼" (64.8 x 97.2 cm)
B.73.3

INSCRIBED (BELOW IMAGE): Wild Turkey, ME-LEAGRIS GALLOPAVO. Linn. Female and Young (center); Engraved by W.H. Lizars. / Retouched by R. Havell, Jun.ʳ (right); Drawn from Nature by J. J. Audubon F, R, S F, L, S (left).

PROVENANCE: See cat. no. W17.

TECHNICAL NOTES: J WHATMAN watermark in upper right corner.

REFERENCES: John James Audubon, *The Birds of America*, 1824–38, pl. 6.

W73*

Mississippi Kite

1838
Robert Havell, Jr. (1793–1878), London, after John
James Audubon (1785–1851), United States
Hand-colored aquatint on wove paper; sheet:
26¼ x 21¼" (66.7 x 54 cm) [severely trimmed]
Gift of the estate of Miss Ima Hogg, B.79.188

PROVENANCE: Miss Ima Hogg.

INSCRIBED: Nº 24 (upper left); PLATE CXVII (upper right); Mississippi Kite, / FALCO PLUMBEUS. Gmel. / Male, 1. Female, 2. (below image, center); Drawn from Nature by J.J. Audubon F, R, S. F, L, S. (below image, left); Engraved, Printed, & Coloured, by R. Havell (below image, right).

TECHNICAL NOTES: Partial J WHATMAN watermark in upper right corner.

REFERENCES: John James Audubon, *The Birds of America*, 1824–38, pl. 117.

W74*

Boat-tailed Grackle

1834
Robert Havell, Jr. (1793–1878), London, after John James Audubon (1785–1851), United States
Hand-colored aquatint on wove paper; sheet: 26¼ x 21¼" (66.6 x 54.1 cm) [severely trimmed]
B.71.4

INSCRIBED: Nọ 38 (upper left); Plate CLXXXVII (upper right); Boat-tailed Grackle. / QUISCALUS MAJOR. Vieill. / Male, 1. Female, 2. / Live oak—Quercus virens (below image, center); Drawn from Nature by J. J. Audubon, F.R.S. F.L.S. (below image, left); Engraved, Printed, & Coloured, by R. Havell, 1834 (below image, right).

PROVENANCE: Probably purchased by Miss Hogg from The Old Print Shop, New York, 1951.

TECHNICAL NOTES: J WHATMAN watermark in lower right corner.

REFERENCES: John James Audubon, *The Birds of America*, 1824–38, pl. 187.

W75*

Louisiana Heron

1834
Robert Havell, Jr. (1793–1878), London, after John James Audubon (1785–1851), United States
Hand-colored aquatint on wove paper; sheet: 24¾ x 32¼" (62.9 x 81.9 cm); plate: 21½ x 26" (54.6 x 66 cm)
B.71.2

INSCRIBED: Nọ 44 (upper left); PLATE, CCXVII (upper right); Drawn from Nature by J.J. Audubon. F.R.S. F.L.S. (below image, left); Engraved, Printed, & Coloured, by R. Havell, 1834 (below image, right); Lousiana Heron, ARDEA LUDOVICIANA, Wils Male Adult (below image, center).

PROVENANCE: See cat. no. W17.

TECHNICAL NOTES: J WHATMAN watermark in upper left corner.

REFERENCES: John James Audubon, *The Birds of America*, 1824–38, pl. 217.

W76*

Roseate Spoonbill

1836
Robert Havell, Jr. (1793–1878), London, after John James Audubon (1785–1851), United States
Hand-colored aquatint on wove paper; sheet: 25½ x 38⅛" (64.8 x 96.8 cm)
B.75.60

INSCRIBED: Nọ 65 (upper left); PLATE CCCXXI (upper right); Drawn from Nature by J.J. Audubon F.R.S. F.L.S. (below image, left); Engraved, Printed and Coloured by R. Havell, 1836 (below image, right); Roseate Spoonbill. / PLATALEA AJAJA, L / Male Adult (below image, center).

PROVENANCE: See cat. no. W42.

TECHNICAL NOTES: J WHATMAN watermark in upper right corner.

REFERENCES: John James Audubon, *The Birds of America*, 1824–38, pl. 321.

W77*

American Flamingo

1838
Robert Havell, Jr. (1793–1878), London, after John James Audubon (1785–1851), United States
Hand-colored aquatint on wove paper; sheet: 38 x 24⅞" (96.5 x 63.2 cm)
B.71.5

INSCRIBED: Nọ 87 (upper left); PLATE CCCCXXXI (upper right); Drawn from Nature by J. J. Audubon, F. R. S. F. L. S. Engraved, Printed and Coloured by Robt Havell. 1838. / American Flamingo. / PHOENICOPTERUS RUBER.Linn. / Old Male. (below image, center); 1._Profile view of Bill at its greatest extension. / 2._Superior front view of upper Mandible. / 3._Interior front view of upper Mandible. / 4._Inferior front view of lower Mandible. / 5._Interior front view of lower Mandible with the Tongue in. (below image, left); 6._Profile view of Tongue. / 7._Superior front view of Tongue. / 8._Inferior front view of Tongue. / 9._Perpendicular front view of the foot fully expanded. (below image, right).

PROVENANCE: See cat. no. W17.

TECHNICAL NOTES: J WHATMAN watermark in upper left corner.

REFERENCES: John James Audubon, *The Birds of America*, 1824–38, pl. 431.

W78*

Black-tailed Hare

1845
John T. Bowen (act. 1838–56), Philadelphia, after John Woodhouse Audubon (1812–1862), United States
Hand-colored lithograph on wove paper; sheet: 21¼ x 27¼" (54 x 69.2 cm)
Gift of Eleanor Searle Whitney McCollum, B.91.24

INSCRIBED: Nọ 13 (upper left); PLATE LXIII (upper right); Lithᵈ Printed & Colᵈ by J. T. Bowen. Philadᵃ 1845 (below image, right); Drawn from Nature by J.J. Audubon. F.R.S. F.L.S. (below image, left); LEPUS NIGRICAUDATUS, BENNET, / BLACK-TAILED HARE. / MALE / Natural Size. (below image, center).

PROVENANCE: Gertrude Vanderbilt Whitney; to Whitney Museum (deaccessioned 1941); Eleanor McCollum.

TECHNICAL NOTES: Framing instructions in pencil on verso.

REFERENCES: John James Audubon and Rev. John Bachman, *The Quadrupeds of North America*, 1845–48, pl. 63.

W79*

Texian Hare

1848
John T. Bowen (act. 1838–56), Philadelphia, after John Woodhouse Audubon (1812–1862), United States
Hand-colored lithograph on wove paper; sheet: 20¾ x 26⅝" (52.7 x 67.6 cm)
Gift of Mr. and Mrs. Robert D. Jameson, B.67.20

INSCRIBED: Nọ 27 (upper left); PLATE CXXXIII (upper right); Drawn from Nature by J. W. Audubon (below image, left); Lithᵈ, Printed & Colᵈ by J. T. Bowen, Philadᵃ 1848 (below image, right); LEPUS TEXIANUS, AUD. & BACH. / TEXIAN HARE / MALE. / Natural Size (below image, center).

PROVENANCE: Purchased by Robert Jameson from an unknown source, 1967.

REFERENCES: John James Audubon and Rev. John Bachman, *The Quadrupeds of North America*, 1845–48, pl. 133; Warren 1988, p. 61.

W80*

Map of the United States of America

1830
Benjamin Tanner (1775–1848), Philadelphia,
after John Melish (1771–1822), Philadelphia
Hand-colored engraving on wove paper;
sheet: 17½ x 21½" (44.5 x 54.6 cm) [trimmed]
Gift of the estate of Miss Ima Hogg, B.79.191

INSCRIBED: Nº 68 (upper right); United States
/ of / AMERICA / Compiled from the latest &
best Authorities / BY / JOHN MELISH / En-
graved by B. Tanner (below image, right).

PROVENANCE: Miss Ima Hogg.

W81

Map of Texas

1830
Stephen F. Austin (1793–1836), Texas, compiler
John and William W. Warr (act. 1835–37),
Philadelphia, engravers[1]
Henry S. Tanner (1786–1858), Philadelphia,
publisher
Hand-colored lithograph on wove paper; sheet:
29¾ x 24¼" (75.6 x 61.6 cm)
B.69.264

This rare map, one of about ten surviv-
ing, documents for the first time the im-
migration of Americans into the Texas
region of Mexico. Their presence is noted
not only with the vast land grants that are
delineated in color but also by the newly
founded towns of San Felipe de Austin,
Harrisburg, and Brazoria, as well as the
older settlements at Bexar, Goliad, and
Nacogdoches.

INSCRIBED: See Streeter 1960, p. 102, no. 1115.

PROVENANCE: Unknown (at Bayou Bend
prior to 1965).

REFERENCES: Streeter 1960, p. 102, no. 1115.

1. John and William Warr were listed individu-
ally as engravers in the Philadelphia city
directories from 1825 to 1843. Although their
partnership was listed only from 1835 to
1837, John and William Warr collaborated at
other times on larger projects.

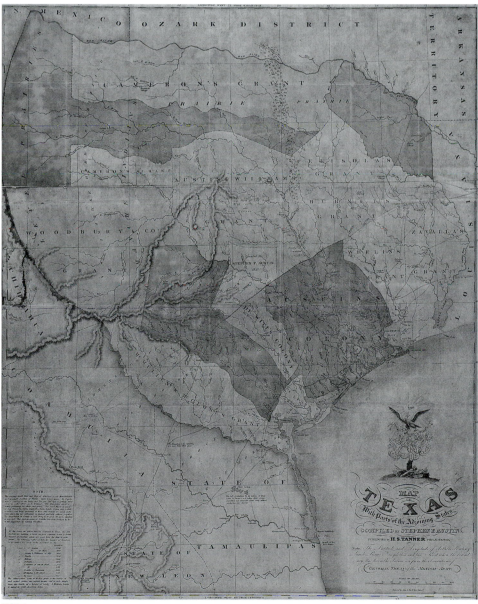

W81

W82*

Pressler's Map of Texas

1867
American Photo Lithographic Company
(ca. 1867–ca. 1885), New York, printer
Swenson Perkins & Co., New York, and Perkins
Swenson & Co., New Orleans, distributors
Lithograph, in book form; closed: 8¹¹⁄₁₆ x 5⁵⁄₁₆"
(22.1 x 13.5 cm)
B.69.432

INSCRIBED: Pressler's Map of Texas / Ameri-
can Photo Lithographic Co. / Osborne's
Process Room 19 Herald Building N.Y. / State
of Texas / Compiled from the Records of the
General Land Office the maps of the Coast Sur-
vey, the reports of the Boundary Commission
and reconaissences by Charles W. Pressler 1867.

PROVENANCE: Unknown (at Bayou Bend
prior to 1933).

W83*

View of Houston

ca. 1846
J. Kick (n.d.)
Watercolor on wove rag paper with gelatin
highlights on secondary support of wove paper;
image: 4½ x 6½" (11.4 x 16.5 cm); sheet: 8½ x
11³⁄₁₆" (21.6 x 28.4 cm)
Gift of Meredith J. Long, B.74.22

INSCRIBED (LOWER RIGHT OF IMAGE): JKICK.

PROVENANCE: Purchased by Meredith Long at auction in England, date unknown.

TECHNICAL NOTES: J WHATMAN TURKEYMILL 1846 watermark.

W84*

View of Houston, Capital of Texas

ca. 1852
Unknown engraver, Boston
Hand-colored wood engraving; image: 5 x 6"
(12.7 x 15.2 cm); sheet: 5¾ x 6¼" (14.6 x 15.9 cm)
B.71.51

INSCRIBED (BELOW IMAGE): VIEW OF HOUSTON, CAPITAL OF TEXAS.

PROVENANCE: Purchased by Miss Hogg from The Old Print Shop, New York, 1970.

REFERENCES: Gleason's Pictorial Drawing Board Companion, May 22, 1852, p. 332; Fuermann 1962, p. 2.

W85*

Houston, Hauptstadt von Texas

ca. 1855–60
Unknown engraver
Engraving on wove paper; image: 3¾ x 6" (9.5 x 15.2 cm); sheet: 11⅜ x 8⅝" (28.9 x 21.9 cm)
Gift of the estate of Miss Ima Hogg, B.79.163

INSCRIBED (BELOW IMAGE): Houston, Hauptstadt von Texas.

PROVENANCE: See cat. no. W84.

W86*

Vue de la Ville de Houston

ca. 1855–65
E. Therond (n.d.), Paris, after L. Regnier (n.d.), Paris
Hand-colored wood engraving on wove wood pulp paper; image: 9 x 12¾" (22.9 x 32.4 cm); sheet: 10¼ x 14½" (26 x 36.8 cm)
B.71.50

This print was a companion to cat. no. W87, and both were originally published in the French magazine L'Illustration Journal Universel sometime after 1854.

INSCRIBED: L. REGNIER (lower left of image); E. THEROND DEL. (lower right of image); VUE DE LA VILLE DE HOUSTON ('Texas, Etats-Unis).-Voir la note . . . la page pr,c,dente (below image); 28 L'ILLUSTRATION, JOURNAL UNIVERSEL (sideways in right margin).

PROVENANCE: Purchased by Miss Hogg from The Old Print Shop, New York, before 1961.

REFERENCES: Fuermann 1962, p. 2.

W87*

Vue de la Rade et de la Ville de Galveston

ca. 1855–65
E. Therond (n.d.), Paris, after L. Regnier (n.d.), Paris
Hand-colored wood engraving on wove wood pulp paper; image: 9¹⁄₁₆ x 12⅝" (23 x 32.1 cm); sheet: 10¼ x 14½" (26 x 36.8 cm)
B.71.48

INSCRIBED: L. REGNIER (lower left of image); E. THEROND, DEL (lower right of image); VUE DE LA RADE ET DE LA VILLE DE GALVESTON (Texas, Etats-Unis).—voir la page suivante (below image); L'ILLUSTRATION, JOURNAL UNIVERSEL 29 (sideways in left margin).

PROVENANCE: See cat. no. W86.

W88*

Port of Galveston, Texas

late 1800s
Washes on wove paper; sheet: 6¼ x 7½" (15.9 x 19.1 cm)
Gift of the estate of Miss Ima Hogg, B.79.140

INSCRIBED (BELOW IMAGE, LEFT): Port of Galveston / Texas.

PROVENANCE: Miss Ima Hogg.

W89*

The House Intended for the President of the United States in Ninth Street Philadelphia

1798–99
W. Birch & Son (act. ca. 1798–1800), Philadelphia[1]
Hand-colored engraving on wove paper, first

state; image: 8⅝ x 11" (21.9 x 27.9 cm); sheet: 13⅛ x 14½" (33.3 x 36.8 cm)
Museum purchase with funds provided by John B. Brent, S. Reed Morian, and Gene M. Woodfin in honor of Meredith J. Long at "One Great Night in November, 1992," B.92.15

INSCRIBED: See Snyder 1975b, p. 234, fig. 149.

PROVENANCE: Purchased by Bayou Bend from The Philadelphia Print Shop, Philadelphia, 1992.

REFERENCES: The City of Philadelphia, in the State of Pennsylvania North America (Philadelphia, 1798–99); Snyder 1975b, p. 234, fig. 149.

1. William Russell Birch (1755–1834) and Thomas Birch (1779–1851).

W90

The City of Philadelphia in the State of Pennsylvania North America

1801
Samuel Seymour (act. 1796–1823), Philadelphia, after Thomas Birch (1779–1851), Philadelphia
William Russell Birch (1755–1834), Philadelphia, publisher
Hand-colored line engraving on wove paper, second state; image: 18½ x 23½" (47 x 59.7 cm); sheet: 21 x 24½" (53.3 x 62.2 cm)
B.63.157

Between 1798 and 1800 William Birch and his son Thomas designed and published twenty-eight engraved views of Philadelphia. Occasionally William reworked those that did not satisfy him. This impression, dated 1801, represents a second state, where the description of Philadelphia's location was changed from "on the River Delaware" to "in the State of Pennsylvania."

INSCRIBED (BELOW IMAGE): The City of / Philadelphia in the State of Pennsylvania North America / Drawn by Tho.ᵉ Birch Published May 1st 1801 by Wm. Birch, Enamel Painter on Neshaminy . . . Bristol, Pennsylvania.

PROVENANCE: Purchased by Miss Hogg from Kennedy Galleries, New York, 1963.

RELATED EXAMPLES: Snyder 1975b, p. 226, fig. 137, illustrates the first state.

REFERENCES: Roylance 1990, p. 81.

W90

W92

W91*

View of West Point, United States Military Academy

1848
Robert Havell, Jr. (1793–1878), New York
Hand-colored aquatint and engraving on wove paper; image: 16⅛ x 23⅞" (41 x 60.6 cm); sheet: 18⅞ x 25" (47.9 x 63.5 cm)
Museum purchase with funds provided by Jack Trotter and Edward Gaylord at "One Great Night in November, 1988," B.89.16

INSCRIBED (BELOW IMAGE): Fort Putnam. Crows Nest. Cementery. Cornwell. Pollopels Island. N. Windsor. Newburgh. Magazine. H. R. Rail Road. Grand Sachem. / Hotel. Kosciusko Monument. Cold Springs. New Barracks Chapel. Academic Hall. Foundry / VIEW OF WEST POINT, / UNITED STATES MILITARY ACADEMY, / Painted by Robᵗ Havell, from Fort Putnam. / Published by Robᵗ Havell, Sing Sing _ W.A. Colman, 203 Broadway Williams & Stevens 353 Broadway, N. York. / Ackermann & Cº. 96 Strand, London.

PROVENANCE: Purchased by Bayou Bend from Susan Sheehan, Inc., New York, 1992.

RELATED EXAMPLES: West Point 1944, p. 48; *Antiques* 142 (August 1992), p. 138, advertisement of The Old Print Shop shows an earlier state.

W92

Cornelius & Baker

1856
W. H. Rease (b. ca. 1818), Philadelphia, lithographer

Wagner and McGuigan (act. 1845–58), Philadelphia, printers
J. H. Colton & Co. (act. ca. 1854–ca. 1859), New York, publisher
Chromolithograph on wove paper; image: 15⅛ x 23¼" (38.4 x 59.1 cm); sheet: 18¼ x 26⅝" (46.4 x 67.6 cm)
Museum purchase with funds provided by John C. Berryman, Charlie Chambers, Harry Cullen, Jr., Tom Gholson, Henry Hamman, Don Ison, Harry Jones, Joseph D. McCord, and Lester H. Smith in honor of Harry H. Cullen, Sr., at "One Great Night in November, 1992," B.92.13

INSCRIBED (BELOW IMAGE): CORNELIUS & BAKER, 181 Cherry Street PHILADELPHIA / MANUFACTURERS OF LAMPS GAS FIXTURES & c.[1]

PROVENANCE: Purchased by Bayou Bend from The Philadelphia Print Shop, Philadelphia, 1992.

1. This lithograph was originally published in *Colton's Atlas of America*, New York, 1856.

W93

Cornelius & Baker

1856
W. H. Rease (b. ca. 1818), Philadelphia, lithographer
Wagner and McGuigan (act. 1845–58), Philadelphia, printers
J. H. Colton & Co. (act. ca. 1854–ca. 1859), New York, publisher
Chomolithograph on wove paper; image: 12 x 23¼" (30.5 x 59.1 cm); sheet: 18½ x 26⅝" (47 x 67.6 cm)
Museum purchase with funds provided by John C. Berryman, Charlie Chambers, Harry Cullen, Jr., Tom Gholson, Henry Hamman, Don Ison, Harry Jones, Joseph D. McCord, and Lester H. Smith in honor of Harry H. Cullen, Sr., at "One Great Night in November, 1992," B.92.14

W93

INSCRIBED (BELOW IMAGE): CORNELIUS & BAKER / MANUFACTURERS OF / LAMPS, CHANDELIERS, GAS FIXTURES, &c. / MANUFACTORIES: Nº 181 CHERRY STREET & COLUMBIA AVENUE & 5.ᵗʰ STREET / PHILADELPHIA.

PROVENANCE: Purchased by Bayou Bend from The Philadelphia Print Shop, Philadelphia, 1992.

The advent of chromolithography not only made possible affordable reproductions of works of art, but it also revolutionized the business of advertising. These lithographs served as advertisements for the two Cornelius & Baker factories, which were located two miles apart.[1] W. H. Rease was the leading trade card artist in Philadelphia before the Civil War.[2]

1. Cornelius & Baker manufactured primarily light fixtures. See cat. no. M269 for an example of their work and for more information on the firm.
2. Marzio 1979, p. 68.

W94

Fishing Party

ca. 1815
Probably Susan Parker (n.d.), Bradford, Massachusetts
Watercolor on wove paper; image: 12½ x 16¼" (31.8 x 41.3 cm); sheet: 15¼ x 18⅜" (38.7 x 46.7 cm)
B.55.18

The importance of needlework pictures in the curricula of the many early nineteenth-century young lady's academies is well known today (see cat. nos. T39–T44). Although the newspaper advertisements of various teachers and schools often mention instruction in painting as well as needlework, reading, and writing, scholarship of the schoolgirl watercolor is a relatively uncharted territory. This example, depicting a bucolic waterside scene, appears at first glance to be a charming naive painting. However, at least two other virtually identical watercolors are known, confirming that this is a schoolgirl work. The common source was a ca. 1800 print after a painting by the English artist George Morland (1763–1804), titled The Angler's Repast.[1] Indeed, the original églomisé mat for this work bears the similar title, Fishing Party. It is most likely that the watercolor was completed by Susan Parker from Woburn, Massachusetts, a student at the Bradford Academy.[2]

INSCRIBED (ON LABEL ON VERSO): Designed and painted by / Susan Parker of Woburn, Mass. / -1815- / Wife of Marshall Wyman of Winchester, Mass. / and mother of Clara M. Wyman. (typed); To be given to Winchester / Historical Society / (Request of L.C. Pruitt) (in pencil).

PROVENANCE: Purchased by Miss Hogg from Teina Baumstone, New York, 1955.

TECHNICAL NOTES: WHATMAN watermark.

RELATED EXAMPLES: One, thought to have been made at the Bradford Academy, is by Lydia Hosmer of Concord, Massachusetts, ca. 1812 (Wood 1996, p. 132, fig. 53.1, pl. 26). Another was in the Garbisch Collection (Garbisch 1966, p. 27, no. 11).

1. The painting is located at the Yale Center for British Art, New Haven, and an impression of the print is in the Abby Aldrich Rockefeller Folk Art Collection, Williamsburg.
2. For information on the Bradford Academy, see Krueger 1978, p. 167.

W95

Ariadne

1835
Asher Brown Durand (1796–1886), New York, after John Vanderlyn (1775–1852), Paris
Line engraving on wove paper, seventh state; image: 14⅜ x 17¹⁵⁄₁₆" (36.5 x 45.6 cm); sheet: 17 x 20¼" (43.2 x 51.4 cm)
Museum purchase with funds provided by the Bayou Bend Docent Organization, B.95.2

This copy is a proof impression of a print that Durand had hoped would sell well. Unfortunately, the discomfort of Americans with the nude proved inhibiting to sales. Apparently copies were given to art collectors and fellow New York artists, one of whom, as the penciled inscription indicates, was John Ferguson Weir.

INSCRIBED: See Fowble 1987, pp. 532–33, no. 390; Ariadne—Gift of J. F. Weir (below image, in pencil), subsequently altered to read: John Ferguson Weir (1841–1926).

PROVENANCE: John Ferguson Weir (1841–1926), New York; Winterthur (deaccessioned 1994); purchased by Bayou Bend from Winterthur, 1995.

REFERENCES: Fowble 1987, pp. 532–33, no. 390; Roylance 1990, p. 115.

W96★

Bookplate for Isaiah Thomas (1749–1831)

ca. 1765–70
Paul Revere, Jr. (1734–1818), Boston
Engraving on laid paper; sheet: 3½ x 3³⁄₁₆" (8.9 x 8.1 cm)

W94

W95

Museum purchase with funds provided by the Bayou Bend General Accessions Fund, B.81.3

INSCRIBED: See Brigham 1954, pl. 53.

PROVENANCE: Purchased by Bayou Bend from American Antiquarian Society, Worcester, Massachusetts, 1980.

REFERENCES: Brigham 1954, pp. 110–15, pl. 53.

W97*

Lottery Ticket

1771
Philadelphia
Ink on laid paper; sheet: 1½ x 3¼″ (3.8 x 8.3 cm)
Museum purchase with funds provided by the Friends of Bayou Bend, B.83.5

This ticket was for a lottery in support of the struggling American China Manufactory (Bonnin & Morris) (see cat. no. C94).

INSCRIBED: NEW-CASTLE LOTTERY, / For the Encouragement of the American China Manufacture. / 1771. No. 430 [430 is handwritten] / THIS TICKET entitles the Bearer to Such / Prize as may be drawn against its Num- / ber, free from any Deduction. / G Sam^l Patterson [last line is handwritten].

PROVENANCE: Graham Hood; purchased by Bayou Bend from The Stradlings, New York, 1983.

REFERENCES: Brown 1989, p. 575, fig. 11.

W98

Child's Prayer of Thanksgiving

1798
Martin Brechall (1757–1831), Maxacany Township, Northampton (now Lehigh) County, Pennsylvania
Watercolor and ink on laid paper; sheet: 16 x 13″ (40.6 x 33 cm)
B.60.41

The body of illuminated manuscripts produced by the Pennnsylvania Germans, including birth and baptismal certificates, house blessings, child's blessings, and writing samples, are generically referred to as frakturs. The term is derived from the late broken Gothic script often incorporated by the ministers and schoolmasters who produced them. The earliest, as here, are entirely hand drawn, while later examples include elements of printed design.

Martin Brechall, a Hessian schoolmaster and prolific fraktur artist active in Northampton County between 1783 and about 1820, produced many signed frakturs, most of them birth certificates. This example is extremely rare in that it represents a child's prayer of thanksgiving for good parents, rather than the more common child's blessing. It also seems to be a very early example of the artist's work. Brechall's pride in his penmanship is evident in the variety of scripts employed in the text. The vertical format relates this piece to religious texts, as opposed to the horizontal one used for the early birth certificates.

INSCRIBED (AT BOTTOM): 26 February 1798 / An Philip Stambach / Geschrieben von Martin Brechall Schulmeister in Maxacany.

W98

PROVENANCE: Purchased by Miss Hogg from Richard H. and Virginia A. Wood, Baltimore, 1960.

TECHNICAL NOTES: JB watermark.

RELATED EXAMPLES: Weiser and Heaney 1976, no. 62, 311–20.

W99

Birth and Baptismal Certificate

1800–1810
Attributed to the "Engraver Artist," Upper Milford Township, Northampton (now Lehigh) County, Pennsylvania
Made for Jacob Fischer, born 19 August 1795, christened 25 September 1795, son of Johannes Fischer and Margaretta, née Kern
Ink and watercolor on laid paper; sheet: 8$\frac{1}{16}$ x 13" (20.5 x 33 cm)
B.60.43

W99

W100

This yet unidentified artist produced a body of readily recognizable works in which the apparently faded text contrasts with the darker inked specifics. The surrounding ovoid floral wreath is also typical of this particular hand.

PROVENANCE: See cat. no. W98.

RELATED EXAMPLES: Weiser and Heaney 1976, no. 340, is closely related, and no. 341 has a starburst flower similar to that at the top of the wreath here.

W100

Birth and Baptismal Certificate

ca. 1800
Friedrich Krebs (act. ca. 1790–1815), Dauphin County, Pennsylvania, and an anonymous scrivener
Printed by J. Schneider and Company, Reading,

Pennsylvania, 1798
Inscribed in Lower Saucon Township, Northampton County, Pennsylvania, 1798
Made for Earl Gross, born 6 February 1798, christened 6 April 1798, son of Frederick Gross and Eatgarina, née Albert
Oxgall ink, watercolor, and engraving on laid paper; sheet: 12$\frac{7}{8}$ x 15$\frac{3}{4}$" (32.7 x 40 cm)
Gift of David B. Warren in memory of Florence Prickett Warren Hershey, B.97.13

PROVENANCE: Purchased by Florence Warren (Hershey) from Andree Yule, Wilmington, Delaware, 1951; given to David Warren, 1985.

RELATED EXAMPLES: Weiser and Heaney 1976, nos. 303–4; Shelley 1961, no. 197.

W101

Birth and Baptismal Certificate

ca. 1815
Friedrich Krebs (act. ca. 1790–1815), Dauphin County, Pennsylvania, and an anonymous scrivener
Probably printed in Reading, Pennsylvania, 1790–1800
Inscribed in Forks Township, Northampton County, Pennsylvania, ca. 1815
Made for Peter Kind, born 27 May 1810, christened 25 August 1810, son of Isaac Kind and Elizabeth, née Messinger
Oxgall ink, watercolor, and engraving on laid paper; sheet: 12$\frac{1}{4}$ x 15$\frac{3}{8}$" (31.1 x 39.1 cm)
B.63.152

PROVENANCE: Purchased by Miss Hogg from Richard H. and Virginia A. Wood, Baltimore, 1963.

RELATED EXAMPLES: PMA (Garvan 1982, p. 298, no. 9); Weiser and Heaney 1976, no. 55; Shelley 1961, no. 198.

Friedrich Krebs was an extremely prolific fraktur artist who lived in Dauphin County near Harrisburg. From the 1790s on, he used forms printed especially for him that incorporated a large central heart flanked by two smaller hearts, all containing text. These printed forms, hand-embellished by Krebs, represent a combination important in the evolution of the fraktur. The Earl Gross certificate (see cat. no. W100) is characteristic of Krebs's third style, where the form does not yet have the printed legend "Geburts

W101

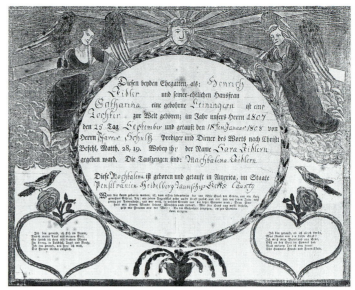

W102

und Tauf-shein" at the top as seen in later examples, and the watercolor ornament features leaf chains, pinwheel-like flowers, and little flamelike strokes projecting from the edge of the hearts.[1] The Peter Kind certificate typifies Krebs's mature style. Its decoration includes large Carolina parrots, stars with faces, and a central crown above and a basket below the large central heart. The ornamented blank documents were sold by Krebs for use by others.

1. Shelley 1961, nos. 197, 198, describes the earlier fraktur ornament as style III and the later, mature type as style IV.

rounded by a bold printed border, here a circle. The flying angels represent a new motif that became popular in the early nineteenth century. The watercolor decoration is applied directly over the printed details.

PROVENANCE: Probably purchased by Miss Hogg from Hattie Klapp Brunner, Reading, Pennsylvania, 1963.

RELATED EXAMPLES: Weiser and Heaney 1976, nos. 459–61. That these examples were used in Lebanon, Lehigh, and Lancaster Counties is indicative of the wide distribution of this printed form.

W102

Birth and Baptismal Certificate

ca. 1815
Unknown southeastern Pennsylvania printer,
ca. 1810
Inscribed in Heidelberg Township, Berks County,
ca. 1815
Made for Sara Fidlern, born 25 September 1807,
christened 18 January 1808, daughter of Heinrich
Fidler and Catharina, née Feininger
Hand-colored wood engraving on laid paper;
sheet: 12¾ x 15½" (32.4 x 39.4 cm)
B.63.146

This fraktur relates to the earlier design of Krebs (see cat. no. W101) with printed verses surrounded by hearts in the lower corners and the central statistical data sur-

W103

Birth and Baptismal Certificate

ca. 1828
Printed by John Wiestling (1787–1842),
Harrisburg, Pennsylvania
Inscribed in Hanover Township, Lebanon
County, Pennsylvania
Made for Johannes Schuy, born 23 September
1811, christened 6 October 1811, son of Ludwig
Schuy and Anna Margareta, née Cress
Hand-colored wood engraving on laid paper;
sheet: 15½ x 13¼" (39.4 x 33.7 cm)
Collection gift, B.84.2

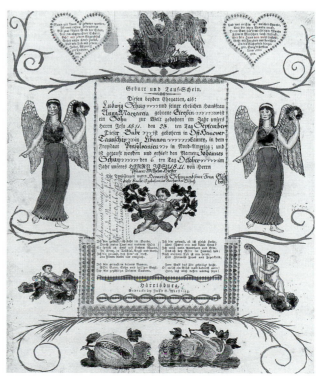

W103

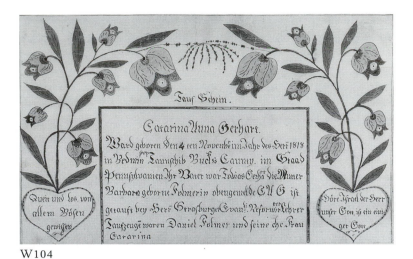

W104

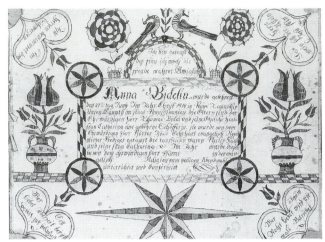

W105

This vertical printed certificate, flanked by standing Neoclassical angels, represents a type widely produced, with small variations of detail, in Harrisburg, Reading, and Allentown. Introduction of the American eagle is indicative of the growing assimilation of the Pennsylvania Germans in the 1820s.

PROVENANCE: Procured by Mrs. Max Levine as a door prize at the museum ball, 1954; transferred to Bayou Bend, 1984.

RELATED EXAMPLES: PMA (Garvan 1982, p. 304, nos. 27, 28); Weiser and Heaney 1976, nos. 115, 507.

W104

Baptismal Certificate

1820–25
Unknown artist, Bucks County, Pennsylvania
Made for Caterina Anna Gerhart of Bedminster Township, baptised 4 November 1818, daughter of Tobias Gerhart and Barbara, née Fulmer
Ink and watercolor on laid paper; sheet: 7⅞ x 12½" (20 x 31.8 cm)
B.60.40

For the 1820s, when the vertical format and preprinted text had become dominant, this entirely hand-produced horizontal certificate is unusual. Unlike cat. no. W105, which is also a late hand-executed example, this fraktur was only intended to be a baptismal certificate, as the legend "Tauf Schein" at the top indicates.

PROVENANCE: See cat. no. W98.

TECHNICAL NOTES: O PATRIA watermark.

RELATED EXAMPLES: Weiser and Heaney 1976, no. 68, also Bucks County, features similar tulips with little circles and dots, has "Tauf Schein" at the top, and includes the same biblical quote, "Hear, Oh Israel, the Lord our God is one God."

W105

Birth Certificate

ca. 1820–30
Unknown artist, Union (now Snyder) County, Pennsylvania
Inscribed in Penns Township, Union County
Made for Anna Bidel born 22 June 1814, daughter of Thomas Bidel and Caterina, née Schoffer
Ink and watercolor on wove paper; sheet: 12 x 16" (30.5 x 40.6 cm)
B.60.42

While this fraktur, which is entirely hand drawn, would appear to be early, the use of the drawing compass to produce the pinwheels at the corners of the text and the arch at the top is a feature that is found in work of the 1820s onward. Confirmation among the Pennsylvania Germans had no set age but rather occurred between 13 and 21 at the pastor's convenience. The artist here left room for the confirmation date, but it was never filled in.

PROVENANCE: See cat. no. W98.

W106

Birth and Baptismal Certificate

ca. 1850
Printed by John Ritter (1779–1857), Reading, Pennsylvania
Inscribed for Johannes David Shiltz, born 15 July 1843, christened 29 October 1843, son of William Schiltz and Heriella, née Deppy
Hand-colored engraving on wove paper; sheet: 16 x 13¹/₁₆" (40.6 x 33.2 cm)
B.63.147

John Ritter, one of Reading's most prolific printers, published variations on the standing angel certificate format for many years. This example, where he has anglicized his name from Johannes to John, as it appeared on earlier editions, represents a

W106

late example of the genre. The person who added the watercolor personalized the certificate by adding crests to the perched birds' heads.

PROVENANCE: See cat. no. W102.

RELATED EXAMPLES: Weiser and Heaney 1976, no. 485; earlier examples at PMA (Garvan 1982, pp. 302–3, nos. 21–23; Shelley 1961, no. 259, and p. 154, where he discusses this late type, which he calls Angel VI.

W107

W107

Bandbox

ca. 1842
Probably New York
Pasteboard and painted paper; 11½ x 17¾ x 14½″
(29.2 x 45.1 x 36.8 cm)
B.72.110

PROVENANCE: Katharine Prentis Murphy; purchased by Miss Hogg at O. Rundle Gilbert Auctioneers, New York, *Auction of the Estate of Katharine Prentis Murphy,* September 7, 1967, lot 269, through Miss Mary Allis.

TECHNICAL NOTES: Covering paper decorated with spread-wing American Eagle, weeping willow, and foliage; lined with *New York Herald* dated Saturday, January 22, 1842.

RELATED EXAMPLES: Hornung 1972, no. 1967.

W108

Bandbox

1830–50
Probably New York
Pasteboard and painted paper; 13¼ x 18¾ x 16¼″
(33.7 x 47.6 x 41.3 cm)
B.72.111

PROVENANCE: See cat. no. W107 (lot 267).

TECHNICAL NOTES: Covering paper, entitled "Grand Canal," decorated with scenes along the Erie Canal.

RELATED EXAMPLES: Shelburne Museum, Vermont (Carlisle 1960, p. 132).

W109

Bandbox

1830–50
Probably New York
Pasteboard and painted paper; 13 x 18¾ x 15⅞″
(33 x 47.6 x 40.3 cm)
B.72.112

PROVENANCE: See cat. no. W107 (lot 270).

TECHNICAL NOTES: Covering paper, titled "Castle Garden," decorated with scene of Castle Garden in New York's harbor.

RELATED EXAMPLES: Shelburne Museum, Vermont (Carlisle 1960, p. 165); Hornung 1972, no. 1975.

W110

Bandbox

1830–50
United States
Pasteboard and painted paper; 12¼ x 19¾ x 14¾″ (31.1 x 50.2 x 37.5 cm)
B.72.113

PROVENANCE: See cat. no. W107 (lot 268).

TECHNICAL NOTES: Covering paper decorated with traveling coach drawn by spirited horses pulling up in front of a brick inn.

RELATED EXAMPLES: Cooper-Hewitt Museum, New York (Lynn 1980, p. 299, fig. 13–9); Shelburne Museum, Vermont (Carlisle 1960, p. 117).

Pasteboard boxes, which held ribbons, bands, or lace, had been known since the seventeenth century. However, they reached their apex of popularity in America between 1830 and 1850 when new modes of transportation, such as the Erie Canal and turnpikes, enabled Americans to travel more easily. Such boxes were made in great quantity and functioned

W108

W109

W110

much as shopping bags do today. Made of light pasteboard, they were in their heyday decorated with specially printed, highly decorative paper. These four examples are extremely representative, with subjects ranging from our national symbol, to a depiction of coaching where the boxes were used, to the Erie Canal, a new symbol of industry and progress, to Castle Garden, a recreational park at the edge of New York City's harbor and the site of LaFayette's 1824 American landfall and Jenny Lind's 1850 American debut.

TEXTILES

T1*

Wholecloth Quilt

ca. 1760–1800
Great Britain or United States
Wool (see Technical notes); 90 x 87" (228.6 x 220.1 cm); face fabric: W. 29" (73.7 cm)
B.76.69

Most wholecloth woolen quilts of this period were probably made with fabric produced in Great Britain. While Britain had many professional quilters at the time this type of quilt was made, every indication is that this group reflects the needlework of North Americans. Earlier generations referred to this type of quilt as linsey-woolsey or calamanco.

PROVENANCE: Purchased by Miss Hogg from Curtis Tavern Antiques, West Granville, Massachusetts, 1958.

TECHNICAL NOTES AND DESCRIPTION: Twill-weave 2/2 wool face; tabby-weave wool back; wool fleece filling; wool thread. With a four-panel face of deep indigo, probably imported, glazed, worsted fabric, this quilt is patterned with blue quilting running stitches in a bold, five-branch Tree of Life motif, which springs from a central tuliplike bottom source. An undulating flowering vine serves as the border. Diagonal rows of quilting stitches detail the background while securing three layers: gold and blue backing, black fleece filling, and face fabric. The face fabric has permanent creases in both warp and weft directions from the glaze pressing process.

T2

Wholecloth Quilt

ca. 1760–1840
Great Britain or United States
Wool and linen (see Technical notes); 88½ x 84½" (224.8 x 214.6 cm); face fabric: W. 24¾" (62.8 cm)
B.76.71

PROVENANCE: Unknown.

TECHNICAL NOTES AND DESCRIPTION: Tabby-weave wool face; wool filling; tabby-weave wool and linen backing; wool thread. Five pieces of bright pink, probably imported, glazed, worsted fabric form the face of this quilt, which is patterned with cream quilting running stitches in an overall random, scrolling vegetal motif. The background is filled with diagonal lines. Quilting stitches secure pale blue-green backing, wool batting filling, and face fabric. The face fabric retains permanent creases in the warp direction from glaze pressing process.

T3*

Wholecloth Quilt

ca. 1760–1840
Probably United States
Wool (see Technical notes); 85 x 84" (215.9 x 213.4 cm); face fabric: W. 24½" (62.3 cm)
B.76.70

PROVENANCE: Purchased by Miss Hogg from John Kenneth Byard, Norwalk, Connecticut, 1953.

TECHNICAL NOTES AND DESCRIPTION: Tabby-weave wool face and back; wool filling; wool thread. The face of this quilt is composed of three panels plus a narrow width piece. It is made of bright pink, probably imported, glazed, worsted fabric. It is patterned in a delightfully idiosyncratic quilting running stitch with a floral center surrounded by four leaf forms, which in turn are surrounded by an over-scale floral and leaf garland and exterior border of half clusters of feathers or leaves. A small female figure is found on the center bottom edge. The background is filled with diagonal lines, and quilting stitches secure pieced mustard wool homespun backing, wool batting filling, and face fabric.

T4

Wholecloth Quilt

ca. 1780–1840
Great Britain or United States
Wool (see Technical notes); 101 x 90" (256.5 x 228.6 cm); face fabric: W. 30" (76.2 cm)
B.56.52

PROVENANCE: Purchased by Miss Hogg from Mrs. Lawrence J. Ullman.

TECHNICAL NOTES AND DESCRIPTION: Twill-weave wool face; tabby-weave wool back; wool filling; wool thread. The three-panel face of this quilt, of dark green, probably

T2

T4

imported, glazed, worsted fabric, is patterned with green thread in quilting running stitches that create a central motif: two confronting units from which floral sprays spread. Bold featherlike leaves form a scrolling border. The background is covered with diagonal lines. Quilting stitches secure napped green backing, wool filling, and face fabric.

T5★

Wholecloth Quilt

ca. 1780–1840
Attributed to Deborah Faulkner (n.d.),
New England
Wool (see Technical notes); 95 x 80" (241.3 x 203.2 cm); face fabric: W. 33" (83.8 cm)
B.76.75

The names inscribed in the center top pair of medallions of this quilt suggest it was made for or by Deborah Faulkner in commemoration of her marriage to Daniel Faulkner.

INSCRIBED (CENTER TOP): Deborah Faulkner / Daniel Faulkner.

PROVENANCE: Unknown.

TECHNICAL NOTES AND DESCRIPTION: Tabby-weave wool face and back; wool filling; wool thread. This tri-panel, dark blue, probably imported, worsted fabric faced quilt is patterned with running stitches that create forty-eight ten-inch circles containing flowers or a basket. The quilt is bordered on three sides with semicircles containing baskets. Lattice lines fill the background. Blue quilting stitches secure a yellowish-tan backing to wool filling and face fabric.

T6★

Wholecloth Quilt

ca. 1780–1840
Great Britain or United States
Wool (see Technical notes); 96½ x 100½" (245.1 x 255.3 cm); face fabric: W. 32" (81.3 cm)
B.76.76

PROVENANCE: Unknown.

TECHNICAL NOTES AND DESCRIPTION: Tabby-weave wool face and back; wool filling; wool thread. The three-panel face, with cutouts at the foot for bedposts, is of dark indigo, probably imported, worsted fabric. It is patterned with dark blue quilting running

stitches in a flowering Tree of Life form, which branches from center bottom to top sides. The border is composed of an undulating leaf garland with alternating stylized floral forms. Seven-pointed stars are spaced within the diagonal lines of the ground. Quilting stitches secure tan wool backing, wool filling, and face fabric. The face fabric retains permanent creases in the direction of warp threads from the glazing pressing pressure. The glaze is worn off.

T7★

Wholecloth Quilt

ca. 1780–1840
Great Britain or United States
Wool (see Technical notes); 92¼ x 100" (234.3 x 254 cm); face fabric: W. 26" (66 cm)
B.62.25

INSCRIBED (CROSS-STITCHED ON UPPER CORNER OF BACKING): I.T. (refers to the owner, who was not necessarily the maker).

PROVENANCE: Purchased by Miss Hogg from Curtis Tavern Antiques, West Granville, Massachusetts, 1962, who noted that the quilt came from the New Hampshire area.

TECHNICAL NOTES AND DESCRIPTION: Tabby-weave wool face and back; wool filling; wool thread. The three-panel, plus partial widths, face of this quilt is of deep pink, probably imported, glazed, worsted fabric. It is patterned with quilting running stitches in creamish-gold thread that create a spreading

Tree of Life center. From an inverted heart, with crosshatch filling, spring three vines: the middle vine moves up the center and branches off to fill the field with vines that curve downward to enclose bold flowers and leafy surrounds; the left and right vines curve downward on either side of the heart. An undulating leaf garland forms border at sides and bottom. Quilting stitches secure gold backing, wool filling, and face fabric. The panel has been notched to accommodate bed foot posts.

T8

Wholecloth Quilt

ca. 1790–1820
United States
Wool and cotton (see Technical notes); 92 x 94" (233.7 x 238.8 cm); face fabric: W. approx. 20" (50.8 cm)
B.79.233

PROVENANCE: Unknown.

TECHNICAL NOTES AND DESCRIPTION: Tabby-weave wool face and back; wool thread; cotton filling. The five-panel face of this quilt is of salmon colored, probably imported, worsted fabric. It is patterned with gold thread quilting running stitches that create a central panel of a large circle filled with pineapples, or hearts, surrounded by a frame of diamonds with a fan in each corner. A leafy serpentine forms the inner border. The design on the drops consists of swag and bow garland. Quilting stitches secure gold backing, wool filling, and face fabric.

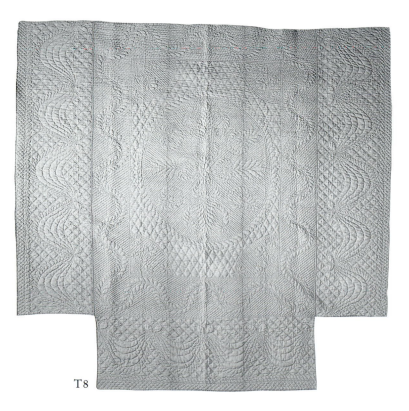

T8

RELATED EXAMPLES: A whitework cotton quilt made by Elizabeth Holmes Adams (1797–1838), Peterborough, New Hampshire, in the Spencer Museum of Art, University of Kansas (Brackman 1989, p. 134).

T9★

Bedroom Furnishings

ca. 1790–1820
Possibly Rocky Hill, Connecticut, area
Cotton (see Technical notes); B.61.38.1, quilt: 84 x 88″ (213.4 x 223.5 cm), face fabric: W. 44″ (111.8 cm); B.61.38.2, table cover: 37 x 35″ (94 x 88.9 cm); B.61.38.3, table cover: 23½ x 37″ (59.7 x 94 cm); B.61.38.4, bed skirt: 220 x 20″ (559 x 50.8 cm); B.61.38.5, bed valance: 220 x 16¾″ (559 x 42.5 cm) B.61.38.1–.5

PROVENANCE: Purchased by Miss Hogg from Curtis Tavern Antiques, West Granville, Massachusetts, 1961.

TECHNICAL NOTES AND DESCRIPTION: Tabby-weave cotton face and back; cotton filling. Designed as coordinating all-white textiles for a bedroom setting, the surviving pieces in this suite are all patterned by stuffing within backstitch outlines. Such work is variously known as stuffed-work, trapunto, and Marseilles quilting. The coverlet boasts a central basket from which arc foliate branches. Along the sides and across the foot is an undulating, twisted garland, while across the top a bowed swag forms the border. Although not so exuberant, the table covers likewise feature a central basket containing a foliate spray and a modified crescent undulating border. The valance is edged with a row of partial scallop-shell motifs above which undulates a floral garland. The matching bed skirt is worked only with the scallop motif.

RELATED EXAMPLES: Table covers at Williamsburg (acc. nos. G 1971-133; G 1982-147; G 1985-188).

REFERENCES: Safford and Bishop 1972, p. 82.

T10★

Wholecloth Quilt

ca. 1800–1825
Middle Atlantic States
Cotton (see Technical notes); 95 x 98″ (241.3 x 248.9 cm)
B.76.263

PROVENANCE: Unknown.

TECHNICAL NOTES AND DESCRIPTION: Tabby-weave cotton face and back; cotton filling. Four panels of cloth form this near square, white, stuffed-work quilt. The motif is outlined with running stitches beginning with a central floral and fruit basket framed by four garland borders: wheat, coiling morning-glorylike vine, floral and fruit swag rising to bowknots, and grapevine. The last two border only three sides, and in the pillow area the decorative quilting ends.

RELATED EXAMPLES: Hoke 1985, pp. 20–21; Nelson and Houck 1982, p. 59; White 1948, pp. 42–43.

T11★

Wholecloth Quilt

ca. 1810
New England[1]
Cotton (see Technical notes); 85 x 71″ (215.9 x 180.3 cm); face fabric: W. 34″ top (86.3 cm)
Gift of Mrs. Dan H. Carpenter, B.76.66

PROVENANCE: By descent through the Hall, Andrus, and Gibbs families.

TECHNICAL NOTES AND DESCRIPTION: Tabby-weave cotton face and back; cotton fringe and filling. This rectangular quilt boasts a central oval medallion divided into bracket-outlined, blossom-filled quadrants. It is framed in turn by eight stars with a laurel leaf oval. The remainder of the ground is filled with an outer garland border of fruits—grapes, cherries, pineapples—and flowers that are embellished with French knots. The filled outline pattern is worked in running stitch, and a hand-knotted fringe borders three sides.

RELATED EXAMPLES: Voorhees family quilt, Long Island, New York, 1830–31, in the Newark Museum, New Jersey (acc. no. 49.50).

1. By tradition the quilt is the work of Rebecca Hall of Connecticut.

T12★

Wholecloth Quilt

ca. 1820–50
Great Britain or United States
Cotton (see Technical notes); 84½ x 82½″ (214.6 x 209.5 cm); face fabric: W. 27½″ (69.8 cm)
B.76.39

PROVENANCE: Unknown.

TECHNICAL NOTES AND DESCRIPTION: Tabby-weave cotton face and back; cotton filling. This all-white, almost square quilt has a large central medallion incorporating three birdlike motifs. The center is surrounded by two inner circles, the outline of which resembles, in a calligraphic manner, mirror-image scrolls and hearts. Filling the corners and outer borders is a lattice ground. The exterior border is composed of scroll-like forms. Quilting stitches secure the three layers of cotton products.

T13★

Wholecloth Quilt

ca. 1825–50
United States
Wool and cotton (see Technical notes); 83 x 86″ (210.8 x 218.4 cm); face fabric: W. 28½″ (72.4 cm) Gift of the estate of Miss Ima Hogg, B.76.25

PROVENANCE: Unknown.

TECHNICAL NOTES AND DESCRIPTION: Tabby-weave wool and cotton face and back; wool filling; wool thread. The three-panel face is of unevenly dyed blue fabric with cotton warp and wool weft. The overall quilting pattern is of shallow zigzags. Quilting stitches secure tan cotton and wool backing, wool filling, and face fabric.

T14

Wholecloth Quilt

ca. 1859–61
United States
Cotton (see Technical notes); 84 x 72½″ (213.3 x 184.2 cm)
B.63.150

PROVENANCE: Purchased by Miss Hogg from Mary Alice Antiques, Southport, Connecticut, 1963.

TECHNICAL NOTES AND DESCRIPTION: Tabby-weave cotton face and back; cotton filling. This quilt shows the eagle spreading its wings without the usual framing. A coiled floral garland forms an exterior border. In the talons of the eagle are olive branches and spearheads, while thirty-three stars float above the halo. The figural elements have been

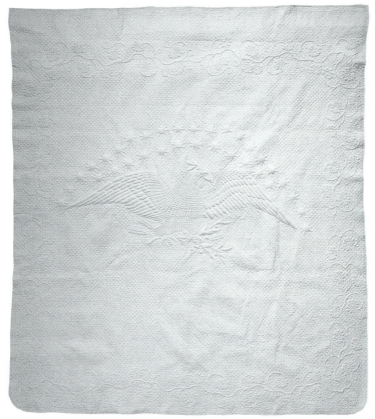

T14

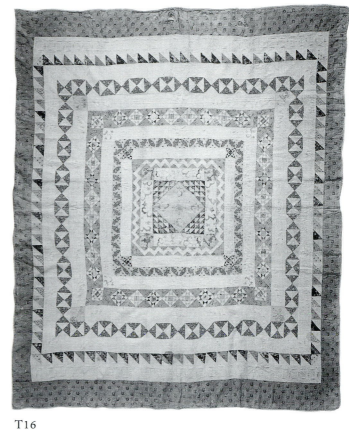

T16

given extra stuffing to raise them above the latticed ground of the quilt. Such enhancement has been referred to as stuffed-work, Marseilles, or trapunto quilting and is applied within the borders established by the quilting stitches that unite the face, back, and ordinary layer of filling.

RELATED EXAMPLES: Carlisle 1957, pp. 10–11; Betterton 1978, p. 125.

T15*

Bed Spread

ca. 1830
Textile: Great Britain
Spread: United States
Tabby-weave cotton; 105 x 102″ (266.7 x 259 cm)
B.76.73

INSCRIBED (CENTER TOP, CROSS-STITCHED): TW.

STAMPED (CENTER TOP): T. Wilson.

PROVENANCE: Unknown.

TECHNICAL NOTES AND DESCRIPTION: Of single-bed proportion and with deep drops, this glazed roller- and block-printed, quilted spread features floral bands related to the pillar prints of the same era. In reds, greens,

and brown on a white ground, the design features an ostrichlike bird. The fabric is typical of the many roller-printed fabrics made in Great Britain in the early nineteenth century.[1] The quilting is a series of diagonal lines. Raw seams are finished with a polychrome twilled tape.

1. Roller and cylinder are used interchangeably to describe the fabric printing process. Additional detailing might sometimes be printed with a block to alter slightly a particular design.

T16

Framed Medallion Piecework Quilt

ca. 1790–1820
Great Britain or United States
Cotton, linen, and wool (see Technical notes);
98 x 78″ (248.9 x 198.1 cm)
Gift of the estate of Miss Ima Hogg, B.79.229

PROVENANCE: Unknown.

TECHNICAL NOTES AND DESCRIPTION: Tabby-weave cotton face and back; tabby-weave linen face; wool filling; cotton yarn. This quilt is composed of thirteen concentric

squares that radiate from a central up-ended panel embroidered with a floral motif in crewel yarns. The first frame consists of piecework triangles, which form the flying geese pattern. Next comes a border of more crewel embroidery on a cream ground. It is followed by a sawtooth piecework band, then whitework quilting. The predominantly brown, ground-block-printed cottons alternate with white quilting with elliptical leaf forms, then a band of whitework quilting cornered with blocks of crewelwork. The next row of piecework is a chain of alternating blocks of stars and crosses followed by whitework. A link of bows, sawtooth triangles, and an exterior plain border are separated by more whitework quilting.

RELATED EXAMPLES: Williamsburg (acc. nos. 78.23, G63.71); Orlofsky and Orlofsky 1974, pl. 56.

T17

Piecework Autograph Cross Friendship Quilt

1842–44
Elizabeth C. Loudenslager and others,
Mauricetown, New Jersey, and vicinity
Cotton (see Technical notes); 113 x 113″ (287 x 287 cm)
B.76.90

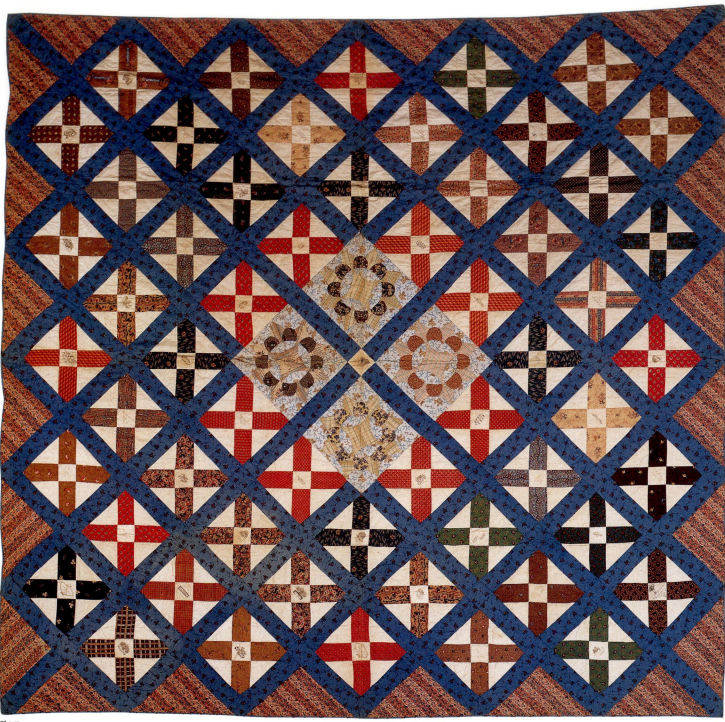

T17

PROVENANCE: Unknown.

TECHNICAL NOTES AND DESCRIPTION:
Tabby-weave cotton face and back; cotton filling. This quilt is constructed of sixty on-point squares, each composed of a central square surrounded by four rectangular arms with triangular fillers set within a lattice framework in a five- or six-by-eleven-row configuration. The blocks are assembled from thirty-seven unique printed fabrics and bear either ink or stamped signatures and/or emblems. The quilt was probably assembled over a two-and-a-half-year span (1842–44) by Elizabeth (E.C.) Loudenslager, wife of circuit-rider

preacher Jacob Loudenslager. It probably commemorates the building of the Methodist Episcopal Church in Mauricetown, New Jersey, in 1842, and the death of the couple's first granddaughter, Ann Elizabeth Loudenslager, who died in infancy before her surviving, namesake sibling was born in 1845.

Reading from top to bottom, left to right, the blocks are inscribed with the names of the Loudenslager relatives, friends, and members of the congregation:

1. Sarah Turner [daughter of Joseph], Paulsboro [New Jersey], 1843
2. Elizabeth S. Baker, Paulsboro, 1843

3. John Loudenslager
4. Mary Haily, Mauricetown [New Jersey], March 30, 1843
5. Mary S. Loudenslager [great-niece of Elizabeth and daughter of George, Jr.], Philadelphia, February 29, 1844 [see no. 12, below]
6. Joseph Turner [father of Sarah], Paulsboro, 1843
7. Loretta Shropshire, Mauricetown, March 30, 1843
8. Charles Parker, Clonmell [New Jersey], 1844
9. Susan Loudenslager, Philad, 1943
10. M. Baker, Paulsborough, NJ, 1842

11. Hannah E. Loudenslager [great-niece of Elizabeth and daughter of George, Jr.], Philad, 1843
12. Rebecca S. Loudenslager [great-niece of Elizabeth and daughter of George, Jr.], Philadelphia, February 29, 1844 [see no. 5, above]
13. Sopia Compton, Mauricetown, 1843
14. Henry and Mary Clymer
15. Martha W. Paul [sister of Elizabeth C. Loudenslager], Paulsboro, 1843
16. Elizabeth Howell, Mauricetown, March 30, 1843
17. Lavinia Bostick [or Bostwick], Philada, 1843
18. Catharine Stelwaggon, Philada, 1844
19. David Loudenslager [great-nephew of Elizabeth, son of George, Jr.], Philadelphia, 1843
20. Rachel Haley
21. Isabella Loudenslager
22. Miriam Greess [?], Mauricetown, 1843
23. Margaret B. Loudenslager, Philadelphia, February 29, 1844
24. Wm Loudenslager [great-nephew of Elizabeth, son of George, Jr.], Phila, 1843
25. [Embroidered center block]
26. William Haley
27. Philip L. Baker [husband of Ann, father of John], Paulsboro, NJ
28. Thomas Loudenslager [nephew of Jacob]
29. George Loudenslager [brother of Jacob ?]
30. [Embroidered center block] Ann Elizabeth Loudenslager [inscribed under willow by tombstone]
31. [Embroidered center block]
32. [Memorial dedication to Michael and Elizabeth Loudenslager, Paulsboro, with willow and tombstone]
33. Caroline R. Compton, Mauricetown, April, 1843
34. Geo. Loudenslager [Jr.] [nephew of Elizabeth], Philada, 1843
35. Ashsoh Loudenslager, Paulsboro, NJ [sister-in-law of Jacob]
36. [Embroidered center block]
37. Mary Clymer, Philada, 1843
38. Jacob Loudenslager
39. Mary Rea, Mauricetown, March 31, 1843
40. Charles C. Loudenslager, Paulsboro
41. John Loudenslager [brother or nephew of Jacob], Paulsboro, NJ
42. Vashti Sharp, Mauricetown, March 30, 1843
43. Elizabeth Loudenslager [aunt of George, Jr., and great-aunt of David, William, Mary Rebecca, Joseph, Hannah], Philadelphia
44. Jane Haley
45. Ann S. Baker [wife of Philip and mother of John], Paulsboro, January 18, 1843
46. Nancy Paul [mother of Elizabeth C. Loudenslager], Paulsboro, 1843
47. George and Sarah Loudenslager
48. E. C. Loudenslager
49. George Haley
50. Eliza Compton

51. Elizabeth Haily, Mauricetown, March 30, 1843
52. John C. S. Baker [son of Philip and Ann S.]
53. Harriott Eliza Parvin, Cedarville [New Jersey], February 29, 1844
54. James J. Loudenslager [nephew of Jacob], Paulsboro
55. David P. Haley
56. Elizabeth Gray
57. Margaret C. Bacon
58. Joseph L. Loudenslager [great-nephew of Elizabeth and son of George, Jr.], Philadelia, 1843
59. Sarah Compton, Mauricetown, 1843
60. Mary S. Compton, Mauricetown, April 1843

RELATED EXAMPLES: Kiracofe and Johnson 1993, p. 82.

T18

Carpenter's Wheel, Dutch Rose, or Octagon Star Piecework Quilt

ca. 1850–1900
Probably United States
Cotton (see Technical notes); 77 x 75" (195 x 190.5 cm)
B.76.84

PROVENANCE: Unknown.

TECHNICAL NOTES AND DESCRIPTION: Tabby-weave cotton face and back; cotton filling. Five rows of five radiating eight-point stars compose the grid of this plain printed red, green, and white quilt top. The design's geometry is built on alternating rings of diamonds and squares. This particular motif can be identified by at least three different popular titles.

RELATED EXAMPLES: Texas Quilts 1986, p. 75; Fox 1981, pp. 22, 42.

T19

T19

Star of Lemoyne Piecework and Surface-appliqué Quilt

ca. 1850–1900
United States, possibly southern states
Cotton (see Technical notes); 105 x 90" (266.7 x 228.6 cm)
Gift of Mrs. Barbara Arnold Sterrett, B.83.12

PROVENANCE: Acquired (by donor?) in Marietta, Georgia, late 1930s.

TECHNICAL NOTES AND DESCRIPTION: Tabby-weave cotton face and back; cotton filling. Forty-two eight-pointed stars of blue and white printed calico form this piecework pattern. The stars are bordered within an appliqué garland of swags peaking in curved segments. The top center (pillow area) is undecorated, and the individuality of the piece is achieved by the application of two different blue and white sprig prints in the top corners. The diamond ground running stitch quilting is superseded by a garland following concentric lines around the edges.

RELATED EXAMPLES: DeGraw 1974, pp. 67–68; Peck 1990, p. 204.

T20

Mariner's Compass Piecework and Surface-appliqué Quilt

1852
Probably Dutchess County, New York
Cotton (see Technical notes); 100 x 79" (254 x 200.6 cm)
B.76.98

T20

T21

INSCRIBED (IN STITCHES WITHIN THE GARLAND AREA): J.H.D. M.C.D. / VD 1852 / A.J.B. ED or E.J.D. / A.E.D.

PROVENANCE: Purchased by Miss Hogg at Sotheby Parke Bernet, May 15, 1975, sale 3760, lot 68, whose catalogue stated that the quilt was found in Dutchess County, New York, and is associated with a Millbrook family.

TECHNICAL NOTES AND DESCRIPTION: Tabby-weave cotton face and back; cotton filling. Piecework and surface appliqué, the two primary methods of fabricating tops for quilts, are represented in this example. This design has been identified by a variety of names, including Rising Star, Rising Sun, and, most frequently, Mariner's Compass. Piecework composes the starbursts. There are twelve of these red, green, pink, and brown patterned fabric units separated by clusters of leaves. The surrounding border is a green swag caught by red-bowed tassels. The running quilting stitches follow the surface motifs.

REFERENCES: White 1948, pp. 52–53; Orlofsky and Orlofsky 1974, p. 60; Brackman 1989, p. 167; Rich 1991, pp. 34–36, 206.

T21

Appliqué Quilt

ca. 1840–60
Attributed to America Brinham, United States

Cotton (see Technical notes); 89½ x 89½″ (227.3 x 227.3 cm)
B.76.96

INSCRIBED (IN QUILTING ON ONE OF THE FOUR CENTRAL MEDALLIONS): America Brinham.

PROVENANCE: Purchased by Miss Hogg at Sotheby Parke Bernet, May 15, 1975, sale 3670, lot 67.

TECHNICAL NOTES AND DESCRIPTION: Tabby-weave cotton face and back; cotton filling. Folding and cutting a piece of paper in quadrants would yield a template for a distinctive square appliqué motif. The stylized floral blossom print of the red cotton seems appropriately suited to make up the grid of three by four central units. The four-leafed dahlia-like blossom border adds a spontaneity to the formality of the central ground. The windblown blossoms have red and gold printed cotton heads and vermicelli-printed leaves. Quilting running stitch follows the appliqué elements along the border, and in the void between central motifs are vases with flowers and grapes.

RELATED EXAMPLES: Dunham 1963, pp. 50–51, identifies a similar pattern as Kansan and dating to 1937. The motif can also be related to Hawaiian quilts.

EXHIBITED: "Family Quilts," Houston, Museum of Natural Science, November 1975.

T22

Odd Fellows Appliqué Album Quilt

ca. 1850
Mary Ann McCue (n.d.), Philadelphia
Cotton and silk (see Technical notes); 91¼ x 90″ (231.8 x 228.6 cm)
B.76.62

While closely resembling the more famous Baltimore Album quilts, this example represents a particular style associated with Philadelphia.

PROVENANCE: The McCue family to son John and then granddaughters, the Misses McCue of New Castle, Delaware; subsequent provenance unknown.

TECHNICAL NOTES AND DESCRIPTION: Tabby-weave cotton face and replaced back; silk thread. This quilt incorporates three distinct design elements: the solid cylinder-printed chintz strip border, an inner frame composed of twelve squares, and a central medallion. The schematic appliqués include diagonally placed matching open-wreath motif corner squares, one pair having a dove and harp and the other arrow-pierced hearts. Along the two sides and bottom, the remaining squares offer a cherry wreath, a pair of concentric wreaths of alternating green and red leaves and tulip flower, a snowflake, and a

floral basket. The unique squares are the central medallion featuring two rose wreaths, one open and one closed, both surrounding a dove in flight above a harp. Across the top, one finds a square detailed with Independent Order of Odd Fellows symbols, including an all-seeing eye, a linked chain, Death's head, moon and stars, a dove of peace, three arrows, an hourglass, a serpent, a globe, and hearts and hand. One also finds along the top a fruit bowl filled with melons, cherries, grapes, pineapples, and peaches. The fruits are flanked by two birds and a rose. The motifs are appliquéd from plain fabric, printed dress goods, and printed fruits and flowers. The quilt is composed of appliqué pieces of cylinder-printed chintz highlighted with chain and outline running stitches.

REFERENCES: Dunton 1946, pp. 94–97.

RELATED EXAMPLES: Bishop 1975, p. 72, for similar Odd Fellows square; Katzenberg 1981, pp. 112–13, 118–19.

T23

Surface-appliqué Quilt

ca. 1850–70
United States
Cotton (see Technical notes); 100 x 88½" (254 x 224.8 cm)
Gift of the estate of Miss Ima Hogg, B.76.87

PROVENANCE: Unknown.

T23

T22

TECHNICAL NOTES AND DESCRIPTION: Tabby-weave cotton face and back; cotton filling. Within an eccentric grapevine border, plain squares alternate with appliqués of a traditional laurel leaf motif and an unidentified, but similar, foliate arrangement. All have red four-petal flowers in the center with green leaves radiating from a central point. The grid is six-by-six blocks, and there are a total of twenty-one appliqué calico squares. The quilting patterns in the plain squares range from feathered circles to cornucopia. The ground is simply quilted with parallel diagonal lines. All quilting unites the three layers: face, back, and filling.

T24

Whig Rose Surface-appliqué Quilt

ca. 1850–75
United States
Cotton (see Technical notes); 79 x 79" (200.7 x 200.7 cm)
B.76.97

T24

PROVENANCE: Purchased by Miss Hogg at Sotheby Parke Bernet, May 15, 1975, sale 3760, lot 67.

TECHNICAL NOTES AND DESCRIPTION: Tabby-weave cotton face and back; cotton filling. Five floral motifs, popularly known as Whig Roses, compose the X-shaped format of this square quilt. The applied printed cottons (calicos) are in red, pink, solid dark green, and solid yellow. Framing the motifs is a serpentine blossom chain from which sprout floral sprays to fill the voids between motifs. The ground quilting in running stitch follows a pattern of scrolling leaves, while the border is quilted with chevrons.

RELATED EXAMPLES: Lipsett 1985, p. 91; Safford and Bishop 1972, no. 270.

T25

Album Quilt

1860
United States, possibly Middle Atlantic States
Cotton (see Technical notes); 109 x 90" (276.8 x 228.6 cm)
B.76.63

INSCRIBED: L, M (in borders); Northern Liberty, 1860 (on fire pumper); American Shield (on shield).

PROVENANCE: Unknown.

TECHNICAL NOTES AND DESCRIPTION: Tabby-weave cotton face and back; cotton

batting and thread. This is a twenty-square appliqué quilt (four-by-five rows), with squares framed in red with white corners surrounded by an outer border of an undulating floral garland in solid reds, greens, and golds. Half the squares are initialed with an "L" in running stitch and the remainder with an "M" (perhaps the initials of the makers). From left to right, top to bottom, the squares depict: star or dahlia blossom, wreathed star, tulip wreath, stars, rose wreath, eagle-topped shield and nineteen stars, rose (?) wreath, oak leaves, bud wreath, fire pumper dated 1860, grape wreath garland, encircled blossoms, footed floral urn, leaf-outlined heart wreath, garland-encircled vase, footed vase with flowers, blossoms, pineapple, footed vase with flowers, and blossoms.

RELATED EXAMPLES: Carlisle 1957, p. 62.

T25

T26

T26

Agriculture and Manufacturers Double-cloth Coverlet

ca. 1825–40
Probably Hudson River Valley (Ulster or Dutchess County?)
Cotton and wool (see Technical notes); 98 x 75½"
(248.9 x 191.8 cm)
Gift of the estate of Miss Ima Hogg, B.76.34

Although this coverlet cannot be dated precisely, it is known that General Lafayette revisited the United States in 1825 (see Inscribed). While the design can be related to woven coverlets by James Alexander (1770–1870), this example is probably the work of another weaver. The name G. Dimond on this textile (see Inscribed) could refer to an undiscovered weaver or a client.

INSCRIBED: AGRICUL / TURE & MAN / UFACTUR-ERS. / ARE THE FOUND / ATION OF / OUR INDE / PENDENCE / JULY 4. / 1825. / GNR.LAFAYETTE (in all corners); G=DIMOND (at ends).

PROVENANCE: Purchased by Miss Ima Hogg from Hackberry Hill Antiques, Round Top, Texas, 1975.

TECHNICAL NOTES AND DESCRIPTION: Cotton warp and wool weft Jacquard double-weave cloth. In one wide panel of undyed cotton and dark blue wool, this coverlet was executed on a handloom with an attached Jacquard mechanism. The fancy central field has four-and-a-half medallions depicting parrot tulips and other blossoms, which are separated by nine bold two-dimensional blooms.

T27

The borders feature confronting eagles (as on the Great Seal of the United States) flanking Masonic emblems, which are separated by small creatures resembling monkeys, rabbits, and humans. Above these units is a three-band arc of eleven stars, eight cloverleaves, and five stars.

RELATED EXAMPLES: MMA, acc. no. 67.33, from the workshop of James Alexander, and acc. no. 25.127, dated July 4, 1837; Baltimore Museum of Art, Katzenberg loan; Henry Ford Museum, Dearborn, Michigan, dated July 4, 1826 (Safford and Bishop 1972, p. 253); Museum of Our National Heritage, Lexington, Massachusetts, dated July 4, 1830.

T27

Double-cloth Coverlet

1831
United States
Cotton and wool (see Technical notes), 82 x 81"
(208.3 x 205.7 cm), plus 5" (12.7 cm) fringe from warp
Gift of the estate of Miss Ima Hogg, B.76.35

INSCRIBED (IN CROSS-STITCH): SL / 31.

PROVENANCE: Unknown.

TECHNICAL NOTES AND DESCRIPTION: Cotton warp and wool weft Jacquard double-weave cloth. A variant of the Lover's Chain or Lover's Knot pattern composes the field of this two-panel, handloomed quilt. The borders surrounding three sides are composed of a geometric block and double-link motif. A dark side featuring olive green and brick red wool yarns is contrasted against a reverse in which cream cotton predominates.

RELATED EXAMPLES: Davison and Mayer-Thurman 1973, pp. 62–63; DeGraw 1974, pp. 105–6; Schorsch 1978, p. 231.

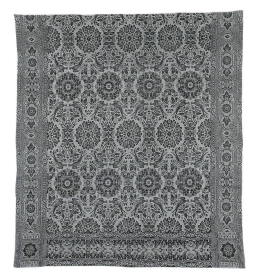

T28

RELATED EXAMPLES: Davison and Mayer-Thurman 1973, pp. 110–11.

T29

Double-cloth Coverlet

mid-19th century
United States
Cotton and wool (see Technical notes); 89 x 75"
(226 x 190.5 cm)
Gift of the estate of Miss Ima Hogg, B.76.93

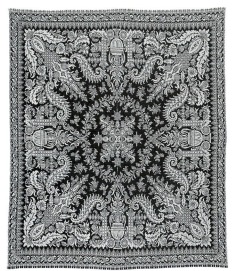

T29

PROVENANCE: Unknown.

TECHNICAL NOTES AND DESCRIPTION: Cotton warp and wool weft Jacquard double-weave cloth. The eclectic design of this coverlet would seem to be drawn from Middle Eastern and Southeast Asian references. Its central floral snowflake medallion surrounded by a floral wreath is more Western, but with the outer flame-edged scrolls, tall-footed floral bearing urns, and arabesque corner elements, the vocabulary of the East comes into play. The outer border consists of a spiked gallery, fruited sprays, and a more diminutive spiked border.

RELATED EXAMPLES: Safford and Bishop 1972, no. 420.

T30

Double-cloth Coverlet

1851
Ira Hadsell (act. ca. 1842–72), Palmyra, Wayne County, New York[1]
Cotton and wool (see Technical notes); 86 x 75"
(218.4 x 190.5 cm)
Gift of the estate of Miss Ima Hogg, B.76.36

INSCRIBED (BOTTOM EDGE): 1851 / Julia Seely WOVEN.AT.PALMYRA.N.Y.BY. IRA HADSELL.

PROVENANCE: Unknown.

T28

Double-cloth Coverlet

1840
Possibly Genesee or Ontario County, New York
Cotton and wool (see Technical notes); 98 x 75½" (248.9 x 191.7 cm)
Gift of the estate of Miss Ima Hogg, B.76.86

INSCRIBED (IN BOTTOM CORNERS): A D/ 1840 (mirror image).

PROVENANCE: Unknown.

TECHNICAL NOTES AND DESCRIPTION: Cotton and wool warp and weft Jacquard double-weave cloth. This figured and fancy two-panel coverlet of natural cotton and crimson red wool was fabricated on a handloom with an attached Jacquard mechanism. The central field has alternating rows of cherry spraylike rondels and floral (hibiscus) rondels. The rondels are separated by double-ended clusters of berried vegetation and confronting pairs of long-tailed exotic birds. The side borders are composed of a foliate chain set against an angled spotted bar background, and the foot border is a broad floral band.

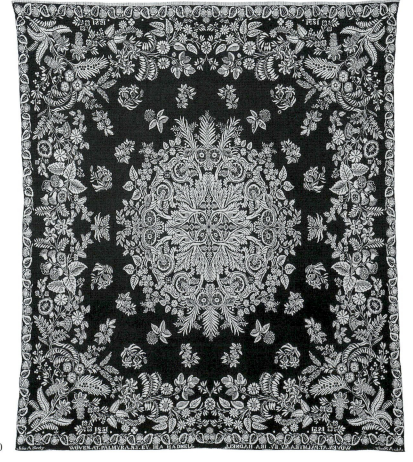

T30

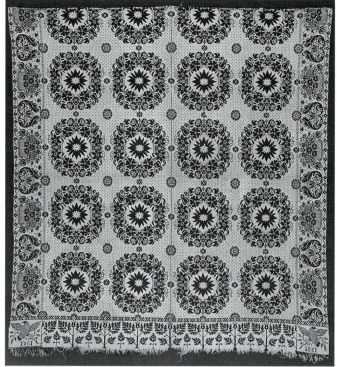

T31

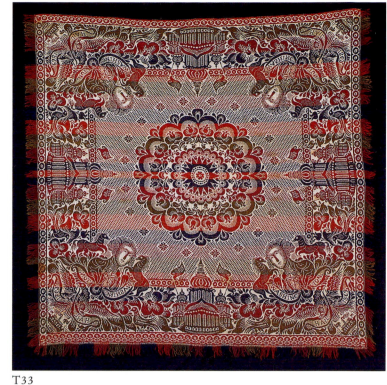

T33

TECHNICAL NOTES AND DESCRIPTION: Cotton and wool warp and weft Jacquard double-weave cloth. This fancy coverlet was woven in one piece from natural cotton and dark indigo, wool yarns on a handloom with an attached Jacquard mechanism. It features a large central medallion radiating out from a leafed central quatrefoil surrounded by floral wreath. A narrow leaf border encompasses the exterior border and frames an inner foliate band from which four corner sprays extend inward. The middle range ground is spotted with random floral sprays. The owner's name is included as part of the inscription (see above).

RELATED EXAMPLES: Davison and Mayer-Thurman 1973, pp. 114–15, 122.

1. It appears that Hadsell may have worked in partnership with a neighbor, J. Van Ness. The names of both can be identified with distinctive, related patterns. See Heisey 1978, pp. 66, 113.

T31

Double-cloth Coverlet

1851
Attributed to Samuel Graham (1805–1871),
New Castle, Henry County, Indiana
Cotton and wool (see Technical notes); 85½ x 82"
(217.2 x 208.3 cm), plus 2½" (6.3 cm) fringe on
bottom end
Gift of the estate of Miss Ima Hogg, B.76.68

INSCRIBED (IN BOTTOM CORNERS): A spread-wing eagle above a leafy branch [trademark associated with the weaver Samuel Graham] / 1851.

PROVENANCE: Unknown.

TECHNICAL NOTES AND DESCRIPTION: Cotton and wool warp and weft double-weave cloth. This two-panel coverlet in navy and white is composed of sixteen sunburst medallions framed by floral wreaths in a spotted ground. The exterior border is formed from alternating floral baskets and foliate lyres.

RELATED EXAMPLES: Heisey 1978, p. 33, for an example woven in 1868 by John Klein of Hamilton County, Indiana.

T32★

Double-weave Coverlet

ca. 1860–80
Probably Pennsylvania
Cotton and wool (see Technical notes); 73 x 80"
(185.4 x 203.2 cm), plus 3½" (8.9 cm) fringe on all
sides
Gift of the estate of Miss Ima Hogg, B.76.67

By the time of the American Civil War, most coverlets were produced by power looms in a factory-like setting. Such production allowed for wide weaves that eliminated the need for a central seam. By the

late 1860s artificial dyes (aniline) were in use, providing a whole new color palette.

PROVENANCE: Unknown.

TECHNICAL NOTES AND DESCRIPTION: Cotton warp and cotton and wool weft Jacquard double-weave cloth. This red, blue, brown, and green coverlet boasts a central rectangular medallion framed by a wreath of flowers and supported in the four exterior corners by an eagle fronted by a shield and bow and arrows and holding an olive branch in its beak. The whole is bordered by a wide band of florals.

T33

Double-weave Coverlet

1869
Lancaster Carpet, Coverlet, Quilt, and Yarn
Manufacturing (n.d.), Lancaster, Pennsylvania
Cotton and wool (see Technical notes); 79½ x
74½" (201.9 x 189.2 cm), plus 2½" (6.3 cm) fringe
on both ends
Gift of the estate of Miss Ima Hogg, B.76.64

Philip Schum (1814–1880), born in the Grand Duchy of Hesse-Darmstadt (Germany), settled in Lancaster, Pennsylvania. By 1856 he owned a weaving business, which in 1875 was producing 400 "quilts" a week. However, pieces such as this four-color

wool combined with natural cotton may be the half-wool coverlets referred to in a business inventory. This Jacquard-weave pattern is associated with Schum's workshop.

INSCRIBED (IN ALL CORNERS): WASHINGTON / HALL / 1869.[1]

PROVENANCE: Unknown.

TECHNICAL NOTES AND DESCRIPTION: Cotton and wool warp and wool weft Jacquard tied Biederwand weave cloth. The coverlet is of natural cotton and royal blue, olive, scarlet, and magenta wool. It boasts a star and floral central medallion and a figurative border of a stylized United States Capitol and a bust of George Washington, flanked by a pair of rearing horses, which are placed above a spreadwing eagle supporting an inscribed banner. All four corners contain a representation of a small steamboat.

RELATED EXAMPLES: Illinois State Museum, Springfield (acc. no. 746561; Wass 1988, fig. 75).

1. The date could refer to the year the coverlet was woven, the date commemorating 80 years since the inauguration of George Washington, or the date marking 80 years since the ratification of the Constitution.

T34*

Double-weave Coverlet

ca. 1876 or later
United States
Cotton and wool (see Technical notes); 78 x 78"
(198.1 x 198.1 cm), plus 2" (5.1 cm) self fringe
along selvage sides and 1½" (3.8 cm) bottom
warp-end fringe
Gift of the estate of Miss Ima Hogg, B.76.38

Memorial Hall was one of the buildings constructed in Fairmont Park, Philadelphia, to commemorate the United States Centennial in 1876. While a similarly modified seamless coverlet carries the inscription "PATENTED AUG^T 17th 1875," no attribution to the factory or weaver(s) has yet been made.[1] It is believed that coverlets of this type were woven as souvenir commodities. These coverlets are generally red and white, although a few are red, blue, green, brown, and white.

INSCRIBED: CENTENNIAL (top edge); MEMORIAL HALL (bottom edge).

PROVENANCE: Unknown.

TECHNICAL NOTES AND DESCRIPTION: Cotton warp and wool weft double-weave cloth. Reading from top to bottom, this coverlet shows a pair of eagles, modified from the Great Seal of the United States, flanking an almost cherubic Liberty atop the building cupola. An anthemion-like blossom forms the framing border.

RELATED EXAMPLES: Illinois State Museum, Springfield (acc. no. 746564; Wass 1988, fig. 76); PMA (Safford and Bishop 1972, p. 267); Sotheby's, New York, February 2, 1991, lot 1276; Skinner, March 25, 1989, sale 1246, lot 171; Christie's East, New York, December 14, 1988, lot 42.

1. Christie's East, New York, December 14, 1988, lot 42.

T35

T35

Biederwand Woven Coverlet

ca. 1835–55
United States
Cotton and wool (see Technical notes); 88½ x 74½" (224.8 x 189.2 cm), fringe varies between 2¾" (7 cm) and 3¼" (8.2 cm)
Gift of the estate of Miss Ima Hogg, B.76.32

The patriotism conveyed by this coverlet's depiction of the Capitol in Washington is reinforced by its red, white, and dark blue colors. The edifice might have been difficult to identify without its caption, as the dome of the Capitol was not installed until 1865, a number of years after this coverlet was made.

INSCRIBED (ON SIDES): MARY.A. / ANDERSON. [probably refers to the client]; CAP. WASHIN / GTON.

PROVENANCE: Unknown.

TECHNICAL NOTES AND DESCRIPTION: Cotton and wool warp and weft tied Biederwand weave cloth. Four rows of three full circles with four trumpet-shaped blossoms set in a star-poked wheel make up the ground. The four corners feature a dovelike bird in profile.

T36

Biederwand Jacquard Coverlet

1846
Jacob W. Bohn (act. ca. 1846), Green Castle, Franklin County, Pennsylvania
Cotton and wool (see Technical notes); 76½ x 75½" (194.3 x 191.8 cm), plus 2¼" (5.7 cm) fringe on sides and 1" (2.5 cm) fringe at bottom edge
Gift of the estate of Miss Ima Hogg, B.76.37

INSCRIBED (BOTTOM CORNERS): MADE.BY / JACOB.W / BOHN / GREEN / CASTLE / PA.1846 / ROSANNA.

PROVENANCE: Unknown.

TECHNICAL NOTES AND DESCRIPTION: Cotton and wool Biederwand weave cloth. A Jacquard attachment was employed on a handloom to achieve the weave of this near square coverlet. Pinkish-red, mustard, and deep indigo bars traverse the coverlet, which is predominately deep indigo and white. The eight-and-one-half pattern of two alternating rows consists of rondels of tulip blossoms or four pairs of leaves and tighter rondels with alternating tulips and peonylike buds. These motifs are centered and separated by snowflakelike devices. Three sides are bordered with small, alternating, stylized floral arrangements of a trefoil composition.

T37

Biederwand Woven Coverlet

1852
John Redick (act. ca. 1852–69), Troy Township, Richland County, Ohio
Cotton and wool (see Technical notes); 87 x 71¼" (221 x 181 cm), plus 3" (7.6 cm) fringe on bottom and 3½" (8.9 cm) fringe on sides
Gift of Mr. and Mrs. Paul Radtke in honor of Lila Van Goss Black, B.83.6

INSCRIBED (BOTTOM CORNERS): JOHN. / REDICK. / TROY. / TOWNSHIP / RICHLAND / OHIO. / # 1852 #.

T36

T37

PROVENANCE: Unknown.

TECHNICAL NOTES AND DESCRIPTION: Cotton and wool warp and weft tied Biederwand weave cloth. The white is natural cotton, and the blue is dyed wool yarn. The use of only two colors makes this quilt relatively unusual. Woven in two panels, it is patterned with four rows of five star-centered, scallop-edged medallions, separated by leafed crosses. The bottom border is composed of a swagged garland cradling confronting fowl and resting on rosettes. The side borders are divided in half with a branch supporting a squat urn.

REFERENCES: Heisey 1978, p. 96.

T38

Biederwand Woven Coverlet

1839
John Denholm (n.d.), possibly Pennsylvania[1]
Cotton and wool (see Technical notes), 98 x 83″
(248.9 x 210.8 cm), plus 4″ (10.2 cm) fringe on
bottom and 3½″ (8.9 cm) on sides
Gift of Mr. and Mrs. Robert E. Griffith, B.90.7

INSCRIBED (BOTTOM CORNERS): MADE BY / JOHN / DENHOLM / 1839.

PROVENANCE: Purchased by Mary R. Griffith, from the estate of Mrs. John Black, Jr., Jones Mill, Pennsylvania, around 1970.

TECHNICAL NOTES AND DESCRIPTION: Cotton warp and wool weft tied Biederwand weave cloth. This coverlet, striped in indigo, red, brass, and white, is patterned by a narrow upended square and double-tier tassel exterior border, a scrolling vine foot border, and a floral vine side border. The central ground has four by five rows of medallion motifs of stylized compass point tuliplike flowers divided by leaf and blossom blocks. The overall impression of the ground motif is one of substance, as it is counterpointed by the horizontal lines.

RELATED EXAMPLES: Denver Art Museum (acc. no. A-2029), identical patterns for center

and borders, woven in 1837 by John Mellinger of Pennsylvania; Dayton Art Institute (acc. no. 88.121), for similar center, dated 1848.

1. Several woven coverlets dating between 1837 and 1861 that carry the Denholm name have been located.

T39

Hatchment

1785
Hannah Babcock (1769/70–1856), Boston
Silk and satin (see Technical notes); 33 x 33″
(83.8 x 83.8 cm)
Museum purchase with funds provided by Mr. and Mrs. James Anderson, Jr., Mr. and Mrs. Thomas D. Anderson, Mr. and Mrs. Mark Edward Andrews, Mr. and Mrs. A. Leslie Ballard, Jr., Mrs. Patricia B. Carter, Mr. and Mrs. B. W. Crain, Mrs. Jean Forsythe Garwood, Mr. Morgan Garwood, Miss Susan Garwood, Dr. and Mrs. Mavis P. Kelsey, Mrs. William H. Lane, Mr. and Mrs. Maurice McAshan, Mr. and Mrs. Albert Maverick, III, Mr. Hugo Neuhaus, and Mr. Herbert C. Wells, B.84.7

According to a contemporary source, Mrs. (Deborah) Snow "kept a finishing boarding school for young ladies where

T38

T39

there were teachers of music, drawing . . . and fancy sewing" in Boston on Green Street, Pemberton Hills.[1] On the school's roster was Hannah Babcock, who was probably the daughter of Joseph and Hannah Howe Babcock of nearby Milton. As part of her education, she executed this embroidered hatchment.[2]

INSCRIBED: Babcock and Howe (on scroll); Wrought by H[ann]ah Babcock at Mrs. Snow's school, Pemberton Hills, Boston, 1785 (on label at bottom point).

PROVENANCE: Auctioned in Massachusetts or New Hampshire; anonymous Maine or New Hampshire owner; Frank Dingley, Farmington, Maine; purchased by Hazel Marcus, Ebenezer Alden House, Union, Maine, from

Ross Levett, Tenants Harbor, Maine; purchased by Bayou Bend from Bernard and S. Dean Levy, New York, 1984.

TECHNICAL NOTES: Satin ground; silk embroidery thread. The original frame is black walnut with carved, gessoed, and gilded details.[3] The backboard is white pine. The hatchment has a black ground and is embroidered in a variety of colored silks in satin, Rouma-

nian outline, couching, and chain stitches. Its layout follows the standard Gore pattern. John Gore and his son Samuel were heraldic painters in Boston. They probably used stencils to transfer the shield and surrounding foliate and helmet design onto the fabric and then added a crest and emblazonment within the shield.[4]

RELATED EXAMPLES: Isaiah Thomas Arms, MMA (acc. no. 36.28); Meers and Rivers Arms, SPNEA (acc. no. 1962.20); May and Williams Arms, private collection; Thomas Clap Arms, Yale University Library Manuscript and Archive Collection (Ring 1993, p. 267).

REFERENCES: Brown 1985; Bolton and Coe 1921, pp. 399–408, pls. CXXI, CXXII; *Antiques* (June 1990), p. 332; Ring 1992, pp. 622–31; Ring 1993, vol. 1, pp. 73–74.

1. New Hampshire Historical Society 1973, p. 61.
2. In eighteenth-century America, hatchments—a word derived from the word *achievement* meaning an armorial insignia, especially square or lozenge shape—functioned to exhibit the armorial bearings of a deceased person and were usually given a place of honor in the home. Most Americans have not been entitled to bear coats of arms; they have frequently appropriated a design from a published source that can be associated with their family name.
3. A number of embroidered coats of arms of this period by female students are framed nearly identically.
4. Ring 1992, p. 626.

T40

View of Mount Vernon

ca. 1805–10
Nancy Ellis Brewster (after 1791–1846),
Plymouth, Massachusetts
Silk and watercolor (see Technical notes); 12½ x 16¾" (31.7 x 42.5 cm) [unframed]
B.54.15

On March 31, 1800, Francis Jukes (1747–1812) issued an aquatint engraving in London that was to inspire a variety of adaptations by needleworkers and amateur painters. The print, *Mount Vernon in Virginia / The seat of the late Lieut. General George Washington*, was made after a drawing by Alexander Robertson (1772–1841). The embroidered and painted picture at Bayou Bend was presumably a project at a school like Deerfield Academy, Deerfield, Massachusetts, or Misses Patten's School, Hartford, Connecticut. It was worked by Plymouth, Massachusetts, resident Nancy Ellis Brewster, probably between 1805 and 1810.

INSCRIBED (PAINTED ON GLASS OF FRAME): Washington Seat, Mount Vernon / Wrought by Nancy E. Brewster.

PROVENANCE: Purchased by Miss Hogg from Ginsburg and Levy, New York.

TECHNICAL NOTES: Tabby-weave silk ground; silk chenille embroidery threads. The needlework is executed in satin and couching stitches and has been mounted in an inscribed frame. Details have been painted in watercolor on the silk ground.

REFERENCES: Ring 1987, p. 89; Flynt 1988, pp. 27–28.

T41

T41

Memorial Embroidered Picture

ca. 1805–15
Possibly Boston
Silk, linen, and watercolor (see Technical notes); 17½ x 15" (44.5 x 38.1 cm) [unframed]
Gift of William James Hill, B.86.13

The life of George Washington was commemorated in many early American needlework projects. Often the imagery was painted in watercolor by a professional on a silk ground, and the needlework was executed by a schoolgirl or other needleworker. John Johnson (ca. 1753–1818) of Boston was responsible for the patterns for a related group of homages to Washington.[1] Each is characterized by a seated Columbia, her hand resting on the eagle of the Great Seal of the United States. She sits on an obelisk containing an oval portrait of the President. While the print source for Columbia and the eagle remains unknown, more elaborate related examples incorporate elements

T40

T42

In Memory of
M.rs MARY VOSE,
Who Died July 22.d
1807
Aged 38 Years

Wro.t By Miſs ANN VOSE 1807.

that can be traced to print sources.[2] Davida Deutsch offers additional insight when she indicates that the Philadelphia firm of Akin and Harrison proposed in January 1800 to print their engraving *America Lamenting her Loss at the Tomb of General Washington* on white satin, thus forming a foundation for a needlework pastime for ladies.[3]

INSCRIBED (BOTTOM RIGHT): GW.

PROVENANCE: Unknown.

TECHNICAL NOTES: Ribbed silk taffeta ground; silk embroidery thread; tabby-weave linen lining.

RELATED EXAMPLES: Massachusetts Historical Society, Boston; Betty Ring Collection, Houston; private collection.

1. Deutsch 1991, p. 376.
2. Ring 1993, vol. 1, p. 84.
3. Deutsch 1991, p. 376.

T42

Memorial Embroidered Picture

1807
Ann Vose (1797–1861), Boston
Silk, applied paper, watercolor, and ink (see Technical notes); 17⅜ x 15½" (44.1 x 39.4 cm) [framed]
B.70.51

In the early 1800s many young women memorialized recently departed family members and national heroes in multi-media pictures. The present work honors the memory of Mary Bemis Vose (1769–1807), wife of Isaac Vose (1767–1823), a Boston cabinetmaker. To create this tribute to her mother, Ann Vose, at only ten years of age, probably executed the needlework herself. However, she presumably had professional assistance with the pattern outline, detail painting, and calligraphy. The isolation of separation is poignantly depicted in this picture: a contemplative female is seated between two tomb markers and under the shield of a willow tree. Only a small area of barren horizon is revealed.

INSCRIBED: In Memory of / Mrs. Mary Vose. / who died July 22 / 1807 / Age 38 years (on headstone); Wro.ᵗ By Miss ANN VOSE 1807. (on glass).

PROVENANCE: Purchased by Miss Hogg from Gooseneck Antiques, Chapel Hill, North Carolina.

TECHNICAL NOTES: Ribbed silk taffeta ground; silk embroidery thread; applied paper; watercolor; ink. Original painted glass and frame.

REFERENCES: Ring 1993, vol. 1, p. 86.

T43

Memorial Embroidered Picture

dated 1807, worked 1820–26
Attributed to a member of the Davis Family, Kittery, Maine
Silk, ink, paper, and watercolor (see Technical notes); 21½ x 24¾" (54.6 x 62.9 cm) [unframed]
B.70.53

Death came early to three Davis sisters, who are believed to have been residents of Kittery, Maine. In this painted and needle-worked picture, one surviving sister commemorated their short lives. This work follows iconographic traditions associated with an extensive surviving group of schoolgirl embroideries from the Portland area. Characteristic features include a seaside village; large, bold, foreground flowers; a winged, cherublike head; and extensive verse.

INSCRIBED (ON TOMB MARKER): Sacred / to the memory of / Harriet Davis, / who died Sept. 16, 1802, aged 1 y'r & 8 mo. / Eunice Davis, / who died Aug. 4, 1807, aged 14 months, / and / Mercy Davis, / who died Dec. 21, 1807, aged 9 years & 8 months. / "Death nips the opening flower." And "Who needs a teacher to ad-

monish him / That flesh is grass? That earthly things are mist? / What are our days but dreams? And what our hopes? / But goodly shadows in the summer clouds? / Not a moment flies but puts its sickle / In the fields of life and mows its thousands / With its joys and cares?"

PROVENANCE: See cat. no. T42.

TECHNICAL NOTES: The outlines are drawn with pencil on a tabby-weave silk ground. Black wash is applied. The inscription is printed in ink by a professional printer. The embroidery is worked. Watercolors were painted last. The face is painted on paper and applied to the picture instead of being painted directly on the silk, as is more usual. Silk chenille applied with satin, split, and French knot stitches. The glass and frame are original.

T44

Memorial Embroidered Picture

ca. 1815–20
Attributed to Almira Earle (1800–1831), Milton, Massachusetts
Silk and watercolor (see Technical notes); 34¼ x 33" (87 x 83.8 cm) [framed]
B.70.52

The Winthrop Earle family of Milton, Massachusetts, was struck twice by death in the fall of 1807 (see Inscribed). It is natural to assume that the four remaining Earle family members, seen in this picture flanking a tomb, were recorded shortly after the deaths in 1807. However, logic, fashions, and childhood development suggest another scenario. The surviving Earle daughter, Almira, was only seven years old when the double deaths occurred and probably did not yet possess needlework skills sufficient to accomplish this sophisticated picture. Second, both Almira and two of her younger brothers, Theodore (1801–1821/22) and Otis (1805–1830), are depicted here as young adults, not children. Finally, the style of apparel worn by both sexes dates to around 1815 or shortly thereafter, suggesting the picture was also completed at this time. Almira may have executed this work at a New England girls' school. It follows a compositional formula also seen in many related examples: the mourners are placed in a familiar, if somewhat artificial,

T43

T44

landscape with a weeping willow tree, and scattered about are a church, several public buildings, and waterways.

INSCRIBED (ON TOMBSTONE): Sacred / to the / memory / of / Mr. Winthrop Earle, / who died October 18th, 1807, aged 33 years. / A husband kind and good, a parent dear, / To all obliging, and to all sincere, / True to his God, the orphan's friend and guide / He liv'd beloved and lamented died. / Horace, who died May 2nd, 1800, aged 22 / months, and Eliza who died November 3d, / 1807, aged 4 years; children of Mr. / Winthrop and Mrs.

Persis Earle. / To these, so mourn'd in death, so lov'd in life, / The lonesome parent, and the widow'd wife, / With tears inscribe this monu-mental stone, / That holds their ashes and expects her own.

PROVENANCE: Betty Daniels; purchased by Miss Hogg from Gooseneck Antiques, Chapel Hill, North Carolina.

TECHNICAL NOTES: Silk taffeta ground; silk and silk chenille embroidery threads; watercolor. The embroidery is worked in split, stem, satin, back, and French knot stitches.

T45

Flight into Egypt

1861
Mary Ann (Tipple) Crocheron (1812–1888), Bastrop, Texas
Linen and wool (see Technical notes); 25⅜ x 21⅜" (64.5 x 54.3 cm)
Gift of Mr. Roy M. Needham, B.91.20

Born in Suffolk, England, Mary Ann Tipple came to Bastrop, Texas, with assorted family members in about 1840. There she met her husband, Henry Crocheron, and

T45

T46

became a member of the Methodist congregation. Mrs. Crocheron is known to have embroidered several pictures depicting religious subjects. Such needlework images united descriptions from the Old and New Testament with the iconography of popular religious prints. The rage for Berlin canvas work coincided with the interest in historical and Biblical subjects, here represented by the Holy Family's exodus to Egypt.

INSCRIBED (AT BOTTOM): M A Crocheron / Flight into Egypt. / August.1861.

PROVENANCE: By descent in Crocheron family to Mr. Roy M. Needham.

TECHNICAL NOTES: Linen canvas; Berlin wool yarn.

EXHIBITED: Texas State Fair, prior to 1919.

The terms "Berlin wool work" and "tapestry embroidery" were used interchangeably well into the twentieth century. This picture's composition is traditional, with the subjects shown in a classically inspired interior with drapery swags pulled back above their heads. King Saul is seated, with a servant nearby, while David stands before him playing a harp.

INSCRIBED (AT BOTTOM): M Crocheron. David Playing before Saul. March. 1852.

PROVENANCE: By descent in Crocheron family to Mr. Roy M. Needham.

TECHNICAL NOTES: Linen canvas; Berlin wool yarn.

EXHIBITED: Texas State Fair, prior to 1919.

In the eighteenth century, both men and women carried accessories in their pockets that were designed to hold personal papers and currency. Many were decorated with counted thread needlework. The ground fabric, generically known as canvas, was frequently embroidered in colored wool yarn.

PROVENANCE: Unknown.

TECHNICAL NOTES AND DESCRIPTION: Wool yarn; tabby-weave wool lining; wool binding and ties; linen canvas. The canvas ground of this rectangular single envelope pocketbook with two inner compartments is covered by Irish stitching in a blunted sawtooth pattern in red, green, navy, and mustard yarns. The lining is made of bright pink, glazed, worsted wool, and the unit is bound and tied with pink and green twill tapes.

T46

David Playing before Saul

1852
Mary Ann (Tipple) Crocheron (1812–1888),
Bastrop, Texas
Linen and wool (see Technical notes); 24⅛ x
17⅛" (61.3 x 43.5 cm)
Gift of Mr. Roy M. Needham, B.91.21

T47

Pocketbook

ca. 1750–1800
United States
Wool and linen (see Technical notes); 4½ x 7⅜"
(11.4 x 18.7 cm) [closed]
B.69.244

T47

T48*

Pocketbook

ca. 1750–1800
United States
Wool, linen, silk, and buckram (see Technical notes); 3½ x 4¼" (8.9 x 10.8 cm) [closed]
B.69.211

PROVENANCE: Unknown.

TECHNICAL NOTES AND DESCRIPTION:
Wool yarn; linen canvas; tabby-weave silk lining; buckram foundation; black wool binding and ties (probably replacements). Irish stitch in red, pink, blue, purple, yellow, and green yarns covers the canvas ground of this rectangular single envelope pocketbook with two inner compartments.

T49*

Pocketbook

ca. 1770–1800
United States
Wool and linen (see Technical notes); 4⅛ x 7"
(10.5 x 17.8 cm) [closed]
B.69.155

PROVENANCE: Unknown.

TECHNICAL NOTES AND DESCRIPTION:
Wool yarn; linen canvas. The canvas ground of this rectangular single envelope pocketbook with three inner compartments is covered by an Irish stitch in red, green, and gold yarns. The pocketbook has been relined, has insect damage, and is faded.

T50*

Pocketbook

1773
United States
Wool and linen (see Technical notes); 4¼ x 6¾"
(10.8 x 17.1 cm) [closed]
B.69.133

INSCRIBED (UNDERNEATH FLAP): A [or M] S; 1773.

PROVENANCE: Unknown.

TECHNICAL NOTES AND DESCRIPTION:
Wool yarn; linen canvas; wool lining; wool binding. This single envelope pocketbook with three interior paperboard separated compartments is covered with bright teal wool. The decorative exterior, bound and secured with a greenish wool tape, is worked in Irish, cross, and tent stitches in a design of carnations and a five-petal blue flower. Pink, purple, green, gold, and blue are the primary colors.

METALS

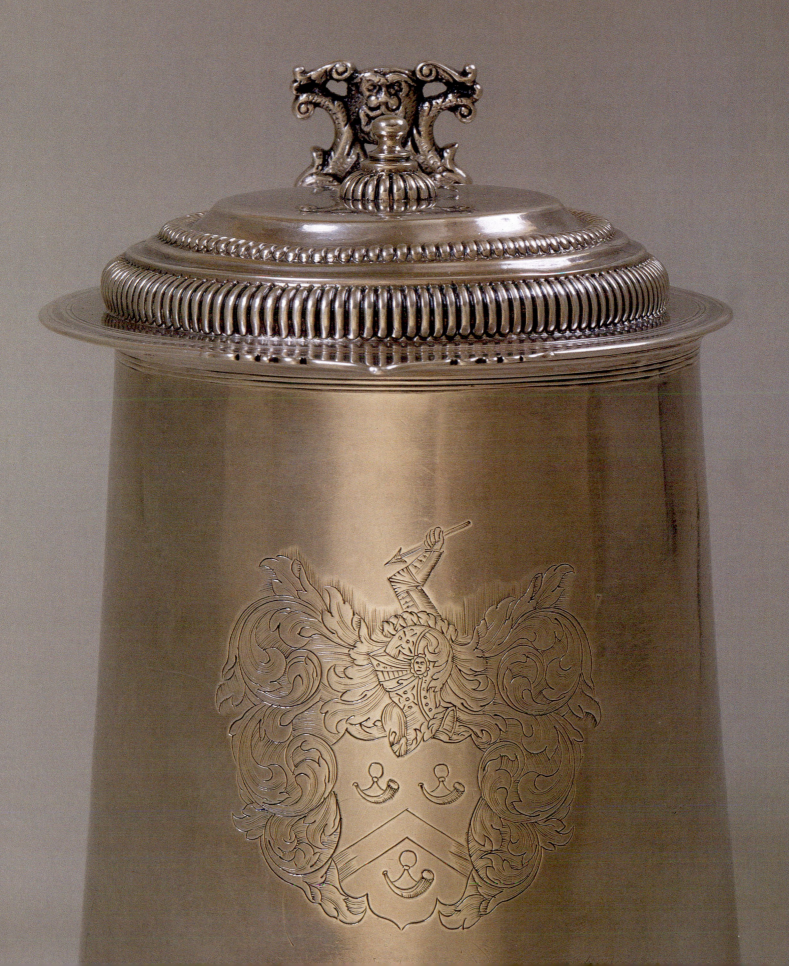

M1

Pine Tree Shilling

1667–82
Shop of John Hull (1624–1683) and Robert
Sanderson, Sr. (1608–1693), Boston[1]
Diam.: 1″ (2.5 cm)
B.68.8

M1

John Hull and Robert Sanderson, Sr., are the earliest American silversmiths whose work is known. Hull records in his diary that the formation of their partnership was prompted by the institution of a mint by the Massachusetts General Court for the purpose of offsetting the prevalence of counterfeit coins.[2] Hull was appointed mint master and chose Robert Sanderson, Sr., to be his partner. Besides directing the mint, Hull and Sanderson produced a wide range of silver forms and trained a number of apprentices. Their partnership firmly established the silversmith's craft in Boston and, in turn, throughout much of New England.

PROVENANCE: Purchased by Miss Hogg from Ginsburg and Levy, New York, 1968.

RELATED EXAMPLES: Fales 1970, p. 218, no. 186; Naeve 1978, p. 2, no. 2; Ward and Ward

1979, p. 58, no. 15d; Fairbanks and Trent 1982, pp. 492–93, no. 460; Safford 1983, p. 4, no. 3; Johnston 1994, p. 76; Quimby 1995, p. 121, no. 78b.

REFERENCES: Warren 1975, p. 151, no. 278.

1. Partnership 1652–83. For Hull and Sanderson, see Hull 1857; Clarke 1940, p. 57; Morgan 1942; Flynt and Fales 1968, pp. 253, 318; Buhler 1972, vol. 1, pp. 1, 4; Roe and Trent 1982; Kane 1987; Quimby 1995, pp. 118, 166; Kane 1998, pp. 567–72, 882–86.
2. Crosby 1875; Noe 1973, in which the example closest to the Bayou Bend shilling is N-17.

M2

Porringer

1675–1700
Shop of Jeremiah Dummer (1645–1718), Boston[1]
1½ x 4⅞ x 7″ (3.8 x 12.4 x 17.8 cm)
B.69.116

The porringer's name, shape, and function are derived from the French *potager*, or soup bowl, and the form is also related to the *écuelle*. Produced in England by the 1620s, the earliest examples, both English and American, are characterized by a simplicity of form, the bowl having little contour and the handle a shield-shaped or geometric pattern.

Contemporary accounts identify the porringer as a multipurpose vessel. Its conventional use was as a bowl from which one ate or drank. Other sources identify a diversity of uses. William Penn's wife, Gulielma, adapted a pewter porringer as a measure and a silver one for steeping shredded lemon peel. Perhaps its most unconventional application was noted by Dr. Alexander Hamilton,

who observed a woman mixing her rouge in a porringer.

Jeremiah Dummer is the earliest native-born silversmith whose work is known. His porringer, with its slightly domed bottom, rounded sides, and everted lip, realizes the shape that remains characteristic today.

PROVENANCE: Yale University Art Gallery, New Haven, by 1935[2]; purchased by Miss Hogg from James Graham and Sons, New York, 1956.

TECHNICAL NOTES: Typically, silver holloware was raised, or hammered up, while the handle was cast and soldered on; its tip is a replacement.

MARKED: Buhler and Hood 1970, vol. 1, p. 325, nos. 7–18, 20 (right of handle; back of handle).

ENGRAVED: s^DI (front of bowl).

WEIGHT: 6 oz, 3 dwt.

RELATED EXAMPLES: Dummer is known to have employed no fewer than five different patterns for porringer handles. The Bayou Bend example is related to Flynt and Fales 1968, pp. 73–75, no. 49; Buhler 1972, vol. 1, p. 20, no. 17; and an unpublished example belonging to the Addison Gallery of American Art, Andover, Massachusetts. The prototype can be found in English silver and pewter, such as a porringer by London pewterer John Waite (Payson 1978, p. 12). A variant was later adopted by American pewterers (see cat. no. M236).

REFERENCES: Clarke and Foote 1935, p. 151, no. 61; Minor 1946, p. 239; Art Dealers 1955, no. 121; Warren 1975, p. 155, no. 290; Kane 1998, p. 392.

1. For Dummer, see Clarke and Foote 1935; Buhler 1965, pp. 11–15; Buhler 1972, vol. 1, p. 10; Buhler 1979, pp. 9–10; Puig et al. 1989, p. 206; Quimby 1995, pp. 85–86; Kane 1998, pp. 385–97.

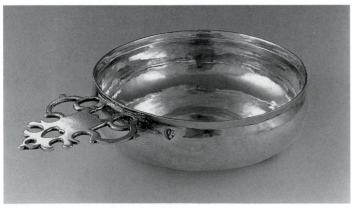

M2

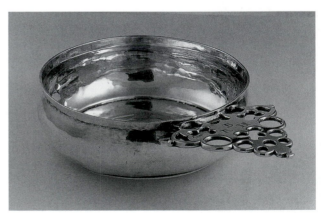

M3

2. An enigmatic note dated 1920 in the Bigelow papers at Yale refers to the porringer's early history. It bears the name Alice Gray and an address in Roxbury, Massachusetts. It also implies that the porringer once belonged to Luke Vincent Lockwood.

M3

Porringer

ca. 1704–36
Shop of William Cowell, Sr. (1682/83–1736), Boston[1]
1¹⁵/₁₆ x 5³/₈ x 7⁷/₈" (4.9 x 13.7 x 20 cm)
B.63.74

A geometric porringer handle exhibiting a more complex configuration was introduced during the final quarter of the seventeenth century. This pattern, composed of circular, crescent, tablet, cross, and quatrefoil piercings, is based on contemporary English examples. In addition to William Cowell, Sr., craftsmen working throughout the principal urban centers, also produced this design (see cat. no. M4).

PROVENANCE: Purchased by Miss Hogg from Carl and Celia Jacobs, Southwick, Massachusetts, 1963, who noted that the porringer was owned by the Butler family of Boston.[2]

TECHNICAL NOTES: The bowl is raised up, and the handle cast. The center point may be obliterated by Cowell's stamp.

MARKED: Buhler and Hood 1970, vol. 1, p. 324, nos. 86–88 (center of bowl).

ENGRAVED: R^B H [possibly for Robert and Hannah Butler] (handle).

WEIGHT: 8 oz, 1 dwt.

RELATED EXAMPLES: Parke-Bernet Galleries, New York, sale 971, May 14–15, 1948, lot 206.

REFERENCES: Warren 1975, p. 156, no. 291; Kane 1998, p. 352.

1. For Cowell, see Buhler 1960c, p. 75; Buhler 1965, pp. 35–37; Flynt and Fales 1968, p. 191; Buhler 1972, vol. 1, p. 123; Ward 1983, p. 359; Puig et al. 1989, p. 223; Kane 1998, pp. 349–55.
2. The engraved initials match those of Robert and Hannah Francis Butler, who married in 1723 (Boston 1898, p. 111).

M4

M4

Porringer

ca. 1704–37
Shop of Samuel Vernon (1683–1737), Newport[1]
2¹/₁₆ x 5¹/₈ x 7⁷/₁₆" (5.2 x 13 x 18.9 cm)
B.69.93

The similarity of Samuel Vernon's porringer handles to English and Boston examples (see cat. no. M3) suggests their derivation. Years after this design was no longer fashionable in silver, it was reintroduced in pewter by another Newport metalworker, David Melville.[2]

PROVENANCE: Edward Eastman Minor (d. 1953), Mount Carmel, Connecticut; to his daughter Margaret (Mrs. Gregory S. Prince); purchased by Miss Hogg from Mrs. Prince, 1954.

TECHNICAL NOTES: The bowl is raised, and the handle cast. There is no center point.

MARKED: Buhler and Hood 1970, vol. 1, p. 332, nos. 454–59 (within bowl; back of handle).

ENGRAVED: s*s (top of handle); A^S M (underneath handle).

WEIGHT: 10 oz, 5 dwt.

RELATED EXAMPLES: Buhler and Hood 1970, vol. 1, pp. 270–71, no. 455; Buhler 1972, vol. 2, p. 555, no. 485; Conger 1991, p. 309, no. 186; Quimby 1995, pp. 170–71, nos. 126–27.

REFERENCES: Minor 1946, p. 239; Warren 1975, p. 156, no. 292.

1. For Vernon, see Carpenter 1954, pp. 155–56; Buhler 1960c, p. 86; Flynt and Fales 1968, p. 347; Buhler 1972, vol. 2, p. 554; Buhler 1979, p. 79; Quimby 1995, p. 170.
2. Pewter in American Life 1984, p. 72.

M5

Porringer

1720–25
Shop of John Dixwell (1680–1725), Boston[1]
1³/₁₆ x 5¹/₄ x 7⁷/₁₆" (3 x 13.3 x 18.9 cm)
B.61.19

The keyhole-handle porringer was first produced during the 1720s and in time superseded all other patterns. John Dixwell was among the first to adopt the design. Characteristic of the earliest castings are the double arches, where the handle and bowl join.

M5

PROVENANCE: Purchased by Miss Hogg from James Graham and Sons, New York, 1961, who noted it had descended in the Williams family of Portsmouth, New Hampshire.

TECHNICAL NOTES: The bowl is raised, and the handle cast. There is no indication of a center point.

MARKED: Buhler and Hood 1970, vol. 1, p. 324, nos. 80–83 (back of handle).

ENGRAVED: I^W M (top of handle).

WEIGHT: 6 oz, 11 dwt.

RELATED EXAMPLES: Parke-Bernet Galleries, New York, sale 995, October 21, 1948, lot 118; *Antiques* 118 (July 1980), p. 91; Levy Gallery 1986, p. 32.

REFERENCES: *Antiques* 79 (June 1961), p. 505; Warren 1975, p. 157, no. 294; Kane 1998, p. 380.

1. For Dixwell, see Buhler 1960c, p. 75; Flynt and Fales 1968, p. 203; Buhler 1972, vol. 1, p. 116; Ward 1983, p. 360; Puig et al. 1989, p. 222; Quimby 1995, p. 83; Kane 1998, pp. 375–82.

M6

Porringer

1720–46
Shop of John Edwards (1671–1746), Boston[1]
2 1/16 x 5 5/8 x 7 5/8" (5.2 x 14.3 x 19.4 cm)
B.69.101

Since 1300 the English have used hallmarks to identify a silversmith's shop, along with the city of origin and the date of manufacture, and to ensure the quality of the alloy used. In colonial America this system was never instituted, yet craftsmen occasionally struck a series of their own stamps to suggest English hallmarks, which may explain why this porringer is

struck five times with John Edwards's mark.

PROVENANCE: Purchased by Miss Hogg from Robert Ensko, New York, 1954.

TECHNICAL NOTES: The bowl is raised, and the handle cast.

MARKED: Buhler and Hood 1970, vol. 1, p. 325, nos. 66–73 (twice to left of handle; three times to the right).

ENGRAVED: I^B S (handle).

WEIGHT: 7 oz, 3 dwt.

RELATED EXAMPLES: Avery 1920, pp. 44, 46, nos. 29–30; Quimby 1995, pp. 95–96, nos. 52, 53; and an unpublished example at the Smithsonian Institution, Washington, D. C.

REFERENCES: Warren 1975, p. 156, no. 293; Kane 1998, p. 416.

1. For Edwards, see Buhler 1951; Buhler 1960c, p. 76; Buhler 1965, pp. 32–34; Flynt and Fales 1968, p. 212; Buhler 1972, vol. 1, p. 95; Buhler 1979, p. 18; Puig et al. 1989, pp. 217–18; Ward 1989a, pp. 66–84; Quimby 1995, p. 94; Kane 1998, pp. 405–22.

M7

Porringer

1720–46
Shop of John Burt (1692/93–1745/46), Boston[1]
2 x 5 1/4 x 7 13/16" (5.1 x 13.3 x 19.8 cm)
B.69.94

Porringers were often produced in sets of two to six.[2] Over the years most sets were divided, and today they are known only through manuscript references. The Bayou Bend example was originally one of a set of at least three.

PROVENANCE: Purchased by Miss Hogg from Gebelein Silversmiths, Boston, 1954.

MARKED: Buhler and Hood 1970, vol. 1, p. 323, nos. 111–15 (top of handle).

ENGRAVED: S*B (top of handle).

WEIGHT: 6 oz, 12 dwt.

RELATED EXAMPLES: The Bayou Bend porringer's engraved initials indicate it was originally part of a set with one now at RISD (acc. no. 22.110), and another was auctioned by Parke-Bernet Galleries, New York, sale 2919, October 28, 1969, lot 132. Kane 1998 lists thirty-one porringers from the John Burt shop.

REFERENCES: Warren 1975, p. 157, no. 295; Kane 1998, p. 254.

1. For Burt, see Buhler 1965, pp. 38–40; Flynt and Fales 1968, pp. 173–74; Buhler 1972, vol. 1, p. 145; Ward 1983, pp. 358–59; Puig et al. 1989, p. 235; Quimby 1995, p. 65; Kane 1998, pp. 246–60.
2. Fales 1974b, p. 119. Buhler 1972, vol. 1, pp. 269–70, no. 226.

M8

Porringer

ca. 1768–88
Shop of Benjamin Burt (1729–1805), Boston[1]
2 x 5 1/4 x 7 11/16" (5.1 x 13.3 x 14.4 cm)
B.56.33

Benjamin Burt was the youngest son of John Burt, and the third to follow in his father's footsteps, a common practice during the colonial period. A comparison of this porringer with the previous example from John Burt's shop (see cat. no.

M6

M7

M8

M9

M7) reveals slight variations in the casting patterns.

PROVENANCE: Probably Elizabeth Fellows (Mrs. David Watts Bradley, 1768–1791, married 1788), Boston[2]; purchased by Miss Hogg from James Graham and Sons, New York, 1956.

MARKED: Buhler and Hood 1970, vol. 1, p. 323, nos. 219, 220 (handle).

ENGRAVED: Eliz[h] Fellows (handle); 17″3″12, 1730 [probably the scratch weight] (base).

WEIGHT: 6 oz, 18 dwt.

RELATED EXAMPLES: Benjamin Burt porringers in museum collections include Buhler and Hood 1970, vol. 1, pp. 165–67, nos. 212–14; Buhler 1972, vol. 1, p. 347, no. 306; Davidson and Stillinger 1985, p. 215; Johnston 1994, p. 13.

REFERENCES: Warren 1975, p. 158, no. 297; Kane 1998, p. 236.

1. For Burt, see Buhler 1960c, p. 74; Buhler 1965, pp. 76, 78, 81–83; Flynt and Fales 1968, p. 173; Buhler 1972, vol. 2, p. 338; Buhler 1979, p. 33; Puig et al. 1989, p. 261; Quimby 1995, p. 63; Kane 1998, pp. 224–45.
2. Doggett 1878, pp. 19–25.

M9

Porringer

ca. 1753–1803
Shop of Samuel Minott (1732–1803), Boston[1]
2 x 5⅜ x 8¹/₁₆″ (5.1 x 13.7 x 20.5 cm)
B.69.105

PROVENANCE: Purchased by Miss Hogg from Robert Ensko, New York, 1953, who noted its descent in the Jennings family of Boston.[2]

TECHNICAL NOTES: See cat. no. M6.

MARKED: Buhler and Hood 1970, vol. 1, p. 328, nos. 229–33 (top; back of handle).

ENGRAVED: A wyvern with an arrow in its mouth (handle); D[I] (base).

WEIGHT: 8 oz.

RELATED EXAMPLES: Buhler 1965, pp. 95–96; Flynt and Fales 1968, p. 99, no. 76; and an unpublished example in the Rosenbach Foundation, Philadelphia. According to Kane 1998, p. 693, the Bayou Bend porringer was originally part of a larger set.

REFERENCES: Warren 1975, p. 158, no. 298; Kane 1998, p. 693.

1. For Minott, see Buhler 1960c, p. 81; Buhler 1965, pp. 89–90; Flynt and Fales 1968, p. 277; Buhler 1972, vol. 1, p. 363; Buhler 1979, p. 40; Puig et al. 1989, pp. 267–68; Kane 1998, pp. 686–99.
2. Boston 1903, p. 255. The porringer's initials match those of Isabella and Daniel Jennings, who married in 1790.

M10

Porringer

1772–1820
Shop of Benjamin Bunker (1751–1842), Nantucket[1]
2¹/₁₆ x 5¼ x 7⅝″ (5.2 x 13.3 x 19.4 cm)
B.61.20

Once the silversmith's trade became firmly established, some craftsmen migrated from urban centers to less densely populated areas. There they benefited from less competition but, concomitantly, had to contend with a reduced clientele. These rural craftsmen usually produced simpler forms and retailed more complex objects made by their urban counterparts, in addition to finding supplemental employment. Typical of such craftsmen, Benjamin Bunker also worked as a clock and watchmaker to assure his livelihood.

PROVENANCE: Purchased by Miss Hogg from Robert Ensko, New York, 1961.[2]

TECHNICAL NOTES: See cat. no. M6.

MARKED: Flynt and Fales 1968, p. 171, second mark (back of handle; inside bowl).

ENGRAVED: I[P]M (handle).[3]

WEIGHT: 9 oz, 8 dwt.

RELATED EXAMPLES: Carpenter and Carpenter 1987, pp. 130–32.

REFERENCES: Warren 1975, p. 158, no. 299.

1. For Bunker, see Carpenter and Carpenter 1987, pp. 130–32.
2. John and Mary Coleman Pinkham of Nantucket, whose initials and marriage corresponds with Bunker's activity, may have been the original owners.
3. See n. 2 above.

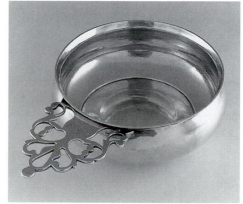

M10

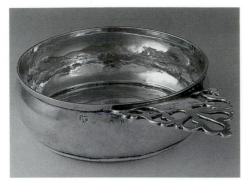

M11

M11

Porringer

ca. 1734–85
Shop of John Tanner (1713–1785), Newport[1]
1⅞ x 5⁵⁄₁₆ x 8″ (4.8 x 13.8 x 20.3 cm)
B.69.107

PROVENANCE: Purchased by Miss Hogg from Robert Ensko, New York, 1953.

TECHNICAL NOTES: See cat. no. M6.

MARKED: Buhler and Hood 1970, vol. 1, p. 331, nos. 474, 475 (back of handle; left of handle).

ENGRAVED: wᶜm (handle).

WEIGHT: 7 oz, 10 dwt.

RELATED EXAMPLES: Buhler and Hood 1970, vol. 1, pp. 284–85, no. 474; an unpublished porringer at MMA (acc. no. 33.120.359).

REFERENCES: Warren 1975, p. 157, no. 296.

1. For Tanner, see Carpenter 1954, pp. 158, 199; Flynt and Fales 1968, pp. 335–36.

M12

Porringer

ca. 1732–50
Shop of Joseph Richardson, Sr. (1711–1784),
Philadelphia[1]
1¾ x 5⁵⁄₁₆ x 7¹³⁄₁₆″ (4.4 x 13.5 x 19.8 cm)
B.58.155

Francis Richardson (1681–1729) was among the first Philadelphia silversmiths to produce keyhole-handle porringers. At the time of his death the vessel's popularity was on the rise in the American colonies and, conversely, on the wane in England. This may explain why the form never appears among his son Joseph's extensive orders to London suppliers; however, the younger Richardson's shop

accounts record the production of no fewer than 129 porringers between 1733 and 1748. These revealing documents specify that his journeyman, John S. Hutton (1684/85–1792), and apprentice, David Harper (d. 1761), fashioned many of the porringers, which, once completed, were stamped with Richardson's mark.[2]

PROVENANCE: Purchased by Miss Hogg from Ginsburg and Levy, New York, 1958.

TECHNICAL NOTES: See cat. no. M6.

MARKED: Buhler and Hood 1970, vol. 2, p. 284, nos. 843–47 (twice on the back of handle).

ENGRAVED: 8–8 [the scratch weight]; 25 (base); EWBA from MWAM (side, probably added later). Initials may have been engraved on the keyhole handle, but if so, they have been removed.

WEIGHT: 8 oz, 5 dwt.

RELATED EXAMPLES: Buhler and Hood 1970, vol. 2, pp. 186–87, no. 836; Buhler 1972, vol. 2, p. 604, no. 516; Fales 1974b, pp. 119–22; Quimby 1995, p. 426, no. 441.

REFERENCES: Warren 1975, p. 159, no. 301.

1. For Richardson, see Fales 1974b; PMA 1976, p. 46; Buhler 1979, p. 85; Quimby 1995, p. 423.
2. Fales 1974b, pp. 63, 119, 295.

M13

Porringer

ca. 1747–1810
Shop of Elias Pelletreau (1726–1810),
Southampton, New York[1]
1¹⁵⁄₁₆ x 4¹⁵⁄₁₆ x 6¹⁵⁄₁₆″ (4.9 x 12.5 x 17.6 cm)
B.69.114

New York City artisans employed a broad range of patterns for porringer handles. Among the most characteristic is this distinctive design with its three large piercings, also employed by silversmiths working in Albany, Utica, and parts of Long Island, Connecticut, and Rhode Island,[2] regions that evince a New York City influence in their decorative arts.

PROVENANCE: See cat. no. M4.

TECHNICAL NOTES: See cat. no. M6.

MARKED: Buhler and Hood 1970, vol. 2, p. 283, nos. 668, 670–75 (back of handle).

ENGRAVED: Mᴮe (base).

WEIGHT: 6 oz, 14 dwt.

RELATED EXAMPLES: The Bayou Bend porringer was originally one of a pair; its mate descended in the Floyd-Jones family until it was bequeathed to the Museum of the City of New York (acc. no. 90.51.11). Other Pelletreau porringers with this handle include Buhler 1972, vol. 2, p. 592, no. 508; Failey 1976, pp. 142, 210, nos. 165, 244; Conger 1991, p. 323, no. 198; Quimby 1995, p. 275, no. 238.

REFERENCES: Warren 1975, p. 159, no. 300; Quimby 1995, p. 281.

1. For Pelletreau, see Weaks 1931; Elias Pelletreau 1959; Flynt and Fales 1968, pp. 296–97; Failey 1971a; Buhler 1972, vol. 2, p. 590; Failey 1976, pp. 200–201, 300–301; Trupin 1984; Puig et al. 1989, pp. 255–56; Quimby 1995, p. 274.
2. These include Peter David; Jacob Gerritse Lansing; one attributed to John Cluett; Jacob Ten Eyck; Samuel Vernon; Daniel Russell; Adrian Bancker; John Brevoort; John Osborn; Bartholomew Schaats; Simeon Soumain; Christopher Robert; Charles Le Roux; and Thauvet Besley.

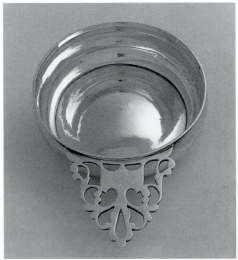

M12

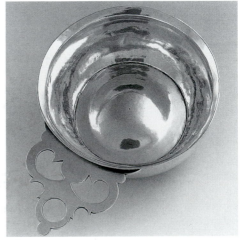

M13

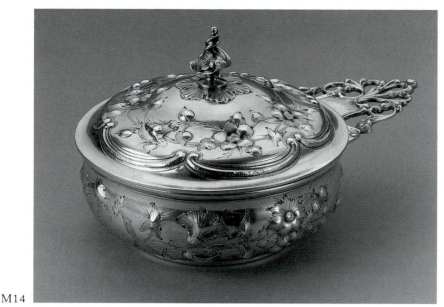

M14

M14

Porringer

ca. 1856
Manufactory of William Forbes (1799–after 1864), New York[1]
Ball, Black & Co. (act. 1851–74), New York, retailer[2]
4 x 5 1/16 x 7 9/16" (10.2 x 12.8 x 19.2 cm)
Museum purchase with funds provided by Mr. and Mrs. Don McMillian, B.95.18

By the nineteenth century, the porringer was used mainly as a child's dining vessel.[3] In William Forbes's example the traditional form was beautifully adapted to the exuberant dictates of the Rococo Revival style. While this porringer is unmistakably a product of the mid-nineteenth century, the addition of a cover harks back to an earlier form, the *écuelle*.

PROVENANCE: Purchased by Bayou Bend from Whirligig Antiques, Austin, Texas, 1995.

TECHNICAL NOTES: The bowl and lid are spun, the finial is soldered on.

MARKED: Darling 1964, p. 23, third mark from top (back of handle).

ENGRAVED: M.K.C. / September 22, 1856 (side).

WEIGHT: 11 oz, 9 dwt.

RELATED EXAMPLES: Hammerslough and Feigenbaum 1973, pp. 16, 17.

1. For Forbes (act. 1826–50, 1863–64), see *Antiques* 103 (March 1973), pp. 561–63; von Khrum 1978, p. 49.

2. For Henry Ball and William Black, see Venable 1994, p. 315. The chronology of this company is as follows: Ball, Tompkins & Black, 1839–51; Ball, Black & Co., 1851–74; Black, Starr & Frost, 1874–1908; Black, Starr & Frost, Inc., 1908–29; Black, Starr & Frost-Gorham, Inc., 1929–40; Black, Starr & Gorham, Inc., 1940–62; Black, Starr & Frost, Ltd., 1962–90.

3. Carpenter and Carpenter 1978, p. 138.

M15

Dram Cup

1655–64
Shop of John Hull (1624–1683) and Robert Sanderson, Sr. (1608–1693), Boston[1]
1 x 3 5/8 x 2 1/4" (2.5 x 9.2 x 5.7 cm)
Museum purchase with funds provided by the Theta Charity Antiques Show, B.96.8

The dram cup is recorded in English silver as early as the fourteenth century, and in the American colonies its popularity persisted until the beginning of the eighteenth century. Previously its name was thought to refer to the vessel's capacity; however, variations in size among the surviving examples suggest otherwise. In this period the word "dram" referred to a small draught of liquor, which offers a more plausible explanation of the name. Fewer than forty examples of Hull and Sanderson's flatware and holloware are known from a partnership that spanned more than three decades. The existing forms encompass spoons, porringers, two-handled cups, beakers, wine cups, a tankard, and dram cups.

It is believed that this diminutive cup was made for Daniel and Patience Denison.[2] As early as 1635 Denison served as a representative to the Massachusetts General Court. By 1652, when the court appointed John Hull mint master, Denison was its speaker, and he remained a member of the Court for the rest of his life.

PROVENANCE: Probably Daniel Denison (d. 1682) and Patience Denison (d. 1690), Ipswich, Massachusetts, married in 1632[3]; a member of the Derby family, presumably Dr. Perley Derby (1823–1897); the Pierce family; [Willoughby Farr]; purchased by Mrs. Thomas B. Gannett; Mrs. Dorothy Draper Hamlen; Mark Bortman (1896–1967); his daughter; who sold it to Bayou Bend, 1996.

TECHNICAL NOTES: The body is raised, the handles are twisted wire. The results of a nondestructive energy-dispersive X-ray fluorescence analysis are on file at Bayou Bend.

MARKED: Buhler 1972, vol. 1, p. 1, b, p. 4, c (side).

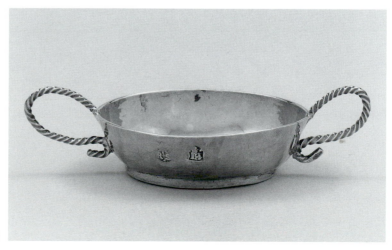

M15

ENGRAVED: D^DP [probably Daniel and Patience Denison] (underside).

WEIGHT: 12 dwt.

RELATED EXAMPLES: Approximately a dozen American dram cups survive, four of them from the Hull and Sanderson shop, including Buhler 1972, vol. I, pp. 6, 9, nos. 3, 6; Buhler and Hood 1970, vol. I, p. 3, no. I.

REFERENCES: Parke-Bernet Galleries, New York, sale 814, November 30, 1946, lot 112; Parks 1958, no. I; Kane 1987, pp. 424–26; *Antiques* 133 (May 1988), p. 1074; Kane 1998, pp. 570, 885.

1. See cat. no. M1.
2. Kane 1987, pp. 424–26; Denison 1882. Daniel Denison was an important figure in the Massachusetts Colony and his wife was a daughter of Governor Thomas Dudley.
3. Efforts to substantiate this history through probate records have proved futile since all the Denison silver was listed by weight rather than being itemized (Brainard 1908).

M16

Two-handled Bowl

1696–1731
Shop of Cornelius Kierstede (1674/75–1757),
New York, Albany, and New Haven[1]
2³⁄₁₆ x 6⁵⁄₁₆ x 4³⁄₈″ (5.6 x 16 x 11.1 cm)
B.63.3

The two-handled bowl, known as brandy-wine bowl in the Netherlands, demon-strates the persistence of strong cultural traditions in the New York area long after the British seized control from the Dutch in 1664. Typically, the Netherlandish prototypes are fashioned in a lobate shape, on a high foot, with restrained ornament.[2] They are associated with the social gathering known as the *kindermaal*, which celebrated the arrival of a newborn; however, its use in America was not limited to that occasion since it was often employed at weddings and funerals as well. The bowl was filled with raisins soaked in wine, which were served with a ceremonial spoon (see cat. no. M107).[3]

PROVENANCE: Maria Pruyn (Mrs. Elbert Gerritsen, d. 1731), Albany; to her daughter Alida (Mrs. Isaac Grevenraedt, b. 1701); to her son Hendrick Grevenraedt (b. 1737); to Henry Grevenraedt (b. ca. 1776–80), either the son or nephew of Hendrick; to his daughter Maria (Mrs. David Van Ness Radcliffe, 1812–1853); to her daughter Cornelia (Mrs. Martin Heermance, 1847–1905); to her son Radcliffe Heermance; purchased by Miss Hogg from James Graham and Sons, New York, 1963.

TECHNICAL NOTES: The body is raised, and the handles are twisted wire. Following a Continental practice, Kierstede incorporated a French coin, an *écu aux palmes*, dated 1693, into the bottom of the bowl.

MARKED: Buhler and Hood 1970, vol. I, p. 327, no. 329 (twice on rim).

ENGRAVED: M⋆G [Maria Gerritsen] (below rim).

WEIGHT: 4 oz, 11 dwt.

RELATED EXAMPLES: Buhler and Hood 1970, vol. I, pp. 230–31, no. 329; Safford 1983, pp. 14–15, nos. 12, 13.

REFERENCES: Miller 1962, no. 28; *Antiques* 83 (January 1963), p. 14; Pearce 1966, p. 524; Warren 1975, p. 159, no. 302; Agee et al. 1981, p. 65; Warren 1982, pp. 234, 237; Ward 1989b, pp. 138, 146–47, no. 58.

1. For Kierstede, see Ward 1989b, pp. 136–51.
2. Pearce 1961, pp. 342–43; Pearce 1966, pp. 524–25; Ward 1989b, pp. 146–47, no. 59.
3. Blackburn et al. 1988, p. 278.

M17

Two-handled Cup

ca. 1666–72
Shop of Jeremiah Dummer (1645–1718), Boston[1]
3¹¹⁄₁₆ x 6¾ x 5″ (9.4 x 17.1 x 12.7 cm)
Museum purchase with funds provided by the Theta Charity Antiques Show, B.90.4

The Bayou Bend cup is among the earliest documented works by Jeremiah Dummer. This form is now popularity referred to as a caudle cup, implying it was intended as a receptacle for a concoction of warm wine and brandy or tea, mixed with bread, eggs, sugar, and spices. However, in the seventeenth century it probably held a variety of beverages. While this example was originally made for domestic purposes, it was later presented to the First Church, Dorchester, Massachusetts, for use as a Communion vessel. This transformation of household objects into ecclesiastical ones is wholly consistent with the Protestants' efforts to return to the simplicity of early Christianity and to distance themselves from what they considered the excessive trappings and ritual of the Roman Catholic Church.

PROVENANCE: Margaret Webb Sheaffe Thacher (ca. 1625–1693), the wife of the Reverend Thomas Thacher (d. 1678); to the First Church, Dorchester, Massachusetts, 1672; presented to the Second Church, Dorchester, 1876; purchased by Bayou Bend from the congregation through Firestone and Parson, Boston, 1990.

TECHNICAL NOTES: The body is raised, and the handles cast.

MARKED: See cat. no. M2 (side).

ENGRAVED: MT [Margaret Thacher] (base); for the church (base, appears to be early and

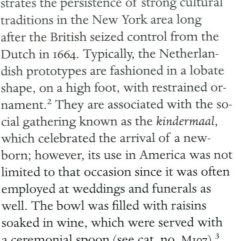

M16

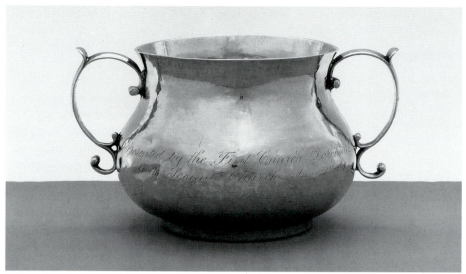

M17

possibly from the time it was donated); Given to First Church by Margaret Thacher / in 1672. / (Her husband, Rev. Mr. Thacher, was first / Pastor of Old South Church / Boston) (base); Presented by the First Church, Dorchester, To the Second Church. Jan^y 1^st 1878. (side).

WEIGHT: 7 oz, 6 dwt.

RELATED EXAMPLES: Those belonging to churches are Jones 1913, p. 150, pl. LIV, p. 178, pl. LXI, no. 2, pp. 304–5, pl. XCIV, no. 1, pp. 393–94, pl. CXXI; Ward and Hosley 1985, pp. 281–82, no. 163. Examples in public collections include Sprackling 1958; Winchester et al. 1959, p. 184; Buhler and Hood 1970, vol. 1, pp. 13–14, no. 8; Hanks 1970, p. 418; Buhler 1972, vol. 1, pp. 17–18, no. 15; Puig et al. 1989, pp. 206–7, no. 172; Quimby 1995, pp. 90–91, no. 47.

REFERENCES: Jones 1913, pp. 149–50, pl. LIV; Clarke and Foote 1935, p. 76, no. 28; *Antiques* 140 (September 1991), p. 308; Kane 1998, p. 390.

1. See cat. no. M2.

M18

Tankard

ca. 1695–1710
Shop of Jeremiah Dummer (1645–1718), Boston[1]
6½ x 5⅛ x 8¼″ (16.5 x 13 x 21 cm)
B.69.115

The tankard is recorded in England by the thirteenth century, and it must have been among the earliest forms fashioned by American silversmiths. Patterned after English examples, this early type is characterized by sharp, vertically oriented sides, generous, sweeping handles, cusped

thumbpieces, and the practical addition of a rat-tail body drop strengthening the juncture between handle and body. The Bayou Bend tankard masterfully incorporates all of these elements, integrating them with Early Baroque motifs such as the lip crenellation and the gadrooning.

PROVENANCE: John Swain (1664–1738) and Experience Folger Swain (d. 1739), Nantucket; to their daughter Hannah (Mrs. Thomas Gardner, Sr., d. 1779); to her son Thomas Gardner, Jr. (1736–1830); to his son Charles Gardner (1769–1848); to his brother Edmund Gardner

(1785–1875); to his son Edmund Barnard Gardner, Jr. (1822–1905); to his son Edmund Gardner (1855–1910); to his son Edmund Sherman Gardner (1892–1942); purchased by Miss Hogg, from his widow, Virginia Newcomb Gardner, 1954.[2]

TECHNICAL NOTES: The body and lid are raised, the two-part handle has air vents on either side at the top and a shield-shaped terminal. The lid is attached by a five-part hinge, and the thumbpiece cast.

ENGRAVED: I^SE [John and Experience Swain] and 1690 (added later); THG 1740 [Thomas and Hannah Gardner, Sr.]; TAG 1784 [Thomas and Anna Gardner]; CAG 1817 [Charles and Abial Gardner]; ESG 1847 [Edmund and Susannah Gardner]; EB & MG 1875. [Edmund Barnard and Martha Gardner]; ECSG 1905 [Edmund and Cornelia Sherman Gardner]; ESG 1910 [Edmund Sherman Gardner] (base).

MARKED: See cat. no. M2 (left of handle).

WEIGHT: 26 oz.

RELATED EXAMPLES: Dummer tankards with gadrooned lids include Jones 1913, p. 380, pl. CXVII, no. 2; Clarke and Foote 1935, no. 92, pl. XVII; Hanks 1971, pp. 277, 279–80, no. 1.

REFERENCES: Phillips 1939, p. 42, pl. XIV; Bullard 1958, pp. 89–91; Warren 1971a, p. 52, no. 26; Warren 1975, p. 153, no. 284; Carpenter and Carpenter 1987, pp. 122–23; Kane 1998, p. 395.

1. See cat. no. M2.
2. Starbuck 1969; Bullard 1958.

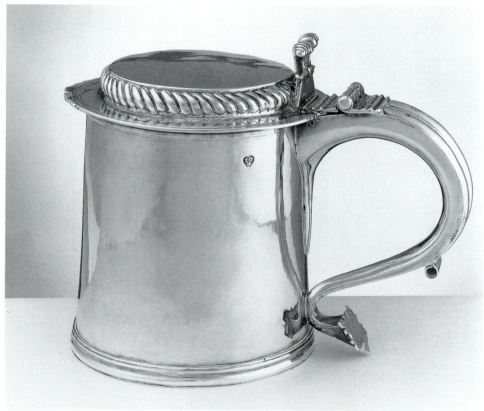

M18

M19

Tankard

ca. 1690–1725
Shop of Edward Winslow (1669–1753), Boston[1]
6¹⁵/₁₆ x 5½ x 8″ (17.6 x 14 x 20.3 cm)
B.63.71

Edward Winslow's tankard, while similar in appearance to the previous example (cat. no. M18), demonstrates the form's evolution. The body has tapered somewhat; the cusped thumbpiece has been replaced by one composed of conjoined dolphins supporting a grotesque mask; and a cut-card ornament was introduced at the base of the handle, which terminates in a cherub's head. Most of these elements were derived from English silver, but some, such as the cast thumbpiece, are uniquely American. The addition of a finial is unusual at this early date.

PROVENANCE: Purchased by Miss Hogg from Carl and Celia Jacobs, Southwick, Massachusetts, 1963.

TECHNICAL NOTES: No center point is in evidence. A rat-tail body drop extends to the cut-card ornament at the handle's juncture with the base. A five-part hinge is attached to the molded handle, which has a loop return midway down. The finial is soldered on the lid.

MARKED: Buhler and Hood 1970, vol. 1, p. 332, nos. 48, 49, 51–57 (lid; left of handle).

ENGRAVED: The Payne arms and crest (side); 30:oz and CFD (base, the initials added later).

WEIGHT: 28 oz, 17 dwt.

RELATED EXAMPLES: Fales 1983, pp. 10–11, no. 3; Johnston 1994, p. 174; Quimby 1995, pp. 177–80, nos. 136, 137. Unpublished tankards belong to the Currier Gallery of Art, Manchester, New Hampshire; and the Detroit Institute of Arts.

REFERENCES: Warren 1975, p. 153, no. 285; Kane 1998, p. 981.

1. For Winslow, see Phillips 1935; Comstock 1942; Buhler 1960c, p. 87; Flynt and Fales 1968, p. 361; Buhler 1972, vol. 1, p. 79; Buhler 1979, pp. 15, 17; Ward 1983, p. 355; Puig et al. 1989, pp. 217–18; Quimby 1995, pp. 176–77; Kane 1998, pp. 967–84.

M20

Tankard

1695–1711
Shop of John Coney (1655/56–1722), Boston[1]
6¹⁵/₁₆ x 5¹/₁₆ x 8″ (17.6 x 12.9 x 20.3 cm)
B.74.19

John Coney is arguably the greatest of all colonial American silversmiths. His shop is recognized as the first in this country to have produced several forms, including the inkstand, fork, sugar box, chafing dish, monteith, and chocolate pot, and the earliest New England teapot. Coney was equally adept as an engraver, executing the plates for some early paper currency for Massachusetts and New Hampshire.

The Bayou Bend tankard is a consummate American expression of Early Baroque silver. It is outstanding for its unusual tiered and reeded lid. It is endowed with a sense of dynamic movement to which only one other piece of American silver from this period corresponds, Coney's great two-handled covered cup that Massachusetts Lieutenant-Governor William Stoughton presented to Harvard College in 1701.[2] The tankard was made for John Foster, a prosperous Boston merchant and prominent official. Foster was clearly a man with sophisticated taste and lofty aspirations. In 1692 he erected in Boston an extraordinary house that is credited with introducing New Englanders to the Italian Renaissance style.[3] Foster's tankard, like his mansion, is one of the most eloquent statements of style in early New England.

PROVENANCE: John Foster (1644–1710/11), Boston; to his daughter Lydia (Mrs. Edward Hutchinson, 1686–1748); to her daughter Elizabeth (Mrs. Nathaniel Robbins, 1731–1793); to her son Edward Hutchinson Robbins (1758–1829); to his daughter Mary (Mrs. Joseph Warren Revere, 1794–1879); to her daughter Maria A. Revere (1828–1905); to her nephew John Phillips Reynolds (1863–1920); to his wife Lucretia R. Reynolds; to her husband's grand-nephew Edward Reynolds, Jr.; purchased by Miss Hogg from Firestone and Parson, Boston, 1974.

TECHNICAL NOTES: Below the handle's juncture with the lip is a boldly executed body drop, and at the base is a graceful cut card. The bezel has been removed.

MARKED: Buhler and Hood 1970, vol. 1, p. 324, nos. 31–33 (bottom; left of handle; lid).

ENGRAVED: The Foster arms and crest (side); the tankard's provenance (base, recorded about 1920, presumably for Mrs. John Phillips Reynolds).

WEIGHT: 26 oz, 11 dwt.

RELATED EXAMPLES: The Bayou Bend tankard is most like Buhler 1979, pp. 12–13, no. 3. Four similarly lidded Coney tankards belong to the First Parish, Cambridge (Jones 1913, pp. 107–8, pl. XLII).

REFERENCES: Coney 1932, no. 36; Harvard 1936, p. 27, no. 98; Flynt and Fales 1968, p. 114;

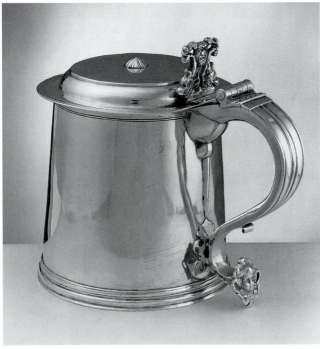

M19

M19 (*detail*)

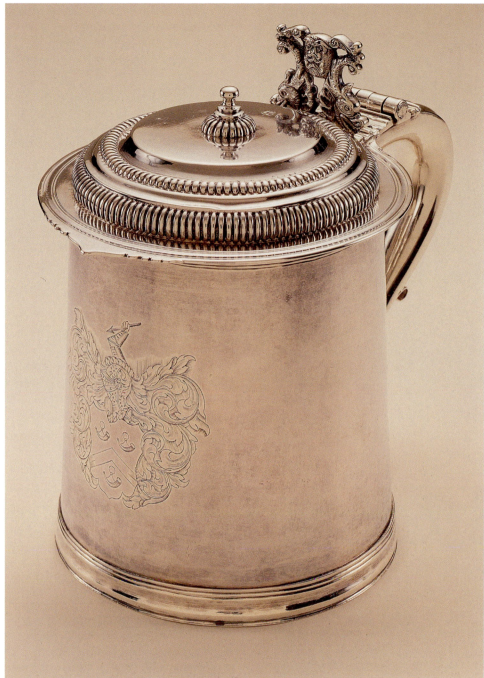

M20

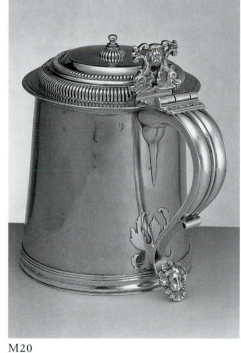

M20

Clarke 1971, p. 36, no. 97, pl. XXVII; Buhler 1972, vol. 1, p. 52; Cooper 1980, pp. 164–65, 171; Agee et al. 1981, pp. 64–65; Warren 1982, pp. 241, 243; Brown 1983b; Marzio et al. 1989, pp. 228–29; Kane 1998, p. 331.

1. For Coney, see Coney 1932; Buhler 1960c, p. 75; Buhler 1965, pp. 23–24; Flynt and Fales 1968, pp. 188–89; Clarke 1971; Buhler 1972, vol. 1, p. 39; Buhler 1979, pp. 10–11; Ward 1983, p. 350; Puig et al. 1989, p. 208; Quimby 1995, pp. 78–79; Kane 1998, pp. 315–34.
2. Warren, Howe, and Brown 1987, pp. 47–49; no. 39.
3. Cummings 1964.

M21

Tankard

ca. 1710
Shop of Peter Van Dyck (1684–1751), New York[1]
7⁷⁄₈ x 6¼ x 9⁷⁄₁₆" (20 x 15.9 x 24 cm)
B.69.118

The New York tankard manifests one of the rare instances in American decorative arts when two distinct cultures merge. This event occurred in 1664 when the Dutch colony of New Amsterdam was taken over by the British, who promptly renamed it New York. While the two peacefully coexisted, the Dutch ardently strove to preserve their native language and culture, succeeding in this effort into the nineteenth century.

Traditionally, the tankard is an English form and not one associated with Holland. Conversely, the profusion of engraved, chased, and cast ornament that adorns Netherlandish and New York silver is rarely encountered in English work. Elements characteristic of Early Baroque New York tankards are the handle's cast lion couchant, the cherub's-head terminal, the double-spiral thumbpiece, and the expertly engraved arms and surround.

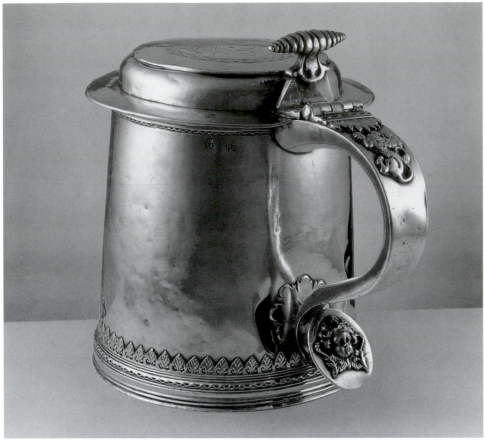

M21

2. According to family tradition recorded by 1848, the merchant ship represents an investment of Thomas Gibbs's that was wrecked on the English coast. Purportedly, the tankard was fashioned from what proceeds were realized from that ill-fated speculation.

M22

Tankard

1727–55
Shop of Henricus Boelen II (1697–1755), New York[1]
6⅞ x 5⁷⁄₁₆ x 8⅝" (17.5 x 13.8 x 21.9 cm)
B.69.102

In the eighteenth century, the New York tankard retained the slightly tapered sides and flat lid introduced during the previous century. Cast ornaments and profuse engraving, favored earlier, were virtually eliminated. The vessel, responding to a Late Baroque aesthetic, now introduces a simplicity of line and uninterrupted surface. A coin incorporated into the vessel's lid, the principal ornament, perpetuates a northern European tradition.[2]

PROVENANCE: Purchased by Miss Hogg from James Graham and Sons, New York, 1954, who noted this tankard was owned by Governor Lewis Morris (1671–1746), Morrisania, New Jersey.

TECHNICAL NOTES: The handle is assembled with an air vent located beneath the upper section and in the cherub's-head terminal. The coin depicts the Holy Roman Emperor Leopold I and was minted at Kremnitz between 1691 and 1693.[3]

MARKED: Buhler and Hood 1970, vol. 2, p. 276, nos. 577, 620–23 (both sides of handle).

ENGRAVED: IᴹM (handle); VCN and an unidentified arms and crest depicting a winged dragonlike animal with the indecipherable motto SUN AR DU HYNE (side, added later); 32 oz. (base).

WEIGHT: 31 oz, 2 dwt.

RELATED EXAMPLES: Miller 1937b, pp. 4, 46, no. 34; Buhler and Hood 1970, vol. 2, pp. 71, 73, no. 622; Puig et al. 1989, p. 224, no. 184, with a related coin attached to its lid.

REFERENCES: Warren 1975, p. 155, no. 288.

1. For Boelen, see Randolph and Hastings 1941; Buhler 1960c, p. 73; Puig et al. 1989,

The cut-card bands that ornament the base molding are unique from shop to shop. The Bayou Bend tankard, notable for its generous size and richly executed decoration, is one of the most splendid expressions of this type.

PROVENANCE: Thomas Gibbs (1671–1716) and Sarah Gibbs, Southampton, Bermuda; to their son George Gibbs (d. 1772); to his daughter Miriam Gibbs Saltus (1757–1851); to her son Samuel Saltus (d. 1880); to his cousin George Judson Gibbs (1833–1899); to his son George Albert St. George Gibbs (1866–1938); to his cousin Ralph Gibbs Whedon (1891–1967); [Ginsburg and Levy, New York, ca. 1946]; purchased by Richard Loeb; purchased by Miss Hogg from Richard Loeb through Ginsburg and Levy, 1953.

MARKED: Buhler and Hood 1970, vol. 2, p. 286, nos. 587–92 (once on the flange; twice left of handle).

ENGRAVED: Tᴳs [Thomas and Sarah Gibbs] and 1710 (bottom). Engraved on the side is a pouncing griffin, the crest of the Rich family, from whom Thomas Gibbs was descended. The lid is engraved with a merchant ship.[2]

WEIGHT: 42 oz, 17 dwt.

RELATED EXAMPLES: Eight tankards from Van Dyck's shop are recorded. Those in public

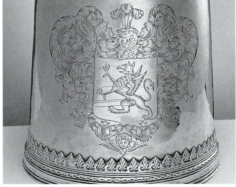

M21 (*detail*)

collections include Buhler and Hood 1970, vol. 2, pp. 39–41, 51, nos. 587, 596; Puig et al. 1989, pp. 228–29, no. 187; PMA (acc. no. 51–103–1). Examples with similarly engraved lids include Avery 1920, pp. 17–20, no. 9; Hyde 1971, pp. 176–77, no. 402.

REFERENCES: Correspondence between Samuel Saltus and (probably) George Gibbs, November 22, 1847, and August 25, 1848 (copies in object files); *Antiques* 50 (November 1946), p. 300; *Antiques* 90 (December 1966), p. 803; Warren 1971a, p. 52, no. 26; Warren 1975, p. 154, no. 287.

1. For Van Dyck, see Hastings 1937; McKinsey 1984; Puig et al. 1989, p. 228; Quimby 1995, p. 311.

p. 224; Ensko 1989, p. 22; Quimby 1995, p. 196.

2. The coin also provided a means to identify a stolen vessel (Gottesman 1938, p. 31).

3. Voglhuber 1971, pp. 264–67, no. 225; Davenport 1974, p. 80, no. 3261.

M23

Tankard

ca. 1692–1734
Shop of Johannes Nys (1671–1734), New York,
Philadelphia, and Kent County, Delaware[1]
7¼ x 5½ x 8⅝″ (18.4 x 14 x 21.9 cm)
B.58.117

Cesar Ghiselin (ca. 1663–1733) and Johannes Nys were the first to establish the silversmith's craft in Philadelphia. Ghiselin was among the thousands of French Protestants forced to leave their homeland to escape religious persecution. Nys's surname also suggests a Huguenot origin; however, he was born in New York and presumably apprenticed there, as evidenced by the cut-card bands and spiral-shaped thumbpieces employed on his tankards. In Philadelphia silver, these elements are unique to Nys's work, implying that he had little or no influence

on subsequent generations of silversmiths.

PROVENANCE: Possibly made for William Evans (d. ca. 1728) and Elizabeth Evans, Evesham Township, Burlington County, New Jersey; to their son Thomas Evans (d. 1783); purchased by Miss Hogg from Philip H. Hammerslough, West Hartford, Connecticut, 1958.

TECHNICAL NOTES: The terminal is shield shaped. The lid is attached by a five-part hinge. The bezel has been removed.

MARKED: Buhler and Hood 1970, vol. 1, p. 283, nos. 820–22 (three times on lid, once right of handle).

ENGRAVED: W^E to T✶E [possibly William and Elizabeth Evans to Thomas Evans] (handle); oz 33½ (base).

WEIGHT: 30 oz, 8 dwt.

RELATED EXAMPLES: Ten Nys tankards are recorded. The Bayou Bend tankard most closely relates to that in Buhler 1972, vol. 2, pp. 599–600, no. 512. Cut-card bands on other objects bearing Nys's stamp include Keyes 1936; Harrington 1939, pp. 99 (top), 117; Sotheby Parke Bernet, New York, sale 3691, November 12–16, 1974, lot 1028; Quimby 1995, pp. 409–10, no. 418.

REFERENCES: Warren 1975, p. 155, no. 289; Nys 1977, case 4.

1. For Nys, see Woodhouse 1932; Keyes 1936; Prime 1938, pp. 68–70; Harrington 1939, pp. 5–7; Buhler 1960c, p. 82; Hindes 1967, pp. 283–84; Buhler 1972, vol. 2, p. 598; PMA 1976, pp. 7–8; Waters 1984, p. 52; Quimby 1995, p. 409.

M24

Tankard

ca. 1711–40
Shop of Isaac Anthony (1690–1773), Boston,
Newport, and Swansea, Massachusetts[1]
9⅜ x 5⅝ x 7¾″ (23.8 x 14.3 x 19.7 cm)
B.69.106

This tankard attests to the level of sophistication that Rhode Island silversmiths achieved by the early eighteenth century. Isaac Anthony apprenticed and began his career in Boston, and the Bayou Bend tankard evinces a design influence from that town. It also contrasts markedly with the earlier examples, notably in its domed lid and flame finial, a stylistic incongruity explained simply as a replacement. The tankard's popularity declined by the century's end as wine and spirits replaced beer, cider, and ale as the beverages of choice.

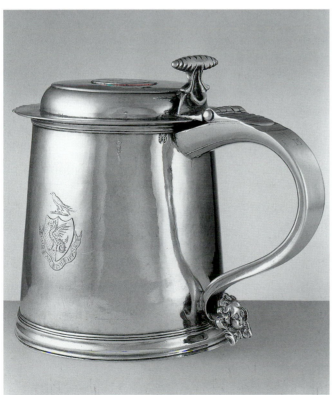

M22

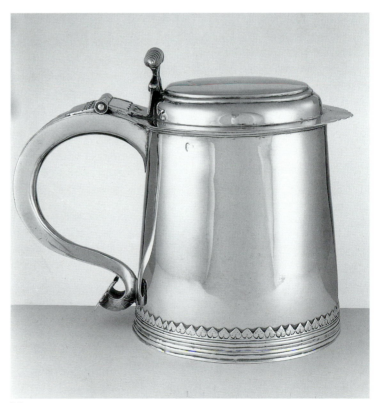

M23

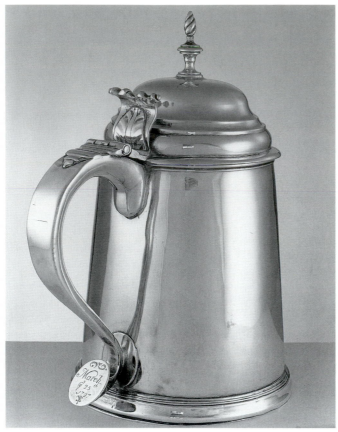

M24

2. William A. Thompson is the subject of a sketch in Quinlan 1873, pp. 515–22. See also Thompson, 1911, pp. 13–14; Amy 1960, pp. 13, 28, 56–57, 89.
3. Signs of wear such as these could be used to assist in the identification of stolen silver (Gottesman 1938, pp. 75–76). The silversmith realized part of his livelihood from repairs such as "Making a New lid to an old Tank⁽ᵈ⁾" (Revere 1761–97, vol. 1, January 15, 1772).

M25

Can

ca. 1705–51
Shop of Peter Van Dyck (1684–1751), New York[1]
3¾ x 3⁹/₁₆ x 5½" (9.5 x 9 x 14 cm)
B.69.119

Resembling a small lidless tankard, the can was not produced in England or America before the final quarter of the seventeenth century. The earliest examples are characterized by a globular belly and cylindrical neck—a shape probably derived from English redware and stoneware drinking vessels.[2] Van Dyck's diminutive can displays a contour introduced about 1700, which constitutes an evolution from the vessel's earliest form. In place of the usual two-part handle is a simple strap handle, reminiscent of seventeenth-century cast ones, and ornamented with a beaded rat tail.

PROVENANCE: Purchased by Miss Hogg from James Graham and Sons, New York, 1955.

TECHNICAL NOTES: The can is raised. The molded foot is soldered on.

MARKED: Buhler and Hood 1970, vol. 2, p. 286, nos. 593–97 (either side of handle).

ENGRAVED: DI over a fleur-de-lis flanked by S and R (base).

WEIGHT: 8 oz, 5 dwt.

RELATED EXAMPLES: Jones 1913, p. 450, pl. CXXXII; Avery 1920, p. 52, no. 45; *Antiques* 48 (November 1945), p. 263.

REFERENCES: Warren 1975, p. 151, no. 279.

1. See cat. no. M21.
2. For related ceramic examples, see Taggart 1967, p. 65, no. 173; Fairbanks and Trent 1982, pp. 389–90, 427, no. 393, pl. XVI (bottom); Grigsby 1990, pp. 37, 89, no. 22.

PROVENANCE: The tankard descended in the Thompson family of Connecticut to William Abdial Thompson (1762–1847), Thompsonville, New York[2]; purchased by Edward Eastman Minor from descendants in the Philadelphia area. For its subsequent history, see cat. no. M4.

TECHNICAL NOTES: A disk is intended to strengthen the body at its juncture with the lower handle. The scrolled thumbpiece is embellished on the back with an acanthus leaf. The domed lid and soldered finial are later additions, as corroborated by the presence of two rather than one set of thumbpiece impressions on the handle. The results of a nondestructive energy-dispersive X-ray fluorescence analysis (on file at Bayou Bend) confirm this alteration and suggest it was done at an early date.[3]

MARKED: Flynt and Fales 1968, p. 145; IA (in an oval, left of handle); I. ANTHONY (in a rectangle on handle).

ENGRAVED: The Arnold arms (side); B and E, below, the latter worn and difficult to decipher, and a top initial that is completely obliterated (handle); March yᵉ 25th 1727 (terminal); oz = d / 31 = 4 (base).

WEIGHT: 29 oz, 8 dwt.

RELATED EXAMPLES: Gourley 1965, no. 221; Sotheby Parke Bernet, New York, sale 4113, April 25–26, 1978, lot 641. The Bayou Bend tankard's engraving relates to that on the latter as well as to that on a tankard and a can by Samuel Vernon (Buhler and Hood 1970, vol. 1, pp. 273–75, no. 459; Gourley 1965, no. 307). Another engraved tankard, marked by John Coney and made for the Cranston family of Rhode Island, may have inspired the engraving on the Anthony and Vernon silver (Fairbanks et al. 1981, p. 627).

REFERENCES: Warren 1971a, p. 52, no. 26; Warren 1975, p. 154, no. 286; Kane 1998, p. 151.

1. For Anthony, see Carpenter 1954, p. 156; Flynt and Fales 1968, p. 145; Buhler 1979, p. 79; Ward 1983, p. 357; Kane 1998, pp. 149–51.

M24 *(detail)*

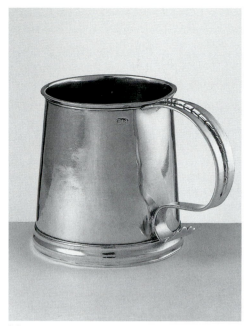

M25

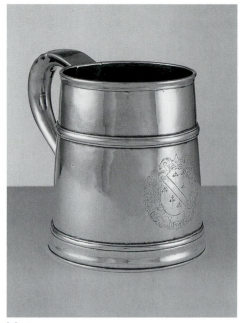

M26

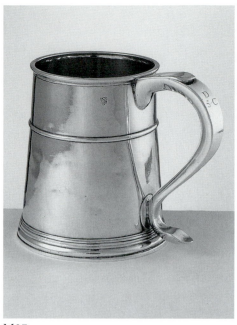

M27

M26

Can

ca. 1703–12
Shop of Peter Oliver (ca. 1682–1712), Boston[1]
4¼ x 3¹¹⁄₁₆ x 5⁵⁄₁₆″ (10.8 x 9.4 x 13.5 cm)
B.69.92

Today the term "mug" describes silver vessels with straight or slightly tapered sides, while the word "can" denotes the same form but with a pear-shaped body. During the colonial period these terms were used interchangeably. At the beginning of the eighteenth century the form evolved into an upward-tapering cylinder with a hollow handle, of which the Bayou Bend can is one of the earliest datable examples.

PROVENANCE: Hermann F. and Dorothy Locke Clarke, until ca. 1941; purchased by Richard Loeb; purchased by Miss Hogg from Mr. Loeb through Ginsburg and Levy, New York, 1953.

TECHNICAL NOTES: The can is raised with a two-part handle, which is attached to a small disk above the base molding.

MARKED: Buhler 1972, vol. 1, p. 121 (left of handle; base).

ENGRAVED: I^M (handle); the Howard arms (side).[2]

WEIGHT: 9 oz, 6 dwt.

RELATED EXAMPLES: This is the only Oliver can recorded. Vessels engraved with these

same arms include Puig et al. 1989, pp. 239–40, no. 196; *Antiques* 138 (July 1990), p. 92; Quimby 1995, pp. 133–34, no. 91.

REFERENCES: Warren 1975, p. 151, no. 280; Quimby 1995, p. 134; Kane 1998, p. 742.

1. For Oliver, see Whitmore 1865; Buhler 1960c, p. 82; Flynt and Fales 1968, p. 291; Buhler 1972, vol. 1, p. 121; Buhler 1979, p. 20; Ward 1983, pp. 366–67; Quimby 1995, p. 145; Kane 1998, pp. 741–42.
2. Guillim 1724, sec. 4, chap. 2, p. 433.

M27

Can

ca. 1704–36
Shop of William Cowell, Sr. (1682/83–1736), Boston[1]
4⁹⁄₁₆ x 3¹³⁄₁₆ x 5½″ (11.6 x 9.7 x 14 cm)
B.61.54

During the course of his career a silversmith used one or more stamps to sign his shop's production. In time these marks either wore out or were updated, responding to changes within the shop or the latest style. Initial marks can be difficult to attribute; for instance, William Cowell, Sr. and Jr., used the same surname stamp. The Bayou Bend can is enlightening as it is struck with the Cowell surname mark as well as an initial mark, which predates the son's tenure. This vessel, with a thinner midband and more

complex base molding than the Peter Oliver can (cat. no. M26), demonstrates the form's evolution.

PROVENANCE: Purchased by Miss Hogg from Whimsy Antiques, Arlington, Vermont, 1961.

TECHNICAL NOTES: The can is raised with a two-part handle, which is attached to a disk at the base.

MARKED: Buhler and Hood 1970, vol. 1, p. 324, nos. 89–90, 93–94 and 90–92, 179–81. Initial and surname stamps (base); initial mark (left of handle).

ENGRAVED: S^DC (handle); H-M (added later, bottom).

WEIGHT: 10 oz, 2 dwt.

RELATED EXAMPLES: Jones 1913, pp. 207–8, pl. LXXIII,1; *Antiques* 107 (March, 1975) p. 418.

REFERENCES: *Antiques* 80 (August 1961), p. 107; Warren 1975, p. 152, no. 281; Kane 1998, p. 352.

1. See cat. no. M3.

M28

Can

ca. 1724–40
Shop of Jacob Hurd (1702/3–1758), Boston[1]
4½ x 3⅜ x 4¹¹⁄₁₆″ (11.4 x 8.6 x 11.9 cm)
B.69.99

About 1720 the shape of the can began to evolve from a cylindrical form into a curvilinear contour corresponding with

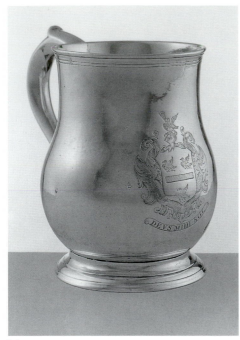

M28

the Late Baroque aesthetic. The earliest version of this type, while retaining its cylindrical shape, is rounded at the base, with a cast handle substituted for the earlier strap or two-part handle. Although this design is not represented in Bayou Bend's collection, this slightly later can by Jacob Hurd is related. It combines a cylindrical neck with a bulbous lower body. Its diminutive size identifies it as a half-pint can, to use a term of the period.

PROVENANCE: By tradition, Joshua Peirce (1670–1742/43), Portsmouth, New Hampshire; to his son Daniel Peirce (1709–1773); to his son John Peirce (1746–1814); to his son Daniel Hall Peirce (1801–1877); by descent to Joseph P. Peirce[2]; [Rudolph P. Pauly, Boston, 1939]; purchased by Edward Eastman Minor. For its subsequent history, see cat. no. M4.

TECHNICAL NOTES: The body is raised, the foot and vented handle are cast.

MARKED: Buhler and Hood 1970, vol. 1, p. 327, nos. 144–47, 157, 160 (surname stamp left of handle; full name stamp on base).

ENGRAVED: The Peirce arms and crest and, beneath, the motto *Deus Mihi Sol* [The Sun is to me a God].[3]

WEIGHT: 9 oz, 7 dwt.

RELATED EXAMPLES: A mate is recorded in American Art Association, Anderson Galleries, New York, sale 4314, April 2–3, 1937, pp. 90–91, lot 281, purchased by the Detroit Institute of Arts (acc. no. 37.143). Kane 1998, pp. 588–91, lists fifty-five examples.

REFERENCES: French 1939, p. 34, no. 61; Warren 1975, p. 152, no. 283; Kane 1998, p. 588.

1. For Hurd, see French 1939; Buhler 1960c, p. 78; Buhler 1965, pp. 53–56; Buhler 1972, vol. 1, p. 201; Ward 1983, p. 364; Puig et al. 1989, pp. 239–40; Quimby 1995, p. 122; Kane 1998, pp. 578–615.
2. Hoyt 1875.
3. Guillim 1724, sec. 3, chap. 20, p. 233.

M29

Can

ca. 1724–40
Shop of Jacob Hurd (1702/3–1758), Boston[1]
5⅛ x 3¾ x 5³⁄₁₆″ (13 x 9.5 x 13.2 cm)
B.61.18

This can's rotund body, attenuated contour, and outward flaring lip present a mature expression of the Late Baroque form. Referred to as a pint can, it was more common than the previous can of smaller capacity (cat. no. M28). Later Rococo examples retained the pear shape of the Late Baroque but often had a C-scrolled handle, on occasion further embellished with an acanthus leaf grip.

PROVENANCE: The Honorable Breckinridge Long, Montpelier, Maryland; purchased by Miss Hogg from James Graham and Sons, New York, 1961, who noted that the can was made for John Green, Charlestown, Massachusetts.

TECHNICAL NOTES: The body is raised, the foot and vented handle are cast. The handle is attached to a small disk above the base molding. The bottom's center point may be filled in.

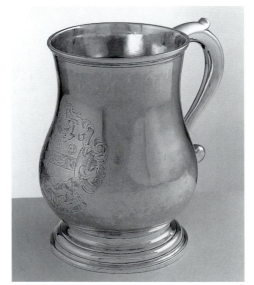

M29

MARKED: Buhler and Hood 1970, vol. 1, p. 327, nos. 144–47 (left of handle).

ENGRAVED: The Green arms and crest (side)[2] and, beneath, the motto *Nil Conscire Sibi* [One should not presume anything]; M·V (base).

WEIGHT: 11 oz, 10 dwt.

RELATED EXAMPLES: A spoon marked by Jacob Hurd's shop and engraved with the same crest, inscribed "Joshua Green," is in Buhler 1972, vol. 1, p. 204, no. 166. A can and a pair of casters marked by Joseph Edwards, Jr., are also ornamented with this crest and originally belonged to Joshua and Hannah Green, in Buhler 1972, vol. 2, pp. 473–74, no. 424; Buhler and Hood 1970, vol. 1, pp. 205–6, no. 272. Nathaniel Hurd engraved a heraldic bookplate for Francis Green, in French 1939, pp. 106–7.

REFERENCES: *Antiques* 79 (June 1961), p. 505; Warren 1975, p. 152, no. 282; Kane 1998, p. 589.

1. See cat. no. M28.
2. Guillim 1724, sect. 4, chap. 19, p. 367.

M30

Spout Cup

1725–46
Shop of John Burt (1692/93–1745/46), Boston[1]
5¹⁵⁄₁₆ x 4¾ x 4⅜″ (15.1 x 12.1 x 11.1 cm)
B.69.108

The spout cup is a colonial drinking vessel believed to have been used by the infirm, although it has also been suggested that it was designed for frothy beverages such as posset and syllabub. The cup is shaped like a can with a spout that functioned like a straw attached at the base. For convenience, the handle was positioned at a right angle to the spout, and the cover prevented spillage, kept the beverage warm, and protected against insects. Judging from the number of extant examples, it was most common in Boston.[2]

PROVENANCE: Possibly fashioned by John Burt for his own family (see Engraved below); Edward Eastman Minor (d. 1953), Mount Carmel, Connecticut. For its subsequent history, see cat. no. M4.

TECHNICAL NOTES: The cup is raised. The foot, handle, and finial are cast. The interior is pierced for the spout. The lid is attached with a three-part hinge. The finial is soldered on. Decorative engraving around the center point suggests a fleur-de-lis.

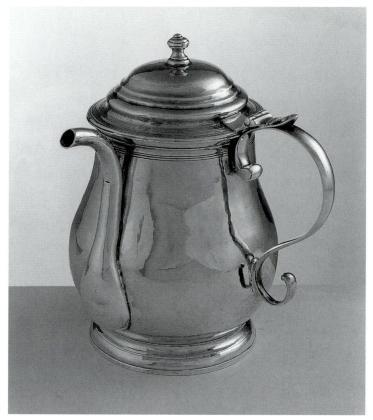

M30

MARKED: Buhler and Hood 1970, vol. 1, p. 323, nos. 109, 110 (right of handle).

ENGRAVED: Shaw / F.S³; 17 00 (scratched on bottom).

WEIGHT: 8 oz, 9 dwt.

RELATED EXAMPLES: This spout cup is the only extant example of the form from John Burt's shop. One other hinged spout cup is recorded, perhaps inspired by covered cream pots, in Buhler 1972, vol. 1, p. 180, no. 144.

REFERENCES: Minor 1946, p. 238; Warren 1975, p. 160, no. 303; Kane 1998, p. 254.

1. See cat. no. M7.
2. Miller 1943; Sotheby's, New York, sale 6731, June 22, 1995, lot 440.
3. The initials might refer to the silversmith's daughter, Sarah Burt Shaw (1720–ca. 1799), who married Francis Shaw (1721–1784) in 1747, approximately a year after her father's death. In this case, the inscription postdates John Burt's death, fueling speculation that the cup originally was his and inherited by Sarah. Unfortunately, his estate inventory does not itemize the silver. His widow's contains a vague reference to "1 cup," while Francis Shaw's estate inventory lists 122 ounces of unitemized silver, and Sarah's records 47½ unitemized ounces (Suffolk County Probate Court, Boston: John Burt, vol. 39, pp. 160–61; Abigail Burt, no. 77, p. 226; Francis Shaw, vol. 83, pp. 1060–63; Sarah Shaw, vol. 97, p. 726; genealogical information is recorded in Shaw 1880).

M31

Cup

1846–52
Gregg, Hayden & Company (1846–52),
Charleston[1]
3⅛ x 2¹¹⁄₁₆ x 3⁷⁄₁₆" (7.9 x 6.8 x 8.7 cm)
B.73.10

The principal technological advance in eighteenth-century silver production was a process of manufacturing flat sheets of silver by rolling, which eliminated the need for the time-consuming processes of raising and planishing.[2] Simple vessels,

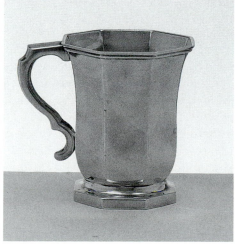

M31

such as this cup, were manufactured more efficiently and inexpensively by cutting the sheet and soldering the seams.

PROVENANCE: Purchased by Miss Hogg from Ronald Bourgeault Antiques, Salem, Massachusetts, 1973.

MARKED: Warren 1975, p. 180, no. 339 (base).

ENGRAVED: CPSJ (side).

WEIGHT: 2 oz, 16 dwt.

REFERENCES: Warren 1975, p. 180, no. 339.

1. For William Gregg (1800–1867), H. Sidney Hayden (n.d.), and Augustus H. Hayden (act. 1846–ca. 1867), see Burton 1938; Burton 1942, pp. 85–86; Cutten 1952, pp. 113–14.
2. Victor 1979, pp. 23–29.

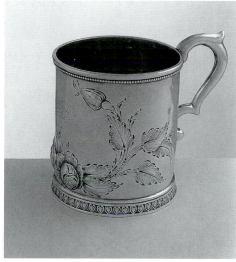

M32

M32

Cup

1845–61
Unknown maker
Hyde & Goodrich (1829–61), New Orleans,
retailer[1]
3⅞ x 3¼ x 4⅝" (9.8 x 8.3 x 11.7 cm)
Gift of Craig and Tarlton, B.68.2

In the nineteenth century, the can's name, style, method of production, and function changed altogether. Known as a cup, it was intended for children as a gift or an award. Rather than raised and planished to achieve a smooth surface, it was simply cut out of sheet silver and seamed together. Even the decorative band of anthemia forming the foot was mass-produced with a roller die.

PROVENANCE: Craig and Tarlton, Raleigh, North Carolina.

MARKED: Mackie, Bacot, and Mackie 1980, p. 126, center column, sixth from top (base).

ENGRAVED: SHD (side).

WEIGHT: 5 oz, 9 dwt.

RELATED EXAMPLES: Mackie, Bacot, and Mackie 1980, pp. 12–13, no. 10.

REFERENCES: Warren 1968, F-5-E; Warren 1975, p. 179, no. 334.

1. For James Nevins Hyde (1788–1838), Charles Whiting Goodrich (1780–1849), Edward Goodrich Hyde, William McCleary Goodrich, Henry Thomas, Jr., and Arthur Breeze Griswold (1829–1877), see Mackie, Bacot, and Mackie 1980, pp. 2–34, 120–21, 126.

M33

Cup

1851–52
Shop of John Kitts (ca. 1805–1863) and David Stoy (ca. 1822–ca. 1855), Louisville, Kentucky[1]
3⅜ x 3⅞ x 2¾" (8.6 x 9.8 x 7 cm)
Museum purchase, B.96.24

PROVENANCE: Purchased by Bayou Bend from Isaacs and Isaacs, Louisville, Kentucky, 1996.

TECHNICAL NOTES: The body is a seamed construction.

MARKED: Boultinghouse 1980, p. 303, no. 84, KITTS & STOY (incuse, base).

ENGRAVED: R.M. Fletcher / from / Grand Mamma Fletcher (side).

WEIGHT: 3 oz, 5 dwt.

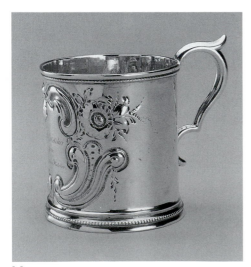

M33

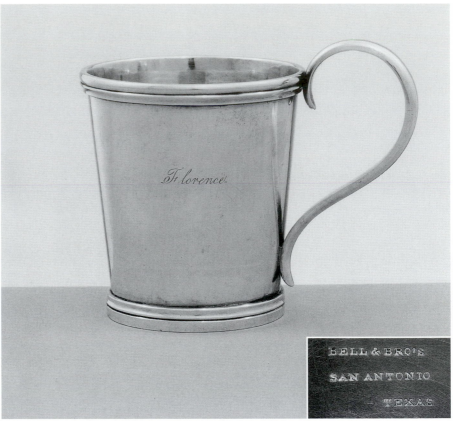

M34

1. Partnership 1851–52. See Hiatt and Hiatt 1954, pp. 54, 95; Boultinghouse 1980, pp. 179–80, 267.

M34

Cup

ca. 1867
Bell & Brothers (partnership ca. 1860–95), San Antonio, Texas[1]
3¾ x 3 x 4½" (9.5 x 7.6 x 11.4 cm)
Museum purchase with funds provided by Alice C. Simkins, B.81.6

Samuel Bell was Texas's finest and most prolific silversmith. Born near Pittsburgh, Pennsylvania, he later moved to Knoxville, Tennessee, where he advertised swords and pistols, spurs, jewelry, spoons, and cups. In 1851 Bell left Knoxville and settled in San Antonio. There he reestablished his business and eventually formed a partnership with his three sons. Small cups, both with and without handles, are the Bells' most prevalent extant holloware form. The uncomplicated design, fine craftsmanship, and heavy gauge of Bayou Bend's cup is characteristic of their best silver.

PROVENANCE: Florence Eager (Mrs. Harris Lee Roberts, 1867–1969), San Antonio; to her son Robert Pierpont Roberts; purchased by Bayou Bend from Fred Nevill, Houston, 1981.

TECHNICAL NOTES: The body is a seamed construction.

MARKED: BELL & BRO'S / SAN ANTONIO / TEXAS (incuse, base).

ENGRAVED: Florence [Florence Eager Roberts] (side).

WEIGHT: 8 oz, 7 dwt.

RELATED EXAMPLES: Warren 1968, K-1-A; Steinfeldt and Stover 1973, pp. 162–63.

REFERENCES: Brown 1985, pp. 523, 525; Brown 1987, pp. 30–31.

1. For Samuel Bell (1798–1882), David Bell (1831–1911), Powhattan Bell (b. 1836), and Jessup Bell (1837–1918), see Steinfeldt and Stover 1973; Caldwell 1988, pp. 32–36. The R. G. Dun and Company reports, compiled to determine individual and business credit ratings, impart a more personal appraisal. In March 1856, "Samuel Bell, Jeweller," it was reported, "Came here from Penn[sylvania]: where he had been rich, but became poor by endorsing. . . . very indus[trial] & frugal + of unexceptable hab[its]." By December 1856 Bell is "same house of J.G. & D. Bell." Over the next decade the reports consistently laud the Bells as industrious,

economical, honest, of good standing, with steady habits. On June 9, 1854, the business was operated by Samuel and David Bell, his other son, "J.G.," having left for California. On November 11, 1860, Dun first refers to the firm as Bell & Bros., including J. G. and David Bell. They explain that it is "Composed of the Same Parties forming the old firm. The fath[er] Sam[l] is at the head in position directs +cc but does not form one of the firm. The bro[ther]s are y[ou]ng. active. Indus[trious]. work constant + are economical, stand high here in cr[edit] & as worthy y[ou]ng men one marr[ie]d + the other single. They h[a]v[e] on hand a fine + bal[anced] assortment in st[oc]k. do not kn[ow] the value say 15 @ 20 [m]$; do not know of th[o]s[e] being pressed with debts. believe them worthy of cr[edit]. do not th[in]k they w[oul]d over trade or strain th[ei]r. cr[edit]." By January 1, 1861, the business included all three brothers. The next, and final reference, dated March 1, 1866, chronicles continued success: "Still in bus[iness] doing well making money, Capable & reliable w[ith] over 10 [m]$." Texas Vol. 3, p. 96, R.G. Dun & Co. Collections, Baker Library, Harvard University Graduate School of Business Administration.

M35

Tumbler

ca. 1801–6
Shop of Charles A. Burnett (1769–1848) and John E. Rigden (d. 1806), Georgetown, D.C., retailer[1]
3⅞ x 3¹/₁₆" (diam.) (9.8 x 7.8 cm)
Gift of Maconda and Ralph O'Connor in honor of Mrs. Alice Pratt Brown, B.82.20

Burnett and Rigden described themselves as jewelers and watchmakers, advertising silver, plated wares, jewelry, clocks, watches, chains, seals and keys, and framed prints, as well as pocketbooks for both sexes. Their advertisement heralds the major reorganization that occurred within the silver industry as individuals assumed the role of retailers, while an expanded, more specialized workforce transformed the shop master into a manufacturer and wholesaler.[2] The Bayou Bend cup may have been manufactured by Burnett and Rigden or just retailed by them.

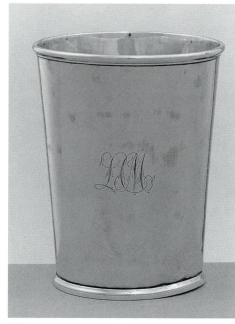

M35

PROVENANCE: Purchased by Maconda and Ralph O'Connor from Hinda Kohn, Fort Lee, New Jersey, 1981.

TECHNICAL NOTES: The body is a seamed construction.

MARKED: BURNETT & RIGDEN (base).

ENGRAVED: LCM (side).[3]

WEIGHT: 4 oz, 13 dwt.

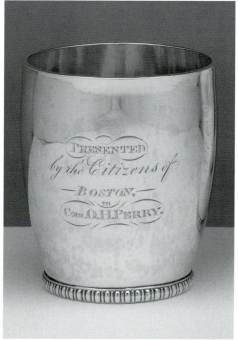

M36

RELATED EXAMPLES: Hollan 1994, pp. 43–44, nos. 16, 17.

REFERENCES: *Antiques* 119 (March 1981), p. 550; Brown 1987, p. 31.

1. Partnership ca. 1801–6. For Burnett, see Cutten 1952, pp. 7–9; Hollan 1994, pp. 34–56.
2. Layton 1992.
3. The dealer Hinda Kohn suggested these initials were for Lucinda Cooksey Mathews, Georgetown, D.C. No reference to this woman is known, and it has been alternatively suggested that the initials are for Lucy Cunningham Mathews of Georgetown.

M36

Pair of Tumblers

1813–14
Shop of Jesse Churchill (1773–1819) and Daniel Treadwell (d. ca. 1814), Boston[1]
3⅜ x 2¹⁵/₁₆" (diam.) (8.6 x 7.5 cm)
Museum purchase with funds provided by Mrs. Edward Babcock, the Sarah Campbell Blaffer Foundation, Jack G. Jones, and Mr. and Mrs. William S. Kilroy, B.91.36.1–.2

Public presentations of silver were made to honor heroes of the War of 1812 such as George Armistead, Jacob Brown, Isaac Hull, Andrew Jackson, Stephen Decatur (cat. no. M86), and others. This pair of cups formed part of a fifty-three-piece service given to Commodore Oliver Hazard Perry by the citizens of Boston. Their unusual barrel-like contour and gadrooned foot band must have been intended to complement the set's wine coolers.[2]

PROVENANCE: Oliver Hazard Perry (1785–1819); by descent to Perry Lewis, Wrightsville Beach, North Carolina; purchased by Bayou Bend from Perry Lewis, 1991.[3]

TECHNICAL NOTES: The gadrooned feet and body are a seamed construction.

MARKED: Flynt and Fales 1968, p. 181 (base).

ENGRAVED: PRESENTED / by the Citizens of BOSTON, / TO / Com. O.H. PERRY. (side).

WEIGHT: 4 oz, 13 dwt (each).

RELATED EXAMPLES: These came from a set of twenty-four tumblers; another pair belongs to the Peabody Essex Museum, Salem, Massachusetts (acc. no. M23, 294–5). A fifth cup was auctioned at Christie's, New York, sale 7624, January 22, 1993, lot 78.

REFERENCES: Mason 1884, p. 305.

1. Partnership 1805–ca. 1814. For Churchill and Treadwell, see Buhler 1972, vol. 2, p. 529; Buhler 1979, p. 64; Puig et al. 1989, pp. 285–86.
2. Warren, Howe, and Brown 1987, p. 107.
3. Adams 1955.

M37

Tumbler

1842–53
Attributed to the manufactory of William Forbes (1799–after 1864), New York[1]
Horace E. Baldwin & Co., Newark, New Jersey (1836–45), and New Orleans (1842–53), retailer[2]
3⅝ x 3⅛ x 3⅛" (9.2 x 7.9 x 7.9 cm)
Gift of the Wunsch Americana Foundation, B.74.12

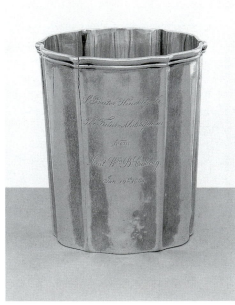

M37

M37 *(detail)*

A cylindrical shape proved the most efficient and economical in the fabrication of a tumbler. Occasionally craftsmen altered the form, as exemplified by the Bayou Bend example. This serpentine contour, the most elegant of the variant forms, was introduced during the second half of the eighteenth century. It was adapted to a variety of media, including a teapot Paul Revere made as early as 1786.[3]

PROVENANCE: Commander William B. Cushing (1842–1874), Washington, D.C.[4]; to S. Baitor Hinckley, Jr.; Mr. and Mrs. Charles F. Montgomery, by 1968; purchased by the Wunsch Americana Foundation from Bernard and S. Dean Levy, New York, 1974.

TECHNICAL NOTES: The body is a seamed construction.

MARKED: H. E. BALDWIN & C̲O̲ (in a curved banner above a star); NEW. ORLEANS (in a rectangle); W.F (below, in a rectangle); a beaver in an oval at either end of the arc.

ENGRAVED: S. Baitor Hinckley Jr. / The Future Midshipman. / From Lieut. Wᵐ B. Cushing. / Jan. 19ᵗʰ 1864 (side).

WEIGHT: 4 oz, 7 dwt.

REFERENCES: Warren 1968, F-1-A; Mackie, Bacot, and Mackie 1980, p. 92, no. 97.

1. For Forbes (act. 1826–50, 1863–64), see cat. no. M14.
2. For Baldwin & Co., see Johnson 1966b, p. 16; Mackie, Bacot, and Mackie 1980, pp. 92–93, 118, 125.
3. Sotheby's, New York, sale 3923, November 18–20, 1976, lot 608.
4. Cushing 1905, pp. 383–86.

M38

Set of Eight Tumblers

1836–37
Scovil, Willey & Co. (partnership 1836–37), Cincinnati, Ohio[1]
Each 3⁷⁄₁₆ x 2⅞" (diam.) (8.7 x 7.3 cm)
B.57.74.1–.8

PROVENANCE: Purchased by Miss Hogg from Schindler's Antique Shop, Charleston, South Carolina, 1957.

TECHNICAL NOTES: The body is a seamed construction.

MARKED: Beckman 1975, p. 121, third from top p. 146, second from top (base).

ENGRAVED: AGJ (side).

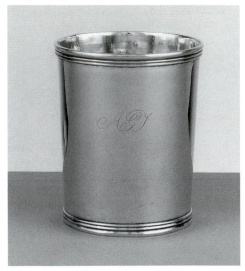

M38

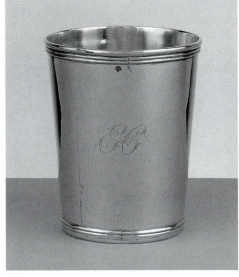

M39

WEIGHT: B.57.74.1, B.57.74.6: 4 oz, 2 dwt; B.57.74.2, B.57.74.3: 3 oz, 18 dwt; B.57.74.4: 3 oz, 15 dwt; B.57.74.5, B.57.74.7, B.57.74.8: 4 oz, 1 dwt.

REFERENCES: Warren 1975, p. 179, no. 337.

1. For Pulaski Scovil and Bushnell Willey (1806–1855), see Beckman 1975, pp. 121–22, 146–47.

M39

Pair of Tumblers

1834–61
Shop of Edward Kinsey and David Kinsey (partnership 1844–61); or Edward Kinsey (act. 1834–44); or F. Kinsey (act. 1837), Cincinnati, Ohio[1]
B.57.72.1: 3⅝ x 2¹⁵⁄₁₆" (diam.) (9.2 x 7.5 cm); B.57.72.2: 3⁹⁄₁₆ x 2¹⁵⁄₁₆" (diam.) (9 x 7.5 cm)
B.57.72.1–.2

PROVENANCE: Purchased by Miss Hogg from Rebel's Rest Antiques, Lexington, Kentucky, 1957.

TECHNICAL NOTES: The body is a seamed construction.

MARKED: Warren 1975, p. 179, no. 338 (base).

ENGRAVED: E.C. (side).

WEIGHT: B.57.72.1: 3 oz, 19 dwt; B.57.72.2: 3 oz, 10 dwt.

REFERENCES: Warren 1975, p. 179, no. 338.

1. For Edward Kinsey (1810–1865) and David Kinsey (1819–1874), see Beckman 1975, pp. 81–87.

M40

Tumbler

1856–61
Manufactory of Peter L. Krider (1821–1895), Philadelphia[1]
Wriggins & Warden (partnership 1856–68), Philadelphia, retailer[2]
3⁷⁄₁₆ x 3″ (diam.) (8.7 x 7.6 cm)
Gift of Mrs. Albert Bel Fay, B.87.13

Silversmiths often looked to the work of their predecessors and contemporaries as sources for their own design. This practice is evidenced by Krider's tumbler with its distinctive foot and lip, which is the prototype for cat. no. M41.

PROVENANCE: Dr. John Miller Haden (1825–1892), Galveston, Texas[3]; to his son Dr. Henry Cooper Haden (1873–1956); to his daughter Homoiselle (Mrs. Albert Bel Fay).

TECHNICAL NOTES: The body is a seamed construction. The borders are handworked rather than die-rolled, which is more typical of this date. This tumbler and cat. no. M41 were studied using nondestructive energy-dispersive X-ray fluorescence analysis; the results are on file at Bayou Bend.

MARKED: WRIGGENS & WARDEN; 5ᵗʰ & CHESTNUT Sᵀˢ (in an arch); PHILADᴬ (within the banner); STANDARD; ✦P.L.K.✦ (incuse, base).

ENGRAVED: JMH [John Miller Haden] (side).

WEIGHT: 4 oz, 15 dwt.

RELATED EXAMPLES: This is one of a pair; the mate remains in the donor's family.

REFERENCES: Warren 1968, K-2-A.

1. For Krider (act. 1851–1910), see Cramer 1988b; Venable 1994, p. 320; Quimby 1995, p. 380.
2. For Thomas Wriggins and Abijah B. War-

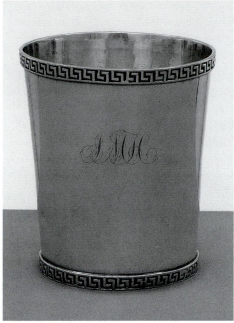

M40

M40 *(detail)*

den, see Whisker 1993, pp. 277, 290.
3. For biographical information on John Miller Haden, see Tyler 1996, pp. 400–401.

M41

Tumbler

1856–61
Unknown maker, El Paso, Texas, or Juárez, Mexico
3⁷⁄₁₆ x 3″ (diam.) (8.7 x 7.6 cm)
Gift of Mrs. Albert Bel Fay, B.87.14

Initially this tumbler appears to be the mate to cat. no. M40. However, closer examination clearly reveals it to be the work of another craftsman. Differences include a substantially greater troy weight, the present tumbler approximately 50 percent heavier than the previous example. According to the donor, this tumbler was fashioned from Mexican silver coins paid

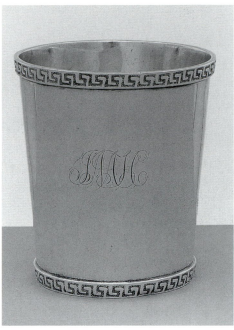

M41

by Mexican patients to Dr. John M. Haden while he was a U.S. Army assistant surgeon stationed at Fort Bliss in El Paso.[1]

PROVENANCE: See cat. no. M40.

TECHNICAL NOTES: See cat. no. M40. The family tradition that the tumbler was fashioned from Mexican silver coins is given further credence by quantitative energy-dispersive X-ray fluorescence analysis (results on file at Bayou Bend). Traditionally, Mexican coins had a higher percentage of silver than American. The content of the unmarked tumbler exceeds 94 percent, approximately 5 percent more than the Krider-Wriggins & Warden example.

ENGRAVED: JMH [John Miller Hadden] (side).

WEIGHT: 7 oz, 9 dwt.

RELATED EXAMPLES: This is one of a pair; the mate remains in the donor's family.

REFERENCES: Warren 1968, K-2-A.

1. The 1860 United States census for El Paso County does not record any silversmiths or jewelers.

M42

Tumbler

1839–42 or 1847–52
Jaccard & Co. (act. 1839–42, 1847–52), St. Louis, Missouri[1]
3⁵⁄₈ x 3¼″ (diam.) (9.2 x 8.3 cm)
Museum purchase with funds provided by Mrs. James P. S. Griffith in memory of Mary Bradley Randolph, B.85.8

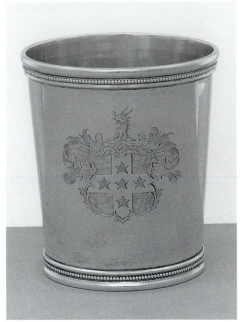

M42

This tumbler, with its delicate pearlwork border, skillfully engraved arms, and gilded interior, is an exceptional example of a common form.

PROVENANCE: [I. Freeman & Son, New York]; auctioned by Phillips, New York, June 5, 1984; purchased by Bayou Bend from William Core Duffy, New Haven, 1985.

TECHNICAL NOTES: The body is a seamed construction. The cup's interior has been gilded, but it has not been established whether it was gilded originally or if it was done at a later time.

MARKED: Roach 1967, p. 45, second mark (base).

ENGRAVED: Randolph arms and crest (side).

WEIGHT: 5 oz, 14 dwt.

RELATED EXAMPLES: Roach 1967, p. 43.

REFERENCES: Phillips, New York, sale 541, June 5, 1984, lot 108.

1. For Jaccard & Co., see Roach 1967, pp. 41–45; Binder 1981, pp. 6, 27, 29.

M43

Goblet

ca. 1849
Unknown maker
Hyde & Goodrich (1829–61), New Orleans, retailer[1]
7½ x 3¾ x 3⅝" (19.1 x 9.5 x 9.2 cm)

Museum purchase with funds provided by the William Hill Land and Cattle Company in honor of Caroline W. Law, B.93.8

Silver vessels were first presented as yachting trophies in the 1840s. The earliest datable example of these prizes is a simple water pitcher awarded for the New York Yacht Club Subscription Stakes in 1846. Three years later the Bayou Bend goblet functioned as a promotion for Captain Dan Hickok's new hotel, the Franklin House in New Orleans.[2] The *Daily Picayune* announced, "The prizes to be disposed of at Capt. Dan Hickok's regatta on Wednesday, may be seen at the Verandah. They are, without doubt, the most splendid prizes that have yet been contended for in any of our sailing matches. The regatta promises to be a magnificent affair."[3]

PROVENANCE: Purchased by Bayou Bend at Sotheby's, New York, January 28, 1993.

TECHNICAL NOTES: The goblet is assembled from four components: foot, stem, bowl bottom, and bowl sides.

MARKED: Mackie, Bacot, and Mackie 1980, p. 126, Hyde & Goodrich, no. 1, top (underneath bowl).

ENGRAVED: Capt Dan Hickok's / 2nd Regatta. / Oct. 10th 1849. / N.O. (side).

WEIGHT: 9 oz, 15 dwt.

REFERENCES: The *Daily Picayune*, October 6 and 9, 1849; Sotheby's, New York, sale 6392, January 28–31, 1993, lot 97.

1. See cat. no. M32.
2. Warren, Howe, and Brown 1987, pp. 101–2, no. 117. A goblet stamped by James Conning, Mobile, is inscribed, "Daphne Regatta to the Adrienne July 30th 1849"; *Antiques* 103 (May 1973), p. 1007.
3. *Daily Picayune*, October 6, 1849.

M44

Goblet

1852–53
Manufactory of Christopf Christian Kuchler (n.d.) and Adolph Himmel (1825/26–1877), New Orleans[1]
Hyde & Goodrich (partnership 1829–61), New Orleans, retailer[2]
7⁷⁄₁₆ x 3⅞" (diam.) (18.9 x 9.8 cm)
Gift of Craig and Tarlton, B.70.50

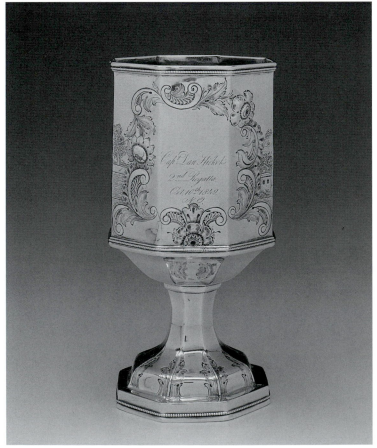

M43

Kuchler and Himmel's goblet is an early example of spun silver. Spinning, a manufacturing technique whereby simple vessels or components could be formed on a lathe, was introduced by the second quarter of the nineteenth century. This process was first used by manufacturers of Britannia, a pewter-related alloy, and later adapted to the production of silver. A sheet disk was placed against a wooden pattern in the shape to be replicated. The chuck was secured on the lathe; as it revolved, pressure was applied, and the silver blank conformed to the desired shape.[3]

PROVENANCE: Craig and Tarlton, Raleigh, North Carolina.

TECHNICAL NOTES: The goblet is spun in two parts, which are joined at the upper stem and wafer.

MARKED: Mackie, Bacot, and Mackie 1980, p. 126, Kuchler & Himmel, no. 6 (underneath bowl).

WEIGHT: 10 oz, 5 dwt.

RELATED EXAMPLES: Mackie, Bacot, and Mackie 1980, p. 33, no. 34; Mackie, Bacot, and Mackie 1982, p. 303.

REFERENCES: Warren 1975, p. 178, no. 333.

1. For Kuchler & Himmel (partnership 1852–53), see Mackie, Bacot, and Mackie 1980, pp. 2–25, 30–55, 120–21.
2. See cat. no. M32.
3. Victor 1979; Venable 1994, pp. 13–14.

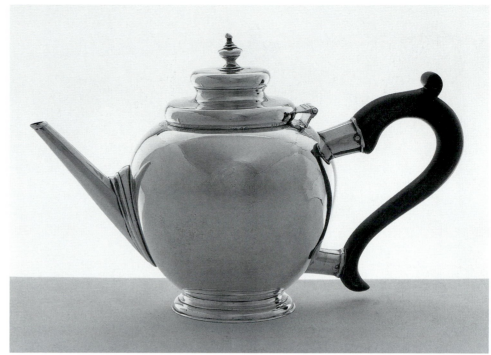

M45

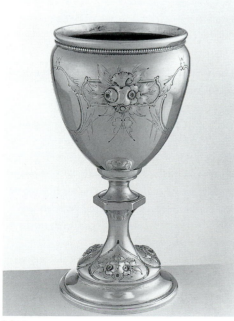

M44

M45

Teapot

1728–48
Shop of Bartholomew Schaats (1670–1758), New York[1]
6½ x 4¾ x 9¹³⁄₁₆" (16.5 x 12.1 x 24.9 cm)
B.69.111

Tea was introduced to the English by the middle of the seventeenth century. Initially valued for its curative properties, it became the social beverage of choice by the century's end. Initially, its considerable expense limited its enjoyment to the upper classes, they being the only ones who could afford the precious leaves and requisite vessels to make and serve properly the exotic Chinese brew.

The first American silver teapots, patterned after Oriental wine pots, date to the beginning of the eighteenth century, and most bear the stamps of New York craftsmen. The Bayou Bend teapot, fashioned in the Late Baroque style, is virtually devoid of ornament, relying instead on the curvilinear contour for its pleasing aesthetic. Concurrently, New York silversmiths produced larger, pear-shaped teapots with either round or polygonal contours, which, based on extant examples, appear to have been preferred over this spherical shape.

PROVENANCE: Sarah Bogert (Mrs. Richard Ray, 1728–1781, married 1748), New York; to her son Cornelius Ray (1755–1827); to his son Robert Ray (1794–1879); to his daughter Nathalie (Mrs. Edmund Lincoln Baylies, Sr., 1837–1912); [David Anderson, Boston, 1935]; purchased by Miss Hogg from Richard Loeb through Ginsburg and Levy, New York, 1953.

TECHNICAL NOTES: The body and lid are raised. A pin passes from the interior into the base of the cast spout. The cast handle sockets and spout are polygonal. Below the rim is a subtly engraved border of cross-hatching. The vented lid is attached by a three-part hinge, and its finial base is set in and soldered in place. The wooden handle is a replacement.

MARKED: Buhler and Hood 1970, vol. 2, p. 284, nos. 575, 576 (base).

ENGRAVED: SB [Sarah Bogert]; 18:oz 6 pw (base).

RELATED EXAMPLES: A teapot struck with the stamp of Simeon Soumain (ca. 1685–1750), closely related to the Bayou Bend example, belongs to the Museum of the City of New York (acc. no. 78.11). Other examples include Bohan and Hammerslough 1970, pp. 46–47, pls. 23–24; Safford 1983, p. 20, no. 20; Davidson and Stillinger 1985, p. 209.

REFERENCES: Singleton 1902, pp. 138, 149–50, 228; Miller 1937b, p. 28, no. 271; Warren 1971a, p. 53, no. 27; Warren 1975, p. 161, no. 307; Cooper 1980, pp. 191, 194–95, no. 217.

1. For Schaats, see Buhler 1960c, p. 84; Ensko 1989, p. 183.

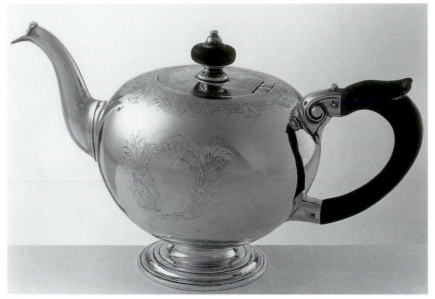

M46

M46

Teapot

1745–66
Shop of Jonathan Clarke (1706–1766), Newport and Providence, Rhode Island[1]
5½ x 5¹¹⁄₁₆ x 9⁹⁄₁₆" (14 x 12.9 x 24 cm)
B.69.117

This rotund teapot is one of a small group unique to Jonathan Clarke's Newport shop. They are characterized by ovoid bodies rather than the more conventional spherical, apple, and pear shapes preferred in Boston, New York, and Philadelphia. Another unusual aspect is the high, splayed foot, a component usually identified with later inverted pear-shaped Rococo examples. A number of Edinburgh and Glasgow silversmiths produced teapots similar to Clarke's between 1720 and 1750, although at this time it is not known whether an actual relationship exists between the Clarke and Scottish teapots or if their similarities are coincidental.[2]

PROVENANCE: Purchased by Miss Hogg from Robert Ensko, New York, 1954, who noted that the teapot may have been made for Thomas and Mary Helm of Newport.[3]

TECHNICAL NOTES: The wooden handle may be original. The lid is vented, its finial secured by a nut and bolt.

MARKED: Flynt and Fales 1968, p. 185, bottom mark (base).

ENGRAVED: A cartouche lacking a crest, suggesting it never framed a coat-of-arms and instead may have had an atypical treatment, such as the owner's initials (side); THM (base); an elaborate border of masks, shells, leaves, and related baroque motifs (shoulder).

RELATED EXAMPLES: Gourley 1965, nos. 39, 40.

REFERENCES: Warren 1975, p. 162, no. 308.

1. Silversmiths named Jonathan and Joseph Clarke worked in Newport and Boston, which has complicated the identification of their marks. This teapot and its related examples' unique design and provenance support an assignment to the Newport smith (Flynt and Fales 1968, pp. 182–83). See also Kane 1998, p. 284.
2. Finlay 1948, p. 91, no. XV; Finlay 1956, pp. 125–26; *Antiques* 93 (February 1968), p. 194; Ticher 1972, no. 28; Clayton 1985, p. 421, no. 651.
3. This acquisition signals an expansion of Miss Hogg's collecting to include silver, probably in anticipation of assembling room settings at Bayou Bend.

M47

Teapot

1745–75
Shop of Joseph Richardson, Sr. (1711–1784), Philadelphia[1]
6¼ x 4⅝ x 8⁹⁄₁₆" (15.9 x 11.7 x 21.7 cm)
B.60.29

The Rococo's earliest American manifestation occurs in silver dating from the mid-1740s, approximately a decade before the publication of Thomas Chippendale's *The Gentleman and Cabinet-Maker's Director.*[2] This teapot is the most fully developed expression of the style in the museum's silver collection. The earlier form has evolved into an inverted pear shape, despite the fact that this configuration was less efficient for brewing tea. In Philadelphia, Joseph Richardson's letters and accounts, as well as his surviving silver, provide insights into the integration of the Rococo style into Philadelphia, colonial America's principal style center.[3]

M47

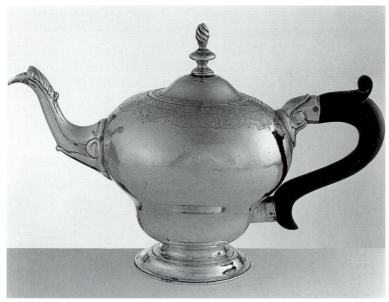

M48

1972, vol. 1, pp. 307, 312, nos. 262, 267; Ward and Hosley 1985, pp. 288–89, no. 172; Conger 1991, pp. 314–15, no. 191.

REFERENCES: *Antiques* 64 (August 1953), p. 80; Warren 1975, p. 162, no. 309; Brown 1984, p. 50; Kane 1998, p. 304.

1. For Coburn, see Buhler 1960c, p. 74; Buhler 1965, pp. 68–70; Flynt and Fales 1968, pp. 185–86; Buhler 1972, vol. 1, p. 302; Buhler 1973, p. 22; Buhler 1979, p. 29; Quimby 1995, p. 75; Kane 1998, pp. 293–306.
2. Kane 1998, pp. 297–98. In addition to engraving, Revere supplied Coburn with finished silver.
3. Buhler 1972, vol. 2, p. 412, no. 359; Buhler 1979, pp. 43–45, no. 51.
4. This pattern is also employed on teapots marked by Benjamin Burt (1729–1805), Joseph Edwards, Jr. (1737–1783), and William Simpkins (1704–1780). Similar finials are also seen on Boston tankards, their design derived from related components on Massachusetts case furniture (see cat. no. F142).
5. The teapot is inscribed for Thomas Dwyer and Eunice Trumbull. Kane 1998, p. 305.

M49

Cream Pot

1745–ca. 1755
Shop of Jacob Hurd (1702/3–1758), Boston[1]
4 1/16 x 2 1/2 x 3 1/2" (10.3 x 6.4 x 8.9 cm)
B.69.112

The Western custom of serving cream with tea became customary by the beginning of the eighteenth century, although the earliest American silver cream pots date from the second quarter of the century. Patterned after the can, they were composed of a pear-shaped body; molded foot; small, triangular spout; cast, scrolled handle; and, at times, a hinged, domed lid. The Bayou Bend example, with its cabriole legs and outward flaring spout, represents the subsequent phase in the vessel's evolution. Hurd's chased and engraved cream pots are unique in American silver. Their ornament was possibly inspired by contemporary Irish silver, but a more plausible interpretation is that it evolved in response to the deteriorating relations between France, England, and her American colonies at midcentury.[2]

PROVENANCE: William Cory (1711–ca. 1771) and Mary Aiken Cory, Providence, Rhode Island; to their daughter Rebecca (Mrs. Nicholas

PROVENANCE: Joseph Morgan (1718–1804) and Sarah Mickle Morgan (d. 1775, married 1745), Haddonfield, New Jersey; to their grandson Samuel Morgan Reeves (1791–1886); to his daughter Agnes Reeves Carter (b. 1840); [Harry Arons, Ansonia, Connecticut]; purchased by Miss Hogg from Israel Sack, New York, 1960.

TECHNICAL NOTES: The foot, body, and lid are all raised. A ruffle is engraved around the upper handle socket. The handle is a replacement. The lid is vented and its finial riveted.

MARKED: See cat. no. M12 (underneath body).

ENGRAVED: JSM [Joseph and Sarah Morgan] (side); 1762 (reverse side, added later, its significance unknown).

RELATED EXAMPLES: Most closely related is Fales 1974b, p. 86, fig. 42.

REFERENCES: Warren 1975, p. 163, no. 310; PMA 1976, pp. 76–77, no. 58.

1. See cat. no. M12.
2. Buhler 1965, pp. 57–60; Warren, Howe, and Brown 1987, p. 59.
3. Fales 1974b, pp. 77–89.

M48

Teapot

ca. 1745–90
Shop of John Coburn (1724–1803), Boston[1]
6 3/16 x 4 7/8 x 9 1/2" (15.7 x 12.4 x 24.1 cm)
B.69.113

The silversmith's trade involved master craftsmen, journeymen, apprentices, artisans working in related trades, and both American and English merchants. The

Bayou Bend teapot offers an insight into the workings of this complex system. In order to fill his customers' orders, John Coburn either completed the commission in his own shop or contracted with an outside source. For example, between 1762 and 1774 Paul Revere engraved no fewer than 109 objects for him.[2] Although the engraver of this teapot is not known, the pattern of its Rococo borders are similar to those ornamenting Revere's teapots.[3] Furthermore, Coburn's cast spout is virtually identical to one used by Revere; perhaps they were derived from a common source.[4]

PROVENANCE: Purchased by Miss Hogg from James Graham and Sons, New York, 1953, who noted that the teapot was formerly owned by William T. H. Howe (ca. 1872–1939), Cincinnati, Ohio.

TECHNICAL NOTES: The spout and upper handle surrounds are engraved with a ruffle. The hinge consists of three parts. The lid is vented, its finial riveted. The wooden handle is a replacement.

MARKED: Buhler and Hood 1970, vol. 1, p. 324, nos. 201, 202 (twice, underneath body).

ENGRAVED: GVLD and Doilge (bottom); 20:4 (foot).

RELATED EXAMPLES: Most closely related is a teapot in the Detroit Institute of Arts (acc. no. 34.3); and another, location unknown, bearing English hallmarks, including a 1746 date letter, which are struck over Coburn's stamp.[5] The greatest number of known Rococo teapots in Boston came from Coburn's shop, including Flynt and Fales 1968, pp. 134–36, nos. 117, 118; *Antiques* 100 (December 1971), p. 840; Buhler

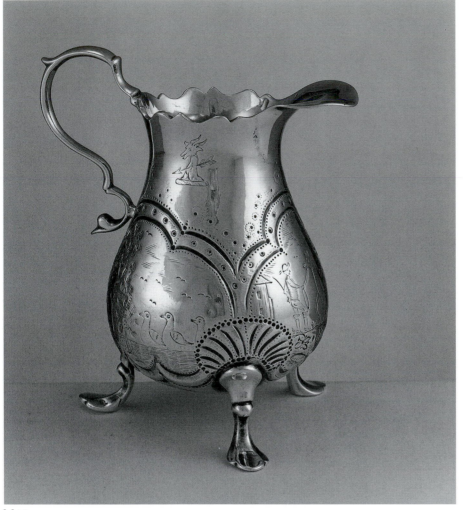

M49

MARKED: Buhler and Hood 1970, vol. 1, p. 327, nos. 148–58, 160 (left of handle).

ENGRAVED: W^CM; Cory (underneath body); Power, with the crest of a goat's head, an arrow piercing its neck (below rim).

WEIGHT: 3 oz, 18 dwt.

RELATED EXAMPLES: Buhler and Hood 1970, vol. 1, pp. 127–29, nos. 149, 150; Johnston 1994, p. 80.

REFERENCES: Warren 1971a, p. 53, no. 27; Warren, 1975, p. 165, no. 314; Kane 1998, p. 594.

1. See cat. no. M28.
2. Irish Silver 1971, pp. 34, 35, 44, 45, nos. 98, 159; Ticher 1972, pp. 3, 12, 17–18, 20–21, pls. 36, 38, 63a-b, 64, 72–74, 80a-b; Teahan and McClelland 1982, p. 36, no. 36. According to a member of the family there is an "Extract from the journal of his [William Cory's] granddaughter Rebecca Power Tillinghast that mentions his silver noting that 'on one piece was chased the panoramic history of his career.'" The latter interpretation is based on Patricia E. Kane's study of this group of objects.
3. Rhode Island Families 1983, vol. 1, pp. 706–10.

Power, V, 1746–1825); to her son Nicholas Power, VI (1771–1844); to his daughter, Sarah (Mrs. John Winslow Whitman, 1803–1878); to her friend Ellen Richmond Parsons; to Mary Boykin Williams (Mrs. Thomas B. Hamson), a great-great-granddaughter of Rebecca Power; to her son Harry C. Thompson; purchased by Miss Hogg from Israel Sack, New York, 1955.[3]

TECHNICAL NOTES: The body is raised, and the feet and handle cast. The spout is soldered on rather than integral with the raised body, a construction technique characteristic of early Boston cream pots.

M50

Cream Pot

1754–82
Shop of John Bayly (d. 1806), Philadelphia[1]
4⅜ x 2¾ x 4⅛" (11.1 x 7 x 10.5 cm)
B.69.100

M49 (*detail*)

M49 (*detail*)

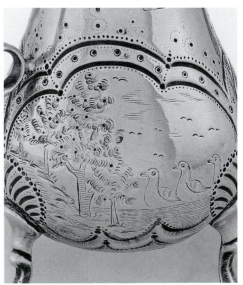

M49 (*detail*)

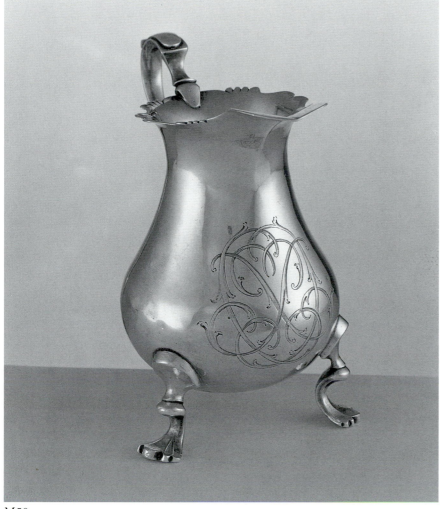

M50

rarely appear in New England, where armorial engraving was preferred.

4. Coates 1906, pp. 153–54, 160–61, 172–73. Coincidentally, Phebe Coates had a sister, Priscilla (1767/69–1849), with the same initials.
5. Based on a design published in Sympson 1726, p. 20. Contrary to the cream pot's purported history, the engraver used the cipher CP rather than PC.

M51

Cream Pot

1780–1800
Shop of William Gilbert (1746–1832), New York[1]
5⅞ x 2¾ x 4⅝" (14.9 x 7 x 11.7 cm)
Museum purchase with funds provided by Jeanne M. and Tom A. Cunningham, in memory of Rose Van Moran, B.90.8

During the Rococo period the cream pot's contours, like those of other tea and coffee vessels, assumed an inverted pear shape. A complex, asymmetrical scrolled handle added a distinctive feature. This element appears on Gilbert's cream pots, as well as on those by Myer Myers, Pieter de Riemer, Elias Pelletreau, Samuel Tingley, Daniel Van Voorhis, and Elias Boudinot.[2] The similarity suggests that the component had a common source.

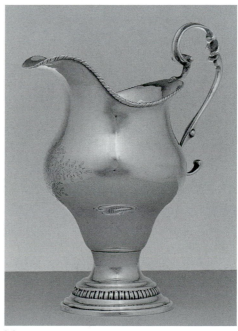

M51

Engraving—incising with a graver—is a method of decorating and inscribing silver. Initials were engraved for a variety of reasons, including to communicate a sense of style, to suggest position in society, and from a more practical point of view to identify property, as attested by a contemporary notice: "Stolen or taken away from Lewis Grant, in Market street, above the coffee-house, on the 22d instant, a silver Cream pot, market (marked) L G M, maker John Buly (Bayly). Whoever takes up the thief or pot, shall have 15s. by applying to the Printer."[2] Initials ranged from simple block letters to graceful mirror-image ciphers consistent with a Late Baroque aesthetic.[3] The presence of both on this example implies that the former were intended for identification, the latter purely decorative.

PROVENANCE: By tradition Phebe Coates (Mrs. Samuel Lane, 1754–1807, married by 1782), Phoenixville, Pennsylvania; Edward Eastman Minor, by 1945.[4] For its subsequent history, see cat. no. M4.

TECHNICAL NOTES: In contrast with cat. no. M49, the spout is integral.

MARKED: Warren 1975, p. 165, no. 315 (underneath body).

ENGRAVED: The reverse cipher CP (beneath the spout); P+C (underneath body).[5]

WEIGHT: 4 oz, 6 dwt.

RELATED EXAMPLES: *Antiques* 100 (July 1971), p. 16; Bartlett 1984, p. 15.

REFERENCES: Buhler 1945, pp. 349–50; Warren 1975, p. 165, no. 315; Almquist 1996, p. 22.

1. For Bayly, see Hindes 1967, pp. 255–56; Whisker 1993, pp. 55–56; Quimby 1995, p. 334; Almquist 1996.
2. Prime 1969, vol. 1, pp. 50–51.
3. Reverse ciphers were introduced on New York silver during the 1690s and enjoyed their greatest popularity during the Late Baroque period. American engravers consulted English cipher books, the most widely used being Samuel Sympson's (London, 1726, 1736, ca. 1745, 1750, ca. 1755). While reverse ciphers are characteristic of New York and Philadelphia silver, they

PROVENANCE: Purchased by Bayou Bend from Jonathan Trace, Putnam Valley, New York, 1990.

TECHNICAL NOTES: The foot and body are raised, the handle cast. In 1990 the cream pot was analyzed using nondestructive energy-dispersive X-ray fluorescence; the results are on file at Bayou Bend.

MARKED: Ensko 1989, p. 268, second mark (underneath body).

ENGRAVED: JER (below spout).

WEIGHT: 4 oz, 11 dwt.

RELATED EXAMPLES: Similar Gilbert cream pots include *Antiques* 75 (May 1959), p. 488; Doty 1979, p. 128, no. 102b; another, with cast cabriole legs, is in Quimby 1995, p. 241, no. 202.

REFERENCES: *Antiques* 137 (May 1990), p. 1124.

1. For Gilbert, see Miller 1937b, p. 41; Decatur 1947; Buhler 1960c, p. 77; Ensko 1989, p. 86; Rasmussen 1991; Quimby 1995, p. 240.
2. *Antiques* 38 (October 1940), p. 148; Buhler and Hood 1970, vol. 2, p. 110, no. 671; Failey 1976, p. 181, no. 213; Sotheby's, New York, sale 6132, January 30–February 2, 1991, lot 115; Heckscher and Bowman 1992, pp. 80–81, 91–92, nos. 48, 56; Christie's, New York, sale 7624, January 22, 1993, lots 120, 123; Quimby 1995, pp. 269–70, no. 232.

M52

Sugar Dish

ca. 1744–75
Shop of Myer Myers (1723–1795), New York[1]
3½ x 4½" (diam.) (8.9 x 11.4 cm)
B.69.96

"Coffee, Chocolate, and Tea, were at first us'd only as Medicines while they continued unpleasant, but since they were made delicious with Sugar, they are become Poison."[2] The Western custom of adding a sweetener to tea became popular in the late seventeenth century. The earliest American silver sugar dishes, dating to the 1730s, were patterned after Chinese covered rice bowls. A few are literal translations of their Oriental prototype.[3] Others are Western adaptations, such as the present example where the cover was reconfigured to overlap. Not only did the cover prove effective at controlling insects and humidity, but it could also be reversed to function as a spoon tray when tea was being served.

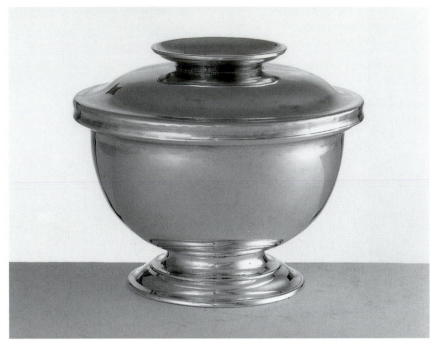

M52

PROVENANCE: Purchased by Miss Hogg from Robert Ensko, New York, 1953.

TECHNICAL NOTES: Myers's stamp may cover the bowl's center point.

MARKED: Buhler and Hood 1970, vol. 2, p. 283, nos. 659–65 (lid; base).

WEIGHT: 9 oz, 2 dwt.

RELATED EXAMPLES: Biddle 1963, p. 54, no. 106; Quimby 1995, p. 269, no. 231.

REFERENCES: Rosenbaum 1954, pp. 88, 128, pl. 22; Warren 1971a, p. 53, no. 27; Warren 1975, p. 166, no. 316.

1. For Myers, see Rosenbaum 1954; Buhler 1960c, p. 81; Larus 1964; Larus 1965; Buhler 1979, p. 83; Feigenbaum 1979; Werner 1979; Quimby 1995, p. 267.
2. Duncan 1706, p. 12.
3. Buhler and Hood 1970, vol. 2, pp. 56–57, no. 603; Buhler 1972, vol. 2, pp. 577–78, no. 500.

M53

Sugar Dish

1755–75
Shop of Paul Revere, Jr. (1734–1818), Boston[1]
6⅛ x 4½" (diam.) (15.6 x 11.4 cm)
B.69.109

The Bayou Bend sugar dish, while Rococo in contour, maintains a Late Baroque aesthetic with its smooth, unadorned surface. The simplicity of this vessel may be interpreted as a patron's conscious choice for a more conservative taste or, simply, frugality.

PROVENANCE: Probably made for Lucretia Greene (Mrs. John Callahan, 1748–1824, married 1774), Boston[2]; to her daughter Mary Callahan (1776–1855); to her niece Mary Timmins Quincy Hill (Mrs. Benjamin Pollard Winslow, 1813–1902); to her son Alfred Erving Winslow (1839–1922); to his son Charles Edward Amory Winslow (1877–1957); purchased by Miss Hogg from Mrs. Charles Winslow, 1956.

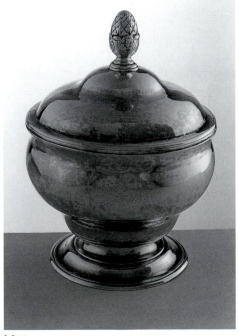

M53

TECHNICAL NOTES: The body and lid are raised. The foot and finial are cast, and the latter is vented and soldered on.

MARKED: Buhler and Hood 1970, vol. 1, p. 330, nos. 238–40, 243–47, 252–54 (underneath body).

ENGRAVED: M.C. TO M.T.Q.H [Mary Callahan to Mary Timmins Quincy Hill] (side, added later); 13 oz, 12 dwt (beneath bowl).

WEIGHT: 13 oz, 13 dwt.

RELATED EXAMPLES: The Bayou Bend sugar dish may bear more than just the same contour as the exuberantly ornamented example that Benjamin Greene gave his sister-in-law, Lucretia Chandler Murray (Buhler 1972, vol. 2, p. 394, no. 344). Following her older sister's death she moved to Boston to oversee his household and family. Presumably the museum's sugar dish was made for her niece and namesake (Sturgis 1903, p. 30).

REFERENCES: Phillips 1939, p. 72; Warren 1971a, p. 53, no. 27; Warren 1975, p. 166, no. 317; Kane 1998, p. 826.

1. Since the publication of Elbridge Henry Goss's 1891 two-volume biography *The Life of Colonel Paul Revere*, a plethora of books and articles has been published on the most famous American craftsman, more recently Federhen 1988; Boorstin 1987; Leehey et al. 1988; Kane 1998, pp. 795–848; and, perhaps best known, Forbes 1969.
2. See Related examples.

M54
Slop Bowl

1797
Shop of Paul Revere, Jr. (1734–1818), Boston[1]
4⁷⁄₁₆ x 5½″ (diam.) (11.3 x 14 cm)
B.69.98

The slop bowl functioned as a receptacle for the teapot's dregs and cold tea. Joseph Richardson's accounts document its production by the 1740s, but the first mention in Paul Revere's daybooks does not appear any earlier than 1790.[2] They record the purchase of the Bayou Bend bowl by Bossenger Foster in May 1797, noting its weight, the value of the silver, and the charge for labor.[3] This vessel is unique in Revere's oeuvre, its inverted pear shape confirming the persistence of the Rococo idiom into the late 1790s.

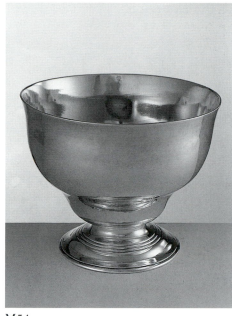

M54

PROVENANCE: Bossenger Foster (1742–1805) and Mary Craigie Foster, Cambridge, Massachusetts[4]; Caroline Phelps Ingersoll (Mrs. Richard S. Ely, 1838–1922), by 1909; to her daughter Maud (Mrs. John H. Gibbons, 1876–1953)[5]; purchased by Miss Hogg from James Graham and Sons, New York, 1954.

TECHNICAL NOTES: The foot is cast, the bowl raised.

MARKED: Buhler and Hood 1970, vol. 1, p. 330, nos. 255–57, 263, 264 (underneath bowl). Attached to the foot is an illegible label.

ENGRAVED: BMF (underneath bowl); 2659 (foot).

WEIGHT: 9 oz, 16 dwt.

RELATED EXAMPLES: Most closely related is a Myer Myers bowl in *Antiques* 64 (October 1954), p. 262.

REFERENCES: Kent and Levy 1909, vol. 2, p. 123, no. 442; *Antiques* 65 (April 1954), p. 272; Warren 1975, pp. 166–67, no. 318; Kane 1998, p. 844.

1. See cat. no. M53.
2. Fales 1974b, p. 95.
3. Revere 1761–97, vol. 2, ca. May 24, 1797.
4. Pierce 1899, pp. 936–40.
5. Cutter 1910, p. 2633.

M55
Tea Caddy

1728–33
Shop of Simeon Soumain (ca. 1685–1750), New York[1]
5³⁄₁₆ x 3⁵⁄₁₆ x 2½″ (13.2 x 13.5 x 6.4 cm)
B.62.38

The tea caddy derives its name from the Malay *kati*, a measure by which tea was sold that is equivalent to 1.2 pounds. It was introduced in America by the 1720s, and surviving examples suggest that it was most prevalent in New York.[2] Often tea caddies were made in pairs and, like the present example, engraved to specify their contents, be it green tea, bohea, hyson, or black. The domed cap measured out the leaves in addition to sealing the container. As tea became less expen-

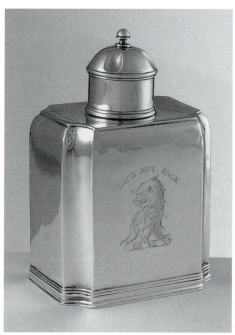

M55 (*front*)

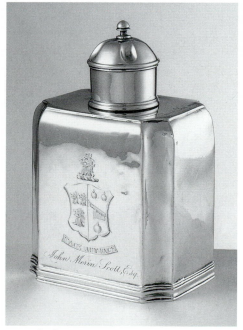

M55 (*back*)

sive and more widely available in the early nineteenth century, the caddy became obsolete.

PROVENANCE: John Scott (1702–1733) and Marian Morin Scott, married 1728, New York; to their son General John Morin Scott (1730–1784)[3]; purchased by Miss Hogg from Ginsburg and Levy, New York, 1962.

TECHNICAL NOTES: The bottom is recessed. The collar and domed top are separate components soldered together. The finial is soldered on.

MARKED: Buhler and Hood 1970, vol. 2, p. 285, nos. 602–10 (base).

ENGRAVED: I[S]M [John and Marian Scott] (base); the Scott crest and motto TACE AUT FACE (side). The Scott arms, crest, and John Morin Scott Esq. (reverse side, added later); John Scott and Marian Morin / Married about 1728 (base, added later); Green Tea (shoulder).

WEIGHT: 7 oz, 1 dwt.

RELATED EXAMPLES: Also by Soumain's shop is a unique set consisting of a pair of tea caddies and a sugar box, in Safford 1983, p. 39; Christie's, New York, sale 6742, January 20–21, 1989, lots. 300, 301.

REFERENCES: Warren 1975, p. 164, no. 313.

1. For Soumain, see Buhler 1960c, p. 84; Buhler 1972, vol. 2, p. 577; Puig et al. 1989, pp. 225–26; Quimby 1995, p. 288.

2. A London tea caddy, with the date 1724–25, descended in the Norman W. Cabot family (Bigelow 1917, p. 359).
3. Chance and Smith 1930, between pp. 324 and 325; Christie's, New York, sale 7436, April 28, 1992, lots 251–53.

M56

Coffeepot

ca. 1751–77
Shop of Nathaniel Hurd (1729/30–1777), Boston[1]
9¾ x 4½ x 8¼" (24.8 x 11.4 x 21 cm)
B.69.95

Coffee was an exotic Turkish beverage introduced to Europe in the 1630s. First used as a curative, it soon became a popular social drink. Boston's town minutes for 1670–71 grant permission for "a house of publique Entertainment for the sellinge of Coffee & Chuchaletto [chocolate]."[2] However, some time would pass before coffee attained a status deeming it suitable for domestic gatherings. The earliest coffeepots have tall, cylindrical, upward-tapering bodies, with rounded or polygonal cast spouts and domed lids.

Later, the form began to assume a pear shape, its lid slightly domed, and its spout adorned with ornament. With its Rococo engraving, the Bayou Bend coffeepot is a composite of these two types.

PROVENANCE: Purchased by Miss Hogg from James Graham and Sons, New York, 1954.

TECHNICAL NOTES: The body and lid are raised. The side is cut out in an oval for the spout. Both handle sockets are attached to disks mounted at the handle juncture. The wooden handle is pinned through the top socket but not the bottom. The finial is riveted.

MARKED: Flynt and Fales 1968, p. 255 (left of handle; base).

ENGRAVED: Arms and crest of Mayor[3] (arms on one side, a sheep's head crest on reverse); 28..4..0 and 28..4 (base).

RELATED EXAMPLES: The only other Nathaniel Hurd coffeepot is published in *Antiques* 102 (December 1972), p. 966. The Bayou Bend pot also closely relates to two other examples, the earlier marked by Jacob Hurd (Quimby 1995, pp. 122–24, no. 79), the second by his former apprentice and son-in-law, Daniel Henchman (Buhler and Hood 1970, vol. 1, pp. 172–74, no. 221).

REFERENCES: Warren 1971a, p. 53, no. 27; Warren, 1975, p. 163, no. 311; Kane 1998, p. 619.

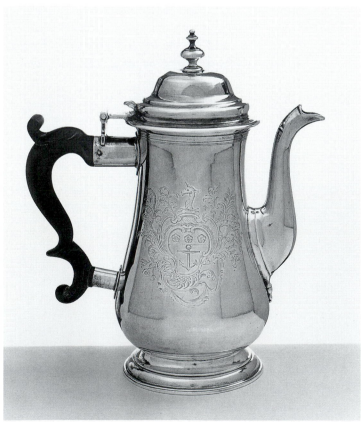

M56

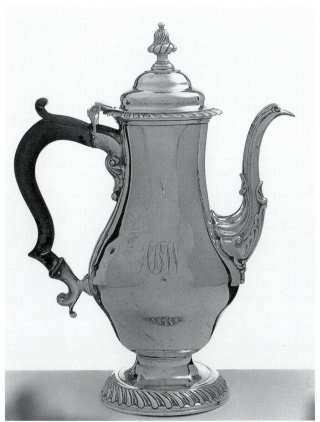

M57

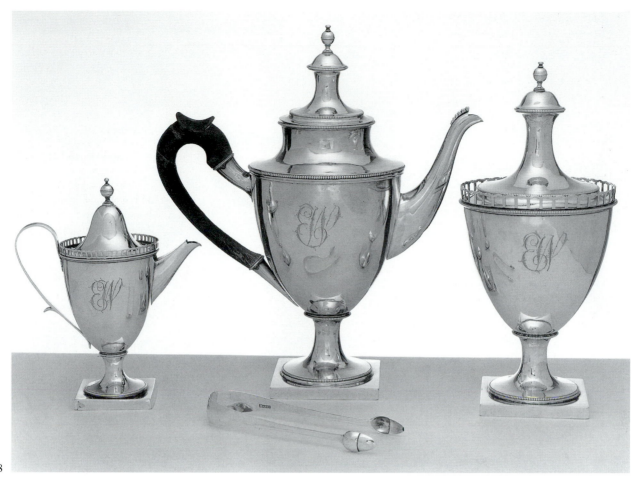

M58

1. For Hurd, see French 1939; Buhler 1960c, p. 78; Fielding 1965, p. 181; Flynt and Fales 1968, p. 255; Buhler 1972, vol. 1, p. 354; Quimby 1995, p. 133; Kane 1998, pp. 615–22.
2. Boston Records 1881, p. 58.
3. Guillim 1724, sec. 4, chap. 10, p. 314. A copy of this volume appears in John Singleton Copley's portrait of Nathaniel Hurd (Prown 1966, vol. 1, p. 220, no. 177).

M57

Coffeepot

1750–1806
Shop of John Bayly (d. 1806), Philadelphia[1]
13 x 5¼ x 9½" (33 x 13.3 x 24.1 cm)
B.71.75

Philadelphians were probably introduced to Rococo design through imported English silver. In response to the new style, the coffeepot, like other vessels, evolved from the single-bellied to the double-bellied shape. The addition of cast elements—finials, handle sockets, and spouts, along with gadrooned rims, engraved ornament, and a scrolled

wooden handle—completed the form's transformation.

PROVENANCE: Alexander Belt Wickersham; to Frances Belt (Mrs. Robert Hadfield, Bt., F.R.S.); [Thomas Lumley, London, by 1941][2]; purchased by Miss Hogg from Firestone and Parson, Boston, 1970.

TECHNICAL NOTES: The finial is soldered.

MARKED: Warren 1975, p. 164, no. 312 (underneath body).

ENGRAVED: ABW [Alexander Belt Wickersham] (side, added later).

RELATED EXAMPLES: One other Bayly coffeepot is recorded, at the Sterling and Francine Clark Art Institute, Williamstown, Massachusetts (acc. no. 1962.3).

REFERENCES: *Connoisseur* 107, no. 476 (May 1941), inside front cover; *Antiques* 98 (September 1970), p. 364; Failey 1971b, p. 64; *Antiques* 103 (February 1973), p. 251; Warren 1975, p. 64; Almquist 1996, p. 44.

1. See cat. no. M50.
2. It was advertised, along with a tea set, by Thomas Lumley in *Connoisseur* in 1941 (see References); the tea set was lot 286 in a sale at Sotheby Parke Bernet, New York, sale 3947, January 26–29, 1977.

M58

Tea Set

ca. 1784–1815
Shop of Standish Barry (1763–1844), Baltimore[1]
B.67.5.1, teapot: 12 x 5¼ x 10½" (30.5 x 13.3 x 26.7 cm); B.67.5.2, sugar urn: 10¾ x 4⅞" (diam.) (27.3 x 12.4 cm); B.67.5.3, cream pot: 7½ x 3¹⁄₁₆ x 5¾" (18.1 x 7.8 x 14.6 cm); B.67.5.4, tongs: 6⅛ x 2⅛ x ¾" (15.6 x 5.4 x 1.9 cm)
Gift of Tiffany & Company, B.67.5.1–.4

Neoclassicism was an appropriate style for the young democracy of the United States. It was largely inspired by British reconfigurations of ancient Greek and Roman motifs. In the former colonies, the years immediately following the Revolution are characterized by growing prosperity and technological innovations, both reflected in the silver objects they produced. Earlier, tea sets with matching vessels were rarely commissioned; by the Neoclassical period they were commonplace. Standish Barry's tea set, with its beading and pierced galleries, typifies the Philadelphia-Baltimore interpretation,[2] although the cream pot is a singular

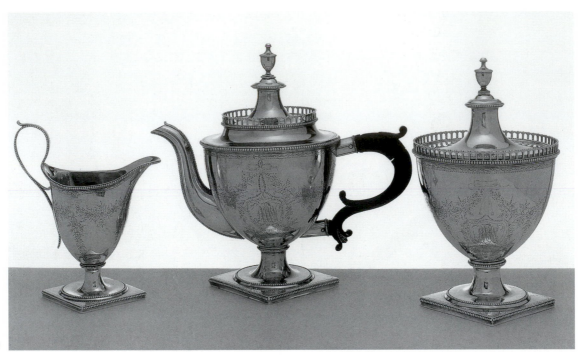

M59

expression, its cover to keep warmth in and insects out and its unique spout more reminiscent of a teapot's.

PROVENANCE: Tiffany & Co., New York, by 1956.

TECHNICAL NOTES: The pearlwork's consistency suggests it was cast. The teapot collar is fashioned separately and soldered on. Its lid is not hinged. The teapot and sugar urn's finials are bolted. The cream pot's is soldered on, and its lid is vented. A device that seems to be a cross between a shell and an anthemion secures the silver handle just below the rim.

MARKED: Goldsborough et al. 1983, p. 240, no. 18, surname mark (teapot and sugar urn's bases; inside the bow of sugar tongs); Goldsborough et al. 1983, p. 240, no. 18 (in each corner of the cream pot's base).

ENGRAVED: EW (side of each vessel and the tongs' bow).

WEIGHT: Sugar urn, 16 oz, 5 dwt; cream pot, 7 oz, 19 dwt; tongs, 1 oz, 8 dwt.

RELATED EXAMPLES: A range of Barry's silver is illustrated in Pleasants and Sill 1972, pl. XVII; Goldsborough et al. 1983, p. 82, no. 29.

REFERENCES: *Antiques* 69 (June 1956), p. 480; Warren 1968, G-4-A; Warren 1975, pp. 168–69, no. 322; Goldsborough et al. 1983, pp. 80–81, nos. 25–27.

1. For Barry, see Prime 1938, pp. 19–20; Pleasants and Sill 1972, pp. 94–98, pls. XVI, XVII; Goldsborough 1975, pp. 49–50. A portrait of Standish Barry is in the Bayou Bend Collection (see cat. no. P37).

2. An early reference to decorative beading appears in 1777 in an advertisement of Lancaster, Pennsylvania, silversmith Charles Hall (Prime 1969, vol. 1, p. 66).

M59

Tea Set

1783–1800
Shop of Henry Lupp (1760–1800), New Brunswick, New Jersey[1]
B.66.4.1, teapot: 9 x 5¹/₁₆ x 9⁷/₁₆" (22.9 x 12.9 x 24 cm); B.66.4.2, sugar urn: 8⅝ x 4⅞" (diam.) (21.9 x 12.4 cm); B.66.4.3, cream pot: 6½ x 3¹³/₁₆ x 5³/₁₆" (16.5 x 9.7 x 13.2 cm)
Gift of Mrs. Harry C. Hanszen, B.66.4.1–.3

In 1783 Henry Lupp advertised that he "Makes and sells . . . articles, in the modern and the ancient mode,"[2] and his tea set is arguably the most mature expression of the latter in New Jersey silver. Its pierced galleries, beading, and diagonal orientation are clearly inspired by Philadelphia, and the engraving is indebted to New York; however, the teapot's novel configuration is unprecedented. The accompanying vessels are more predictable, the sugar dish inspired by a classical urn, the cream pot by an inverted helmet.

PROVENANCE: Brigadier General Anthony Walton White (1750–1803)[3] and Margaret Ellis White (1767–1850, married 1783), New Brunswick, New Jersey; to their daughter Elizabeth Mary (Mrs. Thomas M. Evans, 1792–1861); to her daughter Elizabeth Margaret Evans (1813–1898) or her son Thomas Sunderland Evans (1819–1868); to Thomas Evans's daughter Transita Isabella (Bellita) Evans (Mrs. Stephen Watts Kearney, before 1868–1950); to Dr. and Mrs. Royall M. Calder, San Antonio, Texas; purchased by Mrs. Harry C. Hanszen for Bayou Bend, 1966.

TECHNICAL NOTES: The top of each foot has an engraved border. The teapot sockets are beaded, the wooden handle is original, its lid is not hinged, and the finial is soldered on. Both the sugar urn and cream pot are assembled in a similar manner.

MARKED: Buhler and Hood 1970, vol. 2, p. 282, no. 811 (base).

ENGRAVED: AMW [Anthony and Margaret White] (side of each vessel); M-E [possibly Mary Evans] (teapot base); 18 oz.-3 dwt (sugar urn base); 6 oz.-12 dwt (cream pot base).

WEIGHT: Sugar urn, 18 oz, 3 dwt; cream pot, 6 oz, 12 dwt.

RELATED EXAMPLES: A sugar urn and cream pot at the Newark Museum, Newark, New Jersey (Williams 1949, pp. 88–90).

REFERENCES: White 1964, pp. 78–79; Warren 1975, p. 170, no. 323; Corlette 1976, p. 247, nos. 416, 417.

1. For Lupp, see Williams 1949, pp. 87–91; White 1964, pp. 77–79.
2. Williams 1949, p. 91.
3. A miniature of General White is reproduced in Corlette 1976, p. 248.

M60

Cream Pot and Sugar Dish

ca. 1797
Attributed to the shop of Joseph Loring
(1743–1815), Boston[1]
B.69.256.2, cream pot: 5 x 3 1/16 x 5 5/16" (12.7 x 7.8 x
13.5 cm); B.69.256.3, sugar dish: 5 3/16 x 7 3/4 x
4 1/4" (13.2 x 19.7 x 10.8 cm)
Gift of Mrs. Ernst Auerbach in memory of Ernst
Auerbach, B.69.256.2–.3

Although neither of these pieces is marked, their descent from Joseph Loring's daughter prompts the attribution to his shop (see cat. nos. M61, M115, M116). Objects such as these offer a rare insight into a craftsman's personal taste.

PROVENANCE: Joseph Loring's daughter Mary Loring (1770–1833), Boston; to her niece Mary Hall Loring (1802–1883); to the executor of her estate, James Edward Swan (1839–1917); presumably, to his son James Swan (1870–1944); Mrs. Ernst Auerbach, by 1969.[2]

TECHNICAL NOTES: The cream pot's foot is seamed, its body raised. The sugar dish lid has cutouts to accommodate the handles. Its vented finial is soldered on.

ENGRAVED: ML / 1797 [Mary Loring] and M.H.L. to J.E.S [Mary Hall Loring to James Edward Swan] (the sugar bowl's side and below the cream pot's spout).

WEIGHT: Sugar dish, 12 oz, 17 dwt; cream pot, 5 oz.

RELATED EXAMPLES: Similar cream pitchers are recorded in Sprague 1987, p. 197, no. 113; Buhler 1979, pp. 60–61, nos. 84, 85, the latter with its accompanying sugar bowl. Interest-

ingly all three vessels cited are marked by the shop of Ebenezer Moulton (1768–1824). Joseph Loring's stamp has also been found on objects marked by Moulton, indicating some form of business relationship.

REFERENCES: Warren 1975, p. 171, nos. 325, 326; Kane 1998, pp. 669, 671.

1. For Loring, see Buhler 1960c, p. 81; Buhler 1965, pp. 112–15; Flynt and Fales 1968, p. 269; Buhler 1972, vol. 2, p. 483; Buhler 1979, pp. 51–52; Kane 1998, pp. 665–75.
2. Pope and Loring 1917.

M61

Teapot and Cream Pot

ca. 1797
Attributed to the shop of Joseph Loring
(1743–1815), Boston[1]
B.69.256.1, teapot: 6 7/8 x 4 3/4 x 11 3/8" (17.5 x 12.1 x
28.9 cm); B.69.256.4, cream pot: 4 7/8 x 3 1/8 x 5 7/8"
(12.4 x 7.9 x 14.9 cm)
Gift of Mrs. Ernst Auerbach in memory of Ernst
Auerbach, B.69.256.1, .4

This unmarked teapot and cream pot, like cat. no. M60, descended in Joseph Loring's family. These vessels, however, present a wholly different aesthetic, revealing a more restrained, maturing interpretation of Neoclassicism.

PROVENANCE: John Hall to Susan [Hall] Loring (d. 1841), who married Joseph Loring, Jr. (1761–1838), the silversmith's son, in 1797; to their daughter Mary Hall Loring (1802–1883); to the executor of her estate James Edward Swan (1839–1917); to his son James Swan (1870–1944), about 1901; Mrs. Ernst Auerbach, by 1969.

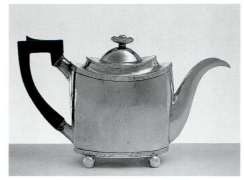

M61

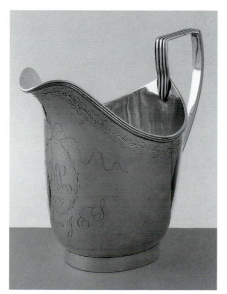

M61

ENGRAVED: teapot: s. H. L. / 1797 (on side); M. H. L. / to / J. E. S. / 1883 / J. E. S. / to J. S. / 1901 (on other side); John Hall / to / Susan Loring (under handle). Cream pot: s. H. L. / 1797 (on side); M. H. L. / to / J. E. S. / 1883 / J. E. S. / to J. S. / 1901 (on other side); s. H (on underside).

WEIGHT: Cream pot, 6 oz, 6 dwt.

RELATED EXAMPLES: A similar but more refined rendition of this teapot is marked by Paul Revere's shop in Buhler 1972, vol. 2, pp. 464–65, no. 414.

REFERENCES: Warren 1975, pp. 171–72, nos. 324, 327; Kane 1998, p. 669, 672.

1. See cat. no. M60.

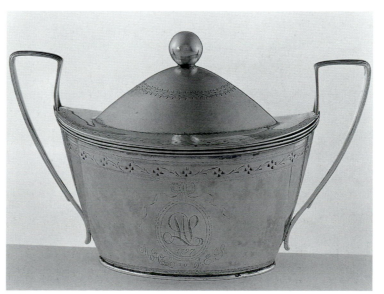

M60

M60

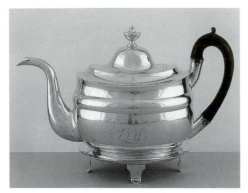

M62

M62

Teapot and Stand

ca. 1798–1812
Shop of Asa Whitney (d. 1812), New York[1]
B.69.167.1, teapot: 7¹/₁₆ x 5½ x 12³/₁₆″ (17.9 x 14 x 31 cm); B.69.167.2, stand: 1⅜ x 5¼ x 6⁷/₁₆″ (3.5 x 13.3 x 16.4 cm)
B.69.167.1–.2

Asa Whitney's teapot combines Neoclassical simplicity with the generous proportions that characterize the Grecian taste. Accompanying the teapot is a matching stand, an optional addition to protect linens and tabletops from spills and burns.[2] Stands were introduced during the Late Baroque period, and with the advent of the flat-bottomed Neoclassical teapot, a paired stand became a welcome adjunct. Both functional and aesthetic, the stand raises the teapot and alleviates a ponderous appearance.

PROVENANCE: The John Wells Company, New York; purchased by Miss Hogg at the American Art Association, New York, October 22–27, 1923.[3]

TECHNICAL NOTES: The body is hammered and seamed behind the handle; its shoulder is a separate component that is soldered on.

MARKED: Belden 1980, p. 443, a (base of each object).

ENGRAVED: ELH (the teapot's side; the stand's top).

WEIGHT: Stand, 5 oz, 5 dwt.

RELATED EXAMPLES: A matching sugar dish and slop bowl were auctioned with the teapot. The sugar dish's location is unknown; the bowl belongs to the Newark Museum, Newark, New Jersey (acc. no. 23.203).

REFERENCES: American Art Association, New York, October 22–27, 1923, lot 2141; Warren 1975, p. 172, no. 328.

1. For Whitney (act. ca. 1798–1812), see Gottesman 1965, pp. 123–24; von Khrum 1978, p. 138.
2. Between 1785 and 1797, Paul Revere's daybooks (Massachusetts Historical Society, Boston) record the production of thirty-five teapots, of which only nine were ordered with an accompanying stand (Revere 1761–97, vol 2).
3. This is the lone example of early American silver collected by Miss Hogg between 1920 and 1953.

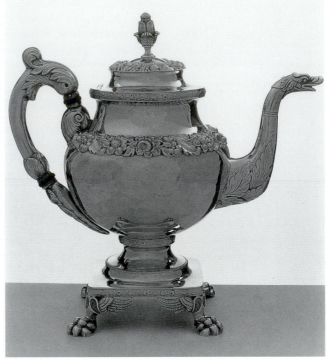

M63 (B.71.89.1)

M63

Tea and Coffee Service

1824–29
Manufactory of Samuel Kirk (1793–1872), Baltimore[1]
B.71.89.1, coffee or hot-water pot: 12¾ x 6¾ x 12¾″ (32.4 x 17.1 x 32.4 cm); B.71.89.2, teapot: 11¼ x 6 x 11½″ (28.6 x 15.2 x 29.2 cm); B.71.89.3, teapot: 11⅛ x 5¾ x 11¼″ (28.3 x 14.6 x 28.6 cm); B.71.89.4, sugar bowl: 9⅛ x 8⅛ x 8⅛″ (23.2 x 20.6 x 20.6 cm); B.71.89.5, cream pitcher: 7½ x 4⅜ x

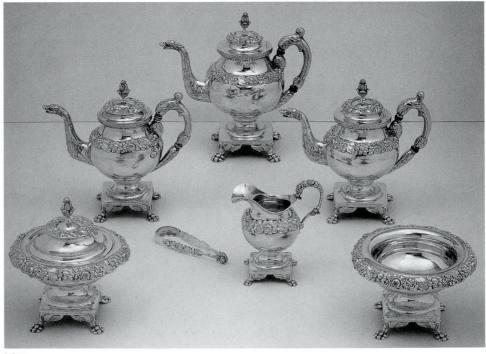

M63

6½" (19.1 x 11.1 x 16.5 cm); B.71.89.6, slop bowl: 5¾ x 8¼ x 8⅛" (14.6 x 21 x 20.6 cm)
Gift of Miss Ima Hogg and the Friends of Bayou Bend, B.71.89.1–.6

Silver conforming to the dictates of the archaeologically correct Grecian taste paralleled the period's architecture, furniture, and other decorative arts. During these years the number of tea pieces in a service continued to grow, often comprising an extensive group of hollowware and flatware. The grandest vessel in this set was intended for coffee or hot water, while the two smaller pots were either for coffee or one or more varieties of tea. Each of these vessels is struck with an assay mark, in the United States unique to Baltimore, where assaying was mandatory between 1814 and 1830.

PROVENANCE: Purchased by Bayou Bend from Peter Hill, Washington, D.C., 1970.

TECHNICAL NOTES: The winged paw feet are cast. The spherical bodies and shoulders are raised and soldered together, the joint concealed by the cast floral bands. The spouts of the two smaller pots are pierced, where they attach to the side as strainers. The joints for the decorative spout heads are concealed in the collars, whereas on the larger pot it is attached below the collar. The finials on the two larger pots and sugar bowl are soldered on and vented, while that on the smallest is bolted.

MARKED: Goldsborough et al. 1983, p. 29, fig. 5; an oval Maryland shield in an octagonal reserve and C in a rectangular reserve (underneath sugar bowl).

ENGRAVED: 30. 03 (underneath slop bowl).

WEIGHT: Coffee or hot-water pot, 62 oz, 9 dwt; teapot, 47 oz, 19 dwt; teapot, 44 oz, 10 dwt; sugar bowl, 36 oz, 8 dwt; cream pitcher, 19 oz, 12 dwt; slop bowl, 29 oz, 14 dwt.

RELATED EXAMPLES: Goldsborough et al. 1983, p. 142, nos. 157–62; Christie's, New York, sale 6622, June 4, 1988, lot 55.

REFERENCES: *Antiques* 97 (May 1970), p. 636; Warren 1970a, pp. 96–97; Warren 1971a, p. 53, no. 28; Warren 1975, pp. 172–74, no. 329; Goldsborough et al. 1983, p. 142.

1. For Kirk, see Durbin 1968; Pleasants and Sill 1972, pp. 145–49; Goldsborough 1975, pp. 135–36, 152; Goldsborough et al. 1983; Quimby 1995, p. 374. The chronology of this company is Kirk & Smith, 1815–20; Samuel Kirk, 1820–46; Samuel Kirk & Son, 1846–61;

Samuel Kirk & Sons, 1861–68; Samuel Kirk & Son, 1868–96; Samuel Kirk & Son Co., 1896–1924; Samuel Kirk & Son, Inc., 1924–79; Kirk-Stieff Inc., 1979–present.

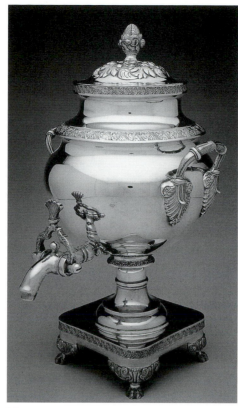

M64

M64

Hot-Water or Coffee Urn

1825–46
R. & W. Wilson (partnership 1825–46), Philadelphia[1]
16 x 9⅞ x 10¾" (40.6 x 25.1 x 27.3 cm)
Museum purchase with funds provided by Mr. George Sealy and his family in memory of Ann McSween Sealy, B.93.28

During the 1760s English silversmiths began to fashion hot-water urns, cleaner and more efficient vessels than the kettle on stand. In 1774 John Waddham patented a design incorporating a cylindrical tube into which a heated iron bar was inserted, similar to a device on the Bayou Bend urn.[2] When using the urn, great care was called for, as a contemporary publication cautioned: "You must always have the urn nearly full of water, or coffee, if the heater be very hot, or else it will burn the urn and do it harm: put the heater into it gently, or you will in time knock out the bottom of the urn. . . ."[3]

PROVENANCE: Eliza Bruce; purchased by Bayou Bend from Hirschl & Adler Galleries, New York, 1993.

TECHNICAL NOTES: The cast feet are soldered to the base. The two-part stem and body are raised. A die-rolled band conceals the joint between the body and collar, and a second band forms the rim. The cast handle supports are inverted anthemia with floral pendants. The interior cylinder is attached to an inner lid that spans the rim, while a smaller concentric lid covers the cylinder.

MARKED: Belden 1980, p. 450, Robert and William Wilson, a (underneath body).

ENGRAVED: 275 (underneath platform).

WEIGHT: 101 oz.

RELATED EXAMPLES: Another Philadelphia example is catalogued in Buhler 1972, vol. 2, pp. 360–61, no. 536.

1. For Robert Wilson (d. 1846) and William Wilson (d. after 1858), see PMA 1976, p. 336; Whisker 1993, p. 285; Quimby 1995, p. 466.
2. Clayton 1985, pp. 424–25.
3. Coleman 1992, p. 100.

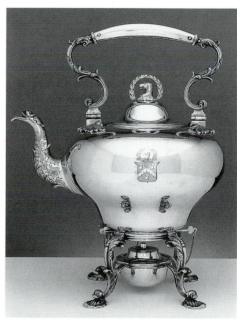

M65

M65

Kettle on Stand

1827–43
Manufactory of John Chandler Moore (ca. 1803–ca. 1855), New York[1]
John and James Cox (act. 1817–39, 1846–53), New York, retailer[2]
13 x 7¾ x 10¼" (33 x 19.7 x 26 cm)
Museum purchase with funds provided by

Jack Doherty at "One Great Night in November, 1994," B.94.15

Only two colonial kettles on stand are known.[3] The identification of a small number of English examples with American histories suggests that it was more efficient and economical to import rather than manufacture the vessel's aggregate castings. The Bayou Bend kettle harks back to these earlier interpretations in its Rococo—or, more accurately, Rococo Revival—style, complete with the Hull family crest as its knob.

PROVENANCE: Commodore Isaac Hull (1773–1843); to his nieces Sarah Hull (Mrs. Phillip Galpin, 1817–1904) and Mary Augusta Hull (Mrs. Frederic Augustus Platt, 1813–1890); to the latter's son Dr. Isaac Hull Platt (1853–1912); to his widow, Emma Haviland Platt; to her son Philip G. Platt; to his widow Mary M. Platt, until 1971; private collection; purchased by Bayou Bend from Hirschl & Adler Galleries, New York, 1994.[4]

TECHNICAL NOTES: The stand is cast with vents located at the top of each support. The body and lid are raised. The spout is extended with a plain collar, perhaps originally intended as a coffeepot or teapot spout, and on the interior it has a decorative cutout rather than piercing. The kettle is hinged to its stand, allowing it to tilt in place. Ivory insulators ensure that the silver handle does not heat up. The finial is secured by a bolt.

MARKED: NEW YORK (incuse) in an arch with pseudohallmarks of a star, M, and anchor below (Moore). For Cox's mark, see Belden 1980, p. 124 (base of kettle and lamp).

ENGRAVED: Hull arms and crest (side).

WEIGHT: 53 oz.

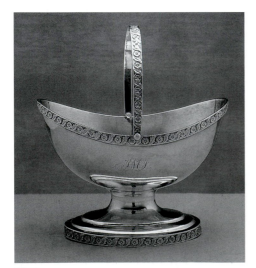

M66

RELATED EXAMPLES: Another nineteenth-century kettle in this revival style is by Edward Lownes (1792–1834), in Quimby 1995, pp. 387–88, no. 386.

REFERENCES: Burton 1997, p. 224b.

1. For Moore (act. 1827–ca. 1851), see Venable 1994, p. 320.
2. For John and James Cox, see von Khrum 1978, pp. 33–34.
3. Buhler 1972, vol. 2, pp. 462–64, no. 543; Buhler and Hood 1970, vol. 2, pp. 189–91, no. 843.
4. Platt 1891.

M66

Sugar Basket

1847–53
Unknown maker
Hugh Allcock and David W. Allen (partnership 1847–53), New York, retailer[1]
6¾ x 6¹¹⁄₁₆ x 4½" (17.1 x 15.4 x 11.4 cm)
Gift of Mrs. Raybourne Thompson, B.91.52

Precedents for the sugar basket are found in imported English and Irish Neoclassical silver and Sheffield plate.[2] In the United States the sugar basket was never produced in great quantity, although it was less expensive than a covered bowl. Presumably, a sealed vessel was preferred since it protected the contents from humidity and insects.

PROVENANCE: The basket descended in the family to the donor.

TECHNICAL NOTES: The foot, basket rim, and hinged handle are die-rolled. The foot is soldered to the hammered stem.

MARKED: Darling 1964, p. 10 (underneath bowl).

ENGRAVED: JMcJ or JMcI (both sides).

WEIGHT: 9 oz, 12 dwt.

1. For Allcock and Allen, see Venable 1994, p. 314.
2. Davis 1976, p. 102; Goldsborough et al. 1983, p. 174, no. 224.

M67

Sugar Bowl

ca. 1830–50
Unknown maker, Baltimore
9 x 6¾" (diam.) (22.9 x 17.1 cm)
Gift of William James Hill in honor of Michael K. Brown, B.93.12

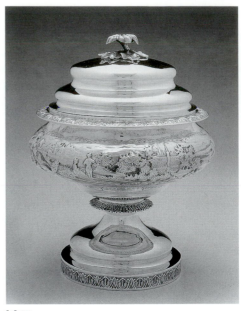

M67

By the second quarter of the nineteenth century, Baltimoreans developed a passion for silver embossed with complex confections of flora, fauna, and architectural fantasies. The inspiration for this profuse display can be found in contemporary English and Chinese export silver.[1] Stylistically, this sugar bowl dates from the earliest phase of this taste. While the Kirk firm produced much of this silver, Andrew Ellicott Warner, Canfield Brothers & Co., Francis A. Greshoff, and the Stieff Co. manufactured similar wares as late as the 1940s.

PROVENANCE: Purchased by William James Hill from Pillsbury and Michel, Houston, Texas, who noted it came from the Carroll family of Mount Clare, Baltimore, and descended in the Shippen and Schenck families to Mary Shippen Schenck Sagendorph.

TECHNICAL NOTES: Die-rolled bands comprise the foot, decorative collar, and rim. The stem, body, and lid are raised. The finial is soldered on.

WEIGHT: 30 oz, 16 dwt.

RELATED EXAMPLES: Quimby 1995, pp. 374–76, no. 370a–f.

1. An example of this decoration is a covered entree dish by London silversmith Thomas Gairdner, hallmarked 1818/19. Other silver that may have inspired this Baltimore fashion includes a Chinese cup bearing Andrew E. Warner's mark, as well as sets of Chinese export silver that supplemented locally made silver (Goldsborough et al. 1983, pp. 12, 118, no. 99).

M68

Cream pitcher

1846–61 or 1868–96
Manufactory of Samuel Kirk & Son
(act. 1846–61, 1868–96), Baltimore[1]
9⅜ x 3⅜ x 5½″ (23.8 x 8.6 x 14 cm)
Gift of Mrs. Dudley C. Sharp, Sr., B.89.11

Heavily repoussé surfaces were decorated by hand and therefore unique. A range of motifs, including flowers, landscapes, Chinese pagodas, Gothic castles, and, in spite of their obvious incongruity, landmark Baltimore buildings, was integrated into these fictional scenes. Samuel Kirk and Andrew Ellicott Warner were the principal disseminators of this style. The pitcher's elongated form and characteristic angular handle, probably French-derived, was adapted for ewers and water pitchers as well as cream pitchers.

PROVENANCE: Richard Wayne, the donor's great-grandfather.

MARKED: Goldsborough et al. 1983, p. 264, no. 164 (underneath body). The stamp incorporates a quality mark that first appears in Baltimore after the passage of the 1830 Assay Law.[2]

ENGRAVED: RW [Richard Wayne] (below spout).

WEIGHT: 13 OZ.

RELATED EXAMPLES: Goldsborough et al. 1983, pp. 148, 151, nos. 171, 172, 178; McFadden and Clark 1989, pp. 86, 89; Conger 1991, pp. 364–65, no. 233; Weidman et al. 1993, p. 161; Talbott 1995, pp. 119, 123–24, nos. 64a, b. A kettle on stand by Samuel Kirk & Son Co. that came from another branch of the donor's family was given to the MFA, Houston (acc. no. 86.326.1, .2).

1. See cat. no. M63.
2. The assay marks are explained and reproduced in Goldsborough et al. 1983, pp. 32–33.

M69

Teapot

1845–72
Attributed to Wood & Hughes (act. 1845–99), New York[1]
James Conning (ca. 1813/15–1872), New York and Mobile, Alabama, retailer[2]
12¾ x 6⅜ x 11⅜″ (32.4 x 16.2 x 28.9 cm)
Museum purchase with funds provided by the Friends of Bayou Bend, B.82.3

In the nineteenth century small, individual shops began to limit their production to flatware and simpler objects, relying increasingly on large, highly organized manufacturers for more complex forms. The Bayou Bend teapot is a product of this trend. Its stamp implies James Conning's manufacture, yet, while he trained in New York, there is no evidence that he produced any hollowware while he was in Mobile, where he sold this article. He also retailed silver by Wood & Hughes, and similar cast and die-rolled elements on their work form a basis for the teapot's attribution.

PROVENANCE: Purchased by Bayou Bend from Gary E. Young, Lexington, Missouri, 1982.

TECHNICAL NOTES: The foot is a die-rolled band. The stem is spun and the body raised. The vented finial is soldered on.

MARKED: J. CONNING / MOBILE (underneath body).

ENGRAVED: H (side).

WEIGHT: 31 OZ, 19 dwt.

RELATED EXAMPLES: The Bayou Bend teapot was originally part of a service now in the Museum of the City of Mobile. A related Wood & Hughes tea set, also retailed by Conning, is recorded in Smith 1977, p. 485.

REFERENCES: *Antiques* 121 (March 1982), p. 647; *Antiques* 126 (September 1984), p. 428; Brown 1987, p. 32.

1. For Jacob Wood (d. 1850) and Jasper W. Hughes (1811–1864), see Venable 1994, p. 324. Wood & Hughes were the successors to Gale, Wood & Hughes, 1833–45. In 1899 they, in turn, were succeeded by Graff, Washbourne & Dunn.

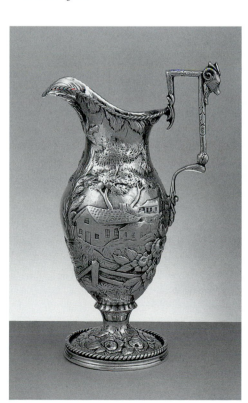

M68

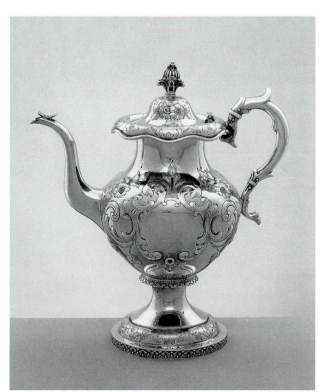

M69

M69 (*detail*)

2. For Conning (New York, act. ca. 1834–40; Mobile, Alabama, act. 1842–70), see Summers 1958, pp. 142–43; Smith 1970b; Smith 1971, pp. 409–11; Green 1978b; Cormany 1993.

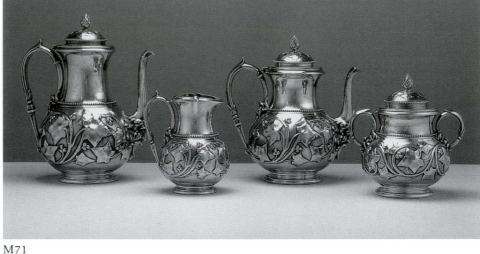

M71

M70

Sugar Bowl and Cream Pitcher

1850–54
Vincent Laforme & Brother (partnership 1850–54), Boston[1]
Hyde & Goodrich (act. 1829–61), New Orleans, retailer[2]
B.89.9.1, sugar bowl: 5⅝ x 8 x 3⅝" (14.3 x 20.3 x 9.2 cm); B.89.9.2, cream pitcher: 5 x 2³∕₁₆ x 4¾" (12.7 x 5.6 x 12.1 cm)
Gift of Mr. and Mrs. Fred Renaud, Jr., B.89.9.1–.2

The complexities of this design's origin have yet to be unraveled. While both the sugar bowl and creamer are stamped by the Boston silversmiths Vincent Laforme & Brother, they are closely related in design to a New York service by John Chandler Moore for Tiffany, Young & Ellis. The latter, like the Bayou Bend silver, also possesses a Louisiana provenance.[3]

PROVENANCE: Elizabeth (1828–1919) and David Cohen Labatt (1826–1893), New Orleans, married 1849[4]; to their daughter Caroline (Mrs. Orlando Phelps, 1852–1941); to her daughter Almira Louise (Mrs. Fred Renaud, Sr.), Houston; to Mr. and Mrs. Fred Renaud, Jr.

TECHNICAL NOTES: Both vessels are assembled from sheet silver. The finial of the sugar bowl is vented and soldered on. There is no

indication that the cartouche of either vessel was ever engraved.

MARKED: HYDE & GOODRICH. / NEW ORLEANS. LA. / PURE COIN / old English L (Laforme), and an eagle (incuse, base).

WEIGHT: Sugar bowl, 15 oz, 11 dwt; cream pitcher, 6 oz, 14 dwt.

RELATED EXAMPLES: Originally part of a more extensive service that was later dispersed among the Labatt descendants. For related silver by John Chandler Moore for Tiffany, Young & Ellis, see Mackie, Bacot, and Mackie 1980, pp. 26–27, no. 29; *Antiques* 130 (October 1986), p. 702.

REFERENCES: Warren 1968, F-5-J; Mackie, Bacot, and Mackie 1980, p. 27.

1. For Vincent Laforme (1823–1893) and Francis J. Laforme (1827–1895), see Skerry 1981, pp. 6–11; Quimby 1995, p. 138.
2. See cat. no. M32.
3. Mackie, Bacot, and Mackie 1980, pp. 26–27, no. 29.
4. David Cohen Labatt is profiled in Memoirs of Louisiana 1892, pp. 521–23.

M71

Tea and Coffee Service

1856–59
Manufactory of Edward Chandler Moore (1827–1891), New York[1]
Tiffany & Co. (act. 1837–present), New York, retailer[2]
B.91.37.1, coffeepot: 10¾ x 6⅛ x 8½" (27.3 x 15.6 x 21.6 cm); B.91.37.2, teapot: 9¾ x 8¾ x 6" (24.8 x 22.2 x 15.2 cm); B.91.37.3, sugar bowl: 7¼ x 6⅞ x 5¼" (18.4 x 17.5 x 13.3 cm); B.91.37.4, cream pitcher: 6⅜ x 5¼ x 4¾" (16.2 x 13.3 x 12.1 cm)
Museum purchase with funds provided by Mr. and Mrs. Robert F. Strange, Sr., B.91.37.1–.4

John Chandler Moore wholesaled silver to Tiffany, Young and Ellis, along with William Bogert, Henry Hebbard, John Polhamus, and others. In 1851 Moore and his son Edward entered into an arrangement whereby they would manufacture exclusively for the Tiffany firm. The Bayou Bend tea service, a composite of Baroque and Rococo motifs, incorporates an all-over ivy pattern. Seventeen years after the agreement, Tiffany purchased the Moore factory outright, making Edward C. Moore a principal stockholder and appointing him general manager with responsibility for overseeing the company's production.

PROVENANCE: Purchased by Bayou Bend from William Core Duffy, Kittery Point, Maine, 1991.

TECHNICAL NOTES: The bodies and necks of all four vessels are spun. The vented finials are soldered on.

MARKED: Carpenter and Carpenter 1978, p. 249, no. 10 (the base of each object).

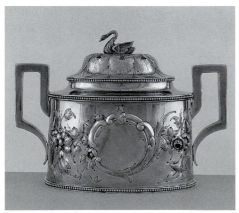

M70

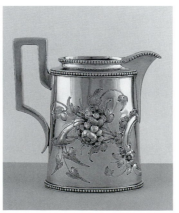

M70

WEIGHT: Coffeepot, 34 oz, 10 dwt; teapot, 32 oz, 13 dwt; sugar bowl, 22 oz, 2 dwt; cream pitcher, 14 oz, 5 dwt.

RELATED EXAMPLES: Skinner, sale 1401, September 27–28, 1991, lot 80; Christie's, New York, sale 7624, January 22, 1993, lot 183; Christie's, sale 7830, January 21, 1994, lot 12; Christie's, sale 8696, June 17, 1997, lot 34.

1. For Edward Chandler Moore, see Venable 1994, p. 320.
2. For Tiffany, see Carpenter and Carpenter 1978 and Venable 1994.

M72

Pitcher

1815
Manufactory of Thomas Fletcher (1787–1866)
and Sidney Gardiner (1785–1827), Boston and
Philadelphia[1]
13½ x 6½ x 10⅛" (34.3 x 16.5 x 25.7 cm)
Gift of Mrs. James P. Houstoun, Jr., in memory
of Mr. James P. Houstoun, Jr., B.77.16

The Bayou Bend pitcher is among the earliest in the great progression of presentation commissions awarded to the celebrated partnership of Thomas Fletcher and Sidney Gardiner. While intended for domestic use, it incorporates many of the same elements as the partners' impressive trophies. The massive paw feet, acanthus leaves, eagle's head, and frolicsome dolphin finial, all derived from antiquity, are integrated into a bold statement of Grecian taste. The itemized bill for the pitcher indicates that the silver amounted to slightly less than half the total price for the finished product.[2]

PROVENANCE: Commissioned by Ann Moodie Houstoun, Lady Houstoun (1749–1821); to Colonel James Johnston (1769–1822), her attorney and son-in-law[3]; to his daughter Louisa C. (Mrs. Patrick Houstoun Woodruff); to Louisa C. Woodruff; to Edith Duncan Johnston; to her nephew James Houstoun Johnston, III; purchased by Mrs. James P. Houstoun, Jr., from James Houstoun Johnson, III.

TECHNICAL NOTES: The feet are hollow-cast and soldered to triangular corner brackets concealed within the base. Repoussé acanthus leaves encircle the body and crown the lid. The eagle's neck conceals an air vent. The lid is hinged.

MARKED: Belden 1980, p. 170, Fletcher & Gardiner, b (underneath body).

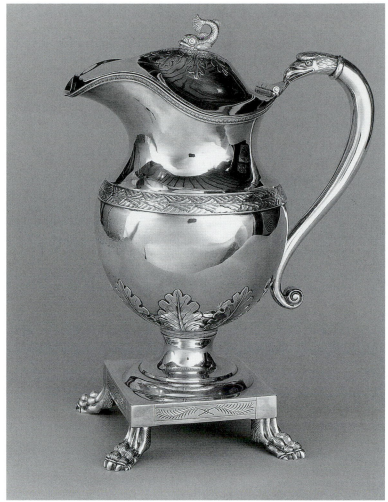

M72

ENGRAVED: Lady Houstoun presents this Pitcher to / Colonel Johnston with her grateful thanks / for his attention in settling the Estates of / Sir Patrick and Sir George Houstoun. (below spout); 252–05 and 238 (underneath base).

WEIGHT: 53 oz.

RELATED EXAMPLES: Most closely related is one in the MFA, Boston (acc. no. 1995.45). Similar examples include Quimby 1995, p. 358, no. 347; one with Hirschl & Adler Galleries, New York. Some of the same cast elements employed on the Bayou Bend pitcher are incorporated into other vessels by Fletcher and Gardiner, for example, Fales 1970, p. 150, no. 137; McClinton 1970b, pp. 213–14, no. 4; Buhler and Hood 1970, vol. 2, pp. 235–37, no. 928; PMA 1976, pp. 292–93, no. 247; Waters 1984, p. 80, no. 43; Feld et al. 1991, p. 91, no. 65.

REFERENCES: Johnston 1950, p. 160; Agee et al. 1981, p. 92, no. 160; Warren, Howe, and Brown 1987, pp. 118–19, no. 147; Brown 1987, pp. 28–30.

1. For Fletcher and Gardiner (partnership 1808–ca. 1830), see Wood 1967; McClinton 1970b; Fennimore 1971; Fennimore 1972, pp. 642–49; PMA 1976, pp. 280–81; Quimby 1995, p. 357.

2. Fletcher and Gardiner's November 15, 1815, bill has descended in another branch of the family. It enumerates "1 Silver Pitcher, round. on Square Pedistal & claw feet chased leaves on the body & lid, with dolphin Top $150.00," and "Engraving Inscription on do 4.00." Lady Houstoun purchased a silver coffeepot at the same time.

3. Lady Houstoun was the widow of Sir George Houstoun (d. 1795), the seventh, and last, baronet. Sir George and his elder brother Patrick were Loyalists, and during the American Revolution, Georgia confiscated their properties and revoked their citizenships. With peace they petitioned the state, attempting to recover their lands and rights. In 1785 Sir Patrick died and was succeeded by his brother, who survived him by a decade. Following Sir George's death his widow assumed responsibility for a complex legal situation due to the size of the two estates and complications resulting from Georgia's property claims dating back to the Revolution. Twenty years passed before they were finally resolved by Colonel Johnston. A conversation piece by Henry Benbridge includes a depiction of Lady Houstoun, illustrated in *Antiques* 118 (November 1980), p. 1012.

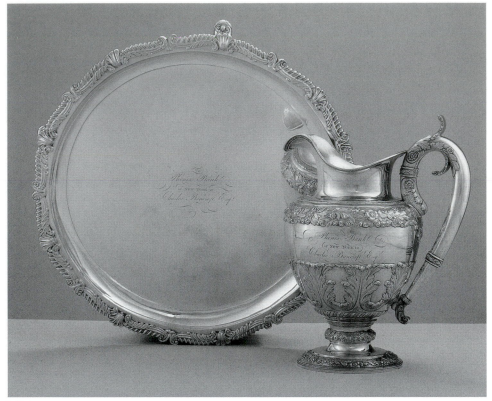

M73

1. For Richard, see Ensko 1989, p. 72; Quimby 1995, p. 277. Richard's earliest working date has been given as 1802; however, an advertisement for "G. & S. Richards, Jewelers" documents an earlier partnership (Gottesman 1965, p. 101).
2. Evidently, on occasion, Richard signed his silver by lightly engraving it. See also Related examples.

M74

Pitcher

ca. 1839
R. & W. Wilson (partnership 1825–46),
Philadelphia[1]
15 1/16 x 6 3/4 x 10 7/8" (38.3 x 17.1 x 27.6 cm)
Museum purchase with funds provided by Frank J. Hevrdejs, William R. Camp, Jr., and William Oehmig in honor of the Sterling Group at "One Great Night in November, 1993," B.93.24

A series of Grecian water pitchers in the Bayou Bend collection testifies to the variety of individual interpretations (see cat. nos. M72, M73, M75). The pitcher owned by John Swift, along with other silver he received, is indicative of the increasing popularity of silver vessels for presentation occasions. In 1832, Swift, a physician, received a five-piece tea service for his heroic response to an outbreak of cholera. While that silver was supplied by Edward

M73

Tray

1815–39
Shop of Stephen Richard (d. 1839), New York[1]

Pitcher

1815–39
Attributed to the shop of Stephen Richard
B.91.48.1, pitcher: 13 1/4 x 7 1/4 x 9 7/8" (33.7 x 18.4 x 25.1 cm); B.91.48.2, tray: 2 x 18 1/4" (diam.) (5.1 x 46.4 cm)
Museum purchase with funds provided by Mr. Peter Coneway in honor of Mr. Fayez Sarofim at "One Great Night in November, 1991," B.91.48.1–.2

The pitcher, introduced to the United States at the end of the eighteenth century, became a predominant table form in the nineteenth century. English creamware and pearlware pitchers provided silversmiths with the earliest prototypes. While that shape is now popularly identified with Paul Revere, other Boston and New York silversmiths fashioned similar vessels. The Bayou Bend pitcher presents the subsequent interpretation, which, along with its companion tray, magnificently adheres to the Grecian aesthetic.

PROVENANCE: Charles Bancroft; by descent to Stephen Bancroft; auctioned by Sotheby Parke Bernet, New York, sale 4905Y, June 30–July 1, 1982, lot 192; private collection; purchased by Bayou Bend from Hirschl & Adler Galleries, New York, 1991.

TECHNICAL NOTES: A band has been incorporated below the tray's decorative rim, undoubtedly to strengthen it. The handle terminal is vented.

MARKED: See Engraved.

ENGRAVED: THE Phenix Bank of NEW YORK to Charles Bancroft Esq.[r] (side of the pitcher and face of the tray); S Richard / Maker / New York (the guidelines still visible, back of tray).[2]

WEIGHT: Pitcher, 56 oz, 5 dwt; tray, 82 oz, 14 dwt.

RELATED EXAMPLES: An identical pitcher and tray purportedly were presented to Horatio Gates, whose niece married Charles Bancroft. It is said to remain with Gates's descendants. Other silver engraved with Richard's name includes *Antiques* 82 (December 1962), p. 581; Christie's, New York, sale 5370, June 2, 1983, lot 69; Feld et al. 1991, p. 20, no. 2; Quimby 1995, pp. 277–78, no. 242.

REFERENCES: Denison 1966, p. 78; Sotheby Parke Bernet, New York, sale 4905Y, June 30–July 1, 1982, lot 192; Warren, Howe, and Brown 1987, pp. 92–93, no. 103; Feld et al. 1991, p. 35, no. 18; Quimby 1995, p. 277.

M74

Lownes, R. & W. Wilson later fashioned this pitcher to complement the service.

PROVENANCE: John Swift (1790–1873), Philadelphia; purchased by Bayou Bend from Hirschl & Adler Galleries, New York, 1993.

TECHNICAL NOTES: The cast feet are soldered to the base, the stem, its collar, the body, its upper section, and the handle, which is vented at the lowest scroll in the upper part.

MARKED: Belden 1980, p. 450, Robert and William Wilson, a; R & W. WILSON / STANDARD (underneath body); R & W. WILSON (each corner of base).

ENGRAVED: A token of respect / TO / John Swift Esquire / LATE MAYOR OF THE CITY OF PHIL.ᴬ / PRESENTED / By / His Commissioned Officers. / Janᵞ 15ᵗʰ 1839. (below spout).

WEIGHT: 63 oz, 13 dwt.

RELATED EXAMPLES: The pitcher was designed to complement a tea service presented earlier to John Swift (Hanks and Peirce 1983, pp. 14–15).

REFERENCES: Feld et al. 1991, p. 115, no. 86.

1. See cat. no. M64.

M75

Pitcher

1809–45
Shop of William Thomson (act. 1809–45), New York[1]
12¼ x 6¼ x 9⅝" (31.1 x 15.9 x 24.4 cm)
Museum purchase with funds provided by Tom Alan and Chris Cunningham in honor of Jeanne Moran Cunningham at "One Great Night in November, 1993," B.93.23

This pitcher introduces a totally different aesthetic from the previous examples (cat. nos. M72–M74). Its design is firmly rooted in the Grecian style, complete with scrolled acanthus leaf handle and dolphin finial. Its body is characterized by an expanse of smooth surfaces and a restrained ornament. The principal die-rolled band appears to be unique: a panoramic depiction of a fox hunt, it presents mounted hunters dashing cross-country with their hounds in pursuit of the prey. Regrettably, this vessel's early history is not known, although the decorative band suggests that it might have been commissioned for presentation at a hunt.[2]

M75

PROVENANCE: Purchased by Bayou Bend from Hirschl & Adler Galleries, New York, 1993.

TECHNICAL NOTES: The foot stem, body, and collar are all raised and soldered together. Air vents are located in the lowest scrolls at the top and bottom of the handle. The dolphin finial is soldered in place with an interior air vent. The five-part hinged lid is secured by a removable pin, which allows the cover to be detached.

MARKED: Darling 1964, p. 176 (underneath body).

ENGRAVED: MSM (side).

WEIGHT: 40 oz, 16 dwt.

RELATED EXAMPLES: Although no similar pitcher from Thomson's shop is published, the form is reminiscent of Rice 1964, pp. 48, 53, 55.

1. For Thomson, see von Khrum 1978, p. 128; Puig et al. 1989, p. 288; Quimby 1995, p. 298.
2. Perhaps this pitcher was intended for a specific occasion, its function similar to that of a Chinese export porcelain punch bowl (Palmer 1976, p. 125).

M76

Pitcher

ca. 1853
Manufactory of Andrew Ellicott Warner (1786–1870), Baltimore[1]
14⅝ x 6¾ x 9" (37.1 x 17.1 x 22.9 cm)
Museum purchase with funds provided by Mr. and Mrs. M. S. Stude, B.89.7

This pitcher is the most extravagant example of Rococo Revival silver with a

Texas history. Its presentation inscription relates that Captain Thomas Forbes, upon arrival of his passenger boat in New Orleans, learned of an outbreak of yellow fever. He decided against disembarking and safely returned his passengers to Galveston.[2] The pitcher, with its vigorous repoussé decoration, is impressive in its scale and ornament, but does not represent a special commission. Perhaps it was obtained through Joseph Osterman (1779–1861), a Galveston merchant and one of the three official presenters whose names are engraved below the inscription. Prior to his arrival in Galveston Osterman had worked in Baltimore as a silversmith and probably maintained business connections with that city. The other presenters were General Memucan Hunt (1807–1856) and Dr. Anson Jones (1798–1858), the last president of the Republic of Texas.

PROVENANCE: Captain Thomas Forbes (1817–1906), Sherman, Texas; to his son, Thomas Forbes, Jr.; to his daughter Bessye (Mrs. T. W. House, III, 1877–1946); to her son Edward M. House, II[3]; purchased by Bayou Bend from Edward House through Phyllis Tucker, Houston, 1989.

TECHNICAL NOTES: The pitcher is composed of a foot rim, stem, body with a cast lip, and handle, which is not vented.

M76

MARKED: Belden 1980, p. 431 (foot band).

ENGRAVED: Presented to / Cap.ᵗ Tho.ˢ Forbes, / by the passengers of the 'Perseverance,' / from Galveston to New Orleans, Aug.ᵗ 7.ᵗʰ 1853. / as a token of their grateful recollection of / his kindness in preserving (by his unexampled / despatch) their health and lives from exposure to / the fatal epidemic, prevailing at the time of / their arrival in the latter port. / Committee of presentation, / Gen. Memucan Hunt, Joseph Osterman & D.ᵣ Anson Jones. (below spout); 4610–58763 (foot band interior, added later).

WEIGHT: 38 oz, 14 dwt.

RELATED EXAMPLES: Bartlett 1984, p. 37.

1. For Warner (act. 1805–70), see Pleasants and Sill 1972, pp. 193–95; Goldsborough et al. 1983, pp. 202–15, 287.
2. "The steamship Perseverance has arrived at the quarantine ground but up to the time of our going to press for our morning mail, we have been unable to get any news from her," *Galveston Weekly News*, 10, no. 24 (August 30, 1853), p. 2.
3. For another object presented to Captain Forbes, see cat. no. M102.

M77

Pair of Ewers

1837–48
Manufactory of Taylor & Lawrie (partnership 1837–61), Philadelphia[1]
Bailey & Kitchen (1832–48), Philadelphia, retailer[2]
B.67.24.1: 19¼ x 6⅞ x 9¼" (48.9 x 17.5 x 23.5 cm);
B.67.24.2: 19⅛ x 6¾ x 9⅛" (48.6 x 17.1 x 23.2 cm)
B.67.24.1–.2

The eclecticism that defines nineteenth-century American art is exuberantly manifested in these remarkable ewers, which may have been intended more as decorative rather than functional objects. Their contours reproduce the inverted pear shape characteristic of Rococo silver, and the asymmetrical scrolls, flora, and putti are consistent with the prevailing Rococo Revival aesthetic. The startling juxtaposition of a Baroque mask, Neoclassical beading, Grecian-inspired acanthus leaves, and the exotic Persian diaper pattern produces a summation of nineteenth-century American taste.

PROVENANCE: Purchased by Miss Hogg from Krupsaw's Antique Shop, Washington, D.C., 1967.

TECHNICAL NOTES: The ewer consists of a foot rim, a foot, and raised body. The mask is

M77

cast. Aside from the engraved owner's monogram, the decoration is chased and repoussé.

MARKED: Belden 1980, p. 42, Bailey & Kitchen, a (beneath body).

ENGRAVED: TSHF (below spout).

WEIGHT: **B.67.24.1**: 64 oz, 2 dwt; **B.67.24.2**: 65 oz, 11 dwt.

RELATED EXAMPLES: Sotheby's, New York, sale 5968, January 24–27, 1990, lots 140–47.

REFERENCES: *Antiques* 91 (May 1967), p. 596; Warren 1971a, p. 54, no. 29; Warren 1971b, p. 35; Warren 1975, p. 178, no. 332.

1. For Robert Taylor and Robert Dickson Lawrie, see Cramer 1988b; Soeffing 1988c; Quimby 1995, p. 456.
2. For Joseph T. Bailey and Andrew B. Kitchen, see PMA 1976, p. 326; Venable 1994, p. 315. The chronology of this company is Bailey & Kitchen, 1832–48; Bailey & Co., 1848–78; Bailey, Banks & Biddle, 1878–present.

M78

Ewer

1845–61
Shop of Eli C. Garner, Sr. (1818–1878), and Daniel Franklin Winchester (1818–1868), Lexington, Kentucky, probably retailer[1]
15⅝ x 5⅜ x 7⅛" (39.7 x 13.7 x 18.1 cm)
Museum purchase with funds provided by the Heitman Foundation, B.81.10

Northeastern silversmiths supplied the southern market with a vast array of goods. Often these objects introduced new styles and patterns to the local craftsmen. Another principal means of transferring designs was through the migration of craftsmen. While Eli C. Garner was apprenticed to Asa Blanchard, Kentucky's most famous silversmith, the Bayou Bend ewer's ornament, and possibly manufacture, more likely represents

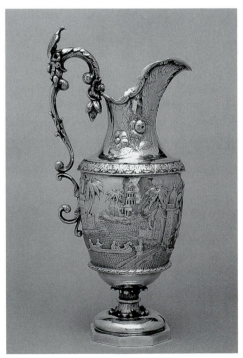

M78

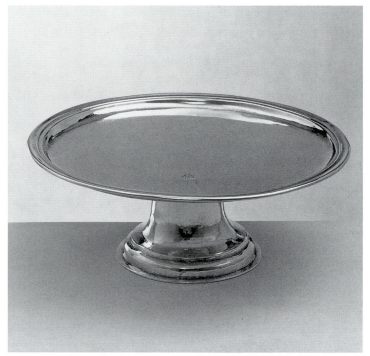

M79

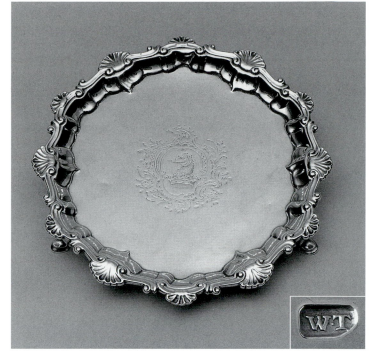

M80

Daniel Franklin Winchester's contributions to the partnership. A native of Baltimore, Winchester apprenticed to Samuel Kirk.[2] At one time this vessel was paired with a virtually identical example, retailed by Bailey & Co. of Philadelphia, which complicates the identification of its origins.[3]

PROVENANCE: Purchased by Bayou Bend from Shreve, Crump & Low, Boston, 1981.

MARKED: Boultinghouse 1980, p. 301, no. 60B (foot).

WEIGHT: 40 oz, 9 dwt.

RELATED EXAMPLES: One marked by Garner and Winchester that appears to be identical, inscribed "Citizens / Stake Won by Lexington / Times 3.42½ 3.41½ 3.49 / Spring 1853," is in Boultinghouse 1980, p. 24. See also *Antiques* 119 (March 1981), back cover.

REFERENCES: *Antiques* 119 (March 1981), back cover; *Antiques* 128 (October 1985), p. 628; Denker 1985, p. 36.

1. For Garner and Winchester (partnership 1838–61), see Hiatt and Hiatt 1954, pp. 34–36, 100; Boultinghouse 1980, pp. 130–32, 284.
2. Goldsborough et al. 1983, p. 289.
3. *Antiques* 119 (March 1981), back cover.

M79
Salver

ca. 1690–1730
Shop of Edward Winslow (1669–1753), Boston[1]
2¼ x 5¹³⁄₁₆" (diam.) (5.7 x 14.8 cm)
B.74.5

The salver was defined in 1661 as "a new fashioned piece of wrought plate, brought and flat, with a foot underneath" that was used "in giving Beer or other liquid thing to save the Carpit or Cloathes from drops." The form's versatility is implied in a 1700 Virginia inventory description of "one small salver or Bread Plate."[2] Seventeenth- and early-eighteenth-century examples consist of a cylindrical tapering foot and a wide border that could be engraved. Stylistically, the Bayou Bend salver is slightly later in date, as evidenced by the thin, reeded rim substituted for the earlier border.

PROVENANCE: Elizabeth Clark (Mrs. John Hancock, 1687–1760); to her daughter-in-law Mary Hawke (Mrs. John Hancock, b. 1711); to her son Ebenezer Hancock (1741–1819); to his son John Hancock (1774–1830); to his daughter Elizabeth (Mrs. Joseph Moriarity, 1814–1857); to her daughter Elizabeth (Mrs. Charles H. Wood, 1844–1929); to her daughter Mary (Mrs. George A. Cole, 1875–1954); to her son Morton Cole; purchased by Miss Hogg from Firestone and Parson, Boston, 1974.

TECHNICAL NOTES: The foot and plate are raised and soldered together.

MARKED: Buhler and Hood 1970, vol. 1, p. 332, nos. 48, 49, 51–57 (face).

ENGRAVED: Ex: E:H to M:H [Elizabeth Hancock to Mary Hancock] (underneath).

WEIGHT: 7 oz, 5 dwt.

RELATED EXAMPLES: Jones 1913, pp. 64–65, pl. XXVI (bottom), p. 97, pl. XXXVI (top); Buhler and Hood 1970, vol. 1, p. 59, no. 52; Buhler 1972, vol. 1, p. 83, no. 68; Sotheby's, New York, sale 5142, January 26–28, 1984, lot 414.

REFERENCES: *Antiques* 100 (August 1971), p. 210; Kane 1998, p. 980.

1. See cat. no. M19.
2. Buhler 1960b, p. 36; Davis 1976, pp. 124–25.

M80
Salver

1771–79
Shop of William Taylor (act. 1771–79), Philadelphia[1]
1 x 7⅛ x 7¼" (2.5 x 18.1 x 18.4 cm)
Museum purchase with funds provided in memory of Marilyn Perkins Buie, B.81.1

The substitution of small cast feet for a central foot facilitated the salver's use; with its center of gravity closer to the

table top, it became more stable. Replacing the cusped rim was a cast shell-and-scroll design similar to those on the tops of Rococo tea tables. The cast supports also relate to furniture as miniature versions of pad, trifid, scroll, and ball-and-claw feet. Salvers were complicated forms to produce, from fashioning a flat sheet by hand to casting and assembling the border sections. Their diameters varied, as did their name and use. Joseph Richardson ordered "waiters" as stands for teapots and coffeepots, while another Philadelphia silversmith, Edmund Milne, advertised "waiters, chased and plain, holding from 3 to 12 glasses. . . ."[2]

PROVENANCE: Purchased by Bayou Bend from S. J. Shrubsole, New York, 1980.

MARKED: w·t (underneath).

ENGRAVED: A crest used by Thomas Brereton of Baltimore and, beneath, PHILLOTT [significance not known].[3]

WEIGHT: 8 oz, 9 dwt.

RELATED EXAMPLES: Buhler and Hood 1970, vol. 2, pp. 215–16, no. 887. It also recalls one stamped by the London silversmith Richard Rugg that belonged to George Mason IV (1725–1792), in Brown 1980, pp. 287–88.

REFERENCES: *Antiques* 119 (January 1981), p. 84.

1. For Taylor, see Whisker 1993, p. 269.
2. Prime 1969, vol. 1, pp. 80–82.
3. For Brereton, see Matthews 1901, p. 367.

M81
Pair of Salt Dishes

ca. 1758–83
Shop of Joseph Edwards, Jr. (1737–1783), Boston[1]
1¹³/₁₆ x 3¹/₁₆" (diam.) (4.6 x 7.8 cm)
Museum purchase with funds provided by the Friends of Bayou Bend, B.80.4.1–.2

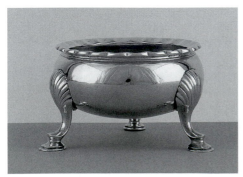

M81

Prior to the seventeenth century, salt was a precious commodity. The earliest surviving English salt dishes, dating from the late fifteenth century, were imposing objects securing a prominent position at the table. In colonial America the earliest examples were spool shaped, succeeded in about 1700 by the trencher salt, a simpler form that communicates the increasing availability of the commodity. By the mid-eighteenth century, small circular dishes supported by diminutive cast feet, such as this pair by Joseph Edwards, Jr., became popular.

PROVENANCE: Purchased by Bayou Bend from William Core Duffy, New Haven, 1980.

MARKED: Buhler and Hood 1970, vol. 1, p. 325, no. 272 (bottom).

ENGRAVED: w★p (bottom).

WEIGHT: **B.80.4.1**: 3 oz, 12 dwt; **B.80.4.2**: 3 oz, 6 dwt.

RELATED EXAMPLES: These salt dishes, characteristic of the period, are the only ones recorded from Joseph Edwards's shop.

1. For Edwards (act. ca. 1758–83), see Buhler 1951; Buhler 1972, vol. 2, p. 473; Puig et al. 1989, p. 264; Kane 1998, pp. 422–26.

M82
Salt Dish

ca. 1785–1803
Attributed to the shop of Jacob Gerritse Lansing (1736–1803), Albany, New York[1]
2¹/₈ x 3³/₁₆ x 2³/₈" (5.4 x 8.1 x 6 cm)
Gift of Mrs. Raybourne Thompson, B.91.53

Oval salt dishes were a popular eighteenth-century form, fashioned in both the Rococo and Neoclassical idioms. In the United States their designs were derived from imported English silver and silver-

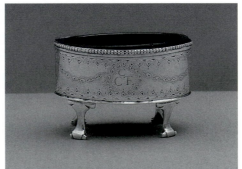

M82

plate.[2] The Bayou Bend salt is an ambitious elucidation of Neoclassicism, possessing a naive charm that reveals the work of a talented craftsman.

PROVENANCE: Conradt Ten Eyck (1741–1832) and Charlotte Ten Eyck (b. 1751); to their daughter Maria (Mrs. Jonas Bronck); to her daughter Charlotte (Mrs. Abraham Houghtaling, 1799–1891); to her daughter Emma Agusta (Mrs. Alonzo Newbury, 1840–1913); to her daughter Mary (1880–1965); to her sister Helen (Mrs. Ned Sayford, 1878–1970); to her daughter Mary Helen (Mrs. Raybourne Thompson).

TECHNICAL NOTES: The base is a cut-out oval. The body is seamed on the side. The pearlwork border appears to be handworked. The red glass liner may be original.

ENGRAVED: C C E [Conradt and Charlotte Ten Eyck] (side).

RELATED EXAMPLES: Most closely related is a pair engraved for Maria Egberts (1748–1819), in Rice 1964, p. 30. In 1776 she married Antony Ten Eyck, a son of Jacob C. Ten Eyck (1705–1793), the Albany silversmith, and a brother of Conradt, who originally owned Bayou Bend's salt. While it would be natural to assume that their silver was a product of the Ten Eyck shop, the Egberts's salts are marked with Jacob Gerritse Lansing's stamp. They are supported by cast scrolled legs seemingly identical to those on the Bayou Bend salt and retain what are believed to be their original red glass liners. The visual and family relationships between these objects is the basis for attributing the Bayou Bend salt.

1. For Lansing (act. ca. 1757–1803), see Rice 1964, p. 70.
2. McKinstry 1984, no. 1658.

M83
Pair of Salt Dishes

1852
William Gale, Son & Co. (act. 1850–53), New York[1]
1⁷/₈ x 3¹/₄ x 3¹/₄" (4.8 x 8.3 x 8.3 cm)
Gift of Fred Nevill, B.92.2–.3

With their foliate and scroll ornament, these salt dishes are beguiling expressions of the Rococo Revival. They retain their green glass liners, which are in all likelihood the product of an American manufactory.

PROVENANCE: Fred M. Nevill, Houston.

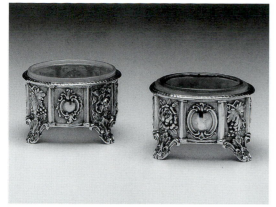

M83

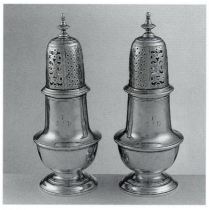

M84

vol. 1, pp. 99–100, no. 113, Spokas et al. 1980, p. 90, no. 104; and one belonging to the MMA (acc. no. 24.109.30).

REFERENCES: Phillips 1939, p. 21, no. 18B-C; Warren 1975, p. 160.

1. See cat. no. M7.
2. In a rare instance a set of casters, marked by Wilmington, Delaware, silversmith Bancroft Woodcock (1732–1817), are engraved "Black Pepper," "Cayenne Pepper," and "Sugar" (Schwartz 1993, no. 21).
3. Minor's correspondence offers a clue to the casters' provenance: "the parties from whom I obtained them thought the 'P' stood for the Parkman family. I should not feel any assurance, however, of this." The casters' date and combination of initials correspond with Samuel and Darcus Bowes Parkman, who married in 1729. Parkman's 1767 inventory lists 72 ounces of unitemized silver (Boston 1898, p. 151; Suffolk County Probate Court, Boston, vol. 66, pp. 189–90).

TECHNICAL NOTES: The base is a ring. The colonnaded sides are stamped out.

MARKED: Belden 1980, p. 181, William Gale & Son, b, with the numbers for the year 1852 within a diamond (base ring).

WEIGHT: B.92.2: 2 oz, 2 dwt; B.92.3: 2 oz, 2 dwt.

RELATED EXAMPLES: *Antiques* 95 (April 1969), p. 473.

1. For William Gale, Son & Co., see Green 1978a; Venable 1994, p. 319; Quimby 1995, p. 238. The chronology of this company is Gale & Stickler, 1821–23; John L. & W. Gale, 1825–27; Gale & Moseley, 1828–33; Gale, Wood & Hughes, 1833–45; Gale & Hayden, 1845–49; Wm. Gale, Son & Co., 1850–53; Wm. Gale & Son, 1853–59; Gale & Willis, 1859–62; Wm. Gale & Son, 1862–67; William Gale, Jr. & Co., 1867–68; Gale, North & Dominick, 1868–69; Gale & Corning, 1869–70; Gale, Dominick & Haff, 1870–72; Dominick & Haff, 1872–1928.

revolutionary period, when a Neoclassical urn shape replaced it.

PROVENANCE: [Shreve, Crump & Low, Boston]; purchased by Francis P. Garvan, New York; given to Yale University Art Gallery, New Haven; [James Graham and Son, New York, ca. 1940]; Edward Eastman Minor, about 1942. For their subsequent history see cat. no. M4.[3]

TECHNICAL NOTES: Both tops are pierced.

MARKED: Buhler and Hood 1970, vol. 1, p. 323, nos. 111–15 (neck).

ENGRAVED: S^PD (side).

WEIGHT: B.69.97.1: 4 oz, 1 dwt; B.69.97.2: 4 oz.

RELATED EXAMPLES: Other recorded John Burt casters include Buhler and Hood, 1970,

M84

Pair of Casters

1725–46
Shop of John Burt (1692/93–1745/46), Boston[1]
5½ x 2 3/16" (diam.) (14 x 5.6 cm)
B.69.97.1–.2

Spices accentuated food's flavor—or disguised it if it was spoiling—and functioned as a preservative.[2] By the 1650s English silversmiths began to fashion containers to store and to "cast" spices. The earliest casters were cylindrical, followed by pear-shaped and polygonal examples in the eighteenth century. The Burt casters' vase shape followed, introduced during the 1720s, and persisted until the post-

M85

Cruet Stand

ca. 1757–98
Shop of John David (1736–1798), Philadelphia[1]
9¼ x 7½ x 7¾" (23.5 x 19.1 x 19.7 cm)
Museum purchase with funds provided by the Friends of Bayou Bend, B.82.1

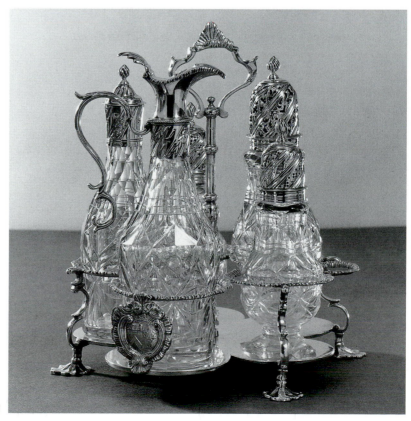

M85

Frames for casters were produced by English silversmiths by the early eighteenth century.[2] The cruet stand was also fitted with glass bottles for condiments such as dry mustard, sugar, pepper, catsup, vinegar, oil, and soy. Marked American examples are rare, as most colonial silversmiths probably chose to import cruet stands, it being more efficient and economical than attempting to produce the complex castings themselves. The close similarity between the Bayou Bend stand and contemporary English examples suggests that John David's shop derived the cast patterns directly from the latter.[3]

PROVENANCE: Presumably for the Chew family; auctioned by Samuel T. Freeman, Philadelphia, 1970[4]; purchased by Bayou Bend from F. J. Carey, III, Penllyn, Pennsylvania, 1982.

TECHNICAL NOTES: The base is cast, with reinforcing rings for the handle, casters, and bottles. The handle is threaded and screws into the base. The results of a nondestructive energy-dispersive X-ray fluorescence analysis are on file at Bayou Bend.

MARKED: Buhler and Hood 1970, vol. 2, p. 278, no. 853 (handle).

ENGRAVED: The Chew arms impaling a set of unidentified arms (cartouche).

WEIGHT: 25 oz, 5 dwt.

RELATED EXAMPLES: One other cruet stand bears John David's stamp, in Quimby 1995, pp. 348–49, no. 334. Other Philadelphia examples include one attributed to Jeremiah Elfreth, at Delaware State Museum, Dover; another with the stamp of William Hollingshead in a private collection; and a third by Joseph Richardson, Jr., and Nathaniel Richardson, in *Antiques* 97 (April 1970), p. 512. English examples with Philadelphia provenances are discussed in Backlin-Landman 1969; Lindsey 1993.

REFERENCES: Samuel T. Freeman, Philadelphia, December 14, 1970, lot 314; Brown 1987, p. 24.

1. For David (act. ca. 1757–98), see Buhler 1960c, p. 75; Whisker 1993, pp. 104–5; Quimby 1995, p. 348.
2. One of the earliest American references appears in Governor William Burnet's 1728 inventory (Fales 1970, p. 145).
3. Winchester et al. 1959, p. 187, no. 18.
4. At the time of the auction, the casters and bottles were separated from the stand and offered as a second lot, no. 315.

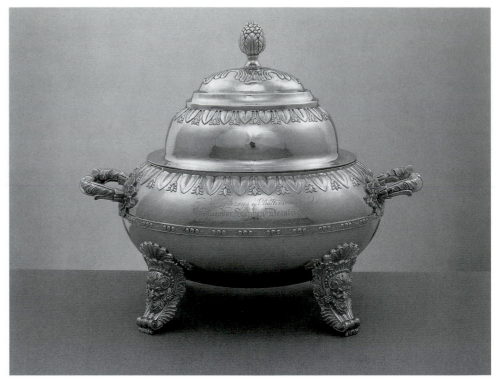

M86

M86

Soup Tureen

1817
Manufactory of Andrew Ellicott Warner
(1786–1870), Baltimore[1]
12½ x 14¾ x 9½" (31.8 x 37.5 x 24.1 cm)
Museum purchase with funds provided by the
Theta Charity Antiques Show in honor of
Betty Black Hatchett, B.80.6

The War of 1812 produced a column of heros and occasions that were immortalized in silver. Thomas Fletcher and Sidney Gardiner fashioned the earliest of these great vessels, a covered vase weighing over 500 ounces that the citizens of Philadelphia presented to Captain Isaac Hull in 1812.[2] Not all of these commissions were for monumental trophies; some assumed the form of domestic vessels. While there is some discrepancy as to the size of the Decatur service, Andrew Ellicott Warner's accounts record the commission at six thousand dollars.

In 1761 Joseph Pinto, a New York silversmith, advertised a "very fine silver chass'd turene, dish and spoon," yet prior to the mid-nineteenth century the form remained uncommon, undoubtedly due to the amount of silver required, combined with high production costs.[3] The Warner shop's inspiration for this remarkable ves-

sel is not recorded; however, its satyr-mask feet were probably inspired by English castings.[4] The *Niles' Weekly Register* (September 13, 1817) described the completed Decatur service: "The work was executed by Mr. A. E. Warner, of Baltimore, and may bear a comparison with any thing of the kind. It is truly superb."

PROVENANCE: Stephen Decatur, Jr. (1779–1820), Washington, D.C.; to his widow, Susan Wheeler Decatur; purchased by Bayou Bend from Bernard and S. Dean Levy, New York, 1980, who noted its descent in the Fitzgerald family, Baltimore, and the Lodento family, New Jersey.

TECHNICAL NOTES: The body is raised as a single piece; its midband is purely decorative. The finial is vented.

MARKED: Pleasants and Sill 1972, p. 195, no. 9 (underneath bowl).

ENGRAVED: The Citizens of Baltimore to / Commodore Stephen Decatur / Rebus gestis insigni: Ob virtutes dilecto [Renowned for his valor; beloved for his virtues] (side).

WEIGHT: 130 oz, 17 dwt.

RELATED EXAMPLES: The entire Decatur service is discussed under References. Period documents indicate that it originally included two soup tureens, but the whereabouts of the second is not known. Two smaller tureens, intended for sauce, were also part of the service (Brown 1983a, pp. 400–401). Warner adapted

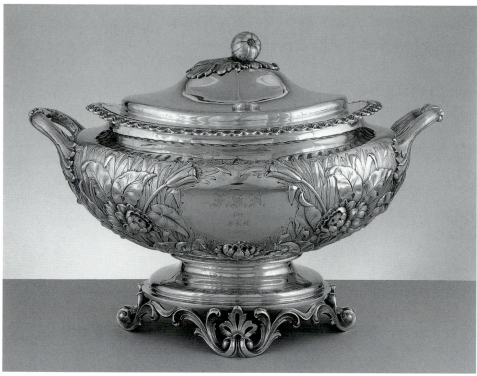

M87

some of the tureen's motifs for the engraved soup tureen depicted on his trade card.

REFERENCES: Warner's bill of lading for the full service is in the files of the Maryland Historical Society.[5] The *Niles' Weekly Register*, September 13, 1817, publishes a slightly different inventory.[6] For the set, see Pleasants and Sill 1972, p. 193; *Antiques* 116 (November 1979), p. 937; Goldsborough et al. 1981, pp. 14–17; *Antiques* 122 (September 1982), p. 416; *Antiques* 124 (September 1983), p. 426; Brown 1983a, pp. 400–401; Brown 1985, pp. 518–19; Warren, Howe, and Brown 1987, pp. 109–10, no. 131; Brown, Warren, and Howe 1988, p. 276; Marzio et al. 1989, pp. 254–55; Weidman et al. 1993, pp. 149, 152.

1. See cat. no. M76.
2. Cooper 1993, pp. 240–41, nos. 193, 194.
3. Gottesman 1938, p. 57.
4. The only other American silver vessel that employs satyr-mask feet is the great tureen and stand by Simon Chaudron (Hood 1971, pp. 201–3, no. 226). This motif may be patterned after English silver, such as the silver-gilt fruit stand Paul Storr supplied to the first duke of Wellington (Penzer 1954, pp. 144–45, pl. XXXIII).
5. It enumerates a candelabrum, two ice pails, two soup tureens, two twenty-three-inch oval dishes, two sixteen-inch oval dishes, four sauce tureens, and a vase with a gilded interior.
6. According to the paper it comprised a candelabrum (private collection), two soup tureens, two twenty-one-inch dishes, two seventeen-inch dishes (MMA; Decatur

House), four fifteen-inch dishes (two at Decatur House), two vegetable dishes (Decatur House), and two sauce tureens (private collection).

M87

Soup Tureen

ca. 1858
Gorham Manufacturing Company (act. 1831–present), Providence[1]
11¾ x 16⅛ x 10¼" (29.8 x 41 x 26 cm)
Museum purchase with funds provided by the Houston Junior Woman's Club, B.95.1

By the mid-nineteenth century the Gorham Manufacturing Company had achieved a reputation for some of the finest silver then produced in America. The Bayou Bend soup tureen eloquently manifests the company's advanced design work as well as its technical capabilities.

In 1831 Jabez Gorham (1792–1869) established the Gorham Manufacturing Company, which during the first two decades of its operation limited its output largely to flatware. As the company expanded its production lines during the 1850s, its accompanying growth is readily apparent in the Gorham records. In 1850 it employed just fourteen workers and reported an-

nual sales at $29,000. By the end of that decade, its workforce had increased to two hundred, with sales falling just short of $400,000.

The Bayou Bend soup tureen dates from this dynamic period in the company's early history. It is an unusually complex and rich interpretation of the form, executed in the style now known as the Rococo Revival. The lush, three-dimensional repoussée flowers and leaves are of a character and quality rarely encountered in any medium during this period. This naturalistic profusion introduced a precedent for the taste and interpretation that characterize the Aesthetic Movement a generation later.[2]

PROVENANCE: Frances S. Newman (Mrs. Arthur B. Griswold, 1838–1915, married 1858), New Orleans[3]; purchased by Bayou Bend from Constantine Kollitus, New York, 1995.

TECHNICAL NOTES: The scrolled feet are cast, the foot, bowl, and lid are raised. At one end of the lid is an ogival cutout for a ladle. The gourd finial is cast in two parts. The knop is bolted to the lid and is further secured by a guidepost that slips through a hole drilled in the lid. The interior retains much of its original gilding.

MARKED: Carpenter 1982, p. 282, no. 10. GORHAM & CO, COIN, with the standard three Gorham marks (underneath body).

ENGRAVED: F.S.N. / from / S.E.M. / 1858. [Frances S. Newman] (side, the identity of the second set of initials has not been determined); 9 7 / 4 VEITS (over) VE- (over) VE- (with a line below) and VOITS (scratched in the well).

WEIGHT: 96 oz, 17 dwt.

RELATED EXAMPLES: Tureens by William Gale & Son are similar in contour, in McClinton 1968, p. 54; Venable 1994, p. 59.

REFERENCES: Burton 1997, p. 224d.

1. Gorham Manufacturing Company's vast archive is in the John Hay Library, Brown University, Providence, Rhode Island. The most complete study of the company is given in Carpenter 1982.
2. Hanks and Toher 1986, p. 254, fig. 8.2; Venable 1994, pp. 134–35, fig. 6.11.
3. Arthur B. Griswold (1829–1877) was the successor to the well-known firm Hyde & Goodrich, New Orleans, as well as the former's store. Coincidentally, his company became the New Orleans agent for Gorham. A sketch of A. B. Griswold & Co. is published in Mackie, Bacot, and Mackie 1980, pp. 56–58.

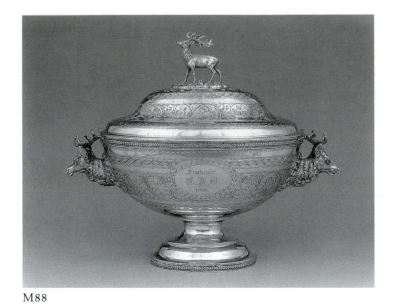

M88

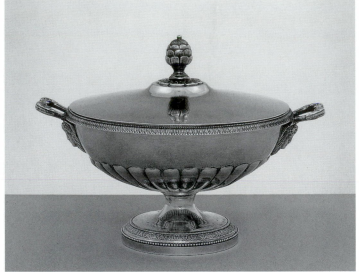

M89

M88

Soup Tureen

ca. 1860
Manufactory of William Forbes (1799–after 1864), New York[1]
Ball, Black & Co. (act. 1851–74), New York, retailer[2]
13⅛ x 15¾ x 9" (33.3 x 40 x 22.9 cm)
Museum purchase with funds provided by Shell Oil Company Foundation, B.96.22

This fantastically conceived and executed soup tureen, with its profuse engraving and realistic castings of stag heads and what appears to be a cross between an elk and a moose, certainly must be among the most complex, costly examples of the form produced up to this date. Its iconography recalls hunting, foodstuffs, and dining, all themes espoused earlier in Dutch and French painting. By the mid-nineteenth century these motifs could be interpreted variously, ranging from humanity's attempts to conquer nature to an effort to transform the commonplace act of eating into the civilized ceremony of dining. The soup tureen evokes an abundance intended to convey a sense of plenty, as well as a spirit and lifestyle wholly appropriate for a richly appointed dining room of the day.

PROVENANCE: Auctioned by Sotheby's, New York, June 22, 1995; purchased by Bayou Bend from Constantine Kollitus, New York, 1996.

TECHNICAL NOTES: The foot is seamed. The stem, bowl, and cover are raised. The cast

handles are vented. The finial, incorporating a cast base, is bolted to the lid.

MARKED: See cat. no. M14.

ENGRAVED: Souvenir / C.A.D. / 1860 (side).

WEIGHT: 83 oz, 14 dwt.

RELATED EXAMPLES: Campbell 1972, no. 28.

REFERENCES: Sotheby's, New York, sale 6731, June 22, 1995, lot 375.

1. See cat. no. M14.
2. See cat. no. M14.

M89

Set of Sauce Tureens

1805–19
Shop of Simon Chaudron (1758–1846), Philadelphia[1]
Each, 6 x 8⅛ x 6½" (15.2 x 20.6 x 16.5 cm)
Museum purchase with funds provided by the Sarah Campbell Blaffer Foundation, B.86.15.1–.3

The sauce tureen was introduced as an alternative to the sauceboat. The earliest English sauce tureens are in the Neoclassical style, while in the United States the form is unknown prior to the nineteenth century. The Bayou Bend tureens divulge Simon Chaudron's French origins and his shop's refined interpretations of the Grecian aesthetic.

PROVENANCE: Purchased by Bayou Bend from S. J. Shrubsole, New York, 1986.

TECHNICAL NOTES: The feet are assembled from two elements, as are the stems and

bowls. Each handle support is a female classical mask. The finials are bolted.

MARKED: CHAUDRON and STER·AMERI·MAN· (foot).

ENGRAVED: The tureens are numbered on the foot and lid to ensure that both components are properly matched.

WEIGHT: B.86.15.1: 23 oz, 11 dwt; B.86.15.2: 24 oz, 4 dwt; B.86.15.3: 24 oz, 2 dwt.

1. For Chaudron, see PMA 1976, pp. 226–27; Cormany 1992; Miles 1994, p. 268, no. 157; Quimby 1995, p. 339.

M90

Entree Dish

ca. 1830–42
Manufactory of Thomas Fletcher (1787–1866), Philadelphia[1]
5⅝ x 12 x 9¾" (14.3 x 30.5 x 24.8 cm)
Museum purchase with funds provided by Fayez Sarofim in honor of Gillian Stude Sarofim at "One Great Night in November, 1994," B.94.14

The entree dish was first produced in England during the 1770s and in the United States approximately a half century later. Its introduction may have been

in response to the evolution of dining customs, as well as to economic factors. After the household staff brought the entree dishes into the dining room and served the guests, the dishes remained, thereby reducing the number of servants required and allowing the diners greater privacy. In England the entree dish more often was made of fused (Sheffield) silver plate, and it is plausible that this example was patterned after an imported one. Fletcher's preparatory drawing for this dish, or one like it—quite possibly the earliest American example of this form—survives in a collection of his designs.[2]

PROVENANCE: Purchased by Bayou Bend from Constantine Kollitus, New York, 1994.

TECHNICAL NOTES: The foliate, scrolled handle is a separate component; when rotated, it unlocks and can be removed. The lid can then be reversed and used as a second dish. Its interior rim is embellished with a scaled-down version of the same decorative border used on the larger dish.

MARKED: Belden 1980, p. 169, a (base).

ENGRAVED: H.G.E. (lid, added later).

WEIGHT: 76 oz, 3 dwt.

RELATED EXAMPLES: This is the only entree dish known from Thomas Fletcher's shop. Other early examples include *Antiques* 136 (September 1989), p. 426; Conger 1991, p. 364, no. 232; Fowler 1993, p. 28; and an example marked by Edward Lownes at the MFA, Boston (acc. no. 1994.33).

REFERENCES: *Antiques* 139 (January 1991), p. 178; Burton 1997, p. 224f.

1. For Fletcher (act. ca. 1830–42), see cat. no. M72.
2. MMA, The Elisha Whittelsey Collection, acc. no. 53.562.22.

M91

Covered Vegetable Dish

1876
Manufactory of Dominick & Haff (act. 1872–1928), New York[1]
Bailey & Company (act. 1848–78), Philadelphia, retailer[2]
7⅞ x 13¾ x 8⅛" (20 x 34.9 x 20.6 cm)
Gift of Anne Rowland, Williamsburg, Virginia, B.82.10

Allover repoussé decoration reached its height during the second and third quarters of the nineteenth century. While this excess of ornament has long been identified with Baltimore silver, examples such as this vegetable dish bear witness that it also enjoyed a degree of popularity in other geographic centers.

PROVENANCE: Annie Margaret Fitler (Mrs. Charles Harkness Howell, 1851–1937, married 1880); to her daughter Cecile F. Howell (Mrs. William O. Rowland, Jr., 1893–1953); to her daughter, Anne Rowland.

TECHNICAL NOTES: The dish consists of a foot, bowl, molded rim, lid, and handles. The central handle can be unlocked and removed and the lid used as a second dish.

MARKED: Rainwater 1966, p. 41, which includes the numbers for 1876 within a diamond (base).

ENGRAVED: AMF [Annie Margaret Fitles] (side); 9027 and 282 (scratched on base).

WEIGHT: 56 oz, 16 dwt.

RELATED EXAMPLES: Sotheby's, New York, sale 5809, January 27, 1989, lot 810.

1. Venable 1994, p. 318.
2. See cat. no. M77.

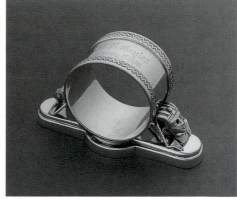

M92

M92

Napkin Ring

ca. 1868
Unknown maker
2⅛ x 1⅜ x 3⅝" (5.4 x 3.5 x 9.2 cm)
Gift of Jas A. Gundry in honor of Jeanne Cunningham, B.95.19

"Fold your napkin when you are done with it and place it in your ring, when at home. If you are visiting, leave your napkin unfolded beside your plate."[1] This period directive clarifies that the napkin ring, first introduced during the 1830s, was intended for daily use by the family or boardinghouse residents, thereby reducing the need to launder napkins. The Bayou Bend example responds to the vogue for Egyptian design in the late 1860s, a period when the world focused its attention on Khedive Ismail Pasha's modern nation (1863–1879) and its ambitious program of reforms and innovations.

TECHNICAL NOTES: The base is a separate component, secured by a bolt and guideposts.

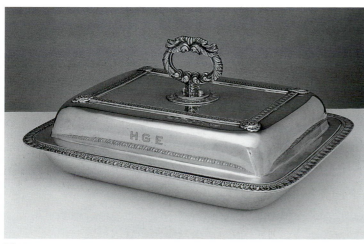

M90

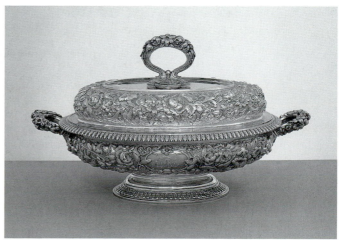

M91

ENGRAVED: M.E. Cuyler / January 1st 1868 (exterior band).

WEIGHT: 2 oz, 10 dwt.

1. Williams 1985, p. 44.

M93

Pair of Candlesticks

1730–70
Unknown maker, probably New York
B.83.2.1: 6¾ x 3¾ x 3¹³⁄₁₆" (17.1 x 9.5 x 9.7 cm);
B.83.2.2: 6¾ x 3¹³⁄₁₆ x 3¹³⁄₁₆" (17.1 x 9.7 x 9.7 cm)
Museum purchase with funds provided in memory of Shirley Briscoe, B.83.2.1–.2

In December 1773 Philip Vickers Fithian recorded his impressions of a holiday party: "The room looked luminous and splendid; four very large candles burning on the table where we supp'd, three others in different parts of the Room"[1] Candles were costly, and whether made of animal or vegetable fat, they were inefficient. Silver candlesticks are a rare form in colonial America. The earliest were wrought from sheet metal, but by the second quarter of the eighteenth century casting became the standard method of production, the patterns being taken directly from imported English silver or brass examples.[2]

PROVENANCE: Johanna Staats (Mrs. Anthony White, b. ca. 1694, married 1716); to her son Anthony White (1717–1787); to his son Brigadier General Anthony Walton White (1750–1803); to his daughter Elizabeth Mary (Mrs. Thomas M. Evans, 1792–1861); to her daughter Elizabeth Margaret Evans (1813–1898) or her son Thomas Sunderland Evans (1819–1868); to Thomas Evans's daughter Transita Isabella (Bellita) Evans (Mrs.

M93

M94

Stephen Watts Kearny, before 1868–1950); to Dr. and Mrs. Royall M. Calder, San Antonio, Texas[3]; purchased by Bayou Bend from Mrs. Calder's estate, 1983.

TECHNICAL NOTES: The base was cast separately, the shaft in two halves, which were soldered together. The undersides were not skimmed. The results of a nondestructive energy-dispersive X-ray fluorescence analysis are on file at Bayou Bend.

ENGRAVED: ⅃S [Johanna Staats] (bottom).

WEIGHT: B.83.2.1: 14 oz, 8.1 dwt; B.83.2.2: 14 oz, 0.3 dwt.

RELATED EXAMPLES: More surviving colonial candlesticks come from New York than from any other center. Marked examples include those by Simeon Soumain (*Antiques* 43 [May 1943], p. 224); Charles Le Roux (Hood 1971, p. 123); Adrian Bancker (Parke-Bernet, Galleries, New York, sale 1202, November 29–December 2, 1950, lot 582); George Ridout (Buhler and Hood 1970, vol. 2, pp. 122–23, no. 694; Puig et al. 1989, p. 249, no. 204); and William Anderson (*Antiques* 52 [September 1947], p. 198).

1. Farish 1943, p. 45.
2. A pair of London tapersticks with an

American provenance are recorded in Sotheby's, New York, sale 6660, January 24, 26, 27, 30, 1995, lot 1452.
3. Cat. nos. M59 and M120 also descended in this family (Staats 1921).

M94

Vase

1832
Shop of John Ewan (1786–1852), Charleston[1]
13 x 9" (diam.) (33 x 22.9 cm)
Museum purchase with funds provided by William James Hill and Miss Ima Hogg, by exchange, B.88.19

This classically inspired vase is the most distinguished example of Charleston silver dating from the first half of the nineteenth century. It was commissioned by a group of the Reverend Samuel Gilman's Charleston admirers to recognize the patriotic ode he penned advocating national unity. John Ewan was awarded the prestigious commission and probably patterned his design after im-

ported porcelain. On its completion local newspapers announced that the vase could be viewed in the silversmith's King Street shopwindow prior to its official presentation. Gilman and his descendants highly prized the vase, and they preserved its official letter of presentation and a nineteenth-century photograph showing it prominently displayed on a specially designed shelf in the family home.

PROVENANCE: The Reverend Samuel Gilman (1791–1858), Charleston; to his widow, Caroline Howard Gilman (1794–1888); to her daughter Abby Louisa Gilman (Mrs. Francis Porcher, 1820–1883); to her daughter Louisa Porcher (1855–1937); to her cousin Marguerite Allen Sinkler (Mrs. Howard Alston Deas, 1895–1984); to her daughter Milward Blamyre Deas (Mrs. Lucian Whitaker Pinckney), Palm Desert, California; purchased by Bayou Bend from Mrs. Pinckney through V. C. Schwerwin, Charleston, 1988.

TECHNICAL NOTES: The urn is raised, composed of a base, a two-part stem, the body, and cast handles.

MARKED: Belden 1980, p. 160, b (on each side of the plinth).

ENGRAVED: An American eagle, clutching a scroll inscribed E PLURIBUS UNUM. Below, within a wreath of palm and laurel: TO THE AUTHOR / of The National Ode written / for the 4th of July 1831, / The Revd Samuel Gilman / and as a tribute of affectionate respect / for the Patriot the Scholar / and The Poet / the friends of National Union / have Presented / THIS VASE. / Charleston So. Ca (side); 63–13 (base). On the reverse, framed by engraved laurel branches, the poem that Gilman penned for the Union meeting of July 4, 1831:

THE ODE

I
Hail, our country's natal morn,
Hail, our spreading kindred-born!
Hail, thou banner, not yet torn,
 Waving o'er the free!
While, this day, in festal throng,
Millions swell the Patriot-song,
Shall not we thy notes prolong,
 Hallow'd Jubilee?

II
Who would sever Freedom's shrine?
Who would draw the invidious line?
Though by birth, one spot be mine,
 Dear is all the rest:—
Dear tome the South's fair land,
Dear, the central Mountain-band,
Dear, New-England's rocky strand;
 Dear the prairied West.

III
By our altars, pure and free,
By our Law's deep rooted tree,
By the past's dread memory,
 by our WASHINGTON;
By our common parent tongue,
By our hopes, bright, buoyant, young,
By the tie of country strong—
 We will still be ONE.

IV
Fathers! have ye bled in vain?
Ages! must ye droop again?
MAKER! shall we rashly stain
 Blessings sent by THEE?
No! receive our solemn vow,
While before thy throne we bow,
Ever to maintain, as now,
 "UNION-LIBERTY!"

WEIGHT: 62 oz, 15 dwt.

REFERENCES: *Charleston Courier*, April 24, 1832; Saint-Amand 1941, pp. 26–29; Burton 1942, p. 55; Belden 1980, p. 160; Andrews 1982, p. 65; Cooper 1993, pp. 246–47, no. 199.

1. For Ewan, see Rose 1928, p. 306; Burton 1942, pp. 54–57.

M95

Whistle, Bells, and Coral

1727–57
Shop of Thauvet Besley (d. 1757), New York[1]
5½ x 2¼" (diam.) (14 x 5.7 cm)
Museum purchase with funds provided by William James Hill, B.87.11

On occasion silver was used to fashion a variety of forms intended for children, including toys, porringers, and the whistle, bells, and coral. Recorded in England by the mid-seventeenth century and in America as early as 1675, a "whissle silver chain and childe's bell" was inventoried in the Boston estate of Captain John Freake. As the whistle and bells entertained, the coral functioned as a teether, and, at a time characterized by a high infant mortality rate, it was also believed to be an amulet to protect children from the evils of the underworld.[2] It was an extremely popular form, as evidenced by the Philadelphia silversmith Joseph Richardson's letter book, which in 1759 alone recorded orders for no fewer than sixty-eight "Correll & Bells." While the accounts

confirm his shop produced the form, the scarcity of marked examples implies that it was more economical to purchase and import them from a London specialist.

The Bayou Bend whistle, bells, and coral is the only known example from Thauvet Besley's shop. Fashioned in the Late Baroque style, it assumes a complex hexagonal shape rather than the usual octagonal one. Its masterful proportions were perhaps inspired by designs for a church pulpit from an architectural pattern book.[3] The mounted coral suggests a collaboration between the silversmith and jeweler; coincidentally, Besley advertised that "Peter Lorin, a Jeweller, from London who setts after the neatest & Newest Fashions, all sorts of Jewels," could be contacted at his house.[4]

M95

PROVENANCE: William T. H. Howe (ca. 1872–1939), Cincinnati, Ohio; Mrs. Lena D. Howe, by 1946; auctioned by Parke-Bernet Galleries, New York, November 9, 1946; Mark Bortman (1896–1967); to Bortman's daughter, from whom it was purchased by Bayou Bend through William Core Duffy, Kittery Point, Maine, 1987.

TECHNICAL NOTES: One of the eight bells is lost. The results of a nondestructive energy dispersive X-ray fluorescence analysis are on file at Bayou Bend.

MARKED: Belden 1980, p. 59 (whistle).

ENGRAVED: RG [presumably the original owner]; RS and RMC (whistle, added later).

RELATED EXAMPLES: The majority of the marked American examples of the whistle, bells, and coral in silver and gold are by New York silversmiths: Daniel Christian Fueter (Buhler and Hood 1972, vol. 2, pp. 134–35, no. 716); George Ridout (Blackburn et al. 1988, pp. 194–95); Nicholas Roosevelt; and Richard Van Dyck (Libin 1985, pp. 40–41, nos. 11, 12).

REFERENCES: Parke-Bernet Galleries, sale 805, November 9, 1946, lot 3; Buhler 1960a, p. 85; Buhler 1960b, p. 71; Buhler 1960c, p. 42, pl. 31; Hansen 1981, p. 1429; Brown 1987, pp. 25–26.

1. For Besley (act. 1727–57), see Buhler 1960c, p. 72.
2. Davidson 1951, pp. 140–41; Ball 1961; McClinton 1970a, pp. 22–29; Hansen 1981; Cramer 1992a.
3. Mussey and Haley 1994, p. 77, fig. 6.
4. In 1746 Besley advertised that Lorin could be found at his house (Gottesman 1938, p. 30). Five years later Lorin advertised that he had moved from Captain Troup's house to Mr. Peck's (Gottesman 1938, p. 70).

M96

Pap Boat

1809–27
Shop of Louis Boudo (1786–1827), Charleston[1]
1⁷⁄₁₆ x 2¾ x 5½" (3.7 x 7 x 14 cm)
Gift of William James Hill, B.85.12

The pap boat is a simple vessel for feeding infants and invalids pap, a concoction of bread or flour sprinkled with sugar combined with milk or water.[2] The form appears in English silver by the second decade of the eighteenth century and in the American colonies by 1738, when Joseph Richardson records making one.[3] The number of extant Charleston exam-

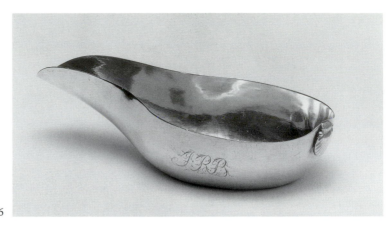

M96

ples attests to its popularity there, and Louis Boudo's are distinctive for the addition of a decorative scallop shell on the back. The form persisted well into the nineteenth century, as evidenced by Tiffany's 1880 *Blue Book*.[4]

PROVENANCE: Purchased for Bayou Bend by William James Hill from Argentum Antiques, San Francisco, 1985.

MARKED: Belden 1980, p. 69 (base).

ENGRAVED: JRB (side).

WEIGHT: 2 oz, 3 dwt.

RELATED EXAMPLES: An identical pap boat is pictured in Warren 1968, I-1-B. A simpler example is recorded in a private collection.[5]

REFERENCES: Brown 1987, pp. 29–30.

1. For Boudo (act. 1809–27), see Rose 1928, p. 306; Burton 1942, pp. 27–28.
2. *Antiques* 10 (November 1926), p. 358.
3. *Antiques* 6 (December 1924), pp. 300–302; *Antiques* 28 (December 1935), p. 233; Fales 1974b, pp. 125–26.
4. Carpenter and Carpenter 1978, p. 137.
5. Museum of Early Southern Decorative Arts, Winston-Salem, North Carolina, research files, no. S-9854 A, B.

M97

Medal

ca. 1850
Manufactory of Samuel Kirk & Son (act. 1846–1861, 1868–96), Baltimore[1]
³⁄₁₆ x 2⅜" (diam.) (0.2 x 6 cm)
Museum purchase with funds provided by the Bayou Bend Docent Organization, B.88.22

Precious metals have traditionally been used for medals and awards. The majority

of early American examples were presented to military allies, particularly Indian chiefs; to students to acknowledge their academic achievement; to members of organizations such as the Society of Cincinnati, the Masons, agricultural, and other associations. The Bayou Bend medal is inscribed to "Miss J. Jones," a young African-American woman, and recognizes her proficiency at needlework. It was presented by Dr. Daniel Alexander

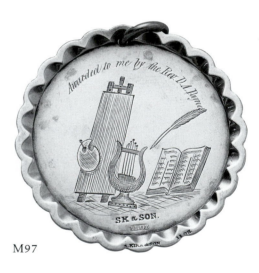

M97

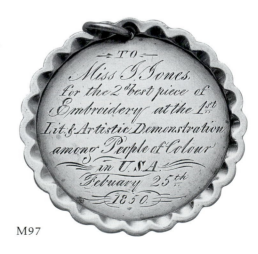

M97

Payne (1811–1893), a prominent leader in the African Methodist Episcopal Church.[2] In 1849 he organized the first "Literary and Artistic Demonstration for the Encouragement of Literature and the Fine Arts among the Colored Population" in an effort to cultivate artistic talents through the church.

PROVENANCE: Probably Jane E. Jones (b. ca. 1832), Rockerle, Montgomery County, Maryland[3]; private collection, California; purchased by Bayou Bend from Argentum Antiques, San Francisco, California, 1988.

TECHNICAL NOTES: The medal's face and rims comprise three separate components soldered together.

MARKED: SK & SON. (incuse) and 11.OZ in a rectangular recess (both stamps on face near rim); S.KIRK & SON and 11 OZ. (incuse, on rim), Goldsborough 1983, p. 264, no. 164, bottom.

ENGRAVED: Awarded to me by the Rev. D.A. Payne [with an easel, palette, lyre, song book, and quill pen (face)]; To / Miss J. Jones, / for the 2d best piece of / Embroidery at the 1st / Lit. & Artistic Demonstration / among People of Colour / in U.S.A. / February 25th. / 1850 (reverse).

WEIGHT: 1 OZ, 17 dwt.

REFERENCES: *Baltimore Sun,* February 25, 1850, announces the demonstration and cites the categories; Payne 1891, pp. 459–60; Fales 1995, p. 271.

1. See cat. no. M63.
2. Smith 1894; Bragg 1925, pp. 20–21; Payne 1891.
3. The 1850 Maryland census identifies only one African-American who could have been the medal's recipient, Jane E. Jones, the eighteen-year-old daughter of Mary and William Jones, Rockerle, Montgomery County. The family is not listed in the 1860 federal census for Maryland.

M98

Snuffbox

ca. 1840
J. Hayden (act. ca. 1840), Columbus, Georgia, probably retailer[1]
¾ x 1¹¹⁄₁₆ x 2⅞″ (0.8 x 4.3 x 7.3 cm)
Museum purchase with funds provided by the Houston Junior Woman's Club, B.80.5

Snuff, a tobacco derivative, was first produced in the late seventeenth century, and

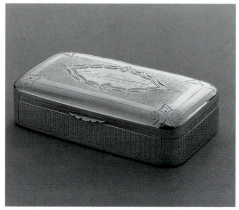

M98

shortly thereafter the snuffbox made its appearance. These diminutive containers, patterned after tobacco boxes, were fabricated in materials such as horn, wood, brass, tortoiseshell, enamels, porcelain, silver, and even gold. The boxes were personal and precious objects, often embellished with engraved or raised decoration. This example is engine-turned, a process introduced during the second quarter of the nineteenth century.

PROVENANCE: S. J. Hubbard; purchased by Bayou Bend from William Core Duffy, New Haven, 1980.

TECHNICAL NOTES: The lid is fitted with a seven-part hinge.

MARKED: Farnham and Efird 1971, p. 384, no. 11 (flange).

ENGRAVED: S. J. Hubbard (lid).

WEIGHT: 1 OZ, 16 dwt.

1. For Hayden, see Cutten 1958, p. 47.

M99

Snuffbox

1853
Manufactory of Albert Coles (1815–1877), New York[1]
1 x 3⁷⁄₁₆ x 2⅜″ (2.5 x 8.7 x 6 cm)
Museum purchase with funds provided in honor of David B. Warren's 25th anniversary with the Museum of Fine Arts, Houston, B.91.1

Albert Coles was one of the nineteenth-century's foremost manufacturers of flatware in the United States, in addition to supplying cups, goblets, napkin rings,

bouquet holders, portemonnaies, infant's rattles, and coffin plates, as well as matchboxes, tobacco boxes, and snuffboxes. This box, poignantly engraved to Coles from his employees, regrettably fails to elucidate on the occasion for its presentation.

PROVENANCE: Albert Coles; to his widow, Mary E. Coles; to Knox McAfee, the executor of her estate; Francis C. Lang, by 1910; purchased by Bayou Bend from Phyllis Tucker, Houston, 1991.[2]

TECHNICAL NOTES: The box is constructed with a seven-part hinge. Its interior is gilded, a standard practice, since snuff is corrosive.

MARKED: Belden 1980, p. 118; A.C & CO (rim); 925.

ENGRAVED: Albert Coles, / from, / his Workmen. (lid); a seated figure of Liberty similar to the composition on nineteenth-century coins (base).

WEIGHT: 3 OZ, 1 dwt.

RELATED EXAMPLES: Other Coles snuffboxes were auctioned at Christie's, New York, sale 7624, January 22, 1993, lot 58.

1. For Coles, see Venable 1994, pp. 317–18.
2. Accompanying the snuffbox is a handwritten note detailing its provenance.

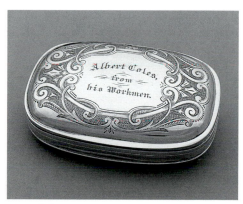

M99 (*lid*)

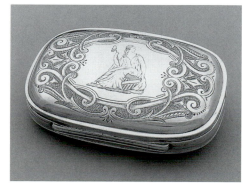

M99 (*base*)

M100

Calling Card Case

1847–50
Leonard and Wilson (partnership 1847–50),
Philadelphia[1]
3⅝ x 2⅝ x ⅜" (9.2 x 6.7 x 1 cm)
Gift of Phyllis and Charles Tucker in honor of
Rodney Angel, B.92.12

The calling card case probably evolved
from the eighteenth-century English
tablet, or writing, case. Intended for the
obligatory cards left when paying social
calls, they were particularly popular
among American women from the 1850s
through the 1920s. One social arbiter ad-
vised, "Gentlemen ought simply to put
their cards into their pocket, but ladies
may carry them in a small elegant portfo-
lio, called a card-case. This they can hold
in their hand and it will contribute essen-
tially (with an elegant handkerchief of
embroidered cambric,) to give them an
air of good taste."[2] The Bayou Bend card
case depicts the United States Capitol as it
appeared prior to 1851, when Thomas U.
Walter began supervision of the addition
of two outer wings and its landmark dome.

TECHNICAL NOTES: The design is stamped
out, its reverse embossed with a Rococo Re-
vival bouquet. The lid is hinged on one side.

MARKED: L & W (flange).

ENGRAVED: W.H.H.R. to M.A.R. (within a car-
touche on the lid).

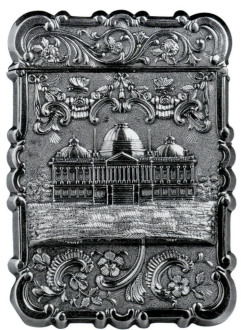

M100

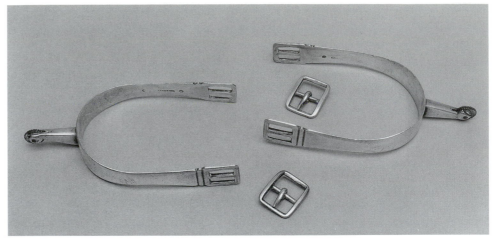

M101

WEIGHT: 1 oz, 14 dwt.

RELATED EXAMPLES: An identical case is as-
cribed to Tifft and Whiting, in Bishop and
Coblentz 1982, p. 176, pl. 203.

1. For Leonard and Wilson, see Whisker 1993,
 p. 195.
2. Ames 1992, pp. 35–43.

M101

Pair of Spurs and Buckles

1815–45
Shop of William Mitchell, Jr. (1795–1852),
Richmond, Virginia[1]
¾ x 2¹¹⁄₁₆ x 4¾" (1.9 x 6.8 x 12.1 cm)
Museum purchase with funds provided by
William James Hill, B.86.3.1–.2

As early as 1642 Kiliaen van Rensselaer
presented a pair of gold- and silver-plated
spurs to William Kieft, who represented
his American interests.[2] Spurs must be
counted among the more unusual com-
missions that the American silversmith
received. Paul Revere, Jr., never mentions
the form in his silversmithing accounts,
whereas Joseph Richardson's papers indi-
cate that he produced and imported both
silver- and close-plated examples, the latter
referring to steel dipped in tin with a sil-
ver foil burnished on.

PROVENANCE: Purchased by Bayou Bend
from Bernard and S. Dean Levy, New York,
1986.

TECHNICAL NOTES: The wheels, or rowels,
are iron and secured by pins.

MARKED: Cutten 1952, p. 153, second row, left,
with pseudohallmarks of an eagle and a head.

WEIGHT: 2 oz, 15 dwt (each).

REFERENCES: Brown 1987, pp. 29–30.

1. For Mitchell (act. 1815–45), see Cutten 1952,
 pp. 150–53.
2. Van Laer 1908, p. 624.

M102

Walking Stick

ca. 1862
Gold
Unknown maker, possibly New Orleans
36³⁄₁₆ x 1¹⁄₁₆" (diam.) (91.9 x 2.7 cm)
Gift of Mr. Edward House, B.93.27

The walking stick became a requisite of
fashion during the seventeenth century.
When crafted from exotic woods and
capped with a gold head, it was suddenly
elevated to an object of status.[1] The
Bayou Bend example carries an enigmatic
inscription. Captain Thomas Forbes, its
recipient, was a blockade runner during
the Civil War and is believed to have re-
ceived the walking stick, with a compass
mounted in the head, in recognition for
having outrun an enemy steamer and
safely returned to New Orleans from
Havana with desperately needed arms,
powder, and coffee.[2]

PROVENANCE: See cat. no. M76.

ENGRAVED: Capt Forbes / Presented by /
N.C.T. / Feb.y 9th 1862 [while the initials
imply an individual's name, they could stand
for Navigating Cuban Territory] (four sides of
the octagonal head).

1. Nelson 1937; Dike 1987.
2. An incident published six days after the date

M102

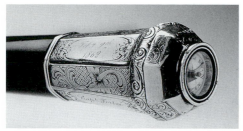

M102 (detail)

engraved on the head may reveal the presentation. The *Daily Picayune* of February 15, 1862, reported: "Safe Arrival of the Victoria.—This steamer commanded by Capt. Forbes, coming from Havana to this port with a valuable 'assorted' cargo attempting to pass into Barataria Bay, on Friday night, got aground, within about a mile of Fort Livingston. The next morning the Federal steamer South Carolina came up within about three miles of the Victoria, as near as the blockader dare venture, on account of the shallowness of the water, and opened fire upon the Victoria. Whilst exposed to his fire at long range, there were two hundred and eighty-five shells thrown at her by the enemy, but all but two, though many of them were disagreeably near, fell short of their aim. The damage done by those two was very significant. Relief was dispatched hence on Thursday night to the beleaguered steamer, and she was finally got off, with vessel, cargo, and everybody on board perfectly safe, and anchored under the guns of the fort. Part of her valuable freight has already come up to the city, and the rest will arrive duly. Three cheers for the Victoria and Capt. Forbes!"

M103

Masonic Jewel

ca. 1855
Gold
Attributed to the shop of John Eugene Smith (1816–1897), St. Louis, Missouri, and Galena, Illinois[1]
2⁹⁄₁₆ x 2³⁄₁₆ x ¹⁄₁₆" (6.5 x 5.6 x 0.1 cm)
Gift of Jas A. Gundry, B.93.21

Freemasons belong to an oath-bound secret fraternity, the purpose of which is to

develop sound moral and social virtues among its members and humankind. Its origins were in seventeenth-century England, and by the 1730s lodges were established in the American colonies. Many of the founding fathers of the United States, including George Washington, Benjamin Franklin, John Hancock, and their French ally the marquis de Lafayette, became members. The past master's jewel was regarded as both regalia and personal memento. Its design varied, and this example, its radiant sun framed within a square and quadrant, is patterned after one used in Scottish lodges.[2] This unmarked jewel, presented by Dubuque Lodge No. 3, may have been supplied by John Eugene Smith, who worked in nearby Galena.

PROVENANCE: General Caleb Hoskins Booth (1814–1877), Dubuque, Iowa[3]; by descent to Jas A. Gundry.

ENGRAVED: A carpenter's square and compass framing a radiating sun; Presented To Past Master CH Booth By Dubuque Lodge No. 3 (on reverse).

WEIGHT: 56 carat grains.

RELATED EXAMPLES: Hamilton 1994, pp. 134–39, nos. 4.38–4.41, 4.43–4.45.

1. John Eugene Smith (act. ca. 1836–ca. 1861) is little known for his tenure in the jewelry trade. His family emigrated from Switzerland and settled in Philadelphia, where he

M103

was apprenticed. In 1836 he established a jewelry business in St. Louis and later relocated to Galena, Illinois. During the Civil War he organized the Forty-fifth Illinois Infantry and in 1862 was appointed brigadier general, serving brilliantly throughout the remainder of the conflict. Later he was made brigadier general in the army and was stationed at a number of western outposts before retiring in 1881. A spoon from Smith's shop (see cat. no. M163) is also a gift of the donor, although there is no evidence to confirm that it belonged to Caleb H. Booth, it helps to support the jewel's attribution.

2. On the integration of Masonic symbols into American decorative arts, see Masonic Symbols 1976; Hamilton 1994, pp. 124–25.

3. Iowa 1894, pp. 217–18. Booth, a thirty-third-degree mason, served as master of Dubuque Lodge No. 3 in 1848, 1855, and 1856. The minutes of the October 18, 1855, meeting record the presentation.

M104

Pair of Sleeve Buttons

ca. 1744–75
Gold
Shop of Jonathan Otis (1723–1791), Newport and Middletown, Connecticut[1]
¹⁄₂ x 1 x ¹⁄₈" (1.3 x 2.5 x 0.3 cm)
Museum purchase with funds provided by the Sarah Campbell Blaffer Foundation, B.88.23

Sleeve buttons, predecessor to the cuff link, were popular throughout much of

M104

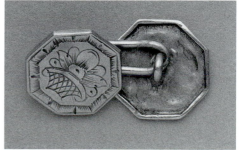

M104

the seventeenth and eighteenth centuries. They were fashioned from a variety of materials including stone, enamel, silver, and gold. The octagonal shape of the Bayou Bend sleeve buttons was favored during the second and third quarters of the eighteenth century.[2]

PROVENANCE: Fred Roberts; purchased by Bayou Bend from Argentum Antiques, San Francisco, 1988.

TECHNICAL NOTES: Each button has a rolled edge and an eye, the latter linked to its mate by an elongated ring. The results of a nondestructive energy-dispersive X-ray fluorescence analysis are on file at Bayou Bend.

MARKED: Flynt and Fales 1968, p. 292 (center mark).

WEIGHT: 6 carat grains (each).

RELATED EXAMPLES: Otis's only other published work in gold is a necklace, the clasp similarly engraved, in Bohan 1963, p. 34, no. 46.

1. For Otis (act. ca. 1744–75), see Carpenter 1954, p. 158; Flynt and Fales 1968, p. 292; Buhler 1970, vol. 2, p. 560.
2. Russell-Smith 1957; Noël Hume 1961; Fales 1995, p. 56.

M105

M105

Mourning Ring

ca. 1763
Gold
Shop of Houghton Perkins (1735–1778), Boston[1]
³⁄₁₆ x ¾″ (diam.) (0.5 x 1.9 cm)
Museum purchase with funds provided by the Friends of Bayou Bend, B.82.7

The mourning ring is the most prevalent form of gold jewelry surviving from colonial America. It is a tangible reminder of the elaborate funeral services staged in the period. For instance, in 1752 when Sarah Dennie died in Boston, her funeral expenses totaled more than six hundred

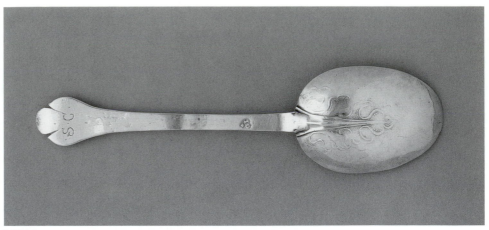

M106

pounds—or approximately 30 percent of the estate.[2] These rituals often included the presentation of gold rings to the most prominent mourners as a token of remembrance.[3] At various times the Massachusetts legislature attempted to limit these extravagances, but their efforts were never entirely successful. In the Bayou Bend ring, Houghton Perkins incorporated the symbolic death's head on the band.

PROVENANCE: Mark Bortman (1896–1967), Boston; to his daughter; purchased by Bayou Bend from Bortman's daughter through William Core Duffy, New Haven, 1982.

MARKED: Buhler 1972, vol. 1, p. 380, a (inside band).

ENGRAVED: E-Quill, Ob 1 July 1763 Æt 22 (inside band).[4]

WEIGHT: 8 carat grains.

RELATED EXAMPLES: While no other mourning ring bearing Perkins's stamp is known, this example relates to two others, one by Jacob Hurd and the other by his son Nathaniel, in Bohan 1963, pp. 20–21, no. 98; and Kernan 1966, p. 569, no. 4.

REFERENCES: Brown 1985, pp. 521–23; Warren, Howe, and Brown 1987, p. 71; Brown 1987, pp. 24–26; Kane 1998, p. 767.

1. For Perkins, see Flynt and Fales 1968, p. 297; Buhler 1972, vol. 1, p. 380; Kane 1998, pp. 766–67.
2. Warren, Howe, and Brown 1987, p. 71.
3. Morgan 1930; Fales 1964; Anderson and Anderson 1991; Fales 1995, pp. 23–27.
4. Elizabeth Harris and John Quill's 1762 wedding is recorded in Boston 1903, p. 420. Trinity Church's burial and funeral records specify a service for Elizabeth Quill on July 4, 1763 (Oliver and Peabody 1982, p. 779).

M106

Spoon

ca. 1680–1715
Shop of Jeremiah Dummer (1645–1718), Boston[1]
Length 7⁷⁄₁₆″ (18.4 cm)
Museum purchase with funds provided by the Houston Junior Woman's Club, B.88.21

Three early types of spoons, slip-end, disk-end, and Puritan spoons, are known from Boston silversmiths working during the third quarter of the seventeenth century. The last, with its notched end, later evolved into the trifid handle on the example by Dummer owned by Bayou Bend. It is the earliest type to employ a rat tail on the underside of its bowl, an addition that ensured a stronger joint with the handle. Raised foliate decoration and engraved owner's initials ornament the back. The trifid form remained popular at least through the first decade of the eighteenth century, when the wavy-end handle, a type not represented in the collection, began to replace it.

PROVENANCE: [George C. Gebelein, Boston]; Paul M. Hamlen; Mark Bortman (1896–1967); his daughter; William F. Kayhoe; purchased by Bayou Bend from Mary Kayhoe Irvin through William Core Duffy, Kittery Point, Maine, 1988.

TECHNICAL NOTES: The results of a nondestructive energy-dispersive X-ray fluorescence analysis are on file at Bayou Bend.

MARKED: Buhler and Hood 1970, vol. 1, p. 325, nos. 7–18, 20 (bowl; back of handle).

ENGRAVED: SC (back of handle).

RELATED EXAMPLES: A slip-end Dummer spoon is published by Buhler and Hood 1970,

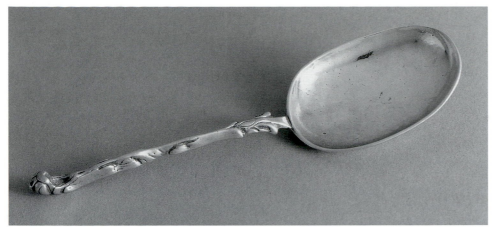

M107

1. For Boelen, see Randolph and Hastings 1941; Buhler 1960c, p. 73; Puig et al. 1989, p. 216; Quimby 1995, p. 199.
2. Rice 1964, p. 62.
3. Rice 1964, p. 54.

M108*

Spoon

Shop of Jonathan Clarke (1706–1766), Newport and Providence[1]
Gift of Robert Ensko, Inc., B.73.14

MARKED: Flynt and Fales 1968, p. 185.

ENGRAVED: A*S.

REFERENCES: Warren 1975, p. 181, no. 342.

1. See cat. no. M46.

M109

Spoon and Teaspoon

1751–77
Shop of Nathaniel Hurd (1729/30–1777), Boston[1]
B.83.7.1, teaspoon: length 4⁷⁄₁₆" (11.4 cm);
B.83.7.2, spoon: length 8" (20.3 cm)
Museum purchase with funds provided by the Houston Junior Woman's Club in memory of Patricia D. Baker, B.83.7.1–.2

The wavy-end spoon was succeeded by the spatulate type, first produced in England about 1710 and in the American colonies the following decade. The earliest examples retain the rat-tail joint, which was soon replaced with either a spatulate drop or a Late Baroque stylized shell. By mid-century a simple double drop, as seen on the Bayou Bend spoons, was introduced as an alternative. The earliest American teaspoons were fashioned during this period. However, it is highly unusual at this date to have matching dining and teaspoons.

PROVENANCE: Mark Bortman (1896–1967), Boston; to his daughter; purchased from Bortman's daughter through William Core Duffy, New Haven, 1983.[2]

MARKED: Belden 1980, p. 242.

ENGRAVED: The Stoddard crest (back of each handle).

WEIGHT: Teaspoon, 7.7 dwt; Spoon, 2 oz, 2.4 dwt.

vol. 1, p. 12, no. 7; and Puritan, trifid, and wavy-end types are in Buhler 1972, vol. 1, pp. 11, 16, 29, nos. 7, 13, 25. Other trifid-handle Dummer spoons are published in Buhler and Hood 1970, vol. 1, pp. 21, 25, nos. 12, 13, 17; Safford 1983, pp. 14, 18, nos. 16, 17; Ward and Hosley 1985, pp. 280–81, no. 162; Johnston 1994, p. 45; Quimby 1995, p. 92, no. 49.

REFERENCES: Clarke and Foote 1935, p. 150, no. 71, pl. XIV (bottom); Buhler 1960c, p. 51, no. 40; Buhler 1973, p. 27, no. 31; Kane 1998, p. 393.

1. See cat. no. M2.

M107

Spoon

1675–1700
Shop of Jacob Boelen, I (ca. 1657–1729), New York[1]
Length 6½" (16.5 cm)
Gift of the William S. and Lora Jean Kilroy Foundation, B.92.1

This type of spoon, notable for its distinctive cast handle, was first produced in Holland during the late sixteenth century.[2] There, as in the American colonies, it was reserved for holidays or family occasions, when it was set out with the brandywine bowl (cat. no. M16). Inscriptions on related spoons indicate that at times they were intended as presentations at a funeral, a custom that persisted in New York State into the early nineteenth century.[3]

PROVENANCE: Hinda Kohn, Fort Lee, New Jersey; auctioned by Sotheby's, New York, 1991; purchased by the William S. and Lora Jean Kilroy Foundation from S. J. Shrubsole, New York, 1992.

MARKED: Buhler and Hood 1970, vol. 2, p. 276, nos. 555–58 (back of bowl).

ENGRAVED: A*C (back of bowl).

RELATED EXAMPLES: Jacob Boelen, I, spoons with foliate bud terminals include Buhler and Hood 1970, vol. 2, pp. 11–12, no. 555; Quimby 1995, p. 201, no. 158. Cast-handle spoons terminating in caryatids, owls, or animal hooves by Cornelius van der Burch and Gerrit Onckelbag are recorded, and examples are attributed to Jurian Blanck, Jr., Hendrick Boelen, I, Jacobus Van der Speiegel, and Ahasuerus Hendricks.

REFERENCES: Sotheby's, New York, sale 6132, January 30–February 2, 1991, lot 152; *Antiques* 141 (January 1992), p. 79.

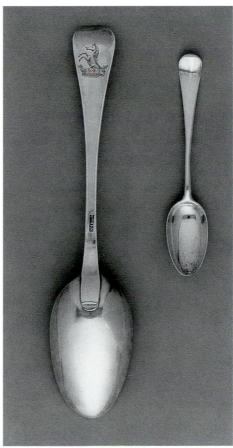

M109

RELATED EXAMPLES: French 1939, p. 52, no. 312; *Antiques* 102 (September 1972), p. 368.

REFERENCES: Buhler 1973, p. 36, nos. 61a, b; Kane 1998, pp. 620–21.

1. See cat. no. M56.
2. Perhaps these are the spoons auctioned by Parke-Bernet Galleries, New York, sale 805, November 9, 1946, lot 89, a sale at which Bortman is known to have purchased silver.

M110*

Teaspoon

1780–87
Shop of Zachariah Brigden (1734–1787), Boston[1]
Gift of William James Hill, B.87.8

MARKED: Belden 1980, p. 75, b.

ENGRAVED: N[F]E.

REFERENCES: Kane 1998, p. 216.

1. For Brigden, see Buhler 1960c, p. 73; Buhler 1965, p. 97; Flynt and Fales 1968, p. 166; Buhler 1972, vol. 1, p. 372; Puig et al. 1989, p. 259; Quimby 1995, p. 60; Anderson 1996; Kane 1998, pp. 208–10.

M111

Spoon

1781
Shop of Paul Revere, Jr. (1734–1818), Boston[1]
Museum purchase with funds provided by the Houston Junior Woman's Club, B.86.5

A small group of spoons and teaspoons fully demonstrates how stylistic attributes could be integrated into the design of the least complicated forms. These examples are distinguished by their stamped Rococo cartouche terminals, the richest expression of this style in American flatware. Only Paul Revere, Jr.'s shop is known to have employed this device. By the third quarter of the eighteenth century, the spoon's profile changed as its handle was bent slightly backward.

PROVENANCE: John Codman and Margaret Russell Codman (1757–1789, married 1781)[2]; purchased by Bayou Bend from Firestone and Parson, Boston, 1986.

TECHNICAL NOTES: The back of the bowl has a raised foliate scroll. The results of a non-

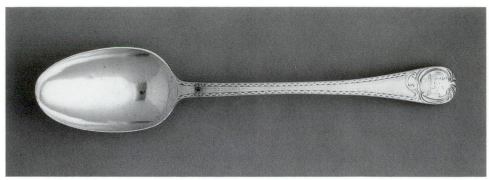

M111

destructive energy-dispersive X-ray fluorescence analysis are on file at Bayou Bend.

MARKED: Buhler 1972, vol. 2, p. 385, b.

ENGRAVED: The Russell crest.

WEIGHT: 2 oz, 4.4 dwt.

RELATED EXAMPLES: Six spoons from this set were formerly in the Bortman Collection; another was auctioned at Christie's, New York, sale 8578, January 18, 1997, lot 78; and another is in a Houston private collection. Spoons with cartouche terminals from other sets by Paul Revere include Buhler and Hood 1970, vol. 1, p. 190, no. 245; Buhler 1972, vol. 2, p. 413, no. 360; Fales 1983, pp. 24–25, no. 17; Quimby 1995, p. 159, nos. 115a, b.

REFERENCES: Brown 1987, pp. 26–27; Kane 1998, p. 834.

1. See cat. no. M53.
2. On September 1, 1781, Revere debited Thomas Russell for twelve tablespoons with engraved crests, presumably for his daughter (Revere 1761–97, vol. 1).

M112

Teaspoon

ca. 1765–90
Shop of Paul Revere, Jr. (1734–1818), Boston[1]
Museum purchase with funds provided by the Houston Junior Woman's Club, B.86.6

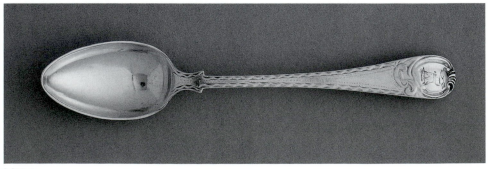

M112

PROVENANCE: Purchased by Bayou Bend from Firestone and Parson, Boston, 1986.

TECHNICAL NOTES: See cat. no. M111.

MARKED: Buhler 1972, vol. 2, p. 385, c.

ENGRAVED: The Belcher crest.[2]

WEIGHT: 9 dwt.

RELATED EXAMPLES: Another from the set is illustrated in Warren 1996, pp. 727, 731. Other Revere cartouche-tip-handle teaspoons include Sack 1969–92, vol. 2, p. 481, no. 1176; Sack 1969–92, vol. 3, p. 716, no. P3264; Buhler 1972, vol. 2, p. 413, no. 360; Fairbanks et al. 1975, p. 233, nos. 386, 387; Quimby 1995, pp. 158–59, no. 113b; Kane 1998, p. 844.

1. See cat. no. M53.
2. Sarson Belcher is the only customer with this surname recorded in Revere 1761–97.

M113

Pair of Teaspoons

ca. 1796–ca. 1806
Shop of Paul Revere, Jr. (1734–1818), Boston[1]
Length 5¼" (13.3 cm)
Museum purchase with funds provided by family and friends in memory of Aurelia Kurth Jameson, B.87.10.1–.2

Paul Revere's teaspoons with their dazzling fluted bowls are the most fully developed Neoclassical expressions in Ame-

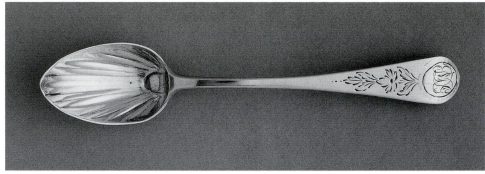

M113

rican flatware. Unique to his shop in the United States, they were undoubtedly patterned after contemporary English spoons, such as the set engraved for Elizabeth Derby West of Danvers, Massachusetts.[2] Surviving examples suggest Revere produced them for only four clients, his daybooks referring to them as "Scolop[d] Tea Spoons."[3] The contoured bowls were fashioned to complement a variety of teawares, with fluted sides inspired by classical columns.

PROVENANCE: Nathaniel Gilman (1759–1847) and his second wife, Dorothy Folsom Gilman (1775–1859, married 1796), Exeter, New Hampshire[4]; Mark Bortman (1896–1967), Boston; to his daughter; purchased by Bayou Bend from Bortman's daughter through William Core Duffy, Kittery Point, Maine, 1987.

TECHNICAL NOTES: The drop is modeled. The results of a nondestructive energy-dispersive X-ray fluorescence analysis are on file at Bayou Bend.

MARKED: Buhler 1972, vol. 2, p. 385, c.

ENGRAVED: NDG [Nathaniel and Dorothy Gilman].

RELATED EXAMPLES: Seven spoons from this set are in Houston private collections (Warren 1996, pp. 727, 731); others are engraved for Gilman and his first wife, Abigail (1768–1796, married 1785), in *Antiques* 72 (December 1957), p. 504; Buhler 1972, vol. 2, p. 428, no. 379. Other examples are Buhler and Hood 1970, vol. 2, p. 191, no. 248; Quimby 1995, pp. 158–59, no. 113a; and the State Department collection, Washington, D.C. (acc. no. 91.37.1–.12). On occasion Revere's shop also produced fluted salt spoons and ladles.

REFERENCES: Brown 1987, pp. 26–28; Kane 1998, p. 842.

1. See cat. no. M53.
2. Hipkiss 1941, p. 248, no. 174.
3. Revere 1761–97, vol. 2, June 9, 1787; Buhler and Hood, vol. 1, p. 191.
4. Gillman 1895, pp. 230–31; Chapman 1882, p. 104.

M114*

Teaspoon

1785–1800
Shop of Joseph Warner (1742–1800),
Wilmington, Delaware[1]
Gift of Fred Nevill, B.87.16

TECHNICAL NOTES: Stamped with a pigeon-like bird on the back of the bowl.

MARKED: Belden 1980, p. 432, a.

ENGRAVED: RW.

1. For Warner, see Harrington 1939, pp. 15–16; Hindes 1967, pp. 296–98; Waters 1984, p. 72.

M115*

Tablespoon

ca. 1797
Shop of Joseph Loring (1743–1815), Boston[1]
Gift of Mrs. Ernst Auerbach in memory of Ernst Auerbach, B.69.256.5

PROVENANCE: Susan Hall (d. 1841), who married Joseph Loring, Jr. (1767–1838), the silversmith's son, probably in 1797; to their daughter Mary Hall Loring (1802–1883); to Susie J. Swan; to James Edward Swan (1839–1917); presumably to his son James Swan (1870–1944); Mrs. Ernst Auerbach.

MARKED: Buhler and Hood 1970, vol. 1, p. 328, no. 276.

ENGRAVED: SH [Susan Hall] and 1797 (probably added later); MHL to SJS 1883 [Mary Hall Loring to Susie J. Swan] (back of handle).

REFERENCES: Warren 1975, p. 181, no. 344; Kane 1998, p. 672.

1. See cat. no. M60.

M116*

Dessert Spoon

ca. 1797
Shop of Joseph Loring (1743–1815), Boston[1]
Gift of Mrs. Ernst Auerbach in memory of Ernst Auerbach, B.69.256.6

In English silver differences in the size of spoons first became apparent about 1700. Exactly when the dessert spoon was introduced to the American colonies is not known. An early reference is James Jacks's 1798 advertisement offering "Table, tea and dessert spoons."[2] The dessert spoon, like other silver forms, was multifunctional, as evidenced by an 1862 etiquette book that counseled, "Eat peas with a dessert-spoon, also tarts, puddings, curry, &c."[3]

PROVENANCE: Susan Hall Loring (d. 1841), the silversmith's daughter-in-law; to her son Henry Hall Loring (1798–1840); to his sister Mary Hall Loring (1802–1883). For its subsequent history, see cat. no. M60.

MARKED: Buhler and Hood 1970, vol. 1, p. 328, nos. 275, 277, 278.

ENGRAVED: SL to HHL [Susan Loring to Henry Hall Loring].

REFERENCES: Warren 1975, p. 181, no. 345; Kane 1998, p. 669.

1. See cat. no. M60.
2. Prime 1969, pp. 122–24.
3. Etiquette 1862, p. 78.

M117*

Pair of Spoons

1800–1816
Shop of Joseph Moulton, III (1744–1816),
Newburyport, Massachusetts[1]
Gift of Mr. and Mrs. Richard J. Price,
B.68.9.1–.2

MARKED: Belden 1980, pp. 305–6, e.

ENGRAVED: AV.

1. For Moulton, see Decatur 1941; Flynt and Fales 1968, p. 282; Buhler 1972, vol. 2, p. 681; Belden 1980, pp. 305–6; Kane 1998, pp. 714–19.

M118*

Spoon

ca. 1777–90
Shop of Joseph Richardson, Jr. (1752–1831), and
Nathaniel Richardson (1754–1827), Philadelphia[1]
Gift of Mr. and Mrs. Robert D. Jameson, B.86.8

MARKED: Belden 1980, p. 356.

ENGRAVED: MᴱC.

RELATED EXAMPLES: Fales 1974b, p. 182, fig.
162a; Quimby 1995, p. 441, nos. 462a–e, 463a–c.

1. For Joseph and Nathaniel Richardson, see
 Fales 1974b; PMA 1976, p. 158; Puig et al.
 1989, p. 269; Quimby 1995, p. 441.

M119*

Spoon

1782–1809
Shop of William Richardson (1757–1809),
Richmond, Virginia[1]
Gift of Mrs. Junius F. Estill, B.82.19

PROVENANCE: Jonathan Clark (1750–1811) and
Sarah Hite Clark (1758–1817, married 1782),
Louisville, Kentucky; to their son George
Washington Clark (1798–1883); to his daughter
Sarah (Mrs. Jere E. Rogers, 1823–1904); to her
son Jere E. Rogers, Jr. (1853–1898); to his daugh-
ter Laura Rogers; to her nephew Jacob Embry
(d. 1957); to his daughter, Mrs. Junius F. Estill.

MARKED: Childs 1978, p. 41, fig. 12a.

ENGRAVED: JSC [Jonathan and Sarah Clark].

1. For Richardson, see Cutten 1952, pp. 156–59;
 Childs 1978.

M120*

Set of Twelve Teaspoons

1787–1800
Shop of Henry Lupp (1760–1800), New
Brunswick, New Jersey[1]
Gift of Dr. Royall Calder, B.66.5.1–.12

PROVENANCE: Colonel John B. Bayard
(1738–1807) and his third wife, Johanna White
Bayard (1744–1834, married 1787), New Bruns-
wick, New Jersey; probably to her niece Eliza-
beth Mary White (Mrs. Thomas M. Evans,
1792–1861). For its subsequent history, see cat.
no. M59.[2]

MARKED: Buhler and Hood 1970, vol. 2,
p. 282, no. 811.

ENGRAVED: JJB [John and Johanna Bayard].

RELATED EXAMPLES: Buhler and Hood 1970,
vol. 2, p. 170, no. 811.

REFERENCES: Warren 1975, p. 181, no. 343.

1. See cat. no. M59.
2. Wilson 1885.

M121

Teaspoon

1793–95
Shop of Rowland Parry (d. 1796) and James
Musgrave (d. 1813), Philadelphia[1]
Gift of William James Hill, B.87.9

MARKED: P&M.

ENGRAVED: CF.

1. Partnership act. 1793–95. For Parry and
 Musgrave, see Prime 1969, vol. 2, p. 135;
 PMA 1976, p. 171; Whisker 1993, pp. 213–14,
 222–23.

M122*

Tablespoon

1804–31
Shop of John Owen, Jr. (act. 1804–31),
Philadelphia[1]
Gift of William James Hill, B.87.5

MARKED: Belden 1980, p. 322, b.

ENGRAVED: AW.

1. For Owen, see Whisker 1993, p. 220;
 Quimby 1995, p. 412.

M123

Pair of Teaspoons

ca. 1802–19
Shop of John A. Shaw (act. ca. 1802–19),
Newport[1]
Gift of Ralph Carpenter, B.66.23.1–.2

During the 1790s, American silversmiths,
including John Shaw, introduced a type of
handle unique to American flatware and
now commonly referred to by the melan-
choly name coffin handle.

MARKED: Belden 1980, p. 379.

ENGRAVED: RHP.

REFERENCES: Warren 1975, p. 181, no. 346.

1. For Shaw, see Carpenter 1954, p. 159; Flynt
 and Fales 1968, pp. 320–21.

M124*

Teaspoon

1795–1817
Shop of Nicholas Geffroy (ca. 1761–1839), Newport[1]
Gift of David B. Smith, B.88.8

In 1801 Thomas Bruff of Chestertown,
Maryland, received the first American
patent for manufacturing spoons. His ad-
vertisements claimed that his machine
"with one impression and one hand to

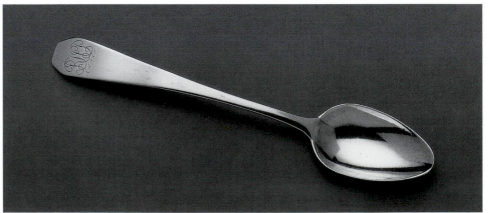

M123

work it, will turn out from a flat bar, a spoon in a minute, ready for the punch, with the heel and name impressed upon it." John Adam, a contemporary, remarked that using Bruff's invention, he could turn out twenty-five spoons in the time that it previously took to produce one. With improved production methods, American silver manufacturers, such as Nicholas Geffroy, began to supply flatware to a greater spectrum of consumers.[2]

MARKED: Flynt and Fales 1968, p. 224, right.

ENGRAVED: AT.

1. For Geffroy (act. Newport ca. 1795–1817), see *Antiques* 54 (September 1948), pp. 184, 186; Carpenter 1954, p. 159; Flynt and Fales 1968, p. 224.
2. Waters 1977.

M125[*]

Teaspoon

1795–1824
Shop of Major Timothy Chandler (1762–1848),
Concord, New Hampshire[1]
Gift of William James Hill, B.88.26.1

MARKED: Belden 1980, p. 103.

ENGRAVED: SC.

1. For Chandler (act. ca. 1783–1824), see Flynt and Fales 1968, p. 179; Parsons 1983, pp. 89–90, 133.

M126[*]

Three Soup Spoons

1795–1824
Shop of Major Timothy Chandler (1762–1848),
Concord, New Hampshire[1]
Gift of William James Hill, B.88.26.2–.4

MARKED: B.88.26.2, Belden 1980, p. 103; B.88.26.3, B.88.26.4, Parsons 1983, p. 89, Chandler, G.

ENGRAVED: SC.

RELATED EXAMPLES: Cat. no. M125 is part of this set.

1. See cat. no. M125.

M127[*]

Tablespoon

1790–1815
Shop of William Ball (1763–1815), Baltimore[1]
Gift of William James Hill, B.87.4

MARKED: Belden 1980, p. 47.

ENGRAVED: AEH.

1. For Ball (act. ca. 1786–1815; with Israel H. J. Johnson, ca. 1786–90; with J. S. Heald, 1811–12), see Pleasants and Sill 1972, pp. 89–92; Goldsborough 1975, p. 67; Belden 1980, p. 47; Goldsborough et al. 1983, pp. 72–77, 239, 257, 262; Quimby 1995, p. 331.

M128[*]

Tablespoon

1793–1829
Shop of Joseph Shoemaker (1764–1829),
Philadelphia[1]
Gift of Anne Rowland, Williamsburg, Virginia,
B.82.25

PROVENANCE: Descended in the donor's family.

MARKED: Belden 1980, p. 381, a.

ENGRAVED: SM.

1. For Shoemaker (act. 1793–1829), see Whisker 1993, p. 253.

M129[*]

Spoon

ca. 1787–1800
Shop of Abner Reeder (1766–1841), Philadelphia
and Trenton, New Jersey[1]
Gift of Anne Rowland, Williamsburg, Virginia,
B.82.26

PROVENANCE: Descended in the donor's family.

MARKED: Belden 1980, p. 351.

ENGRAVED: RN.

1. For Reeder (act. ca. 1787–1800), see White 1964, pp. 80–82; Belden 1980, pp. 283, 351; Whisker 1993, p. 233.

M130[*]

Tablespoon

1810–11
Shop of Liberty Browne (act. 1799–1812) and
William Seal, Jr. (n.d.), Philadelphia[1]
Gift of Anne Rowland, Williamsburg, Virginia,
B.82.18

PROVENANCE: Michael Baker (1758–1834) and Jane Nice Baker (1763–1830, married 1784), Philadelphia; to their son Joseph (1797–1872); to his daughter Josephine (Mrs. Edwin Henry Fitler, 1831–1904); to her daughter Annie (Mrs. Charles Harkness Howell, 1851–1937); to her daughter Cecile (Mrs. William Overington Rowland, Jr., 1893–1953); to her daughter, Anne Rowland.

MARKED: Belden 1980, Browne & Seal, p. 81.

ENGRAVED: MJB [Michael and Jane Baker]; Sept. 23rd 1784 (back of handle, added later).

1. Partnership act. 1810–11. For Browne and Seal, see Goldsborough 1975, p. 177; Belden 1980, p. 81; Goldsborough et al. 1983, p. 243; Whisker 1993, p. 73.

M131[*]

Teaspoon

1796–1818
Shop of John Sayre (1771–1852), Southampton,
New York; New York; Cohoes, New York; and
Plainfield, New Jersey,[1] or Joel Sayre (1778–1818),
Southampton, New York; and New York[2]
Gift of Fred M. Nevill, B.87.17

MARKED: Belden 1980, p. 374, b.

ENGRAVED: D^{K}P.

1. For John Sayre (act. 1798, 1802–18), see Darling 1964, p. 156; Buhler 1972, vol. 2, p. 593; Failey 1976, p. 302; von Khrum 1978, p. 115; Quimby 1995, p. 284.
2. For Joel Sayre (act. 1796–1813), see Darling 1964, p. 156; Failey 1976, p. 302; von Khrum 1978, p. 115; Belden 1980, p. 373.

M132

Pair of Teaspoons

1815–21
Shop of Robert Shepherd (1781–1853) and
William Boyd (1775–1840), Albany, New York[1]
Gift of Mrs. Raybourne Thompson, B.91.54.1–.2

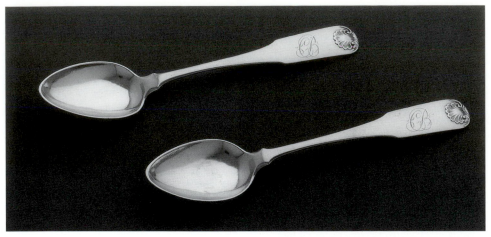

M132

PROVENANCE: Charlotte Bronck (Mrs. Abraham Houghtaling, 1799–1891, married 1821); to her daughter Emma Agusta (Mrs. Alonzo Newbury, 1840–1913); to her daughter Mary Newbury (1880–1965); to her sister Helen (Mrs. Ned Sayford, 1878–1970); to her daughter Mary Helen Sayford (Mrs. Raybourne Thompson).

MARKED: Belden 1980, p. 380, c.

ENGRAVED: CB [Charlotte Bronck].

1. Partnership act. 1806–30. For Shepherd and Boyd, see Rice 1964, pp. 75–76.

M133

Teaspoon

1810–40
Shop of William Stoddard Nichols (1785–1871), Newport[1]
Matthew Miller (act. ca. 1801–40), Charleston, retailer[2]
Gift of Natalie L. Gayle, B.87.19

MARKED: M. MILLER with pseudohallmarks. For William Stoddard Nichols, see Beldon 1980, pp. 314–15.

ENGRAVED: WG[?]D.

1. For Nichols (act. ca. 1806–71), see Carpenter 1954, p. 159; Flynt and Fales 1968, p. 287.
2. For Miller, see Burton 1942, pp. 123–24.

M134★

Set of Twelve Tablespoons

1816–50
Shop of William Baily, Jr. (act. 1816–57), Philadelphia[1]
Gift of William James Hill, B.87.6.1–.12

MARKED: Belden 1980, p. 42.

ENGRAVED: AR.

1. Baily was in partnership with his son Thomas between 1850 and 1857.

M135★

Set of Four Soup Spoons

1827–49
Shop of Henry J. Pepper (1789–1853), Wilmington, Delaware, and Philadelphia[1]
Gift of Anne Rowland, Williamsburg, Virginia, B.82.14

PROVENANCE: Descended in the donor's family.

MARKED: Belden 1980, p. 332, b.

ENGRAVED: HSB.

1. For Pepper (act. Philadelphia 1827–49), see Harrington 1939, pp. 61–64; Hindes 1967, pp. 286–87; Whisker 1993, p. 225; Quimby 1995, p. 414.

M136

Teaspoon

1835–49
Shop of Henry J. Pepper (1789–1853), Wilmington, Delaware, and Philadelphia[1]
Gift of Phyllis and Charles Tucker, B.89.3

This teaspoon is jointly stamped by Henry Pepper and Isaac Newton, the latter a name otherwise unrecorded in American silver bibliography. Pepper has struck his stamp in the usual location on the back of the handle, while Newton's is more prominently located on the front. The positioning of the engraved initials suggests that they were probably completed after the Newton stamp was struck. An Isaac Newton, listed as a tailor, first appears in the 1835–36 Philadelphia directory. By 1847 he is described as a confectionary on Chestnut Street; he was at this address in 1853 when Pepper died.

MARKED: H.I.PEPPER; ISAAC NEWTON (front of handle).

ENGRAVED: MJE.

1. See cat. no. M135.

M137★

Set of Seven Teaspoons

1824–46
Shop of Jean-Marie Lamothe (1795–1880) and Jean-Baptiste Lamothe (1800–1874), New Orleans[1]
Museum purchase with funds provided by Mr. and Mrs. Junius F. Estill, Jr., B.81.7.1–.7

PROVENANCE: P. O. Chaler (b. ca. 1821), Natchitoches, Louisiana; to his niece Lise Chaler Rachel; to the Misses Addie and Ivy Tanzin; to Mrs. Francis Robicheaux; purchased by Bayou Bend from Mrs. Robicheaux, 1981.

MARKED: Mackie, Bacot, and Mackie 1980, p. 126.

ENGRAVED: P.O.C. [P. O. Chaler].

1. Partnership 1824–46. For Jean-Marie and Jean-Baptiste Lamothe, see Mackie, Bacot, and Mackie 1980, pp. 71–73.

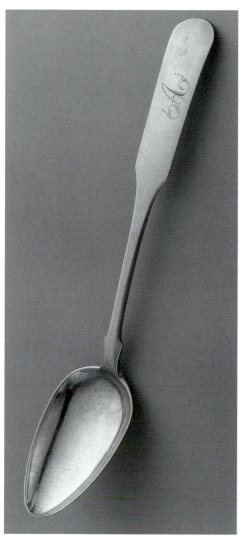

M138

M138

Soup Spoon

1819–52
Shop of Samuel Bell (1798–1882), Pittsburgh,
Pennsylvania; Knoxville, Tennessee; and San
Antonio, Texas[1]
Museum purchase with funds provided by
Charles W. Duncan, Jr., and Table 14 in honor
of Jack Trotter at "One Great Night in
November, 1994," B.94.12

PROVENANCE: Purchased by Bayou Bend
from Whirligig Antiques, Austin, Texas, 1994.

MARKED: BELL & C[o] (with concentric circles
on either side).

ENGRAVED: A.

1. See cat. no. M34.

M139

Pair of Dessert Spoons

1819–ca. 1860
Shop of Samuel Bell (1798–1882), Pittsburgh,
Pennsylvania; Knoxville, Tennessee; and San
Antonio, Texas[1]
Gift of Fred M. Nevill, B.84.14.1–.2

MARKED: S.BELL. (with segmented circles on
either side).

ENGRAVED: M[c]C.

RELATED EXAMPLES: Steinfeldt and Stover
1973, pp. 164–69; Caldwell 1988, p. 34, fig. 35e.

1. See cat. no. M135.

M140

Teaspoon

1858–61
Manufactory of Hugh Mulligan (act. 1852–61),
Philadelphia[1]
Gift of Phyllis and Charles Tucker, B.89.2

PROVENANCE: Descended in and acquired
from the Potts family.

MARKED: H. MULLIGAN 444 N.2ND ST.PHILA.

H.MULLIGAN 444 N.2ND ST.PHILA.

ENGRAVED: JMR.

1. Mulligan first appears in the 1852 Philadel-
phia directory as a jeweler. Between 1858
and 1861 his address was 444 North Second
Street (Whisker 1993, p. 212).

M141★

Teaspoon

1823–33
Shop of Amos Pangborn (1800–1843),
Burlington, Vermont[1]
Gift of David B. Smith, B.88.13

MARKED: Carlisle 1970, p. 220.

ENGRAVED: OM.

1. For Pangborn (partnership with James E.
Brinsmaid, 1833–43), see Carlisle 1970,
pp. 220–23.

M142★

Teaspoon

1820–60
Shop of Samuel Musgrove (1800–1860),
Cincinnati, Ohio; Larue County, Kentucky; and
Nashville[1]
Gift of Dr. and Mrs. Benjamin Caldwell, B.72.5

MARKED: Caldwell 1988, p. 133, no. 101a.

ENGRAVED: W.P.G.

REFERENCES: Warren 1975, p. 182, no. 351.

1. For Musgrove (act. 1820–60), see Caldwell
1988, pp. 132–33.

M143★

Pair of Teaspoons

1850–55
Shop of John Campbell (1803–ca. 1857),
Fayetteville, North Carolina; Cheraw, South
Carolina; and Nashville[1]
Gift of Dr. and Mrs. Benjamin Caldwell,
B.67.8.1–.2

MARKED: Caldwell 1988, p. 54, no. 48b.

ENGRAVED: Eubanks.

REFERENCES: Warren 1975, p. 182, no. 347.

1. For Campbell, see Burton 1942, p. 211; Cut-
ten 1948, pp. 29–32; Caldwell 1988, pp. 54–57.

M144★

Three Soup Spoons and
Two Dessert Spoons

ca. 1849
Manufactory of John A. Cole(s) (act. 1830–59),
New Britain-Berlin, Connecticut, area and
New York[1]
Samuel W. Benedict (act. 1823–64), New York,
retailer[2]
Gift of Mrs. John A. Beck, B.88.16.1–.5

PROVENANCE: Dr. Jasper Gibbs (1810–1876)[3]
and Laura Jane Drake Gibbs (1821–1855, mar-
ried 1839), and his second wife, Sallie Candler
Gibbs (1839–1928, married 1857), Mexia, Texas;

to their daughter Mary Gibbs (Mrs. Jesse H. Jones, 1872–1962); to her granddaughter Mrs. John A. Beck.

MARKED: Belden 1980, p. 56.

ENGRAVED: Gibbs; 1849 (the date only on B.88.16.1).

RELATED EXAMPLES: A dozen forks, a butter knife, a tablespoon, and a teaspoon from this set belong to the Gibbs Memorial Library, Mexia, Texas. See also cat. nos. M145, M214.

1. For Cole, see von Khrum 1978, p. 31; Belden 1980, pp. 116–17.
2. For Benedict, see von Khrum 1978, p. 13. The city directories for 1840 and 1846–50 record Benedict at 5 Wall Street.
3. Dr. Gibbs came to Texas from the Edgefield, South Carolina, area, where he maintained an interest in the local potteries. See Baldwin 1993.

M145
Set of Three Dessert Spoons

ca. 1849
Manufactory of John A. Cole(s) (act. 1830–59), New Britain-Berlin, Connecticut, area and New York[1]
Gift of Mrs. John A. Beck, B.88.17.1–.3

The fiddle-thread handle was patterned after an English design. The date of its earliest manufacture by American silversmiths is not known; however, by 1796, the Philadelphia smith Joseph Richardson records the production of spoons with threaded handles.[2]

PROVENANCE: See cat. no. M144.

MARKED: B&H (incuse); pseudohallmarks consisting of a head facing right, a lion passant, and C, each in a rectangle with canted corners (Belden 1980, p. 116, a).

ENGRAVED: Gibbs.

RELATED EXAMPLES: See cat. nos. M144, M214.

1. See cat. no. M144.
2. Fales 1974b, p. 195.

M146
Pair of Teaspoons

1825–46
Manufactory of R. & W. Wilson (partnership 1825–46), Philadelphia[1]
Gift of Phyllis and Charles Tucker, B.89.5.–.6

MARKED: B.89.5, R.&W.WILSON; B.89.6, Belden 1980, p. 450, e.

ENGRAVED: RIP.

1. See cat. no. M64.

M147*
Soup Spoon

1826–46
Manufactured or retailed by R. & W. Wilson (partnership 1825–46), Philadelphia[1]
Gift of Anne Rowland, Williamsburg, Virginia, B.82.16

PROVENANCE: Thomas Rowland (1801–1881) and Mary Rowland (1806–1874, married 1826); to their son Benjamin Rowland, II (1828–1911); to his son William Overington Rowland, Sr. (1861–1915); to his son William Overington Rowland, Jr. (1891–1934); to his daughter Anne Rowland.

MARKED: Belden 1980, p. 450, a.

ENGRAVED: TMR [Thomas and Mary Rowland].

RELATED EXAMPLES: Cat. nos. M148 and M149 share the same provenance.

1. See cat. no. M64.

M148*
Dessert Spoon

1826–46
Manufactured or retailed by R. & W. Wilson (partnership 1825–46), Philadelphia[1]
Gift of Anne Rowland, Williamsburg, Virginia, B.82.24.2

PROVENANCE: See cat. no. M147.

MARKED: Belden 1980, p. 450, b.

ENGRAVED: TMR [Thomas and Mary Rowland].

RELATED EXAMPLES: Cat. nos. M147 and M149 share the same provenance.

1. See cat. no. M64.

M149*
Dessert Spoon

1837–46
Manufactory of Taylor & Lawrie (partnership 1837–61), Philadelphia[1]
R. & W. Wilson (partnership 1825–46), Philadelphia, retailer[2]
Gift of Anne Rowland, Williamsburg, Virginia, B.82.24.1

PROVENANCE: See cat. no. M147.

MARKED: Belden 1980, p. 450, a.

ENGRAVED: TMR [Thomas and Mary Rowland].

RELATED EXAMPLES: Cat. nos. M147 and M148 share the same provenance.

1. For Robert Taylor and Robert Dickson Lawrie, see cat. no. M77.
2. See cat. no. M64.

M150
Set of Six Teaspoons

1831–63
Shop of Osmon Reed (d. ca. 1863), Philadelphia[1]
Gift of Anne Rowland, Williamsburg, Virginia, B.82.13.1–.6

PROVENANCE: Margaretta Garsted (Mrs. William Overington Rowland, Sr., 1870–1941); to her son William Overington Rowland, Jr. (1891–1934); to his daughter Anne Rowland.

MARKED: O. REED with pseudohallmarks of an eagle, W, and a profile (incuse).

ENGRAVED: R.M.G.[2]

1. For Reed (act. 1831–63), see PMA 1976, p. 319.
2. Perhaps a Garsted family member.

M151

Teaspoon

1831–63
Shop of Osmon Reed & Son (act. 1831–63),
Philadelphia[1]
Gift of Phyllis and Charles Tucker, B.89.4

MARKED: O.REED&SON.

ENGRAVED: ST.

1. See cat. no. M150.

M152*

Soup Spoon

1846–57
Samuel M. Hopper (act. 1835–59), Philadelphia,
retailer[1]
Gift of the estate of Miss Ima Hogg, B.77.29

MARKED: Belden 1980, p. 234.

ENGRAVED: HHS.

1. For Hopper, see Belden 1980, p. 234;
 Whisker 1993, p. 170.

M153*

Set of Six Teaspoons

1848–61
Shop of Edward Kinsey and David Kinsey
(partnership 1844–61), Cincinnati, Ohio[1]
B.62.34.1–.6

PROVENANCE: Purchased by Miss Hogg from
Heritage House, 1962.

MARKED: Belden 1980, p. 259.

ENGRAVED: ACG.

REFERENCES: Warren 1975, p. 182, no. 348.

1. See cat. no. M39.

M154*

Pair of Dessert Spoons

1852–61
Shop of Joseph Rafel (1810–after 1870),
Cincinnati, Ohio, and New Orleans[1]
Museum purchase with funds provided by
William James Hill, B.87.3.1–.2

PROVENANCE: Purchased by Bayou Bend at
Neal Alford Company, February 13, 1987.

MARKED: Mackie, Bacot, and Mackie 1980, p. 127.

ENGRAVED: H.

REFERENCES: Neal Alford Company, New
Orleans, February 13, 1987, lot 193A.

1. For Rafel (act. New Orleans 1852–61), see
 Mackie, Bacot, and Mackie 1980, pp. 100–101.

M155*

Teaspoon

1855–77
Manufactory of Albert Coles (1815–1877),
New York[1]
Gift of Natalie L. Gayle, B.87.18

PROVENANCE: Matilda Kaapke (Mrs. Frederick
Marion Lege, 1855–1909, married 1881), Eagle
Pass, Texas; to her son Emil Gideon Lege (1893–
1952); to his daughter, Mrs. Natalie L. Gayle.

MARKED: Belden 1980, p. 118.

ENGRAVED: MK [Matilda Kaapke].

1. See cat. no. M99.

M156*

Teaspoon

1853–ca. 1879
Shop of F. S. Adolph Bahn (1823–1901),
Westphalia; Prussia; and Austin, Texas[1]
Museum purchase with funds provided by the
Bayou Bend Provisional Class of 1994 in
memory of Nancy Burns, B.97.4

Adolph Bahn was one of the large num-
ber of Germans who immigrated to
Texas during the mid-nineteenth century.
He established a working shop in Austin
in 1853; however, as the following group
of spoons documents (cat. nos. M157,
M158), he also supplemented his income
as a jeweler and retailer.

PROVENANCE: Purchased by Bayou Bend
from Phyllis Tucker, Houston, 1996.

MARKED: A. BAHN (incuse) (similiar to mark
of cat. no. M157).

RELATED EXAMPLES: The mate to this spoon
is privately owned; Steinfeldt and Stover 1973,
p. 180, no. 229.

1. On January 2, 1871, R. G. Dun & Co. re-
 ported on the partnership of Bahn & Schu-
 man, jewelers, describing them as "Both
 steady indus(trious) men, un not less than
 15M\$ clear. Germans." Six months later
 their business was prospering. They owned
 real estate valued at fifteen thousand dol-
 lars, with a capital of five thousand dollars,
 and commanded good credit. By July 1872
 the partnership had dissolved and Bahn was
 on his own. The January 1873 report com-
 ments that Bahn had married and "Is rich
 and prosperous and doing a safe bus(iness)."
 He obviously was well respected, as evi-
 denced by a January 26, 1875, entry: "G(oo)d
 man & d(oin)g g(oo)d bus(iness). stands
 well. consid(ere)d worthy of confidence,"
 and similar evaluations appear throughout
 the report. Two years later Bahn is described
 as doing "the best bus(iness) in the City,
 perf(ec)t(l)y safe for any am(oun)t he buys,
 but is now gradually retiring from bus(iness)."
 His impending retirement is mentioned in
 the July 1, 1877, entry: "Is gradually selling
 off stock to retire from bus(iness)." Evi-
 dently Bahn had a change of mind, as the
 February 1, 1878, report pronounced that he
 "has just completed 2 handsome stores-Is
 cons'(idere)d good for anything he buys-."
 The two final entries, June 24, 1878, and Jan-
 uary 17, 1879, indicate no change. Texas vol.
 30, p. 227, R.G. Dun & Co. Collections,
 Baker Library, Harvard University Graduate
 School of Business Administration.

M157

Pair of Dessert Spoons

1853–ca. 1879
Manufactory of Wood & Hughes (act. 1845–99),
New York[1]
F. S. Adolph Bahn (1823–1901), Westphalia,
Prussia; Austin, Texas, retailer[2]
Museum purchase with funds provided by
William James Hill, B.93.14.1–.2

PROVENANCE: Whirligig Antiques, Austin,
Texas, 1993.

MARKED: A.BAHN (incuse). For Wood &
Hughes, see Belden 1980, p. 454, a.

ENGRAVED: N.H.S.

1. See cat no. M69.
2. See cat. no. M156.

M158

Pair of Teaspoons

ca. 1860–71
Manufactory of John R. Wendt (1826–1907),
New York[1]
F. S. Adolph Bahn (1823–1901), Austin, Texas,
retailer[2]
Museum purchase with funds provided by
William James Hill, B.93.15.1–.2

PROVENANCE: Whirligig Antiques, Austin,
Texas, 1993.

MARKED: ADOLPH BAHN; STERLING; PATENT.

REFERENCES: Turner 1972, p. 124.

1. While this design is attributed to Wendt
 and was introduced prior to 1870, it was ac-
 tually patented by Charles Witteck in 1875.
 For Wendt (act. 1860–71), see Soeffing
 1988b, pp. 76, 78; Cramer 1992c; Cramer
 1992d; Venable 1994, p. 323.
2. See cat. no. M156.

M159*

Teaspoon

ca. 1860
F. H. Clark & Co. (act. 1850–66), Memphis, retailer[1]
Gift of Dr. and Mrs. Benjamin Caldwell, B.72.4

MARKED: Caldwell 1988, p. 63, no. 54a.

REFERENCES: Warren 1975, p. 182, no. 349.

1. For Frederick Harvey Clark (1811–1866),
 James S. Wilkins (1822–after 1871), and
 Albert C. Wursbach (1823–after 1859),
 see Caldwell 1988, pp. 62–66, 169, 171.

M160*

Teaspoon

1850–55
Shop of William Henry Calhoun (1815–1865),
Nashville[1]
Gift of Dr. and Mrs. Benjamin Caldwell, B.72.3

MARKED: Caldwell 1988, p. 50, no. 47b.

ENGRAVED: FRG.

REFERENCES: Warren 1975, p. 182, no. 350.

1. For Calhoun, see Caldwell 1988, pp. 49–53.

M161*

Soup Spoon

ca. 1841–60
Attributed to the shop of James E. Merriman
(1815–ca. 1860), Memphis, retailer, or Charles G.
Merriman (b. 1823–after 1860), Memphis and
New Haven, retailer[1]
Gift of Dr. and Mrs. Benjamin Caldwell, B.72.2

MARKED: Caldwell 1988, p. 127, bottom, nos.
99b, 99c.

ENGRAVED: CMJ.

REFERENCES: Warren 1975, p. 183, no. 352.

1. For James E. Merriman, see Caldwell 1988,
 pp. 126–29. For Charles G. Merriman, see
 Caldwell 1988, p. 126.

M162*

Soup Spoon

1841–47
Attributed to the shop of James E. Merriman
(1815–ca. 1860), Memphis, retailer, or Charles G.
Merriman (b. 1823–after 1860), Memphis and
New Haven, retailer[1]
Gift of William James Hill, B.87.7

MARKED: Caldwell 1988, p. 127, nos. 99b, 99c.

ENGRAVED: BLL.

1. See cat. no. M161.

M163

Teaspoon

ca. 1836–61
Shop of John Eugene Smith (1816–1897),
St. Louis and Galena, Illinois[1]
Gift of Jas A. Gundry, B.95.16

PROVENANCE: Descended in the donor's
family.

MARKED: J.E.SMITH&CO.

1. See cat. no. M103.

M164*

Set of Four Teaspoons

1836–81
Manufactory of Farrington & Hunnewell
(partnership 1836–81), Boston and Lowell,
Massachusetts[1]
Gift of David B. Smith, B.88.7.1–.4

MARKED: Belden 1980, p. 164, b.

ENGRAVED: C.

RELATED EXAMPLES: For other flatware from
this service, see cat. nos. M167–69, M195.

1. For John Farrington and George W. Hun-
 newell, see Belden 1980, p. 164.

M165*

Teaspoon

1844–ca. 1863
Charles C. Coleman (act. 1844–ca. 1863),
Worcester, Massachusetts, retailer[1]
Gift of David B. Smith, B.88.6

MARKED: Belden 1980, p. 117.

ENGRAVED: M.S.C.

1. For Coleman, see Belden 1980, p. 117.

M166

Dessert Spoon

1846–51
Manufactory of Palmer & Bachelders
(act. 1846–51), Boston[1]
Gift of David B. Smith, B.88.12.2

MARKED: ★ PALMER&BACHELDER'S (worn and
difficult to determine if the stamp ends with a
period [.], in a rectangle).

ENGRAVED: A.G. to M.S.C.

1. For Palmer and Bachelders, whose princi-

pals were Jacob P. Palmer, Julius A. Palmer, Augustus E. Bachelders, and Josiah G. Bachelders & Co., see Belden 1980, p. 324; Palmer and Palmer 1973, pp. 105–6.

M167

Dessert Spoon

1846–51
Manufactory of Palmer & Bachelders (act. 1846–51), Boston[1]
Gift of David B. Smith, B.88.12.1

MARKED: PALMER BACHELDERS ★ CO (incuse).

![PALMER BACHELDERS ★ CO mark](incuse mark)

ENGRAVED: C.

RELATED EXAMPLES: For other flatware from this service, see cat. nos. M164, M168, M169, M195.

1. See cat. no. M166.

M168

Set of Four Teaspoons

1846–51
Manufactory of Palmer & Bachelders (act. 1846–51), Boston[1]
Gift of David B. Smith, B.88.12.3–.6

MARKED: PALMER BACHELDERS ★ CO (incuse).

![PALMER BACHELDERS ★ CO mark](incuse mark)

ENGRAVED: C.

RELATED EXAMPLES: For other flatware from this service, see cat. nos. M164, M167, M169, M195.

1. See cat. no. M166.

M169

Soup Spoon

ca. 1820–70
Unknown maker, probably Boston area
Gift of David B. Smith, B.88.14

MARKED: P.&M (incuse).

![P. & M mark](incuse mark)

ENGRAVED: C.

RELATED EXAMPLES: For other flatware from this service, see cat. nos. M164, M167, M168, M195.

M170★

Soup Spoon

ca. 1849–53
Shop of James H. Carleton (act. ca. 1849–53), Haverhill, Massachusetts[1]
Gift of David B. Smith, B.88.5.1

MARKED: Belden 1980, p. 98, a (appears to be struck over another mark).

ENGRAVED: M.E. Taggart.

RELATED EXAMPLES: Cat. no. M189 shares the same maker and engraving.

1. For Carleton, see Belden 1980, p. 98.

M171★

Five Soup Spoons

1869–77
The Adolph Himmel Silverware Manufactory (act. 1869–77), New Orleans[1]
B.69.400.1–.5

PROVENANCE: Purchased by Miss Hogg from Waldhorn Company, New Orleans, 1962.

MARKED: Mackie, Bacot, and Mackie 1980, p. 126, top mark.

ENGRAVED: EC.

REFERENCES: Warren 1975, p. 183, no. 353.

1. See cat. no. M44.

M172★

Five Soup Spoons

1869–77
The Adolph Himmel Silverware Manufactory (act. 1869–77), New Orleans[1]
Gift of Mrs. John A. Beck, B.81.13.1–.2 and B.88.15.1–.3

PROVENANCE: Mary Gibbs (Mrs. Jesse H. Jones, 1872–1962); to her granddaughter Mrs. John A. Beck.

MARKED: Mackie, Bacot, and Mackie 1980, p. 126, top mark.

ENGRAVED: MH (three spoons) and MP (the remaining two).

RELATED EXAMPLES: Cat. nos. M144, M145, M214, descended in the same family.

1. See cat. no. M44.

M173

Tablespoon

ca. 1855
Manufactory of William Gale & Son (act. 1853–59, 1862–67), New York[1]
Museum purchase with funds provided by Virginia T. Elverson, B.81.8

Gothic motifs, rediscovered and reinterpreted during the mid-eighteenth century, had evolved in a new, romanticized style by the 1840s. Although rarely adapted to silver, it found one of its most beguiling expressions in William Gale and Nathaniel Hayden's pattern *Gothic*, patented in 1847.[2] Gale was a great innovator, in 1826 patenting a process by which a silver blank was run through a roller die, emerging as a piece of flatware complete with decoration on both sides.[3]

M173

PROVENANCE: New York Horticultural Society to W. Cranstoun, 1855; purchased by Bayou Bend from Kingsley & O'Brennan, Philadelphia, 1980.

TECHNICAL NOTES: The handle is double struck.

MARKED: Belden 1980, p. 181, William Gale & Son, b.

ENGRAVED: N.Y. Hort. Soc. to / W. Cranstoun for best 6 var[es] / of Pears, Sept. 1855.

RELATED EXAMPLES: Howe and Warren 1976, pp. 70–71, no. 143; Ward and Ward 1979, p. 172, no. 180; Venable 1994, pp. 56–57.

1. See cat. no. M83.
2. Cramer 1991b.
3. Waters 1977, p. 27; Venable 1994, p. 20.

M174

Coffee Spoon

ca. 1868–71 or ca. 1875–80
Unknown maker, probably New York
Fred Allen (1849–1901) and Company, Galveston, Texas, and Memphis, retailer[1]
Length 4⅞" (12.4 cm)
Gift of William James Hill, B.92.9

The integration of cameo profiles into flatware design is unique to American silver manufacturers. Medallion-handled flatware enjoyed a brief period of popularity, concluding by the mid-1870s. Contemporary sources stressed that coffee be served in the French manner: "After dinner coffee should always be cafe noir, or strong black coffee. It should be poured out in the kitchen or butler's pantry and handed round on a salver in tiny cups, with tiny gold or silver spoons and lump sugar, but no cream or milk."[2]

TECHNICAL NOTES: The spoon bowl is gilded. The design is struck on one side.

M174

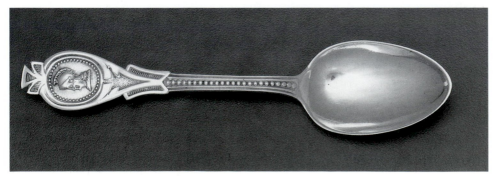

MARKED: F.A&CO.GAL.TX. (incuse).

RELATED EXAMPLES: Five mates remain in the donor's collection.

1. Act. in Galveston 1868–ca. 1871, ca. 1875–1901; Memphis, ca. 1871–ca. 1875. Fred Allen and Company is among the few Texas jewelers and retailers that stamped their wares. A native of Galveston, Allen was the son of Ebenezer Allen, secretary of the Republic of Texas. At the age of twelve he enlisted in the Confederate Army. Afterwards he trained as an engraver and described himself as such in the 1868–69 Galveston directory, when he was employed by Prince and Barnum. The following year he is listed independently as a watchmaker and jeweler. Following a brief sojourn in Memphis (ca. 1871–ca. 1875), Allen returned to Galveston and managed T. E. Thompson's jewelry store until 1895, when he purchased the business, operating it under his own name. His obituary appeared in the *Galveston Daily News* of May 10, 1901.
2. Hall 1887, p. 78.

M175★

Four Ice Cream Spoons

1860–75
Gorham Manufacturing Company (act. 1831–present), Providence[1]
Length 6" (15.3 cm)
Gift of Jas A. Gundry, B.97.7.1–.4

Ice cream has been favored and savored by Americans at least since the second quarter of the eighteenth century, when Maryland's royal governor Thomas Bladen served it to his guests. It remained a prerogative of the upper classes until the early nineteenth century. With the in-

vention of the hand-cranked freezer in the 1840s and the process of pasteurization slightly later, it became more widely available.[2] These spoons and the accompanying flatware that comprise this service indicate the trend toward specialized place and service pieces that evolved in the United States during the nineteenth century.

TECHNICAL NOTES: The spoon bowls are gilded.

MARKED: The standard Gorham marks of a lion, an anchor, and an old English G (incuse).

ENGRAVED: MTH.

RELATED EXAMPLES: These spoons were originally part of a more extensive service that included eight additional ice cream spoons, two pierced ladles (see cat. no. M210), and a berry spoon.

1. See cat. no. M87.
2. Tice 1990.

M176

Dessert Fork

ca. 1820–58
Shop of Anthony Rasch (1778/80–1858), New Orleans[1]
Length 6⁷⁄₁₆" (16.4 cm)
Gift of William James Hill, B.90.17

The fork is believed to have originated in Italy and was not recorded in England prior to the sixteenth century. In the American colonies, only a few examples dating from the colonial period are known, as steel-tined English forks predominated until the second quarter of the nineteenth century.[2] This design was produced by Anthony Rasch's Philadelphia and New Orleans shops, although the mark on this dessert fork clearly identifies it as a product of the latter.

PROVENANCE: Argentum Antiques, San Francisco, 1990.

MARKED: Mackie, Bacot, and Mackie 1980, p. 127, top mark.

ENGRAVED: An unidentified crest of a bird clutching a sprig; 114 (back of handle).

1. For Rasch (act. Philadelphia ca. 1801/03–20; act. New Orleans 1820–58), see Mackie, Bacot, and Mackie 1980, pp. 76–81, 123.

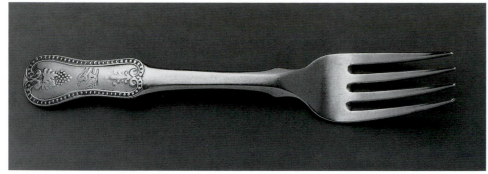

M176

2. Buhler 1972, vol. 1, pp. 56–57, 113, nos. 46, 92; Buhler and Hood 1970, vol. 2, p. 59, no. 605. Paul Revere, Jr.'s accounts bear this out; between 1761 and 1797 they record approximately 875 spoons and 1,500 teaspoons, but only one set of six forks and two sets of twelve.

M177

Set of Six Forks

1822–70
Louis Müh (1801–1882), New Orleans, retailer[1]
B.69.399.1–.6

The fork was not deemed a necessity for the dining room table until well into the nineteenth century. Its increasing popularity prompted authors of etiquette books to counsel readers against eating with their knife blades, encouraging them instead to use the fork "even at the peril of seeming affected than to offend the taste of another by making a mess with the fingers. . . ."[2]

PROVENANCE: Purchased by Miss Hogg from Waldhorn Company, New Orleans, 1962.

MARKED: Mackie, Bacot, and Mackie 1980, p. 126, and a series of unidentified pseudohallmarks.

ENGRAVED: L.

1. Act. 1822–70. For Müh, see Mackie, Bacot, and Mackie 1980, p. 122.
2. Grover 1987, pp. 135–36.

M178★

Set of Four Forks

1838–79
Shop of Edward A. Tyler (1815–1879), Belfast, Maine, and New Orleans[1]
Gift of the estate of Miss Ima Hogg, B.77.30.1–.4

PROVENANCE: Purchased by Miss Hogg from Waldhorn Company, New Orleans, 1963.

MARKED: Mackie, Bacot, and Mackie 1980, p. 127.

ENGRAVED: SB.

1. For Tyler (act. Belfast, Maine, 1834–38; act. New Orleans 1838–79), see Mackie, Bacot, and Mackie 1980, pp. 96–98.

M179

Fork

ca. 1860–95
Bell & Brothers (partnership ca. 1860–95), San Antonio, Texas[1]
Length 7⅝" (19.3 cm)
Museum purchase with funds provided by William James Hill, B.92.8

Bell & Brothers flatware transcends the conventional fiddle-handle pattern, trans-

forming it into one that is notable for its distinctive shape and substantial weight.[2]

PROVENANCE: Purchased by Bayou Bend from Whirligig Antiques, Austin, Texas, 1992.

MARKED: BELL&BRO'S (incuse).

RELATED EXAMPLES: This fork is originally from a set of five; the other examples are in Houston private collections (Warren 1996, p. 731). See also Steinfeldt and Stover 1973, pp. 170–71, nos. 206, 207.

1. See cat. no. M34.
2. Steinfeldt and Stover 1973, pp. 164–73, nos. 193, 197–99, 201, 205–8.

M180★

Dessert Fork

ca. 1868–71 or ca. 1875–1901
Unknown maker
Fred Allen (1849–1901) and Company, Galveston, Texas, and Memphis, retailer[1]
Length 6¾" (17.1 cm)
Museum purchase with funds provided by William James Hill, B.92.7

At the end of the eighteenth century the dessert fork and spoon (see cat. no. M116) became the latest accompaniment to the American dining table.[2] The dessert fork, along with its accompanying knife, was one of the essential dining utensils Thomas Webster included in his *Encyclopaedia of Domestic Economy* (1845) among "the usual articles in silver required to furnish a table. . . ."[3]

PROVENANCE: Purchased by Bayou Bend from Whirligig Antiques, Austin, Texas, 1992.

MARKED: See cat. no. M174.

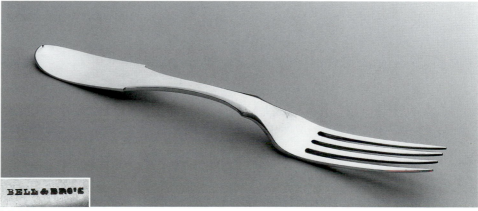

M179

1. See cat. no. M174.
2. Buhler and Hood 1970, vol. 2, p. 232, no. 919.
3. Webster 1845, p. 338.

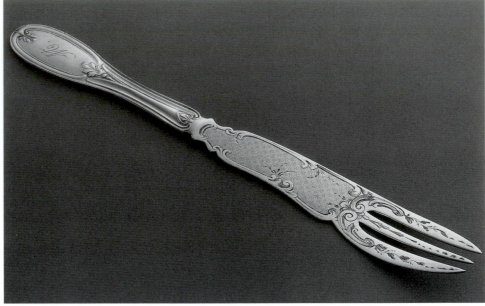

M181

M181

Pair of Melon Knives

1866–71
*Attributed to the Whiting Manufacturing
Company (act. 1866–1924), New York or
Attleboro, Massachusetts[1]*
James E. Spear (1817–1871), Charleston, retailer[2]
Length 8¼" (20.1 cm)
*Museum purchase with funds provided by an
anonymous donor in honor of the birthday of
William S. Kilroy, Jr., B.90.3.1–.2*

These intriguing instruments, intended as
melon knives, are indicative of the emerg-
ing rules of etiquette and accompanying
proliferation of specialized dining uten-
sils in mid-nineteenth-century America.
As one social arbitrator admonished her
readers: "No lady looks worse than when
gnawing a bone, even of game or poultry.
Few *ladies* do it. In fact, nothing should be
sucked or gnawed in public; neither corn
bitten off the cob, nor melon nibbled
from the rind."[3] The knives are double
struck in Michael Gibney's *Tuscan,* one of
the earliest American flatware patterns.[4]

PROVENANCE: Purchased by Bayou Bend
from Marian N. Soloway, West Orange, New
Jersey, 1990.

TECHNICAL NOTES: The backs have not been
decorated by engine turning.

MARKED: Belden 1980, p. 389.

ENGRAVED: M.

RELATED EXAMPLES: Other pairs from this
set are at Winterthur and the Charleston
Museum.

1. The design of these knives is attributed to
 Michael Gibney (d. 1860), who supplied
 work to Ball, Black & Co. and Gorham. Fol-
 lowing his death, Gibney's flatware dies were
 acquired by the Whiting Manufacturing
 Company (Venable 1994, pp. 25, 156, 315, 324).
2. For Spear (act. ca. 1846–71), see Burton 1942,
 pp. 175–77.
3. Williams 1985, p. 48.
4. Turner 1972, p. 126.

M182

Set of Twelve Knives

1835–70
*Handle: Manufactory of Andrew Ellicott
Warner (1786–1870), Baltimore[1]*
*Blade: Manufactory of Albert Coles (1815–1877),
New York[2]*
Length 10" (25.4 cm)
*Museum purchase with funds provided by the
Houston Junior Woman's Club, B.85.1.1–.12*

Silver-handled knives were fashionable ac-
companiments to the English dining table
early in the eighteenth century. To effi-
ciently and economically produce the
form, hollow handles were fashioned in
halves, soldered together, and filled with a
resinous composition. In America, English
knives with steel blades were predomi-
nant, and no American example dating
prior to the second quarter of the nine-
teenth century is known. Albert Coles
became a major manufacturer of flatware
and at an early date specialized in the pro-
duction of knives.

PROVENANCE: Private collection, Georgia;
[S. J. Shrubsole, New York]; purchased by
Bayou Bend at Christie's, New York, January
26, 1985.

TECHNICAL NOTES: The handles were struck
in halves, filled, and then soldered together.
The blades and ferrules are made of close-
plated steel.

MARKED: B.85.1.1–.3, B.85.1.5–.6, B.85.1.8, and
B.85.1.12, Goldsborough et al. 1983, p. 287, no.
274 (on the handle near the ferrule); on the re-
maining knives, the mark is directly on the fer-
rule, along with Albert Coles's trefoil mark,
Belden 1980, p. 118. Each of the ferrules is
struck II (incuse), signifying the silver's purity.

ENGRAVED: An unidentified crest of a stork
with a serpent in its beak (handle).

RELATED EXAMPLES: Fales 1958, no. 84.

REFERENCES: Christie's, New York, sale 5810,
January 26, 1985, lot 41.

1. See cat. no. M76.
2. See cat. no. M99 (Soeffing 1988b, p. 28).

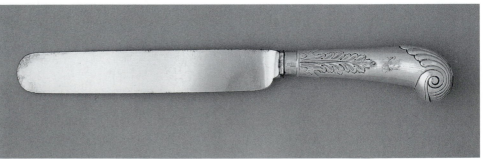

M182

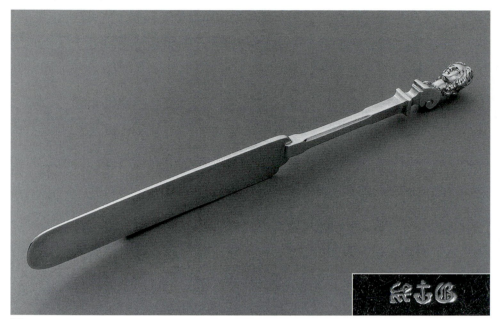

M183

M183

Pair of Dessert Knives

ca. 1866–68
Gorham Manufacturing Company
(act. 1831–present), Providence[1]
Length 8" (20.4 cm)
Gift of Phyllis and Charles Tucker, B.95.9.1–.2

In 1845 Thomas Webster commented that dessert knives and forks were essentials among "the usual articles in silver required to furnish a table. . . ."[2] These dessert knives by Gorham terminate in a three-dimensional head, the ultimate development of a series of related flatware patterns introduced by several silver manufacturers in the 1860s that incorporated medallion portraits. Gorham's pattern *Bust,* which entered into the cost books in 1866, is perhaps the best known of the three-dimensional variety. The manufacturer also offered individual place, tea, butter, and crumb knives in this pattern.[3]

MARKED: The standard Gorham marks of a lion, an anchor, and an old English G (incuse), similar to cat. no. M175, are struck on the side of the knife blade.

RELATED EXAMPLES: This pair originally comes from a set of twelve; another pair belongs to Winterthur, and the others are privately owned.

1. See cat. no. M87.
2. Webster 1845, p. 338.
3. Samuel J. Hough assembled a detailed analysis of Gorham's *Bust* pattern, which is on file at Bayou Bend.

M184

Pair of Individual Asparagus Tongs

1848–78
Bailey & Co. (act. 1848–78), Philadelphia,
manufacturer or retailer[1]
Length 4⅜" (11.1 cm)
Museum purchase with funds provided by
William Robinson in honor of Mr. and Mrs.
Fred T. Couper, Jr., B.90.10.1–.2

Utensils designed for serving asparagus were first produced in England during the

1760s; however, the date for the introduction of individual tongs is uncertain. In all probability their earliest production corresponds with the mid-nineteenth-century social dictate to resist handling food with the fingers. The Bayou Bend pair are among the earliest extant American asparagus tongs.[2] Their brilliantly executed decoration, inspired by Neoclassical bright-cut engraving, produces an effect consistent with the colonial revival aesthetic.

PROVENANCE: Purchased by Bayou Bend from Phyllis Tucker, Houston, 1990.

MARKED: Belden 1980, p. 42.

RELATED EXAMPLES: This pair originally comes from a set of six; another pair is illustrated in Venable 1994, p. 139, and the third pair is privately owned.

REFERENCES: Venable 1994, pp. 139, 339.

1. See cat. no. M77.
2. Cramer 1986; Rabinovitch 1991, pp. 263, 271–72, 274–75, nos. 37–39.

M185

Pair of Corn Scrapers

B.95.10.1: 1863–78; B.95.10.2: 1866–78
Bailey & Co. (act. 1848–78), Philadelphia,
retailer[1]
Length 7" (17.8 cm)
Gift of Phyllis and Charles Tucker, B.95.10.1–.2

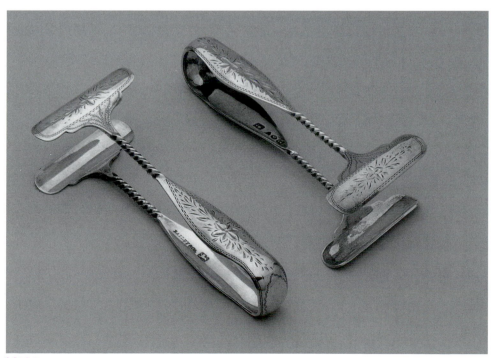

M184

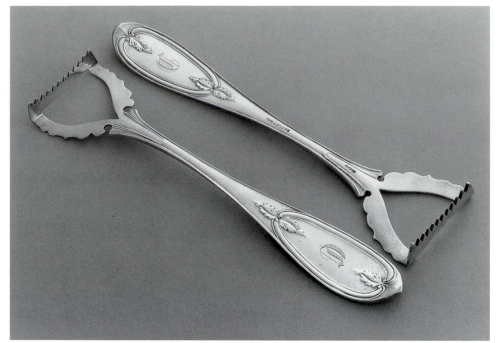

M185

"Some people think it is very barbarous to eat corn from the cob. . . ."[2] For the Victorians, corn on the cob presented a direct challenge to etiquette rules about the handling of food. The corn scraper was developed to shave off kernels for more polite consumption. The second half of the nineteenth century witnessed a succession of related utensils, including corn holders, forks, butterers, and even a scorer scraper. The Bayou Bend scrapers are among the earliest American examples of this specialized form.[3]

TECHNICAL NOTES: The handle is double struck.

MARKED: **B.95.10.1**, Belden 1980, p. 42, PATENT 1863 (incuse); **B.95.10.2**, PAT'D JAN.16.66 (incuse).

ENGRAVED: D.

RELATED EXAMPLES: This pair originally comes from a set of twelve, each displaying slight variations in their profiles.

1. See cat. no. M77.
2. Hall 1887, p. 94.
3. Cramer 1987.

M186*

Salt Shovel

1820–70
Shop of J. W. Backus (n.d.), probably central New York State[1]
Gift of David B. Smith, B.88.4

Salt was generally taken from a knife blade prior to the development of a specialized utensil, during the second quarter of the eighteenth century. Its earliest manifestation was in the form of a shovel followed by a spoon.

MARKED: Belden 1980, p. 39.

ENGRAVED: AHB.

1. For Backus, see Soeffing 1991.

M187

Pair of Salt Shovels

1800–1870
Unknown maker
Gift of David B. Smith, B.88.3.1–.2

Possible retailers for this pair of salt shovels include Thomas W. Bell, of Philadelphia and Petersburg, Virginia; S. W. Bell, Philadelphia; J. J. Bell, Auburn, New York; J. & G. R. Bell, Ogdensburg, New York; and William H. Bell, Concord, New Hampshire.

MARKED: BELL (incuse), pseudohallmarks of D, eagle, and a profile facing left.

ENGRAVED: EJO.

M188*

Salt Spoon

1852–81
Newell Harding & Co. (act. 1852–81), Boston[1]
Gift of David B. Smith, B.88.10

MARKED: Belden 1980, p. 214, a.

ENGRAVED: MS.

1. For Newell Harding (1796–1862), Francis L. Harding, Louis Kimball, A. H. Lewis, and John D. Sullivan, see Belden 1980, p. 214.

M189*

Pair of Salt Spoons

ca. 1849–53
Shop of James H. Carleton (act. ca. 1849–53), Haverhill, Massachusetts[1]
Gift of David B. Smith, B.88.5.2–.3

MARKED: Belden 1980, p. 98, b.

ENGRAVED: M.E. Taggart.

RELATED EXAMPLES: Cat. no. M170 shares the same maker and engraving.

1. See cat. no. M170.

M190

Mustard Spoon

1846–51
Manufactory of Palmer & Bachelders (act. 1846–51), Boston, retailer[1]
Length 5⅛" (13 cm)
Gift of David B. Smith, B.88.12.8

The mustard spoon, with its elongated handle to scoop dry mustard from a caster, was introduced in England during the third quarter of the eighteenth century.

MARKED: PALMER&BACHELDERS.

ENGRAVED: M.S. from L.S.

1. See cat. no. M166.

M191*

Mustard Spoon

1856–87
Shop of Theron M. Howard (1829–after 1888),
St. Johnsbury, Vermont, retailer[1]
Length 4⅞″ (12.4 cm)
Gift of David B. Smith, B.88.11

MARKED: Carlisle 1970, p. 17.

1. For Howard, see Carlisle 1970, pp. 170–72.

M192

Sugar or Tea Tongs

ca. 1745–95
Unknown maker
Length 4¹³⁄₁₆″ (12.2 cm)
B.69.110

The earliest tongs date from late-seventeenth-century England. Their close affinity with the fire tongs has encouraged speculation that a toy pair was adapted for the purpose. By the eighteenth century a spring bow replaced the spring hinge, and scissor-type tongs, such as this pair, were the result. While English-made tongs were imported and retailed, American silversmiths' accounts attest that they also produced them in quantity. The earliest American examples of this type date from the second quarter of the eighteenth century. Both Joseph Richardson's and Paul Revere, Jr.'s accounts used the terms "sugar tongs" and "tea tongs" interchangeably, although the former is more prevalent.[1]

PROVENANCE: Enoch Freeman (1706–1788) and Mary Wright Freeman (d. 1785, married 1742), Portland, Maine; to their son Samuel (1743–1821); to his son William (1783–1861); purchased by Miss Hogg from Gebelein Silversmiths, Boston, 1954.[2]

ENGRAVED: EᶠM [Enoch and Mary Freeman] (inside shell tip).

RELATED EXAMPLES: Previously these tongs were attributed to John Coburn, since Enoch Freeman is known to have patronized his shop. No examples of this type marked by his shop are known, although another pair are attributed, in Buhler 1972, vol. 1, p. 315, no. 271. Frequently individuals patronized more than one shop, which complicates making an attribution based merely on provenance.

REFERENCES: Warren 1975, p. 167, no. 319; Kane 1998, p. 303.

1. Fales 1974b, pp. 221, 227, 235, 239, 244, 253, 255, 260; Revere 1761–97; Buhler 1979, p. 47, no. 57.
2. According to the dealer, Enoch Freeman owned a can marked by John Coburn. A biographical profile on Freeman is published in Shipton 1951, pp. 572–81.

M193

Sugar Tongs

ca. 1790–1820
Shop of Charles A. Burnett (1769–1848),
Alexandria, Virginia, and Georgetown, D.C.[1]
Length 5⅝″ (14.3 cm)
Museum purchase with funds provided by
Jack McGregor, B.85.13

Bow-shaped sugar tongs were introduced during the third quarter of the eighteenth century. The earliest examples, vigorous Rococo expressions, combine the scissor tongs' shell-like grips, with arms that are complex compositions of interlacing strapwork. By the Neoclassical period the grips were transformed into either an acorn shape, such as that on these Burnett tongs, or simply an oval. The arms became solid and relied solely on engraving for their decoration.

PROVENANCE: Purchased by Bayou Bend from Firestone and Parson, Boston, 1985.

MARKED: Belden 1980, p. 86, a.

ENGRAVED: JCHW.

RELATED EXAMPLES: Hollan 1994, pp. 48–50, nos. 21–23.

1. For Burnett, see cat. no. M35.

M194

Sugar Tongs

1824–29
Manufactory of Samuel Kirk (1793–1872),
Baltimore[1]
Length 6⅞″ (17.5 cm)
Gift of Miss Ima Hogg and the Friends of Bayou Bend, B.71.90

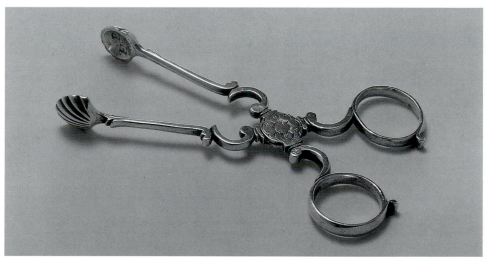

M192

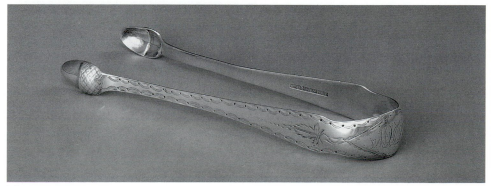

M193

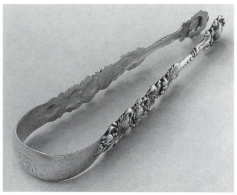

M194

PROVENANCE: Purchased by Bayou Bend from Peter Hill, Washington, D.C., 1970.

MARKED: Goldsborough et al. 1983, p. 29, fig. 5.

ENGRAVED: LBI.

REFERENCES: Warren 1970a, pp. 96–97; Warren 1975, p. 174, no. 329.

M195

Sugar Spoon

1846–51
Manufactory of Palmer & Bachelders
(act. 1846–51), Boston, retailer[1]
Gift of David B. Smith, B.88.12.7

MARKED: See cat. no. M168.

ENGRAVED: C.

RELATED EXAMPLES: For other flatware from this service see cat. nos. M164, M167, M168, M169.

1. See cat. no. M166.

M196

Sugar Scoop

1848–51
D. Goddard & Son (act. ca. 1848–51), Worcester, Massachusetts, retailer[1]
Gift of David B. Smith, B.88.9

MARKED: D. GODDARD & SON.; WORCESTER

ENGRAVED: MHW to MS.

1. Daniel Goddard (1796–1884) is first listed in the Worcester directory along with Charles W. Rice, an engraver, in 1844. A year earlier the firm D. Goddard & Co., with Benjamin Goddard, is recorded. Daniel Goddard and Son, advertised as watchmakers and jewelers, first appear in the 1848 edition, but by 1852 their business relationship had been severed.

M197

Preserve Spoon

1871–1930
Tiffany & Co. (act. 1837–present), New York, retailer
Edward Chandler Moore (1827–1891), New York, designer[1]
Gift of the estate of Miss Ima Hogg, B.78.57

Edward Chandler Moore was one of nineteenth-century America's principal silver designers and is largely credited with the phenomenal success of Tiffany's flatware. Between 1869 and 1889 he patented ten different designs, including this one—the *Palm* pattern—which was patented on July 4, 1871.

MARKED: TIFFANY&CO; STERLING; PAT 1871; M. See also Carpenter and Carpenter 1978, p. 256, no. 36.

ENGRAVED: WCH [William Clifford Hogg].

RELATED EXAMPLES: The rest of this service belongs to the Governor's Mansion, Austin, Texas.

REFERENCES: Turner 1972, pp. 115, 379; Carpenter and Carpenter 1978, pp. 97, 111, 118.

1. See cat. no. M71.

M198

Serving Spoon

1852–81
Newell Harding & Co. (act. 1852–81), Boston[1]
Length 12″ (30.5 cm)
Gift of Phyllis and Charles Tucker in memory of Mr. Pat Greenwood, B.91.33

By the mid-nineteenth century Neoclassical design was resurrected and reconfigured into a new style now popularly referred to as colonial revival. George Washington, as "Father of his Country," was the historical figure most celebrated. The profile employed here is perhaps his best-known likeness, based on Jean-Antoine Houdon's classic portrait bust.

MARKED: N HARDING&CO; PURE COIN (incuse).

RELATED EXAMPLES: Soeffing 1988b, pp. 54–55; the Ineson-Bissell Collection at Winterthur.

1. See cat. no. M188.

M199*

Pudding Spoon

1866–75
Whiting Manufacturing Company
(act. 1866–1924), New York and Attleboro, Massachusetts[1]
Length 9″ (22.9 cm)
Gift of Jas A. Gundry, B.96.27

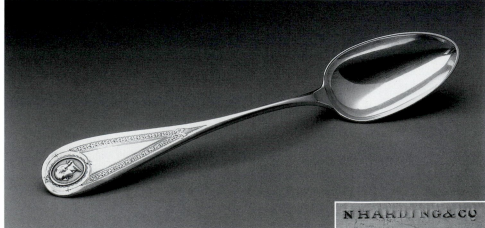

M198

Whiting Manufacturing Company's *Egyptian* was one of many ancient-inspired patterns introduced during the late 1860s (see cat. no. M203).

TECHNICAL NOTES: The spoon bowl is gilded.

MARKED: STERLING/PAT.APPL.FOR.

ENGRAVED: Belle.

REFERENCES: Turner 1972, p. 129.

1. See cat. no. M181.

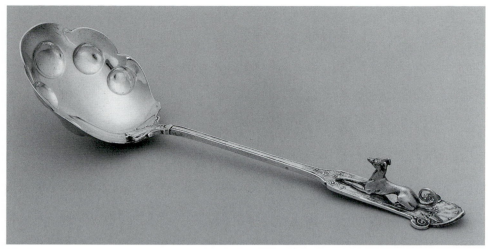

M200

M200

Berry Spoon

ca. 1865
Gorham Manufacturing Company
(act. 1831–present), Providence[1]
Length 10" (25.5 cm)
Gift of Jas A. Gundry, B.97.10

Byzantine, one of the Gorham Manufacturing Company's most enduring patterns, was introduced about 1865. Shortly thereafter Gorham offered this variant, known as *Hound,* by simply attaching a cast canine to the end of the handle.

MARKED: A variation on the standard Gorham marks of a lion, an anchor, and an old English G (incuse), similar to cat. no. M175, and STERLING.

ENGRAVED: Transposed H over a stylized Y.

REFERENCES: Carpenter 1982, p. 294.

1. See cat. no. M87.

M201

Nut Spoon

1869
Gorham Manufacturing Company
(act. 1831–present), Providence[1]
Length 10¾" (27.3 cm)
Gift of Phyllis and Charles Tucker, B.95.8

Mid-nineteenth-century American silver often integrates specific elements and motifs into its design that allude to the utensil's function. The Gorham nut spoon represents an early instance of this vogue, and one with undeniable charm. A deceptively complex object, its gilded,

pierced, canopied bowl is further enhanced by the imaginative transformation of its intricately cast handle into a wooden branch, complete with foliate sprigs and perched squirrel poised to crack open a nut.

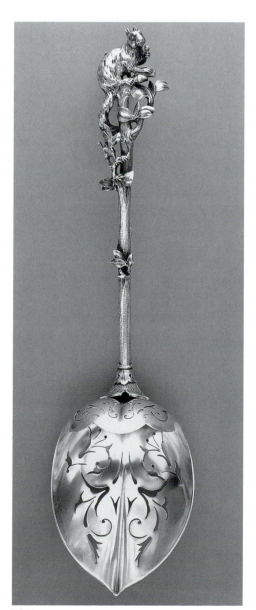

M201

PROVENANCE: California governor Milton Slocum Latham (1827–1882) and his second wife, Mary McMullin Latham (d. 1939, married 1870); to Mary McMullin Latham; to her cousin Mary McMullin Godley; to her daughter Margaret S. Godley; [Gary Sprat, Healdsburg, California]; purchased by Phyllis and Charles Tucker from Argentum Antiques, San Francisco, 1995.

TECHNICAL NOTES: The handle is completely in the round and terminates in an ogival arch where it joins the bowl. The Gorham records identify this server as "nut spoon 113" and first document it on October 30, 1869. The net factory price was $21.85, an immense sum at the time that translates as ten working hours, comparable to the fabrication of a pitcher or a bowl.[2]

MARKED: Carpenter 1982, p. 286, no. 18; STERLING, 113, and B (incuse).

REFERENCES: Burton 1997, p. 224h.

1. See cat. no. M87.
2. The last two refer to the object and the year; Samuel J. Hough supplied the explanation of the Gorham stamps.

M202

Ice Cream Knife or Vegetable Spoon

ca. 1865–75
Patrick Ford (act. 1874–81), New York, probably retailer[1]
Length 11" (27.9 cm)
Gift of Phyllis and Charles Tucker, B.97.11.1–.2

This captivating design embodies the prevailing aesthetic of the 1860s. Its birdlike claw handle is transformed into a mean-

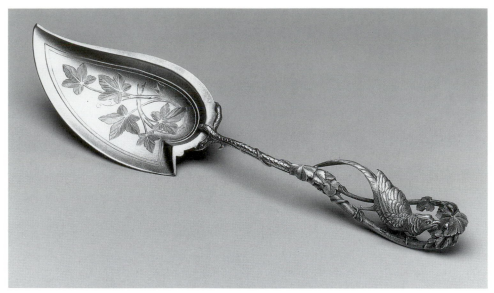

M202

executed in *Isis*. Egyptian designs prolifer-ated at Gorham, which introduced three additional patterns by 1870: *Egyptian Ivy*, *Lotus*, and *Egyptian*.

MARKED: The standard Gorham marks of a lion, an anchor, and an old English G (incuse), similar to cat. no. M175, and STERLING.

ENGRAVED: SF.

RELATED EXAMPLES: Ward and Ward 1979, p. 175, no. 183; Ward and Ward 1981, p. 325; Carpenter 1982, pp. 83, 85, no. 79; Venable 1994, pp. 64, 69, 331.

1. See cat. no. M87.

dering vine that repeats the bowl's con-tour as a three-dimensional pheasant scurries along the end of the handle and into the foilate ornament. At this time an attribution to any manufacturer is prema-ture, since no documented example is known.[2] The original purpose for this utensil may have been as an ice cream knife, although later catalogues identify it as a vegetable spoon.

PROVENANCE: Donald Ritchie, San Francisco; purchased by Phyllis and Charles Tucker at Butterfield & Butterfield, San Francisco, June 19, 1997, through Argentum Antiques, San Francisco.

TECHNICAL NOTES: The bowl has a granu-lated surface and gilt trim. The serving piece comes in a box, which is believed to have origi-nally accompanied it, labeled "P. Ford, 847 Broadway, N.Y."

MARKED: The ice cream knife is marked STER-LING I A.

ENGRAVED: M (back of bowl).

RELATED EXAMPLES: Venable 1994, pp. 152–53, fig. 6.25.

REFERENCES: Butterfield & Butterfield, San Francisco, sale 6548, June 19, 1997, lot 5140.

1. For Ford, see Venable 1994, p. 319.
2. A related fork is assigned to the Whiting Manufacturing Company (see Related ex-amples), an attribution based on a similar yet different pattern that is marked by the company.

M203

Ice Spoon

1870–75
*Gorham Manufacturing Company
(act. 1831–present), Providence[1]*
Length 10″ (25.4 cm)
Gift of Phyllis and Charles Tucker, B.93.13

The *Isis* pattern officially entered Gor-ham's cost books on March 3, 1870. It was among the most labor-intensive and expensive designs that the company had undertaken up to that time. An ice spoon was included among its utensils, despite the apparent anomaly of the form in an Egyptian-inspired pattern. With its deli-cate piercing and engraved ornament, it proved one of the more complex utensils

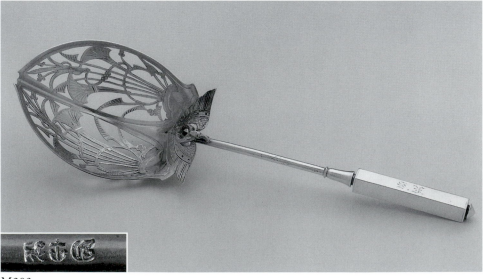

M203

M204

Ice Tongs

1862–71
*Attributed to the manufactory of John R. Wendt
(1826–1907), New York[1]*
*Ball, Black & Co. (act. 1851–74), New York,
retailer[2]*
Length 13″ (33 cm)
*Gift of Phyllis and Charles Tucker in memory
of Jack Clemens Skaggs, B.91.32*

John R. Wendt was issued the earliest design patent for medallion flatware in 1862, followed by Gorham's designer, George Wilkinson two years later, John Polhamus in 1865, and Philo B. Gilbert in 1867. The popularity of medallion pat-terns is affirmed by these and another twenty unpatented designs identified today. Wendt maintained a close business relationship with Ball, Black & Co.;

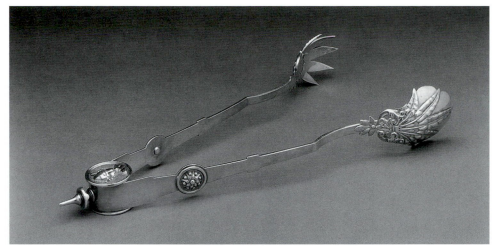

M204

REFERENCES: Failey 1972; Warren 1975, p. 180; Mackie, Bacot, and Mackie 1980, p. 69.

1. For Lamothe (act. New Orleans 1809–23), see Mackie, Bacot, and Mackie 1980, pp. 68–69, 122.

in fact, both were located at the same Broadway address. As Wendt was a wholesaler, his silver rarely bears a manufacturer's mark.

TECHNICAL NOTES: The medallion is only on one side. Within the bow is an inner cylinder secured by a finial screw. The rosettes are bolted on.

MARKED: Darling 1964, p. 23 top (inside the arm).

1. See cat. no. M158.
2. See cat. no. M14.

M205*

Ladle

1802–20
Shop of Nathaniel Vernon (1777–1843),
Charleston[1]
Length 13¼″ (33.6 cm)
Gift of the estate of Miss Ima Hogg, B.76.183

MARKED: Belden 1980, p. 421.

ENGRAVED: HMC.

1. For Vernon (act. 1802–ca. 1835), see Burton 1942, pp. 187–89.

M206

Ladle

1809–23
Shop of Pierre Lamothe (act. ca. 1803–23),
St. Marc, Santo Domingo, Santiago de Cuba,
and New Orleans[1]
Length 13¾″ (34.9 cm)
Gift of the Friends of Bayou Bend, B.71.93

PROVENANCE: Purchased by Bayou Bend from Robert Ray, III, Alexandria, Virginia, 1971.

MARKED: Mackie, Bacot, and Mackie 1980, p. 126.

ENGRAVED: NG and F.Q. (back of handle, the latter added later).

M207

Ladle

1820–58
Shop of Anthony Rasch (1778/80–1858),
Philadelphia and New Orleans[1]
Length 13″ (33 cm)
Gift of Jack McGregor, B.87.21

PROVENANCE: Ursuline Convent, New Orleans.

MARKED: A.RASCH.

ENGRAVED: S.U over PEN (back of handle).

1. See cat. no. M176.

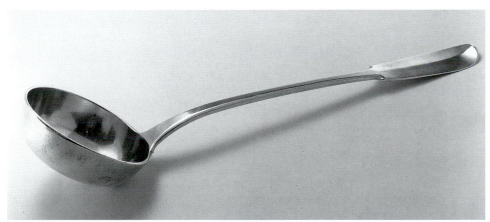

M206

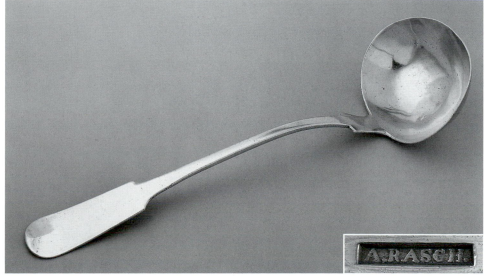

M207

M208*

Ladle

1853–70
Shop of Henry Peat Buckley (1822–1903),
New Orleans[1]
Length 12⅝″ (32.1 cm)
Museum purchase with funds provided by
William James Hill in honor of Mrs. Daniel
Japhet, B.96.25

PROVENANCE: Elva Needles Antiques, Kansas
City, Missouri, 1996.

MARKED: H.P.BUCKLEY.N.O. (incuse).

ENGRAVED: S.

1. For Buckley (act. 1842–1903), see Mackie,
 Bacot, and Mackie 1980, pp. 102–3.

M209

Pierced Ladle

1825–46
Shop of R. & W. Wilson (partnership 1825–46),
Philadelphia[1]
Length 8¹/₁₆″ (20.5 cm)
Gift of Jas A. Gundry, B.93.20

PROVENANCE: Probably the Booth family of
Dubuque, Iowa; by descent to Jas A. Gundry.

TECHNICAL NOTES: The design is struck
only on one side.

MARKED: Belden 1980, p. 450, a.

ENGRAVED: HAB.

1. See cat. no. M64.

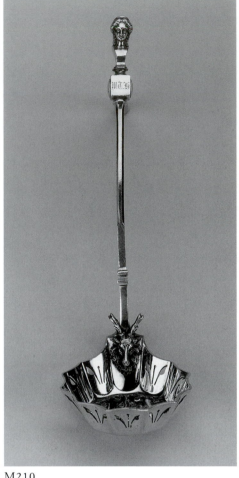

M210

M210

Pierced Ladle

1860–75
Gorham Manufacturing Company
(act. 1831–present), Providence[1]
Length 7½″ (19.2 cm)
Gift of Jas A. Gundry, B.97.8

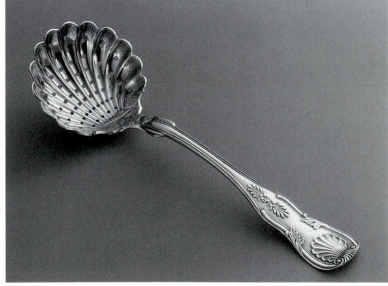

M209

Originally this diminutive ladle was one
of a pair included in an extensive dessert
service that also included a dozen ice
cream spoons (see cat. no. M175). The
stag's head, where the handle is joined to
the bowl, terminates in a classical bust
terminal, an unusual configuration.

TECHNICAL NOTES: The bowl is gilded.

MARKED: The standard Gorham marks of a
lion, an anchor, and an old English G (incuse),
similar to cat. no. M175.

ENGRAVED: MTH.

RELATED EXAMPLES: Cat. no. M175 records
spoons from the same service.

1. See cat. no. M87.

M211

Pierced Ladle

1868–75
Gorham Manufacturing Company
(act. 1831–present), Providence[1]
Henry Rowlands (n.d.), retailer
Length 9″ (22.4 cm)
Gift of Phyllis and Charles Tucker in memory
of David Bland, B.93.2

The naturalistic motifs central to the
eighteenth-century Rococo aesthetic
assumed an even greater prominence as
the style was reinterpreted a century
later. Gorham's morning glory pattern,
probably known at the time as *Convolvu-
lus,* is one of the most beautifully articu-
lated expressions of nineteenth-century
America's infatuation with nature.[2] This
ladle's bowl is pierced to suggest ivy, com-
plementing the three-dimensional leaves
that serve as a transition between bowl
and handle. The Victorians often assigned
symbolic significance to flowers; one con-
temporary source couples the morning
glory with coquetry.

MARKED: The standard Gorham marks of a
lion, an anchor, and an old English G (incuse),
similar to cat. no. M175; below, HENRY ROW-
LANDS; and below, STERLING (incuse, handle,
back of bowl).[3]

RELATED EXAMPLES: Fennimore 1984, no. 39;
Venable 1994, p. 122.

1. See cat. no. M87.
2. This design has been attributed to George
 Wilkinson (1819–1894) or Thomas J. Pair-

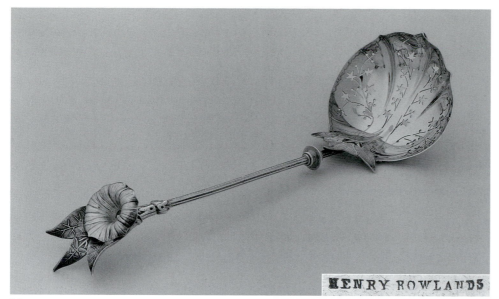

M211

point (1847–1902); Draper 1990; Draper 1991a; Draper 1991b. According to Samuel J. Hough there is no record of this pattern's introduction in the Gorham archives.

3. According to Samuel J. Hough, on May 1, 1868, Gorham began to use the mark STERLING.

M212★

Pierced Ladle

1865–75
Gorham Manufacturing Company
(act. 1831–present), Providence[1]
Length 8⅛″ (20.6 cm)
Gift of Jas A. Gundry, B.96.26

This handsome ladle makes an illuminating contrast with the previous example (cat. no. M211). While the components are similar in appearance, they are not identical. The treatment of the ladle reveals how a manufacturer could variously interpret and integrate contemporary motifs, most notably on this example in the sphinx terminal, which relates it to Gorham's other Egyptian-inspired designs (see cat. nos. M203, M213).

TECHNICAL NOTES: The bowl is gilded.

MARKED: The standard Gorham marks of a lion, an anchor, and an old English G (incuse), similar to cat. no. M175.

ENGRAVED: EL (back of bowl).

1. See cat. no. M87.

M213★

Ladle

1870–75
Gorham Manufacturing Company
(act. 1831–present), Providence[1]
Length 13⅞″ (35.2 cm)
Gift of Phyllis and Charles Tucker, B.96.11

The name for this simple, elegant pattern is not known; however, its introduction coincided with Gorham's other Egyptian-inspired designs. The ladle's graceful stylized bowl and kneeling figures seem paradoxical with its spare reed-shaped handle and its ornamental reel, reminiscent of a sixteenth-century English seal-top spoon.

TECHNICAL NOTES: The bowl is gilded.

MARKED: The standard Gorham marks of a lion, an anchor, and an old English G (incuse), similar to cat. no. M175, and STERLING.

ENGRAVED: A superimposed over O.

RELATED EXAMPLES: Venable 1994, pp. 64, 69.

1. See cat. no. M87.

M214

Butter Knife

ca. 1849
Manufactory of Wood and Hughes
(act. 1845–99), New York[1]
Samuel W. Benedict (act. 1823–64), New York, retailer[2]
Length 7⅜″ (18.7 cm)
Gift of Mrs. John A. Beck, B.88.18

In 1861, butter was first commercially produced. While critics argued that farm butter was of higher quality, the factory-produced equivalent was an acceptable alternative. Metal butter dishes, equipped with a special knife, made their first appearance during this period, while Catharine Beecher advised hostesses that when setting the table "a small plate should be placed at each place for butter. . . ."[3]

PROVENANCE: See cat. no. M144.

MARKED: Belden 1980, pp. 56, 454.

ENGRAVED: J.G. [Jasper Gibbs].

RELATED EXAMPLES: Cat. nos. M144, M145; also retailed by Samuel W. Benedict, descended in the same family.

1. See cat. no. M69.
2. See cat. no. M144.
3. Williams 1985, pp. 117, 121–22; Grover 1987, p. 195.

M215

Cheese Knife

1871–80
Manufactory of Peter L. Krider (1821–1895), Philadelphia[1]
Length 7⅝″ (19.4 cm)
Gift of Phyllis and Charles Tucker, B.92.4

By the 1850s the production of cheese had become one of America's major industries.

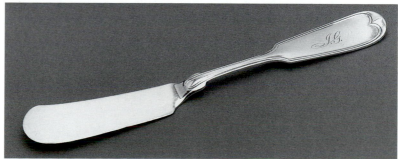

M214

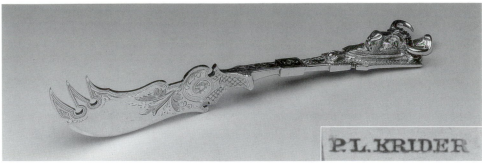

M215

"Cheese is often made a course by itself; indeed, the general tendency of the modern dinner is to have each dish all alone by itself."[2] Alternatively, it could be served at the meal's conclusion, as it was believed to aid digestion. In response to the increasing popularity of cheese, silver manufacturers introduced a range of specialized dining utensils, such as the cheese knife with its succession of bifurcated points terminating its blade or, for softer varieties, the cheese scoop. By the 1870s both forms were deemed integral to the complete dinner service.[3]

MARKED: STERLING / P.L.KRIDER (incuse); pseudohallmarks of a lion, R, and crown, on the blade.

1. See cat. no. M40.
2. Carpenter and Carpenter 1978, p. 94.
3. Cramer 1990; Kelly 1991.

M216

Fish Slice

ca. 1830–42
Shop of Thomas Fletcher (1787–1866),
Philadelphia[1]
Length 13⅜" (34 cm)
Museum purchase with funds provided by the
Bayou Bend Docent Organization, B.87.2

The fish slice was intended to filet fish at the table. An eighteenth-century form,

the earliest examples resembled wood-handle trowels and were distinguished by elaborately pierced and engraved blades. By the third quarter of the century the form was first produced in the American colonies.[2] Thomas Fletcher's slice resonates with the boldness and scale that characterizes Grecian flatware. Its blade is painstakingly engraved with a classically inspired dolphin, and its fiddle thread and shell handle proffers the most fully developed expression of this conventional pattern.

PROVENANCE: Purchased by Bayou Bend from William Core Duffy, Kittery Point, Maine, 1987.

MARKED: Belden 1980, p. 169, a.

ENGRAVED: J E P.

1. See cat. no. M72.
2. Hammerslough and Feigenbaum 1973, p. 102.

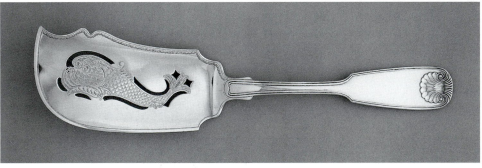

M216

M217

Fish Set

1860–74
Ball, Black & Co. (act. 1851–74), New York,
retailer[1]
Slice: Length 12⅜" (31.4 cm); fork: Length 9¾"
(24.8 cm)
Gift of Jas A. Gundry, B.97.9.1–.3

By the mid-nineteenth century a companion fork was coupled with the fish slice to form a standard pairing. No other flat service pieces approached the scale, amount of ornament, or popularity of these utensils. The Bayou Bend set, a handsome example of the *King's* pattern, is suitably engraved with fish, a basket, a rod, and a net within a Rococo surround.

TECHNICAL NOTES: Both objects are double struck. The set has survived with its original box, which bears the address 565 & 567 Broadway.

MARKED: BALL BLACK & CO/STERLING (incuse, both pieces).

ENGRAVED: MEW.

1. See cat. no. M14.

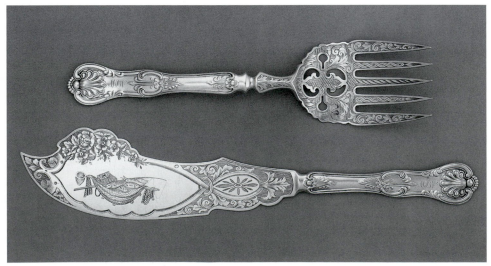

M217

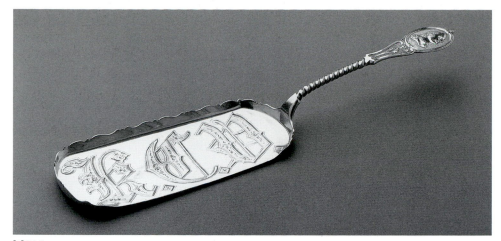

M218

Toast Tongs (?)

1862–71
Attributed to the manufactory of John R. Wendt
(1826–1907), New York[1]
Braverman & Levy (act. 1852–81), San Francisco,
retailer[2]
Length 11¾" (29.8 cm)
Gift of Phyllis and Charles Tucker in memory of
Charles Thomas Tucker, B.94.10

M218

Crumb Knife

1846–51
Shop of Hall, Hewson & Brower (act. 1846–51),
Albany, New York[1]
Length 12¼" (31.1 cm)
Gift of Phyllis and Charles Tucker in memory of
Mr. Pat Greenwood, B.91.34

The crumb knife, intended for collecting
and removing the table crumbs prior to
serving the dessert course, was introduced
during the mid-nineteenth century. This
early example with the seemingly incon-
gruous profile of George Washington as
the handle terminal testifies to his endur-
ing legacy as a national icon.

MARKED: Belden 1980, p. 209.

ENGRAVED: K.C.V.

1. For Green Hall (1782–1863), John D. Hewson
 (1790–1852), and Sperry Douglas Brower
 (1808–after 1867), see Rice 1964, p. 76; Belden
 1980, p. 209.

Medallion flatware was in vogue during
the 1860s and remained popular well into
the following decade. John R. Wendt's de-
signs are recognized as some of the finest
executed, as this unusual server attests.
While its original purpose has not been
confirmed from period sources, it is be-
lieved these impressive tongs, with their
mechanical spring handle, were intended
for serving toast.

MARKED: STERLING; PATENT; 925; BRAVERMAN
&LEVY (incuse).

ENGRAVED: AJIS (later).

1. See cat. no. M158.
2. For Braverman & Levy, see Morse 1986, p. 107.

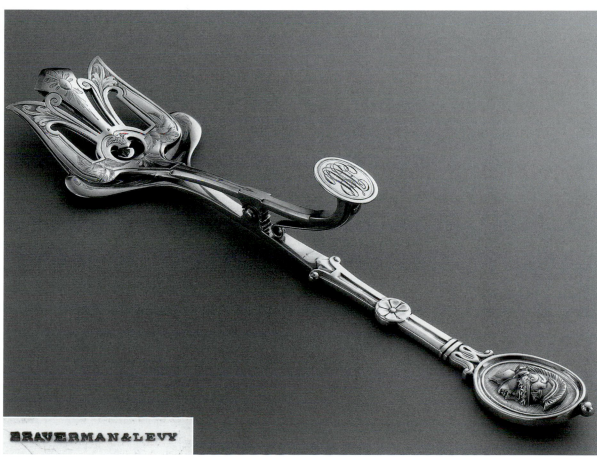

M219

M220

Dish

1755–82
Shop of Thomas Danforth, II (1731–1782),
Middletown, Connecticut[1]
1 x 12⅛" (diam.) (2.5 x 30.8 cm)
B.60.71

Pewter is an alloy composed largely of tin, with copper, lead, antimony, and bismuth added to strengthen the metal, create a smooth surface, and enhance its color. Pewter was less expensive than silver and, accordingly, its use more widespread. Damaged and outmoded objects retained much of their value since they could be melted down and recast. Thomas Danforth, II's dish, possibly dating from the 1750s, is probably the earliest example of American pewter in the Bayou Bend collection.

PROVENANCE: Purchased by Miss Hogg from Thomas D. and Constance R. Williams, Litchfield, Connecticut, 1960.

TECHNICAL NOTES: Dishes, as well as plates, saucers, and basins, were cast in a two-part mold. As part of the finishing process, the booge, the curved section between the bottom and the brim, was hammered. This technique strengthened what was a brittle area, reducing the likelihood of cracking from stress. Such handwork, usually limited to colonial examples, was optional, representing an additional production expense.

MARKED: Laughlin 1940, vol. I, pl. LIII, nos. 362 (double struck), 363; HB, each letter crowned (incuse, presumably the original owner's initials).

RELATED EXAMPLES: Hood 1965, p. 13, no. 5; Kernan, Ross, and Eilers 1969, pp. 14, 46, no. 11; Fairbanks 1974, p. 108, nos. 165, 168; Montgomery 1978, p. 293.

REFERENCES: Butler 1985, p. 13.

1. For Danforth (act. ca. 1755–82), see Myers 1926, pp. 21–22, 24, 27, 34, 36; Laughlin 1940, vol. I, pp. 107–8; Laughlin 1971, pp. 65–67; Thomas 1976, pp. 67–75; Herr 1995, p. 130.

M221

Dish

1767–1856
Shop of Samuel Hamlin (1746–1801), Hartford and Middletown, Connecticut, and Providence, or Samuel Ely Hamlin (1774–1864), Providence[1]
1½ x 14¹³⁄₁₆" (diam.) (3.8 x 37.6 cm)
B.58.71

Pewter dishes ten inches in diameter or greater were intended for serving food. In America the form was produced in round

M221

and, on occasion, oval shapes.[2] The Hamlin dish is the largest in the museum's collection.

PROVENANCE: Purchased by Miss Hogg from George Abraham and Gilbert May, West Granville, Massachusetts, 1958.

MARKED: Laughlin 1940, vol. I, pl. XLIX, nos. 330 (double struck), 331 (underside).

RELATED EXAMPLES: Fairbanks 1974, p. 110, no. 219.

1. For Samuel Hamlin (act. 1767–1801) and Samuel Ely Hamlin (act. 1801–56), see Laughlin 1940, vol. I, pp. 95–97; Laughlin 1971, pp. 55–57; Thomas 1976, pp. 149–51.
2. Montgomery 1978, p. 140; Communion Services 1976, pp. 83, 95.

M222

Dish

ca. 1762–93
Shop of John Danforth (1741–1799), Norwich, Connecticut[1]
1 x 12¼" (diam.) (2.5 x 31.1 cm)
B.60.74

PROVENANCE: See cat. no. M220.

MARKED: Laughlin 1940, vol. I, pl. LI, nos. 352, 353 (underside).

M220

M222

RELATED EXAMPLES: Kernan, Ross, and Eilers 1969, p. 14, no. 12; Fairbanks 1974, p. 107, no. 138; Montgomery 1978, p. 294; Barquist 1985, p. 87, no. 207.

REFERENCES: Butler 1985, p. 12.

1. For Danforth (act. ca. 1762–93), see Laughlin 1940, vol. 1, p. 106; Laughlin 1971, pp. 63–64; Thomas 1976, pp. 75–81.

M223

Plate

1760–90
Shop of John Skinner (1733–1813), Boston[1]
½ x 9⅛" (diam.) (1.3 x 23.2 cm)
B.60.75

Colonial plates and dishes, patterned after English examples, are characterized by brims that are multiple-reeded or broad and narrow. By the second quarter of the eighteenth century, they were replaced by either single-bead or smooth brims. In England the latter survive in quantity, yet in the United States their relative scarcity suggests they were never produced in comparable numbers. In addition to its rarity, John Skinner's plate is distinguished by the prominent stamping of its original owner's initials.

PROVENANCE: See cat. no. M220.

M223

MARKED: Laughlin 1940, vol. 1, pl. XLV, nos. 293 (twice), 294 (underside); A^W E (incuse, presumably the original owner's initials).

RELATED EXAMPLES: Fairbanks 1974, p. 105, nos. 90, 91.

REFERENCES: Butler 1985, p. 13.

1. For Skinner (act. 1760–90), see Myers 1926, pp. 65–66; Laughlin 1940, vol. 1, pp. 73–74; Laughlin 1971, vol. 3, pp. 42–43.

M224

Plate

1761–99
Shop of Frederick Bassett (1740–1800), New York and Hartford[1]
⅝ x 8⅜" (diam.) (1.6 x 21.3 cm)
B.60.72

Plates measuring between eight and ten inches in diameter were produced in both shallow and deep sizes, the latter designated as soup plates. Frederick Bassett's plate carries the stamp "New York," perhaps as other pewter was marked "London" (see cat. no. M229), to imply a high quality. Another plausible explanation for the locational stamp is that it was intended as a means of promoting domestic manufactures over English imports, as other patriotic American artisans did prior to the Revolution.[2]

M224

PROVENANCE: See cat. no. M220.

MARKED: Laughlin 1940, vol. 1, pl. LIX, nos. 464a, 466, 467 (twice, underside).

RELATED EXAMPLES: Watts 1968, p. 65, no. 180; Fairbanks 1974, p. 111, no. 242; Montgomery 1978, p. 292; Butler 1983, p. 140, no. 223.

REFERENCES: Butler 1985, p. 12.

1. For Bassett (act. 1761–99), see Myers 1926, pp. 9–12; Button 1930; Laughlin 1940, vol. 2, pp. 6–8; Laughlin 1971, p. 100; Bowen 1976, p. 154; Herr 1995, p. 128.
2. Locational marks were also used by John Danforth, Johann Christoph Heyne, William Kirby, John Skinner, and John, Henry, Philip, and William Will.

M225

Saucer

ca. 1777–1820
Shop of Thomas Danforth, III (1756–1840), Middletown and Stepney, Connecticut, and Philadelphia[1]
¾ x 6¼" (diam.) (1.9 x 15.9 cm)
B.60.76

M225

The smallest plate is defined as no less than 6½ inches in diameter; anything smaller is described in the period as a saucer, although its specific purpose is not known at present.

PROVENANCE: See cat. no. M220.

MARKED: Laughlin 1940, vol. 1, pl. LIII, no. 368 (underside).

RELATED EXAMPLES: Kernan, Ross, and Eilers 1969, pp. 15, 47, no. 13; Montgomery 1978, p. 292; Krile 1989, p. 13, no. 14.

REFERENCES: Butler 1985, p. 13.

1. For Danforth (act. ca. 1777–1820), see Myers 1926, pp. 22, 24–25, 27, 32, 34–36; Laughlin 1940, vol. 1, pp. 111–12; Laughlin 1971, pp. 70–71; Thomas 1976, pp. 83–86; Herr 1995, p. 130.

M226*

Saucer

ca. 1777–1820
Shop of Thomas Danforth, III (1756–1840), Middletown and Stepney, Connecticut, and Philadelphia[1]
¾ x 6¼" (diam.) (1.9 x 15.9 cm)
B.60.73

PROVENANCE: See cat. no. M220.

MARKED: Laughlin 1940, vol. 1, pl. LIII, no. 368 (underside).

RELATED EXAMPLES: See cat. no. M225.

REFERENCES: Butler 1985, p. 13.

1. See cat. no. M225.

M227

Basin

1760–90
Shop of John Skinner (1733–1813), Boston[1]
1⁵⁄₁₆ x 8⅛" (diam.) (3.3 x 20.6 cm)
B.60.82

The size and capacity of a basin dictated its function. A stock item, typically between six and twelve inches in diameter, it was employed for ecclesiastical as well as domestic use. Those belonging to churches were designated as baptismal

M227

basins, while secular examples were used either for dining or personal grooming.

PROVENANCE: See cat. no. M220.

MARKED: Laughlin 1940, vol. 1, pl. XLV, no. 295 (inside bottom).

1. See cat. no. M223.

M228

Basin

1767–1856
Shop of Samuel Hamlin (1746–1801), Hartford and Middletown, Connecticut, and Providence, or Samuel Ely Hamlin (1774–1864), Providence[1]
2¹⁄₁₆ x 7¾" (diam.) (5.2 x 19.7 cm)
B.60.83

Basins with a diameter of six to eight inches were intended for food and drink. Contemporary references to "breakfast bowls" and "mess bowls" in all likelihood refer to this size basin.[2] Alternatively they may have also been used as slop bowls, for disposing of cold tea and dregs.

PROVENANCE: See cat. no. M220.

M228

MARKED: Laughlin 1940, vol. 1, pl. XLIX, no. 330a (inside bottom).

RELATED EXAMPLES: Hood 1965, p. 15, no. 22; Fairbanks 1974, pp. 55, 110, no. 215; Montgomery 1978, p. 144, no. 8-11; Barquist 1985, p. 39, no. 226.

REFERENCES: Butler 1985, p. 13.

1. See cat. no. M221.
2. Dow 1967, p. 79; Montgomery 1978, p. 144.

M229

Basin

1781–93
Shop of John Andrew Brunstrom (ca. 1753–93), Philadelphia[1]
1¾ x 6¹¹⁄₁₆" (diam.) (4.4 x 17 cm)
B.60.81

Throughout the eighteenth century, London pewter was synonymous with the finest quality and enjoyed an international reputation. Some provincial English, American, and even Continental craftsmen, seeking to further their own business, stamped their work "London." Perhaps this was done to suggest their wares were comparable with London pewter, or possibly it was an attempt to pass off their work as an English product.

M229

PROVENANCE: See cat. no. M220.

MARKED: Laughlin 1971, pl. CIX, nos. 868, 869 (inside bottom).

REFERENCES: Butler 1985, p. 13.

1. For Brunstrom (act. 1781–93), see Laughlin 1940, vol. 2, pp. 55–56; Laughlin 1971, pp. 137–41; Whisker 1993, p. 74; Herr 1995, pp. 129–30.

M230

M230

Porringer

ca. 1770–1807
Attributed to the shop of Isaac Jackson
(1734–1807), New Garden Township, Chester
County, Pennsylvania, or Robert Porter (d. 1785),
Caln Township, Chester County[1]
2⅛ x 5¼ x 6¹⁵⁄₁₆" (5.4 x 13.3 x 17.6 cm)
B.53.1.5

In most instances American pewterers' work parallels the designs and techniques employed by British craftsmen, yet on occasion Continental influences are perceptible. The tab-handle porringer is an excellent example; unknown in England, it is a product of Pennsylvania's immigrant German culture. The simple design and unusual construction of casting basin and handle as a single unit are unique in American pewter.

PROVENANCE: T. Van C. Phillips, West Chester, Pennsylvania; [Charlotte and Edgar Sittig, Shawnee on Delaware, Pennsylvania]; purchased by Miss Hogg from John S. Walton, New York, 1953.[2]

TECHNICAL NOTES: The handle and bowl are cast in a single two-part mold.

MARKED: 1682 (incuse, top of handle).[3]

REFERENCES: Butler 1985, p. 11.

1. For Jackson (act. 1774–1807) and Porter (act. ca. 1770–85), see Laughlin 1940, vol. 2, p. 64; James 1962, pp. 128–29; Laughlin 1971, pp. 141–43; Gibbs 1984, p. 126; Krile 1989, pp. 6–9; Whisker 1993, pp. 181–82, 228.
2. According to the Sittigs this porringer, along with cat. nos. M231, M232, M234, was used at the Quaker School in Westtown Township, Chester County, Pennsylvania (Smedley 1948; Krile 1989, pp. 3–5, 14).
3. The significance of this number is not known.

M231*

Porringer

ca. 1770–1807
Attributed to the shop of Isaac Jackson
(1734–1807), New Garden Township, Chester
County, Pennsylvania, or Robert Porter (d. 1785),
Caln Township, Chester County[1]
2¹⁄₁₆ x 5⁵⁄₁₆ x 7" (5.2 x 13.5 x 17.8 cm)
B.53.1.1

The tab-handle porringer is associated with five shops: those of Isaac Jackson, Robert Porter, Elisha Kirk, Samuel Pennock, and Pennock's son Simon, all situated in southeastern Pennsylvania. Jackson and Porter were probably the first to produce these distinctive vessels. In many respects they typify the rural pewterer, in that pewter often represented a sideline to augment their principal livelihood—Jackson's as a clockmaker and Porter's as a carpenter.

PROVENANCE: See cat. no. M230.

TECHNICAL NOTES: See cat. no. M230.

REFERENCES: See cat. no. M230.

1. See cat. no. M230.

M232

Porringer

ca. 1780–90
Attributed to the shop of Elisha Kirk (1757–1790),
York, Pennsylvania[1]
2¹⁄₁₆ x 5½ x 7⅛" (5.2 x 14 x 18.1 cm)
B.53.1.6

Elisha Kirk is the only maker of tab-handle porringers who identified his vessels with a full name mark. He apprenticed with Isaac Jackson to learn clockmaking and at that time is believed to have picked up the rudiments for cast-

M232

ing and finishing pewter. Eventually he left Chester County, resettling in York, where he is credited with introducing the tab-handle porringer to that locale. The contour and dimensions of the Bayou Bend porringer correlate with fully stamped Kirk examples, thereby forming the basis for this attribution.

PROVENANCE: See cat. no. M230.

RELATED EXAMPLES: Winchester et al. 1959, pp. 188–89, no. 4; Hood 1965, p. 53, no. 193; Montgomery 1978, pp. 197, 155–56, 252; Pewter in American Life 1984, p. 86.

REFERENCES: Butler 1985, p. 11.

1. For Kirk (act. ca. 1780–90), see Myers 1926, p. 51; *Antiques* 13 (February 1928), pp. 112–14; Laughlin 1940, vol. 2, p. 64; Brinton 1947; Kirk 1960; James 1962, p. 129; Laughlin 1971, pp. 141–43; Gibbs 1984, pp. 126, 199–200; Whisker 1993, pp. 187–88.

M233*

Porringer

ca. 1781–90
Attributed to the shop of Elisha Kirk (1757–1790),
York, Pennsylvania[1]
2⅛ x 5¼ x 7" (5.4 x 13.3 x 17.8 cm)
B.79.187.1

PROVENANCE: Purchased by Miss Hogg possibly from Thomas D. and Constance R. Williams, Litchfield, Connecticut, 1953.

RELATED EXAMPLES: See cat. no. M232.

1. See cat. no. M232.

M234

Porringer

ca. 1775–1825
Attributed to the shop of Samuel Pennock (1754–
ca. 1843), East Marlborough Township, or Simon
Pennock (1783–1868), East Marlborough
Township, Chester County, and Drumore
Township, Lancaster County, Pennsylvania[1]
2⅛ x 5¼ x 7¹⁄₁₆" (5.4 x 13.3 x 17.9 cm)
B.53.1.3

Samuel Pennock and his son Simon were the last pewterers to produce the tab handle porringer. At least three different con-

M234

tours, each with slight variations, are attributed to the Pennocks.

PROVENANCE: See cat. no. M230.

RELATED EXAMPLES: Pennock porringers, as well as the molds for casting them, are published in Montgomery 1978, pp. 155–56; Krile 1989, pp. 23, 26–27, nos. 60, 61, 75–77.

REFERENCES: Butler 1985, p. 11.

1. For Samuel Pennock (act. 1775–ca. 1843) and Simon Pennock (act. ca. 1810–68), see Laughlin 1940, vol. 2, p. 64; Kauffman 1948; James 1962, pp. 129–30; Evans 1963, pp. 145–46; Laughlin 1971, pp. 143–44; Krile 1989, pp. 6–9, 23, 26–27, nos. 60, 61, 73, 75–77; Whisker 1993, p. 225.

M235*

Porringer

ca. 1775–1825
Attributed to the shop of Samuel Pennock (1754–ca. 1843), East Marlborough Township, or Simon Pennock (1783–1868), East Marlborough Township, Chester County, and Drumore Township, Lancaster County, Pennsylvania[1]
2³⁄₈ x 5¹⁄₂ x 7¹⁄₄″ (6 x 14 x 18.4 cm)
B.79.187.2

PROVENANCE: See cat. no. M233.

RELATED EXAMPLES: See cat. no. M234.

1. See cat. no. M234.

M236

Porringer

1795–1816
Shop of Samuel Danforth (1774–1816), Hartford[1]
1¹³⁄₁₆ x 4¹⁵⁄₁₆ x 7¹⁄₄″ (4.6 x 12.5 x 18.4 cm)
B.58.97

As its modern-day name aptly implies, the "Old English" handle was patterned after

British silver and pewter porringers dating from the second half of the seventeenth century.[2] In the American colonies this design was first adopted by Boston silversmiths, most notably Jeremiah Dummer (see cat. no. M2), in the late seventeenth century. Its introduction in pewter occurs somewhat later, probably by the second quarter of the eighteenth century, and continued to be produced by Samuel Danforth and others through the early nineteenth century.

PROVENANCE: Purchased by Miss Hogg from Carl and Celia Jacobs, Southwick, Massachusetts, 1958.

TECHNICAL NOTES: This porringer is fabricated following the usual method of construction for this form. A mold for the handle was aligned with the bowl and the molten alloy poured in. The bowl was held in place by cloth-covered tongs, which prevented the molten pewter in the handle mold from melting a hole in the bowl. In response, the weave of the fabric was often translated into the softened metal, leaving an impression that is called a linen mark. As it cooled, the newly cast handle was joined to the bowl.

MARKED: Laughlin 1940, vol. 1, pl. LV, no. 401 (upper side of handle).

RELATED EXAMPLES: Hood 1965, p. 23, nos. 71, 72. Another example, with a basin rather than the usual bellied bowl, is in Kernan, Ross, and Eilers 1969, p. 17, no. 25.

REFERENCES: Butler 1985, p. 13.

1. For Danforth (act. 1795–1816), see Laughlin 1940, vol. 1, pp. 118–19; Laughlin 1971, p. 77; Thomas 1976, pp. 102–12.
2. Raymond 1959b; Thomas 1976, pp. 30–31.

M236

M237

Porringer

1801–20
Shop of Samuel Ely Hamlin (1774–1864), Providence[1]
1⁷⁄₈ x 5³⁄₈ x 7⁷⁄₈″ (4.8 x 13.7 x 20 cm)
B.58.98

The flowered-handle porringer is one of the most pleasing designs unique to eighteenth-century America.[2] It is likely that this pattern originated with Samuel Hamlin since he made and retailed molds; furthermore, the greatest number of these known porringers carry the mark of Hamlin or, as in this instance, of his son.[3]

PROVENANCE: See cat. no. M236.

MARKED: Laughlin 1940, vol. 1, pl. XLIX, no. 337 (upper side of handle).

RELATED EXAMPLES: Hood 1965, p. 15, no. 21; Fairbanks 1974, p. 57, no. 221.

REFERENCES: Butler 1985, p. 13.

1. See cat. no. M221.
2. Laughlin 1940, vol. 1, p. 92; vol. 2, p. 160.
3. Laughlin 1971, p. 56; Montgomery 1978, p. 154.

M238

Porringer

ca. 1810–30
Shop of Thomas Danforth Boardman (1784–1873) and Sherman Boardman (1787–1861), Hartford[1]
1¹⁵⁄₁₆ x 5³⁄₈ x 7⁷⁄₈″ (4.9 x 13.7 x 20 cm)
B.58.99

Flowered-handle porringers are most closely associated with Rhode Island pewterers, yet occasionally examples are found with the stamps of other New England makers, such as the Boardmans and Richard Lee.[2] The pattern remained in favor through the first half of the nineteenth century.

PROVENANCE: See cat. no. M236.

MARKED: Laughlin 1940, vol. 1, pl. LVII, no. 428 (top of handle).

RELATED EXAMPLES: Hood 1965, p. 25, no. 96; Kernan, Ross, and Eilers 1969, pp. 26, 59, no. 66; Fairbanks 1974, p. 34, no. 123.

M237

M239

M238

REFERENCES: Butler 1985, p. 12.

1. For Thomas Danforth and Sherman Board-
man (partnership ca. 1810–60), see Myers
1926, pp. 15–16; Laughlin 1940, vol. 1,
pp. 128–30; Fales 1962; Hilt 1964; Hilt 1965;
Laughlin 1971, pp. 84–87; Thomas 1976,
pp. 119–43.
2. Raymond 1959a.

M239

Porringer

ca. 1810–30
Shop of Thomas Danforth Boardman
(1784–1873) and Sherman Boardman (1787–1861),
Hartford[1]
1⅞ x 5³⁄₁₆ x 7⅜″ (4.8 x 13.2 x 18.7 cm)
B.56.186.1

The crown-handle porringer, as its em-
blematic design suggests, is patterned
after English examples. In the American
colonies this motif was probably pro-
duced first during the mid-eighteenth
century by a group of New York pewter-
ers and subsequently by their Boston,
Newport, Connecticut, and Pennsylvania
counterparts. The political disparity be-
tween England and its American colonies
does not seem to have impacted the royal-
ist symbol's acceptance, for pewterers,
such as the Boardmans, continued to find
a market for it among the newly indepen-
dent Americans.

PROVENANCE: Purchased by Miss Hogg
possibly from Thomas D. and Constance R.
Williams, Litchfield, Connecticut, 1956.

MARKED: Laughlin 1940, vol. 1, pl. LVII, no.
429 (upper side of handle).

RELATED EXAMPLES: Winchester et al. 1959,
p. 188, no. 4; Hood 1965, pp. 24, 27, nos. 90,
109; Kernan, Ross, and Eilers 1969, pp. 26, 59,
no. 65; Fairbanks 1974, p. 35, no. 124; Mont-
gomery 1978, p. 146, no. 9-1.

REFERENCES: Butler 1985, p. 12.

1. See cat. no. M238.
2. Pewter in American Life 1984, pp. 76–77.

M240

Porringer

ca. 1750–1850
The "IC" shop, New England, probably Boston[1]
1¹¹⁄₁₆ x 4¹¹⁄₁₆ x 6½″ (4.3 x 11.9 x 16.5 cm)
B.69.241

This porringer belongs to a group of
crown-handle porringers that are distin-
guished by the initials cast on their han-
dles. Marked examples are recorded with
the letters RG, SG, GS, WN, DN over
1844, and IC. It is believed that these
markings refer to Boston pewterers or
mold makers; however, efforts to identify
them have not proved convincing.[2]

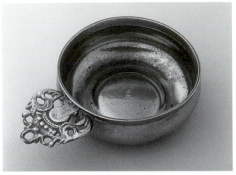

M240

PROVENANCE: Unknown.

MARKED: Laughlin 1940, vol. 2, pl. LXVIII, no. 576 (underside of handle).

RELATED EXAMPLES: Fairbanks 1974, pp. 84, 115, no. 319; Blaney 1983, pp. 288–98 (the Bayou Bend porringer relates to C-3-B, figs. 7A–D).

1. For the "IC" shop, see Laughlin 1940, vol. 2, pp. 86–87; Raymond 1946a; Raymond 1946b; Raymond 1946c; Raymond 1948; Raymond 1958; Thomas 1972; Wolf 1975; Blaney 1978; Bowen 1981, pp. 149–50; Hornsby 1982; Blaney 1983.
2. Blaney 1983, p. 289.

M241

Beaker

1777–1818
Shop of Thomas Danforth, III (1756–1840), Middletown and Stepney, Connecticut, and Philadelphia[1]
5³⁄₁₆ x 3³⁄₈″ (diam.) (13.2 x 8.6 cm)
B.60.62

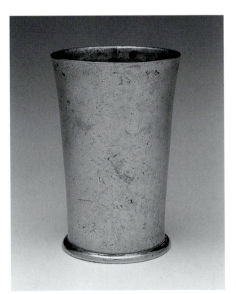

M241

The beaker is more closely associated with Continental traditions than with English customs. Nonetheless, extant silver and pewter examples indicate that the vessel was most common in New England, despite the Continental origins of a greater percentage of the middle colonies' populace.[2] The earliest extant American examples are in silver, dating from the third quarter of the seventeenth century, and in pewter from the second quarter of the eighteenth century.

PROVENANCE: Purchased by Miss Hogg from Whimsy Antiques, Arlington, Vermont, 1960.

MARKED: Laughlin 1940, vol. 1, pl. LIII, no. 369; below, a crown; X (incuse, below rim).

TECHNICAL NOTES: Beakers were fabricated in two parts; the base has a circular slot to receive the cylinder.

RELATED EXAMPLES: Montgomery 1939, p. 120, fig. 9c.

REFERENCES: Butler 1985, p. 13.

1. See cat. no. M225.
2. Garvan et al. 1968, p. 100, table 1.

M242

Beaker

1786–ca. 1800
Shop of Edward Danforth (1765–1830), Hartford[1]
5¹⁄₈ x 3¹⁄₂″ (diam.) (13 x 8.9 cm)
B.60.61

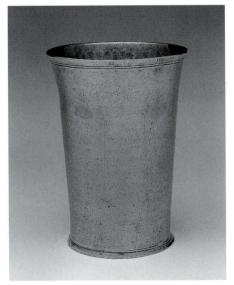

M242

The tall beakers stamped by Edward Danforth are among the most noble American interpretations of this simple drinking vessel. By the early nineteenth century the form began to diminish in height, and occasionally a handle was introduced. As production methods improved, reflecting the use of new alloys and technology, examples were either fashioned of seamed sheet metal or by spinning.

PROVENANCE: See cat. no. M241.

MARKED: Laughlin 1940, vol. 1, pl. LIV, no. 389 (inside bottom).

RELATED EXAMPLES: Montgomery 1939, p. 120; Herr 1982, p. 201.

REFERENCES: Butler 1985, p. 12.

1. For Danforth (act. 1786–ca. 1800), see Myers 1926, pp. 24, 25, 27, 33; Laughlin 1940, vol. 1, p. 117; Laughlin 1971, pp. 73–74; Blaney 1974; Thomas 1976, pp. 90–93.

M243

Tankard

1761–99
Shop of Frederick Bassett (1740–1800), New York and Hartford[1]
6⁷⁄₈ x 5³⁄₈ x 7³⁄₈″ (17.5 x 13.7 x 18.7 cm)
B.60.55

The tankard was a popular drinking vessel in seventeenth- and eighteenth-century America, and some pewter examples are known as late as the first quarter of the nineteenth century. Their capacity ranged from a pint to as much as two quarts, although most held one quart. New York tankards, in either silver or pewter, exhibit little concession to the stylistic dictates of this period. By the second quarter of the eighteenth century, the tankard's lid had evolved into a dome shape in Boston and Philadelphia, while New York's preference for the crenellated flat lid persisted throughout the century.

On the death of John Bassett in 1761, his son Frederick, who had recently completed his apprenticeship, assumed responsibility for the operation of his father's shop and became the third generation of his family to ply the craft. As his surviving work demonstrates a consistently high level of quality, he is acknowl-

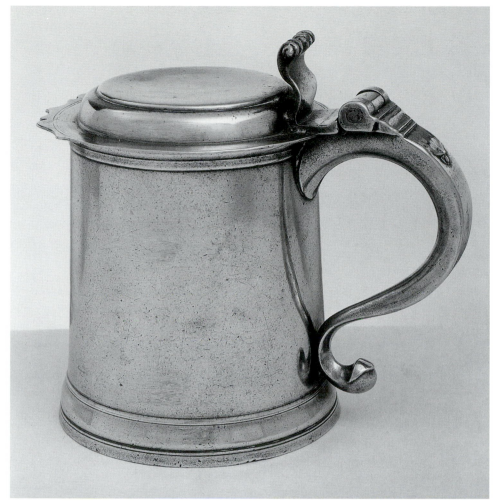

M243

Tankard

1781–93
Attributed to the shop of John Andrew
Brunstrom (ca. 1753–1793), Philadelphia[1]
7⅝ x 4¾ x 6⅞″ (19.4 x 12.1 x 17.5 cm)
B.61.44

Late eighteenth-century tankards, spe-
cifically those dating after the Revolution,
exhibit an evolution of form that on occa-
sion responds to the recently introduced
Neoclassical style. In general the vessel's
diameter decreased and its orientation be-
came more vertical in comparison with
earlier examples. In addition to stylistic
changes, Bayou Bend's tankard displays a
cultural evolution. John Andrew Brun-
strom's Swedish background must account
for the suggestion of a disk that ornaments
the lid, just as Continental metalworkers
frequently set in a coin for decoration.

PROVENANCE: Purchased by Miss Hogg from
Whimsy Antiques, Arlington, Vermont, 1961.

TECHNICAL NOTES: See cat. no. M243. The
lid is attached by a five-part hinge.

MARKED: Laughlin 1971, pl. CIX, nos. 868, 869
(inside bottom).

edged as the last of New York City's great
pewterers.

PROVENANCE: See cat. no. M241.

TECHNICAL NOTES: The tankard is among
the most complex domestic forms the
pewterer produced. Five different molds were
used to cast the base, body, handle, thumb-
piece, and lid, the latter attached with a three-
part hinge here.

MARKED: Laughlin 1940, vol. 2, pl. LIX, no.
468 (inside bottom).

RELATED EXAMPLES: Most closely related is
Kerfoot 1942, fig. 20. Tankards in museum col-
lections include Winchester et al. 1959, p. 189,
no. 7; Fairbanks 1974, p. 63, no. 239; Mont-
gomery 1978, pp. 118–19, 122, nos. 6-18, 6-22.

REFERENCES: Warren 1966, p. 808; Agee et al.
1981, p. 77, no. 137; Butler 1985, pp. 11–12; War-
ren 1988, p. 15; American Heritage 1994, p. 826.
Seven years after Miss Hogg's acquisition of
Bassett's tankard in 1960, the dealer advertised
what appears to be the same vessel in *Antiques*
92 (October 1967), p. 423.

1. See cat. no. M224.

M244

RELATED EXAMPLES: Ruckman 1954, p. 388.

REFERENCES: *Antiques* 79 (June 1961), p. 534; Butler 1985, p. 13.

1. See cat. no. M229.

REFERENCES: Butler 1985, p. 13.

1. See cat. nos. M220, M225.
2. Laughlin 1940, vol. 1, pp. 107, 113, 115; Thomas 1976, pp. 69, 87, 147–49.

1. For Whitmore (act. 1758–90), see Myers 1926, pp. 67–68; Laughlin 1940, vol. 1, p. 113; Laughlin 1971, p. 71; Thomas 1976, pp. 146–49.
2. Laughlin 1940, vol. 1, pp. 107, 113, 115; Thomas 1976, pp. 69, 87, 147–49.

M245

Can

1755–1818
Shop of Thomas Danforth, II (1731–1782), Middletown, Connecticut, or Thomas Danforth, III (1756–1840), Middletown and Stepney, Connecticut, and Philadelphia[1]
5¹⁵⁄₁₆ x 4¹³⁄₁₆ x 6⅞" (15.1 x 12.2 x 17.5 cm)
B.69.25

Contemporary sources refer to this form as a can, mug, or pot. The earliest examples were patterned after eighteenth-century silver, yet unlike its precious counterpart, in pewter this shape persisted well into the nineteenth century. Thomas Danforth, II's estate inventory suggests the extent of an American shop's production, attesting that he owned outright or in partnership with Jacob Whitmore more than 260 pounds of molds.[2]

PROVENANCE: Purchased by Miss Hogg from Carl and Celia Jacobs, Deep River, Connecticut, 1964.

MARKED: Laughlin 1940, vol. 1, pl. LIII, no. 368 (inside bottom).

RELATED EXAMPLES: Barquist 1985, p. 34, no. 217.

M246

Can

1758–1790
Shop of Jacob Whitmore (1736–1825), Middletown, Connecticut[1]
5⅞ x 4¾ x 6¾" (14.9 x 12.1 x 17.1 cm)
B.64.27

Expensive molds were required for casting pewter. As a consequence the forms evolved gradually, if at all. Whitmore and Thomas Danforth, II, jointly owned a number of molds, a practical, albeit rarely documented, arrangement. Danforth bequeathed his interest to his oldest sons, Thomas, III, and Joseph. The close similarity between Whitmore's and the Danforths' cans (see, for example, cat. nos. M245, M247) may be explained by the fact that as many as four different pewterers could have used these molds.[2]

PROVENANCE: Purchased by Miss Hogg from Carl and Celia Jacobs, Deep River, Connecticut, 1964.

MARKED: Laughlin 1940, vol. 1, pl. LIV, no. 382 (inside bottom).

RELATED EXAMPLES: Hood 1965, p. 14, no. 10.

REFERENCES: Butler 1985, p. 13.

M247

Can

ca. 1779–88
Shop of Joseph Danforth, Sr. (1758–1788), Middletown, Connecticut[1]
5⅞ x 4¾ x 7" (14.9 x 12.1 x 17.8 cm)
B.60.65

This quart can, along with two others in the collection bearing the mark of Thomas Danforth, II, Thomas Danforth, III, or Jacob Whitmore, were produced at various times from a common set of molds (see cat. no. M246).[2]

PROVENANCE: See cat. no. M220.

MARKED: Laughlin 1940, vol. 1, pl. LIII, no. 374 (left of handle).

ENGRAVED: WLL (underside).

RELATED EXAMPLES: Hood 1965, pp. 18–19, nos. 40, 42.

REFERENCES: Butler 1985, p. 13.

1. For Danforth (act. ca. 1779–88), see Myers 1926, pp. 23–27, 32–33, 36; Laughlin 1940, vol. 1, pp. 115–16; Laughlin 1971, p. 72; Thomas 1976, pp. 86–90.
2. See cat. no. M245, n. 2.

M245

M246

M247

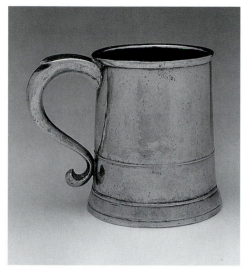

M248

M248

Can

ca. 1779–88
Shop of Joseph Danforth, Sr. (1758–1788),
Middletown, Connecticut[1]
4½ x 3¹³⁄₁₆ x 5⅜″ (11.4 x 9.7 x 13.7 cm)
B.60.66

Pewter cans were produced in America as late as the 1830s. More common than the tankard because of its lower cost, the can, too, was intended for hard cider, beer, or malt liquors. Typically it is of a cylindrical shape tapering downward, although bellied and barrel-shaped examples are also

known. Quart and pint cans, such as the museum's examples by the shop of Joseph Danforth, Sr. (cat. no. M247), were the most popular sizes but, as Samuel Danforth's 1816 estate inventory records, half-pint, gill, and, presumably, half-gill sizes were also available.[2]

PROVENANCE: See cat. no. M220.

MARKED: Laughlin 1940, vol. 1, pl. LIII, nos. 374 (left of handle), 375 (inside bottom).

RELATED EXAMPLES: Similar Joseph Danforth cans in public collections include Hood 1965, p. 18, no. 41; Fairbanks 1974, pp. 39, 107, nos. 139, 140.

REFERENCES: Butler 1985, p. 13.

1. See cat. no. M247.
2. Bowen 1977, pp. 212–13.

M249

Can

1763–1807
Shop of Nathaniel Austin (1741–1816),
Charlestown, Massachusetts[1]
6⅛ x 4¾ x 6⁵⁄₁₆″ (15.6 x 12.1 x 16 cm)
B.60.64

Tapered cans with solid strap handles constitute a variation on this popular drinking vessel that is unique to New England.[2] Certainly the most distinctive

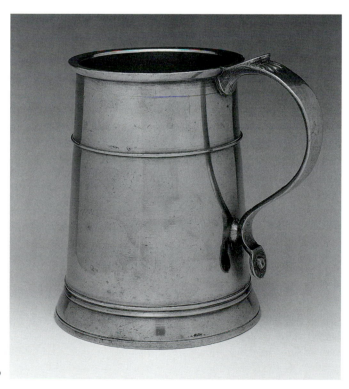

M249

interpretations of this motif are those marked by Nathaniel Austin. In addition to their unusual strap handles, Austin's cans are characterized by raised shell-shaped thumb grips and unique terminals that incorporate the pewterer's name, N-AUSTIN, into the disk.

PROVENANCE: See cat. no. M220.

MARKED: Laughlin 1940, vol. 1, pl. XLV, no. 296 (handle terminal).

TECHNICAL NOTES: The strap handle exhibits distinctive construction techniques. These include the solid handle cast in place against the body, much as a porringer's handle is produced and attached (see cat. no. M236).

RELATED EXAMPLES: Hood 1965, pp. 14, 16, no. 13; Watts 1968, p. 18, no. 6; Fairbanks 1974, p. 7, no. 11; Brandt 1976, pp. 16–17, no. 1; Montgomery 1978, pp. 107, 109, no. 6-5.

REFERENCES: Butler 1985, p. 12.

1. For Austin (act. 1763–1807), see Laughlin 1940, vol. 1, pp. 75–76; Laughlin 1971, p. 45.
2. Thomas 1975, pp. 47–50.

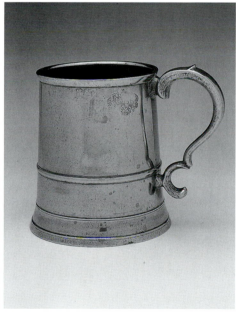

M250

M250

Can

1767–1856
Shop of Samuel Hamlin (1746–1801), Hartford and Middletown, Connecticut, and Providence, or Samuel Ely Hamlin (1774–1864), Providence[1]
4⁹⁄₁₆ x 3¹⁵⁄₁₆ x 5⁹⁄₁₆″ (11.6 x 10 x 14.1 cm)
B.61.46

The solid, double-scroll handle employed in the Hamlins' work, as well as in Joseph Belcher's, is a Rococo design that seems to be unique to their Rhode Island shops.[2] By coincidence, the earliest known American references to mold making are in documents concerning business between Samuel Hamlin and William Proud, a Providence chairmaker and turner. In 1773, Hamlin incurred charges for both the production and alteration of molds, which included "To a mold for a handl."[3] The accounts also detail that Proud carved handles for coffeepots, probably in a double-scroll pattern, raising the likelihood that the design for this element may have originated with the mold maker rather than the pewterer.

PROVENANCE: Charles F. Hutchins, Worcester, Massachusetts; purchased by Miss Hogg from Whimsy Antiques, Arlington, Vermont, 1961.

TECHNICAL NOTES: Painted in red on the underside: MET. MUS EXB. 1939, H2.16, referring to the landmark pewter exhibition held by the Metropolitan Museum of Art, New York.

MARKED: Laughlin 1940, vol. 1, pl. XLIX, no. 330a (left of handle).

RELATED EXAMPLES: Fairbanks 1974, pp. 56, 110, no. 217.

REFERENCES: Butler 1985, p. 13.

1. See cat. no. M221.
2. Thomas 1975, p. 47; Bowen 1978.
3. Montgomery 1978, p. 33.

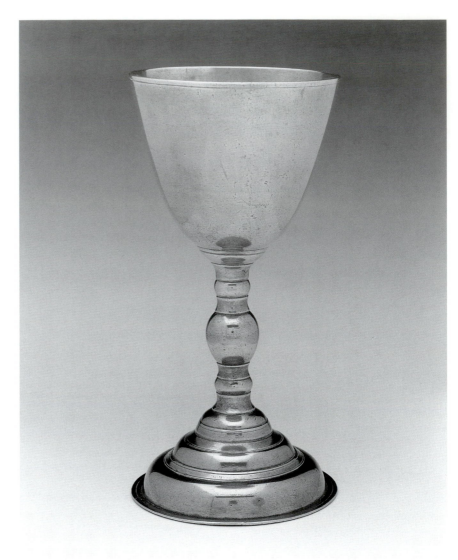

M251

M251

Pair of Church Cups

1775–97
Shop of Peter Young (1749–1813), New York and Albany[1]
B.66.9.1: 8⁷⁄₁₆ x 4¼" (diam.) (21.4 x 10.8 cm);
B.66.9.2: 8⁹⁄₁₆ x 4⁵⁄₁₆" (diam.) (21.7 x 11 cm)
B.66.9.1–.2

Peter Young's church cups rank among the finest work by any American pewterer. The form is based on a domestic vessel, the Protestants consciously embracing this shape as an alternative to the traditional chalice. His distinctive design appears to be unique, there being no known European or American prototype in pewter or silver. An eighteenth-century reference indicates that these vessels were called church cups, identifying their intended function for receiving and distributing the consecrated wine during the Holy Eucharist. A 1797 bill signed by Eva Young, the pewterer's wife, specifies the sale of "2 church cups," and, indeed, many of these vessels survive in pairs.[2] Unlike their silver counterparts, these cups are rarely engraved.[3] Probably, no one in Young's shop possessed the necessary skills, making it necessary to subcontract out the work.

PROVENANCE: Purchased by Miss Hogg from Whimsy Antiques, Arlington, Vermont, 1966.

MARKED: Laughlin 1940, vol. 2, pl. LXIV, no. 518 (inside bowl).

TECHNICAL NOTES: The cup and foot were cast separately, and the stem probably as two halves, which were soldered together. Young, like so many pewterers, adapted his castings for different components. The cup's domed foot could also function as a lid (Ruckman 1962).

RELATED EXAMPLES: Fairbanks 1974, p. 76, no. 288; Montgomery 1978, pp. 73, 75, no. 4-29; Barquist 1985, pp. 54–55, no. 248; and four unpublished examples at the Albany Institute of History and Art (acc. nos. 1937.5.2–.3; 1995.30.50.1–.2). Similar cups are marked by Timothy Brigden (1774–1819), who worked in Albany a generation after Young, suggesting that some type of relationship existed between these craftsmen.

REFERENCES: *Antiques* 89 (June 1966), p. 779; Warren 1966, p. 808; Warren 1982, pp. 234, 237; Butler 1985, pp. 11, 13.

1. For Young (act. 1775–ca. 1797), see Myers 1926, pp. 77–80; Laughlin 1940, vol. 2, pp. 22–23, 29–30; Laughlin 1971, pp. 108–9, 115.
2. Laughlin 1971, pp. 108–9.
3. A pair of Young's cups inscribed and dated 1784 are recorded in the DAPC, Winterthur.

M252

Teapot

1785–98
Shop of William Will (1742–1798), Philadelphia[1]
7 5/16 x 5 x 8 3/4" (18.6 x 12.7 x 22.2 cm)
B.61.27

The earliest American pewter teapots are spherical and, like most pewter forms, patterned after their silver counterparts. The pear shape was introduced by the second decade of the eighteenth century in silver and by the 1740s in pewter. Not only was it visually pleasing, but also the rotund body lent itself to the task of brewing tea. The latest silver interpretations date from the 1760s, whereas pewterers, rarely wont to relinquish their costly molds, continued to produce pear-shaped teapots well into the following century.

William Will's interpretation of the vessel, like the rest of this accomplished pewterer's work, is characterized by a high-quality metal, exacting craftsmanship, and a range of patterns unequaled by any other American pewterer.[2] His teapots exhibit an evolution of design be-

ginning with the pear-shaped form, which was later updated with ball-and-claw feet and finally replaced by a Neoclassical drum shape.[3] Bayou Bend's teapot, while pear-shaped, dates from the latest period, the design being updated with beading, or pearlwork, similar to that ornamenting Philadelphia silver.

PROVENANCE: [Charles F. Montgomery]; Charles K. Davis, Fairfield, Connecticut; Winterthur; purchased by Miss Hogg from Thomas D. and Constance R. Williams, Litchfield, Connecticut, 1961.

TECHNICAL NOTES: The teapot's body was cast in two parts and joined at its greatest diameter by fusing the components. The vented lid is attached by a five-part hinge, and the finial is riveted. The handle is an unidentified wood. Will altered his teapot mold during the 1780s in an effort to adapt his castings to the later Neoclassical style.

MARKED: x (beneath six dots), similar to Laughlin 1940, vol. 2, pl. LXVI, nos. 538, 539 (inside bottom).[4]

RELATED EXAMPLES: Montgomery 1978, pp. 173, 175, no. 11-7.

REFERENCES: *Antiques* 48 (October 1945), pp. 204–5; Warren 1966, p. 808; Hamilton 1972, p. 157, no. 164; Butler 1985, pp. 11, 13.

1. For Will (act. 1764–98), see Myers 1926, p. 73; Laughlin 1940, vol. 2, pp. 51–55; Laughlin 1971, pp. 133–34; Hamilton 1972, pp. 129–32; Whisker 1993, pp. 283–84; Herr 1995, pp. 135–37.
2. Swain 1982, p. 171.
3. Montgomery 1978, pp. 172–76, nos. 11-5–11-8.
4. Presumably this teapot was struck with Will's full mark, yet all that remains is the quality symbol unique to his shop.

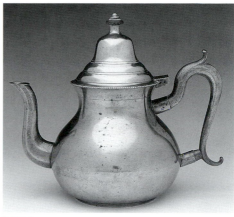

M253

M253

Teapot

1825–27
Manufactory of Boardman & Company (act. 1825–27), New York and Hartford[1]
7 11/16 x 5 1/2 x 8 3/4" (19.5 x 14 x 22.2 cm)
B.60.77

Thomas Danforth Boardman reminisced that in about 1806 he was experiencing problems working up some English tin for teapots. In preparing the alloy, he introduced copper and an equal amount of antimony. Boardman described the vessels as "the best I had ever made," noting that "with the propper proportion of Regulus of antimony and copper the ware would finish up equal to English bright."[2] Members of the Boardman family are believed to be the first American pewterers to produce Britannia, an alloy that, in addition to possessing a high sheen, was more easily worked. Before long it spelled out pewter's demise and completely transformed the industry, with objects now assembled from sheet as well as by stamping and spinning.[3]

PROVENANCE: See cat. no. M220.

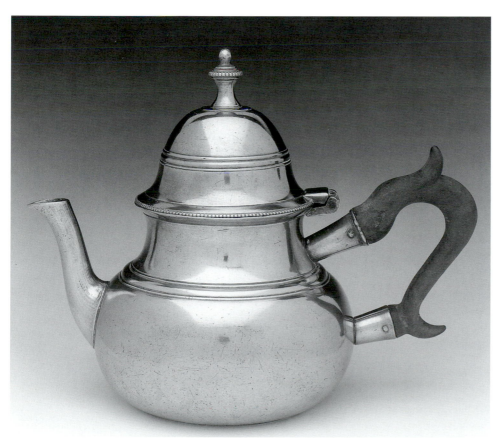

M252

TECHNICAL NOTES: The body is composed of two fused components (see cat. no. M252). The lid is attached by a three-part hinge and is vented. Its finial is riveted in place. The handle is Britannia rather than wood.

MARKED: Laughlin 1940, vol. 1, pl. LVII, no. 431, X (underside).

RELATED EXAMPLES: Kernan, Ross, and Eilers 1969, p. 29, no. 79; Evans 1972, pp. 1030–31; Butler 1983, p. 142, no. 227; Barquist 1985, p. 25, no. 203.

REFERENCES: Butler 1985, p. 12.

1. For Boardman & Company (Thomas D. Boardman and Lucius Hart), see Laughlin 1971, p. 86.
2. Goyne 1965, p. 168.
3. Goyne 1965.

M254

Teapot

ca. 1829–42
Shop of Allen Porter (ca. 1799–1862), Westbrook, Maine, and Hartford[1]
10⅞ x 6 x 10½" (27.6 x 15.2 x 26.7 cm)
Gift of Mrs. James Walker Cain, B.71.96

Allen Porter is the earliest of Maine's Britannia manufacturers whose work is known. He appears to have divided his time between Westbrook and Hartford until 1842, when he left New England for Racine, Wisconsin, to set up a cabinet-making shop.

TECHNICAL NOTES: Concentric rings attest that the components were spun on a lathe.

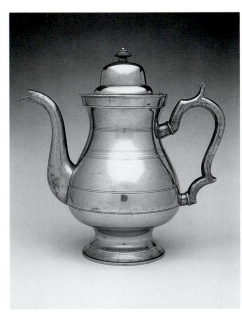

M254

The body consists of two parts (see cat. no. M252). The collar is a separate element. The lid is attached by a five-part hinge; its finial is riveted.

MARKED: Laughlin 1940, vol. 2, p. 109 (underside).

RELATED EXAMPLES: *Antiques* 32 (November 1937), p. 241; Churchill 1992, p. 7.

REFERENCES: Warren 1972b, p. 63; Butler 1985, p. 13.

1. For Porter (act. ca. 1829–42), see Woodside and Watkins 1932, pp. 8, 10; *Antiques* 31 (February 1937), pp. 62–63; Churchill 1992, p. 5.

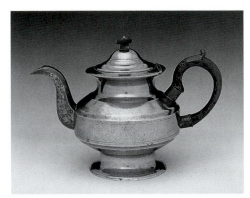

M255

M255

Teapot

1835–ca. 1860
Shop of Freeman Porter (ca. 1808–1887), Westbrook, Maine[1]
6¾ x 5¼ x 9⁄16" (17.1 x 13.3 x 23 cm)
B.71.1

About 1832 Freeman Porter entered into a brief partnership with his brother Allen before setting up his own shop. The 1850 census specifies that his shop employed four workmen, relied on horses as his source of power, and specialized in manufacturing teapots.

PROVENANCE: Unknown.

TECHNICAL NOTES: The body is spun, composed of two sections fused together at the base of the midband section. The metal handle retains traces of ebonizing. The lid, attached by a three-part hinge, has an air vent, and its finial is soldered on.

MARKED: Laughlin 1940, vol. 2, p. 110, No. 7 (within a rectangle inside the ring struck on the underside).

RELATED EXAMPLES: Churchill 1992, p. 9.

REFERENCES: Warren 1972b, p. 63; Butler 1985, p. 13.

1. For Porter (act. 1835–ca. 1860), see Woodside and Watkins 1932, pp. 8, 10; Churchill 1992, p. 8.

M256

Coffeepot

1820–40
Shop of Israel Trask (1786–1867), Beverly, Massachusetts[1]
12¾ x 515⁄16 x 10½" (32.4 x 15.1 x 26.7 cm)
B.53.9

The coffeepot is among the largest and most complex domestic forms the American pewterer fashioned. While eighteenth-century manuscripts occasionally refer to them, only a few examples— all associated with William Will—are known. Their scarcity implies that few shops possessed the costly molds required to produce the vessel. By the early nineteenth century, with the invention of Britannia and the attendant new production methods, more American craftsmen began to manufacture coffeepots. Israel Trask's vessels are distinctive for their design and construction.

PROVENANCE: Purchased by Miss Hogg from Carl and Celia Jacobs, Southwick, Massachusetts, 1953.

TECHNICAL NOTES: Trask and other Beverly craftsmen, including Ebenezer Smith, Jr., and the partnership of Lee and Creesy, constructed their coffeepots from rolled and seamed sheet metal. A six-inch plate was set in for the bottom of the Bayou Bend example. A three-part hinge is attached to the lid, and its finial is riveted. Although the object is referred to as a coffeepot, its spout has a strainer such as one would find on a teapot.

MARKED: Laughlin 1940, vol. 2, p. 114 (bottom).

RELATED EXAMPLES: Garrett et al. 1985, p. 147, no. 160. Trask adapted this design for flagons, in Watts 1968, pp. 45–46, nos. 117, 119.

REFERENCES: Warren 1972b, pp. 61–62; Butler 1985, pp. 11, 13.

1. For Trask (act. ca. 1813–56), see Webber 1924; Laughlin 1940, vol. 2, pp. 114–15; Flynt and Fales 1968, p. 342; Laughlin 1971, pp. 191–93.

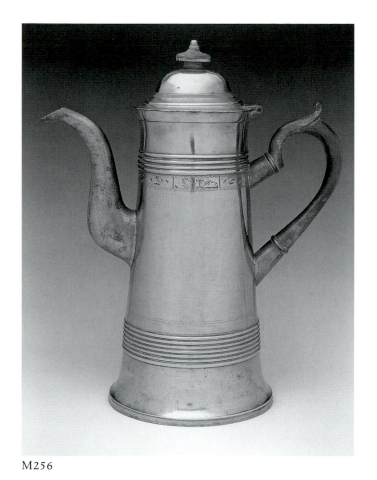

M256

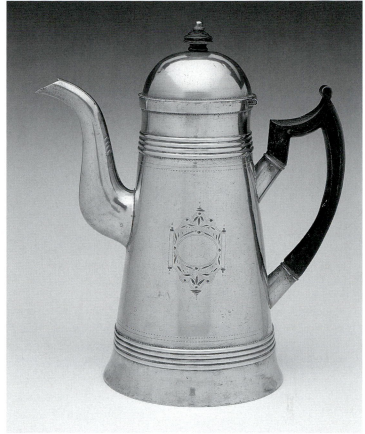

M257

M257

Coffeepot

ca. 1814–25
Shop of Ebenezer Smith, Jr. (1773–1848), Beverly,
Massachusetts[1]
11¹⁵⁄₁₆ x 6 x 10¹⁄₁₆" (30.3 x 15.2 x 25.6 cm)
B.53.15

Ebenezer Smith may have served his apprenticeship under Israel Trask; certainly, his handsome coffeepots are closely related in design and construction to examples from Trask's shop. This so-called lighthouse shape is recognized as among the noblest American interpretations of the form, its profile apparently derived from earlier silver examples or perhaps contemporary ceramics.[2] Another obvious relationship to silver is the bright-cut engraved border and fanciful cartouche.[3]

PROVENANCE: See cat. no. M256.

TECHNICAL NOTES: The vented lid is attached by a three-part hinge, and the finial is soldered. This coffeepot is equipped with a strainer. The handle is made of wood.

MARKED: Laughlin 1940, vol. 2, p. 113 (bottom).

RELATED EXAMPLES: Watts 1968, p. 47, no. 122; Brandt 1976, pp. 59–60; Sander 1986, p. 605.

REFERENCES: Warren 1972b, pp. 62–63; Butler 1985, pp. 11, 13.

1. For Smith (act. 1814–56), see Laughlin 1940, vol. 2, p. 113; Laughlin 1971, p. 190; Montgomery 1978, pp. 178–79.
2. Fales 1958, no. 98; Buhler 1972, vol. 2, pp. 577–78, no. 499.
3. Smith's coffeepots are unusual in American pewter and Britannia in being engraved. The Bayou Bend coffeepot is typical in having an engraved cartouche that was never filled in with the owner's name or initials.

M258

Flagon

1825–27
Manufactory of Boardman & Company
(act. 1825–27), New York and Hartford[1]
12¹¹⁄₁₆ x 5¹³⁄₁₆ x 8¼" (32.2 x 14.8 x 21 cm)
B.53.10

Pewter flagons were used both domestically and ecclesiastically until the eighteenth century, when the form became exclusively a Communion vessel. Prior to the nineteenth century, pewter examples of this form were usually imported from England. American pewterers rarely produced flagons, probably because infrequent commissions did not justify the investment the large molds required.[2]

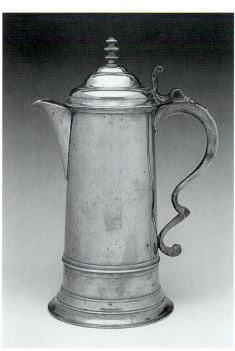

M258

PROVENANCE: See cat. no. M256.

TECHNICAL NOTES: The lid is secured by a five-part hinge, and its finial is soldered on.

MARKED: Laughlin 1940, vol. 1, pl. LVII, no. 431, X (incuse, underside).

RELATED EXAMPLES: Hood 1965, pp. 27–28, no. 106; Kernan, Ross, and Eilers 1969, pp. 29, 61, no. 81; Thomas 1976, p. 136; Krile 1989, pp. 5, 15, no. 24; and an unpublished example at the Albany Institute of History and Art (acc. no. 1974.48.1).

REFERENCES: Butler 1985, pp. 11–12.

1. See cat. no. M253.
2. The sinuous handle found on several English flagons with American histories is closely related to Boardman & Company's cast handle, suggesting that the latter was fashioned after an earlier imported example. Ely 1978, pp. 316–17; Benes and Zimmerman 1979, pp. 90–92, 157; Barquist 1985, pp. 56–57, 59–61.

M259

Pair of Oil Lamps

ca. 1840–60
Unknown maker, Northeastern United States
9½ x 4″ (diam. base) (24.1 x 10.2 cm)
B.56.54.1–.2

M259

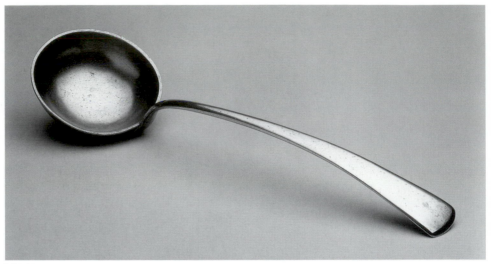

M260

A series of innovations at the end of the eighteenth century significantly improved artificial lighting. Pertinent to the pewter and Britannia industry was John Mile's "agitable" oil lamp, invented in 1787, which was notable for its oil-tight font. By the 1820s manufacturers began producing a variety of Britannia lamps that burned whale oil or burning fluid.[1] Contrary to popular belief, the "bull's-eye" lamp did not focus the light, but its limited diffusion seems to have reduced the effect of flickering. The quantity of these lamps surviving attests to their popularity, while slight variations indicate that a number of manufacturers produced them.

PROVENANCE: Purchased by Miss Hogg from Mrs. Lawrence J. Ullman, Tarrytown, New York, 1956.

TECHNICAL NOTES: The bases are weighted. The lenses are fitted into metal frames, which are secured by brackets.

RELATED EXAMPLES: An example stamped by Roswell Gleason of Dorchester, Massachusetts, is the only marked example of this lighting device, in Hood 1965, p. 29, no. 121.

1. Wolf 1984.

M260

Ladle

ca. 1833–52
Shop of Lewis Kruiger (d. ca. 1852),
Philadelphia[1]
Length 11⅞″ (30.2 cm)
Museum purchase with funds provided by
Catherine Campbell Hevrdejs, B.97.5

Both inexpensive and durable, pewter and Britannia were ideally suited for flatware. Because they were used daily, only a fraction of spoons and ladles predating 1825 survive. Lewis Kruiger is one of the better-known flatware manufacturers. The number of ladles known with his stamp suggests he specialized in this form.

PROVENANCE: Purchased by Bayou Bend from Bette & Melvyn Wolf, Flint, Michigan, 1997.

MARKED: Kerfoot 1942, fig. 283.

RELATED EXAMPLES: Kerfoot 1942, fig. 282.

1. For Kruiger (act. ca. 1833–ca. 1852), see Laughlin 1940, vol. 2, p. 106; Kerfoot 1942, pp. 58, 165. Kruiger is an elusive figure, appearing only in the 1833 Philadelphia directory and in none of the federal censuses taken in 1830, 1840, and 1850. The administration and inventory of his estate suggest 1852 as his date of death. His widow, Elizabeth "Kruger," is listed at 202 Parrish Street. The inventory records the contents of a three-story home in addition to "Shop fixtures + Stock." It enumerates: 168 pounds of lead, 250 of "mixt metal," 630 pounds of block tin, and 26 of "harde Metal," as well as other raw materials. His equipment included molds, a bench, lathe, saws, and burnishers as well as a casting stove and grinding stone. The manuscript furthers the belief that Kruiger specialized in the production of ladles, noting more than 236 dozen of various types and in stages, including handles and bowls (Register of Wills, County of Philadelphia, Pennsylvania, Philadelphia, City Hall, Administration Book Q, p. 132).

OTHER METALS

M261

Andirons

1760–1800
Unknown maker, probably Boston
Brass and iron; B.61.108.1: 20⅞ x 12⅜ x 21½″
(53 x 31.4 x 54.6 cm); B.61.108.2: 21⅛ x 12⅜ x 20″
(53.7 x 31.4 x 50.8 cm)
B.61.108.1–.2

Brass is an alloy of copper and zinc, valued for its pleasing color and slow rate of tarnishing. Evidence of brass production in seventeenth-century America is limited; however, by the eighteenth century advertisements chronicle the manufacture of everything from buckles to cannons. Regrettably, few of these objects can be separated from English examples, with andirons comprising the only group confidently attributed to American braziers.

The Baroque configuration of the Bayou Bend andirons recalls an earlier English design, fabricated in either brass or steel and distinguished by disklike feet, molded bosses, baluster uprights, and spherical knobs. This type may represent

the earliest pattern cast by American braziers. Traditionally attributed to Newport, it is now believed that most are of English manufacture.[1] Singular aspects of the Bayou Bend pair prompt an American attribution, more specifically to Boston. To begin with, the billet bar's curved step-down is not typical of English examples. Details that suggest a Boston origin include the cabriole legs and plinth base cast as a single unit and, in an effort to conserve metal, hollowed out on the back. Red brass, an alloy with a preponderance of copper, was seemingly preferred in Boston. The sliding log stop is another feature associated with Boston.

PROVENANCE: Purchased by Miss Hogg from Israel Sack, New York, 1961.

TECHNICAL NOTES: The log stops, upright, and knob are cast in halves and seamed. The plinth's circular boss is riveted to disguise the juncture with the billet bar.

1. Similar andirons ascribed to Newport but probably of English manufacture include Kauffman 1968, p. 147; Montgomery and Kane 1976, pp. 232, 309, no. 204; Schiffer and Schiffer 1978, p. 71, A; Jobe et al. 1991, pp. 145–46, no. 56; Fennimore 1996, p. 130, no. 51.

M262

Andirons

1760–80
Unknown maker, probably New York
Brass and iron; B.76.242.1: 23⅜ x 14⅛ x 20¼″
(59.4 x 35.9 x 51.4 cm); B.76.242.2: 23⅝ x 14⅛ x 20″ (60 x 35.9 x 50.8 cm)
Gift of the estate of Miss Ima Hogg, B.76.242.1–.2

In large part, the American home was furnished with products from the English brass manufacturing centers of Bristol and Birmingham. As these objects were damaged or became outmoded, they were normally recycled, the American brazier rarely having access to copper and zinc. By the mid-eighteenth century dwindling supplies of firewood rendered andirons superfluous in English households, which had turned to coal, whereas in America, unlimited forests ensured the form's persistence. Although British foundries continued to manufacture andirons for export, American braziers began to produce distinctive regional patterns. The Bayou Bend andirons represent one of the most dynamic Rococo designs,

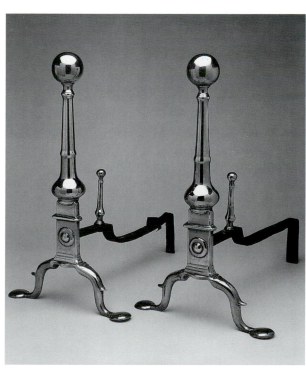

M261

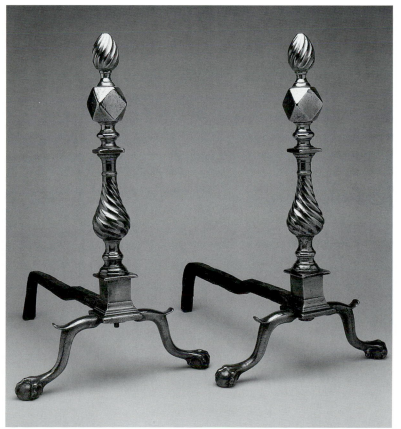

M262

undoubtedly similar to those described by Charleston merchant James Duthie in his advertisement: "just imported . . . a few pair of Chamber Dogs, the handsomest that were ever brought into this province, with large brass twisted, plain and fluted pillars . . . made in New York."[1]

PROVENANCE: Purchased by Miss Hogg from John S. Walton, New York, 1961.

TECHNICAL NOTES: The legs are integral with the plinth base. The plinth, baluster, and finial are hollow-cast and vertically seamed. They are assembled with an internal rod secured by a threaded nut at the bottom and peened at the top.

RELATED EXAMPLES: Other examples include Ward 1980, p. 1307; Stillinger 1990, pp. 57, 152; Fennimore 1996, p. 139, no. 59. Similar andirons were once attributed to Paul Revere, Jr., and Son based on a set on which the mark is no longer considered authentic (Davidson 1967, p. 270, no. 410).

1. Fennimore 1996, p. 138.

M263

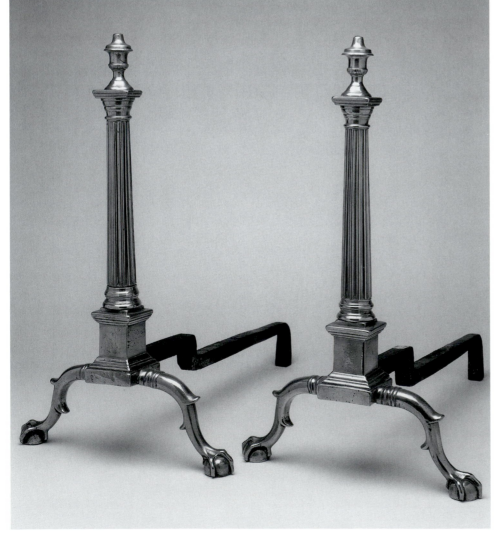

M263

Andirons

1760–1800
Attributed to the foundry of Daniel King, Sr. (1731–1806), or Daniel King, Jr. (1757–1836), Philadelphia[1]
Brass and iron; B.86.9.1: 21⅞ x 12⅞ x 22" (55.6 x 32.7 x 55.9 cm); B.86.9.2: 22⅛ x 13⅛ x 22" (56.2 x 33.3 x 55.9 cm)
Museum purchase with funds provided by the Friends of Bayou Bend, B.86.9.1–.2

Daniel King, Sr., was the principal brazier working in Philadelphia during the second half of the eighteenth century. He established his South Front Street foundry in 1760 and within a decade had earned a reputation for products that rivaled English or Continental imports. Between 1770 and 1771 he executed for General John Cadwalader what must have been one of his most important domestic commissions. Surviving bills enumerate purchases of door hardware and fireplace equipment. The latter consisted of six pairs of andirons, including a "Pare of the Best Rote (rate) fier Dogs With Corinthen Coloms," for which Cadwalader paid King twenty-five pounds, approximately the same amount he paid Charles Willson Peale that same year for two three-quarter-length portraits of his parents.[2]

Regrettably, Cadwalader's andirons are not known. There is only one signed set of andirons from King's foundry, to which the Bayou Bend set is most closely related.[3]

PROVENANCE: Purchased by Bayou Bend from William T. Thistlethwaite, Washington, D.C., 1986.

TECHNICAL NOTES: The front legs are brazed to the plinth base. The plinth, base, fluted column, and urn are cast and vertically seamed, and the cap is a separate component, all secured by an internal rod.

RELATED EXAMPLES: Fennimore 1996, p. 134, no. 54.

1. For Daniel King, Sr., see PMA 1976, pp. 102–3.
2. Wainwright 1964, pp. 37–38, 77, 108–11.
3. Fennimore 1996, p. 134, no. 54.

M264

Andirons

1790–1815
Unknown maker, probably Boston
Brass and iron; B.76.257.1: 32 x 13½ x 24⅜" (81.3 x 34.3 x 61.9 cm); B.76.257.2: 31⅞ x 13¾ x 25½" (81 x 34.9 x 64.8 cm)
Gift of the estate of Miss Ima Hogg, B.76.257.1–.2

Base metal objects respond slowly to stylistic developments, in part because of the exorbitant investment for the molds needed to cast them. This circumstance may offer a plausible explanation for the lingering Rococo motifs of these architectonic andirons, elements of their ornament simply updated in response to the Neoclassical idiom. In keeping with the new style, engraved or stamped decoration was introduced, much in the same manner as on a piece of silver, in this instance to highlight the plinths and finials. The red brass, commonly referred to as bell metal, along with the cabriole legs' hollow castings recommend a Boston

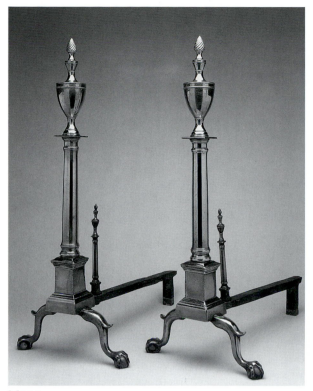

M264

M265

origin. Their monumental proportions, Neoclassical ornament, and fully articulated log stops distinguish these andirons.

PROVENANCE: Purchased by Miss Hogg from John S. Walton, New York, 1955.

TECHNICAL NOTES: The legs and plinth base are integral. The upright is composed of three vertically seamed components, the plinth, column, and urn, along with the columnar cap. Both uprights and log stops are engraved and stamped.

ENGRAVED: Neoclassical style decoration.

RELATED EXAMPLES: *Antiques* 55 (May 1949), back cover; *Antiques* 101 (April 1972), p. 571; *Antiques* 113 (March 1978), p. 586; Skinner, Bolton, sale 1222, October 29, 1988, lot 49; Fennimore 1996, p. 147, no. 67.

M265

Andirons

1807–17
Attributed to the shop of Isaac Conklin (act. 1807–17) and the foundry of Richard Whittingham, Jr. (b. 1776), New York[1]
Iron and brass; B.96.2.1: 24½ x 11¼ x 18¾" (62.2 x 28.6 x 47.6 cm); B.96.2.2: 24⅝ x 11⅛ x 18½" (62.5 x 28.3 x 47 cm)
Museum purchase with funds provided by Mr. and Mrs. Alfred C. Glassell, Jr., and Mr. and Mrs. Wallace S. Wilson, B.96.2.1–.2

Andirons composed of iron and brass elements evince a collaboration between the blacksmith and the brazier. From a practical consideration, their wrought-iron feet, legs, and upright better withstood the fire's intensity and did not require polishing. To the practicality of the iron, the brass elements added their stylishness, as Jacob Wilkins's 1765 advertisement for an "assortment of iron andirons with brass heads" implies.[2] The two-dimensional baluster shape of the Bayou Bend andirons must have found its inspiration in the brass examples popular at the time as well as earlier (see cat. no. M261). The Conklin-Whittingham andirons are the only marked examples of this type.

PROVENANCE: Oveta Culp Hobby, Houston; purchased by Bayou Bend through Phyllis Tucker, Houston, 1996.

TECHNICAL NOTES: The brass cap and urn are separate elements, the latter cast in halves and seamed.

MARKED: Fennimore 1996, p. 145 (plinth).

RELATED EXAMPLES: *Antiques* 40 (October 1941), p. 192; *Antiques* 126 (August 1984), p. 329; *Antiques* 140 (September 1991), p. 264; Fennimore 1996, p. 145, nos. 65a, b; Skinner, Bolton, sale 1755, January 12, 1997, lot 112.

1. Previously the mark was thought to be for John Constantine, a New York City black-

smith; however, more recently it has been reattributed to another blacksmith, Isaac Conklin (Fennimore 1996, p. 145). The most complete study on the Whittinghams is Kernodle and Pitkin 1957.
2. Gottesman 1938, p. 197.

M266

Andirons

1840–1900
Unknown maker, Northeastern United States
Iron; B.92.10.1: 19⅜ x 10¾ x 17¾" (49.2 x 27.3 x 45.1 cm); B.92.10.2: 19¼ x 10¾ x 17¼" (48.9 x 27.3 x 43.8 cm)
Gift of Sue Rowan Pittman, B.92.10.1–.2

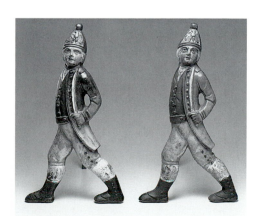

M266

Figural andirons became popular by the late eighteenth century, as evidenced by the trade card Paul Revere engraved for Joseph Webb, a Boston iron merchant and manufacturer.[1] The Bayou Bend andirons represent a nineteenth-century version traditionally described as Hessian soldiers, the German mercenaries who fought for the British in the American Revolution. Variations suggest that more than one manufacturer produced them; however, at present they are associated only with New York City's Phoenix Works.[2]

TECHNICAL NOTES: The figures are hollow-cast with an integral horizontal tab on the back that aligns with the billet bar and is secured by a nut and bolt. The figures are painted.

MARKED: MII3; PAT. PEN; and below, 2000 (each in a rectangle, back of each figure).

RELATED EXAMPLES: A similar set is at Winterthur (acc. no. 64.1546.1–.2). For examples with the foundry marks A.W.S. and MBB, see *Maine Antique Digest*, October 1994, p. 19-E; *Maine Antique Digest*, December 1994, p. 11-E.

1. Brigham 1954, pp. 119–20, pl. 54.
2. A copy of *Phoenix Works Circular of Prices* for 1859 belongs to the Metropolitan Museum of Art, New York.

M267

Warming Pan

1760–1820
Unknown maker, probably Boston
Brass; 43¼ x 7⅝" (diam.) (109.9 x 19.4 cm)
B.74.20

Warming pans, passed between the bed sheets to remove the chill and moisture, were introduced during the second half of the seventeenth century and soon became requisite in northern Europe, England, and North America. The earliest pans were constructed entirely of metal and the covers often pierced; however, before long the openings were reduced in number and size in order to retain warmth and prevent straying coals.

PROVENANCE: Unknown.

TECHNICAL NOTES: A socket is riveted to the pan for the wooden handle. The lid is riveted to a hinged arm.

M268

Pair of Sinumbra Lamps

1820–40
Attributed to the manufactory of William Carleton (act. 1820–61), Boston
Brass, tinned iron, and glass; each: 17½ x 3¾ (base) x 3¾ (base)" (44.5 x 9.5 x 9.5 cm)
Bequest of Libbie Johnston Masterson, B.79.79.1–.2, B.79.82.1–.2

Invented in France about 1820, the sinumbra lamp employed an argand-type burner, with its annular ring oil reservoir concealed within the shade, raised above the flame, and therefore casting little shadow, as its Latin derivation *sine umbra*, translates: without shadow. The form became immensely popular and typically was positioned on a center table to allow for maximum light. The American market was largely dominated by imported English fixtures, William Carleton being one of the few competitive domestic

M268

manufacturers. The sinumbra's popularity endured two decades, until it was superseded by gas lighting.

PROVENANCE: Unknown.

TECHNICAL NOTES: There is a very early, possibly original, shellac base coating on the brass that makes it look like bronze. The tinned iron reservoir is painted white.

RELATED EXAMPLES: Feld et al. 1991, pp. 76–77, no. 54.

M269

Girandoles

1849–51
Manufactory of Cornelius & Co. (act. 1839–51), Philadelphia[1]
Isaac F. Baker (n.d.), designer
Silver-plated brass, marble, and glass; B.70.54.1, centerpiece: 17⅜ x 17¾ x 4⅝" (44.1 x 45.1 x 11.7 cm); B.70.54.2: 16¾ x 5¾ x 3¼" (42.5 x 14.6 x 8.3 cm); B.70.54.3: 16⅝ x 5¾ x 3¼" (42.2 x 14.6 x 8.3 cm)
B.70.54.1–.3

Girandoles were integral accessories for the properly furnished mid-nineteenth-century American parlor. Manufactured

M267

M269

PROVENANCE: Purchased by Miss Hogg from Peter Hill, Washington, D.C., 1968.

MARKED: Cornelius & Co., Patented, April 10, 1849 (back of each figure).

TECHNICAL NOTES: The figures are hollow-cast; the candle sockets and prism brackets are separate elements. The metal consists of silver electroplated on brass.

RELATED EXAMPLES: Tracy et al. 1970, no. III; Bacot 1987, pp. 174–76; Fennimore 1996, pp. 226–27, no. 137.

1. Cornelius & Co. was founded by Christian Cornelius and his son Robert in 1827. In 1835 Isaac F. and William C. Baker joined the company; PMA 1976, p. 334; Jones 1983.

M270

Girandoles

1849–52
Manufactory of William F. Shaw (1820–1900), Boston[1]
Patinated brass, marble, and glass; B.94.7.1, centerpiece: 16⅛ x 16⅞ x 3½″ (41 x 42.9 x 8.9 cm); B.94.7.2, B.94.7.3: 13¾ x 6⁹⁄₁₆ x 3½″ (34.9 x 16.7 x 8.9 cm)
Museum purchase with funds provided by the Houston Junior Woman's Club, B.94.7.1–.3

in Boston, New York, and Philadelphia, they came in a variety of finishes and bases. The girandoles' decorative figures included historical and fictional personages, architecture, flowers, and even a menagerie of animals. The Bayou Bend girandole, the centerpiece of a three-piece set, indicates the variation available. This example from Cornelius & Co. represents Cora Munro, a character from James Fenimore Cooper's *The Last of the Mohicans,* and is executed in the then unusual, innovative surface treatment of electroplated silver.

M270

William F. Shaw's architectonic girandoles are the most memorable expression of the Gothic revival in American lighting devices. In 1845 he established both a factory and a store, advertising that he retailed American and English fixtures. The girandoles in the Bayou Bend collection depict the Bigelow Chapel at Mount Auburn Cemetery in Cambridge, Massachusetts. Notable as America's first planned, nonsectarian graveyard, its chapel was designed by Jacob Bigelow (1787–1879), one of the cemetery's founders. Coincidentally, William F. Shaw is interred there.

PROVENANCE: Purchased by Bayou Bend from Galleria Hugo, New York, 1994.

TECHNICAL NOTES: The chapel and floral-scrolled branches are separate castings. These girandoles' bronze patination and gilt highlights are exceedingly rare. The centerpiece's marble foot may represent an old replacement.

MARKED: WF SHAW; 174 WASHINGTON; BOSTON; PATENT. DEC.18 1849 (cast on the back of each piece).[2]

RELATED EXAMPLES: Howe and Warren 1976, p. 62; Hanks and Peirce 1983, p. 83; Bacot 1987, pp. 154, 188–89; Douglas 1994.

1. For Shaw (act. 1845–1900), see Bacot 1987, pp. 154–56, 187–89; Douglas 1994.
2. Shaw was at 174 Washington Street until 1852. Earlier examples are cast with the address of 270 Washington Street.

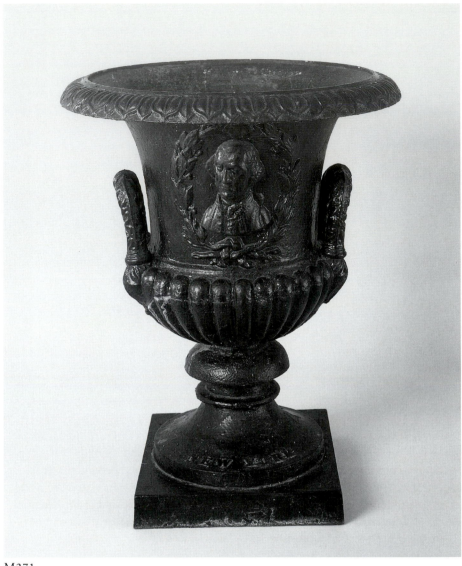

M271

M271

Vase

ca. 1862
J. L. Mott Iron Works (act. 1828–1906), Mott Haven, New York[1]
Iron; 29 x 25″ (diam.) (73.7 x 63.5 cm)
Museum purchase with funds provided by the Wunsch Americana Foundation, B.80.2

Paramount among Jordan L. Mott's multitudinous inventions was his design for an anthracite coal-burning stove. When Mott was unable to engage a founder to produce his furnace, he did it himself, and it became a model for the industry. The

J. L. Mott Iron Works, while principally known for its line of stoves, bathtubs, plumbing supplies, and stable fittings, also manufactured ornamental ironwork, including gates, railings, balconies, lamps and lampposts, fountains, furniture, and even aquariums. The company's 1862 catalogue is the only one to picture the Washington Vase.[2] Essentially, it was a modified version of Mott's Palo Alto Vase, to which a bust of George Washington framed within a laurel wreath was added.

PROVENANCE: Purchased by Bayou Bend from Bernard and S. Dean Levy, New York, 1980.

MARKED: J L MOTT; NEW YORK (stem).

REFERENCES: Mott 1862, p. 61; *Antiques* 110 (August 1976), p. 215; Brown 1985, pp. 521–22.

1. For the Mott Iron Works and Jordan L. Mott (1799–1866), see Bishop 1868, pp. 498, 576–78.
2. Mott 1862, p. 61.

CERAMICS

C1*

Pitcher

1849–58
Lyman, Fenton & Co. or United States Pottery Co. (1849–58), Bennington, Vermont[1]
Flint enamel-glazed earthenware[2]; 6⅝ x 4½ x 5¾" (16.8 x 11.4 x 14.6 cm)
B.57.53

PROVENANCE: Purchased by Miss Hogg from Whimsy Antiques, Arlington, Vermont, 1957.

MARKS: [Lyman, Fenton & Co. / Fenton's ENAMEL / PATENTED / 1849] / BENNING[TO]N, Vt.] (impressed on underside; Barret 1958, p. 14, fig. IXa).

DESCRIPTION: Small pitcher with tulip and heart pattern. Eight panels with small heart design at top of each rib.

RELATED EXAMPLES: Barret 1958, p. 26, pl. 24.

1. Lyman, Fenton & Co. was formed in 1848 or 1849, and in 1849 its name became the United States Pottery Co. The 1849 Lyman, Fenton & Co. mark was also used by the U.S. Pottery Co. in the 1850s (Ketchum 1983, p. 428).
2. Flint enamel was a patented invention of Fenton. Applied to a yellow or white earthenware body, it is a streaky, multicolored glaze produced by dusting metallic oxides over a clear glaze before firing.

C2

Toby Jug

ca. 1853–58
Lyman, Fenton & Co. or United States Pottery Co. (1849–58), Bennington, Vermont
Flint enamel-glazed earthenware; 6½ x 3½ x 5½" (16.5 x 8.9 x 14 cm)
B.57.49

The toby form, traditionally a seated figure holding a mug and a pipe and wearing a tricorn hat, was introduced into English pottery in the mid-eighteenth century.[1] Widely manufactured and popular into the nineteenth century, the toby jug was first produced at the Bennington factory in the late 1840s. The firm made several models of bust-length pitchers as well as this full-length seated figure, all

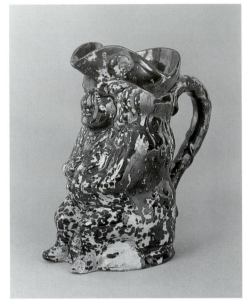

C2

with Rockingham-style glazes.[2] The form was also adapted to create small covered match safes (see cat. no. C58). While most examples bear the Lyman, Fenton mark, this one is unusual in bearing the mark more commonly seen on scroddled wares.

PROVENANCE: See cat. no. C1.

MARKS: UNITED STATES / POTTERY CO. / BEN-NINGTON, Vt. (impressed on underside; Barret 1958, p. 14, fig. Xh).

DESCRIPTION: Seated toby figure holds a goblet. Crabstock handle and terminal (flowering vine). Chocolate brown mottled glaze on cream body.

RELATED EXAMPLES: PMA (Spargo 1969, pl. XI); a scroddled example (Barret 1958, p. 318, pl. 415); a Rockingham example (Barret 1958, p. 319, pl. 416e).

1. The name is thought to be derived from Toby Philpot, the subject of a song "The Brown Jug" published in 1761. Toby Philpot was the nickname for Harry Elwes, a celebrated toper (Savage and Newman 1976, p. 293).
2. Rockingham glaze is a rich, brown glaze, sometimes mottled with yellow, blue, and orange. The glaze was first introduced at the English pottery of the Marquess of Rockingham in the 1820s and was often used on pottery made in Bennington, Vermont. The term is now used to describe any rich, brown glaze.

C3*

Pitcher

1850–1900
United States
Rockingham-glazed earthenware; 10½ x 7¼ x 9⅝" (26.7 x 18.4 x 24.4 cm)
B.62.36

PROVENANCE: Purchased by Miss Hogg from Myrtle Eull Antiques, Houston, 1962.

TECHNICAL NOTES: Lip chipped; glaze badly pitted around base and on front.

DESCRIPTION: Large pear-shaped pitcher with relief portrait of George Washington in oval frame on both sides. Somewhat flattened loop handle with thumb hold. Brown and yellow Rockingham glaze, showing some opalescence.

C4

Pitcher

1852–58
Attributed to United States Pottery Co. (1849–58), Bennington, Vermont
Rockingham-glazed earthenware; 11¼ x 8⅝ x 11⅛" (28.6 x 21.9 x 28.3 cm)
B.72.98

PROVENANCE: Unknown (at Bayou Bend prior to 1965).

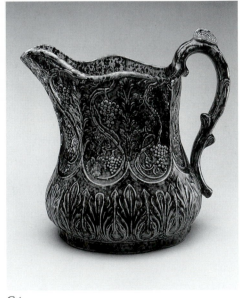

C4

DESCRIPTION: Large octagonal-shaped pitcher, cream colored with mottled brown glaze. Lower portion has molded acanthus leaf pattern; upper panels have a molded grapevine and leaf pattern. Handle is branch shaped. Rim and spout are gently scalloped.

RELATED EXAMPLES: Ketchum 1983, p. 112. See Barret 1958, pl. 68A, for a blue and white porcelain example, pl. 68B, for a graniteware example, and pl. 70B, for a Rockingham example.

C5

Pitcher

ca. 1849–58
Possibly Bennington, Vermont
Rockingham-glazed earthenware; 9⅝ x 7¼ x 9¼" (24.4 x 18.4 x 23.5 cm)
B.57.48

This pitcher and the previous example (cat. no. C4) exemplify the almost limitless shapes, ornaments, and allusions to high style given to the basic, molded, mass-produced Rockingham-glazed product. Cat. no. C4, with its molded acanthus leaves and grape ornaments, reflects the shift away from classicism to naturalism at mid-century, echoed by the branch form handle. The swirl ribbed design seen on the present example represents the Rococo revival, referencing eighteenth-century Continental silver forms.

PROVENANCE: George S. McKearin; purchased by Miss Hogg from Whimsy Antiques, Arlington, Vermont, 1957.

MARKS: Indiscernible (part of a circle approximately 2½ inches in diameter).

DESCRIPTION: Pear-shaped pitcher with exaggerated waist with sixteen wide ribs alternating with narrower ones, all of which swirl downward right to left from the rim (known as the "swirled alternate rib" pattern). Molded applied strap handle with scrolled thumb stop and finger rest. Large lip with scroll or wave-shaped decorations. The glaze is green, gold, and brown on cream.

RELATED EXAMPLES: Barret 1958, p. 26, pl. 25g.

C6

Pitcher

1840–50
Possibly modeled by Daniel Greatbach[1]
American Pottery Co. (1833–ca. 1850), Jersey City, New Jersey
Lead-glazed earthenware; 9 x 7 x 8⅝" (22.9 x 17.8 x 21.9 cm)
B.63.16

This pitcher is the product of the American Pottery Company, a firm formed in 1833 by David Henderson, who had earlier established the D. & I. Henderson Company as the successor to the failing Jersey Porcelain and Earthenware Company. The factory introduced to America sophisticated English-style pottery modeled by such designers as Daniel Greatbach, who joined the firm in 1839. The

pottery was also the first to produce large quantities of refined earthenware using patterned molds.[2] Here the finely detailed molded ornament combines exotic Gothic or Moorish arches with naturalistic roses suggestive of the eclectic romantic taste at mid-century. The paneled hexagonal form was also popular at this time.

PROVENANCE: Louis M. King, Utica, New York[3]; purchased by Miss Hogg from George Abraham and Gilbert May Antiques, Granville, Massachusetts, 1963.

MARKS: AMERICAN / POTTERY Co / JERSEY CITY NJ (impressed on underside; Thorn 1947, p. 115, no. 16, and Barber 1976a, pp. 41, 44).

DESCRIPTION: Hexagonal pitcher with a foliated scrolled handle attached to a rib. Embossed floral panels of three different designs. Each is enclosed in a Gothic-type arched panel; hexagonal panels above.

RELATED EXAMPLES: Watkins 1946, p. 392, fig. 16, with a Rockingham glaze; New Jersey Pottery 1972, no. 34, with a yellow glaze.

1. Greatbach came to America from England around 1838 and was active in Jersey City from 1839–52 and in Bennington from 1852–58.
2. See Watkins 1946.
3. Letter from Louis King (August 1934, in object files) indicates there is a history of previous ownership in his family.

C7–8

Pitchers

ca. 1850–56
Modeled by Charles Coxon (1805–1868)
E. & W. Bennett (1848–56), Baltimore
Rockingham-glazed earthenware; B.57.23: 8¾ x 5½ x 7⅞" (22.2 x 14 x 20 cm); B.63.14: 8½ x 5¼ x 7¾" (21.6 x 13.3 x 19.7 cm)
B.57.23, B.63.14

Edward and William Bennett, brothers who emigrated from England in 1841, were part of a large family of potters who worked together in New Jersey and Ohio before they opened their own Baltimore factory in 1848. They retained Charles Coxon, an Englishman from Staffordshire, who worked as the firm's principal modeler from 1850 until 1858.[1] Prior to William's departure in 1856, the firm used this mark (see Marks) and produced a

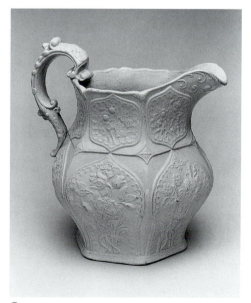

C5 C6

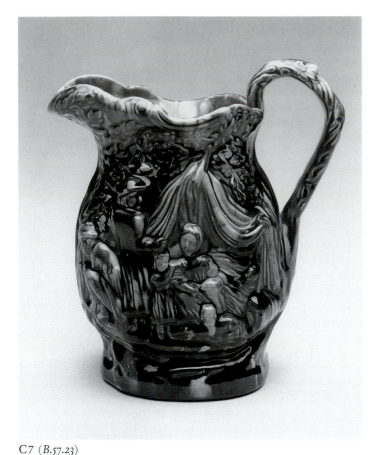

C7 (B.57.23)

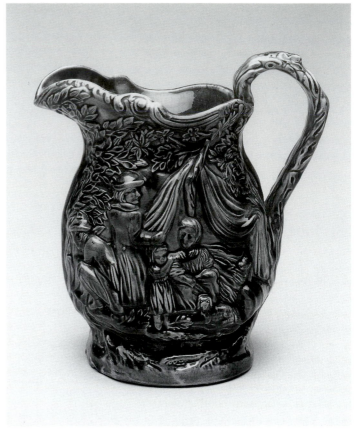

C8 (B.63.14)

variety of pottery, including earthenware and stoneware. While it has been suggested that this pattern is properly called "The Good Samaritan," the design was described as "Gipsey" when it was first published by Staffordshire potters Jones and Walley in 1841, no doubt because of the figures in front of a tent and around a fire.[2] It is likely that Coxon is responsible for introducing this relatively new English design to the Bennett pottery.

PROVENANCE: **B.57.23**, George S. McKearin; purchased by Miss Hogg from George Abraham and Gilbert May Antiques, West Granville, Massachusetts, 1957; **B.63.14**, purchased by Miss Hogg from George Abraham and Gilbert May Antiques, West Granville, Massachusetts, 1963.

MARKS: **B.57.23**, E. & W. BENNETT / CANTON AVENUE / BALTI[MORE MD.]; **B.63.14**, E. & W. BENNETT / CANTON AVENUE / BALTIMORE [MD.] (impressed on underside of each; Barber 1976, p. 143).

DESCRIPTION: Molded body including handle. Decorated with scenes of women in front of a tent on one side, around a fire on the other. Leaves around top of pitcher with scroll decor around lip of spout. Indented foot tree roots. Dark and light brown glaze covers entire piece, including inside and bottom.

C8 (detail of mark)

RELATED EXAMPLES: For Parian examples of the pattern from Bennington and the English factory of Jones and Walley, see Barret 1958, p. 47, pls. 60, 61; for a stoneware example made by Edward Walley's Villa Pottery after 1845, see Mudge et al. 1985, p. 45.

1. Coxon left the Bennett pottery in 1858 to run the Swan Hill Pottery in South Amboy, New Jersey (Goldberg 1994, p. 43). Coxon was the modeler who introduced the oft reproduced "Rebekah at the Well" (see cat. no. C12). See also Myers 1987.
2. Barret 1958, p. 47, calls it "The Good Samaritan"; however, Mudge et al. 1985 cites the published Jones and Walley pattern as "Gipsey" (p. 45). See also Goldberg 1994, p. 40, fig. 11, and p. 57, no. 12.

C9

Pitcher

1855–75
United States
Rockingham-glazed earthenware; 12¼ x 7½ x 11½" (31.1 x 19.1 x 29.2 cm)
B.63.17

Corn, a native plant of the New World, conveyed specifically American connota-

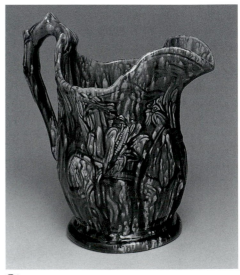

C9

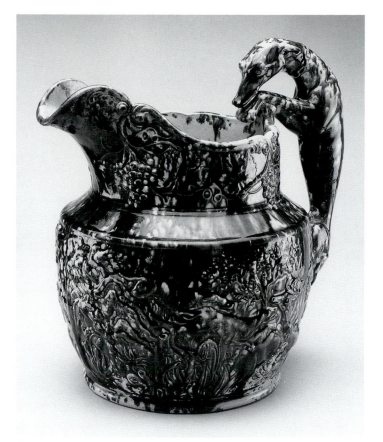

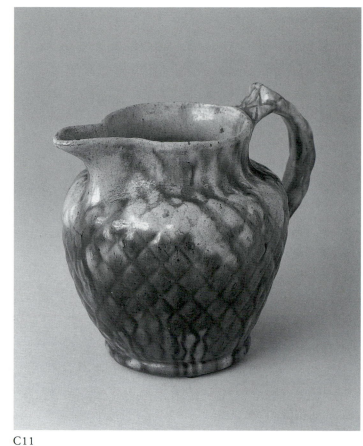

C10

C11

tions when used as a decorative motif. Molded porcelain pitchers, such as the present example, were first produced by factories in Greenpoint, New York, in about 1850.[1] This pitcher exemplifies the widespread adaptation of porcelain forms to the mass market of Rockingham-glazed earthenware.

PROVENANCE: See cat. no. C10.

MARKS: Illegible oval-shaped impression.

DESCRIPTION: Brown-glazed, molded relief of three corn ears protruding from stalk on each side of pitcher. Handle simulates corn-stalk. Wide-mouth spout slightly curved. Brown glaze on exterior with drips on inside over cream colored body.

1. Frelinghuysen 1989, nos. 21, 22, 25.

C10

Pitcher

ca. 1850–1907
Brockville Works (ca. 1850–1907), Schuylkill County, Pennsylvania[1]
Rockingham-glazed earthenware; 10½ x 7⅝ x 10¼" (26.7 x 19.4 x 26 cm)
B.63.15

Daniel Greatbach is generally credited with introducing the so-called Hound pitcher to America, first at the American Pottery Company in Jersey City, New Jersey, and later at Bennington.[2] This English form is distinguished by a handle in the shape of a greyhound whose rear paws rest on the body and whose forepaws and nose are at the upper lip. The sloping ovoid body is typically ornamented in relief with a stag hunt and the neck with grapevines. The form's enormous popularity is reflected in its widespread production from New England to Maryland and west to Ohio.

PROVENANCE: Purchased by Miss Hogg from George Abraham and Gilbert May Antiques, Granville, Massachusetts, 1963.

MARKS: BROCKVILLE WORKS / NEAR / POTTSVILLE, SCH'L CO. / PENNA. (impressed on underside; Lehner 1988, p. 57).

DESCRIPTION: Yellow glaze with brown over-glaze. Body of pitcher has raised scenic design. Narrow foot rim and rim at base of flat, undecorated shoulder. The top with pouring spout is decorated with grapes, vines, leaves, and scrolls in relief. Handle is hound shaped with smooth body.

RELATED EXAMPLES: Barret 1958, pp. 30–33, illustrates similar pitchers made at Benning-

ton. For New York and New Jersey examples, see Levin 1988, p. 34, figs. 22, 23, and New Jersey Pottery 1972, nos. 30, 31, 119; for a Baltimore example without the shoulder by Bennett, see Perry 1989, p. 45, no. 39. See also Ketchum 1971, no. 110.

1. Lehner 1988, p. 57, discusses the Brockville factory.
2. Watkins 1968, p. 219. An 1837 handbill lists "Hound Pattern" pitchers in six sizes (New Jersey Pottery 1972, no. 119).

C11

Pitcher

ca. 1887–1900
Attributed to Samuel Bell and Son (act. ca. 1882–1908) or J. Eberly and Brother (act. 1880–1906), Strasburg, Virginia
Lead, manganese, and copper-glazed slip covered earthenware; 6⅜ x 5⅝ x 7¾" (16.2 x 14.3 x 19.7 cm)
B.72.96

The potteries of the Shenandoah Valley were prolific in the late nineteenth century. This small pitcher represents a type based on a Bennington pattern, which

was produced in the middle Shenandoah Valley by the Eberly family, who called the pattern "diamond," and the Bell family, who called the pattern "pineapple."[1]

PROVENANCE: Purchased by Miss Hogg from McKearins' Antiques, New York, 1929.

DESCRIPTION: Molded diamond pattern with incised lines. Applied strap handle with a thumb rest at the top.

RELATED EXAMPLES: Comstock 1994, p. 245, no. 5.142.

1. Comstock 1994, p. 245.

C12
Teapot

ca. 1850–52
Modeled by Charles Coxon (1805–1868)
E. & W. Bennett (1848–56), Baltimore
Rockingham-glazed earthenware; 6¼ x 4½ x 6½" (15.9 x 11.4 x 16.5 cm)
B.57.22

Charles Coxon's models were often inspired by English sources (see also cat. nos. C7, C8), in this case Samuel Alcock and Company of Staffordshire.[1] Ten-sided teapots with molded figures at a well were produced in enormous numbers by Bennett and commonly bore the legend "Rebekah and the Well" embossed on a rectangle below the scene.[2] Several factors, however, suggest that this example is an early Bennett model preceding the Rebekahs. The clarity of the mold and lightness of the body differ from most Rebekahs. The embossed title below

clearly identifies it as "Rachel at Jacob's Well," not Rebekah. In addition, the lid of this pot is not, as is the norm with the Rebekahs, fitted out with lugs, an improved Bennett design that prevented the lid from coming off when the pot was being poured.[3]

PROVENANCE: George S. McKearin; purchased by Miss Hogg from George Abraham and Gilbert May Antiques, West Granville, Massachusetts, 1957.

MARKS: E. & W. BENNETT / CANTON AVENUE / BALTIMORE MD. (impressed on base; Barber 1976a, p. 143).

TECHNICAL NOTES: The lid is broken and repaired. The body is more sharply molded and noticeably lighter than the Rebekah examples.

DESCRIPTION: Ten-sided teapot with raised figure of a woman holding a ewer standing by a well on each side; impressed in raised rectangle below, "RACHEL AT JACOB'S WELL." Swan-neck spout with molded design on each side. Scroll-type handle. Separate domed lid with floral finial.

RELATED EXAMPLES: Barber 1976b, pp. 196–97, fig. 83; Ramsay 1939, p. 51, pl. 12; Stradling 1997, p. 336.

REFERENCES: Stradling 1997, p. 333, pl. II.

1. Spargo 1926, p. 334; Myers 1987, p. 31, fig. 1.
2. An example at the Smithsonian Institution bears a paper label on which Bennett wrote that he designed the teapot and began production of it around 1850 (Myers 1987, p. 32, fig. 2).
3. Depiction of Rachel at a well, where she first met Jacob, would have been readily identified by Bennett's biblically well-versed clientele. Similarly, the story of Rebekah, Jacob's mother, begins with her meeting

the servant of her future husband, Abraham, at the city well of Nahor. Research by J. Garrison Stradling has linked the advent and popularity of the Rebekah pots to the rise of the female membership in the International Order of Odd Fellows, who were called Rebekahs. An example in the Goldberg collection has the title rectangle with embossed legend upside down, indicating that it was not part of the scene mold but was molded and applied separately. Thus it could be that Rachels and Rebekahs were produced at the same time, but the fact that less than half a dozen Rachels and thousands of Rebekahs are known strongly suggests that Rachel was an early and limited product. I am grateful to Mr. Stradling for sharing this information as well as that about the Bennett lid design. For further discussion, see Stradling 1997.

C13
Creamer

1849–58
Lyman, Fenton & Co. or United States Pottery Co. (1849–58), Bennington, Vermont
Flint enamel-glazed earthenware; 6¼ x 4¼ x 5" (15.9 x 10.8 x 12.7 cm)
B.57.50

PROVENANCE: See cat. no. C5.

MARKS: Fenton's ENAMEL / 1849. / PATENTED (impressed on underside; Barret 1958, p. 14, fig. IXc).

DESCRIPTION: Octagonal tulip-shaped pitcher with brown and cream glaze. Each division on pitcher shows cream base.

RELATED EXAMPLES: Barret 1958, p. 27, pl. 27c.

C14
Sugar Bowl

1849–58
Lyman, Fenton & Co. or United States Pottery Co. (1849–58), Bennington, Vermont
Flint enamel-glazed earthenware; 8½ x 6¼ x 5⅝" (21.6 x 15.9 x 14.3 cm)
B.57.51

PROVENANCE: See cat. no. C5.

MARKS: Lyman Fenton & Co. / Fenton's / ENAMEL / PATENTED / 1849. / BENNINGTON, Vt. (impressed on underside; Barret 1958, p. 14, fig. IXa).

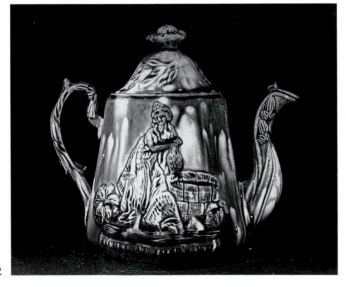

C12

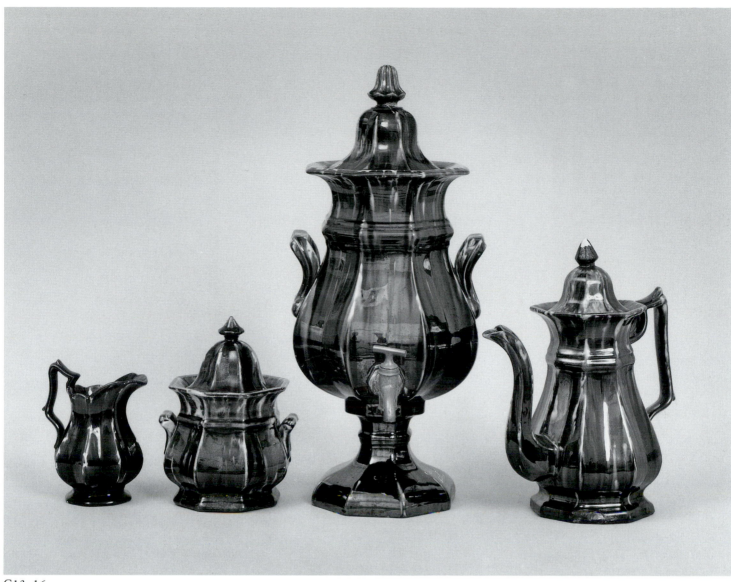

C13–16

DESCRIPTION: Octagonal sugar bowl with flint enamel glaze of brown, blue, green, gold, and cream. Its cover has a ten-sided finial. The inside of the lid and the bottom of the bowl are covered only with a clear glaze. Flaring rectangular handles, flared lip.

RELATED EXAMPLES: Barret 1958, p. 98, pl. 135.

C15

Coffeepot

1849–58
Attributed to United States Pottery Co. (1849–58), Bennington, Vermont
Flint enamel-glazed earthenware; 12⅜ x 6⅜ x 10¾" (31.4 x 16.2 x 27.3 cm)
B.57.19

PROVENANCE: See cat. no. C12.

TECHNICAL NOTES: Small repair on base; finial of lid restored; age crack on base.

DESCRIPTION: Octagonal coffeepot with helmet cover. Flint enamel glaze of dark brown with orange and yellow streaks mottled on cream ground.

RELATED EXAMPLES: Barret 1958, p. 98, pl. 136a.

C16

Coffee Urn

1849–58
Attributed to United States Pottery Co. (1849–58), Bennington, Vermont
Flint enamel-glazed earthenware and pewter; 20 x 8⅞ x 11¾" (50.8 x 22.5 x 29.8 cm)
B.57.20

PROVENANCE: See cat. no. C12.

MARKS: FENN'S PATENT NO. 2 / NEW YORK No. 2 (stamped on spigot).

TECHNICAL NOTES: Badly broken lid fits loosely (possibly not original) and is repaired in several places.

DESCRIPTION: Octagonal urn with pair of applied strap handles; pewter spigot screwed through hole at lower center. Octagonal-domed lid with pagoda finial. Covered in mottled brown, cream, and green flint enamel glaze.

RELATED EXAMPLES: Spargo 1924, p. 235, fig. 6; Barret 1958, p. 83, pl. 109; Spargo 1969, pl. XVIII.

The paneled form that was so popular at mid-century in both glass and ceramics was frequently used by the Fenton factory for tea and coffee serving equipment. The form is either plain or ornamented with a

raised band around the neck (see cat. nos. C13, C14). While creamers and coffee urns came only in one size, sugar bowls, teapots, and coffeepots were made in several sizes. The items were apparently sold separately rather than as sets, and the price varied according to the size and complexity of the form.[1]

1. Barret 1958, p. 10. 1852 Price List quote per dozen for the largest form offered: creamers $2, sugar bowls $4, teapots $7, coffeepots $12, coffee urns $26.

C17*

Sugar Bowl with Lid

1849–58
Lyman, Fenton & Co. or United States Pottery Co. (1849–58), Bennington, Vermont
Flint enamel-glazed earthenware; 7⅛ x 5¾ x 5¼″ (18.1 x 14.6 x 13.3 cm)
B.57.46

PROVENANCE: See cat. no. C5.

MARKS: Lyman Fenton & Co. / Fenton's / ENAMEL / [P]A[TENTED] / 184[9] / BENNIN[GTON], Vt. (impressed on underside; Barret 1958, p. 14, pl. IXa).

TECHNICAL NOTES: Large piece broken out of insert portion under lid.

DESCRIPTION: Molded bowl of graduated bulbous shape and alternating rib pattern. Handles are branch type with leaf terminals. The lid's finial is a stylized flower. Glaze is brown with mottled yellow and green.

RELATED EXAMPLES: Barret 1958, p. 93, pl. 126d.

C18*

Mugs

1844–58
Possibly Bennington, Vermont
Rockingham-glazed earthenware; B.63.112: 3 x 3³⁄₁₆ x 4¼″ (7.6 x 8.1 x 10.8 cm); B.63.113: 3⅛ x 3 x 3⅞″ (7.9 x 7.6 x 9.8 cm)
B.63.112–.113

PROVENANCE: Purchased by Miss Hogg from Margo Authentic Antiques, St. Louis, Missouri, 1963.

MARKS: B.63.112, Illegible one-inch circular stamp on base; B.63.113, none.

DESCRIPTION: Handle strap molded. Indented rolled foot rim.

C19*

Mug

1844–58
Possibly Bennington, Vermont
Rockingham-glazed earthenware; 2⅞ x 3¼ x 4⅛″ (7.3 x 8.3 x 10.5 cm)
B.63.114

PROVENANCE: See cat. no. C18.

DESCRIPTION: Mottled brown mug with strap handle and curved foot rim. Body of cup is gently shaped inward, then flares at top.

RELATED EXAMPLES: Barret 1958, p. 97, pls. 133, 134.

C20*

Mug

1844–58
Possibly Bennington, Vermont
Rockingham-glazed earthenware; 3⅜ x 3⁵⁄₁₆ x 4¼″ (8.6 x 13.5 x 10.8 cm)
B.57.38

PROVENANCE: See cat. no. C12.

DESCRIPTION: Paneled. Dark brown glaze on cream ground.

C21*

Plates

1862–1900
Willoughby Smith (1839–1905), Womelsdorf, Berks County, Pennsylvania
Lead-glazed earthenware; B.63.95: 1⅝ x 7⅞″ (diam.) (4.1 x 20 cm); B.63.96: 1⅝ x 7¾″ (diam.) (4.1 x 19.7 cm)
B.63.95–.96

PROVENANCE: Purchased by Miss Hogg from Lamb's Mill Antiques, Kutztown, Pennsylvania, 1963.

MARKS: W SMITH / WOMELSDORF (impressed on underside; Ramsay 1939, p. 280, or Lehner 1988, p. 430).

DESCRIPTION: Reddish-brown. Four black S-shaped figures, each with two yellow dashes, on red glaze in interior. Exterior unglazed. Rim has black edge. Red unglazed ware apparent on back and in chips.

RELATED EXAMPLES: One formerly in the George H. Lorimer Collection, now in the Henry Ford Museum, Dearborn, Michigan (*Antiques* 73 [February 1958], p. 164); Lasansky 1990, pp. 328–29, pl. IV.

C22*

Plates

ca. 1882–89
Griffin, Smith, and Hill (1879–82) or Griffin Smith and Company (1882–89), Phoenixville, Pennsylvania
Majolica ware; B.71.27.1: 1⅞ x 12⅛ x 9¼″ (4.8 x 30.8 x 23.5 cm); B.71.27.2: 2⅛ x 12⅛ x 9¼″ (5.4 x 30.8 x 23.5 cm)
B.71.27.1–.2

PROVENANCE: See cat. no. C10.

MARKS: ETRUSCAN MAJOLICA (elaborate, circular stamp on the back of each), around the overlapping letters G S and H (see James 1978, p. 117).

DESCRIPTION: Leaf-shaped green plates with pink rim. Overlapping inner leaf is edged in yellow. Handle is brown stem with two yellow tassel-type flowers. Covered with clear lead glaze.

RELATED EXAMPLES: Illustrated in the 1884 Griffin Smith Catalogue of Majolica, see James 1978, p. 134, no. C12.

C23*

Bowl

mid-19th century
Possibly Pennsylvania
Slip covered earthenware; 1¾ x 10⅞″ (diam.) (4.4 x 27.6 cm)
B.72.93

PROVENANCE: Unknown.

DESCRIPTION: Red clay body decorated with yellow slip. Sgraffito star decoration with

brown slip added. Vine incised into serrated edge of rim.

RELATED EXAMPLES: Similar decoration on a Pennsylvania dish (Spargo 1926, pl. 14).

C24★

Dish

19th century
Possibly Bennington, Vermont
Rockingham-glazed earthenware; 2⅝ x 9⅝"
(diam.) (6.7 x 24.4 cm)
B.63.81

PROVENANCE: Unknown.

TECHNICAL NOTES: Glaze bubbles. Large unglazed area on outside rim.

DESCRIPTION: Deep dish. Rare base decor of eight raised hearts.

C25★

Pie Plate

1849–58
Lyman, Fenton & Co. or United States Pottery Co. (1849–58), Bennington, Vermont
Flint enamel-glazed earthenware; 1⅛ x 7⅞"
(diam.) (2.9 x 20 cm)
B.57.54

PROVENANCE: See cat. no. C1.

MARKS: Lyman Fenton & Co. / Fenton's / ENAMEL / PATENTED / 1849. / BENNINGTON, Vt. (impressed on underside; Barret 1958, p. 14, fig. IXa).

DESCRIPTION: Circular plate with sloping rim and flat bottom. Brown mottled glaze covers entire surface.

C26★

Pie Plate

1849–58
Lyman, Fenton & Co. or United States Pottery Co. (1849–58), Bennington, Vermont
Flint enamel-glazed earthenware; 1⅛ x 8"
(diam.) (2.9 x 20.3 cm)
B.57.55

PROVENANCE: See cat. no. C1.

MARKS: Lyman Fenton & Co. / Fenton's / ENAMEL / PATENTED / 1849. / BENNINGTON, Vt. (impressed on underside; Barret 1958, p. 14, fig. IXa).

DESCRIPTION: Circular plate with sloping sides and flat bottom. Deep well, rolled rim. Brown mottled glaze over entire surface.

C27★

Pie Plate

1849–58
Lyman, Fenton & Co. or United States Pottery Co. (1849–58), Bennington, Vermont
Flint enamel-glazed earthenware; 1½ x 9⅞"
(diam.) (3.8 x 25.1 cm)
B.57.56

PROVENANCE: See cat. no. C1.

MARKS: Lyman Fenton & Co. / Fenton's / ENAMEL / PATENTED / 1849. / BENNINGTON, Vt. (impressed on underside; Barret 1958, p. 14, fig. IXa).

DESCRIPTION: Rich mottled brown glaze.

C28★

Pie Plate

1849–58
Lyman, Fenton & Co. or United States Pottery Co. (1849–58), Bennington, Vermont
Earthenware; 1½ x 10" (diam.) (3.8 x 25.4 cm)
B.57.57

PROVENANCE: See cat. no. C1.

MARKS: Lyman Fenton & Co. / Fenton's / ENAMEL / PATENTED / 1849. / T / BENNINGTON, Vt. (impressed on underside; Barret 1958, p. 14, fig. IXa).

DESCRIPTION: Sloping rim. Mottled brown glaze.

C29★

Pie Plate

1852
Pennsylvania
Lead-glazed slip covered earthenware; 1¾ x 9⅜"
(diam.) (4.4 x 23.8 cm)
B.72.89

PROVENANCE: Parke E. Edwards and Mable M. Edwards; purchased by Sydney Jolles for Miss Hogg, 1969.

DESCRIPTION: Sgraffito decoration of two birds perched on tulip tree and tulip band on brown/green background. Crimped rim. Dark yellowish slip on face. Clear lead over-glaze.

REFERENCES: *Americana Antique Sale: The Renowned Collection of Parke E. Edwards and Mable M. Edwards*, Pennypacker Auction Center, Reading, Pennsylvania, vol. 13, no. 3, April 28, 1969, lot 274.

C30★

Pie Plate

1852
Pennsylvania
Lead-glazed slip covered earthenware; 1¼ x 6¾"
(diam.) (3.2 x 17.1 cm)
B.72.90

PROVENANCE: See cat. no. C29.

MARKS: 2 (impressed on underside).

DESCRIPTION: Earthenware with slightly crimped edge. Stylized floral tree with six branches, and "1852" and initials "H C" in yellow slip. Clear lead overglaze. Underside is unglazed.

REFERENCES: *Americana Antique Sale: The Renowned Collection of Parke E. Edwards and Mable M. Edwards*, Pennypacker Auction Center, Reading, Pennsylvania, vol. 13, no. 3, April 28, 1969, lot 290.

C31★

Pie Plate

mid-19th century
Pennsylvania
Lead-glazed slip covered earthenware; 1¾ x 10¾"
(diam.) (4.4 x 27.3 cm)
B.72.91

PROVENANCE: Unknown.

DESCRIPTION: Earthenware plate with serrated edge. Yellow slip decoration of wavy lines. Lead glaze.

RELATED EXAMPLES: Ramsay 1939, opp. p. 33, no. 23; Chew 1959, pl. 182.

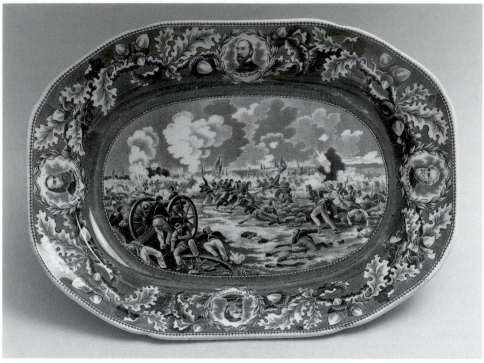

C32

C32

Platter

1890–1900
Edwin Bennett Pottery Co. (1890–1936),
Baltimore
Lead-glazed earthenware; 13¹/₁₆ x 9¹¹/₁₆ x 1³/₈″
(33.2 x 24.6 x 3.5 cm)
B.58.176

The nineteenth-century tradition of commemorating American historical scenes on blue transfer-printed china had a long history by the time of the Civil War. While almost all this transfer-printed ware was made in England for the American market, the Bayou Bend example was made in the United States. The scene depicted here represents the valiant but ultimately unsuccessful charge of July 3, 1863, led by Confederate General George E. Pickett. The repulse at Gettysburg by Union forces marked the turning point of the war. Four roundels set within the unusual oak leaf and acorn border contain portraits of the leading generals at Gettysburg: Robert E. Lee and James Longstreet for the Confederacy; Winfield Scott Hancock and George G. Meade for the Union. The Bennett factory is known to have produced transfer-printed wares. The recent discovery of the original engraved plates for the borders and central

scene confirms the long-standing attribution of this platter to the Bennett company.[1]

PROVENANCE: Purchased by Miss Hogg from Louis Lyons, New York, 1958.

INSCRIBED: Eagle on back with shield, banner reading "E Pluribus Unum," underneath "Pickett's Charge, Gettysburg," each in underglaze blue.

TECHNICAL NOTES: Some crazing.

DESCRIPTION: Blue transfer-print platter. Rectangular with chamfered corners. Center scene of battle. Portrait medallion on each side. Transfer-printed spread-wing eagle with shield on breast and banner.

RELATED EXAMPLES: Barber 1901, p. 181; Laidacker 1954, p. 5; Ketchum 1971, p. 134 and pl. 142d; Henry Ford Museum, Dearborn, Michigan (Bishop and Coblentz 1982, p. 193, fig. 220); Ramsay 1939, pl. 86; McKearin 1931, p. 20, no. 169; *Antiques and The Arts Weekly*, May 31, 1991, p. 78 (for one sold at auction). The placement of the portrait roundels seems to vary from example to example.

1. Edwin Atlee Barber (Barber 1901) discusses the resurgence of transfer printing at the time of the Centennial and also mentions products commemorating the Spanish American War. He discusses "recent efforts" to reproduce old English dark blue transfer wares and specifically cites and illustrates a platter with a view of "Pickett's Charge, Gettysburg" (pp. 180–81) but does not identify it as by Bennett. The checklist

of the 1955 exhibit "The Potter's Craft in Maryland . . ." compiled by Eugenia Calvert Holland for the Maryland Historical Society (see Holland 1955), includes as item number 47, "Whiteware platter, blue underglaze print. Hi. 13″, L. 9½." Pickett's charge at Gettysburg, made by Henry Brunt of Bennett Pottery. . . . " Two copper plates, inscribed S. Doncaster on the reverse, were discovered in Baltimore in the early 1990s among the possessions of George Bauer whose father had been a Bennett employee (letter, March 11, 1992, Robert B. Wright, Rehoboth Beach, Delaware, to The Stradlings, New York). I am indebted to Diana Stradling for bringing this to my attention.

C33★

Loaf Dish

1820–50
Pennsylvania
Lead-glazed slip covered earthenware; 3 x 13¾ x 10⅛″ (7.6 x 34.9 x 25.7 cm)
B.74.24

PROVENANCE: Purchased by Miss Hogg from Kinnaman and Ramaekers Antiques, Houston, 1974.

TECHNICAL NOTES: Back has black sides and bottom from use in fire or oven.

DESCRIPTION: Deep rectangular bowl with slip decoration in ropelike decor across length of bowl. Stylized leaves in each corner; smaller stylized leaves on two sides.

RELATED EXAMPLES: Similar decoration on Pennsylvania redware pie plate in Ramsay 1939, pl. 23. See also Chew 1959, pl. 182.

C34★

Cake Mold

1847–67
Probably Bennington, Vermont
Rockingham-glazed earthenware; 3½ x 8⅞″ (diam.) (8.9 x 22.5 cm)
B.57.29

PROVENANCE: See cat. no. C12.

MARKS: s (impressed on underside).

DESCRIPTION: Circular form with fifteen internal concave sections. Domed center with ¼-inch indent. Brown and yellow spotted glaze on buff background.

RELATED EXAMPLES: Barret 1958, p. 105, pl. 145.

C35★
Fish Mold

early 19th century
Pennsylvania
Lead-glazed slip covered earthenware; 3¼ x
18¹¹⁄₁₆ x 8⅜" (8.3 x 47.5 x 21.3 cm)
B.57.40

PROVENANCE: See cat. no. C12.

DESCRIPTION: Slip decorated, boldly modeled, and supported by two molded attached brackets in pottery. Interior covered with brilliant saffron yellow glaze.

C36★
Fish Mold

ca. 1850–1900
Probably Berks County, Pennsylvania
Lead-glazed slip covered earthenware; 3 x 13¼ x
6⅞" (7.6 x 33.7 x 17.5 cm)
B.63.91

PROVENANCE: See cat. no. C21.

DESCRIPTION: Mold in shape of a fish with light brown slip glaze. Four feet pressed with thumbs.

RELATED EXAMPLES: Lasansky 1990, pp. 334–35; Christie's, New York, sale 8116, June 3, 1995, lot 12.

C37★
Fish Mold

1870–90
Willoughby Smith (1839–1905), Berks County,
Pennsylvania
Lead-glazed earthenware; 1⅞ x 11⅞ x 4" (4.8 x
30.2 x 10.2 cm)
Gift of Pamela Diehl, B.95.17

PROVENANCE: Purchased by the donor from Jane McClafferty, New Canaan, Connecticut, 1995.

DESCRIPTION: Fish-shaped earthenware mold with curved body. Brown glaze with sponged and streaked finish.

RELATED EXAMPLES: Lasansky 1990, pp. 334–35; Christie's, New York, sale 8116, June 3, 1995, lot 12.

C38
Flask

ca. 1850–60s
Midwestern United States, possibly Ohio
Rockingham-glazed earthenware; 7⅛ x 4½ x
2¼" (18.1 x 11.4 x 5.7 cm)
B.57.26

The distinctive ornament on this earthenware flask, with an eagle on one side and a morning glory on the other, together with the fluting at the neck, has been bor-

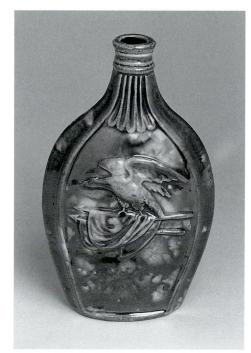

C38 (*front*)

C38 (*back*)

rowed exactly from glass flasks thought to have been produced in the Midwest. It would seem likely that the present flask also originated there.

PROVENANCE: See cat. no. C12.

DESCRIPTION: All surfaces are glazed. Neck composed of upper and lower rings with concave wider ring between. Gadrooning in five sections at top of panel and base of neck on both sides. Bright, mottled, tortoiseshell appearance to glaze. Shown on front in ovoid panel is American eagle, facing left, standing on two furled flags; on back in ovoid panel is morning glory and vine with five leaves and one bud. Pint sized.

RELATED EXAMPLES: Ramsay 1939, pl. 63; McKearin and Wilson 1978, p. 562, GII-19 (identical in design to glass flask).

C39★
Storage Jar

ca. 1870–1905
Possibly Athens or Canton, Texas
Albany slip-glazed earthenware¹; 8 x 7¼"
(diam.) (20.3 x 18.4 cm)
Gift of Mrs. Paul Arnold, B.86.10

PROVENANCE: Mrs. Paul Arnold.

DESCRIPTION: Straight-sided cylindrical shape jar with dark brown glaze. Top of rim is unglazed.

1. Albany slip is a lustrous brown slip formed from mixing water with a brown clay mined near Albany, New York, as well as in other parts of the United States.

C40★
Pair of Crocks

1882–95
Samuel Bell and Son (act. ca. 1882–1908),
Strasburg, Virginia
Lead-glazed slip covered earthenware; B.72.94:
6½ x 5½" (diam.) (16.5 x 14 cm); B.72.95: 6⅜ x
5⅜" (diam.) (16.2 x 13.7 cm)
B.72.94–.95

PROVENANCE: See cat. no. C11.

MARKS: S. BELL & SON / STRASBURG (impressed on body; Comstock 1994, p. 240, fig. 5.116).

DESCRIPTION: Cream slip mottled with copper and manganese. Hand turned on a wheel.

Sloping, rounded, unglazed rim, possibly used to attach a cloth cover. Interior is unglazed.

RELATED EXAMPLES: Wiltshire 1975, p. 85, pl. 38.

C41*

Candlesticks

1849–58
Modeled by Christopher Webber Fenton
(1806–1865) and Alanson Potter Lyman (n.d.)
United States Pottery Co. (1849–58), Bennington,
Vermont
Flint enamel-glazed earthenware; B.57.14.1: 9¾ x
4¾" (diam.) (24.8 x 12.1 cm); B.57.14.2: (9⅝ x
4¾") (diam.) (24.4 x 12.1 cm)
B.57.14.1–.2

PROVENANCE: Dr. Pleasant Hunter; George S. McKearin; purchased by Miss Hogg from Whimsy Antiques, Arlington, Vermont, 1957.

DESCRIPTION: Round rolled tops with graduated rolls beneath. Round base up to large rolled extension.

RELATED EXAMPLES: Barret 1958, p. 135, pl. 198.

C42*

Candlestick

mid-19th century
Bennington, Vermont
Rockingham-glazed earthenware; 8¼ x 4³⁄₁₆"
(diam.) (21 x 10.6 cm)
B.57.37.1

PROVENANCE: See cat. no. C12.

DESCRIPTION: Dark brown glaze on cream body. Molded column candlestick with extended circles at top and around bottom.

RELATED EXAMPLES: Barret 1958, p. 134, pl. 196, figs. a, b.

C43

Flowerpot

1829–54
Attributed to the pottery of Enos Smedley
(1805–1892), Downingtown or West Chester,
Chester County, Pennsylvania[1]
Lead-glazed slip covered earthenware; 8¾ x 8⅝"
(diam.) (22.2 x 21.9 cm)
B.60.44

C43

Early in the nineteenth century, the potters of Chester County, Pennsylvania, developed a distinctive fancy flowerpot form. Commonly made of red clay with slip glazes, the pots are distinguished by the use of hand-crimped ruffles at the upper edge of the pot and on the saucer, as seen here, and occasionally multiple rows of ruffles on the body. As these pieces were usually inscribed with the owner's name, place of residence, and often a date, it is likely that they were intended as presentation pieces. However, since none of the dates have been linked to a recorded event in the life of the owners, they probably indicate the date of manufacture.[2] The makers, often Quakers of English or Irish descent, followed the traditions of English potters, embellishing their works with simple naturalistic motifs and English flowing script. While many of the owners were Quakers, Ann Hogg, the original owner of the present pot, was a Methodist, which may account for the omission of a date on her pot. This English-style pottery contrasts with that of the nearby Germans who used stylized ornament and Germanic script. An 1834 bill of Enos Smedley lists a variety of forms including five different flowerpots ranging in size from four to twelve inches. He notes that he also has on hand a general assortment of fancy

flowerpots, undoubtedly this type.[3] However, it is clear that this personalized pot would have been a commissioned piece.

PROVENANCE: Ann Bouldin Hogg (1803–1881), New Castle County, Delaware[4]; offered to Miss Ima Hogg by Schuylkill House, Phoenixville, Pennsylvania, 1953 (then described as from Strasburg, Virginia); purchased by Miss Hogg from Richard H. and Virginia A. Wood, Baltimore, 1960.

INSCRIBED: Ann B. Hogg Elkton (sgrafitto, on body of pot).

TECHNICAL NOTES: The saucer has been broken and repaired in a small section of the rim. Differences in the style of the beaded ornament and coloration of the glazes between the saucer and the pot suggest that the saucer may not have always been with the pot. In 1953 the pot was offered for sale with a saucer.

DESCRIPTION: Red body with a clear lead glaze over a cream colored coating of slip with streaks of brown. Bulbous shape with scalloped top. Single ruffle above and below. Ropelike banding. Bottom hole for drainage.

RELATED EXAMPLES: All of globular-footed form originally with separate saucer: one inscribed "Ann K. Palmer, Concord, 4 month 3rd 1826" and on the bottom of the saucer "Enos Smedley Westtown" (James 1978, p. 159); one inscribed "Elizabeth Canby Brandywine" and using the Quaker system of dating "11th mo. 21st 1825" at Abby Aldrich Rockefeller Folk Center, Williamsburg, Virginia (acc. no.

83.900.1), attributed to Smedley or to one of the James potters (Griffith 1985, p. 10); one inscribed "Tacy Lewis, Newtown Township Delaware County 10th Mo 5th 1824" in MMA (Griffith 1985, p. 8). Another straight-sided saucerless pot with related beaded ornament attributed to Smedley is located at Chester County Historical Society, West Chester, Pennsylvania (acc. no. 1990.16.1). Although it has been suggested that the Bayou Bend example might be the product of the John Vickers factory at Lionville, his documented examples of the 1830s all feature sgrafitto floral spray decoration.

1. Smedley was active in Westtown from 1820–23; in Downington from 1829–30; and in West Chester from 1831–54.
2. Griffith 1985, p. 7. Some of the inscriptions show the Quaker system of dating, which used simple numbers rather than pagan month and day names.
3. James 1978, pp. 160–61.
4. Ann married John Robinson Hogg (1805–?) in 1829. According to family history, the Hoggs lived with Ann's mother in Glascow, Delaware, until they built their own house in nearby Elkton, Maryland, in the early 1840s. If this is correct, the pot cannot have been made until that time; at any rate it cannot date earlier than the Hoggs' marriage in 1829.

C44*

Flowerpots

1850–60
United States
Lead-glazed earthenware; B.57.33.1: 9⅞ x 8¹/₁₆"
(diam.) (25.1 x 20.5 cm); B.57.33.2: 10 x 8¼"
(diam.) (25.4 x 21 cm)
B.57.33.1–.2

PROVENANCE: George S. McKearin; purchased by Miss Hogg from George Abraham and Gilbert May Antiques, West Granville, Massachusetts, 1957.

TECHNICAL NOTES: The glazing and quality of workmanship on each piece are quite different, and they do not seem to be a pair.

DESCRIPTION: **B.57.33.1**, flat rim overlapping urn shape with rolled indentations on bottom onto a round pedestal base. Covered with glaze bubbles. The base appears to have been cemented on separately; **B.57.33.2**, same shape as other pot, but is in two pieces and does not have glaze bubbles on the base. Interior drainage hole is much larger than that in B.57.33.1.

RELATED EXAMPLES: See Barret 1958, pls. 188–90, for urns of similar shape.

C45*

Jardiniere

1850–60
United States
Rockingham-glazed earthenware; 10¾ x 8⅜"
(diam.) (27.3 x 21.3 cm)
B.64.1

PROVENANCE: Purchased by Miss Hogg from Dorothy Dawes Chillman, Houston, 1964.

DESCRIPTION: Large leaf decoration vertical on sides. Flared rim.

RELATED EXAMPLES: Barret 1958, p. 130, pl. 188a.

C46

Celery Vase

ca. 1849–58
Attributed to United States Pottery Co.
(1849–58), Bennington, Vermont
Flint enamel-glazed earthenware; 10 x 5⅛ x 5¼"
(25.4 x 13 x 13.3 cm)
B.62.27

C46

C47

Celery Vase

1849–58
Attributed to United States Pottery Co.
(1849–58), Bennington, Vermont
Flint enamel-glazed earthenware; 10⅛ x 5¼ x 5¼"
(25.7 x 13.3 x 13.3 cm)
B.57.15

PROVENANCE: Purchased by Miss Hogg from Whimsy Antiques, Arlington, Vermont, 1962.

MARKS: D (incised, underside of base, struck over once)

DESCRIPTION: Mottled brown-yellow cream glaze on exterior of vase, interior light to dark brown with some white. Brown-white cream base consists of eight panels. Bowl of vase has eight panels, each with a petal-shaped scallop at top.

RELATED EXAMPLES: Barret 1958, p. 146, pl. 213; Spargo 1969, pl. XXV. For pressed glass examples, see Palmer 1993, p. 276, no. 250; Spillman 1981, p. 219, no. 843f.

C47

PROVENANCE: See cat. no. C5.

TECHNICAL NOTES: Slightly misshapen base.

DESCRIPTION: Mottled brown-yellow glaze on exterior of vase, light brown glaze on interior. Base consists of eight panels. Bowl of vase has eight panels, each with a petal-shaped scallop at top.

RELATED EXAMPLES: Barret 1958, p. 146, pl. 213; Spargo 1969, pl. XXV. For pressed glass examples, see Palmer 1993, p. 276, no. 250; Spillman 1981, p. 219, no. 843f.

These two pieces represent brown-glazed pottery models of the celery vase form (commonly called tulip vases) that became very popular at mid-century. The faceted body and scalloped top echo closely pressed glass models, which in turn emulate cut glass examples (see cat. no. G115).

C48*

Pair of Deer Flower Holders

1849–58
Lyman, Fenton & Co. or United States Pottery Co. (1849–58), Bennington, Vermont
Flint enamel-glazed earthenware; B.48.1.1: 8⅞ x 11⅝ x 6" (22.5 x 29.5 x 15.2 cm); B.48.1.2: 10¾ x 11½ x 6⅞" (27.3 x 29.2 x 17.5 cm)
B.48.1.1–.2

PROVENANCE: Purchased by Miss Hogg from Ginsburg and Levy, New York, 1948.

MARKS: Lyman Fenton & Co., / FENTON'S / ENAMEL / PATENTED / 1849 / BENNINGTON, Vt. (impressed on underside; Barret 1958, p. 14, fig. IXa).

TECHNICAL NOTES: **B.48.1.1**, both ears broken and repaired. Chip and crack near front left leg; **B.48.1.2**, neck broken and poorly repaired.

DESCRIPTION: Large buck lying down against hollow tree stump on roughly rectangular base. Doe in similar pose. Both pieces are covered with greenish-brown glaze and have a firing hole in bottom.

RELATED EXAMPLES: Barret 1958, p. 283, pl. 365 and p. 284, pl. 366; Spargo 1924, p. 233.

C49

C49

Washbasin and Pitcher

1849–58
Lyman, Fenton & Co. or United States Pottery Co. (1849–58), Bennington, Vermont
Flint enamel-glazed earthenware; B.57.31 (washbasin): 4⅞ x 14⅞" (diam.) (12.4 x 37.8 cm); B.57.32 (pitcher): 12⅛ x 7⅛ x 8¾" (30.8 x 18.1 x 22.2 cm)
B.57.31–.32

By the mid-nineteenth century, the washbasin and pitcher were essential hygiene items and virtually every American household contained at least one set. These sets were among the most popular forms produced at the Fenton pottery. Indeed, a basin and pitcher were two of the items chosen by the firm for the 1853 Crystal Palace Exhibition.[1] A variety of patterns and glazes were offered; the broad surfaces of these large pieces provided an excellent opportunity for the display of the multicolored Rockingham glazes.

PROVENANCE: See cat. no. C12.

MARKS: Lyman Fenton & Co. / Fenton's / ENAMEL / PATENTED / 1849. / BENNINGTON, Vt. (impressed on underside of both vessels; Barret 1958, p. 14, fig. IXa).

DESCRIPTION: Twelve-sided washbasin with rich brown and olive-green glaze on cream. Large pitcher with brown and dark green glaze on cream. Scalloped rib pattern; strap handle.

RELATED EXAMPLES: Barret 1958, following p. 108, color plate B, and p. 118, pl. 167; Perry 1989, p. 49, no. 45.

1. Barret 1958, p. 15, fig. XI, and p. 102.

C50

Washbasin

1770–90
Attributed to the Daniel Bayley Pottery (act. 1764–99), Newburyport, Massachusetts
Lead-glazed slip covered earthenware; 2⅞ x 14⅛" (diam.) (7.3 x 35.9 cm)
B.57.21

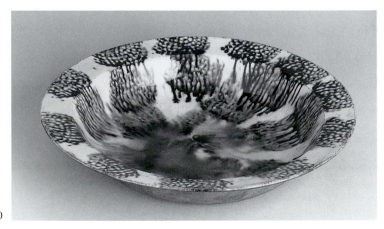

C50

Shards of a very similar basin were found at the site of the Bayley pottery, suggesting that this large basin, with its distinctive light slip and dark brown sponged decoration, was made there.[1]

PROVENANCE: See cat. no. C12.

DESCRIPTION: Interior is coated with a yellow slip, sponged with dark brown under a clear glaze. Exterior of basin is unglazed.

RELATED EXAMPLES: Watkins 1968, pl. 29.

1. Watkins 1968, pp. 57–58, and pl. 20.

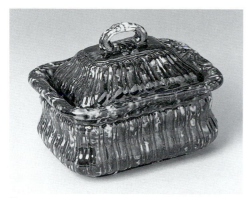

C51

C51

Soap Box

1849–58
Lyman, Fenton & Co. or United States Pottery Co. (1849–58), Bennington, Vermont
Flint enamel-glazed earthenware; 4⅛ x 5½ x 4¼" (10.5 x 14 x 10.8 cm)
B.57.52

Today this item would be called a soap dish, but that name does not appear in the Fenton pottery price list of 1852. Instead there is a listing for "Soap Boxes," which cost $4.00 per dozen.[1]

PROVENANCE: See cat. no. C5.

MARKS: Lyman Fenton & Co. / Fenton's / ENAMEL / PATENTED / 1849. / BENNINGTON, Vt. (impressed on underside; Barret 1958, p. 14, fig. IXa).

TECHNICAL NOTES: Lid has chip.

DESCRIPTION: Alternating rib pattern. Rectangular bombé shape with narrow foot rim and flared top rim. The top rim consists of a molded decoration of flowers and vines with leaves. The slightly bombé lid tapers upward

to a flat surface with a branch-shaped handle and terminals of leaves and flowers.

RELATED EXAMPLES: Barret 1958, p. 117, pl. 165c.

1. Barret 1958, p. 10.

C52

Shaving Mug

1850–55
Modeled by Charles Coxon (1805–1868)
E. & W. Bennett (1848–56), Baltimore
Rockingham-glazed earthenware; 4⅜ x 4⅜ x 5¼" (11.1 x 11.1 x 13.3 cm)
B.57.24

With the increasing use of the pitcher and basin for personal hygiene within the American home in the early nineteenth century (see cat. no. C49), the need lessened for the large barber's basin, designed to hold water and to catch the soap and whiskers removed when shaving. About 1830 the shaving mug—a new, smaller, more

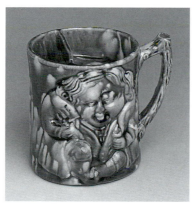

C52

easily handled form—was introduced. The straight-sided beverage mug was adapted, and a compartment was added to hold the shaving soap, occasionally on the outside or more commonly inside the lip (as seen on the present example). The Bennett design, with the relief ornament on each side, evokes the Toby form.

PROVENANCE: See cat. no. C12.

MARKS: E. & W. BENNETT / CANTON AVENUE / BALTIMORE MD. (inscribed on underside; Barber 1976a, p. 143).

DESCRIPTION: Mug is molded in two sections. Seated Toby figure on front and on back. Applied handle is log shaped. Glaze is light to dark brown with cream color visible.

RELATED EXAMPLES: Barret 1958, p. 97, pl. 134; Goldberg 1994, pp. 37, 60, figs. 8, 21, the latter illustrates a New Jersey example also modeled by Coxon.

C53

Footbath

ca. 1849–58
Attributed to United States Pottery Co. (1849–58), Bennington, Vermont
Flint-glazed earthenware; 8½ x 19¾ x 14¾" (21.6 x 50.2 x 37.5 cm)
B.57.34

Among the items that appear on an 1852 Fenton pottery price list is the footbath, costing a hefty $26.00 for the first dozen.[1] While this example is not marked, it was probably made by the Fenton firm and is the same footbath that appears on the price list.

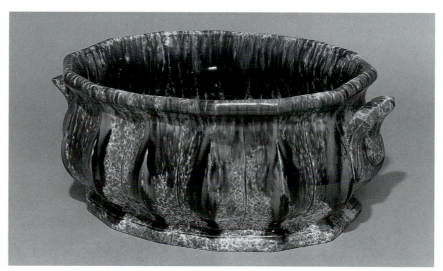

C53

PROVENANCE: See cat. no. C12.

DESCRIPTION: Scalloped rib pattern. Two handles, molded hollow lug type. Foot rim follows rib pattern. Glaze of brown, olive green, dark blue, and orange on cream.

RELATED EXAMPLES: Art Institute of Chicago (*Antiques* 104 [October 1973], p. 558); Barret 1958, p. 126, pl. 180; Ketchum 1983, no. 274.

1. The footbath was one of the most expensive items offered by the dozen. Barret 1958, p. 10.

C54

Footwarmer

ca. 1847–58
Bennington, Vermont
Rockingham-glazed earthenware; 11⅛ x 9⅞ x 7″
(28.3 x 25.1 x 17.8 cm)
B.57.39

In an era when the American household was heated by either fireplace or stove, the bed was often a cold and clammy place. Bed warmers and other similar devices were used to comfort the sleeper. This example is particularly ingenious. Its bottlelike form could be filled with hot liquid or hot sand and placed upright under the covers; the molded "footprint" surface provided a perfect resting place for the sleeper's feet.

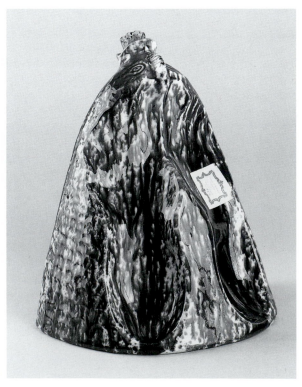

C54

PROVENANCE: See cat. no. C12.

DESCRIPTION: Tall bottle with cork stopper. Impression of two feet on front. Owl-like face at top. Back flat, front base rounded. Sides have rows of scallops or feathers molded on them. Glaze mottled brown and green on buff colored body.

RELATED EXAMPLES: Barret 1958, p. 127, pl. 183; Ketchum 1983, no. 275; Guilland 1971, p. 277.

C55

Harvest Jug

1850–80
Probably United States
Lead, copper, and manganese-glazed earthenware; 8⅛ x 7¹¹⁄₁₆ x 1⅝″ (20.6 x 17.9 x 4.1 cm)
B.62.33

This type of ring-shaped jug first appeared in Italy in the sixteenth century. It is believed that the container was carried on the arm of the harvester working in the fields. The form must have been rare in nineteenth-century America because it does not appear on any of the pottery price lists.

PROVENANCE: Purchased by Miss Hogg from The Earl Osborns Antiques, Easthampton, Massachusetts, 1962.

C55

DESCRIPTION: Cylindrical, donut-shaped flask with cylindrical spout at right angles at top. Molded with raised acanthus leaf design on front and back. Mottled green, yellow, and brown glaze.

RELATED EXAMPLES: Ketchum 1983, no. 284; an identically molded Rockingham-glazed example with heavily repaired neck is in the teaching collection at Bayou Bend (TC 25).

C56

Toby Barrel Flask or Bottle

ca. 1840–50
United States
Rockingham-glazed earthenware; 9⅛ x 4⅛ x 3″ (23.2 x 10.5 x 7.6 cm)
B.57.30

PROVENANCE: See cat. no. C12.

DESCRIPTION: Figure of a man wearing top hat astride a barrel, which is marked with an embossed "2." "Jem Crow" written in relief at base of bottle. The entire piece, including interior and bottom, is covered with a brown glaze that appears to have been dipped; some areas are darker than others. Capacity is approximately 1.2 pints (550 ml).

RELATED EXAMPLES: A closely related, probably American, example with similar flared base impressed "J Smith . . . Mormon Prophet," apparently dated 1831 (Wearin 1965, pp. 45, 56).

C57

Toby Barrel Flask or Bottle

1849–58
Lyman, Fenton & Co. or United States Pottery Co. (1849–58), Bennington, Vermont
Flint-glazed enamel earthenware; 10¾ x 4¼ x 4″ (27.3 x 10.8 x 10.2 cm)
B.57.17

This bar bottle with the figure astride a cask provides an interesting variant on the classic Toby (see also cat. no. C56). The form has an English prototype dating from the 1830s. The character is dressed in sailor's clothes of the second quarter of the nineteenth century. The significance of the "Jem Crow" inscription on cat. no. C56 is not entirely clear.[1] Two Bennington pottery bottles are inscribed "Old Tom" and "Bill," suggesting that they may have been named after characters familiar to the bartender and his clientele, or possibly nicknames for gin and whiskey. However, the mold of the "Jem Crow" bottle, with its flaring base, differs from English examples. The detail of molding is also sufficiently different from that of the inscribed Bennington bottles and other plain examples, suggesting it was made in another American factory.

1. By the mid-nineteenth century Jim Crow had become a generic term for Negro. It derives from a minstrel show of the same name, introduced by Thomas Dartmouth Rice about 1828, in which Rice was dressed as a sailor. English flasks depicting him date from the 1830s (Johnson 1966a, p. 430; letter from Ivor Noël Hume, January 18, 1996).

PROVENANCE: See cat. no. C5.

MARKS: Lyman Fenton & Co. / Fenton's / ENAMEL / PATENTED / 1849. / BENNINGTON, Vt. (impressed on underside; Barret 1958, p. 14, fig. IXa).

TECHNICAL NOTES: Stopper missing.

DESCRIPTION: Whiskey container in shape of a man holding a bottle and glass, astride a barrel. Olive-brown Rockingham glaze.

RELATED EXAMPLES: Three identically marked Bennington examples, of varying sizes, are inscribed "GG," "Old Tom," and "Bill" (Barret 1958, p. 323, pl. 422); for English examples of Man on a Barrel, including one inscribed "Old Tom" and marked by Oldfield and Company, see Ashley 1982, p. 65.

C58*

Toby Match Safe

1849–58
Lyman, Fenton & Co. or United States Pottery Co. (1849–58), Bennington, Vermont
Flint enamel-glazed earthenware; 4¼ x 4 x 4⅜"
(10.8 x 10.2 x 11.1 cm)
B.57.16

PROVENANCE: See cat. no. C5.

MARKS: 5; Lyman Fenton & Co. / Fenton's / ENAMEL / PATENTED / 1849. / BENNINGTON, Vt.

(impressed on underside; Barret 1958, p. 14, fig. IXa).

TECHNICAL NOTES: The hat may not be original because of the difference in its color.

DESCRIPTION: Small seated figure with pitcher in right hand, glass in left. Broad brimmed hat forming lid; brown-yellow glaze. Hat very dark, underside of hat is yellow.

RELATED EXAMPLES: Barret 1958, p. 320, pl. 417; design like Spargo 1969, pl. XI, bottom row, no. 3; Ramsay 1939, pl. 36; a pale gray glazed example at MMA (acc. no. 1984.395.10).

C59

Coachman Bottle

1852–58
Possibly modeled by Daniel Greatbach[1]
United States Pottery Co. (1849–58), Bennington, Vermont
Flint-glazed enamel earthenware; 11 x 4½ x 4½"
(27.9 x 11.4 x 11.4 cm)
B.57.18

Among the novelty wares introduced by the English modeler Daniel Greatbach and produced at the Fenton factory were utilitarian objects that assumed the shape

C56

C57

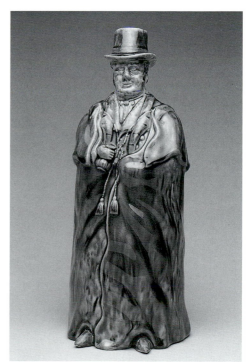

C59

C60

of a human figure. Most common is the Toby, which had a long English history and was made at Bennington in the pitcher and match safe forms (cat. nos. C2, C56–58). Another, made in three sizes and with differing glazes, is a bar bottle depicting a man in a long coachman's cloak and top hat.[2] This form also continues an English tradition of human-shaped bottles produced to hold gin and distributed by local bars to their clients.[3] The cloak provides a useful adaptation of the human body to the requisite bottle shape, and the top hat accommodates the cork. The Bayou Bend bottle, which is the largest of the three sizes, is a variant where the cloak has tassels and the man holds a small bottle.

PROVENANCE: See cat. no. C5.

MARKS: Lyman Fenton & Co. / Fenton's / ENAMEL / PATENTED / 1849. / BENNINGTON, Vt. (impressed on underside; Barret 1958, p. 14, fig. IXa).

TECHNICAL NOTES: Cork still inside. Feet repaired.

DESCRIPTION: Olive-brown, blue-green, and orange glazes.

RELATED EXAMPLES: Levin 1988 p. 30; for examples of the various glazes (Barret 1958, color plate G); for the three sizes and other variants (Barret 1958, pp. 321–23, pls. 419, 420, 421, 423); MMA (acc. no. 14.11.19–.21).

1. See cat. no. C6, n. 1.
2. Watkins 1968, p. 218.
3. "When This You See Remember Me," lecture by Ivor Noël Hume, American Ceramic Circle Meeting, Williamsburg,

Virginia, November 18, 1995. Another variant of that genre is the book bottle form (see cat. no. C60).

C60

Book Flask

1845–47
Norton and Fenton (act. ca. 1844–47),
Bennington, Vermont
Flint enamel-glazed earthenware; 5⅝ x 2¹/₁₆ x 4³/₁₆" (14.3 x 5.2 x 10.6 cm)
B.57.28

This flask represents the smallest of the novelty book-shaped bottles produced at the Fenton pottery. That they were a fairly standard product is evidenced by their appearance on the 1852 price list. The mark (see below), one usually reserved for Parian wares, and only known on a few other pieces of colored glazed ware, indicates that the Bayou Bend flask is a rare and early example.[1]

PROVENANCE: See cat. no. C12.

MARKS: Fenton's Works / Bennington, / Vermont (impressed on underside; see Barret 1958, p. 14, fig. Xe).

DESCRIPTION: Plain book-shaped flask with flint enamel glaze, with mottled yellow and brown tortoiseshell effect. Has twenty-nine pages, spine is divided horizontally into four sections. Small hole on top has raised lip. Capacity is 1 pint.

RELATED EXAMPLES: See Barret 1958, p. 316, pl. 411; Ketchum 1983, no. 283; MMA (acc. no. 40.150.310).

1. Barret 1958, p. 10, fig. III; Barret 1958, p. 14, fig. Xe.

C61*

Shovel Plate

1849–58
Lyman, Fenton & Co. or United States Pottery Co. (1849–58), Bennington, Vermont
Flint-glazed earthenware; 7⁵/₁₆ x 7½ x 1⅜" (18.6 x 19.1 x 3.5 cm)
B.57.47

PROVENANCE: See cat. no. C41.

MARKS: Lyman Fenton & Co.; / Fenton's / ENAMEL / PATENTED / 1849. / BENNINGTON, Vt. (impressed on underside; Barret p. 14, no. 9a, except that Bayou Bend example has a ";" after "Co.").

DESCRIPTION: Light brown, olive, and yellow on cream square tile. Concave moldings and waffled center.

RELATED EXAMPLES: Barret 1958, p. 133, pl. 194a.

C62*

Dog Doorstop

1850–80
Possibly East Liverpool, Ohio
Rockingham-glazed earthenware; 10⅜ x 10⅞ x 8¾" (26.4 x 27.6 x 22.2 cm)
B.70.34

PROVENANCE: Unknown (at Bayou Bend prior to 1933).[1]

DESCRIPTION: Spaniel with floppy ears and long tail seated on high, plain, rectangular base with rounded corners. Brown, mottled glaze over entire surface.

RELATED EXAMPLES: Spargo 1926, pl. 28; one in the collection of John Ramsay made by Knowles, Taylor & Knowles of East Liverpool, Ohio (*Antiques* 49 [January 1946], p. 44); another on the cover *2 Day Antiques Auction: Early American Furniture and Accessories*, Garth's Auctions, Delaware, Ohio, Auctions 11 and 12, April 22–23, 1994, lot 5.

1. Old Hogg inventory number (228a) suggests that it was acquired prior to a 1933 inventory.

C63

Dog Doorstop

ca. 1882–1908
Samuel Bell and Son (act. ca. 1882–1908),
Strasburg, Virginia
Lead-glazed earthenware; 9⅛ x 6⅜ x 4¾″
(23.2 x 16.2 x 12.1 cm)
Gift of Miss Mary Allis, B.63.23

PROVENANCE: Mary Allis, Fairfield,
Connecticut.

MARKS: S. BELL & SON / STRASBURG (impressed
on underside; Lehner 1988, p. 42, no. 8); S B &
SON (incised on underside).

DESCRIPTION: Strongly resembles an English
Staffordshire dog. The ears and tail are deco-
rated in a honeycomb motif. Has chain-type
collar around neck with a leash extending
down the right side. Hanging from his collar
is impressed pear-shaped design. Brownish-
green and orange glazes.

RELATED EXAMPLES: Wiltshire 1975, pp. 30–31,
pl. 5; Rice and Stoudt 1929, p. 242, no. 1586;
Comstock 1994, p. 251.

The lapdog served as the inspiration for
enormous numbers of earthenware
figures produced in the Staffordshire pot-
teries during much of the nineteenth cen-
tury. Unlike their naturalistically colored
English cousins, American spaniels were
traditionally glazed in allover brown
tones. They were made in pairs of various
sizes, with and without bases, and served
multiple purposes, including that of book-
ends and doorstops. Unlike the doorstop
from the Midwest that is molded simply
(see cat. no. C62), the dogs produced by
Bell were often embellished with hand
tooling, as seen around the eyes of the
present example.

C63

STONEWARE

C64

Pitcher

1857–61
Martin Crafts (1807–1885), Whately,
Massachusetts
Salt-glazed stoneware; 11½ x 8½ x 8¼″
(29.2 x 21.6 x 21 cm)
B.72.25

PROVENANCE: Unknown.

MARKS: MARTIN: CRAFTS: / WHATELY / 1½
(impressed under spout).

TECHNICAL NOTES: Shape slumped in kiln.

DESCRIPTION: Bowl-shaped base tapering to
high shoulder. Indentation across front of
pitcher. Incised line between body and shoul-
der. High neck with pinched lip. Beaded edge
at base and top of neck. Applied strap handle.
Concave bottom. Pulled spout. Tan salt glaze,
blue slip floral decoration, brown slip glazed
interior. 1½ gallon capacity.

C65*

Jug

ca. 1842–52
J. B. Caire & Co. (ca. 1842–52), Poughkeepsie,
New York
Salt-glazed stoneware; 12¾ x 10 x 10⅛″
(32.4 x 25.4 x 25.7 cm)
B.72.23

PROVENANCE: Unknown.

MARKS: J. B. CAIRE & CO / POKEEPSIE NY [*sic*]
(impressed on neck; Lehner 1988, p. 70).

DESCRIPTION: Pear shape tapering sharply at
shoulder, incised line at shoulder. Narrow,
high neck with incised line at base. Applied
strap handle. Tan salt glaze. Brushed floral
decoration in cobalt blue glaze.

C66*

Jug

1850–59
J. & E. Norton (act. 1850–59), Bennington, Vermont[1]
Salt-glazed stoneware; 11½ x 7⅛ x 7¼"
(29.2 x 18.1 x 18.4 cm)
B.73.8

PROVENANCE: Unknown.

MARKS: J[.] & E. NORTON, / BENNINGTON VT. (impressed on neck; Lehner 1988, p. 323).

TECHNICAL NOTES: Discolored and stained around mouth and sides.

DESCRIPTION: Small cylindrical jug with rounded shoulders, strap handle off the wide band or collar neck. Small mouth opening. Decorated with bird on a branch in cobalt blue glaze.

RELATED EXAMPLES: For similar shapes, see Greer 1981, p. 76.

1. Julius (1809–1861) and Edward (1815–1885) Norton. In 1859 Julius's son entered the business, and the company operated under the name J. & E. Norton and Co. until 1861.

C67*

Jug

1859–61
J. & E. Norton and Co. (act. 1859–61), Bennington, Vermont
Salt-glazed stoneware; 15⅜ x 10¼ x 10⅜"
(39.1 x 26 x 26.4 cm)
B.72.24

PROVENANCE: Unknown.

MARKS: J. NORTON & CO: / BENNINGTON VT. / 3 (impressed on front below rim; Lehner 1988, p. 323).

DESCRIPTION: Cylindrical shape tapering sharply at shoulder to narrow banded neck. Applied strap handle. Gray salt glaze. Floral decoration on body in cobalt blue glaze. Three gallon capacity.

RELATED EXAMPLES: For similar shapes, see Greer 1981, p. 76.

C68*

Jug

1859–61
J. & E. Norton and Co. (act. 1859–61), Bennington, Vermont

Salt-glazed stoneware; 15½ x 10 x 10" (39.4 x 25.4 x 25.4 cm)
B.72.21

PROVENANCE: Unknown.

MARKS: J. NORTON & CO. / BENNINGTON VT. / 3 (impressed on shoulder; Lehner 1988, p. 323).

DESCRIPTION: Cylindrical shape tapering sharply at shoulder to narrow banded neck. Applied strap handle. Gray salt glaze. Decoration of bird on branch in cobalt blue glaze. Three gallon capacity.

RELATED EXAMPLES: For similar shapes, see Greer 1981, pp. 60, 76.

C69*

Jug

1876–82
N. A. White and Son (1867–90), Utica, New York
Salt-glazed stoneware; 16⅜ x 10⅛ x 10" (41.6 x 25.7 x 25.4 cm)
B.74.25

PROVENANCE: See cat. no. C33.

MARKS: WHITES UTICA, N.[Y.] / 3 (impressed on shoulder; Lehner 1988, p. 520).

DESCRIPTION: Decoration of six abstract leaves in cobalt blue glaze. Brown/tan slip glaze background. Strap handle applied at neck, continuous ridge around neck. Three gallon capacity.

C70

Jug

ca. 1872–92
Ottman Brothers & Co. (act. ca. 1872–92), Fort Edward, New York
Salt-glazed stoneware; 18⅝ x 11⅝ x 11½" (47.3 x 29.5 x 29.2 cm)
B.68.16

Utilitarian salt-glazed storage vessels were routinely decorated with floral or bird ornaments in cobalt blue glaze, but the rendering was usually somewhat rough. However, the decorator of this piece has produced, with rapid and economical strokes, a sophisticated depiction of a plump bird perched on a stump, which lends distinction to an otherwise average jar.

PROVENANCE: Purchased by Miss Hogg from A Horse of a Different Color, San Antonio, 1968.

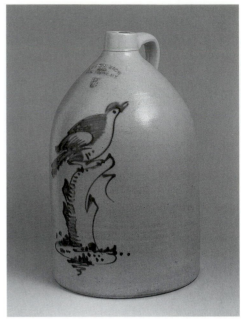

C70

MARKS: OTTMAN BRO'S / & CO. / FORT EDWARD, N. Y. / 5 (impressed on shoulder; Lehner 1988, p. 332).

DESCRIPTION: Cylindrical shape tapering sharply at shoulder to narrow vertical neck with incised band at base. Strap handle. Decoration of bird on tree stump in cobalt blue glaze. Tan salt glaze. Five gallon capacity.

C71

Jar

1806–13
Attributed to Thomas Warne (1763–1813) and Joshua Letts (n.d.), South Amboy, New Jersey[1]
Salt-glazed stoneware; 10⅞ x 9¼ x 9⅛" (27.6 x 23.5 x 23.2 cm)
Gift of Miss Ima Hogg, B.72.19

PROVENANCE: Purchased by Miss Hogg from Richard H. and Virginia A. Wood, Baltimore, 1963.

MARKS: LIBERTY FOR EV / [S A]MBOY N JERSY (impressed on shoulder).

TECHNICAL NOTES: Broken and poorly repaired. Slumped on one side.

DESCRIPTION: Deep bowl shape tapering to incised foot. Concave shoulder with three bands of beading. Slightly flaring neck with cogglewheel decoration. Applied rope, lug-type handles. Beneath mark is incised bat-wing design colored with blue glaze. Covered with tan salt glaze. Blue glaze also applied at handle joints.

RELATED EXAMPLES: Webster 1971, p. 161; Ramsay 1939, pl. 21.

1. Thomas Ware and Joshua Letts were in partnership as Warne and Letts from 1806–13 in South Amboy, New Jersey. See Branin 1988, pp. 70–75.

C72*

Jar

1841
Possibly New York State
Salt-glazed stoneware; 11 x 10⅛ x 9¾" (27.9 x 25.7 x 24.8 cm)
B.72.20

PROVENANCE: Unknown.

TECHNICAL NOTES: Large cracks and discoloration.

DESCRIPTION: Deep bowl shape tapering at base. Slightly concave shoulder. Incised at applied demilune handles. Wide mouth with flat rim. Tan salt glaze decorated with trailed cobalt blue glaze and date 1841 at base. Brown glazed interior. Two gallon capacity.

C73

Storage Jar

ca. 1830–60
Attributed to the Pottersville Stoneware Manufactory (act. ca. 1819–ca. 1860) or Lewis Miles Pottery (act. ca. 1835–65), Edgefield District, South Carolina[1]
Alkaline-glazed stoneware; 14⅞ x 12¼ x 12⅝" (37.8 x 31.1 x 32.1 cm)
B.74.26

In 1810 the first of a series of potteries was established by Abner Landrum in south central South Carolina along the border with Georgia. Over the next fifty years the number grew to at least ten potteries, the majority of them being large companies employing many workers, including slaves. The vessels produced there

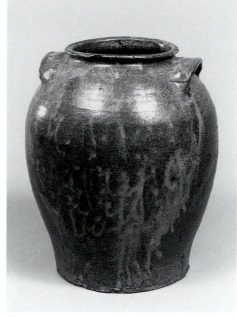

C73

are unique for their combination of English forms with Asian glazes. It is believed that many of the potters were either English or Scots-Irish and that the glaze formulas were probably derived from published missionaries' letters.

PROVENANCE: See cat. no. C33.

TECHNICAL NOTES: Slash lines by potter near bottom.

DESCRIPTION: Ovoid-shaped body covered with ash colored glaze. Flat bottom, rolled rim. Attached lug-type ear handles.

1. Letter from Cinda Baldwin, Guest Curator, Folk Pottery Project, McKissick Museum, November 18, 1987, in Bayou Bend object files. For more information on the Edgefield District potters, see Edgefield 1976.

C74

Storage Jar

ca. 1840–50
Thomas M. Chandler Pottery (act. ca. 1840–50), Edgefield District, South Carolina
Alkaline-glazed stoneware; 19½ x 16⅝ x 16½" (49.5 x 42.2 x 41.9 cm)
B.74.27

Thomas Chandler (1810–1854) was probably the most skilled and innovative of all the Edgefield potters. It is believed that he is a descendent of John Chandler of Fulham, one of Britain's earliest stoneware

potters. Like many of the vessels produced at Edgefield, this jar assumes a shape that essentially is English, complete with four lug handles. It is most closely related to the bread pots produced in the northeast of that country. Here Chandler uses the alkaline glaze that Edgefield was renowned for. The stylized flowers and swags that ornament the jar's shoulders are made with iron slip. Such decoration is highly unusual in southern stoneware and may represent one of Chandler's most significant contributions to the medium.

PROVENANCE: Robert Hinely, Sr., Georgia; purchased by Miss Hogg from Kinnaman and Ramaekers Antiques, Houston, 1974.

MARKS: Chandler / Maker (inscribed within one of the jar's handles).

TECHNICAL NOTES: Has losses to one of the handles and minor chips to the other three handles. There are two large blind cracks on the body, running about twenty inches. Bottom shows a continuation of one of the cracks split into three forks, one of which is associated with a cut in the base by the potter.

DESCRIPTION: Tall ovoid body with everted lip and four lug handles.

RELATED EXAMPLES: Ferrell Collection (Edgefield 1976, no. 51); ad for Estate Antiques (*Antiques* 148 [September 1995], p. 293).

REFERENCES: MFA, Houston, *Bulletin* (April 1971), p. 40; Warren 1982, pp. 238, 242; Horne 1990, p. 71.

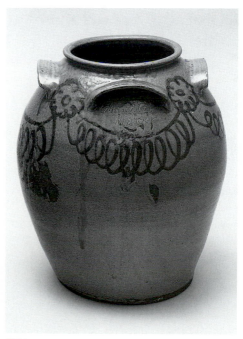

C74

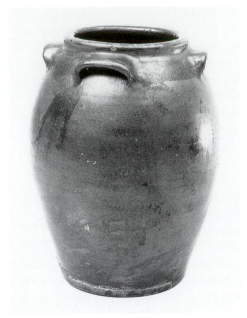

C75

C75

Storage Jar

ca. 1850–60
Jefferson S. Nash Pottery (act. ca. 1850–60),
Jefferson, Marion County, Texas
Alkaline-glazed stoneware; 19¾ x 15½ x 15½"
(50.2 x 39.4 x 39.4 cm)
Museum purchase with funds provided by the
Ima Hogg Ceramic Circle, B.82.2

As American territory extended westward, many Edgefield potters migrated in the same direction, settling in Alabama, Mississippi, and Texas. In 1849 Jefferson S. Nash published a notice in the *Edgefield Advertiser* that he was tentatively planning to leave for Texas in February. Nash himself was not a potter, but rather a farmer and the proprietor of an iron foundry. However, the 1850 census for the Marion County area lists J. N. Gibbs, born in South Carolina, as living in the house next to Nash. No occupation is cited, but the possibility exists that Gibbs was a potter who brought the Edgefield potting and glazing traditions with him to Texas and produced the pottery for Nash. Nash's storage jar is certainly reminiscent of the forms and glazes so closely identified with the Edgefield district.

PROVENANCE: Purchased by Bayou Bend from Billy F. Allen, Commerce, Georgia, 1982.

MARKS: J.S.NASH (incuse on shoulder, just below the rim; Horne 1990, p. 102).

TECHNICAL NOTES: Iron oxide has been splashed or smeared around the shoulder of the piece and on the handles.

DESCRIPTION: Reddish-brown color. The jar has four lug handles spaced equidistantly around the neck. Ten gallon capacity.

REFERENCES: Gustafson 1984a, p. 122; Warren 1988, p. 58.

C76

Storage Jar

ca. 1872–84
H. Wilson & Co. (act. ca. 1872–84), Guadalupe County, Texas
Salt-glazed stoneware; 16¾ x 11¾ x 11⅝" (42.5 x 29.8 x 29.5 cm)
Museum purchase with funds provided by The Brown Foundation, Inc., B.93.1

In March 1872, Hiram (d. 1884), James (n.d.), and Wallace (n.d.) Wilson opened a pottery in rural Guadalupe County, Texas. The Wilsons, who were not related, took their name from the Reverend John M. Wilson, who brought them to

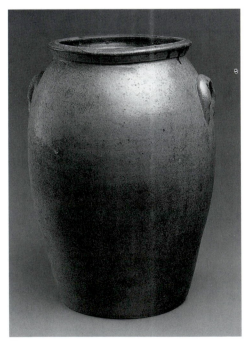

C76

Texas as slaves in the 1830s. They learned their craft in the nearby pottery established in 1857 by their owner. The utilitarian products of the J. M. Wilson firm were made using alkaline glazes in a tradition transferred to Texas from South Carolina (see cat. no. C75). The new firm, named H. Wilson & Company, continued to use the same shapes but predominately used salt glazes. The successful African-American enterprise prospered and continued under Hiram Wilson's ownership until his death in 1884 when the company was dissolved.

PROVENANCE: Georgeanna H. Greer, San Antonio; purchased by Bayou Bend from Harmer Rooke Galleries, New York, 1993.[1]

MARKS: H.WILSON & CO. (impressed twice on the shoulder; see Steinfeldt and Stover 1973, p. 201, no. 275); 5 (impressed on shoulder, left of mark).

DESCRIPTION: Five gallon semi-ovoid jar with crescent handles.

RELATED EXAMPLES: A similar four gallon marked example in Steinfeldt and Stover 1973, pp. 200–201, no. 275.

REFERENCES: Vlach 1978, pp. 94–95, 168, no. 92; Johnson 1993, p. 38-D.

1. Georgeanna H. Greer Stoneware Collection Sale, January 13, 1993, lot 759.

C77*

Preserve Jar

ca. 1861–67
John Burger, Jr. (n.d.), Rochester, New York
Salt-glazed stoneware; 12⅛ x 8¾ x 9" (30.8 x 22.2 x 22.9 cm)
Gift of the estate of Miss Hogg, B.76.11

PROVENANCE: Miss Ima Hogg.

MARKS: JOHN BURGER. / ROCHESTER (impressed on body; Lehner 1988, p. 67, no. 2).

DESCRIPTION: Straight-sided crock with round shoulders and two cupped handles applied at neck, which is flared and banded. Simple flat lid. Decoration of a flower on a stem having twelve petals in cobalt blue glaze. Jar has dark brown interior glaze.

RELATED EXAMPLES: For similar shapes, see
Greer 1981, p. 90; for a John Burger price list
that mentions preserve jars, see Ketchum
1987, p. 374.

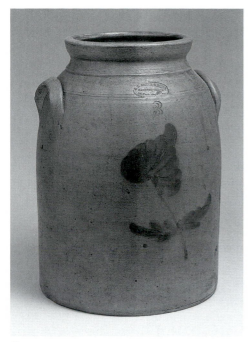

C78

C78

Crock

ca. 1860–74
A. E. Smith and Sons (1825–74), Norwalk,
Connecticut; retailed in New York
Salt-glazed stoneware; 13¾ x 10 x 10⅛″ (34.9 x
25.4 x 25.7 cm)
Gift of the estate of Miss Ima Hogg, B.76.139

Asa E. Smith established a stoneware fac-
tory in Norwalk in 1825. By mid-century
he was in partnership with his sons,
Theodore and Asa, and Howard Hobart.
They were also retailing stonewares and
brown wares from the firm's distributing
agency at 38 Peck Slip, in New York City.

PROVENANCE: Miss Ima Hogg.

MARKS: A. E. SMITH & SONS, / MANUFACTURERS,
/ 38 Peck Slip [AV]E (impressed below neck); 3
(impressed below mark).

TECHNICAL NOTES: Two small chips in back
of body that appear to have existed prior to
firing.

DESCRIPTION: This jug is mud brown rather
than the more common gray color. A darker
brown floral sprig adorns its body. Two ap-
plied semi-circular handles. Three gallon ca-
pacity.

C79*

Crock

ca. 1872–92
Ottman Brothers & Co. (act. ca. 1872–92),
Fort Edward, New York
Salt-glazed stoneware; 11⅜ x 12⅛ x 11⅝″ (28.9 x
30.8 x 29.5 cm)
Gift of the estate of Miss Ima Hogg, B.79.189

PROVENANCE: Miss Ima Hogg.

MARKS: OTTMAN BRO'S / & CO., / FORT ED-
WARD, N.Y. / 4 (impressed on front below rim;
Lehner 1988, p. 332).

DESCRIPTION: Grayish-brown crock with
decoration of bird on leaf in cobalt blue glaze.
Lug-type handles at each side. Rolled, flat-
tened rim. Interior of brown glaze. Four gal-
lon capacity.

C80

Churn

1869–1900
Attributed to Jim Haden, Rushton Pottery
(act. ca. 1869–1900), Rusk County, Texas[1]
Alkaline-glazed stoneware; 19⅝ x 11 x 11¼″
(49.8 x 27.9 x 28.6 cm)
Museum purchase, B.93.9

PROVENANCE: Georgeanna H. Greer, San
Antonio; purchased by Bayou Bend from
Harmer Rooke Galleries, New York, 1993.[2]

MARKS: JH / 3 / 3 (impressed near handle).

DESCRIPTION: Two lug-type handles. Olive
colored alkaline glaze with spots. Six gallon
capacity.

REFERENCES: Johnson 1993, p. 30-D.

1. Lynda Mason Jones, Henderson, Texas.
2. Georgeanna H. Greer Stoneware Collection
 Sale, January 13, 1993, lot 554.

C81

Churn and Lid

1880–90
Charles S. Kline (1854–1917/23), Howells Mills,
Georgia
Salt-glazed stoneware; 17½ x 10¾ x 11″
(44.5 x 27.3 x 27.9 cm)
B.72.22

PROVENANCE: Unknown.

MARKS: C. S. KLINE / HOWELLS.MILLS / GA:
(impressed on rim); 5 (impressed on rim, right
of mark).

TECHNICAL NOTES: Dasher is a replacement.

DESCRIPTION: Cylindrical shape tapering at
shoulder. High, slightly flaring neck. Incised
band at base of neck, demilune handles. The
number "5" in top center with an "S" scroll on
either side, with three upside down apples
below. Tan salt glaze with faded blue design.
Brown slip interior glaze. Five gallon capacity.

RELATED EXAMPLES: For similar shapes, see
Greer 1981, p. 94.

C82

Cuspidor or Spittoon

1840–50
American Pottery Co. (act. 1833–ca. 1850), Jersey
City, New Jersey
Rockingham-glazed stoneware; 3 x 7¼″ (diam.)
(7.6 x 18.4 cm)
Museum purchase with funds provided by
Robert D. Jameson, B.88.20

The cuspidor, which takes its name from
the Latin and old French words meaning

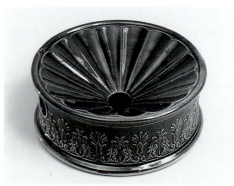

C82

to spit, is a vessel designed to sit on the floor and receive either spittle or expectorated tobacco. Traditionally the form has an inward sloping upper section that drains into the lower body. With a large population of tobacco chewers in nineteenth-century America, the form, produced in both ceramics and metalwares, found widespread use.[1] Despite its mundane purpose, the designer of this example aspired to be more stylish, as evidenced by the finely molded classical anthemion on the sides and the classical fluting on the upper section.

PROVENANCE: Purchased by Bayou Bend from W. M. Schwind, Jr., Antiques, Yarmouth, Maine, 1988.

MARKS: AMERICAN / POTTERY CO / JERSEY CITY NJ (impressed on bottom; see Barber 1976a, p. 44; Thorn 1947, p. 115, no. 16).

DESCRIPTION: Sides are decorated with molded anthemion design. Top slopes downward with simple line decoration toward one-inch hole. Side also has one-inch hole, presumably for emptying contents.

RELATED EXAMPLES: Classicism was not the only high-style reference for American Pottery Co. cuspidors. For an octagonal example inspired by medieval motifs, see New Jersey Pottery 1972, no. 41.

1. An 1850s price list of the Swan Hill Pottery in South Amboy, New Jersey, lists seven different patterns with stylish names like "French Flute" and "Apostle" and calls them spittoons, suggesting the period terminology (Branin 1988, p. 200).

PORCELAIN

C83–84

Pair of Pitchers

ca. 1828
William Ellis Tucker (1800–1832) or Tucker and Hulme (n.d.), Philadelphia[1]
Porcelain with polychromy and gilding; B.71.53: 9³⁄₈ x 5³⁄₄ x 7¹¹⁄₁₆″ (23.8 x 14.6 x 19.5 cm); B.80.1: 9³⁄₈ x 5⁷⁄₈ x 7¹⁄₂″ (23.8 x 14.9 x 19.1 cm)
Gift of 1970 Class of Bayou Bend docents, B.71.53
Museum purchase with funds provided by Mr. and Mrs. Garrett R. Tucker, B.80.1

PROVENANCE: B.71.53, purchased by Bayou Bend from Frey's Antiques, Houston, 1970[2]; B.80.1, purchased by Bayou Bend from Sander's Antiques, Houston, 1980.

INSCRIBED: R.S. and 1828 (gilded on body, below spout).

DESCRIPTION: Vase-shaped pitchers with ribbed bases, painted in enamel with naturalistic flowers. Leaf molding under spouts and handles. Gold bands outline the bases and necks.

RELATED EXAMPLES: The American Museum in Britain, Bath, with the initials "ES" and dated 1828 (Elsdon 1993, p. 460, pl. XI).[3]

REFERENCES: MFA, Houston, *Bulletin* (April 1971), p. 23; Agee et al. 1981, p. 94, no. 164.

1. The Tucker factory was in production from 1827 to 1838. William Ellis Tucker was in partnership with Thomas Hulme for a brief period in 1828. From 1831 until his death in

1832, Tucker was in partnership with Joseph Hemphill. Hemphill continued alone until the factory's closing in 1838.
2. While identified verbally at the time of purchase as being initialed for a "Ruth Slade," it is very probable that they were owned by Ruth Bucklin Slater of Pawtucket, Rhode Island.
3. That example came with a history of ownership in the Slater family of Derbyshire, England, and Pawtucket, Rhode Island, and the original owner was identified as Elizabeth. It seems more likely that "ES" is Esther Parkinson, a Philadelphia widow who married Samuel Slater, the son of Elizabeth, in 1817. He and his brother John, who married Ruth Bucklin in 1807, were partners in a cotton milling business in Pawtucket. It is likely the pitchers were ordered for the two Slater wives.

C85

Pair of Pitchers

1827–38
William Ellis Tucker (1800–1832), Tucker and Hulme, Tucker and Hemphill, or Joseph Hemphill (act. 1827–38), Philadelphia
Porcelain with polychromy and gilding; B.22.7.1: 9³⁄₈ x 5⁷⁄₈ x 7³⁄₄″ (23.8 x 14.9 x 19.7 cm); B. 22.7.2: 9¹⁄₄ x 5³⁄₄ x 7¹⁄₂″ (23.5 x 14.6 x 19.1 cm)
B.22.7.1–.2

PROVENANCE: William B. Montague, Norristown, Pennsylvania; purchased by Miss Hogg from Montague, 1922.

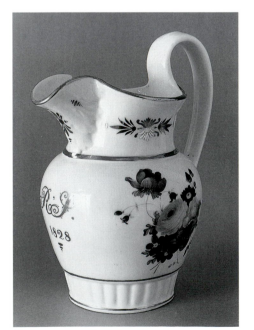

C83

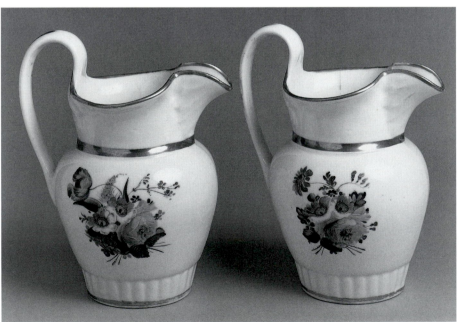

C85

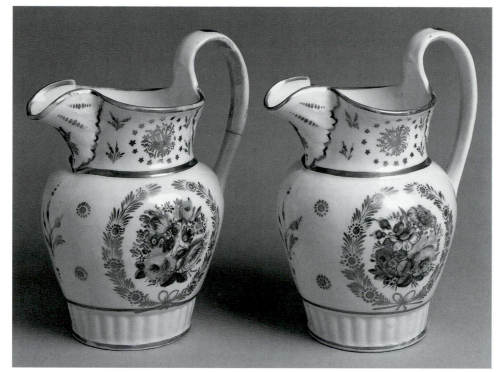

C86

DESCRIPTION: **B.22.7.1**, vase-shaped pitcher with ribbed base, painted in enamel with naturalistic flowers and gold band accents. Molded spout and handle with leaf-shaped terminals; **B.22.7.2**, same, but with slightly different floral decor.

PROVENANCE: See cat. no. C85.

DESCRIPTION: Vase-shaped pitchers with ribbed bases. Enamel floral decorations framed with gold wreaths on both sides. Two gold bands outline the bases and necks. On necks, gold design featuring musical instruments on leafy background; beneath spouts, gold floral spray on fields sprinkled with gold stars and dots.

REFERENCES: Warren 1988, p. 37.

C87

Pair of Pitchers

1827–38

William Ellis Tucker (1800–1832), Tucker and Hulme, Tucker and Hemphill, or Joseph Hemphill (act. 1827–38), Philadelphia Porcelain with polychromy and gilding; B.22.5.1: 9⅜ x 5⅞ x 7¹³⁄₁₆″ (23.8 x 14.9 x 19.8 cm); B.22.5.2: 9⁷⁄₁₆ x 5¾ x 7¾″ (24 x 14.6 x 19.7 cm) B.22.5.1–.2

C88

Pitcher

1827–38

William Ellis Tucker (1800–1832), Tucker and Hulme, Tucker and Hemphill, or Joseph Hemphill (act. 1827–38), Philadelphia Porcelain with polychromy and gilding; 9¼ x 5¾ x 7¾″ (23.5 x 14.6 x 19.7 cm) B.22.4

PROVENANCE: See cat. no. C85.

DESCRIPTION: Vase-shaped pitcher with ribbed base and gilt edges. Broad apricot band at neck with gilt edges and gilt floral and leaf decoration. Gilt designs on spout and below top of handle. Molding marks are visible on pitcher.

C86

Pair of Pitchers

1827–38

William Ellis Tucker (1800–1832), Tucker and Hulme, Tucker and Hemphill, or Joseph Hemphill (act. 1827–38), Philadelphia Porcelain with polychromy and gilding; B.22.6.1: 9⅜ x 5¾ x 7⅝″ (23.8 x 14.6 x 19.4 cm); B.22.6.2: 9³⁄₁₆ x 5¾ x 7¾″ (23.3 x 14.6 x 19.7 cm) B.22.6.1–.2

PROVENANCE: See cat. no. C85.

DESCRIPTION: Vase-shaped pitchers with ribbed bases, painted in enamel with naturalistic flowers and gold band accents. Molded spouts and handles with leaf-shaped terminals. Floral decoration framed by a gold wreath of leaves and stylized flowers. On the necks are designs of gold lyres, horns, and leaves within a circle of stars flanked by floral sprays.

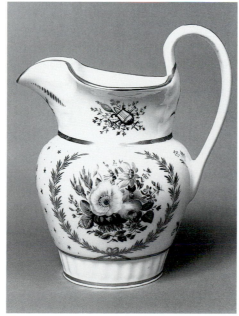

C87

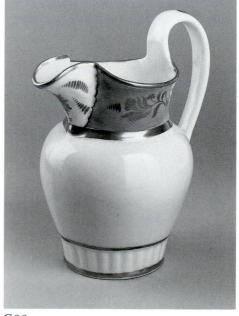

C88

C89

Pitcher

1827–38
William Ellis Tucker (1800–1832), Tucker and
Hulme, Tucker and Hemphill, or Joseph
Hemphill (act. 1827–38), Philadelphia
Porcelain with polychromy and gilding; 9⅜ x
5⅝ x 7⅞" (23.8 x 14.3 x 19.4 cm)
B.22.8

PROVENANCE: See cat. no. C85.

MARKS: C (perhaps for William Chamberlain,
a workman at the factory, incised on bottom).

DESCRIPTION: Vase-shaped pitcher with
ribbed base. Top and bottom of lip and bot-
tom of pitcher edged in gold. Enamel floral
pattern on both sides; stylized gold patterns
around lip.

On February 16, 1827, Benjamin Tucker
wrote to Isaac and Hannah Jones thank-
ing them for caring for his sick daughter
and presenting them with a ". . . speci-
men of American China, manufactured
by my son William Ellis." In a postscript
he notes, "N.B. These pitchers are from
his first kiln of china ware." The return
letter from Mr. and Mrs. Jones describes
"two elegantly white Pitchers." On July 18
of the same year Benjamin writes to Mar-
cus C. Stephens that ". . . six pairs of
Porcelain Jugs from my son's factory
might be forwarded for sale in your
town."[1] These letters reveal several

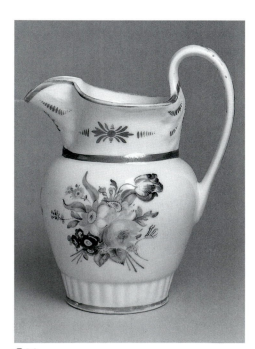

C89

important aspects of the Tucker factory
production, namely that pitchers were an
early ware, they were made in pairs, and
they probably were intended as presenta-
tion rather than utilitarian pieces. Indeed,
most of the surviving Tucker is the dis-
tinctive pitcher form recorded as no. 7 in
their monochrome pattern book, where it
was described as Vase shape. Although an
English pitcher with a similar shape and
molded decoration under the spout is
known, the Tucker form, with its fluted
base, seems to be unique.[2] To the basic
blank, which sold for one dollar, could
be added various embellishments, from
simple banding to complex gilt and poly-
chrome floral decoration. While the
polychrome pattern book illustrates eleven
different floral and gilt decorations for
this type of pitcher, none of the Bayou
Bend examples conforms exactly to the
patterns, suggesting that they served
more as a guideline than an exact model.
In terms of decoration, the vase-shaped
pitchers at Bayou Bend range from the
severe but sophisticated example with
peach banding at the neck in the French
taste (cat. no. C88) to simple polychrome
floral with minimal gilding (cat. no. C85)
to floral decoration enclosed in gilt
wreaths with musical trophies above
(cat. nos. C86 and C87).

1. Tucker Papers, PMA.
2. Frelinghuysen 1989, p. 90. Porcelain jugs
 made by the firm of H. & R. Daniel at
 Stoke-upon-Trent, Staffordshire, England,
 are similar to the overall shape of the
 Tucker vase pitchers and have a similar
 molded leaf detail under the spout. How-
 ever, they have angular handles rather
 than the simple loop of the Tucker form
 and lack the fluting at the base of the body.
 See Godden 1983, p. 287, figs. 427–29.

C90

Pitcher

1827–38
William Ellis Tucker (1800–1832), Tucker and
Hulme, Tucker and Hemphill, or Joseph
Hemphill (act. 1827–38), Philadelphia
Porcelain with polychromy and gilding; 8⅜ x
6¾ x 8⅞" (21.3 x 17.1 x 22.5 cm)
Museum purchase with funds provided by the
Alice Sneed West Foundation in memory of
Natalie Gallager, B.89.8

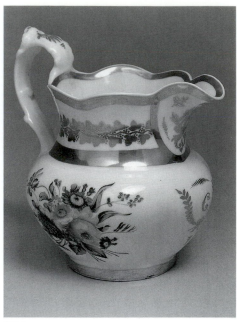

C90

This pitcher form, no. 8 in Tucker's
monochrome pattern book and identified
there as Grecian shape, represents an al-
ternative to the ubiquitous Vase shape
(see cat. nos. C83–89). The Grecian shape
was also produced by the short-lived, rival
firm of Smith Fife and Company.[1] The
present example is richly ornamented
with typical polychrome floral bouquets
and gilt bandings and is personalized with
the monogram cypher "C."[2]

PROVENANCE: Purchased by The Stradlings,
New York, at Christie's, New York, sale 6805,
April 26, 1989; purchased by Bayou Bend from
The Stradlings, New York, 1989.

INSCRIBED: C (below spout).

DESCRIPTION: Grecian shape with scalloped
rim and scroll handle. The shoulder decorated
with gilt meandering grape and vine motif
centering on a lyre under the spout. Enclosed
with gilt bands above and below, the body
decorated with enamel floral bouquets on the
obverse and reverse centering on a laurel en-
closed gilt monogram. Gilt band around base
and gilt highlights on handle.

RELATED EXAMPLES: A very similar painted
pair with gilt cypher "TBC" and another with
simpler gilding (Tucker 1957, nos. 327, 328, and
384).

1. Tucker 1957, p. 30; for Smith Fife examples,
 see Frelinghuysen 1989, p. 106, no. 19. An
 unmarked English bone china example of
 this shape is at Winterthur (acc. no. 72.114).
2. The cost for one to four letters for gilt

cyphers was an additional two cents. Thomas Tucker, "Price for Painting," September 26, 1832. Tucker Papers, PMA.

C91

Pitchers

1827–38
William Ellis Tucker (1800–1832), Tucker and Hulme, Tucker and Hemphill, or Joseph Hemphill (act. 1827–38), Philadelphia
Porcelain with polychromy and gilding; B.22.13: 6⅞ x 4⅛ x 6¼" (17.5 x 10.5 x 15.9 cm); B.96.6: 5⅞ x 4⅛ x 6⅛" (15 x 10.5 x 15.6 cm)
Gift of Miss Ima Hogg, B.22.13
Museum purchase with funds provided by Mr. and Mrs. Russell M. Frankel, B.96.6

The Tucker monochrome pattern book identifies this form as the Walker shape and indicates that it came in four sizes. That the shape has no known English or Continental prototype and is the only design named after a person associated with the firm suggests that the form may have been introduced by Andrew Craig Walker, one of the foremost modelers at the factory.[1] Judging from the relatively few number of surviving examples, the production must have been smaller than that of the Vase shape (see cat. nos. C83–89), although the cost for the large size, one dollar, was the same.[2] Typically these Walker pitchers are decorated with gilt and enamel floral patterns that are similar to ornaments of other Tucker forms. The relative crudeness of design

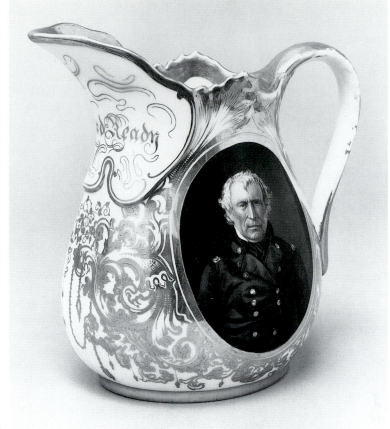

C92

and dull color of the enamel of B.22.13 suggest that it may have been a white blank that was painted outside of the factory.

PROVENANCE: **B.22.13**, see cat. no. C85; **B.96.6**, purchased by Bayou Bend from Philip H. Bradley Co., 1996.

INSCRIBED: **B.22.13**, G (impressed on underside).

DESCRIPTION: Squat, rectangular molded bodies with applied angular handles. **B.22.13**,

enamel floral decoration ("moss rose") on both sides; **B.96.6**, enamel floral and gilt decoration on both sides.

RELATED EXAMPLES: Winchester 1936, p. 165, fig. 3, and p. 166, fig. 5; Tucker 1957, nos. 145, 275–78, 360–68; Hammerslough 1958; Jayne 1957, p. 238; Frelinghuysen 1989, p. 92, no. 11.

1. Barber 1976a, p. 17. A Rockingham porcelain model made between 1826–30 is very similar in overall design. However, it lacks the distinctive gadrooned border along the lip (Cox and Cox 1983, p. 181 fig. 134).
2. Monochrome pattern book, Tucker Pattern Books, PMA; these examples are the smaller size that was priced at 37½ cents.

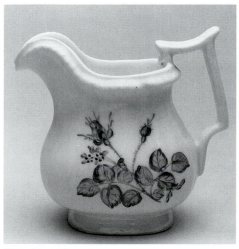

C91 *(B.22.13)*

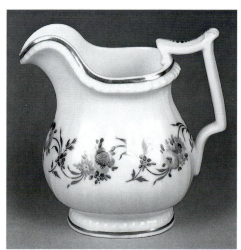

C91 *(B.96.6)*

C92

Presentation Pitcher

ca. 1848–50
France (body); decoration possibly New York
Porcelain with polychromy and gilding; 9⅝ x 6¼ x 9" (24.4 x 15.9 x 22.9 cm)
B.54.16

While the exact origin of this large porcelain pitcher is not entirely clear, its purpose is undisputed. The pitcher was ordered as a salute to General Zachary Taylor's brilliant victory at Buena Vista, Mexico, on February 23, 1847, where, commanding an inexperienced army of about 5,000 troops, he soundly defeated the 15,000 man force of General Antonio de Santa Anna. The victory made Taylor an instant hero and led to his election to the White House in 1848. The battle scene, based on the 1847 engraving by H. R. Robinson (see cat. no. W21), is painted with great detail on one side; Taylor's portrait appears on the other. An 1848 engraving made by Alexander Ritchie (1822–1895) after a daguerreotype of Taylor provided a widely disseminated image, but the portrait here differs in such details as the closeness of Taylor's eyes and coloring of the neckerchief, suggesting another unidentified source.[1] Taylor's fondness for casual dress earned him the nickname "Rough and Ready," which appears in Gothic letters under the pitcher's spout. The porcelain body and design, particularly the rococo ruffles behind the upper edge of the spout, do not relate to mid-century American porcelain pitchers. The practice of importing blank French porcelain for decoration in New York was not uncommon. At the time the most prominent practitioner of this method was the firm of Haughwout and Daily who were described as ". . . engaged in decorating porcelain which is imported or manufactured for them."[2] It is possible that this pitcher was commissioned from them in celebration of Taylor's remarkable victory.

PROVENANCE: Purchased by Miss Hogg from Charles L. Wright of Neiman-Marcus, Dallas, 1954.

MARKS: c̲ (incised on base).

DESCRIPTION: Decorated in polychrome enamel and gilding, with portrait of General Taylor on one side. Landscape of battle formation on reverse.

RELATED EXAMPLES: There is a body of painted presentation porcelain decorated in New Orleans by Rudolph T. Lux (ca. 1815–1868), who emigrated from Germany in 1857.[3] However, Lux usually signed his pieces. In addition, Lux's style was more relaxed than the work on the Bayou Bend pitcher, and his subjects were usually placed in a large reserve

rather than a tight oval. A small pair of Rockingham pitchers—one bearing "Rough" and the other "Ready" on the hat—attests to Taylor's popularity (Barret 1958, p. 324, pl. 425).

1. The engraving was published in *The Wig Portrait Gallery* (New York, 1848). A miniature based on the same print is also at Bayou Bend (cat. no. P46).
2. Silliman and Goodrich 1854, p. 129. Accompanying the discussion of Haughwout and Daily's production are illustrations of their work, including "A Presentation Vase from the operatives to Mr. William Woram a former partner in the establishment bears this gentleman's portrait." The parallel of a presentation piece painted with a portrait is interesting. Porcelain made by the Haviland firm in Limoges, France, very popular in America, was sold at their retail outlet at 47 John Street, New York ("Porcelain of the 1850s," *Antiques* 34 [October 1938], p. 210, illustrates a Haviland advertisement).
3. One pitcher with Grant and Farragut sold at Skinner's Fine Ceramic sale, September 26, 1990; another with Farragut and Major General B. F. Butler sold at Parke-Bernet's Americana Collection of the late Mrs. J. Amory Haskell sale, May 17–20, 1944, lot 443; also see "Shop Talk" *Antiques* 68 (August 1955), p. 108.

C93

Pitcher

1861–62
William Bloor's East Liverpool Porcelain Works or United States Porcelain Works (act. 1861–62), East Liverpool, Ohio
Parian porcelain; 9⅞ x 7⅛ x 8⅜" (25.1 x 18.1 x 21.3 cm)
Museum purchase with funds provided by the Ima Hogg Ceramic Circle, B.90.15

Like many American pottery proprietors, William Bloor was somewhat peripatetic, moving from New Jersey to Ohio and back again a number of times. His East Liverpool, Ohio, pottery was only in business for two years, yet he was able to produce quality glazed porcelain and Parian ware. Perhaps with an eye toward marketing, the tulip pattern, as shown here, is drawn on English prototypes, and Bloor's diamond-shaped mark consciously emulates the English mark of registry.[1]

PROVENANCE: Purchased by Bayou Bend from David Lackey Antiques, Houston, 1990.

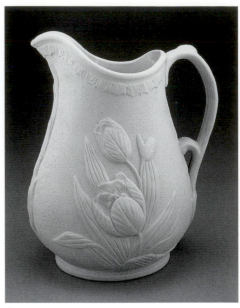

C93

MARKS: IV / w / Bloor / 3 (raised and incised on underside; Frelinghuysen 1989, p. 151).

DESCRIPTION: Leaf and tulip blossoms in relief on both sides of the pitcher, extending up from the base. The handle is in the form of a tulip leaf.

RELATED EXAMPLES: New Jersey State Museum, Trenton (Frelinghuysen 1989, no. 46).

1. For a full discussion of Bloor's tulip-shaped pitcher, see Frelinghuysen 1989, pp. 150–53.

C94

Sauceboat

1770–72
American China Manufactory (Bonnin & Morris) (1769–72), Philadelphia
Porcelain with underglaze blue; 2¼ x 2⅝ x 4⅞" (5.7 x 6.7 x 12.4 cm)
Museum purchase with funds provided by the Friends of Bayou Bend, B.83.4

Unlike the Continent, where the production of porcelain received royal patronage and financial support, porcelain manufacture in England was the purview of the individual entrepreneur. Traditionally the colonies had depended on the mother country for such luxury goods. However, in December 1769, the same year as the Non-Importation Agreement, Gousse Bonnin, a recent immigrant from England, and George Anthony Morris, a well-connected native of Philadelphia, announced that they would soon be pro-

ducing " . . . as good porcelain as any heretofore manufactured at the famous factory at Bow, near London."[1] Between 1770 and 1772, the private partnership produced fine soft-paste porcelain dinner and tea wares, decorated primarily in underglaze blue. The molded rococo forms related closely to the imported English competition, porcelain made at Bow, Lowestoft, and Plymouth. The letter "P" for Philadelphia was proudly used as a mark.[2] However, once the colonists ended their boycott of English goods in 1770, the competition became extremely stiff. Not even a lottery was able to rescue the venture (see cat. no. W97), and the business closed in November 1772. While archaeological evidence indicates the production included a wide variety of forms, less than twenty examples are known today. These range from pickle stands to fruit baskets and sauceboats, all luxury goods, which may account for their survival. The present sauceboat, with its fluted body and underglaze blue chinoiserie landscape ornament, relates very closely to a model produced only a few years earlier at Plymouth.[3]

PROVENANCE: Unknown private collection, Philadelphia; purchased at a rummage sale in Philadelphia by Mrs. George K. Stout, Wellesley Hills, Massachusetts, mid-1940s; purchased by Bayou Bend through The Stradlings, New York, 1983.

MARKS: P (on underside in underglaze zaffer [cobalt] blue).

TECHNICAL NOTES: Handle has been restored. Sauceboat was warped in firing. Base shows slightly different fluorescence than body interior.

DESCRIPTION: Scalloped rim, ribbed body, and a collet foot. Underglaze blue chinoiserie decoration. Molded body (exterior) is decorated in Chinese landscape scene with zaffer (cobalt) blue underglaze. Interior is decorated with image of a small house. The splayed, scalloped, ribbed base is decorated with three small floral vines. The restored handle has underglaze blue decoration along its center.

RELATED EXAMPLES: Just one other sauceboat of this type is known (Hood 1972, pp. 31–32, figs. 27–29). Bayou Bend's painted scene is closely related to that on a small pickle shell (Hood 1972, fig. 10); the arc and pendent drop ornament inside the lip is repeated at the base of covered openwork dish at Williamsburg (Hood 1972, fig. 35). A Plymouth example of the same fluted design (Cushion 1982, pl. 46).

REFERENCES: Clement 1947, p. 18; "Found! Bonnin and Morris Porcelain," *Antiques* 59 (February 1951), p. 139; Hood 1972, figs. 14–15; *Maine Antiques Digest* (June 1983), p. 27A; ad for The Stradlings, *Antiques* 123 (April 1983), p. 755; Brown 1985, p. 520; Warren 1988, p. 27; Brown 1989, p. 568, fig. 6; Marzio et al. 1989, p. 242.

1. Brown 1989, p. 556.
2. For a comprehensive survey of the Bonnin and Morris factory, see Hood 1972.
3. Another, slightly larger sauceboat at the Brooklyn Museum is of different design but is also closely related to one from Plymouth (Heckscher and Bowman 1992, p. 235, figs. 169, 170).

C95

Serving Dish

1827–38
William Ellis Tucker (1800–1832), Tucker and Hulme, Tucker and Hemphill, or Joseph Hemphill (act. 1827–38), Philadelphia
Porcelain with gilding; 1⅞ x 8¾ x 8¾" (4.8 x 22.2 x 22.2 cm)
Museum purchase with funds provided by Janie C. Lee and David B. Warren, B.88.24

The body of this example is somewhat more creamy in color than other examples made by the Tucker factory. However, it is decorated with the Spider pattern that seems to be unique to Tucker ornament. Thomas Tucker's list for the cost of making products includes references that may refer to this form:

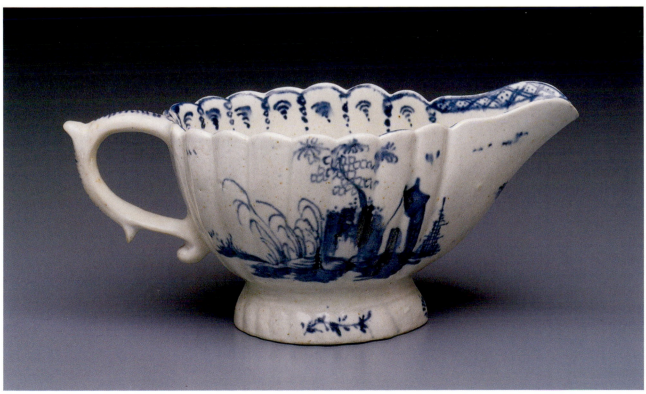

C94

C95

"shell dish which cost 10 cents each to produce; square comport which cost 8 cents; Salad-octagon which cost 20 cents."[1]

PROVENANCE: Purchased by Bayou Bend from The Stradlings, New York, 1988.

DESCRIPTION: Square serving dish with scalloped sides and fluted fans at the corners. Gilt highlights at outer edges and gilt Spider pattern along outer edge of interior.

RELATED EXAMPLES: Winterthur (acc. no. 57.9.43).

1. Thomas Tucker list, Tucker Papers, PMA.

C96

Pair of Fruit Baskets

1827–38
William Ellis Tucker (1800–1832), Tucker and Hulme, Tucker and Hemphill, or Joseph Hemphill (act. 1827–38), Philadelphia
Possibly molded by William Hand (n.d.), Philadelphia
Porcelain with gilding; Each: 7⅝ x 8¼" (diam.) (19.4 x 21 cm)
B.22.1.1–.2

This form has commonly been called a fruit basket, and it was likely used for that purpose. Tucker's monochrome pattern book indicates that the form came in two models and two sizes. This pair represents the smaller size, no. 17, which has a slightly simpler design in the upper section of the basket work. "$3.00 each" is written at the bottom of the drawing in the pattern book. The same form appears in the polychrome pattern book as nos. 62 and 65. While Thomas Tucker's price list includes "Fruit Baskets," which sold at $2.00 each, that reference is clearly to the flat-bottomed basket form that appears in

the monochrome pattern book as no. 16, with a price noted as $2.00 each.[1] Moreover, the list also includes something called "high Comporteers," which sold at $2.50 each, the most expensive price on the list and the closest to that noted on the drawing. As a result it is almost certain that the term "high comporteers" refers to this type of basket raised on a compotelike base. Related examples that have survived along with large tea and coffee services with matching ornament suggest that the form was intended to be used in that context.

PROVENANCE: Jacob Paxson Temple, Tanguy, Chester County, Pennsylvania; purchased by William C. Hogg from The Anderson Galleries, New York, *The Jacob Paxson Temple Collection*, sale 1626, January 23–28, 1922.

MARKS: **B.22.1.1**, H (for William Hand, incised on underside).

TECHNICAL NOTES: The baskets are of a two-part construction. The bases rest on the stands' concave disc and are attached by iron rods.

DESCRIPTION: Each basket with twenty-eight divisions. Narrow horizontal banding around basketing. Solid wide band and tapering base below. Knopped stem with flared foot resting on a square plinth. Gilding on basket work, narrow band, and tapering base. Gilt banding on knop, foot, and plinth. Pale yellow glaze with small white blossoms and sprigs on wide band at base of baskets.

RELATED EXAMPLES: A pair of the same small size, Chester County Historical Society, West Chester, Pennsylvania (Tucker 1957, nos. 407–8); a larger 11-inch model, no. 15, made for Anne Tucker and part of her gold and white tea and coffee service at PMA (Tucker 1957, no. 166); a large 10-inch pair, part of an extensive polychrome tea and coffee service, Hirschl and Adler, New York, as of 1996.

REFERENCES: Anderson Galleries, New York, *The Jacob Paxson Temple Collection*, sale 1626, January 23–28, 1922, lot 1283.

1. Monochrome and polychrome pattern books; Thomas Tucker undated price list, PMA. The larger model, no. 15, which has a pierced lozenge banding at the top edge of the basket, bears the price $3.25.

C97

Plate

1827–38
William Ellis Tucker (1800–1832), Tucker and Hulme, Tucker and Hemphill, or Joseph Hemphill (act. 1827–38), Philadelphia
Porcelain with polychromy and gilding; ⅞ x 6¼" (diam.) (.9 x 15.9 cm)
Gift of Philip Hammerslaugh, B.59.12

PROVENANCE: Philip Hammerslough, Hartford, Connecticut.

DESCRIPTION: Enamel hand-painted flowers in center surrounded by a gilt line and loop design. Rim is decorated with four hand-

C96

C98

C97

painted enamel flower groups, alternating with four gilt spiders. Border outlined with two gilt lines, ¼-inch wide gilt band on edge of rim.

RELATED EXAMPLES: Similar design in The Polychrome Pattern Book, 1832–38, no. 34, illustrated in Tucker 1957, p. 33, pl. XIV.

C98

Plates

1827–38
William Ellis Tucker (1800–1832), Tucker and Hulme, Tucker and Hemphill, or Joseph Hemphill (act. 1827–38), Philadelphia
Porcelain with gilding; Each: ⅞ x 6¼″ (diam.)
(.9 x 15.9 cm)
B.60.53.1–.2

In 1830 Benjamin Tucker wrote a letter to a client that discussed a tea set sold to his daughters and listed the items form by form. One curious entry immediately following twenty-four cups and twenty-four saucers is "12 muffins." William Ellis Tucker commented in a letter to another client about the price of ". . . my porcelain teas & muffins plain and gilded. The best quality of gilded teas such as are warranted to wear well are five Dollars for 12 cups and 12 saucers and four Dollars for Muffins of the same."[1] Tucker's price list also mentions "muffins" and indicates that they cost 1½ cents to make, the same cost as saucers and cup plates.[2] Were

these small plates then used for muffins served at tea? Plates the same diameter as these examples have survived with three tea and coffee services, including one made for Anne Tucker, confirming that these plates were made as part of the tea and coffee sets.[3]

PROVENANCE: Sweet Collection; purchased by Miss Hogg from Richard H. and Virginia A. Wood, Baltimore, 1960.

DESCRIPTION: White plates with wide gilt band. Gilt Spider pattern on rim.

RELATED EXAMPLES: Tucker Pattern Books, PMA.

REFERENCES: Tucker 1957, no. 192.

1. Benjamin Tucker to John Griscom, January 29, 1830, Tucker Papers, PMA. William Ellis Tucker to Marcus C. Stephens "6mo 12 1827."
2. Tucker Papers, PMA.
3. Tucker 1957, nos. 177–80, 190–93, 206–7.

C99★

Cup and Saucer

1827–38
William Ellis Tucker (1800–1832), Tucker and Hulme, Tucker and Hemphill, or Joseph Hemphill (act. 1827–38), Philadelphia
Porcelain with gilding; B.63.104.1: 2¹⁵⁄₁₆ x 3⁹⁄₁₆ x 4″ (7.5 x 9 x 10.2 cm); B.63.104.2: 1¼ x 5⅝″ (diam.) (3.2 x 14.3 cm)
B.63.104.1–.2

PROVENANCE: Purchased by Miss Hogg from Margo Authentic Antiques, St. Louis, Missouri, 1963.

DESCRIPTION: Tucker Pattern Books, no. 22, PMA. Cup has Spider pattern on exterior. Saucer has Spider pattern on rim. Gilt band around inside edge of both cup and saucer.

RELATED EXAMPLES: Sotheby's, York Avenue Galleries, *The American Heritage Auction of Americana*, sale 4785Y, January 27–30, 1982, lot 337.

C100★

Cups and Saucers

1827–38
William Ellis Tucker (1800–1832), Tucker and Hulme, Tucker and Hemphill, or Joseph Hemphill (act. 1827–38), Philadelphia
Porcelain with gilding; B.60.54.1a and B.60.54.2a: 2⅞ x 3⅝ x 4″ (7.3 x 9.2 x 10.2 cm); B.60.54.1b: 1³⁄₁₆ x 5⅞″ (diam.) (3 x 14.9 cm); B.60.54.2b: 1¼ x 5⅞″ (diam.) (3.2 x 14.9 cm)
B.60.54.1; B.60.54.2

PROVENANCE: See cat. no. C98.

DESCRIPTION: Tucker Pattern Books, no. 22, PMA. Cups have Spider pattern on exterior. Saucers have Spider pattern on rim. Gilt band around inside edge of both cups and saucers.

RELATED EXAMPLES: Sotheby's, York Avenue Galleries, *The American Heritage Auction of Americana*, sale 4785Y, January 27–30, 1982, lot 337.

C101

C103

C101

Cup and Saucer

1827–38
William Ellis Tucker (1800–1832), Tucker and Hulme, Tucker and Hemphill, or Joseph Hemphill (act. 1827–38), Philadelphia
Porcelain with gilding; B.93.6.1: 2⅝ x 3⅜ x 3⅞″ (6.7 x 8.6 x 9.8 cm); B.93.6.2: 1¼ x 5⅝″ (diam.) (3.2 x 14.3 cm)
Museum purchase with funds provided in honor of Mr. and Mrs. Fred T. Couper, Jr., B.93.6.1–.2

PROVENANCE: Purchased by Bayou Bend from The Stradlings, New York, 1993.

INSCRIBED: CC (gilt script monogram on cup exterior, opposite handle, and in center of plate).

DESCRIPTION: Tucker Pattern Books, no. 22, PMA, with cypher. Cup has Spider pattern on interior. Saucer has Spider pattern on rim. Gilt band around inside edge of both cup and saucer.

RELATED EXAMPLES: Sotheby's, York Avenue Galleries, *The American Heritage Auction of Americana,* sale 4785Y, January 27–30, 1982, lot 337.

C102★

Cup and Saucer

1827–38
William Ellis Tucker (1800–1832), Tucker and Hulme, Tucker and Hemphill, or Joseph Hemphill (act. 1827–38), Philadelphia
Porcelain with gilding; B.63.105.1: 2¾ x 3⁹/₁₆ x 4³/₁₆″ (7 x 9 x 10.6 cm); B.63.105.2: 1⅛ x 5⅝″ (diam.) (2.9 x 14.3 cm)
B.63.105.1–.2

PROVENANCE: See cat. no. C99.

TECHNICAL NOTES: Handle on cup has been broken and repaired.

DESCRIPTION: Tucker Pattern Books, no. 25, PMA. Gilt band around inside edge of both cup and saucer.

C103

Cup and Saucer

1827–38
William Ellis Tucker (1800–1832), Tucker and Hulme, Tucker and Hemphill, or Joseph Hemphill (act. 1827–38), Philadelphia
Porcelain with polychromy and gilding; B.93.7.1: 2¾ x 3¹¹/₁₆ x 4³/₁₆″ (7 x 9.4 x 10.6 cm); B.93.7.2: 1³/₁₆ x 5¹¹/₁₆″ (diam.) (3 x 14.4 cm)
Museum purchase with funds provided in honor of Mr. and Mrs. Fred T. Couper, Jr., B.93.7.1–.2

PROVENANCE: See cat. no. C101.

DESCRIPTION: Tucker Pattern Books, no. 35, PMA. Gilt band on inner rim, foot rim, and handle of cup. Gilt leaf and green flower garland on side of cup. Gilt banding and garland on saucer.

Cups and saucers were one of the staples of the Tucker factory's production. The present examples, with the evert rims and tight loop handles, were manufactured at a cost of three cents each for the cups and two and a quarter cents for each saucer. They were sold in lots of twelve or twenty-four at a cost of five dollars per dozen.[1] The decoration used patterns that matched other tea service items.

Here, three of the examples carry the so-called Spider decoration, one that seems unique to Tucker and appears without identification in the polychrome pattern book. However, in the 1832 list for burnishing costs, Thomas Tucker divides the wares into two groups, "Banded Teas" and "Phoenix Teas." The lid of an 1828 Tucker sugar bowl, inscribed on the body "Phoenix Hose Co," is decorated with the identical distinctive gilt Spider ornament.[2] As the sugar bowl was part of a tea set that was one of the first Tucker commissions, perhaps Thomas Tucker's term "Phoenix" is a reference to this pattern.

1. The cups are shape no. 57 of the Tucker Pattern Books, PMA. See also Tucker's price list of September 26, 1832. William Ellis Tucker's letter of September 17, 1830, to Wm. Shotwell, Jr., of New York quotes prices for a dozen gilded cups and saucers. Benjamin Tucker's letter of January 29, 1830, to John Griscom of New York cites two dozen cups and saucers as part of a larger tea set (Tucker Papers, PMA).
2. Tucker Pattern Books, no. 22, PMA. Tucker Prices for Burnishing, September 26, 1832, Tucker Papers, PMA. For data on the sugar bowl see Frelinghuysen 1989, p. 83, no. 7.

C104–105

Plate, Coffee Cup, and Saucer

France, mid-1860s (body)
Painted by Rudolph T. Lux (ca. 1815–1868)[1]
Porcelain with polychromy and gilding; B.96.4 (plate): 1 x 8⁷/₁₆″ (diam.) (2.5 x 21.4 cm); B.96.3.1

C104

C105

(cup): 3⅛ x 3⁷⁄₁₆ x 4¼" (7.9 x 8.7 x 10.8 cm);
B.96.3.2 (saucer): 1³⁄₁₆ x 6⅜" (diam.) (3 x
16.2 cm)
*Museum purchase with funds provided by the
Houston Junior Woman's Club, B.96.4,
B.96.3.1–.2*

Rudolph T. Lux, a German-born porcelain painter who set up shop in New Orleans in the mid-1850s, advertised "porcelains and china sceneries."[2] The present examples, from the end of Lux's career, embody a number of facets pertaining exclusively to New Orleans. Horse racing was introduced there in 1838 and became enormously popular. The horse Dexter made a record-breaking run in 1867, and the Currier and Ives print, *Celebrated Horse Dexter, The King of the World,*[3] issued immediately thereafter, made his name synonymous with speed. Speed was essential for the steamships that were the lifeblood of New Orleans. This porcelain was painted by Lux for use on board the *Dexter*, a boat of the Louisville, Evansville, and New Orleans line, which was commissioned in 1868.

PROVENANCE: Purchased by Bayou Bend from The Stradlings, New York, 1996.

INSCRIBED: **B.96.4**, R.T. Lux / Painter & Decorator / on China / No. 112 Bienville Str / N.O.; **B.96.3.1**, identical inscription to B.96.4, except that address is 116 Bienville and La is added at end; **B.96.3.2**, no inscription.

DESCRIPTION: **B.96.4**, polychrome painting of packet *Dexter* in center, polychrome depiction of race horse on rim above; Sam Mont-

gomery Master in gilt below; **B.96.3.1**, same polychrome painting of packet on outside front flanked left by Samuel and right Montgomery Master in gilt; **B.96.3.2**, polychrome painting of packet on rim, gilt banding rim edge and circular banding in cup well.

RELATED EXAMPLES: A plate from the steamboat MS *Mepham* (Leonard 1949, p. 219, no. 331); a Black Hawk saucer at the Historic New Orleans Collection (acc. no. 1957.21b).

1. Act. New Orleans (ca. 1857–68). Lux was located on Bienville street from 1866–68.
2. *Daily Creole*, New Orleans, March 26, 1857, p. 3.
3. Gale 1984, p. 97, no. 0977.

C106

Tea Warmer

1827–38
William Ellis Tucker (1800–1832), Tucker and Hulme, Tucker and Hemphill, or Joseph Hemphill (act. 1827–38), Philadelphia
Porcelain with polychromy and gilding; 7 x 5⅜"
(diam.) (17.8 x 13.7 cm)
B.22.16

This relatively rare example is based on a form that was developed in France about 1800 and was intended to warm food or beverage in an invalid's bedroom. The French term *veilleuse* is derived from the verb *veiller*, to keep a night vigil, which likely accounts for this form being described as a night lamp.[1] The cylindrical section held a spirit lamp to provide the heat. The unit was completed with a

small tea pot (now missing), as is indicated by the drawing of the form that appears in the Tucker pattern book as "no. 18 2nd size"; a cost of $1.60 is listed.[2]

PROVENANCE: See cat. no. C85.

DESCRIPTION: In two parts. Cylindrical upper section tapering inward toward top, then flaring outward, terminating in six rectangular projecting supports. Upper section is decorated with painted rural scenes bordered by gilding. Circular base section fitted to receive upper section, with four circular draft holes. Bottom decorated with gilt lines.

RELATED EXAMPLES: An example with identical gilt ornament and a similar landscape

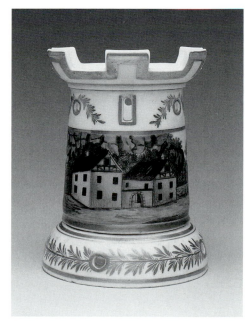

C106

scene with half-timbered building, also missing its teapot (Barber 1976b, p. 152); a landscape ornamented example with teapot but plainer gilding at the PMA (Tucker 1957, pl. XI). Each of these is described as a nightlight.

1. This type was called *veilleuse-théière* (Savage and Newman 1976, p. 307).
2. Tucker Pattern Books, no. 2, PMA.

C107

Pair of Vases

1827–38
William Ellis Tucker (1800–1832), Tucker and Hulme, Tucker and Hemphill, or Joseph Hemphill (act. 1827–38), Philadelphia
Porcelain with polychromy and gilding;
B.72.118.1: 11½ x 5⅝ x 5¼" (29.2 x 14.3 x 13.3 cm);
B.72.118.2: 11⅝ x 5⅝ x 5" (29.5 x 14.3 x 12.7 cm)
B.72.118.1–.2

The classical-shaped vase stands out as the Tucker factory's most sophisticated product. Based on French prototypes, these vases came in two standard sizes.

The larger, 14 inches high, was made with caryatid handles and cost $2.00 undecorated, while the smaller, about 11 inches high, had more simple volute handles, as shown here, and cost $1.50 undecorated.[1] Thomas Tucker's price list for painting notes something called "Mantles richly [raised?]," and his list for burnishing also lists "Mantles Bands 4 [cents] / do full gilt 9 [cents]/ do Less 6 [cents]." Whether the term "Mantle" is a reference to this type of vase or the more common beaker-shaped vases that were used as mantle garnitures is not clear.[2] The gilt palmetto-like ornament at the base of the body of the Bayou Bend vases is a motif that appears on a beaker-shaped vase that graces the title page of the polychrome pattern book.[3] These vases are richly ornamented with gilding and dense polychrome inverse floral swags. A note of extra sophistication in the French taste is seen in the use of peach for the banding at the base of the body and in the spandrels at the shoulders. The bold gilt laurel wreath at the neck also echoes French ornament. The feet, which shrank in the firing, curl up at the corners.

PROVENANCE: James Peale (1749–1831), Philadelphia; to his great-great-great grandson, James Ogelsby Peale; purchased by Miss Hogg from James Ogelsby Peale, 1972.

DESCRIPTION: Classical-shaped urns decorated with a wreath of hand-painted enamel flowers on each side. A gilt acanthus leaf is painted beneath each wreath. A wreath of gilt leaves and a gilt band decorate the neck and shoulders. Peach within a gilt design on shoulder and at the base of the body. The pedestal base and handles are also decorated with gilt.

RELATED EXAMPLES: Less than 20 exist today. Eleven-inch examples (Tucker 1957, nos. 296 and 298, part of a garniture with a 14-inch example [no. 297]; nos. 491–92, 493–94); a pair at the White House with portraits of Lafayette and Jackson (Frelinghuysen 1989, p. 19, fig 13); 14-inch examples with caryatids (Tucker 1957, nos. 130, 267, 496–97, 498–99); two pairs of oversize vases with ormolu handles at PMA (Frelinghuysen 1989, nos. 14, 15); another oversize pair with gilt bronze handles sold at auction April 17, 1997 (*Maine Antique Digest* [June 1997], p. 8-E).

1. Tucker Pattern Books, PMA.
2. Thomas Tucker price list, September 26, 1832, Tucker Papers, PMA.
3. Tucker Pattern Books, PMA.

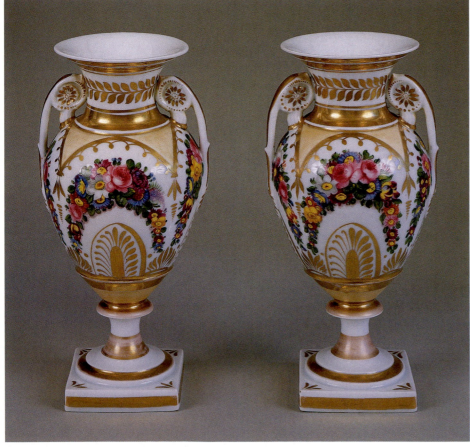

C107

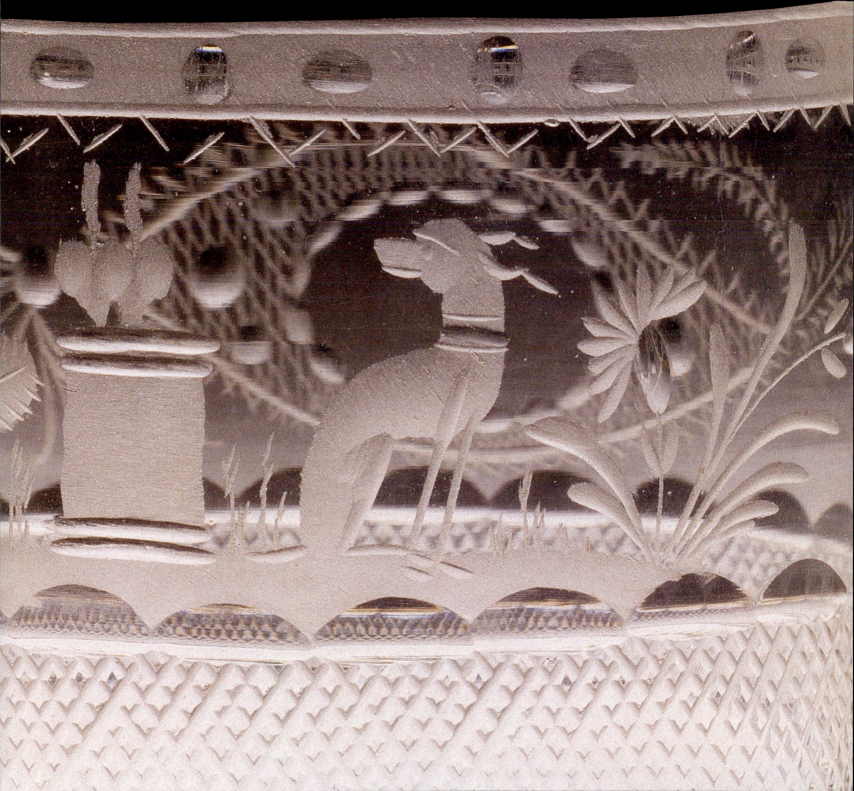

G1

Pocket Bottle

1769–74
Attributed to Glass Works of Henry William
Stiegel (act. 1764–74), Manheim, Pennsylvania
Amethyst colored nonlead glass; 5¼ x 3¹³⁄₁₆ x 2¾"
(13.3 x 9.7 x 7 cm)
B.59.80

Although the exact usage of the pocket
bottle is not entirely clear, evidence indi-
cates that in the eighteenth century they
were intended to hold alcoholic bever-
ages. The factory of Henry William
Stiegel produced thousands of pocket
bottles.[1] The most famous of the Stiegel
patterns is the so-called diamond and
daisy. Until the 1963 Corning-Smithsonian
dig at the Frederick, Maryland, site of the
Amelung factory, where diamond and
daisy shards were discovered, the pattern
was thought to be unique to Stiegel. It is
clear, however, that the diamond and
daisy, which has no exact European proto-
type, originated in America with Stiegel.[2]

PROVENANCE: Aldrich Collection; purchased
by Miss Hogg from Abraham and May An-
tiques, West Granville, Massachusetts, 1959.

DESCRIPTION: Blown. Globular body with
cylindrical neck. Pattern molded with three
rows of five diamonds each, twelve petal flow-
ers in diamonds, above thirty vertical ribs of
varying heights.

RELATED EXAMPLES: Winterthur (Palmer
1993, pp. 361–64, nos. 354–56); PMA (Garvan
1982, pp. 238–40, nos. 1–12); Toledo (Wilson

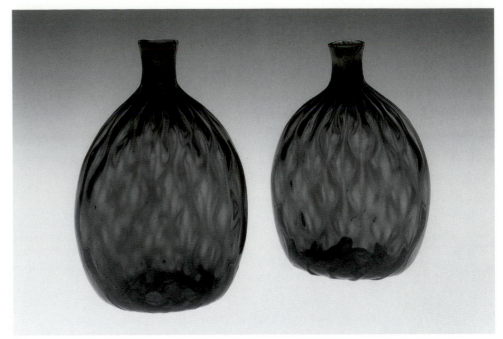

G2–3

1994, p. 67, no. 2); McKearin and McKearin
1941, pl. 231, no. 1; MMA (Davidson and Stil-
linger 1985, p. 251, fig. 378).

1. Palmer 1993, p. 364.
2. For European versions of the diamond and
 daisy pattern, see Palmer 1993, p. 364, and
 Palmer 1989, pp. 230–31.

G2

Pocket Bottle

1769–74
Attributed to Glass Works of Henry William
Stiegel (act. 1764–74), Manheim, Pennsylvania
Amethyst colored nonlead glass; 5⅝ x 3¾ x 2⅝"
(14.3 x 9.5 x 6.7 cm)
B.58.7

PROVENANCE: Purchased by Miss Hogg from
Arthur J. Sussel, Philadelphia, 1958.

DESCRIPTION: Blown. Compressed oval body
with cylindrical neck. Pattern molded with
twelve rows of "nipt" diamonds.

This bottle and the previous example (cat.
no. G2) are made in one of several mold
patterns that have been associated with
the Stiegel factory. Here the vertical flutes
of the mold have been manipulated, or
pinched, while in a molten state and prior
to the blower expanding the gather, creat-
ing an allover ogival pattern, which then
took on the soft appearance after the
gather was expanded.

PROVENANCE: Unknown (at Bayou Bend
prior to 1965).

DESCRIPTION: Blown. Globular body with
cylindrical neck. Pattern molded with twelve
rows of "nipt" diamonds.

RELATED EXAMPLES: Winterthur (Palmer
1993, p. 361, no. 351); PMA (Garvan 1982, pp.
242, 243, nos. 19, 20, 21, 23); private collection
(Palmer 1989, p. 214, fig. 6); McKearin and
McKearin 1941, pl. 232, no. 2.

G1

G3

Pocket Bottle

1769–74
Attributed to Glass Works of Henry William
Stiegel (act. 1764–74), Manheim, Pennsylvania
Amethyst colored nonlead glass; 5⅜ x 4 x 2¾"
(13.7 x 10.2 x 7 cm)
B.69.470

G4

Pocket Bottle

1763–74
Attributed to Glass Works of Henry William
Stiegel (act. 1764–74), Manheim, Pennsylvania
Amethyst colored nonlead glass; 5⅛ x 3⁷⁄₁₆ x 2⅝"
(13 x 8.7 x 6.7 cm)
B.69.481

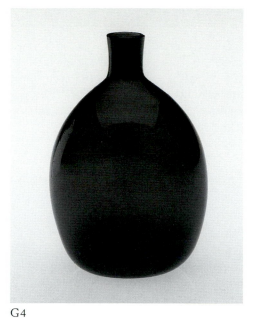

G4

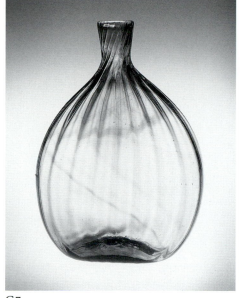

G7

PROVENANCE: **B.57.2**, purchased by Miss Hogg from McKearins' Antiques, Hoosick Falls, New York, 1957; **B.58.13**, Miller Collection; McKearin Collection, Odenwalder Collection; purchased by Miss Hogg from George Abraham and Gilbert May Antiques, West Granville, Massachusetts, 1958.

DESCRIPTION: Blown. Pattern molded twenty-eight ogival diamonds over twenty-eight flutes.

RELATED EXAMPLES: Six at Winterthur (Palmer 1993, p. 361, no. 353); PMA (Garvan 1982, pp. 241–42, nos. 13–18); McKearin and McKearin 1941, pl. 232, no. 1.

While the Stiegel factory is best known for its pattern molded pocket bottles (see cat. nos. G1–3), a few very rare examples without molded decoration are known, including the present piece.

PROVENANCE: Unknown (at Bayou Bend prior to 1965).[1]

DESCRIPTION: Blown spherical body with cylindrical neck. No pattern.

RELATED EXAMPLES: Winterthur (Palmer 1993, p. 361, no. 348); McKearin and McKearin 1941, pl. 232, no. 5.

1. Possibly purchased by Miss Ima Hogg from George S. McKearin, New York, in 1931.

G5–6

Pocket Bottles

1769–74
Attributed to Glass Works of Henry William Stiegel (act. 1764–74), Manheim, Pennsylvania
Amethyst colored nonlead glass; B.57.2: 4⅞ x 3¹¹⁄₁₆ x 2¾" (12.4 x 9.4 x 7 cm); B.58.13: 5⅛ x 3⅜ x 2⅞" (13 x 8.6 x 7.3 cm)
B.57.2, B.58.13

These pattern molded pocket bottles represent yet another type associated with the Stiegel factory. The pattern visually approximates the effect of faceted cut glass.

G7

Pocket Bottle

1790–1825
United States
Amethyst colored nonlead glass; 7¹⁄₁₆ x 5 x 2⅜" (17.9 x 12.7 x 6 cm)
B.69.490

PROVENANCE: Unknown (at Bayou Bend prior to 1965).[1]

DESCRIPTION: Blown. Pattern molded with eighteen vertical ribs that swirl slightly to the right.

RELATED EXAMPLES: McKearin and McKearin 1941, pl. 232, no. 4.

1. Possibly purchased in 1929.

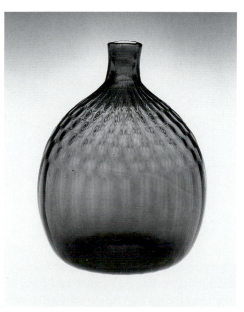

G5

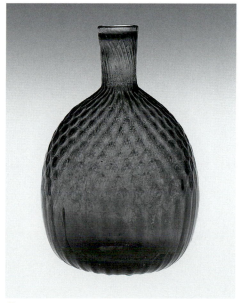

G6

G8

Pocket Bottle

1785–1825
New England, possibly Connecticut
Olive colored nonlead glass; 6⅜ x 4 x 2¹¹⁄₁₆" (16.2 x 10.2 x 6.8 cm)
B.58.29

PROVENANCE: Princess Canatacuzene Collection (Julia Grant); purchased by Miss Hogg from Sam Laidacker, West Bristol, Pennsylvania, 1958.

DESCRIPTION: Blown. Compressed oval body with thirty-six vertical ribs that do not extend to top of swirl.

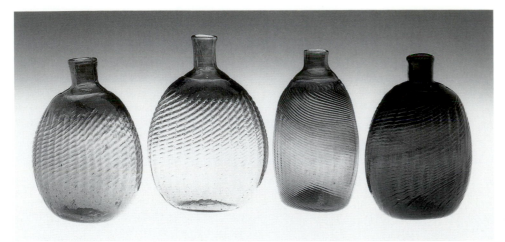

G11, G10, G8, G9

G9

Pocket Bottle

1815–45
Midwestern United States
Amber colored nonlead glass; 6⅜ x 4½ x 2¼″
(16.2 x 11.4 x 5.7 cm)
B.58.30

PROVENANCE: Private collection, Lebanon, Pennsylvania; purchased by Miss Hogg from Sam Laidacker, West Bristol, Pennsylvania, 1958.

DESCRIPTION: Blown. Compressed oval body with twenty-four vertical ribs.

G10

Pocket Bottle

1815–50
Ohio
Light green colored nonlead glass; 7 x 4¾ x 2⅛″ (17.8 x 12.1 x 5.4 cm)
B.58.31

PROVENANCE: See cat. no. G9.

DESCRIPTION: Blown. Compressed oval body with thirty vertical ribs.

G11

Pocket Bottle

1815–50
Ohio
Amber colored nonlead glass; 6¼ x 4¾ x 2⅜″ (15.9 x 12.1 x 6 cm)
B.69.457

PROVENANCE: Purchased by Miss Hogg at American Art Galleries, New York, *The Jacob*

Paxson Temple Collection: Two Hundred Years of Glasswork in America, November 17, 1923, lot 638, through Wayman Adams.

DESCRIPTION: Blown. Flattened spherical body with thirty-two vertical ribs.

This type of pocket bottle (see also cat. nos. G8–10) was made by the German half post method, in which a partially inflated gather (the post) was dipped into the molten glass to add a second layer (the half post) that extends part way up the body. The ribbing on each layer was made in a ribbed dip mold, and in the case where the maker wanted a swirl, he would twist the gather after it was removed from the dip mold. In the 1920s it was thought that this type of bottle was only made at the Pitkin Glassworks in East Hartford, Connecticut, and "Pitkin" became their generic name. In actuality, they were produced at many factories in both New England and the Midwest.

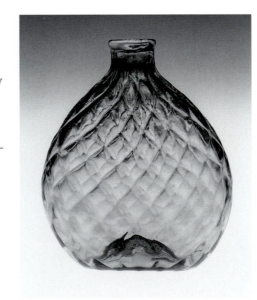

G13

G12

Pocket Bottle

1815–35
Attributed to Zanesville, Ohio, area
Amber colored nonlead glass; 5⅛ x 3⅞ x 2⅛″ (13 x 9.8 x 5.4 cm)
B.69.452

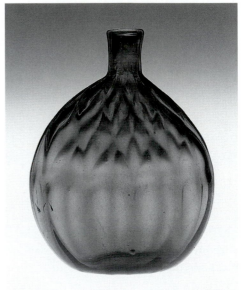

G12

The Midwestern ten diamond pattern molded bottle, believed to have been made in the Zanesville area, is far more common than the fifteen diamond examples (see cat. no. G13).

PROVENANCE: Unknown (at Bayou Bend prior to 1965).

DESCRIPTION: Blown. Pattern molded ten diamond over ten fluted cylindrical neck.

RELATED EXAMPLES: Toledo (Wilson 1994, p. 101, no. 16).

G13

Pocket Bottle

1820–45
Midwestern United States
Light green colored nonlead glass; 4¾ x 3¹³⁄₁₆ x 2⅛″ (12.1 x 9.7 x 5.4 cm)
B.69.484

As craftsmen migrated to the expanding frontier in the late eighteenth and early nineteenth centuries, the traditions of the Stiegel factory were carried to western

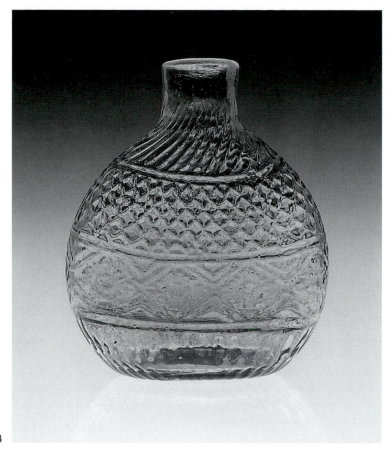

G14

Pennsylvania and into the Midwest. This extremely rare pocket bottle, with its diamond over flute design, recalls the pattern seen in the Stiegel factory's twenty-eight diamond over twenty-eight flute bottles (see cat. nos. G5–6).

PROVENANCE: Unknown (at Bayou Bend prior to 1965).[1]

DESCRIPTION: Blown globular body with short cylindrical neck. Pattern molded with fifteen diamonds above fifteen flutes.

RELATED EXAMPLES: McKearin and Wilson 1978, p. 320, no. 2.

1. This piece was possibly purchased in 1925.

G14

Pocket Bottle

1820–40
United States
Blue-tinged colorless lead glass; 4¼ x 3⅝ x 2¹⁄₁₆″
(10.8 x 9.2 x 5.2 cm)
Museum purchase with funds provided by
Houston Junior Woman's Club, B.93.17

This little pocket bottle is unusual on two counts. It is a rare example of the form blown into a three-part geometric mold. The diamond and floral motif in the lower section of this pattern echoes the diamond and daisy pattern found on eighteenth-century pocket bottles associated with the factories of Stiegel and others. In addition, this bottle is unusually small.

PROVENANCE: Alberta Rogers Patterson, Slippery Rock, Pennsylvania; Garth's Auctions, Delaware, Ohio, *Sale of American Bottles and Blown Glass—The Collection of Alberta Rogers Patterson*, September 17–18, 1993, lot 181; [W. M. Schwind, Jr., Antiques, Yarmouth, Maine]; purchased by Bayou Bend from W. M. Schwind, 1993.

DESCRIPTION: Patterned in a three-part mold, GIII-24 (McKearin and McKearin 1941, p. 256).

RELATED EXAMPLES: Two at Winterthur (Palmer 1993, pp. 374–75, nos. 381–82); another blue one at Yale (Palmer 1993, p. 375).

FIGURED FLASKS

Figured flasks, most of them depicting Mexican War subjects, form the single largest component of the glass collection at Bayou Bend. Unfortunately, their acquisition is not as thoroughly documented as that of other objects in the collection. A 1933 inventory of the contents of Bayou Bend indicates that approximately forty rare figured flasks were displayed in the Tap or Game Room, located on the first floor of the east wing (where the Murphy Room is today). These flasks, pertinent to Texas history, make an interesting link to the colonial objects the Hoggs were collecting. The dates for the objects in this section come from McKearin and Wilson 1978 and indicate when the flasks were first produced.

CORNUCOPIA/URN

G15*

Figured Flask

probably 1820s
Coventry Glass Works (1813–49), Connecticut
Dark olive colored nonlead glass; 6¾ x 4⅜ x 2⅝″
(17.1 x 11.1 x 6.7 cm)
B.72.60

PROVENANCE: Unknown.

REFERENCES: McKearin and Wilson 1978, p. 588, GIII-4.

G16*

Figured Flask

probably 1820s
Coventry Glass Works (1813–49), Connecticut
Olive-amber colored nonlead glass; 7 x 4½ x 2⅝″
(17.8 x 11.4 x 6.7 cm)
B.72.65

PROVENANCE: Unknown.

REFERENCES: McKearin and Wilson 1978, p. 588, GIII-4.

G17*

Figured Flask

probably 1820s
Coventry Glass Works (1813–49), Connecticut

Amber-pink colored nonlead glass; 6¾ x 4⁷/₁₆ x
2⅝″ (17.1 x 11.3 x 6.7 cm)
B.72.61

PROVENANCE: Unknown.

REFERENCES: McKearin and Wilson 1978,
p. 588, GIII-4.

*EAGLES WITH DEVICES
AND EMBLEMS*

G18★

Figured Flask

1846–60
*Possibly Granite Glass Co. (1846–60), Stoddard,
New Hampshire*
*Amber-brown colored nonlead glass; 6 x 3¼ x 2″
(15.2 x 8.3 x 5.1 cm)*
B.72.83

PROVENANCE: Unknown.

REFERENCES: McKearin and Wilson 1978,
p. 575, GII-86.

G19★

Figured Flask

1846–60
*Granite Glass Co. (1846–60), Stoddard, New
Hampshire*
*Olive-amber colored nonlead glass; 7⅜ x 4⅛ x
2½″ (18.7 x 10.5 x 6.4 cm)*
B.72.75

PROVENANCE: Purchased by Miss Hogg from
E. R. Guerin, Suncook, New Hampshire, 1927.

REFERENCES: McKearin and Wilson 1978,
p. 576, GII-81.

G20★

Figured Flask

ca. 1836
Coffin and Hay (1836–40), Hammonton, New Jersey
*Clear green nonlead glass; 7¾ x 5⅝ x 3½″
(19.7 x 14.3 x 8.9 cm)*
B.72.100

PROVENANCE: Purchased by Miss Hogg from
Sam Laidacker, West Bristol, Pennsylvania, 1958.

REFERENCES: McKearin and Wilson 1978,
p. 567, GII-48.

G21★

Figured Flask

ca. 1850
*Probably Kentucky Glass Works (ca. 1850–55),
Louisville*
*Aquamarine colored nonlead glass; 6⅝ x 4½ x
2¼″ (16.8 x 11.4 x 5.7 cm)*
B.72.53

PROVENANCE: Unknown.

REFERENCES: McKearin and Wilson 1978,
p. 563, GII-24.

G22★

Figured Flask

ca. 1866
*Probably A. R. Samuels (ca. 1866–ca. 1874),
Philadelphia*
*Aquamarine colored nonlead glass; 9⅛ x 5⅜ x
4⅛″ (23.2 x 13.7 x 10.5 cm)*
*Gift of Mr. and Mrs. George F. Murphy, III,
B.74.30*

PROVENANCE: Unknown.

REFERENCES: McKearin and Wilson 1978,
p. 656, GXII-43.

"SUCCESS TO THE RAILROAD"

G23★

Figured Flask

late 1820s–1830s
Coventry Glass Works (1813–49), Connecticut
*Clear deep olive-green colored nonlead glass;
6¾ x 4½ x 2⅞″ (17.1 x 11.4 x 7.3 cm)*
B.72.67

PROVENANCE: Unknown.

REFERENCES: McKearin and Wilson 1978,
p. 603, GV-6.

*"LAFAYETTE" / "DE WITT
CLINTON"*

G24★

Figured Flask

1824–25
*Thomas Stebbins (act. 1820–25), Coventry Glass
Works (1813–49), Connecticut*

Shaded olive colored nonlead glass; 7⅜ x 4⅛ x
2⅝″ (18.7 x 10.5 x 6.7 cm)
B.58.45

PROVENANCE: See cat. no. G20.

REFERENCES: McKearin and Wilson 1978,
p. 544, GI-80.

LAFAYETTE / LIBERTY CAP

G25★

Figured Flask

1825
*Stebbins and Stebbins (1825), Coventry,
Connecticut[1]*
*Olive-amber colored nonlead glass; 7⅜ x 4⅛ x
2⅝″ (18.7 x 10.5 x 6.7 cm)*
B.58.46

PROVENANCE: J. G. Laidacker Collection;
purchased by Miss Hogg from Sam Laidacker,
West Bristol Pennsylvania, 1958.

REFERENCES: McKearin and Wilson 1978,
p. 545, GI-85.

1. Thomas Stebbins worked with another
 Stebbins, whose first name is unknown—
 hence the mark S. & S. (McKearin and Wil-
 son 1978, p. 110).

*"BENJAMIN FRANKLIN" /
"T. W. DYOTT, M.D."*

G26★

Figured Flask

ca. 1826–28
*Kensington Glass Works (ca. 1818–38),
Philadelphia*
*Aquamarine colored nonlead glass; 8 x 5¾ x 3⅝″
(20.3 x 14.6 x 9.2 cm)*
B.58.47

PROVENANCE: See cat. no. G25.

REFERENCES: McKearin and Wilson 1978,
p. 547, GI-96.

G27★

Figured Flask

ca. 1826
*Kensington Glass Works (ca. 1818–38),
Philadelphia*

Aquamarine colored nonlead glass; 6¾ x 4½ x 2¾" (17.1 x 11.4 x 7 cm)
B.58.153

PROVENANCE: Hamilton Collection; purchased by Miss Hogg from Sam Laidacker, West Bristol, Pennsylvania, 1958.

REFERENCES: McKearin and Wilson 1978, p. 547, GI-94.

"GENL TAYLOR NEVER SURRENDERS" / "A LITTLE MORE GRAPE CAPT BRAGG"

G28★

Figured Flask

ca. 1847
Attributed to Baltimore Glass Works (1800–1880), Maryland
Aquamarine colored nonlead glass; 7 x 4⅜ x 2⁵⁄₁₆" (17.8 x 11.1 x 5.9 cm)
B.58.163

PROVENANCE: See cat. no. G20.

REFERENCES: McKearin and Wilson 1978, p. 629, GX-4.

G29

Figured Flask

ca. 1847
Attributed to Baltimore Glass Works (1800–1880), Maryland
Aquamarine colored nonlead glass; 7⅛ x 4⅜ x 2⅜" (18.1 x 11.1 x 6 cm)
B.72.57

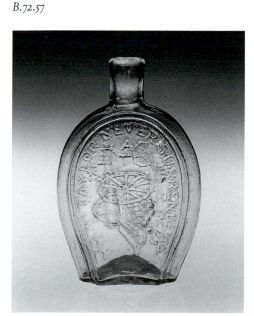

G29 *(front)*

PROVENANCE: Purchased by Miss Hogg from Stephen Van Rensselaer, Peterborough, New Hampshire, 1927.

REFERENCES: McKearin and Wilson 1978, p. 629, GX-4.

G30★

Figured Flask

ca. 1847
Attributed to Baltimore Glass Works (1800–1880), Maryland
Amber-brown colored nonlead glass; 5¾ x 3¾ x 1¾" (14.6 x 9.5 x 4.4 cm)
B.58.36

PROVENANCE: Alfred B. Maclay Collection; purchased by Miss Hogg from Sam Laidacker, West Bristol, Pennsylvania, 1958.

DESCRIPTION: Has tooled lip not shown in McKearin and Wilson 1978.

REFERENCES: McKearin and Wilson 1978, p. 629, GX-6.

BALTIMORE MONUMENT / "A LITTLE MORE GRAPE CAPT BRAGG"

G31★

Figured Flask

ca. 1847
Baltimore Glass Works (1800–1880), Maryland
Puce colored nonlead glass; 5⅞ x 3⅞ x 1¾" (14.9 x 9.8 x 4.4 cm)
B.61.36

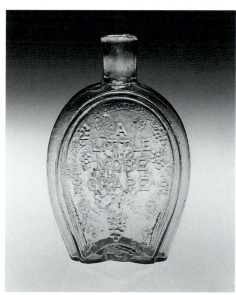

G29 *(back)*

PROVENANCE: Purchased by Miss Hogg from Richard H. and Virginia A. Wood, Baltimore, 1961.

REFERENCES: McKearin and Wilson 1978, p. 605, GVI-1.

G32★

Figured Flask

ca. 1847
Baltimore Glass Works (1800–1880), Maryland
Aquamarine colored nonlead glass; 5⅞ x 3¾ x 1¹³⁄₁₆" (14.9 x 9.5 x 4.6 cm)
B.72.81

PROVENANCE: Purchased by Miss Hogg from McKearins' Antiques, Hoosick Falls, New York, 1954.

REFERENCES: McKearin and Wilson 1978, p. 605, GVI-1.

G33★

Figured Flask

ca. 1847
Baltimore Glass Works (1800–1880), Maryland
Aquamarine colored nonlead glass; 5¾ x 3¾ x 1⅞" (14.6 x 9.5 x 4.8 cm)
B.72.56

PROVENANCE: Unknown (at Bayou Bend prior to 1965).[1]

REFERENCES: McKearin and Wilson 1978, p. 605, GVI-1.

1. Possibly Stephen Van Rensselaer, Peterborough, New Hampshire, 1927, or George S. McKearin, Hoosick Falls, New York, 1954.

"ROUGH AND READY" / EAGLE

G34★

Figured Flask

ca. 1846–48
Midwestern United States
Aquamarine colored nonlead glass; 8⁵⁄₁₆ x 5⅛ x 3½" (21.1 x 13 x 8.9 cm)
B.72.80

PROVENANCE: Unknown.

REFERENCES: McKearin and Wilson 1978, p. 543, GI-77.

"ROUGH AND READY" / "MAJOR RINGGOLD"

G35*

Figured Flask

ca. 1846
Probably Baltimore Glass Works (1800–1880), Maryland
Aquamarine colored nonlead glass; 6¾ x 4¼ x 2¾" (17.1 x 10.8 x 7 cm)
B.59.24

PROVENANCE: Purchased by Miss Hogg from Sam Laidacker, West Bristol, Pennsylvania, 1959.

REFERENCES: McKearin and Wilson 1978, p. 543, GI-71.

G36*

Figured Flask

ca. 1846
Probably Baltimore Glass Works (1800–1880), Maryland
Aquamarine colored nonlead glass; 6⅞ x 4¼ x 2¹³⁄₁₆" (17.5 x 10.8 x 7.1 cm)
B.72.76

PROVENANCE: Purchased by Miss Hogg from Sam Laidacker, West Bristol, Pennsylvania, 1961.

REFERENCES: McKearin and Wilson 1978, p. 543, GI-71.

G37*

Figured Flask

ca. 1846
Probably Baltimore Glass Works (1800–1880), Maryland
Aquamarine colored nonlead glass; 6¾ x 4¼ x 3" (17.1 x 10.8 x 7.6 cm)
B.58.33

PROVENANCE: Probably purchased by Miss Hogg from Stephen Van Rensselaer, Peterborough, New Hampshire, 1927, or from Sam Laidacker, West Bristol, Pennsylvania, 1958.

REFERENCES: McKearin and Wilson 1978, p. 543, GI-71.

G38*

Figured Flask

ca. 1846
Probably Baltimore Glass Works (1800–1880), Maryland
Aquamarine colored nonlead glass; 6⅞ x 4¼ x 2⅞" (17.5 x 10.8 x 7.3 cm)
B.72.84

PROVENANCE: Probably purchased by Miss Hogg from Stephen Van Rensselaer, Peterborough, New Hampshire, 1927.

REFERENCES: McKearin and Wilson 1978, p. 543, GI-71.

WASHINGTON / EAGLE

G39*

Figured Flask

1840s
Possibly Baltimore Glass Works (1800–1880), Maryland, or Bridgeton Glass Works (1836–55), Bridgeton, New Jersey
Aquamarine colored nonlead glass; 8¼ x 5⅝ x 3¾" (21 x 14.3 x 9.5 cm)
B.58.42

PROVENANCE: See cat. no. G32.

REFERENCES: McKearin and Wilson 1978, p. 529, GI-26.

G40*

Figured Flask

1840s
Possibly Baltimore Glass Works (1800–1880), Maryland, or Bridgeton Glass Works (1836–55), Bridgeton, New Jersey
Aquamarine colored nonlead glass; 8⅛ x 3⅝ x 5¾" (20.6 x 9.2 x 14.6 cm)
B.72.59

PROVENANCE: Possibly purchased by Miss Hogg from McKearins' Antiques, Hoosick Falls, New York, 1954.

REFERENCES: McKearin and Wilson 1978, p. 529, GI-26.

"WASHINGTON" / "JACKSON"

G41*

Figured Flask

1832
Keene-Marlboro Street Glass Works (1815–41), Keene, New Hampshire
Amber or deep gold-brown colored nonlead glass; 7 x 4⅜ x 2¾" (17.8 x 11.1 x 7 cm)
B.72.69

PROVENANCE: See cat. no. G29.

REFERENCES: McKearin and Wilson 1978, p. 531, GI-31.

G42*

Figured Flask

1832
Keene-Marlboro Street Glass Works (1815–41), Keene, New Hampshire
Amber-olive colored nonlead glass; 6⅝ x 4½ x 2⅝" (16.8 x 11.4 x 6.7 cm)
B.58.37

PROVENANCE: Purchased by Miss Hogg from Sam Laidacker, West Bristol, Pennsylvania, 1958.

REFERENCES: McKearin and Wilson 1978, p. 531, GI-31.

"WASHINGTON" / TAYLOR

G43*

Figured Flask

ca. 1828
Bridgeton Glass Works (1836–55), Bridgeton, New Jersey
Aquamarine colored nonlead glass; 6⅝ x 4½ x 2¾" (16.8 x 11.4 x 7 cm)
B.72.55

PROVENANCE: See cat. no. G36.

REFERENCES: McKearin and Wilson 1978, p. 529, GI-24.

G44★

Figured Flask

ca. 1828
Bridgeton Glass Works (1836–55), Bridgeton,
New Jersey
Aquamarine colored nonlead glass; 6⅞ x 4½ x
2¾" (17.5 x 11.4 x 7 cm)
B.72.64

PROVENANCE: See cat. no. G37.

REFERENCES: McKearin and Wilson 1978,
p. 529, GI-24.

"THE FATHER OF HIS
COUNTRY" / "I HAVE
ENDEAVOR,D TO DO MY
DUTY"

G45★

Figured Flask

ca. 1848
Probably Dyottville Glass Works (1842–ca. 1860),
Philadelphia
Sapphire-blue colored nonlead glass; 7 x 4¾ x
2⅜" (17.8 x 12.1 x 6 cm)
B.72.74

PROVENANCE: See cat. no. G29.

REFERENCES: McKearin and Wilson 1978,
p. 535, GI-44.

"THE FATHER OF HIS
COUNTRY" / "A LITTLE MORE
GRAPE CAPTAIN BRAGG"

G46★

Figured Flask

ca. 1848
Probably Dyottville Glass Works (1842–ca. 1860),
Philadelphia
Aquamarine colored nonlead glass; 8¼ x 5⅝ x
3⅜" (21 x 14.3 x 8.6 cm)
B.72.58

PROVENANCE: Unknown.

REFERENCES: McKearin and Wilson 1978,
p. 534, GI-42.

G47★

Figured Flask

ca. 1848
Probably Dyottville Glass Works (1842–ca. 1860),
Philadelphia
Sapphire-blue colored nonlead glass; 8⅛ x 5⅝ x
3⅜" (20.6 x 14.3 x 8.6 cm)
B.69.442

PROVENANCE: Purchased by Miss Hogg from
C. W. Lyon, New York, 1948.

REFERENCES: McKearin and Wilson 1978,
p. 534, GI-42.

G48★

Figured Flask

ca. 1848
Probably Dyottville Glass Works (1842–ca. 1860),
Philadelphia
Aquamarine colored nonlead glass; 8¾ x 5⅝ x
3¼" (22.2 x 14.3 x 8.3 cm)
B.58.56

PROVENANCE: See cat. no. G25.

REFERENCES: McKearin and Wilson 1978,
p. 534, GI-42.

G49★

Figured Flask

ca. 1848
Probably Dyottville Glass Works (1842–ca. 1860),
Philadelphia
Aquamarine colored nonlead glass; 8⁹⁄₁₆ x 5⅝ x
3⅜" (21.7 x 14.3 x 8.6 cm)
B.72.71

PROVENANCE: Purchased by Miss Hogg from
Arthur J. Sussel, Philadelphia, 1956.

REFERENCES: McKearin and Wilson 1978,
p. 534, GI-42.

"THE FATHER OF HIS
COUNTRY" / "GEN. TAYLOR
NEVER SURRENDERS"

G50★

Figured Flask

ca. 1848
Probably Dyottville Glass Works (1842–ca. 1860),
Philadelphia

Aquamarine colored nonlead glass; 6 x 3⅞ x 2"
(15.2 x 9.8 x 5.1 cm)
B.72.54

PROVENANCE: Unknown.

REFERENCES: McKearin and Wilson 1978,
p. 534, GI-40.

G51★

Figured Flask

ca. 1848
Probably Dyottville Glass Works (1842–ca. 1860),
Philadelphia
Aquamarine colored nonlead glass; 5⅝ x 3¾ x
1⅞" (14.3 x 9.5 x 4.8 cm)
B.72.79

PROVENANCE: Unknown.

REFERENCES: McKearin and Wilson 1978,
p. 534, GI-41.

G52★

Figured Flask

ca. 1847
Dyottville Glass Works (1842–ca. 1860),
Philadelphia
Blue colored nonlead glass; 8⅛ x 5⅝ x 3¼"
(20.6 x 14.3 x 8.3 cm)
B.58.55

PROVENANCE: William Wanamaker, Jr., Col-
lection; purchased by Miss Hogg from Sam
Laidacker, West Bristol, Pennsylvania, 1958.

REFERENCES: McKearin and Wilson 1978,
p. 533, GI-37; Warren 1988, p. 53.

G53★

Figured Flask

ca. 1847
Dyottville Glass Works (1842–ca. 1860),
Philadelphia
Amber colored nonlead glass; 8½ x 5⅞ x 2⅞"
(21.6 x 14.9 x 7.3 cm)
B.72.72

PROVENANCE: Probably purchased by Miss
Hogg from Stephen Van Rensselaer, Peterbor-
ough, New Hampshire, 1927.

REFERENCES: McKearin and Wilson 1978,
p. 532, GI-37.

G54*

Figured Flask

ca. 1847
Dyottville Glass Works (1842–ca. 1860),
Philadelphia
Aquamarine colored nonlead glass; 8¼ x 5⅝ x
3¼″ (21 x 14.3 x 8.3 cm)
B.72.82

PROVENANCE: Unknown.

REFERENCES: McKearin and Wilson 1978,
p. 532, GI-37.

G55*

Figured Flask

ca. 1847
Dyottville Glass Works (1842–ca. 1860),
Philadelphia
Aquamarine colored nonlead glass; 8¼ x 5⅝ x
3¼″ (21 x 14.3 x 8.3 cm); 8½ x 5⅝ x 3″ (21.6 x
14.3 x 7.6 cm)
B.72.78

PROVENANCE: Unknown.

REFERENCES: McKearin and Wilson 1978,
p. 532, GI-37.

G56*

Figured Flask

ca. 1847
Dyottville Glass Works (1842–ca. 1860),
Pennsylvania
Clear green colored nonlead glass; 6⅞ x 4¾ x
2⅜″ (17.5 x 12.1 x 6 cm)
B.72.63

PROVENANCE: See cat no. G32.

REFERENCES: McKearin and Wilson 1978,
p. 532, GI-37.

G57*

Figured Flask

ca. 1847
Dyottville Glass Works (1842–ca. 1860),
Philadelphia
Yellow-green colored nonlead glass; 8½ x 5¾ x 3″
(21.6 x 14.6 x 7.6 cm)
B.72.46

PROVENANCE: Unknown.

REFERENCES: McKearin and Wilson 1978,
p. 532, GI-37.

G58*

Figured Flask

ca. 1847
Dyottville Glass Works (1842–ca. 1860),
Philadelphia
Amber colored nonlead glass; 8½ x 5⅝ x 2⅞″
(21.6 x 14.3 x 7.3 cm)
B.72.73

PROVENANCE: See cat. no. G32.

REFERENCES: McKearin and Wilson 1978,
p. 532, GI-37.

"WASHINGTON"/ "GEN. Z. TAYLOR"

G59*

Figured Flask

ca. 1847
Dyottville Glass Works type, Philadelphia
Aquamarine colored nonlead glass; 6⅞ x 4¹¹⁄₁₆ x
2⅝″ (17.5 x 11.9 x 6.7 cm)
B.58.50

PROVENANCE: See cat. no. G20.

REFERENCES: McKearin and Wilson 1978,
p. 536, GI-49.

WASHINGTON/TAYLOR

G60*

Figured Flask

ca. 1847
Dyottville Glass Works type, Philadelphia
Deep green colored nonlead glass; 8¾ x 5⅝ x 3¼″
(22.2 x 14.3 x 8.3 cm)
B.72.68

PROVENANCE: See cat. no. G29.

REFERENCES: McKearin and Wilson 1978,
p. 537, GI-54.

G61*

Figured Flask

ca. 1847
Dyottville Glass Works type, Philadelphia
Clear green colored nonlead glass; 8½ x 5¾ x 3⅜″
(21.6 x 14.6 x 8.6 cm)
B.72.66

PROVENANCE: Unknown.

REFERENCES: McKearin and Wilson 1978,
p. 537, GI-51.

"JENY. LIND"

G62*

Figured Flask

ca. 1850 or 1851
Whitney Glass Co. (1834–57), Glassboro,
New Jersey
Aquamarine colored nonlead glass; 9⅞ x 5⅞ x
4¾″ (25.1 x 14.9 x 12.1 cm)
Gift of Mr. and Mrs. George F. Murphy, III,
B.74.29

PROVENANCE: Unknown.

REFERENCES: McKearin and Wilson 1978,
p. 549, GI-103.

HUNTER/FISHERMAN

G63*

Figured Flask

late 1840s or early 1850s
United States
Clear aquamarine colored nonlead glass; 9¼ x
5½ x 4½″ (23.5 x 14 x 11.4 cm)
Gift of the estate of Miss Ima Hogg, B.79.167

PROVENANCE: Unknown.

REFERENCES: McKearin and Wilson 1978,
p. 657, GXIII-5.

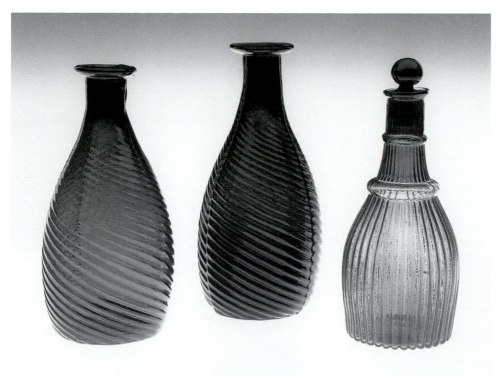

G65, G64, G66

G64

Toilet Water Bottle

1815–40
New England
Amethyst colored nonlead glass; 6³⁄₁₆ x 2⁷⁄₈″
(diam.) (15.7 x 7.3 cm)
B.69.489

PROVENANCE: Purchased by Miss Hogg at American Art Galleries, New York, *The Jacob Paxson Temple Collection: Two Hundred Years of Glasswork in America*, November 17, 1923, lot 655, through Wayman Adams.

TECHNICAL NOTES: Stopper missing.

DESCRIPTION: Patterned in a three-part mold, GI-3 Type 2 (McKearin and McKearin 1941, p. 247, pl. 84).

G65

Toilet Water Bottle

1815–40
New England
Sapphire-blue colored nonlead glass; 5¹³⁄₁₆ x 2⁷⁄₈″
(diam.) (14.8 x 7.3 cm)
B.69.472

PROVENANCE: Purchased by Miss Hogg from the Maple Antique Shop, Darien, Connecticut, 1927.

TECHNICAL NOTES: Stopper missing.

DESCRIPTION: Patterned in a three-part mold, GI-3 Type 2 (McKearin and McKearin 1941, p. 247, pl. 84).

G66

Toilet Water Bottle

1825–40
New England
Sapphire-blue colored nonlead glass; (including stopper) 6¹⁄₁₆ x 2¹⁄₂″ (diam.) (15.4 x 6.4 cm)
B.69.478

PROVENANCE: Unknown (at Bayou Bend prior to 1965).[1]

TECHNICAL NOTES: Stopper replaced.

DESCRIPTION: Patterned in a three-part mold, GI-7 Type 4 (McKearin and McKearin 1941, p. 247, pl. 84).

RELATED EXAMPLES: Corning Museum of Glass, Corning, New York, straight ribbed and swirl ribbed (Wilson 1972, p. 269, fig. 223); Toledo, straight-ribbed examples (Wilson 1994, p. 231, nos. 273, 274); two examples at MMA (30.120.287 is straight ribbed and 1980.502.35 is swirled ribbed).

These examples represent a type of bottle for the storage of toilet water that became fashionable in the early nineteenth century. The form of cat. nos. G64 and G65, which are slightly earlier, may derive from the swirl-rib smelling salts or scent bottle popular in England and America in the eighteenth and nineteenth centuries.

1. Old number 27-1 indicates that this bottle may have been purchased by Miss Hogg in 1927.

G67–68★

Medicine Vials

1810–60
United States
Aquamarine colored nonlead glass; Each: 4⁵⁄₈ x ¹⁵⁄₁₆ x ¹⁵⁄₁₆″ (11.7 x .9 x .9 cm)
B.69.60–.61

PROVENANCE: Unknown (at Bayou Bend prior to 1965).

DESCRIPTION: Blown, molded. Long rectangular form with short cylindrical neck and flanged long rim.

RELATED EXAMPLES: McKearin and McKearin 1941, pl. 242, no. 13.

G69★

Double Flask

ca. 1820–60
Possibly New Jersey
Light olive-green free-blown nonlead bottle glass; 10¹⁄₂ x 4⁵⁄₈ x 2¹⁄₂″ (26.7 x 11.7 x 6.4 cm)
B.69.447

PROVENANCE: Unknown (at Bayou Bend prior to 1933).

DESCRIPTION: Ovoid-shaped bodies of flattened dimension. Tapered toward the base with small circular foot. Rounded shoulders to straight-sided, cylindrical necks with plain rim. Decorated with applied rigaree and quilling bands.

RELATED EXAMPLES: McKearin and McKearin 1941, p. 433, pl. 229.

G70

Sugar Bowl Cover

1785–95
Attributed to New Bremen Glass Manufactory of John Frederick Amelung (1785–95), Frederick, Maryland

G70

Dark amethyst colored nonlead glass; 1⅝ x 4⁹⁄₁₆"
(diam.) (4.1 x 11.6 cm)
Museum purchase with funds provided by
various donors, B.85.11

The factory of John Frederick Amelung produced a variety of sample molded utilitarian wares (see cat. no. G1) and elaborately engraved pieces. While more recently used as a bowl, this object was originally the lid of a sugar bowl. The scar on its base indicates where the finial or handle was once attached. Even in its fragmentary state, the piece, with its fine rococo engraving and brilliant amethyst color, conveys a sense of the finest of the Amelung products.

PROVENANCE: Colonel M. Robert Guggenheim; Mrs. John A. Logan, Washington, D.C.; John Tiffany Gotjen; purchased by Bayou Bend from The Stradlings, New York, 1985.

DESCRIPTION: Free blown.

RELATED EXAMPLES: The famous CG presentation sugar bowl at Winterthur has similar color and rococo engraving on its lid (Palmer 1993, p. 199, no. 158); closely related engraving on a goblet at the Corning Museum of Glass, Corning, New York (Lanmon et al. 1990, p. 70, no. 13).

REFERENCES: Gotjen 1984; Lanmon et al. 1990, p. 104, no. 32.

G71

Sugar Bowl with Cover

1812–27
Attributed to Thomas Cains (1779–1865)[1]
South Boston Flint Glass Works or Phoenix
Glass Works, Boston
Colorless flint glass; 5⅞ x 5¹⁄₁₆" (diam.) (14.9 x 12.9 cm)

Museum purchase with funds provided by various donors in memory of Eveline Biehl, B.85.10

The salient feature of this sugar bowl is the chainlike applied ornament on the lid and body. A technique that dates back to antiquity, the effect is achieved by the application of two molten threads, which are then pinched at regular intervals to create the appearance of chain links. This method, which became fashionable in England in the late eighteenth century, is thought to have been brought to America by Thomas Cains, an English glassmaker who came to Boston in 1812. Attribution of glass with this sort of ornament is based on an example that descended in the family of the glassmaker.[2]

PROVENANCE: Purchased by Bayou Bend from W. M. Schwind, Jr., Antiques, Yarmouth, Maine, 1985.

DESCRIPTION: Applied chain decoration on the body and cover.

RELATED EXAMPLES: DAR Museum, Washington, D.C. (Garrett et al. 1985, p. 116, fig. 114); Old Sturbridge Village, Sturbridge, Massachusetts (Wilson 1972, p. 223, fig. 178); MMA (acc. no. 69.168); St. Louis Art Museum (acc.

no. 484:61); Currier Gallery of Art, Manchester, New Hampshire (Doty 1979, p. 136); McKearin and McKearin 1941, p. 55, no. 3; private collection. An engraved, footed sugar bowl made by Cains is at MMA (Davidson and Stillinger 1985, p. 262, no. 394).

REFERENCES: Advertisement of W. M. Schwind, *Antiques & The Arts Weekly* (May 3), 1985; Brown 1985, p. 522.

1. Cains was active at the South Boston Flint Glass Works from 1814–ca. 1819 and at the Phoenix Glass Works from 1819–52.
2. Wilson 1972, p. 214, fig. 163.

G72

Sugar Bowl

1820–50
New York or New Jersey
Aquamarine colored lead glass; 5⅜ x 4¹⁄₁₆"
(diam.) (13.7 x 10.3 cm)
B.69.487

This free-blown bowl is related to a group of mold-blown examples with a similar lid design. In the 1920s the molded group was ascribed to New York State's Mount Vernon Glass Works on the archaeological

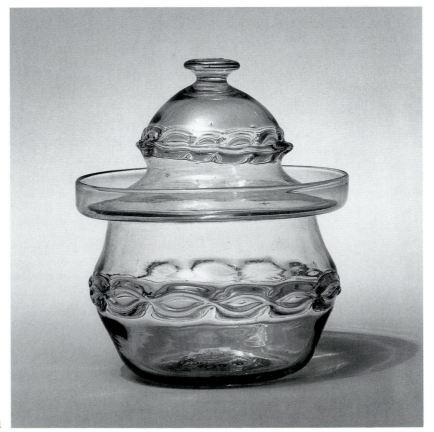

G71

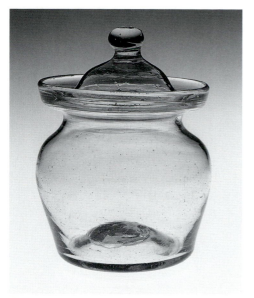

G72

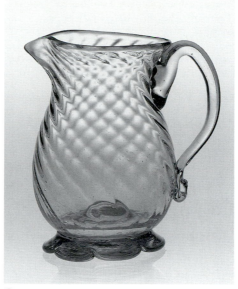

G73

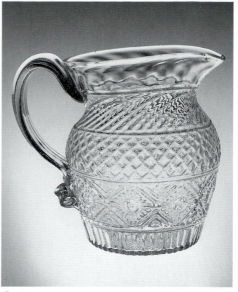

G74

evidence of molded shards found there.[1] That the telltale mold was not used here and the closeness of New York and New Jersey traditions necessitate a broader attribution for this bowl.

PROVENANCE: Purchased by Miss Hogg from George S. McKearin, New York, 1925.

DESCRIPTION: Free blown.

RELATED EXAMPLES: One of the molded examples is at Winterthur (Palmer 1993, p. 213, no. 174); McKearin and McKearin 1941, pl. 122, no. 7.

1. Palmer 1993, p. 213; McKearin, in a 1925 letter to Miss Hogg, ascribes the Bayou Bend piece to a factory near Saratoga founded by the Grangers who had worked earlier at Mount Vernon (Bayou Bend object files).

G73

Cream Jug

1800–40
United States
Light green colored nonlead glass; 4⅛ x 2¹¹⁄₁₆ x 3⅝″ (10.5 x 6.8 x 9.2 cm)
B.69.448

Small glass pouring vessels for cream were an important part of tea table equipment. Often the design echoed more expensive silver prototypes. This swirled pattern molded example represents the continuum of the Stiegel tradition into the early nineteenth century. The petal-like design of the foot is seen on both

Pennsylvania and Midwestern products, making a specific attribution difficult.

PROVENANCE: Unknown (at Bayou Bend prior to 1965).

DESCRIPTION: Twenty swirled ribs, applied double rib handle, applied petal foot.

RELATED EXAMPLES: McKearin and McKearin 1941, pl. 80, no. 15, is virtually identical and identified as Midwestern; for an early Pennsylvania or Maryland sugar bowl with a similar low flat version of the lobed foot (Palmer 1993, p. 194, no. 153); a later Ohio pitcher has the higher version of the lobed foot (Palmer 1993, p. 162, no. 120).

G74

Cream Jug

1820–40
New England
Colorless lead glass; 4⅛ x 3¼ x 4½″ (10.5 x 8.3 x 11.4 cm)
B.69.468

PROVENANCE: Purchased by Miss Hogg at American Art Galleries, New York, *The Jacob Paxson Temple Collection: Two Hundred Years of Glasswork in America*, November 17, 1923, lot 683, through Wayman Adams.

DESCRIPTION: Patterned in a three-part mold, GIII-24 (McKearin and McKearin 1941, p. 256); rayed base type, VIIA (McKearin and McKearin 1941, p. 256).

RELATED EXAMPLES: Toledo (Wilson 1994, p. 224, no. 254); Winterthur (Palmer 1993, p. 168, no. 127).

G75★

Cream Jug

1820–50
Ohio
Light smoky amethyst colored nonlead glass; 4¾ x 2⅞ x 4¼″ (12.1 x 7.3 x 10.8 cm)
B.69.488

PROVENANCE: Unknown (at Bayou Bend prior to 1965).

DESCRIPTION: Free blown. Tooled rim. Applied handle with tooled, leafy terminal.

G76

Cream Jug

1825–40
Possibly Boston and Sandwich Glass Works (1825–88), Sandwich, Massachusetts
Purple-blue colored lead glass; 4⅜ x 3 x 4⅛″ (11.1 x 7.6 x 10.5 cm)
B.69.477

This cream jug varies from most pattern molded examples, which usually have flat bottoms rather than a flared foot (see cat. no. G74). Fragments of cream jugs and small decanters with this unusual pattern have been found at the Boston and Sandwich site.[1]

PROVENANCE: See cat. no. G72.

DESCRIPTION: Ringed type III base (McKearin and McKearin 1941, p. 261). Applied solid handle. Similar to GIII-26 (McKearin and McKearin 1941, p. 256).

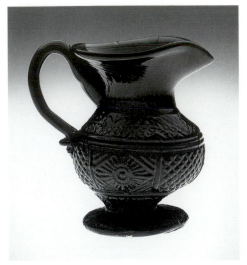

G76

RELATED EXAMPLES: An identical one at Toledo (Wilson 1994, p. 224, no. 255).

1. Wilson 1994, p. 224.

G77

Cream Jug

1830–60
United States
Light green colored nonlead bottle glass;
4½ x 3⅛ x 4" (11.4 x 7.9 x 10.2 cm)
B.69.458

This free-blown cream jug with applied thread decoration at the neck represents the type of glass long associated with New Jersey and described by early collectors as Wistarburg. However, it is now known that this style of glass was also made in New York, New England, and in the Midwest.

PROVENANCE: Purchased by Miss Hogg at American Art Galleries, New York, *The Jacob*

Paxson Temple Collection: Two Hundred Years of Glasswork in America, November 17, 1923, lot 574, through Wayman Adams.

DESCRIPTION: Free blown. Applied solid loop handle. Threaded neck.

RELATED EXAMPLES: Winterthur (Palmer 1993, p. 174, no. 136).

G78

Cream Jug

1840–60
Probably Pennsylvania
Light aquamarine colored nonlead bottle glass;
4³⁄₁₆ x 3⅜ x 4⅜" (10.6 x 8.6 x 11.1 cm)
B.69.461

The globular body and visually low center of gravity of this free-blown pitcher are nicely balanced by the bold loop handle and flared lip.

PROVENANCE: Purchased by Miss Hogg from E. R. Guerin, Simcoak, New Hampshire.[1]

DESCRIPTION: Free blown.

1. While the date of acquisition is unknown, the old number 119 suggests that it was at Bayou Bend prior to the 1933 inventory.

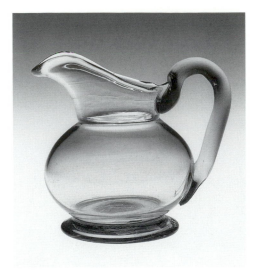

G78

G79

Pitcher

1830–50
Probably New Jersey
Deep amber colored nonlead glass; 8⅞ x 4⁹⁄₁₆ x 6⅝" (22.5 x 11.6 x 16.8 cm)
B.69.466

This pitcher, made of relatively thick glass, was obviously utilitarian. However, the classically inspired helmet shape lends an attractive element of style.

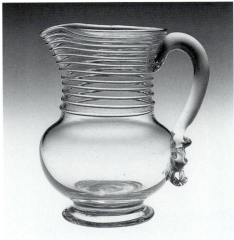

G77

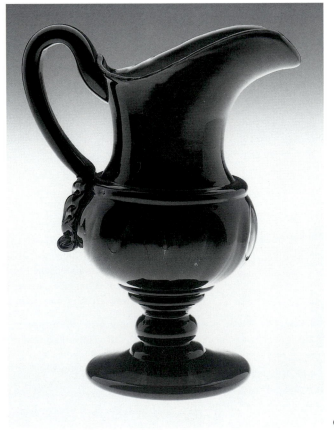

G79

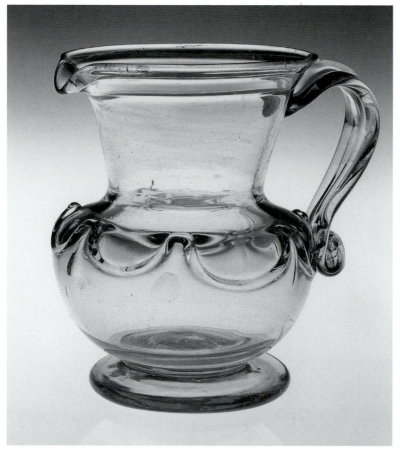

G80

RELATED EXAMPLES: Winterthur (Palmer 1993, p. 176, nos. 138–42); Toledo (Wilson 1994, pp. 142–44, nos. 124–28).

1. Possibly purchased in the 1920s as an old number (210) suggests it was at Bayou Bend prior to the 1933 inventory.

G81

Pitcher

1840–65
New York or Pennsylvania
Light green colored nonlead bottle glass; 6½ x 5¹¹/₁₆ x 7″ (16.5 x 14.4 x 17.8 cm)
B.69.62

PROVENANCE: Unknown (at Bayou Bend prior to 1933).

DESCRIPTION: Free-blown globular body with rounded shoulders to a broad cylindrical neck. Narrow flaring rim and tiny pinched lip. Applied solid loop handle.

G82–83

Pitcher, Covered Butter Dish, and Celery Vase

ca. 1876–85
Gillinder and Sons (1867–1900), Philadelphia
Colorless pressed glass; B.86.11.1 (pitcher): 9⁷/₁₆ x 5¼ x 9¼″ (24 x 13.3 x 23.5 cm); B.86.11.2 (covered butter dish): 8¾ x 7⅛″ (diam.) (22.2 x 18.1 cm); B.85.9 (celery vase): 8⅝ x 3¹⁵/₁₆″ (diam.) (21.9 x 10 cm)
Gift of Mr. and Mrs. Oscar Glenn, B.86.11.1–.2
Gift of Alice C. Simkins, B.85.9

This glass, a pattern today called Westward Ho but named Pioneer by its maker, was apparently produced at the time of the Centennial. The buffalo, deer, and log cabins decorating the body are complemented by the kneeling Native American who forms the handle of the butter dish, making a subliminal salute to the nation's westward expansion and manifest destiny. The frosted matte surface was made with an acid etching process introduced about 1870. The floral ornament on the upper section of the celery vase is unusual.

PROVENANCE: **B.86.11.1–.2**, Mr. and Mrs. Oscar Glenn; **B.85.9**, Mrs. Michael (Alice

PROVENANCE: Purchased by Miss Hogg at American Art Galleries, New York, *The Jacob Paxson Temple Collection: Two Hundred Years of Glasswork in America*, November 17, 1923, lot 591, through Wayman Adams.

DESCRIPTION: Free blown.

RELATED EXAMPLES: A very similar pitcher, with a slightly different design to the stem, at the Detroit Institute of Arts (McKearin and McKearin 1941, pl. 16, no. 3).

REFERENCES: Riefstahl 1923, illustrated on p. 9, as Wistarburg and noted as collection of Jacob Paxson Temple.

G80

Pitcher

1835–65
Probably New York or New Jersey
Aquamarine colored nonlead bottle glass; 7 x 5⁷/₁₆ x 6⅞″ (17.8 x 13.8 x 17.5 cm)
B.69.462

In the early nineteenth century, it became more commonplace for Americans to consume water with meals. As a result, large glass pitchers became a prevalent form. This pitcher is ornamented on the

lower body with a second gather of glass that has been manipulated into seven vertical peaks. In the early twentieth century, this type of ornament was dubbed "Lily Pad" and was commonly thought to have been made only in southern New Jersey. However, it is now known that this decoration was also used in New York and New England.

PROVENANCE: Unknown.[1]

DESCRIPTION: Free blown.

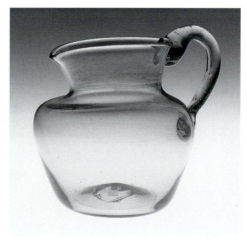

G81

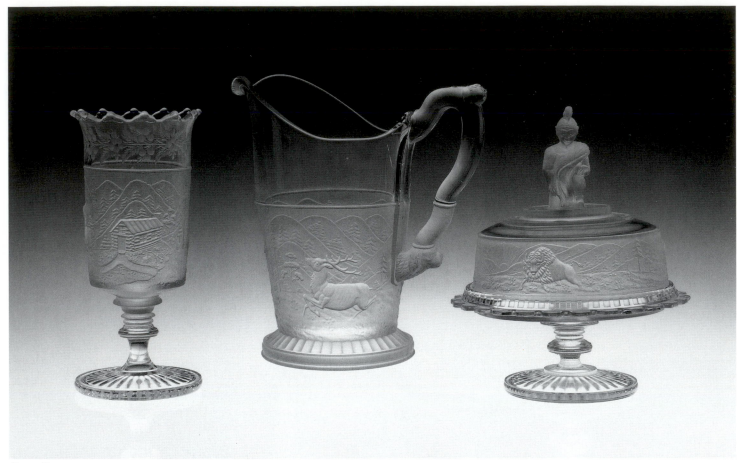

G83, G82

Nicholson) Hogg (later Mrs. Harry Hanszen); Alice C. Simkins (niece).

RELATED EXAMPLES: Corning Museum of Glass, Corning, New York (Spillman 1981, p. 280, nos. 1102, 1103); Toledo (Wilson 1994, p. 504, nos. 839, 840); a sugar bowl with the same pattern at MMA (acc. no. 1991.26.4).

G84

Decanter

1815–30
Probably Keene-Marlboro Street Glass Works (1815–41), Keene, New Hampshire
Olive-amber colored nonlead glass; 7 x 3¹³/₁₆"
(diam.) (17.8 x 9.7 cm)
B.69.453

PROVENANCE: Unknown (at Bayou Bend prior to 1965).

DESCRIPTION: Patterned in a three-part mold, GIII-16 (McKearin and McKearin 1941, p. 255); base pattern, VIIA (McKearin and McKearin 1941, p. 261); bull's-eye sunburst motif (McKearin and McKearin 1941, p. 263, fig. 5).

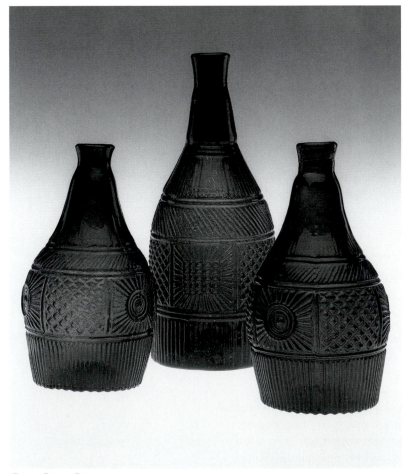

G85, G86, G84

G85

Decanter

1815–30
Probably Keene-Marlboro Street Glass Works
(1815–41), Keene, New Hampshire
Olive-green colored nonlead glass; 6⅞ x 3¹³/₁₆"
(17.5 x 9.7 cm)
B.69.456

PROVENANCE: Unknown (at Bayou Bend prior to 1965).

DESCRIPTION: Patterned in a three-part mold, GIII-16 (McKearin and McKearin 1941, p. 255); base pattern, VIIA (McKearin and McKearin 1941, p. 261); bull's-eye sunburst motif (McKearin and McKearin 1941, p. 263, fig. 5).

RELATED EXAMPLES: Wilson 1972, p. 166, fig. 125; McKearin and McKearin 1941, p. 255, pattern GIII-16, p. 261, pl. 100, fig. 32, p. 263, pl. 101, fig. 5.

G86

Decanter

1820–40
Keene-Marlboro Street Glass Works (1815–41),
Keene, New Hampshire
Olive-green colored nonlead glass; 9½ x 4⅛"
(diam.) (24.1 x 10.5 cm)
B.69.455

PROVENANCE: Unknown (at Bayou Bend prior to 1965).

DESCRIPTION: Patterned in a three-part mold, GIII-16 (McKearin and McKearin 1941, p. 255); rayed type VIIA truncated base (McKearin and McKearin 1941, p. 261); bull's-eye sunburst motif (McKearin and McKearin 1941, p. 263, fig. 5).

RELATED EXAMPLES: Toledo (Wilson 1994, p. 221, no. 245).

The earliest of the six bottle glass houses operating in New Hampshire between 1815 and 1880 was established at Keene in 1815. These decanters were made with a patterned, three-part mold, with which, in an inexpensive and quick way, it was possible to produce a bottle whose surface resembled expensive hand-cut glass. Decanters were produced in large quantities at Keene; these examples are made in

a distinctive pattern attributed to that glass house.[1]

1. McKearin and McKearin 1941, p. 296; Wilson 1972, p. 166.

G87–88*

Decanters and Stoppers

1820–40
Probably New England
Colorless nonlead glass; B.68.35: 10¼ x 4⅝"
(diam.) (26 x 11.7 cm); B.69.159: 10½ x 4⅝"
(diam.) (26.7 x 11.7 cm)
B.68.35, B.69.159

PROVENANCE: Unknown.

DESCRIPTION: Diamond molded. Patterned in a three-part mold, GII-18 (McKearin and McKearin 1941, p. 251). Triple ring collar with each ring composed of double mill bands. Base pattern Diamond Type XII (McKearin and McKearin 1941, p. 261, no. 16). Hand-pressed stoppers (McKearin and McKearin 1941, p. 273, no. 23).

RELATED EXAMPLES: Toledo (Wilson 1994, p. 217, no. 233).

G89

Decanter with Handle and Stopper

1825–40
Eastern United States
Colorless lead glass; 11¼ x 4¾ x 6" (28.6 x 12.1 x
15.2 cm)
Gift of Helen York, B.91.19

This decanter is unusual in that it has been made with a lip for pouring and a bold handle, much in the style of a large cruet. It is beautifully cut in a pattern commonly called Sheaf of Wheat. Although it had been thought earlier that this pattern was indicative of a Pittsburgh origin, there is contemporary evidence that the pattern was widely used.[1] That it was also found on pattern molded glass is indicative of its popularity. Indeed, the motif does resemble sheaves of wheat, but there is also a strong visual relationship with the Gothic Revival style of a group of Baltimore chairs (cat. no. F202). The uncut voids read as Gothic arches, while the cut crosshatched lower section

topped by horizontal lines could be seen as a pillar and cap, and the spreading lines above resemble Gothic vaulting. The Gothic motifs and the paneled treatment of the central part of the body may suggest a date closer to the middle of the century.

PROVENANCE: Helen York, Houston.

TECHNICAL NOTES: Repair to neck above juncture with handle.

DESCRIPTION: Horizontal cuts on the upper half including the spout. The lower portion and stopper are cut in the Sheaf of Wheat pattern. Uncut applied handle and starburst carving on underside.

RELATED EXAMPLES: For examples cut with the Sheaf of Wheat pattern attributed to Pittsburgh, see Innes 1976, figs. 112, 113; for related pattern molded glass from New England, see Wilson 1972, figs. 205, 227; see McKearin Pattern GIV-3 (McKearin and McKearin 1941, p. 257); for a paneled mid-century cut glass decanter, see Innes 1976, fig. 106.

1. Telephone conversation, May 18, 1995, with Arlene Palmer Schwind, who has found references in her research from Baltimore up the coast to New York.

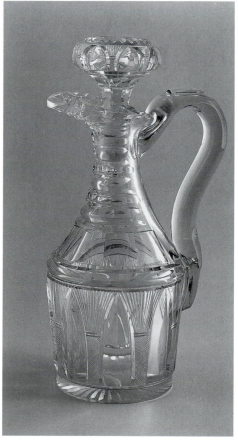

G89

G90

Footed Decanter and Stopper

1825–40
Eastern United States
Colorless lead glass; 10⅞ x 5″ (diam.)
(27.6 x 12.7 cm)
Museum purchase with anonymous funds donated in honor of Mr. and Mrs. Fred T. Couper, Jr., B.93.4

While cut glass decanters of this type with a footed, pear-shaped body, ringed neck, and globular stopper have been ascribed to Pittsburgh on the basis of a documented presentation piece, it is likely that this popular form was also made in other glass factories. Similarly the strawberry diamond and blaze motif was widely used, making specific attribution difficult.

PROVENANCE: Purchased by Bayou Bend from The Stradlings, New York, 1993.

DESCRIPTION: Body cut with band of strawberry diamonds with a blaze above and a band of half strawberry diamonds below. Stopper similarly engraved. Band of flat panels at shoulder. Bottom plain.

G91

RELATED EXAMPLES: For another with strawberry diamonds, see Spillman 1982, no. 106; one at the Corning Museum of Glass, Corning, New York, with similar but not identical cut ornament (Innes 1976, p. 138, fig. 92); Toledo (Wilson 1994, p. 199, fig. 193); MMA (Davidson and Stillinger 1985, p. 253, fig. 381); for one in the comet pattern and discussion about other sources making the form, see Palmer 1993, p. 138, no. 93.

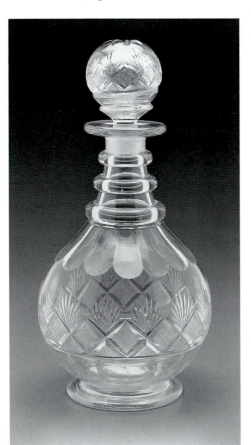
G90

G91

Punch Bowl

1820–40
New England
Colorless lead glass; 5⅝ x 9⅛″ (diam.)
(14.3 x 23.2 cm)
Museum purchase with funds provided by an anonymous donor in honor of William James Hill at "One Great Night in November, 1993," B.93.16

Blown three-mold glass, as its name implies, was made by a process in which molten glass was introduced into a three-part mold that imparted its distinctive

pattern to the glass. The glass-blower then inflated the molded gather of glass to the desired shape and size. The design of the present example was an attempt to emulate the faceted surfaces of more expensive Anglo-Irish style cut glass. The size and shape of this bowl suggest that it was intended to function as a punch bowl, yet there is no contemporary mention of molded punch bowls in either advertisements or glass house lists, a fact that suggests that this was not a common form.

PROVENANCE: Alberta Rogers Patterson, Slippery Rock, Pennsylvania; Garth's Auctions, Delaware, Ohio, *Sale of American Bottles and Blown Glass—The Collection of Alberta Rogers Patterson*, September 17–18, 1993, lot 53; [W. M. Schwind, Jr., Antiques, Yarmouth, Maine]; purchased by Bayou Bend from W. M. Schwind, 1993.

DESCRIPTION: Patterned in a three-part mold, GII-18 (McKearin and McKearin 1941, p. 251). Applied foot and folded rim. Vertical fluting above and below wide band of diamond diapering.

RELATED EXAMPLES: Two similar punch bowls with a different pattern are at Winterthur (Palmer 1993, p. 184, no. 147, who also cites the absence of contemporary reference to the form).

G92*

Bowl

1875–1900
Probably New York State
Amber-orange colored lead glass; 3¼ x 6½"
(diam.) (8.3 x 16.5 cm)
B.69.485

PROVENANCE: Louis Guerineau Myers;
purchased by Miss Hogg from George S.
McKearin, New York, 1925.

G93

Tumbler

ca. 1825–30
Bakewell, Page, and Bakewell (1824–32),
Pittsburgh
Colorless lead glass; 3⅜ x 2¹³⁄₁₆" (diam.)
(8.6 x 7.1 cm)
Museum purchase with funds provided by the
Houston Junior Woman's Club in memory of
Suzie Handal, B.86.14

It is rare that a piece of early American
cut glass can be ascribed with certainty
to a specific factory. Two contemporary
documents, one of which discusses Bake-
well's factory and describes a tumbler
with an engraved greyhound, and the
other that states a tumbler (with an en-
graved greyhound) was purchased by the
writer at the Bakewell factory, confirm
the origin of the Bayou Bend piece.[1]

To date, six tumblers ornamented with en-
graved greyhounds are known. Although
they vary in the fluted and cut diamond
decorations, the tumblers clearly relate to
each other and to other pieces attributed
to Bakewell. As two of the greyhound
tumblers are documented gifts, it is possi-
ble that they were not produced in large
sets but were intended to be presentation
pieces.[2] The iconography of fidelity, the
greyhound, and love, the hearts and the
altar, further suggests that these tumblers
represented tokens of friendship.

PROVENANCE: Purchased by Bayou Bend
from The Stradlings, New York, 1986.

DESCRIPTION: Engraved with greyhound,
two flaming hearts on an altar, flowers, and
other symbols of friendship and devotion,
with a reserve intended for a name or initials.

RELATED EXAMPLES: Winterthur (Palmer
1993, no. 60); two at The Historical Society of
Western Pennsylvania, Pittsburgh (Innes 1976,
p. 116, fig. 65); PMA (Innes 1976, p. 122, fig. 72);
MMA (acc. no. 1982.216); private collection
(Innes 1976, p. 119, fig. 68); an engraved tum-
bler, presented in 1825 to De Witt Clinton, has
similar fine-cut diamond ornament (Innes
1976, p. 132, fig. 84).

1. Description of Anne Royall of her 1829
 travels in America (Innes 1976, p. 118); 1821
 letter from Antoinette Brevost to Victorine
 du Pont Bauduy (Palmer 1993, p. 107).
2. Victorine Bauduy's tumbler, now at
 Winterthur, was a gift from her friend
 Antoinette Brevost; one at The Historical
 Society of Western Pennsylvania has a

tradition of being given by Benjamin
Bakewell to William Reynolds of Meadville,
Pennsylvania; the De Witt Clinton tumbler
was presented to celebrate his 1825 visit
to Pittsburgh.

G94

Tumbler

ca. 1825
Bakewell, Page, and Bakewell (1824–32),
Pittsburgh
Colorless lead glass and white clay; 3⅛ x 2¹⁵⁄₁₆"
(7.9 x 7.5 cm)
Museum purchase with funds provided by
Mrs. William S. Kilroy in honor of William S.
Kilroy's birthday, B.93.18

As with cat. no. G93, the attribution of
this cut tumbler with a sulfide likeness of
George Washington inset into its bottom

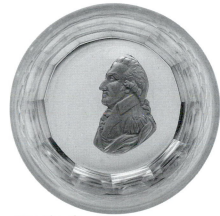

G94 (detail)

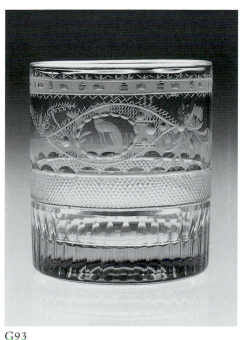

G93

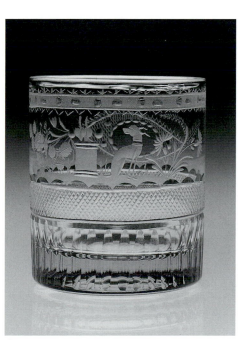

G93

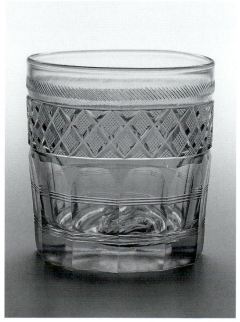

G94

is secure. It is documented to Pittsburgh and the Bakewell factory by two contemporary references. One, in an 1825 issue of a Baltimore newspaper, is a description of a display of cut glass tumblers with likenesses of notable Americans made by Bakewell, Page, and Bakewell; the other is an 1825 Philadelphia auction notice for cut glass tumblers with medallion likenesses of Washington and others.[1] Neoclassical white clay medallions imbedded into glass, today commonly called sulfides, came into fashion in Europe in the early nineteenth century and in America were first made in Pittsburgh.[2] As these sulfide ornamented tumblers can be documented as being on public display and offered at auction, it is less likely that they were intended to be presentation pieces.

PROVENANCE: Alberta Rogers Patterson, Slippery Rock, Pennsylvania; Garth's Auctions, Delaware, Ohio, *Sale of American Bottles and Blown Glass—The Collection of Alberta Rogers Patterson*, September 17–18, 1993, lot 159; [W. M. Schwind, Jr., Antiques, Yarmouth, Maine]; purchased by Bayou Bend 1993 from W. M. Schwind, 1993.

DESCRIPTION: Crizzled. Blown. Cylindrical form with thick base and polished bottom. Cut decoration of strawberry diamonds set off with horizontal rings from short blaze cuts above and wide panels below. A sulfide profile portrait of George Washington embedded in base.

RELATED EXAMPLES: Winterthur (Palmer 1993, p. 110, no. 65); DAR Museum, Washington, D.C., with a history of ownership by revolutionary era Delaware hero, Caesar Rodney (acc. no. 1916); (Innes 1976, p. 132, figs. 85, 86); MMA (Davidson 1980, p. 46), with a sulfide portrait of Lafayette.

1. Palmer 1993, p. 110.
2. Ibid., p. 110.

G95
Set of Six Wine Glasses

ca. 1825–32
Possibly Bakewell, Page, and Bakewell (1824–32), Pittsburgh
Colorless lead glass; Each: 4¼ x 2½″ (diam.) (10.8 x 6.4 cm)
Museum purchase with funds provided by Mrs. Harry H. Cullen in honor of Mrs. Joseph D. Jamail, B.95.11.1–.6

These wine glasses, with their Gothic arches in the so-called Sheaf of Wheat pattern, relate to a decanter also at Bayou Bend (cat. no. G89). However, distinguished ornamental details, such as the horizontal rings and faceted base of the bowl and particularly the faceted knop on the stem, elevate these glasses to the most expensive "rich cut" or "best cut" category.

PROVENANCE: Purchased by Bayou Bend from W. M. Schwind, Jr., Yarmouth, Maine, 1995.

DESCRIPTION: Tapering bowl blown and finished by tooling. Applied tooled stem with faceted medial knop. Applied tooled foot cut with sixteen-pointed star on underside. Bowl cut with three plain and three faceted Gothic arches with Sheaf of Wheat cutting in the spandrels. Horizontal banding above and below and faceted cutting around base.

RELATED EXAMPLES: Wine glasses with similarly faceted medial knops are associated with Bakewell, Page, and Bakewell. One at The Historical Society of Pennsylvania, Philadelphia, descended in the family of Frederick Graff.[1] Similar glasses, at The Hermitage, Nashville, Tennessee, are thought to be those ordered by Andrew Jackson from Bakewell, Page, and Bakewell in 1832.[2] Both the Pennsylvania and Hermitage wine glass models differ, however, in that the basic shape of the bowl has straight rather than tapered sides (Palmer 1990). A wine glass with a similar shaped bowl and Gothic ornament but with an unfaceted medial knop is at the Currier Gallery of Art, Manchester, New Hampshire (Innes 1976, p. 150, fig. 113).

1. Graff was the renowned waterworks engineer who worked with Benjamin Bakewell, chairman of the Pittsburgh Watering Committee. This wine glass as well as a decanter and tumbler are thought to be part of the glass presented to Graff by the Committee in 1828.

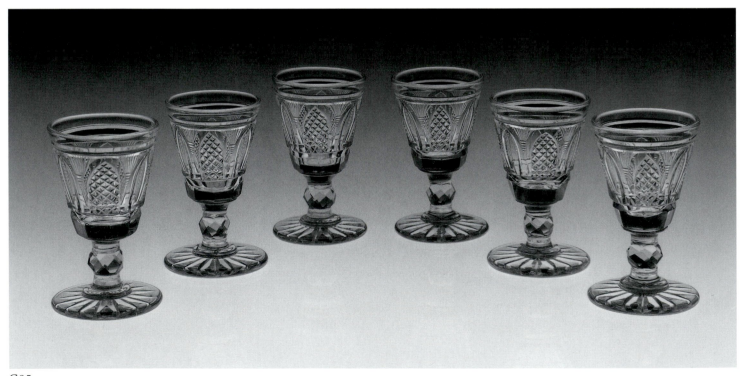

G95

2. Information on the Graff and Jackson glasses provided in a letter from Arlene Palmer Schwind, November 26, 1995 (Bayou Bend object files).

G96*

Goblets

1850–70
Probably New England Glass Company (1818–88), East Cambridge, Massachusetts
Clear flint glass; 6³/₁₆ x 3⁹/₁₆″ (diam.) (15.7 x 9 cm); B.69.58.2: 6³/₁₆ x 3¹/₂″ (diam.) (15.7 x 8.9 cm); B.69.58.3: 6¹/₈ x 3⁵/₈″ (diam.) (15.6 x 9.2 cm); B.69.58.5: 6 x 3¹/₂″ (diam.) (15.2 x 8.9 cm); B.69.58.6: 6 x 3⁵/₈″ (diam.) (15.2 x 9.2 cm)
B.69.58.1–.6

PROVENANCE: Purchased by Miss Hogg from George Abraham and Gilbert May Antiques, Granville, Massachusetts, 1963.

DESCRIPTION: Ashburton pattern.

G97

Compote

1830–45
Massachusetts
Yellow pressed lead glass; 6³/₈ x 10¹/₂ x 8³/₄″ (16.2 x 26.7 x 22.2 cm)
B.70.8

The process of making glass pressed by a machine mold was introduced in New England in the 1820s. With typical Yankee ingenuity, the new technology of concurrent shape and ornament enabled the rapid production of a wide variety of objects, often with interchangeable parts. The process could be done by relatively unskilled labor. The complex surface ornament of the pressed mold masked the inherent imperfections of the body that came with the process. This compote, or footed bowl, is made in two parts—the upper section, essentially the same pattern as the base of covered vegetable dishes, is joined to the somewhat plainer octagonal foot by a wafer. The pattern seen here takes its name from the stylized heart and scroll decoration, called princess feather, found on each of the short ends. The leafy scrolled, diapered reserves on the long sides hint at the Rococo revival, while the organic foot that

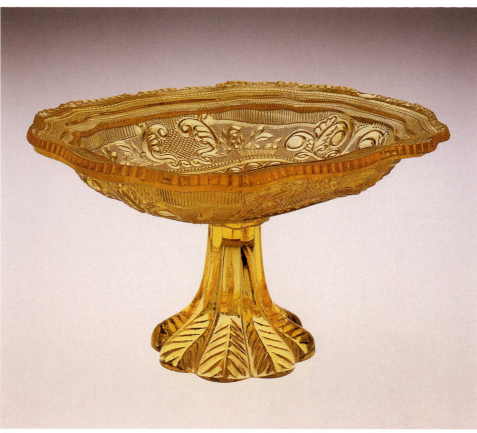

G97

sweeps up to the octagonal stem has Gothic overtones, an eclectic stylistic array that is characteristic of mid-nineteenth century.

PROVENANCE: Unknown (at Bayou Bend prior to 1965).

DESCRIPTION: Princess feather motif and basket of flowers alternating in design of bowl with sawtooth (ruffled) edge. Pedestal has eight fluted panels with leaf design.

RELATED EXAMPLES: The princess feather compote, made in yellow, amethyst, light blue, dark blue, and clear glass, is a relatively rare form of pressed glass (Lee 1947, p. 384); examples are at Winterthur (Palmer 1993, p. 243, no. 208); Corning Museum of Glass, Corning, New York (Spillman 1981, nos. 269–71); Toledo (Wilson 1994, p. 372, no. 502); Currier Gallery of Art, Manchester, New Hampshire (Doty 1979, p. 139); MMA (acc. no. 57.131.14).

G98

Salt

1815–45
New England
Clear glass; 2¹/₄ x 2¹/₂ x 2⁵/₈″ (5.7 x 6.4 x 6.7 cm)
B.69.505

For many years, small pattern molded beaver-style hats were considered to be whimsies. However, contemporary references identify their usage, describing them as hat salts.[1]

PROVENANCE: Unknown (at Bayou Bend prior to 1965).

DESCRIPTION: Patterned in a three-part mold, GII-18 (McKearin and McKearin 1941, p. 251); rayed Type 1 base (McKearin and McKearin 1941, p. 261).

RELATED EXAMPLES: Toledo (Wilson 1994, pp. 241–43, nos. 302–7); Winterthur (Palmer

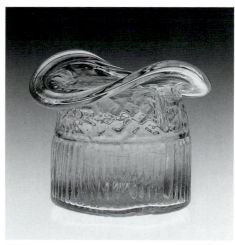

G98

1993, p. 263, no. 233); MMA (acc. nos. 1980.502.28, 13.1.14a).

1. Palmer 1993, p. 263.

G99

Salt

1825–40
Probably Boston and Sandwich Glass Works (1825–88), Sandwich, Massachusetts
Purple-blue colored lead glass; 2⅝ x 3″ (diam.) (6.7 x 7.6 cm)
B.69.493

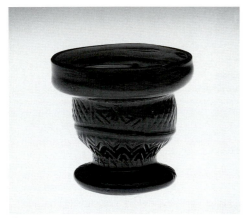

G99

While the pattern molded salt is a form that was made at a number of locations, fragments of this particular pattern, with its basket weave motif on the foot, have been found at the Boston and Sandwich factory site.

PROVENANCE: Purchased by Miss Hogg from George S. McKearin, New York, 1925.

DESCRIPTION: Patterned in a three-part mold, GIII-25 (McKearin and McKearin 1941, p. 256).

RELATED EXAMPLES: Toledo (Wilson 1994, p. 240, no. 301, which discusses this attribution based on fragments).

G100*

Salt

1830–50
Boston and Sandwich Glass Works (1825–88), Sandwich, Massachusetts
Opalescent white nonlead glass; 2⅛ x 3⅛ x 1⅞″ (5.4 x 7.9 x 4.8 cm)
Gift of the estate of Miss Ima Hogg, B.78.8

PROVENANCE: Unknown (at Bayou Bend prior to 1965).

DESCRIPTION: Basket of flowers and rosette pattern.

RELATED EXAMPLES: McKearin and McKearin 1941, pl. 169, no. 5; Spillman 1981, nos. 633–39.

G101–102

Jars with Ball Stoppers

1790–1830
New Hampshire or Connecticut
B.27.3.1–.2 olive colored glass; B.27.4.1–.2 snuff-brown colored glass; B.27.3.1–.2: 10⅝ x 5⁹⁄₁₆″ (diam.) (27 x 14.1 cm); B.27.4.1–.2: 10⅞ x 5⁹⁄₁₆″ (diam.) (27.6 x 14.1 cm)
B.27.3.1–.2; B.27.4.1–.2

Jars with wide mouths, as seen here, were used to store fruit preserves or pickled products. Preservation of these foods was essential, and these jars were normally sealed with cork and pitch or wax, which was then covered by a piece of leather that was tied on around the neck. The globular balls that have been with these jars since at least the 1920s are, in fact, glassmakers' whimsies.[1] It is unlikely that these stoppers, called witches balls in the

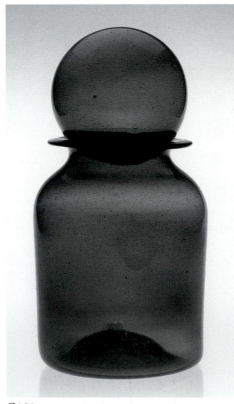

G101

late nineteenth and early twentieth century, were always used with these jars. Indeed, only one stopper was purchased with the jars. The other, which probably dates to the late nineteenth century, was presumably acquired later.

PROVENANCE: Purchased by Miss Hogg from the King Hooper Shop, Boston, 1927.

DESCRIPTION: Blown.

RELATED EXAMPLES: Wilson 1972, p. 90, fig. 65; p. 133, fig. 94 and fig. 95 illustrate a globular whimsey.

1. An 1840 account tells of a visit to a glass house, where the blowers made " . . . small globes, canes and similar baubles for the Ladies and Gents." Wilson 1972, p. 91.

G103

Pickle Bottle

1850–60
Eastern United States
Molded green soda lime glass; 14⅜ x 5¾ x 5⅛″ (36.5 x 14.6 x 13 cm)
B.75.31

PROVENANCE: Estate of Miss Ima Hogg.

TECHNICAL NOTES: Sixth side has an undecorated lancet arch, to which a label was probably affixed.

DESCRIPTION: Hexagonal body with Gothic arches in each panel.

REFERENCES: Howe and Warren 1976, p. 69, no. 138.

G104

Pickle Bottle

1850–60
Possibly Boston area
Molded green soda lime glass; 11¼ x 3½ x 3½″ (28.6 x 8.9 x 8.9 cm)
B.75.30

PROVENANCE: See cat no. G103.

TECHNICAL NOTES: Paper label on bottom that reads "197" in faded ink.

DESCRIPTION: Square body with ogee arches on each side.

RELATED EXAMPLES: Henry Ford Museum, Dearborn, Michigan, with original label

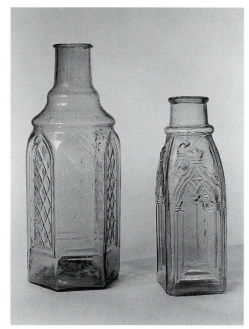

G103–104

(McKearin and Wilson 1978, pl. 73, no. 10); another with fragmentary Boston-area label (McKearin and Wilson 1978, pl. 74, no. 12).

REFERENCES: Howe and Warren 1976, p. 69, no. 139.

Related examples with traces of original paper labels indicate that this stylish type of Gothic ornamented pickle bottle was intended for commercial rather than domestic use.

G105

Set of Four Candlesticks

1840–55
New England
Greenish-yellow lead glass; B.69.380.1: 7 x 4⁵⁄₁₆"
(diam.) (17.8 x 11 cm); B.69.380.2,.4: 6⁷⁄₈ x 4³⁄₈"
(diam.) (17.5 x 11.1 cm); B.69.380.3: 7 x 4³⁄₈"
(diam.) (17.8 x 11.1 cm)
B.69.380.1–.4

PROVENANCE: Unknown (at Bayou Bend prior to 1965).

DESCRIPTION: Pressed petal and loop pattern (McKearin and McKearin 1941, p. 387, pl. 200, no. 35).

G106

Pair of Candlesticks

1840–55
New England
Turquoise-blue lead glass; Each: 6³⁄₄ x 4⁵⁄₁₆"
(diam.) (17.1 x 11 cm)
B.69.392.1

PROVENANCE: Purchased by Miss Hogg from C. E. Larkin Antiques, Newburyport, Massachusetts, 1927.

DESCRIPTION: Pressed petal and loop pattern (McKearin and McKearin 1941, p. 384, pl. 200, no. 35).

G107★

Candlestick

1840–55
New England
Clear lead glass; 6⁷⁄₈ x 4¹⁄₄" (17.5 x 10.8 cm)
B.78.18

PROVENANCE: See cat. no. G103.

DESCRIPTION: Pressed petal and loop pattern (McKearin and McKearin 1941, p. 387, pl. 200, no. 35).

G108

Candlestick

1840–60
New England
Amethyst lead glass; 7¹¹⁄₁₆ x 3¹⁄₂ x 3⁷⁄₈" (19.5 x 8.9 x 9.8 cm)
B.76.142

PROVENANCE: See cat. no. G103.

DESCRIPTION: Pressed hexagonal pattern (McKearin and McKearin 1941, p. 387, pl. 200, no. 29).

G109

Pair of Candlesticks

1850–60
Southern New Jersey
Amethyst and deep wine colored low-lead glass; 9¹⁄₂ x 3¹⁵⁄₁₆" (diam.) (24.1 x 10 cm)
B.69.465, B.69.467

This pair of candlesticks was among the earliest glass to enter Miss Hogg's collection. Historically they have been assigned to southern New Jersey and dated to the eighteenth century. Certainly the free-blown teardrop lower section relates to eighteenth-century shapes, as do the deep sockets. Yet the deep wine color of the knops and the ring at the base of the stem above the foot are more typical of the nineteenth century. Furthermore, the flat foot is not seen on other eighteenth-century examples.[1] Similarly, the deeply everted rim of the nozzle is a feature found on vases of the mid-nineteenth century (see cat. no. G117).

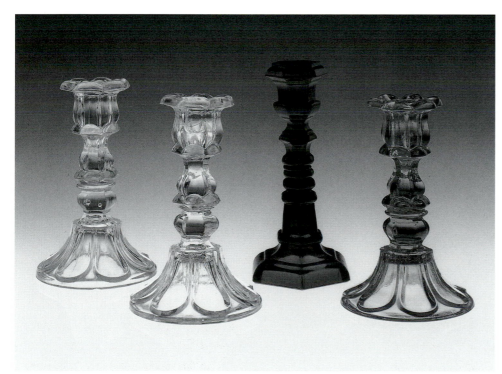

G105, G108, G106

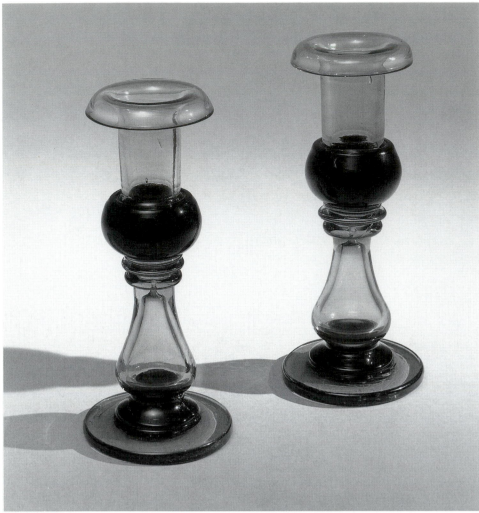

G109

Whale Oil Lamp

1815–30
New England
Clear and blue lead glass; 5⅛ x 3⅝″ (diam.)
(13 x 9.2 cm)
B.78.29

PROVENANCE: See cat. no. G103.

DESCRIPTION: Free-blown clear spherical body. Blue base.

G111

Oil Lamps

1840–60
Probably New England
Deep blue lead glass; Each: 10½ x 3¼″ (diam.)
(26.7 x 8.3 cm)
B.78.9.1–.2

PROVENANCE: See cat. no. G103.

DESCRIPTION: Pressed Bigler pattern (McKearin and McKearin 1941, p. 387, pl. 198, no. 14).

PROVENANCE: Purchased by Miss Hogg at American Art Galleries, New York, *The Jacob Paxson Temple Collection: Two Hundred Years of Glasswork in America*, November 17, 1923, lot 592, through Wayman Adams.

DESCRIPTION: Long cylindrical socket with turned down rim resting on solid oval ball of deep wine color. Applied stem with large pear-shaped tear. Applied circular foot.

RELATED EXAMPLES: A pair of vases at Toledo have nearly identical amber knops on the stem and very similar amber flat feet. The upper section of these vases has opaque applied white thread loop ornament of a type often seen in Jersey glass. One of them has an 1840 Colombian half dime in the hollow knop; the other an 1848 half dime (Wilson 1994, p. 147, no. 139).

REFERENCES: Riefstahl 1923, illustrated on p. 9, as Wistarburg and noted as collection of Jacob Paxson Temple.

1. McKearin and McKearin 1941, p. 66.

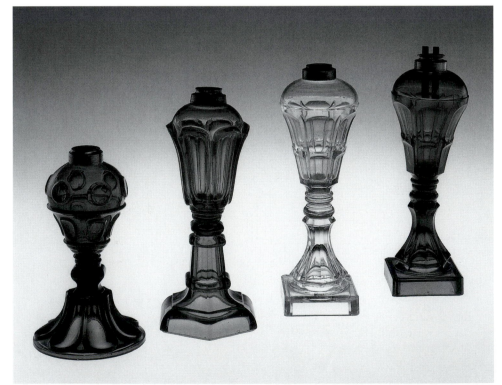

G113, G114, G112, G111

G112

Oil Lamp

1840–60
Probably New England
Yellow lead glass; 10¼ x 3¼" (diam.) (26 x 8.3 cm)
B.78.14

PROVENANCE: See cat. no. G103.

DESCRIPTION: Pressed Bigler pattern (McKearin and McKearin 1941, p. 387, pl. 198, no. 14).

G113

Oil Lamp

1840–60
Probably New England
Amethyst lead glass; 7⅝ x 4½" (diam.) (19.4 x 11.4 cm)
B.78.15

PROVENANCE: See cat. no. G103.

DESCRIPTION: Pressed ring and oval pattern (McKearin and McKearin 1941, p. 387, pl. 200, no. 36).

G114

Oil Lamps

1840–60
Probably New England
Blue lead glass; Each: 9½ x 3⅞ x 4½" (24.1 x 9.8 x 11.4 cm)
B.78.17.1–.2

PROVENANCE: See cat. no. G103.

DESCRIPTION: Pressed loop pattern (McKearin and McKearin 1941, p. 387, pl. 200, no. 28).

G115

Celery Glass

1840–60
Eastern United States
Clear lead glass; 9⅝ x 6⅛" (diam.) (24.4 x 15.6 cm)
Gift of Jack McGregor, B.91.55

During the nineteenth century, American tables were set with increasingly specialized serving containers. Among them was the celery glass, a vase in which celery, an exotic and expensive vegetable, was served. It was presented much like a

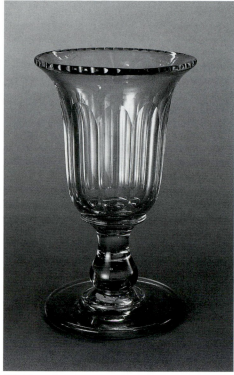

G115

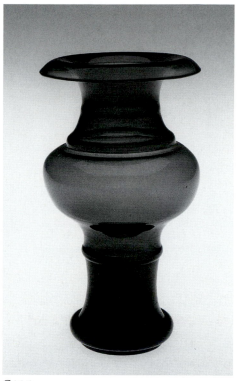

G116

flower arrangement with the raw stalks placed vertically in cold water. The cut panel ornament seen on this example became popular at mid-century.

PROVENANCE: Jack McGregor, Houston.

DESCRIPTION: Blown body cut with ten panels. Rim cut with small ovoid repeat decoration. Baluster-shaped stem. Flared foot.

RELATED EXAMPLES: A compote with similar paneled decoration (Innes 1976, p. 149, fig. 109); a mid-century paneled decanter (Innes 1976, p. 146, fig. 106); an eight-panel pressed glass celery glass at Winterthur (Palmer 1993, p. 276, no. 250).

G116

Vase

1840–60
Possibly New England
Emerald green lead glass; 6⅞ x 4" (diam.) (17.5 x 10.2 cm)
B.69.463

In the 1920s this vase, and others like it with paneled decoration, were thought to be by Stiegel and were highly prized.[1] However, the everted rim of this vase and the paneled decoration of related vases help to date this group to the middle of the nineteenth century.

PROVENANCE: Purchased by Miss Hogg at American Art Galleries, New York, *The Jacob Paxson Temple Collection: Two Hundred Years of Glasswork in America*, November 15, 1923, lot 203, through Wayman Adams.

TECHNICAL NOTES: Free blown. Tooled foot rising into a straight, circular hollow stem to the neck rising from bowl to everted rim.

RELATED EXAMPLES: McKearin and McKearin 1941, p. 92 and pl. 34, nos. 9–11; a group of paneled examples are at Winterthur (Palmer 1993, p. 284, nos. 259–61).

1. This example was catalogued for the Temple sale as Stiegel, and it fetched $115.

G117*

Vase

1840–60
New England
Clear canary lead glass; 10³⁄₁₆ x 4¼" (diam.) (25.9 x 10.8 cm)
B.78.13

PROVENANCE: Unknown (at Bayou Bend prior to 1965).[1]

DESCRIPTION: Pressed with loop bowl, gauffered rim, ringed knop. Standard composed of flared petal top supported by eight scrolled brackets, below which is cavetto molding and round base with eight petal-shaped panels.

G119

REFERENCES: McKearin and McKearin 1941, p. 387, pl. 199, no. 19.

1. This vase is possibly one of a pair purchased by Miss Hogg in 1927 from C. E. Larkin Antiques, Newburyport, Massachusetts.

G118*

Pair of Vases

ca. 1850
Ohio or Pittsburgh
Purple lead glass; B.72.129.1: 9⁵⁄₁₆ x 3⁷⁄₈ x 4³⁄₁₆"
(23.7 x 9.8 x 10.6 cm); B.72.129.2: 9¹¹⁄₁₆ x 3¹¹⁄₁₆ x
4¹⁄₈" (24.6 x 9.4 x 10.5 cm)
B.72.129.1–.2

PROVENANCE: Unknown (at Bayou Bend prior to 1965).

DESCRIPTION: Hexagonal bases. Scalloped rims.

A rare manifestation of pressed-glass production is a small number of window panes richly ornamented with classically inspired motifs. They were intended as side lights or transom lights for the front doors of Greek Revival houses. One surviving example has a history of usage around Sandwich, Massachusetts, and another came from the transom of a Wheeling, West Virginia, house (see Related examples).

PROVENANCE: Purchased by Bayou Bend from W. M. Schwind, Jr., Antiques, Yarmouth, Maine, 1996.

DESCRIPTION: Pressed glass with anthemion and scroll decoration.

RELATED EXAMPLES: An opalescent example at the Corning Museum of Glass, Corning, New York, was found at Sandwich, Massachusetts (Spillman 1981, p. 99, no. 294); amber examples are at the MMA, found in Wheeling, West Virginia (acc. no. 1984.229), and the St. Louis Art Museum (acc. no. 56.1996).

G119

Pane

1840–60
New England or West Virginia
Amber colored lead glass; 10 x 16 x ½" (25.4 x
40.6 x 1.3 cm)
Museum purchase, B.96.7

Bibliography

Adams 1955. Adams, Bertram. *An Incomplete History of the Descendants of John Perry of London 1604–1954.* Salt Lake City: Utah Printing Co., 1955.

Adamson and Muller 1984. Adamson, Jack, and Charles Muller. "The Furniture of Zoar." *Ohio Antique Review.* February 1984: 15–17. Reprinted from *Ohio Antique Review,* August 1983.

Agee et al. 1981. Agee, William C., et al. *The Museum of Fine Arts, Houston: A Guide to the Collection.* Houston: Museum of Fine Arts, Houston, 1981.

Alexander 1925. Alexander, Letitia Hart. "The Myth of the Julep Cup." *Antiques* 8 (December 1925): 364–65.

Almquist 1996. Almquist, Barbara A. "A Touch of Class: Silver in Social Settings." In *The 1996 Philadelphia Antiques Show: A Benefit for the Hospital of the University of Pennsylvania:* 17–48.

American Folk Paintings 1988. Abby Aldrich Rockefeller Folk Art Center. *American Folk Paintings: Paintings and Drawings other than Portraits from the Abby Aldrich Rockefeller Folk Art Center.* Boston: Little, Brown, and Co. 1988.

American Folk Sculpture 1931. *American Folk Sculpture: The Work of Eighteenth and Nineteenth Century Craftsmen.* Exh. cat. Newark: Newark Museum, 1931.

American Heritage 1992. *The American Heritage Dictionary of the English Language.* Third college edition. New York: Houghton Mifflin Co., 1992.

American Heritage 1994. *The American Heritage Dictionary.* Office edition. Based on the *American Heritage Dictionary of the English Language,* Third edition, Houghton Mifflin Co. New York: Dell Publishing, 1994.

American Sampler 1987. *An American Sampler: Folk Art from the Shelburne Museum.* Exh. cat. Washington, D.C.: National Gallery of Art, 1987.

Ames 1992. Ames, Kenneth L. *Death in the Drawing Room and Other Tales of Victorian Culture.* Philadelphia: Temple University Press, 1992.

Amy 1960. Amy, Henry Joseph. *Anthony, William and John Thompson of New Haven, Connecticut: Being Mostly a Record of Seven Generations of Descendants of Anthony Thompson, Some of Whom Migrated to Dutchess County, New York, via Goshen, Connecticut.* Eastchester, N.Y.: Typescript deposited at the New York Public Library, 1960.

Anderson 1990. Anderson, Mark J. "The History and Current Direction of Minimally Intrusive Upholstery Treatments." In *Upholstery Conservation.* East Kingston, N.H.: American Conservation Consortium, 1990: 13–28.

Anderson 1995. Anderson, Clarita S. "Ohio Coverlets in the Stuck Collection." *Antiques* 147 (March 1995): 418–27.

Anderson 1996. Anderson, Hilary. "Earning a Living in Eighteenth-Century Boston: Silversmith Zachary Brigden." University of Delaware, Master's Thesis, 1996.

Anderson and Anderson 1991. Anderson, Clara, and David Anderson. "Search for Mourning Rings." *Silver* 24, no. 4 (July–August): 9–12.

Andrews 1982. Andrews, Gail C. *Silver from the Collection of the Birmingham Museum of Art.* Birmingham, Ala.: Birmingham Museum of Art, 1982.

APS 1961. American Philosophical Society. *A Catalog of Portraits and Other Works of Art in the Possession of the American Philosophical Society.* Memoirs of the American Philosophical Society, 54. Philadelphia, 1961.

Arnold 1891. Arnold, James Newell. *Vital Record of Rhode Island: 1636–1850.* Vol. 4. Providence, R.I.: Narragansett Historical Publishing Co., 1891– .

Aronson 1965. Aronson, Joseph. *The Encyclopedia of Furniture.* Third edition. New York: Crown Publishers, 1965.

Art Dealers 1955. *Art Treasures Exhibition.* New York: Antique and Art Dealers Association, 1955.

Ashley 1982. Ashley, Derek. *Stoneware Bottles.* Brighton, England: Bowman Graphics, 1982.

Askew 1969. Askew, Richard Burton Marlowe. "The Basin Stand in England and America." *Antiques* 95 (February 1969): 258–63.

Atterbury 1989. Atterbury, Paul, ed. *The Parian Phenomenon: A Survey of Victorian Parian Porcelain Statuary and Busts.* Somerset, England: Richard Dennis, 1989.

Avery 1920. Avery, C. Louise. *American Silver Of The XVII & XVIII Centuries: A Study Based On The Clearwater Collection.* New York: Metropolitan Museum of Art, 1920.

Backlin-Landman 1969. Backlin-Landman, Hedy. "Boudinot Furnishings in the Art Museum of Princeton University." *Antiques* 96 (September 1969): 366–71.

Bacot 1987. Bacot, H. Parrott. *Nineteenth Century Lighting, Candle-Powered Devices: 1783–1883.* Exton, Pa.: Schiffer Publishing, 1987.

Bailey 1736. Bailey, N. *Dictionarium Britannicum: Or a More Compleat Universal Etymological.* Second edition, London: 1736.

Baldwin 1993. Baldwin, Cinda K. *Great and Noble Jar: Traditional Stoneware of South Carolina.* Athens: University of Georgia Press, 1993.

Ball 1961. Ball, Berenice. "Whistles with Corals and Bells." *Antiques* 80 (December 1961): 552–55.

Baltimore 1947. *Baltimore Furniture: The Work of Baltimore and Annapolis Cabinetmakers from 1760–1810.* Exh. cat. Baltimore: Baltimore Museum of Art, 1947.

Banfield 1989. Banfield, Edwin. *Visiting Cards and Cases.* Trowbridge, Wiltshire: Baros Books, 1989.

Banfield 1991. Banfield, Edwin. *Barometer Makers and Retailers, 1660–1900.* Trowbridge, Wiltshire: Baros Books, 1991.

Barber 1901. Barber, Edwin Atlee. *Anglo-American Pottery.* Second edition. Philadelphia: Patterson and White Co., 1901.

Barber 1970. Barber, Edwin Atlee. *Tulip Ware of the Pennsylvania-German Potters: An Historical Sketch of the Art of Slip-Decoration in the United States.* Second edition, 1926. Reprint, New York: Dover Publications, 1970.

Barber 1976a. Barber, Edwin Atlee. *Marks of American Potters.* 1904. Reprint, combined with *The Pottery and Porcelain of the United States,* New York: Feingold and Lewis, 1976.

Barber 1976b. Barber, Edwin Atlee. *The Pottery and Porcelain of the United States.* Third edition, 1909. Reprint, combined with *Marks of American Potters,* New York: Feingold and Lewis, 1976.

Barber 1991. Barber, James G. *Andrew Jackson: A Portrait Study.* Washington, D.C.: National Portrait Gallery; Nashville: Tennessee State Museum in association with the University of Washington Press, 1991.

Barker 1950. Barker, Virgil. *American Painting.* New York: Macmillan Co., 1950.

Baron 1995. Baron, Donna K. "Definition and Diaspora of Regional Style: The Worcester County Model." In *American Furniture 1995.* Edited by Luke Beckerdite and William N. Hosley. Hanover, N.H.: Chipstone Foundation, 1995.

Barquist 1985. Barquist, David L. *American and English Pewter at the Yale University Art Gallery.* New Haven: Yale University Art Gallery, 1985.

Barquist 1991. Barquist, David L. "Imported Looking Glasses in Colonial America." *Antiques* 139 (June 1991): 1108–17.

Barquist 1992. Barquist, David L. "American Looking Glasses in the Neoclassical Style, 1780–1815." *Antiques* 141 (February 1992): 320–31.

Barquist, Garrett, and Ward 1992. Barquist, David L., Elisabeth Donaghy Garrett, and Gerald W. R. Ward. *American Tables and Looking Glasses in the Mabel Brady Garvan and Other Collections at Yale University.* New Haven: Yale University Art Gallery, 1992.

Barret 1958. Barret, Richard Carter. *Bennington Pottery and Porcelain: A Guide to Identification.* New York: Bonanza Books, 1958.

Bartlett 1984. Bartlett, Louisa. *American Silver.* The Saint Louis Art Museum Bulletin (Winter 1984).

Battison and Kane 1973. Battison, Edwin A., and Patricia E. Kane. *The American Clock, 1725–1865.* Greenwich, Conn.: New York Graphic Society, 1973.

Baumgarten 1993. Baumgarten, Linda. "Protective Covers for Furniture and Its Contents." In *American Furniture 1993.* Edited by Luke Beckerdite. Hanover, N.H.: Chipstone Foundation, 1993: 2–14.

Bayley 1915. Bayley, Frank W. *The Life and Works of John Singleton Copley.* Boston: Taylor Press, 1915.

Bayley 1929. Bayley, Frank W. *Five Colonial Artists of New England*. Boston: Privately printed, 1929.

Beale 1969. Beale, Rebecca J. *Jacob Eichholtz, 1776–1842: Portrait Painter of Pennsylvania*. Philadelphia: Historical Society of Pennsylvania, 1969.

Beard and Gilbert 1986. Beard, Geoffrey, and Christopher Gilbert, eds. *Dictionary of English Furniture Makers, 1660–1840*. Leeds, England: Furniture History Society and W. S. Maney and Son Ltd., 1986.

Beckerdite 1985. Beckerdite, Luke. "Philadelphia Carving Shops. Part II: Bernard and Jugiez." *Antiques* 128 (September 1985): 498–513.

Beckerdite 1987. Beckerdite, Luke. "Philadelphia Carving Shops. Part III: Hercules Courtenay and His School." *Antiques* 131 (May 1987): 1044–63.

Beckerdite 1993. Beckerdite, Luke. "Origins of the Rococo Style in New York Furniture and Interior Architecture." In *American Furniture 1993*. Edited by Luke Beckerdite. Hanover, N.H.: Chipstone Foundation, 1993: 15–37.

Beckerdite 1994. Beckerdite, Luke. "An Identity Crisis: Philadelphia and Baltimore Furniture Styles of the Mid Eighteenth Century." In *Shaping a National Culture: The Philadelphia Experience, 1750–1800*. Edited by Catherine E. Hutchings. Winterthur: Henry Francis du Pont Winterthur Museum, 1994: 243–81.

Beckerdite 1996. Beckerdite, Luke. "Immigrant Carvers and the Development of the Rococo Style in New York, 1750–1770." In *American Furniture 1996*. Edited by Luke Beckerdite. Hanover, N.H.: Chipstone Foundation, 1996: 233–65.

Beckman 1975. Beckman, Elizabeth D. *An In-depth Study of the Cincinnati Silversmiths, Jewelers, Watch and Clockmakers through 1850*. Cincinnati: B. B. and Co., 1975.

Beecher 1874. Beecher, Catharine B. *Miss Beecher's Housekeeper and Healthkeeper*. New York: Harper and Brothers, 1874.

Belden 1898. Belden, Jessie Perry Van Zile. *Concerning Some of the Ancestors and Descendants of Royal Denison Belden and Olive Cadwell Belden*. Philadelphia: J. B. Lippincott Co., 1898.

Belden 1980. Belden, Louise Conway. *Marks of American Silversmiths in the Ineson-Bissell Collection*. Charlottesville: University Press of Virginia for the Henry Francis du Pont Winterthur Museum, 1980.

Bellows 1983. "Fireplace Bellows." *Colonial Homes* 9, no. 6 (November–December 1983): 78–81.

Benes 1982. Benes, Peter. *Two Towns, Concord and Wethersfield: A Comparative Exhibition of Regional Culture 1635–1850*. Exh. cat. Vol. 1. Concord, Mass.: Concord Antiquarian Museum, 1982.

Benes and Zimmerman 1979. Benes, Peter, and Phillip D. Zimmerman. *New England Meeting House and Church: 1630–1850*. Manchester, N.H.: Trustees of Boston University and Currier Gallery of Art, 1979.

Bentley 1962. *The Diary of William Bentley, D. D., Pastor of the East Church, Salem Massachusetts*. Vol. 1. (April 1784–December 1792). Gloucester, Mass.: Peter Smith, 1962.

Bermingham 1986. Bermingham, Ann. *Landscape and Ideology: The English Rustic Tradition, 1740–1860*. Berkeley and Los Angeles: University of California Press, 1986.

Betterton 1976. Betterton, Sheila. *The American Quilt Tradition*. Bath: American Museum in Britain, 1976.

Betterton 1978. Betterton, Sheila. *Quilts and Coverlets from the American Museum in Britain*. Bath: American Museum in Britain, 1978.

Betts and Betts 1888. Betts, C. Wyllys, and Frederic H. Betts. *Thomas Betts (1618–1688) and His Descendants*. New York: Privately printed, 1888.

Biddle 1963. Biddle, James. *American Art from American Collections*. Exh. cat. New York: Metropolitan Museum of Art, 1963.

Biddle and Fielding 1969. Biddle, Edward, and Mantle Fielding. *The Life and Works of Thomas Sully*. 1921. Reprint, Charleston: Garnier and Co., 1969.

Bigelow 1917. Bigelow, Francis Hill. *Historic Silver of the Colonies and Its Makers*. New York: Macmillan Co., 1917.

Binder 1981. Binder, Deborah J. *St. Louis Silversmiths*. Exh. cat. St. Louis Art Museum, 1981.

Bird 1994. Bird, Michael S. *Canadian Country Furniture, 1675–1950*. Toronto: Stoddart Publishing Co., 1994.

Bishop 1868. Bishop, John Leander. *A History of American Manufacturers From 1608–1860*. Philadelphia: Edward Young and Co., 1868.

Bishop 1972. Bishop, Robert. *Centuries and Styles of the American Chair, 1640–1970*. New York: E. P. Dutton and Co., 1972.

Bishop 1973. Bishop, Robert. *How to Know American Antique Furniture*. New York: E. P. Dutton and Co., 1973.

Bishop 1974. Bishop, Robert. *American Folk Sculpture*. New York: E. P. Dutton and Co., 1974.

Bishop 1975. Bishop, Robert. *New Discoveries in American Quilts*. New York: E. P. Dutton and Co., 1975.

Bishop 1979. Bishop, Robert. *Folk Painters of America*. New York: E. P. Dutton and Co., 1979.

Bishop and Coblentz 1981. Bishop, Robert, and Patricia Coblentz. *A Gallery of American Weathervanes and Whirligigs*. New York: E. P. Dutton and Co., 1981.

Bishop and Coblentz 1982. Bishop, Robert, and Patricia Coblentz. *American Decorative Arts: 360 Years of Creative Design*. New York: Harry N. Abrams, 1982.

Bivins 1988. Bivins, John, Jr. *The Furniture of Coastal North Carolina, 1700–1820*. Winston-Salem: Museum of Early Southern Decorative Arts, 1988.

Bivins 1989. Bivins, John, Jr. *Wilmington Furniture 1720–1860*. Wilmington, N.C.: St. John's Museum of Art and Historic Wilmington Foundation, 1989.

Black 1980. Black, Mary. "Contributions Toward a History of Early Eighteenth-Century New York Portraiture: Identification of the Aetatis Suae and Wendell Limners." *The American Art Journal* 11, no. 4 (Autumn 1980): 5–31.

Blackburn 1976. Blackburn, Roderic H. *Cherry Hill, The History and Collections of a Van Rensselaer Family*. Bethlehem, N.Y.: Historic Cherry Hill, 1976.

Blackburn 1983. Blackburn, Roderic H. "Gilbert Ash Inscriptions Reconsidered." *Antiques* 123 (February 1983): 428–31.

Blackburn et al. 1988. Blackburn, Roderic H., et al. *Remembrance of Patria Dutch Arts and Culture in Colonial America 1609–1776*. New York: Albany Institute of History and Art, 1988.

Blaney 1974. Blaney, William O. "Edward Danforth, Pewterer 1765–1830." *The Pewter Collectors' Club of America* 70 (December 1974): 1, 5–6.

Blaney 1978. Blaney, William O. "Porringers for Export?" *The Pewter Collectors' Club of America* 76 (March 1978): 253–55.

Blaney 1983. Blaney, William O. "The Porringer Corner Chapter 2—The Initialed Crowns." *The Pewter Collectors' Club of America* 87 (September 1983): 288–98.

Bloch 1986. Bloch, E. Maurice. *The Paintings of George Caleb Bingham: A Catalogue Raisonné*. Columbia: University of Missouri Press, 1986.

Bohan 1963. Bohan, Peter J. *American Gold, 1700–1860*. Exh. cat. New Haven: Yale University Art Gallery, 1963.

Bohan and Hammerslough 1970. Bohan, Peter, and Philip Hammerslough. *Early Connecticut Silver, 1700–1840*. Middletown, Conn.: Wesleyan University Press, 1970.

Bolton 1923. Bolton, Theodore E. *Early American Portrait Draftsmen in Crayons*. New York: F. F. Sherman, 1923.

Bolton and Binsse 1930. Bolton, Theodore, and Harry Lorin Binsse. "John Singleton Copley." *Antiquarian* (December 1930): 116.

Bolton and Binsse 1931. Bolton, Theodore, and Harry Lorin Binsse. "Wollaston: An Early American Portrait Manufacturer." *Antiquarian* (June 1931): 30–33, 50, 52.

Bolton and Coe 1921. Bolton, Ethel S., and Eva J. Coe. *American Samplers*. Boston: Massachusetts Society of the Colonial Dames of America, 1921.

Boorstin 1987. Boorstin, Daniel J. "The Transforming of Paul Revere." In *Hidden History*. Edited by Daniel J. Boorstin and Ruth F. Boorstin. New York: Harper and Row, 1987: 24–28.

Bordes 1974. Bordes, Marilynn Johnson. *Twelve Great Quilts from the American Wing*. New York: Metropolitan Museum of Art, 1974.

Boston 1898. *A Report of the Record Commissioners of the City of Boston, Containing the Boston Marriages from 1700 to 1751*. Boston: Municipal Printing Office, 1898.

Boston 1903. *A Volume of Records Relating to the Early History of Boston, Containing Boston Marriages from 1752 to 1809*. Boston: Municipal Printing Office, 1903.

Boston Records 1881. *A Report of the Record Commissioners of the City of Boston Containing the Boston Records from 1660 to 1701*. Boston: Rockwell and Churchill, 1881.

Boultinghouse 1980. Boultinghouse, Marquis. *Silversmiths, Jewelers, Clock and Watch Makers of Kentucky 1785–1900*. Lexington, Ky.: Privately printed, 1980.

Bowen 1976. Bowen, Richard L., Jr. "Francis and Frederick Bassett." *The Pewter Collectors' Club of America* 73 (August 1976): 154.

Bowen 1977. Bowen, Richard L., Jr. "Porringer Capacities." *The Pewter Collectors' Club of America* 75 (September 1977): 212–13.

Bowen 1978. Bowen, Richard L., Jr. "Some Rhode Island Mugs." *The Pewter Collectors' Club of*

America 77 (September 1978): 333–37.

Bowen 1981. Bowen, Richard L., Jr. "Some of Roswell Gleason's Early Workers." *The Pewter Collectors' Club of America* 83 (September 1981): 148–61.

Brackman 1989. Brackman, Barbara. *Clues in the Calico: A Guide to Identifying and Dating Antique Quilts.* McLean, Va.: EPM Publications, 1989.

Bragg 1925. Bragg, George F., Jr. *Men of Maryland.* Baltimore: Church Advocate Press, 1925.

Brainard 1908. [Brainard, Albion Hale.] Descendants of Patience Dudley Denison. Governor Thomas Dudley Family Association, 1908.

Brandt 1976. Brandt, Frederick R. *American Pewter.* Richmond: Virginia Museum of Fine Arts, 1976.

Branin 1988. Branin, M. Lelyn. *The Early Makers of Handcrafted Earthenware and Stoneware in Central and Southern New Jersey.* Rutherford: Fairleigh Dickinson University Press; London: Associated University Presses, 1988.

Braulein et al. 1977. Braulein, John H., et al. *Johannes Nys, Silversmith c. 1671–1734.* Wilmington: Historical Society of Delaware, 1977.

Brazer 1943. Brazer, Esther Stevens. "The Early Boston Japanners." *Antiques* 43 (May 1943): 208–11.

Brewster 1972. Brewster, Charles W. *Rambles About Portsmouth.* 2 vols. 1869. Reprint, with an introduction by Raymond A. Brighton, Somersworth: New Hampshire Publishing Co., 1972.

Bridwell 1940. Bridwell, Margaret M. "Asa Blanchard, Early Kentucky Silversmith." *Antiques* 37 (March 1940): 135–36.

Brigham 1954. Brigham, Clarence S. *Paul Revere's Engravings.* Worcester, Mass.: American Antiquarian Society, 1954.

Brigham 1995. Brigham, David R. *Public Culture in the Early Republic, Peale's Museum and Its Audience.* Washington and London: Smithsonian Institution Press, 1995.

Brinton 1947. Brinton, Francis D. "New Light on Elisha Kirk." *Antiques* 51 (April 1947): 253.

Brown 1977. Brown, Joan Sayers. "William Faris Sr., His Sons, and Journeymen—Annapolis Silversmiths." *Antiques* 111 (February 1977): 378–85.

Brown 1980. Brown, Joan Sayers. "Silver Associated with George Mason IV at Gunston Hall." *Antiques* 118 (August 1980): 285–89.

Brown 1983a. Brown, Joan Sayers. "Silver and Gold Owned by Stephen Decatur, Jr." *Antiques* 123 (February 1983): 399–405.

Brown 1983b. Brown, Michael K. "A Tankard by John Coney." *The Museum of Fine Arts, Houston Bulletin,* n.s., 8, no. 2 (Winter 1983): 2–10.

Brown 1984. Brown, Michael K. "A Tempest of Economics and Politics in the Eighteenth-Century Teapot." *Theta Charity Antiques Show Catalogue.* Houston, 1994: 48–52.

Brown 1985. Brown, Michael K. "A Decade of Collecting at Bayou Bend." *Antiques* 128 (September 1985): 514–25.

Brown 1987. Brown, Michael K. "American Silver at Bayou Bend." *The Museum of Fine Arts, Houston Bulletin,* n.s., 11, no. 1 (Fall 1987): 22–33.

Brown 1989. Brown, Michael K. "Piecing Together the Past: Recent Research on the American China Manufactory 1769–1772." *Proceedings of the American Philosophical Society.* Vol. 133, no. 4 (1989): 555–79.

Brown 1997. Brown, Michael K. "A Boston Tambour Desk." *Antiques* 151 (January 1997): 202–5.

Brown and Shelton 1994. Brown, Michael K., and Chris A. Shelton. "Bayou Bend's Latest Acquisition: Old World Inspiration for a New World Masterpiece." *Theta Charity Antiques Show Catalogue.* Houston, 1994: 22–23, 26–27, 30.

Brown, Warren, and Howe 1988. Brown, Michael K., David B. Warren, and Katherine S. Howe. "Four Centuries of American Presentation Silver and Gold." *Antiques* 133 (January 1988): 266–81.

Buckley 1969. Buckley, Charles E. "Decorative Arts in the City Art Museum of Saint Louis." *Antiques* 96 (July 1969): 76–81.

Buhler 1945. Buhler, Kathryn C. "Some Engraved American Silver: Part II. From about 1740 to 1810." *Antiques* 48 (December 1945): 348–52.

Buhler 1951. Buhler, Kathryn C. "John Edwards, Goldsmith, and His Progeny." *Antiques* 59 (April 1951): 288–92.

Buhler 1960a. Buhler, Kathryn C. "Masterpieces of American Silver." *Antiques* 77 (January 1960): 84–86.

Buhler 1960b. Buhler, Kathryn C. *Masterpieces of American Silver.* Exh. cat. Richmond: Virginia Museum of Fine Arts, 1960.

Buhler 1960c. Buhler, Kathryn C. *American Silver and Art Treasures.* London: English-Speaking Union, 1960.

Buhler 1965. Buhler, Kathryn C. *Massachusetts Silver in the Frank L. and Louise C. Harrington Collection.* Worcester, Mass.: Barre Publishers, 1965.

Buhler 1972. Buhler, Kathryn C. *American Silver 1655–1825 in the Museum of Fine Arts, Boston.* 2 vols. Boston: Museum of Fine Arts, Boston, 1972.

Buhler 1973. Buhler, Kathryn C. "Early American Silver, American Gold, English Silver in America." In *Silver Supplement to the Guidebook to the Diplomatic Reception Rooms.* Washington, D.C.: Department of State, 1973: 15–95.

Buhler 1979. Buhler, Kathryn C. *American Silver: From the Colonial Period through the Early Republic in the Worcester Art Museum.* Worcester, Mass.: Worcester Art Museum, 1979.

Buhler and Hood 1970. Buhler, Kathryn C., and Graham Hood. *American Silver: Garvan and Other Collections in the Yale University Art Gallery.* 2 vols. New Haven: Yale University Press, 1970.

Bulkeley 1967. Bulkeley, Houghton. *Contributions to Connecticut Cabinet Making.* Hartford: Connecticut Historical Society, 1967.

Bullard 1958. Bullard, John M. *Captain Edmund Gardner of Nantucket and New Bedford.* Milford, N.H.: Cabinet Press, 1958.

Bumgardner 1986. Bumgardner, Georgia Brady. "Political Portraiture: Two Prints of Andrew Jackson." *American Art Journal* 18 (1986): 84–95.

Burke 1981. Burke, Margaret R., ed. *Bowdoin College Museum of Art: Handbook of the Collections.* Brunswick, Maine: Bowdoin College Museum of Art, 1981.

Burroughs 1936. Burroughs, Alan. *Limners and Likeness: Three Centuries of American Painting.* Cambridge: Harvard University Press, 1936.

Burroughs 1943. Burroughs, Alan. *John Greenwood in America, 1745–1753.* Andover, Mass.: Phillips Academy, 1943.

Burroughs 1967. Burroughs, Paul H. *Southern Antiques.* 1931. Reprint, New York: Bonanza Books, 1967.

Burton 1938. Burton, E. Milby. *Hayden and Gregg, Jewellers of Charleston.* Charleston: Charleston Museum, 1938.

Burton 1942. Burton, E. Milby. *South Carolina Silversmiths 1690–1860.* Charleston: Charleston Museum, 1942.

Burton 1952. Burton, E. Milby. *Thomas Elfe: Charleston Cabinet-Maker.* Charleston: Charleston Museum, 1952.

Burton 1955. Burton, E. Milby. *Charleston Furniture, 1700–1825.* Charleston: Charleston Museum, 1955.

Burton 1997. Burton, Marda. "The Ima Hogg Collection: Acquisitions at Bayou Bend." *Veranda* (Summer 1997): 224b–224j.

Bush 1962. Bush, Alfred L. *Catalogue of an Exhibition at the University of Virginia Museum of Fine Arts.* Charlottesville: Thomas Jefferson Memorial Foundation, 1962.

Butler 1973. Butler, Joseph T. *American Furniture From the First Colonies to World War I.* London: Triune Books, 1973.

Butler 1983. Butler, Joseph T. *Sleepy Hollow Restorations: A Cross-section of the Collections.* Tarrytown, N.Y.: Sleepy Hollow Press, 1983.

Butler 1985. Butler, Barbara. "Pewter at Bayou Bend." *The Pewter Collectors' Club of America* 90–91 (March–September 1985): 10–13.

Butler 1988. Butler, Joseph T. "Montgomery Place Revisited." *Antiques* 134 (August 1988): 294–303.

Byrde 1992. Byrde, Penelope. *Nineteenth-Century Fashion.* London: B. T. Batsford, 1992.

Cabot 1979. Cabot, Harriet Ropes. *Handbook of the Bostonian Society.* Boston: Old State House, 1979.

Caldwell 1985. Caldwell, Desiree. "Germanic Influences on Philadelphia Early Georgian Seating Furniture." University of Delaware, Master's Thesis, 1985.

Caldwell 1988. Caldwell, Benjamin Hubbard, Jr. *Tennessee Silversmiths.* Winston-Salem: Museum of Early Southern Decorative Arts, 1988.

Caldwell and Rodriguez Roque 1994. Caldwell, John, and Oswaldo Rodriguez Roque. *American Paintings in the Metropolitan Museum of Art.* New York: Metropolitan Museum of Art in association with Princeton University Press, 1994.

Campbell 1972. *The Campbell Museum Collection.* Camden, N.J.: Campbell Museum, 1972.

Campbell 1975. Campbell, Christopher M. *American Chippendale Furniture 1755–1790.* Dearborn, Mich.: Edison Institute, 1975.

Carlisle 1957. Carlisle, Lilian Baker. *Pieced Work and Applique Quilts at Shelburne Museum.* Shelburne, Vt.: Shelburne Museum, 1957.

Carlisle 1960. Carlisle, Lilian Baker. *Hat Boxes and Bandboxes at Shelburne Museum.* Shelburne, Vt.: Shelburne Museum, 1960.

Carlisle 1970. Carlisle, Lilian Baker. *Vermont Clock and Watchmakers Silversmiths and Jewelers.* Burlington, Vt.: Privately printed, 1970.

Carpenter 1954. Carpenter, Ralph E., Jr. *The Arts and Crafts of Newport, Rhode Island, 1640–1820.* Newport, R.I.: Preservation Society of Newport County, 1954.

Carpenter 1972. Carpenter, Ralph E., Jr. "Mow-

bra Hall and a Collection of Period Rooms: Part 2." *Connoisseur* 180 (August 1972): 284–95.

Carpenter 1982. Carpenter, Charles H., Jr. *Gorham Silver, 1831–1981.* New York: Dodd, Mead and Co., 1982.

Carpenter and Carpenter 1912. Carpenter, Edward, and General Louis Carpenter. *Samuel Carpenter and His Descendants.* Philadelphia: J. B. Lippincott Co., 1912.

Carpenter and Carpenter 1978. Carpenter, Charles H., Jr., and Mary Grace Carpenter. *Tiffany Silver.* New York: Dodd, Mead and Co., 1978.

Carpenter and Carpenter 1987. Carpenter, Charles H., Jr., and Mary Grace Carpenter. *The Decorative Arts and Crafts of Nantucket.* New York: Dodd, Mead and Co., 1987.

Carpenter and Zapata 1987. Carpenter, Charles H., Jr., and Janet Zapata. *The Silver of Tiffany and Co., 1850–1987.* Boston: Museum of Fine Arts, Boston, 1987.

Carrick 1928. Carrick, Alice Van Leer. *Shades of Our Ancestors: American Profiles and Profilists.* Boston: Little, Brown, and Co., 1928.

Carson 1947. Carson, Marian Sadtler. "Philadelphia Chippendale at Its Best." *American Collector* 16, no. 11 (December 1947): 10–13.

Carson 1968. Carson, Marian S. "Thomas Chippendale, A London Cabinetmaker in Colonial Philadelphia." *Connoisseur* (March 1968): 187–91.

Carson 1987. Carson, Barbara. *The Governor's Palace.* Williamsburg: Colonial Williamsburg Foundation, 1987.

Carved and Painted 1984. *Carved and Painted: New England Country Arts from the Collection of Bertram K. and Nina Fletcher Little.* Exh. cat. Boston: Museum of Fine Arts, Boston, 1984.

Catalano and Nylander 1980. Catalano, Kathleen, and Richard C. Nylander. "New Attributions to Adam Hains, Philadelphia Furniture Maker." *Antiques* 117 (May 1980): 1112–16.

Chamberlain 1977. Chamberlain, Narcissa G. "History in Houses: The Jeremiah Lee Mansion in Marblehead, Massachusetts." *Antiques* 112 (December 1977): 1164–73.

Chance and Smith 1930. Chance, Maria Scott Beale, and Mary Allen Evans Smith, comps. *Scott Family Letters: The Letters of John Morin Scott and His Wife Mary Emlen Scott; with Notes Relating to Them, Their Ancestors and Their Descendants.* Philadelphia: Biddle Press, Privately printed, 1930.

Chandler 1883. Chandler, George. *The Chandler Family: The Descendants of William and Annis Chandler who Settled in Roxbury, Mass. 1637.* Worcester, Mass.: C. Hamilton, 1883.

Chapman 1882. Chapman, Jacob. *A Genealogy of the Folsom Family: John Folsom and His Descendants.* Concord, N.H.: Republican Press Association, 1882.

Chase 1940. Chase, Ada R. "Two Eighteenth-Century Clockmakers." *Antiques* 38 (September 1940): 116–18.

Cheek 1981. Cheek, Mary Tyler. "Stratford Hall, the Virginia Home of the Lees." *Antiques* 119 (March 1981): 642–51.

Chevalier and Gheerbrant 1994. Chevalier, Jean, and Alain Gheerbrant. *Dictionary of Symbols.* Translated by John Buchanan-Brown. Oxford: Blackwell Publishers, 1994.

Chew 1959. Chew, Paul A., comp. and ed. *Two Hundred and Fifty Years of Art in Pennsylvania.* Greenburg, Pa.: Westmoreland County Museum of Art, 1959.

Childs 1978. Childs, Elizabeth Taylor. "Wm. & Geo. Richardson: Goldsmiths and Jewellers, Richmond, Virginia." *Journal of Early Southern Decorative Arts* 4, no. 1 (May 1978): 25–44.

Chippendale 1966. Chippendale, Thomas. *The Gentleman & Cabinet-Maker's Director.* Third edition, 1762. Reprint, with a biographical sketch and photographic supplement of Chippendale-type furniture, New York: Dover Publications, 1966.

Chotner 1992. Chotner, Deborah. *American Naive Paintings: The Collections of the National Gallery of Art Systematic Catalogue.* Washington, D.C.: National Gallery of Art, 1992.

Church Silver 1911. *American Church Silver of the Seventeenth and Eighteenth Centuries with a Few Pieces of Domestic Plate.* Exh. cat. Boston: Museum of Fine Arts, Boston, 1911.

Churchill 1992. Churchill, Edwin A. *Hail Britannia: Maine Pewter and Silverplate.* Augusta: Maine State Museum, 1992.

Cirker and Cirker 1967. Cirker, Hayward, and Blanche Cirker, eds. *Dictionary of American Portraits.* New York: Dover Publications, 1967.

Clabburn 1976. Clabburn, Pamela. *The Needleworker's Dictionary.* New York: William Morrow and Co., 1976.

Clark 1956. Clark, Raymond B., Jr. "Jonathan Gostelow (1744–1795): Philadelphia Cabinetmaker." University of Delaware, Master's Thesis, 1956.

Clarke 1940. Clarke, Hermann Frederick. *John Hall: A Builder of the Bay Colony.* Portland: Southworth-Anthoensen Press, 1940.

Clarke 1971. Clarke, Hermann Frederick. *John Coney Silversmith, 1655–1722.* Boston: Houghton Mifflin, 1932. Reprint, New York: Da Capo Press, 1971.

Clarke and Foote 1935. Clarke, Hermann Frederick, and Henry Wilder Foote. *Jeremiah Dummer, Colonial Craftsman and Merchant, 1645–1718.* Boston: Houghton Mifflin, 1935.

Clarkson 1869. Clarkson, Thomas Streasfield. *A Biographical History of Clermont or Livingston Manor, Before and During the War of Independence.* Clermont, New York: 1869.

Clayton 1985. Clayton, Michael. *The Collector's Dictionary of the Silver and Gold of Great Britain and North America.* Second edition. Woodbridge, Suffolk, England: Baron Publishing, 1985.

Clement 1947. Clement, Arthur W. *Our Pioneer Potters.* New York: Privately printed, 1947.

Clunie 1977. Clunie, Margaret Burke. "Joseph True and the Piecework System in Salem." *Antiques* 111 (May 1977): 1006–13.

Clunie, Farnham, and Trent 1980. Clunie, Margaret Burke, Anne Farnham, and Robert Trent. *Furniture at the Essex Institute.* Salem, Mass.: Essex Institute, 1980.

Coates 1906. Coates, Truman. *A Genealogy of Moses and Susanna Coates Who Settled in Pennsylvania in 1717, and Their Descendants with Brief Introductory Notes of Families of the Same Name.* 1906.

Coleman 1992. Coleman, Feay Shellman. *Nostrums for Fashionable Entertainments: Dining in Georgia, 1800–1850.* Savannah: Telfair Academy of Arts and Sciences, 1992.

Communion Services 1976. "Communion Services on View at Lancaster." *Pewter Collectors' Club of America* 72 (February 1976): 83, 95–100.

Comstock 1942. Comstock, Helen. "Silver by Edward Winslow of Boston, 1669–1753." *Connoisseur* 108 (January 1942): 205–9.

Comstock 1947. Comstock, Helen. "Drawings by John Singleton Copley." *Panorama* 2, no. 9 (May 1947): 99–107.

Comstock 1953. Comstock, Helen. "American Chairs in the Collection of Mr. and Mrs. Irving S. Olds." *Antiques* 64 (December 1953): 473–76.

Comstock 1954. Comstock, Helen. "American Furniture in California." *Antiques* 65 (January 1954): 52–61.

Comstock 1957a. Comstock, Helen. "The Collection of Dr. William S. Serri." *Antiques* 71 (March 1957): 254–59.

Comstock 1957b. Comstock, Helen. "McIntire in Antiques." *Antiques* 71 (April 1957): 338–41.

Comstock 1957c. Comstock, Helen. "Spanish-Foot Furniture." *Antiques* 71 (January 1957): 58–61.

Comstock 1958. Comstock, Helen. "History in Houses: Stratford Hall." *Antiques* 73 (April 1958): 366–71.

Comstock 1959. Comstock, Helen. "Portraits of American Craftsmen." *Antiques* 76 (October 1959): 320–27.

Comstock 1961. Comstock, Helen. "The American Lowboy: An Antiques Survey." *Antiques* 80 (December 1961): 570–73.

Comstock 1962. Comstock, Helen. *American Furniture, Seventeenth, Eighteenth, and Nineteenth Century Styles.* New York: Viking Press, 1962.

Comstock 1965. Comstock, Helen. "Cabinetmakers of the Norwich Area." *Antiques* 87 (June 1965): 696–99.

Comstock 1966. Comstock, Helen. "American Furniture in the Collection of Mr. and Mrs. Edward H. Tevriz." *Antiques* 89 (February 1966): 256–61.

Comstock 1994. Comstock, H[arold]. E[ugene]. *The Pottery of the Shenandoah Valley Region.* Winston-Salem: Museum of Early Southern Decorative Arts, 1994.

Coney 1932. *Exhibition of Silversmithing by John Coney, 1655–1732.* Exh. cat. Boston: Museum of Fine Arts, Boston, 1932.

Conger 1979. Conger, Clement E. "Decorative Arts at the White House." *Antiques* 116 (July 1979): 112–34.

Conger 1991. Conger, Clement E. *Treasures of State: Fine and Decorative Arts in the Diplomatic Reception Rooms of the U.S. Department of State.* Edited by Alexandra W. Rollins. New York: Harry N. Abrams, 1991.

Conover 1907. Conover, Charlotte Reeve. *A History of the Beck Family: Together with a Genealogical Record of the Alleynes and Chases From Whom They are Descended.* Dayton: Privately printed, 1907.

Cooke 1889. Cooke, Harriet Ruth (Waters). *The Driver Family: A Genealogical Memoir of the Descendants of Robert and Phebe Driver of Lynn, Mass.* New York: John Wilson and Son, 1889.

Cooke 1987. Cooke, Edward S., Jr. "The Nathan

Low Easy Chair: High Quality Upholstery in Pre-Revolutionary Boston." *Maine Antique Digest* (November 1987): 1C–3C.

Cooke and Shorto 1979. Cooke, Colin, and Sylvia Shorto. "Some Notes on Early Bermudian Furniture." *Antiques* 116 (August 1979): 328–40.

Cooney 1978. Cooney, Alice Knotts Bossert. "Ornamental Painting in Boston, 1790–1830." University of Delaware, Master's Thesis, 1978.

Cooper 1973a. Cooper, Wendy A. "The Purchase of Furniture and Furnishings by John Brown, Providence Merchant. Part I: 1760–1788." *Antiques* 103 (February 1973): 328–39.

Cooper 1973b. Cooper, Wendy A. "The Purchase of Furniture and Furnishings by John Brown, Providence Merchant. Part II: 1788–1803." *Antiques* 103 (April 1973): 734–43.

Cooper 1977. Cooper, Wendy A. "American Chippendale Chairback Settees: Some Sources and Related Examples." *The American Art Journal* 9, no. 2. (November 1977): 34–45.

Cooper 1980. Cooper, Wendy A. *In Praise of America: American Decorative Arts, 1650–1830.* New York: Alfred A. Knopf, 1980.

Cooper 1982. Cooper, Helen A. *John Trumbull: The Hand and Spirit of a Painter.* Exh. cat. New Haven: Yale University Art Gallery, 1982.

Cooper 1993. Cooper, Wendy A. *Classical Taste in America 1800–1840.* New York: Abbeville Press, 1993.

Copley-Pelham Letters 1972. *Letters and Papers of John Singleton Copley and Henry Pelham, 1739–1776.* Edited by Guernsey Jones. Boston: Massachusetts Historical Society, 1914. Reprint, New York: AMS Press, 1972.

Corlette 1976. Corlette, Suzanne. *The Pulse of the People: New Jersey 1763–1789.* Exh. cat. Trenton: New Jersey State Museum, 1976.

Cormany 1992. Cormany, James R. "Jean Simon Chaudron, Silversmith, Poet and American Pioneer." *Silver* 25, no. 4 (July–August 1992): 8–11.

Cormany 1993. Cormany, James R. "J. Conning, Mobile." *Silver* 26, no. 1 (January–February 1993): 10–13.

Cornelius 1928. Cornelius, Charles Over. "John Townsend: An Eighteenth Century Cabinet-Maker." *Metropolitan Museum of Art Studies* 1 (1928): 72–80.

Cox and Cox 1983. Cox, Alwyn, and Angela Cox. *Rockingham Pottery and Porcelain 1745–1842.* Boston: Faber and Faber, 1983.

Cramer 1986. Cramer, Diana. "Asparagus Anyone?" *Silver* 19, no. 6 (November–December 1986): 38–41.

Cramer 1987. Cramer, Diana. "Rare and Interesting Pieces: Corn Things." *Silver* 20, no. 1 (January–February 1987): 30–32.

Cramer 1988a. Cramer, Diana. "Bailey and the Mysterious Philadelphia Marks." *Silver* 21, no. 4 (July–August 1988): 12–15.

Cramer 1988b. Cramer, Diana. "Peter L. Krider, The Marks." *Silver* 21, no. 1 (January–February 1988): 31–33.

Cramer 1989a. Cramer, Diana. "George Sharp." *Silver* 22, no. 4 (July–August 1989): 36–37.

Cramer 1989b. Cramer, Diana. "George Sharp and the Lion S Shield Mark." *Silver* 22, no. 6 (November–December 1989): 26–27.

Cramer 1990. Cramer, Diana. "Cheese Knives, Forks, and Scoops." *Silver* 23, no. 2 (March–April 1990): 36–40.

Cramer 1991a. Cramer, Diana. "George Sharp: The Products." *Silver* 24, no. 5 (September–October 1991): 24–30.

Cramer 1991b. Cramer, Diana. "William Gale and His Partners." *Silver* 24, no. 3 (May–June 1991): 28–32.

Cramer 1992a. Cramer, Diana. "Baby Rattles." *Silver* 25, no. 6 (November–December 1992): 38–39.

Cramer 1992b. Cramer, Diana. "Egyptian Revival Style by Gorham." *Silver* 25, no. 2 (March–April 1992): 7–9.

Cramer 1992c. Cramer, Diana. "John R. Wendt." *Silver* 25, no. 4 (July–August 1992): 18–26.

Cramer 1992d. Cramer, Diana. "John R. Wendt and Associates New Discoveries." *Silver* 25, no. 6 (November–December 1992): 20–28.

Cramer 1992e. Cramer, Diana. "John R. Wendt of Boston and New York." *Silver* 25, no. 3 (May–June 1992): 12–13.

Craven 1968. Craven, Wayne. *Sculpture in America.* New York: Thomas Y. Crowell Co., 1968.

Craven 1975. Craven, Wayne. "John Wollaston: His Career in England and New York." *The American Art Journal* 7, no. 2 (November 1975): 19–31.

Craven 1986. Craven, Wayne. *Colonial American Portraiture: The Economic, Religious, Social, Cultural, Philosophical, Scientific, and Aesthetic Foundations.* Cambridge: Cambridge University Press, 1986.

Crean 1990. Crean, Hugh R. "Gilbert Stuart and the Politics of Fine Arts Patronage in Ireland, 1787–1793: A Social and Cultural Study." City University of New York, Ph.D. dissertation, 1990.

Crookshank 1969. Crookshank, Anne. *Irish Portraits 1660–1860.* Exh. cat. London: Paul Mellon Foundation for British Art, 1969.

Crosby 1875. Crosby, Sylvester S. *The Early Coins of America.* Boston, 1875.

Cummings 1964. Cummings, Abbott Lowell. "The Foster-Hutchinson House." *Old-Time New England* 54, no. 3 (January–March 1964): 59–76.

Cummings et al. 1957. Cummings, Abbott Lowell, et al. *Samuel McIntire: A Bicentennial Symposium 1757–1957.* Salem, Mass.: Essex Institute, 1957.

Currie 1995. Currie, Christina. "19th-Century Portraits on Scored Panels in the Cleveland Museum of Art." *Journal of the American Institute for Conservation* 34, no. 1 (Spring 1995): 69–75.

Curtis 1973. Curtis, Phillip H. "American Quilts in the Newark Museum Collection." *The Museum,* n.s., 25, nos. 3–4 (Summer-Fall 1973): 2–68.

Cushing 1905. Cushing, James S. *The Genealogy of the Cushing Family, An Account of the Ancestors and Descendants of Matthey Cushing, Who Came to America in 1638.* Montreal: Perrault Printing Co., 1905.

Cushion 1982. Cushion, John. *English Porcelain.* Revised edition. London: Charles Letts Books Limited, 1982.

Cutten 1948. Cutten, George Barton. *The Silver-smiths of North Carolina.* Raleigh: State Department of Archives and History, 1948.

Cutten 1950. Cutten, George Barton. "Sucket Forks." *Antiques* 57 (June 1950): 440–41.

Cutten 1952. Cutten, George Barton. *The Silver-smiths of Virginia (Together with Watchmakers and Jewelers) from 1694 to 1850.* Richmond, Va.: Dietz Press, 1952.

Cutten 1958. Cutten, George Barton. *The Silver-smiths of Georgia: Together with Watchmakers and Jewelers—1733 to 1850.* Savannah, Ga.: Pigeon-hole Press, 1958.

Cutter 1910. Cutter, William Richard. *Genealogical and Personal Memoirs Relating to the Families of the State of Massachusetts.* New York: Lewis Historical Publishing Co., 1910.

Cutter 1911. Cutter, William Richard, ed. *Genealogical and Family History of the State of Connecticut.* 4 vols. New York: Lewis Historical Publishing Co., 1911.

DAB 1964–81. *Dictionary of American Biography.* 20 vols. 1928–36. Reprinted in 10 vols. with 7 supplements, New York: Charles Scribner's Sons, 1964–81.

Daniell 1924. Daniell, L. E. *Texas—The Country and Its Men.* [Austin, 1924].

Darling 1964. *New York State Silversmiths.* Eggertsville, New York: Darling Foundation of New York State Early American Silversmiths and Silver, 1964.

Davenport 1974. Davenport, John S. *European Crowns 1600–1700.* Galesburg, Ill.: n.p., 1974.

Davidson 1940. Davidson, Marshall. "Colonial Cherubim in Silver." *Antiques* 37 (April 1940): 184–86.

Davidson 1951. Davidson, Ruth Bradbury. "Antiques of Childhood." *Antiques* 59 (February 1951): 140–41.

Davidson 1953. Davidson, Ruth Bradbury. "American Gaming Tables." *Antiques* 64 (October 1953): 294–96.

Davidson 1967. Davidson, Marshall B. *The American Heritage History of Colonial Antiques.* New York: American Heritage Publishing Co., 1967.

Davidson 1968. Davidson, Marshall B. *The American Heritage History of American Antiques From the Revolution to the Civil War.* New York: American Heritage Publishing Co., 1968.

Davidson 1980. Davidson, Marshall B. *The American Wing: A Guide.* New York: Metropolitan Museum of Art, 1980.

Davidson and Stillinger 1985. Davidson, Marshall B., and Elizabeth Stillinger. *The American Wing at The Metropolitan Museum of Art.* New York: Alfred A. Knopf, 1985.

Davis 1972. Davis, Felice. "A Young Collector and American Antiques." *Connoisseur* 179 (March 1972): 192–99.

Davis 1976. Davis, John D. *English Silver at Williamsburg.* Williamsburg: Colonial Williamsburg Foundation, 1976.

Davison and Mayer-Thurman 1973. Davison, Mildred, and Christa C. Mayer-Thurman. *Coverlets: A Handbook on the Collection of Woven Coverlets in the Art Institute of Chicago.* Chicago: Art Institute of Chicago, 1973.

De Mare 1954. De Mare, Marie. *G. P. A. Healy, American Artist.* New York: David McKay Co., 1954.

Deák 1988. Deák, Gloria Gilda. *Picturing America:*

1497–1899. 2 vols. Princeton: Princeton University Press, 1988.

Decatur 1941. Decatur, Stephen. "The Moulton Silversmiths." *Antiques* 39 (January 1941): 14–17.

Decatur 1947. Decatur, Stephen. "William Gilbert, Silversmith of New York." In *A Treasury of Old Silver.* Edited by Kurt M. Semon. New York: Robert M. McBride, 1947: 61–63.

Deerfield 1956. "The Furniture [of Deerfield]." *Antiques* 70 (September 1956): 224–37.

DeGraw 1974. DeGraw, Imelda G. *Quilts and Coverlets.* Denver: Denver Art Museum, 1974.

Denison 1882. *Denison Memorial: Two Hundredth Anniversary of the Death of Major-General Daniel Denison.* Ipswich, Mass.: Denison Memorial Committee, 1882.

Denison 1966. Denison, Merrill. *Canada's First Bank: A History of the Bank of Montreal.* Vol. 1. Toronto: McClelland and Stewart, 1966.

Denker 1985. Denker, Ellen Paul. *After the Chinese Taste: China's Influence in America, 1730–1930.* Salem, Mass.: Peabody Museum, 1985.

Dennis 1968. Dennis, Jessie McNab. "Franks Family Silver by Lamerie." *Antiques* 93 (May 1968): 636–41.

Detroit 1967. *American Decorative Arts: From the Pilgrims to the Revolution.* Exh. cat. Detroit: Detroit Institute of Arts, 1967.

Detwiller 1977. Detwiller, Frederic C. "Thomas Dawes: Boston's Patriot Architect." *Old-Time New England* 68, nos. 1–2 (July–December 1977): 1–18.

Deutsch 1977. Deutsch, Davida Tenenbaum. "Washington Memorial Prints." *Antiques* 111 (February 1977): 324–31.

Deutsch 1989. Deutsch, Davida Tenenbaum. "The Polite Lady: Portraits of American Schoolgirls and Their Accomplishments, 1725–1830." *Antiques* 135 (April 1989): 742–53.

Deutsch 1991. Deutsch, Davida Tenenbaum. "Needlework Patterns and Their Use in America." *Antiques* 139 (February 1991): 368–81.

Dexter 1862. Dexter, Elias. *The St.-Mémin Collection of Portraits: consisting of seven hundred and sixty medallion portraits, principally of distinguished Americans, photographed by J. Gurney and Son, of New York, from proof impressions of the original copper-plates engraved by M. de St.-Mémin, from drawings taken from his life by himself, during his exile in the United States from 1793–1814.* New York: Elias Dexter, 1862.

Dickson 1947. Dickson, H. E. "A Note on Jeremiah Paul: American Artist." *Antiques* 51 (June 1947): 392–93.

Dike 1987. Dike, Catherine. "Silver and Gold Cane Handles in the United States." *Silver* 20, no. 4 (July–August 1987): 8–12.

Dike 1994. Dike, Catherine. *Canes in the United States: Illustrated Mementos of American History 1607–1953.* Ladue, Mo.: Cane Curiosa Press, 1994.

Distin and Bishop 1976. Distin, William H., and Robert Bishop. *The American Clock: A Comprehensive Pictorial Survey, 1723–1900.* New York: E. P. Dutton and Co., 1976.

Doggett 1878. Doggett, Samuel Bradlee. *History of the Bradlee Family, with Particular Reference to Descendants of Nathan Bradley of Dorchester, Mass.* Boston: Rockwell and Churchill, 1878.

Doty 1979. Doty, Robert M., ed. *The Currier Gallery of Art: Handbook of the Collection.* Manchester, N.H.: Currier Gallery of Art, 1979.

Douglas 1990. Douglas, Ed Polk. "Belter: Unmasking the Southern Myth." *Antique Monthly* (October 1990): 12–14.

Douglas 1994. Douglas, Ed Polk. "Mount Auburn for the Mantel—The Bigelow Chapel Girandoles." *The Rushlight* 60, no. 1 (March 1994): 6–8.

Dow 1967. Dow, George Francis. *The Arts & Crafts in New England, 1704–1775.* 1927. Reprint, New York: Da Capo Press, 1967.

Downing 1965. Downing, Antoinette F. "John Brown House." *Antiques* 87 (May 1965): 556–63.

Downing 1969. Downing, A. J. *The Architecture of Country Houses.* 1850. Reprint, with a new introduction by J. Stewart Johnson, New York: Dover Publications, 1969.

Downs 1937. Downs, Joseph. "American Japanned Furniture." *Old-Time New England* 28, no. 2 (October 1937): 61–67. (Reprinted from *The Metropolitan Museum of Art Bulletin,* March 1933.)

Downs 1951. Downs, Joseph. "Furniture of the Hudson Valley." *Antiques* 60 (July 1951): 45–47.

Downs 1952. Downs, Joseph. *American Furniture, Queen Anne and Chippendale Periods, in the Henry Francis du Pont Winterthur Museum.* New York: Macmillan Co., 1952.

Draper 1990. Draper, Elaine. "'The Silver King.'" *Silver* 23, no. 2 (March–April 1990): 16–17.

Draper 1991a. Draper, Elaine. "George Wilkinson: The Gorham Years." *Silver* 24, no. 2 (March–April 1991): 22–23.

Draper 1991b. Draper, Elaine. "The Wilkinson Influence." *Silver* 24, no. 3 (May–June 1991): 13–15.

Drepperd 1928. Drepperd, Carl W. "Three Battles of New Orleans." *Antiques* 14 (August 1928): 129–31.

Duncan 1706. Duncan, Daniel. *Wholesome Advice Against the Abuse of Hot Liquors.* London, 1706.

Duncan 1794. Duncan, William. *The New-York Directory, and Register for 1794.* New York: Thomas and James Swords, 1794.

Dunham 1963. Dunham, Lydia Roberts. *Denver Art Museum Quilt Collection.* Denver: Denver Art Museum, 1963.

Dunlap 1969. Dunlap, William. *A History of the Rise and Progress of the Arts of Design in the United States.* 2 vols. 1834. Reprint in 3 vols., New York: Dover Publications, 1969.

Dunton 1946. Dunton, William Rush. *Old Quilts.* Catonsville, Md.: Privately printed, 1946.

Durbin 1968. Durbin, Louise. "Samuel Kirk, Nineteenth-Century Silversmith." *Antiques* 94 (December 1968): 868–73.

Eberlein and McClure 1914. Eberlein, Harold Donaldson, and Abbot McClure. *The Practical Book of Period Furniture.* Philadelphia: J. B. Lippincott Co., 1914.

Eckhardt 1955. Eckhardt, George H. *Pennsylvania Clocks and Clockmakers: An Epic of Early American Science, Industry, and Craftsmanship.* New York: Bonanza Books, 1955.

Edgefield 1976. *Early Decorated Stoneware of the Edgefield District South Carolina.* Exh. cat. Greenville, S.C.: Greenville County Museum of Art, 1976.

Edwards 1986. Edwards, Lee M. *Domestic Bliss: Family Life in American Painting, 1840–1910.* Exh. cat. Yonkers, N.Y.: Hudson River Museum, 1986.

Edwards and Darly 1754. Edwards, George, and Mathias Darly. *New Book of Chinese Designs.* London, 1754.

Edwards and Macquoid 1986. Edwards, Ralph, and Percy Macquoid. *The Dictionary of English Furniture.* 3 vols. Second edition, revised and enlarged by Ralph Edwards, 1954. Reprint, Woodbridge, England: Antique Collectors' Club, 1986.

Elder 1968. Elder, William Voss, III. *Maryland Queen Anne and Chippendale Furniture of the Eighteenth Century.* Exh. cat. Baltimore: Baltimore Museum of Art, 1968.

Elder 1972. Elder, William Voss, III. *Baltimore Painted Furniture 1800–1840.* Exh. cat. Baltimore: Baltimore Museum of Art, 1972.

Elder 1992. Elder, William Voss, III. "Living with Antiques: A Collection of American Furniture in Baltimore." *Antiques* 141 (May 1992): 834–41.

Elder and Stokes 1987. Elder, William Voss, III, and Jayne E. Stokes. *American Furniture, 1680–1880.* Baltimore: Baltimore Museum of Art, 1987.

Elias Pelletreau 1959. *Elias Pelletreau, Long Island Silversmith and His Sources of Design.* Exh. cat. New York: Brooklyn Museum, 1959.

Ellet 1873. Ellet, Elizabeth F., ed. *The New Cyclopedia of Domestic Economy and Practical Housekeeper.* Norwich, Conn.: Henry Bill Publishing Co., 1873.

Elliott 1876. Elliott, Charles Wyllys. *The Book of American Interiors.* Boston: James R. Osgood and Co., 1876.

Ellsworth 1970. Ellsworth, Robert Hatfield. *Chinese Furniture: Hardwood Examples of the Ming and Early Ch'ing Dynasties.* London: Wm. Collins and Sons, 1970.

Elsdon 1993. Elsdon, Judith. "The American Museum in Britain: The Ceramics" *Antiques* 143 (March 1993): 456–61.

Elwell 1896. Elwell, Newton W. *Colonial Furniture and Interiors.* Boston: George H. Polley and Co., 1896.

Ely 1978. Ely, Elizabeth M. "Some English Church Pewter at The Museum of Fine Arts." *The Pewter Collectors' Club of America* 77 (September 1978): 316–21.

Emmons 1905. Emmons, Edward Neville. *The Emmons Family Genealogy.* Syracuse: Lyman Bros., 1905.

Ensko 1989. Ensko, Stephen Guernsey Cook. *American Silversmiths and Their Marks IV.* Revised and enlarged edition compiled by Dorothea Ensko Wyle. Boston: David R. Godine, 1989.

Estes 1894. Estes, David Foster. *The History of Holden Massachusetts, 1684–1894.* Worcester, Mass.: C. F. Lawrence and Co., 1894.

Etiquette 1862. *Etiquette for Ladies and Gentlemen; or, the Principles of True Politeness: to which is added the Ball-Room Manual.* Halifax: Milner and Sowerby, 1862.

Evans 1959. Evans, John J., Jr. "Lovebirds and Lions: A Pewter Mystery Solved." *Antiques* 76 (August 1959): 142–43.

Evans 1963. Evans, John J., Jr. "Provident Preservation." *The Pewter Collectors' Club of America* 48 (March 1963): 145–46.

Evans 1972. Evans, Nancy Goyne. "Some American Britannia Ware in the Winterthur Collection." *Antiques* 101 (June 1972): 1030–36.

Evans 1974. Evans, Nancy Goyne. "The Genealogy of a Bookcase Desk." In *Winterthur Portfolio 9*. Charlottesville: University Press of Virginia, 1974: 213–22.

Evans 1980. Evans, Dorinda. *Benjamin West and His American Students*. Exh. cat. Washington, D.C.: Smithsonian Institution Press for the National Portrait Gallery, 1980.

Evans 1982. Evans, Nancy Goyne. "The Tracy Chairmakers Identified." *Maine Antique Digest.* March 1982: 32A–33A. (Reprinted from *The Connecticut Antiquarian,* December 1981, a publication of the Antiquarian and Landmarks Society, Inc.)

Evans 1993. Evans, Nancy Goyne. "Design Transmission in Vernacular Seating Furniture: The Influence of Philadelphia and Baltimore Styles on Chairmaking from the Chesapeake Bay to the 'West.'" In *American Furniture 1993*. Edited by Luke Beckerdite. Hanover, N.H.: Chipstone Foundation, 1993: 75–116.

Evans 1996. Evans, Nancy Goyne. *American Windsor Chairs*. New York: Hudson Hills Press, 1996.

Evans 1997. Evans, Nancy Goyne. "When the Top Came Off: A Connecticut Chest Identified." *Maine Antique Digest* (April 1997): 26B–27B.

Failey 1971a. Failey, Dean F. "Elias Pelletreau, Long Island Silversmith." University of Delaware, Master's Thesis, 1971.

Failey 1971b. Failey, Dean F. "Silver Coffeepot by John Bayly." *The Museum of Fine Arts, Houston Bulletin*, n.s., 2, no. 5 (September 1971): 64.

Failey 1972. Failey, Dean F. "The Bayou Bend Collection: A Gift of Southern Silver." *The Museum of Fine Arts, Houston Bulletin,* n.s., 3, no. 2 (April 1972): 19–20.

Failey 1976. Failey, Dean F. *Long Island is My Nation: The Decorative Arts and Craftsmen, 1640–1830*. Setauket, N.Y.: Society for the Preservation of Long Island Antiquities, 1976.

Fairbanks 1967. Fairbanks, Jonathan. "American Antiques in the Collection of Mr. and Mrs. Charles L. Bybee. Part I." *Antiques* 92 (December 1967): 832–39.

Fairbanks 1974. Fairbanks, Jonathan. *American Pewter in the Museum of Fine Arts, Boston*. Boston: Museum of Fine Arts, Boston, 1974.

Fairbanks and Bates 1981. Fairbanks, Jonathan L., and Elizabeth Bidwell Bates. *American Furniture, 1620 to the Present*. New York: R. Marek, 1981.

Fairbanks and Trent 1982. Fairbanks, Jonathan L., and Robert F. Trent. *New England Begins: The Seventeenth Century*. 3 vols. Boston: Museum of Fine Arts, Boston, 1982.

Fairbanks et al. 1975. Fairbanks, Jonathan L., et al. *Paul Revere's Boston: 1735–1818*. Exh. cat. Boston: Museum of Fine Arts, Boston, 1975.

Fairbanks et al. 1981. Fairbanks, Jonathan L., et al. "A Decade of Collecting American Decorative Arts and Sculpture at the Museum of Fine Arts, Boston." *Antiques* 120 (September 1981): 590–636.

Fairbanks et al. 1991. Fairbanks, Jonathan L., et al. *Collecting American Decorative Arts and Sculpture: 1971–1991*. Exh. cat. Boston: Museum of Fine Arts, Boston, 1991.

Fairbrother 1981. Fairbrother, Trevor J. "John Singleton Copley's Use of British Mezzotints for His American Portraits: A Reappraisal Prompted by New Discoveries." *Arts Magazine* 55, no. 7 (March 1981): 122–30.

Falconer 1789. Falconer, William. *An Universal Dictionary of the Marine*. London: Thomas Cadell, 1789.

Fales 1958. Fales, Martha Gandy. *American Silver in the Henry Francis du Pont Winterthur Museum*. Winterthur: Henry Francis du Pont Winterthur Museum, 1958.

Fales 1962. Fales, Dean A., Jr. "T. D. B. Tells All." *The Pewter Collectors' Club of America* 46 (February 1962): 109–10.

Fales 1964. Fales, Martha Gandy. "The Early American Way of Death." *Essex Institute Historical Collections* 100 (April 1964): 75–84.

Fales 1965. Fales, Dean A., Jr. *Essex County Furniture: Documented Treasures from Local Collections 1660–1860*. Salem, Mass.: Essex Institute, 1965.

Fales 1970. Fales, Martha Gandy. *Early American Silver for the Cautious Collector*. New York: Funk and Wagnalls, 1970.

Fales 1972. Fales, Dean A., Jr. *American Painted Furniture 1660–1880*. Robert Bishop and Cyril I. Nelson, eds. New York: E. P. Dutton and Co., 1972.

Fales 1974a. Fales, Dean A., Jr. "Boston Japanned Furniture." *Boston Furniture of the Eighteenth Century*. Charlottesville: University Press of Virginia, 1974: 49–69.

Fales 1974b. Fales, Martha Gandy. *Joseph Richardson and Family, Philadelphia Silversmiths*. Middletown, Conn.: Wesleyan University Press for the Historical Society of Pennsylvania, 1974.

Fales 1976. Fales, Dean A., Jr. *The Furniture of Historic Deerfield*. New York: E. P. Dutton and Co., 1976.

Fales 1983. Fales, Martha Gandy. *Silver at the Essex Institute*. Salem, Mass.: Essex Institute, 1983.

Fales 1995. Fales, Martha Gandy. *Jewelry in America 1600–1900*. Woodbridge, Suffolk: Antique Collectors' Club, 1995.

Farish 1943. Farish, Hunter Dickinson, ed. *Journal and Letters of Philip Vickers Fithian, 1773–1774: A Plantation Tutor of the Old Dimenion.* Williamsburg: Colonial Williamsburg, 1943.

Farnam 1977. Farnam, Anne. "Furniture at the Essex Institute, Salem, Massachusetts." *Antiques* 111 (May 1977): 958–73.

Farnham 1972. Farnham, Katharine Gross. "Living with Antiques: The Gordon-Banks House in the Georgia Piedmont." *Antiques* 102 (September 1972): 434–47.

Farnham and Efird 1971. Farnham, Katharine Gross, and Callie Huger Efird. "Early Silversmiths and the Silver Trade in Georgia." *Antiques* 99 (March 1971): 380–85.

Fede 1966. Fede, Helen Maggs. *Washington Furniture at Mount Vernon*. Mount Vernon, Va.: Mount Vernon Ladies' Association of the Union, 1966.

Federhen 1988. Federhen, Deborah Anne. "Paul Revere, Silversmith: A Study of His Shop Operation and His Objects." University of Delaware, Master's Thesis, 1988.

Federhen 1994. Federhen, Deborah Anne. "Politics and Style: An Analysis of the Patrons and Products of Jonathan Gostelowe and Thomas

Affleck." In *Shaping a National Culture: The Philadelphia Experience, 1750–1800.* Winterthur: Henry Francis du Pont Winterthur Museum, 1994: 283–311.

Feigenbaum 1979. Feigenbaum, Rita. "Craftsman of Many Styles." *American Art and Antiques* 2, no. 3 (May /June 1979): 58–59.

Feld et al. 1991. Feld, Stuart P., et al. *Neo-Classicism in America: Inspiration and Innovation 1810–1840*. Exh. cat. New York: Hirschl and Adler Galleries, 1991.

Fennimore 1971. Fennimore, Donald L. "Elegant Patterns of Uncommon Good Taste: Domestic Silver by Thomas Fletcher and Sidney Gardiner." University of Delaware, Master's Thesis, 1971.

Fennimore 1972. Fennimore, Donald L. "Thomas Fletcher and Sidney Gardiner." *Antiques* 102 (October 1972): 642–49.

Fennimore 1975. Fennimore, Donald L. "Metalwork." *The American Art Journal* 7, no. 1 (May 1975): 93–106.

Fennimore 1984. Fennimore, Donald L. *Silver and Pewter*. The Knopf Collectors' Guides to American Antiques. New York: Alfred A. Knopf, 1984.

Fennimore 1990. Fennimore, Donald L. "Egyptian Influence in Early Nineteenth-Century Furniture." *Antiques* 137 (May 1990): 119–201.

Fennimore 1996. Fennimore, Donald L. *Metalwork in Early America: Copper and Its Alloys From the Winterthur Collection*. Winterthur: Winterthur Museum, 1996.

Fennimore et al. 1994. Fennimore, Donald L., et al. *Eye for Excellence: Masterworks from the Winterthur*. Winterthur: Winterthur Museum, 1994.

Fielding 1965. *Mantle Fielding's Dictionary of American Painters, Sculptors and Engravers: With an Addendum Containing Corrections and Additional Material on the Original Entries*. Compiled by James F. Carr. New York: James F. Carr, 1965.

Finlay 1948. Finlay, Ian. "Scottish Silver in Edinburgh." *Connoisseur* 122, no. 510 (December 1948): 88–93.

Finlay 1956. Finlay, Ian. *Scottish Gold and Silver Work*. London: Chatto and Windus, 1956.

Fitz-gerald 1981. Fitz-gerald, Desmond. "The Dublin Del Vecchios." *Antiques* 120 (October 1981): 910–14.

Fitzgerald 1982. Fitzgerald, Oscar P. *Three Centuries of American Furniture*. Englewood Cliffs, N.J.: Prentice-Hall, 1982.

Flanigan 1986. Flanigan, J. Michael. *American Furniture from the Kauffman Collection*. Washington, D.C.: National Gallery of Art, 1986.

Fleischer 1988. Fleischer, Roland E. "Emblems and Colonial American Painting." *The American Art Journal* 20, no. 3 (1988): 2–35.

Flexner 1947. Flexner, James Thomas. *First Flowers of our Wilderness*. Boston: Houghton Mifflin Co., 1947.

Flexner 1948. Flexner, James Thomas. *John Singleton Copley*. Boston: Houghton Mifflin Co.; Cambridge: Riverside Press, 1948.

Flick 1925. Flick, Alexander C. *The Papers of Sir William Johnson*. Vol. 4. Albany: University of the State of New York, 1925.

Flick 1930. Flick, Alexander C. *The Papers of Sir

William Johnson. Vol. 7. Albany: University of the State of New York, 1930.

Flick 1962. Flick, Alexander C. *The Papers of Sir William Johnson.* Vol. 13. Albany: University of the State of New York, 1962.

Flower 1943. Flower, Milton E. "Schimmel the Woodcarver." *Antiques* 44 (October 1943): 164–66.

Flower 1960. Flower, Milton E. "Aaron Mountz, Primitive Woodcarver." *Antiques* 77 (June 1960): 586–87.

Flower 1965. Flower, Milton E. *William Schimmel and Aaron Mountz: Wood Carvers.* Williamsburg: Abby Aldrich Rockefeller Museum, 1965.

Floyd 1974. Floyd, William Barrow. "Kentucky Coin-Silver Pitchers." *Antiques* 105 (March 1974): 576–80.

Flynt 1988. Flynt, Suzanne L. *Ornamental and Useful Accomplishments: Schoolgirl Education and Deerfield Academy, 1800–1830.* Deerfield, Mass.: Pocumtuck Valley Memorial Association and Deerfield Academy, 1988.

Flynt and Fales 1968. Flynt, Henry N., and Martha Gandy Fales. *The Heritage Foundation Collection of Silver With Biographical Sketches of New England Silversmiths, 1625–1825.* Old Deerfield, Mass.: Heritage Foundation, 1968.

Foote 1930. Foote, Henry Wilder. *Robert Feke.* Cambridge: Harvard University Press, 1930.

Foote 1950. Foote, Henry Wilder. *John Smibert: Painter.* Cambridge: Harvard University Press, 1950.

Foote 1957. Foote, Henry Wilder. "Benjamin Blyth of Salem: Eighteenth-Century Artist." *Proceedings of the Massachusetts Historical Society* 71 (October 1953–May 1957): 63–107.

Forbes 1969. Forbes, Esther. *Paul Revere and the World He Lived In.* 1942. Sentry Edition, Boston: Houghton Mifflin Co., 1969.

Ford 1952. Ford, Alice. *Edward Hicks: Painter of the Peaceable Kingdom.* Philadelphia: University of Pennsylvania Press, 1952.

Ford 1985. Ford, Alice. *Edward Hicks: His Life and Art.* New York: Abbeville Press, 1985.

Forman 1970. Forman, Benno M. "Urban Aspects of Massachusetts Furniture in the Late Seventeenth Century." In *Winterthur Conference Report 1969: Country Cabinetwork and Simple City Furniture.* Edited by John D. Morse. Charlottesville: University Press of Virginia for the Henry Francis du Pont Winterthur Museum, 1970: 1–33.

Forman 1980. Forman, Benno M. "Delaware Valley 'Crookt Foot' and Slat Back Chairs: The Fussell-Savery Connection." In *Winterthur Portfolio* 15, no. 1. Chicago: University of Chicago Press, 1980: 41–64.

Forman 1983. Forman, Benno M. "German Influences in Pennsylvania Furniture." In *Arts of the Pennsylvania Germans.* New York: W. W. Norton for the Henry Francis du Pont Winterthur Museum, 1983: 102–70.

Forman 1987. Forman, Benno M. "Furniture for Dressing in Early America, 1650–1730: Forms, Nomenclature, and Use." In *Winterthur Portfolio* 22, nos. 2/3. Chicago: University of Chicago Press, 1987: 149–64.

Forman 1988. Forman, Benno M. *American Seating Furniture, 1630–1730: An Interpretive Catalogue.* New York: W. W. Norton, 1988.

Fowble 1987. Fowble, E. McSherry. *Two Centuries of Prints in America: 1680–1880.* Charlottesville: University Press of Virginia for the Henry Francis du Pont Winterthur Museum, 1987.

Fowler 1993. "The Francis E. Fowler, Jr. Collection of Silver." *Silver* 26, no. 5 (November–December 1993): 8–9, 24–28, 34–35.

Fowler and Cornforth 1974. Fowler, John, and John Cornforth. *English Decoration in the Eighteenth Century.* Princeton: Pyne Press, 1974.

Fox 1968. Fox, Claire Gilbride. "Catherine MacCaulay, An Eighteenth Century Clio." In *Winterthur Portfolio 4.* Charlottesville: University Press of Virginia, 1968: 129–42.

Fox 1981. Fox, Sandi. *Quilts in Utah: A Reflection of the Western Experience.* Salt Lake City: Salt Lake Art Center, 1981.

Franco 1973. Franco, Barbara. "New York City Furniture Bought for Fountain Elms by James Watson Williams." *Antiques* 104 (September 1973): 462–67.

Franco 1986. Franco, Barbara. "Fraternal Artifacts in the Museum of Our National Heritage, Lexington, Massachusetts." *Antiques* 130 (December 1986): 1242–49.

Fraser 1933. Fraser, Esther Stevens. "The Tantalizing Chests of Taunton." *Antiques* 23 (April 1933): 135–38.

Frelinghuysen 1989. Frelinghuysen, Alice Cooney. *American Porcelain 1770–1920.* New York: Metropolitan Museum of Art, 1989.

French 1939. French, Hollis. *Jacob Hurd and His Sons Nathaniel and Benjamin, Silver-smiths, 1702–1781.* Cambridge, Mass.: Riverside Press for the Walpole Society, 1939.

Freund 1993. Freund, Thatcher. *Objects of Desire.* New York: Pantheon Books, 1993.

Frothingham 1892. Frothingham, Washington. *History of Montgomery County* Syracuse: D. Mason and Co., 1892.

Fulton and Mylin 1973. Fulton, Eleanore Jane, and Barbara Kendig Mylin. *An Index to the Will Books and Intestate Records of Lancaster County, Pennsylvania 1729–1850.* 1936. Reprint, Baltimore: Genealogical Publishing Co., 1973.

Gaines 1959. Gaines, Edith. "Paintings and Antiques in the Loudonville, New York Home of Mrs. Ledyard Cogswell Jr." *Antiques* 76 (November 1959): 430–33.

Gaines 1961. Gaines, Edith. "The Clintons of New York." *Antiques* 79 (May 1961): 463–65.

Gale 1984. Gale Research Co., comp. *Currier and Ives: A Catalogue Raisonné.* 2 vols. Detroit: Gale Research Co., 1984.

Garbisch 1966. *101 American Primitive Water Colors and Pastels from the Collection of Edgar William and Bernice Chrysler Garbisch.* Washington, D.C.: National Gallery of Art, 1966.

Garrett 1959. Garrett, Wendell D. "The Furnishings of Newport Houses, 1780–1800." *Rhode Island History* 18, no. 1 (January 1959): 1–19.

Garrett 1966. Garrett, Wendell D. "Providence Cabinetmakers, Chairmakers, Upholsterers, and Allied Craftsmen, 1756–1838: A Check List." *Antiques* 90 (October 1966): 514–19.

Garrett 1976. Garrett, Elisabeth Donaghy. "American Furniture in the DAR Museum." *Antiques* 109 (April 1976): 750–59.

Garrett 1977. Garrett, Elisabeth Donaghy. "Living with Antiques: The Manhattan Apartment of Mr. and Mrs. Robert Lee Gill." *Antiques* 111 (May 1977): 990–1001.

Garrett 1981. Garrett, Elisabeth Donaghy. "Living with Antiques: Pumpkin House in New England." *Antiques* 119 (March 1981): 674–81.

Garrett 1982. Garrett, Wendell. "The Goddard and Townsend Joiners of Newport." *Antiques* 121 (May 1982): 1153–55.

Garrett 1993. Garrett, Wendell. *Victorian America: Classical Romanticism to Gilded Opulence.* Edited by David Larkin. New York: Rizzoli, 1993.

Garrett et al. 1969. Garrett, Wendell, et al. *The Arts in America: The Nineteenth Century.* New York: Charles Scribner's Sons, 1969.

Garrett et al. 1985. Garrett, Elizabeth Donaghy, et al. *The Arts of the Independence: The DAR Museum Collection.* Washington, D.C.: National Society, Daughters of the American Revolution, 1985.

Garvan 1982. Garvan, Beatrice B. *The Pennsylvania German Collection.* Philadelphia: Philadelphia Museum of Art, 1982.

Garvan 1987. Garvan, Beatrice B. *Federal Philadelphia.* Philadelphia: Philadelphia Museum of Art, 1987.

Garvan et al. 1969. Garvan, Anthony N. B., et al. "American Church Silver: A Statistical Study." In *Winterthur Conference Report 1968: Spanish, French, and English Traditions in the Colonial Silver in North America.* Winterthur: Henry Francis du Pont Winterthur Museum, 1969: 73–104.

Garvin, Garvin, and Page 1979. Garvin, Donna-Belle, James L. Garvin, and John F. Page. *Plain and Elegant, Rich and Common: Documented New Hampshire Furniture, 1750–1850.* Exh. cat. Concord: New Hampshire Historical Society, 1979.

Geffen 1961. Geffen, Elizabeth M. *Philadelphia Unitarianism: 1796–1861.* Philadelphia: University of Philadelphia Press, 1961.

Gerdts and Burke 1971. Gerdts, William H., and Russell Burke. *American Still Life Painting.* New York: Praeger Publishers, 1971.

Gibbs 1984. Gibbs, James W. *Pennsylvania Clocks and Watches.* Pennsylvania: Pennsylvania State University, 1984.

Gilbert 1978. Gilbert, Christopher. *Furniture at Temple Newsam House and Lotherton Hall.* 2 vols. London: National Art-Collections Fund and the Leeds Art Collections Fund, 1978.

Gillman 1895. Gillman, Alexander W. *Searches into the History of the Gillman or Gilman Family* Vol. 2. London: Eliot Stock, 1895.

Gilman 1869. Gilman, Arthur. *The Gilman Family Traced in the Line of Hon. John Gilman, of Exeter, N.H. with an Account of Many Other Gilmans in England and America.* Albany: Joel Munsell, 1869.

Ginsburg 1974. Ginsburg, Benjamin. "The Barbour Collection of Connecticut Furniture in the Connecticut Historical Society." *Antiques* 105 (May 1974): 1092–111.

Ginsburg and Levy 1942. *A Century of American Chairs: 1720–1820.* Exh. cat. New York: Ginsburg and Levy, 1942.

Godden 1983. Godden, Geoffrey. *Staffordshire Porcelain.* New York: Granada Publishing, 1983.

Goetzmann and Goetzmann 1986. Goetzmann, William H., and William N. Goetzmann. *The West of the Imagination.* New York and London: W. W. Norton and Co., 1986.

Goldberg 1993. Goldberg, Marcia. "Textured Panels in 19th-Century American Painting." *Journal of the American Institute for Conservation* 32, no. 1 (Spring 1993): 33–42.

Goldberg 1994. Goldberg, David J. "Charles Coxon: Nineteenth-Century Potter, Modeler-Designer, and Manufacturer." *American Ceramic Circle Journal* 9. Washington, D.C.: American Ceramic Circle, 1994: 28–64.

Golding 1936. Golding, Augustus C. *Descendants of Rev. Thomas Hanford.* Vol. 1. Norwalk, Conn.: Case, Lockwood and Brainard Co., 1936.

Goldsborough 1975. Goldsborough, Jennifer Faulds. *Eighteenth and Nineteenth Century Maryland Silver in the Collection of the Baltimore Museum of Art.* Baltimore: Baltimore Museum of Art, 1975.

Goldsborough et al. 1981. Goldsborough, Jennifer Faulds, et al. *A Silver Tribute to Valor.* Washington, D.C.: Preservation Press, 1981.

Goldsborough et al. 1983. Goldsborough, Jennifer Faulds, et al. *Silver in Maryland.* Baltimore: Maryland Historical Society, 1983.

Golovin 1970. Golovin, Anne Castrodale. "Daniel Trotter: Eighteenth-Century Philadelphia Cabinetmaker." In *Winterthur Portfolio* 6. Charlottesville: University Press of Virginia, 1970: 151–84.

Goodfriend 1992. Goodfriend, Joyce D. *Before the Melting Pot: Society and Culture in Colonial New York City, 1664–1730.* Princeton: Princeton University Press, 1992.

Goodison 1968. Goodison, Nicholas. *English Barometers 1680–1860: A History of Domestic Barometers and Their Makers.* New York: Clarkson N. Potter, 1968.

Goodrich 1967. Goodrich, Laurence B. *Ralph Earl: Recorder of an Era.* [Albany: State University of New York, 1967.]

Goss 1891. Goss, Elbridge Henry. *The Life of Colonel Paul Revere.* 2 vols. 1891.

Gotjen 1984. Gotjen, J. T. Letter to the Editor, *Journal of Glass Studies* 26 (1984): 157–58.

Gottesman 1938. Gottesman, Rita Susswein, comp. *The Arts and Crafts in New York 1726–1776.* New York: New York Historical Society, 1938.

Gottesman 1954. Gottesman, Rita Susswein, comp. *The Arts and Crafts in New York 1777–1799.* New York: New York Historical Society, 1954.

Gottesman 1965. Gottesman, Rita Susswein, comp. *The Arts and Crafts in New York 1800–1804.* New York: New York Historical Society, 1965.

Gourley 1965. Gourley, Hugh J., III. *The New England Silversmith.* Exh. cat. Providence: Museum of Art, Rhode Island School of Design, 1965.

Goyne 1965. Goyne, Nancy A. "Brittania in America: The Introduction of a New Alloy and a New Industry." In *Winterthur Portfolio* 2. Winterthur: Henry Francis du Pont Winterthur Museum, 1965: 160–96.

Goyne 1967. Goyne, Nancy A. "The Bureau Table in America." In *Winterthur Portfolio* 3. Winterthur: Henry Francis du Pont Winterthur Museum, 1967: 24–36.

Green 1976a. Green, Henry D. *Furniture of the Georgia Piedmont Before 1830.* Atlanta: High Museum of Art, 1976.

Green 1976b. Green, Robert Alan. "The Gift of Franklin." *Silver* 9, no. 5 (September–October 1976): 6–9.

Green 1977. Green, Robert Alan. "Boston Silversmiths and Related Tradesmen (1840–1850)." *Silver* 10, no. 5 (September–October 1977): 10–15.

Green 1978a. Green, Robert Alan. "William Gale and Son, New York." *Silver* 11, no. 2 (March–April 1978): 6–11.

Green 1978b. Green, Robert Alan. "The Silversmiths of Alabama (1820–80)." *Silver* 11, no. 3 (May–June 1978): 6–13.

Greenlaw 1974. Greenlaw, Barry A. *New England Furniture at Williamsburg.* Williamsburg: Colonial Williamsburg Foundation, 1974.

Greenlaw 1978a. Greenlaw, Barry A. "Ornamental and Plain: American Card Tables." *Newtown Bee (Antiques and the Arts Weekly).* September 29, 1978.

Greenlaw 1978b. Greenlaw, Barry A. "Ornamental and Plain: American Card Tables in the Bayou Bend Collection." *Theta Charity Antique Show Catalogue.* Houston, 1978: 14–17.

Greenlaw 1979. Greenlaw, Barry A. "American Furniture in Houston Collections." *Antiques* 116 (September 1979): 548–53.

Greer 1981. Greer, Georgeanna H. *American Stonewares, The Art and Craft of Utilitarian Potters.* Exton, Pa.: Schiffer Publishing, 1981.

Grier 1988. Grier, Katherine C. *Culture and Comfort: People, Parlors, and Upholstery 1850–1930.* Rochester, N.Y.: The Strong Museum, 1988.

Griffith 1985. Griffith, Lee Ellen. "Chester County Redware: The English Tradition." In *Chester County Historical Society Antiques Show: Chester County Redware.* Exh. cat. West Chester, Pa.: Chester County Historical Society, 1985: 7–8, 10, 12.

Griffith 1986a. Griffith, Lee Ellen. "The Pennsylvania Spice Box." *Antiques* 129 (May 1986): 1062–67.

Griffith 1986b. Griffith, Lee Ellen. *The Pennsylvania Spice Box: Paneled Doors and Secret Drawers.* West Chester, Pa: Chester County Historical Society, 1986.

Grigsby 1990. Grigsby, Leslie B. *English Pottery: Stoneware and Earthenware 1650–1800.* London: Philip Wilson Publishers Limited for Sotheby's Publications, 1990; distributed in the U.S. by Rizzoli International Publications, New York.

Groce 1952. Groce, George C. "John Wollaston: A Cosmopolitan Painter in the British Colonies." *The Art Quarterly* 15, no. 2 (Summer 1952): 133–48.

Grover 1987. Grover, Kathryn, ed. *Dining in America: 1850–1900.* Amherst: University of Massachusetts Press; Rochester, N.Y.: Margaret Woodbury Strong Museum, 1987.

Guadagni 1967. Guadagni, G. D. "Collector's Notes: Paul's Washington Family in Oil on Canvas." Edited by Edith Gaines. *Antiques* 91 (April 1967): 519, 527–28.

Guilland 1971. Guilland, Harold F. *Early American Folk Pottery.* Philadelphia: Chilton Book Co., 1971.

Guille 1967. [Guille, Peter.] "Great Silver from Three Centuries: English, Dutch, and American [at the Sterling and Francine Clark Institute in Williamstown, Massachusetts]." *Antiques* 92 (September 1967): 332–35.

Guillim 1724. Guillim, John. *Display of Heraldry.* 1724.

Gustafson 1983. Gustafson, Eleanor H. "Museum Accessions." *Antiques* 123 (May 1983): 950, 954, 956.

Gustafson 1984a. Gustafson, Eleanor H. "Museum Accessions." *Antiques* 125 (January 1984): 122.

Gustafson 1984b. Gustafson, Eleanor H. "Museum Accessions." *Antiques* 126 (October 1984): 780, 784, 788.

Gustafson 1986. Gustafson, Eleanor H. "Museum Accessions." *Antiques* 129 (May 1986): 956, 966.

Guyol 1958. Guyol, Philip N. "The Prentis Collection." *Historical New Hampshire* 14. Concord: New Hampshire Historical Society (December 1958): 9–16.

Hagler 1976. Hagler, Katharine Bryant. *American Queen Anne Furniture 1720–1755.* Dearborn, Mich.: Greenfield Village and Henry Ford Museum, 1976.

Haines and Foote 1984. Haines, Carol L., and Lisa H. Foote. *"Forms to Sett On": A Social History of Concord Seating Furniture.* Concord, Mass.: Concord Antiquarian Museum, [1984].

Hall 1887. Hall, Florence Howe. *Social Customs.* Boston: Estes and Lauriat, 1887.

Hall 1974. Hall, James. *Dictionary of Subjects and Symbols in Art.* New York: Harper & Row Publishers, 1974.

Hall 1981. Hall, Virginius Cornick, Jr. *Portraits in the Collection of the Virginia Historical Society.* Charlottesville: University of Virginia Press, 1981.

Hall and Kretsinger 1935. Hall, Carrie A., and Rose G. Kretsinger. *The Romance of the Patchwork Quilt in America.* New York: Bonanza Books, 1935.

Halsey 1918. Halsey, R.T.H. "William Savery, the Colonial Cabinet-Maker, and His Furniture." *Bulletin of the Metropolitan Museum of Art* 13 (December 1918): 254–67.

Hamilton 1972. Hamilton, Suzanne. "The Pewter of William Will: A Checklist." In *Winterthur Portfolio* 7. Charlottesville: University Press of Virginia, 1972: 129–60.

Hamilton 1994. Hamilton, John D. *Material Culture of the American Freemasons.* Lexington, Mass.: Museum of Our National Heritage, 1994.

Hammerslough 1958. Hammerslough, Philip H. "Rarities in Tucker Porcelain in the Collection of Philip H. Hammerslough." *Antiques* 74 (September 1958): 241.

Hammerslough 1965. Hammerslough, Philip H. *American Silver Collected by Philip H. Hammerslough.* Vol. 3. Hartford, Conn.: Privately printed, 1965.

Hammerslough and Feigenbaum 1973. Hammerslough, Philip H. and Rita F. Feigenbaum. *American Silver Collected by Philip H. Hammerslough.* Vol. 4. Hartford, Conn.: Privately printed, 1973.

Hanks 1970. Hanks, David A. "American Silver at the Art Institute of Chicago." *Antiques* 98 (September 1970): 418–22.

Hanks 1971. Hanks, David A. "American Colonial and Federal Art in Chicago Collections." *Connoisseur* 177 (August 1971): 277–83.

Hanks 1972. Hanks, David A. "Queen Anne Side Chair." *Calendar of the Art Institute of Chicago* 66, no. 2 (March 1972): 10–11.

Hanks and Peirce 1983. Hanks, David A., and

Donald C. Peirce. *The Virginia Carroll Crawford Collection: American Decorative Arts, 1825–1917.* Atlanta: High Museum of Art, 1983.

Hanks and Toher 1986. Hanks, David A., with Jennifer Toher. "Metalwork: An Eclectic Aesthetic." In *In Pursuit of Beauty.* New York: Metropolitan Museum of Art, 1986: 252–93.

Hansen 1948. "Living with Antiques: The Grosse Pointe Home of Mr. and Mrs. R. M. Hansen." *Antiques* 54 (December 1948): 426–28.

Hansen 1981. Hansen, Abby. "Coral in Children's Portraits: A Charm Against the Evil Eye." *Antiques* (December 1981): 1424–31.

Harrington 1939. Harrington, Jessie. *Silversmiths of Delaware 1700–1850.* Camden, N.J.: National Society of Colonial Dames of America in the State of Delaware, 1939.

Harrison 1971. Harrison, Molly. *People and Furniture: A Social Background to the English Home.* London: Ernest Benn Limited, 1971.

Hart 1904. Hart, Charles H. *Engraved Portraits of Washington.* New York: Grolier Club, 1904.

Hart 1909. Hart, Charles H. *A Register of Portraits Painted by Thomas Sully, 1801–1871.* Philadelphia: n.p., 1909.

Hart 1925. Hart, Virginia Packard. "Tilt-top Tables: They Were Popular in Early Half of the Eighteenth Century." *Antiquarian* 5, no. 1 (August 1925): 13–14.

Harvard 1936. *Harvard Tercentenary Exhibition Catalogue of Furniture, Silver, Pewter, Glass, Ceramics, Paintings, Prints, Together with Allied Arts and Crafts of the Period 1636–1836.* Cambridge: Harvard University Press, 1936.

Hastings 1937. Hastings, Mrs. Russel. "Peter Van Dyck of New York, Goldsmith, 1684–1750. Parts 1 and 2." *Antiques* 31 (May 1937): 236–39; (June 1937): 302–5.

Hastings 1941. Hastings, Mrs. Russel. "Some Franklin Memorabilia Emerge in Los Angeles. Part 3: Furniture by the Seymours of Portland and Boston." *Antiques* 40 (September 1941): 146–49.

Hatfield 1975. "Living with Antiques: Hatfield Plantation in Washington County, Texas." *Antiques* 153 (September 1975): 522–31.

Hawley 1989. Hawley, Henry. "A Livingston Chair." *The Bulletin of The Cleveland Museum of Art* 76, no. 9 (November 1989): 326–31.

Hayes 1974. Hayes, Charles W. *Galveston: History of the Island and the City.* 1879. Reprint, Austin: Jenkins Garrett Press, 1974.

Hayward and Kirkham 1980. Hayward, Helena, and Pat Kirkham. *William and John Linnell: Eighteenth-Century London Furniture Makers.* 2 vols. New York: Rizzoli in association with Christie's, 1980.

Healy 1894. Healy, George P. A. *Reminiscences of A Portrait Painter.* Chicago: A. C. McClurg and Co., 1894.

Heckscher 1973. Heckscher, Morrison H. "The New York Serpentine Card Table." *Antiques* 103 (May 1973): 974–83.

Heckscher 1982. Heckscher, Morrison H. "John Townsend's Block-and-Shell Furniture." *Antiques* 121 (May 1982): 1144–52.

Heckscher 1985. Heckscher, Morrison H. *American Furniture in The Metropolitan Museum of Art.* New York: Metropolitan Museum of Art and Random House, 1985.

Heckscher 1987a. Heckscher, Morrison H. "Eighteenth-Century American Upholstery Techniques: Easy Chairs, Sofas, and Settees." In *Upholstery in America and Europe from the Seventeenth Century to World War I.* Edited by Edward S. Cooke, Jr. New York: W. W. Norton, 1987: 97–111.

Heckscher 1987b. Heckscher, Morrison H. "Living with Antiques: Mount Cuba in Delaware." *Antiques* 131 (May 1987): 1078–87.

Heckscher 1989. Heckscher, Morrison H. "Philadelphia Furniture, 1760–90: Native-Born and London-Trained Craftsmen." In *The American Craftsman and the European Tradition, 1620–1820.* Edited by Francis J. Puig and Michael Conforti. Minneapolis: Minneapolis Institute of Arts, 1989: 92–111.

Heckscher 1994. Heckscher, Morrison H. "English Furniture Pattern Books in Eighteenth-Century America." In *American Furniture 1994.* Edited by Luke Beckerdite. Hanover, N.H.: Chipstone Foundation, 1994: 172–205.

Heckscher and Bowman 1992. Heckscher, Morrison H., and Leslie Greene Bowman. *American Rococo, 1750–1775: Elegance in Ornament.* New York: Metropolitan Museum of Art and Los Angeles County Museum of Art, 1992.

Heckscher, Safford, and Fodera 1986. Heckscher, Morrison H., Frances Gruber Safford, and Peter Lawrence Fodera. "Boston Japanned Furniture in the Metropolitan Museum of Art." *Antiques* 129 (May 1986): 1046–61.

Heisey 1978. Heisey, John W. *A Checklist of American Coverlet Weavers.* Edited by Gail C. Andrews and Donald R. Walters. Williamsburg: Colonial Williamsburg Foundation, 1978.

Held 1951. Held, Julius. "Edward Hicks and the Tradition." *Art Quarterly* 14 (Summer 1951): 123–36.

Hendrickson 1983. Hendrickson, Hope Coppage. "Cliveden." *Antiques* 124 (August 1983): 259–65.

Hepplewhite 1969. Hepplewhite, George. *The Cabinet-Maker & Upholsterer's Guide.* Third edition, 1794. Reprint, New York: Dover Publications, 1969.

Herr 1982. Herr, Donald M. "Marked American Beakers." *The Pewter Collectors' Club of America* 84 (March 1982): 193–212.

Herr 1995. Herr, Donald M. *Pewter in Pennsylvania Churches.* Birdsboro: Pennsylvania German Society, 1995.

Hewitt 1982. Hewitt, Benjamin A. "Regional Characteristics of Inlay on American Federal Card Tables." *Antiques* 121 (May 1982): 1164–71.

Hewitt, Kane, and Ward 1982. Hewitt, Benjamin A., Patricia E. Kane, and Gerald W. R. Ward. *The Work of Many Hands: Card Tables in Federal America, 1790–1820.* New Haven: Yale University Art Gallery, 1982.

Hiatt and Hiatt 1954. Hiatt, Noble W., and Lucy F. Hiatt. *The Silversmiths of Kentucky: Together with Some Watchmakers and Jewelers 1785–1850.* Louisville: Standard Printing Co., 1954.

Hill 1976. Hill, John H. "The History and Technique of Japanning and the Restoration of the Pimm Highboy." *American Art Journal* 8, no. 2 (November 1976): 59–84.

Hilt 1964. Hilt, Wendell. "The Remarkable Mr. Boardman." *The Pewter Collectors' Club of America* 51 (December 1964): 34–35.

Hilt 1965. Hilt, Wendell. "The Boardman Group." *The Pewter Collectors' Club of America* 52 (May 1965): 52–59.

Hinckley 1953. Hinckley, F. Lewis. *A Directory of Antique Furniture.* New York: Bonanza Books, 1953.

Hinckley 1960. Hinckley, F. Lewis. *Directory of the Historic Cabinet Woods.* New York: Crown Publishers, 1960.

Hind 1979. Hind, Jan Garrett. *The Museum of Early Southern Decorative Arts: A Collection of Southern Furniture, Paintings, Ceramics, Textiles, and Metalwares, Winston, Salem.* Old Salem: N.C., 1979.

Hindes 1967. Hindes, Ruthanna. "Delaware Silversmiths, 1700–1850." *Delaware History* 12, no. 4 (October 1967): 247–308.

Hipkiss 1941. Hipkiss, Edwin J. *Eighteenth-Century American Arts: The M. and M. Karolik Collection.* Cambridge: Harvard University Press, 1941.

Hirschl and Adler 1954. Hirschl and Adler Galleries. *Two Hundred Years of American Art.* New York: Hirschl and Adler Galleries, 1954.

Hitchings 1974. Hitchings, Sinclair H. "Boston's Colonial Japanners: The Documentary Record." In *Boston Furniture of the Eighteenth Century.* Boston: Colonial Society of Massachusetts, 1974: 71–76.

Hogarth 1908. Hogarth, William. *The Analysis of Beauty.* 1753. Reprint, Chicago: Reilly and Lee Co., 1908.

Hoke 1985. Hoke, Donald, comp. *Dressing the Bed: Quilts and Coverlets from the Collections of the Milwaukee Public Museum.* Exh. cat. Milwaukee: Milwaukee Public Museum, 1985.

Hollan 1994. Hollan, Catherine B. *In the Neatest, Most Fashionable Manner: Three Centuries of Alexandria Silver.* Exh. cat. Alexandria, Va.: Lyceum, 1994.

Holland 1955. Holland, Eugenia Calvert. *The Potter's Craft in Maryland: An Exhibition of Nearly 200 Examples of Pottery Manufactured 1793 to 1890.* Baltimore: Maryland Historical Society, 1955.

Holloway 1927. Holloway, Edward Stratton. "Furniture of the Federal Era." *House and Garden* 51 (May 1927): 98–99.

Holloway 1928. Holloway, Edward Stratton. *American Furniture and Decoration: Colonial and Federal.* Philadelphia: J. B. Lippincott Co., 1928.

Holmes 1893. Holmes, S. P. *Avery Family Record.* Plymouth: W. W. Avery, 1893.

Holzer, Boritt, and Neely 1984. Holzer, Harold, Gabor S. Boritt, and Mark E. Neely, Jr. *The Lincoln Image: Abraham Lincoln and the Popular Print.* New York: Scribner Press, 1984.

Hood 1965. Hood, Graham. *American Pewter: Garvan and Other Collections at Yale.* New Haven: Yale University Art Gallery, 1965.

Hood 1968. Hood, Graham. "A New Form in American Seventeenth-Century Silver." *Antiques* 94 (December 1968): 879–81.

Hood 1971. Hood, Graham. *American Silver: A History of Style, 1650–1900.* New York: Praeger Publishers, 1971.

Hood 1972. Hood, Graham. *Bonnin and Morris of Philadelphia: The First American Porcelain Factory, 1770–1772.* Chapel Hill: University of North Carolina Press, 1972.

Hoopes 1930. Hoopes, Penrose R. *Connecticut Clockmakers of the Eighteenth Century.* Hartford,

Conn.: Edwin Valentine Mitchell; New York: Dodd, Mead and Co., 1930.

Hoopes 1933. Hoopes, Penrose R. "Notes on Some Colonial Cabinetmakers of Hartford." *Antiques* 23 (May 1933): 171–72.

Hope 1971. Hope, Thomas. *Household Furniture & Interior Decoration: Classic Style Book of the Regency Period.* London, 1807. Reprint, with a new introduction by David Watkin, New York: Dover Publications, 1971.

Horne 1990. Horne, Catherine Wilson, ed. *Crossroads of Clay, The Southern Alkaline-Glazed Stoneware Tradition.* Columbia: McKissick Museum, University of South Carolina, 1990.

Hornor 1977. Hornor, William MacPherson, Jr. *Blue Book, Philadelphia Furniture, William Penn to George Washington.* 1935. Reprint, Washington, D.C.: Highland House Publishers, 1977.

Hornsby 1982. Hornsby, Peter. "An Interesting English Porringer." *The Pewter Collectors' Club of America* 84 (March 1982): 183.

Hornung 1972. Hornung, Clarence P. *Treasury of American Design.* 2 vols. New York: Harry N. Abrams, 1972.

Hough 1989. Hough, Samuel J. "The Class of 1870 Gorham Sterling Ice Bowls." *Silver* 22, no. 5 (September–October 1989): 30–33.

House and Garden 1973. "Christmas at Bayou Bend." *House and Garden* 144 (December 1973): 90–93.

Howat et al. 1970. Howat, John K., et al. *Nineteenth-Century America: Paintings and Sculpture.* Exh. cat. New York: Metropolitan Museum of Art, 1970.

Howe 1979. Howe, Katherine S. "Nineteenth-century American Decorative Arts in Houston." *Antiques* 115 (March 1979): 556–63.

Howe and Warren 1976. Howe, Katherine S., and David B. Warren. *The Gothic Revival Style in America, 1830–1870.* Houston: Museum of Fine Arts, Houston, 1976.

Howgego 1958. Howgego, James L. "Copley and the Corporation of London." *Guildhall Miscellany* 1, no. 9 (July 1958): 34–43.

Hoyt 1875. Hoyt, Albert H. *Daniel Peirce, of Newbury, Massachusetts, 1638–1677, the Founder of the Peirce Family of Newbury, Mass., Portsmouth, N.H.* Boston: n.p., 1875.

Huitson 1993. Huitson, John. "The American Museum in Britain: Domestic Settings." *Antiques* 143 (March 1993): 408–21.

Hull 1857. Hull, "The Diaries of John Hull, Mint-Master and Treasurer of the Colony of Massachusetts Bay." *Transactions and Collections of the American Antiquarian Society* 3. Boston: Privately printed, 1857: 109–316.

Hummel 1970/71. Hummel, Charles F. "Queen Anne and Chippendale Furniture in the Henry Francis du Pont Winterthur Museum." Parts 2 and 3. *Antiques* 98 (December 1970): 900–9; 99 (January 1971): 98–107.

Hummel 1976. Hummel, Charles F. *A Winterthur Guide to American Chippendale Furniture: Middle Atlantic and Southern Colonies.* New York: Crown Publishers, 1976.

Hunter 1931. Hunter, Walter C. "The Spoon as a Funerary Souvenir." *Antiques* 19 (April 1931): 302–3.

Hunter 1932. Hunter, Walter C. "Fancy Fiddle Spoons." *Antiques* 22 (November 1932): 181–82.

Hurst and Priddy 1990. Hurst, Ronald L., and Sumpter Priddy, III. "The Neoclassical Furniture of Norfolk, Virginia, 1770–1820." *Antiques* 137 (May 1990): 1140–53.

Hurst and Prown 1997. Hurst, Ronald L., and Jonathan Prown. *Southern Furniture 1680–1830: The Colonial Williamsburg Collection.* Williamsburg: Colonial Williamsburg Collection in association with Harry N. Abrams, 1997.

Husher and Welch 1980. Husher, Richard W., and Walter W. Welch. *A Study of Simon Willard's Clocks.* Nahant, Mass.: Husher and Welch, 1980.

Hyde 1971. Hyde, Bryden Bordley. *Bermuda's Antique Furniture & Silver.* Bermuda: Bermuda National Trust, 1971.

Innes 1976. Innes, Lowell. *Pittsburgh Glass 1797–1891.* Boston: Houghton Mifflin, 1976.

Iowa 1894. *Portrait and Biographical Record of Dubuque, Jones and Clayton Counties, Iowa.* Chicago: Chapman Publishing Co., 1894.

Irish Silver 1971. *Irish Silver: An Exhibition of Irish Silver from 1630–1820 at Trinity College Dublin.* Dublin, Ireland: Trinity College, 1971.

Jackson 1981. Jackson, Mrs. E. Nevill. *Silhouettes: A History and Dictionary of Artists.* 1938. Reprint, New York: Dover Publications, 1981. (Originally published under the title *Silhouette: Notes and Dictionary.*)

Jaffe 1975. Jaffe, Irma B. *John Trumbull: Patriot-Artist of the American Revolution.* Boston: New York Graphic Society, 1975.

James 1962. James, Arthur E. "Chester County Pewter and Pewterers." *The Pewter Collectors' Club of America* 47 (September 1962): 128–30.

James 1978. James, Arthur E. *The Potters and Potteries of Chester County, Pennsylvania.* Exton, Pa.: Schiffer Publishing, 1978.

Jayne 1957. Jayne, Horace H. F. "Tucker Porcelain: Thomas Tucker's Share." *Antiques* 72 (September 1957): 237–39.

Jeffers 1995. Jeffers, Wendy. "Holger Cahill and American Folk Art." *Antiques* 148 (September 1995): 326–35.

Jensen 1978. Jensen, James F. "Eighteenth- and Early Nineteenth-Century American Furniture at the Honolulu Academy of Arts." *Antiques* 113 (May 1978): 1086–97.

Jobe 1974. Jobe, Brock. "The Boston Furniture Industry 1720–1740." In *Boston Furniture of the Eighteenth Century.* Boston: Colonial Society of Massachusetts, 1974: 3–48.

Jobe 1987. Jobe, Brock. "The Boston Upholstery Trade, 1700–1775." In *Upholstery in America and Europe from the Seventeenth Century to World War I.* Edited by Edward S. Cooke, Jr. New York: W. W. Norton, 1987.

Jobe 1991. Jobe, Brock. "A Boston Desk-and-Bookcase at the Milwaukee Art Museum." *Antiques* 140 (September 1991): 412–19.

Jobe and Kaye 1984. Jobe, Brock, and Myrna Kaye. *New England Furniture: The Colonial Era.* Boston: Houghton Mifflin Co., 1984.

Jobe et al. 1991. Jobe, Brock, et al. *American Furniture with Related Decorative Arts, 1660–1830.* Edited by Gerald W. R. Ward. New York: Hudson Hills Press, 1991.

Jobe et al. 1993. Jobe, Brock, et al. *Portsmouth Furniture: Masterworks from the New Hampshire Seacoast.* Hanover, N.H.: University Press of New England, 1993.

John Hull 1857. "The Diaries of John Hull, Mint-Master and Treasurer of the Colony of Massachusetts Bay." *Transactions and Collections of the American Antiquarian Society* 3. Boston: John Wilson and Son, 1857: 109–316.

Johns 1991. Johns, Elizabeth. *American Genre Painting: The Politics of Everyday Life.* New Haven: Yale University Press, 1991.

Johnson 1961. Johnson, Philip A. "The Leffingwell Inn." *Antiques* 79 (June 1961): 566–69.

Johnson 1966a. Johnson, Thomas H., ed. *The Oxford Companion to American History.* New York: Oxford University Press, 1966.

Johnson 1966b. Johnson, J. Stewart. *Silver in Newark: A Newark 300th Anniversary Study.* Exh. cat. *The Museum,* n.s., 18, nos. 3 and 4. Newark: Newark Museum, 1966.

Johnson 1993. Johnson, Don. "The Georgianna H. Greer Stoneware Collection." *Maine Antique Digest* (February 1993): 36D–38D, and "Greer Stoneware Auction, Session 2." (April 1993): 28D–30D.

Johnston 1950. Johnston, Edith Duncan. *The Houstouns of Georgia.* Athens: University of Georgia Press, 1950.

Johnston 1979. Johnston, Phillip. "Eighteenth- and Nineteenth-Century American Furniture at the Wadsworth Atheneum." *Antiques* 115 (May 1979): 1016–27.

Johnston 1994. Johnston, Phillip M. *Catalogue of American Silver: The Cleveland Museum of Art.* Cleveland: Cleveland Museum of Art in association with Indiana University Press, 1994.

Jones 1908. Jones, Emma C. Brewster. *The Brewster Genealogy 1566–1907.* 2 vols. New York: Grafton Press, 1908.

Jones 1913. Jones, E. Alfred. *The Old Silver of American Churches.* Letchworth, England: Privately printed for the National Society of Colonial Dames of America at the Arden Press, 1913.

Jones 1983. Jones, J. Kenneth. "Cornelius and Co. of Philadelphia." *Antiques* 124 (December 1983): 1218–22.

Jordan 1911. Jordan, John W. *Colonial and Revolutionary Families of Pennsylvania: Genealogical and Personal Memoirs.* Vol. 1. New York: Lewis Historical Publishing Co., 1911.

Jouett 1965. Jouett, Matthew H. "Notes Taken by M.[atthew] H. Jouett while in Boston from Conve[r]sations on Painting with Gilbert Stuart Esqr." In *American Art, 1700–1960: Sources and Documents.* Edited by John W. McCoubrey. Englewood Cliffs, N.J.: Prentice-Hall, 1965: 20–25.

Kalm 1966. Kalm, Peter. *The America of 1750: Peter Kalm's Travels in North America.* English version, 1770. Revised and edited by Adolph B. Benson with a translation of new material from Kalm's diary notes. 2 vols. in 1. New York: Dover Publications, 1966.

Kamensky 1995. Kamensky, Jane. *The Colonial Mosaic: American Women, 1600–1760.* New York and Oxford: Oxford University Press, 1995.

Kamerling 1977. Kamerling, Bruce. "Edward C. Moore, The Genius Behind Tiffany Silver." 2 parts. *Silver* 10, no. 5 (September–October 1977): 16–20; 10, no. 6 (November–December 1988): 8–13.

Kane 1973. Kane, Patricia E. *Furniture of the New Haven Colony: The Seventeenth Century Style.*

New Haven: New Haven Colony Historical Society, 1973.

Kane 1975. Kane, Patricia E. "Seventeenth Century Furniture of the Connecticut Valley: The Hadley Chest Reappraised." In *Winterthur Conference Report 1974: Arts of the Anglo-American Community in the Seventeenth Century.* Edited by Ian M. G. Quimby. Charlottesville: University Press of Virginia for the Henry Francis du Pont Winterthur Museum, 1975: 79–122.

Kane 1976. Kane, Patricia E. *Three Hundred Years of American Seating Furniture: Chairs and Beds from the Mabel Brady Garvan and Other Collections at Yale University.* Boston: New York Graphic Society, 1976.

Kane 1980. Kane, Patricia E. "American Furniture in the Yale University Art Gallery." *Antiques* 117 (June 1980): 1314–27.

Kane 1987. Kane, Patricia E. "John Hull and Robert Sanderson: First Masters of New England Silver." Yale University, Ph.D. Dissertation, 1987.

Kane 1998. Kane, Patricia E., ed. *Colonial Massachusetts Silversmiths and Jewelers: A Biographical Dictionary Based on the Notes of Francis Hill Bigelow and John Marshall Phillips.* New Haven: Yale University Art Gallery, 1998.

Karolik 1947. [An American Correspondent.] "Eighteenth-Century American Chairs and Their English Background as Represented by Examples in the Karolik Collection." *Connoisseur* 120, no. 505 (September 1947): 45–49.

Katzenberg 1971. Katzenberg, Dena S. *The Great American Cover-Up: Counterpanes of the Eighteenth and Nineteenth Centuries.* Baltimore: Baltimore Museum of Art, 1971.

Katzenberg 1981. Katzenberg, Dena S. *Baltimore Album Quilts.* Baltimore: Baltimore Museum of Arts, 1981.

Kauffman 1948. Kauffman, Henry J. "Simon Pennock, Pewter Maker." *Antiques* 53 (March 1948): 196–97.

Kauffman 1968. Kauffman, Henry J. *American Copper & Brass.* Camden, N. J.: Thomas Nelson and Sons, 1968.

Kaye 1974. Kaye, Myrna. "Eighteenth-Century Boston Furniture Craftsmen." *Boston Furniture of the Eighteenth Century.* Boston: Colonial Society of Massachusetts, 1974: 267–302.

Kaye 1985. Kaye, Myrna. "The Furniture of Samuel Sewall." *Antiques* 128 (August 1985): 276–84.

Keen 1881. Keen, Gregory B. "The Descendants of J"ran Kyn, the Founder of Upland." *Pennsylvania Magazine of History and Biography* 2, no. 3 (1881): 334–42.

Kelly 1991. Kelly, Mackenzie L. "Cheese Knives 1830–1920." *Silver* 24, no. 2 (March–April 1991): 16–20.

Kennedy and Sack 1977. *Age of the Revolution and Early Republic in Fine and Decorative Arts: 1750–1824.* Exh. cat. New York: Kennedy Galleries and Israel Sack, 1977.

Keno, Freund, and Miller 1996. Keno, Leigh, Joan Barzilay Freund, and Alan Miller. "The Very Pink of the Mode: Boston Georgian Chairs, Their Export, and Their Influence." In *American Furniture 1996.* Edited by Luke Beckerdite. Hanover, N.H.: Chipstone Foundation, 1996: 266–306.

Kent and Levy 1909. Kent, Henry Watson, and Florence N. Levy. *The Husdon-Fulton Celebration: Catalogue of an Exhibition Held in the Metropolitan Museum of Art.* Vol. 2. New York: Metropolitan Museum of Art, 1909.

Kerfoot 1942. Kerfoot, J. B. *American Pewter.* New York: Crown Publishers, 1942.

Kernan 1966. Kernan, John D. "Gold Funeral Rings." *Antiques* 89 (April 1966): 568–69.

Kernan, Ross, and Eilers 1969. Kernan, John Devereux, W. Ogden Ross, and F. Farny Eilers, Jr. *An Exhibition of Connecticut Pewter.* Meriden, Conn.: Meriden Gravure Co., 1969.

Kernodle and Pitkin 1957. Kernodle, George H., and Thomas M. Pitkin. "The Whittinghams: Brassfounders of New York." *Antiques* 71 (April 1957): 350–53.

Ketchum 1971. Ketchum, William C., Jr. *The Pottery and Porcelain Collector's Handbook: A Guide to Early American Ceramics from Maine to California.* New York: Funk and Wagnalls, 1971.

Ketchum 1982. Ketchum, William C., Jr. *Chests, Cupboards, Desks, and Other Pieces.* The Knopf Collectors' Guides to American Antiques. New York: Alfred A. Knopf, 1982.

Ketchum 1983. Ketchum, William C., Jr. *Pottery and Porcelain.* The Knopf Collectors' Guides to American Antiques. New York: Alfred A. Knopf, 1983.

Keyes 1925. Keyes, Homer Eaton. "Another Tea Chair." *Antiques* 8 (December 1925): 355.

Keyes 1932. Keyes, Homer Eaton. "A Clue to New York Furniture." *Antiques* 21 (March 1932): 122–23.

Keyes 1936. Keyes, Homer Eaton, ed. "John Nys vs. John Newkirke." *Antiques* 30 (December 1936): 270–71.

Keyes 1937. K[eyes], H[omer] E[aton]. "Two Branches of the Newport Townsends." *Antiques* (June 1937): 308–10.

Keyes 1938. Keyes, Homer Eaton. "Dennis or a Lessor Light?" *Antiques* 34 (December 1938): 296–300.

Kimball 1929. Kimball, Marie G. "The Original Furnishings of the White House. Part 1." *Antiques* 15 (June 1929): 481–86.

Kimball 1930/31. Kimball, Fiske. "Furniture Carvings by Samuel McIntire." 5 parts. *Antiques* 18 (November 1930): 388–92; 18 (December 1930): 498–502; 19 (January 1931): 30–2; 19 (February 1931): 116–19; 19 (March 1931): 207–10.

Kimball 1931a. Kimball, Marie G. "The Furnishings of Governor Penn's Town House." *Antiques* 19 (May 1931): 374–78.

Kimball 1931b. Kimball, Marie G. "The Furnishings of Lansdowne, Governor Penn's Country Estate." *Antiques* 19 (June 1931): 450–55.

Kimball 1932. Kimball, Fiske. "The Estimate of McIntire." *Antiques* 21 (January 1932): 23–25.

Kimball 1933a. Kimball, Fiske. "Salem Secretaries and Their Makers." *Antiques* 23 (May 1933): 168–70.

Kimball 1933b. Kimball, Fiske. "Salem Furniture Makers: II. Nehemiah Adams." *Antiques* 24 (December 1933): 218–20.

Kimball 1957. Kimball, Fiske. "Samuel McIntire." In *Samuel McIntire: A Bicentennial Symposium 1757–1957.* Salem, Mass.: Essex Institute, 1957: 10–36.

Kindig 1978. Kindig, Joseph K., III. *The Philadel-phia Chair 1685–1785.* York, Pa.: Historical Society of York County, 1978.

Kiracofe and Johnson 1993. Kiracofe, Roderick, with Mary Elizabeth Johnson. *The American Quilt: A History of Cloth and Comfort 1750–1950.* New York: Clarkson N. Potter, 1993.

Kirk 1960. "Wanted: A Kirk Sermon." *The Pewter Collectors' Club of America* 43 (September 1960): 57–58.

Kirk 1965. Kirk, John T. "Sources of Some Regional Furniture. Part I." *Antiques* 88 (December 1965): 790–98.

Kirk 1967. Kirk, John T. *Connecticut Furniture.* Exh. cat. Hartford: Wadsworth Atheneum, 1967.

Kirk 1970. Kirk, John T. *Early American Furniture.* New York: Alfred A. Knopf, 1970.

Kirk 1972a. Kirk, John T. "An Antiques Book Preview: *American Chairs: Queen Anne and Chippendale.*" *Antiques* 102 (September 1972): 422–24.

Kirk 1972b. Kirk, John T. *American Chairs: Queen Anne and Chippendale.* New York: Alfred A. Knopf, 1972.

Kirk 1982. Kirk, John T. *American Furniture & the British Tradition to 1830.* New York: Alfred A. Knopf, 1982.

Kloss 1988. Kloss, William. *Samuel F. B. Morse.* New York: Harry N. Abrams in association with the National Museum of American Art, 1988.

Knox 1972. Knox, Katharine McCook. *The Sharples: Their Portraits of George Washington and His Contemporaries.* New Haven: Yale University Press, 1930; Reprint, New York: Da Capo Press, 1972.

Konkle 1932. Konkle, Burton Alva. *Benjamin Chew 1722–1810.* Philadelphia: University of Pennsylvania Press, 1932.

Kornhauser 1988. Kornhauser, Elizabeth Mankin. "Ralph Earl, 1751–1801: Artist-Entrepreneur." Boston University, Ph.D. Dissertation, 1988.

Kornhauser 1991. Kornhauser, Elizabeth Mankin. *Ralph Earl: The Face of the Young Republic.* Exh. cat. New Haven: Yale University Press; Hartford: Wadsworth Atheneum, 1991.

Kraemer 1975. Kraemer, Ruth. *Drawings by Benjamin West and His Son Raphael Lamar West.* New York: Pierpont Morgan Library, 1975.

Krile 1989. Krile, Katherine M. *Measure, Mug, and a Lot of Pewter Plates: Pewter in the Delaware Valley.* West Chester, Pa.: Chester County Historical Society, 1989.

Krueger 1978. Krueger, Glee F. *A Gallery of American Samplers: The Theodore H. Kapnek Collection.* New York: E. P. Dutton and Co. and the Museum of American Folk Art, 1978.

LACMA 1955. "American Ships in the China Trade: The Chinese Export Porcelains and Other Cargo They Brought from Canton in the Half-Century from 1784 to the 1830s." *Los Angeles County Museum Bulletin of the Art Division* 7, no. 1 (Winter 1955).

Ladies Amusement. *The Ladies Amusement, or Whole Art of Japanning Made Easy.* London, n.d.

Laidacker 1954. Laidacker, Sam. *Anglo-American China.* Part I. Second edition. Bristol, Pa.: Sam Laidacker, 1954.

Landman 1975. Landman, Hedy B. "The Pendleton House at the Museum of Art, Rhode Island School of Design." *Antiques* 107 (May 1975): 923–38.

Lanmon et al. 1990. Lanmon, Dwight P., et al. *John Frederick Amelung: Early American Glassmaker.* Corning, N.Y.: Corning Museum of Glass Press, 1990. (Revised version of the 1976 issue of the *Journal of Glass Studies,* issued by the Corning Museum of Glass.)

Larus 1964. Larus, Jane Bortman. *Myer Myers, Silversmith, 1723–1795.* Washington, D.C.: B'nai B'rith, 1964.

Larus 1965. Larus, Jane Bortman. *Myer Myers: American Silversmith.* New York: Jewish Museum, 1965.

Lasansky 1990. Lasansky, Jeannette. "Berks County Redware Pottery, 1767–1909." *Antiques* 137 (January 1990): 325–39.

Laughlin 1940. Laughlin, Ledlie Irwin. *Pewter in America: Its Makers and Their Marks.* 2 vols. Boston: Houghton Mifflin Co., 1940.

Laughlin 1971. Laughlin, Ledlie Irwin. *Pewter in America: Its Makers and Their Marks.* Vol. 3. Barre, Mass.: Barre Publishers, 1971.

Layton 1992. Layton, Rachel E. C. "Samuel Williamson's Presentation Silver: Important New Discoveries." *Silver* 25, no. 1 (January–February 1991): 8–13.

le Bourhis 1989. le Bourhis, Katell, ed. *The Age of Napoleon: Costume from Revolution to Empire, 1789–1815.* New York: Metropolitan Museum of Art in association with Harry N. Abrams, 1989.

Lea 1960. Lea, Zilla Rider, ed. *The Ornamented Chair.* Rutland, Vt.: Charles Tuttle Co., 1960.

Lee 1947. Lee, Ruth Webb. *Sandwich Glass Handbook.* Wellesley Hills, Mass.: Lee Publications, 1947.

Leehey et al. 1988. Leehey, Patrick M., et al. *Paul Revere—Artisan, Businessman, and Patriot: The Man Behind the Myth.* Boston: Paul Revere Memorial Association, 1988.

Lehner 1988. Lehner, Lois. *Lehner's Encyclopedia of U. S. Marks on Pottery, Porcelain and Clay.* Paducah, Ky.: Collector Books, 1988.

Lenape 1971. New Jersey State Museum. *From Lenape Territory to Royal Province: New Jersey 1600–1750.* Exh. cat. Trenton: New Jersey State Museum, 1971.

Leonard 1949. Leonard, H. Stewart. *Mississippi Panorama.* St. Louis: City Art Museum of St. Louis, 1949.

Leslie 1864. Leslie, Eliza. *The Ladies' Guide to True Politeness and Perfect Manners: or, Miss Leslie's Behavior Book.* Philadelphia: T. B. Peterson and Brothers, 1864.

Levin 1988. Levin, Elaine. *The History of American Ceramics From Pipkins and Bean Pots to Contemporary Forms, 1607 to the Present.* New York: Harry N. Abrams, 1988.

Levy 1984. Levy, Bernard. "Living with Antiques: A Collection in Westchester County, New York." *Antiques* 125 (May 1984): 1134–39.

Levy 1993. Levy, Frank M. "A Maker of New York Card Tables Identified." *Antiques* 143 (May 1993): 756–63.

Levy Gallery 1975. *Bernard and S. Dean Levy Gallery Catalogue.* Number 3. New York: Bernard and S. Dean Levy, December 1975.

Levy Gallery 1984. *Bernard and S. Dean Levy Gallery Catalogue.* Vol. 4. Comp. and written by Bernice K. Kimball. New York: Bernard and S. Dean Levy, 1984.

Levy Gallery 1986. *Bernard and S. Dean Levy Gallery Catalogue.* Vol. 5. Comp. and written by Bernice K. Kimball. New York: Bernard and S. Dean Levy, 1986.

Levy Gallery 1988a. *An American Tea Party: An Exhibition of Colonial Tea and Breakfast Tables, 1715–1783.* Exh. cat. New York: Bernard and S. Dean Levy, 1988.

Levy Gallery 1988b. *Bernard and S. Dean Levy Gallery Catalogue.* Vol. 6. Comp. and written by Bernice K. Kimball. New York: Bernard and S. Dean Levy, 1988.

Levy Gallery 1992. *Vanity and Elegance: An Exhibition of the Dressing Table and Tall Chest in America 1685–1785.* Exh. cat. New York: Bernard and S. Dean Levy, 1992.

Libin 1985. Libin, Laurence. *American Musical Instruments in the Metropolitan Museum of Art.* New York: Metropolitan Museum of Art, 1985.

Lindsey 1991. Lindsey, Jack L. "An Early Latrobe Furniture Commission." *Antiques* 139 (January 1991): 208–19.

Lindsey 1993. Lindsey, Jack L. "Lynford Lardner's Silver: Early Rococo in Philadelphia." *Antiques* 143 (April 1993): 608–15.

Linley 1996. Linley, David. *Extraordinary Furniture.* London: Mitchell Beazley, 1996.

Lipman 1948. Lipman, Jean. *American Folk Art: In Wood, Metal and Stone.* New York: Pantheon, 1948.

Lipsett 1985. Lipsett, Linda Otto. *Remember Me.* San Francisco: Quilt Digest Press, 1985.

Little 1972a. Little, Nina Fletcher. *American Decorative Wall Painting, 1700–1850.* 1952. Enlarged reprint, New York: E. P. Dutton and Co., 1972.

Little 1972b. Little, Nina Fletcher. "The Blyths of Salem: Benjamin, Limner in Crayons and Oil, and Samuel, Painter and Cabinetmaker." *Essex Institute Historical Collections* 108, no. 1 (January 1972): 49–57.

Little 1984. Little, Nina Fletcher. *Little by Little: Six Decades of Collecting American Decorative Arts.* New York: E. P. Dutton and Co., 1984.

Lloyd 1983. Lloyd, Sandra Mackenzie. "Wyck." *Antiques* 124 (August 1983): 276–83.

Locke 1913. Locke, John. *Some Thoughts Concerning Education.* London, 1693. Reprint, Cambridge: Cambridge University Press, 1913.

Lockwood 1913. Lockwood, Luke Vincent. *Colonial Furniture in America.* Second edition. 2 vols. New York: Charles Scribner's Sons, 1913.

Lockwood 1957. Lockwood, Luke Vincent. *Colonial Furniture in America.* Third edition, 1926. 2 vols. Reprint, New York: Castle Books by arrangement with Charles Scribner's Sons, 1957.

London 1802. *The London Chair-Makers' and Carvers' Book of Prices for Workmanship.* 1802.

Longworth 1798. *Longworth's American Almanack, New-York Register, and City Directory* New York: Thomas and James Swords, 1798.

Lovell 1974. Lovell, Margaretta Markle. "Boston Blockfront Furniture." In *Boston Furniture of the Eighteenth Century.* Boston: Colonial Society of Massachusetts, 1974: 77–135.

Lyle and Zimmerman 1980. Lyle, Charles T., and Philip D. Zimmerman. "Furniture of the Monmouth County Historical Association." *Antiques* 117 (January 1980): 186–205.

Lynn 1980. Lynn, Catherine. *Wallpaper in America: From the Seventeenth Century to World War I.* New York: W. W. Norton, 1980.

Lyon 1925. Lyon, Irving Whitall. *The Colonial Furniture of New England.* Third edition. Boston, New York: Houghton Mifflin Co., 1925.

MacBeth 1971. MacBeth, Jerome R. "Portraits by Ralph E.W. Earl." *Antiques* 100 (September 1971): 390–93.

Mackie, Bacot, and Mackie 1980. Mackie, Carey T., H. Parrott Bacot, and Charles L. Mackie. *Crescent City Silver: An Exhibition of Nineteenth-Century New Orleans Silver.* Exh. cat. New Orleans: Historic New Orleans Collection, 1980.

Mackie, Bacot, and Mackie 1982. Mackie, Carey T., H. Parrott Bacot, and Charles L. Mackie. "Hyde and Goodrich and Its Successors: Nineteenth-century New Orleans Silver Manufacturers." *Antiques* 122 (August 1982): 293–303.

Macquoid 1987. Macquoid, Percy. *A History of English Furniture. Vol. 1: The Age of Oak and The Age of Walnut.* (1904, 1905). *Vol. 2: The Age of Mahogany and The Age of Satinwood.* (1906, 1908). England: Antique Collectors' Club, 1987.

Manwaring 1970. Manwaring, Robert. *The Cabinet and Chair-maker's Real Friend and Companion.* 1765. Reprint, London: Alec Tiranti, 1970.

Marvin 1973. Marvin, Pearson. *American Pewter (c. 1730–c. 1870) in the Collection of Dr. and Mrs. Melvyn D. Wolf.* Flint: Flint Institute of Arts, 1973.

Marzio 1979. Marzio, Peter C. *The Democratic Art: Pictures for a 19th-Century America—Chromolithography 1840–1900.* Boston: David R. Godine, 1979.

Marzio et al. 1989. Marzio, Peter C., et al. *A Permanent Legacy: 150 Works from the Collection of the Museum of Fine Arts, Houston.* Houston: Museum of Fine Arts, Houston, 1989.

Mason 1884. Mason, George C. *Reminiscences of Newport.* Newport: Charles E. Hammett, Jr., 1884.

Mason 1989. Mason, George C. "Gilding." In *The Application of Art to Manufactures.* G. P. Putnam, 1858. Reprinted in *Silver* 22, no. 3 (May–June 1989): 34–37.

Masonic Symbols 1976. *Masonic Symbols in American Decorative Arts.* Exh. cat. Lexington, Mass.: Scottish Rite Masonic Museum of Our National Heritage, 1976.

Mather 1973. Mather, Eleanor Price. "A Quaker Icon: The Inner Kingdom of Edward Hicks." *Art Quarterly* 36, no. 1/2 (Spring/Summer 1973): 84–99.

Mather 1975. Mather, Eleanor Price. "Introduction." In *Edward Hicks: A Gentle Spirit.* Exh. cat. New York: Andrew Crispo Gallery, 1975: unpaginated.

Mather and Miller 1983. Mather, Eleanor Price, and Dorothy Canning Miller. *Edward Hicks: His Peaceable Kingdom and Other Paintings.* Newark: University of Delaware Press, 1983.

Matthews 1901. Matthews, J., ed. *Matthews' American Armoury and Blue Book.* London: J. Matthews, 1901.

McClelland 1939. McClelland, Nancy. *Duncan Phyfe and the English Regency 1795–1830.* New York: William R. Scott, 1939.

McClinton 1968. McClinton, Katharine Morrison. *Collecting American 19th-Century Silver.* New York: Charles Scribner's Sons, 1968.

McClinton 1970a. McClinton, Katharine Morrison. *Antiques of American Childhood.* New York: Bramhall House, 1970.

McClinton 1970b. McClinton, Katharine Morrison. "Fletcher and Gardiner: Silversmiths of the American Empire." *Connoisseur* 173 (March 1970): 211–21.

McCoubrey 1965. McCoubrey, John W. *American Art, 1700–1960: Sources and Documents.* Englewood Cliffs, N.J.: Prentice-Hall, 1965.

McFadden and Clark 1989. McFadden, David Revere, and Mark A. Clark. *Treasures for the Table: Silver from the Chrysler Museum.* New York: Hudson Hills Press, 1989.

McGarry 1993. McGarry, Susan Hallsten. "The Bayou Bend Collection." *Southwest Art* 23, no. 5 (October 1993): 89–93.

McGuire 1983. McGuire, James Patrick. *Hermann Lungkwitz, Romantic Landscapist on the Texas Frontier.* Austin: University of Texas Press for the Institute of Texan Cultures at San Antonio, 1983.

McInnis and Leath 1996. McInnis, Maurie D., and Robert A. Leath. "Beautiful Specimens, Elegant Patterns: New York Furniture for the Charleston Market, 1810–1840." In *American Furniture 1996.* Edited by Luke Beckerdite. Hanover, N.H.: Chipstone Foundation, 1996.

McKearin 1931. *Loan Exhibition of Early American Pottery and Early American Glass: The Examples Shown are from the Private Collection of George S. McKearin, Hoosick Falls, New York.* The Third International Antiques Exposition, New York City, February 27–March 7, 1931.

McKearin and McKearin 1941. McKearin, George S., and Helen McKearin. *American Glass.* New York: Crown Publishers, 1941.

McKearin and Wilson 1978. McKearin, Helen, and Kenneth M. Wilson. *American Bottles and Flasks and Their Ancestry.* New York: Crown Publishers, 1978.

McKinsey 1984. McKinsey, Kristan Helen. "New York City Silversmiths and Their Patrons, 1687–1750." University of Delaware, Master's Thesis, 1984.

McKinstry 1984. McKinstry, E. Richard. *Trade Catalogues at Winterthur, A Guide to the Literature of Merchandising.* New York: Garland Publishing, 1984.

McNairn 1980. McNairn, Alan. "American Paintings in the National Gallery of Ottawa, Canada." *Antiques* 118 (November 1980): 1010–17.

Memoirs of Louisiana 1892. *Biographical and Historical Memoirs of Louisiana.* Vol. 6. 1892.

Meyer 1975. Meyer, Jerry D. "Benjamin West's Chapel of Revealed Religion: A Study in Eighteenth-Century Protestant Religious Art." *The Art Bulletin* 57, no. 2 (June 1975): 247–65.

Middendorf 1967. *American Paintings and Historical Prints From the Middendorf Collection.* Exh. cat. Foreword by Stuart P. Feld. New York: Metropolitan Museum of Art, 1967.

Middleton 1953. Middleton, Margaret Simons. *Jeremiah Theus: Colonial Artist of Charles Town.* Columbia: University of South Carolina Press, 1953.

Middleton 1968. Middleton, W. E. Knowles. *The History of the Barometer.* Baltimore: Johns Hopkins Press, 1968.

Miles 1994. Miles, Ellen G. *Saint-Mémin and the Neoclassical Profile Portrait in America.* Washington, D.C.: National Portrait Gallery and Smithsonian Institution Press, 1994.

Miles 1995. Miles, Ellen G. *American Paintings of the Eighteenth Century: The Collections of the National Gallery of Art Systematic Catalogue.* Washington, D.C.: National Gallery of Art, 1995.

Miller 1937a. Miller, Edgar G., Jr. *American Antique Furniture, A Book For Amateurs.* 2 vols. New York: M. Barrows & Co., 1937.

Miller 1937b. Miller, V. Isabelle. *Silver by New York Makers.* Exh. cat. New York: Museum of the City of New York, 1937.

Miller 1943. Miller, V. Isabelle. "American Silver Spout Cups." *Antiques* 44 (August 1943): 73–75.

Miller 1956. Miller, V. Isabelle. *Furniture by New York Cabinetmakers 1650–1860.* Exh. cat. New York: Museum of the City of New York, 1956.

Miller 1962. Miller, V. Isabelle. *New York Silversmiths of the Seventeenth Century.* New York: Museum of the City of New York, 1962.

Miller 1981. Miller, Lillian B. "Charles Willson Peale as History Painter: *The Exhumation of the Mastodon.*" *The American Art Journal* 13, no. 1 (Winter 1981): 47–68.

Miller 1984. Miller, Steve. *The Art of the Weathervane.* Exton, Pa.: Schiffer Publishing, 1984.

Miller 1993. Miller, Alan. "Roman Gusto in New England: An Eighteenth-Century Boston Furniture Designer and His Shop." In *American Furniture 1993.* Edited by Luke Beckerdite. Hanover, N.H.: Chipstone Foundation, 1993: 160–200.

Miller 1996. Miller, Lillian B., ed. *The Peale Family: Creation of a Legacy, 1770–1870.* Exh. cat. New York: Abbeville Press in association with the Trust for Museum Exhibitions and the National Portrait Gallery, 1996.

Miller and Miller 1986. Miller, Mary Warren, and Ronald W. Miller. *The Great Houses of Natchez.* Jackson: University Press of Mississippi, 1986.

Miller and Ward 1991. Miller, Lillian B., and David C. Ward, eds. *New Perspectives on Charles Willson Peale: A 250th Anniversary Celebration.* Pittsburgh: University of Pittsburgh Press, 1991.

Milley 1975. Milley, James C. "Thoughts on Attribution of John Sharples Pastels." *University Hospital Antiques Show Catalogue.* Philadelphia, 1975.

Milley 1980. Milley, John C., ed. *Treasures of Independence: Independence National Historical Park and Its Collections.* New York: Mayflower Books, 1980.

Minor 1946. Minor, Edward E. "Notes on Early American Silver." *Antiques* 49 (April 1946): 238–40.

MOMA 1932. Museum of Modern Art. *American Folk Art: The Art of the Common Man in America: 1750–1900.* Exh. cat. New York: Museum of Modern Art, 1932.

Monahon 1965. Monahon, Eleanore Bradford. "Providence Cabinetmakers of the Eighteenth and Early Nineteenth Centuries." *Antiques* 87 (May 1965): 573–79.

Monahon 1980. Monahon, Eleanore Bradford. "The Rawson Family of Cabinetmakers in Providence, Rhode Island." *Antiques* 118 (July 1980): 134–47.

Monkhouse and Michie 1986. Monkhouse, Christopher P., and Thomas S. Michie. *American Furniture in Pendleton House.* Providence: Rhode Island School of Design, Museum of Art, 1986.

Montgomery 1939. Montgomery, Charles F. "Important Early American Pewter." *Antiques* 36 (September 1939): 118–21.

Montgomery 1966a. Montgomery, Charles F. "An Antiques Book Preview: *American Furniture of the Federal Period, 1788–1825.*" *Antiques* 90 (September 1966): 326–33.

Montgomery 1966b. Montgomery, Charles F. *American Furniture: The Federal Period in the Henry Francis du Pont Winterthur Museum.* New York: Viking Press, 1966.

Montgomery 1970. Montgomery, Florence M. *Printed Textiles: English and American Cottons and Linens, 1700–1850.* New York: Viking Press, 1970.

Montgomery 1978. Montgomery, Charles F. *A History of American Pewter.* New York: E. P. Dutton and Co., 1978.

Montgomery 1984. Montgomery, Florence M. *Textiles in America, 1650–1870.* New York: W. W. Norton, 1984.

Montgomery and Kane 1976. Montgomery, Charles F., and Patricia E. Kane, eds. *American Art: 1750–1800 Towards Independence.* Boston: New York Graphic Society for Yale University Art Gallery and the Victoria and Albert Museum, 1976.

Moon 1908. Moon, Robert C. *The Morris Family of Philadelphia, Descendants of Anthony Morris.* Philadelphia: Ketterlinus Litho. Manufacturing Co., 1908.

Mooney 1978. Mooney, James E. "Furniture at the Historical Society of Pennsylvania." *Antiques* 113 (May 1978): 1034–43.

Moore 1903. Moore, N. Hudson. *The Old Furniture Book.* New York: Frederick A. Stokes Co., 1903.

Mooz 1968. Mooz, R. Peter. "New Clues to the Art of Robert Feke." *Antiques* 94, no. 5 (November 1968): 702–7.

Mooz 1971a. Mooz, R. Peter. "Anne McCall by Robert Feke." *The Museum of Fine Arts, Houston Bulletin,* n.s., 2, no. 8 (December 1971): 151–54.

Mooz 1971b. Mooz, R. Peter. "The Origins of Newport Block-Front Furniture Design." *Antiques* 99 (June 1971): 882–86.

Mooz and Weekley 1978. Mooz, R. Peter, and Carolyn J. Weekley. "American Furniture at the Virginia Museum of Fine Arts." *Antiques* 113 (May 1978): 1052–63.

Morgan 1918. Morgan, John Hill. "The Work of M. Fevret de Saint-Mémin." *The Brooklyn Museum Quarterly* 5, no. 1 (January 1918): 5–26.

Morgan 1930. Morgan, John Hill. "Memento Mori: Mourning Rings, Memorial Miniatures, and Hair Devices." *Antiques* 17 (March 1930): 226–30.

Morgan 1942. Morgan, Edmund S. "Light on the Puritans from John Hull's Notebooks." *New England Quarterly* 15, no. 1 (1942): 95–101.

Morse 1924. Morse, Frances Clary. *Furniture of the Olden Time.* New edition. New York: Macmillan Co., 1924.

Morse 1986. Morse, Edgar W., ed. *Silver in the Golden State.* Oakland: Oakland Museum History Department, 1986.

Moses 1984. Moses, Michael. *Master Craftsmen of Newport: the Townsends and the Goddards.* Tenafly, N.J.: MMI Americana Press, 1984.

Moses and Moses 1982. Moses, Lisa, and Michael Moses. "Authenticating John Townsend's and John Goddard's Queen Anne and Chippendale Tables." *Antiques* 121 (May 1982): 1130–43.

Mott 1862. *The J. L. Mott Iron Works, . . . Manufacturers of Stoves, Ranges, Farmers' Boilers, Ornamental Iron Work, Plumbers' Iron and Enameled Ware, of all Kinds.* New York: Stater & Riley, 1862.

Mount 1946. Mount, Charles Merrill. *Gilbert Stuart: A Biography.* New York: W. W. Norton, 1946.

Mourot 1975. Mourot, Arthur J. "An Eighteenth-Century New Yorker: Information on Cabinetmaker Ash Elusive." *Antique Monthly* (March 1975): 18B–19B.

Mudge et al. 1985. Mudge, Jean M., et al. *Ceramics and Glass at the Essex Institute.* Salem, Mass.: Essex Institute, 1985.

Mugridge and Conover 1972. Mugridge, Donald H., and Helen F. Conover. *An Album of American Battle Art, 1755–1918.* Washington, D.C.: Library of Congress, 1947; reprint, New York: Da Capo Press, 1972.

Mussey and Haley 1994. Mussey, Robert, and Anne Rogers Haley. "John Cogswell and Boston Bombé Furniture: Thirty-Five Years of Revolution in Politics and Design." In *American Furniture 1994.* Edited by Luke Beckerdite. Hanover, N.H.: Chipstone Foundation, 1994: 73–106.

Myers 1926. Myers, Louis Guerineau. *Some Notes on American Pewterers.* Garden City, New York: Country Life Press, 1926.

Myers 1987. Myers, Susan H. "Edwin Bennett: An English Potter in Baltimore." *Ars Ceramica et Artes Glaesum.* No. 4. Wedgwood Society of New York, 1987: 31–35.

Myers and Mayhew 1974. Myers, Minor, Jr., and Edgar de N. Mayhew. *New London County Furniture 1640–1840.* New London, Connecticut: Lyman Allyn Museum, 1974.

Naeve 1978. Naeve, Milo M. *The Classical Presence in American Art.* Chicago: Art Institute of Chicago, 1978.

Naeve 1981. Naeve, Milo M. *Identifying American Furniture: A Pictorial Guide to Styles and Terms, Colonial to Contemporary.* Nashville: American Association for State and Local History, 1981.

Neff 1995. Neff, Emily Ballew. *John Singleton Copley in England.* Exh. cat. Houston: Museum of Fine Arts, Houston, in association with Merrell Holberton Publishers, London, 1995.

Nelson 1937. Nelson, Edna Deu Pree. "Walking Out with the Walking Stick." *Antiques* 32 (September 1937): 128–30.

Nelson and Houck 1982. Nelson, Cyril, and Carter Houck. *The Quilt Engagement Calendar Treasury.* New York: E. P. Dutton and Co., 1982.

New England Historical and Genealogical Register 1878. *New England Historical and Genealogical Register* 32 (January 1878): 59–60.

New Hampshire Historical Society 1973. *The Decorative Arts of New Hampshire: A Sesquicentennial Exhibition.* Exh. cat. Concord: New Hampshire Historical Society, 1973.

New Jersey 1958. *Early Furniture Made in New Jersey: 1690–1870.* Exh. cat. Newark: Newark Museum, 1958.

New Jersey Pottery 1972. *New Jersey Pottery to 1840.* Exh. cat. Trenton: New Jersey State Museum, 1972.

New-York Historical Society 1870. *New-York Historical Society Collections.* Vol. 3. (1870).

New-York Historical Society 1899. *New-York Historical Society Collections.* Vol. 32. (1899).

New-York Historical Society 1935. *New-York Historical Society Collections.* Vol. 68. (1935).

New-York Historical Society 1974. *Catalogue of American Portraits in the New-York Historical Society.* 2 vols. New Haven: Yale University Press, 1974.

New York Prices 1810. *The New-York Revised Prices for Manufacturing Cabinet and Chair Work June 1810.* Southwick and Pelsue, 1810.

New York Prices 1815. *Additional Prices Agreed Upon by the New-York Society of Journeymen and Cabinet Makers.* 1815.

New York Prices 1817. *The New-York Book of Prices from Manufacturing Cabinet and Chair Work.* Printed by J. Seymour, 1817.

New York Prices 1834. *The New-York Book of Prices for Manufacturing Cabinet and Chair Work.* Printed by Harper and Brothers, 1834.

Noe 1952. Noe, Sydney P. "The Pine Tree Coinage of Massachusetts." *Numismatic Notes and Monographs.* No. 125. New York: American Numismatic Society, 1952.

Noe 1973. Noe, Sydney P. *The Silver Coinage of Massachusetts.* Lawrence, Mass.: 1973.

Noël Hume 1961. Noël Hume, I. "Sleeve Buttons: Diminutive Relics of the Seventeenth and Eighteenth Centuries." *Antiques* 79 (April 1961): 380–83.

Norton 1923. Norton, Malcolm A. "More Light on the Block-Front." *Antiques* 3 (February 1923): 63–66.

Norton 1994. Norton, Bettina. "The Brothers Blyth: Salem in Its Heyday." In *Painting and Portrait Making in the American Northeast.* The Dublin Seminar for New England Folklife Annual Proceedings. Boston: Boston University, 1994: 46–63.

Nutting 1962. Nutting, Wallace. *Furniture Treasury (Mostly of American Origin).* 1928, 1954. 3 vols. Reprint, in 1 vol., New York: Macmillan Co., 1962.

Nutting 1965. Nutting, Wallace. *Furniture of the Pilgrim Century (of American Origin) 1620–1720.* Revised edition 1924. Reprint, in 2 vols., New York: Dover Publications, 1965.

Nygren et al. 1986. Nygren, Edward J., et al. *Views and Visions: American Landscape before 1830.* Exh. cat. Washington, D.C.: Corcoran Gallery of Art, 1986.

Nylander 1972. Nylander, Richard C. "Joseph Badger: American Portrait Painter." State University of New York College at Oneonta, Master's Thesis, 1972.

Nys 1977. *Johannis Nys, Silversmith c. 1671–1734.* Exh. brochure. Wilmington: Historical Society of Delaware, [1977].

Olcott 1974. Olcott, Lois L. "Kentucky Federal Furniture." *Antiques* 105 (April 1974): 870–82.

Olderr 1986. Olderr, Steven. *Symbolism: A Comprehensive Dictionary.* Jefferson, N.C.: McFarland and Co., 1986.

Oliver and Peabody 1982. Oliver, Andrew, and James Bishop Peabody, eds. *Publications of the Colonial Society of Massachusetts.* Vol. 56. Boston: Colonial Society of Massachusetts, 1982.

Orlofsky and Orlofsky 1974. Orlofsky, Patsy, and Myron Orlofsky. *Quilts in America.* New York: McGraw-Hill Book Co., 1974.

Ormsbee 1929. Ormsbee, Thomas H. "Phyfe né Fife." *Antiques* 16 (December 1929): 496–99.

Ormsbee 1944. Ormsbee, Thomas H. "The Del Vecchio Family, Mirror Makers of New York." *American Collector* 13, no. 4 (May 1944): 5.

Ormsbee 1957. Ormsbee, Thomas H. *Early American Furniture Makers: A Social and Biographical Study.* New York: Archer House, 1957.

Osterberg 1996. Osterberg, Richard. *Silver Hollowware for Dining Elegance: Coin and Sterling.* Atglen, Pa.: Schiffer Publishing Ltd., 1996.

Ott 1965. Ott, Joseph K. *The John Brown House Loan Exhibition of Rhode Island Furniture.* Providence: Rhode Island Historical Society, 1965.

Ott 1968. Ott, Joseph K. "John Townsend, a Chair, and Two Tables." *Antiques* 94 (September 1968): 388–90.

Ott 1975. Ott, Joseph K. "Some Rhode Island Furniture." *Antiques* 107 (May 1975): 940–51.

Ott 1982. Ott, Joseph K. "Lesser-Known Rhode Island Cabinetmakers: The Carliles, Holmes Weaver, Judson Blake, the Rawsons, and Thomas Davenport." *Antiques* 121 (May 1982): 1156–63.

Otto 1960. Otto, Celia Jackson. "The Secretary with Tambour Cartonnier." *Antiques* 77 (April 1960): 378–81.

Otto 1965. Otto, Celia Jackson. *American Furniture of the Nineteenth Century.* New York: Viking Press, 1965.

Palmer 1976. Palmer, Arlene M. *A Winterthur Guide to Chinese Export Porcelain.* New York: Crown Publishers, 1976.

Palmer 1989. Palmer, Arlene M. "'To the Good of the Province and Country': Henry William Stiegel and American Flint Glass." In *The American Craftsman and the European Tradition 1620–1820.* Edited by Francis J. Puig and Michael Conforti. Minneapolis: Minneapolis Institute of Arts, 1989: 202–39.

Palmer 1990. Palmer, Arlene M. "Book Review: *White House Glassware: Two Centuries of Presidential Entertaining* by Jane Shadel Spillman." *The Glass Club Bulletin* 160 (Winter 1989/90): 8–9.

Palmer 1993. Palmer, Arlene M. *Glass in Early America: Selections from the Henry Francis du Pont Winterthur Museum.* Winterthur: Henry Francis du Pont Winterthur Museum, 1993.

Palmer and Palmer 1973. Palmer, Richard N. and Eunice (Wood) Palmer, ed. *Palmer Families in America: Vol. III, William Palmer of Plymouth and Duxbury, Mass.* Somesworth: New Hampshire Publishing Co., 1973.

Park 1917. Park, Lawrence. "An Account of Joseph Badger, and a Descriptive List of His Work." *Proceedings of the Massachusetts Historical Society* 51 (October 1917–June 1918): 158–201.

Park 1926. Park, Lawrence, comp. *Gilbert Stuart: An Illustrated Descriptive List of His Works.* 4 vols. New York: W. E. Rudge, 1926.

Park 1973. Park, Helen. *A List of Architectural Books Available in America Before the Revolution.* Revised edition with a foreword by Adolf K.

Placzek. Los Angeles: Hennessey and Ingalls, 1973.

Parker and Wheeler 1938. Parker, Barbara Neville, and Anne Bolling Wheeler. *John Singleton Copley: American Portraits in Oil, Pastel, and Miniature with Biographical Sketches*. Boston: Museum of Fine Arts, Boston, 1938.

Parks 1958. Parks, Robert O. *Early New England Silver Lent from the Mark Bortman Collection*. Exh. cat. Northhampton, Mass.: Smith College Museum of Arts, 1958.

Parsons 1983. Parsons, Charles S. *New Hampshire Silver*. [Exeter, N. H.]: Adams Brown Co., 1983.

Passeri and Trent 1983. Passeri, Andrew, and Robert F. Trent. "Two New England Queen Anne Easy Chairs with Original Upholstery." *Maine Antique Digest* (April 1983): 26B–28B.

Payne 1891. Payne, Daniel A. *History of the African Methodist Episcopal Church*. Nashville: Publishing House of the A.M.E. Sunday School Union, 1891.

Payson 1978. Payson, Huldah Smith. *Museum Collections of the Essex Institute*. Salem, Mass.: Essex Institute, 1978.

Peale Papers 1983–96. *The Selected Papers of Charles Willson Peale and His Family*. Vol. 1: *Charles Willson Peale: Artist in Revolutionary America, 1735–1791*. Vol. 2, parts 1 and 2: *Charles Willson Peale: The Artist as Museum Keeper, 1791–1810*. Vol. 3: *The Belfield Farm Years, 1810–1820*. Vol. 4: *Charles Willson Peale: His Last Years, 1821–27*. Edited by Lillian B. Miller, Sidney Hart, Toby A. Appel, and David C. Ward. New Haven: Yale University Press for The National Portrait Gallery, Smithsonian Institution, 1983–96.

Pearce 1961. Pearce, John N. "New York's Two-Handled Paneled Silver Bowls." *Antiques* 80 (October 1961): 341–45.

Pearce 1966. Pearce, John N. "Further Comments on the Lobate Bowl Form." *Antiques* 90 (October 1966): 524–25.

Peck 1990. Peck, Amelia. *American Quilts and Coverlets in the Metropolitan Museum of Art*. New York: Metropolitan Museum of Art and Dutton Studio Books, 1990.

Peirce 1880. Peirce, Frederick Clifton. *Peirce Genealogy: Being the Record of the Posterity of John Pers, an Early Inhabitant of Watertown, in New England, Who Came from Norwich, Norfolk County, England; with Notes on the History of Other Families of Peirce, Pierce, Pearce, etc*. Worcester, Mass.: C. Hamilton, 1880.

Peirce 1997. Peirce, Donald C. "The Century Vase in the High Museum of Art." *Antiques* 151 (January 1997): 230–31.

Peirce and Alswang 1983. Peirce, Donald C., and Hope Alswang. *American Interiors: New England and the South*. Introduction by Diane H. Pilgrim. New York: Brooklyn Museum, 1983.

Pennsylvania 1811. *The Journeymen Cabinet and Chair Makers' Pennsylvania Book of Prices*. Printed for the Society, 1811.

Penzer 1954. Penzer, N. M. *Paul Storr: The Last of the Goldsmiths*. London: B. T. Batsford, 1954.

Perkins 1873. Perkins, Augustus Thorndike. *Sketch of the Life and a List of Some of the Works of John Singleton Copley*. Boston: James R. Osgood and Co., 1873.

Perry 1989. Perry, Barbara, ed. *American Ceramics:*

The Collection of Everson Museum of Art. New York: Rizzoli, 1989.

Peters 1976. Peters, Harry T. *America on Stone*. 1931. Reprint, New York: Arno Press, 1976.

Petraglia 1995. Petraglia, Patricia. *American Antique Furniture: 1640–1840*. New York: Friedman/Fairfax Publishers, 1995.

Pewter in American Life 1984. *Pewter in American Life*. Exh. cat. Boston: Pewter Collectors' Club of America; Providence: Mowbray Co., 1984.

Pforr 1974. Pforr, Effie Chalmers. *Progressive Farmer Award Winning Quilts*. Birmingham: Oxmoor House, 1974.

Philadelphia 1997. The 1997 Philadelphia Antiques Show: A Benefit for the Hospital of the University of Pennsylvania. [Pennsylvania, 1997.]

Philadelphia Painting and Printing 1971. *Philadelphia Painting and Printing to 1776*. Exh. cat. Philadelphia: Pennsylvania Academy of Fine Arts, 1971.

Phillips 1935. Phillips, John Marshall. *Early Connecticut Silver 1700–1830*. Exh. cat. New Haven: Yale University Art Gallery, 1935.

Phillips 1939. Phillips, John Marshall. *Masterpieces of New England Silver 1650–1800*. New Haven: Gallery of Fine Arts, Yale University, 1939.

Pierce 1899. Pierce, Frederick Clifton. *Foster Genealogy Being the Record of the Posterity of Reginald Foster. . . .* Vol. 2. Chicago: Frederick Clifton Pierce, W. B. Conkey Co., 1899.

Pierce and Slautterback 1991. Pierce, Sally, and Catharina Slautterback. *Boston Lithography 1825–1880*. Boston: Boston Athenaeum, 1991.

Pillsbury 1972. Pillsbury, William M. "Earning a Living 1788–1818: Job Danforth, Cabinetmaker." *Rhode Island History* 31, nos. 2 and 3 (Spring and Summer 1972): 80–93.

Pinckney 1967. Pinckney, Pauline. *Painting in Texas: The Nineteenth Century*. Fort Worth: Amon Carter Museum, 1967.

Piwonka 1986. Piwonka, Ruth. *A Portrait of Livingston Manor, 1686–1850*. Germantown, New York: Friends of Clermont, 1986.

Platt 1891. Platt, G. Lewis. *The Platt Lineage: A Genealogical Research and Record*. New York: Thomas Whittaker, 1891.

Pleasants 1947. Pleasants, J. Hall. *The Saint-Mémin Water Color Miniatures*. First published in the Walpole Society Notebook. Reprint, Portland, Maine: Anthoensen Press, 1947.

Pleasants and Sill 1972. Pleasants, J. Hall, and Howard Sill. *Maryland Silversmiths 1715–1830*. 1930. Reprint, with a foreword by the publisher, Harrison, N.Y.: Robert Alan Green, 1972.

PMA 1976. *Philadelphia: Three Centuries of American Art*. Philadelphia: Philadelphia Museum of Art, 1976.

Podmaniczky and Zimmerman 1994. Podmaniczky, Michael S., and Philip D. Zimmerman. "Two Massachusetts Bombé Desk-and-Bookcases." *Antiques* 145 (May 1994): 724–31.

Poesch 1972. Poesch, Jessie. *Early Furniture of Louisiana*. New Orleans: Louisiana State Museum, 1972.

Pointon 1993. Pointon, Marcia. *Hanging the Head: Portraiture and Social Formation in Eighteenth-Century England*. New Haven: Yale University Press for the Paul Mellon Centre for Studies in British Art, 1993.

Pope 1897. Pope, Charles Henry. *The Cheney Genealogy*. Boston: Charles H. Pope, 1897.

Pope and Loring 1917. Pope, Charles Henry, and Katharine Peabody Loring. *Loring Genealogy*. Cambridge, Mass.: Murray and Emory Co., 1917.

Porter 1937. "More Pots by A. Porter, Pewterer." *Antiques* 32 (November 1937): 241.

Prime 1938. Prime, Phoebe P., comp. and ed. *Three Centuries of Historic Silver: Loan Exhibitions under the Auspices of the Pennsylvania Society of the Colonial Dames of America*. Philadelphia: The Society, 1938.

Prime 1969. Prime, Alfred Coxe. *The Arts and Crafts in Philadelphia, Maryland, and South Carolina, 1721–1800: Gleaning from Newspapers*. 2 vols. 1929. Reprint, New York: Da Capo Press, 1969.

Prown 1966. Prown, Jules D. *John Singleton Copley*. 2 vols. Cambridge: Harvard University Press for the National Gallery of Art, 1966.

Prown 1986. Prown, Jules D. "John Singleton Copley in New York." *The Walpole Society Notebook*. The Society, 1986.

Puig 1989. Puig, Francis J. "The Early Furniture of the Mississippi River Valley, 1760–1820." In *The American Craftsman and the European Tradition 1620–1820*. Edited by Francis J. Puig and Michael Conforti. Minneapolis: Minneapolis Institute of Arts, 1989: 152–78.

Puig et al. 1989. Puig, Francis J., et al. *English and American Silver in the Collection of The Minneapolis Institute of Arts*. Minneapolis: Minneapolis Institute of Arts, 1989.

Quimby 1995. Quimby, Ian M. G., with Dianne Johnson. *American Silver at Winterthur*. Winterthur: Henry Francis du Pont Winterthur Museum, 1995.

Quinlan 1873. Quinlan, James Eldridge. *History of Sullivan: Embracing an Account of Its Geology, Climate, Aborigines, Early Settlement, Organization . . . with Biographical Sketches*. Liberty, New York: G. M. Beebe and W. T. Morgans, 1873.

Rabinovitch 1991. Rabinovitch, Benton Seymour. *Antique Silver Servers for the Dining Table*. Concord, Mass.: Joslin Hall Publishing, 1991.

Rainwater 1966. Rainwater, Dorothy T. *American Silver Manufacturers*. Hanover, Pa.: Everybody's Press, 1966.

Ramsay 1939. Ramsay, John. *American Potters and Pottery*. Boston: Hale, Cushman and Flint, 1939.

Ramsey 1954. Ramsey, L.G.G., ed. *The Concise Encyclopedia of Antiques*. 5 vols. New York: Hawthorn Books, 1954.

Randall 1959. Randall, Richard H., Jr. "Seymour Furniture Problems." *Museum of Fine Arts, Boston Bulletin* 57, no. 310 (1959): 103–13.

Randall 1960. Randall, Richard H., Jr. "An Eighteenth-Century Partnership." *Art Quarterly* 23 (Summer 1960): 152–61.

Randall 1962. Randall, Richard H., Jr. "Works of Boston Cabinetmakers, 1795–1825." Parts I and II. *Antiques* 81 (February 1962): 186–89; 81 (April 1962): 412–15.

Randall 1964a. Randall, Richard H., Jr. *The Decorative Arts of New Hampshire, 1725–1825*. Manchester, N.H.: Currier Gallery of Art, 1964.

Randall 1964b. Randall, Richard H., Jr. "George Bright, Cabinetmaker." *Art Quarterly* 27, no. 2 (1964): 134–49.

Randall 1965. Randall, Richard H., Jr. *American Furniture in the Museum of Fine Arts Boston*. Boston: Museum of Fine Arts, 1965.

Randall 1974. Randall, Richard. "William Randall, Boston Japanner." *Antiques* 105 (May 1974): 1127–31.

Randolph and Hastings 1941. Randolph, Howard S., and Mrs. Russell Hastings. "Jacob Boelen, Goldsmith, of New York and His Family Circle." *The New-York Genealogical and Biographical Record* 72, no. 4 (October 1941): 265–94.

Rasmussen 1991. Rasmussen, James A. "Gilbert Family of Albany and New York." *The New-York Genealogical and Biographical Record* 122, no. 3 (July 1991): 164–66.

Rather 1993. Rather, Susan. "Stuart and Reynolds: A Portrait of Challenge." *Eighteenth-Century Studies* 27, no. 1 (Fall 1993): 61–84.

Raymond 1946a. Raymond, Percy E. "Crown-Handled Porringers." *The Pewter Collectors' Club of America* 17 (January 1946): 9–14.

Raymond 1946b. Raymond, Percy E. "The Crown-Handle—An Interpretation." *The Pewter Collectors' Club of America* 19 (December 1946): 7–8.

Raymond 1946c. Raymond, Percy E. "Crown-Handled Porringers Again." *The Pewter Collectors' Club of America* 19 (December 1946): 15–16.

Raymond 1948. Raymond, Percy E. "Unique Crown-Handled Porringers." *Antiques* 53 (January 1948): 60–61.

Raymond 1958. Raymond, Percy E. "Crown-Handled Porringers." *The Pewter Collectors' Club of America* 39 (March 1958): 144–49.

Raymond 1959a. Raymond, Percy E. "American Pewter Porringers with Flowered Handles." *The Pewter Collectors' Club of America* 40 (January 1959): 1–9.

Raymond 1959b. Raymond, Percy E. "American 'Old English' Pewter Porringer Handles." *The Pewter Collectors' Club of America* 41 (September 1959): 19–25.

Read 1938. "Some Worth-While Examples of Maple Furniture From the Collection Made by Albert M. Read." *Antiques* 33 (March 1938): 138.

Rebora and Staiti 1995. Rebora, Carrie, and Paul Staiti. *John Singleton Copley in America*. Exh. cat. New York: Metropolitan Museum of Art, 1995.

Reilly 1991. Reilly, Bernard F. *American Political Prints 1766–1876: A Catalog of the Collection in the Library of Congress*. Boston: G. K. Hall and Co., 1991.

Reinert 1947. Reinert, Guy F. *Pennsylvania German Coverlets*. Plymouth Meeting, Pa.: C. N. Keyser, 1947.

Revere 1761–97. *Waste and Memoranda Book for the Workshop at Boston. Vol. 1, 1761–1783; Vol. 2, 1783–1797*. [These are sometimes referred to as daybooks.] Revere Family Papers. Massachusetts Historical Society.

Rhoades and Jobe 1974. Rhoades, Elizabeth, and Brock Jobe. "Recent Discoveries in Boston Japanned Furniture." *Antiques* 105 (May 1974): 1082–91.

Rhode Island 1908. *Representative Men and Old Families of Rhode Island*. Vol. 1. Chicago: J. H. Beers and Co., 1908.

Rhode Island Families 1983. *Genealogies of Rhode Island Families*. Baltimore: Genealogical Publishing Co., Inc., 1983.

Ribeiro 1984. Ribeiro, Aileen. *Dress in Eighteenth-Century Europe, 1715–1789*. New York: Holmes & Meier Publishers, 1984.

Rice 1962. Rice, Norman S. *New York Furniture Before 1840 in the Collection of the Albany Institute of History and Art*. Albany: Albany Institute of History and Art, 1962.

Rice 1964. Rice, Norman S. *Albany Silver, 1652–1825*. Exh. cat. Albany: Albany Institute of History and Art, 1964.

Rice and Stoudt 1929. Rice, A. H., and John Baer Stoudt. *The Shenandoah Pottery*. Strasburg, Va.: Shenandoah Publishing House, 1929.

Rich 1991. Rich, Amelia. *American Quilts and Coverlets*. New York: Metropolitan Museum of Art and Dutton Studio Books, 1991.

Richards 1974. Richards, Nancy E. "A Most Perfect Resemblance at Moderate Prices: The Miniatures of David Boudon." In *Winterthur Portfolio 9*. Charlottesville: University Press of Virginia, 1974: 77–101.

Richardson 1956. Richardson, Edgar P. *A Short History of Painting in America*. New York: Thomas Y. Crowell Co., 1956.

Richardson 1971. Richardson, Jonathan. *An Essay on the Theory of Painting*. Second edition, 1725. Reprint, Menston, Yorkshire: Scolar Press, 1971.

Richardson, Hindle, and Miller 1982. Richardson, Edgar P., Brooke Hindle, and Lillian B. Miller. *Charles Willson Peale and His World*. Exh. cat. New York: Harry N. Abrams, 1982.

Riefstahl 1923. Riefstahl, R. M. "Early American Glass Produced by the Foreign-Born Wistar and Steigel, But a True Expression of the Colonial Spirit." *International Studio* (April 1923): 8–11.

Rifken 1987. Rifken, Blume J. *Silhouettes in America, 1790–1840: A Collector's Guide*. Burlington, Vt.: Paradigm Press, 1987.

Ring 1975. Ring, Betty, ed. *Needlework: An Historical Survey*. New York: Universe Books, 1975.

Ring 1981. Ring, Betty. "Check List of Looking-Glass and Frame Makers and Merchants Known by Their Labels." *Antiques* 119 (May 1981): 1178–95.

Ring 1983. Ring, Betty. *Let Virtue Be a Guide to Thee: Needlework in the Education of Rhode Island Women, 1730–1830*. Providence: Rhode Island Historical Society, 1983.

Ring 1987. Ring, Betty. *American Needlework Treasures: Samplers and Silk Embroideries from the Collection of Betty Ring*. New York: E. P. Dutton and Co. and the Museum of American Folk Art, 1987.

Ring 1992. Ring, Betty. "Heraldic Embroidering in Eighteenth-Century Boston." *Antiques* 141 (April 1992): 622–31.

Ring 1993. Ring, Betty. *Girlhood Embroidery: American Samplers & Pictorial Needlework 1650–1850*. 2 vols. New York: Alfred A. Knopf, 1993.

Roach 1967. Roach, Ruth Hunter. *St. Louis Silversmiths*. N.p.: Roach, 1967.

Robert Gould Shaw 1880. The New England Historical and Genealogical Society. *A Biographical Sketch of Robert Gould Shaw*. Boston: 1880.

Roberts 1977. *The House Servant's Directory*. 1827. Reprint, with a foreword by Charles A. Hammond, Waltham, Mass.: Gore Place Society, 1977.

Rodriguez Roque 1984. Rodriguez Roque, Os-waldo. *American Furniture at Chipstone*. Madison: University of Wisconsin Press, 1984.

Roe and Trent 1982. Roe, Albert S., and Robert F. Trent. "Robert Sanderson and the Founding of the Boston Silversmiths' Trade." In *New England Begins: The Seventeenth Century*. 3 vols. Boston: Museum of Fine Arts, Boston, 1982: 480–500.

Rollins 1984. Rollins, Alexandra W. "Furniture in the Collection of the Dietrich American Foundation." *Antiques* 125 (May 1984): 1100–19.

Root 1975. Root, Arden. "Living with Antiques in the South." *Antiques* 107 (May 1975): 956–63.

Rose 1928. Rose, Jennie Haskell. "Some Charleston Silversmiths and Their Work." *Antiques* 13 (April 1928): 301–7.

Rosenbaum 1954. Rosenbaum, Jeanette W. *Myer Myers, Goldsmith 1723–1795*. Philadelphia: Jewish Publication Society of America, 1954.

Ross 1997. Ross, Charles L. "Harvest: The Bounty of a Farmhouse." *Veranda* (Summer 1997): 156–67.

Roth 1988. Roth, Rodris. "Tea Drinking in Eighteenth-Century America: Its Etiquette and Equipage." In *Material Life in America, 1600–1860*. Edited by Robert Blair St. George. Boston: Northeastern University Press, 1988: 439–62.

Rousseau 1979. Rousseau, Jean-Jacques. *Emile, or On Education*. 1762. Translated by Allan Bloom. Reprint, New York: Basic Books, 1979.

Roy 1992. Roy, Carolyn Parsons. "Textiles and Clothing." *Antiques* 142 (July 1992): 110–15.

Roylance 1990. Roylance, Dale. *American Graphic Arts: A Chronology to 1900 in Books, Prints, and Drawings*. Princeton: Princeton University Library, 1990.

Ruckman 1954. Ruckman, John F. "More about 'Love.'" *Antiques* 65 (May 1954): 388–89.

Ruckman 1962. Ruckman, John F. "Two More Forms Attributable to Peter Young." *The Pewter Collectors' Club of America* 47 (September 1962): 127–28.

Russell-Smith 1957. Russell-Smith, Faith. "Sleeve-Buttons of the Seventeenth and Eighteenth Centuries." *Connoisseur* 139, no. 559 (March 1957): 36–40.

Ruth 1883. Ruth, John A. *Decorum: A Practical Treatise on Etiquette and Dress of the Best American Society*. Revised by S. L. Louis, New York: Union Publishing House, 1883.

Rutledge 1955. Rutledge, Anna Wells. *The Annual Exhibition Record of the Pennsylvania Academy of the Fine Arts, 1807–1870: Being a Reprint with Revisions of the 1955 Edition of Anna Wells Rutledge's Cumulative Record of Exhibition Catalogues Incorporating The Society of Artist, 1800–1814 and The Artist's Fund Society, 1835–1845*. 3 vols. Edited by Peter Hastings Falk. Madison, Conn.: Sound View Press, 1988–89.

Sack 1950. Sack, Albert. *Fine Points of Furniture: Early American*. New York: Crown Publishers, 1950.

Sack 1969–92. *American Antiques from Israel Sack Collection*. Vols. 1–10. Washington, D.C.: Highland House Publishers, 1969–92 (to date).

Sack 1987. Sack, Harold. "The Furniture [in the United States Department of State]." *Antiques* 132 (July 1987): 160–73.

Sack 1988. Sack, Harold. "The Development of

the American High Chest of Drawers." *Antiques* 133 (May 1988): 1112–27.

Sack 1989. Sack, Harold. "The Bombé Furniture of Boston and Salem, Massachusetts." *Antiques* 135 (May 1989): 1178–89.

Sack 1993. Sack, Albert. *The New Fine Points of Furniture: Early American.* New York: Crown Publishers, 1993.

Sack and Levison 1990. Sack, Harold, and Deanne Levison. "Queen Anne and Chippendale Armchairs in America." *Antiques* 137 (May 1990): 1166–77.

Sack and Levison 1991. Sack, Harold, and Deanne Levison. "American Roundabout Chairs." *Antiques* 139 (May 1991): 934–47.

Sack and Wilk 1986. Sack, Harold, and Max Wilk. *American Treasure Hunt, The Legacy of Israel Sack.* Boston: Little, Brown, and Co., 1986.

Safford 1983. Safford, Frances Gruber. "Colonial Silver in the American Wing." *The Metropolitan Museum of Art Bulletin* 41, no. 1 (Summer 1983): 1–56.

Safford and Bishop 1972. Safford, Carleton L., and Robert Bishop. *America's Quilts and Coverlets.* New York: E. P. Dutton and Co., 1972.

Saint-Amand 1941. Saint-Amand, Mary Scott. *A Balcony in Charleston.* Richmond, Va.: Garrett and Massie Incorporated, 1941.

Sander 1986. Sander, Penny J. "Collections of the Society." *Antiques* 129 (March 1986): 596–605.

Sandon 1992. Sandon, John. "Shell-Decorated Worcester Porcelain." *Antiques* 141 (June 1992): 946–55.

Sands 1993. Sands, John O. "An Effect Which Far Exceeds any Conception" *The Colonial Williamsburg Journal* (Spring 1993): 72–73.

Sandweiss, Stewart, and Huseman 1989. Sandweiss, Martha A., Rick Stewart, and Ben W. Huseman. *Eyewitness to War: Prints and Daguerreotypes of the Mexican War, 1846–1848.* Fort Worth: Amon Carter Museum; Washington, D.C.: Smithsonian Institution Press, 1989.

Sanford 1911. Sanford, Carlton E. *The Thomas Sanford Family.* Rutland, Vt.: n.p., 1911.

Sanford 1947. "The First Hundred Years of American Furniture: The Sanford Collection at the Chicago Art Institute." *Antiques* 52 (September 1947): 183–85.

Santore 1981. Santore, Charles. *The Windsor Style in America.* Philadelphia: Running Press, 1981.

Santore 1987. Santore, Charles. *The Windsor Style in America.* Vol. 2. Philadelphia: Running Press, 1987.

Saunders 1979. Saunders, Richard H. "John Smibert (1688–1751): Anglo-American Portrait Painter." 2 vols. Yale University, Ph.D. Dissertation, 1979.

Saunders 1995. Saunders, Richard H. *John Smibert: Colonial America's First Portrait Painter.* New Haven: Yale University Press, 1995.

Saunders and Miles 1987. Saunders, Richard H., and Ellen G. Miles. *American Colonial Portraits, 1700–1776.* Exh. cat. Washington, D.C.: Smithsonian Institution Press for the National Portrait Gallery, 1987.

Savage and Newman 1976. Savage, George, and Harold Newman. *An Illustrated Dictionary of Ceramics.* 2nd ed. New York: Van Nostrand Reinhold Co., 1976.

Scherer 1984. Scherer, John L. *New York Furniture at the New York State Museum.* Alexandria, Va.: Highland House Publishers, 1984.

Scherer 1988. Scherer, John L. *New York Furniture: The Federal Period 1788–1825.* Albany: New York State Museum, 1988.

Schiffer 1978. Schiffer, Margaret Berwind. *Furniture and Its Makers of Chester County, Pennsylvania.* 1966. Revised and expanded edition, Exton, Pa.: Schiffer Publishing, 1978.

Schiffer, Schiffer, and Schiffer 1978. Schiffer, Peter, Nancy Schiffer, and Herbert Schiffer. *The Brass Book: American, English and European, Fifteenth Century through 1850.* Exton, Pa.: Schiffer Publishing, 1978.

Schorsch 1978. Schorsch, Anita. *The Art of the Weaver.* New York: Universe Books, 1978.

Schwartz 1982. Schwartz, Marvin D. *Chairs, Tables, Sofas and Beds.* The Knopf Collectors' Guides to American Antiques. New York: Alfred A. Knopf, 1982.

Schwartz 1993. Schwartz Philadelphia Gallery. *Fifty Years on Chestnut Street.* Exh. cat. *Philadelphia Collection* 52. Philadelphia: Schwartz, 1993.

Schwartz, Stanek, and True 1981. Schwartz, Marvin D., Edward J. Stanek, and Douglas K. True. *The Furniture of John Henry Belter and the Rococo Revival.* New York: E. P. Dutton and Co., 1981.

Seale 1970. Seale, William. *Sam Houston's Wife: A Biography of Margaret Lea Houston.* Norman: University of Oklahoma Press, 1970.

Sellers 1952. Sellers, Charles Coleman. *Portraits and Miniatures by Charles Willson Peale.* Philadelphia: American Philosophical Society, 1952.

Sellers 1957. Sellers, Charles Coleman. "Mezzotint Prototypes of Colonial Portraiture: A Survey Based on the Research of Waldron Phoenix Belknap, Jr." *Art Quarterly* 20, no. 4 (Winter 1957): 407–68.

Sellers 1969a. Sellers, Charles Coleman. *Charles Willson Peale.* New York: Charles Scribner's Sons, 1969.

Sellers 1969b. Sellers, Charles Coleman. *Charles Willson Peale with Patron and Populace: A Supplement to Portraits and Miniatures by Charles Willson Peale, with a Survey of his Work in other Genres.* Transactions of the American Philosophical Society, n.s., 59, pt. 3. Philadelphia, 1969.

Sellers 1974. Sellers, Charles Coleman. "The Portrait of a Little Lady: C. W. Peale's *Henrietta Maria Bordley.*" *Honolulu Academy of Arts Journal* 1 (1974): 9–15.

Sessions 1997. Sessions, Ralph. "Ship Carvers and the New York City Shop Figure Style." *Antiques* 151 (March 1997): 470–77.

Severens 1985. Severens, Martha R. "Jeremiah Theus of Charleston: Plagiarist or Pundit?" *The Southern Quarterly* 24, no. 1/2 (Fall/Winter 1985): 56–70.

Shadwell 1969. Shadwell, Wendy A. *American Printmaking: The First 150 Years.* Washington, D.C.: Smithsonian Institution Press, 1969.

Sharp 1989. "George Sharp." *Silver* 22, no. 4 (July–August 1989): 36–37.

Shaw 1880. *A Biographical Sketch of Robert Gould Shaw.* Boston: New England Historical and Genealogical Society for the Family, 1880.

Shawe-Taylor 1990. Shawe-Taylor, Desmond. *The Georgians: Eighteenth-Century Portraiture and Society.* London: Barrie and Jenkins, 1990.

Shelley 1961. Shelley, Donald A. *The Fraktur-Writings on Illuminated Manuscripts of the Pennsylvania Germans.* Allentown: Pennsylvania German Folklore Society, 1961.

Shepherd 1976. Shepherd, Raymond V., Jr. "Cliveden And Its Philadelphia-Chippendale Furniture: A Documented History." *The American Art Journal* 8 (November 1976): 2–16.

Sheraton 1970a. Sheraton, Thomas. *The Cabinet-Maker and Upholster's Drawing-Book.* 3rd ed., London, 1802. Reprint, edited by Wilford P. Cole and Charles F. Montgomery, New York: Praeger Publishers, 1970.

Sheraton 1970b. Sheraton, Thomas. *The Cabinet Dictionary.* London, 1803. 2 vols. Reprint, edited by Wilford P. Cole and Charles F. Montgomery, New York: Praeger Publishers, 1970.

Sherman 1932. Sherman, Frederick Fairchild. *Early American Painting.* New York: Century Co., 1932.

Sherman 1939. Sherman, Frederick Fairchild. "The Painting of Ralph Earl with a List of His Portraits." *Art in America* 27, no. 4 (October 1939): 163–78.

Shipton 1942. Shipton, Clifford K., ed. *Biographical Sketches of Those Who Attended Harvard College in the Classes 1713–1721 with Bibliographical and Other Notes.* Vol. 6 of *Sibley's Harvard Graduates.* Boston: Massachusetts Historical Society, 1942.

Shipton 1945. Shipton, Clifford K., ed. *Biographical Sketches of Those Who Attended Harvard College in the Classes 1722–1725 with Bibliographical and Other Notes.* Vol. 7 of *Sibley's Harvard Graduates.* Boston: Massachusetts Historical Society, 1945.

Shipton 1951. Shipton, Clifford K., ed. *Biographical Sketches of Those Who Attended Harvard College in the Classes 1726–1730 with Bibliographical and Other Notes.* Vol. 8 of *Sibley's Harvard Graduates.* Boston: Massachusetts Historical Society, 1951.

Shipton 1960. Shipton, Clifford K., ed. *Biographical Sketches of Those Who Attended Harvard College in the Classes 1741–1745 with Bibliographical and Other Notes.* Vol. 11 of *Sibley's Harvard Graduates.* Boston: Massachusetts Historical Society, 1960.

Shipton 1962. Shipton, Clifford K., ed. *Biographical Sketches of Those Who Attended Harvard College in the Classes 1746–1750 with Bibliographical and Other Notes.* Vol. 12 of *Sibley's Harvard Graduates.* Boston: Massachusetts Historical Society, 1962.

Shipton 1975. Shipton, Clifford K., ed. *Biographical Sketches of Those Who Attended Harvard College in the Classes 1746–1750 with Bibliographical and Other Notes.* Vol. 17 of *Sibley's Harvard Graduates.* Boston: Massachusetts Historical Society, 1975.

Shixiang 1986. Shixiang, Wang. *Classic Chinese Furniture—Ming and Early Qing Dynasties.* San Francisco: China Books and Periodicals and Joint Publishing Co. (HK), 1986.

Shoemaker 1903. Shoemaker, Benjamin H. *Genealogy of the Shoemaker Family of Cheltenham, Pennsylvania.* Philadelphia: J. B. Lippincott Co., 1903.

Silliman and Goodrich 1854. Silliman, Benjamin, Jr., and C. R. Goodrich, eds. *The World of Science, Art and Industry Illustrated from Examples in*

the *New-York Exhibition, 1853–54*. New York: G. P. Putnam and Co., 1854.

Simpson 1979. Simpson, Marc. *All that Glitters: Brass in Early America*. Exh. cat. New Haven: Yale University Printing Service, 1979.

Singleton 1901. Singleton, Esther. *The Furniture of our Forefathers*. 2 vols. New York: Doubleday, Page and Co., 1901.

Singleton 1902. Singleton, Esther. *Social New York Under the Georges 1714–1776*. New York: D. Appleton and Co., 1902.

Sizer 1950. Sizer, Theodore. *The Works of Colonel John Trumbull, Artist of the American Revolution*. New Haven: Yale University Press, 1950.

Sizer 1967. Sizer, Theodore. *The Works of Colonel John Trumbull, Artist of the American Revolution*. Revised edition. New Haven: Yale University Press, 1967.

Skerry 1981. Skerry, Janine Ellen. "Mechanization and Craft Structure in Nineteenth-Century Silversmithing: The Laformes of Boston." University of Delaware, Master's Thesis, 1981.

Sloane 1987. Sloane, Jeanne Vibert. "John Cahoone and the Newport Furniture Industry." *Old-Time New England: New England Furniture* 72. Boston: Society for the Preservation of New England Antiquities, 1987.

Smedley 1948. Smedley, Susanna. "The Story of Westtown Pewter." *The Pewter Collectors' Club of America* 21 (February 1948): 49–52.

Smibert 1969. *The Notebook of John Smibert*. Boston: Massachusetts Historical Society, 1969.

Smith 1883. Smith, John Chaloner. *British Mezzotint Portraits Being a Descriptive Catalogue of These Engravings From the Introduction of the Art to the Early Part of the Present Century*. London: Henry Sotheran and Co., 1883.

Smith 1894. Smith, C. S. *The Life of Daniel Alexander Payne*. 1894.

Smith 1896. Smith, Anna Wharten. *Genealogy of the Fisher Family 1682 to 1896*. Philadelphia: 1896.

Smith 1969. Smith, Robert C. "China, Japan, and the Anglo-American Chair." *Antiques* 96 (October 1969): 552–58.

Smith 1970a. Smith, George. *George Smith's Collection of Designs for Household Furniture and Interior Decoration*. 1808. Reprint, edited by Charles F. Montgomery and Benno M. Forman, New York: Praeger Publishers, 1970.

Smith 1970b. Smith, Sidney Adair. *Mobile Silversmiths and Jewelers 1820–1867*. Mobile: Historic Mobile Preservation Society, 1970.

Smith 1971. Smith, Sidney Adair. "Mobile Silversmiths and Jewelers 1820–1867." *Antiques* 99 (March 1971): 407–11.

Smith 1973. Smith, Robert C. "The Furniture of Anthony G. Quervelle. Part II: The Pedestal Tables." *Antiques* 104 (July 1973): 90–99.

Smith 1974. Smith, Edgar Newbold. *American Naval Broadsides: A Collection of Early Naval Prints (1745–1815)*. New York: Philadelphia Maritime Museum and Clarkson N. Potter, 1974.

Smith 1977. Smith, Sidney Adair. "The Arts in Mobile." *Antiques* 112 (September 1977): 482–91.

Smith et al. 1985. Smith, Jane Webb, et al. *Georgia's Legacy: History Charted Through the Arts*. Athens: Georgia Museum of Art, University of Georgia, 1985.

Snow 1965. Snow, Barbara. "Living with Antiques: The Providence Home of Mrs. R. H.

Ives Goddard." *Antiques* 87 (May 1965): 580–85.

Snyder 1975a. Snyder, John J., Jr. "Carved Chippendale Case Furniture from Lancaster, Pennsylvania." *Antiques* 107 (May 1975): 964–75.

Snyder 1975b. Snyder, Martin P. *City of Independence: Views of Philadelphia Before 1800*. New York: Praeger Publishers, 1975.

Soeffing 1988a. Soeffing, D. Albert. "Comments on the James Watts Article." *Silver* 21, no. 5 (September–October 1988): 36–37.

Soeffing 1988b. Soeffing, D. Albert. *Silver Medallion Flatware*. New York: New Books, Inc., 1988.

Soeffing 1988c. Soeffing, D. Albert. "Taylor and Lawrie, Philadelphia Silversmiths." *Silver* 21, no. 5 (September–October 1988): 18–19.

Soeffing 1991. Soeffing, D. Albert. "An Investigation of 'Premium' Marks." *Silver* 24, no. 4 (July–August 1991): 13–15.

Solny 1996. Solny, Susan. "Repose for the Noble Grape: A Study of Early Nineteenth-Century New York Sarcophagus-Shaped Cellerets." The Cooper-Hewitt and the Parsons School of Design, Master's Thesis, 1996.

Solny 1997. Solny, Susan. "Some Unusual Stylistic Preferences in New York Cellaret Design, 1810–1834." *Studies in the Decorative Arts* 5, no. 1. (Fall–Winter 1997–1998): 83–128.

Spargo 1924. Spargo, John. "The Facts About Bennington Pottery. Part II: The Works of Christopher Webber Fenton." *Antiques* 5 (May 1924): 230–37.

Spargo 1926. Spargo, John. *Early American Pottery and China*. New York: Century Co., 1926.

Spargo 1969. Spargo, John. *Potters and Pottery of Bennington*. 1926. Reprint, Southampton, New York: Cracker Barrel Press, 1969.

Spillman 1981. Spillman, Jane Shadel. *American and European Pressed Glass in the Corning Museum of Glass*. Corning, New York: Corning Museum of Glass, 1981.

Spillman 1982. Spillman, Jane Shadel. *Glass Tableware, Bowls, and Vases*. New York: Alfred Knopf, 1982.

Spillman and Frelinghuysen 1990. Spillman, Jane Shadel, and Alice Cooney Frelinghuysen. "The Dummer Glass and Ceramic Factories in Jersey City, New Jersey." *Antiques* 137 (March 1990): 706–17.

Spokas et al. 1980. Spokas, Anne E., et al. *American Silver 1670–1830: The Cornelius C. Moore Collection at Providence College*. Introduction by Alice H. R. Hauck. Providence: Rhode Island Bicentennial Foundation and Providence College, 1980.

Sprackling 1958. Sprackling, Helen. "Another American Caudle Cup." *Antiques* 74 (October 1958): 341.

Sprague 1987. Sprague, Laura Fecych, ed. *Agreeable Situations: Society, Commerce, and Art in Southern Maine, 1780–1830*. Kennebunk, Maine: Brick Store Museum, 1987.

Springer 1980. Springer, Lynn E. *American Furniture. Saint Louis Art Museum Bulletin* 15, no. 3. Saint Louis: Saint Louis Art Museum, 1980.

Springer 1982. Springer, Lynn E. "American Furniture in the Saint Louis Art Museum." *Antiques* 121 (May 1982): 1184–94.

Springer and Binder 1980. Springer, Lynn E., and Deborah J. Binder. *St. Louis Silversmiths*.

St. Louis: St. Louis Art Museum, 1980.

St. George 1979. St. George, Robert Blair. *The Wrought Covenant*. Brockton, Mass.: Brockton Art Center Fuller Memorial, 1979.

Staats 1921. Staats, Harold. *Genealogical Record of the Staats Family*. 1921.

Staiti 1981. Staiti, Paul. "Samuel F. B. Morse's Search for a Personal Style." In *Winterthur Portfolio* 16, no. 4. Chicago: University of Chicago Press, 1981: 253–81.

Staiti 1989. Staiti, Paul. *Samuel F. B. Morse*. Cambridge: Cambridge University Press, 1989.

Stalker and Parker 1960. Stalker, John, and George Parker. *A Treatise of Japanning and Varnishing*. 1688. With an introduction by H. D. Molesworth, London: Alec Tiranti, 1960.

Starbuck 1969. Starbuck, Alexander. *The History of Nantucket, County, Island and Town (Including Genealogies of First Settlers)*. Rutland, Vt.: Charles E. Tuttle Co., 1969.

Stauffer 1907. Stauffer, David McNeely. *American Engravers Upon Copper and Steel*. 2 vols. New York: Grolier Club, 1907.

Stebbins et al. 1983. Stebbins, Theodore E., Jr. *A New World: Masterpieces of American Painting 1760–1910*. Boston: Museum of Fine Arts, Boston, 1983.

Stein 1976. Stein, Roger B. "Copley's *Watson and the Shark* and Aesthetics in the 1770s." In *Discoveries and Considerations: Essays on Early American Literature and Aesthetics Presented to Harold Jantz*. Edited by Calvin Israel. Albany: State University of New York Press, 1976: 85–130.

Stein 1981. Stein, Roger B. "Charles Willson Peale's Expressive Design: The Artist in His Museum." *Prospects* 6 (1981): 139–85.

Steinberg 1993. Steinberg, David. "The Characters of Charles Willson Peale: Portraiture and Social Identity, 1769–1776." University of Pennsylvania, Ph.D. Dissertation, 1993.

Steinfeldt 1993. Steinfeldt, Cecilia. *Art for History's Sake: The Texas Collection of the Witte Museum*. Austin: Texas State Historical Association for the Witte Museum of the San Antonio Museum Association, 1993.

Steinfeldt and Stover 1973. Steinfeldt, Cecilia, and Donald L. Stover. *Early Texas Furniture and Decorative Arts*. San Antonio: Trinity University Press, 1973.

Stewart 1983. Stewart, J. Douglas. *Sir Godfrey Kneller and the English Baroque Portrait*. Oxford: Clarendon Press, 1983.

Stillinger 1980. Stillinger, Elizabeth. *The Antiquers*. New York: Alfred A. Knopf, 1980.

Stillinger 1990. Stillinger, Elizabeth. *American Antiques: The Hennage Collection*. Williamsburg: Colonial Williamsburg Foundation, 1990.

Stockwell 1961. Stockwell, David. "Irish Influence in Pennsylvania Queen Anne Furniture." *Antiques* 79 (March 1961): 269–71.

Stoneman 1959. Stoneman, Vernon C. *John and Thomas Seymour, Cabinetmakers in Boston, 1794–1816*. Boston: Special Publications, 1959.

Stoneman 1965. Stoneman, Vernon C. *A Supplement to John and Thomas Seymour, Cabinetmakers in Boston, 1794–1816*. Boston: Special Publications, 1965.

Stradling 1997. Stradling, J. G. "Puzzling Aspects of the Most Popular Piece of American Pottery Ever Made." *Antiques* 151 (Feb 1997): 332–37.

Streeter 1960. Streeter, Thomas W. *Bibliography of Texas 1795–1845.* Vol. 1. Cambridge: Harvard University Press, 1960.

Stretch 1932. Stretch, Carolyn Wood. "Early Colonial Clockmakers in Philadelphia." *The Pennsylvania Magazine of History and Biography* 56, no. 3 (July 1932): 225–35.

Sturgis 1903. Sturgis, Mrs. E.O.P. "A Sketch of the Chandler Family, in Worcester Massachusetts." From *Proceedings of Worcester Society of Antiquity.* Worcester: Charles Hamilton, 1903.

Summers 1958. Summers, Frances Rudulph. "James Conning, Southern Silversmith-Armorer." *Antiques* 74 (August 1958): 142–43.

Susswein 1934. Susswein, Rita. "Pre-Revolutionary Furniture Makers of New York City." *Antiques* 25 (January 1934): 6–10.

Swain 1982. Swain, Charles V. "X Quality Marks of the Wills." *The Pewter Collectors' Club of America* 84 (March 1982): 171–72.

Swan 1931a. Swan, Mabel M. "A Revised Estimate of McIntire." *Antiques* 20 (December 1931): 338–43.

Swan 1931b. Swan, Mabel M. "Where Elias Hasket Derby Bought His Furniture." *Antiques* 20 (November 1931): 280–82.

Swan 1932. Swan, Mabel M. "McIntire: Check and Countercheck." *Antiques* 21 (February 1932): 86–87.

Swan 1934a. Swan, Mabel M. "McIntire Vindicated: Fresh Evidence of the Furniture Carvers of Salem." *Antiques* 26 (October 1934): 130–32.

Swan 1934b. Swan, Mabel M. *Samuel McIntire, Carver and The Sandersons, Early Salem Cabinet Makers.* Salem, Mass.: Essex Institute, 1934.

Swan 1937. Swan, Mabel M. "John Seymour and Son, Cabinetmakers." *Antiques* 32 (October 1937): 176–79.

Swan 1945. Swan, Mabel M. "Newburyport Furniture Makers." *Antiques* 47 (April 1945): 222–25.

Swan 1946. Swan, Mabel M. "The Goddard and Townsend Joiners." 2 parts. *Antiques* 49 (April 1946): 228–31; (May 1946): 292–95.

Swan 1953. Swan, Mabel M. "American Slab Tables." *Antiques* 63 (January 1953): 40–43.

Swan 1957. Swan, Mabel M. "A Factual Estimate of Samuel McIntire." *Samuel McIntire: A Bicentennial Symposium 1757–1957.* Salem, Mass.: Essex Institute, 1957: 88–98.

Swan 1975. Swan, Susan B. "Worked Pocketbooks." *Antiques* 107 (February 1975): 298–303.

Swan 1977. Swan, Susan B. *Plain and Fancy: American Women and Their Needlework 1700–1850.* New York: Holt, Rinehart and Winston, 1977.

Sweeney 1963. Sweeney, John A. H. *Winterthur Illustrated.* New York: Chanticler Press, 1963.

Sweeney 1984a. Sweeney, Kevin M. "Furniture and the Domestic Environment in Wethersfield, Connecticut, 1639–1800." *The Connecticut Antiquarian* (The Bulletin of The Antiquarian and Landmarks Society, Incorporated) 36, no. 2 (December 1984): 10–39.

Sweeney 1984b. Sweeney, Kevin M. "Furniture and Furniture Making in Mid-Eighteenth Century Wethersfield, Connecticut." *Antiques* 125 (May 1984): 1156–63.

Sweeney 1988. Sweeney, Kevin M. "Furniture and the Domestic Environment in Wethersfield, Connecticut, 1639–1800." In *Material Life in America, 1600–1860.* Edited by Robert Blair St. George. Boston: Northeastern University Press, 1988: 261–90.

Sweeney 1995. Sweeney, Kevin M. "Regions and the Study of Material Culture: Explorations Along the Connecticut River." In *American Furniture 1995.* Edited by Luke Beckerdite and William N. Hosley. Hanover, N.H.: Chipstone Foundation, 1995: 146–166.

Symonds 1935. Symonds, R.W. "The English Export Trade in Furniture to Colonial America." 2 parts. *Antiques* 27 (June 1935): 214–17; 28 (October 1935): 156–59.

Sympson 1726. Sympson, Samuel. *A New Book of Cyphers More Compleat and Regular Than Any Yet Extant.* London, 1726.

Taft 1930. Taft, Lorado. *The History of American Sculpture.* 1903. Reprint, New York: MacMillan Co., 1930.

Taggart 1967. Taggart, Ross E. *The Frank P. and Harriet C. Burnap Collection of English Pottery in the William Rockhill Nelson Gallery.* Second edition. Kansas City, Mo.: Nelson Gallery-Atkins Museum, 1967.

Taggart 1982. Taggart, Ross E. "American Paintings in the Nelson-Atkins Museum of Art, Kansas City, Missouri." *Antiques* 122 (November 1982): 1026–39.

Talbott 1975. Talbott, Page. "Boston Empire Furniture: Part I." *Antiques* 107 (May 1975): 878–87.

Talbott 1991. Talbott, Page. "Seating Furniture in Boston, 1810–1835." *Antiques* 139 (May 1991): 956–69.

Talbott 1995. Talbott, Page. *Classical Savannah: Fine and Decorative Arts, 1800–1840.* Savannah: Telfair Museum of Art, 1995.

Tatham 1981. Tatham, David. "Edward Hicks, Elias Hicks and John Comly: Perspectives on the Peaceable Kingdom Theme." *The American Art Journal* 13, no. 2 (Spring 1981): 37–50.

Taylor 1909. Taylor, Agnes Longstreth. *The Longstreth Family Records.* 2 vols. Philadelphia: Ferris and Leach, 1909.

Taylor and Warren 1975. Taylor, Lonn, and David B. Warren. *Texas Furniture: The Cabinetmakers and Their Work, 1840–1880.* Austin: University of Texas Press, 1975.

Teahan and McClelland 1982. Teahan, John, and Donald R. McClelland. *Irish Silver from the Seventeenth to the Nineteenth Century.* Exh. cat. Washington, D.C.: Smithsonian Institution, 1982.

Texas 1895. *History of Texas Together with a Biographical History of the Cities of Houston and Galveston.* Chicago: Lewis Publishing Co., 1895.

Texas Quilts 1986. *Texas Quilts—Texas Treasures.* Kingwood: Texas Heritage Quilt Society, 1986.

Theta 1988. *Theta Charity Antiques Show Catalogue.* Houston, 1988.

Thomas 1972. Thomas, John Carl. "A Variant IC Porringer." *The Pewter Collectors' Club of America* 67 (December 1972): 249.

Thomas 1973. Thomas, M. Halsey, ed. *The Diary of Samuel Sewall.* New York: Farrar, Straus, and Giroux, 1973.

Thomas 1975. Thomas, John Carl. "Pewter Mugs, Pots or Cans." *The Pewter Collectors' Club of America* 71 (August 1975): 43–50.

Thomas 1976. Thomas, John Carl. *Connecticut Pewter and Pewterers.* Hartford: Connecticut Historical Society, 1976.

Thomas and Ward 1989. Thomas, Moira, and Barbara Ward, eds. *The Making of a Mansion: Samuel McIntire and the Creation of the Derby's Dream.* Exh. cat. Salem, Mass.: Essex Institute, 1989.

Thompson 1911. Thompson, William Baker. *Thompson Lineage and Allied Families.* Harrisburg, Pa.: Telegraph Printing Co., 1911.

Thorn 1947. Thorn, C. Jordan. *Handbook of Old Pottery and Porcelain Marks.* New York: Tudor Publishing Co., 1947.

Tice 1990. Tice, Patricia M. *Ice Cream For All.* Rochester: The Strong Museum, 1990.

Ticher 1972. Ticher, Kurt. *Irish Silver in the Rococo Period.* Shannon, Ireland: Irish University Press, 1972.

Torrey 1928. Torrey, Arthur H. "The Morgan Collection of Portraits." *The Brooklyn Museum Quarterly* 15, no. 2 (April 1928): 52–54.

Totten 1935. Totten, John Reynolds. "Richaud and Richard Family Notes." *The New York Genealogical And Biological Record* 66, no. 2 (April 1935): 122–39; no. 3 (July 1935): 245–57.

Townsend 1932. Townsend, Annette. *The Auchmuty Family of Scotland and America.* New York: Grafton Press, 1932.

Tracy 1981. Tracy, Berry B. *Federal Furniture and Decorative Arts at Boscobel.* New York: Boscobel Restoration and Harry N. Abrams, 1981.

Tracy and Gerdts 1963. Tracy, Berry B., and William H. Gerdts. *Classical America 1815–1845.* Exh. cat. Newark: Newark Museum, 1963.

Tracy et al. 1970. Tracy, Berry B., et al. *Nineteenth-Century America: Furniture and Other Decorative Arts.* Exh. cat. New York: Metropolitan Museum of Art, 1970.

Tracy et al. 1976. Tracy, Berry B., et al. *A Bicentennial Treasury: American Masterpieces from the Metropolitan.* New York: Metropolitan Museum of Art, 1976.

Trent 1975. Trent, Robert F. "The Joiners and Joinery of Middlesex County, Massachusetts, 1630–1730." In *Winterthur Conference Report 1974: Arts of the Anglo-American Community in the Seventeenth Century.* Edited by Ian M. G. Quimby. Charlottesville, University Press of Virginia for the Henry Francis du Pont Winterthur Museum, 1975: 123–48.

Trent 1989. Trent, Robert F. "The Colchester School of Cabinetmaking, 1750–1800." In *The American Craftsman and the European Tradition 1620–1820.* Edited by Francis J. Puig and Michael Conforti. Minneapolis: Minneapolis Institute of Arts, 1989: 112–35.

Trent and Nelson 1985. Trent, Robert F., and Nancy Lee Nelson. "A Catalogue of New London County Joined Chairs." *The Connecticut Historical Society Bulletin* 50 (Fall 1985): 37–195.

Trupin 1984. Trupin, Bennett W. *Elias Pelletreau, 1726–1810: Goldsmith of Southampton, Long Island, New York.* Smithtown, N.Y.: Exposition Press, 1984.

Tucker 1957. *Tucker China 1825–1838.* Exh. cat. Philadelphia: Philadelphia Museum of Art, 1957.

Tuckerman 1867. Tuckerman, Henry T. *Book of the Artists: American Artist Life.* New York: G. P. Putnam and Son, 1867.

Turner 1972. Turner, Noel D. *American Silver Flatware 1837–1910.* South Brunswick and New York: A. S. Barnes and Co., 1972.

Tyler 1983. Tyler, Ron, ed. *Prints of the American West: Papers Presented at the Ninth Annual North American Print Conference.* Fort Worth: Amon Carter Museum, 1983.

Tyler 1987. Tyler, Ron. *American Frontier Life.* New York: Abbeville Press, 1987.

Tyler 1996. Tyler, Ron, ed. *The New Handbook of Texas.* Austin: State Historical Association, 1996.

Utica Silver 1972. *Utica Silver.* Exh. cat. New York: Munson-Williams-Proctor Institute, 1972.

V&A Press Cuttings. Press Cuttings collected at the National Art Library of the Victoria and Albert Museum, London.

Van Cott 1989. Van Cott, Margaret C. "The Del Vecchios of New York." *Furniture History* 25 (1989): 221–34.

Van Laer 1908. Van Laer, A.J.F. *Van Rensselaer Bowier Manuscripts.* Albany: University of the State of New York, 1908.

Venable 1985. Venable, Charles L. "Texas Biedermeier Furniture." *Antiques* 127 (May 1985): 1166–71.

Venable 1989. Venable, Charles L. *American Furniture in the Bybee Collection.* Austin: University of Texas Press, 1989.

Venable 1994. Venable, Charles L. *Silver in America, 1840–1940: A Century of Splendor.* Dallas: Dallas Museum of Art, 1994.

Victor 1979. Victor, Stephen K. "'From the Shop to the Manufactury' Silver and Industry, 1800–1970." In *Silver in American Life: Selections from the Mabel Brady Garvan and Other Collections at Yale University.* Edited by Barbara McLean Ward and Gerald W. R. Ward. New York: American Federation of Arts, 1979: 23–32.

Vincent 1974a. Vincent, Clare. "John Henry Belter: Manufacturer of All Kinds of Fine Furniture." In *Winterthur Conference Report 1973: Technological Innovation and the Decorative Arts.* Edited by Ian M. G. Quimby and Polly Anne Earl. Charlottesville: University Press of Virginia for the Henry Francis du Pont Winterthur Museum, 1974: 207–34.

Vincent 1974b. Vincent, Gilbert T. "The Bombé Furniture of Boston." In *Boston Furniture of the Eighteenth Century.* Boston: Colonial Society of Massachusetts, 1974: 137–96.

Vlach 1978. Vlach, John Michael. *The Afro-American Tradition in Decorative Arts.* Cleveland: Cleveland Museum of Art, 1978.

Voglhuber 1971. Voglhuber, Rudolf. *Taler Und Schautaler Des Erzhauses Habsburg.* Frankfort a. M.: Numismatischer Verlag, 1971.

von Erffa and Staley 1986. von Erffa, Helmut, and Allen Staley. *The Paintings of Benjamin West.* New Haven: Yale University Press, 1986.

von Khrum 1978. von Khrum, Paul. *Silversmiths of New York City, 1684–1850.* New York: von Khrum, 1978.

Voorsanger 1994. Voorsanger, Catherine Hoover. "From Bowery to Broadway: The Herter Brothers and the New York Furniture Trade." In *Herter Brothers: Furniture and Interiors for a Gilded Age.* New York: Harry N. Abrams, 1994: 56–77.

Vose 1981. Vose, Robert C., Jr. "Boston's Vose Galleries: A Family Affair." *Archives of American Art Journal* 21, no. 1 (1981): 8–20.

Wainwright 1964. Wainwright, Nicholas B. *Colonial Grandeur in Philadelphia: The House and Furniture of General John Cadwalader.* Philadelphia: Historical Society of Pennsylvania, 1964.

Walsh 1988. Walsh, Susan. *The Elmer R. Webster and Robert A. Titsch Collection of American Quilts and Coverlets.* Dayton, Ohio: Dayton Art Institute, 1988.

Ward 1977. Ward, Gerald W. R., ed. *The Eye of the Beholder: Fakes, Replicas and Alterations in American Art.* Exh. cat. New Haven: Yale University Art Gallery, 1977.

Ward 1980. Ward, Gerald W. R. "American Pewter, Brass, and Iron in the Yale University Art Gallery." *Antiques* 117 (June 1980): 1304–7.

Ward 1983. Ward, Barbara McLean. "The Craftsman in a Changing Society: Boston Goldsmiths, 1690–1730." Boston University, Ph.D. Dissertation, 1983.

Ward 1986. Ward, Gerald W. R. *American Case Furniture.* New Haven: Yale University Art Gallery, 1986.

Ward 1988. Ward, Gerald W. R. *American Case Furniture in the Mabel Brady Garvan and Other Collections at Yale University.* New Haven: Yale University Press, 1988.

Ward 1989a. Ward, Barbara McLean. "The Edwards Family and the Silversmithing Trade in Boston, 1692–1762." In *The American Craftsman and the European Tradition 1620–1820.* Edited by Francis J. Puig and Michael Conforti. Minneapolis: Minneapolis Institute of Arts, 1989: 66–91.

Ward 1989b. Ward, Gerald W. R. "The Dutch and English Traditions in American Silver: Cornelius Kierstede." In *The American Craftsman and the European Tradition 1620–1820.* Edited by Francis J. Puig and Michael Conforti. Minneapolis: Minneapolis Institute of Arts, 1989: 136–51.

Ward and Hosley 1985. Ward, Gerald W. R., and William N. Hosley, Jr., eds. *The Great River: Art and Society of the Connecticut Valley, 1635–1820.* Hartford: Wadsworth Atheneum, 1985.

Ward and Ward 1979. Ward, Barbara McLean, and Gerald W. R. Ward, eds. *Silver in American Life: Selections from the Mabel Brady Garvan and Other Collections at Yale University.* New York: American Federation of Arts, 1979.

Ward and Ward 1981. Ward, Barbara McLean, and Gerald W. R. Ward. "Silver in American Life, An Exhibition." *Antiques* 120 (August 1981): 312–25.

Waring 1968. Waring, Janet. *Early American Stencils on Walls and Furniture.* 1937. Reprint, New York: Dover Publications, 1968.

Warren 1958. Warren, William Lamson. "The Pierpont Limner and Some of His Contemporaries." *The Connecticut Historical Society Bulletin* 23, no. 4 (October 1958): 97–128.

Warren 1966. Warren, David B. "American Decorative Arts in Texas: The Bayou Bend Collection of The Museum of Fine Arts of Houston." *Antiques* 90 (December 1966): 796–815.

Warren 1968. Warren, David B. *Southern Silver: An Exhibition of Silver Made in the South Prior to 1860.* Exh. cat. Houston: Museum of Fine Arts, Houston, 1968.

Warren 1970a. Warren, David B. "Baltimore Silver By Samuel Kirk." *The Museum of Fine Arts, Houston Bulletin,* n.s., 1, no. 8 (December 1970): 96–97.

Warren 1970b. Warren, David B. "The Bayou Bend Collection: A Maryland Low Chest." *The Museum of Fine Arts, Houston Bulletin,* n.s., 1, no. 6 (October 1970): 72–73.

Warren 1970c. Warren, David B. "The Bayou Bend Collection: A Philadelphia Card Table." *The Museum of Fine Arts, Houston Bulletin,* n.s., 1, no. 5 (September 1970): 60–61.

Warren 1970d. Warren, David B. "The Empire Style at Bayou Bend: New Period Rooms in Houston." *Antiques* 97 (January 1970): 122–27.

Warren 1971a. Warren, David B. "A Great Texas Collection of Americana: The Bayou Bend Collection at the Museum of Fine Arts, Houston." *The Connoisseur* 178 (September 1971): 36–55.

Warren 1971b. Warren, David B. "Recent Acquisitions, The Belter Parlor at Bayou Bend." *The Museum of Fine Arts, Houston Bulletin,* n.s., 2, no. 3 (1971): 30–36.

Warren 1972a. Warren, David B. "The Bayou Bend Collection: A Gift of Thomas Chippendale's *Director.*" *The Museum of Fine Arts, Houston Bulletin,* n.s., 3, no. 1 (March 1972): 8–10.

Warren 1972b. Warren, David B. "A Selection of Nineteenth Britannia at Bayou Bend." *The Museum of Fine Arts, Houston Bulletin,* n.s., 3, no. 5 (September 1972): 61–63.

Warren 1975. Warren, David B. *Bayou Bend: American Furniture, Paintings and Silver from the Bayou Bend Collection.* Houston: Museum of Fine Arts, Houston; Boston: New York Graphic Society, 1975.

Warren 1982. Warren, David B. "Ima Hogg, Collector." *Antiques* 121 (January 1982): 228–43.

Warren 1985. Warren, David B. "Focus on a Masterpiece." *Antique Monthly* (June 1985): 20B.

Warren 1988. Warren, David B. *Bayou Bend: The Interiors and the Gardens.* Houston: Museum of Fine Arts, Houston, 1988.

Warren 1993. Warren, David B. "The Reopening of Bayou Bend in Houston, Texas." *Antiques* 144 (September 1993): 328–37.

Warren 1996. Warren, David B. "Living with Antiques: A Houston Collection." *Antiques* 149 (May 1996): 726–35.

Warren, Howe, and Brown 1987. Warren, David B., Katherine S. Howe, and Michael K. Brown. *Marks of Achievement: Four Centuries of American Presentation Silver.* Houston: Museum of Fine Arts, Houston, in association with Harry N. Abrams, New York, 1987.

Wass 1988. Wass, Janice Tauer. *Weaver's Choice: Patterns in American Coverlets.* Springfield: Illinois State Museum, 1988.

Waters 1977. Waters, Deborah Dependahl. "From Pure Coin: The Manufacture of American Silver Flatware 1800–1860." In *Winterthur Portfolio* 12. Charlottesville: University Press of Virginia, 1977: 19–33.

Waters 1979. Waters, Deborah Dependahl. "Wares and Chairs: A Reappraisal of the Documents." In *Winterthur Portfolio* 13. Chicago: University of Chicago Press, 1979: 161–73.

Waters 1981. Waters, Deborah Dependahl. "The Workmanship of an American Artist: Philadelphia's Precious Metals Trades and Crafts, 1788–1832." University of Delaware, Ph.D. Dissertation, 1981.

Waters 1984. Waters, Deborah Dependahl. *Dela-*

ware Collections in the Museum of the Historical Society of Delaware. Wilmington: Historical Society of Delaware, 1984.

Watkins 1946. Watkins, Lura Woodside. "Henderson of New Jersey and His Pitchers." *Antiques* 50 (December 1946): 388–92.

Watkins 1968. Watkins, Lura Woodside. *Early New England Potters and Their Wares.* 1950. Reprint, Hamden, Conn.: Archon Books, 1968.

Watts 1968. Watts, Melvin E. *Pewter in America 1650–1900.* Manchester, N.H.: Currier Gallery of Art, 1968.

Weaks 1931. Weaks, Mabel C. "Captain Elias Pelletreau, Long Island Silversmith." 2 parts. *Antiques* 19 (May 1931): 365–68; (June 1931): 438–40.

Wearin 1965. Wearin, Otha D. *Statues That Pour.* Des Moines: Homestead Book Co., 1965.

Webber 1924. Webber, John Whiting. "A Massachusetts Pewterer." *Antiques* 5 (January 1924): 26–28.

Webster 1845. Webster, Thomas. *Encyclopaedia of Domestic Economy* New York: D. Meridith Reese, 1845.

Webster 1971. Webster, Donald Blake. *Decorated Stoneware Pottery of North America.* Rutland, Vt.: Charles E. Tuttle Co., 1971.

Webster 1983. Webster, J. Carson. *Erastus D. Palmer.* Newark: University of Delaware Press, 1983.

Weekley 1976. Weekley, Carolyn Jeannette. "John Wollaston, Portrait Painter: His Career in Virginia, 1754–1758." University of Delaware, Master's Thesis, 1976.

Weidman 1984. Weidman, Gregory R. *Furniture in Maryland, 1740–1940: The Collection of the Maryland Historical Society.* Baltimore: Maryland Historical Society, 1984.

Weidman et al. 1993. Weidman, Gregory R., et al. *Classical Maryland 1815–1845: Fine and Decorative Arts from the Golden Age.* Exh. cat. Baltimore: Maryland Historical Society, the Museum and Library of Maryland History, 1993.

Weil 1979. Weil, Martin Eli. "A Cabinetmaker's Price Book." *American Furniture and Its Makers.* In *Winterthur Portfolio* 13. Chicago: University of Chicago Press, 1979: 175–92.

Weiser and Heaney 1976. Weiser, Frederick Sheely, and Howell J. Heaney, comps. *The Pennsylvania German Fraktur of the Free Library of Philadelphia.* Breinigsville: Pennsylvania German Society, 1976.

Welsh 1965. Welsh, Peter C. *American Folk Art: The Art and Spirit of a People from the Eleanor and Mabel Van Alstyne Collection.* Washington, D.C.: Smithsonian Institution, 1965.

Werner 1979. Werner, Alfred. "Myer Myers: Silversmith of Distinction." *American Art and Antiques* 2, no. 3 (May–June 1979): 50–57.

West Point 1944. [An American Correspondent.] "Some Early Views of West Point: The United States Military Academy." *The Connoisseur* 114 (September 1944): 46–49.

Westervelt 1982. Westervelt, A. B., and W. T. Westervelt. *American Antique Weather Vanes: The Complete Illustrated Westervelt Catalog of 1883.* 1883. Reprint, New York: Dover Publications, 1982. Originally published under the title *Illustrated Catalogue and Price List of Copper*

Weather Vanes, Bannerets and Finials, Manufactured by A. B. & W. T. Westervelt.

Whatman 1987. Whatman, Susanna. *The Housekeeping Book of Susanna Whatman, 1776–1800.* Introduction by Christina Hardyment. London: Century, 1987.

Whig Portrait Gallery 1848. [The American Whig Review.] *The Whig Portrait Gallery.* [New York: American Review, 1848].

Whisker 1993. Whisker, James B. *Pennsylvania Silversmiths, Goldsmiths, and Pewterers, 1684–1900.* Lewiston, N.Y.: E. Mellen Press, 1993.

White 1948. White, Margaret E. *Quilts and Counterpanes in the Newark Museum.* Newark: Newark Museum, 1948.

White 1964. White, Margaret E. *The Decorative Arts of Early New Jersey.* Princeton: D. Van Nostrand Co., 1964.

White 1990. White, Elizabeth, comp. *Pictorial Dictionary of British Eighteenth Century Furniture Design: The Printed Sources.* Woodbridge, Suffolk, England: Antique Collectors' Club, 1990.

White House 1975. *The White House: An Historic Guide.* Twelfth edition. Washington, D.C.: White House Historical Association, 1975.

Whitehill, Jobe, and Fairbanks 1974. Whitehill, Walter Muir, Brock Jobe, and Jonathan Fairbanks. Foreword to *Boston Furniture of the Eighteenth Century.* Boston: Colonial Society of Massachusetts, 1974: v–xv.

Whitmore 1865. Whitmore, W. H. "The Oliver Family." *New England Historical and Genealogical Register* 19, no. 2 (April 1865): 100–06.

Whitney 1976. Whitney Museum of American Art. *Two Hundred Years of American Art.* Exh. cat. New York: Whitney Museum, 1976.

Willard 1968. Willard, John Ware. *Simon Willard and His Clocks.* New York: Dover Publications, 1968. Unabridged and corrected republication of the work originally printed by E. O. Cockayne, Boston, in 1911 under the title *A History of Simon Willard, Inventor and Clockmaker.*

Williams 1949. Williams, Carl M. *Silversmiths of New Jersey 1700–1825: With Some Notice of Clockmakers Who Were Also Silversmiths.* Philadelphia: George S. MacManus Co., 1949.

Williams 1985. Williams, Susan. *Savory Suppers and Fashionable Feasts: Dining in Victorian America.* New York: Pantheon Books in association with the Margaret Woodbury Strong Museum, 1985.

Wilson 1885. Wilson, James Grant. "Colonel John Bayard (1738–1807) and the Bayard Family of America." *The New York Genealogical and Biographical Record* 16, no. 2 (April 1885): 49–72.

Wilson 1972. Wilson, Kenneth M. *New England Glass and Glassmaking.* New York: Thomas Y. Crowell Co., 1972.

Wilson 1994. Wilson, Kenneth M. *American Glass, 1760–1930: The Toledo Museum of Art.* 2 vols. New York: Hudson Hills Press in association with the Toledo Museum of Art, 1994.

Wilson 1996. Wilson, Janet. *The Ingenious Mr. Peale: Painter, Patriot and Man of Science.* New York: Antiques, 1961.

Wiltshire 1975. Wiltshire, William E., III. *Folk Pottery of the Shenandoah Valley.* New York: E. P. Dutton and Co., 1975.

Winchester 1936. Winchester, Alice. "Footnote to

Tucker History." *Antiques* 30 (October 1936): 164–67.

Winchester 1941. Winchester, Alice. *Living with Antiques.* New York: Robert M. McBride, 1941.

Winchester 1956. Winchester, Alice. "Living with Antiques: The Milwaukee Home of Mr. and Mrs. Stanley Stone." *Antiques* 69 (May 1956): 436–39.

Winchester 1957a. Winchester, Alice. "Among the Young Collectors." *Antiques* 71 (February 1957): 150–55.

Winchester 1957b. Winchester, Alice. "The Prentis House at the Shelburne Museum." *Antiques* 71 (May 1957): 440–42.

Winchester 1959. Winchester, Alice. "Living with Antiques: Cliveden, the Germantown home of Mr. and Mrs. Samuel Chew." *Antiques* 76 (December 1959): 532–36.

Winchester 1961a. Winchester, Alice, ed. *Collectors and Collections: The Antiques Anniversary Book.* New York: Antiques, 1961.

Winchester 1961b. Winchester, Alice. "Early America in Texas." *Antiques* 80 (September 1961): 237.

Winchester 1963. Winchester, Alice, ed. *Living with Antiques: A Treasury of Private Homes in America.* New York: E. P. Dutton and Co., 1963.

Winchester et al. 1959. Winchester, Alice, et al., eds. *The Antiques Treasury.* New York, E. P. Dutton and Co., 1959.

Wister and Jayne 1924. W[ister], F[rances] K., and H[orace] H. F. J[ayne]. "Exhibition of Furniture in the Chippendale Style." *The Pennsylvania Museum Bulletin* (now *Philadelphia Museum of Art Bulletin*) 19, no. 86 (May 1924): 146–65.

Wolf 1975. Wolf, Melvyn D. "Crown-Handled Porringers—A Method of Identification." *The Pewter Collectors' Club of America* 71 (August 1975): 54–65.

Wolf 1984. Wolf, Melvyn D. "Marked Nineteenth Century American Pewter Fluid Lamps." *The Pewter Collectors' Club of America* 88 (March 1984): 303–63.

Wood 1967. Wood, Elizabeth Ingerman. "Thomas Fletcher: A Philadelphia Entrepreneur of Presentation Silver." In *Winterthur Portfolio 3.* Winterthur: Henry Francis Du Pont Winterthur Museum, 1967: 136–71.

Wood 1996. Wood, David F., ed. *The Concord Museum: Decorative Arts from a New England Collection.* Concord, Mass.: Concord Museum, 1996.

Woodhouse 1925. Woodhouse, Samuel W., Jr. "Philadelphia Cabinet Makers." *Philadelphia Museum of Art Bulletin* 20, no. 91 (January 1925): 62–69.

Woodhouse 1930. Woodhouse, Samuel W., Jr. "More About Benjamin Randolph." *Antiques* 17 (January 1930): 21–25.

Woodhouse 1932. Woodhouse, Samuel W., Jr. "John De Nys, Philadelphia Silversmith." *Antiques* 21 (May 1932): 217–18.

Woodhull 1882. Woodhull, Anna M.W., comp. "Memoir of Brig. Gen. Anthony Walton White of the Continental Army." Presented to the New Jersey Historical Society at Newark, May 18, 1882.

Woodside and Watkins 1932. Woodside, Charles L., and Lura Woodside Watkins. "Three Maine Pewterers." *Antiques* 22 (July 1932): 8–10.

Wright et al. 1966. Wright, Louis B., et al. *The*

Arts in America: The Colonial Period. New York: Charles Scribner's Sons, 1966.

Yarmon 1952. Yarmon, Morton. *Early American Antique Furniture*. Greenwich, Conn.: Fawcett Publications, 1952.

Yarnall and Gerdts 1986. Yarnall, James L., and William H. Gerdts, comps. *The National Museum of American Art's Index to American Art Exhibition Catalogues*. 6 vols. Boston: G. K. Hall and Co., 1986.

Young 1985. Young, Deborah A. *A Record for Time*. Halifax: Art Gallery of Nova Scotia, 1985.

Zimmerman 1981. Zimmerman, Philip D. "Workmanship as Evidence: A Model for Object Study." In *Winterthur Portfolio* 16, no. 4. Chicago: University of Chicago Press, 1981: 283–307.

Zimmerman 1996. Zimmerman, Philip D. "Philadelphia Queen Anne Chairs in Wright's Ferry Mansion." *Antiques* 149 (May 1996): 736–45.

Zimmerman 1997. Zimmerman, Philip D. "The Livingstons' Best New York City Furniture." *Antiques* 151 (May 1997): 716–23.

Zimmerman and Levy 1995. Zimmerman, Philip D., and Frank M. Levy. "An Important Block-Front Desk by Richard Walker of Boston." *Antiques* 147 (March 1995): 436–41.

Zoar 1984. "Zoar, Ohio: The Number One House." *Colonial Homes* (January–February 1984): 82–87.

Index

Gardner, Martha Goodwin Sanford Jordan Gardner and Martha Jordan Gardner (Mrs. Denny), 144

Gardner family, 22, 23; Samuel Pickering Gardner, 22; Mary Gardner (Mrs. Francis Cabot Lowell), George Gardner, Elizabeth Gardner (Mrs. Charles W. Amory), 23n.3

Gardner family: Thomas Gardner, Jr., Charles Gardner, Edmund Gardner, Edmund Barnard Gardner, Jr., Edmund Gardner, Edmund Sherman Gardner, Virginia Newcomb Gardner, 275

Garland, Thomas and Rachel, 182

Garner, Eli C., Sr., 308, 309

Garret family: Frank Robinson Garrett, Valeria Demarest Garrett, Lillie May Garrett, 192

Garsted, Margaretta (Mrs. William Overington Rowland, Sr.), 330

Garth's Auctions, 407, 420, 422

Garvan, Francis P., XVII, 311

Garwood, Mrs. Jean Forsythe, Morgan, and Susan, 259

Gates, Horatio, 306

Gatty, Joseph, 114n.2

Gayle, Natalie L., 328, 331

Gaylord, Edward, 237

Gebelein Silversmiths, 270, 339

Geffroy, Nicholas, 326, 327

George Abraham and Gilbert May Antiques, 348, 371, 372, 373, 374, 375, 376, 378, 379, 380, 381, 382, 383, 384, 404, 405, 423

George C. Bingham & Co., 230

George Corliss House, 146, 146n.1

Georgetown (D.C.), silver from: tongs, 339, M193; tumbler, 287, M35

Georgia, ceramic from: churn, 391, C81

Georgia, furniture from: side chairs, 126–27, F203

Georgia, silver from: snuffbox, 319, M98

Gerhart family: Tobias, Barbara (née Fulmer), Caterina Anna, 242

Germon, Dr. John T., 76

Gerretson, Abraham and Maria (Mrs. Abraham Newkirk), 51

Gerritsen, Alida (Mrs. Isaac Grevenraedt), 274

Gerry, John, 167–68, 168n.1; portrait of, 167–68, P5–6

Gerry, Robert L., III, 221

Gerry family: Thomas Gerry, 167, 168; Elizabeth Greenleaf Gerry, 167; Samuel Gerry, Elbridge Gerry, 167–68, 168n.2; Sarah Gerry, 168

Ghiselin, Cesar, 279

Gholson, Tom, 237

Gibb, General, 223

Gibbes, Ann, portrait of, 175

Gibbons, Edward, 106n.1

Gibbs, J. N., 390

Gibbs, James, 72

Gibbs, Mary (Mrs. Jesse H. Jones), 330, 333

Gibbs family, 248

Gibbs family: Dr. Jasper Gibbs, 329, 330n.3; Laura Jane Drake Gibbs, Sallie Candler Gibbs, 329

Gibbs family: Thomas and Sarah Gibbs, George Gibbs, Miriam Gibbs (Mrs. Saltus), George Judson Gibbs, George Albert St. George Gibbs, 278

Gibney, Michael, 336, 336n.1

Gibson, Thomas, 138

Gilbert, Elhana W., 233, 233n.1

Gilbert, Philo B., 342

Gilbert, William, 293, 294

Gill, Michael, portrait of, 182–83

Gill, Moses, portrait of, 178n.1

Gillinder and Sons, 417

Gillingham, James, 52

Gillows, the, 35n.2

Gilman family: Nathaniel and Dorothy Folsom Gilman, Abigail Gilman, 325

Gilman family: Rev. Samuel Gilman, 316–17; Caroline Howard Gilman, Abby Louisa Gilman (Mrs. Francis Porcher), 317

Gilmor, Mrs. Robert, portrait of, 207

Ginsburg and Levy, xv, 3, 8, 11, 12, 15, 16, 17, 24, 33, 35, 36, 37, 39, 40, 41, 43, 44, 46, 50, 52, 53, 57, 60, 61, 63, 66, 68, 69, 76, 79, 84, 91, 93, 94, 96, 100, 102, 106, 107, 112, 121, 133, 138, 152, 196, 261, 268, 272, 278, 281, 289, 296, 382

Glaever, Henryk, 6n.5

Glassell, Mr. and Mrs. Alfred C., Jr., 365

Glass Works of Henry William Stiegel, 404–6, 415, 427, 427n.1

Gleason, Roswell, 362

Glenn, Mr. and Mrs. Oscar, 417

Goddard, John, 24, 65, 73, 75nn. 1–2

Goddard, Thomas, 75n.1

Godefoy, Maximilian, 126

Godley, Mary McMullin and Margaret S., 341

Goldberg, Marcia, 199

Goldthwaite, Scott and Mildred, 29

Gooseneck Antiques, 263, 264

Gore, John and Samuel, 261

Gorham, Jabez, 313

Gorham family, 178, 179n.5

Gorham Manufacturing Company, 313, 313n.1, 334, 337, 341, 342, 344, 345, 345n.2

Goss, Elbridge Henry, The Life of Colonel Paul Revere, 295n.1

Gostelowe, Jonathan, 34, 34n.3

Gotjen, John Tiffany, 414

Gould, Nathaniel, 85

Gould, Mr. and Mrs. Richard N., 137

Governor's Mansion, Austin, Tx., XIII, XIV, XX, 144n.1

Graff, Frederick, 422

Graff, Washbourne & Dunn, 304n.1

Graham, Samuel, 257

Grangers, the, 415

Granite Glass Co., 408

Grant, Julia, 405

Grant, Ulysses S., 396n.3

Gray, Alice, 269

Greatbach, Daniel, 371, 373, 385

Great Britain, textiles from, 246–49, T1–2, T4, T6–7, T12, T15–16

Green, Francis, 282

Green, John, 282

Green, John, Clayton Trott, 178

Green, Joshua and Hannah, 282

Greenberg, William, 114

Green Bottle, The, 228

Greene, Benjamin, 295

Greene, Lucretia (Mrs. John Callahan), 294

Greenleaf, Dr. and Mrs. John, 170

Greenleaf, Mrs. John, portrait of, 170, P8

Greenleaf, Priscilla, Elizabeth, and John, 170; portraits of, 170

Greenwood, John, 170; Mrs. Benjamin Austin, 170; Portrait of Mrs. John Greenleaf, 170, P8

Greenwood, Pat, 340, 347

Greer, Georgeanna H., 390, 391

Gregg, Hayden & Company, 283

Greshoff, Francis A., 302

Grevenraedt family: Hendrick Grevenraedt, Henry Grevenraedt, Maria Grevenraedt (Mrs. David Van Ness Radcliffe), 274

Gridley, Enoch G., Pater Patriae, 231, W57

Griffin, Smith, and Hill, 376

Griffin Smith and Company, 376

Griffith, Mrs. James P. S., 287

Griffith, Mary R., 259

Griffith, Mr. and Mrs. Robert E., 259

Griscom, John, 399n.1, 400n.1

Griswold, Arthur B., 313n.3

Gros, Antoine-Jean, 206

Gross family: Frederick, Eatgarina (née Albert), Earl, 240

Grossman, H., 95

Guerazzi, John B., The Burning of the American Fregate the Philadelphia, 221

Guerin, E. R., 408, 416

Guggenheim, M. Robert, 414

Gulf Coast Chapter of the American Society of Interior Designers, 103

Gundry, Jas A., 141, 315, 321, 332, 334, 340, 341, 344, 345, 346

H

Hackberry Hill Antiques, 255

Haden, Dr. Henry Cooper, 287

Haden, Dr. John Miller, 287

Haden, Jim, 391

Hadsell, Ira, 256, 257n.1

Hales, Sir Thomas, portrait of, 172n.7

Hall, Charles, 298n.2

Hall, Ebenezer and Mary Jones, 38

Hall, Hewson & Brower, 347

Hall, John, 299

Hall, Rebecca, 248

Hall, Susan (Mrs. Joseph Loring, Jr.), 299, 325

Hallowell, Charlotte Bartlett Williamina Gray, 178, 179n.4

Halpert, Edith Gregor, 214, 214n.1, 216, 217

Hamilton, Andrew, 41

Hamilton, Dr. Alexander, 268

Hamilton, James, 27

Hamilton, William, 67n.3

Hamilton Collection, 409

Hamilton family, 41

Hamlen, Mrs. Dorothy Draper, 273

Hamlen, Paul M., 322

Hamlin, Samuel, 348, 350, 357, 358

Hamlin, Samuel Ely, 348, 350, 352, 357, 358

Hamman, Henry, 237

Hammerslough, Philip H., 279, 398

Hammitt, Kenneth, 127

Hancock, Dorothy Quincy, portrait of, 178, 179n.3, 183n.3

Hancock, John, 321; portraits of, 177, 178, 179n.3

Hancock, John George, 178, 178–79n.3

Hancock, Winfield Scott, portrait of, 378

Hancock family, 58

Hancock family: Ebenezer Hancock, John Hancock, Elizabeth Hancock (Mrs. Joseph Moriarity), 309

Hand, William, 398

Handal, Suzie, 421

Hanford, Hester, portrait of, 200

Hanszen, Mrs. Harry C. (Alice Nicholson; Mrs. Michael Hogg), 133, 135, 203, 204, 298, 417–18

Harding, Samuel, 38

Hardy, Sir Charles, portrait of, 172

Hare, Thomas Powel (Thomas Hare Powel), 124

Hare family: Esther Binney Hare, 124, 169; J. Innes Clark Hare, T. Truxton Hare, Jr., 169

Tucker, Charles, 221, 320, 328, 329, 330, 331, 337, 340, 341, 342, 344, 345, 347

Tucker, Charles Thomas, 347

Tucker, Mr. and Mrs. Gerrett R., 392

Tucker, Phyllis, 221, 307, 319, 320, 328, 329, 330, 331, 337, 340, 341, 342, 344, 345, 347, 365

Tucker, Thomas, 397, 398, 400, 402

Tucker, William Ellis, 392, 393, 394, 395, 397, 398, 399, 400, 401n.1, 401, 402

Tucker and Hemphill, 392, 393, 394, 395, 397, 398, 399, 400, 401, 402

Tucker and Hulme, 392, 393, 394, 395, 397, 398, 399, 400, 401, 402

Tuckerman, Henry, 205

Tufft, Thomas, 52

Turner, Helen H., 92

T. V. Carey Antiques and Decorations, 215

Tyler, Edward A., 335

U

Ullman, Mrs. Lawrence J., 246, 362

Union Porcelain Works, 209

United States, eastern, furniture from: dining table, 134, F216; mantel mirror, 149–50, F242; window cornices, 150, F243

United States, eastern, glass from: bottle, 424, G103; celery glass, 427, G115; decanters, 419–20, G89–90

United States, midatlantic states, textiles from, 248, 254, T10, T25

United States, midwestern, ceramic from: flask, 379, C38

United States, midwestern, glass from: pocket bottles, 406–7, G9, G13; figured flask, 409, G34

United States, northeastern, furniture from: box, 141, F231

United States, northeastern, iron from: andirons, 365–66, M266

United States, northeastern, pewter from: oil lamps, 362, M259

United States, southern, textile from, 251, T19

United States Porcelain Works, 396

United States Pottery Co., 370, 374–76, 377, 380, 381–82, 383, 384–86

Ursuline Convent, New Orleans, 343

V

Valdenuit, Thomas Blugeut de, 197

Van Buren, Martin, 197

van der Burch, Cornelius, 323

Vanderlyn, John, *Ariadne,* 238

Vanderspeigel, Jacobus, 323

Van Dyck, Sir Anthony, 181; *Algernon Percy, 10th Earl of Northumberland,* 172n.3

Van Dyck, Peter, 277, 278, 280

Van Dyck, Richard, 318

Van Loo, Jean-Baptiste, *Colley Cibber and His Daughter,* 189

Van Moran, Rose, 293

Van Ness, J., 257n.1

van Rensselaer, Kiliaen, 320

Van Rensselaer, Stephen, 409, 410, 411, 412

Van Voorhis, Daniel, 293

Varner Plantation, XIV, XV, 130n.1, 159

Vaughan, John, 194, 195nn. 1–2; portraits of, 194–95, P32

Vaughan family: John A. Vaughan, Dr. Charles Everett Vaughan, John F. Vaughan, 194; Samuel and Sarah Hollowell Vaughan, 195n.1

Vergoose, Elizabeth Foster, 83

Vermont, ceramics from. *See* Bennington

Vermont, silver from: spoons, 329, 339, M141, M191

Vernet, Claude or Carle, 133

Vernon, Nathaniel, 343

Vernon, Samuel (silversmith), 269, 272n.2, 280

Vernon family: Samuel Vernon, Elizabeth Vernon (Mrs. Valentine Wightman), William Vernon, Ann Vernon (Mrs. Robert M. Oliphant), 88

Verplanck, Daniel Crommelin, portrait of, 178, 182

Ver Plank family, 164

Vickers, John, 381

View of Houston, Capital of Texas, 236, W84

Villa Pottery, 372

Village Green Antiques, 232

Vincent Laforme and Brother, 304

Virginia, ceramics from: crock, 379–80, C40; doorstop, 387, C63; pitcher, 373–74, C11

Virginia, furniture from: table, 14, F25; wall cupboard, 113, F180

Virginia, silver from: spurs and buckles, 320, M101; spoon, 326, M119; tongs, 339, M193

Vose, Ann, 262, 263

Vose, Elijah, portrait of, 181

Vose, Isaac, 263

Vose, Mary Bemis, 263

Vose Galleries, 164, 165, 166, 169, 170, 178, 180, 195

W

Wade, Mr. and Mrs. Frank, 84, 85

Wagner and McGuigan, 237

Wainwright, Jack, 26

Wainwright family: John Tillotson Wainwright, I, John Tillotson Wainwright, II, Alice Cutts Wainwright, 25

Waldhorn Company, 333, 335

Waldo, Cornelius, 72

Waldo, Samuel Lovett, 199–200; *Hester Hanford,* 200; *Mrs. John Gamble,* 200; *Portrait of a Woman,* 199–200, P39

Wales, Mary Anne and Elizabeth (Mrs. Nathaniel Henry Emmons), 46

Walker, Andrew Craig, 395

Walker, Guy Warren, Jr., 24, 102

Walker, James B., 228; *The Storming of the Capultepec,* 227

Walker, Richard, 72

Wallace, Charles, 190, 191n.3

Walley, Edward, 372

Waln, William, 122, 123n.1, 124

Walter, Thomas U., 320

Walton, John S., 4, 10, 13, 16, 19, 22, 26, 34, 36, 46, 51, 56, 58, 62, 74, 88, 89, 92, 95, 100, 104, 130, 153, 351

Ward family: Mrs. Ephraim Ward (Mary Colman), Benjamin Colman Ward, Ellen Maria Ward, Julia Elizabeth Ward, 166, 167nn. 7–8

Ware family, 31

Warne, Thomas, 388, 389n.1

Warne and Letts, 389n.1

Warner, Andrew Ellicott, 302, 302n.1, 303, 307, 312, 313, 320

Warner, Joseph, 325

Warr, John and William W., 235n.1; *Map of Texas,* 235, W81

Warren, David B., XIX, 240, 319, 397

Warren, Florence, 240

Washburne, E. G., and Company, 215

Washington, D.C., painting from, 204–5, P43

Washington, D.C., silver from. *See* Georgetown

Washington, George, 35, 110, 193, 258n.1, 261, 321; images of, 194, 195n.2, 204, 209, 230–31, 258, 261–62, 340, 368, 370, 421–22

Watson, James, *Lady Ann Fortescue,* 176

Watson, John F., *Annals of Philadelphia and Pennsylvania,* 204

Wayne, Richard, 303

W. Birch & Son, *The House Intended for the President,* 236, W89

weathervanes, 213–15, P57–60

Webb, Electra (Havemeyer), XVIII

Webb, Joseph, 366

Webber, James and Keturah Jenkins, 13

Webster, John, 57–58

Webster, Thomas, 132, 337; *Encyclopaedia of Domestic Economy,* 132

Weeden family: Daniel Weeden, John Weeden, William Augustus Weeden, George W. Weeden, 64; Lucy A. Weeden, Elizabeth C. Weeden (Mrs. Barber), 64, 65

Weems, Mason L. (Parson Weems), 204

Weil, Henry V., 40

Weiner, Hyman, 220

Weir, John Ferguson, 238

Welch, John, 72

Wellford, Robert, 99n.6

Wellington, first Duke of, 313n.4

Wells, Mr. Herbert C., 259

Wendell, Henry, 55n.2

Wendt, John R., 332, 332n.1, 342, 343, 347

West, Benjamin, 174n.1, 180, 184, 186–87, 188, 188n.3, 192, 193, 195, 199, 200, 203n.3, 205, 206; *Battle of La Hogue,* 185; *Conversion of Onesimus,* 186, P24; *Noah Sacrificing,* 186–87, P25

West, Elizabeth Derby, 325

West, William Edward, *Battle of New Orleans and Death of Major General Packenham,* 223

Westall, Richard, 202

Weston family, 56

West Virginia, glass from: pane, 428, G119

Wetherill, Thomas, 122, 123n.1

Wevill, Richard, 104n.3

Wharton family: Joseph Wharton, Charles Wharton, Hannah Wharton (Mrs. Thomas G. Hollingsworth), XVIII, 83

Wheaton, Caleb, 75

Whedon, Ralph Gibbs, 278

Whimsy Antiques, 281, 354, 355, 358, 370, 371, 374, 376, 377, 380, 381, 382, 385, 386

Whirligig Antiques, 273, 329, 331, 332, 335

White, Elizabeth Mary (Mrs. Thomas M. Evans), 298, 316, 326

White, Luke, portrait of, 194

White, Thomas, 77, 78, 78n.2

White, William and Nancy Avery, 48–49

White family: Anthony White, 316; Anthony Walton White, 298, 298n.3, 316

Whitefield, George, portrait of, 172n.7

Whiting Manufacturing Company, 336, 336n.1, 340, 341, 342n.2

Whitmore, Jacob, 356

Whitney, Asa, 300

Whitney, Gertrude Vanderbilt, 234

Whitney Glass Co., 412

Whitney Museum, 234

Whittier, John Greenleaf, 229

Edited by Patricia Fidler
Designed by Bruce Campbell
Typeset in Monotype Dante with Centaur display by
The Composing Room, Grand Rapids, Michigan
Printed and bound by CS Graphics, Ltd.,
Singapore